ARTS & HUMANITIES
Through the Eras

ARTS & HUMANITIES
Through the Eras

Medieval Europe
814–1450

Kristen Mossler Figg and
John Block Friedman, Editors

THOMSON

GALE

Detroit • New York • San Francisco • San Diego • New Haven, Conn. • Waterville, Maine • London • Munich

Arts and Humanities Through The Eras: Medieval Europe (814–1450)

Kristen Mossler Figg and John Block Friedman

Project Editor
Rebecca Parks

Editorial
Danielle Behr, Pamela A. Dear, Rachel J. Kain, Ralph G. Zerbonia

Editorial Support Services
Mark Springer

Indexing Services
Barbara Koch

Imaging and Multimedia
Randy Bassett, Mary K. Grimes, Lezlie Light, Mike Logusz, Kelly A. Quin

Rights and Acquisitions
Margaret Chamberlain, Shalice Shah-Caldwell

Product Design
Michelle DiMercurio

Composition and Electronic Prepress
Evi Seoud

Manufacturing
Wendy Blurton

LIBRARY OF CONGRESS CATALOGING-IN-PUBLICATION DATA

Arts and humanities through the eras.
 p. cm.
 Includes bibliographical references and index.
 ISBN 0-7876-5695-X (set hardcover : alk. paper) —
 ISBN 0-7876-5696-8 (Renaissance Europe : alk. paper) —
 ISBN 0-7876-5697-6 (Age of Baroque : alk. paper) —
 ISBN 0-7876-5698-4 (Ancient Egypt : alk. paper) —
 ISBN 0-7876-5699-2 (Ancient Greece : alk. paper) —
 ISBN 0-7876-5700-X (Medieval Europe : alk. paper)
 1. Arts—History. 2. Civilization—History.
NX440.A787 2004
700′.9—dc22
 2004010243

This title is also available as an e-book.
ISBN 0-7876-9384-7 (set)
Contact your Thomson Gale sales representative for ordering information.

Printed in the United States of America
10 9 8 7 6 5 4 3 2 1

CONTENTS

Contents

ABOUT THE BOOK

SEEING HISTORY FROM A DIFFERENT ANGLE. An education in history involves more than facts concerning the rise and fall of kings, the conquest of lands, and the major battles fought between nations. While these events are pivotal to the study of any time period, the cultural aspects are of equal value in understanding the development of societies. Various forms of literature, the philosophical ideas developed, and even the type of clothes worn in a particular era provide important clues about the values of a society, and when these arts and humanities are studied in conjunction with political and historical events a more complete picture of that society is revealed. This inter-disciplinary approach to studying history is at the heart of the *Arts and Humanities Through the Eras* project. Patterned in its organization after the successful *American Decades*, *American Eras*, and *World Eras* products, this reference work aims to expose the reader to an in-depth perspective on a particular era in history through the study of nine different arts and humanities topics:

- Architecture and Design
- Dance
- Fashion
- Literature
- Music
- Philosophy
- Religion
- Theater
- Visual Arts

Although treated in separate chapters, the connections between these topics are highlighted both in the text and through the use of "See Also" references to give the reader a broad perspective on the culture of the time period. Readers can learn about the impact of religion on literature; explore the close relationships between dance, music, and theater; and see parallel movements in architecture and visual arts. The development of each of these fields is discussed within the context of important historical events so that the reader can see history from a different angle. This angle is unique to this reference work. Most history books about a particular time period only give a passing glance to the arts and humanities in an effort to give the broadest historical treatment possible. Those reference books that do cover the arts and humanities tend to cover only one of them, generally across multiple time periods, making it difficult to draw connections between disciplines and limiting the perspective of the discipline's impact on a specific era. In *Arts and Humanities Through the Eras* each of the nine disciplines is given substantial treatment in individual chapters, and the focus on one era ensures that the analysis will be thorough.

AUDIENCE AND ORGANIZATION. *Arts and Humanities Through the Eras* is designed to meet the needs of both the beginning and the advanced history student. The material is written by subject experts and covers a vast array of concepts and masterworks, yet these concepts are built "from the ground up" so that a reader with little or no background in history can follow them. Technical terms and other definitions appear both in the

text and in the glossary, and the background of historical events is also provided. The organization of the volume facilitates learning at all levels by presenting information in a variety of ways. Each chapter is organized according to the following structure:

- Chronology covering the important events in that discipline during that era

- Brief overview of the development of that discipline at the time

- Topics that highlight the movements, schools of thought, and masterworks that characterize the discipline during that era

- Biographies of significant people in that discipline

- Documentary sources contemporary to the time period

This structure facilitates comparative analysis, both between disciplines and also between volumes of *Arts and Humanities Through the Eras*, each of which covers a different era. In addition, readers can access additional research opportunities by looking at the "Further References" and "Media and Online Sources" that appear at the back of the volume. While every effort was made to include only those online sources that are connected to institutions such as museums and universities, the web-

sites are subject to change and may become obsolete in the future.

PRIMARY DOCUMENTS AND ILLUSTRATIONS. In an effort to provide the most in-depth perspective possible, *Arts and Humanities Through the Eras* also includes numerous primary documents from the time period, offering a first-hand account of the culture from the people who lived in it. Letters, poems, essays, epitaphs, and songs are just some of the multitude of document types included in this volume, all of which illuminate some aspect of the discipline being discussed. The text is further enhanced by 150 illustrations, maps, and line drawings that bring a visual dimension to the learning experience.

CONTACT INFORMATION. The editors welcome your comments and suggestions for enhancing and improving *Arts and Humanities Through the Eras*. Please mail comments or suggestions to:

The Editor
Arts and Humanities Through the Eras
Thomson Gale
27500 Drake Rd.
Farmington Hills, MI 48331-3535
Phone: (800) 347-4253

CONTRIBUTORS

Michael A. Batterman received his Ph.D. in art history from Northwestern University in 2000. He has spent the last three years on the faculty of the School of Art and Design at Southern Illinois University, Carbondale, and currently resides in Paris. His research has explored the artistic culture of Jewish communities in later medieval Christian Spain and the visual expression of cultural difference. Publications have also dealt with the modern historiography of medieval Jewish artistic production.

Michael T. Davis received the Ph.D. in the history of art from the University of Michigan in 1979, and taught at Texas Christian University, East Carolina University, and Princeton University before joining the faculty of Mount Holyoke College in 1982. He has also taught at the University of Michigan and Smith College. A collaborative research fellowship from the National Endowment for the Humanities funded a study of the methods of church plan design in the thirteenth and fourteenth centuries (with Professor Linda Neagley of Rice University). Davis has published studies of Clermont Cathedral and Limoges Cathedral, the papal church of Saint-Urbain in Troyes, the Cathedral of Notre-Dame and the royal palace in Paris. His current research is focused on the architecture of late medieval Paris, and he is preparing a book centering on an early fifteenth-century description of the city.

Tim J. Davis has spent the past ten years teaching religion, philosophy, and the humanities in the Columbus, Ohio, area. He holds a full-time position at Columbus State as well as part-time appointments at The Ohio State University and Otterbein College. Tim has earned a Ph.D. in the study of religion, a Master of Arts in medieval church history, as well as the Master of Divinity. His

published books include *St. Bernard of Clairvaux: A Monastic View of Medieval Violence* (McGraw-Hill, 1998), *Readings from the Christian Tradition*, compiled and edited with commentary (Campus Custom Publishing, 2000), and the forthcoming *History of the Abbey of the Genesee*. He has also written various articles on medieval Cistercian monasticism and is currently in the midst of a long-term project involving the assembly and publication of historical information on the Roman Catholic diocese of Youngstown.

Véronique P. Day received her Ph.D. in art history from Northwestern University in 1993. She has taught at the University of Iowa, Rhodes College in Memphis, St. Louis Community College, George Mason University, and Southern Illinois University, Carbondale. She is now an independent scholar living in Paris. Her research focuses on the social context of manuscript production in provincial France during the later Middle Ages. Her publications have dealt with the production and careers of particular illuminators from Poitiers, such as the Master of Yvon du Fou, Jehan Gillemer, and the Master of Walters 222.

Kristen Mossler Figg, Editor, received the Ph.D. in English at Kent State University in 1989 after completing a Bachelor of Arts in humanities and Master of Arts degrees in both French and English. She is professor of English at Kent State University, Salem Campus, where she directs the Honors program and teaches literature, history of the English language, and composition. Her books include *Jean Froissart: An Anthology of Narrative and Lyric Poetry* (New York: Routledge, 2001); *Trade, Travel, and Exploration in the Middle Ages: An Encyclopedia* (with John B. Friedman, Routledge, 2000); and *The*

Short Lyric Poems of Jean Froissart: Fixed Forms and the Expression of the Courtly Ideal (Garland, 1994). Recent articles have focused on genre distinctions in medieval lyrics, the role of animals in medieval society, and the history of Froissart manuscripts. She is past president of the Medieval Association of the Midwest and is currently serving as co-editor of *Publications of the Medieval Association of the Midwest.*

John Block Friedman, Editor, received the Ph.D. in English from Michigan State University in 1965. He taught at Connecticut College, Sir George Williams (Concordia) University, and the University of Illinois at Urbana-Champaign where he retired as professor emeritus of English in 1996. He has been a Woodrow Wilson Fellowship holder, a Guggenheim Foundation fellow, and the recipient of an American Council of Learned Societies award, and is on the editorial board of *The Chaucer Review.* He is currently visiting professor of English at Kent State University, Salem. His books include *Orpheus in the Middle Ages* (Harvard, 1970; Rpt. Syracuse University press, 2000); *The Monstrous Races in Medieval Art and Thought* (Harvard, 1981; Rpt. Syracuse University Press, 2000); *John de Foxton's Liber Cosmographiae (1408) An Edition and Codicological Study* (Leiden, Brill, 1988); *Northern English Books, Owners, and Makers* (Syracuse University Press, 1995); *Medieval Iconography: A Research Guide* (New York: Garland, 1998); and ed. with Kristen Figg, *Trade, Travel and Exploration in the Middle Ages: An Encyclopedia* (New York: Routledge, 2000). He has published many articles on medieval literature and iconography, most recently one on the fifteenth-century French illuminator Robinet Testard and his debt to the graphic arts. Currently, he is completing a book entitled *Realistic Observation of Nature and Society 1360–1530* to appear from Syracuse University Press.

Laura F. Hodges received the Ph.D. in literature from William Marsh Rice University in 1985, and taught literature and composition at the University of Houston at Clear Lake, California State University at Bakersfield, the University of Maryland's European Division, and the University of Houston in Houston, Texas, before retiring. Her books include *Chaucer and Costume: The Secular Pilgrims in the General Prologue*, Chaucer Studies 26 (D. S. Brewer, 2000); and *Chaucer and Clothing: Clerical and Academic Costume in the General Prologue to the Canterbury Tales*, forthcoming from D. S. Brewer, February 2005. She has published a number of articles specializing in depictions, and their functionality, of arms and armor, costumes, textiles, and cloth-making in medieval literature, as well as articles on John Steinbeck, Sir Thomas Malory, and Henry James. Initially schooled in the field of clothing and textiles, she blends this training with her later degree in literature and continues to research both the history of costume and costume as it is portrayed in the literary works of the Middle Ages.

R. James Long received the Licentiate in Mediaeval Studies from the Pontifical Institute of Mediaeval Studies in Toronto and a Ph.D. from the University of Toronto (1968). Following Fulbright and Canada Council post-doctoral fellowships to work at the Vatican Library, he accepted his current position in the Philosophy Department at Fairfield University. He currently serves as the general editor of the Fishacre edition at the Bavarian Academy of Sciences in Munich and is the incoming president of the Society for Medieval and Renaissance Philosophy. His books include (with Maura O'Carroll) *The Life and Works of Richard Fishacre OP. Prolegomena to the Edition of his Commentary on the 'Sentences'*, Band 21 (Munich, 1999); and Bartholomaeus Anglicus, *On the Properties of Soul and Body (De proprietatibus rerum libri III et IV)*, ed. (Toronto, 1979), the first edition since 1601 of the most popular of medieval encyclopedias. His many scholarly articles have focused on philosophy and theology at early thirteenth-century Oxford.

Timothy J. McGee received the Ph.D. in musicology from the University of Pittsburgh in 1974. He was appointed to the Faculty of Music, University of Toronto, in 1973, where, until his retirement in 2002, he taught music history, directed the Historical Performance Ensembles, and was cross-appointed to the Centre for Medieval Studies. In 1972 he founded the professional early music ensemble The Toronto Consort, and in 1993–94 was visiting professor at the Villa I Tatti in Florence. His areas of research include the history of music in Canada and the performance of music in the Western world before 1800. His books include *The Sound of Medieval Song: Vocal Style and Ornamentation According to the Theorists* (Oxford, 1998); *Medieval Instrumental Dances* (Indiana, 1989); *Medieval and Renaissance Music: A Performer's Guide* (University of Toronto, 1985); and *The Music of Canada* (Norton, 1985). He is currently working on a history of the civic musicians of Florence in the late Middle Ages.

Edward Peters, Advisor, received the Ph.D. in medieval studies from Yale University in 1967. He taught at the University of California, San Diego, before moving to the University of Pennsylvania in 1968, where he is the Henry Charles Lea Professor of History and curator of the Lea Library. He has received research fellowships from the American Philosophical Society, the American Council of Learned Societies, and the John Simon Guggenheim Foundation, and he has been a visiting professor twice at Yale University and twice at the Katholieke Universiteit Leuven, in Belgium. Much of his research has focused on the subject of the responses by authorities to heresy and witchcraft, illustrated in the annotated readers *Heresy and Authority in Medieval*

Europe (1980) and, with Alan C. Kors, *Witchcraft in Europe, 400–1700: A Documentary History* (2001). He has also published several articles on these subjects. He is currently collaborating with Richard G. Newhauser on *Curiosity and the Limits of Inquiry in the Western Tradition*, as well as an intellectual biography of Henry Charles Lea.

Lorraine Kochanske Stock received the Ph.D. in medieval studies from Cornell University in 1975, and has taught English and women's studies at the University of Houston since 1976. Stock served as president of the Southeastern Medieval Association (SEMA) from 2001–2003, and currently she serves as an elected councilor to the Modern Language Association "Division of Middle English Literature excluding Chaucer." She has published widely on medieval drama, Dante, Chaucer, the *Gawain*-poet, Langland, Froissart, Arthurian romance, medieval *translatio*, Robin Hood ballads, and various medieval iconographic figures such as the Green Man, the Wild Man, and the Celtic Sheela na Gig. Recently she began teaching and writing about twentieth-century cinematic treatments of medieval literature and culture. She is currently completing an interdisciplinary book about late medieval primitivism and the Wild Man figure.

Carol Symes received the Ph.D. in history from Harvard University in 1999 and has been on the faculty of the University of Illinois at Urbana-Champaign since 2002. Prior to that, she taught European history at Bennington College, while at the same time pursuing a career as a professional actress. She is the author of numerous articles on the manuscript transmission of medieval plays, and is currently at work on a book devoted to the intersection between theater and public life in thirteenth-century Arras. In 2004, she was the recipient of the Van Courtlandt Elliott prize of the Medieval Academy of America and, in 2003, of the Martin Stevens Award of the Medieval and Renaissance Drama Society.

ERA OVERVIEW

DEFINING THE MIDDLE AGES. Although the traditional term "Middle Ages" suggests that the years between the final fall of the Roman Empire in the sixth century and the full flowering of the Renaissance (literally "rebirth" of Roman and later Greek culture) in the fifteenth century was merely an interval between two great periods of civilization, the history of the arts and humanities in Western Europe during these centuries is, in fact, rich and varied. The era begins with the reign of the Frankish king Charlemagne—who by the time of his death in 814 had, under the auspices of the Latin Christian Church, reunited much of the former Western Roman Empire and joined to it parts of northern Europe that had never been under the rule of Rome. The period ends with the rise of humanism, which by 1450 dominated the art and literature of Italy and was spreading its influence northward. Between these two historical movements the medieval period encompassed major developments in political, economic, and cultural systems, all of which were reflected in the artistic, intellectual, and spiritual movements of the era.

A PERIOD OF REORGANIZATION. The emergence of Western Europe as a distinct culture occurred in large part as the result of the administrative division of the Roman Empire into an eastern and a western part in the late fourth century, the cultural and political separation of the two parts in the following centuries, and the migrations of non-Roman settlers and invaders from the east and north. While the strength of the Eastern Empire established by Constantine in his capital of Constantinople (what is now Istanbul, Turkey) allowed for

a continuity of Greek (Byzantine) civilization until the triumph of the Ottoman Turks in 1453, the last ruler of the Western Roman Empire abdicated in 476, leaving the area from what is now Germany and Austria westward to the Atlantic Ocean in disarray. Latin learning was preserved and enriched in monasteries wherever Christianity had been established, with notable examples in Ireland and England, as well as on the Continent. But the lack of a source of centralized political power encouraged vast migrations of non-Roman peoples, including not only the Goths, Visigoths, and Huns who had defeated the Romans, but the Angles, Saxons, and Jutes who settled England in the seventh century, and later the Vikings and their Norman descendants, who continued to raid coastlines and inland regions and establish settlements in both Europe and the New World well into the eleventh century. It was only with the relative stability of the reign of Charlemagne, crowned Emperor in Rome in 800, and the wide cultural and intellectual networks it established and supported that a single dominant influence began to reunify Europe, and the Latin Christian Church became the central focus of Western thought and expression.

LORDSHIP. During the period following the establishment of the Carolingian Empire, a new concept of social and political organization began to take hold, creating what is perhaps the most distinctive institutional development of the medieval era. Called "feudalism" in popular terminology, this complex network of interlinked political, economic, and social obligations extended to and involved almost all sectors of the socioeconomic

hierarchy. In practice, both free peasants and "serfs," the agricultural workforce who tilled the land of medieval estates and manors, owed their physical labor and a large share of the crops they produced to their lord (who might hold a royally-bestowed title like count, duke, or baron), who extended to them his physical and political protection in return for their labor. Knights, the warrior sector of the culture, as the vassals of greater lords owed them homage, usually in the form of military service. In political terms, within the larger hierarchy that was emerging, this meant that dukes and barons were themselves vassals of kings or emperors who, in turn, deferred to the pope, who represented the highest spiritual authority. If the pope asked for military aid from kings or emperors, these monarchs might in turn elicit service from their dukes and barons, who would in turn call upon their vassals from the lower echelons of the aristocratic hierarchy, the knights. These bonds between lords and vassals were never as stable as such a description might suggest, and the term "feudalism" is today widely discredited since there is some argument that it represents a modern, rather than a medieval, formulation of what was really a much more fluid system. But whatever its actual workings, the concept of lordship and obligation, existing side by side with the ongoing traditions of monasticism and the authority of local bishops, established a new kind of balance between secular and spiritual authority.

CRUSADES AND CULTURAL EXCHANGE. Even before the system of lordship began developing in the West, the spread of Islam following the death of the prophet Muhammad in 632 had led to both a flowering of Arab culture and a vast expansion of Islamic power throughout the Middle East, across North Africa, and into Spain, Sicily, and southern Italy. In 1095, Pope Urban II made an appeal for the formation of a Christian army to retake Jerusalem (Christianity's most popular pilgrimage site) from Muslim control, and in response approximately 100,000 soldiers (mostly French) set out on the First Crusade, changing forever the relationship between Western Europe and the rest of the known world. Following the success of the First Crusade, and the resulting increase in trade and travel between the regions, subsequent crusades drew armies from broader geographical areas. The Second Crusade (1147) was led by Emperor Conrad III of Germany and King Louis VII of France, while the Third Crusade (1192) included an English army led by King Richard I (Lionheart), as well as French and German contingents. By the time of the Fourth Crusade (1202–1204), which originated in Venice, the crusade movement had proven to be largely unsuccessful in achieving its military aims, but contact with the Muslim and Byzantine East, as well as with the Arab culture of Spain, had broadened commercial activity and introduced knowledge and learning that would have far-reaching effects on European culture.

THE HOLY ROMAN EMPIRE. Another important development of the twelfth century was the establishment of the Holy Roman Empire as the successor to the series of imperial monarchies that had begun with Charlemagne. After Charlemagne's death and the division of the empire among his sons, there had been a decline in the power of Carolingian rule, but after the German king Otto I defeated the Magyars in 955 and then established the archbishopric of Magdeburg in 968, the eastern Frankish monarchy strengthened its control over Italy and its alliance with the popes. This relationship, while mutually beneficial in terms of securing territory in central and eastern Europe against Byzantine expansion, led eventually to an ongoing series of conflicts over rights and jurisdictions, particularly with regard to the involvement of non-clerical authorities in the control of ecclesiastical property and appointments (known broadly as the Investiture Controversy or the age of Gregorian reform). In response to challenges from the German emperor Henry IV, the liberty of the church was vigorously asserted by Pope Gregory VII in 1075, leading to a rift between the two leaders and disagreements among the German nobles who chose the succeeding emperors. The internal divisions among the imperial electors were, however, temporarily resolved with the selection in 1152 of Frederick I (Barbarossa) who proceeded to consolidate his authority into what was now for the first time referred to as *sacrum imperium*, a sacred or holy empire emphasizing the divine origin of imperial power. The uneasy balance between the Holy Roman emperors (representing "temporal" or earthly authority) and popes (who along with other ecclesiastics represented "spiritual" authority) over the centuries that followed contributed to a number of controversies and even, at times, military conflicts, that extended throughout northern Europe and in the thirteenth century even to Florence and other Italian cities. Other political pressures eventually led to the relocation of the papacy from Rome to Avignon from 1309 to 1376 (during which time the popes were under the influence of strong French kings, beginning with Philip the Fair) and, with the attempt to move the papacy back to Rome, the election of a series of popes and anti-popes in a period of division known as the Great Schism (1378–1417). The political rancor and abuses apparent during this period ushered in a widespread desire for reform and even a questioning of the value of a strong ecclesiastical hierarchy.

THE RISE OF INDIVIDUALISM AND THE NEW MIDDLE CLASS. Along with the challenge to the authority of the papacy came a challenge to the three-tiered manorial structure that had divided human endeavor among those who worked the land, those who fought, and those who prayed. Increasingly, from the thirteenth century onward, the agrarian-based lordship culture was giving way to a more urban culture of tradesmen and artisans offering services for money (a development that gave rise to the first minting since the eighth century of gold coins in Florence and Genoa in 1252) rather than for land tenure. Likewise, the arts of bookmaking and jewelry were coming out of the monasteries and into workshops in towns. Government during this period tended to be increasingly centralized and bureaucratic, especially from the time of Philip Augustus (r. 1180–1223) in France and Henry II (1154–1189) in England. But at the same time the idea of imposing limitations on royal power—as evidenced in the issuing of Magna Carta in England in 1215—points also towards a more modern sense of civil and juridical rights. To meet the needs of the changing social structure, new movements arose within Christianity, including significant numbers of lay religious communities that encouraged greater participation of uncloistered men and women in lives of spiritual activism (sometimes in ways that were judged heretical by the institutional church). Within the Roman Church in the early thirteenth century there emerged mendicant orders of Franciscan and Dominican friars, who turned away from monasticism in favor of a life of interaction that was closely linked both to preaching in urban centers and to teaching in the universities that had been developing there since the late twelfth century. By the fourteenth century, all of these cultural trends were reinforced and hastened by two cataclysmic occurrences that had profound economic and social implications: a series of famines across Europe between 1315 and 1317 and, from 1349 onward, a series of outbreaks of the bubonic plague known as the Black Death, which seems to have been brought to western Europe from central Asia. These two events reduced the population sharply, creating higher wages for those who could work, and mobility across frontiers by people in search of food and jobs. A new class developed in the wake of these disasters, one that could be called a middle class, characterized by well-to-do urban dwellers whose income came from trade and crafts, commerce, banking, and venture capital. At the same time, laborers, no longer tied to the land, began to assert their rights, both in France, in the rebellion known as the Jacquerie, which took place near Paris in 1358, and in England, in the Peasant Rebellion of 1381.

THE GOTHIC AND AFTERWARD. The new commercial class of bankers and merchants in Italy and the new middle class of artisans and tradesmen in England, France, Germany, and the Low Countries soon developed their own interests in music, art, and literature, and by the beginning of the fifteenth century, the Western European world that emerged was the result of a long and dynamic process of negotiation between the traditions of the past and the forces of change. The period known as the Middle Ages had certainly encompassed a desire to identify itself with the lost glory of the Roman Empire that preceded it, evident even in the name "Romanesque" as applied to the massive and rounded churches that dominated architectural style before 1150. But it also had been the age of magnificent innovations, captured most visibly in the pointed arches, stained glass windows, and soaring tracery-filled spires of cathedrals like Chartres, Strasbourg, and the Sainte-Chapelle in Paris, built in the thirteenth century as a symbolic reflection of the glory of God and the spiritual power of the Christian Church. Ironically, the word "Gothic"—still used to identify this style of architecture and applied more broadly to refer to the entire culture of the later Middle Ages (roughly 1225 to about 1375)—is not a medieval term at all but a derogatory one coined in the eighteenth century to describe a period that was seen as Germanic and primitive rather than Roman and classical in culture, an era that was considered merely imitative in its literature and regrettably "monkish" and "superstitious" in religion. But a closer look at the arts and humanities of the period reveals a complexity of response that evolved continuously, taking in not only the institutional grandeur that dominated the architectural landscape, but also, increasingly, the personal expression that gained power with the emergence of strong national identities and respect for the individual conscience. By the time of the Hundred Years' War between France and England (1346–1453), the French and the English had come to see themselves as distinct cultural and political entities in which the Latin learning of the church was being rivaled by secular literature in the vernacular languages and by translations of the most important philosophical and scientific documents. This sense of the importance of the language of the people took on a different meaning in spiritual life with the call for vernacular Bibles, led by John Wyclif, whose preaching was condemned after his death in 1384 but whose followers, the Lollards in England and the Hussites in Bohemia, spread the belief in the right of the individual to read and interpret Scriptures. It is no coincidence that while the new, classically-based movement of humanism was

developing among members of the leisured class in the cities of Italy, one of the final events of the Middle Ages in the north was a transformation of the central document of Christianity, the Bible, from handwritten script to print that used movable type. The Gutenberg Bible (1453) was at once a product of the new technology of moveable type, and a means of making accessible to far more people the very text that had dominated medieval culture and influenced its arts and institutions for over six centuries. As such, it is a fitting symbol of the blend of conservatism, adaptation, and innovation that characterized the Middle Ages.

CHRONOLOGY OF WORLD EVENTS

By Kristen Mossler Figg

330 Roman Emperor Constantine founds the city of Constantinople (present-day Istanbul, Turkey), which becomes the capital of the Eastern (Byzantine) Empire.

476 Romulus Augustus, the last Roman emperor of the West, is deposed by Odoacer, a barbarian chieftain of Italy.

622 The Muslim era begins with the Hegira as the Prophet Muhammad flees, with a few adherents, from Mecca to Medina.

768 Charlemagne (Charles the Great) begins his reign as king of the Franks.

778 Charlemagne's nephew Roland is killed in the battle of Roncevalles in the Pyrenees as Charlemagne's army returns from an unsuccessful campaign in Spain against the Saracens. This event serves as the basis for the most famous heroic poem in French literature.

800 Charlemagne is crowned emperor of the West by Pope Leo III in Rome.

c. 810–c. 820 Vikings begin to settle in the Faroe Islands.

814 Al-Ma'mun, the seventh Abbāsid caliph of the Muslim Empire, establishes the House of Knowledge in Baghdad. Schol-

ars there translate Greek, Syriac, Persian, and Sanskrit works of philosophy, science, and literature, and make discoveries in astronomy, mathematics, and medicine.

The reign of Emperor Louis the Pious, son of Charlemagne, begins, bringing with it the beginning of the disintegration of the Carolingian empire.

837 Byzantine forces begin invasions of the Abbāsid Muslim Empire.

838 Muslim naval forces prepare to lay siege to Constantinople, but their fleet is destroyed in a storm.

843 The iconoclastic controversy in Byzantine Christianity comes to an end, and the use of icons is restored.

The Treaty of Verdun formalizes the division of the Carolingian realm among the three sons of Louis the Pious: Charles the Bald (western section, roughly equivalent to modern France), Louis the German (eastern section), and Lothair (middle section, later called Lotharingia).

847 Arabs sack Rome.

Ruling from Samarra, north of Baghdad, the weakened Abbāsid caliph al-Mutawakkil

begins persecutions of Christians, Jews, and unorthodox Muslim Shiites.

849 An Arab fleet is defeated off the coast of Italy by the forces of an alliance formed by Pope Leo IV.

c. 850 Arabs invent the astrolabe, which allows mariners to use celestial navigation to determine latitude.

c. 860 Viking explorers discover Iceland.

866 Japan begins a period of clan dominance known as the Fujiwara period, which lasts until 1160.

c. 866 The Abbāsid caliphs begin to lose the eastern provinces of their empire as the Saffarid Dynasty is established in what is now eastern Iran.

869 The Saffarid Dynasty expands to include parts of modern-day Afghanistan and Pakistan.

870 Al-Kindī dies. He was the first Islamic thinker to try to reconcile Greek philosophy with Muslim beliefs.

When Lothair II dies, the Treaty of Mersen divides Lotharingia (Burgundy and northern Italy) between Louis the German and Charles the Bald.

876 Saffarid troops fail to conquer Baghdad, but in 879 their leader is recognized by the Abbāsid caliph as governor of the eastern provinces of the Muslim empire.

877 Charles the Bald dies, effectively ending the era of Carolingian supremacy on the Continent.

878 King Alfred the Great of England (r. 871–899) defeats the Danes in a major battle and ends Viking invasions of England by recognizing an area of northeast England (known as Danelaw) as Danish territory.

882 Oleg, Varangian (Viking) ruler of Russia, captures Kiev and makes it his capital.

894 The emperor of Japan is convinced that contact with the T'ang Dynasty in China is undesirable because of growing influence from the Near East and breaks off diplomatic relations, ending three centuries of Chinese influence on Japanese culture.

c. 900 Norse (Viking) explorers settle in Iceland.

Rulers of the powerful Ghanian kingdom of Africa adopt Islam.

The lowland cities of the Mayan empire, which comprised a total population of about two million people in present-day Guatemala, Honduras, southern Mexico, Belize, and El Salvador, are abandoned in favor of the highland cities of the Yucatan peninsula.

902 The Abbāsid ruler al-Muqtafi begins his rule, during which he will regain control of Egypt and repulse an attack by the Byzantines.

907 The T'ang Dynasty falls in China, ending a golden age of Chinese culture and leading to the break-up of China into separate kingdoms.

909 The famous Benedictine monastery of Cluny is founded.

The Fātimid Dynasty is founded when Al-Mahdī, a member of a family claiming descent from Fatimah, daughter of the Prophet Muhammad, declares himself caliph of Tunis and begins his family's gradual conquest of all of North Africa.

910 Following a period of Berber-Arab invasions that had begun in 711, the Muslim Umayyad Dynasty controls all but the northwest corner of Spain.

911 French King Charles III the Simple (r. 898–922) concludes an arrangement with Rollo the Dane that allows the Vikings to control the area of northern France known as Normandy (Norman meaning "north man").

936 Otto I (the Great) becomes king of Germany (r. 936–983) and begins expeditions to Italy during which he intervenes in Italian and papal affairs, leading eventually to unification of Germany and Italy under his rule.

939 Vietnam gains its independence from China.

947 The Khitans of northeastern China proclaim the Liao Dynasty, which rules until 1125.

950 A French bishop named Gotescalc is among the early pilgrims to travel to the town of Santiago de Compostela, which by the twelfth and thirteenth centuries is visited by hundreds of thousands of pilgrims from all parts of Christendom.

c. 950 Harold Bluetooth begins his reign as king of Denmark, during which Christianity will be introduced.

958 The maritime city of Genoa, Italy, is refounded after being destroyed by Muslim raids from North Africa in 934–935; it emerges in 1099 as a medieval commune ruled by an association of citizens and six neighborhood consuls.

960 The newly proclaimed Sung Dynasty begins reunifying China and establishing trade in porcelain and steel.

961 Hugh Capet becomes duke of Francia and Aquitaine, with landholdings that make him more powerful than King Lothair I (954–986), allowing him eventually to take the throne as the first king (987–996) in the Capetian Dynasty of France.

Establishment of German Ottonian rule in northern Italy allows the city of Verona to use its strategic position at the base of Brenner Pass to negotiate for privileges and rights in return for allegiance.

962 German ruler Otto I is crowned emperor of the Romans, establishing the Ottonians as the successors to the Carolingians and reestablishing strong ties between Church and State.

968 The Fātimids establish themselves in Egypt, founding Cairo, and shifting the center of Islamic culture away from Baghdad. The dynasty lasts until 1171.

972 The Chinese begin printing with movable type.

975 Al-Aziz becomes caliph of the Fātimid Dynasty, during which he will conquer Syria and extend Fātimid influence from the Atlantic Ocean in the west to the Euphrates River in the east.

977 A former Turkish slave in modern-day Afghanistan establishes the Ghaznavid Dynasty, rejecting control by the Muslim Sāmānids and expanding eastward to the border of India.

c. 980 By this date, Arabs and Persians have settled the east coast of Africa and begin founding major cities, such as Mogadishu (tenth century) and Mombasa (eleventh century), and establishing trade routes for ivory, gold, and slaves from the interior of Africa to India and the Arabian peninsula.

c. 986 Icelanders led by Erik the Red establish settlements in Greenland and make the first known sighting of the North American continent.

992 Subject to the Eastern, rather than the Western, Roman Empire, Venice is granted relief from port taxes by Byzantine emperors, the first of many privileges that will give Venice an advantage over all other traders in the Mediterranean region.

997 Stephen I (St. Stephen) begins his reign as king of Hungary, during which he is instrumental in establishing Latin-rite Christianity as the religion of Hungary.

998 Under the Great Mahmud of Ghazna, son of the dynasty's founder, the Ghaznavids, now extending into northern India, adopt Sunnite Islam.

1000 Christianity is introduced to Iceland.

c. 1000 Seljuk Turks, originally from Central Asia, become Sunnite Muslims and begin westward expansion.

Persian scientist and court physician Avicenna writes *The Canon of Medicine*, the best known single book in the history of medicine.

The Incan civilization begins to develop in the Andean region of South America.

The West African city-state of Benin, in what is now Nigeria, begins its development into a powerful cultural center renowned for metalwork.

Navajo and Apache peoples from the far north arrive in the American southwest.

1001 The troops of Mahmud of Ghazna (in present-day Afghanistan) begin incursions into India, spreading Islam.

1004 An expedition of about 130 people from Greenland land on the North American continent and settle in an area they call Vinland, probably on the Gulf of the St. Lawrence River. Three years later, they abandon the settlement.

1014 The Cola Empire of southern India begins expansions that will extend the borders northward and include all of Ceylon and portions of the Malay peninsula.

1016 After a renewal of Viking invasions in England, Danish King Cnut (r. 1016–1035) ascends the throne of England, but misgovernance by his heirs results in a return to Anglo-Saxon rule in 1042.

1019 Yaroslav begins his reign of Kievan Russia, during which the oldest Russian law code, the "Russian Truth," is written.

1042 The Anglo-Saxon Edward the Confessor becomes king of England following a period of Danish rule, but he dies childless in 1066.

1046 Henry III, king of Germany, begins his reign as emperor of the West. The Latin Empire is at its height, extending into Hungary, Poland, and Bohemia.

c. 1050 Pueblo peoples in the American Southwest begin building cliff houses and other apartment-like dwellings.

1054 The schism between the Eastern (Orthodox) and Western (Roman) Christian churches is formalized.

1055 Seljuk Turks conquer Baghdad and the Abbāsid caliph recognizes the Seljuk Toghrīl Beg as Sultan.

1056 Henry IV, king of Germany and emperor of the West, begins his reign, during which he struggles with the papacy over lay appointment and investiture of bishops and abbots, resulting in rebellions among those nobles who support the power of the Pope.

1061 The Almoravids, a Berber Dynasty, begin their conquest of Morocco and western Algeria.

1066 William I of Normandy (William the Conqueror) invades England, defeating the Anglo-Saxon King Harold Godwinson (r. 1066) at the Battle of Hastings and establishing the Anglo-Norman dynasty.

1071 At the Battle of Manzikert, the Seljuk Turks seize most of Asia Minor from the Byzantine Empire.

1074 Byzantine Emperor Michael II enlists the aid of the Seljuk Turks against his uncle, who is making a claim to the throne, allowing the Seljuks, in return, to establish themselves in Anatolia (the Asian portion of present-day Turkey).

1075 Responding to the investiture controversy, the *Dictatus Papae* declares Rome's supreme authority in all religious matters.

1076 The Seljuks take Damascus from the Fātimids.

The Almoravids extend their influence into the Ghanian empire of Africa, establishing Islam in the area that is now Mali.

1081 Rodrigo Díaz de Vivar, whose exploits won him the title *Mio Cid*, or "My Lord,"

is banished for the first time as an outlaw by Alfonso VI, king of León, an event that figures in Spain's great heroic poem, *The Poem of the Cid.*

1085 Christians reconquer Toledo from the Muslims in Spain.

1086 The Domesday survey is undertaken in England by King William I (r. 1066–1087), creating surprisingly accurate records of all landed property for tax purposes.

1088 Construction begins on the third abbey church of Cluny (Burgundy), the largest church in Christendom.

1089 The Almoravids begin their conquest of Spain.

c. 1090 A small Shiite minority sect in northern Persia organizes into a secret band of political murderers known as the Assassins (a name derived from the word for hashish); they operate out of a fortress in the mountains, sending out missionaries to convert Sunni Muslims and, if that does not work, dispatching terrorist agents to murder key figures and subvert the power of the Seljuks.

The last Muslim stronghold in Sicily falls to the Normans, who rule Sicily for the next 100 years.

1095 Under threat of invasion by the Seljuks, Byzantine Emperor Alexius I calls on Pope Urban II for assistance.

1096 Responding to Alexius's call, Pope Urban II launches the First Crusade to regain the Holy Land from the Muslims.

1098 The Cistercian Order is founded in an attempt to reform the abuses of medieval monasticism and return to a purer interpretation of the Benedictine Rule.

1099 The Fātimids lose Jerusalem to the Crusaders, who establish Christian kingdoms there and in Edessa, Antioch, and Tripoli.

c. 1100 Inuits from North America settle in northern Greenland.

Use of the stirrup, horseshoe, and saddle with cantle has become common in France, making heavy cavalry engaging in mounted shock combat the dominant force in medieval European armies.

1106 Henry I of England (r. 1110–1135) gains control of Normandy by defeating his brother, Duke Robert, at Tinchebrai. He is later involved in a struggle with the Church, headed by St. Anselm of Canterbury, over lay investiture.

1110 Seljuks invade the Byzantine portion of Anatolia.

c. 1113 The Order of the Hospitallers, which originated as a brotherhood that served poor or sick pilgrims in the city of Jerusalem, is given a charter from Pope Paschal II establishing them as a unique order to be supervised by their own master and answerable only to the pope.

1121 The Seljuks lose southwestern Anatolia to Byzantine forces.

1122 The lay investiture controversy is settled through a compromise at the Concordat of Worms.

1123 The Juchen conquer the Liao Dynasty in northern China and proclaim the Chin Dynasty.

1125 The feud between the Guelphs (supporters of Lothair, Duke of Saxony, of the Welf family) and the Ghibellines (supporters of Frederick of Hohenestaufen, whose family are called the Waiblings) begins after Emperor Henry V dies without a direct heir.

1128 The order of the Knights Templar is established to protect pilgrims and settlers in the Holy Land following the ousting of Muslim rulers by Crusaders.

1130 Fātimid caliph al-Amir is murdered by the Assassins.

1135 The Jewish quarter in Muslim Córdova, Spain, is sacked, causing some Jewish merchants to move from Islamic into

Christian areas, where they played a key role in trade in the later Middle Ages.

1138 The city of Florence is governed as a commune by a consulate made up mainly of knights and a few merchants who serve for one year and preside over an assembly of the people and a grand council.

c. 1140 The rebuilding of the Abbey of St-Denis outside of Paris marks the beginning of the Gothic style of architecture.

1143 Alfonso I Henriques begins his rule as the first king of Portugal, which had previously been a province of León.

1144 Muslims recapture Edessa, leading to the Second Crusade.

1147 King Roger II of Sicily forcibly transports Greek and Jewish silk workers from Thebes and Corinth to Palermo in order to improve the quality of fabrics manufactured in his royal workshop.

1149 The Second Crusade ends, and European troops leave having accomplished little.

1152 After her divorce from King Louis VII of France (r. 1137–1180), Eleanor of Aquitaine marries Henry, count of Anjou and Duke of Normandy, who within two years becomes Henry II of England (r. 1154–1189), shifting the immense territories of Aquitaine from France to England. As both queen of France and queen of England, Eleanor acts as an important patron of the arts.

1157 The earliest Italian sumptuary law dealing with clothing is enacted in Genoa, initiating a series of such laws enacted for economic purposes (to enhance trade and reinforce the social hierarchy) but often expressed in moral terms.

1160 The Taira Kiyomori establish control of the entire country of Japan.

The Hanse, an association of German merchants, begin securing transnational trading concessions that, over the next 300 years, make it the most influential socioeconomic phenomenon in northern Europe, facilitating trade in everything from amber, beer, furs, and timber to linens, wines, and woolens.

1169 Averroës, an Islamic philosopher in Córdova, Spain, completes the first of his commentaries on Aristotle.

Saladin becomes commander of Syrian troops in Egypt, orders the assassination of the Fātimid vizier, and is appointed to replace him.

1170 Thomas Becket is assassinated at Canterbury Cathedral in England by four household knights of Henry II (r. 1154–1189) following a clash over royal and ecclesiastical rights.

1171 Saladin abolishes the Shiite Fātimid caliphates in Egypt and proclaims himself the ruler of a new Sunnite state, establishing the Ayyubid Dynasty.

As many as 10,000 Venetians are residing in Constantinople to assist in business negotiations and carry out trade transactions.

1174 Saladin begins a twelve-year military and diplomatic campaign to unite the Muslim territories of Egypt, Syria, Palestine, and northern Mesopotamia under his rule.

1175 The English monk and scholar Alexander Neckham provides the first European account of sailors using a compass to establish direction on cloudy days.

1177 William II of Sicily (d. 1189) convinces German Emperor Frederick I Barbarossa to end his opposition to a Sicilian monarchy held in fee of the papacy.

1180 Philip II Augustus (1165–1223) becomes king of France and begins an expansion of domains and influence that establishes France as a leading power in Europe.

Bruno of Cologne founds the Carthusian Order of hermits in the Alps north of Grenoble, combining the communal (cenobitic) lifestyle with solitary (eremitic) practice.

1187 Saladin captures the Christian kingdom of Jerusalem, leading to the Third Crusade.

1189 Richard I (Lionheart) begins his ten-year reign of England, which will be spent almost entirely abroad, on crusades and in conflict against Philip Augustus of France.

1191 Forces led by Richard Lionheart of England (r. 1189–1199) and Philip II Augustus of France (r. 1180–1223) conquer Acre, in the kingdom of Jerusalem, and slaughter the inhabitants.

1192 After Christian forces fail to retake Jerusalem, the Third Crusade ends with a three-year truce. Saladin allows the Crusaders to retain a small strip of coastal land and access to Jerusalem.

1198 Pope Innocent III, the last powerful medieval pope, begins a pontificate in which he restores some Italian territories to direct papal control, initiates the Fourth Crusade (1202) and the Albigensian Crusade (1208), and approves the founding of the Franciscan and Dominican orders.

1199 King John of England (c. 1167–1216) begins his reign, which is marked by loss of English possessions to France, a dispute with Pope Innocent III over the election of the archbishop of Canterbury, and the granting of Magna Carta (1215).

c. 1200 The major city-state of Great Zimbabwe is founded in southern Africa by the Shona tribe, who dominate trade in gold, slaves, and ivory between inland areas and the Indian Ocean coast.

Europeans become aware of the Chinese invention of gunpowder, probably by way of the Mongols who have brought it with them.

By this date, Paris has become the leading center in Europe for the study of the liberal arts and theology, with an academic community that may have included as many as 4,000 people.

The Ghanian empire is weakened when it is invaded by desert nomads, making it susceptible to attack, in 1203, by Sumanguru, leader of the Susu kingdom of Kaniaga.

1204 At the end of the Fourth Crusade (begun in 1202), Christian knights capture and brutally sack Constantinople. The Crusaders establish a Latin kingdom that controls Constantinople until 1261.

Philip Augustus of France quadruples the size of his domain by conquering all English land holdings north of the Loire.

1206 Chinggis (Genghis) Khan, ruler of the Mongols, convenes a national assembly declaring him supreme ruler and begins military campaigns that lead to the conquest of Tibet, parts of northern China, Manchuria, and Korea.

1208 Pope Innocent III (1198–1216) proclaims the Albigensian Crusade against the heretics of southern France, causing a long period of conflict that brings an end to the great cultural flowering of Provence.

1209 The Franciscan Order of Friars is founded in Italy by Francis of Assisi.

1212 A French boy, Stephen of Cloyes, leads the Children's Crusade, as a result of which thousands of children who travel to Marseilles are sold into slavery, while many German children traveling eastward die of hunger and disease.

1215 The Fourth Lateran Council convenes and implements major reforms for secular clergy.

The Poor Clares, a Franciscan order for women, is formed.

Magna Carta (The Great Charter) is issued by King John of England, granting privileges to "all the free men of our realm," and establishing precedent for such modern practices as due process of the law and trial by jury.

Chinggis Khan's army takes Beijing.

Peter Lombard's *Books of the Sentences* or *Quattuor libri sententiarum* (1155–1157) —a comprehensive work arranging the

opinions of the Church Fathers, especially Augustine, into a system with a logical order of development—is legislated into the curriculum of all theology students at the University of Paris, where it remains until the sixteenth century.

1216 The Dominican Order of Friars Preachers is founded by the Castilian canon Dominic of Calaruega.

1218 The Fifth Crusade, the most carefully planned and multinational of all the Christian expeditions to the Holy Land, begins its siege of Damietta in Egypt, but by 1220 has failed due to postponements in the arrival of reinforcements.

1220 Frederick II (1194–1250), king of Sicily and Germany, becomes Holy Roman Emperor and enters a long dispute with the papacy over control of Italy and Rome.

Mongols under Chinggis Khan conquer Persia and other areas of western Asia, and large numbers of Persians are massacred.

1221 Crusaders fail to conquer Cairo and sign an eight-year truce with the Egyptians.

1223 Chinggis Khan's son Jochi defeats the Russians and claims the Russian steppes for himself and his descendants.

c. 1230–c. 1250 The Ebstorf World Map, measuring 12 feet in diameter, is created in Germany. Based on the writings of Gervase of Tilbury, the map depicts a round earth surrounded by ocean, with over 1200 legends identifying geographical features, cities, monasteries, and curiosities, including monsters at the edges of the earth.

1231 Holy Roman Emperor Frederick II issues legislation to rebuild royal authority in Sicily, eventually deporting 20,000 disaffected Muslims.

1233 Pope Gregory IX establishes the Inquisition for the investigation of the Albigensian Heresy, which is undertaken by members of the Dominican order.

1236 Alexander Nevski begins his reign as prince of Novgorod (he is later also prince of Vladimir), during which he gains fame for great victories over the Swedes (1240) and the Teutonic Knights (1242).

1240 The Islamic empire of Mali establishes its domination of West Africa, which lasts until 1464.

1241 The Mongol army under Ögödei Khan completes the conquest of nearly all Russian cities and princes just before Ögödei's death.

Louis IX of France (r. 1226–1270) begins building the Sainte-Chapelle in Paris to house a large collection of relics of Christ he purchased from the emperor of Constantinople.

1242 The Mongol threat to Western Europe ends when Batu Khan (nephew of Ögödei) withdraws his troops to Russian territory and establishes the capital of his khanate (the Golden Horde) at Sarai on the lower Volga River, where his descendants continue to rule for the next 250 years.

1245 In response to the recent threat of a Mongol invasion, Innocent IV sends John of Plano Carpini, a first-generation Franciscan friar, on a mission to Karakorum, capital city of the Mongols, a trip of 3,000 miles that was accomplished in only 106 days. On his return, John writes an ethnographic study of the Mongols, *Historia Mongalorum*.

1249 Oxford University is founded.

1250 Mamluks, members of a class of military slaves, seize control of Egypt and Syria from the Ayyubid Dynasty, establishing a dynasty that lasts until the state is conquered by Ottomans in 1517.

A Guelf army defeats a Ghibelline army outside of Florence, and the Guelfs establish the regime of the *popolo*, allowing upwardly mobile, prosperous, non-nobles (mainly merchants and guildsmen) to hold political office.

1252 Genoa and Florence introduce the first regular gold coinage in the west, with the Florentine *florin* soon dominating the coinage of northern Italy.

1254 Upon returning in defeat from the Seventh Crusade, Louis IX of France, later canonized as Saint Louis, begins a series of governmental reforms intended to put into practice his notion of the ideal Christian ruler.

1258 Mongol invaders under Hülegü (younger brother of Khublai Khan) take Baghdad, massacre the inhabitants, and kill the last Abbāsid caliph, ending the rule of the Seljuks and establishing Mongol rule in Persia.

1260 Muslim Mamluk Turks defeat a small garrison force of Mongols in Palestine, ending the advance of the Mongols, who now control all of the Middle East except Egypt.

1271 Khublai Khan declares the Yüan Dynasty in China.

c. 1273 Thomas Aquinas writes his *Summa Theologica*, a massive statement of the whole of Christian theology that becomes the basis of medieval clerical education.

1275 Marco Polo, who left Venice in 1271, arrives at the court of Khublai Khan in Mongolia and lives in his domains for the next seventeen years.

1279 Khublai Khan conquers the Sung kingdom in southern China and reunifies all of China under Mongol rule.

1281 In response to the actions of Japanese authorities who executed Khublai Khan's envoys in 1276, a large army of Mongols, Chinese, and Koreans invades Japan. The Mongols withdraw after a typhoon destroys many of their ships and drowns thousands of their warriors.

1285 Philip IV (the Fair) becomes king of France and expands royal power by dominating both the ecclesiastical and the secular affairs of Western Europe.

1289 Osman I begins his reign as the first Ottoman Turkish sultan.

1290 The Jews are expelled from England by Edward I (r. 1272–1307).

1291 Acre, the last Christian stronghold in the Levant, falls to the Mamluks.

1295 The "Model Parliament" of England, called by Edward I (r. 1272–1307), is the first to represent all classes of society.

1300 By this date, Venice is exporting its own high-grade silk fabrics to England and Spain, replacing more expensive imported silks from the East.

1302 The Ottoman Expansion begins.

Philip IV (the Fair) of France (1268–1314) calls the first of several assemblies of nobles, clergy, and town representatives to solidify support for his ecclesiastical policies, anticipating the "Estates General" that later become part of French government.

1306 Philip IV of France expels the Jews and confiscates their property.

1309 The seat of the papacy moves from Rome to Avignon when Clement V (1305–1314), originally from Bordeaux, acquiesces to the will of Philip IV (the Fair) of France.

1317 Famine strikes Europe, lowering resistance to disease and disrupting social institutions.

1325 Ibn Battuta leaves Tangiers for thirty years of travel in Asia and Africa, providing a major source of information to Western readers.

Mansa Musa, emperor of Mali, annexes the Songhai kingdom of Gao, and continues his transformation of key African cities into important religious and cultural centers with mosques, libraries, and schools.

1326 War begins in Poland against the Teutonic Knights, continuing until 1333, when the Teutonic Knights are victorious.

c. 1330 The Bubonic Plague, or Black Death, begins killing people in northeastern China and is carried westward by traders, travelers, and nomadic peoples.

The medieval galley, with the maneuverability of a warship, is widened to provide room for additional rowers and cargo space, and it is soon adopted by Venice and Genoa for shipping their most valuable goods.

1335 The Sultanate of Delhi dominates most of the Indian subcontinent.

1336 The Ashikaga family (Shoguns) takes control of Japan, ushering in an era of constant warfare accompanied by economic growth.

1338 The Hundred Years' War between England and France begins, precipitated by a dispute involving English interests in the Flemish wool trade, though the underlying cause was a disagreement over control of Aquitaine (held by the English) and Normandy (to which the English claimed rights), and Edward III's ongoing assertion of his claim to the French throne.

1344 The Canary Islands, located off the African coast in the Atlantic Ocean and once colonized by the Romans, are granted to Castile (Spain) by papal bull after being rediscovered by a Genoese explorer operating for the Portuguese in 1341.

1345 Ottoman Turks extend their conquest of Byzantine territory into Europe.

1346 Bubonic Plague reaches the Golden Horde, precipitating the disintegration of Mongol rule in Russia.

Outnumbered English longbowmen defeat mounted French knights at the Battle of Crécy, signaling a shift from chivalric to modern warfare.

1349 Bubonic Plague reaches Austria, Hungary, Switzerland, Germany, and the Low Countries.

1350 Bubonic Plague reaches Scandinavia and the Baltic lands.

1356 At the Battle of Poitiers, the English, under Edward the Black Prince, defeat the French, whose king, John II, is taken prisoner, not to be ransomed until 1360.

1358 A peasant revolt in France called the *Jacquerie*, protesting mainly against unfair taxation, is suppressed by the royal army.

1360 The Peace of Brétigny ends the first period of the Hundred Years' War when Edward III of England (r. 1327–1377) renounces his claim to the throne of France in exchange for control of Aquitaine, Poitou, and Calais.

1368 The Mongol Yüan Dynasty in China is overthrown by the Ming Dynasty, contributing to the closing of the trade routes that have provided silk and spices to Western Europe and leaving remaining trade in the hands of Muslim middlemen.

1378 Gian Galeazzo Visconti begins his rule of Milan, during which he will extend his influence over Padua, Verona, and Vicenza, though ultimately failing to control Florence and create a kingdom of northern Italy.

The Great Schism begins when cardinals opposed to the Italian pope in Rome elect a French pope who rules from Avignon, thus establishing two lines of popes who are supported by various European states according to political affiliations.

1380 Charles VI becomes king of France but, because of his insanity, the country is in an almost constant state of civil war, thus opening the door for Henry V of England (r. 1413–1422) to be named regent in 1420.

1381 The Peasants' Revolt takes place in England when large numbers of peasants, led by Wat Tyler, march on London to protest a poll tax. The young king Richard II (r. 1377–1399) stops the revolt by promising to meet the crowd's demands, but does not keep his word.

1382 The Vulgate Bible is translated into English under the guidance of religious re-

former John Wyclif, whose teachings, rejecting transubstantiation and supporting vernacular Bibles, are condemned.

1396 The Crusade of Nicopolis ends when a European army under Sigismund of Hungary is annihilated by the Ottoman Turks under Bayezid I.

1399 Richard II of England is deposed by his cousin Henry Bolingbroke, who is crowned Henry IV (r. 1399–1413).

1401 Mongols under Timur (Tamerlane) capture Baghdad, slaughter the inhabitants, and destroy the city.

1402 The westward expansion of the Ottoman Turks is halted when the Turks are defeated by invading Mongols under Timur (Tamerlane), who captures Bayezid at the battle of Ankara.

1405 Admiral Zheng He of China begins maritime expeditions that visit Champa (Vietnam), Indonesia, and southern India, and eventually round the tip of India, reaching the Persian Gulf and the eastern coast of Africa.

1409 The Council of Pisa, called to end the Great Schism, elects a new pope, but when the popes in Rome and Avignon refuse to resign, there are three popes.

1415 The Portuguese Expansion begins with the conquest of Morocco and continues with the discovery of the Azores, the circumnavigation of Cape Bojador, and exploration of the western coast of Africa, reaching Gambia by 1446.

The English win an important battle at Agincourt in the Hundred Years' War.

1416 The Czech reformer Jan Hus, a follower of Wyclif's teachings who preached against clerical corruption, is burned as a heretic.

1417 The Council of Constance brings to an end the Great Schism (1378) which had created two lines of popes.

1420 The Hussite Wars begin in Bohemia, involving both issues of religious reform (the teachings of Jan Hus) and issues of nationalism.

1422 Henry V of England (r. 1413–1422) dies, leaving his infant son Henry VI (r. 1422–1461 and 1470–1471) and France's Charles VII as claimants to both the English and the French thrones.

1429 Galvanized by the leadership of Joan of Arc at the siege of Orléans and the subsequent coronation of Charles VII (r. 1422–1461), the French begin winning battles, leading to the eventual defeat of the English in the Hundred Years' War in 1453.

1431 Joan of Arc is burned at the stake in Rouen, France.

1438 The Pragmatic Sanction of Bourges, issued by Charles VII of France, asserts the autonomy of the Church in France against the authority of the Pope.

Albert II (Hapsburg) becomes emperor of Germany, and, from this time on, the imperial title becomes, in practice, hereditary.

1453 The Turks, under Mohammed the Conqueror, breach the walls of Constantinople and capture it, bringing the Byzantine Empire, which has lasted 1,000 years, to an end.

The expulsion of the English from Aquitaine marks the end of the Hundred Years' War.

1455 The Gutenberg Bible is printed in Germany using movable type, effectively ending the predominance of hand-copied manuscripts and making books accessible to ordinary people.

chapter one

1

ARCHITECTURE AND DESIGN

Michael T. Davis

IMPORTANT EVENTS
in Architecture and Design

754 The Abbey of Saint-Denis is begun; its cruciform (cross-shaped) plan imitates that of St. Peter's in Rome.

c. 790 Construction begins on the abbey of St. Savior at Fulda; the church includes a transept modeled on that of St. Peter's in Rome.

Construction begins on Charlemagne's palace at Aachen, which is laid out according to a grid of squares in imitation of Roman methods.

c. 800 Construction begins on the abbey at Lorsch in Germany. Its gateway evokes the Arch of Constantine in Rome.

800 Charlemagne, who began a project of articulating the ideas of power, order, and Christian faith through architecture, is crowned emperor in St. Peter's in Rome by Pope Leo III.

c. 820 The church of San Prassede in Rome is built under Pope Paschal I in conscious imitation of early Christian basilicas.

c. 830 An ideal plan of a monastery is drawn and sent to the abbot of Saint-Gall.

873 At the abbey of Corvey in Germany construction begins on a "westwork," a monumental entry with an upper chapel reached by lateral stair turrets.

962 Otto I is crowned emperor in Rome by Pope John XII, leading to repeated copying of the chapel at Aachen in the design of other structures.

1001 Construction begins on the abbey of Saint-Bénigne, Dijon. Its rotunda emulates the Holy Sepulchre in Jerusalem.

1010 Construction begins on the abbey of St. Michael's in Hildesheim. Its design elaborates on the cruciform basilica.

1012 Construction concludes on a castle at Loches, France, which includes an early example of a "tower keep."

1030 Work begins on the imperial cathedral of Speyer in Germany, a church of enormous scale completed around 1060 and vaulted around 1100.

1037 Construction begins on an abbey church at Jumièges in Normandy. The design introduces a gallery or upper story above the arcade that opens into the main interior space.

1066 England is conquered by the Normans, who will rebuild every cathedral and monastery in the country, obliterating all traces of major Anglo-Saxon architecture.

c. 1078 The Tower of London ("White Tower") is built for William the Conqueror by Gundulf, bishop of Rochester, to dominate the eastern edge of the city and advertise Norman presence.

1078 Construction begins in Spain on the cathedral of Santiago de Compostela, shrine church of St. James, apostle of Jesus.

c. 1080 Construction begins on the pilgrimage church of Saint-Sernin at Toulouse, demonstrating development of barrel vaulting.

1088 Construction begins on the third abbey church of Cluny, the largest in Christendom.

1093 Work begins at the cathedral of Durham. The design features one of the first examples of ribbed groin vaults.

1099 Westminster Hall, the great hall of the palace of Norman kings of England, is completed. It is so wide that it requires internal supports.

c. 1135 Construction begins on the west façade block of the abbey church of Saint-Denis (dedicated in 1140), with three portals and the first example of a rose window.

1139 Construction begins on the abbey of Fontenay, exemplar of Cistercian architecture during the lifetime of influential churchman Bernard of Clairvaux.

1140 Construction begins on the new choir of Saint-Denis (dedicated in 1144) with columns recalling the churches of Rome.

c. 1145 Construction begins on the choir of the abbey of Saint-Germain-des-Prés in Paris, one of the earliest buildings to use flying buttresses.

c. 1150 Laon Cathedral is begun. It is an example of four-story elevation in northern French Gothic architecture.

c. 1155 Construction begins on the cathedral of Paris (Notre-Dame), the interior of which rises to the height of a modern ten-story building.

1179 Master mason William of Sens leaves Canterbury Cathedral after being injured in a fall during the rebuilding of the choir after a fire; he is replaced by master mason William the Englishman. Their work changes the direction of English architecture towards lightness and linearity.

c. 1190 Wells Cathedral's nave is begun, using Gothic forms in independent bits and pieces.

1192 Master mason Geoffroy de Noyers begins work on St. Hugh's choir at Lincoln Cathedral and introduces "crazy vaults."

1194 A fire destroys the Romanesque cathedral of Chartres and work begins on a new Gothic cathedral, which will be known for the expanse of its windows.

1211 Construction begins at Reims Cathedral directed by master mason Jean d'Orbais; it is the first example of bar tracery.

c. 1220 Construction begins on a new choir at the Cistercian abbey of Rievaulx. The struc-

ture will illustrate the achievement of balance through the use of harmonious proportions based on the square.

1228 Construction begins on the church of San Francesco, Assisi (completed 1253) by the Franciscans, one of the new orders of mendicant friars. The church combines new French forms with the local Italian tradition of broad interior space decorated with frescoes.

1229 Work is started on a Dominican church in Toulouse (completed 1292). It is an example of the double-nave church type.

1241 King Louis IX of France begins work on the Sainte-Chapelle (completed 1248) within the royal palace; it includes vertical colonnettes which frame enormous, fifty-foot high stained glass windows.

c. 1244 Work begins on fortifications for the new city of Aigues-Mortes, which serves as a port of embarkation for a crusade led by Louis IX.

1245 Reconstruction of Westminster Abbey choir begins under King Henry III by master mason Henry of Reyns, imitating French *rayonnant* style.

1246 Work begins on the Dominican church of Santa Maria Novella in Florence, stressing a return to functional purity.

1277 Work begins on the west façade of Strasbourg Cathedral where extravagant expressions of bar tracery completely disguise the load-bearing walls behind.

1284 The choir of Beauvais Cathedral, the tallest cathedral (158 feet) in Europe, collapses.

1294 The architect Arnolfo di Cambio begins work on the Franciscan church of Santa Croce in Florence. The design of the church illustrates the simplicity of Franciscan aesthetic values.

1295 Construction begins on Beaumaris castle (in Angelsey, North Wales), the design of which illustrates elaborate defensive structure.

c. 1296 The remodeling and expansion of the royal palace in Paris begins under King Philip IV, combining elements of church and military architecture.

1305 French queen Jeanne de Navarre founds the College of Navarre in Paris; the construction of college buildings begins in 1309, combining elements of monastic and urban palace architecture.

1334 Pope Benedict XII begins construction of a papal palace at Avignon, combining an apparently military exterior with residential and bureaucratic halls; work continues under his successor Clement VI.

1344 Work starts on Prague Cathedral under French master mason Matthew of Arras; Peter Parler becomes master mason in 1352.

1386 Work starts on the Milan Cathedral; in the 1390s debates raise the question of whether a design based on a square or a triangle would be more beautiful and structurally sound.

1394 Architect Henry Yevele and carpenter Hugh Herland begin the remodeling of Westminster Hall and the construction of a hammer-beam ceiling.

1434 Pierre Robin designs the parish church of Saint-Maclou in Rouen. His design illustrates the growing importance of architectural drawings.

OVERVIEW
of Architecture and Design

THE IDEAL FACE OF THE SOCIETY. Change has been a constant of human societies as long as history has been recorded, and the six centuries of the Middle Ages were a period of dynamic transitions and developments in architecture. Europe in 1400 bore little resemblance artistically, economically, politically, or technologically to Europe in 800, although each succeeding generation and century built upon the achievements of its predecessors. As might be expected, architecture offers a complex reflection of the collective concerns of medieval European society, as well as a localized guide to the character and tastes of specific regions or institutions. One twentieth-century French scholar wrote that "architecture is the expression of the very being of societies," but he was also careful to note that architecture represents the ideal face of that society. These structures were erected not only to serve useful purposes as places of worship or residence, but they were, at the same time, visual arguments that were intended to persuade. These important buildings show clearly who had the power and was able to gather the resources of materials, men, and money necessary for their construction. They also reveal the activities and values that were most highly prized and the issues that were deemed the most urgent. Rather than focusing attention on art museums, corporate skyscrapers, or sports stadiums as is common today, the most extravagant medieval architecture was concentrated on churches, aristocratic palaces, and defensive structures.

COMBINING ROMAN AND CHRISTIAN HERITAGE. A rapid sketch of the political and religious landscape of medieval Europe sets the stage for an understanding of medieval architecture, whose beginnings in the late eighth century can be linked to the emergence of a new empire under the leadership of Charlemagne. After the collapse of centralized Roman authority in the fifth century, Europe endured 300 years of political fragmentation and economic decline. Invasions of peoples from western Asia and central Europe, wars, and waves of disease destroyed security, devastated agriculture and commerce,

and emptied urban centers. However, in the later eighth century, the Franks, a Germanic tribe that had settled in what is today France and Germany, began to consolidate their power and expand their territory. To support their claims to rule, they presented themselves as the successors to the Romans, but with one important difference: the Franks were Christian. Their architecture constituted an important part of their persuasive argument, for it looks back for many of its forms to the ancient buildings of Rome and, whenever possible, to those associated with the first Christian emperor, Constantine.

REGIONAL DIVERSITY AND THE ROMANESQUE. Within less than a century, the Carolingian Empire—the kingdom of Charlemagne and his successors—began to lose its central authority once again, and although large-scale political units, such as the empire of the Romans, existed or were revived in theory, effective power settled into the hands of local and regional lords. A system usually referred to as "feudalism," based on hierarchy, land holding, and obligations, arose out of the new political realities. An aristocratic lord gained his wealth from payments (usually in kind) from those who lived on and worked his land. In exchange for his subjects' oath of loyalty and service, he assumed responsibility for their protection. Although great feudal lords might still owe allegiance to the king—for example, the duke of Normandy, even when he was also king of England, was required to swear homage to the king of France for Normandy—they were, in effect, sovereigns in their own regions. A consequence of this political fragmentation is reflected in the diversity of European architecture in the tenth and, especially, the eleventh centuries, a period called the Romanesque. Patrons and their builders continued to employ Roman forms, but did so in such different and imaginative ways that each region's architecture assumes a distinctive flavor. Architectural forms such as monastic buildings, pilgrimage churches, or castles can best be discussed through comparison across both time and space. These architectural types, moreover, such as shrine churches, for example, were not confined to a single art historical period, and their appearance was modified continually.

THE INTERNATIONALIZING OF ARCHITECTURAL FORMS. To a degree, the rise of international monastic orders countered the centrifugal trend of diversity fostered by a political structure based on lordship. Benedictine monastic architectural planning, based on the cloister (walled space) and an orderly arrangement of buildings, was regulated in the ninth century and followed consistently throughout the Middle Ages. In the twelfth century, the Cistercians—a reforming group within Benedictine

monasticism—spread not only consistent methods of planning, but also church types and an artistic attitude of austerity across Europe. Pilgrimage, promoted with special intensity by the Order of Cluny, another group within Benedictine monasticism, also created avenues and institutional connections for the exchange of ideas and innovations in art and architecture. Although precise documentation is lacking, it is obvious, for example, that the builders of the abbey churches of Toulouse (begun in 1080) and Conques in France (begun around 1060) and the cathedral of Santiago de Compostela in distant northwest Spain (1078) were aware of one another's work.

CITIES AND TECHNOLOGIES. The twelfth century was a period of profound change in European society. Modern centralized states began to coalesce as the kings exercised more effective control over their territories and reduced the independence of regional lords. This current culminated around 1300 with the evolution of England and France into nations and the emergence of powerful kingdoms including Aragon and Castile in Spain, and Naples in southern Italy. With improved security, the dramatic increase of agricultural productivity, and the rise of economies based on money gained from surpluses and the increased manufacture of goods, western Europe entered a period of rapid population and urban growth. Paris, for example, experienced roughly a tenfold increase in its population between 1100 and the early fourteenth century, Florence became a metropolis of 100,000 inhabitants, and London and Prague rose to prominence as both royal capitals and artistic centers. It is certainly no accident that a new style of architecture took shape in and around these cities at this time. Gothic architecture, as it later came to be called, first appeared in northern France within royal territory in the mid-twelfth century, and then spread to all areas of Europe. Although the traditional monastic orders remained important sponsors of large-scale building, bishops in their cities assumed greater importance and an affluent laity, whose fortunes were made in commerce and industry, emerged in the thirteenth century as a key source of support for the building efforts of new urban religious communities, notably the convent churches of the Dominican and Franciscan friars. Commercial success, which underscored individual initiative, not only stimulated construction of luxurious residences, but may also have been a factor in the late medieval emphasis on personal piety that was felt architecturally in the demand for spaces for private worship, such as completely outfitted chapels in the home. In addition, the architectural workshop was an important laboratory of new industrial

methods. As the number and scale of building projects increased, techniques of production were devised based on standardized parts, whose fabrication was controlled by drawings. In turn, other industries, such as wool or dye manufacture, offered models of rational organization and efficient labor to the building yard.

ARCHITECTURE AND UNIVERSITY LEARNING. Beginning in the twelfth century and continuing into the fourteenth, universities were founded throughout Europe: Oxford and Cambridge in England; Paris, Toulouse, and Montpellier in France; Bologna in Italy; Salamanca in Spain; and Prague in what is now the Czech Republic (in the Middle Ages part of the Holy Roman Empire). In these centers of intellectual activity, new ways of thinking, based on Aristotelian logic and rhetoric, careful observation, and systematic analysis, pushed received ideas toward original conclusions that transformed European culture. The greatest thinker of the thirteenth century, Thomas Aquinas, a Dominican friar, recognized similarities between the scholar and the architect. Just as the architect orders the raw materials of sand and stone and the skills of his craftsmen into an overall scheme, the philosopher assembles and arranges the disciplines of human learning into an edifice of knowledge. Although the connections may be indirect, the mental processes of the master mason, his acquisition of specialized knowledge in his craft, his ability to think problems through to a solution, and his achievement of innovative combinations of forms can be viewed within the framework of these progressive intellectual trends.

THE ULTIMATE CREATIVITY. Paralleling the development of church architecture throughout the period were technological and conceptual changes in military and domestic architecture. Castles, for example, had evolved from the purely defensive tower that stood alongside a hall for protection, to the residential "donjon" with living spaces for the overlord, and finally to elaborate palace-like structures within fortified walled cities. It was, however, in church architecture that the ultimate expression of medieval creativity was to be found. Gothic cathedrals, as represented by their soaring spires, innovative flying buttresses, and dazzling stained glass, have often been likened to the skyscrapers of the modern era. Despite the obvious differences, the comparison is nonetheless instructive. The modern office building is driven by economic factors, shaped by zoning regulations, designed by skilled architects and engineers, assembled from steel and glass produced in factories and transported by machines to the construction site, run by electricity, accessed by high-speed elevators, climate-controlled by computers, and represents civic pride or

corporate status. It is at once the product of a long developmental process and the awe-inspiring, original creation of the unique forces and capabilities of twentieth-century society. In a similar light, the late medieval cathedral summarized centuries of architectural experience, but also represented the impact of advanced stone-cutting technology and constant structural innovation, patterns of religious devotion, and prosperity as it embodied the visions of earthly power and other-world splendor of its makers.

TOPICS
in Architecture and Design

THE INFLUENCE OF THE CAROLINGIANS

BUILDING AN IMAGE. Medieval architecture, in many ways, was defined during the reign of Charlemagne. Not only was the scale of building enterprises unmatched in Europe since the collapse of the Roman Empire four centuries earlier, but Charlemagne also utilized architecture to create the image of his government. In a biography composed around 830, Einhard, the ruler's friend and advisor, wrote that the emperor

> set in hand many projects which aimed at making his kingdom more attractive and at increasing public utility. … Outstanding among these, one might claim, are the great church of the Holy Mother of God at Aachen, which is really a remarkable construction, and the bridge over the Rhine at Mainz, which is five hundred feet long. … More important still was the fact that he commanded the bishops and churchmen, in whose care they were, to restore sacred edifices which had fallen into ruin through their very antiquity, wherever he discovered them throughout the whole of his kingdom.

During the reign of Charlemagne, the emperor's builders strove to articulate the ideas of power, order, and Christian faith through the arrangement of spaces and the abstract vocabulary of architecture—columns, piers, walls, windows, ceilings. Their task was not unlike the one that the new republic of the United States confronted around 1800: how to give meaningful physical form to guiding political principles. And just as Washington, D.C., wages an eloquent argument in its pediments, domes, porticoes, and temple forms that the United States is heir to the democratic tradition of Greece and the might of Rome, Carolingian buildings turned to ancient Roman architecture to embody the vision of an empire guided by Christian values that would bring unity and peace to a fragmented and conflict-ridden Europe.

AACHEN AND THE EMULATION OF ROME. No project reveals Charlemagne's architectural goals for his new empire better than the palace complex Aix-la-Chapelle at Aachen, in what is now Nord Rhein-Westfalen in northwestern Germany. As another of his biographers, Notker Balbulus (the Stammerer), wrote, "He [Charlemagne] conceived the idea of constructing on his native soil and according to his own plan a cathedral which should be finer than the ancient buildings of the Romans." Built during the 790s, Aachen constituted a palace complex that included a monumental gateway, a chapel, and an audience hall in stone supplemented by residential and utilitarian structures in wood. With this set of impressive buildings, Charlemagne established a permanent and symbolic capital that intended to emulate the great imperial cities of Rome and Constantinople. To make his point clear to the populace, he named his palace "The Lateran," a direct reference to the cathedral and palace, built under Constantine, the first Christian emperor, in Rome. The very plan of Aachen, laid out according to a grid of squares, revived Roman methods to embody the ordered regularity that the emperor wished to impose on his vast territories. Further, the long galleries that linked the three stone structures imitated a feature frequently found in Roman palaces.

ROMAN MODELS. Moreover, the buildings themselves were based on particular Roman prototypes. The palace's great hall, for example, where Charlemagne received visitors and presided over court ceremonies while enthroned in the semicircular space of an apse (a rounded projection from the end of a building), resembled that erected by Constantine around 310 C.E. at nearby Trier on the central western border of modern-day Germany. The palace chapel—this is Notker's "cathedral"—consisting of an outer sixteen-sided polygon enclosing an octagonal central space, looked to a tradition of centralized court chapels found throughout the Mediterranean world from the fourth century on; but it was especially close in form to Justinian's church of San Vitale in Ravenna in Italy (c. 540–548). Charlemagne himself had passed through Ravenna shortly before construction of Aachen was begun and his direct experience of this beautiful imperial church must have been a decisive factor in its design. Like San Vitale, the interior space at Aachen is disposed on two levels: a chapel, dedicated to the Virgin, occupies the ground floor, while the upper gallery level, sheltering the imperial throne and an altar of the Savior, comprises a second chapel. The sturdy piers, the tiers of arches, the sophisticated combination of vaults, and the

MEDIEVAL Architecture Terms

Aisle: A long open narrow area at the sides of a church used to walk through the structure.

Altar: The elevated place in a church where rites are performed.

Ambulatory: The passageway around the end of the choir.

Arcade: A series of arches supported by piers or columns.

Apse: A vaulted semicircular or polygonal recess in the church at the end of the choir.

Ashlar: Stone that is faced and squared, often with a chipped or irregular surface.

Bailey: The open courtyard in a castle between the outer ring of fortified walls and the keep.

Battlement: The low parapet at the top of a fortified wall composed of solid shields of masonry, called merlons, alternating with openings, called crenels.

Bay: Any of a number of similar spaces or compartments between the vertical dividing structures of a large interior.

Capital: The uppermost portion of a column or pillar, often carved with relief sculpture on several faces.

Chapel: A small space for private worship off the aisle of a church.

Chevron: A pattern of angled stripes.

Choir: The part of a church to the east of the transept, occupied by monks during the singing of offices.

Clerestory: A portion of the interior of a church rising above adjacent rooftops and having windows to admit light.

Column: A large post-like support holding up an arch or other architectural feature. The tops of columns were often decorated with sculpture.

Corbel: A short horizontal bracket of stone or timber projecting from a wall and supporting an architectural element.

Crenellation: A battlement (protective wall) with tapered embrasures or squared openings.

Crypt: A chamber or vault below the main floor of a church, often used as a burial spot.

Donjon: The great tower or keep of a castle, sometimes thought to be the residence of the lord of the castle.

Façade: The front of a church, usually imposing and decorated.

Flying buttress: A segmental arch transmitting outward and downward thrust to a solid buttress or square column which transforms the force into a vertical one.

Gallery: A long narrow area open at each end or at sides and sometimes elevated.

Groin vault: The curved line or edge formed by the intersection of two vaults.

Hammerbeam: One of a pair of short cantilevered timbers supporting a ceiling arch.

finely cut stonework of the building are unprecedented in earlier medieval architecture and, once again, suggest that the revival of Roman forms was accompanied by a comparable renewal of Roman building technology. Finally, the decoration of ancient columns and capitals, marble imported from Ravenna, bronze railings and doors, and mosaics all invest the chapel with a dazzling and thoroughly Roman aura. As a whole, Aachen sends the message of Charlemagne as the legitimate successor to the authority of Christian imperial rulership in the West. It was the architectural "first act" of a political drama whose conclusion was staged on Christmas Day 800 with the coronation of Charlemagne as emperor in St. Peter's Basilica in Rome.

THE BASILICA. As the words of Einhard, quoted above, imply, the Carolingian era witnessed a surge of church construction. Although centralized plans were often favored for aristocratic chapels, they were not easily adaptable to the needs of churches that required space for large congregations or housed monastic communi-

ties whose liturgy involved processions to altars located throughout the interior. Once again, Carolingian patrons and builders looked back to early Christian Rome for a model that was at once functional—accommodating crowds of worshippers and the processional liturgy of the Mass—as well as historically resonant and symbolically potent. The basilica fit all three requirements. Adapted from large Roman halls that served a variety of functions, including law courts or public assembly, the Christian basilica is characterized by its longitudinal space organized around a central axis and formed by a dominant central area flanked symmetrically by lower aisles. The usual model contained a long hall or nave, an entry portico on the west side, and an apse (usually semicircular in form, but sometimes polygonal or square) in the east, which usually contained the altar area. The entry and altar were almost always on the short sides of the rectangular configuration, with the altar facing the city of Jerusalem. A large open courtyard or atrium, a feature eliminated in the later Middle Ages, and an entry

Keep: The multi-storied tower that combined living quarters and defensive features in a medieval castle.

Keystone: A wedge-shaped stone at the summit of an arch serving to lock the other stones in place and create structural strength.

Machicolations: A projecting gallery at the top of a fortified wall with floor openings through which heavy objects or boiling liquids could be dropped on attackers.

Moat: A ditch of some width and depth around a fortified area like a castle serving to repel intruders.

Motte: A fortification consisting of a timber tower set atop a conical earth mound. The motte often was surrounded by a ditch and wooden palisade.

Narthex: An enclosed passage between the main entrance and the nave of a church.

Nave: The main longitudinal area of a church.

Parapet: A battlement wall protecting the wall-walk and roof.

Pier: A support for the ends of adjacent spans of arches.

Plate: A horizontal timber laid flat atop a pier or wall used to attach the ends of rafters.

Portcullis: A heavy iron or wooden grill, set in vertical grooves, that can be raised or lowered by chains to protect the entrance to a castle.

Purlin: A longitudinal member in a roof frame usually for supporting common rafters between the plate and the ridge.

Rafter: The beam, usually angled and joined at the top to a similar beam in the form of an inverted V, which is used to support a roof.

Rotunda: A circular high space in a church surmounted by a dome.

Rubble: A wall made of different sizes and types of uncut stone.

Screen: A wooden or iron structure separating the nave from the choir of a church, sometimes called "rood screen" if it had a large crucifix ornamenting its top.

Transept: The transverse part of the rectangular body of the church, usually crossing the nave.

Triforium: The wall at the side of the nave, choir, or transept corresponding to the space between the vaulting or ceiling and the roof of an aisle.

Truss: A triangle of timbers used to support compression, used in the construction of a roof.

Voussoir: A wedge-shaped brick or stone used to form the curved part of an arch or vault.

Wattle and daub: A building material consisting of wattle, a light mesh of laths or interwoven twigs, covered with mud, stucco, or brick.

Westwork: The monumental western front to a church involving a tower or group of towers and containing an entrance and vestibule below and a chapel above.

vestibule, called a narthex, frequently fronted the body of the basilica. This axial sequence of spaces lent itself naturally to hierarchical divisions, marked by barriers, curtains, screens, and differences in decoration. The nave served as the congregational space while the apse enclosing the altar was reserved for the clergy.

SYMBOLIC SHAPE AND NUMBER. In Abbot Fulrad's rebuilding of the abbey of Saint-Denis between around 754 and 775, the Roman inspiration was evident. The church took the shape of a cross through the addition of a transverse space, termed a transept, inserted between the nave and the apse. The transept appeared earlier only at the great martyrs' basilicas of St. Peter's and St. Paul's in Rome, presumably to provide a suitably impressive spatial setting around the tomb of the saint, but once revived, this cruciform plan became common in Christian architecture. Used at Saint-Denis, it served the dual purpose of linking the local saint with the prestige of the apostle Peter and of equating the Frankish kings, many of whom were buried there (including Charlemagne's

father Pepin the Short), with Constantine, the patron of St. Peter's. To judge from its plan, a nearly exact replica of the transept and apse of St. Peter's was also erected over the tomb of St. Boniface, missionary to the Germans, at Fulda in the early ninth century. Another impressive example can be found in the abbey of Saint-Riquier at Centula in northern France, where the cruciform shape of the church combines with an insistent use of three in its plan to emphasize the Trinity. The importance of number in the church's design is characteristic of medieval architecture. Based on a passage in the Wisdom of Solomon, "you have ordered all things in measure and number and weight," Christian theologians from Augustine, writing in the fifth century C.E., on interpreted numbers symbolically. Numbers revealed the underlying harmonies of the universe and their incorporation into the designs and visual rhythms of medieval architecture intended to convey the beauty of divine creation. In all of these basilicas, the references to early Christian Rome served not only as a political symbol,

TYPES
of Churches and Religious Structures

Abbey church: The church of a monastery under the supervision of an abbot or a convent of nuns under the supervision of an abbess.

Basilica: A Roman Catholic church or cathedral given ceremonial privileges by the pope. Christian basilicas were formed out of ancient Roman buildings (originally assembly halls, courts, and exchanges) or built on a similar design.

Cathedral: The principal church of an archdiocese or diocese, the regional administrative districts of the Church. The throne—or cathedra—of the archbishop or bishop is located in the cathedral.

Chapel: A separate area in a church or home, having its own altar and intended for private worship.

Cloister: The enclosed part of a monastery or convent where monks or nuns live and, in some cases, laypeople are not allowed to enter. The term can also refer to the covered walkway around the interior courtyard of a monastery or college.

Convent: The living quarters of nuns or the dwelling of a community of friars.

Monastery: The complex of buildings, including an abbey church, in which a group of people, observing religious vows or rules, lives together. A convent often designates a female religious community. A double monastery refers to one that includes both monks and nuns.

Parish church: The church of a parish, a small division of the larger diocese. The parish church was the focus of religious activity of the local population, who were ministered to by a rector or sometimes a curate whose living came from the rent provided from the lands of that community.

Pilgrimage church: A large church on the major pilgrimage routes, such as the road leading to the shrine of St. James at Compostela. Pilgrimage churches often offered shelter, and provided maps and information about the route.

Shrine: An alcove for a tomb, holy relics, or a religious icon in a church.

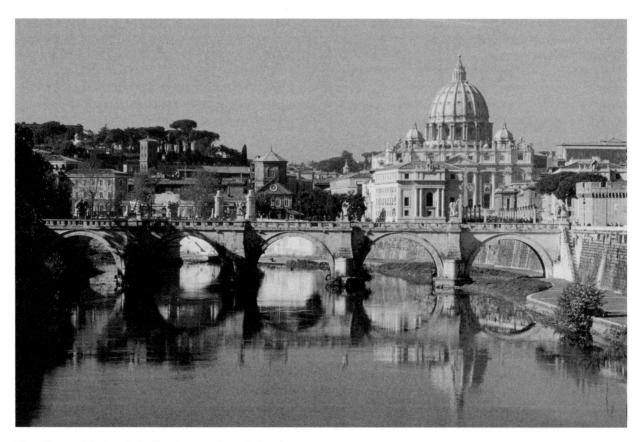

Tiber River and St. Peter's Basilica, Rome, Italy, early fourth century. **JOHN AND LISA MERRILL/CORBIS.**

a PRIMARY SOURCE *document*

ON THE LITURGY AND RELIQUARIES OF THE ABBEY CHURCH OF SAINT-RIQUIER

INTRODUCTION: During the reign of Charlemagne, the Western Church experienced both a rise in the use of Roman liturgy and an increased interest in the cults of saints. Church architecture responded by providing additional pathways for processions and spaces for the exhibition of relics. This architectural tendency is illustrated at the Abbey Church of the Royal Monastery of Saint-Riquier, near Amiens in northern France, where the abbot was a theologian and court-poet known as Angilbert of Saint-Riquier. Born in the late 750s to one of the families of Frankish aristocracy, Angilbert received his schooling in the entourage of Charlemagne and was closely connected to the emperor's family. In his treatise entitled *De perfectione*, Angilbert provides a narrative account of his personal rebuilding of the abbey and treats the elements of the buildings and treasures of the monastery. The excerpt provided below shows how movement around the church to multiple altars and stations had become an important part of worship. The titles preceding the paragraphs have been added for clarity. They do not appear in the original document.

The Liturgy

At all Vespers celebrated in the normal way, when everything has been completed at [the altar of] Saint Richarius, let the brothers proceed by singing psalms up to the holy Passion. When the prayer has been completed, let the choirs be divided into two, of which one proceeds to [the sculpted relief of] the Holy Resurrection, the other to [the sculpted relief of] the Holy Ascension. Then when the prayer has been done, let one choir come to [the altar of] Saint John, the other to Saint Martin. And then afterward [proceeding] through [the altars of] Saint Stephen and Saint Lawrence and the other altars by singing and praying, let them come together at the [altar of] the Holy Cross... But when Vespers and Matins shall have been sung at [the altar of] the Holy Savior, then let one choir descend to [the sculpted relief of] the Holy Resurrection, the other to [the sculpted relief of] the Holy Ascension, and there, praying, let them just as above process singing to [the altars of] Saint John and Saint Martin; when the prayer has been completed, let them enter here and there through the arches of the middle of the church and let them pray at [the sculpted relief of] the Holy Passion. Thence let them proceed to [the altar of] Saint Richarius, where, when the prayers have been said, they shall divide themselves again just as before and shall come through [the altars of] Saint Stephen and Saint Lawrence, singing and praying, up to [the altar of] the Holy Cross. ...

The Relics

These [relics] having been collected ... honorably and fittingly in the name of the Holy Trinity, we have with great diligence prepared a principal reliquary decorated with gold and gems, in which we have placed part of the above-mentioned relics, which we have been eager to place ... under the crypt of the Holy Savior. Moreover, we have taken care to divide the relics of the other saints, which are noted above, into thirteen other smaller reliquaries decorated most handsomely with gold and silver and precious gems, which we merited to collect ... and we have placed them on the beam that we have established on the arch in front of the altar of Saint Richarius [in the apse of the church], so that in every corner in this holy place it will be fitting that the praise of God and the veneration of all of his saints always be adored, worshiped, and venerated.

SOURCE: Angilbert of Saint-Riquier, *De perfectione*, in *Faith, Art, and Politics at Saint-Riquier: The Symbolic Vision of Angilbert.* Ed. Susan Rabe (Philadelphia: University of Pennsylvania Press, 1995): 118, 121–122.

but also as a representation of the true Christian faith that Charlemagne and his theologians took as their mission to protect and proclaim.

INNOVATIONS IN PLANNING. Carolingian church architecture was more than historical and spiritual nostalgia for early Christian Rome. It enriched its borrowings from the past by contributing a greater complexity to spatial planning. In part, this was a response to the promotion among Charlemagne's ecclesiastical allies of the Roman liturgy, whose worship services featured processions through and around the church. With the rise of the cult of saints as a significant component of medieval Christian worship, auxiliary spaces were required for the exhibition of relics with pathways providing access to the tomb or shrine. The underground corridor that was excavated in the apse of St. Peter's in Rome around 600 during the reign of Pope Gregory I (the Great) allowing the faithful to circulate around the saint's burial site was copied at Saint-Denis and San Prassede in Rome (c. 820). An elaborate two-story crypt was added outside the choir of the original church of Saint-Germain, Auxerre, in France in the mid-ninth century. Passages, connecting a series of chapels, including a rotunda dedicated to the Virgin Mary, provided circulation around the sixth-century tomb chamber of

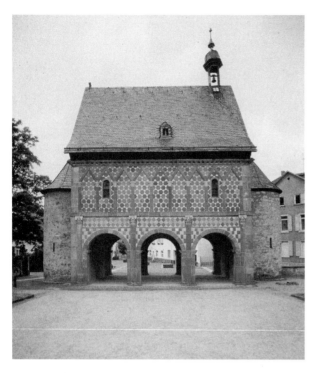

Gatehouse from Abbey of Lorsch, Germany, early ninth century.
VANNI ARCHIVE/CORBIS.

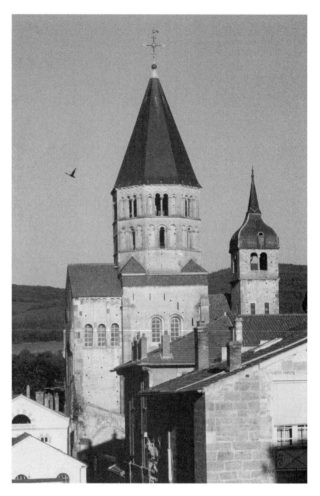

Towers of Benedictine monastery, Cluny, France, 12th century.
HAMISH PARK/CORBIS.

Saint-Germain as well as space for six new altars. A similar multiplication of chapel spaces was echoed above ground in the 870s at the abbey church of Corvey in Germany, where an axial cruciform chapel and two lateral chapels were linked by a curving aisle that wrapped around the choir. These experimental schemes anticipated the development of the ambulatory (an aisle surrounding the end of the choir) and chapel arrangement of Romanesque and Gothic architecture. A further modification of the standard basilica was the "double-ended" plan, found at Fulda in Germany and in the Plan of Saint-Gall in Switzerland (a series of blueprint-like drawings), where the saint's shrine and the main altar were placed in apses at opposite ends of the church, a solution that had a long life in German church design.

PROUD TOWERS. Proclaiming the majesty of the church, towers represent one of the most daring contributions of medieval architecture, for they existed more for the sake of their visual impact and symbolic resonance than they did to fulfill any functional purpose. Concentrated at the "crossing," that is, the intersection of the nave and choir of the basilica, towers accented the area of the main altar, the focal point of the church. At Saint-Denis, a 30-foot-high tower rose above the crossing while at Saint-Riquier, a multi-stage polygonal lantern (a tower-like structure admitting light) flanked by two slim stair turrets formed a monumental vertical cluster

that contrasted dramatically with the 275-foot length of the body of the church. This embellishment of the crossing, often formed by a central tower with taller towers placed at the ends of the transept, continued through the next major architectural period (the Romanesque), as at the third abbey church of Cluny in France or Tournai Cathedral in Belgium, and then into the culminating period of medieval architecture (the Gothic) at the cathedrals of Laon and Chartres in France, and Milan in Italy, where the towers were likened to the "four evangelists surrounding the throne of God." Towers appeared most commonly as integral elements of the façades of church buildings. Twin towers are mentioned at the Carolingian Saint-Denis, an arrangement repeated in the reconstruction of the abbey's new entrance block in the 1130s. However, Carolingian architecture is most notable for its invention of the "westwork," the monumental entry composed of a dominant central element enclosing an upper chapel reached by lateral stair turrets (that is small towers on each side). Described as a *castel-*

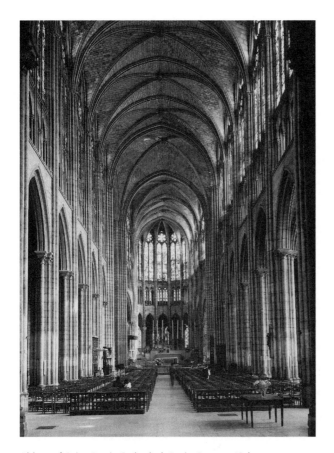

Abbey of Saint-Denis Cathedral, Paris, France, 13th century. **THE ART ARCHIVE/DAGLI ORTI.**

————, *The Politics of Dreaming in the Carolingian Empire* (Lincoln: University of Nebraska Press, 1994).

Einhard and Notker the Stammerer, Two Lives of Charlemagne. Trans. Lewis Thorpe (London: Penguin, 1969): 71.

Louis Halphen, *Charlemagne and the Carolingian Empire.* Trans. Giselle de Nie (Amsterdam: North Holland, 1977).

Rosamond McKitterick, *The Frankish Church and the Carolingian Reforms, 789–895* (London: Royal Historical Society, 1977).

Lawrence Nees, *A Tainted Mantle: Hercules and the Classical Tradition at the Carolingian Court* (Philadelphia: University of Pennsylvania Press, 1991).

Susan Rabe, *Faith, Art, and Politics at Saint-Riquier: The Symbolic Vision of Angilbert* (Philadelphia, Pa.: University of Pennsylvania Press, 1995).

Richard E. Sullivan, *Aix-la-Chapelle in the Age of Charlemagne* (Norman: University of Oklahoma Press, 1963).

J. M. Wallace-Hadrill, *The Frankish Church* (Oxford and New York: Oxford University Press, 1983).

SEE ALSO *Visual Arts: The Carolingian Restoration of Roman Culture*

lum ("castle") or *turris* ("tower") by contemporary writers, the westwork of churches such as Saint-Riquier and Corvey served as a virtual vertical church for the staging of important religious services. In addition, because the façade block housed the emperor's throne at Aachen, it has sometimes been interpreted as an imperial architectural form. Roman city gates, it should be remembered, had included towers and upper chambers used in imperial ceremonies. At the Abbey of Lorsch in Germany, a freestanding triple-arch gateway that probably "copied" the Arch of Constantine in Rome coupled with the church's westwork behind to create a spectacular entry sequence. The tower, like the inventive mix of Roman and medieval forms of Carolingian architecture in general, resonated on multiple levels as it invested the church with the aura of imperial power, triumphal authority, and transcendental spirituality.

SOURCES

Kenneth Conant, *Carolingian and Romanesque Architecture 800–1200* (New York: Penguin, 1974).

Paul Dutton, ed., *Carolingian Civilization: A Reader* (Peterborough, Ontario: Broadview Press, 1993).

OTTONIAN AND NORMAN ARCHITECTURE

CAROLINGIAN QUOTATIONS. Charlemagne's vision of a Christian Roman Empire dissolved in the later ninth century, bringing an end to a great period of public construction. Central authority, undermined by the division of territory and royal rivalries among Charlemagne's grandsons, was shattered by the invasions of Vikings in the north, Magyars in the east, and the Muslims around the Mediterranean. Their attacks devastated hundreds of towns, churches, and monasteries. A new kingdom emerged in central Germany in the mid-tenth century that laid claim to the mantle of the Carolingians, and in 962, Otto I was crowned emperor. In the projects generated by the court and its ecclesiastical allies, architecture reinforced Ottonian political pretensions through a deliberate continuation of Carolingian models. The palace chapel at Aachen was copied repeatedly throughout the eleventh and twelfth centuries: in the chapel of St. Nicholas at Nijmegen in the eastern Netherlands, at Bishop Notger's chapel at Liège in Belgium, and, oddly enough, in nunneries at Essen and S. Maria im Kapitol in Cologne in Germany, and at Ottmarsheim (1049) in eastern France. The interest of these female monastic communities in Charlemagne's chapel underscored their

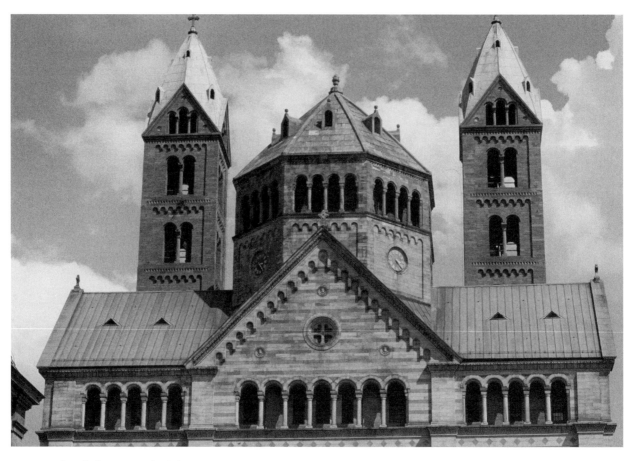

Towers and roof of Speyer Cathedral, Germany, 1030. **CARMEN REDONDO/CORBIS.**

imperial connections, but may have also been suggested by Aachen's dedication to the Virgin Mary and its possession of the relic of her shroud. Westworks appeared in major Ottonian cathedrals and monasteries in Germany, including the cathedrals of Speyer and Worms, and the abbey church of St. Michael's in Hildesheim, suggesting that by this time they were seen as an important component of the imperial architectural image. The cruciform basilica, revived by Carolingians, remained the basis for large-scale church plans. At St. Michael's, Hildesheim, this basic plan was elaborated with a transept and apse at each end of the building with the western choir raised above a crypt whose ambulatory was visible on the exterior.

SPEYER. The Cathedral of Speyer in western Germany, started in 1030 during the reign of Emperor Conrad II and vaulted (given its stone ceiling) around 1100, was the pre-eminent structure of the period and illustrates what might be called the progressive historicism—the creating of new architectural forms inspired by historical models—typical of so much of medieval architecture. A glance at the exterior of the cathedral with its massive

westwork and grouped crossing towers certainly recalls Carolingian precedents, such as Saint-Riquier, but the enormous scale of the cross-shaped plan, 435 feet in length, equals that of Roman imperial churches such as St. Peter's in Rome. The interior conjures up a similar Roman spirit. Its combination of rectangular piers and attached columns reproduces the structure of the Colosseum (Rome's massive amphitheater), while the arcade that rises through the entire 90-foot high elevation to frame each window resembles an aqueduct (Rome's system of raised water channels) or, again, the exterior of Constantine's audience hall at Trier in Germany. Visually, the new mix of piers and columns created a system that articulated the building as a series of repeating units that reflected the geometry of the plan. It also produced a more emphatically three-dimensional architecture whose walls were organized in distinct planes. In a similar vein, the exterior was embellished by the disciplined formal rhythms created by niches, decorative arches, and wall arcades framed by columns or pilasters (flattened or rectangular columns). A setting of overwhelming monumentality was created at Speyer to demonstrate the Roman and Carolingian origins of the

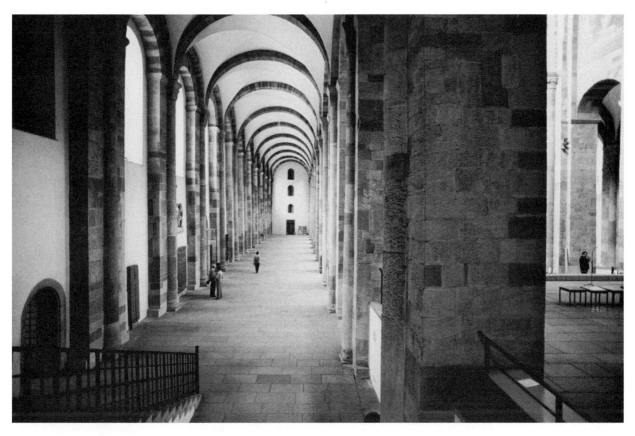

Aisle of Speyer Cathedral, Germany, 1030. VANNI ARCHIVE/CORBIS.

power of the German kings who lay buried in the spacious crypt under the choir.

IMPOSING VERTICALITY IN NORMAN FRENCH ARCHITECTURE. In a treaty of 911, the Carolingian king Charles the Simple granted the area around Rouen in northwestern France to the Vikings, creating what was to become the duchy of Normandy. Converted to Christianity and expanding their territories, the Normans soon turned to the task of building architecture worthy of a powerful state. The cathedrals and monasteries they erected during the eleventh century reveal a far-flung array of sources drawn from southwestern France, Burgundy, and the Holy Roman Empire in Germany. At the Abbey of Jumièges in France, begun in 1037 and completed in 1066, a pair of tall towers flank a projecting porch with an upper chapel to form an impressive frontispiece that is reminiscent of such Carolingian façade blocks as Saint-Denis or Corvey. The interior of the church emphasizes elegant verticality through the use of tall, attached columns that divide the nave wall into a series of regular units or bays. Even more notable, the elevation now contains three levels: above the arcade, a spacious gallery is introduced with a window zone, called a clerestory, at the top of the wall just below the timber ceiling. Appearing in Ottonian church designs, but known in early Christian examples from Jerusalem to Trier, the gallery might have accommodated additional altars or been used by pilgrims. Clearly, it invested the church structure with a lordly height that was a symbol of status. Saint-Etienne at Caen in Normandy, founded around 1060 by William the Conqueror, who was also buried in front of the high altar at his death in 1087, exhibits an even more imposing demeanor. The rigorously ordered façade with its three portals and twin towers offered a scheme that would be repeated until the end of the Middle Ages. Like Jumièges, the interior of Caen contains three stories, including a gallery, but here supported exclusively by piers composed of a bundle of shafts set around a cruciform core that are coordinated with the key structural elements of the arcade, aisle vaults, and original wooden ceiling. Its thick walls, honeycombed by passages, resemble the architecture of contemporary Norman castles—the Tower of London, for example—and capture an image of the church as a Christian fortress as well as a symbol of political might.

NORMAN DOMINATION IN ENGLAND. Few events so thoroughly remodeled an architectural landscape as the Norman conquest of England in 1066. In the generation

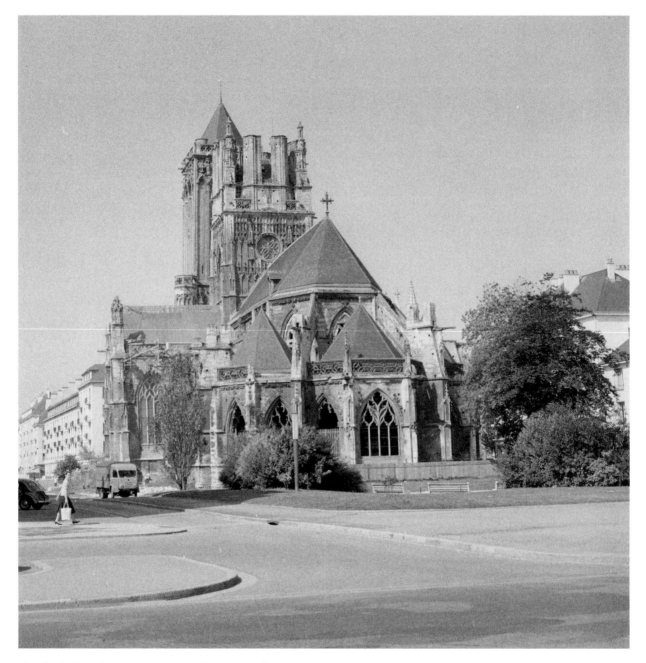

Church of Saint-Etienne, Caen, Normandy, France, under reconstruction. BETTMANN/CORBIS.

following the Battle of Hastings, at which the Norman invaders, led by the future king William I, conquered the Anglo-Saxon king Harold, the Normans rebuilt every major cathedral and monastery in the country, literally obliterating the architecture of the Anglo-Saxons whom they had defeated. Dominating the skylines of English towns, these Norman churches left no doubt as to who was in control. As the twelfth-century historian William of Malmesbury noted in his *Deeds of the English Kings*, "You may see everywhere churches ... [and] monasteries rising in a new style of architecture; and with new

devotion our country flourishes, so that every rich man thinks a day wasted if he does not make it remarkable with some great stroke of generosity." The ambitions of the new regime were apparent immediately in the projects launched by the conqueror and his ecclesiastical entourage, including Lanfranc, archbishop of Canterbury, and Walkelin, bishop of Winchester. If the recent Norman plans of Rouen Cathedral or Saint-Etienne at Caen guided design at the cathedrals of Canterbury, Durham, or Lincoln, the conscious desire to evoke Rome and rival the architecture of the Continent lies behind

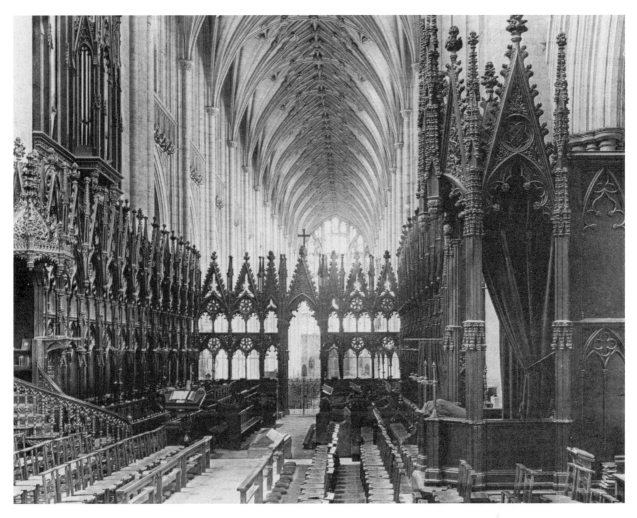

Choir with roof vaulting, stalls, and woodwork of Winchester Cathedral, England, eleventh century. ALAN TOWSE; ECOSCENE/CORBIS.

the pursuit of overwhelming scale, and the selection of majestic forms and materials. By William the Conqueror's death, the kingdom had no fewer than nine churches comparable in scale to St. Peter's. At Winchester, the columns that rise from floor to ceiling, seen in the surviving late eleventh-century transept or in the vaulted choir, parallel the insistent verticality of Speyer Cathedral in Germany and, combined with a huge western entry block, whose outlines have been recovered in archaeological excavations, create an imperial aura based on a mix of Roman, Carolingian, and Ottonian references. In the case of Durham's famous spiral columns, a specific link to St. Peter's is conjured up to reveal the local saint, Cuthbert, as an equal of the apostle. While Durham's architecture draws on Norman features present at Jumièges and Saint-Etienne at Caen, its most significant aspect is its use of pointed arches together with ribbed groin vaults, an innovation that supported the heavy stone roof in a way that was lighter, higher,

and more decorative than the heavy barrel vaults they replaced. Originally planned only over the eastern arm, or choir, of the church, the stone vaults were extended over the entire edifice during the building process. Whatever their structural and aesthetic advantages, they also provided a canopy over sacred space that turns the building into a monumental shrine. This conception of the church as a precious object is reflected at Durham in the lavish decoration of the entire building: the interlacing arches of the aisle walls, the carved patterns on the piers, and the restless chevron (angled stripe) ornament that outlines the arches and ribs.

A SICILIAN BLEND. An independent band of Normans established a kingdom in southern Italy and Sicily during the later eleventh century where they formulated an architecture that was an exotic mixture of Byzantine (Eastern Christian, centered in Constantinople or modern Istanbul), Muslim, and Christian Roman traditions. Best represented by the Palatine Chapel in Palermo or

Mismatched ribbed vaulting for transept ceiling in the Chapel of the Nine Altars, Durham Cathedral, England, 1093–1133. **ANGELO HORNAK/CORBIS.**

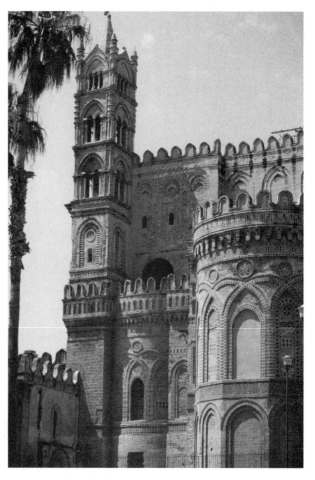

View of Cathedral, Monreale, Palermo, Sicily, 12th century. **ADAM WOOLFITT/CORBIS.**

the cathedral of Monreale on the Italian island of Sicily, the Norman buildings of Sicily serve as a reminder that architecture is a language of communication whose vocabulary is often tailored to local circumstances. Thus, rather than erasing all signs of the past, the Palatine Chapel, built and decorated by King Roger II between 1132 and 1189, recasts the traditional basilican structure in forms absorbed from the conquered Byzantines and Muslims. The alternating smooth and fluted columns, the dome that rises over the crossing, as well as the glittering gold-ground mosaics are Byzantine in style; the pointed arches and elaborately faceted stalactite ceiling draw upon Muslim architecture. Like the imagery that showcases Christ in Majesty accompanied by the Roman saints Peter and Paul under a ceiling with paintings of constellations, courtly entertainments, and scenes of daily life, the church in its combination of traditional and alien forms comprises a text in which the impact of rival cultures, divine sanction, and the sophisticated refinement of the Norman kingdom and its rulers can be read. The same point is made by Monreale Cathedral, begun in 1174. An arresting play of interlacing pointed arches over the exterior invests the church with an ornamental luxury comparable to the most elaborate Islamic palaces, while the cruciform basilica with classical columns and mosaics seems a deliberate recollection of early Christian models. Far different in appearance from the projects undertaken in France and England, Norman architecture in Sicily underlines the bewildering variety of styles and the creative interplay of sources encountered in the Romanesque period.

SOURCES

Bianca Maria Alfieri, *The Cathedral of Monreale* (Novara, Italy: Istituto geografico De Agostini, 1983).

Ian Curry, *Aspects of the Anglo-Norman Design of Durham* (Newcastle-on-Tyne, England: Society of Antiquaries, 1986).

R. H. C. Davies, *The Normans and Their Myth* (London: Thames and Hudson, 1976).

Ernst Gall, *Cathedrals and Abbey Churches of the Rhine* (New York: Abrams, 1963): 26, 27.

Louis Grodecki, *L'architecture ottonienne au seuil de l'art roman* (Paris: Colin, 1938).

John Le Patourel, *The Norman Empire* (Oxford: Clarendon Press, 1976).

Brian Little, *Architecture in Norman Britain* (London: Batsford, 1985).

Graham A. Loud, *The Age of Robert Guiscard: Southern Italy and the Norman Conquest* (New York: Longman, 2000).

SYMBOLIC
Architecture: Copying the Church of the Holy Sepulchre

Imitation and Connection

Every church, no matter its size, plan, or style, was a symbol—or rather a set of simultaneous symbols—of heaven, Noah's Ark, or the Body of Christ, as interpreted by theologians. From the beginning of Christian public architecture in the fourth century, builders often identified holy sites by special plans or by dazzling decoration. In the best known and most widely imitated example, the Church of the Holy Sepulchre in Jerusalem, as it was originally built around 325 C.E. during the reign of Constantine, marked Jesus' tomb with a large circular structure, a type of building associated with commemoration in the Roman world. Religious structures in Western Europe from the ninth through the twelfth centuries frequently copied the Holy Sepulchre to make the experience of Jerusalem, which lay in Muslim hands, more accessible and to encourage devotion to the central beliefs of the faith. Bishop Meinwerk of Paderborn in Germany even sent a representative to the Holy Land to measure the building, but the structure he erected in 1036 was cruciform in shape. Evidently, he (and the many pilgrims who engaged in measurement and even carried back banners cut to symbolic proportions) believed that incorporating selective dimensions and adopting a centralized plan and common dedication to the Holy Sepulchre were sufficient to establish a compelling connection. Rather than an exacting copy, it was the meaning of the Holy Sepulchre as the place of the Crucifixion that was of paramount importance to the bishop.

Symbolic Interpretations

For the Templars, the various versions of the Holy Sepulchre that sprang up in their monastic houses throughout Europe during the twelfth century—for example, at London and Paris—all represented their charge to defend and maintain the sites of the Holy Land. Emphasizing a somewhat different interpretation, in the Baptistery of Pisa of 1153, the quotation of the circular plan, the dimensions, the exotic multicolored masonry, and the steep conical roof of the Holy Sepulchre created a symbolic link between the rite of baptism that would take place there and the death and resurrection of Christ. Shifting the symbolism back to the original idea of commemoration, the monastic church of Saint-Bénigne in Dijon (1001–1018) repeated the rotunda as the setting for the tomb of its saint, and as late as around 1180 another such rotunda was attached to the choir of Canterbury Cathedral, where the cranium of St. Thomas Becket was displayed to the eager eyes of visitors. This imitation of a prestigious model, however flexible its interpretation, was one of the ways by which importance and prestige could be conferred onto a building and the saint whose relics "lived" within.

Donald Matthew, *The Norman Kingdom of Sicily* (Cambridge, England: Cambridge University Press, 1992).

Lucien Musset, *Normandie romane:* Photographies inédits de Zodiaque. (Saint-Léger-Vauban, Yonne: Zodiaque, 1967-1974).

William Tronzo, *The Cultures of His Kingdom, Roger II and the Cappella Palatina in Palermo* (Princeton, N.J.: Princeton University Press, 1997).

William of Malmesbury, *Gesta Regum Anglorum.* Vol. I (ii.228.6). Trans. R. A. B. Mynors, R. M. Thomson, and M. Winterbottom (Oxford: Clarendon Press: 1998): 418–419.

GEOMETRY AND PLANNING

ARCHITECTURE, BEAUTY, AND GEOMETRY. Modern observers are often filled with awe when they consider the combination of engineering and aesthetic sophistication required to achieve the complex structures that were evolving even in the early Middle Ages. Of the many stages involved in the construction of a medieval building, the first step, the planning phase, remains the most elusive. This was the moment when thoughts and conversations began to take physical form as architects translated functional requirements and a patron's vision into structure and space. What strategies did they employ to ensure that an edifice was both stable and beautiful? Geometry provided the means by which masons designed and laid out plans, the common language of communication between craftsman and cleric, and the vehicle by which architectural form could be invested with meaning. Medieval thinkers, such as St. Augustine, followed Vitruvius, a Roman architect who wrote *On Architecture* at the time of Augustus in the late first century B.C.E., by defining beauty as a harmony of parts that arose out of geometrical regularity. Constantly cited by writers from the ninth century on, Vitruvius's ideas on architectural planning, along with other classical works, were well known in the Middle Ages. In 1321, the monks of the abbey of Saint-Ouen in Rouen wrote, as they planned for the reconstruction of their church, that "we have decided to build in accordance with former

learned treatises" by "industrious and accomplished artisans who are recognized to possess proven and well-known experience in such matters." Whether or not medieval masons actually read these "treatises," this document suggests that they were able to put into practice the architectural theories familiar to their scholarly patrons.

SQUARES, CIRCLES, AND TRIANGLES. According to Vitruvius, plans of buildings require geometry that "teaches the use of straight lines and the compass." The designs of most medieval buildings can be understood in terms of skillful combinations of squares, circles, and triangles. An architect might take a "modular" approach based on the repetition of a standard unit, as illustrated by the layout of Charlemagne's palace at Aachen which used a 12-foot length, organized into larger squares of 84- and 360-feet, or the plan of Saint-Gall that was governed by a grid of 40-foot squares. However, after the fifth century and the collapse of centralized Roman authority, different regions of Europe and even cities within the same region adopted their own standards of measurement that might vary by as much as four inches per foot. The potential for chaos if an architect designed a building according to one foot-length while the craftsmen constructed it using another standard of measure was great. To avoid such problems, builders turned to ratios generated by the manipulation of basic geometric figures as the means of organizing and coordinating the complex of parts and spaces of the church. One of the most common techniques was based on the ratio of the side of a square to its diagonal, that is, one to the square root of two (or mathematically 1: 1.414). For example, imagine that a person laid out a square then drew its diagonal. Then the person swung the diagonal until it lined up with the side of the square. That person has just designed most of the twelfth-century Cistercian abbey of Jerpoint in Ireland: its cloister is a 100-foot square while the nave, created by the diagonal, is 142 feet long. Swinging the diagonal in the other direction establishes the width of the east range of the cloister buildings. A similar square root of two ratios ran through Norwich Cathedral, begun in the late eleventh century, and controlled the relation of width to length of the papal church of Saint-Urbain in Troyes which was begun in 1262.

OTHER RATIOS. A second ratio that can be found frequently in medieval architecture is the "golden section" (1: 1.618), easily produced from the diagonal of half a square. Used as far back as ancient Egypt and continued by the Romans in such important Christian structures as Old St. Peter's in the fourth century, the golden section was applied in the designs of Amiens Cathedral, and again at Saint-Urbain in Troyes and Saint-Ouen in Rouen. Despite their differences, each plan reveals a golden section ratio between the wide central space and the flanking aisles. Other ratios detected in medieval monuments include the square root of three (1: 1.732), taken from an equilateral triangle and found at the abbey church of Fontenay, and the square root of five (1: 2.236). All of these ratios involve irrational rather than whole numbers and are derived from working directly from the geometrical figures of the plan. These same ratios were projected upwards into the superstructure. The square root of two controls the composition of the elevation at Durham Cathedral. At Milan, arguments broke out during the 1390s over whether the cathedral should be designed on the basis of a square (*ad quadratum*) or a triangle (*ad triangulatum*). Debate raged over which solution would be more beautiful and structurally sound, and advocates of the various solutions supported their positions by citing the Bible as well as Aristotle.

DRAWING. The plan of a building could be laid out at full scale on the ground using ropes and stakes to mark its outlines. But as medieval architecture developed in complexity, drawing became an increasingly important tool in the process of design and construction. Few drawings are known before the twelfth century: the famous plan of Saint-Gall, created in the early ninth century, is less a construction blueprint than a conceptual diagram that sets out the scheme of an ideal monastery. As late as 1178 when William of Sens, architect of the new choir at Canterbury Cathedral, was seriously injured after falling from scaffolding, he attempted to supervise construction by having himself carried to the building site on a stretcher. Although William had supplied templates or patterns for architectural details, there apparently were no drawings that could keep the project on course in his absence. Numerous full-scale drawings survive from the thirteenth century onwards. Incised into floors, on walls, or on plaster surfaces, the extant engravings encompass preliminary sketches and finished representations of building parts such as windows, piers, gables, portals, and flying buttresses. They offered the master mason a chance to refine his formal ideas, to evaluate the merits of a design before it was executed, and to check the accuracy of the cutting before stones were mortared into place. Finally, in the Gothic period, drawings on parchment evolved as structures were composed of precisely coordinated networks of shafts and moldings, and intricate and finely scaled vault and window patterns. Drawings not only became indispensable to construction, but they allowed an architect to supervise multiple projects simultaneously. In 1434, Pierre Robin, a Parisian master, was hired to design the parish church of Saint-Maclou

a PRIMARY SOURCE *document*

THE CHURCH OF SANTIAGO DE COMPOSTELA

INTRODUCTION: So popular were pilgrimages throughout the Middle Ages that various guidebooks were written to help pilgrims negotiate the voyage and understand the significance of the route and the buildings along the way. Among the most famous of these was the *Liber Sancti Jacobi* (the Book of Saint James), a compilation made between 1139 and 1173 of five books, treating such subjects as the four French roads leading to the major pilgrimage routes, the cities and stations along the way in Spain (treated very negatively), hospices, road maintenance, and rivers to be crossed. The fifth book of the compilation, perhaps written by Aimery Picaud from nearby Poitiers in France, is entitled *The Pilgrim's Guide to Santiago de Compostela*. In the book's eleven chapters, appear a liturgy to serve the cult of Saint James, twenty-two miracles of Saint James, glorification of the cult of Saint James, the story of the legendary Bishop Turpin (who appears as a character in the *Song of Roland*), and three long chapters on relics, reliquaries, peoples, and lands. The section below, describing the cathedral itself, contains details on measurements and proportions.

The Measurements of the Church

The basilica of Saint James measures in length fifty-three times a man's stature, that is to say, from the west portal to the altar of the San Salvador [the eastern chapel]; and in width, thirty-nine times, that is to say, from the French [north transept portal] to the south portal. Its elevation on the inside is fourteen times a man's stature. Nobody is really able to tell its length and height on the outside.

The church has nine aisles on the lower level and six on the upper, as well as a head, plainly a major one, in which the altar of the San Salvador is located, a laurel crown, a body, two members, and further eight small heads [chapels] in each of which there is an altar. ...

In the largest nave there are twenty-nine piers, fourteen to the right and as many to the left, and one is on the inside between the two portals against the north, separating the vaulted bays. In the naves of the transepts of this church, that is to say from the French to the south portal, there are twenty-six piers, twelve on the right and as many on the left, as well as two more placed before the doors on the inside, separating the entrance arches and the portals.

In the crown of the church there are eight single columns around the altar of the Blessed James. ...

In this church, in truth, one cannot find a single crack or defect: it is admirably built, large, spacious, luminous, of becoming dimensions, well proportioned in width, length and height, of incredibly marvelous workmanship and even built on two levels as a royal palace.

He who walks through the aisles of the triforium [gallery] above, if he ascended in a sad mood, having seen the superior beauty of this temple, will leave happy and contented.

Concerning the Towers of the Basilica

There are nine towers in this church, that is to say, two above the portal of the fountain, two above the south portal, two above the west portal, two above each of the corkscrew staircases, and another, the largest one, above the crossing, in the middle of the basilica. By these and by the many other utmost precious works the basilica of the Blessed James shines in magnificent glory. All of it is built in massive bright and brown stone which is hard as marble. The interior is decorated with various paintings and the exterior is perfectly covered with tiles and lead.

SOURCE: *The Pilgrim's Guide to Santiago de Compostela*. Trans. and ed. William Melczer (New York: Italica Press, 1993): 120–121; 126.

in Rouen. He stayed in the city for five months, delivered a complete set of plans, then left the building entirely to local contractors. Although construction at Saint-Maclou lasted for ninety years, Robin's plans were followed scrupulously, and the church displays a remarkable unity despite the participation of many hands. The most lavish drawings of the later Middle Ages, embellished by color washes, might be shown to patrons to confirm the genius of the design, sent to potential donors, or exhibited in public to raise funds for construction. An example of such geometrical drawing occurs in the portfolio of Villard de Honnecourt in the 1230s.

MAKING AND MEANING. While medieval architecture was becoming increasingly technological in its methods, it also maintained symbolic and religious significance. The medieval church building was likened by theologians to the Temple of Solomon as well as to the celestial Jerusalem. The Bible describes these sacred edifices in detail, including their dimensions: the temple was 60 cubits long, 20 cubits wide, and 30 cubits high; the heavenly city measured 12,000 *stadia* with a wall of 144 cubits (cubits were measurements of about 17 to 21 inches and *stadia* were about 607 feet). In addition, Christian theology interpreted numbers in symbolic terms. Four was equated with the gospels, five was the

number of divinity, evoking the five wounds of Jesus, and six was the perfect number, according to St. Augustine, because it was both the sum and product of its factors, 1, 2, and 3. Thus although plan designing was a process that involved the mechanical manipulation of geometric shapes by secular craftsmen, it was possible to endow a building with symbolic meaning by basing the design on a resonant module or by encoding a significant number into its geometry. The chapel at Aachen, for example, was based on a twelve-foot module and its total length was 144 feet, both dimensions clearly intended to connect it with the image of heaven. The royal Sainte-Chapelle in Paris quotes the proportions and dimensions of the Palace of Solomon, described in I Kings 7, perhaps as a way to associate the contemporary French monarch with Solomon, the paragon of the wise ruler. And the design of the papal church of Saint-Urbain in Troyes unfolds out of a central square that is 36 feet per side using the square root of two and golden section operations. Six is, of course, a factor of 36, so that the perfect number literally lies at the heart of the plan. Its height, 72 feet, is determined by two of these squares, but is also a factor of the number 144 associated with heaven. In sum, medieval masons used geometry as the practical means to ensure the harmony of their designs while patrons found in number and shape potent symbols that linked the present with the past and connected their earthly projects to divinely inspired models.

SOURCES

Anne Berthelot, "Numerology," in *Dictionary of the Middle Ages: Supplement 1.* Ed. William Chester Jordan (New York: Charles Scribner's Sons, 2004): 427–428.

Theodore Bowie, ed., *The Sketchbook of Villard de Honnecourt* (Bloomington, Ind.: Indiana University Press, 1959).

J. H. Harvey, *The Medieval Architect* (London: Wayland, 1972).

Robert Mark, ed., *Architectural Technology up to the Scientific Revolution* (Cambridge, Mass.: MIT Press, 1991).

Roland Recht, ed., *Les Bâtisseurs des cathédrales gothiques* (Strasbourg, France: Editions les Musées de la Ville de Strasbourg, 1989).

Vitruvius: Ten Books of Architecture. Trans. Ingrid D. Rowland (New York: Cambridge University Press, 1999).

CONSTRUCTION TECHNIQUES

BUILDING WITH MASONRY. Throughout the Middle Ages, the most prestigious and durable edifices—castles, churches, and palaces—were built of stone. However, the loss of the Roman formula for concrete (a mixture of water, lime, and pozzolanic sand akin to modern Portland cement, to which a coarse aggregate of rubble and broken pottery was added) and its replacement in the Middle Ages by a weak lime mortar made complex masonry ceilings difficult to build. Thus, one of the major achievements of medieval architecture was the recovery of the ability to vault monumental interior spaces to dramatic effect. Medieval masons continued many Roman architectural practices, constructing their buildings with rubble (broken, rather than cut stone) walls faced with cut stone blocks or decorative patterns, as seen in the surviving sections of the late-tenth-century cathedral of Beauvais, Notre-Dame-de-la-Basse-Oeuvre. Yet, there were significant variations from region to region in Europe due to available building materials and established traditions. For example, brick was used in southern France and northern Germany as a substitute for the poor-quality local stone. Ancient Roman architectural elements (remnants of columns, carvings, etc.), called *spolia*, were often incorporated into medieval Italian structures because of their handy abundance as well as their evocative connection to the glory of the past, while timber forms inspired designs in Anglo-Saxon stone buildings in England.

THE LEGACY OF ROME: ARCHES AND VAULTS. By far the most important legacy from Rome was the arch, which constituted the basis of medieval church architecture. An arch is a curved structural form composed of wedge-shaped stones called *voussoirs*. The uppermost voussoir is the keystone which, when dropped into place, locks the other stones of the entire arch together. Pushing against one another, the stones stay in place, and as long as there is enough material around the arch to resist this outward, pushing force, the arch will remain stable. There were many uses for arches: supported by columns or piers to form an arcade, they span space to create passages; they frame doorways and windows; they act as structural reinforcement; and, in miniature, they decorate walls. Arches were, in turn, the basis of vaults. The continuous barrel vault was constructed by extending an arch across an expanse from pier to pier, creating a ceiling that had a concave or half-cylindrical appearance, as occurs in the main nave space at Saint-Sernin at Toulouse, France. Two barrel vaults intersecting at right angles, the "groins" marking the lines of intersection, formed a groined vault. By focusing supporting forces at the corners of the vault compartment or bay, the groined vault relieved the wall of its structural purpose and made large openings and windows possible. But because the stones of the groins had extremely complex geometric shapes, these vaults were difficult to

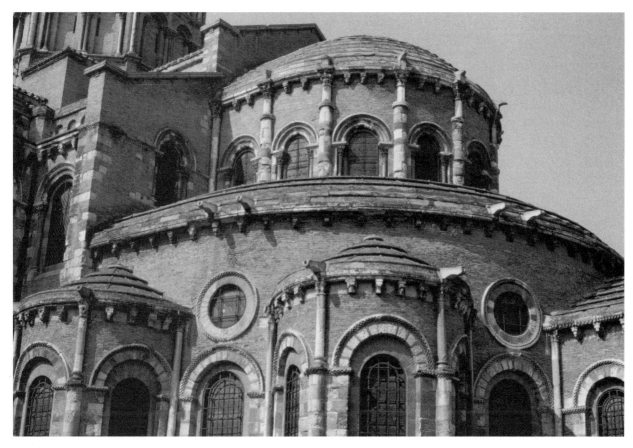

Basilica of Saint-Sernin, Toulouse, France, 11th–14th centuries. **MARC GARANGER/CORBIS.**

build and were used most frequently over smaller spaces that included windows, such as those in the side aisles of Saint-Sernin.

THE COMING OF GOTHIC ARCHES. European architecture in the eleventh and early twelfth century, despite its variety, is commonly called "Romanesque" because its massive walls, its rounded arches, the extension of stone vaulting throughout the entire structure, and many of its ornamental forms resemble Roman buildings. Around 1100, new forms appeared that moved away from the heritage of ancient building and began to transform the appearance of architecture. The first major development can be seen in a change in the shape of arches. Builders from the Carolingian to the Romanesque periods employed semicircular arches. To draw one with a compass requires only a single fixed center point to produce an arch whose height is always one-half of its span. However, a different type of arch appeared in Romanesque buildings, such as Durham Cathedral, that became the dominant form in the Gothic period from the twelfth through the fifteenth centuries: the pointed arch. In this case, the intersecting arcs are struck from two centers whose location is fluid. This

creates an arch that not only can be flexibly tailored to fit almost any spatial need but also is more structurally efficient than the semicircular arch. A second breakthrough came with the invention of the ribbed groin vault. This vault had all the advantages of the groin vault, but added ribs—decorative moldings that masked the groin lines. Ribs facilitated construction, first, because they were assembled from identical pieces and, second, because once built, they offered a scaffolding that was filled in by a light stone membrane or web. An example of vaulting appears in the Chapel of the Heiligen-Geist-Hospital in Lübeck, Germany.

THE FLYING BUTTRESS. Along with pointed arches and ribbed groin vaults, the flying buttress was introduced as a key structural component in mid-twelfth century buildings such as the Abbey of Saint-Germain-des-Prés and the Cathedral of Notre-Dame, both in Paris, and the Cathedral at Chartres, France. Exposed arches "flying" over the aisles of the church act to brace the wall against the outward thrust of the vault and the wind pressure on the roof and to direct these forces to massive slabs of masonry (buttresses). Flying buttresses, coordinated with ribbed groin vaults and pointed arches,

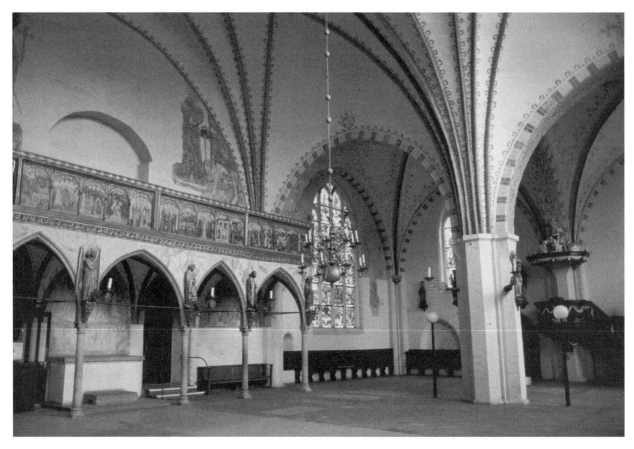

Vaulting, Chapel of Heiligen-Geist-Hospital, Lübeck, Germany, 13th century. WOLFGANG KAEHLER/CORBIS.

composed a completely new system. Rather than a continuous envelope of heavy supporting walls, as was characteristic of the Romanesque style, the structure now resembled the cage of an Erector set, with the flying buttresses appearing both internally and externally. By exploiting the potential of these new features, Gothic church architecture was able to achieve the impossible: unprecedented height combined with walls that were little more than perforated screens whose openings were filled with vast fields of dazzling stained glass.

TIMBER. Most buildings in the Middle Ages—houses, forts, barns, market halls, and even parish churches—were made of timber. Stone construction itself required vast quantities of wood for the temporary scaffolds socketed into walls that served as work platforms in upper levels, for formwork upon which vault stones were laid, and for templates or patterns that guided the cutting of moldings. Cranes and the great wheels that hoisted building materials aloft were made of wood. Timber pilings and lattices were incorporated into the foundations of edifices that rose on marshy ground, a technique still used in the late nineteenth century in Henry Hobson Richardson's Trinity Church

in Boston. Wooden vaults, imitating the appearance of stone, were erected at York Cathedral in the late thirteenth century, and the fourteenth-century crossing of Ely Cathedral, its stone lantern perched atop a pinwheel of wooden vaults, achieved one of the most spectacular spaces of the age. But, by far, the most significant concern of carpentry was the roof structure.

ROOFS. Tall, steeply pitched roofs were more than practical coverings to shed the rain and snow of northern Europe's inclement weather; they were status symbols. Hrothgar's magnificent "mead-hall" of Heorot is described in the early (pre-tenth century) Anglo-Saxon poem *Beowulf* as "high-roofed—and gleaming with gold," and the slate roofs of the palace of the kings of France in Paris struck one fourteenth-century writer as "glistening bright" to the point that "everyone is gladdened by / The very thought of entering." Churches, too, were crowned by prominent roofs whose beams were likened by a late thirteenth-century bishop, William of Mende, to "the princes and preachers who defend and fortify the unity of the Church," while the tiles reminded him of "the soldiers and knights who protect the Church against the attacks of enemies of the faith." Until the

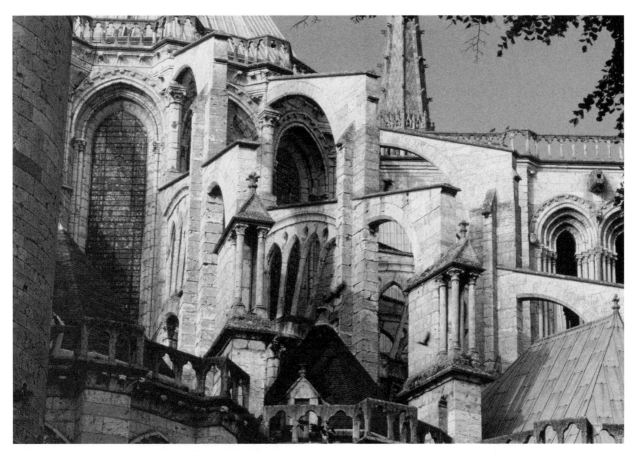

View from the Bell Tower of flying buttresses and stained glass window, Cathedral of Chartres, France, 13th century. ADAM WOOLFITT/CORBIS.

eleventh century, large interior spaces in medieval churches were covered by timber roofs, often open to the space below, devised from a system of members, that included sloping beams called rafters whose ends were connected by horizontal tie beams, to form a triangular truss. Norwegian stave churches, a late example of which is found at Borgund (c. 1250), demonstrate the advanced roofing technology achieved in northern Europe. Trusses, stiffened by curving scissor braces, are supported by tall timber posts or staves to create a bay system that may have influenced the development of a comparably integrated frame in stone architecture.

STONE VAULTS, TIMBER ROOFS. With the spread of masonry vaulting in the Romanesque period, carpenters faced a set of problems that tested their ingenuity. The curving crown of the vault that rose into the space of the roof made it impossible to create a structure based on trusses placed every three or four feet as in an unvaulted building, and they were forced to search for solutions that accommodated the vault but did not sacrifice stability against gravity and wind. The number of tie beams was reduced gradually as supplementary rafters

and braces were added to increase the rigidity of the roof frame. In Gothic architecture of the thirteenth and fourteenth centuries, roofing systems evolved in response to the wide spans of the spaces and the reduction of the thickness of the walls. At Notre-Dame in Paris and Reims Cathedral, trusses were organized into bays consisting of main frames, recognizable by their vertical hangars that support a matrix of beams and rafters that alternate with secondary frames without tie beams. More important, plates that ran along the top of the wall and purlins that supported the additional rafters integrated the system longitudinally. Reaching a pitch of about 60 degrees, these steep roofs emphasized the vertical silhouette of the soaring buildings, making them appear even taller.

THE HALL. Timber architecture was not simply a question of money, nor was it indicative of social class. At Aachen, where Charlemagne's audience hall and chapel were built of stone, the emperor maintained his domestic quarters in a wooden structure. As medieval literature, from *Beowulf* to *Sir Gawain and the Green Knight* (1360–1370) makes clear, the hall stood at the center of palace life, serving as the stage for aristocratic

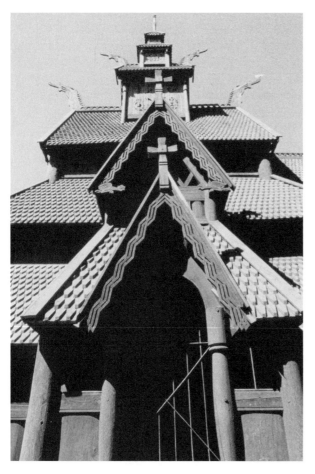

Woodwork and roofs of Stavechurch, Borgund, Norway, 1150.
ELIO CIOL/CORBIS.

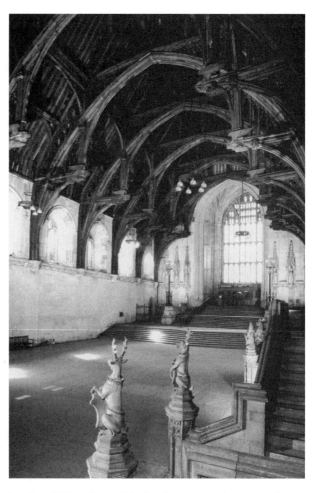

Interior of Westminster Hall showing hammer-beam wooden roof structure and stalls, London, England, 14th century. **ADAM WOOLFITT/CORBIS.**

festivities. But it was also the basis of other structures of daily life such as hospitals, colleges, and commercial buildings. In stark contrast to the arched form of churches, halls were fashioned of vertical post and horizontal beam construction that created aisled interior spaces. After around 1200, there was a general shift toward aisleless structures that is represented by the remarkable rebuilding of Westminster Hall in the palace of the kings of England. Completed in 1099 by the Norman ruler William Rufus, who is reported to have "spared no expense to manifest the greatness of his liberality," the original hall was so wide—around 67 feet—that internal supports were required to carry the ceiling. In the 1390s, Richard II engaged his chief carpenter, Hugh Herland, and master mason, Henry Yevele, to refurbish the hall. Herland's ingenious hammer-beam roof, supported through the use of short cantilevered timbers, covered the enormous space with a single breathtaking span. The hammer beams, projecting from the wall, actually pull in the sloping rafters to keep them from spreading outward. Combined with the heavy vertical

hammer posts and horizontal collar beam (tie beam) as well as the great arch, they transmit the weight and thrust of the roof to the stone brackets, or corbels, located about halfway up the wall, that had been added by Yevele. Masonry and carpentry collaborate in a structure that is at once logical and elegant. Despite the fact that some 600 tons (the weight of a modern diesel locomotive) of oak were used in the frames, the roof—enriched by open grilles—appears to float on the backs of the angels that decorate the ends of the hammer beams. Finally, it is important to remember that this great roof structure was assembled from material provided by trees grown in forests that were legally protected and carefully managed. Eliminating the floor posts was not simply a matter of artistic choice, but permitted the use of smaller trees that were easier to cut and transport. The study of medieval structures reveals the complex interrelationship between architectural form, building technology, natural resources, and human institutions.

SOURCES

Jonathan Alexander and Paul Binski, eds., *Age of Chivalry: Art in Plantagenet England 1200–1400* (London: Royal Academy of the Arts, 1987).

François Bucher, "Medieval Architectural Design Methods 800–1560," *Gesta* 11 (1972): 37–51.

Ragnar Bugge, *Norwegian Stave Churches*. Trans. Ragnar Christophersen (Oslo, Norway: Dreyer, 1953).

Nicola Coldstream, "Architecture," in *The Cambridge Guide to the Arts in Britain*. Vol. 2: *The Middle Ages*. Ed. Boris Ford (Cambridge, England: Cambridge University Press, 1988): 42–87.

————, *Masons and Sculptors* (Toronto: University of Toronto Press, 1991).

————, *Medieval Architecture* (Oxford: Oxford University Press, 2002).

Eric Fernie, *The Architecture of the Anglo-Saxons* (London: Batsford, 1983).

J. Fitchen, *The Construction of Gothic Cathedrals: A Study of Medieval Vault Erection* (Oxford: Clarendon, 1981).

David Macaulay, *Cathedral: The Story of Its Construction* (Boston: Houghton Mifflin, 1973).

Robert Mark, *Light, Wind, and Structure: The Mystery of the Master Builders* (Cambridge, Mass.: MIT Press, 1990).

————, ed., *Architectural Technology up to the Scientific Revolution* (Cambridge, Mass.: MIT Press, 1993).

Harold M. Taylor and Joan Taylor, *Anglo-Saxon Architecture* (Cambridge, England: Cambridge University Press, 1965–1978).

MONASTIC ARCHITECTURE

MONASTIC RULES FOR CLOISTERED LIFE. From the earliest days of Christianity, there have been men and women who have withdrawn from the world to seek solitude in order to devote themselves to prayer and meditate upon God. For some, this spiritual quest was a solitary endeavor, but in many cases the holy hermit attracted groups of followers who sought to emulate the ascetic lifestyle, and this formation of groups eventually necessitated the development of specialized architecture. Beginning in the fourth century, life in these religious communities was ordered by rules that divided the day into periods of work, prayer, and reading. Basil the Great (c. 330–379) wrote the first set of rules that became the basis of monasticism in the Orthodox church in eastern Mediterranean regions, and this was followed in the West by the Rules of St. Augustine in the late fourth century, and the Rule of St. Benedict, written around 530, which predominated in Europe throughout the Middle Ages. In drawing up the regulations for his "school for the Lord's service," Benedict included directions for all facets of a monk's life. In 73 chapters, he set an abbot in charge of the monastery, offered guidelines for food, drink, and clothing, addressed sleeping arrangements, prescribed punishments for misbehavior and mistakes in religious services, and detailed the reception of guests. The day was structured by seven offices, beginning in the middle of the night, at which the Psalms were sung, but also included six to eight hours of manual labor and periods of study and reading. Although the Rule did not contain specific architectural directions, its requirements for eating and sleeping in common, the importance of the oratory as the hub of liturgical life, and the mention of kitchens, an infirmary, cellars, and guest quarters assume a complex of structures that would compose a self-sufficient community. As Benedict wrote in chapter 66, "The monastery should, if possible, be so constructed that within it all necessities, such as water, mill, and garden, are contained, and the various crafts are practiced. Then there will be no need for the monks to roam outside, because this is not at all good for their souls."

THE PLAN OF SAINT-GALL AND THE CLOISTER. The Carolingians translated the framework for monastic life envisioned by St. Benedict into architectural form in the ninth century. With the same view toward uniformity that guided the reform of imperial administration, the development of a more legible script for copying the Bible, and the planning of architectural monuments, Charlemagne commanded all monasteries in his realm to adopt the Benedictine Rule and convened assemblies in Aachen in 816–817 to consider policies that directly affected the layout of the proposed structures. At about the same time, a large plan, drawn on five sheets of parchment and measuring about 44 by 30 inches, was sent to the abbot of Saint-Gall, apparently portraying an ideal scheme of what buildings a monastery should contain and how to arrange them. A model built from the plan shows the monastery's appearance. The multiplex, dominated by the large "double-ended" church, is organized in a series of concentric zones like an onion. Animal pens, industrial buildings employing secular artisans, guest quarters, and the school formed an outer ring. At the heart of the plan lay the cloister, the focus of monastic life. With a fountain at its center, the square courtyard was surrounded by covered and arcaded walkways that provided sheltered circulation between the primary spaces of monastic activity: church, dormitory, refectory (dining hall), cellar, and scriptorium (book production center). Chapter rooms, for general meetings, became standard features in Cistercian abbeys and were always

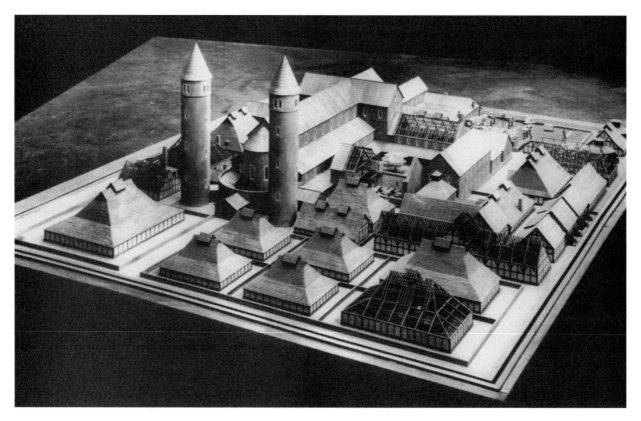

Architectural model showing towers and transept of the 9th-century Benedictine Monastery at Saint-Gallen, Switzerland. THE GRANGER COLLECTION.

located in the east gallery of the cloister under the dormitory. They were the most important structure of a monastery, after the church, and served as places where the monks assembled after morning Mass to receive spiritual advice or discipline from the abbot, read chapters of the Rule of St. Benedict, and discuss the internal affairs of the community. Because the new orders of the Franciscan and Dominican friars established themselves in cities during the thirteenth and fourteenth centuries and were not cloistered, they did not need the large cellars, barns, animal pens, and industrial buildings required by monks living in remote rural areas. Further, each Franciscan or Dominican friar lived in his own small cell in the convent—as the houses of friars were called—rather than together in a dormitory. Nevertheless, despite these additions and modifications, the scheme created in the ninth century and represented by the Saint-Gall plan remained the essential template for the cloister for the rest of the Middle Ages.

THE DILEMMA OF THE MONASTIC CHURCH. Monastic churches were designed according to the same plans and were assembled from the same architectural forms—columns or piers, arches, masonry vaults or timber ceilings—as other churches. The Rule of Saint Bene-

dict, which all monks followed, left no directions concerning the style or appearance of the church. Thus, there is a noticeable variety in the approaches of the different orders to the physical structure of the church and its decoration, a range of interpretation that reflects a dilemma in the character and purpose of monastic life. On the one hand, monks were constantly urged to embrace humility, to avoid arrogance, to seek moderation, and to be content with poverty in emulation of Christ. On the other hand, the monk spent his life in the task of glorifying God and seeking the vision of his kingdom. And that kingdom, as described in Revelations, chapter 21, was a glittering jeweled structure irradiated by light with streets paved in gold. So what should a monastic church be: a representation of humility and a simple "workshop of prayer," or an image of heaven and an offering of unsurpassed grandeur to God?

CLUNY AND THE ROMAN MODEL. The most important of the monastic churches to represent the argument for opulence was the one begun in 1088 in Cluny. Founded in Burgundy in 910, the abbey of Cluny was not subject to any bishop or secular authority, only to the pope. Other monastic houses, attracted to Cluny's concept of spiritual improvement through constant

THE
Buildings of the Cloister

One of the most enduring influences of the Carolingian period was the idea that monasteries should have a uniform kind of architecture that was suited to the rules of monastic life. The scheme created in the ninth-century Saint-Gall plan remained the essential template for the cloister for the rest of the Middle Ages. Dominated by a large church on the north side, such a cloister was organized in a series of concentric zones, with such things as stables, pens for oxen and cattle, a mill, a smithy, a tannery, guest quarters, and a school in the outer ring. Outside and to the east might lie orchards, gardens, and fishponds. The abbot's residence, accommodations for distinguished visitors, and the monks' infirmary also lay outside the walls, usually to the east. At the heart of the plan was the cloister itself, the focus of monastic life. With a fountain at its center, the square courtyard was surrounded by covered and arcaded walkways that allowed residents to walk between the primary spaces of monastic activity: church, dormitory, refectory (dining hall), cellar, and scriptorium (book production center). Chapter rooms, for general meetings, became standard features in Cistercian abbeys and were always located in the east gallery of the cloister under the dormitory. The entrance gatehouse and service courts (controlling agricultural and industrial activity) were generally in the west range, as were the refectory and dormitory of the lay brothers, whose princi-

pal responsibilities involved the agricultural or industrial functions of the abbey.

Cellar: Space used for storage and located on the ground level of the west range.

Chapter room: A room usually located along the east range of the cloister used by the monastic community for daily meetings.

Day room: A room in which the monks pursued manual labor within the cloister; sometimes it was used as a scriptorium. The day room was often located next to the chapter room along the east range and below the dormitory.

Dormitory: The common sleeping room of the monks. The dormitory was customarily attached directly to the south arm of the church and was located above the chapter room on the east side of the cloister.

Infirmary: The building devoted to the care of sick and infirm monks often was situated outside the cloister precinct to the east. With its own cloister and chapel, it formed a monastery in miniature.

Kitchen: Conveniently located next to the refectory in the south range buildings.

Refectory: The dining hall of the monastery, usually located on the south walk of the cloister.

Warming room: A space, often adjacent to the refectory on the south side (under the dormitory in the Saint-Gall plan), where a fire was kept burning during the winter months.

prayer and their resulting splendid liturgy, were reformed by the abbey and brought under its rule so that by around 1100, it controlled about 1,450 monasteries throughout western Europe. Cluny's direct link to Rome and its role as the virtual capital of an international religious empire found expression in one of the most daring and magnificent churches erected during the Middle Ages. Fueled by a donation of 10,000 gold talents from King Alfonso VI of Aragon, the new structure, the third in the history of the abbey, was built between 1088 and about 1130, replacing a mid-tenth-century edifice that had been one of the first fully stone vaulted churches in medieval architecture, but had grown too congested to accommodate the throng of 460 monks who celebrated Mass in the choir. Legend records that a retired monk named Gunzo, who was also a musician, was shown the plan in a dream by saints Peter and Paul. Whether or not this is true, the new design does echo the basilica of St. Peter's in Rome in its inclusion of five aisles that were graded in height and a prominent projecting transept. Further, the interior walls, which rise to a height of about 100 feet, were embellished by fluted pilasters and the piers crowned by luxurious foliate capitals that emulate the forms of Roman architecture.

DEPICTIONS OF POWER AND GLORY. At the same time that it was emulating the design and forms of Rome, Cluny utterly transformed these traditional features by remounting them in an elaborate setting. The 635-foot long plan, the largest in Christendom, included two transepts as well as an ambulatory ringed by a necklace of chapels. Four mighty towers rose above the transepts and two more stood at the western entrance, creating an impressive silhouette. Inside, the elevation was composed of three levels: a tall arcade; a middle zone, or triforium, decorated with cusped arches that resembled Islamic ornament; and a clerestory. Pointed barrel vaults covered the main spaces, while pointed arches were used in the arcade. Given Cluny's extreme height and breadth—the nave vault alone spans 35 feet—this precocious decision to use the pointed arch, which was to become such an

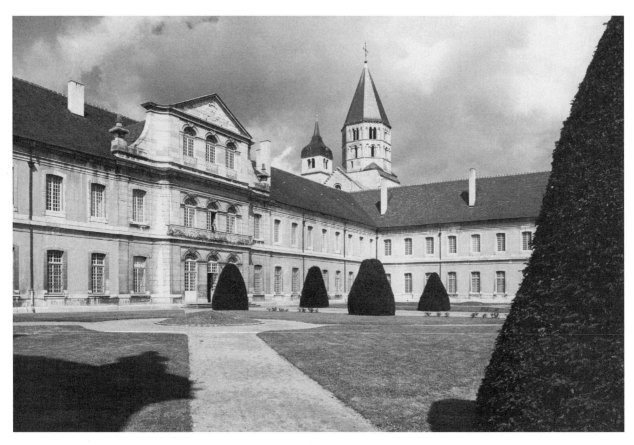

Grounds (with much later buildings) of Abbey at Cluny, France, 910. SANDRO VANNINI/CORBIS.

important component of the Gothic style, was likely based upon structural considerations. Finally, the choir composed an opulently decorated stage where the daily round of monastic offices was sung. Beautifully sculpted capitals topped the tall columns that ringed the apse, depicting figures of the eight tones of plainchant, the four seasons, and the four rivers of paradise, while a monumental painting of Christ in Majesty filled the half dome of the choir above the altar. Taken as a whole, the abbey church of Cluny not only made a compelling statement about the power of the Order but also composed an image of heaven. As the author of the *Life of St. Hugh*, the abbot under whom the new church was built, wrote, "if it were possible for those who dwell in heaven to take pleasure in a house made by human hands, you would say this was the walk of angels."

THE CISTERCIANS. At the very moment that Cluny was nearing completion, Bernard, abbot of Clairvaux, voiced his criticism of contemporary monastic architecture in his famous *Apologia* written around 1125 to his friend, William of Saint-Thierry: "I say nothing of the immense height of your churches, their immoderate length, their superfluous breadth, the costly polishings,

the curious carvings and paintings which attract the worshipper's attention and impede his devotion. ... But I, as a monk, ask of my brother monks, 'tell me you paupers, what business has gold in the sanctuary?'" The monastic reformers that settled at Cîteaux in 1098 and created the Cistercian Order sought to return to the letter of the Rule of St. Benedict as they rejected the materialism and sensory overload of Cluny. The architectural simplicity of the order's churches reflected their spiritual ideals and their search for perfection through silence and interior meditation. Although there was neither a set formula for planning nor a clearly defined style shared among the more than 1,100 houses of the order established from Ireland to Greece and from Spain to Sweden, Cistercian architecture can be identified by a common attitude within the variety of its expression. For example, the abbey of Le Thoronet (second half of the twelfth century) strips away all of the grand forms and decorative flourishes so characteristic of Cluny to achieve a structure where every space and stone is directed to function. In a manner typical of Cistercian architecture, the church is laid out on a straightforward cruciform plan, the choir is reduced to a simple square, and the small chapels that open off the main vessels provide additional

altars for those monks who were ordained priests to celebrate individual masses. The interior uses piers, pointed arches, and a pointed barrel vault similar to those at Cluny, but it contains only a single story. Sculpture is banished, stained glass is absent, and no towers ennoble the exterior. Indeed, the crisp cubic mass of the church can hardly be distinguished from the adjacent dormitory or nearby forge. This renunciation, however, should not be viewed as evidence that Cistercian monks and builders were crude or unsophisticated. Like Shaker architecture in nineteenth-century America, Cistercian structures were endowed with a profound balance (using harmonious proportions based on the square), careful craftsmanship, and consistently up-to-date building technology. As seen in the new choirs of Rievaulx in England (1220s) or Altenberg abbey near Cologne (c. 1255–1280), thirteenth-century projects incorporated ribbed vaults, flying buttresses, and even bar tracery. Yet, despite this architectural evolution, the message of humility endured as the essential expression of Cistercian identity.

FRANCISCANS AND DOMINICANS. In the early thirteenth century, a new wave of religious thought stressed engagement in the world rather than withdrawal from it. This change in purpose led to a new type of religious community whose members were called friars (brothers) or mendicants (from the fact that they begged for their sustenance). The friars were not cloistered or closed off from the world, but rather lived in convents, often on the edges of cities. First the Dominicans, founded in 1216, and soon afterwards the Franciscans, whose rule was approved by the pope in 1223, began to settle in the rapidly growing cities of Europe where they preached to the faithful, performed charitable works, and defended the Christian faith from heretical interpretation. Both orders embraced poverty; indeed, each rejected the ownership of property, and their members sustained themselves by begging and the acceptance of donations. Although Francis of Assisi opposed church building of any kind and asked to be buried in the refuse dump of Assisi, his followers erected a splendid church, San Francesco, in his honor. Built between 1228 and 1253 on two levels with a lower, crypt-like church surmounted by a taller upper church, the architecture of San Francesco, Assisi, reveals the clear impact of such "modern" French forms as finely scaled engaged columns, ribbed vaults, and bar tracery that frame stained glass windows. Yet the broad interior space and the insistence on prominent surfaces of wall, decorated with frescoes of the life of St. Francis, adhere to the local Italian traditions.

HALLS FOR PREACHING. Perhaps more emblematic of Franciscan attitudes is the church of Santa Croce in

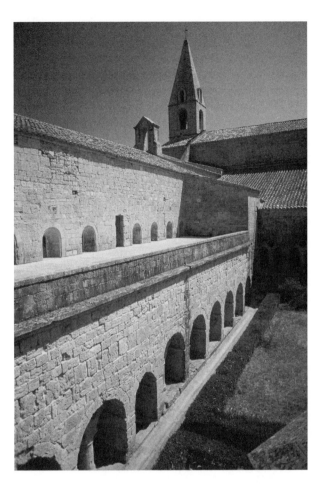

Arcaded Cloisters of Cistercian Abbey of Le Thoronet, France, late twelfth century. **GAIL MOONEY/CORBIS.**

Florence, begun in 1294 and probably designed by the architect and sculptor Arnolfo di Cambio. Like the Cistercians before them, the Franciscans legislated against architectural extravagance. Statutes of 1260 declared that, "any superfluity in length, width, or height above what is fitting to the requirements of the place [should] be more strictly avoided. ... Churches shall in no wise be vaulted, save for the presbytery [the choir]." The nave of Santa Croce appears as an updated version of an early Christian church with thin brick walls supported by octagonal columns and covered by a timber roof. The vast barn-like space was perfectly suited to the large crowds that came to hear the friars' sermons. In a similar vein, Dominican churches were also created as preaching halls. The striking church of the Jacobins (Dominicans) in Toulouse that took shape in a series of building phases between 1229 and 1292 adopts an unusual double-nave scheme that resembles a monastic refectory or hospital: a single file of columns marches down the center of the church to the choir, which is covered by a magnificent star-shaped vault. On the other hand, the Dominican

a PRIMARY SOURCE *document*

A BUILDING ACCOUNT FROM THE CHURCH OF SAINT-BERNARD, PARIS

INTRODUCTION: Saint-Bernard was the church of the College of the Bernardins (Cistercians) in Paris. Pope Benedict XII, who had studied at the college, underwrote the construction of a new church after he was elected pope in 1334. Begun in May 1338, work on Saint-Bernard stopped with the pope's death in April 1342 and remained incomplete. It was demolished during the nineteenth-century urban renewal of the city. The following account offers a detailed record of the materials, methods, and expenses involved in the project, with summaries divided according to the types of materials required.

The Year of Our Lord 1339

The payments that follow were made for lumber and large beams and other timbers and are contained in the payments that were necessary for the work of Saint-Bernard made by brother Pons de Madieiras.

Friday the ninth day of April:

To Simon Grapeli for 200 timbers for the work of making the arches for the work; per 100 6 £ 10 sous (20 sous = 1 £): 13 £

Wednesday the fourteenth day of April:

Item, to Denis le Franc for 260 timbers to make the said arches: 11 £ 10 sous

Monday the twenty-sixth day of April:

To Simon Grapeli for 20 beams called joists three toises (the toise, a medieval unit of length, measured six feet) long for the work on the lifting engine: 55 sous

Monday the seventh day of June:

To Jean Champion paid for two pieces of timber six toises long. Item for three other timbers called joists for work on the engine: 11 sous

The Year of Our Lord 1340

Saturday the twenty-fourth day of June:

Item to Jean Champion for two big beams for the work of covering the apse of the church to make the strong arches to support the centering: 45 sous

Item to the said Jean for three large timbers to place across the chapels to make the strong arches; paid for each 2 sous 6 deniers (12 deniers = 1 sous): 7 sous 6 deniers

Sunday the twentieth day of August:

To Jean Champion for three big beams each six toises long for the work of placing them above the apse of the church to make the strong arches to place the keystone of the said apse and to make the vault.

Saturday the eleventh day of November:

To Jean Polemlang for two beams of three toises in length for the work of making the centering for the flying buttress: 7 sous

Item for fifteen pieces of timber for the work of roofing and to make the roof of the apse of the church, each one three toises long: 50 sous

Item to Jean Champion for forty timbers two and a half toises long. And for twenty-five timbers four toises long to make the roof of the said apse of the church: 100 sous

Item to Jean de Beumon for eight hundred eighty laths for the work of the said roof; paid per one thousand 45 sous: 39 sous 11 deniers

The Year of Our Lord 1341

Saturday the twenty-first day of April:

To Jean Champion for three beams to make the centering of the aisles ("the little naves"): 11 sous 4 deniers

Saturday the second day of June:

To the said Jean (Polermlang) for five beams to carry the centering of the aisles: 75 sous

Item to Jean Belabocha for four posts for the work of making the centering of the aisles: 11 sous 9 deniers

Sunday the twenty-sixth day of August:

To Jean Beumon of the (Place) de Greve for two big beams to place across the large nave to make the strong arches: 10 £

churches of Santa Maria Novella in Florence (begun 1246) or Santa Maria sopra Minerva in Rome (1280) return to a cross-shaped and three-aisled plan with a two-story elevation inspired by Cistercian designs. Once again, their use of current building technology remains restrained. In place of a complex structure composed of a worldly vocabulary of shafts, moldings, and screens that emphasized visual drama, verticality, and framed fields of imagery, Dominican and Franciscan architecture offered functional purity. Purging virtually every sign of evocative resonance and material luxury, these churches worked to embody the spiritual ideals of humility and

Saturday the twentieth day of October:

To Jean Champion for six big beams to place across the large nave for the work of making strong scaffolding; paid for each 100 sous: 30 £

Sunday the eighteenth day of November:

Item to the said Jean (Maurelet) for thirty planks to cover the ribs of the quadripartite vaults of the aisles so that it does not rain in: 7 £ 5 sous

Item to Philippot Dupin for three cartloads of thatch to cover the vaults of the aisles; paid for each cartload delivered to Saint-Bernard 13 sous 6 deniers: 40 sous 6 deniers

Sunday the twenty-third day of December:

Item for five large pieces of timber for the work of bracing the piers that are in danger of breaking: 13 £

The year 1339

In the year 1339 were made the following payments by brother Pons de Madieiras for plaster to make the floors where the drawings necessary for the work were made and to make the webbing of the vaults of the large nave as well as in the chapels and in the aisles …

In the year 1339 brother Pons de Madieiras made the following payments for ironwork that was necessary for the work of Saint-Bernard:

Friday the twenty-second day of May:

Item for 2800 nails for work on the lifting engine; paid per thousand 5 sous: 14 sous

Saturday the twenty-sixth day of June:

Item for the cost of 2000 nails for the work on the engine: 8 sous

Item for the cost of 40 big nails for the work on the engine: 2 sous 8 deniers

Saturday the fourteenth day of August:

Item to Robert Lengles, blacksmith of the Place Maubert for four hinges for the doors of the church weighing thirty-two pounds; paid per pound 8 deniers: 21 sous 4 deniers

The year 1340

Saturday the third day of June:

Item to Thomas Lengles, blacksmith, for twelve bars of iron for the windows, which weigh 175 pounds; paid per pound 6 deniers: 4 £ 7 sous 6 deniers

Sunday the twentieth day of August:

Item for a bar of iron to place in one of the lifting engines that is used to haul the beams up to the apse of the church for the vault and to place the keystone which weighs four pounds: 2 sous

Saturday the twenty-eighth day of October:

Item for the cost of 3000 nails for the work of nailing the laths above the apse of the church; paid per thousand 2 sous 8 deniers: 8 sous

Item to P. Lullier for covering the said apse of the church with tiles and for climbing on top of the said apse: 32 sous 8 deniers

Monday the twenty-fifth day of December:

To Jean au Louvre for one cartload for the work of hauling the large stones of the round piers and the large cartloads of stone: 60 sous.

The year 1341

Sunday the twenty-fifth day of February:

To the said Thomas (Lengles) for three iron anchors that are placed into the piers of the chapels and in the round piers (of the nave). Each of the anchors has a ring which is outside the body of the pier and into the ring one iron tie rod is placed to hold the round piers and weighs one hundred twelve pounds; paid per pound 6 deniers: 56 sous.

SOURCE: *Introitus and Exitus*. MS no. 181, folios 94–121, Vatican Archives. Translated from the medieval Occitan by Michael T. Davis.

moral reform, and to provide an answer to the criticism of the decadent superfluity of elite religious architecture.

SOURCES

Marcel Aubert, *L'Architecture cistercienne en France* (Paris: Vanoest, 1947).

Lucien Hervé, *Architecture of Truth: The Cistercian Abbey of Le Thoronet* (London and New York: Phaidon, 2001).

William A. Hinnebusch, *The History of the Dominican Order* (New York: Alba House, 1966).

Noreen Hunt, *Cluny under Saint Hugh, 1049–1109* (Notre Dame, Ind.: University of Notre Dame Press, 1968).

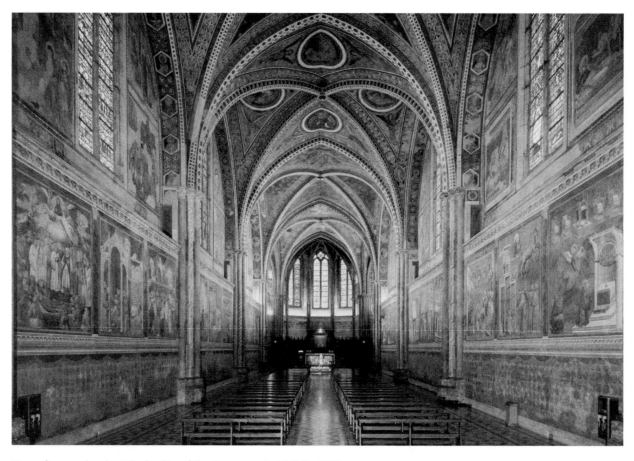

Nave of upper church at the basilica of San Francesco, Assisi, Italy, 1228. **ELIO CIOL/CORBIS.**

Terryl N. Kinder, *Cistercian Europe; Architecture of Contemplation* (Grand Rapids, Mich., and Cambridge, England: William B. Erdmans Publishing Co.; Kalamazoo, Mich.: Cistercian Publications, 2002).

Louis J. Lekai, *The Cistercians: Ideals and Reality* (Kent, Ohio: Kent State University Press, 1977).

Bernard Montagnes, *Architecture dominicaine en Provence* (Paris: CNRS, 1979).

John Moorman, *A History of the Franciscan Order from Its Origins to the Year 1517* (Oxford: Clarendon, 1968).

SEE ALSO *Religion: Cluny and the Monastic Reforms of the Tenth and Eleventh Centuries; Religion: Twelfth- and Thirteenth-Century Monastic Movements*

PILGRIMAGE ARCHITECTURE

SYMBOLIC PLACES. Because medieval Christians believed that holy places bore the mark of divinity, they were drawn to the sites of important historical and spiritual events, such as those in the Holy Land where Jesus had lived and died, the tombs of revered saints, or important collections of their relics. To visit these spots—the tomb of Jesus in Jerusalem or the footprints of St. Peter in Rome—not only revealed the truth of the scriptures, but also allowed the Christian worshipper to remember the past through the rituals of the present. In religious journeys or pilgrimages to these special places of spiritual power, relics—the physical remains of bones, skin, hair, and fingernails or objects touched by saints—offered concrete points of contact with Christian martyrs, who, though long dead, provided accessible and inspiring models for behavior. While pilgrimage and the cult of saints and their relics originated in the first centuries of Christian devotion, they became especially important in the Middle Ages. The church, and particularly its monastic orders, fostered pilgrimage as one strategy to refocus the energies of secular society away from destructive fighting toward more peaceful concerns. By 1100, the shrine of Saint James, apostle of Jesus, at Santiago de Compostela in northwestern Spain had become the most popular pilgrimage destination in Western Europe and joined Jerusalem and Rome in importance. Dozens of other churches sheltering the miracle-working

relics of saints—Sainte-Foy at Conques, Saint-Trophîme at Arles, Saint-Sernin at Toulouse—rose along the major routes that fanned out through France from the road to Santiago. For local communities, pilgrimage was a lucrative source of income from services provided for the pious travelers and the donations they left behind. Medieval architecture played a critical role in giving form to religious memory and experience, but the cash generated by those encounters with the divine also fueled the burst of building.

THE AMBULATORY AND CHAPEL PLAN. As early as the ninth century, the Church of the Holy Sepulchre in Jerusalem, with its circular plan and dome, had been a model for many kinds of religious buildings in Western Europe. Likewise, St. Peter's in Rome was reproduced repeatedly in the Carolingian period to honor saints, and in Italy its T-shaped plan with a transept and apse inspired other designs, such as that of Bari, where the body of St. Nicholas was placed in 1089, as well as nearby Trani, where the cult of a rival St. Nicholas was promoted. During the eleventh century, however, a new and more complex plan came together that skillfully orchestrated spaces around the multiple functions that a shrine church needed to accommodate. Simply put, the cruciform basilica that maintained the association to the venerable martyrs' churches of St. Peter's and St. Paul's in Rome was joined to the kind of ambulatory and chapel arrangement found in crypts arranged around saints' tombs and pioneered in Carolingian churches such as Saint-Germain at Auxerre and Corvey. The breakthrough came when the apse of the body of the church was spatially connected with the ambulatory through an open arcade. As a result, like a modern highway system, the ambulatory allowed pilgrims to circulate around the outer edge of the interior, bypassing the liturgical area of the choir and leaving the clergy undisturbed. Visitors might descend into the crypt where they could peer in through arches or windows at the tomb of the saint, or they might make the circuit of the ambulatory above to glimpse the golden and jeweled reliquary boxes displayed on altars in the main choir and chapels. Five of the major churches along the route to Compostela—Saint-Martin in Tours, Sainte-Foy at Conques, Saint-Martial at Limoges, Saint-Sernin at Toulouse, and Santiago—adopted this plan, each with a nearly identical two-story elevation composed of an arcade with a gallery above and crowned by a barrel vault. Although this design is often called the "pilgrimage roads" type, it is by no means typical of pilgrimage churches in general. To cite but one example, Saint-Front at Périgueux in southwestern France, begun in the late eleventh century, turned to St.

Mark's in Venice for its cross-shaped plan capped by five domes. By quoting St. Mark's, itself based on the sixth-century church of the Holy Apostles in Constantinople, Périgueux advertised its saint's identity as one of the seven apostles of early Christian France.

CHURCH AS GUIDEBOOK. In addition to the general plan of a pilgrimage church, other architectural features sometimes served to remind visitors of their purpose and impress upon them the scope of their undertaking. A striking example of this phenomenon is the exterior design of the church of Mary Magdalene (La Madeleine) of Vézelay. This church was originally built as a shrine for the relics of Mary Magdalene; once their authenticity had been confirmed by the pope in 1058, the church became a major destination for pilgrims, both because of its own significance and because it lay at the intersection of the roads leading to Compostela and a major route towards Jerusalem. One of the key features of this church is its tympanum, the huge semi-circular carving above the main portal inside the narthex of the church, which was begun in 1124 and sculpted in a style that resembles the choir capitals in Cluny in 1115. This relief carving, which would be one of the first things every visitor would see because of its location at the main entry to the church, depicts the ascension of Christ combined with the mission of the apostles. In this scene of Christ flanked by the apostles, his power both to condemn and to save mankind is clearly revealed to all who walk into the church. The lintel—the horizontal frieze at the bottom of the semi-circle—contains various peoples, including imagined Ethiopians and monstrous races of men with the heads of dogs believed to live in the remote parts of the world, all illustrating Christ's successes in preaching to and converting non-Christians. Appropriately for a church where the Second Crusade was to be preached, the tympanum showed pilgrims the symbolic liberation of the Holy Land, a subject matter that would be easily recognized by later pilgrims as a sort of prophecy.

THE DECORATED CHURCH. Church portals were not the sole focus of figural decoration in the medieval church. Gold-ground mosaics that narrated stories of the lives of Christ or the saints, as seen in the Norman churches of Sicily, sometimes covered wall surfaces. Other churches adorned their walls and even the ceilings with extensive cycles of paintings. In the Romanesque period, the capital, the topmost part of a column or pilaster, became a favorite field for sculptural decoration. Often brightly painted, capitals were most frequently carved with figures of animals and fantastic beasts such as griffins, harpies, or sirens. Their appearance on capitals

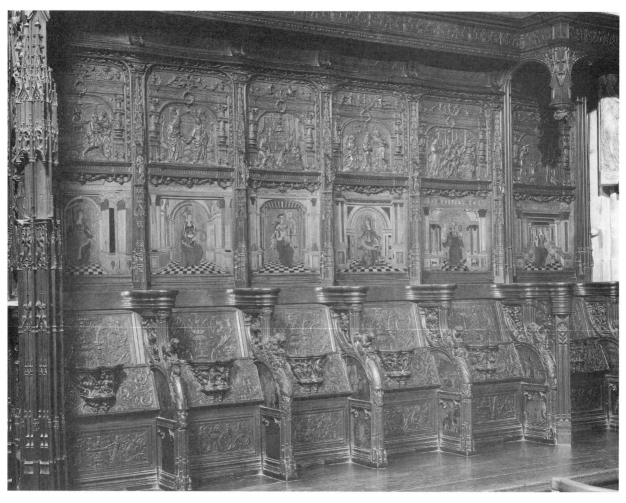

Relief carved choirstalls and paneling from church of Saint-Denis, Paris, added in 15th century. THE ART ARCHIVE/BASILIQUE SAINT DENIS PARIS/DAGLI ORTI.

in monastic cloisters prompted Bernard of Clairvaux to condemn them as distractions.

> In the cloisters, before the eyes of the brothers while they read what are the filthy apes doing there? The fierce lions? The monstrous centaurs? The creatures part man and part beast? The striped tigers? The fighting soldiers? The hunters blowing horns? You may see many bodies under one head, and conversely many heads under one body? In short, everywhere so plentiful and astonishing a variety of contradictory forms is seen that one would rather read in the marble than in books, and spend the whole day wondering at every single one of them than in meditating on the law of God.

But in addition to this menagerie of imaginative creatures, capitals in such notable churches as La Madeleine in Vézelay or Saint-Lazare at Autun—both in Burgundy, France—were carved with religious and moralizing subjects. As viewers moved through the interior space of the church, they might look on devils tormenting the lustful or leading misers to hell, the temptation of Christ, or the miracles performed by St. Benedict. Complementing the monumental images of the divine in stone and paint at the portals and in the apse, these capitals offered a vivid reminder to the congregation of the paths that led to heaven or hell.

CHURCH AS RELIQUARY. The ambulatory and chapel scheme remained in force during the twelfth century at such magnetic pilgrimage churches as Saint-Denis, Canterbury, and Chartres. The Canterbury itinerary, for example, led from the altar in the north transept where the archbishop Thomas Becket had been murdered, down into the crypt, then up and around the ambulatory to the stations where Becket's relics were displayed, while pilgrims at Saint-Denis circulated around tombs set on the raised stage-like platform of the choir, in a setting enhanced by an innovative use of glass and a more unified sense of space. It was mainly in drawing upon these new possibilities that shrine architecture of

the thirteenth century adopted a radically different language. Rather than looking to the past for plans and references, commemorative structures during this later "Gothic" era increasingly replicated the delicate, brittle effects of contemporary metalwork. The most breathtaking example of this new taste is embodied by the Sainte-Chapelle, built by Louis IX between 1241 and 1248 as the repository for the fabulous horde of relics of Christ he had purchased from the emperor in Constantinople and transferred to his palace in Paris. With the summit of the exterior walls embellished by an intricate filigree of bar tracery (a network of slender ornamental shafts), bristling with ornate pinnacles, and crowned by a diadem of pierced gables, the royal chapel appears as a monumental stone and glass version of a reliquary fashioned of gold, silver, enamel, and precious stones. The building literally assumed the form of its function. While the construction cost of the chapel itself was reported at 40,000 pounds (as a gauge, the annual salary of a master mason would have been about 10 pounds), the king spent 100,000 pounds on the relic containers, and 135,000 pounds for the relics themselves. Thus, the meaning of the building was not created through connections to historical models, but by emulating objects closely associated with the veneration of holy figures and their symbolically resonant precious materials. Similarly, Saint-Urbain at Troyes, built between 1262 and around 1285 to commemorate the birthplace of Pope Urban IV and as a shrine to his patron St. Urban, advertises its memorial character in the fretwork of sharp gables and tracery that encase the exterior. And at Notre-Dame in Paris, the two tiers of ornate gables added between 1300 and 1350 transformed the choir into an otherworldly container for the body of Christ and the relics of the saints.

SOURCES

William Melczer, ed., *The Pilgrim's Guide to Santiago de Compostela* (New York: Italica Press, 1993).

Raymond Oursel, *Pèlerins du Moyen Age: Les hommes, les chemins, les sanctuaires* (Paris: Fayard, 1978).

Conrad Rudolph, *The Things of Greater Importance: Bernard of Clairvaux's Apologia and the Medieval Attitude Toward Art* (Philadelphia: University of Pennsylvania Press, 1990).

Francis Woodman, *The Architectural History of Canterbury Cathedral* (London: Routledge and Kegan Paul, 1981).

SEE ALSO *Literature:* **The Canterbury Tales*; Religion: Relics, Pilgrimages, and the Peace of God; Visual Arts: The Cult of the Saints and the Rise of Pilgrimage**

A NEW VISION: SAINT-DENIS AND FRENCH CHURCH ARCHITECTURE IN THE TWELFTH CENTURY

OLD AND NEW AT SAINT-DENIS. As the history of pilgrimage churches suggests, the reconstruction of the monastery church at Saint-Denis, begun in 1135 under the direction of Suger (1081–1151), abbot of Saint-Denis, initiated a new age of French architecture. Now nearly 400 years old, the original Carolingian church was too small for the many pilgrims who came to visit the relics of the saints and for the monks who needed more altars to accommodate an increasing number of worship services. To alleviate the crowding at the abbey, the first phase of work focused on enlarging the entrance and extending the nave of the eighth-century structure. Although echoing the general form of the old Carolingian west block, Suger's front looked to more recent Norman examples, such as the abbey of Saint-Etienne at Caen, the burial church of William the Conqueror, for a design that included three portals with two soaring towers. Including the first known example of a rose window—a large circular window in the façade of a church, usually decorated with a pattern of radiating tracery that frames stained glass depicting stories from the Bible and the lives of the saints—as well as battlements drawn from military architecture, the twelfth-century façade presented an impressive gateway into the church that was an original blend of old and new, castle and church forms. In the three short accounts that he wrote describing the stages of the construction project and the celebrations upon their completion (held in 1140 for the new west front and in 1144 for the dedication of the choir), Suger declared that his "first thought" was to make sure that the new work harmonized with the old building—believed to have been touched by Jesus himself. To match the interior forms of the eighth-century church, the abbot launched a search for stone to make columns. He considered importing them from Rome, but this proved too expensive and the problems of shipping were too difficult. Finally, a nearby quarry was found where stone for columns could be cut, shaped, and transported by river to Saint-Denis, allowing Suger to realize his architectural plans.

A RETURN TO COLUMNS. Columns were rarely seen in Ottonian and Romanesque church architecture; for example, Speyer Cathedral in Germany and Saint-Sernin in Toulouse in France used complex piers to support their tall, heavy structures. As in the Carolingian abbey, the columns of Suger's Saint-Denis were intended to recall the churches of Rome, such at St. Peter's, St. Paul's, or St. John-in-the-Lateran, which had been built

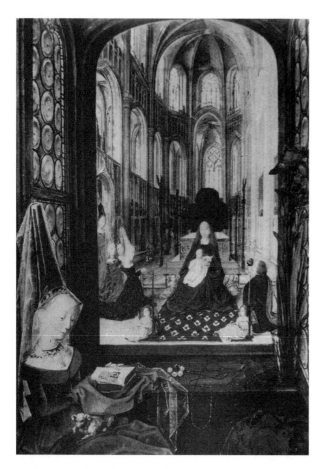

Vaulting and glass of a cathedral as seen by a medieval painter. *Adoration of the Virgin with Mary of Burgundy. Hours of Mary of Burgundy,* by Alexander Bening. Vienna, Austrian State Library MS 1857, folio 14v. Bruges, 1467–1480. BILDARCHIV D. ONB, WIEN.

at the beginning of the age of Christian art and architecture. The columns not only emphasized the prestige of Saint-Denis by imitating famous models, but they also served as reminders that Denis, the saint buried at the abbey who was the first bishop of Paris and the special protector of French kings, had been sent from Rome, so it was thought, by St. Peter. The capitals atop the Saint-Denis columns turned away from the usual figural sculpture of Romanesque architectural decoration and instead adopted baskets of richly carved foliage that emulated the Corinthian order used in ancient Roman and early Christian architecture. This elimination of narrative and animal subjects from capitals was followed throughout northern France in churches influenced by Saint-Denis.

LIGHT. At the same time, Suger wanted a church that was filled with light. The choir, he wrote, included a "circular string of chapels, by virtue of which the whole [church] would shine with the wonderful and uninterrupted light of most luminous windows." Filling the width of the wall, the windows tell stories of biblical history, such as the birth of Jesus, or illustrate theological ideas. They were composed of richly colored stained glass that made light, interpreted by medieval writers as an image of God and a metaphor for spiritual realities, visible, almost tangible. The intended effect of the jewel-like colors, dominated by deep reds and blues, together with the sacred subjects, was to urge the viewer, in Suger's words, "onward from the material to the immaterial." These windows were made by the use of cartoons, large patterns that laid out the stories to be told. Then many pieces of colored glass were cut and fitted together by means of soft flexible channels made of lead (called *cames*), which held the glass in position; these were soldered to each other to create glass fabric that could endure for many centuries. Often the individual stories had written explanations in the glass that were very carefully crafted, though they were so far above the congregation that they can today be read only by means of binoculars.

THE ARCHITECTURE OF THE SAINT-DENIS CHOIR. By demanding columns along with large stained glass windows, Abbot Suger forced his master mason to devise a strikingly original structure that was light, yet could achieve an impressive height. He described how his master mason had laid out the choir through arithmetic and geometry. The builder turned to new architectural techniques as well as new technology—most importantly, of the pointed arch and the ribbed groin vault. Although these forms had appeared in Romanesque buildings, they remained part of a massive, even overpowering structure. However, set on top of slender cylindrical columns and used to frame expansive window openings at Saint-Denis, they produced a completely different effect. First, because the pointed arch was flexible, it could be adjusted to create a uniform ceiling height and a fluid, integrated interior space. Looking through the twelfth-century ambulatory of Saint-Denis, the eye slides past the smooth, rounded columns and moves to the stained glass windows without interruption. (A wonderful rendition of stained glass and vaulting as seen by the contemporary medieval eye appears in a book of hours by the Master of Mary of Burgundy, Alexander Bening, now in Vienna.) Second, the pointed arch combined with the rib vault to direct weight to the corners of each structural compartment or bay in a system that was both architecturally efficient and conducive to maximum spaciousness. This upper-level structure rested on an overall plan that continued the well-established formula of an ambulatory with a series of radiating chapels, seen in Romanesque pilgrimage churches such as Saint-Sernin at Toulouse, but it achieved a new sense of unity. Instead of a collection of separate blocks that appear to be added to one another (at Saint-Sernin, for example, the semi-circular

chapels, the curving ambulatory, and the apse are clearly distinguished from one another), Saint-Denis fused all of the parts of the choir into an integrated composition. The chapels form a continuously undulating exterior wall and, in the interior, their space merges with that of the outer choir aisle or ambulatory.

A HEAVENLY VISION. Saint-Denis offered a new vision for church architecture. Upon entering the grand west façade and passing through the narthex with its architecture of stout piers and thick walls, visitors to the abbey found themselves in a building in which solid stone walls appeared to dissolve into surfaces of glass, and vaults were transformed into delicate, hovering canopies that framed broad, open spaces shimmering with colored light. Again, as abbot Suger wrote about the choir in his account "On the Consecration of the Church of Saint-Denis," "we made good progress—and, in the likeness of things divine, there was established to the joy of the whole earth, Mount Zion." In other words, the church was built as an image of heaven. The twelfth-century abbey of Saint-Denis, and the Gothic churches that followed it during the next three centuries, captured the aura of the celestial city of Jerusalem that would descend to earth at the end of time, described by St. John in Revelations, chapter 21: "And he (the angel) showed me the holy city of Jerusalem coming down out of heaven from God, having the glory of God, its radiance like a most rare jewel, like a jasper, clear as crystal. The wall was built of jasper, while the city was pure gold, clear as glass. The foundations of the wall of the city were adorned with every jewel. And the twelve gates were twelve pearls, each of the gates made of a single pearl, and the street of the city was pure gold, transparent as glass."

SOURCES

Jean Bony, *French Gothic Architecture of the Twelfth and Thirteenth Centuries* (Berkeley: University of California Press, 1983).

Caroline A. Bruzelius, *The Thirteenth-Century Church at Saint Denis* (New Haven, Conn.: Yale University Press, 1985).

Paula Gerson, ed., *Abbot Suger and Saint-Denis: A Symposium* (New York: Metropolitan Museum of Art, 1986).

Erwin Panofsky, ed. and trans., *Abbot Suger on the Abbey Church of Saint-Denis and Its Art Treasures* (Princeton, N.J.: Princeton University Press, 1979).

IMMEDIATE IMPACT: NOTRE-DAME AND CHARTRES

NOTRE-DAME. Saint-Denis had an immediate impact on major church-building projects throughout northern

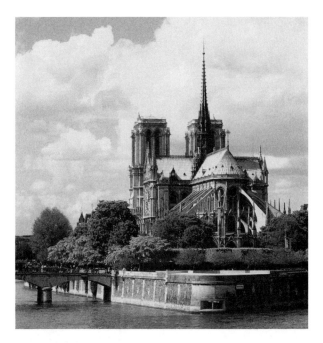

View of the Cathedral of Notre-Dame, Paris, France, 1163–1250. **BILL ROSS/CORBIS.**

France. One of the most important appeared in nearby Paris, where the new cathedral of Notre-Dame was begun in the 1150s. The cylindrical columns and other elements in the nave can be recognized immediately as inspired by the architecture of the abbey. But in comparing the two churches, one is struck by the differences. Notre-Dame is enormous. The interior space rises to a height of about 108 feet—the height of a ten-story building. In its original twelfth-century state (remodeled in the thirteenth century and partially restored in the nineteenth) it was composed of four levels: an arcade supported by those monumental columns; a gallery that created a second-story aisle; above that, a series of circular openings in the wall that corresponded to the zone of the pitched roof over the gallery; and, finally, the high windows or clerestory. One views the structure with awe, wondering how such a fragile assemblage of columns, spaghetti-thin colonnettes rising to join with the taut ribs that arc across the vaults, and walls consisting of little more than arched openings can enclose such a vast space. The answer is displayed on the exterior by the cage of flying buttresses that transfer the outward thrust of the walls downward into the ground and thus assure the cathedral's stability.

HEIGHT. Notre-Dame's monumental scale and the three levels of stained glass windows, in the ground floor aisles, gallery, and clerestory, sought to represent, as at Saint-Denis, the miraculous architecture of heaven. At the same time, the cathedral was more than just a religious symbol. Set in the heart of a rapidly growing city, the

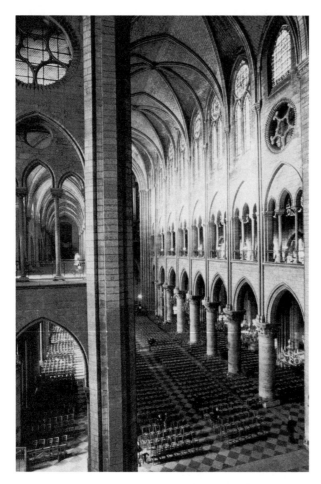

Nave of the Cathedral of Notre-Dame showing stained glass, vaulting and columns, Paris, France, 1163–1250. **ADAM WOOLFITT/CORBIS.**

great bulk of Notre-Dame towered over the surrounding rooftops and flanking hills to give tangible expression to the prestige of its powerful bishop and clergy. Bishop Maurice de Sully (1120–1196), who spearheaded the construction project, must have aimed to erect the most impressive church in the kingdom of France, outdoing even the new cathedral of his superior, the Archbishop of Sens. This competition among elite churchmen of the time to build larger, higher, and more luxurious churches was critically noted by Peter the Chanter, one of the most powerful members of the Notre-Dame clergy. While he did not mention his cathedral by name, he must have had it mind when he wrote, "If these builders believed that the world would ever come to an end, no such lofty masses would be reared up to the very sky, nor would such foundations be laid into the abysses of the earth. In that they resemble those giants who built the tower of Babel (men sin even in building churches). Today, on the contrary, the choirs of churches are built higher and higher."

CHARTRES. One of the finest examples of twelfth-century church architecture—and the one preserving the largest collection of Gothic stained glass, with 173 windows—is the cathedral of Notre-Dame at Chartres. A fire in 1134 destroyed the façade of the Romanesque church that was replaced by three new portals, with their renowned sculpture influenced by Suger's west façade of Saint-Denis, and two towers built between c. 1140 and 1165. A second fire swept through the town on 10 June 1194 devastating the body of the cathedral, but sparing the new west front. The church that rose from the ashes of the 1194 blaze reached 118 feet in height, and was briefly the tallest building in Europe. The cathedral, dedicated like the earlier church to the Virgin, was not only the seat of the bishop that made it the administrative headquarters of a large church territory called a diocese, but it was also a popular pilgrimage destination because it sheltered a prized relic, a tunic or garment believed to have been worn by the Virgin Mary. After the fire in 1194, the bishop and chapter donated part of their large incomes to the new construction and also collected gifts from Christians from as far away as England who wished to honor the Virgin by supporting the rebuilding of her church. Construction proceeded quickly, and in 1221 the clergy moved back into the choir of the nearly completed new edifice.

SIMPLIFYING THE DESIGN. Rapid construction was possible not only because of the wealth of the Chartres building fund, but also as a result of the design of the cathedral and developments in building techniques. Unlike the large French churches, including the cathedrals of Paris, Arras, Cambrai, Laon, and Noyon, or the abbey of Saint-Remi at Reims, built between 1150 and 1190, Chartres rejected the four-story interior. A three-level elevation re-appeared at Chartres, composed of an arcade, a dark, narrow passage called a triforium about halfway up the wall, and huge clerestory windows. In many ways, Chartres is a version of Suger's choir at Saint-Denis, except that it is about twice as high. The master mason may have realized that with flying buttresses providing the necessary structural reinforcement, the gallery, seen at Notre-Dame in Paris, became irrelevant. Eliminating the gallery simplified the design and led to the enlargement of both the arcade and the clerestory, which created two equally tall zones of space and light balanced by the dark horizontal belt of the triforium. Verticality was also emphasized: four slim shafts were added to the arcade columns, which alternate subtly between cylinders and octagons, creating continuous lines that rise from floor to vault and join all of the parts and levels into a unified whole. Further simplification of the design reduced the number of components needed for

the structure, and at Chartres the individual pieces form extremely regular repeating units. Indeed, the piers, triforium, and window patterns are almost identical in each bay. In addition, Chartres used four-part vaults throughout the entire building, in contrast to the six-part vaults seen in Paris, that were at once consistent in their appearance, made from the same limited group of parts, and easier to build. As with a car in a modern automobile plant, Chartres was assembled from a series of mass-produced parts that promoted speedy, efficient construction even though it was part of a trend to construct buildings of ever-increasing size.

VARIATIONS ON A THEME. Chartres Cathedral is the most famous example of late twelfth-century developments that established a basic system of construction and a pattern for elite Christian church architecture that continued for the rest of the Middle Ages. To be sure, there were many design variations, such as the Cathedral of Saint-Stephen at Bourges, where tall arcades stressed spatial expansion rather than the vertical concentration of Chartres, but the major monuments of the thirteenth and fourteenth centuries—the cathedrals of Reims, Amiens, Beauvais, and Narbonne in France; Tournai in Belgium; Cologne in Germany; Burgos, Léon, and Toledo in Spain; as well as cathedrals in Prague and Milan—bear witness to the enduring impact of these architectural ideas. It is also important to think about the architectural process that produced these marvelous structures as a complex recipe that was shaped not only by religious ideas and symbols, but also by considerations of money, by available technology, and by strategies of production. The church may have been an image of heaven, but it was also the product of practical reality.

SOURCES

Robert Branner, ed., *Chartres Cathedral* (New York: Norton, 1969).

Caroline A. Bruzelius, "The Construction of Notre-Dame de Paris," *Art Bulletin* 69 (1987): 540–569.

Alain Erlande-Brandenburg, *Notre-Dame de Paris* (Paris: Nathan, 1991).

Teresa Frisch, *Gothic Art 1140–c. 1450* (Englewood Cliffs, N.J.: Prentice Hall, 1971): 32–33.

SEE ALSO *Visual Arts: Political Life and the New State*

THE GOTHIC IN ENGLAND

SEA CHANGE AT CANTERBURY. Although Gothic architecture developed in the direction of a highly ra-

tionalized set of forms responding to a combination of religious, technological, and practical conditions, it was never conceived as a rigid formula or an integrated system that obeyed a set of rules. English architecture during the half century from 1175 to 1230 reveals that it is better understood as a kit of parts, including columns, piers, shafts, pointed arches, and ribbed vaults, that could be selectively combined in endless variations. The rebuilding of the choir of Canterbury Cathedral after a fire in 1174 marked the beginning of this change of direction in English architecture. Designed by the French master mason William of Sens (late twelfth century), and completed by William the Englishman, the extraordinarily long east arm includes two transepts and two choirs that accommodated a community of monks as well as the secular clergy of the archbishop and chapter (the canons charged with administration of the church). With its ambulatory and rotunda on the eastern axis, it also provided a splendid theater for the display of the relics of St. Thomas Becket, who had been murdered in the cathedral in 1170. Although it incorporated portions of the old Norman walls into its fabric, Canterbury is thoroughly French in character. In place of the massive walls of the Romanesque period, the choir rose, as at Saint-Denis, in three tiers of light screen walls carried by slender columns and supported on the exterior by flying buttresses. The constantly varying columns that appear in cylindrical and polygonal shapes, as pairs or enriched with additional shafts, enhance the visual complexity of the building. Complemented by the dark marble shafts and moldings that play over the piers and walls, the polished marble columns of the apse, and the incomparable stained glass and wall paintings, the Canterbury choir emphasizes luxurious variety that was a hallmark of medieval definitions of beauty, intended to achieve an almost literal representation of the Heavenly City.

LINCOLN. The importance of Canterbury lay not so much in inspiring a series of copies based on French styles, but in directing English architecture toward new effects of lightness and linearity. This is best illustrated at Lincoln Cathedral, where rebuilding that began in 1192 after the collapse of the crossing tower in the original Romanesque church went on through a series of campaigns and eventually resulted, by 1250, in the replacement of the two transepts, St. Hugh's (the western) choir, and the nave—indeed, everything except the west block and towers. Although the Canterbury type of elevation formed the starting point, and a Gothic sensibility is apparent in the adoption of pointed arches, ribbed vaults, and finely scaled shafts and moldings, the

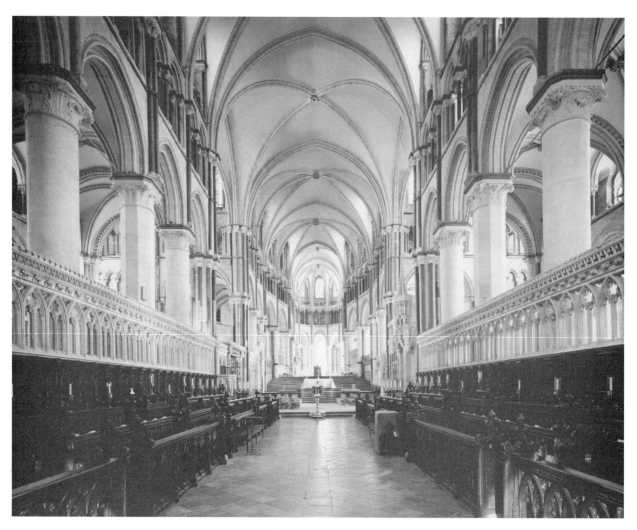

Interior from choir, with columns, capitals, and vaulting of Canterbury Cathedral, England, late twelfth century. **ARCHIVO INCONO-GRAFICO, S.A./CORBIS.**

Lincoln design was guided by principles of syncopation and a rich layering of the wall in depth that recalls the powerful three-dimensionality of Norman Romanesque. The dark shafts of the vault are cut off above the level of the arcade and meet the rib at a seemingly arbitrary level in the triforium, effectively severing the relationship between the vault and the piers. Looking upward into the vaults of St. Hugh's choir only aggravates the visual uncertainty. These so-called "crazy vaults" comprising groups of three ribs that converge on two centers at the crown, marked the appearance of *tiercerons*, ribs that arc from the wall to an off-center keystone. By multiplying the number of ribs and introducing two keystones tied by a longitudinal ridge rib, the Lincoln vaults broke down the clear definition of the bay unit and intensified the sense of continuous zigzag movement down the length of the interior space. However, the vaults were not the work of an eccentric architect, but

rather an ingenious solution that permitted an expansion of the windows in the choir to include three broad lights per bay. In this regard, the importance of light and color that shaped twelfth-century developments in northern France as well as Canterbury remain central concerns for the Lincoln master. But rather than pursuing the visual logic of a rigorously integrated structure, the Lincoln builder may have turned to disjunction and multiplicity as the effective means to capture the unearthly architecture of heaven. The vaults of St. Hugh's choir were elaborated into star patterns in the nave in the 1220s and 1230s through the addition of *liernes*, short ribs within the surface of the vault that tie tiercerons together. The tierceron and lierne vault was to be repeated in ever more intricate variations throughout the thirteenth and fourteenth centuries in such buildings as Exeter Cathedral and the Lady Chapel of Ely Cathedral.

a PRIMARY SOURCE *document*

THE MASTER MASON WILLIAM OF SENS AND THE RECONSTRUCTION OF THE CHOIR OF CANTERBURY CATHEDRAL

INTRODUCTION: In 1174 there was a great fire at Canterbury Cathedral when sparks from burning cottages nearby ignited the wooden timbers supporting the roof, which were hidden between the sheet lead covering above and the painted ceiling below. By the time the fire was discovered, the burning timbers had fallen down onto the choir and set the wooden seats on fire, sending flames twenty-five feet high that damaged the columns of the structure. So severe was the damage to the church that experts were called in to decide how it might be reconstructed. Gervase of Canterbury, a monk at the Cathedral from 1163 to 1210, describes this process in "Of the Burning and Repair of the Church of Canterbury."

[1174] However, amongst the other workmen, there had come a certain William of Sens, a man active and ready, and as a workman most skilled both in wood and stone. Him, therefore, they [the monks of Canterbury], retained, on account of his lively genius and good reputation, and dismissed the others. And to him, and to the providence of God was the execution of the work committed.

And he, residing many days with the monks and carefully surveying the burnt walls in their upper and lower parts, within and without, did yet for some time conceal what he found necessary to be done, lest the truth should kill them in their present state of pusillanimity.

But he went on preparing all things that were needful for the work. ... And when he found that the monks began to be somewhat comforted, he ventured to confess that the pillars [piers] rent with the fire and all that they supported must be destroyed if the monks wished to have a safe and excellent building. ...

And now he addressed himself to the procuring of stone from beyond [the] sea. He constructed ingenious machines for loading and unloading ships, and for drawing cement and stones. He delivered molds for shaping the stones to the sculptors who were assembled, and diligently prepared other things of the same kind. The choir thus condemned to destruction was pulled down, and nothing else was done in this year. ...

In that summer [1178] he [William of Sens] erected ten piers, starting from the transept ... five on a side. ... Above these he set ten arches and the vaults. But after two triforia and the upper windows on both sides were completed and he had prepared the machines ... for vaulting the great vault, suddenly the beams broke under his feet, and he fell to the ground, stones and timbers accompanying his fall, from the height of the capitals of the upper vault, that is to say, of fifty feet. Thus sorely bruised by the blows from the beams and stones he was rendered helpless alike to himself and for the work, but no other person than himself was in the least injured. Against the master only was this vengeance of God or spite of the devil directed.

The master, thus hurt, remained in his bed for some time under medical care in expectation of recovering, but was deceived in this hope, for his health amended not. ... But the master reclining in bed commanded all things that should be done in order. Thus the vault between the four main piers was completed; in the keystone of this quadripartite ribbed vault ... the choir and the arms of the transept seem, as it were, to [converge]. ... Two quadripartite ribbed vaults were also constructed on each side before winter. Heavy continuous rains did not permit of more work. With that the fourth year was concluded and the fifth begun. ...

And the master, perceiving that he derived no benefit from the physicians, gave up the work, and crossing the sea, returned to his home in France.

SOURCE: Gervase of Canterbury, "Of the Burning and Repair of the Church of Canterbury," in *Gothic Art, 1140–c. 1450*. Ed. Teresa G. Frisch (Englewood Cliffs, N.J.: Prentice-Hall, 1971): 17–19.

WELLS AS MODERN ARCHITECTURE. A glance at the interior of the Wells Cathedral nave, begun around 1190, reveals the way in which English architects used Gothic forms as independent bits and pieces. Pointed arches and ribbed vaults do not work together as parts of a unified skeleton, but appear as repeating forms arranged in three distinct horizontal zones stacked on top of one another. Vertical connections are reduced to a fragmentary clasp between the two upper levels, leaving the vault in a tenuous, hovering relationship to the lateral walls. With its brawny piers and thick walls with passages, Wells might be seen as an old Norman structure dressed in fashionable new Gothic clothes, but its mantle of sharp forms, increased luminosity, and restless linearity demonstrate the creation of an architecture that is divorced from the forms and effects of the classical Roman tradition. The singular west front, at once majestic and delicate, rearranges the French type by shrinking the portals and emphasizing the stout mass of the towers. Row upon row of statue niches evoke the "many

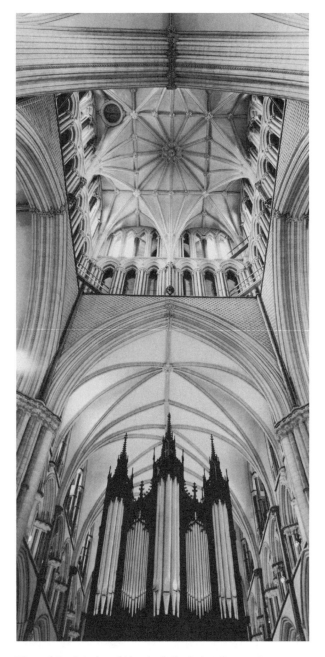

View of the interior of Lincoln Cathedral at the crossing, 13th–14th century. ARCHIVO ICONOGRAFICO, S.A./CORBIS.

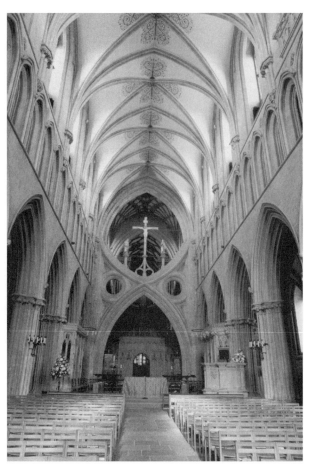

View of the nave of Wells Cathedral, Wells, Somerset, England, 1175–1239. COLIN HOSKINS; CORDAIY PHOTO LIBRARY LTD./CORBIS.

rooms in my Father's house" mentioned by Jesus in the Gospel of John (14:2) and created more than 500 places for the residents of heaven, prophets, apostles, kings, martyrs, virgins, bishops, and abbots. Choirs hidden in the singing galleries within the thickness of the west wall would have brought these statues to life during liturgical ceremonies throughout the year. Rather than relying on quotations of models and forms from the past to create meaning, Wells is a fully realized example of the Gothic invention of an architecture of persuasive symbolic power drawn from a formal repertory that was both completely original and infinitely flexible.

SOURCES

Jean Bony, "French Influence on the Origins of English Gothic Architecture," *Journal of the Warburg and Courtauld Institutes* 12 (1940): 1–15.

L. S. Colchester, ed., *Wells Cathedral: A History* (Shepton Mallett: Open Books, 1982).

Gervase of Canterbury, "Canterbury Cathedral" in *Architectural History of Some English Cathedrals: A Collection in Two Parts of Papers Delivered During the Years 1842–1863*. Trans. Robert Willis (Chicheley, England: Minet, 1972–1973).

Dorothy Owen, ed., *A History of Lincoln Minster* (Cambridge, England: Cambridge University Press, 1994).

Nikolaus Pevsner and Priscilla Metcalf, *The Cathedrals of England: Midland, Eastern and Northern England* (New York: Viking, 1985).

SEE ALSO *Visual Arts: Political Life and the New State*

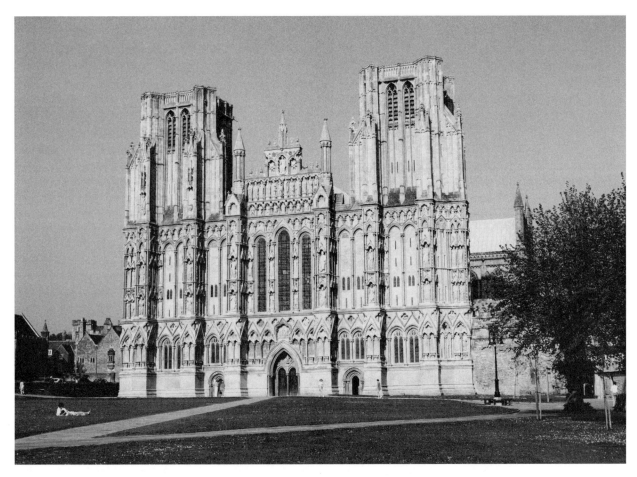

Western facade of Wells Cathedral, Wells, Somerset, England, 1175–1239. **ARCHIVO ICONOGRAFICO, S.A./CORBIS.**

THE ILLUMINATED CHURCH AND THE RAYONNANT STYLE

LIGHT, VISION, AND ARCHITECTURE. There is an intimate relation between architecture and its decoration. Whereas in early Christian and early medieval churches mosaics and paintings on walls had been the primary medium for the presentation of sacred stories, the elimination of solid mural surfaces and the transformation of the Gothic building into a skeletal frame led to the ascendancy of stained glass during the twelfth century. No doubt, the importance of an aesthetic that emphasized light as a metaphor of the Divine and spiritual experience spurred the creation of an architectural system that made a maximum expanse of stained glass possible. A third factor to consider is the rise of interest, during the twelfth century, in vision and optics. Not only were scholars curious about how physical objects and visual phenomena—rocks or rainbows—were seen, but they also explored the nature of what might be called "spiritual vision." How was it possible to understand St. John when he wrote in Revelations, chapter 21, "Then

I saw a new heaven and a new earth—And I saw the holy city, new Jerusalem, coming down out of heaven from God"? As an explanation, Richard of Saint-Victor (d. 1173), the author of a commentary on Revelations, formulated four categories of vision. The first was the "simple perception of matter": I see a tree. The second viewed an object's "outward appearance," but saw a mystical significance in it: I see a rose that is a symbol of the Virgin Mary. The third level of vision was that of spiritual perception in which one discovered, to quote Richard, "the truth of hidden things by means of forms and figures." This is the experience described by St. John, who saw heaven in the form of a city. The fourth and highest level was the mystical mode in which the divine was encountered face to face. It is important to keep these notions of vision in mind when thinking about medieval architecture and its figurative decoration. Images, of course, were physical things, but through them Christians gained access to a realm beyond the mundane world. And the architecture of the church composed an elaborate frame for those pictures that could lead the worshipper to that higher, spiritual mode of vision.

STAINED
Glass

Historical Origins

Stained glass work is a phenomenon of the twelfth century, but one whose history can be traced far earlier. Indeed, the Romans had used glass made of local sand or silica in windows to transmit light and keep out insects and the elements. Decorative glass was used in windows in sacred buildings in the Byzantine Empire, in Syria, and in France (by about the sixth century at Lyon), as well as in Britain in Northumberland during the Anglo-Saxon period. Windows in the Carolingian period used colored glass, but the glass did not represent people or stories and was not painted. Augsburg Cathedral in Germany in about 1130 seems to have had decorative windows with fairly elaborate programs of painting, and Saint-Denis (1135) seems to have been the earliest full program (depicting a series of linked narrative episodes) in France.

Making Stained Glass

Shortly before the first mention of decorative stained glass windows in churches, detailed instructions for making them appeared in the treatise *On Various Arts* (c. 1100) by the monk Theophilus. He gave instructions for coloring glass, cutting and laying it out in designs on flat worktables, and assembling the pieces in a frame. The glass used in cathedrals and the wealthier parish church windows could be of two types—an older kind known as "potmetal" glass, colored in molten state by the addition of various metal oxides, or a "painted" type, further colored for detailed areas like faces or clothing folds by the addition of paints made of iron filings and pulverized glass suspended in a vehicle of wine or sometimes of urine. This paint could range in color from thick black to light gray, and it created a translucent effect. Once the pattern was achieved, the glass was fired in a kiln, bonding the paint to the surface permanently as a sort of glaze.

Color and Shapes

Ingeniously, the flat pieces of colored glass had designs traced on them with the tip of a tool like a hot poker, and then cold water was applied, causing the glass to crack exactly along the lines. The shape was further refined by using a holding tool called a *grozer* and a pair of pliers with a nipper-like jaw to crack off tiny pieces of the glass until the desired shape was reached. During the fourteenth century, a new addition to the glassmaker's toolbox was a stain made of silver oxide, which gives a range of colors from lemon yellow to bright orange, depending on how long the glass was fired. Thus, the artist could virtually paint on the glass and not have to join so many different colored pieces to obtain the desired design. Typical palettes included green, pink, yellow, blue, and shades of red. When the design was created, the pieces of glass were assembled on the flat glassmaker's board and held together in a mosaic of irregular shapes given structural strength by lead channels called *cames*. A groove along each edge of the came fit the piece of glass, and the resultant pattern was securely soldered together to form a large sheet that was shaped to fit in the arch of the window, encased in a stiffening iron frame.

Variations

About 100 years after the general introduction of stained glass, the dark, rich colors—reds and blues—changed to *grisaille*, a type of monochrome silvery gray which admitted more light. Grisaille could be unpainted when used in floral or geometric patterns, but was sometimes painted with foliate motifs, as at Salisbury Cathedral in England. From about 1150 on, grisaille glass in its natural state of green, pink, or clear was especially popular with the Cistercians, who avoided spectacular decoration; eventually grisaille was combined with the regular painted glass in some churches, such as Clermont Cathedral in France. As early as 1080–1100, stained glass was used in windows in York Minster in figurative scenes. Canterbury Cathedral was glazed with figurative windows from about 1180 to 1220. From about 1225, in addition to the scenes of New and Old Testament events and the lives of the saints, heraldic motifs and royal arms began to appear in church windows, often signifying the social status of a donor of the window or benefactor of the church. Patrons or donors sometimes had themselves memorialized in the windows of churches, as in the case of Abbot Suger, shown supplicating the Virgin in a window at Saint-Denis. Guilds who gave windows were often represented with scenes of their members (for example, shoemakers or bakers) pursuing their trades in the lower parts of the windows. Stained glass was carefully placed for best viewing, often in the windows of the end of the transept to give maximum visibility. Aisles had biblical subjects, and rose windows showed cosmological scenes or perhaps depictions of the Apocalypse and Last Judgment, while upper or clerestory windows often had large-scale individual figures, which were easier to interpret from far below.

RAYONNANT ARCHITECTURE. The course of Gothic architecture can be described in terms of a series of structural innovations, all leading in the direction of greater light and visual space. The combination of the pointed arch, ribbed vault, and flying buttresses led to a new type of structure that was no longer an opaque box punctu-

ated by intermittent window openings but rather a cage-like frame. As the size of windows expanded in the twelfth century, glass surfaces were subdivided into manageable sections. In the Chartres clerestory, the two tall pointed lancets with an *oculus* ("circular opening") are partitioned by flat pieces of stone, or plate tracery, that make them appear to be three holes punched through a solid wall. A new solution was proposed at Reims Cathedral in the 1210s, where the window was designed along the same lines as the other elements of the structure—as a taut network of slender ornamental shafts or mullions called "bar tracery." This invention had an enormous impact on the appearance of buildings, and, ultimately, on the way architecture was experienced. By the mid-thirteenth century, not only had bar tracery been developed into elaborate window patterns—at Amiens Cathedral, four-part windows decorate the clerestory while six-lancet compositions appear in the choir—but grids of delicate shafts began to spread over the remaining solid walls of the interior and exterior. In the interiors of new projects, including the rebuilding of Saint-Denis, the nave of Strasbourg Cathedral, or the choir of Clermont Cathedral, the networks of tracery were coordinated with piers composed of bundles of thin colonnettes to create an overall architecture of consistently delicate scale. On the exterior, the west façade of Strasbourg Cathedral (1275 fl.) in eastern France presents one of the most extravagant expressions of bar tracery, in which a fantastic fretwork of stone completely disguises the load-bearing walls behind. Gothic architecture between around 1240 and 1380 is often called the "Rayonnant," taking its name from the radiating spokes of the spectacular rose windows that dominate façades, as in the transepts of Notre-Dame in Paris or the west façade at Strasbourg. Although the Rayonnant is usually discussed as a phase in which architects refined forms to achieve an even greater degree of lightness and elegance, its development was a response to the visual experience of the church interior illuminated by stained glass.

THE SAINTE-CHAPELLE. In two separate purchases of 1239 and 1241, Louis IX, king of France, acquired the most precious relics in Christendom: objects associated with the Crucifixion of Jesus. After bringing the Crown of Thorns, a large piece of the Cross, nails, the sponge, and the lance to his capital in Paris, he set about erecting an appropriately magnificent chapel to honor them in the heart of his palace. Like Charlemagne's chapel at Aachen, the Sainte-Chapelle, built between 1241 and 1248, contained two levels. A low, broad chapel on the ground floor, dedicated to the Virgin Mary, provided a base for the tall upper chapel where

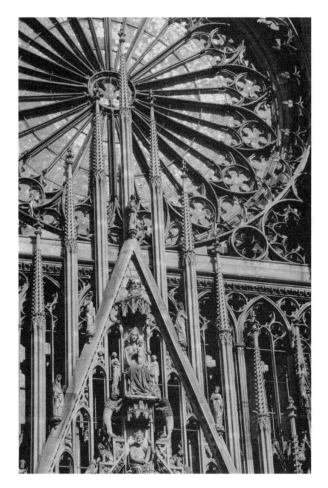

Gable and rose window above the center portal of the west facade of Strasbourg Cathedral, Strasbourg, France, 1277. **FARRELL GREHAN/CORBIS.**

the relics of Christ were displayed and the king and his court worshipped. In this remarkable upper chapel, the architecture is reduced to thin clusters of vertical colonnettes, linked by iron chains that support the vault canopies and frame enormous, fifty-foot high stained glass windows. Its design resembles closely the triforium and clerestory of the nave of Amiens Cathedral, built in the 1220s and 1230s, producing the sensation that the visitor has been lifted up into a zone of space and light. Moreover, the architecture is clearly arranged as scaffolding that provided visual cues for apprehending the different ranks represented by the painting, sculpture, and stained glass. For example, closest to eye level and framed in the quatrefoils (four-lobed ornaments) of the wall arcade are paintings (now badly damaged) of local Parisian saints. Sculpted figures of the twelve apostles then appear attached to the columns, their architectural symbols, and lead the gaze up to the windows that present the entire cycle of divine history from Genesis to the Second Coming. Here the architecture creates distinct

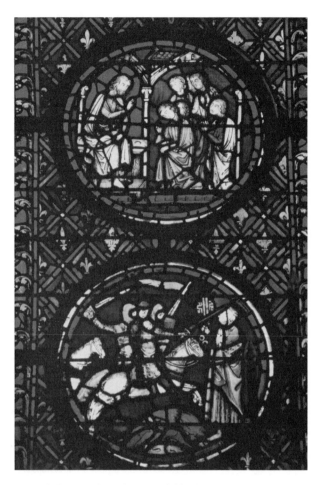

Stained glass windows depicting biblical stories, Sainte-Chapelle, Paris, France, 1240s. ROBERT HOLMES/CORBIS.

patterns for each level. The images of the earthly lives of local saints are framed by arcades organized in three units of two, while the stained glass narratives appear in two- and four-lancet windows. Second, as one moves upward across these architectural thresholds, the medium also changes from the more physical substance of opaque paint and three-dimensional sculpture to the jewel-like light of the windows. Although the architecture of the Sainte-Chapelle did not impose a rigid system that dictated the placement of certain images or media in specific locations, its careful organization and relentless subdivision of surfaces into panels, arcades, and niches on multiple levels created a flexible, but structured framework that measured the stages of devotional experience. A measure of the international impact of the Sainte-Chapelle and the French rayonnant style can be seen in the choir of Aachen Cathedral that was added to Charlemagne's church beginning in 1355. The majestic, solid masonry of Carolingian architecture has been replaced by an armature of shafts and ribs that frame enormous windows. Instead of Roman columns and Corinthian capitals, there

are taut screens of tracery, animated sculpted figures of saints, and glowing panels of stained glass that combine in a building whose meaning no longer resides in historical references, but rather is created through the emulation of the dazzling effects of shrines and the evocation of a heavenly edifice.

CLERMONT CATHEDRAL. Clermont Cathedral, located in the modern city of Clermont-Ferrand in central France, may well have been inspired by the Sainte-Chapelle. The bishop of Clermont, Hugues de la Tour, attended the dedication of the royal chapel on 26 April 1248, and within a few months launched a new structure in his own diocese to replace the old Romanesque church. The thirteenth-century master mason, Jean Deschamps, adopted an up-to-date Rayonnant style that appears tailor-made for its role as a monumental picture frame. Looking into the deep chapels from the ambulatory, one first sees a section of bare, solid wall. Then, moving into the chapel, the eye first encounters a blind tracery pattern, and then is pulled to the expanse of luminous glazed walls. The colonnettes, moldings, and ribs that constitute the architectural structure define a sequence of thresholds through which one looks: from a location in the ambulatory into the chapel which only the clergy could enter; from a world of solid matter into a realm of light that presents the stories of sacred and saintly history. The paintings added to the lower wall beautifully articulate this visionary path. In one chapel, an angel leads a procession of canons forward into the presence of the saint, while in another, a canon kneels in devotion as his celestial guide points to the altar and the glass cycle beyond. As one gazes upward into the main space of the choir, the clerestory windows appear to hover above the dark band of the triforium that creates a gateway to the visionary realm above. In the clerestory, the rich color of the narrative windows of the chapels evaporates into the cool light of fields of grisaille glass (decorated monochromatically in shades of gray) in which figurative panels of Old Testament prophets, apostles, and in the axial lancets, the Assumption of the Virgin, float. This switch from full color to grisaille, a style of glazing that became widespread in the second half of the thirteenth century, offers another metaphor for spiritual ascent: from the almost tangible colored light, characteristic of terrestrial perception and appropriate to the subject of saints' lives to the brighter, flashing divine light at the highest level of the church.

DIFFERENT PATHS. The Westminster Abbey choir (1245–1272), Cologne Cathedral in Germany (begun 1248), and León Cathedral in Spain (begun around 1254) adopted the Rayonnant style in its entirety along

with stained glass as an essential part of the decoration. While this may reflect the prestige that French art and culture acquired during the reign of Louis IX, these royal churches were not trying to be French. Glazing programs were geared to local saints and rulers, suggesting that French architecture was emulated primarily because of its effective representation of the church as an image of heaven, as well as its ability to organize complex ensembles of pictures. Apart from a handful of clearly French-inspired edifices, European architecture between 1300 and 1500 presents an overwhelming variety. For example, the influential church of Saint-Rombout, Mechelen, in the Brabant region of Belgium was rebuilt after a fire in 1342 in the fashionable rayonnant style with wiry patterns of bar tracery that fill the windows and spread over the walls. But its enormous (unfinished) west tower, begun in 1452 and supervised by the architect Andries Keldermans between 1468 and 1500, looked to such contemporary German designs as Ulm Cathedral as well as the great towers of local secular civic structures. Finally, the choir of the church of St. Lorenz in Nuremberg, built 1439–1477, could hardly be more different from Amiens or Clermont in France. A hall church, a type in which the aisles rise to the same height as the central vessel, capped by an intricate net vault and exhibiting a variety of tracery designs, St. Lorenz offered fluid, indeterminate space in place of clear organization. Nevertheless, the ribbed vaults defined interior spatial compartments and the bar tracery created hierarchies of arches, repeated at different scales in which a worshipper was free to plot his own itinerary through stained glass panels, painted altarpieces, and sculpted keystones. Like the Sainte-Chapelle, St. Lorenz's architecture delineated the thresholds and setting of meditation in which the objects and images encountered as a spatial sequence became the material vehicles for an inward journey.

SOURCES

Marcel Aubert, et al., *Les Vitraux de Notre-Dame et de la Sainte-Chapelle de Paris.* Corpus Vitrearum Medii Aevii (Paris: Caisse nationale des monuments historiques, 1959).

Robert Branner, *Saint Louis and the Court Style in French Gothic Architecture* (London: Zwemmer, 1965).

Sarah Brown and David O'Connor, *Medieval Craftsmen: Glass Painters* (London: The British Museum, 1991).

Madeline Caviness, "Stained Glass," in *English Romanesque Art 1066–1200.* Ed. George Zarnecki et al. (London: Weidenfeld and Nicolson, 1984): 135–145.

Sarah Crewe, *Stained Glass in England 1180–1540* (London: HMSO, 1987).

Jean-Michel Leniaud and Françoise Perrot, *La Sainte-Chapelle* (Paris: Nathan, 1991).

Meredeth Parsons Lillich, *The Armor of Light: Stained Glass in Western France 1250–1325* (Berkeley: University of California Press, 1993).

Richard Marks, "The Medieval Glass of Wells Cathedral," in *Wells Cathedral: A History.* Ed. L. S. Colchester (Shepton Mallet: Open Books, 1982): 132–147.

———, *Stained Glass in England during the Middle Ages* (Toronto: University of Toronto Press, 1993).

THE ARCHITECTURE OF SECURITY AND POWER

CASTLES. Although the design of churches was the primary focus of medieval architectural creativity, structures for the daily living and defense of members of the upper level of society also displayed technical ingenuity and an awareness of the importance of image. Just as the monastery assembled different kinds of buildings—church, hall, infirmary, barn—to accommodate all of the activities—prayer, work, eating, sleeping—of the monk's life, the castle fulfilled an equally varied array of functions in the secular world. With the collapse of the centralized authority and administration of the Carolingian Empire in the later ninth century, power was increasingly concentrated in the hands of local lords. Rather than providing a common defense for the towns under his control, the lord built only for his own security. The great circuits of walls and gateways that had protected cities in the past, such as Rome or Constantinople (modern Istanbul), gave way to fortified independent residences. Castles thus developed as multi-purpose structures at once a dwelling, a governmental headquarters, and fortress. But along with these practical duties, castle architecture projected an image of power and security that aimed to impress both the lord's subjects and peers. Rather than pursuing the celestial vision of a "walk of angels" as in religious construction such as at Cluny, it spoke a language of form whose vocabulary was assertive gateways, thick walls, and tall towers. Nevertheless, religious structures drew upon castle features, such as battlements, narrow windows, or towers, to enhance their own image of authority. Building techniques, including the use of precisely cut ashlar masonry and engaged columns, that first appeared in castle construction were soon adopted by church builders, suggesting that despite differences in function and appearance there was an interchange of ideas between the two areas of construction.

THE KEEP. Castles appear to have developed from the union of the *motte*, a purely defensive wooden tower set upon a conical earth mound, and the hall. Halls, used for feasts and spectacles, official audiences, rendering

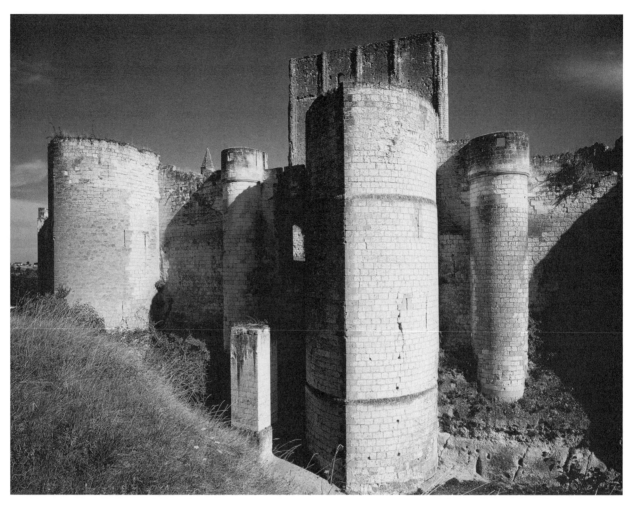

Donjon of the castle at Loches, France. 11th century. **THE ART ARCHIVE/DAGLI ORTI.**

justice, and administrative business, were complemented by a private chamber for sleeping, a kitchen, and a chapel for worship; these few structures constituted the essential domestic spaces of early castles. Around the year 1000, and apparently beginning in the Loire river valley of France, these separate areas were combined into a single, multi-storied tower called a keep or *donjon* surrounded by a circuit of protective walls that created an inner courtyard or bailey, where stables or industrial buildings were located. At Loches, one of the earliest examples, the ground floor was probably used for storage while the hall on the first floor, with its fireplace and latrines located in the surrounding wall passages, was entered through an attached rectangular building. A staircase within the massive walls climbed to the private chamber and chapel, distinguished by its apse, on the second floor. A spiral stair on the upper level provided access to another private room. A similar design was used at the Tower of London (White Tower), built by William the Conqueror immediately after his conquest of England in 1066, where the apse of the two-story chapel is visible on the exterior and the great hall was also likely intended to rise through two levels to create a noble festival space. Marked by four towers at the corners of the square block (118 by 107 feet), the enormous tower that dominated the eastern edge of the city ostentatiously advertised the Norman presence and left no doubt as to who was in charge. Even in the fourteenth century at Vincennes to the east of Paris, King Charles V erected a mighty tower in which residential chambers and a chapel were combined with military features that included provisions for the use of new gunpowder weapons.

WALLS AND DEFENSE. The defensive character of the tower or keep of a castle is clearly indicated by its sheer and solid walls and the reduction in the size of windows to narrow slits or small openings. As the last inner stronghold of the castle, the architecture of the keep and the castle continually incorporated new fea-

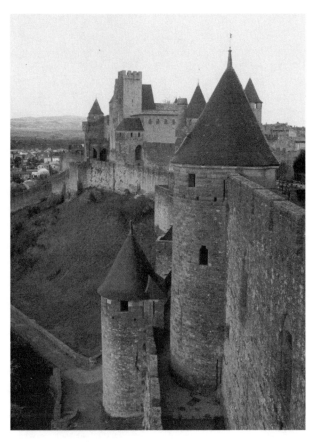

Upper city ramparts of Carcassonne, Aude, France, mid-thirteenth century. ENTZMANN CYRIL/CORBIS SYGMA.

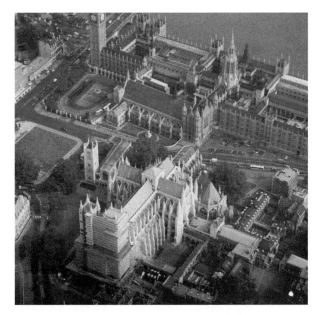

Westminster Palace and Abbey from the air, London, England, begun late eleventh century. LONDON AERIAL PHOTO LIBRARY/CORBIS.

tures designed to repel the advances in weapons and technology of warfare. In Norman castles of the eleventh century, for example, the battlements formed a protective parapet (a wall with both taller areas for defense and openings for deployment of weapons) for the use of defenders. Cantilevering the battlements forward on supporting arches or corbels created machicolations (openings) through which a variety of missiles, rocks, boiling water, pitch, or refuse could be dropped onto attackers below. Inclining or battering the base of the wall then ensured that the volley would bounce or splash onto an enemy unable to flatten himself against the wall. A moat or deep ditch, often filled with water, and one or two rings of walls then surrounded the keep. A fortified gateway and a heavy portcullis (an iron grating that could be lowered from above) further protected access into the castle, which was gained over a drawbridge. Additional towers studded the outer walls of the castle, each floor with narrow slit windows that widened toward the interior, allowing archers within to cover the entire field of fire around the tower. With this description in mind, one might imagine the difficulties of trying to capture Beaumaris castle, built 1295–1323 by King Edward I on

England's western border with Wales. After climbing the steep hill, somehow crossing the bridge and fighting their way through the gate, attackers would find themselves marooned in a courtyard facing another set of walls, another ring of towers. In this case, the inner gateway is not aligned with the outer entry so that troops are forced to change directions and are exposed to fire from a different angle. Each tower formed an independent bastion so that the fortress would have to be taken tower-by-tower and ring-by-ring. Similar ideas of defense were also applied to cities. The thirteenth-century wall systems of the southern French town of Carcassonne offers a particularly well-preserved example of a double ring of walls, fortified gateways, and directional changes, while Aigues-Mortes, begun in the 1240s by Louis IX, joins an intimidating circular keep, the Tour Constance, that protected the port to a towered precinct wall that enclosed the entire city.

PALACES. In contrast to castles, palaces were non-fortified residences that were more ceremonial and administrative in character. At Aachen, for example, Charlemagne's palace consisted of a great audience hall and monumental chapel tied together by long galleries in a scheme that emulated Roman luxury villas and imperial palaces. In the ninth century, a poet described Charlemagne's palace at Ingelheim as "a large palace with a hundred columns, with many different entrances, a multitude of quarters, thousands of gates and entrances, innumerable chambers built by the skill of masters and

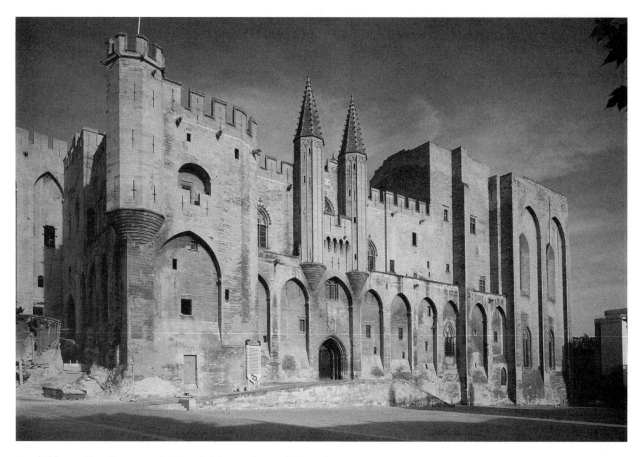

Papal Palace with military crenelations at Avignon, France, 14th century. ANGELO HORNAK/CORBIS.

craftsmen. Temples dedicated to the Lord rise there, joined with metal, with bronze gates and golden doors. There, God's great deeds and man's illustrious generations can be reread in splendid paintings." Ranges of rooms, a great hall, a banqueting hall with three apses, and a chapel were set around two spacious courtyards, one rectangular, the other semicircular, and connected by porticoes. The lobed hall carried particular architectural importance for it denoted "the house of the lord." Featured in the banqueting structures of the imperial palace of Constantinople, a similar type would have been seen by Charlemagne in the papal palace of the Lateran in Rome. As in church architecture, German emperors of the eleventh century continued Carolingian traditions in palace design, best represented at Goslar (begun around 1050). Unfortified, the palace's regular organization, double-level hall, and towered chapel composed the ideal expression of heritage and magnitude of the ruler's authority. Because of political instability, palaces such as that at Westminster in England all but disappeared from European architecture until around 1300 when the nation-states led by powerful monarchs created a climate in which display superseded defense.

PARIS AND AVIGNON. In the 1290s, King Philip IV ("the Fair") of France began to enlarge and transform the motley collection of buildings, ranging from the eleventh-century donjon to the thirteenth-century Sainte-Chapelle, that composed the royal palace in Paris. In the space of about twenty years, his architect, Jean de Cerens, added a huge new hall, the largest in Europe, built a chamber for the Parlement, towers for civil and criminal courts, and offices for the kingdom's financial departments, and remodeled the royal apartments. All of the branches of government were united in the complex, efficiently grouped around a series of courtyards, and linked by long corridors. Statues of Philip and his royal ancestors decorated the main door into the palace and the piers of the festival hall, the Grand'Salle. Although the king seldom resided in his chambers that looked out onto an extensive garden, its walls encompassed the entire machinery of royal administration and justice, made room for commerce in the galleries, and showcased the Sainte-Chapelle as a religious jewel that signified France's divine favor. The high walls and clusters of towers that encircled the palace gave the appearance of strength but, in reality, these features were decorative and symbolic.

a PRIMARY SOURCE *document*

ON THE SAINTE-CHAPELLE AND THE ROYAL PALACE IN PARIS

INTRODUCTION: In 1323, Jean of Jandun, a philosophy professor and translator of Aristotle at the University of Paris, wrote his *Treatise in Praise of Paris*, a work in the tradition of the "city encomium," a genre that had been popular since Carolingian times. In Jean's case, he was hoping to convey to his readers his own sentiment that "to be Parisian is to be." The two passages below describe the effect of the ornamentation in the Sainte-Chapelle and the carefully planned arrangement of the various chambers of the Royal Palace, reflecting the author's sense of how the best examples of architecture are planned to create a perfect harmony between form and function.

Part II, Chapter II: On the Churches and Principally on Notre-Dame and the Sainte-Chapelle

In Paris, privileged sanctuary of the Christian religion, beautiful edifices consecrated to God are founded in such great number that there are not many cities among the most powerful in Christianity that can boast of counting so many houses of God.

But the most beautiful of the chapels, the chapel of the King, conveniently located within the walls of the royal residence, is admirable through its strong structure and the indestructible solidity of the materials of which it is made. The carefully chosen colors of its paintings, the precious gilding of its images (statues), the transparency of the windows which shine from all sides, the rich cloths of its altars, the marvelous virtues of its sanctuaries, the exotic ornaments of its reliquaries decorated with sparkling jewels, give to this house of prayer such a degree of beauty that upon entering, one feels transported to heaven and one imagines that one has been ushered into one of the most beautiful chambers of Paradise.

Oh! How salutary are the prayers that ascend from these sanctuaries towards all-powerful God when the inner purity of the faithful corresponds exactly to the outer corporal ornaments of the oratory!

Oh! How gentle are the praises of God the most merciful sung in these tabernacles when the hearts of those who sing are embellished by virtues in harmony with the lovely paintings of the tabernacles.

Oh! How agreeable to God most glorious are the sacrifices prepared on these altars when the life of the priest shines with a brilliance equal to that of the gold of the altars!

Chapter II: On the Palace of the King in Which Are the Masters of Parlement, the Masters of Requests, and the Royal Notaries

In this illustrious seat of the French monarchy a splendid palace has been built, a superb testimony to royal magnificence. Its impregnable walls enclose an area vast enough to contain innumerable people. In honor of their glorious memory, statues of all the kings of France who have occupied the throne until this day are reunited in this place; they have such an expressive demeanor that at first glance one would think they are alive. The table of marble, whose uniform surface presents the highest sheen, is placed in the west under the reflected light of the windows in such a way that the banqueters are turned toward the east; it is of such grandeur that if I cited its dimensions without furnishing proof for my statement, I fear that one would not believe me.

The palace of the king was not decorated for indolence and the crude pleasures of the senses, nor raised to flatter the false vanity of vainglory, nor fortified to shelter the perfidious plots of proud tyranny; but it was marvelously adapted to the active, effective, and complete care of our wise monarchs who seek continually to increase the public well-being by their ordinances. In fact, nearly every day, one sees on the raised seats which are placed on the two sides of the room, the men of state, called according to their functions either Masters of Requests or Notaries of the King. All, according to their rank and obeying the orders of the king, work for the prosperity of the republic; it is from them that the generous and honorable favors of grace flow incessantly; it is by them that appeals, weighed with the scales of sincerity, are presented.

In a vast and splendid chamber, entered through a special door in the northern wall of the palace because the difficult negotiations that take place there demand the utmost tranquility and privacy, the skillful, far-sighted men, called the Masters of Parlement, sit on the tribunals. Their infallible knowledge of law and customs permits them to discuss cases with complete maturity and clemency and to hurl the thunder of their final sentences which give joy to the innocent and to the just because they are rendered without regard to persons or presents and in the contemplation of God alone and law. But the criminal and the impious, according to the measure of their evil, are overwhelmed by bitterness and misfortune.

SOURCE: Jean of Jandun, *Treatise in Praise of Paris*, in *Paris et ses historiens au XIVe et XVe siècles*. Ed. A. J. V. le Roux de Lincy (Paris: Imprimerie Impériale, 1867). Text modernized by Michael T. Davis.

Jean de Jandun's description of 1323 eloquently captures the character of the royal palace. Rising in the midst of the capital city, its unusual combination of military features, delicate gables and window tracery from church architecture, and a garden embodied the might, the piety, and the prosperity secured for the realm by a wise monarch's good government. Much the same can be said about the palace at Avignon built by the popes in the fourteenth century during their exile from Rome. Begun by Benedict XII in 1334, the original palace with its offices, assembly and banqueting halls, chapel, and residential wing arranged around a central court was not unlike a monastery's plan, perhaps not surprising in light of the fact that Benedict had been a Cistercian monk before his election to the papacy. His successors, Clement VI and Innocent VI, enlarged the papal apartments and added new wings including the west façade with its muscular arches, battlements, archers' slits, battered walls, and machicolations. Who would guess from this forbidding, even ferocious exterior that the palace enclosed an essentially bureaucratic compound and that the pope wielded little effective political power? The towers, like modern office buildings, contained work spaces, libraries, chapels, and apartments; a small garrison could be deployed on the roof platform in case of attack, but the palace was not designed to withstand a determined or prolonged assault.

SOURCES

Castles from the Air (Cambridge, England: Cambridge University Press, 1989).

Gabriel Fournier, *Le Château dans la France médiévale* (Paris: Aubier Montaigne, 1978).

Matthew Johnson, *Behind the Castle Gate: From Medieval to Renaissance* (London and New York: Routledge, 2002).

Guillaume Mollat, *The Popes at Avignon*. Trans. Janet Love (London: Nelson, 1963).

N. G. J. Pounds, *The Medieval Castle in England and Wales: A Social and Political History* (Cambridge, England: Cambridge University Press, 1990).

Yves Renouard, *The Avignon Papacy, 1305–1403*. Trans. Denis Bethell (Hamden, Conn.: Archon Books, 1970).

Kathryn Reyerson and Faye Powe, eds., *The Medieval Castle: Romance and Reality* (Dubuque: Kendall/Hunt, 1984).

Whitney S. Stoddard, "Avignon," in *Medieval France: An Encyclopedia*. Ed. William W. Kibler and Grover A. Zinn (New York and London: Garland, 1995): 87–88.

THE ARCHITECTURE OF DAILY LIFE

COLLEGE ARCHITECTURE. One of the most original architectural contributions of the late Middle Ages was collegiate architecture. In the wake of the rise of universities throughout Europe in the late twelfth century, colleges were founded as safe and regulated residences for students who, at the beginning of their liberal arts studies, might be as young as thirteen or fourteen. Initially, colleges in Bologna, Cambridge, Paris, or Oxford were simply established in houses donated or purchased by a benefactor. The famous Sorbonne, founded in 1259 for theology students at the university, was initially located in a series of nondescript houses in the Latin Quarter of Paris. However, in the mid-thirteenth century monastic orders, such as the Cistercians and the Cluniacs, arriving in these centers of learning created enclosed compounds that limited contact with the seductions of the secular world. They adapted the cloister to the new educational requirements, reducing the church to a chapel and lodging students in a building that included a refectory with a dormitory above. The College of Navarre in Paris, established by Philip IV's queen, Jeanne de Navarre, in her will of 1304, marked a further step as it forged a new blend of building types for its seventy students from the liberal arts, law, and theology faculties. Part urban palace, part monastery, the college was composed of fine stone residential houses and included a chapel and a library arranged around an interior court. In England, the Oxford and Cambridge colleges of the fourteenth and fifteenth centuries display various combinations of halls, chapel, residential cells, monumental bell towers, and entrance gates built around open quadrangles, a scheme that has been widely imitated in American universities, such as Yale and Michigan.

THE GUILD HALL. As Europe made the transition from an economy based on large aristocratic landholdings to a commercial economy with a thriving merchant class, a new kind of architecture emerged to meet the needs of the groups called "guilds." Guilds began as voluntary associations of individuals to control training, membership, prices and quality in a trade or craft, and grew to have social and political significance as the trades gained economic power. These organizations began to own property from donations and bequests, and real estate provided a steady source of income, so they began to construct their own buildings in cities for meetings, celebrations, and political activity. By 1192, the city of Gloucester, in England, had its own guildhall, and as traders came from various countries their guilds erected halls for their members in the cities in which they did business. By the mid-twelfth century, for example, merchants from Cologne had established a guildhall in London. In the great cloth trading city of Ghent in modern Belgium, a variety of different trades such as bakers,

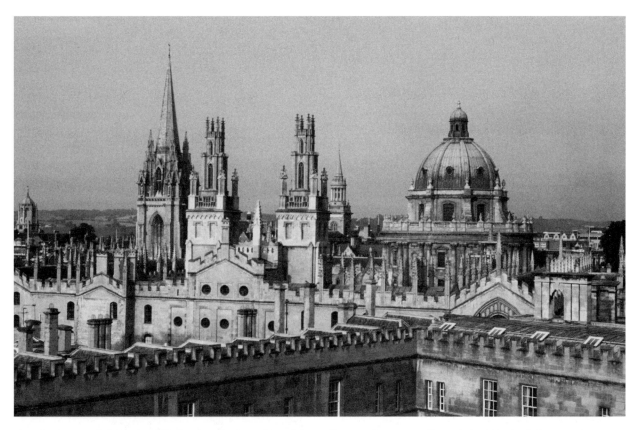

The Tom Tower of Christ Church College, and spires of Magdalen College, and Merton College, Oxford, England, fourteenth century. **CHRIS ANDREWS; CHRIS ANDREWS PUBLICATIONS/CORBIS.**

brewers, butchers, carpenters, cheesemongers, shoemakers, and coverlet weavers had their own guildhalls. Perhaps the most elaborate of these structures was the Ghent Cloth Hall where members of other trades in the city obtained their materials and women were even allowed to have stalls to sell cloth and related items. Such guildhalls could even politically and economically dominate a city neighborhood. By the early fifteenth century, there were 1,200 craft associations in London alone, and in 1411 a new guildhall was constructed on a site of one dating back to 1128; the borough called "Guildhall," surrounding the present building, has been the center of London city government since the Middle Ages. The London Guildhall, which is very large, has stained glass windows, echoing a pattern very common in Belgium, where guildhalls consciously imitated Gothic churches. In these barn-like civic structures the steep roofs and large lancet windows created a sense of spaciousness and importance for the crowds doing business just as a Gothic church accommodated and inspired its congregation. The cloth hall at Ypres, built in the thirteenth century, is generally considered the most impressive of secular Gothic buildings. It had sumptuous decorations and elaborate woodwork, as well as huge front steps from which proclamations

could be read. Such buildings expressed not only a belief in the power of commercial enterprise, but a newfound spirit of civic freedom and pride.

STANDARD PLANS FOR LIVING. Although non-aristocratic domestic architecture did not go through the number of changes and technical developments that characterized public, religious, and aristocratic architecture, the housing of peasants and working people did reflect an evolution towards multi-room and multi-level architecture. During the earliest period of the Middle Ages, and even as late as 1300, many peasant families lived in single-room buildings called "longhouses," which they shared with livestock. The bulk of surviving houses, however, had three rooms, usually with a large central room called the "hall" that was heated by an open-hearth fireplace and no real chimney (that is, smoke rose to the rafters and exited through an open hole in the thatched roof). At one end, there would be an entrance passage and service area, screened off to prevent drafts and sometimes subdivided into a pantry and buttery; at the other end of the hall was a private room, which in some plans was on a second or loft level called a *solar*. As more people moved into cities and land became more valuable,

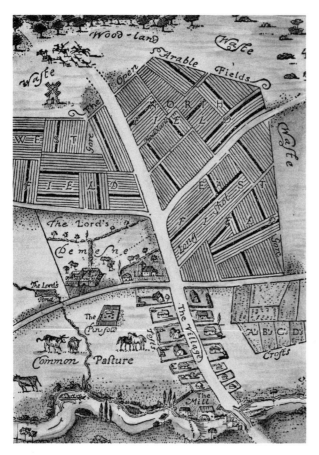

Plan of a medieval English manor showing houses and buildings. **THE GRANGER COLLECTION, NEW YORK.**

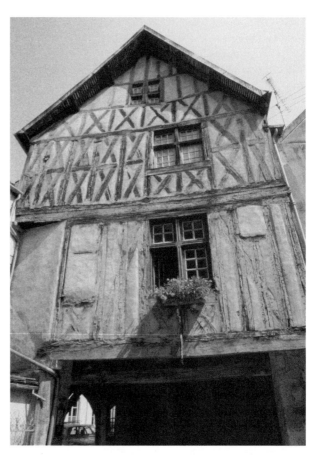

Half timbered house in Noyers-sur-Serein, France, 15th century. © **MARC GARANGER/CORBIS.**

use of vertical space increased. Plans, materials, and styles varied according to local building traditions, physical context, climate, and wealth, yet houses throughout Europe had certain basic features in common. Surviving medieval houses from the eleventh into the fifteenth century tended to include a shop or commercial space on the ground floor (sometimes open to the street by day and shutterable by night), with the living quarters arranged above in the upper stories. A warehouse or manufacturing area might be located towards the rear. Unlike modern houses with rooms that accommodate specific activities and that allow for ample individual private space, medieval dwellings generally were still composed of a few multipurpose rooms, often grouped around an inner courtyard or light well. Surviving twelfth-century houses in the town of Cluny had one large front room connected by a corridor to a smaller back room per floor.

REFLECTIONS OF URBAN WEALTH. Nevertheless, later medieval houses, for example the Palazzo Davanzati in Florence of the mid-fourteenth century, could include sophisticated comforts and lavish decoration. Each of the

three floors that rise above the street-level loggia (open arcade) is composed of a large room that stretches the entire width of the house together with smaller chambers decorated with carved and painted ceilings and wall frescoes. A well shaft ran through the main rooms at every level and lavatories were provided on each floor, reflecting the high standard of living enjoyed by this wealthy merchant family. The crenellations that topped the house, later replaced by an open loggia, were a mark of social distinction. The monumental city halls, the Palazzo Vecchio of Florence (c. 1300) or the Palazzo Pubblico in Siena (c. 1300), are in effect enlarged versions of these grand urban palaces. Decorative detailing of houses, seen in door frames or window moldings, mirrored contemporary and local architectural fashion: twelfth-century houses sport classicizing pilasters, columns, capitals, and semi-circular arches; thirteenth-century dwellings feature pointed arches and traceried lights.

HALF-TIMBER CONSTRUCTION. But the most widespread and enduring type of town-house construction was the half-timber frame, built with interlocking beams and a wattle and daub filling. With an appearance that

is familiar today in homes that imitate Tudor architecture, this new type of house featured an exposed frame of hewn timbers notched and pinned together to form a cage-like structure in such a way that the dark vertical and diagonal beams remained flush with the finished surface of the exterior wall. To create the wall itself, the spaces between the timbers were filled with "wattle"— actually a mixture of interwoven twigs and branches— and then sealed with a thick coating of mud and straw, the predecessor of modern stucco or plaster. The upper stories of these three- or four-floor houses (five or six floors in crowded cities like Paris) were corbeled out over the street on projecting brackets, a technique that increased precious interior space. Houses of this type, with their distinctive high-pitched roofs and dormers, later sheathed by clapboards, were transplanted to America in the seventeenth century by the first settlers who continued construction techniques learned in Europe.

SOURCES

Jeremy Catto, ed., *The History of the University of Oxford.* Vol. 1: *The Early Oxford Schools* (Oxford: Clarendon, 1984).

Alan B. Cobban, *The Medieval English Universities: Oxford and Cambridge to c. 1500* (Aldershot, England: Scolar Press, 1988).

M. Gardiner, "Vernacular Buildings and the Development of the Later Medieval Domestic Plan in England," *Medieval Archaeology* 44 (2000): 159–180.

M. Girouard, *Life in the French Country House* (London: Cassell, 2000).

J. Greville, *Medieval Housing* (Leicester, England: Leicester University Press, 1997).

G. Meirion-Jones and M. Jones, *Manorial Domestic Buildings in England and Northern France* (London: Society of Antiquaries, 1993).

M. W. Thompson, *The Medieval Hall: A Study in Secular Domestic Life, 600–1600 AD* (Aldershot, England: Scolar Press, 1995).

SIGNIFICANT PEOPLE
in Architecture and Design

BERNARD OF CLAIRVAUX

c. 1090–1153

Cistercian abbot

A DEFINER OF MONASTIC AUSTERITY. Born into an aristocratic family in Burgundy, France, Bernard entered the Cistercian monastery of Cîteaux in 1112. In 1115, he founded the monastery of Clairvaux, and by the end of his life, the order had grown into an international monastic organization of prestige and influence. Bernard's ideas on monastic life and the role of art in the cloister were reflected in the definition of Cistercian architecture. His views, eloquently set out in such tracts as the *Apologia*, offer a radically different attitude than those of traditional Benedictine monasticism or Cluny. Instead of seeing art and beauty as a vehicle for spiritual illumination, Bernard, certainly aware of images' attractive power, judged them as distractions that hindered the monks' devotions. He also condemned lavish church building as an arrogant and needless expenditure of money. Churches built in the mid-twelfth century—for example Fontenay or Pontigny—were laid out on a cruciform scheme, often called the "Bernardine plan," and emptied of images and sculptural flourishes. This plan, along with the restrained height that expressed the ideal of humility, was emulated widely in other Cistercian houses that, in turn, served as important conduits by which French architectural ideas were introduced into other countries. Thus, Bernard's defense of an architecture of austerity resonated across Europe.

SOURCES

Bernard of Clairvaux, *Selected Works.* Trans. Gillian R. Evans (New York: Paulist, 1987).

Adriaan Hendrik Bredero, *Bernard of Clairvaux: Between Cult and History* (Grand Rapids, Mich.: W. B. Eerdmans, 1996).

Georges Duby, *Bernard de Clairvaux et l'art cistercien* (Paris: Arts et Métiers Graphiques, 1976).

JEAN DESCHAMPS

Early 13th century–Late 13th century

Architect

A FAMILY OF MASTER BUILDERS. The inscription of his lost tombstone in the cathedral of Clermont-Ferrand informs modern scholars that Jean Deschamps ("Joannis de Campis") began construction of the choir of the church in 1248 and was buried alongside his wife, Marie, and their children. Judging from the forms and construction methods employed at Clermont, Deschamps came to that city in the central French province of Auvergne from Paris, for the cathedral's design can be linked closely to work at Saint-Denis, the Notre-Dame nave chapels, and the Sainte-Chapelle of the 1230s and 1240s. In 1286, a Jean Deschamps was appointed "first master" ("premier maistre") of the works at Narbonne Cathedral,

an event that offers the tempting possibility to propose that this is the same builder four decades later in the twilight of his career. Despite general similarities with Clermont, Narbonne appears to be the work of a different master, who headed construction until 1295 and left drawings for piers in the floor of one of the choir chapels. Nevertheless, Jean Deschamps of Clermont may have been the eldest member of an extended family of architects that included not only his namesake at Narbonne, but also a Pierre Deschamps, who worked at Clermont and possibly at Rodez in the mid-fourteenth century, and Bertrand Deschamps, master mason of Bordeaux Cathedral around 1320. Familial connections in the craft are common in architecture and are encountered in the late Gothic German "dynasties" of the Parlers, whose members worked at Cologne and Prague or the Roriczers. These ties would also explain the similarities between the southern French cathedrals of Clermont, Limoges, Rodez, Narbonne, and Bordeaux, based on northern French verticality enriched by the linearity characteristic of the rayonnant style.

SOURCES

Robert Branner, *Saint Louis and the Court Style in Gothic Architecture* (London: Zwemmer, 1965).

Michael Davis, "The Choir of the Cathedral of Clermont-Ferrand: The Beginning of Construction and the Work of Jean Deschamps" *Journal of the Society of Architectural Historians* 40 (1981): 181–202.

SUGER

1081–1151

Abbot
Royal advisor
Author

AN INFLUENTIAL ABBOT. Given to the abbey of Saint-Denis as a child, Suger, was, as told by his biographer, "small of body and family; constrained by twofold smallness, he refused in his smallness to be a small man." Once elevated to the abbacy in 1122, he set about realizing his childhood dream of refurbishing the church, now nearly 400 years old. After reorganizing Saint-Denis' finances to support the cost of construction, he launched the building campaign in the mid-1130s. Although he was not, as sometimes asserted, the architect of the new church, his travels throughout Europe and France gave him an extraordinarily wide horizon of knowledge of buildings and their decoration. He obviously drew upon his far-flung network of contacts to assemble an international team of masons, sculptors,

glass painters, and goldsmiths in the abbey's workshops. He was also clearly a "hands-on" patron, riding out into the forest in search of tall trees to provide roof timbers. It was, no doubt, his demands for columns, for large stained glass, for a harmonious union of the old structure with the new, that pushed the master mason to realize the novel combination of architectural elements that produced the spacious, light interior that changed the course of western architecture. In addition to his duties as head of a powerful abbey, advisor to King Louis VI, and regent of France during Louis VII's absence on Crusade in the late 1140s, Suger authored a life of Louis VI and, most famously, three booklets, *De Administratione* (On what was Done Under his Administration), *De Consecratione* (The Other Little Book on the Consecration of the Church of Saint-Denis), and the *Ordinatio* (Ordinance Enacted in the Year 1140 or in the Year 1141), in which Suger describes the building campaigns, works of art, and dedication ceremonies of his beloved abbey church.

SOURCES

Lindy Grant, *Abbot Suger of St.-Denis: Church and State in Early Twelfth-Century France* (London: Longman, 1998).

Erwin Panofsky and Gerda Panofsky-Soergel, eds., *Abbot Suger: On the Abbey Church of Saint-Denis and Its Art Treasures.* 2nd ed. (Princeton, N.J.: Princeton University Press, 1973).

WILLIAM OF SENS

Mid-twelfth century–Late twelfth century

Master mason
Architect

THE RIGORS OF DIRECT SUPERVISION. The sole source of information on William of Sens comes from Gervase of Canterbury's account of the rebuilding of the choir of Canterbury Cathedral following the ruinous fire of 1174. William's expertise and reputation recommended him for the job over other masters who had been gathered to assess the rebuilding project. Not only was he a skillful and subtle designer who incorporated sections of the Romanesque walls into his new structure, but he also fabricated the machinery to lift stones and provided the sculptors with templates for shaping stones. Although his name suggests that he was a native of Sens in France, his architecture shows closer connections to northern France and Flanders. The proportions of his three-story elevation, the use of wall passages screened by arcades, the sexpartite vaults, and the preference for decorative colored marble shafts point to his close affin-

ity with recent building projects in Arras, Cambrai, and Laon. William supervised construction until badly injured in a fall from the triforium in 1178. Although he attempted to supervise work from his bed, he simply was not up to the physical rigor of the job, and was forced to leave Canterbury for France. William's forced retirement suggests that in the late twelfth century construction was not guided by an overall set of plan and detail drawings, and that the master mason's on-site presence was still required. As drawings became more frequently and widely used in the thirteenth and fourteenth centuries, architects were able to take on several projects at once, leaving workshops in the hands of assistants and directing by "remote control."

SOURCES

Jean Bony, "French Influence on the Origins of English Gothic Architecture," *Journal of the Warburg and Courtauld Institutes* 12 (1940): 1–15.

Gervase of Canterbury, "Canterbury Cathedral," in *Architectural History of Some English Cathedrals: A Collection in Two Parts of Papers Delivered during the Years 1842–1863.* Trans. Robert Willis (Chicheley, England: Minet, 1972–1973).

Peter Kidson, "Gervase, Becket, and William of Sens," *Speculum* 68 (1993): 969–991.

HENRY YEVELE

c. 1320–1400

Master mason
Architect

FROM MASTER MASON TO ARCHITECT. The long and prolific career of Henry Yevele encompasses major works of both secular and religious architecture. In many ways, Yevele functioned like a modern architect, directing a workshop that was responsible for design, construction, and maintenance. First mentioned in London in 1353, he was soon appointed master mason to Edward ("the Black Prince"), prince of Wales and, thereafter, became Edward III's Deviser of Masonry and in charge of all works of the crown. Among his many works, either documented directly or attributed to him on the basis of form and style, are Prince Edward's chantry chapel in Canterbury Cathedral, the Neville screen (1372–1376) in the choir of Durham Cathedral (1376–1379), the nave of Canterbury Cathedral (1377–1403), the nave of Westminster Abbey (1387), and the remodeling of Westminster Hall carried out under Richard II between 1394 and 1399 in collaboration with the carpenter, Hugh Herland. These architectural works are executed in a refined Perpendicular style in which delicate grids of tracery organized the wall surfaces and spread onto the vaults in elaborate rib patterns. Yevele also designed the tomb of the Black Prince at Canterbury along with the tomb chests of Richard II and his wife Anne of Bohemia, and, probably, that of Edward III at Westminster Abbey. He also served as consultant to the projects of William of Wykeham, bishop of Winchester, such as New College, Oxford.

SOURCES

John Hooper Harvey, *English Mediaeval Architects: A Biographical Dictionary down to 1550: Including Master Masons, Carpenters, Carvers, Building Contractors, and Others Responsible for Design* (Gloucester: Sutton, 1987).

———, *Henry Yvele, c. 1320–1400; The Life of an English Architect* (London: Batsford, 1946).

Spiro Kostof, ed., *The Architect: Chapters in the History of the Profession* (New York: Oxford University Press, 1977).

DOCUMENTARY SOURCES
in Architecture and Design

Aachen Palace Complex (c. 784–796)—Located in Aix-la-Chapelle in what is now Germany, the Aachen complex was one of fourteen residences of the emperor Charlemagne. Based on specific Roman prototypes, the buildings were intended to convey and legitimize the idea that Charlemagne was the successor to western Christian Roman rule.

Avignon Palace Complex (c. 1335–1345)—While Avignon served as the seat of the papacy during the early fourteenth century, this complex was constructed as a grand papal residence with two huge palaces around a large walled courtyard, with defensive towers at either end. From the outside, it remains today a fine specimen of military architecture, while on the inside it is a repository for grand wall paintings.

Canterbury Cathedral (1100–1175)—This site was both the seat of the diocese's archbishop—the spiritual center of the English church—and also, after 1170, an important pilgrimage site of the shrine of Thomas Becket. Begun in the Norman style around 1100 on the site of a vanished Anglo-Saxon church, Canterbury has had several devastating fires and periods of reconstruction. Gervase of Canterbury's narrative of one such period of construction beginning in 1175 (in the Gothic style) is perhaps the most complete account of the building of a cathedral extant.

Cluny Abbey Church (1088–1130)—Now ruined but re-constructed in drawings and plans, the monastery of Cluny (Saône-et-Loire) is a complex of buildings begun in 909; the several churches are referred to as Cluny I, II (c. 955–1040) and III. Its great period was the 1080s when the abbey held about 200 monks, leading to the construction of a much more massive church (Cluny III) between 1088 and 1130. It was perhaps the largest church in Europe. Only small portions of the complex survive today.

Durham Cathedral (1093–1133)—Sitting in a military posi-tion atop a hill overlooking the virtually unscalable bank of the river Wear, this cathedral, the burial place of Saint Cuthbert, was intended to convey the presence of Norman power. In its mass it recalls the basilicas of Rome and competes with other great cathedrals such as Winchester. It has stone vault work with extremely fine ribbing, molding, and carved chevron decoration.

Loches Castle (eleventh century)—Located in the French department of Indre-en-Loire and intended to control the Roman roads from Tours, Angers, and Orléans, this castle, first built in the sixth century, was many times reconstructed. The eleventh-century *donjon*, or keep, is a particularly fine specimen of a defensive tower also used at several periods as a prison.

Monreale Cathedral (1174)—Located in Palermo, Sicily (Italy), this cathedral was built by the Norman king Roger of Sicily. Constructed in the Roman basilica style with a Byzantine transept, it combines motifs of east and west in structure and is highly decorated inside and out with massive bronze doors (late 12th century) with bib-lical scenes in relief, magnificent carved capitals atop the interior columns, and Byzantine and Venetian mosaics of biblical scenes covering the walls.

Sainte-Foy at Conques (1031–1100?) Located in Aveyron, southeastern France, this Romanesque abbey church in the "ambulatory and chapel" plan is one of the most beautiful of pilgrimage churches. It has a magnificent tympanum of Christ at the Last Judgment and many fine sculptural capitals on its columns.

Santiago de Compostela (1075–1128)—Located in Galicia, northern Spain, this Romanesque cathedral is believed to hold the relics of James the Apostle, as well as a supposed piece of the True Cross. A place of pilgrimage for over a thousand years, it has a magnificent portal with three doorways and sculpture representing the Last Judgment. The symbol of the church and of its role as a pilgrimage site is a scallop shell, the emblem of Saint James.

Speyer Cathedral (1030 and late eleventh century)—Located in western Germany, this enormous church is in the basilica style with four towers and two domes. It was the earliest cathedral to have a full gallery.

chapter two

DANCE

Timothy J. McGee

IMPORTANT EVENTS
in Dance

c. 1190 Troubadour Raimbaut de Vaqueiras composes the *estampie* "Kalenda Maya." This is the earliest known estampie melody.

1235 *Roman de la Rose*, a lengthy allegorical poem, is begun by Guillaume de Lorris and completed before 1275 by Jean de Meun. The poem includes several descriptions of courtly dancing.

c. 1250 A copy of the *Magnus liber organi*, containing sixty sacred round dances, is sent from Paris to Florence, demonstrating the influence of Parisian music.

The earliest known English instrumental dance is included in Oxford's Bodleian Library: MS Douce 139, a manuscript from Coventry, England.

c. 1275 Four dance tenors (that is, melodies that could be used to structure new compositions) are copied into Montpellier, Bibliothèque de l'Ecole de Médecine, MS H 196, one of the largest sources of early motets.

c. 1280 Eleven instrumental dances are copied into the *Chansonnier du Roi* (Paris, Bibliothèque Nationale MS fr. 844). This is the only known medieval collection of French estampies and carols.

c. 1285 Three English estampies are copied into London, British Library, MS Harley 978.

c. 1300 *De musica*, a music treatise by Johannes Grocheio, includes the earliest detailed descriptions of dances and dance music.

1300 *Doctrina de compondre dictatz*, a Catalan treatise on poetry by Jofre Goixà, gives instructions on how to compose a *dansa*.

1316 *Le Roman du Comte d'Anjou*, a narrative poem by Jean Maillart, includes a description of a carol.

c. 1320 Three dances, two of them estampies, are copied into London, British Library, MS Additional 28550, known as the *Robertsbridge Codex*.

1320 Raimon de Cornet cites the *basse danse* as one of the poetic forms that a jongleur (a court entertainer or minstrel) would learn.

1328 A set of rules for composing troubadour poetry, including the dance poem estampie, is included in the *Lays d'amors*, by Guillaume Molinier.

1337 *The Effects of Good Government*, a fresco by Ambrogio Lorenzetti, painted in the Palazzo Pubblico of Siena, contains a scene with round and line dances.

1353 The *Decameron* by Giovanni Boccaccio narrates the fictional activities of ten nobles who travel to the country to escape the Black Death, and includes descriptions of dancing after each day's events.

1365 *The Church Militant*, a fresco by Andrea di Bonaiuto, painted in the Spanish Chapel of Santa Maria Novella in Florence, includes a scene with dancers.

c. 1380 A single instrumental dance tenor, called *Czaldy Waldy*, is copied into Prague's Czechoslovakia State Library, MS XVII F9.

c. 1390 The largest set of medieval Italian instrumental dances is copied into British Library, MS Additional 29987. The manuscript originated near Milan.

c. 1395 *The Canterbury Tales*, by Geoffrey Chaucer, mentions dancing in several of the tales.

c. 1400 Over 100 English carols with music are copied into several manuscripts in England.

Dança general de la Muerte (Common Dance of Death), a poem of 79 stanzas originating in Spain, describes the dance of death.

1400 *Il Sapporitto,* a literary work by Simone Prodenzani containing a number of poems, includes scenes of courtly dancing.

1420 Included in a set of frescos painted in the Castello del Buonconsiglio in Trent is a depiction of a processional dance.

1430 Three estampies are copied into Faenza, Biblioteca Comunale MS 117 (the *Faenza Codex*).

1445 Domenico da Piacenza writes *De la arte di ballare et Danzare* (On the Art of Dancing and Choreography), the earliest known treatise on dancing.

1455 Poet, statesman, and humanist Antonio Cornazano writes *Libro dell'arte del danzare* (Book on the Art of Dancing), the second treatise on dancing, and dedicates it to his student, Ippolita Maria Sforza, one of the first ballerinas known by name.

1463 Guglielmo Ebreo (also known as Giovanni Ambrosio) writes the earliest version of his dance treatise *De pratica seu arte tripudii* (On the Practice or Art of Dancing). Six later copies also exist.

1465 Ippolita Maria Sforza, the earliest known ballerina, dances with Lorenzo de' Medici in Florence as she travels to Naples to meet her bridegroom and become the Duchess of Calabria.

1470 The earliest surviving collection of Burgundian basses danses is copied into Brussels Bibliothèque Royale, MS 9085. The repertory is largely retrospective and shows connections to the Court of Burgundy from at least as early as 1420.

OVERVIEW
of Dance

DANCE IN SOCIETY. Dance was one of the major pastimes during the late Middle Ages. It was the favorite leisure activity of all levels of society from the peasants to the aristocrats and was a part of most celebrations, just as it is in modern times. In the Middle Ages, however, dance could also be found in sacred settings as a part of many church feasts, and there is an entire repertory of sacred dance songs that celebrate these events. This is not to say that dancing was completely approved by the Christian church. Alongside accounts that speak of sacred dance in a positive way, proclamations can also be found that forbid dance: some are aimed at a specific audience (e.g. clerics); others at specific occasions or locations (holy days, churches, churchyards, and cemeteries); and others are a wholesale condemnation of the entire activity as immoral.

SOURCES OF INFORMATION. Information about dance in the late Middle Ages is found in a number of sources, although few of them contain sufficient details to allow scholars to reconstruct a clear picture of the activity. Literary accounts are very helpful for placing dancing in a social context, as are iconographic images such as paintings, drawings, and sculptures. To these can be added several types of documentary evidence, including treatises on poetry, since much dancing was done to dance songs whose forms and subject matter are discussed along with those of other kinds of poems. Music treatises also provide some details when they include dance music among the descriptions of musical forms. And finally, the dance music itself, the songs and instrumental pieces that are identified as intended for dancing, add other kinds of information that aid in the understanding of what dance must have been like during those centuries.

SURVIVING DANCE MUSIC. The surviving repertory of medieval dance music is relatively small and consists mostly of dance songs. Although it is clear from existing evidence that musical instruments frequently accompanied dance, very little of that repertory was ever written down. Few instrumentalists could read music; they learned the tunes by ear and passed them on in that manner from generation to generation. The names of some of the favorite tunes come down to us in literature, but few of the melodies are preserved as written music. A large variety of instruments were used in conjunction with dancing; some, such as the bagpipe, are almost exclusively associated with it. In spite of that fact, however, the surviving instrumental dance repertory consists of fewer than fifty compositions.

DANCE AND POETRY. It is interesting to note that many of the secular musical forms found in all regions of late medieval Europe bear names indicating that their origins were in dance. Since the music was directly related to the poetry that it set, the names of the musical forms also represent poetic forms. In France, the three most popular secular musical forms were *rondeau* (round dance), *virelai* (twist), and *ballade* (dance). In Italy the *ballata* (dance) was very common; and in England, the round and carol were frequently performed as both music and dance. Throughout the late Middle Ages and well into the Renaissance, these dance types continued to provide the standard formats for secular music, although by the late fifteenth century most of the written compositions with these names were somewhat removed from their dance origins and probably were no longer actually intended for dance. Their very existence, however, suggests the extent to which dance played a central role in the culture of all regions during these centuries.

STYLES AND VARIATIONS. Until the late fourteenth century there would seem to have been little difference between the kinds of dances engaged in by the different social classes. There was undoubtedly some difference in style and perhaps in the refinement of the steps due to the kind of clothing worn and the locations where dancing took place, but the existing records show that, for the most part, the dances themselves were very much the same for all levels of society, as were the types of occasions on which dancing took place. Regional differences can be found, having to do with a local or larger regional preference for a particular type of dance, or simply on the level of a local variation in the execution of steps for a dance that was popular in all areas.

DANCING IN GROUPS. Most dances were group dances, involving as many participants as wished to join in. They can be thought of as line dances, in which the dancers join hands and follow the leader, often breaking into formations, such as dancing in a circle or forming "under the bridge." Solo dances were also performed, often allowing demonstrations of impressive athletic ability. Small group dances, involving two or three dancers, were

another part of the tradition, and processional dances usually involved couples holding hands, but all of these dances were related to the line formations; couples never embraced as in later "ballroom" dancing.

THE BIRTH OF CHOREOGRAPHY. Sometime in the late fourteenth century, no doubt as a part of the increasing self-consciousness of aristocratic courts, a new form of dance was created in which the individual steps were choreographed and fitted to what might be considered to be a theme or perhaps a mini-drama. That is, there was often a story acted out in the choreography, having to do with the patterns traced by the dancers as well as with their body gestures. There is no record of where or exactly when choreographed dances began, although some evidence does point toward the Burgundian court (centered in modern-day eastern France) of Philip the Bold in the last third of the fourteenth century, an area closely linked after 1350 or so with the county of Flanders, the duchy of Brabant, and the duchy of Hainaut—that is, modern Benelux, Pas-de-Calais, and Nord. By the early fifteenth century, there is evidence that choreographed dancing was widespread in the courts of France, Italy, Spain, and England.

DANCING MASTERS. Choreographed dance was a radical change on several levels. It separated these dances from those of the past and created the element of class distinction by introducing a studied and rehearsed element into an activity that formerly was spontaneous. Whereas each of the earlier dances was composed of a single set of steps that were repeated over and over throughout the dance, each of the new choreographed dances contained a specific sequence of several different steps, a sequence it did not share with any other dance, meaning that the steps for each new dance had to be individually memorized. Professional dance teachers not only designed the new choreographies, rehearsed the dancers, and showed them the step sequence, but also taught body movement and leg and hand gestures that would help convey the theme or story of the dance. This type of dance was completely restricted to the noble classes, who could afford to employ the dancing masters. The practice of themed, individually choreographed dances continued to grow through the period of the Renaissance, blossoming into ballet in the seventeenth century.

CONTINUING TRADITIONS. At the end of the Middle Ages, dance continued to be an important form of celebration and relaxation for all classes and cultures. The advent of choreographed dances supplemented the more conventional repertory in aristocratic courts, bringing a new dimension to the traditional activity, one that would

TERMS in Medieval Dance

Choreographed dance: A dance having a unique sequence of steps.

Conventional dance: A dance consisting of the continuous repetition of a single pattern of steps.

Monophony: (mono = one; phony = sound) Music of one part, including not only solo song, but also a single melody performed by more than one person or instrument.

Polyphony: (poly = several) Music of more than one part, each musical line having a separate rhythm and melody.

Tempo: The speed of the composition.

Tenor: A melody borrowed from another composition and used as a basis of a new polyphonic composition. The notes are held as long notes, which explains the use of the word (tenere = to hold). Music for dance sometimes was written only as a tenor line, requiring the musicians to improvise the accompanying lines.

Vocal dance: A dance song—that is, one with words to be sung, as differentiated from an instrumental dance.

continue to flourish throughout the Renaissance and beyond. The dances themselves, both conventional and choreographed, continued to evolve and adjust to political and cultural changes throughout the period. But although our knowledge of dance accelerates from this point forward, thanks to new dance treatises and a growing repertory of written music, for the next several centuries the importance of dance to society as a whole, as well as the general styles and types of dances, remained more or less the way it had been at the end of the Middle Ages.

TOPICS
in Dance

DANCING IN MEDIEVAL LIFE

COURT AND COUNTRYSIDE. Throughout the Carolingian era (eighth to tenth centuries) and the later Middle Ages, dancing was a part of all types of celebrations, both formal and informal. It could involve a solo dancer, couples, or groups of any size, and was accompanied by

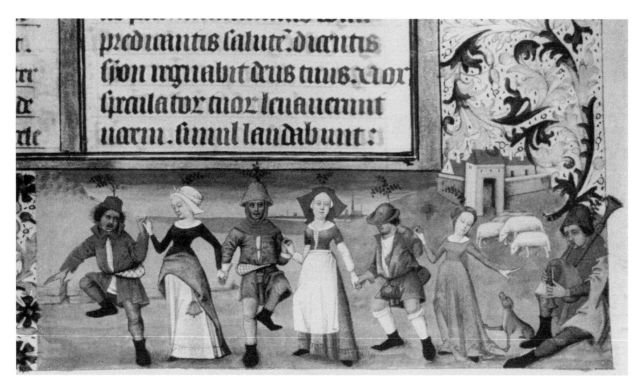

Rabardie or Branle, peasant dance, missal from Montierneuf, Robinet Testard, Paris, Bibliothèque nationale MS lat. 873, fol. 21, 1485. THE GRANGER COLLECTION, NEW YORK.

music that was either sung or played on instruments of all types. The dances themselves could be simple or complex, sedate or energetic, and contributed to the social life of every level of society. Dancing filled a variety of needs: it could be a way of expressing happiness, a casual relief from the toils of daily labors, an occasion for amorous flirtation, or a vehicle for displaying elegance and wealth. It took place in castles and manor houses, in town streets and squares, and in neighboring fields. Typical instances of dancing—on joyous occasions outside of churches or churchyards—occurred in a variety of private and public locations and involved a number of different formations and steps, most of which we know from images and descriptions recorded after 1300.

CONVENTIONAL VERSUS CHOREOGRAPHED DANCE. Broadly speaking, there are two basic divisions that can be applied to a discussion of medieval dance: conventional dances, in which a single set of steps is repeated over and over until the music stops; and choreographed dances, in which each dance has a unique sequence of steps. The two types are quite different in terms of their origins and purpose, although there are many similarities in steps, social function, and level of importance in the cultural lives of the people of the period. The story of conventional dances begins long before recorded history, continuing to the present day, and

although it is not documented in full detail, there is sufficient evidence to provide a clear outline of the various forms it took and the functions it filled between the ninth and the fifteenth centuries. Choreographed dance, on the other hand, was an invention of the late Middle Ages, and a number of treatises have survived that provide a fairly accurate picture of how it was performed and what it was intended to achieve.

OCCASIONS FOR DANCING. Most circumstances in which dancing takes place have not changed much over the centuries. In the Middle Ages, as now, people danced at weddings, on holidays, and at political or cultural gatherings, as well as for simple evening entertainment. There are two occasions in the Middle Ages, however, that would seem to be unusual, both of which involve the church and the clergy: sacred dance, in which life is celebrated, and its opposite, the dance of death. These examples, in particular, demonstrate how widespread dance was as a means of expression in medieval society.

SOURCES

Jonathan Alexander, "Dancing in the Streets," in *The Journal of the Walters Art Gallery* 54 (1996): 147–162.

B. Fassbinder, *Gotische Tanzdarstellungen* (Frankfort: Europäische Hochschuleschriften, 1994).

Curt Sachs, *World History of the Dance* (New York: W. W. Norton, 1963).

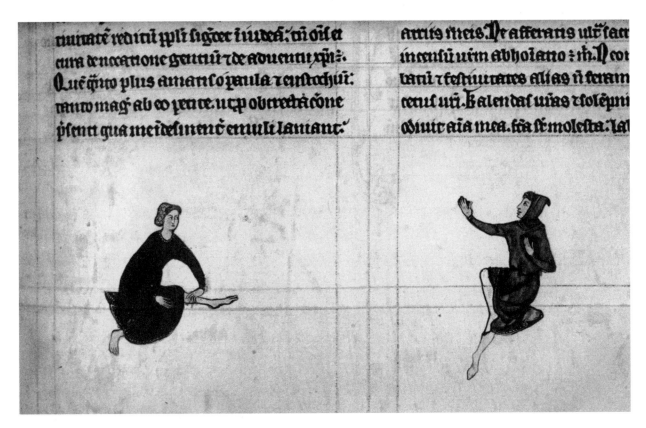

Acrobatic dancers, English manuscript, 13th century. THE GRANGER COLLECTION, NEW YORK.

SACRED AND SYMBOLIC DANCE

LITURGICAL DANCE. There is ample evidence from as early as the fourth century that dance was a frequent occurrence in church, serving as a component of liturgical services on special occasions, especially Easter and Christmas. That the tradition continued throughout the Middle Ages is attested to by a twelfth-century description of girls dancing during the Easter celebrations in London and references to thirteenth-century clerics in Gournay (near Rouen, France) dancing as a part of the feasts of the Innocents and of St. Madeline. The troubadour Pierre de Corbiac wrote in his *Tesaur* around the year 1250 that he knew how "to dance the Sanctus and the Agnus and the Cunctipotens," which refers to three prayers chanted during the celebration of the Mass. In 1313, members of the congregation of St. Bartholomew in Tauste, Spain, were taught by Rabbi Hacén ben Salomo to perform choral dances around the altar. All of this is clear evidence that throughout the period, dancing continued to be associated with sacred occasions, including the celebration of the Mass, and that laymen as well as clerics took part.

PROHIBITIONS. At the same time, there are also frequent warnings throughout the period against dance, beginning as early as the late sixth century, when the rather austere English monk, St. Augustine of Canterbury (d. 604), wrote that "it is better to dig and plough on festival days than to dance," a sentiment echoed a century later by the theologian and English historian the Venerable Bede (673–735). A number of church writings indicate that dancing was frowned upon because it was considered to have pagan as well as erotic overtones. In the first decade of the thirteenth century both the bishop of Paris and the Council of Avignon forbade dancing the carol in processions or during the vigil ceremonies on saints' days, and in 1325 the General Chapter of the Church in Paris threatened excommunication for clerics who danced on any occasion, with the exception of sacred dancing on Christmas and the feasts of St. Nicholas and St. Catherine. An extremely negative view of dancing is found in the fourteenth-century preacher's handbook *Fasciculus morum*, which describes a scene in which the devil gathers up his followers by sending one of his daughters to lead a round dance. The same source also connects dancing to gluttony and lechery in the midst of a discussion of the sin of Sloth:

> Notice that it is absurd to say that such worldly joy
> as is generated by dancing and singing and the like
> on holy day—activities which rouse people rather

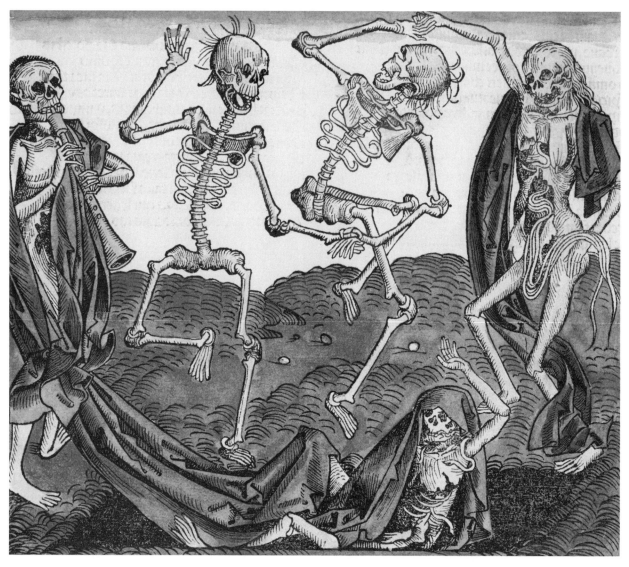

Dance of Death, Hartmann Schedel, *Liber cronicarum* (Nuremberg: Wohlgemuth, 1493). HISTORICAL PICTURE ARCHIVE/CORBIS.

to gluttony, lechery, and similar wretched deeds than to the praise of God and his saints—can possibly please God; and yet they think they please him the more they devote themselves to such unwarranted activities.

A legend circulating in England and western France, found in a collection of stories known as *Marvels of the East* (Oxford, Bodleian Library, MS Bodley 614), told the story of seven women dancing in a circle on a Sunday. As a punishment, they were cursed by the priest and turned into stones. A number of megalithic stone circles in Brittany and England have been identified as these women, including the stone circle in Cornwall known as the "Merry Maidens." In spite of such prohibitions, however, there is ample evidence that dancing on sacred occasions continued throughout the late Middle Ages

and beyond. Documents recording the presence of dance at sacred ceremonies, as well as those forbidding it, can be found into the seventeenth century. The objections to dancing were mostly aimed at clerics taking part in secular dances. The reasons for this strong prohibition included the lascivious nature of the texts of some of the secular dance songs. Also, secular dancing usually involved the participation of women, a temptation seen as best avoided by the celibate clergy.

SACRED DANCE SONGS. Although there are no detailed descriptions of what steps may have been danced on these occasions, the music that has survived provides a few clues, which, when matched with the iconography (mostly images from manuscript illuminations), establishes a fairly reliable picture. The largest repertory of sacred dance songs with music can be found at the very

Arts and Humanities Through the Eras: Medieval Europe (814–1450)

end of a copy of the *Magnus liber organi* (Great Book of Organum), a book that contains music for the liturgy that originated in Paris in the twelfth century, located today in Florence, Italy. The section containing the dance songs has an illumination depicting five men standing in a semicircle. From their garb and the fact that all have been tonsured (that is, they have a shaved patch on the crowns of their heads), it is obvious that they are clerics. Their mouths are open, indicating that they are singing, and they appear to be holding hands, a standard way of symbolizing dance. There are sixty short dance songs in this collection, nearly all of them in a verse and refrain format known as *rondeau*, meaning round (see Round, below). Some of the texts specifically mention dance: "Let the joyful company this day resound in a joyful dance," and "With a vocal dance this assembly sings."

THE DANSE MACABRE. In sharp contrast to the joyful celebration of church feasts is the dance that was often associated with hysteria of various kinds, a type dating back to ancient times. Stories of wild dancing, often ending in complete exhaustion or even death, are a standard part of the tales and myths of the Middle Ages. The Dance of Death (Danse Macabre), one of the more bizarre preoccupations of late medieval literature and iconography, always involves humans and skeletons, and was frequently referred to in sermons as a reminder of mortality. Literary origins of the tradition have been traced back before 1280 in the *Dit des trois morts et des trois vifs* (Story of Three Dead and Three Living) by Baudouin de Condé. Another account, dating from late fourteenth-century Spain, is a poem of 79 stanzas, the *Dança general de la Muerte* (Common Dance of Death), in which Death summons two maidens, Beauty and Pride, and then invites clergy and laymen to dance with them, using their excuses as a forum for social criticism.

ST. VITUS'S DANCE. The literary versions of hysterical dancing are nearly all symbolic, but there are also accounts of actual events taking place, sometimes called "St. Vitus's dance," described as happening in a church graveyard and associated with a desire to communicate with the dead. These events usually involved large numbers of people and went on for hours or even days. The narratives of such dances usually describe them as spontaneous and uncontrollable, provoked by something akin to mass hysteria. In the mid-fourteenth century in particular, mass hysterical dancing was recorded as a reaction to the Black Death, the plague that resulted in the deaths of nearly one-third of the population of Europe. In modern times St. Vitus's dance has been identified as Sydenham's Chorea, a tremor of the nerves and body caused by eating rotten grain containing ergot, a parasitic fungus.

a PRIMARY SOURCE *document*

HYSTERICAL DANCING

INTRODUCTION: Gerald of Wales (Giraldus Cambrensis), a twelfth-century writer from Cambria (in Wales), has provided the most detailed surviving account of a medieval hysterical event in his *Journey Through Wales*, which was completed around 1189. As a writer who specialized in "eyewitness" narrations, Gerald, who himself had both Welsh and Norman ancestors, was fascinated not only with the details of nature and geography in the places he visited, but also with unusual variations in manners and customs, as this passage illustrates.

You can see young men or maidens, some in the church itself, some in the churchyard and others in the dance which threads its way round the graves. They sing traditional songs, all of a sudden they collapse on the ground, and then those who, until now, have followed their leader peacefully, as if in a trance, leap in the air as if seized by frenzy. In full view of the crowds they mime with their hands and feet whatever work they have done contrary to the commandment on sabbath days. You can see one man putting his hand to an [imaginary] plough, another, goading on the oxen with a stick, and all as they go singing country airs, to lighten the tedium of their labour. This man is imitating a cobbler at his bench, that man over there is miming a tanner at his work. Here you see a girl pretending that she has a distaff in her hand, drawing out the thread with her hands, stretching it at arm's length, and then winding it back onto the spindle; another, as she trips along, fits the woof to the warp; a third tosses her shuttle, now this way, now that, from one hand to the other, and with jerky gestures of her tiny tool seems for all the world to be weaving cloth from the thread which she has prepared. When all is over, they enter the church. They are led up to the altar and there, as they make their oblation, you will be surprised to see them awakened from their trance and recover their normal composures.

SOURCE: Gerald of Wales, *The Journey Through Wales/ The Description of Wales*. Trans. Lewis Thorpe (Harmondsworth, England: Penguin, 1978): 92–93.

SOURCES

Aubrey Burl, *The Stone Circles of the British Isles* (New Haven, Conn.: Yale University Press, 1976).

James Midgley Clark, *The Dance of Death in the Middle Ages and the Renaissance* (Glasgow: Jackson, 1950).

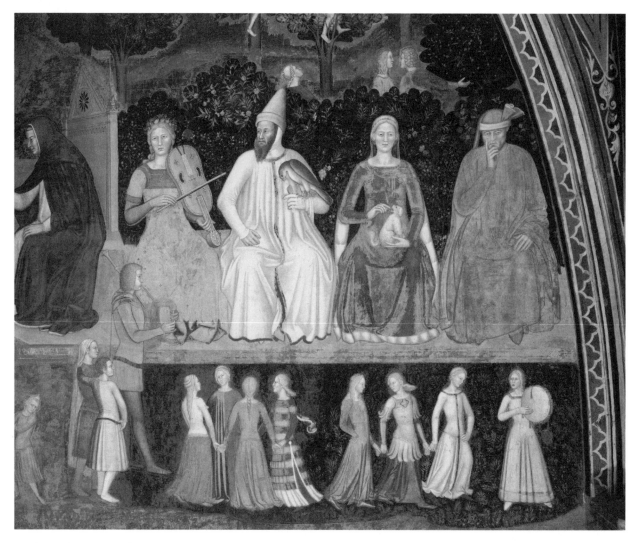

Carolers with musicians, fresco, "Militant Church and Triumphant Church," Andrea di Buonaiuto, Florence, Santa Maria Novella, Spanish Chapel, 1343. **SANDRO VANNINI/CORBIS.**

Fasciculus Morum: A Fourteenth-Century Preacher's Handbook. Ed. and trans. Siegfried Wenzel (University Park, Pa.: Pennsylvania State University Press, 1989).

M. R. James, ed., *The Marvels of the East* (Oxford: Roxburgh Club, 1929).

Yvonne Rokseth, "Danses cléricales du XIIIe siècle," in *Mélanges 1945 des publications de la Faculté des lettres de Strasbourg* (Strasbourg, France: Faculté des lettres, 1947).

Curt Sachs, *World History of the Dance* (New York: W. W. Norton, 1963).

CONVENTIONAL DANCE FORMATIONS AND STEPS

COMMON ELEMENTS. Dances that require continuous repetition of a small set of steps have a tradition that precedes written history. Movement to a steady rhythm springs from an essential human desire that includes the need for exercise as well as for self-expression, and it is often associated with mating rituals. From the surviving evidence, we can see that many of the basic dance movements and formations remained more or less unchanged over many centuries. A variety of different formations were employed in dancing, the choice often having to do with the occasion and the space available. The formations, in turn, required different kinds of steps, and each dance was performed to a particular type of musical composition that matched the dance step and its speed. Changes in the dance movements coincided with changes in the phrases of the music. Although our information is incomplete, from the descriptions and the iconography, the following formations and steps seem to have been the most popular.

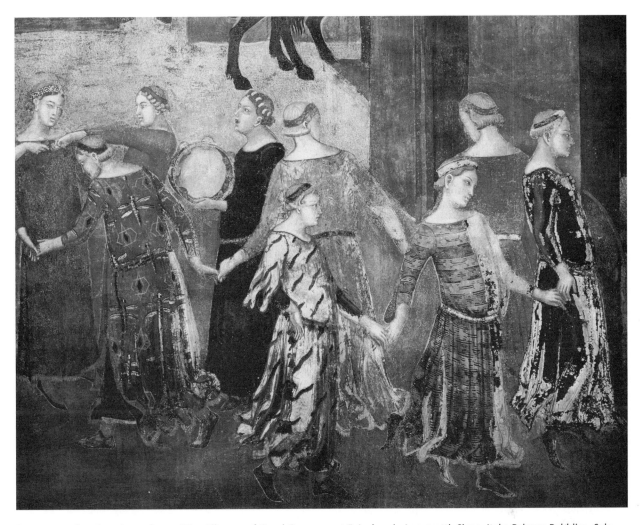

Dancers, tambourine player, fresco "The Allegory of Good Government," Ambrogio Lorenzetti, Siena, Italy, Palazzo Pubblico, Sala della Pace, east wall, 1338–1340. ARCHIVO ICONOGRAFICO, S.A./CORBIS.

ROUND DANCES. The round dance formation, which is associated with the dance of the same name, involves a group of people holding hands in the form of a circle, usually with a leader in the center. The dance steps require the circle to move first in one direction and then the other, reversing its direction at the beginning of each new verse. The leader sings the verses and the entire group joins in the chorus.

LINE DANCES. The most popular dance of the period was called a carol; it is the most frequently depicted formation in medieval art and is described in a number of the literary sources. The principle arrangement calls for dancers to join in a line holding hands, fingers, or a scarf, while they move along, often through the streets, following the leader. One French literary source mentions a line dance "nearly a quarter league long" (Philippe de Remi, in *La Manekine*, c. 1270), which may be an exaggeration, but it does suggest that any number of

people could join this kind of formation. A passage from *Le Roman du Comte d'Anjou*, written in 1316 by Jean Maillart, vividly portrays this kind of dance:

> Then the napery was taken up, and when they had washed their hands, the carols began. Those ladies who had sweet voices sang loudly; everyone answered them joyfully, anyone who knew how to sing, sang along.

The iconographic and literary descriptions of this dance often indicate that it could break into other formations, including a round or "under the bridge." The mid-fourteenth-century fresco by Andrea di Bonaiuto, in the Spanish Chapel of Santa Maria Novella in Florence, shows both a line dance of three people and a round dance of four. The steps in a line dance vary depending on the direction the line is traveling—forward, to the side, or in one of the other formations described here.

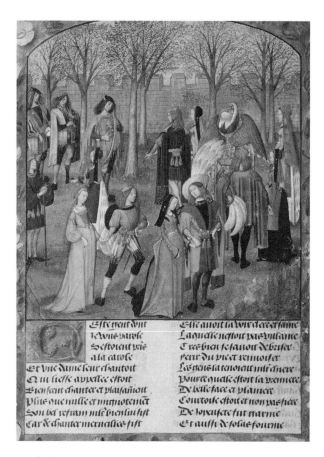

Carol dancers, *Roman de la Rose*, Flemish, 15th century. **THE ART ARCHIVE/BRITISH LIBRARY.**

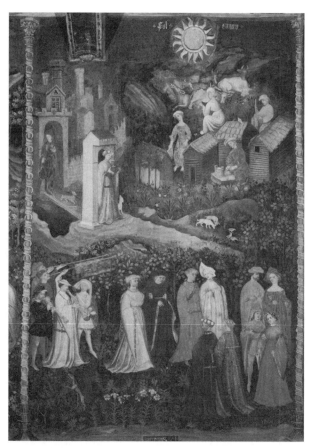

Stately processional dance. Labor of the Month of June. Fresco, Castello dei Buonconsiglio, Trent, Italy, 1420. **SCALA/ART RESOURCE NY.**

UNDER THE BRIDGE. This formation involves dancers in pairs with the first of the couples joining their hands to form a bridge while others take their turn first ducking under the bridge and then emerging on the other end to form a part of the bridge, thus providing an endless series. The early fourteenth-century Siena fresco by Ambrogio Lorenzetti, *The Effects of Good Government*, depicts this formation together with the round. In both this painting and that by Bonaiuto (above) there is only a single dance leader (playing a tambourine and singing), which suggests that in the round, in line, and "under the bridge" all were possible variations of a carol.

PROCESSION. In many paintings couples are seen moving forward side by side, often holding hands, such as in the "under the bridge" formation, above, or in a more stately procession, such as that in both the *Buonconsiglio* and *Adimari* paintings. It is possible that in the processional-type dances, the steps used are a version of the "simple" and "double" steps employed in the choreographed processional *basse danse* and *bassadanza* (see Choreographed Dances, below). Additional support for this suggestion comes from the Renaissance processional

dance the "Pavan," which also used those steps. They survive today as the steps of the bridal party during a wedding procession.

SOLO DANCING. There are a number of paintings that show a single man or woman dancing while others watch. The gestures of the solo dancer usually indicate a very active, athletic dance, but exactly which of the jumping or twisting dances is being depicted is never stated. The contexts of a large number of the illustrations of solo dancing suggest that they are intended to condemn wild or immoral living. A number of them are found in Psalters and books of hours or sacred manuscripts in conjunction with passages about morality. One illustration, for example, shows a woman of loose morals (skirt up showing legs, arms raised above her head) dancing for a monk who is absurdly trying to play a musical instrument using a *crozier* (a bishop's staff) as a bow. Depictions such as these must be considered to be symbolic exaggerations rather than typical scenes. On the other hand, there are also pictures of apparently athletic solo dancing in settings that are quite realistic.

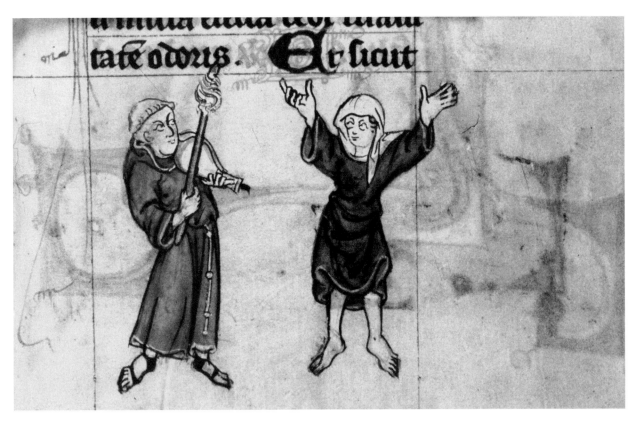

Monk plays for dancing woman. Book of Hours, Maastricht, 13th–14th century. **LONDON, BRITISH LIBRARY, MS STOWE 17, FOLIO 38.**

OTHER DANCE MOVEMENTS. Many kinds of steps are mentioned in literature in conjunction with dance—walk, slide, glide, hop, jump, strut, sway, etc.—although it is rarely clear which dance is being referred to. It is possible to connect some, but not all, of these movements with the named dances below, but the information that has survived is insufficient to show how many of these movements would be employed in any particular dance. As literary narrative tells us, even when specific steps are stated, it was always the dancer's prerogative to ornament and personalize a step by spontaneously introducing other movements.

SOURCES

Otto Gombosi, "About Dance and Dance Music in the Late Middle Ages," in *The Musical Quarterly* 27 (1941): 289–305.

Timothy J. McGee, *Medieval Instrumental Dances* (Bloomington: University of Indiana Press, 1989): 19–22.

POPULAR DANCES

GENERAL CHARACTERISTICS. Literary sources, including music treatises, provide the names of several dances and a few descriptions, although some of the references are so incomplete that little can be deduced from them. Medieval literature includes far more dance names than are described in the treatises, leaving an impression of a society that enjoyed a wide variety of dances, only a few of which are known in any detail. The Catalan treatise written by Jofre Goixà, the *Doctrina de compondre dictatz* (Treatise for Composing Poetry), from about 1300, for example, gives instructions on how one may write a *dansa*, a dance name that is not found elsewhere. According to the treatise, the dansa should have three stanzas, a refrain, and one or two envoys ("send-off" stanzas, used for summing up or offering a dedication), the text should be about love, it should have a nice melody, and it is to be sung with an instrumental accompaniment. That description, unfortunately, could apply to nearly all dance songs, and perhaps that is really what is intended: a general characterization of the contents of dance songs rather than instructions for a particular dance called *dansa*.

SOURCES OF INFORMATION. The most detailed of the early descriptions are found in the treatise *De musica*, written in Paris around the year 1300 by Johannes de Grocheio. In this work, Grocheio defines both vocal and instrumental dances. By combining Grocheio's statements with poetry treatises and other, less specific

a PRIMARY SOURCE *document*

DANCE TERMS FROM DE MUSICA

INTRODUCTION: The following is a list of dance terms from Johannes de Grocheio's *De musica*, written in Paris around the year 1300.

Sung Dances

Refrain: A refrain is the way all [dance] songs begin and end. They are different in the round, carol, and estampie. In the round they agree in sound and rhyme. In the carol and estampie, however, some agree and some are different.

Round: We call round or rotundellus [those songs] that do not have a different melody in the verse and the refrain. It is sung in a slow rhythm … and is often sung in the West country, for example in Normandy, by young men and women to celebrate festivals and other grand occasions.

Vocal estampie: A song called an estampie [stantipes] is that in which there is a diversity in its parts in its refrain, not only in the rhyme of the words but also in the melody. … This type causes the souls of young men and women to concentrate because of its difficulty, and turns them from improper thinking.

Vocal carol: A carol [ductia] is a light song, rapid in its rise and fall, which is sung in carol by young men and women. … This influences the hearts of young men and women and keeps them from vanity and is said to have force against that passion which is called love or eros.

Instrumental Dances

Instrumental carol: An instrumental carol [ductia] is an untexted piece with appropriate percussion. I say with regular percussion because these beats measure it and the movement of the performer, and excite the souls of men and women to moving ornately according to that art they call dancing.

Instrumental estampie: The estampie is also an untexted piece, having a complicated succession of sounds, determined by its verses. … Because of its complicated nature, it makes the souls of the performer and listener pay close attention. Its form is determined by its [irregular] verses since it is lacking that [regular] beat which is in a carol.

SOURCE: Johannes de Grocheio, *Concerning Music (De musica)*. Trans. Albert Seay (Colorado Springs: Colorado College Music Press, 1974): 17–21.

literary references, as well as the evidence of the music itself, it is possible to obtain an idea of some of the dances. The dances described in the rather dry and academic accounts of the treatises take on more human and real presence in Simone Prodenzani's *Il Sapporitto*, and Guillaume de Lorris's *The Romance of the Rose*. These poems capture the spirit of the occasions and supply us with vivid glimpses of a very lively dance culture in which everyone took part. The dance music discussed below provides additional details about the nature and spirit of the dance steps and formations.

THE ROUND DANCE/RONDEAU. The round and the carol must have been the two most popular dances in the Middle Ages. They are the two most often mentioned in literature and depicted in manuscripts and paintings. The description by Grocheio tells us that the music has a refrain and that the melody of the refrain is exactly the same as that of the verse. A good example of what he is describing can be seen in the round "with a vocal dance" (*Vocis tripudio*), a sacred dance found in the *Magnus liber organi*, which demonstrates how the text is to be sung and also suggests the kind of dancing that would accompany the song. To perform this song, a soloist (the dance leader) would sing the first phrase, "With a vocal dance," and the rest of the dancers (the chorus) would respond with the half refrain, "This assembly sings," using the same melody. The soloist would then sing the next phrase, "With a vocal dance but with a temperate mind," and the chorus would answer with the full refrain, "This assembly sings of Paschaltide," again using the same melody supplied by the soloist. All of the following verses would proceed in the same way with the soloist singing the new words of each verse, followed by the chorus singing the same half and full refrain. The name of this type of verse and refrain song, *rondeau* (round dance), implies that the dance was done in the formation of a circle, perhaps with the leader actually standing in the center of the circle rather than as a part of it. (For practical reasons of size and perspective, manuscript illuminations would often only suggest the formation, but the raised hands of participants would indicate that they were to be joined in a circle.) The usual steps for this kind of dance are leg over leg to the side, going around in a circle, reversing direction at the beginning of each new verse. As Grocheio explains, this kind of song is sung by young men and women on all festive occasions.

THE CAROL. Along with the round, the carol is the other most frequently mentioned and depicted dance from this period. The two dances are closely related in that the round is one of the possible formations for the carol. But unlike most other dance formations, the carol

a PRIMARY SOURCE *document*

TWO EVENINGS OF DANCE

INTRODUCTION: These witty poems from *Il Sapporitto*, by Si-
mone Prodenzani (c. 1400), contain the names of a num-
ber of dances as well as some detailed descriptions of
dance steps not found elsewhere. The poems accompany
a narrative about a "bon vivant" named Sollazzo, who is
apparently good at dancing, singing, and playing musi-
cal instruments. Although fictional, the poems present a
fairly accurate picture of music and dance in aristocratic
Italian circles during the late Middle Ages.

We come now to the second evening:
I tell you truly that by the light of the double candles
they danced a rigoletto rather lightly,
jumping forward and back and in waves.
Of those who were seen in the round
each one arose and danced to "al bicchieri."
No dancer had ever been seen
to make such beautiful moves and turns to the hurdy-
 gurdy,
with slave-like bends and turns, forward and backward
 jumps,
some with new halting moves,
and some made small circles on the point of their feet.
Some made their bows with head and shoulders,
while others did it with hands and feet raised
as if they were sailors or Greeks.

The third evening they danced two by two
beginning with "ranfo," and then "l'achinea."

Here one finds Cagnetto and Monna Mea,
who would never miss that dance.
And on the dance floor also was il Vicaro,
who took Monna Tomea by the hand.
Nor did there remain either a good woman or a queen
who did not dance with a man of her status.
Then came the dance of "La pertusata"
and after a while came "La palandra"
and then they did "Donna Innamorata."
Never was seen a lark who could sing as well
as did Solazo play on this wind instrument,
a performance that was the equal of a piper from Flanders.

With the bagpipe Sollazzo played "La pastorella,"
then in the evening he played "La picchina,"
"La forosetta" and then "La campagnina,"
"A la fonte io l'amai," and "La Marinella."
You would have said "it is fabulous!"
that he played so well in "La palazina"
and "La Guiduccia," also "La montanina,"
"La casa bassa," and "La patrona bella."
To this last tune they danced in the Roman style
with the chest extended and raised
which for the women is more beautiful than the Tuscan
 style.
Then they formed in a circle to do the rigoletto,
arm and arm, because it is a country dance.
All who were there took great pleasure in it.

SOURCE: Simone Prodenzani, *Il Sapporitto*, in *Il "Sollazzo"*. Ed.
Santorre Debenedetti (Turin: Bocca, 1922). Translation by Timothy
J. McGee.

was quite flexible, giving rise to Grocheio's name for it,
ductia, meaning "leader's dance," signifying that the
carol could take on a number of different formations
depending on the whim of the leader. It would begin as
a line dance for as many as wanted to join, with all the
participants holding hands, and could change into round
or under-the-bridge formations as the leader wished.
According to Grocheio's description, the steps of a carol
were lively and light-hearted, with a relatively quick
tempo. He notes that the dance excites the dancers to
move ornately, which suggests that a part of the carol
dancing tradition included some active improvisation on
the part of individual dancers. Grocheio's rather sober
description is augmented by the more fanciful scene de-
picted in *The Romance of the Rose,* written in the mid-
thirteenth century, where we receive a similar impression
of light-hearted gaiety with a variety of activities. The
surviving repertory, in addition to the surviving English
carols, is quite small and consists of three French instru-

mental compositions called *danse* and *danse real.* These
pieces all have very short phrases, with light, simple, and
lively melodies.

THE ESTAMPIE. The *estampie* is mentioned in liter-
ature from France and Italy, and Grocheio discusses both
a vocal and an instrumental form. The word itself prob-
ably derives from the Latin *stante pedes* (stationary feet),
referring to the fact that the dance steps remain close to
the ground, in contrast to those dances that employ jumps
or kicks. Grocheio describes this dance as suitable for
people of all ages, which probably means that it is a less
energetic dance, as is suggested by the "low" steps, and
in contrast to the round and carol that he recommends
for "young men and women." According to the 1328
Lays d'amors of Guillaume Molinier, a set of rules for
composing troubadour poetry, the estampie poem has a
text based on love and homage. At the end it can have
an envoy stanza that serves as a summary or dedication,
or it can possibly repeat the opening or closing couplet.

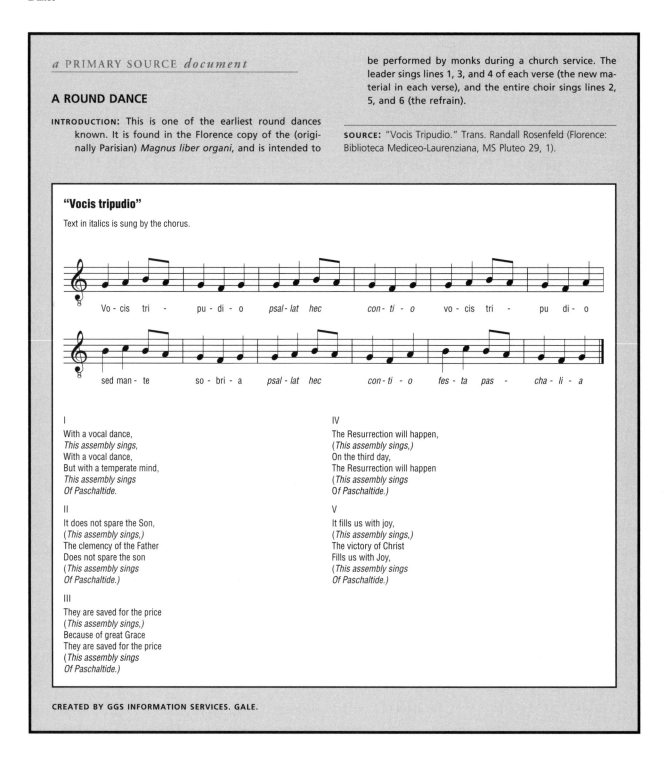

THE "KALENDA MAYA" ESTAMPIE. This description is confirmed by all of the existing twenty troubadour estampie poems, and especially by the single example that survives with both text and music, "Kalenda Maya," by the troubadour Raimbaut de Vaqueiras. (There are minor variants in the construction of all of the texts, such as number of stanzas, which suggests that there was some leeway allowed). The text of "Kalenda Maya" is about both love and homage. It is in five stanzas, with a refrain but without an envoy. From the music of "Kalenda Maya" it can be seen how the individual musical phrases were repeated in pairs, with the refrain at the end of each stanza. This construction suggests that the performance format could have been similar to that of the round, with verses sung by a soloist and a refrain for all to sing. With its dramatic portrayal of a lover who must implore his

a PRIMARY SOURCE *document*

A DANCING SCENE FROM ROMANCE OF THE ROSE

INTRODUCTION: This excerpt from *Romance of the Rose*, a very popular and important thirteenth-century French poem, describes a carol.

No earth-born man had ever seen such folk.
This noble company of which I speak
Had ordered for themselves a caroling.
A dame named Gladness led them in the tune,
Most pleasantly and sweetly rang her voice.
No one could more becomingly or well
Produce such notes; she was just made for song.
She had a voice that was both clear and pure;
About her there was nothing rude, for she
Knew well the dance steps, and could keep good
 time
The while she voiced her song. Ever the first
Was she, by custom, to begin the tune;
For music was the trade that she knew best
Ever to practice most agreeably.
 Now see the carol go! Each man and maid
Most daintily steps out with many a turn
And farandole upon the tender grass.
See there the flutists and the minstrel men,
Performers on the viol! Now they sing
A rondelet, a tune from old Lorraine;
For it has better songs than other lands.
A troop of skillful jugglers thereabout
Well played their parts, and girls with tambourines
Danced jollily, and, finishing each tune,
Threw high their instruments, and as these fell
Caught each on finger tip, and never failed.
Two graceful demoiselles in sheerest clothes,
Their hair in coiffurings alike arrayed,
Most coyly tempted Mirth to join the dance.
Unutterably quaint their motions were:
Insinuatingly each one approached
The other, till, almost together clasped,
Each one her partner's darting lips just grazed
So that it seemed their kisses were exchanged.
I can't describe for you each lithesome glide
Their bodies made—but they knew how to dance!
Forever would I gladly have remained
So long as I could see these joyful folk
In caroling and dancing thus excel themselves.

SOURCE: Guillaume de Lorris and Jean de Meun, *The Romance of the Rose.* Trans. Harry W. Robbin (New York: Dutton, 1962): 16.

a PRIMARY SOURCE *document*

A "CHRISTMAS" CAROL

INTRODUCTION: The term *carol* is usually associated in modern times with a Christmas song that sounds much like a hymn, but the repertory of early English carols shows that they were intended for a number of occasions, including Christmas, and were in the verse and refrain format. (The refrain in an English carol is called a burden.) More than 100 English carols with music have survived from around the year 1400, and nearly five times as many without music, some in Latin, some in English, and some in an alternation of Latin and English known as *macaronic* (mixed texts), where the two languages are blended together in the way illustrated by this carol for the feast of the Annunciation (followed by a modern translation).

This worle wondreth of al thynge
Howe a maide conceyued a kynge;
To yeue vs al therof shewynge,
Veni, Redemptor gencium.

Whan Gabriel come with his gretynge
To Mary moder, that swete thynge,
He graunted and saide with grete lykynge,
"Veni, Redemptor gencium." [3 additional verses]

Above all, this world wonders
how a virgin conceived a king,
to make that manifest to us.
Come, Redeemer of the nations.

When Gabriel came with his greeting
to the Mother Mary, that sweet thing,
he spoke to her and said with great fondness,
"Come, Redeemer of the nations."

SOURCE: Richard Leighton Greene, ed., *The Early English Carols.* 2d ed. (Oxford: Clarendon Press, 1977): 36. Translation by David N. Klausner.

elevated lady to take pity on him, the text of "Kalenda Maya" is typical of courtly love lyrics in the eleventh through the thirteenth centuries.

REGIONAL VARIATIONS IN THE ESTAMPIE. In addition to "Kalenda Maya," the surviving repertory of estampies consists of one additional vocal dance, "Souvent souspire," which is a new text set to the "Kalenda Maya" music, and 21 instrumental pieces—three from England, eight from France (called *estampie royal*), and ten from Italy (called *istanpitta*), many of which have fanciful titles such as "Chominciamento di gioia" (Beginning of

a PRIMARY SOURCE *document*

KALENDA MAYA

INTRODUCTION: "Kalenda Maya," written in 1190 by the troubadour Raimbaut de Vaqueiras, is the earliest known estampie. At the end of each verse, a refrain, beginning with the words "And may I be joined," is repeated. The entire refrain is printed here at the end of the first verse.

As suggested by the words "noble and vivacious lady" and "your fair person" in the first verse, this song is a monologue addressed by a lover to his lady; the use of the phrase "Fair Knight" in verse 4 suggests a comparison to the system of feudalism, as was common in courtly love literature.

SOURCE: Raimbaut de Vaqueiras, "Kalenda Maya," c. 1190. Trans. Robert Taylor.

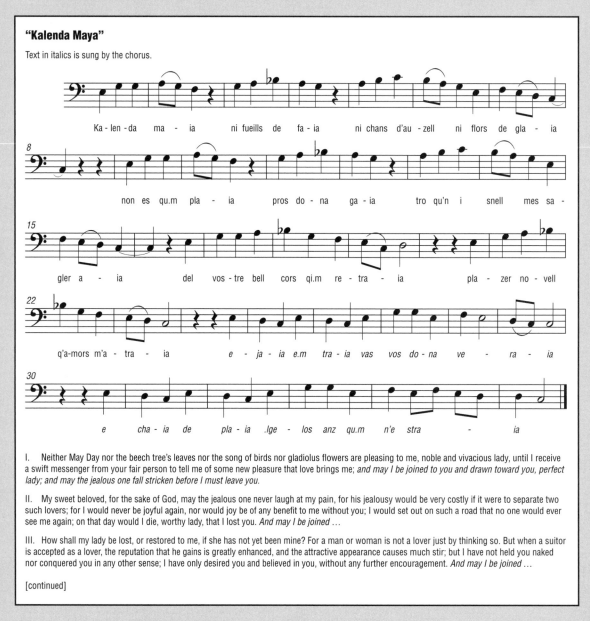

"Kalenda Maya"

Text in italics is sung by the chorus.

I. Neither May Day nor the beech tree's leaves nor the song of birds nor gladiolus flowers are pleasing to me, noble and vivacious lady, until I receive a swift messenger from your fair person to tell me of some new pleasure that love brings me; *and may I be joined to you and drawn toward you, perfect lady; and may the jealous one fall stricken before I must leave you.*

II. My sweet beloved, for the sake of God, may the jealous one never laugh at my pain, for his jealousy would be very costly if it were to separate two such lovers; for I would never be joyful again, nor would joy be of any benefit to me without you; I would set out on such a road that no one would ever see me again; on that day would I die, worthy lady, that I lost you. *And may I be joined …*

III. How shall my lady be lost, or restored to me, if she has not yet been mine? For a man or woman is not a lover just by thinking so. But when a suitor is accepted as a lover, the reputation that he gains is greatly enhanced, and the attractive appearance causes much stir; but I have not held you naked nor conquered you in any other sense; I have only desired you and believed in you, without any further encouragement. *And may I be joined …*

[continued]

"Kalenda Maya" [CONTINUED]

Text in italics is sung by the chorus.

IV. I should not likely find pleasure if I should ever be separated from you, Fair Knight, in anger; for my being is not turned toward anyone else, my desire does not draw me to anyone else, for I desire none but you. I know that this would be pleasing to slanderers, my lady, since this is the only thing that would satisfy them. There are those who would be grateful to you if they were to see or feel my suffering, since they admire you and think presumptuously about that which makes the heart sigh. *And may I be joined …*

V. Lady Beatrice, your worth is so refined by its nature, and it develops and grows beyond that of all other ladies; in my opinion you enhance your dominance with your merit and your admirable speech without fail; you are responsible for initiating praiseworthy actions; you have wisdom, patience, and learning; incontestably, you adorn your worth with benevolence. *And may I be joined …*

VI. Worthy lady, everyone praises and proclaims your merit which is so pleasing; and whoever would forget you places little value on his life; therefore I worship you, distinguished lady, for I have singled you out as the most pleasing and the best, accomplished in worth, and I have courted you and served you better than Eric did Enide. Lord Engles, I have constructed and completed the estampida. *And may I be joined …*

CREATED BY GGS INFORMATION SERVICES. GALE.

Joy), and "Tre fontane" (Three Fountains). The music indicates that the estampie did not take on the same character in all of these regions. In the English and French sources the phrases are all quite short, with simple and lively melodies. The Italian estampies, however, have relatively long phrases with more rhapsodic melodies and are more than ten times the length of the English and French dances. Although the phrases in all of the dances are of irregular lengths, which suggests that all estampies had steps that did not require a specific sequence, the differing characters of the melodic lines hint at a lively dance in England and France, and a more subdued one in Italy.

SOURCES

J. H. Marshall, *The Razos de Trobar of Raimon Vidal and Associated Texts* (London: Oxford University Press, 1972).

Timothy J. McGee, "Medieval Dances: Matching the Repertory with Grocheio's Descriptions," in *Journal of Musicology* 7 (1989): 489–517.

———, *Medieval Instrumental Dances* (Bloomington: Indiana University Press, 1989): 19–22.

"Medieval Carols," in *Musica Britannica*. Trans. and ed. John Stevens. Vol. 4 (London: Stainer and Bell, 1958).

René Nelli and René Lavaud, eds., and trans., *Les Troubadours*. Vol. 2 (Paris: Desclée De Brouwer, 1966).

Ernst Rohloff, *Die Quellenhandschriften zum Musiktraktat des Johannes de Grocheio* (Leipzig, Germany: Deutscher Verlag für Musik, 1972); English translation by Albert Seay, *Johannes de Grocheio Concerning Music* (Colorado Springs, Colo.: Colorado College Music Press, 1974).

SEE ALSO *Music: Polyphonic Secular Music and National Styles*

ADDITIONAL DANCE TYPES

NOTA. The *nota* is an instrumental dance that is neither discussed in any detail nor identified by name in any musical source. It receives a passing reference in Grocheio's treatise, where he points out that it has formal elements of both the carol and the estampie. Jean Maillart, in his *Le Roman du Comte d'Anjou* of 1316, briefly mentions it in a manner that makes it clear that the nota is a distinct dance type: "Some sang pastourelles about Robichon and Amelot, others played on vielles chansons royal and estampies, dances and notas." Four instrumental dances have been tentatively identified as possible notas on the basis of their formal construction; all are in English sources, but nothing at all is known about their formation or steps.

SALTARELLO. Although no description survives of the *saltarello* as an independent dance, the name (from the Italian *saltare*, to jump) indicates a very lively dance step, a fact confirmed by the way the saltarello step is described in the later bassadanza dance manuals. Only four examples of the medieval saltarello are known; all are instrumental and are found in a single Italian manuscript where they are labeled "salterello." The melodies are lively, with repeated phrases, and the fact that their phrases are of different lengths suggests that the saltarello step was relatively simple, something that could be repeated over and over until the music stopped.

MORESCA. The name *moresca* usually refers to a special dance in which the dancers all blackened their faces in imitation of Moors, and dressed in what were thought to be "Moorish" costumes with bells attached to their legs. (The term *Moors* originally referred to the people

of Morocco, but Europeans often used the word to mean anyone from North Africa.) The dance sometimes depicts a fight between Moors and Christians, a reference to recent Spanish history, and sometimes includes a fool as part of the cast of characters. A moresca is recorded as one of the dances performed in 1465 in Siena in honor of the dancer Ippolita Sforza. The cast on that occasion included twelve men and women dressed in "Moorish" costumes and one woman dressed as a nun, all dancing to a song with the text "I don't want to be a nun." Morescas were often danced during large celebrations such as carnival processions, and by the late fifteenth century they were transformed into theater pieces and inserted into banquets and plays for light relief. The later English "morris dance" is related to the moresca. The word *moresca* also had the more general meaning of any unchoreographed or unsophisticated dance.

RIGOLETTO. *Rigoletto* is best known as the name of the jester in Giuseppe Verdi's 1851 opera by that name, which begins at a ball in sixteenth-century Mantua. In Prodenzani's description, the dance includes forward and backward jumps and some type of "waving" motion. Another bit of information about this dance comes from the text of a mid-fifteenth century *lauda* (sacred song) with the title "Chi vuol ballare a righoletto": "Whoever wants to dance the rigoletto, move with the step to the organetto; make your steps to the sweet sound, executing the changes and matching your foot to the tune … Anyone who has weak legs or arms, do not embarrass yourself to enter in, since it changes briskly from leaps to level steps." The term *rigoletto* also was used in a looser context where it carried the meaning "wasting time," as for example, the early fifteenth-century criticism leveled at the executives of the Florentine government who were "dancing the rigoletto" instead of getting down to business. That is, they engaged in much motion but did not get anywhere. Although there is no more detailed description of the rigoletto dance steps, from these vague statements, as well as its use as a political criticism, we could speculate that the forward and backward jumps may not have progressed from the original position, thereby giving the impression of motion that accomplishes little.

TARANTELLA. One theory is that the *tarantella* dance receives its name from the tarantula spider, a reference to the rapid leg motion the spider makes in order to mesmerize its victim before killing it. Another possibility is that the name of the dance comes from its place of origin, the city of Taranto in southern Italy. From all accounts it would seem to involve rapid foot and leg motion while the dancer remains in one spot.

When mentioned in accounts during the late Middle Ages it is usually set in southern Italy, and it is sometimes associated with hysterical dancing.

DANCE PAIRS. There are a number of references to dances in pairs, generally referred to as dance and after-dance, although few details are ever given. Three musical examples exist, all from late fourteenth-century Italy. In each pair, the first dance has a fanciful name, while the after-dance is given a label: "Lamento di Tristano"/ "La Rotta;" "La Manfredina"/"La Rotta della Manfredina;" and "Dança Amorosa"/"Trotto." Tristan (Tristano) and Manfred are characters in medieval romances, and Amorous Dance (Dança Amorosa) probably also would be recognized at the time as a literary reference. The melodic phrases of these dances resemble those in an estampie, and so it is possible to relate these dances to both the Italian estampie and the later bassadanza repertory that also featured fanciful names (see The Bassadanza below). Since the word *rotta* refers to something that moves very quickly and *trotto* means "to trot," it is likely that both words refer to the fact that the after-dance is quick and lively. All of this agrees with literary and theoretical descriptions that speak of pairs as consisting of a slow, sedate dance followed by a quick one. In all of the Italian examples the melodies of the paired dances are closely related, which associates the idea itself with the most popular Renaissance dance pairs, known as "pavan and galliard," in which a sedate processional dance is paired with a leaping dance, both based on the same melody. The concept of organizing dances in sets of contrasting tempos and movements became standardized as dance suites in the late Renaissance, and remained the basic organization of most instrumental music until well into the nineteenth century.

OTHER DANCE NAMES AND MUSIC. There are many more names of dances found in literary sources, such as *espringale, reien, hovetantz, tresche, piva,* and *farandole.* Some of these names appear as particular steps in later dance choreographies (see Origins of Ballet below), but outside of that nothing else is known of their steps, formations, or music. At the same time, there are also a few musical compositions that are identified as dances or thought to be dances, but which do not fit easily into the known descriptions. Some are possibly tenors (basic melodies for choreographed dances) but others simply defy all efforts to identify their types.

SOURCES

Timothy J. McGee, "Medieval Dances: Matching the Repertory with Grocheio's Descriptions," *Journal of Musicology* 7 (1989): 489–517.

CHOREOGRAPHED DANCING

THE SHIFT TO A NEW ART FORM. All of the dances described so far come under the heading "conventional"— that is, they consist of a single set of steps and movements which are to be repeated over and over throughout the length of the dance. Although there were many different types of dances, which resulted in a rich variety of steps and movements, a dancer needed only to learn a single set of steps for any one type; once the basic steps were learned, they could be applied to any and all dances of that type (for example, a saltarello step could be danced to any and all saltarello compositions). This is not to imply that the dancing was static; as the descriptions from "Il sapporitto" and *Roman de la Rose* suggest, the dancers were free to add variations, as well as other body motions, to all of the basic steps, bringing an element of creativity to each occasion. All of these conventional dances continued to be practiced throughout the Middle Ages and into the Renaissance, but sometime in the mid- to late fourteenth century a new level of dancing appeared, one that would blossom into a separate art form in the centuries to come: choreographed dance, the direct ancestor of classical ballet. The very concept of choreographed dancing sets it aside from the conventional type in a number of significant ways. On the technical level, it replaces the spontaneous repetitions of a small number of dance steps with a studied and rehearsed individual sequence. Further, rather than simply being a particular kind of dance (a carol, or an estampie, for example) each choreographed dance was unique; it carried its own order of steps that was not shared by any other dance.

DIFFICULTY AND EXECUTION. On the social level, choreographed dances separated the nobles from the lower classes. This was a sophisticated artistic elaboration that was restricted to courtly circles where the nobles had the time to rehearse and the funds to employ a dancing master (a choreographer) who designed the dances and instructed the dancers. The choreographed dances were complicated and required serious concentration on the part of the performers, who had to memorize a complex series of steps as well as arm and body motions and floor patterns that were particular to each dance. In addition to mastering all of the motions, the most difficult chore for each dancer was to be able to execute the movements with grace and elegance, and at all times to make the task appear to be effortless. Hours of weekly practice were necessary for the dancers to execute the steps properly and stay physically agile. Much of this was done under the guidance of a dance teacher.

SOCIAL DISPLAY. The most notable difference between the choreographed dances and the other repertory, however, was its function. The choreographed dances were not something that everyone in the room performed at once; they were danced by two, three, or, in Italy, up to twelve dancers, depending on the particular dance, while everyone else watched. In reality, therefore, these were performances not far removed from theater. The noble members of the court placed themselves on display in front of their equals, demonstrating their personal grace and elegance. Not the least of the display was the costume, since attention was brought not only to how the dancers moved in the dance, but to their elegant clothes and jewelry, which were chosen to reinforce the image of wealth and taste. (The majority of accounts of dancing from this period, in fact, dwell on what the dancers wore and how elegantly—or inelegantly—they presented themselves, while unfortunately failing to report details of the dance steps.) The courtly choreographed dance, therefore, functioned as a demonstration of social and political power; it was one of the many tools employed by the wealthy and powerful to establish, maintain, and publicize their position.

SOURCES

Ingrid Brainard, "Bassedanse, Bassadanza and Ballo in the 15th Century," in *Dance History Research: Perspectives from Related Arts and Disciplines.* Ed. Joann W. Kealiiohomoku, Committee on Research in Dance (New York: Dance Research, 1970): 64–79.

Guglielmo Ebreo da Pesaro, *De pratica seu arte tripudii; On the Practice or Art of Dancing.* Chapter 3. Ed. and trans. Barbara Sparti (Oxford: Clarendon Press, 1993).

DANCING MASTERS

BURGUNDIAN ORIGINS AND ITALIAN SPLENDOR. Choreographed dances brought into existence a new type of artistic impresario, the dancing master, who invented the dances and taught them to the members of the court. The earliest known of these worked in Italian courts from the beginning of the fifteenth century, although their manuals show a well-developed set of step protocols and dance behavior that suggests that the idea had begun in the previous century, and possibly not in Italy. The name of one of the Italian choreographed dances, bassadanza, is first seen in its French form *basse danse* in a poem by the Provençal troubadour Raimon de Cornet (c. 1340): "A jongleur would rapidly learn stanzas and many little verses, cansos, and basses danses." It is clear that by the fifteenth century the basse danse was choreographed, but since the name simply means "low dance," contrasting

a PRIMARY SOURCE *document*

A NOBLE OFFER

INTRODUCTION: The following letter, dated 10 April 1469, was written to Lorenzo de' Medici, from Filippus Bussus, a dancing master trying to gain a position with the illustrious noble family. Although there is no evidence that Filippus was successful, the letter gives a picture of how a dancing master would function at a special celebration—arriving more than a week before the festivity, bringing a repertory of dances to teach the nobles, and creating original choreographies for the principal members of the family.

My magnificent and most distinguished and honorable lord:

In the last few days I have learned that your Magnificence is about to take a wife during the upcoming May festivities and that you are preparing a noble and triumphant celebration. This gives me the greatest pleasure for all your consolation and well being. A little before the Carnival I left Lombardy with the children of the Magnificent lord Roberto [da Sanseverino] whom I have taught to dance, and from that area in Lombardy I have brought some elegant, beautiful and dignified balli and bassadanze.

These things are indeed worthy of lords such as yourself and not of just anyone. And I firmly believe that if your Magnificence were to see them performed, you would like them exceedingly and you would wish to learn them since they are so beautiful and delicate. Consequently, I have almost decided to come, if it pleases you, of course, to help honor your festa. And if you would like to learn two or three of these balli and a few bassadanze from me, I would come eight or ten days before the festa to teach them to you with my humble diligence and ability; and in that way it will also be possible to teach your brother Giuliano and your sisters [Bianca, Maria, and Nannina] so that you will be able to acquire honor and fame in this festa of yours by showing that not everyone has them [i.e. the dances], since they are so little known and rare. And thus I beg and pray, press and urge you to accept this unworthy and small offer of mine. There is nothing else to say now except that I recommend myself to Your Magnificence, for whose pleasures I offer my unfailing and ready service.

Your servant Filippus Bussus of Biandrate

SOURCE: Filippus Bussus, Letter to Lorenzo de'Medici, April 10, 1469. Trans. Timothy J. McGee (Florence: Archivio di Stato, MAP, Filza XXI, No. 90).

its conservative steps with the more flamboyant jumps, hops, and leaps of other dances, there is no way to know whether the history of choreographed dances goes back as early as 1300 or whether the application of specific choreographies to this dance step was developed later. The earliest French collection of basse danse music and choreographies is associated with the court of Burgundy, an area now in eastern France that was once a powerful independent duchy. Although the manuscript itself, a spectacularly beautiful one with silver and gold musical notation on black parchment, dates from approximately 1470, it is clearly a retrospective collection going back at least to the beginning of the century. Given what is known about the splendor of all of the arts at the Burgundian court beginning with the reign of Philip the Bold in 1364, it would not be surprising to learn that the tradition began under his supervision and encouragement.

CEREMONIES AND CELEBRATIONS. It is clear that the role of the Italian dancing masters extended far beyond the mere teaching of dance. Often, these men also planned the elaborate ceremonies that accompanied a feast, including the plays, parades, processions, jousts, banquets, wild animal hunts, and games that were a part of the celebrations, as well as the decoration of the city

streets and performance venues. Celebrations of this kind were arranged for engagements, weddings, receptions of important guests, and other special occasions that could provide the powerful noble families with an opportunity to show off their wealth, artistic superiority, and social importance. At the end of one of the later copies of his treatise, Guglielmo Ebreo adds a list of thirty events in which he participated. There is no doubt that this is only a partial account, but it probably contains those occasions that seemed to him most memorable. His comments (not reported in chronological order) provide an interesting glimpse of the nature of festive events in the fifteenth century:

Event 6 [1454]: I was present [in Bologna] at the nuptials of Messer Sante del Bentivoglio, when we accompanied Lady Ginevra [daughter of Alessandro Sforza] and the festivities lasted three days; and I never saw finer repasts or finer refreshments or greater ceremony. And the platters of boiled meat, that is, the capons, were in the form of his coat of arms. And moreover, around the tables there were peacocks whose feathers and spread tails seemed like curtains in that hall.

Event 10 [1450]: I was present when Duke Francesco Sforza made his entry into Milan and

a PRIMARY SOURCE *document*

RULES FOR WOMEN IN DANCE

INTRODUCTION: Guglielmo Ebreo's dancing manual, *On the Practice or Art of Dancing*, includes a number of statements about etiquette and proper dress. It also includes this statement about the behavior of women, which provides some interesting evidence of the fifteenth-century attitude toward young women, as well as some details about dancing.

It behoves the young and virtuous woman, who delights in understanding and learning this discipline and art, to behave and conduct herself with far more discretion and modesty than the man. She therefore should fully understand and observe perfectly the aforesaid elements, rules, and exercises, so that she understands measure and is well skilled in music, and is also attentive and able to remember it, and knows how to partition the ground. Her bearing should have the proper measure and an airy modesty, and her manner should be sweet, discreet, and pleasant. The movement of her body should be humble and meek, and her carriage dignified and stately; her step should be light and her gestures shapely. Nor should her gaze be haughty or roaming (peering here and there as many do), but she should for the most part keep her eyes modestly on the ground; not, however, as some do who sink their heads on their breast. Rather, she should carry it upright, aligned with the body, as nature itself—as it were—teaches us. And when she moves she should be nimble, light, and restrained, because when doing a *sempio* or a *doppio* she must be alert and most adaptable. In the same fashion she should also have a gentle, pleasant, and sweet way with her in [performing] *represe*, *continenze*, *riverenze*, or *scossi*, with her mind constantly intent on the music and the measures, so that her actions and gentle gestures will be well formed and in keeping with them. Then, at the end of the dance, when released by the man, she should, turning her sweet gaze on him alone, make a courteous and tender bow in answer to his. And then, with modest demeanour, she should go to take her ease [whence] to note the flaws of others as they occur as well as their correct actions and perfect movements. If these things are well marked by the young woman, and with careful heed kept well in view, she will become deservedly gifted in the aforesaid art of the dance, and merit a virtuous and commendable reputation.

SOURCE: Guglielmo Ebreo, *On the Practice or Art of Dancing*. Trans. Barbara Sparti (Oxford: Clarendon Press, 1993): 109, 111.

was made Duke. And the jousts and the dancing and the great festivities lasted a month. And I saw two hundred knights dubbed. And I understand Giovanni of Castel Nova and Giovanni Chiapa to say to the lord Messer Alessandro Sforza that ten thousand people sat down to table when the trumpet sounded and all of them were in court.

LOCAL PATRONAGE. As a special feature on some of these occasions, the dancing masters invented new choreographies that were directly related to their patrons, naming the dance after a local person or place: Domenico's *balli* (dances in the *ballo* form) called "Belriguardo" and "Belfiore" refer to the Este family residences in Ferrara; those called "Lioncello" and "Marchesana" refer to Marchese Leonello d'Este. These special choreographies would be premiered in front of all of the invited guests, featuring the patrons themselves as the dancers. Some dance teachers, such as Domenico da Piacenza and Antonio Cornazano, were permanent members of the household staff, with duties in addition to dance instruction, while others were hired for particular occasions; the letter from Filippus Bussus to Lorenzo de' Medici shows one such itinerant teacher extolling his own talents while seeking employment in Florence.

ITALIAN AUTHORS. Three of the fifteenth-century Italian dancing masters left treatises that include not only specific dance patterns for bassadanze and balli, but also essays on etiquette, costume, and dance techniques. The earliest of the treatises is from 1445, *De la arte di ballare et Danzare* (On the Art of Dancing and Choreography), by Domenico da Piacenza; the second, *Libro dell'arte del danzare* (Book on the Art of Dancing), from 1455, is by Antonio Cornazano; and the third—the first of seven versions of Guglielmo Ebreo's treatise *De pratica seu arte tripudii* (On the Practice or Art of Dancing)—was written in 1463. We know from various sources, including choreography attributions and statements in the surviving treatises, that there were many other dancing masters in Italy during the fifteenth century, including Giuseppe Ebreo (Guglielmo's brother), Pietro Paolo (Guglielmo's son), Moise Ebreo, and Filippus Bussus. However, their writings have not survived, and little is known of these dancing masters or their lives.

HUMANISTIC INFLUENCES. The Italian dance manuals contain more than just instructions for recreating specific dances; they begin with a section of poems, highly complimentary dedicatory material addressed to their patrons, and essays on a number of different topics.

It is clear that the authors were all formally educated, since the subject matter of some of this material is a reflection of the humanist movement, relating dance to philosophy, history, and world thought. On a more practical level, there are also discussions of the basic elements of dance: measure and rhythm, accurate memory, artistic use of the dance area, graceful movement of the body, considerations when wearing long or short gowns and capes, and special instructions to women on the subject of modesty when dancing.

SOURCES

Ingrid Brainard, "The Role of the Dancing Master in 15th-Century Courtly Society," *Fifteenth Century Studies* 2 (1979): 21–44.

Guglielmo Ebreo da Pesaro, *De pratica seu arte tripudii; On the Practice or Art of Dancing.* Ed. and trans. Barbara Sparti (Oxford: Clarendon Press, 1993).

Alberto F. Gallo, "L'Autobiografia artistica de Giovanni Ambrosio (Guglielmo Ebreo) de Pesaro," *Studi musicali* 12 (1983): 189–202.

———,"Il *Ballare Lombardo* (circa 1435–1475)," *Studi musicali* 8 (1979), 61–84.

Daniel Heartz, "The Basse Dance, Its Evolution circa 1450–1550," *Annales Musicologiques, Moyen Age et Renaissance* 6 (1958–1963): 287–340.

Timothy J. McGee, "Dancing Masters and the Medici Court in the 15th Century," *Studi musicali* 17 (1988): 201–224.

D. R. Wilson, "The Development of French Basse Danse," *Historical Dance* 2 (1984–1985): 5–12.

THE BASSE DANSE AND THE BASSADANZA

BASSE DANSE. Each of the choreographed dances—basse danse, bassadanza, and ballo—has a distinct sequence of steps that are appropriate for only that dance, and all of them also have in common a small number of main steps, although they differ in how they are executed. The Burgundian basse danse is an elegant processional dance, consisting of five basic steps that are arranged in a unique sequence for each composition. The steps themselves are not complicated, and all require that the feet stay close to the floor, in keeping with the name *basse* (low). Basse danse steps include the following movements:

Branle: A swaying motion with the body turning first to one side and then to the other. Since the partners are holding hands, the first turn is away from each other, the second towards the partner. This is always the first step to follow the *reverence*.

Double: Three equal steps forward while raising the body.

Reprise: (also called *demarche*) A small step backward with the right foot, followed by placing the left foot behind the right. The right then moves forward again, thus allowing the dancer to end with the right foot in the place where it began.

Reverence: A bow, executed with one foot behind the other and the knees bent. It was always the first step in each basse danse.

Simple: A single step forward with one foot. This step is always called for in pairs and always begins on the left foot.

This constitutes the complete repertory of steps for all fifteenth-century basses danses. The choreographed versions varied from one another only in the sequence and number of movements. Each basse danse had a specific number of steps that were matched in the music accompanying it by a similar number of units of measure, meaning that the dance and its music were inseparable. Although the descriptions suggest that the steps are not difficult, the exact step sequence for each dance was crucial, and when arm, head, and body motions were added, any one choreographed dance became quite complex, compelling the nobles to spend many hours in dance practice.

THE BASSADANZA. The Italian bassadanza is similar to the basse danse in that it too is basically a processional dance, moving at a single steady tempo and organized around a number of relatively simple basic steps. In fact, four of the basic bassadanza steps (called "natural steps") are quite similar to those of the basse danse. The bassadanza and basse danse differ, however, in a number of details of construction and execution, and especially in their tone and the amount of freedom taken by the choreographers and expected of the dancers. Bassadanza and ballo "natural steps" include the following:

Continenza: A small step to the side with knees bending, usually executed in pairs. It is somewhat similar to the branle.

Doppio: Three equal steps forward, similar to the double.

Mezza volta: A half turn, meaning that the dancer ends up facing in the opposite direction. It is sometimes executed by using other steps (one doppio, or two continenze, or two sempii, or two riprese).

Represa: A large step to the side with one foot, which is then joined by the other.

Riverenza: (two types) The normal bow with one foot behind the other and the knees bent, and *riverenza in terra*, in which the knee of the back leg touches the floor.

Salto: A jump with several possible executions: on one foot or two, or from one foot to the other.

Sempio: A single step forward, similar to the simple.

Volta tondo: A full turn, executed by using the same steps as the mezza volta, but requiring twice as many steps and taking twice as long to execute.

Slide trumpeters. Wedding scene, Master of the Adimari Cassone. Florence, Galleria dell' Academia, 1460. **ARTE & IMMAGINI SRL/CORBIS.**

Ornamental steps (sometimes called "accidental steps") could be interpolated into a performance by the dancers themselves. None of these steps is clearly explained; the descriptions are those suggested by the words themselves:

Escambiamento: A change; perhaps performing the motion or step with the other foot.

Frappamento: A shaking motion, perhaps meaning the foot.

Scorsa: Dragging the foot.

FORMALITY VERSUS FLAMBOYANCE. As can be seen by comparing the steps in both dances, the basse danse, with its limited number of steps executed in a fairly standard sequence, creates an air of sedate and highly controlled formality and elegance, whereas the bassadanza, with its larger repertory of basic steps, numerous variations, and looser tradition of step sequences, results in a far more flamboyant dance. Unlike the two- or three-person formation of the basse danse, which is confined to processional movements with a more or less rigid sequence of the basic steps, all of which are low, the bassadanza allows as many as eight dancers in formations which can be single file, all dancers abreast, or even circular, and there is far more variety in the sequence of the basic steps. The processional aspect of the dance is interrupted by numerous half-turns and even a jumping step, and the bassadanza choreographies include the addition of "accidental" steps to be placed before or after the basic patterns, as well as variations on the basic steps, ornamental movements, and steps borrowed from other dance types. The bassadanza is still a very formal dance, but the greater variety of steps and formations, including larger motions such as full- and half-turns, lend a far more theatrical air. The Italian bassadanza, therefore, although stemming from the same processional idea as its Burgundian counterpart, was a more extravagant product.

MATCHING NOTES AND STEPS. As can be seen in the transcription of a Burgundian basse danse called "La Haulte Bourgongne" (The High Burgundian), the writ-ten music for the bassadanza and basse danse, known as a "tenor," is expressed only as a series of long notes, each representing one measure of time. The word *tenor*, from the Latin *tenere* (to hold), refers to the fact that the notes were sustained. Each bassadanza and basse danse has its own music, which contains exactly the correct number of notes to match the choreography. Some of the melodies of these dances are adapted from known songs, although many of them probably were composed specifically for a particular dance choreography. Since there is no change in the pace of the music, it was also possible to compose a new bassadanza or basse danse to an existing tune; all that was required was that the number of dance steps must correspond with the units of measure in the melody.

DANCE NOTATION AND INSTRUMENTATION. Although the music for both low dances looks the same, the way in which the treatises associate the steps with the music differs in that the bassadanza steps are described only in prose, whereas the French developed a shorthand in which letters designating the steps are placed beneath the appropriate notes of the dance tune, showing at a glance which steps go with which notes. In performance, the music would be more complex than the single line that was written. In addition to the long notes of the monophonic (single-line) tenor, one or two other parts would be improvised, resulting in a polyphonic (multipart) composition full of harmony and ornate interweaving melodic lines. Instrumental musicians were quite skilled at this type of improvisation and would easily fill out the harmonies and melodies around the sparse written outline of the tenor. The most common dance ensemble of the period was a trio consisting of a slide trumpet (predecessor of the trombone), and two or three *shawms* (double-reed instruments, similar to the oboe). In performance, one shawm would play the written melody and the other instruments would improvise faster-moving accompaniment parts above and below the

AN EXAMPLE OF DANCE NOTATION

INTRODUCTION: In Italian treatises the dance steps for the bassadanza were indicated simply by written descriptions that were provided alongside the music. But the French developed a kind of shorthand in which letters designating the steps were placed beneath the appropriate notes of the dance tune, showing at a glance which steps were to go with which notes. In the example below, from a dance called "La Haulte Bourgongne" (The High Burgundian), the letters beneath the notes correspond to the five basic steps of the basse danse: R=reverence, b=branle, s=simple, and so on.

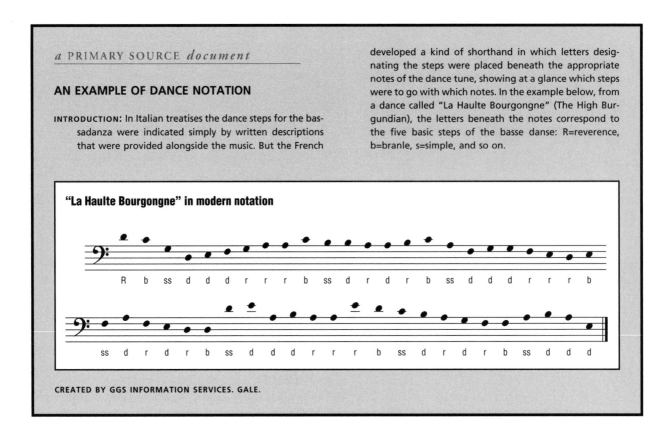

"La Haulte Bourgongne" in modern notation

R b ss d d d r r r b ss d r d r b ss d d d r r r b

ss d r d r b ss d d d r r r r b ss d r d r b ss d d d

CREATED BY GGS INFORMATION SERVICES. GALE.

melody. A similar kind of improvised accompaniment would also be added when the music was performed by a single musician playing harp or lute. Other instruments frequently shown in the company of dancers are tambourines, bagpipes, recorders, and fiddles.

SOURCES

Ingrid Brainard, *Three Court Dances of the Early Renaissance* (New York: Dance Notation Bureau, 1971).

Ernest Closson, *Le Manuscrit dit des Basses Danses de la Bibliothèque de Bourgogne* (Brussels: Société des Bibliophiles et Iconophiles de Belgiques, 1912).

Frederick Crane, *Materials for the Study of the Fifteenth Century Basse Danse* (Ottawa: Institute of Mediaeval Music, 1968).

James L. Jackman, *Fifteenth Century Basse Dances.* The Wellesley Edition, 6 (Wellesley, Mass.: 1984).

Otto Kinkeldey, "Dance Tunes of the Fifteenth Century," in *Instrumental Music.* Ed. David G. Hughes (Cambridge, Mass.: Harvard University Press; reprint, New York: Da Capo Press, 1972): 3–30.

THE BALLO

ORIGINS OF BALLET. The ballo enters more fully into the area of what we would think of as theatrical dance or ballet. Although the ballo employs the same basic steps as the bassadanza, it is quite different in its overall format and in the number of step variations. Instead of being danced at a single steady tempo and measure, as are the bassadanza and the basse danse, the ballo is made up of an irregular series of up to four different tempos (called *misura*), each having a different kind of rhythmic organization and speed. The tempos, from slowest to fastest, were *bassadanza, quaternaria, saltarello,* and *piva.* The changes of tempo result in a large variation in the natural steps. For example, a *saltarello doppio,* which involves a small hop as well as a stepping motion, moves quite a bit faster than a *bassadanza doppio* because the saltarello tempo itself is faster. There is also, of course, a *quaternaria doppio* and a *piva doppio,* and to complicate matters, some of the choreographies call for the execution of one kind of step variation in a different tempo: a *saltarello doppio,* for example, in a bassadanza tempo. The result of the changing tempos and wide variation of steps was a dance form capable of enormous expression. In the hands of the creative Italian dancing masters, such dances were organized into pantomimes and mini-dramas that were highly entertaining. The ballo "Gelosia" (jealousy), for example, involves three couples who flirt with one another while executing a wide variety of dance steps and floor patterns, ending

a PRIMARY SOURCE *document*

A FIFTEENTH-CENTURY BALLO

INTRODUCTION: The ballo "Petit Vriens" is a choreographed dance for three dancers by Guglielmo Ebreo, from one of his dance manuals of the mid-fifteenth century. In performance, a small group of musicians would improvise harmony to this melody.

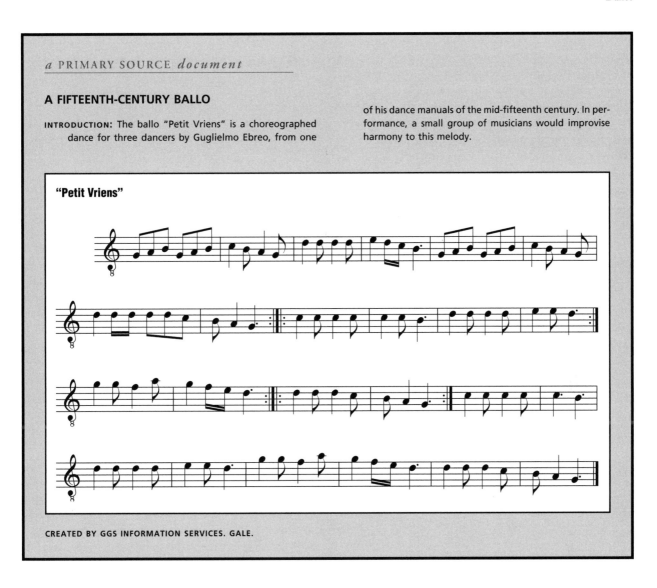

"Petit Vriens"

with an exchange of partners. It would be difficult to exaggerate the enormous amount of time and effort required to present these dances with the flair and elegance they required. Throughout the sixteenth century, the ballo continued to be one of the favorite forms of entertainment, attracting professional dancers by the beginning of the seventeenth century, and eventually—as the name would suggest—becoming the basis of modern ballet.

MUSICAL COMPLEXITY. Ballo musical lines are far more complex than those for the bassadanza and basse danse, each having a unique set of sections that vary in style and meter, as well as in the number of times each section is to be repeated. Because of this, each ballo is inseparable from its music. Similar to the music for the other choreographed dances, in performance the ballo music was filled out by the musicians, who extemporized additional musical lines to what was written. The ballo music, however, was based on a melody with a variety of rhythms (as opposed to a basse danse and bassadanza sustained-note "tenor"), which required the musicians to fill in only harmonic lines. The instruments used in these performances were the same as for the bassadanza; the two types of dances were usually combined during the elaborate feasts in which they were performed.

NOVELTY AND TRADITION. The arrival of choreographed dances brought not only a new repertory and style to the activity of dance, but also a new function in which dance took on unprecedented political and social importance as political leaders used it as a measure of culture, elegance, and taste. The political implications, however, could have been important only to relatively few, meaning that for the majority of those who attended the entertainments of the royal court it was simply a new and sophisticated way to enjoy dancing, though certainly one that required far more preparation than anything

they had previously experienced. Rather than replace the older style of conventional dances, the new form merely augmented the repertory for the nobility, while the conventional dances continued to be performed by all the citizens, including the nobles. The low steps of the new *basse danse* and *bassadanza* forms were derived from earlier *estampie* steps, and the line dances of the earlier centuries continued on as well, acquiring new names and step variants but remaining essentially the same. New dances and styles continued to reflect the ever-changing social and political lives of all Europeans, but regardless of the changes, dancing retained its central place in the recreational activities of late medieval society.

SOURCES

Guglielmo Ebreo da Pesaro, *De pratica seu arte tripudii; On the Practice or Art of Dancing.* Chapter 3. Ed. and trans. Barbara Sparti (Oxford: Clarendon Press, 1993).

SIGNIFICANT PEOPLE
in Dance

ANTONIO CORNAZANO

1430–1484

Poet
Humanist
Statesman

MASTER OF MANY ARTS. Because dance was only one of many arts practiced in the courts of late medieval Italy, it is important to recognize that those engaged in it were not necessarily professionals. Indeed, as the concept of the "Renaissance man" developed, what was most admired was an individual's ability to move easily from one art to another as a cultivated amateur (that is, one who loves a subject but does not make a living from it). Thus, although Antonio Cornazano taught dancing and wrote a dance manual, it would be inaccurate to refer to him as a dancing master. He was not himself a choreographer—his manual contains only choreographies by Domenico da Piacenza—and he was not a professional dancer, as were all the other dancing masters. He is better described as a poet, humanist, and statesman; at his appointment to the household staff of Duke Francesco Sforza, he was described as "counselor, secretary, chamberlain, and teacher of the Duke's children." Cornazano was born into one of Piacenza's leading noble families and, similar to other young men of his status, received

a broad education that included ancient and modern languages, the theory and practice of military arts, and politics. He learned dancing from Domenico, whom he later referred to as "my only teacher and colleague." In 1454 he entered into service in Milan at the Sforza court where a year later he dedicated the first version of his treatise, *Libro dell'arte del danzare* (Book on the Art of Dancing), to his young student Ippolita Maria Sforza. Following the death of Duke Francesco in 1466, Cornazano moved to Venice where he spent eleven years as military adviser to General Bartolomeo Colleoni, leader of the Venetian military forces.

INTERRELATED ARTS. Cornazano was married to Taddea de Varro, a member of an old noble Ferrarese family, and in 1479 he entered the court of Ericole I d'Este in Ferrara, where he spent the remainder of his life. He was noted as an excellent and prolific poet who was also skilled at extemporizing poetry. His writings include *La Sforzeide* in praise of Francesco Sforza, a set of poems divided into 36 chapters, written in the style of Vergil's epic *The Aeneid.* His works also include *Vita di Nostra Donna* (Life of our Lady), a book of poems on the life of the Virgin Mary, dedicated to Ippolita Maria Sforza; and *Opera bellissima de l'arte militare* (The Most Beautiful Work of Military Art), a treatise on the art of war. Though to us the combination of the "arts of war" and the arts of poetry and dance might seem unusual, this was not the case in fifteenth-century courts, where dance, like poetry and the performance of music, was an activity of great interest to almost everyone and was always included as one of the skills required of a successful courtier.

SOURCES

The New Grove Dictionary of Music and Musicians. Edited by Stanley Sadie and John Tyrrell. 29 vols. 2nd ed. (New York: Grove's Dictionaries, 2001).

DOMENICO DA PIACENZA

1390–1477

Dancing master

THE FIRST DANCING MASTER. Domenico da Piacenza (c. 1390–1477) is the earliest known dancing master. He was born in Piacenza (northern Italy), and worked in the major northern Italian courts, including that of the Sforzas in Milan and the Este in Ferrara. He wrote *De la arte di ballare et Danzare* (On the Art of Dancing and Choreography) in 1445, the earliest surviving dance treatise, and taught a number of Italian dancing masters including the other two authors of dance

treatises, Guglielmo Ebreo (also known as Giovanni Ambrosio) and Antonio Cornazano. On the invitation of Duke Francesco Sforza, Domenico, along with Guglielmo and Antonio, took part in the elaborate celebration for the wedding of Tristano Sforza and Beatrice d'Este in Milan. A year later he was appointed to the Este court in Ferrara where he was listed as "spectabilis miles" (worthy knight). Other sources refer to him as a Knight of the Golden Spur. He remained in Ferrara until his death 21 years later.

LASTING INFLUENCE. His treatise was taken as the model by both of his renowned pupils, whose works followed Domenico's format of beginning the treatise with a discussion of dance theory and then providing a set of specific choreographies for balli and bassadanze. It is clear that Domenico was well educated; in his discussion of the aesthetics of dancing he refers to Aristotle. Among his balli are two dance-dramas, "La mercanzia" and "La sobria," which are considered by some dance historians to be the earliest ballets.

SOURCES

The New Grove Dictionary of Music and Musicians. Ed. Stanley Sadie and John Tyrrell. 29 vols. 2nd ed. (New York: Grove's Dictionaries, 2001).

GUGLIELMO EBREO

1420–1484

Dancing master
Author

DANCING MASTER EXTRAORDINAIRE. Guglielmo Ebreo is the best known dancing master of the fifteenth century, owing to the survival of seven manuscripts containing versions of his dance treatise *De pratica seu arte tripudii* (On The Practice or Art of Dancing), as compared to one copy each of the only other treatises from the fifteenth century written by Domenico da Piacenza and Antonio Cornazano. In the early 1460s, while Guglielmo Ebreo (William the Jew) was in the employ of the Sforza court in Pesaro and was a frequent visitor at the Sforza court in Milan, he decided to convert to Christianity and took the name Ambrosio after St. Ambrose, the patron saint of Milan.

AN HONORED CAREER. Guglielmo and his brother Giuseppe (also a dancing master) were born in Pesaro (central Italy), the sons of Moses of Sicily, who for a time was dancing master at that court. Quite a bit is known about Guglielmo's career, thanks to a number of surviving letters he wrote to various courts, and especially to

an autobiographical list that he appended to one of the manuscripts of his dance treatise, describing thirty events in which he took part. His career as a dancing master took him to a number of the finest courts in Italy where he was valued for his ability as a dancer, dance teacher, and choreographer. In addition to the Sforza families in Pesaro and Milan, he served the Montefeltro in Urbino, the Gonzaga in Mantua, King Ferdinand I in Naples, and the Medici in Florence. The esteem in which he was held is attested to by his elevation to Knight of the Golden Spur in Venice in 1469 by the Holy Roman Emperor Frederick III, an honor he shared with Domenico da Piacenza, and one that was bestowed only rarely on artists.

SOURCES

Guglielmo Ebreo da Pesaro, *De pratica seu arte tripudii; On the Practice or Art of Dancing.* Ed. and trans. Barbara Sparti (Oxford: Clarendon Press, 1993).

RAIMBAUT DE VAQUEIRAS

c. 1150–1207

Troubadour
Poet
Composer

A PROLIFIC TROUBADOUR-ADVENTURER. Raimbaut de Vaqueiras (c. 1150–1207) was a troubadour, poet, and composer. Like many of the people associated with early dance, he did not devote his entire career to this interest, but rather was a member of the court who served a variety of personal, literary, and educational functions. Indeed, his life was primarily one of military and diplomatic service. According to his thirteenth-century biography, he was born the son of a poor knight in Provence, near the castle of Vaqueiras. He entered into the service of the Marquis of Monferrat in northern Italy and became a companion at arms to his son Boniface, remaining there until 1180. In 1189, he moved to Provence in the service of Hugues I des Baux, and in 1192 returned to Monferrat. During a military campaign in 1194, Raimbaut saved Boniface's life and was rewarded with a knighthood. In 1202, when Boniface became the leader of the Fourth Crusade and set off from Venice for the Holy Land, Raimbaut at first returned to Provence, but later rejoined his patron and the crusade in Constantinople. Boniface was killed near Messiople on 1207, and it is probable that Raimbaut died at that time.

CONTRIBUTION TO MUSIC AND DANCE. Raimbaut was fluent in several languages, including Occitan (a medieval language spoken in what is now southern France),

Italian, French, Gascon (a dialect of French), and Galician-Portuguese. Scholars attribute 26 poems to Raimbaut, although only seven survive with music. The best known of his works is the estampie "Kalenda Maya," which he composed in honor of Beatrix, daughter of Boniface, to fit a melody that he had heard played on the vielle by two French jongleurs.

SOURCES

Elizabeth Aubrey, *The Music of the Troubadours* (Bloomington: Indiana University Press, 1996): 14–15.

IPPOLITA MARIA SFORZA

1445–1488

Dancer

Duchess

A CHILD PRODIGY OF DANCE. Ippolita Maria Sforza was the daughter of Duke Francesco Sforza of Milan and Bianca Maria Visconti. Her father employed a number of scholars to provide his children with the finest of classical educations, which included Greek, Latin, rhetoric, and the arts. In 1454, Francesco added the humanist poet Antonio Cornazano to his household staff, assigning the instruction of dance as one of his teaching duties. A year later Cornazano dedicated his treatise *Libro dell'arte del danzare* (Book on the Art of Dancing) to his ten-year-old star pupil, Ippolita, making her the earliest known ballerina, that is, a dancer of choreographed dances. The treatise also includes a sonnet by Cornazano, extolling Ippolita's graces in language, echoing Latin mythological poetry. In the spring of that same year, Ippolita was introduced to two of the most famous dancing masters of the century when Domenico da Piacenza and Guglielmo Ebreo were summoned to the Sforza court to work with Cornazano to organize the festivities and dances for the marriage of Tristano Sforza to Beatrice d'Este, a woman widely acclaimed as a dancer. Shortly afterward, in the fall, Ippolita, still only age ten, was promised in marriage by her father to Alfonso of Naples. From that point forward she was usually referred to as the Duchess of Calabria, which would be her title following her marriage ten years later.

A PERFORMING ARTIST. Ippolita's renown as a dancer began at the 1455 Sforza wedding, where she participated in a ballo with Beatrice. The next recorded notice of her dancing is from 1465, associated with her wedding celebration in Milan, followed by the long journey she took from Milan to Naples for her marriage. She was escorted on the trip by Federigo, the youngest son of King Ferrante of Naples, accompanied by two of her brothers and a company of more than a thousand, including 600 nobles, soldiers, servants, and courtiers, among them her dancing teacher Antonio Cornazano. All along the journey the entourage stopped at the major cities and courts where she was lavishly entertained; in Florence she danced with Lorenzo de' Medici (age sixteen), whom she had met and danced with at the earlier wedding celebration in her home palace. Next she traveled to Siena, where one of the entertainments presented in her honor included a costumed *moresca* (Moorish dance). When she finally arrived in Naples after three months on the road, a full week was set aside for the wedding festivities, which included lavish balls. Throughout her reign as Duchess of Calabria, Ippolita was renowned for her learning and her support of the arts, including her beloved dance.

SOURCES

Eileen Southern, "A 15th-Century Prima Ballerina," in *Music and Context, Essays for John M. Ward.* Ed. A. D. Shapiro (Cambridge, Mass.: Harvard University Press, 1985): 183–197.

DOCUMENTARY SOURCES
in Dance

Bodleian Library: MS Douce 139 (1250)—This manuscript from Coventry, England, now housed in Oxford's Bodleian Library, contains the earliest known English instrumental dance.

Chansonnier du Roi (c. 1280)—This collection of eleven instrumental dances, copied into a manuscript now located in Paris (Bibliothèque Nationale fr. 844), is the only medieval collection of French estampies and carols.

Antonio Cornazano, *Libro dell'arte del danzare* or *Book on the Art of Dancing* (1455)—This book, the second known treatise on dancing, was written by poet, statesman, and humanist Antonio Cornazano, who dedicated it to his student, Ippolita Maria Sforza, one of the first ballerinas known by name.

Dança general de la Muerte (c. 1400)—This poem of 79 stanzas, originating in Spain, describes the dance of death. The title, translated as *Common Dance of Death,* acknowledges that mortality is a universal experience.

Domenico da Piacenza, *De la arte di ballare et Danzare* or *On the Art of Dancing and Choreography* (1445)—This work by one of the first dancing masters is the earliest known treatise on dancing and the model for those that

followed. It begins with a discussion of dance theory and then provides a set of specific choreographies for balli and bassadanze.

Guglielmo Ebreo (Giovanni Ambrosio), *De pratica seu arte tripudii* or *On the Practice or Art of Dancing* (1463)— Written by the best known dancing master of the fifteenth century, this dance treatise exists in a total of seven manuscript versions, one of which contains a list of thirty important events in which the author participated.

Jofre Goixà, *Doctrina de compondre dictatz* (1300)—This Catalan treatise on poetry gives instructions on how to compose a *dansa*.

Johannes Grocheio, *De musica* (c. 1300)—This music treatise includes the earliest detailed descriptions of both vocal and instrumental dances and dance music.

Magnus liber organi (c. 1250)—This book of music for the liturgy (the title means the "Great Book of Organum") contains at its end the largest repertory of medieval sacred dance songs with music. The sixty short dance songs in this collection, which originated in Paris, are nearly all in a verse and refrain format known as *rondeau*.

Guillaume Molinier, *Lays d'amors* (1328)—This book, which presents a set of rules for composing troubadour poetry, includes a description of the estampie dance poem.

chapter three

FASHION

Laura F. Hodges

IMPORTANT EVENTS
in Fashion

800 Charlemagne is crowned emperor of a realm that includes much of modern France, Germany, and Italy, creating the social structures necessary for the development of a system of fashion.

c. 808 Emperor Charlemagne decrees the first medieval sumptuary law to regulate the price of clothing.

1066 The Anglo-Saxons are defeated by the Normans at the Battle of Hastings. William the Conqueror, duke of Normandy, now king of England, introduces Norman dress to the English court.

1095 The First Crusade begins, and French warriors travel to Constantinople (the capital of the Christian Byzantine Empire—modern Istanbul, Turkey) to stage a battle for control of the Holy Land, then under Muslim rule. Returning crusaders will popularize Eastern silks in Europe and initiate Byzantine influence in costume.

c. 1100 "Courtly dress" is first described in literature and public records.

1100 The reign of Henry I of England begins, ushering in a period of more luxurious dress style.

c. 1125 The French priest Fulcher of Chartres comments that Westerners living in the Latin settlements in the Holy Land have become orientalized in their clothing and habits.

1135 The reign of King Stephen in England continues the luxurious styles of Henry I's reign.

c. 1140 Earliest forms of Gothic architecture are initiated, paralleling in height the longer silhouette in costume.

c. 1142 Paris becomes a center of learning as universities emerge throughout Europe, leading to the beginnings of academic dress.

1147 Bernard of Clairvaux begins preaching the Second Crusade, influencing Emperor Conrad III of the Holy Roman Empire and Louis VII of France to go on crusade. The result is the extension of the Eastern influence on fashion to the German-speaking world.

c. 1150 Heraldry, a system assigning distinctive coats of arms to identify knights in tournaments, originates in France and influences display of colors and lineage in costume.

1154 Henry II, the first king in the royal family of Plantagenets (1154–1485), takes the throne in England. He marries Eleanor of Aquitaine, who continues to influence female fashion until long after her death; their reign initiates a return to the simpler fashions of 1066.

1157 The earliest Italian sumptuary law dealing with clothing is enacted in Genoa, initiating a series of such laws conceived for economic purposes (to enhance trade and reinforce the social hierarchy) but often expressed in moral terms.

1192 The Third Crusade—consisting of French, English, and German contingents—ends, and Eastern fabrics are again brought back to Europe.

1199 The reign of King John in England begins, during which the court revives lavish dress for men while the ladies continue to imitate Queen Eleanor's simpler fashions.

1204 The end of the Fourth Crusade, which originated in Venice, brings another wave of Eastern fabrics to Europe.

Constantinople falls to the Crusaders, and the Latin Empire is formed. The resulting decline in Byzantine political power corresponds to a decline in Byzantine influence on European fashion.

1216 The reign of King Henry III of England begins. The period will be characterized by unpretentious dress, development of merchants' guilds, and the circulation of "trade poems" (realistic poems depicting the lives of peddlers and artisans) about items of costume.

1226 Louis IX of France (later St. Louis) becomes king. His piety will influence the court towards unpretentious dress.

1272 Edward I becomes king of England. He favors exceptionally simple styles in clothing, and his court adopts his tastes.

1290 In an effort to restrain and control indulgence in excessive dress, laws are passed stating that the women of Florence must register their garments and get them officially approved.

c. 1300 Gothic art and architecture emphasize the beauty of the natural world in decorative details. Parallel ornamentation and natural motifs appear in costume.

1346 The English defeat the French at the Battle of Crécy in northern France. The rich costumes taken as spoils of war after this battle enrich even humble attendants of the English knights, allowing for their display of high style.

1348 The first wave of bubonic plague spreads throughout Europe. Recurring until 1400, the plague greatly reduces Europe's population, resulting in the concentration of the continent's wealth—including property, money, and clothing—in the surviving population. The newly enriched middle classes are thus able to indulge in fashions previously worn primarily by the nobility.

c. 1350 "Fashion" emerges as a recognizable social phenomenon at the same time as Gothic architecture (known as "Flamboyant Gothic") reaches its peak of ornamentation, demonstrating a widespread cultural taste for systems of decoration.

1356 The English defeat the French at Poitiers and return home with treasure and rich clothing, again providing the means by which the lower and middle classes might dress above their social station.

1363 The English Parliament expands earlier fourteenth-century sumptuary laws and establishes price and garment rules for seven social categories so that overspending is discouraged and members of each class are easily distinguished by their costume.

1375 The city-state of Aquila in Italy passes a sumptuary law forbidding males to wear very short doublets.

1377 The reign of King Richard II of England begins, and his court imitates Richard's preferences for extreme richness in fabric, color, and cut.

1380 The reign of King Charles VI of France begins, ushering in brilliant and excessive fashions that are imitated throughout Europe.

1385 Marriages are arranged between the children of Philip the Bold, duke of Burgundy, and members of the ruling counties of Hainaut, Holland, and Zeeland, extending Burgundian influence into the Low Countries, an area that will be a center for fashion until the early sixteenth century.

1399 Henry IV of England becomes king. His court follows the brilliant and extravagant fashions worn throughout Europe.

1413 The reign of King Henry V of England begins, continuing the emphasis on the brilliant and excessive fashions worn throughout Europe.

1415 The English defeat the French at Agincourt and bring home the spoils of war, including rich and fashionable clothing.

1422 The reign of King Henry VI of England begins, instituting a new fashion silhouette characterized by extreme height.

1430 The Statutes of Savoy are instituted by Duke Amadeus VIII, describing a hierarchy of 39 social groups and prescribing appropriate dress for each, disallowing inappropriate items, fabrics, and colors.

1461 The reign of King Louis XI of France begins, bringing with it a return to simpler dress styles.

OVERVIEW
of Fashion

FASHION DEFINED. Fashion, as the term is used in this chapter, refers to a dominant mode in dress in a particular place or time, usually a mode that is established by a perceived social elite or by notable persons. Fashion functions as a social phenomenon, setting standards of dress that periodically change when what once was new and desirable becomes ordinary and then must be supplanted by yet another innovation. Moreover, fashion as a social force possesses its own natural laws. For example, it appears that once innovative fashions move too far from what society perceives as the norm, it rejects these excesses, and a pendulum swing occurs with a return to an older or plainer style. Fashionable clothing must convey the impression of distinction, excellence, originality, and character expressed artistically. And, of course, fashion responds to the availability of new materials, dye stuffs, and technologies. The relative importance of each of these factors, although generally present in some combination, will vary at any given time. Therefore, a fashion system is characterized by constant change. Historians of costume agree that in Europe fashion as a social concept—that is, an ongoing awareness of self-consciously changing styles—began in the Middle Ages. By the middle of the fourteenth century, this system was well enough established to be the subject of ongoing commentary and concern, since the pressure always to be purchasing new and expensive clothing, with its emphasis on the human body, has moral implications. But even before fashion became a major force in society, elements of a fashion system were present in European courts, making it possible to trace the development of fashion as early as the age of Charlemagne in the eighth century.

SOURCES OF INFORMATION. Because of the fragility of materials and the socially downward movement of used garments, very little clothing from the early part of the Middle Ages has survived, but the paintings in illuminated manuscripts provide a wide range of examples of what people wore. Because it was common practice to illustrate even historical texts dealing with biblical or classical subjects with figures wearing "modern" clothing, books as well as the other visual arts (sculptures, reliefs, wall paintings, tapestries) from the ninth to twelfth centuries offer an ongoing record of fashion trends. Literature is also a source of information towards the end of this period, since the newly developing genre of the romance often included detailed descriptions of courtly heroes and heroines (though these, as well as images from the visual arts, must be used carefully since some details are merely conventional). By the thirteenth century, documentary records, including lists of items sold at fairs and expense ledgers from royal households, offer evidence of both the range and cost of clothing, while the trade poems that emerged in the last half of the century provide details of the kinds of costume goods offered by traveling peddlers (known as mercers) to customers at every level of society. One additional source of information is the gradually increasing tradition of recording wills and inventories of belongings, which by the fourteenth century extended to members of every social rank.

CLASS DISTINCTIONS. Members of higher and lower social classes have, of course, always dressed somewhat differently from each other. At the beginning of the period discussed here, society was, for the most part, divided between a small ruling class of warriors and a large laboring class that primarily worked the land. In the 800s, for example, when Charlemagne (Charles the Great) established the first European empire (called "Carolingian" after the Latin word for "Charles") to replace the Roman Empire that had fallen five centuries earlier, laborers throughout Europe wore a similar costume, common to both the newly dominant Germanic tribes and the earlier Celtic tribes they had displaced. This costume, for men, was made up of a short (mid-thigh-length) smock, belted at the waist, worn over leggings in cold weather and supplemented by a short cape, sometimes with a hood. Members of Charlemagne's court, on the other hand, maintained the simple style allowing vigorous movement necessary for warfare, but adopted some details imitating their Roman predecessors, adding a wool or silken braid to the hems of their tunics, loose bloomer-like "braies" (underpants) that tucked into their leggings, and a large rectangular cloak (which could double as a blanket) fastened at the right shoulder. By the late eleventh century, courtly robes had become long and voluminous in a more extensive imitation of Roman and Byzantine styles.

ELABORATION OF STYLES. Eleventh-century England provides an early example of a period that began to exhibit the kinds of changes typical of a fashion system.

The nobles' standard of living rose, cities were established, trade expanded, and craftsmen flourished, catering to the demands of nobles with money to spend. Following the Battle of Hastings in 1066, the victorious Norman nobility acquired the wealth of England. During the period when William I was establishing his rule, styles for both males and females were based on the long tunic and were relatively conservative as to cut and ornamentation. There was a change in taste, however, during the reign of his successor, William II (ruled 1087–1100). Clothes during this period were lavishly cut from luxurious cloth (some of which was brought back from the Holy Land after the First Crusade in 1095–1099), and both men and women adopted a variety of personal decoration. Still, the extravagance during this reign did not involve the creation of new styles so much as it did the exaggeration of known styles. For example, more fabric was used in the tunic; it was made both longer and fuller, resulting in garments with numerous folds and of a length that bunched fabric on the floor. Such tunics represented a considerable economic investment in a period when both cloth and clothing were thought of as commodities of exchange and were used much as money is used today. Across the twelfth, thirteenth, and the first half of the fourteenth centuries, a sporadic but escalating creation of a detailed set of fashions took place and the range of fabrics available expanded (in silks, for example, there were plain, patterned, and figured pieces in twills and other weaves), first brought back from the Christian military expeditions to regain the Holy Land (including the Crusades of 1095, 1146, 1188, and 1202) and later from the resulting expansion of production sites and trade.

CRAFTSMEN AND GUILDS. The increasing trade in both fabrics and dyestuffs became more efficient and vigorous in the middle of the thirteenth century as corporations of craftsmen organized in guilds to supervise training of workers, regulate quality, and specialize in production. In Flanders and in Italy, for example, craftsmen transformed bulk wool from England and silk from Sicily and the East into fine fabrics. In Paris, such specialization had, by the last half of the thirteenth century, resulted in groups of artisans that made doublets, others that made bonnets, and still others that produced shoes. Beyond an increase in quality, an additional benefit of specialization was that the craftsmen were skilled enough to create novel variations in garments and decorative design. These specialized artisans—like those in other kinds of guilds—regulated trade during the Middle Ages; scribes, goldsmiths, bow and arrow makers, and so on tended to intermarry within their own groups and live in certain quarters of the city which took their names

from the trade in question. Thus, a person shopping for certain articles of costume would generally find such items in home-based shops in specific neighborhoods, often indicated by a sign showing, for example, a representation of shoes or hats.

THE AGE OF FASHION. Fashion historians often credit the development of the doublet as the event which gave birth, around 1350, to an "age of fashion." The first appearance of this short jacket, which took its name from the padded garment used as soft body armor under metal armor, occurred at a time when the military importance of the armored knight on a horse was declining, being superseded in actual fighting by the efficient and deadly long- and cross-bowmen. In the latter half of the fourteenth and throughout the fifteenth centuries, the knight continued to be designated as a military leader, even as he became less functionally important as provider and warrior. Simultaneously, his presence in the court took on greater significance, and the knight sought to make a more spectacular impression through dress. At this time, the long, full robe employing rich folds of material, now considered appropriate to the upper civic elite class of lawyers, physicians, and merchants, as well as for male members of the aristocracy, was dramatically replaced by a new silhouette. If the previous generations had preferred to hide the body in sedate movement-encumbering robes that denied physicality, the styles of the 1350s—when the aristocrat's connection to combat was becoming more symbolic than real—emphasized male freedom of movement and sexuality in an hourglass figure. Especially in the 1500s, such new fashions were specifically associated with the courtier class of persons who maintained themselves by various forms of royal and ducal appointments and "preferments." Two features of this costume are notable: the *pourpoint*, or short doublet showing the legs and buttocks, and the long pointed shoes called *poulaines* supposedly originating in Crakow, Poland. These exaggerated styles, as well as a trend towards tall headdresses that seemed to mimic the perpendicularity of Gothic architecture, were the subject of numerous satires against excesses in court dress.

SOCIAL AND ECONOMIC FORCES. In addition to the development of new tastes in the royal courts of Europe, another significant source of fashion change may be found in the increasing affluence of members of the commercial class, which gave them the ability to adopt the styles worn by the nobility. Consequently, the nobility developed yet newer styles to assert their difference from, and superiority to, the commercial elites. This encroachment of the mercantile class upon the clothing styles formerly worn only by the nobility stimulated the

proliferation of sumptuary laws (laws against excess in food, clothing, and celebrations) to regulate dress in terms of income and birth status, with the aim of stabilizing the visual and social distance between the various levels of society, from the aristocracy down to the plowman. An additional factor that contributed significantly, if indirectly, to changes in late fourteenth-century tastes from about 1348 onward was the recurrence of virulent outbreaks of a plague known as the Black Death. The sweeping fatalities from this disease and its later epidemics in the fifteenth century are thought to have eliminated between 35 and 65 percent of Europe's population. Such decimation of the populace does not seem to have halted in any permanent way the overall tendency toward conspicuous consumption, but it is interesting to note that Italian sumptuary laws responded to the mortality caused by the plague by modifying dowry requirements, including those relating to clothing, in a way that would encourage marriages and, of course, repopulation through economic incentives. One additional effect of the plague on ownership of clothing was that survivors of this epidemic inherited the wealth, including valuable garments, of those who were victims, and thus such wealth was concentrated among fewer owners.

AN ARISTOCRATIC PREROGATIVE. In the Middle Ages, regardless of the increase of wealth among the commercial class and their imitation of noble dress, the trendsetters in clothing styles remained those at the highest level of society—especially those courtiers in power at the royal courts. A king was expected to maintain a high standard of magnificence not only in the quality of food and entertainment in his court, but also in his and his family's dress. And he was expected to epitomize *largesse* (generosity) in the giving of gifts, especially of cloth and complete garments, to his courtiers—a virtue the courtiers must in turn imitate with their inferiors. Thus, the consumption of fashionable cloth and garments spread from the top to the bottom of society; as fashion filtered down through the different levels of social class, these garments became increasingly "unfashionable." As a result, from the mid-fourteenth century onward, the pace of spending to create a fashionable appearance accelerated, changes in styles occurred more often, and the search for innovations in apparel eventually resulted in a standard of "precious elegance," overly refined elaboration of details such as slashed hems that revealed contrasting colors underneath, puffed sleeves (and, later, puffed trunks), or appliqué and embroidery work. Furthermore, the adoption of this standard coincided with a new acceptance of the concept of individuality, as opposed to the former custom of emphasizing

familial or social groups. This change in attitudes included the idea that an individual might express his or her unique personality through costume. Thus, fashion, understood as a pattern of change and differentiation, became an aristocratic pleasure, enjoyed by courtiers in the same way that they enjoyed other artistic works and extravagant entertainments.

THE ONGOING FASHION PROCESS. Ultimately, the change from the long flowing costume that completely covered the bodies of men and women alike in the late eleventh century to the short outer clothing assumed by the mid-fourteenth century male and the long fitted gowns with plunging necklines worn by their female contemporaries was a dramatic one. Adoption of the new short costume differentiated a young nobleman from his more conservative elders and emphasized his masculinity. Similarly, lowered necklines displayed female physical beauty. The long styles of earlier centuries persisted in the more conservative ranks of society, reaching their peak of linearity in the fourteenth century and continuing to be fashionable for another hundred years among civil, judicial, and academic professionals. Near the end of the fifteenth century, the masculine style went even further as shoulders broadened, headgear flattened and widened, codpieces (decorative pouches) were added to the crotch area of the wearer's hose, and the toes of shoes became blunt and broad in the so-called "bear paw" shoe style often associated with King François I of France. As previously stated, such periodic reversals are characteristic in a system of fashion.

TOPICS
in Fashion

FASHION AND CULTURAL CHANGE

MEDIEVAL SOCIAL STRUCTURE. In order to understand the history of Western Europe's costume from 800 to 1450 C.E., it is important to recognize the basic social structures and the dynamic changes that took place during this era. In the years leading up to this period, the fall of the Roman Empire had left much of Europe populated by the Germanic tribal peoples who had invaded from the east, pushing the formerly Romanized Celtic tribes westward, so that the society itself might be characterized by its emphasis on warfare and geographic mobility. Under these conditions, costume tended to vary little between that of the local chiefs or kings and that of their subjects, except by its quality of materials

and decoration. The most stable institution of society was the system of Roman Catholic monasteries where much of the wealth and learning that had arrived with the Romans was concentrated, but these were not yet organized into the numerous orders that would later lead to formalized distinctions in religious costume. It is only with the solidification of the power of the Frankish king Charlemagne and the establishment, in 800, of his empire over an area that includes what is now France, Germany, Italy, and the Low Countries, that medieval society began to stabilize, creating the conditions under which the aristocracy, now spending more time in the royal court than on the battlefield, would wish to distinguish itself by costume. By the eleventh century, a change in the economic and political system had created a hierarchy of lords, elite landholders, and land-working peasants, while in the centuries that followed, increased trade and economic development created a rising class of artisans, merchants, and financiers. At each stage, the impulse to distinguish one class of people from another through clothing became more intense, at the same time that the means of creating distinctive costume—through access to materials, craftsmanship, and wealth—were enhanced. Thus fashion in the Middle Ages reflects the complexity of a particular society in transition, as well as certain processes common to the development of fashion in general.

THE THREE ESTATES. Although the period from the twelfth century forward saw a rise in what would now be recognized as a "middle class," the traditional way of describing medieval society was in terms of the "three estates": those who fight (the nobility or aristocracy), those who pray (monks, friars, secular clergy, and the ecclesiastical hierarchy), and those who labor (peasants and serfs). There was also an important division between laity and clergy. This sense of how society was organized is basic to any discussion of fashion, since it is to the interests and concerns of the aristocracy that one must always look for the origin of fashion trends. Because the nobility of Europe originated as a warrior class, the males in this society continued to prefer a style of clothing that was designed for vigorous movement both in walking and in riding until the eleventh century. They wore brief garments called tunics that were cut close to the flanks and hips. Belted at the waist, these tunics were made of wool or linen, and were worn over *braies*—a sort of loose bloomer or shapeless trouser-like undergarment for men that was knee-length or slightly longer. The bottoms of the braies were usually tucked into full-length hose or bound close to the leg, and the large cloak worn over top could double as a blanket. This very practical garment reflected the functional role of the

aristocratic male, but at the same time it took on certain decorative elements more characteristic of a system of "style." During the Carolingian period, the hems of tunics were edged with woolen or silken braid, and the cloak, which was large and square, was fastened at the right shoulder in a style reminiscent of a Roman toga. Both of these touches suggest that costume was being used not only to provide an appropriate garment for work, but also to make a symbolic statement about the relationship between Charlemagne's new empire and the Roman empire that it replaced. The women in this empire wore longer versions of the male tunic. The clothing of the peasant, which often consisted of only a single smock or long shirt, worn over leggings and under a hooded cape in cold weather, would not be marked by decorative elements, nor, as long as a land-based economic system persisted, would it be subject to periodic change. Likewise, clerical garb for daily wear remained static because it was subject to ecclesiastical regulation and, in keeping with the imagined simplicity of Jesus and his disciples, consisted of the plainest of styles, while church vestments for the celebration of the Mass were determined not by fashion, but by their specific symbolic character.

THE HISTORICAL PROCESS. Throughout the Middle Ages, aristocratic costume evolved in a manner characteristic of all fashion change, illustrating the basic principle of periodic shifts and reversals of extremes. The era from the ninth century to the fifteenth saw major changes in social roles, political leadership, economic well-being, foreign influence, and the visual arts, all of which had some direct or indirect influence on styles of clothing. Such influences, however, do not provide the complete explanation for all the shifts that occurred sporadically from the ninth century—when T-shaped styles (cut from a single piece of fabric with a hole for the head, seams down the sides, and sleeves draped over the arms and sewn underneath) and relatively simple fabrics and ornamentation were the norm—to the late fifteenth century when excesses in luxurious, closely fitted, and fanciful dress were commonplace in the upper and middle classes. In this complex historical process, there were periods during which one or more aspects of current dress were carried to such an extreme—for example, the practices of vastly lengthening gowns, widening shoulder proportions, using excessive amounts of fabric in a gown, or tightening a garment to fit the body that had formerly been hidden among folds of fabric—that excesses were followed by a swing or return to conservative, opposite styles in dress. Such reversals in fashion, then, resulted from a variety of factors and contributed to the development of a system of fashion as a powerful force in the

DEFINITIONS
of Medieval Clothing

Bliaut: Either a costly fabric, a knight's court tunic, or a lady's court dress. When this term refers to the lady's garment, it signifies a gown of the richest fabrics, banded at neck and wrist edges with strips of embroidery; fur-lined; having a tightly-laced (at the sides) elongated bodice; a full, long skirt; and sleeves of various styles. The sleeves were often sewn on with each wearing, and one pair might be exchanged with another in the course of the day. As a fabric, bliaut meant silk, satin, or velvet imported from the Orient. This cloth was frequently woven with gold thread and embroidered with gems.

Braies: Loosely fitted linen thigh- or knee-length underpants worn by men of all classes.

Corse: The bodice of a bliaut, or a stiffened garment worn underneath a bodice made of lighter weight fabric. It could be laced tightly to shape the waist and torso.

Cotehardie: A short, tightly-fitting jacket-like garment for men popular from around 1333 through the mid-fifteenth century. In its earliest form, it was a tightly-fitting, low-necked garment reaching only to the knee, worn over a shirt, distinguished by a row of buttons that ran from the neckline to the low waistline. When worn by women, the cotehardie was somewhat less fancy. Buttons were optional, and no girdle was worn with it.

Courtepie: A short garment worn by men and women over other garments in the fourteenth and fifteenth centuries. The courtepie resembled the surcoat, and in its fifteenth-century version may have been the short houppelande.

Doublet (pourpoint, gambeson): A short garment for men with a tight waist and a thickness of padding through the chest; also a garment worn by knights, both as an outer garment (coupled with hose) and as padding under armor.

Girdle: A kind of belt introduced into female costumes in the eleventh century to give the female figure a more distinctive outline, but later worn by both men and women. Girdles were usually constructed as twisted cords, sometimes knotted, made from gold or silver wire and dyed wool or silks, and bound with ornamental fasteners or finished off with tassels. Simpler girdles were also constructed from a length of fabric that was decorated with stitching of a contrasting color.

Gown: See *Houppelande*.

Houppelande: A fourteenth-century garment of variable length that was worn over the doublet and hose. The longest version of this garment was worn for formal occasions and was ground-length or somewhat longer. A short version reached halfway between ankle and knee, and one of an even shorter length hit some inches above the knee. Initial forms of the houppelande had high collars that fanned out, but later collar styles differed. Belts were sometimes worn with houppelandes. Sleeves were funnel shaped, increasingly wide at their ends, and often edged with fancy cut-work ("dagging") and slashed to show fur linings of complementary colors. The short version was named "haincelin" for the jester Haincelin Coq in the court of Charles VI of France. After 1450, the more usual term for this garment was "gown." The houppelande was replaced by the robe later in the fifteenth century.

Mantle: A garment worn to protect its wearer from bad weather while serving also to designate high social status and power. Throughout the Middle Ages, variations in style depended on intended usage. In the period from 1066 to 1154, two shapes of mantles had long been in use—the semi-circular and the rectangular. These outer garments were bordered with contrasting colored embroidery interspersed with gold or silver threads. A mantle was often received from an overlord as a valuable gift, then bequeathed from generation to generation; because of its history, this garment increased in social significance through time.

Paletot: A short-sleeved, short and loose gown for men, sometimes worn as an over-garment with the doublet.

Poulaines: Leather shoes with long pointed toes, sometimes called *crakows*. Both names were associated with Poland where such shoes supposedly originated.

Pourpoint: See *Doublet*.

Robe: A name applied to many different garments during the Middle Ages, ranging from the long tunic in England (late eleventh century) to a complete outfit of a varying number of layers intended to be worn together, some of them made of silk, some furred (fourteenth century). In the fifteenth century, "robe" indicated a particular kind of gown, worn long for important events and short for ordinary purposes.

Tunic: A loose wide-necked garment, usually extending to the hip or knee and gathered with a belt at the waist.

dress of Europe. Regardless of their causes, of course, once the swings had occurred, the movement toward excess in dress would inevitably begin again and build toward another peak. The end of the fifteenth century was one such excessive period in the dress of the nobility and the commercial class that, by this time, also had the money to dress lavishly.

MEN AND THE AGE OF FASHION. Although in recent centuries society has been accustomed to thinking of fashion as an area of greater interest to women than to men, during the Middle Ages it was the clothing of men that underwent the most radical transformations. Female aristocratic costume retained a uniform set of basic elements, including a minimum skirt length at the top of the shoes, throughout the entire period; changes in fashion mostly concerned the tightness of fit, exposure of neck, chest, and shoulders, amount of fabric utilized, decorative elements, and the addition of such accessories as sewn-in sleeves, girdles (belts), and headdress. The clothing of men, on the other hand, underwent more profound alterations in garment type and especially length. These alterations reflect the change from an almost exclusively warrior image to a developing role as both warrior and courtier, and, finally, around 1350–1400, to a status in which the former military role was mainly symbolic. This last shift in male fashion, characterized by a major transformation from long to short costume, took place during a period when other economic and social factors encouraged interest in clothing as a reflection of status, and, as a result, led to an accelerated pace of imitation and alteration. Thus, the period from 1350 onward can be identified as The Age of Fashion.

SOURCES

Georges Duby, *The Three Orders: Feudal Society Imagined.* Trans. A. Goldhammer (Chicago: University of Chicago Press, 1980).

Joan Evans, *Dress in Mediaeval France* (Oxford: Clarendon Press, 1952).

Gilles Lipovetsky, *The Empire of Fashion: Dressing Modern Democracy.* Trans. Catherine Porter (Princeton, N.J.: Princeton University Press, 1994).

Françoise Piponnier and Perrine Mane, *Dress in the Middle Ages* (New Haven, Conn.; London: Yale University Press, 1997).

PEASANT COSTUME

IMAGES OF LABOR. The costume of the nobility is fairly familiar to modern historians thanks to its frequent depiction in manuscript miniatures, wall paintings, and tomb art. While such evidence is not as available for the more humble costume of peasants, there is still a considerable body of evidence to offer a rather precise idea of a costume which remained fairly fixed from about 800 to about 1375. Such sources include manuscript illumination, textual sources (including literature), and numerous French wills and inventories of garments in the possession of agricultural laborers. Moreover, some details of female agricultural costume were preserved in poems called *pastourelles* (from the French word for "shepherdess"), a type of song popular in both northern and southern France during the thirteenth century. These poems told the story of how a knight passing through a rural area tries to seduce or overpower a pretty shepherdess. Since the knight coming upon a shepherdess guarding her flock often describes her clothing as part of her charm, these poems also serve as a source of information about rustic female dress. A variant of the pastourelle called the *bergerie* (meaning "shepherd" in French) features an aristocratic observer of a group of shepherds in conversation or playing games. Information about their clothing or discussions of clothing sometimes form part of these poems.

PEASANT WOMEN. Regardless of class, women's costume had certain elements in common, although costume for peasants was drab in color and used far coarser materials and less ornamentation than did the clothes of the aristocracy. All classes of women apparently wore a white linen or hemp chemise or underdress with full-length sleeves, fitted at the wrists. There is no evidence that women in the Middle Ages wore underpants under the chemise, though men did. Women seem to have worn hose, though they were only calf or knee high. The chemise's neckline sometimes plunged to show the tops of the breasts, and its bodice was often laced horizontally or criss-cross. The chemise could be pleated on occasion. Over the chemise peasant women wore a long, tightly fitting dress similar to that worn by upper-class women. This dress was called a *cote* or *cotte*. The word *robe* in the earlier Middle Ages referred to an entire female costume made up of a chemise, a cote, and a cloak-like over-garment called *surcote* (literally, "overcoat"), or sometimes a mantel. For working outside, they wore a kerchief-like head-cover or a cap with a stiff brim and mittens. In some cases the cote was tucked up into the waistband of a white linen or hemp apron to keep its hem clean while the woman engaged in "dirty work." By the mid-thirteenth century it became fashionable for women to have the cote and a protective outer garment of a matching fabric called *burel*, which is both a coarse wool and a grayish-brown color. In some cases, as noted in death

Male farm worker with seeding apron and woman with sack of seeds. Labor for October, the Playfair Hours, use of Rouen, Victoria and Albert Museum MS L.475–1918, late 15th century. THE ART ARCHIVE/VICTORIA AND ALBERT MUSEUM LONDON/GRAHAM BRANDON.

inventories of possessions of late fourteenth-century Burgundian peasants, the cote is most commonly described as a shade of blue or, next most popular, a shade of red. Against the cold, the rustic woman would often have a cloak or sometimes a hooded surcote; this was apparently a very desirable garment, since in one anonymous thirteenth-century French pastourelle the practical shepherdess tells the narrator that he must give her a "sorcote" before she will make love with him. Somewhat wealthier female peasants wore cloaks trimmed with rabbit or cat fur. In fair weather female agricultural workers wore neither surcote nor cloak. They are often depicted in medieval manuscripts such as the Très Riches Heures of Jean de Berry (1415), sowing in the fields while wearing a special apron or overdress with a fold to hold the seed with the simplest of smocks underneath. Rustic women are easily recognizable in medieval manuscript painting by the presence of a large brimmed, rather flat straw hat, very like that worn today by farm workers in Asia.

MALE AGRICULTURAL COSTUME. Throughout the period, male peasant clothing was largely similar to the costume that upper-class men had worn in the Carolingian period (eighth to tenth century), when the main concern of the warrior class was to have freedom of movement. Even when male aristocratic costume lengthened, peasant costume remained at the knee or just slightly below. Beginning with the feet, typical male peasant costume consisted of hose of a sturdy white fabric (in good weather) worn inside low patchwork shoes with leather soles and heels. In winter, the peasant wore gaiters or leggings, usually made of canvas or leather, over his hose. His undergarments were the chemise, similar to that worn by women but with long split tails in which he often wrapped any coins he might have, and linen *braies* (underwear). Over the chemise he wore a sleeveless cote, often with double facings—broad strips added on the chest and shoulders for warmth and resistance to wear. This was sometimes called in Old French the *jupeau* or *jupel* and could be made of the coarse

a PRIMARY SOURCE *document*

SHEPHERDS' CLOTHING

INTRODUCTION: The only medieval text to describe in some detail the actual dress of shepherds is the treatise by Jean de Brie called Le Bon Berger, or The Good Shepherd, supposedly written at the command of King Charles V of France in 1373. The practicality of the average agricultural costume described here highlights the functionality of shepherds' clothing, which stands in stark contrast to the "luxury" of courtly attire.

The shepherd ought to wear stockings of a sturdy white cloth or of a camel-hair fabric and some slippers with soles and heels of sturdy leather. In winter, he ought to have, over his hose, gaiters or leggings cut from the leather of old boots, to keep off rain. To last longer, the heels and soles ought to be sewn with a stout hempen thread well waxed … And the shepherd ought to be able to squat on his heels, under a bush when it is necessary.

The shepherd's chemise and braies ought to be of a thick and sturdy linen fabric called canvas. The garters or suspenders (brayette) holding the hose to the braies ought to be made of cloth about two fingers wide with two round iron buckles. The chemise should be split into two tails, and these ought to be long and shaped like a small handkerchief so that the shepherd can wrap up his coins inside and tie the bag with a simple knot. Over the chemise he should have a coteron or sleeveless mantle of white linen or of gray camel hair [imitation camelin of goat hair]; this ought to be double faced over the shoulders as far down as the belt in order to protect his chest and belly from wind and storms and to allow him to walk across the fields more surely behind his sheep, for they are of such a nature that they go willingly against the wind.

Over the mantle the shepherd ought to have a surcote, a garment of white linen or of gray camel hair ending in two square bibs. The one hangs like an apron before and the other behind, protecting from cold both belly and loins. It has sleeves and is large and ample enough so that he can get it on easily without buttons. For it is not suitable to have buttonholes or hooks that can annoy him when he is getting dressed. Rather he ought to enter it directly, as if getting into a sack or like Aaron's tunic. Above the surcote he ought to have a surplice of canvas with sleeves and four buttons. This surplice protects the shepherd from the rain, and sometimes he will have to remove it to wrap up a lamb just born in the field. Around his surplice he ought to have a girdle of fine strong cord, braided of three strands, with a round iron buckle. From this girdle he can suspend various things. …

He ought to hang from this girdle a scabbard in old taw or rough-tanned leather or eelskin in which to keep his flail. And he ought to carry a pouch in which to keep his bread and food for his dog. It ought to be of a kind of netting suitably knotted in the fashion of a potter's harness. This pouch ought to be worn on the shepherd's left in order that it not encumber his right side so that he can easily shear, trim, anoint, and bleed his sheep, if need be. And to the pouch ought to be attached a dog leash of about a yard and a half in length which ought to be redoubled back to the pouch. In the middle of the leash he ought to have a piece of leather with a small toggle of wood to attach and unhook his dog and send him easily and quickly against wolves and other annoying animals which wish to seize his sheep. …

It is proper that the shepherd wear a felt hat, round and very large. On the brim and upper part of the crown fabric ought to be doubled a palm's length or more. This doubling is necessary for two reasons. At first to protect the shepherd from rain and bad weather when he goes against the wind behind his sheep. Secondly, for the profit of the master who owns the sheep. For each time that the shepherd goes to anoint the animals against the scab and he cuts the wool away with his scissors to get to the scabbed spot, he puts the wisps of wool and clippings in the folds and doublings of his hat, in order to return them to the master at the house. For he is obliged to look out for his master's interests in doing his offices as a shepherd. This hat is usefully adapted to a shepherd's life as much to protect him from rain, wind and storm as to cover his head. …

In winter the shepherd ought to have some mittens to protect his hands from the cold. He ought not to buy them but make them himself whether he knits them with needles in the fashion of a canon's hood from a skein of wool spun by the hand of a shepherdess, or whether he makes them from cloth of several colors to his own taste; when they are made of such motley bits of cloth they are very pretty. When it is not too cold where the shepherd can work with his hands, he ought to hang these mittens from a small ball hooked to his girdle. …

SOURCE: Jehan de Brie, *Le Bon Berger. Le Vrai Règlement et gouvernement des bergers et bergères.* Ed. Michel Clévenot (Paris: Stock, 1979). Translation by John Block Friedman.

A SHEPHERD'S FASHION ADVICE TO HIS SON

INTRODUCTION: Shepherd costume is often described in a variant form of the pastourelle called the berg-erie, from the French word for "shepherd." These poems were popular in the 1360s; one appearing in a collection of lyrics now in the University of Penn-sylvania Library (MS Van Pelt 15) is particularly rich in concrete information about male peasant cos-tume. It also shows the same satiric attitude toward excesses in costume applied to the ornate head-dresses of women. In this bergerie, a shepherd named Herman, now 100 years old, offers sartorial and moral counsel to his son Robin—a stock name for a shepherd.

"[Make sure] that you wear a white smock, patchwork shoes laced high and fastened with three iron clasps. Beware of short smocks showing your behind and codpiece in tight-gathered drawers when you squat and crouch, and do not wear pointed and windowed shoes." ...

[The dutiful Robin agrees to do just as Herman commands:]

"Father, I will do your will. No poulaines will be my shoes, causing me to trip as I go. I will not walk about with my stomach belted in tightly nor with my hose attached to my smock, for in kneeling when girded thus, all will rip in several places."

Translated from the Middle French by John Block Friedman.

Laborers threshing, with gowns tucked up and braies or under-pants exposed, lower left. Maciejowski Bible. © PIERPONT MOR-GAN LIBRARY 2004. THE PIERPONT MORGAN LIBRARY, NEW YORK. M. 638, F. 12V. PHOTOGRAPHY: DAVID A. LOGGIE.

grayish brown wool called burel if undyed, or perhaps dyed dark gray-blue with woad, a pigment-producing plant. The jupeau could also be made of heavy canvas. For many tasks, the peasant would wear a linen or leather apron over the cote. An example of a male laborer with such an apron for seeding occurs in a calendar for a book of hours (daily devotions and prayers) now in the Victoria and Albert Museum, London. The full peasant costume is illustrated in a manuscript miniature from the Maciejowski Bible in the Pierpont Morgan Library in New York, which shows a peasant at work in a cote, tucked up into his braies. On top of his chemise and mantel against inclement weather was worn the surcote, also of white linen or of matching wool with bib-like extensions at front and rear. This was usually cut large and had no buttons. A girdle or belt on which pouches could be hung to hold sharpening stones, sewing implements,

or, for shepherds, salves or even dog food, completed this outfit. Peasant men usually wore a large round felt hat and fingerless woolen mittens, in contrast to the fancier gloves worn by aristocrats.

A CHANGE FOR MEN. By the mid-fourteenth century (1350–1375), members of the working class less frequently spent their lives confined to manors where they labored and began to have increased access to consumer goods. This new freedom translated into fashion as the male costume changed somewhat and began to imitate courtier garb, which had by then become shorter and more tightly fitted. In particular, the cote was radically shortened, coming just to the buttocks or slightly below, and the plowmen or urban industrial workers wore hose that were tightly fitted and cut on the bias to give them elasticity. The hose were attached to the hem of the cote by laces, sometimes with metal ends called *points*. For vigorous work involving bending, these laces were left unfastened.

SOURCES

Janet Backhouse, *Medieval Rural Life in the Luttrell Psalter* (Toronto: University of Toronto Press, 2000): 24.

Monique Closson, et al., "Le costume paysan au Moyen Age: Sources et méthodes," in *Vêtements et sociétiés (Actes des journées de rencontre des 2 et 3 mars 1979)* (Paris: Laboratoire d'ethnologie du Muséum national d'histoire naturelle: Société des amis du Musée de l'homme, 1981): 161–170.

Jehan de Brie, *Le Bon Berger; Le Vrai Règlement et gouvernement des bergers et bergères.* Ed. Michel Clévenot (Paris: Stock, 1979).

Alma Oakes and Margot Hill, *Rural Costume, Its Origins and Development in Western Europe and the British Isles* (London: Batsford, 1970).

Françoise Piponnier, "Une Révolution dans le costume masculin au XIVe siècle," in *Le Vêtement: Histoire, archéologie et symbolique vestimentaires au Moyen Age.* Vol. 1. Ed. Michel Pastoureau (Paris: Cahiers du Léopard d'Or, 1989): 225–242.

ACADEMIC, CLERICAL, AND RELIGIOUS DRESS

STANDARDIZING FOR SIMPLICITY. Similar to peasants, members of the second estate—those who led a life associated with the church—wore costumes that were not nearly as subject to changes of fashion as the costumes of the aristocracy. Clothing worn by those who served the Christian church was intended to symbolize the simplicity of life modeled by Jesus. The ruling that required all men and women in cloistered religious orders—that is, monks and nuns who lived apart from the world—to wear habits was established by a consensus of church officials several centuries after the founding of the Benedictine Order of monks in 529. Canon 27 (a rule regulating dress) was initiated as early as the Fourth Council of Constantinople (869–870) and reaffirmed in the Fourth Lateran Council in 1215. These councils, known as "ecumenical" (that is, intended for creating unity), included cardinals, bishops, and superior abbots throughout the whole Christian world and were convened by the papacy. The influence of these rules extended to university students, a relatively new group in the later Middle Ages, for whom religious costume was adapted according to their stage of education. Another group that imitated the simplicity of the early church in their costume were pilgrims, who were to be found on land and sea throughout Europe and the Middle East as they made their way to sacred shrines for purposes of penance or, sometimes, the simple desire to travel.

MONASTIC AND SECULAR RELIGIOUS COSTUME. The founder of each holy order in the Roman Church of the Middle Ages established a Rule under which his or her members should live, and these rules specified appropriate and uniform clothing that illustrated the religious beliefs of that order and served as its identifying insignia to the public. It was desirable that these members, often withdrawn from the world, should demonstrate this withdrawal by avoiding all display of worldliness, especially in their dress. For example, the Rule of St. Benedict, written for monks and adapted for nuns, specified that only locally produced, inexpensive fabrics might be used for religious dress, and the finished garment was to be without decoration. The standard garments for Benedictine monks included braies, over which was worn a long robe with cowl or hood, a belt or girdle, stockings, and shoes. Similarly, the basic dress of Benedictine nuns was a *cotte* (a black surcoat with wide sleeves or a mantle), a headdress consisting of a white under-veil and black over-veil, and a white wimple (a cloth covering the neck, sides of the face, and some portion of the forehead still worn by some orders of nuns). A *pilch* (a cloak made of skins or fur), and/or a fur-lined mantle were allowed in more severe climates. For secular clergy—that is, parish priests who lived in quarters near their churches—there were, however, no hard-and-fast rules about what to wear when they were not officiating at Mass. They were urged to dress soberly.

FRIARS. The four orders of friars (Franciscan, Dominican, Augustinian, and Carmelite) differed from members of cloistered religious orders in that they were not removed from the general society. Friars were out and about in the world, begging for their subsistence, hearing confession, sometimes teaching, and sometimes acting as spiritual advisors to wealthy families. Ordinary peasants' dress was the model for their habits. St. Francis set the standard for his followers to have and wear only one tunic with a rope girdle, one hooded coat, and, if needed, a second unhooded coat, and no shoes. He specified that only the simplest materials might be used to make these garments, and they should be patched with the same kind of fabric. Franciscan friars wore brown hoods, brown loose robes with loose sleeves, cord girdles (belts) with knots showing, and sandals. The brown (or indeterminate gray) associated with Franciscans distinguished them from the Dominicans, who wore black over white (they were thus called the Black Friars), as well as from the black monks (Benedictines) and white monks (Cistercians).

STUDENT DRESS. Since universities grew indirectly out of the cathedral schools that first began to be established in the 800s, most students in medieval universities were initially required to take "minor" holy orders, the first step towards becoming priests. Indeed, students

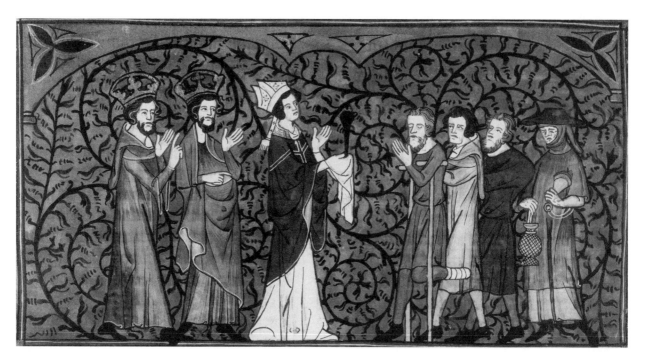

Two priests and a bishop bless beggars. Chronique de St. Denis, London, British Library MS Royal 16. G.VI, 1325–1350. © THE BRITISH LIBRARY/TOPHAM-HIP/THE IMAGE WORKS.

were known in English and French as "clerks," or *clercs*, a word also meaning "cleric." Thus, in certain ways academic costume developed from secular religious dress in the later Middle Ages. As the universities became more formally structured in the thirteenth century, university officials began to pay attention to academic dress for scholars of all ranks in the system. Bit by bit, a detailed system of dress developed that indicated each gradation from bachelor to doctor in a university career. In the thirteenth century, the basic garment was a dark-colored *vestis talaris*, a long tunic. When styles for men were shortened and the pourpoint or short doublet grew popular among younger men in the fourteenth century, student dress retained the "long robe" of sober color, which reached to the ankles. Over this "long robe" students were expected to wear either a formal full-sleeved cope, or cape, which was briefer than the tunic (*cappa manicata*) or, for normal wear, a larger, sleeveless over-garment, also reaching to the feet, having one slit, mid-front, so that arms and hands could reach out, or having slits on each side (*cappa clausa*). These slightly modified religious habits, both for students and for teachers, survive as the academic dress that is still worn for graduation ceremonies today.

VIOLATIONS OF DRESS CODES. The fact that university dress codes—apparently based closely on the disciplinary decrees regarding clerical dress of the Fourth Lateran Council of 1215 held under Pope Innocent III—

were often violated may be inferred from university records where certain items of clothing were periodically and repeatedly forbidden. The wearers of offending garments could be fined or denied privileges. Among the forbidden items were red or green garments (which were considered vain); "secular" shoes (that is, those with cut-out designs); curved or decorative hoods; swords or knives; fancy belts (girdles) enhanced with silver or gold trim; trunkhose, puffed sleeves, red or green hose, or boots that might be seen beneath long garments; and garments that were too short or fitted too tightly to the body (as was increasingly fashionable in late fourteenth-century secular costume). Such attention to color, fabric, and cut showed that the wearer was too worldly and not sufficiently serious for university life. Tailors who made such gowns for academics were subject to imprisonment and non-payment until these tunics were altered to the appropriate dimensions. Certain universities, such as the University of Toulouse, set up systems of dress for scholars of all ranks with economy and seemliness in mind to keep them from spending their fee, book, and subsistence money on clothing. In addition, other rules ensured the plainness of student head coverings: the *pileus*, a close-fitting skullcap; the *biretta*, a square cap with three ridges at the top and sometimes a tuft in the middle; and the hood. Over time, these requirements for plainness gave way to color schemes assigned to each field of study to distinguish one faculty from another and to

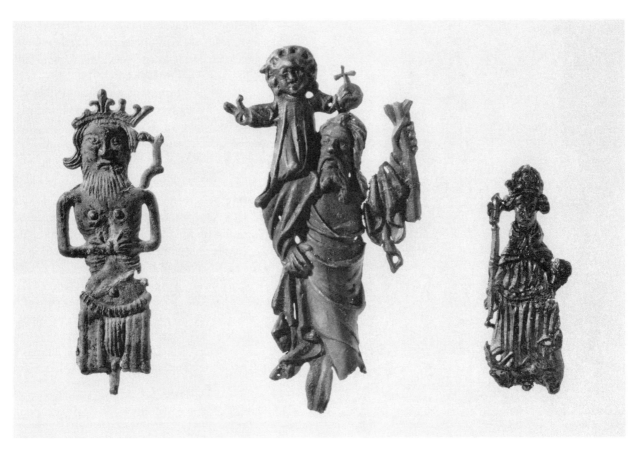

Three pilgrim badges, St. Christopher with Christ child in center. 14–15th centuries. © MUSEUM OF LONDON/TOPHAM-HIP/THE IMAGE WORKS.

satisfy the desire for pageantry and display. For example, those who became Masters (achieved a Master's degree) of Civil Law at some time before the late fifteenth century adopted dark blue as the color of their hoods (a practice in color choices retained in the twenty-first century). Similarly, Doctors of Medicine chose red for the color of their robes. The colorful academic hood worn by those who achieve doctoral degrees today is a remnant of this system, as are the black velvet bands sewn to the arms of academic gowns to signify master's or doctoral status.

CHURCH VESTMENTS. The particular garments worn by priests when officiating at divine worship and administering the sacraments are called vestments. Because they symbolized the glory of God and the church, such garments could be constructed of costly fabrics, with much ornamentation, and dyed in colors established by long use. When the priest celebrated Mass, he wore six specialized garments: the amice, alb, girdle, maniple, stole, and chasuble. The *amice* is a handkerchief-like fabric that covers the shoulders; the *alb* is a floor-length white gown with full, long sleeves. The gir-

dle of white tasseled cord belts the alb at the waist, while the *maniple* (from the Latin word for "hand") is another handkerchief-like cloth that is worn over the left forearm. The stole is a white knee-length scarf around the priest's neck, very much like a modern dress scarf. The chasuble is worn over all of these garments. Other vestments were the dalmatic, surplice, cope, and pallium. A *surplice* was the garment of the choristers or singers in the choir; it was of white linen and knee length. A bishop wore the *pallium*, a narrow woolen scarf with purple crosses embroidered on it, and a cope or chasuble-like outer garment. He carried a *crozier* (a staff with a hooked end like a shepherd's crook) and wore a type of pointed headdress called a *mitre*.

PILGRIM'S COSTUME. Pilgrims were sometimes members of religious orders and sometimes lay travelers who were engaged in a religious or penitent voyage to a sacred shrine. They wore a distinctive set of garments and accessories and were treated by others as religious persons. This costume distinguished them from other travelers as proper recipients of wayside charity and helped protect them from thieves. Medieval pilgrims

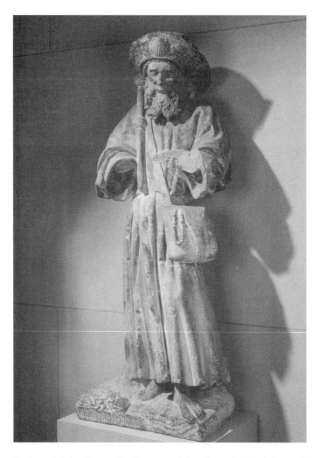

Statue of Saint James the Greater with scrip and wide-brimmed hat with a scallop-shell badge. His staff has broken off. Burgundy, Paris, The Louvre, 15th century. © ADAM WOOLFITT/CORBIS.

carried a walking staff and a *scrip*, or bag, with strap that could be worn across the shoulders for the purpose of transporting the pilgrim's minimal possessions, possibly including a begging bowl, on the journey. Their chief garment was a tunic, normally made of the roughest fabric, sometimes worn or ragged, and a broad-brimmed hat with the brim turned up in the front. Attached to this hat were various insignia in paper, parchment, pewter, or tin that denoted the shrines the pilgrim had visited. The emblem of a scallop shell served as the traditional pilgrim sign of St. James of Compostela. A pilgrim would wear this shell to show that he had made a pilgrimage to the saint's shrine in Spain. For each new pilgrimage the traveler added an appropriate insignia. Thus, someone who made a pilgrimage to Canterbury might return with a badge in the form of a Canterbury cross or one depicting St. Thomas Becket mounted on a horse, while those who came home from Rome displayed Rome's signature pilgrim badge—a *vernicle*, the depiction of Christ's face on a replica of St. Veronica's veil. While on pilgrimage, it was also not uncommon in

the later medieval period to carry a coral rosary (symbolically significant because of the cross-like branching of the original material) in a convenient manner for ready use—over the arm, or suspended from the belt—both for regular prayers and because it was believed that the rosary itself, as well as prayers, protected the pilgrim from possible dangers of the road and from ill health. No shoes are mentioned among these garments and accessories because the greatest piety was demonstrated by going barefoot. Nevertheless, some pilgrims did wear rough sandals or shoes.

RELIGIOUS VANITY. In spite of all this regulation, beneficed priests—that is, parish priests who had the income from a specific church and piece of land in a parish—and even monks and friars often dressed as they liked, and sometimes quite sumptuously. Chaucer's Friar in *The Canterbury Tales*, for example, wore a cope which was too short and turned his tippet or hood into a peddler's bag stuffed full of small items to attract the attentions of parish wives. At the Convocation of the Province of Canterbury in England, held in 1460–1461, a complainant alleges that

> in modern times a certain abuse has appeared … that simple priests and other priests over and above their grade and status openly wear their apparel in the manner of doctors or of other worthy men. … They do not wear their top garments closed but the whole of the front part open, so that their private parts can be seen publicly in the manner of laymen, and many such priests have tight hose and hoods with tippets joined to them and have the collars of their doublets made of scarlet or other bright outlandish dress publicly showing above their gowns or tunics … to the great scandal of holy orders.

Repeated councils dealt with this problem and addressed numerous details of dress that were forbidden in order that the garments of clerics and laypersons might be visibly different. Later councils even set forth regulations with the aim of distinguishing so-called "simple" priests from those who were elevated in status and/or education.

SOURCES

F. R. H. Du Boulay, ed., *Registrum Thomae Bourghier* (Oxford: Oxford University Press, 1957): 92.

W. M. Hargreaves-Mawdsley, *A History of Academical Dress in Europe until the End of the Eighteenth Century* (Oxford: Clarendon, 1963).

Malcolm Jones, *The Secret Middle Ages* (Thrupp, Stroud, Gloucestershire, England: Sutton, 2002): 13–33.

Janet Mayo, *A History of Ecclesiastical Dress* (London: Batsford, 1984).

Diana Webb, *Medieval European Pilgrimage c. 700–c. 1500* (New York: Palgrave, 2002).

SEE ALSO *Literature: The Canterbury Tales; Philosophy: The Universities, Textbooks, and the Flowering of Scholasticism; Religion: Friars; Religion: Relics, Pilgrimages, and the Peace of God*

ARMOR AND HERALDRY

COSTUME FOR MILITARY IDENTITY. Throughout the medieval period, the upper-class male maintained his sense of aristocratic identity in part through wearing the specialized clothing and insignia of military life. This clothing was connected to both military combat itself and the peacetime military exercises known as tournaments, which served not only to provide practice for knights in training but also spectacle for members of the aristocracy. Defensive clothing changed radically during the period from the eighth to the fifteenth centuries, and these changes were largely in response to the evolution of new methods of combat and military organization. While early medieval warriors (before the year 1000) fought in tribes and encountered each other mainly on foot, the development of a system of lordship usually referred to as "feudalism"—based on the idea of an exchange of land for part-time military service as an obligation to an overlord—created a class of mounted soldiers (knights) who were obligated to present themselves, their weapons, and their horses for a certain number of days a year to satisfy the requirements of their contract with the overlord. These knights, known as vassals, formed small troupes accompanied by younger noblemen called squires who acted both militarily as supporters and also as servants. Owing to the cost of their equipment, as well as of the horses for both traveling and combat, only quite wealthy persons could muster such a group and own the armor and weapons that the new style of mounted combat required. The connection between wealth and military costume in this strongly hierarchical social system was further reinforced when decorative elements were added to serve as a way of identifying the individual knight, who was anonymous once clad in his armor. Not only did these decorative elements, in the form of coats of arms, provide a way of distinguishing one knight from another, but they also contributed to the visual stimulation of tournaments and indicated the family lineage that set the aristocrat apart from the other classes.

LEATHER AND CLOTH. The military costume of the Germanic peoples, including the Vikings who conducted

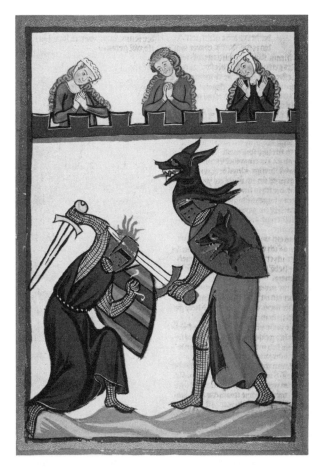

Dietmar der Sezzer and another knight with heraldic coat of arms and helmet disguise. Manesse Manuscript, Heidelberg, Universitätsbibliothek, Cod. Pal. Germ 848, 1300. THE GRANGER COLLECTION, NEW YORK.

raids throughout northern Europe well into the eleventh century, was largely like that of the workers on the land. From about the first century C.E. until about 1150, the warrior's costume was short enough to allow for freedom of movement, and used layers of animal skins or padded fabric to protect the wearer from hacking swords and spear thrusts in close quarters. It was not intended to stop projectile weapons, which were not then in common use. Though this defensive costume had bosses (circular metal plates covering critical areas on the body) and fastening pins of iron or precious metals, only the head covering was of solid metal; this helmet was in the form of a pointed cylinder, often surmounted by an ornament such as the boar's head mentioned in the Old English heroic poem *Beowulf,* which details battles and military life in Scandinavia during the seventh to ninth centuries. Some forms of the helmet during the Carolingian period (eighth to tenth centuries) had a protective bar or "nasal" which came over the nose and sometimes flaps which served as cheek protectors.

CHAIN MAIL AND PLATE ARMOR. Military costume changed markedly with the rise of lordship in the eleventh century. The knight who served as a vassal to an overlord held a well-defined place in the social hierarchy and soon had a costume intended both to distinguish his social class and to protect him in the new style of combat, in which mounted knights charged at each other with lances in an effort to unhorse their opponents. Once the knight was dismounted, he fought with sword, axe, or mace—weapons requiring a defensive costume that protected against piercing and blows. This costume evolved rather quickly between the eleventh and twelfth centuries and differed in a number of ways from the older Germanic or the even earlier Roman style of military dress. Over the knight's outer robe known as the *bliaut* or later the *cote*, he wore a vest, often called a *gambeson*, made of *cuir bouillée* (leather boiled to make it tough) or of padded linen, a garment often worn alone as soft armor by non-aristocratic warriors. It was slit at the sides and in the middle of the lower portion, which allowed its lower panel to drape protectively over each thigh as the knight sat on a horse. Over this vest was another waist-length garment called the *brogne* or *burney* from German and French words meaning "bright," which was made of many tiny rings of iron linked together like chains into a sort of metal "fabric" that allowed movement. Up to the eighth century or so the early version of this garment had not protected the neck, but a caped hood of mail soon developed, called in Old French a *hauberc*. Some armor historians use the term "hauberc" to refer to the whole mail garment, but *haubergeon* is the correct term. This chain-mail garment could be sleeved or sleeveless, but it came up over the head and neck in a characteristic hood-like fashion and was supplemented by an iron skull-cap-like conical helmet for further protection. At the end of the eleventh century, through contact with the great metal-working centers of Damascus in Syria and Toledo in Spain, French knights obtained the finest quality haubergeons of mail, in which each ring was welded for strength and had sleeve-like extensions to protect the lower arms. Matching chain-mail-covered leather gauntlets (forearm-high gloves) and cloth or leather leggings with chain mail came into use about 1150 and continued to about 1330, completing this relatively light and flexible defensive costume, especially suitable for close hand-to-hand combat. From about 1350 onward, armor responding to the technology of archery developed; now key areas of the haubergeon would be reinforced with plates of iron, flattened cow horn, or boiled leather to protect the wearer from the bolts or shafts of the crossbow, which appeared in France as early as the mid-tenth century, and the long bow, in use by 1290 or so. Gunpowder weapons appeared around 1350. From 1330 to about 1450, knights attempted to protect the entire body against these projectile weapons by the addition of plates of iron, eventually linked together by leather straps, and cylindrical helmets with eye and breathing holes. But this standing suit of armor, which is so familiar in modern depictions of castles and medieval life, was unwieldy and eventually became mainly ceremonial.

THE COAT OF ARMS. On top of chain mail, as early as around 1100, knights began to wear a long thin fabric garment. It could be sleeveless and open under the arms, or it could have short sleeves. Beginning around 1130, this shirt, which buttoned down the front, often had painted or embroidered on it a shield-shaped insignia called a *cote a armer*, or coat of arms, which identified the disguised knight at a distance. This technique apparently developed during the period of the Crusades in imitation of an Islamic custom of painting an image (a blazon) on the knight's shield to identify him to his own troops, who could then recognize and defend him. The cote remained in use until 1410, and its ensign or design contained elements such as bars, stars and stripes, flowers, animals, crosses, and other images that enabled the knowledgeable viewer to know the whole lineage of its wearer. Such insignia were also painted on the outside of the knight's shield where they could easily serve to identify him when his cote might be obscured. In addition to these two forms of insignia, knights also often carried banners, wore scarves around the helmet (again probably in imitation of their Islamic rivals), and decorated their horses with cloth trappings. These markings and patterns soon became hereditary so that a knight bore the insignia, with small identifying changes, that had been worn by his father and grandfather. Since the possibilities for deception existed, heralds—persons knowledgeable in family history—were trained as early as the 1130s to recognize and validate the knight's right to display the coat of arms.

THE INFLUENCE OF HERALDIC DECORATION. Over time, displays of arms provided a popular motif for the decoration of civilian costume, as, for example, in the use of the *fleur de lis* (the symbol of the French royal family) as an appliqué on royal robes and dresses. Such designs also began to move from costume to architecture, in the stained glass window of a chapel donated by a certain local family or carved on the façade of a building. The coat of arms might also be inscribed on jewelry (still common on the modern signet ring) or painted on the title page of an illuminated manuscript to indicate ownership. Arms were placed on tombs of knights in churches as early as 1135 where the sculpture

of a knight in lifelike armor, often with his dog at his feet, was displayed atop the tomb chest with armorial shields at the sides of the chest. When members of noble households married, the symbols of the two families were often combined to form a new heraldic device in which the arms are said to be "impaled" or divided down the middle, with those of each family occupying half of the shield. This "impalement" brought the influence of the coat of arms back to fashion as it gave rise to "particolored" costume in which one leg of hose might be red and the other green. With the gradual coming to power of a civic elite through trade or administrative service, a person's arms could often include elements of the occupation his preeminence was founded on; in the north of England, for example, the family called Bowes, from their original trade as makers of bows and arrows, showed a pattern of bows presented vertically in panels on the shield. Eventually corporate entities such as cities, universities, and even colleges within universities all came to have arms which were displayed on plates, draperies, in stained glass, and the like.

SOURCES

Claude Blair, *European Armor circa 1066 to circa 1700* (London: Batsford, 1958).

Jim Bradbury, *The Routledge Companion to Medieval Warfare* (New York: Routledge, 2004).

Gerard Brault, *Early Blazon: Heraldic Terminology in the Twelfth and Thirteenth Centuries with Special Reference to Arthurian Literature* (Oxford: Clarendon, 1972).

François Buttin, *Le Costume militaire au Moyen Age et pendant la Renaissance* (Barcelona: Real Academia de Buenas Letras, 1971).

Claude Gaier, *Armes et Combats dans l'universe médiévale* (Brussels: De Boeck, 1996).

Paul Martin, *Arms and Armor from the 8th to the 17th Century* (Rutland, Vt.: Tuttle, 1968).

David Nicolle, *Arms and Armor of the Crusading Era, 1050–1350.* 2 vols. (White Plains, N.Y.: Kraus, 1988).

Michel Pastoureau, *Heraldry: An Introduction to a Noble Tradition* (New York: Abrams, 1997).

Matthias Pfaffenbichler, *Armorers.* Medieval Craftsmen Series (Toronto: University of Toronto Press, 1992).

SEE ALSO *Religion: The Military Orders*

THE RISE OF COURTLY COSTUME

COURTLY DRESS AND CHRISTIANITY. With the relative calm and stability of the empire established under Charlemagne and his Ottonian successors, a renaissance of court costume—that is, costume to be worn at times when freedom of movement was not required for fighting—arose in the tenth and eleventh centuries. It was characterized by both splendor of fabric and cut and a Roman solemnity or soberness in style. This costume was a reaction to the older pagan Germanic or "Barbarian" dress styles, which were chiefly military and short. This newer courtly costume was considered "Christianized" because it was modeled on the long robes supposedly worn by the Evangelists. It also showed marked Byzantine influence, for costume in the Eastern Christian capital of Constantinople had long been floor length. It appears, then, that long costume in a Roman style was absorbed by the spread of Christianity and became the garb of Christians of both high and middle station, above the peasant class. Thus, when St. Bernard preached the first Crusade in 1095 and complained about the excessively long skirts and rich ornamentation of Western aristocratic costume, he showed that elaboration of cut in the standard long costume was already a fashion element by the end of the eleventh century. Indeed, the fact that so many bishops commented in sermons on this lengthening and ornamenting of long costume indicates that it was the norm for both men and women above the level of the laboring classes and that it was primarily the excessive lengthening and the fashion for dragging trains and rather pointed shoes with curved toes for men and women that was seen as foppery and extravagance by those preaching against the sins of pride and luxury. That people sought to elaborate costume to this degree and that such trends disturbed moralists certainly suggests that a strong desire to imitate the clothing of the elite existed already at the end of the eleventh and through the middle of the twelfth centuries.

BYZANTINE FOUNDATIONS. The courtly fashions of the eleventh century made use of silks and patterns of ornamentation that were popular in the Byzantine Empire, the eastern Christian realm centered in Constantinople (now Istanbul, Turkey). The question of when such styles were introduced to the West is, however, complex. It has for many years been believed by costume historians that long and highly ornamented robes and other garments employing silks came from the East only in the aftermath of the First Crusade at the end of the eleventh century. More recent opinion, however, suggests that such garments had been native to the Carolingian empire for several centuries, largely because of continuing trade between the Byzantine Empire and the West, especially trade in silks that entered Europe by way of Venetian merchants. And after the Moorish conquest of much of what is now Spain, silks from Andalusia also moved eastward along trading routes. Probably, then,

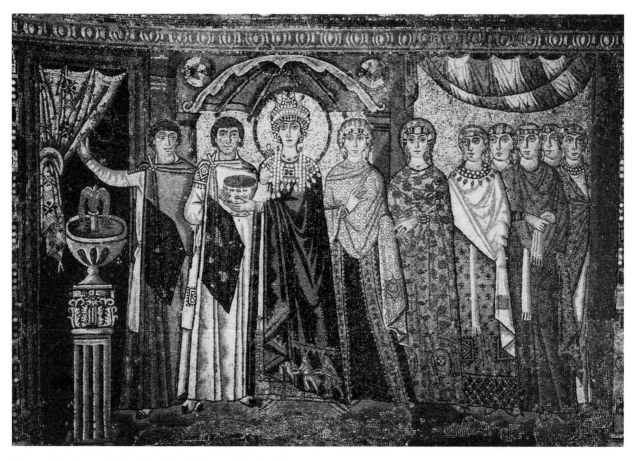

Empress Theodora with handmaids and deacons. Mosaic, 6th century. THE ART ARCHIVE/SAN VITALE RAVENNA ITALY/DAGLI ORTI.

the Crusades introduced a variety of highly ornamented fabrics to the West in the luggage of returning warriors and their retinues, rather more than specifically Eastern garments like turbans and slippers. Beginning with the return of crusaders at the end of the First Crusade in 1099 and terminating with the fall of Constantinople in 1204, both male and female bliauts displayed Byzantine influence that included voluminous amounts of fabric arranged in linear drapery (that is, uninterrupted lines extending from the T-shaped shoulder to the floor). An example of these linear styles can be seen in the sixth-century C.E. mosaic of the Empress Theodora on a wall in the Church of San Vitale, Ravenna, Italy. Other elements of this influence were the Byzantine fashions for purple and for broad bands of bead embroidery, giving the fabric a geometric and dotted or studded look. This quality is still seen in modern Greek icon paintings where gold raised dots outline the nimbus or halo of a holy person. Though there is an element of fancy in the idealized descriptions of aristocratic male costume in the thirteenth-century French Arthurian romances, it is not far wrong to believe that Erec in Chrétien de Troyes' romance of that name "wore a tunic of noble patterned

silk that had been made in Constantinople" (56). Some of the bliauts had long fitted sleeves and others fairly wide ones. Accessories included fancy embroidered silk belts and a brooch used as a fastening at the neck.

TREND TOWARDS LAYERING. The most elaborate ensemble of garments during the Middle Ages would naturally be that of the royal families and their courtiers. Its distinguishing feature was the addition of multiple layers that signified gradations in status and wealth, both because layering required large amounts of the expensive, exotic fabrics now imported from the East and because it allowed display of multiple patterns, textures, and decorations all at once. One of the best examples of this trend would be in the court clothing of the powerful Normans, who, in addition to having conquered Sicily, had also conquered England in 1066. Writers of contemporary chronicles, such as Ordericus Vitalis (1075–1142) and William of Malmesbury (1095–1143), commented on these Norman warriors, describing them as being "particular" about their clothing but not excessively so. During the reign of William I (William the Conqueror, 1066–1087), the king's clothing of state consisted of a

minimum of five garments (from the skin outward). In addition to his braies (male underpants with wide, loose, and short legs and a draw-string waist), hose (Norman French: *chausses*), and shoes, he wore a white, delicately woven long-sleeved shirt of linen with a neckband and wrists decorated with colored stitching (the *chainse* or later the "chemise"). This shirt might be only one of several undergarments of this type, including another warm silken or woolen one (French: *bliaut*) with elbow-length sleeves that might also have decorative edges. The alternate term for the bliaut was "gonelle" that would later become the English word "gown." By this period, French names for garments were largely replacing the old Roman (Latin) terms. Next, he wore an undertunic of fine fabric, reaching almost to the ankles, and over this a silken *dalmatic* (originally a loose outer garment with short, wide sleeves and open sides; later the sides were partially closed) with wide sleeves, and hem, neck, and sleeve edges bordered in silk and gold embroidery. Sometimes the silk fabric of this garment exhibited a pattern or design. At his waist, the king wore a narrow belt, embellished with gold and jeweled studs. Over this ensemble, he wore a mantle, shaped either as a semicircle or rectangle (Norman-French: *manteau*), with edges bordered with embroidery and/or gold. Additional garments also have French names, including the *doublet*—which, as its name suggests, was a vest made of two layers of linen, often padded—and a *peliçon* from the word meaning "animal hide"—a sleeveless jacket or vest-like insulating garment. The *jupe* (or gipon or juperel or jupeau) was a corset-like garment often worn over the chainse, which could serve as soft body armor for men because it was quilted. The jupe, which eventually became the modern English "slip," had lacings down the side.

PRACTICAL AND DECORATIVE ACCESSORIES. In this period of developing courtly costume, accessories such as cloaks, shoes, belts, and headdresses served both practical and decorative functions. In the interest of warmth, both men and women in northern climes wore a *chape*, a sort of cloak cut either as a round piece of fabric or as a rectangle, lined or trimmed with fur, and fastened with a cord held in place by the hand. This garment goes back to the Roman *pallium* and shows the long continuity with Roman styles. The legs were not bare, but were protected by hose, which could be brightly colored or even striped as a decorative touch. Presumably women also wore hose but this element is not shown in representations of female costume. Over the hose men and women wore leather shoes, which gradually took on more shape with curved, pointed toes that reflected a slight Eastern influence, a fashion phenomenon

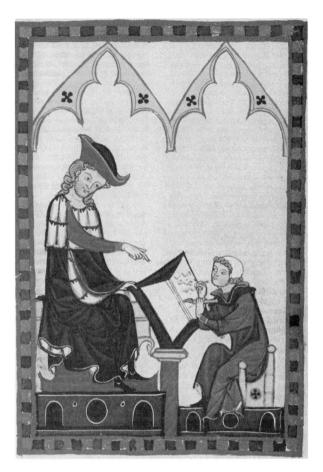

Layered costume, Konrad von Wurzburg dictating to scribe. Manesse Manuscript, Heidelberg Universitätsbibliothek, Cod. Pal. Germ 848, folio 383. c. 1300. H.-J. WISSMAN MINNESANGER IN FRANKEN: RENDEZVOUS MITTELALTERLICHEN SANGERN.

remarked on and criticized at the time. The shoes of various types were made to be open at the top of the foot and closed by long laces, which were wound up around the hose. Headdress for both men and women in the court consisted mainly of circlets made of precious metals, braid, or flowers, though by the thirteenth century both women's and men's hair could be pulled back and hidden by a linen cloth called a *coif*. Also during the twelfth and thirteenth centuries, the importance of belts increased as an accent to dress and a mark of affluence, since many of them were studded with jewels or embellished with gold and silver wire. Some served a protective function, for noblemen suspended small weapons from them, thus presenting the image of being armed at all times as a reminder of the aristocrat's warrior origins.

SOURCES

François Boucher, *20,000 Years of Fashion: The History of Costume and Personal Adornment* (New York: H. N. Abrams, 1987).

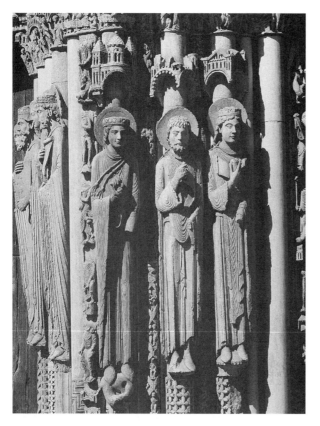

Bliauts and girdles worn by biblical kings and queens. Column statues, Royal Portal, Cathedral of Notre-Dame, Chartres, France 1145–1170. THE ART ARCHIVE/DAGLI ORTI.

EARLY ARISTOCRATIC DRESS FOR WOMEN

LAYERS. During the period when court costume was evolving, the clothing of aristocratic women mirrored the men's layered look, although women did not wear braies or underpants. Throughout the entire period treated in this chapter, noblewomen wore a chemise or *camise* (Anglo-Saxon, "smock") next to their bodies. The aristocratic version of the chemise was similar to the one worn by peasant women, but in the late eleventh century this basic undergarment became more elaborate; the neckline was gathered with cords within a decorative band of piping that was secured at the front, later replaced with a button and loop fastening. The wrists of the sleeves were similarly decorated, and the embroidery of both the sleeves and the neckbands was allowed to show when the lady was completely dressed. The fabric at the shoulder and upper arm and just above the wrist area of the sleeves was pleated or gathered to ensure a close fit. Such garments were usually made of linen, but fine fabrics such as wool or silk were also used to make a chemise, a variation which, along with the careful fit-

ting and elaborate decoration, emphasized the aristocratic woman's access to materials and labor, as well as the use of servants to help her with dressing and undressing. While peasant women wore a single dress or *cote* over the chemise, aristocratic female outerwear consisted of a series of gowns. Directly over the chemise was worn a second long garment known as the undergown. It, too, was made of fine fabric, but was more closely fitted than the outer gown and had tight sleeves. The over-gown was long, reaching at least to the floor, although in periods of costume excess, these gowns sometimes dragged on the ground or extended behind the wearer in trains that also required servants to manage during court appearances. In the second half of the eleventh century, women wore gowns arranged with easy folds of fabric encasing the body; both upper and lower portions of these gowns were generously cut. The outer and most formal garment was a mantle, fastened with cords or a brooch (jeweled pin).

THE SHAPED GOWN. By the late twelfth century, though both men and women wore several layers of gowns, a definite difference between the male and female silhouette began to appear in representations of these garments in works of art. Women's robes now fitted very tightly at the waist and were made to outline the figure through tight bodices with a row of ornamental buttons, tight sleeves, and the girdle, a wide belt-like accessory that went round the hips several times and then was tied off in front with the ends or tags often elaborated to considerable length, even touching the feet. It was during this period that women's costume was amply represented, and sometimes exaggerated, in the newly fashionable medieval romances—long episodic narrative poems describing the adventures of knights, both amorous and military, and their rescues of women from oppressors. The romances often detailed what women were wearing and described ornamentation, such as the embroidery on belts and coifs or head coverings. The *Romance of the Rose*, in its continuation by Jean de Meun (born c. 1237), also discussed the newest styles and fashions for women. Such works showed women how to *wear* their clothes. They provided instructions on how to make the waist of a gown appear smaller by the way the mantle was held, how to lift the skirts so as to reveal a small foot, and how to swing the hips slightly while walking. Notable among mid-thirteenth-century authorial comments was Jean de Meun's observation that the contemporary woman "through the streets [should] go/ With most seductive motion, not too stiff … / So nobly sway her shoulders and her hips/ That men no motion could believe more fair" (Robbins, 282). In this period of increased awareness of the female form, the

ease of the older styles disappeared and the waistlines of the gowns themselves were tightened, first by the use of stiffer fabric, and later by means of a laced corset worn under gowns made of more delicate cloth. These robes were called *bliaut,* a term which could refer either to a knight's outer tunic, or a lady's outer dress, both of costly cloth. Sometimes, especially in Middle High German, the term could simply mean rich fabric, such as silk, satin, or velvet imported from the Orient. This cloth was frequently woven with gold thread and embroidered with gems. In its most distinctive use to refer to a woman's garment, bliaut signifies a gown of the richest fabrics, banded at neck and wrist edges with strips of embroidery, fur-lined, having a tightly-laced (at the sides) elongated bodice, a full, long skirt, and sleeves of various styles. In this manner the upper body silhouette was redefined.

GIRDLES, SLEEVES, AND HEADDRESSES. Typically, female fashions in the Middle Ages changed more in the small detail than in the nature of the garments themselves, since vanity in female costume was considered by preachers to be a dangerous vice. Moreover, the major changes in length that characterized male costume were not adopted by women, who never revealed their legs (though their dresses had trains of varying lengths). Thus, it is to matters of silhouette and accent that women generally turned their attention. Belts, called girdles, were introduced into women's costumes during the century following the Battle of Hastings (1066) and emphasized the fitted styles that gave the female figure more of an outline than in previous centuries. Girdles were constructed as twisted cords, sometimes knotted, made from gold or silver wire and dyed wool or silks. These cords were periodically bound with ornamental brooches or emblematic enameled or jeweled bosses, or convex raised metal engraved or otherwise ornamented and sometimes finished off with tassels. It was customary to pass the doubled decorative cords around the body, to pull the ends through the loop, and to allow them to hang down the front of the gown. Simpler girdles were also constructed from a length of fabric decorated with stitching of a contrasting color. Queen Matilda of England willed one of her two girdles made of gold thread—this one with emblematic ornamentation—to the Abbey of the Holy Trinity to use for hanging a lamp in front of the altar. She left her gold embroidered mantle to this same abbey, to be turned into a cope or religious vestment. By the mid-twelfth century another element of female costume that seems to have been the subject of elaboration was the sleeve. Often sleeves were wide, contributing to the overall bulk of the ensemble, and the cuffs hung so low below the

CINDERELLA'S Furry Slippers

Among the new fashion trends developing in Europe during the period of William II's reign in England was the mantle. These outer garments, always made of the most luxurious fabrics available—some imported from the Orient—became even more elaborate with the innovative addition of a second layer composed of the most expensive furs, especially ermine, vair, and miniver, which symbolized the owner's wealth and power. Ermine is a white fur with black spots created by sewing together the gray backs and white bellies of whole squirrels; it was called *vair* in France from the Latin *varius,* meaning "speckled" or "changeable." A closely related aristocratic fur, *minever,* is a "fabric" made only from a squirrel's white belly area or constructed from this belly fur with only an edge of the gray flank fur.

The association of the fur called "vair" with aristocratic clothing contributed to one of the most distinctive (and rather odd) details in the modern version of the fairy tale "Cinderella." Apparently the strange "glass slippers" that children have accepted for generations without question were, in the original folk story, slippers made of fur or "vair." But when Charles Perrault (1628–1723) wrote the story down for publication, an error was made in transcription, and the word became "verre," meaning glass. Thus, one of the most fascinating elements of this popular story was the result of a mistranslation of a medieval fashion term.

wrists that they touched the ground and were knotted to shorten them. These sleeves were sewn onto the costume with each wearing, so that it was possible to have a number of different variations that could be added to a basic costume. Since the color of these removable sleeves often contrasted with the color of the robe, it was possible for a lady to choose for herself a distinctive sleeve that could be given to a suitor as a token to be worn on his helm or used as a pennon, sometimes at tournaments, reflecting in this way a similarity to the coat of arms or blazon that identified individual knights. A final detail of female fashion was the headdress, which for noblewomen from 1066 to 1154 was in the form of a veil made from fine linen or cambric in a variety of shapes; these veils hid the wearer's hair and sometimes also hid the neck with draped fabric. Called by the Normans a *couvrechef,* such a veil might also be worn with an end

flung across the shoulder. A later variation, in the thirteenth century, was the *caul*, a fine linen cap fastened under the chin.

SOURCES

W. N. Bonds, "Genoese Noblewomen and Gold Thread Manufacturing," *Mediaevalia et Humanistica* 17 (1966): 79–81.

Cecil Cunnington and Phyllis Cunnington, *The History of Underclothes* (London: Michael Joseph, 1951).

Eunice Rathbone Goddard, *Women's Costume in French Texts of the Eleventh and Twelfth Centuries* (Baltimore, Md.: The Johns Hopkins University Press, 1927; rpt. New York, 1973): 40–59.

William W. Kibler and Carleton W. Carroll, trans., *Chrétien de Troyes: Arthurian Romances* (Harmondsworth, Middlesex, England: Penguin, 1991).

Françoise Piponnier, "Linge de maison et linge de corps au Moyen Age," *Ethnologie française* 3 (1986): 343–363.

The Romance of the Rose by Guillaume de Lorris and Jean de Meun. Trans. Harry Robbins (New York: Dutton, 1962).

INTERCULTURAL INFLUENCES AND REGIONAL DISTINCTIONS

THE ISLAMIC INFLUENCE. The First Crusade (1095–1099), in which a mostly French Christian army traveled to the Holy Land to recover it from Islamic control, had markedly influenced noble dress by the mid-twelfth century, ushering in a new "Eastern" style. At this time there was already evidence of Byzantine influence in outer tunics. As returning crusaders also brought back ideas of Islamic dress cut and fabrics woven in the Mediterranean area and far East, Islamic influence may be found in European dress at least as early as the first part of the twelfth century. These included cloth specific to the East such as damask, brocade, and muslin—thin fabric of silk and gold from Mosul in what is now Iraq and other very fine and thin gauze-like materials; they tended to replace the heavier, stiffer fabrics and garments of Byzantine cut. Other fabrics of this type were those woven of cotton from Egypt and the cloth called in Old French "camlet," which was believed to be woven with part camel hair in Syria and Asia Minor, the predecessor of modern "camel hair" fabrics for top coats. Eastern silken fabrics, some of which were manufactured in Islamic workshops in Sicily, remained permanently in European costume throughout the Middle Ages. Other features adapted from Islamic dress and merged with customary European styles were the decorative bands on garment edges and top portions of the sleeves, known as *tiraz*. These bands frequently featured embroidered written charac-

ters, often in strange alphabets. Another major change from the old eleventh-century T-shaped garments was the adoption of the dropped shoulder seam in male tunics. In the northern portion of Europe, the long, fuller gown similar to Islamic cut—which had already been accepted in the south—was adopted at the close of the eleventh century by Normans imitating what was called "Saracen" or Islamic dress, understood as quite exotic.

ENGLAND AND REGIONAL DISTINCTION. By 1204, the Crusaders had captured Constantinople, ending the cultural dominance of Byzantine and Islamic styles, and in time this Eastern city ceased to be a major influence on the clothing of the European nobility. Dress in Western Europe was then subject to tastes and trends developing within individual national borders; differences in styles now reflected geography. As an island nation, separated from the rest of Europe by the English Channel, England provides early examples of trends in dress that were unique to the local political and economic conditions. Male dress, for example, became more ornate during King John's reign (1199–1216), which was known for its extravagant spending on elaborate clothing, but the women of the court did not follow this trend. Instead their dress retained the styles previously instituted by the highly respected former Queen Eleanor (c. 1170), who preferred simplicity. Henry III's reign, beginning in 1216, ushered in a period of costume featuring unpretentious cut and fabric for both the nobility and moneyed commoners. Indeed, between 1220 and 1270 these plainer garments made it more difficult to distinguish between the nobility and merchants, or between shopkeepers and peasants. Of particular influence in this change from courtly ostentation to simplicity was King Louis IX of France, who reigned from 1226 to 1270. Much revered for his piety during his lifetime, he was canonized as Saint Louis in 1297. Through his marriage to the sister of the English queen Eleanor, his influence spread to both English and French courts, with nobles adopting Louis's preference for simple clothing. At the same time, the flourishing woolen industries in England and the Netherlands and various technological advances (in carding and spinning wool, and in looms) increased fabric production and availability. Woolens began to be dyed in yardage, and blue, green, and brunette (a dark brownish red color from woad and the ground-up shells of a small Eastern beetle) dyes were particularly popular. Twill weaves of an extreme fineness developed along with heavy felt-like wools used in the manufacture of hats. Thus court dress during this period, while simple in style, was renowned for the fine quality of the fabrics. Draped in various ways, long robes that fit easily upon the body without the use of excessive fabric were a distin-

guishing feature of this costume. They created an effect of sobriety and dignity while maintaining a quiet magnificence. Such a style also found favor with King Edward I of England (r. 1272–1307), whose personal humility inspired fashions exhibiting even greater simplicity.

DESIGNS FROM NATURE IN FRANCE. Styles in decoration evolved across the centuries as did fashion itself. In the thirteenth century, for example, Gothic art emphasized the beauty of the natural world in its details of flowers and animal life richly distributed throughout the decorative arts of Europe. Cathedrals both inside and out sported carved and sometimes painted friezes showing real and imagined animal and plant forms. And plant and animal life accurately drawn from nature began to appear in the margins and in the bows of letters like O, B, and D in the script of painted manuscripts across Western Europe. This appreciation of beauty found a parallel in the dress of the nobility, in the textures and patterns of fabrics utilized, the silhouettes developed, the patterns of embroidery, and the increasing amounts of additional metallic and jeweled decoration, often in designs representing the beauties of nature. One of the major literary works reflecting the incorporation of natural motifs into fashion is the *Romance of the Rose*, begun by Guillaume de Lorris and completed by Jean de Meun. Guillaume's portion of the poem describes a costume covered in every part with images of geometric shapes (lozenges, escutcheons or small shields), lions, birds, leopards, as well as broom and periwinkle flowers, violets, and other yellow, indigo, or white flowers and rose leaves (ll. 876–98, Robbins, 19). This trend toward naturalistic representation in weaving and embroidery patterns continued into the fourteenth century, by which time it had influenced English fashion as well. The silken band or banner that encircles the hero's helmet in the Middle English romance *Sir Gawain and the Green Knight* (written about 1370) is decorated in such a way that it resembles a border for an illuminated manuscript. It was "embroidered and bound with the finest gems/ on the broad silk fabric/ and over the seams were birds such as parrots painted with periwinkles and turtle doves and true love flowers thickly entwined."

THE GERMAN DECORATIVE TRADITION. German aristocratic fashion differed somewhat from that of other European courts because, owing to lengthy civil wars and a series of dukedoms rather than a more centralized governmental structure, Germany did not develop a single court style which could respond to trends elsewhere in Europe. Unlike the French and English decorative traditions, which tended to emphasize designs from nature, the German tradition leaned more heavily towards geometric shapes, a feature still seen in the so-called "hex" patterns of Pennsylvania "Dutch" (that is, German) barns and quilts. Throughout the history of German costume, the outermost garments are characterized by decorative patterns, either in the weave or pattern of the fabric used, or in decorative woven or embroidered bands. Such bands appear at the mid-calf or mid-thigh level on gowns of the Byzantine style or, later in the twelfth century, as a decorative placket extending downward from ornamental circular yokes or collars, usually ending at mid-chest. Customarily two tunics were worn, with the outermost being made of patterned fabric with a lower border and the one underneath being fuller and longer, made of plain linen; the wealthy sometimes wore a third and plainer tunic overall, with an undecorated lower edge. The preference for decorative patterns may be seen in early thirteenth-century German costumes in stained glass windows in Augsburg Cathedral, which feature patterns of *diaper* (repeated diamond shapes), *foliates* (leaf-shapes), and *quatrefoils* (flowers or leaves with four petals) linked by squares and stripes. Such ornamentation increases in flamboyance throughout the thirteenth century, as can be seen in the painted marble or alabaster effigy of Graf Wiprecht von Groitzsch (1230–1240) at the Klosterkirche of Pegau, near Leipzig. In the effigy he wears a red mantle and a blue tunic, both bejeweled, a fur tippet (a stole with hanging ends), and an elaborate girdle at his waist. By the late thirteenth century, some overcoats featured short sleeves with a slit for the arm that allowed the sleeve to hang empty and free of the body, thus showing the arm dressed only in the tunic's tight sleeve. In addition, buttons could be both ornamental and functional along the neck placket and side slits. The German preference for colorful, patterned fabrics continued into the fourteenth and fifteenth centuries.

THE ITALIAN PENINSULA AND THE MANUFACTURE OF SILK. As early as the time of the Carolingian Empire, Mediterranean styles and Islamic textiles were arriving in Europe, not only directly, by way of East-West trade routes and the return of Crusaders, but also by way of the Italian peninsula. Sicily, an island off the tip of what is now southern Italy, had been controlled by the Muslims until it was reconquered between 1060 and 1091 by the Norman French, and thus it continued to serve as one of the chief geographical areas of contact with the Islamic world. From an early period, many textiles traveled northward from the island to the Italian city-states and the rest of the continent. This region, moreover, early developed a silk manufacturing industry with imported mulberry worms from China. The development of silk manufacturing in Sicily and also in the city of Lucca—which became known especially for

WOOL
and Other Textiles

Sources of Raw Materials.

Medieval European costume employed three main materials—wool, linen, and silk—in varying qualities. Silks had been imported from the Near East since the time of imperial Rome, and sericulture—the growing of silk worms—had reached Sicily by the tenth century, though fine silks continued to come from Byzantium through the medieval period. Linen was grown within Europe, and cotton, coming from Egypt by way of Italy after the Crusades (later produced in Swabia in Germany), began to be mixed with linen to create a popular fabric called *fustian* by the thirteenth century. Like linen, wool was a native fiber, and wool constituted one of the most important commodities in European trade. England, particularly in the north and west of the country, exported raw wool to France for the actual production of cloth in the south around Toulouse, though France was also a large raw wool producer, especially in Flanders, Artois, and Picardy. The actual wool merchants, at least up to the thirteenth century, were the Flemings from Ypres, Ghent, and Bruges, in what would today be called Belgium. By the fifteenth century, Spain and Germany overtook England as raw wool suppliers, while England began to excel as an actual manufacturer of woolen cloth and soon outpaced all other nations in the production of fine woolen fabrics for luxury clothing.

Making Woolen Cloth.

The process by which wool moved from sheep to fine dress or robe was a complex and lengthy one. The English wool brokers sold bulk wool in sacks of 346 pounds to *drapers*, as they were called, who then subcontracted the wool to workers (usually women) who washed, beat, and sorted the wool fibers, often at home in cottage industries, a practice that continued in the northwest of England until the mid-nineteenth century. Sometimes these fibers were dyed blue with a plant called woad, imported from northern Italy, which allowed them better to retain other dye colors, such as reds of varying types (sometimes called "scarlet," though this term also denoted a type of material), a brownish tone (very common for the garments of agricultural laborers), and, by the late Middle Ages, rich blues and black for upper-class clothing. The next link in the chain was the weaver draper, who again subcontracted the fibers to combers and carders (who worked on the shorter fibered wools); these persons readied the material for the spinners. The wool then went back to the weaver drapers, who paid off the artisans at so much per pound, and on to wooden looms—often water powered—where clothing fabrics like worsteds and more expensive broadcloths and serges were woven. Wool could also, in its finer grades, be ornamented with silk and even metallic threads and have shapes of other fabric sewn on. Yet another step for some grades of woolen cloth was fulling, which involved shrinking the cloth and the addition of a sort of chalk called fuller's earth to the fabric to compact and stiffen it. The cloth then went back to the weaver drapers who had the cloth dyed in a mix of pigments and alum from Asia Minor in bolts of a certain length and width (called *ells* in England and *toises* in France) and marketed it to merchant clothiers, where it eventually became clothing in the shops of tailors.

Competing Textiles.

Though woolen cloth was a staple for outer garments for all levels of society, it was expensive because of the many duties and taxes that were collected as it moved from its place of origin as a raw material (for example, England) to the cloth-making regions (usually France) to the actual merchants (in Flanders) and then to the consumer. For this reason, as well as for comfort, undergarments—the chemise or long smock worn by both men and women—were made of linen, a fiber derived from the flax plant, which grew well in France and Italy. It was very durable and less irritating next to the skin. Silk, on the other hand, was preferable to wool for luxury clothing because it was thin and supple, and it could be woven to create shimmering patterns and highlights. By the 1370s there was a taste for very ornate textiles and many new types of fabric became popular. Some of these had come from the East with the returning Crusaders, such as *samite*, a densely woven silk, and *cendal*, a thinner silk much like the silks used in women's clothing today. Others were damask, brocade, and velvet, a fabric soon reproduced in Florence. These Eastern fabrics were imitated in France in lower-cost examples by the 1460s. Still, though silks and silk blends offered greater versatility and visual splendor, many medieval wools were quite beautiful, and wool had the added advantage of being durable and having a high insulative factor. In an age when housing lacked central heating, especially in northern Europe, the use of wool and wool blends was important to help keep the wearer warm.

its fabrics made of silk blended with other fibers—combined with the activity of Venetian merchants, who were importing silks from China, to create a strong taste for silk in both men's and women's attire at least as early as the twelfth century. Evidence of Eastern influence from this early period of Sicilian fabric manufacture survives in a piece of silk fabric, now preserved in the Fabric Museum in Lyon, France, which shows what appear to

be peacocks and dragon-tailed animals surrounding a floral medallion of the sort found on oriental carpets. Though the technology had been acquired from the Far East, the designs were increasingly blended to include Mediterranean patterns of all kinds, especially combinations mixing European designs with Muslim motifs. Merchants distributed these fabrics widely throughout Europe, Britain, and Scandinavia.

THE ITALIAN PENINSULA AS AN EXPORTER OF STYLE. Not only Eastern fabrics, but also fashion itself sometimes moved from south to north during this period. One method of distribution was through aristocratic marriages, as was the case with King Robert II the Pious (972–1031) and Constance of Arles, who were married in 1005; their union brought Mediterranean (in this case, southern French) styles worn by the bride's courtiers to northern France, and these were important enough to be commented on by writers describing the event. These styles involved fabrics with many pleats, a sort of waffle-like pattern called *goffering* crimped into robes more fitted than usual. Indeed, fashion from Italian city-states and the Mediterranean was distinctive from an early period and was exported to France, the Netherlands, England, and Germany. These exports include both actual garments and drawings brought back by courtiers and diplomats on their travels and also renditions of costume in illuminated manuscripts from Italian workshops. One of the distinctive features of fourteenth-century female costume in Italy was the headdress and hairstyle, which was arranged in a large ball or "balza" at the back of the head, covered with braided bands of fabric and light gauzes. Men in the late fourteenth century had a rather square profile with wide shoulders accentuated by padding in rolls over the shoulders, with a full-length or thigh-length tunic and most of the weight and value of the garment concentrated in the chest and shoulders through banding, piping, folds, and rolls. One of the most interesting examples of exported Italian fashion was a trend towards black silks, which was developed in Italy to distinguish members of the upper middle classes from true aristocrats, who alone could wear bright colors such as scarlet and blue. Before long, black did not have good social connotations, and the Italians exported their black silk garments and dark furs to go with them to European courts, who found them to be very original and were not attuned to the negative social implications of the color black in Italy. Though black silks were primarily used for male doublets and gowns, women also wore them, and the fashion for damasks, velvets, and brocades of black silk with a mantle or trimming of sable (a very dark fur from the area of what is now Russia) was popular among aristo-

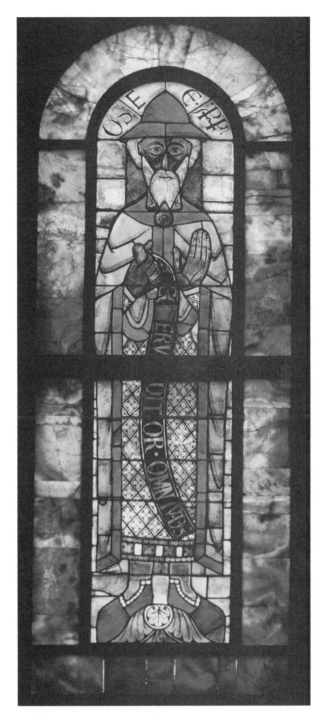

Prophet Isaiah in decorated costume, stained glass window, Augsburg Cathedral, Augsburg, Germany, 1130. ERICH LESSING/ ART RESOURCE, NY.

crats in the fifteenth century. Thus, in the fourteenth century a strong taste for black developed throughout Europe among the aristocracy in marked opposition to the taste for bright colors that had prevailed from about 1330 onward. In this, as in other fashions, Italy seems to have been the source of a major trend.

THE
Battle Between Blue, Red, and Black

The Rise of Black

Clothing colors have long indicated social class, and in the late Middle Ages this was particularly true of the colors blue, red, and black, though it was only during the fifteenth century that black became a competing force against red and blue in bourgeois and aristocratic fashion. Among the most prominent medieval wearers of black were King Charles VI of France (1368–1422), Duke Philip the Good of Burgundy (1396–1467), and King René of Anjou (1409–1480), all of whom dressed in black throughout their adult lives and helped to give the fashion social preeminence. Yet, by an irony of history, their taste for black did not originate with the aristocracy but rather with the upper bourgeoisie in Italy, who in the fourteenth century were forbidden by law to wear garments of "scarlet" or luxurious blues. Although the dull blacks of earlier years had never been an appealing alternative, the medieval dyeing trade was becoming more "industrialized," allowing artisans to create richer and more luminous hues, including wools of a deeper and more striking black. As parallel technological advances among weavers increased the availability of rich black serges and gabardines, a vigorous trade in black cloth developed to meet the demand. Soon the fashion for black moved from Italy to France, England, Germany, and Spain, and the color became a court fashion, appearing in linens, silks, and woolens as well as in black or very dark furs called sable.

Luxurious Scarlet

By the mid-fourteenth century, then, black was a competing color with "scarlet," a term which could refer to several different hues of red as well as to fabrics of various colors but of a generally luxurious appearance, and the dyes used to create them. Authentic scarlet fabric was very expensive to own, as it was created by a special dye called kermes that was laboriously made from the dried shells of a small beetle. Other dyes to make less fancy forms of red involved the use of madder, a plant material common in Western Europe. In either case, however, dyeing fabric red required an additional process with a chemical called a mordant, literally something "biting" (typically urine, lime, or vinegar) which allowed the red pigment to enter the fibers of the fabric and bond with them. Accordingly, scarlet was a color reserved for royalty and persons of high rank. In Portugal, for example, only members of the royal family were allowed to wear it. Red was also the preferred color of royalty in Italy and Germany.

Royal Blue

Early blue fabric was first used in the costume of servants and workmen (a use which it still has in France today and which lingers in the American phrase "blue collar"), and it typically denoted low social status. But again technology played a role in changing aristocratic perceptions of the color's symbolic value. The first blue fabrics were rather pale and lusterless, but as techniques developed for producing blue in more vivid shades (using indigo from India), the color (eventually known as "royal blue") competed with red, and later black, in status. Blue was associated with the Virgin Mary, considered the religious patron of France, and pictures of her in manuscript painting showing her in blue robes helped to make the color fashionable. Perhaps even more important was the appearance of blue as part of the French royal family's coat of arms, where a blue ground with gold lilies (fleurs-de-lis) became standard from the end of the twelfth century. In scenes from the magnificent manuscript called the Très Riches Heures (1416), not only Jean, duke of Berry, but even his horses are draped in blue fabrics with gold fleurs-de-lis as the duke and his entourage go out riding. Well before this time, blue had become a color for others to imitate. As the dyers who made red fabric saw their livelihood threatened (for dyers were forbidden by guild regulations to make several colors in one workshop), they responded with propaganda campaigns against the dyers who worked in blue, and actual violence between these "colors" often occurred. Hence, by the mid-fourteenth century—the period when we begin to find the great interest in colors and extravagance of costume developing—there was a true combat between red, black, and blue which was to have important ramifications for the next two centuries of fashion. Of the three colors, only black retains today some elements of its medieval significance, indicating, for example, not only somberness in mourning, but also social respectability and high status as it is worn for formal occasions in tuxedos and formal dresses.

SPANISH COSTUME. The area now known as Spain is a particularly interesting case for the development of fashion because of its relative geographic isolation. As a peninsula separated from the rest of Europe by the Pyrenees mountains, with a culture that had long been under Islamic influence, Spain developed some fashion trends peculiar to the region, though they could be exported. In the early Middle Ages, dress for the Spanish noble class was modeled on that of ancient Rome, but constructed with exotic fabrics derived from the Islamic presence there. Both male and female Spanish costume resembled that of other Europeans in having as its basic

combination a long tunic with tight sleeves worn under a second long tunic with wide sleeves. During the tenth century, however, men wore a mantle with a slit for the left arm, and for their military dress, tunics with striped fabrics. The outer tunic was sometimes sleeveless, and both "keyhole"-shaped neck openings and armholes were decorated with braid. A distinctive cape or mantle, like the surplice a modern Catholic priest would put on to say Mass, was worn over the back and chest, a style adopted by women as well. In the thirteenth century, ladies' tunics covered their feet, while those for noblemen ended at mid-calf, allowing full visibility of their pointed-toe leather shoes, which were often decorated with gold braid. At this time, noticeable ball-shaped buttons or rosettes ornamented the neck and wrists of the tunics. A distinctively Spanish thirteenth-century fashion trend was the custom of slashing or opening the over-garment under the arms to show the layer below in a contrasting color; lined mantles completed the costume. By the mid-fourteenth century, Spanish nobles had adopted the so-called "short costume" of doublet and hose, worn with long pointed toe shoes, which dominated medieval Europe and Britain from about 1330 onward; it appears that this combination had actually originated in Spain much earlier as a military fashion worn by soldiers in Aragon, after which the concept had taken hold in Naples in Italy, and was later exported from there to France and beyond. The elite retained their semicircular cloak at hip length, decorated with large buttons from neck to breast. In addition to the tighter, shorter fashions, nobles in Spain also continued to wear the two tunics of the older style, but with narrower shoulders, topped with a semicircular flap of fabric reaching to the elbow as a sleeve, and a skirt that gradually flared to the hemline. Though Spanish female costume remained much the same from the early to the late Middle Ages, by the late fifteenth century women did wear a hoop skirt which belled out below the waist through the use of stiffeners, a fashion not yet seen elsewhere. And by the end of the period covered in this chapter, all Spanish garment styles underwent the variety of constant changes in tightness and looseness, and (for men) in lengths of garments and in amount of decoration common in all European courts. Throughout the entire era, cities and regions such as Valencia, Catalonia, Castile, Barcelona, Andalusia, and other places produced fabrics that blended Christian European motifs with Islamic and Far Eastern designs, and Spain retained these patterns long after Moorish control of the country ended in 1492. Catalonian woolens were of the finest quality in the late 1400s and throughout the 1500s, and a thriving silk industry evolved by the late fifteenth century. The peak of such luxury weaving was reached in the production of silk "cloths of gold." Hence, Spanish costume was marked by a fondness for richly patterned fabrics and bright colors, such as white, red, pale blue, pink, light violet, and sea green. These were deviations from the older primary colors in use in the rest of Europe (red, yellow, and blue), and even from the secondary colors (orange, green, and violet), and suggested a subtle refinement of taste. A favored fabric design was that of a large pomegranate, woven in both damask and velvet, one example having a background highlighted with metallic thread on which the image appears in cut velvet. Many of these Spanish fabrics reached Europe and the British Isles through merchants, and London livery companies—trade and religious fraternal groups wearing the same costume or "livery" as a sort of insignia—used some of them for palls or coverings for the casket during processions at the funerals of their members.

SOURCES

N. B. Harte and K. G. Ponting, eds., *Cloth and Clothing in Medieval Europe: Essays in Memory of Professor E. M. Carus-Wilson.* Pasold Studies in Textile History 2 (London: Heinemann Educational, 1983).

David Jenkins, ed., *The Cambridge History of Western Textiles.* Vol. 1. (Cambridge, England: Cambridge University Press, 2003).

Maurice Lombard, *Etudes d'Economie médiévale: Les textiles dans le monde musulman du VIIe au XIIe siècle* (The Hague: Mouton, 1978).

Agnès Page, *Vêtir un prince: Tissus et couleurs à la cour de Savoie 1427–1447* (Lausanne, Switzerland: Cahiers Lausannois d'histoire médiévale, 1993).

Jean Richard, *Louis IX; Crusader King of France.* Trans. Jean Birrell (Cambridge, England: Cambridge University Press, 1992).

Jonathan Riley-Smith, *The Crusades: A Short History* (New Haven, Conn.: Yale University Press, 1987).

THE NEW SILHOUETTE FOR ARISTOCRATIC MEN

BODIES ON DISPLAY. The period around 1330 saw the beginning of Italianate influence on both English and French fashion styles. At this time noblemen abandoned their long robes and, for public appearances, wore short doublets or padded jackets that fit close to the body with leg-hugging hose revealing and emphasizing the thighs and buttocks. This new style first vied in popularity with the long robes worn at the beginning of the century, but, by its end, had fully replaced the traditional fashion among younger men, especially those with ties to the most fashionable courts. The shorter

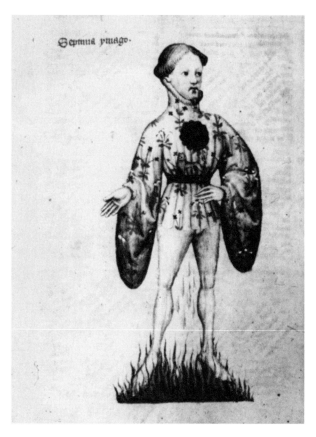

The sun personified as a stylish young man in short houppelande or haincelin with bag sleeves, John de Foxton, *Liber Cosmographiae*, 1408. CAMBRIDGE, TRINITY COLLEGE LIBRARY R.14.21, FOLIO 35V.; PHOTO JOHN BLOCK FRIEDMAN.

garments were initially knee-length, but rose throughout the century to mid-thigh and then nearly to the waistline. In the form known as a *cotehardie*, its distinguishing features were the row of buttons that ran from the neckline to the low waistline, and the elbow-length sleeves from which a long extension of fabric known as a "tippet" hung down. Some costume historians have seen the shortening and exhibitionism of male costume in this period as a reflection of the new interest in the unclothed, partially clothed, or sexualized body becoming evident in late medieval culture. Though there are no literary or philosophical documents that can be cited to support any general consciousness of such an interest, it is certainly present in a variety of medieval artistic manifestations. The rising interest in naturalism (the focus on natural and organic processes and forms) fostered by the study of Aristotle's works in the medieval university, the practice of dissecting bodies in late medieval medical education, and the growing respectability of Greek and Roman mythology with its attention to unclad nymphs and demigods as a subject for literary and artistic imitation all played a part in the idea of a revealed body, especially at the beginning of the fifteenth century. A good example is the medieval revival of the classical myth of Pygmalion, which was depicted frequently in wall paintings, tapestry, poetry, and manuscript illumination. The story in the Tenth Book of Ovid's *Metamorphoses* recounts how a bachelor artist, Pygmalion, made a beautiful ivory statue of a woman with whom he fell in love. He spent much of his time clothing and ornamenting the carving, bringing it presents, and speaking to it. He prayed to Venus to animate this statue and his wish was granted. Among other important medieval representations of female and male bodies are the naked "Venus rising from the waves" scenes of mythographic treatises like the *Fulgentius Metaforalis* in Rome and the famous Zodiac Man in Jean de Berry's *Très Riches Heures*. The last is a miniature showing an unclothed young man, parts of whose body are keyed to the constellations and planets that have astrological influence on them. In a culture where monastic moralism discouraged excessive interest in the flesh, such "distant" or mythological miniatures provided acceptable spaces in which the body, safely dehumanized, could be examined.

PADDING AND LACING. In the fourteenth century, it was customary for knights to wear "soft armor" under their mail or plate armor; in keeping with the continuing identity of the nobility with their military origins, one form of the new short tunic—called the doublet or *pourpoint* (also called *gambeson*)—came to be padded with various fibers, such as hemp, cotton, or silk, and then quilted. In 1322 the Armourers' Company in London laid down specifications for this garment: that it be covered in *sendal* (a silken fabric) and that it be padded with only new cloths of silk and *cadar* (a name for cotton, which was a new and exotic material now being imported from Egypt to the West). To eliminate extra fabric that bunched beneath the arm, this close-fitting doublet had inset sleeves, replacing the older garment that had been cut in a T-shape. The outermost layer of these garments was composed of the costliest of fabrics from the thirteenth century onward; they were often embroidered, and they were worn as ordinary dress before and after a nobleman was armed. Thus, as the new short costume came to be worn independent of the armor it originally had supplemented, this military necessity became high fashion for the courtier. Later, doublets came to be laced to increase their tightness as part of the new silhouette for men. In the fifteenth century, the doublet and hose were the premier garments of male attire, and a variety of over-garments were also worn, such as the *paletot* (a short-sleeved, short and loose gown for men).

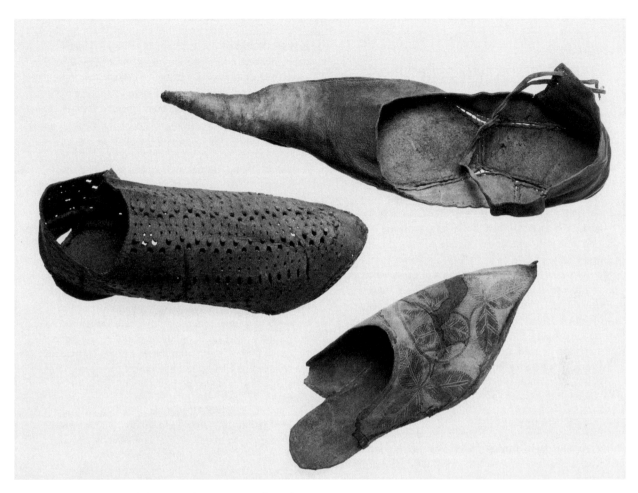

Poulaines or Polish pointed shoes, London, Museum of London, 1380. **BRIDGEMAN ART LIBRARY.**

THE HOUPPELANDE. Over the ensemble of doublet (pourpoint), hose, and poulaines (shoes with very long pointed toes), nobles wore a long-sleeved, generally high-collared robe-like garment called the *houppelande*. The houppelande is sometimes described as a "hybrid garment" because, toward the end of the fourteenth century, it replaced the cote, the surcoat, and mantle that were all parts of the traditional fourteenth-century "robe." Some historians of costume have felt that the houppelande was fostered by the guilds of tailors, who saw a threat to their economic security as the older style of long costume became obsolete except among older men and those needing ceremonial garments, such as jurists. The style that preceded the houppelande is well described in the Middle English romance *Sir Gawain and the Green Knight* where the hero wears a "bliaut of blue that reached to the ground/ his surcote fit him well and was softly furred inside/ and its hood that hung from his shoulder/ was adorned with ermine." In any case, the houppelande quickly became very popular. While the formal houppelande was quite long and

voluminous, a shorter version, called the *courtepie* or *haincelin*, developed as a popular variation. This more abbreviated garment reached halfway between ankle and knee, and an even shorter version hit some inches above the knee. Such a garment appears in miniatures for the *Tacuinum Sanitatis*, a treatise on health popular at the end of the Middle Ages. Painted about 1390, they show men collecting roses for medicinal use; their haincelins illustrate the fashion for "dagged" (also called "cut-work") sleeve and hem edges, scalloped in fanciful shapes such as those of leaves, points (known as "vandykes"), or the square indentations on castle rooftops and towers called battlements or crenellations. The longer and more formal version of the houppelande, which was ground length or even trailing, also appears in these manuscripts. A third version, worn by the figure of the sun personified as a stylish young man from John de Foxton's *Liber Cosmographiae* (1408), features a high collar that fanned out from the neck and funnel-shaped sleeves that become increasingly wide at the wrist end, billowing out into the shape of medieval bag

JOAN
of Arc and Cross-dressing

More famous than almost any woman of the Middle Ages, Joan of Arc is still well known today as the female warrior who led French troops to victory against the English in the Hundred Years' War. Claiming to have been guided by the divine voices of Saint Margaret and Saint Catherine since the age of thirteen, Joan, at age seventeen, left her home in a village in northwestern France, put on men's clothes to identify herself as a military leader, introduced herself to the yet uncrowned future king of France, and turned the tide in favor of the French at the siege of Orléans in 1429. In the version of the story most people remember, her charismatic presence continued to inspire confidence among the French, leading quickly to Charles VII's coronation; then, at the height of her power, after only a year on the battlefield, she was captured by the Burgundians and turned over to the English to be tried. After a lengthy and brutal Inquisition, during which she became ill and recanted her supposed heresy, then relapsed and was condemned, she was burned at the stake.

While most discussions of Joan over the centuries have focused on the trial's inquiry into the validity of the voices she claimed to be hearing, an equally important issue at the time was her decision to wear male dress, which was seen as an overturning of natural order as defined in the biblical book of Deuteronomy: "The woman shall not wear that which pertaineth unto a man, neither shall a man put on a woman's garment; for all that do so are abomination unto the Lord thy God" (Deut. 22:5). Although there was some precedent among earlier holy women to suggest that she might have been forgiven for wearing men's clothing for practical reasons—either to protect her virginity while she was living among soldiers or to make it easier for her to ride a horse—she never offered any such explanation. Her insistence that she wore such clothing at the command of God and his angels, and her refusal to wear women's clothing even while in prison, suggest that she saw men's attire as part of her identity, a symbol of her calling.

The meaning of her clothing is complicated by the fact that Joan—an illiterate peasant who had never even ridden a horse before leaving home—chose to dress not as a simple soldier, but as something of a fashionable dandy. Indeed, one of the charges against her was an accusation of idolatry, a worship of herself. The transcript of the trial indicates that she wore "shirt, breeches, doublet, with hose joined together, long and fastened to said doublet by twenty points, long leggings laced on the outside, a short mantle reaching the knee, or thereabouts, a close-cut cap, tight-fitting boots or buskins, long spurs, sword, dagger, breastplate, lance and other arms in the style of a man-at-arms." The description goes on to mention the sumptuousness of her attire, including cloth of gold, furs, and a surcoat open on the sides. Clearly, Joan loved beautiful clothes, perhaps seeing her attire not only as a statement of independence from the restrictions usually put on women, but also as an homage to male heroism and the royal cause she was attempting to support. From the point of view of her inquisitors, however, her short costume connected her with immoral elements of society (as perceived by the ecclesiastical hierarchy) and was a sign of her demonic nature. Her refusal to put on a dress, even when she was promised that she would again be allowed to hear Mass if she gave up her male costume, made her an easy target for charges of witchcraft.

The grandeur of Joan's appearance—supplemented by the acquisition of a fine horse and knightly weapons, all of which she mastered almost immediately—must have contributed substantially to her ability to raise the confidence of the French troops. And when she was rehabilitated at hearings between 1450 and 1456, less than a single generation later, it was this image of her as a warrior, her connection to the reigning king, and her vindication as a leader of a just cause that dominated the proceedings. The fact that she wore male clothing was no longer an issue since now the trial and execution were attributed to the political maneuvering and hatred of the defeated English enemies, sidestepping entirely the question of the validity of her voices and the impropriety of her attire, which was now depicted artistically only as conservative military trappings. Ironically, even when she was canonized as a saint in the early twentieth century, the petitions focused on her marvelous equestrian skills, the supernatural signs at her death, and her loyalty to the church, optimizing her value as a rallying point for French Catholicism in an increasingly secular climate and minimizing the transgressivity of her cross-dressing.

pipes. Belts were also sometimes worn with houppelandes. The garment's elaborate ornamentation included fur, fabric appliqués, and slashes showing the linings of complementary colors. The combination of pourpoint, hose, poulaines, and houppelande peaked as the ruling fashion at the courts of the English kings Edward III and Richard II in the second half of the fourteenth century. After 1450, the more usual term for the houppelande was "gown," and it was gradually replaced by the robe.

SHOES WITH POINTED TOES. Shoes worn with the tight hose of the new silhouette had long, pointed toes. Before 1350 shoes generally conformed to the shape of the foot, reached to the ankles, and had leather lacings, although there were periods when the toe became more pointed, even exaggeratedly so, and then returned to a more natural shape. Following the mid-fourteenth-century fashion shift in masculine dress, shoes were more visible and therefore more important as an element of fashion. *Poulaines*, sometimes called *crackowes*, were a recurring style. These shoes were named after Poland or its capital because they were thought to have originated in the city of Crakow in Poland. Featuring a pointed toe as much as six inches long that had been stuffed with moss, these shoes were an accompaniment to styles that stressed linear proportions. Besides the long toes, shoemakers employed many other decorative techniques appropriate to leather and fabric shoes: embroidery, tooling, paint, dye, cut-out designs, and elaborate buckles. Such highly ornamental shoes were often described in late medieval literature; for example, in Geoffrey Chaucer's *Miller's Tale*, Absolon, the clerk and would-be lover of Alisoun, is a dandy who wears shoes with cut-out designs on his shoes' insteps that Chaucer likens to the panels in a stained-glass window in St. Paul's Cathedral, London.

HAIR, HOODS, AND HATS. Around 1400 to 1450 it became very fashionable for French, English, and Spanish men to wear an unusual hairstyle in which the hair was cut very short at the sides and nape of the neck, leaving a bowl-like area at the crown and above the ears. It is possible that this style developed in response to the popularity of the "carcaille" collar, very high and fur edged, which was found on the houppelande and other forms of the gown. Joan of Arc adopted this male hairstyle, and this was presented as evidence of her alleged cross-dressing tendencies at her trial. To accompany the new short costume in the fourteenth century, men wore a hood that covered the head and shoulders and revealed more or less of the face according to how it was rolled back. About the end of the twelfth century, the hood had ceased to be attached to the cloak, acquiring a very brief neck cape and becoming a separate piece of male apparel. In the fourteenth century, the hood became a fashion accessory for men, and a tail or band called the "liripipe" developed long enough to be worn as a scarf around the neck, or decoratively arrayed and tied around the head, or hanging down and secured by the girdle. Alternatively, this hood might be folded and tied so as to form a hat. During the fifteenth century, it was arranged over a wicker hoop or roll to give it shape. It competed in popularity with crowned felt hats and sheared or long-furred beaver hats with brims, a fashion exported from Flanders or modern Belgium, which were increasing in size and amount of decoration. These hats took a variety of shapes and some had conical tops, were embroidered and covered with ribbons, or sported peacock or ostrich feathers attached by jeweled pins.

SOURCES

Michael Camille, *The Gothic Idol: Ideology and Image Making in Medieval Art* (Cambridge, Mass.: Harvard University Press, 1989): 298–337.

Kenneth Clark, *The Nude: A Study in Ideal Form* (New York: Doubleday, 1956): 145–147, 400–432.

Norman Davis, ed., *Sir Gawain and the Green Knight* (Oxford: Clarendon Press, 1968): 53.

D. Freedberg, *The Power of Images; Studies in the History and Theory of Response* (Chicago: University of Chicago Press, 1989): 317–377.

Francis Grew and Margrethe De Neergaard, *Shoes and Pattens* (Cambridge, England: Boydell and Brewer, 2001).

Rosita Levi-Pisetzky, *Storia del costume in Italia.* 5 vols. (Milan: Instituto Editoriale Italiano, 1964–1969).

Jean Longnon and Raymond Cazelles, *The Très Riches Heures of Jean, Duke of Berry: Musée Condé, Chantilly* (New York: Braziller, 1969): 14.

Françoise Piponnier and Perrine Mane, *Dress in the Middle Ages* (New Haven, Conn.: Yale University Press, 1997).

Jean Seznec, *The Survival of the Pagan Gods.* Trans. Barbara F. Sessions (New York: Pantheon, 1953).

Marina Warner, *Joan of Arc: The Image of Female Heroism* (Berkeley, Calif.: University of California Press, 1981).

A NEW LOOK FOR WOMEN

NECKLINES AND UPPER BODY COVERINGS. The most significant change occurring in feminine styles around the middle of the fourteenth century in France and England was a low neckline revealing shoulders and the upper portions of the breasts. One explanation for this change is geographic since the lowering of women's necklines in dresses with very tightly laced or buttoned bodices, tight-fitting sleeves, and A-line skirts was perhaps at first a climate-related trend from Italy. But with the new interest in the human body and the belief that the body was a potential source of beauty, the style spread rapidly northward to cooler regions by the fourteenth century. Now visible were areas of the body that had formerly been hidden by a higher neckline and a *wimple*, a portion of the headdress that covered the whole of the neck and even part of the chin. The contrast between the newer, barer style for fashionable women and the older more conservative style was strikingly expressed in the Middle English romance *Sir Gawain and the Green*

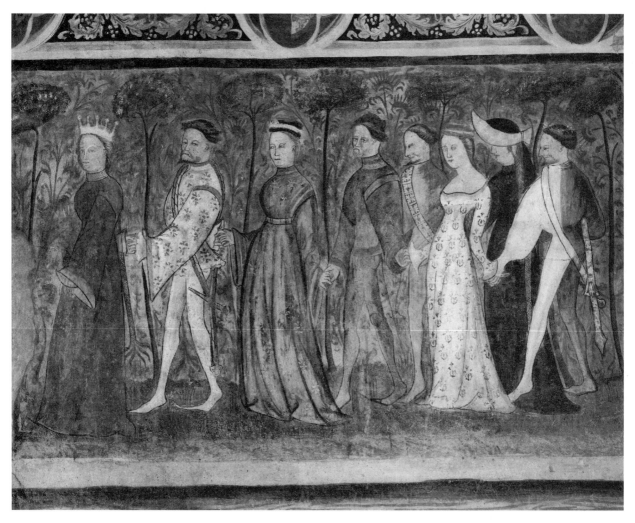

Female dress showing neck and shoulders. Fresco, Runkelstein Castle, Bolzano, South Tyrol, Italy, 14th century. ERICH LESSING/ART RESOURCE, NY.

Knight, where the poet notes of the lady of the house that "her breast and her bright throat were shown bare and gleamed brighter than snow new fallen on hillsides," in contrast to the witch-like Morgan le Faye who had "a gorger or coverchief over her neck, bound over her black chin with chalk-white veils/ her forehead shrouded in silk." Such low necklines were a stylistic feature that lasted through the following century. At the same time, for reasons not fully understood, no matter how revealing of the bosom these low necklines were, women's arms still remained covered by sleeves.

WOMEN AND THE HOUPPELANDE. From about 1350 onward, and coinciding with the advent of the new short costume for men, records for expenditures on clothing purchased by various royal courts survive and provide considerable information regarding styles, color, and fabric choices (especially vernacular or non-Latin terms for colors and costume styles), and the particular

court occasions, such as weddings or festivals, for which the items were ordered. Since male fashion seems to have been documented more than female, it is harder to say with certainty exactly what was purchased for women, and costume historians are forced to rely more on manuscript miniatures and other depictions in the decorative arts. Nonetheless, it seems clear that during the period from 1340 to 1485, feminine fashion remained relatively stable, though throughout the fifteenth century women's necks were decidedly bare, with the exception of a brief period from around 1415 to 1425 when it was fashionable to cover them. In the first quarter of the century, the standard garments for women were the cote and the mantle, with the cotehardie (a sort of vest), the sideless gown or surcoat (adopted from Italy), worn by noblewomen only for the most important court ceremonies. In the second decade of the fourteenth century, the garment formerly reserved for men, the houppelande, with

TYPES of Medieval Head Coverings

Almuce: An elongated, fur-lined hood. Initially worn by the general population, it later became the headdress worn by clerics, especially canons (members of a religious community who lived outside a monastery in "colleges" and were often associated with the daily song rituals in cathedrals).

Bonnet (English "cap"): A general French term denoting a small head-covering. This term was used from the early Middle Ages onward.

Chaperone: A hood with a lower edge long enough to cover the nape of the neck and upper shoulders, having a circular opening for the face and often a long point, sometimes with a tail or tippet added. In the fifteenth century, the chaperone was often worn in an elaborate curved turban-like arrangement on top of the head, with the tippet wrapped to retain the desired shape.

Coif: A small covering for the head, usually of linen, that tied under the chin, resembling a present-day baby bonnet. It was worn beneath other types of headdresses. Dating from the early thirteenth century, it disappeared from men's fashionable dress by the middle of the fourteenth century, except that it continued to be worn by Sergeants at Law in England even after they became judges. In warmer weather, nobles often wore other light headgear such as flower wreaths, garlands of peacock feathers, and jeweled circlets.

Hennin: Primarily a French headdress of the second half of the fifteenth century, the hennin had a cone-shaped construction with soft veiling attached at the peak that hung behind it in varying lengths, some as long as to the floor. At the time when these were popular, ladies shaved or plucked their foreheads to raise their hairlines, and their tall headdresses emphasized this elongated facial effect.

Reticulated headdress: A style in the fourteenth and fifteenth centuries characterized by the enclosure of hair arrangements in a net-like receptacle. The forerunner of this headdress was the *caul* or *crispinette*. Reticulated headdresses were made of gold, silver, or silk nets, sometimes set with jewels at intersections, and fashioned into bags to hold the hair in place.

Wimple: A small veil or shawl-like garment worn over the neck and upper chest, usually draped, pleated, or tucked. Attached at the sides of the head either by ties or pins, they were worn sometimes as loose coverings and at other times fitted so as to adhere closely to the neck. Wimples were stylish in the late thirteenth and early fourteenth centuries, but by the second half of the fourteenth century they were primarily conservative garments worn only by nuns, ladies in mourning, and elderly women.

a variety of fanciful sleeve types, was adopted for feminine wear. This garment's extravagant decoration, with slashings to show contrasting fabric below and cut-out decoration at very full sleeves and hem, was taken over with slight modification by women in the form of full frontal closure and a train. A variation in the style of the sleeves of the houppelande or robe appeared at the middle of the century when a tight sleeve with a cuff covering the knuckles replaced older sleeve types. The female form of the cotehardie was somewhat less fancy than its male counterpart. It was worn over a "kirtle," a term originally designating a short linen under-garment, later an overgown, and still later, analogous to the French cote, the outer garment also known as a robe or surcote. Buttons were optional, and no girdle was worn with it.

HENNINS AND HEADDRESSES. For the whole of the fifteenth century, very fanciful largely vertical headdresses built up on a framework or understructure were in fashion, perhaps because women wanted to participate in the acquisition of ever-changing fashions but were not permitted to make drastic changes to the length of their dress. Continuing the trend of decorative excess, women's fifteenth-century headgear included heart-shaped and "reticulated" headdresses—that is, headdresses characterized by the enclosure of hair arrangements in a stiff net-like receptacle that replaced the earlier "snoods," or bags, to hold the hair in place. The hennin, primarily a French headdress of the fifteenth century, was a cone-shaped construction with soft, often pleated veiling attached by pins at the peak that hung behind it in varying lengths, some as long as to the floor. The origin of the word "hennin" is unknown; it possibly reflects a contemptuous slur meaning "to whinny," which was flung by passersby at women wearing such headdresses on the streets. Another form of such headdresses was that called "cornes" (horns), in which the headcovering branched out like a crescent moon in two horn-like protuberances. Towards the end of the medieval period, perhaps responding to the same taste for "verticality" that appeared in Gothic architecture (and also in men's clothing), women plucked or shaved their hairlines to increase their expanse of foreheads—a style

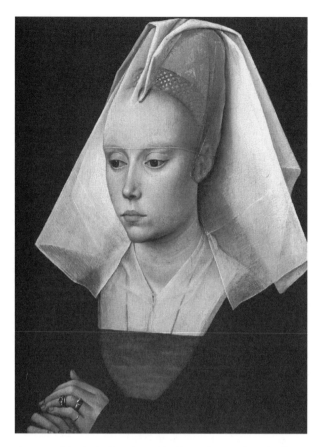

Woman with plucked or shaved hairline, sheer veil, and tall headdress. Oil on canvas, workshop of Rogier van der Weyden, 1399–1464. UK, NATIONAL GALLERY, LONDON.

called "bombé" or "bulged"—and their tall headdresses emphasized this elongated facial effect. A late fifteenth-century panel painting of a young woman with plucked or shaved hairline and a sheer veil and tall headdress from the workshop of Rogier van der Weyden, now in the National Gallery in London, shows this cosmetic and fashion style.

SOURCES

Mireille Madou, "Cornes and Cornettes," in *Flanders in a European Perspective: Manuscript Illumination around 1400 in Flanders and Abroad; Proceedings of the International Colloquium, Leuven, 7–10 September 1993.* Ed. M. Smeyers and Bert Cardon (Leuven, Belgium: Uitgerij Peeters, 1995): 417–426.

Margaret Ruth Miles, *Carnal Knowing; Female Nakedness and Religious Meaning in the Christian West* (Tunbridge Wells, England: Burns and Oates, 1992).

John Scattergood, "Fashion and Morality in the Late Middle Ages," in *England in the Fifteenth Century: Proceedings of the 1986 Harlaxton Symposium.* Ed. David Williams (Woodbridge, Suffolk, England: Brewer, 1987): 255–272.

Cheunsoon Song and Lucy Roy Sibley, "The Vertical Head-dress of Fifteenth–Century Northern Europe," *Dress* 16 (1990): 4–15.

THE SPREAD OF THE AGE OF FASHION

DOWNWARD MOVEMENT AND UPWARD PRESSURE. While at first the development of radically new styles for both aristocratic men and aristocratic women in the mid-fourteenth century probably arose from a combination of intellectual and artistic influences, the increased rate of change and the spread of interest in fashion throughout all levels of society were brought about in large part through a new set of economic and social factors that began to appear around the same time. The significant shift in European styles worn by the fourteenth-century nobility re-instituted class markers in costume that had largely been eliminated in the thirteenth century. Because so many family lines were disrupted by mortality from the bubonic plague, which led to the redistribution of lands and opportunities for the upper bourgeoisie to attain property and power, social status came to be determined in part by the possession of wealth rather than merely by family lineage. The commercial class who survived the plague and became wealthy could afford to imitate the opulent dress of the nobility, and the classes beneath these merchants and citizens, as they were able, followed suit. Likewise, in England, during the Hundred Years' War, the middle and lower classes were able to accomplish such imitation after the English victory over the French at Poitiers (1356) because sumptuous garments flooded the country as a result of booty taken from the defeated French nobility. As the French author Jean Froissart mentions in his *Chronicles of the Hundred Years' War*, from this battle, ransoms were collected for captured French prisoners, dishes made of gold and silver were confiscated, and other treasures were gathered, such as jewels, girdles, and ornaments made of precious metals, and richly furred mantles, all of which the English leader, Edward the Black Prince, shared among his followers. Thus, in the fourteenth century, every time the nobility introduced a new style, there were always immediate imitators whose wearing of the garments took away their appeal and made it necessary for the aristocracy to seek even newer, and often more expensive, fabrics and garments. Some costume historians, for example, have argued that women's headdresses might be used to date costumes with an error factor of only about ten years, presumably because styles in headdresses changed so often and these changes were so well documented that they could be used as dating guidelines. However, this

method of dating should be used cautiously since now a given headdress might be worn even when it was out of style by someone not affiliated with the court, or by someone far removed from the centers of style in the major sites of the court or the cities.

COMPETITION BETWEEN COURTS. After about 1350 European styles in general were heavily influenced by the French court, and became ever more elaborately ostentatious following the death of France's king Charles V in 1380. In England, earlier in the century, King Edward II's French consort, Queen Isabella (married 1308, died 1358), had influenced fashion similarities between the two courts. The succeeding two kings of England—Edward III and Richard II—were members of the Plantagenet family, whose claims to the French throne (the cause of the Hundred Years' War) no doubt contributed to a desire to compete with the French court in matters of opulence and led to a similarly unrestrained attitude towards expensive dress. Indeed, Richard II was reputed the greatest fashion spendthrift of all of the English monarchs to his day, a habit to which some attributed his eventual downfall. Overall, in the fifteenth century expenditures for clothing continued to increase, and the rapidity of fashion changes and excesses of ornamentation contributed to the brilliance of a growing number of European courts, particularly in Burgundy and in the Burgundian Low Countries at Bruges and Ghent. Until 1440, noblemen and women continued to wear the lavish styles, garments, and ornamentation developed in the late fourteenth century, with only minor variations in design. Beginning in 1440, tunics of fashionable European noblemen reached nearly to the knee, but in the following decade tunics were made much shorter. The fourteenth-century fashion known as the *courtepie* (or short houppelande) returned to favor. From then on, short tunics continued to be in fashion into the sixteenth century. In addition, in France and England, Italian styles and those of the court of Burgundy, which also reflected Flemish and German elements, became popular. Germanic influence included the enlarging of sleeves, chest, and shoulders by means of added padding in a manner that some considered a distortion of the human silhouette.

TALL AND NARROW. Perhaps due to a combination of social and economic factors, including the end of the Hundred Years' War, fashion took a turn to a radical new form in the middle of the fifteenth century. In England, toward the close of King Henry VI's first reign (1422–1461), fashionable courtiers wore narrow, long robes, with houppelandes and peliçons again in style. The shoulders were padded, but the skirts were narrow, and these robes were worn as outer garments

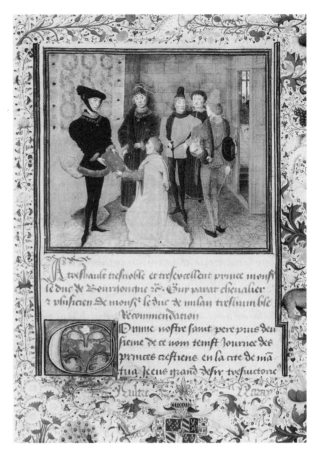

Guy Parat presents *The Preservation of Health* to Philip the Good, duke of Burgundy, wearing black "tall" costume. St. Petersburg, Russia, National Library MS Fr.Q.v.V.i.l, folio 2, 1450. ERICH LESSING/ART RESOURCE, NY.

over the short tunics mentioned above, topped by tall hats. The combination produced a silhouette of extreme height. At the same time, ornamental excesses were appearing in all of the other arts of the period, so that the "perpendicular style" in fashion occurred simultaneously with the period when Gothic architecture was reaching its peak of ornamental linear emphasis. In costume this trend toward extremes was best illustrated in the courts of King Charles VI of France (1380–1422) and the dukes of Burgundy, as the nobility wore garments divided into contrasting color areas—such as red and blue, or green and yellow—and the headdresses of both noblemen and ladies grew more varied and exaggerated in shape, especially in height. Indeed, from mid-century forward, women also sought an elongated fashionable look that included a high, plucked hairline, complemented by a swan-like neck, slender shoulders, and skirts that reached to the ground. Breaking the long line of this fashion look was the fashionable lady's posture, in which her stomach protruded beneath her elevated waistline, an effect often increased by padding.

SOURCES

François Boucher, *20,000 Years of Fashion: The History of Costume and Personal Adornment* (New York: Abrams, 1987).

William Naphy and Andrew Spicer, *The Black Death: A History of Plagues 1348–1730* (Stroud, Charleston, S.C.: Tempus, 2001).

Françoise Piponnier and Perrine Mane, *Dress in the Middle Ages* (New Haven, Conn.: Yale University Press, 1997).

M. Scott, *A Visual History of Costume: The Fourteenth and Fifteenth Centuries* (London: Batsford, 1986).

DRESS CODES AND ANTI-FASHION

THE ORIGINS OF SUMPTUARY LAW. Sumptuary laws, named from a Latin word that joins the ideas of magnificence and expense, were enacted across Western Europe during the Middle Ages. Such laws had economic, moral, and social foundations. Economically, they regulated personal spending, with the intention of controlling inflation, discouraging the depletion of state resources for purposes of ostentatious display, and limiting the trade deficits that could occur through the import of luxury goods from faraway places. At the same time they regulated behavior, reinforcing the virtues of modesty and moral seriousness that were often thought to be especially lacking among women and young men. Finally, they performed a social function in clarifying the lines between classes through visual signs, slowing the encroachment of the commercial classes on the privileges of the aristocracy. The earliest such laws in the Middle Ages were those decreed by Charlemagne and by Louis the Debonnaire who ruled the Frankish kingdom after Charlemagne's death in 814. These were, respectively, attempts to control the prices that nobles might pay for their customary garments and attempts to forbid the wearing of silk and ornaments of gold and silver. Later sumptuary laws, with the earliest dated 1157 in Genoa—followed by similar statutes in France, Spain, and the rest of Italy—attempted to regulate economic conditions of a political area such as entire countries and individual city-states. Sometimes their purpose was to restrict trade with an eye to promoting local production at the cost of other states' profits; for example, in England at certain periods citizens were forbidden to purchase imported cloth and could only wear clothing made of locally produced fabric. When royal coffers were getting depleted, governments attempted to regulate traffic in consumable goods and monies spent on ceremonial occasions, such as weddings, funerals, knightly investitures (the "dubbing" ceremony), and birth celebrations. It should come as no surprise that during a period of lavish

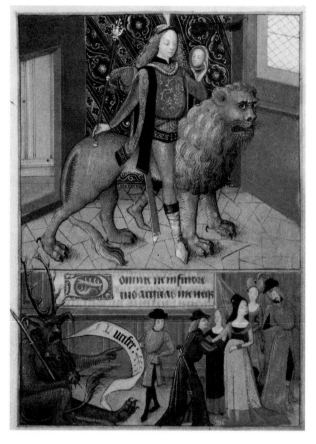

Pride in open-sided jacket and hose. Psalter hours of Rome use, Robinet Testard, Poitiers, late 15th century. THE PIERPONT MORGAN LIBRARY, NEW YORK. M. 1001, F. 84.

and luxurious costume in fourteenth-century England, sumptuary laws were initiated there, as they had been previously in other parts of Europe. From time to time, the king and/or his nobles in Parliament attempted to regulate dress by the two standards of income and birth status. Despite their efforts, these laws—passed, sometimes passed then rescinded (1363), or proposed but rejected (as in the case of Richard II)—were never capable of curbing fourteenth-century fashion excesses. Nonetheless, they serve as valuable indicators of the attitudes of certain portions of the nobility toward costume.

SUMPTUARY LAW AND ITS MORAL IMPLICATIONS. Not only noble wastefulness, but any excess in dress was the target of sumptuary laws. And sometimes a moral point was made—that excessive consumption of these goods, with clothing specifically mentioned, resulted from the sin of pride. Thus, such practices must be moderated or else such sinfulness would draw upon the community natural disasters such as plague, famine, and war as signs of God's punishments. In many cases, especially in Italy, sumptuary laws were directed at women partic-

a PRIMARY SOURCE document

A SATIRE ON WOMEN'S HORNED HEADDRESSES

INTRODUCTION: Medieval moralists singled out female head-dresses as a special target for attack on the immorality of certain fashions. Not only sermons, but also popular poetry pointed out the dangers of excessive headwear. The male writer of the early fourteenth-century poem reproduced here specifically attacks a style in which women fashioned "horns" of false hair enclosed in a net known as a crispinette on both sides of their heads, in this case making the point that women wearing horns were adopting male roles, since horns were a sign of masculinity on animals like bulls and deer. Variations of this style of headdress, with the horns growing longer or taller, survived into the reign of Henry VI (1422–1461 and 1470–1471) and continued to incite satirical comment.

The Bishop of Paris, a theologian
and a philosopher, observes that
a woman who puts false hair on her head
and paints herself to please the world
is too foolish a hussy. …
If we do not take care of ourselves
we shall be slain by these women.
They wear horns to kill men; they carry great masses
of other people's hair upon their heads.

Woman began to turn herself to evil
from the time she caused our first father [Adam]
to descend into hell.
Believe me well—

A woman who adorns her head with horns will pay for it;
if she does not mend her ways. …

They make themselves horned
with worked hemp, or flax,
and counterfeit dumb beasts—
they who wish to be known as worthy ladies.
It would be more to their advantage
to think of their souls; as do
the worthy women of simple manners,
who will not display themselves,
nor show their flesh to attract libertines.
They [horned ladies] make men much worse—greater fools,
and greater sinners—by their enticement;
this foolish behavior entices those who would,
long ago, have kept out of temptation,
I do not doubt.

And I believe,
May God bless me, that a woman
who decorates herself thus,
and disfigures herself, and loves
and values her flesh so much,
is not much occupied with goodness of heart.
Even if she were my cousin, or my sister,
I could only believe that such a one,
horned, is a foolish woman.

SOURCE: Frederick W. Fairholt, ed., *Satirical Songs and Poems on Costume: From the 13th to the 19th Century* (1849; reprint, New York: Johnson Reprint Corp, 1965): 29–39. Text modernized by John Block Friedman.

ularly, the reputed source of all temptation to excess. Indeed, women as temptresses drawing men into sin through pride and lust were a favorite target for medieval moralists. A striking combined attack against prideful exhibition in male and female costume appears in the *Book of the Chevalier de la Tour Landry*, a late medieval French "courtesy book" intended by the author for the moral education of his daughters. The speaker mentions a sermon against pride—preached to a fashionably dressed crowd of men and women—which presents Noah's Flood as an exemplum of destruction caused by bad behavior and then goes on to remark on women in the church who wore "horned" headdress. The preacher compares the women to snails who are displaying their "horns" to men who have come to church in such short costume that they are showing their behinds and their underpants and even their genitals. Thus, each outdid the other in foolish pride, the ones in short clothes and those wearing horns.

OPPOSITION TO EXTRAVAGANT GARMENTS. Many of the styles that took hold from the middle of the fourteenth century onward caused especially strong reactions from conservative members of society. Not surprisingly, one of the concerns was the new trend towards emphasis on the body, as expressed both in the men's short styles just mentioned and women's low necklines. The arguments against these styles took a number of forms. In a poem by Eustache Deschamps, for example, dated around 1398, the concern mainly seems to be a matter of jealousy, the complaint from older women that they are put at a disadvantage when young women use corsets to push up their breasts: "Because bosoms are being shown about / In all manner of places, generally, /A desire has arisen in many a person/ To have them covered again; / For it makes many a heart suddenly fill with sadness / To see them … /For the thing that has put them in this situation /Is youth alone:/ Round, small, firm …" (Ballade 1469). The sideless gown also seems

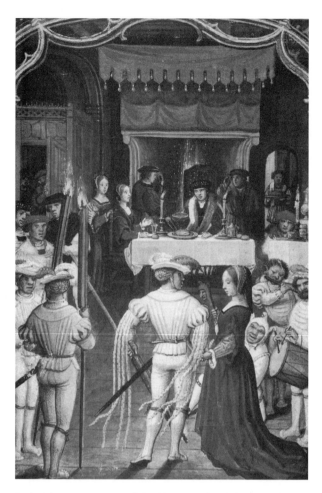

Male "short" costume and doublets seen from the rear. The "Golf" hours, Flemish, Simon Bening, London British Library MS Additional 24098, folio 19v, 1530. © THE BRITISH LIBRARY/ HIP-TOPHAM/THE IMAGE WORKS.

to have disturbed moralists: the resulting openings were called "devil's windows" since it appeared they made women's bodies accessible. For men, the revealing pour-point excited a strong backlash across Europe. For example, the Italian city-state of Aquila passed a sumptuary ordinance in 1375 legislating against men who wore very short pourpoints, and the Middle English poem *Brut* (c. 1346) mentions how the "madness and folly of the foreigners" has brought to England a taste for "short clothes." The well known Middle English satiric poem "Huff A Gallant" remarks on the fashion for "gowns/Too short their knees to hide," while a similar poem, "Now is England perished," mocks those with "short gowns." One Middle English sermon of about 1380 treats several of these points with an added concern about class transgressivity: "Now are the common people afflicted by the sin of pride. For now a wretched knave, who walks behind a plow and a cart, and has no money but serves from year to year for his livelihood, whom once a white

girdle and a russet gown would have served quite well must now have a fancy doublet costing five shillings or even more and over that a costly gown with baggy sleeves hanging down to his knees and pleats under his girdle like those on a bishop's surplice, and a hood on his head with a thousand little tags on his tippet, and gay hose and shoes as though he were a country squire." The extravagant cut of the houppelande, though it was not revealing, likewise excited considerable comment at its appearance in the 1360s because it required so much expensive cloth (and often fur and other decorative touches), resulting in a wasteful display of wealth. French chronicler and poet Jean Froissart wrote a pastourelle in which several humble shepherds discuss this garment with awe and a certain ironic lack of understanding of its function as an indicator of social status.

THE BATTLE OVER SHOES. As early as 1298, extravagant shoe fashions drew criticism from both monarchs and moralists. An edict issued in France by King Philip the Fair in that year intended to curb excess of fashion among the rising bourgeois by restricting the length of the toes on poulaines. Such shoes were condemned at the Council of Anvers in 1365 and again by royal edict, for King Charles V of France on 9 October 1368 forbade the wearing of poulaines by all classes under a penalty of a fine of twelve florins (a gold coin). An English statute of 1465 decreed a fine of 20 shillings—a very large sum of money at the time—for those with pointed shoe tips over two inches long. As with many shifts in fashion in the later Middle Ages such as the replacement of long with short costume, the taste for poulaines had some significance in the economics of the cordwainers' (leatherworkers') guild and the general rise of guild autonomy throughout Europe and the British Isles. According to Gregory's *Chronicles*, the pope issued a bull in 1468 excommunicating those who made any shoes with pointed toes exceeding two inches in length: "And some men said that they would wear shoes with long pointed toes whether the Pope approved or disapproved, for they said the Pope's threat of excommunication was not worth a flea. And a short time later, some members of the Cordwainers guild got privy seals to make such shoes and caused trouble for those fellow guildsmen who heeded the papal edict."

BACKLASH AGAINST WOMEN'S HENNINS. The fashion for the tall dunce-cap-like female headdress called the *hennin* or cornet soon drew the attention of social critics. Although this headdress is the one most commonly associated with medieval female costume in the modern consciousness, it was in fact a late phenomenon mainly limited to France, Burgundy, and the Low

a PRIMARY SOURCE *document*

SHEPHERDS DISCUSS THE HOUPPELANDE

INTRODUCTION: As a poet in the court of Edward III of England in the late 1360s, the French chronicler Jean Froissart wrote a number of "historical pastourelles," poems using the form and context of traditional songs about aristocratic encounters with shepherdesses, but transformed to comment on current events. In a poem that appears as "Pastourelle 1" in both of the original manuscripts, Froissart imagines an aristocratic narrator who overhears a group of shepherds discussing the houppelande fashion of a nobleman who has just passed by. Quoting the words of the shepherds, the poet simultaneously makes fun of both the shepherds' misunderstanding of what they see and the absurdity of the garment itself, which used a tremendous amount of cloth. In the poem, one shepherd wonders if a single ell of cloth (a measurement equal to about 45 inches) would be enough to make a houppelande for himself, and is promptly informed that he would need nine times that much just to line the garment.

Between Aubrecicourt and Mauny
Near the road, upon fallow ground,
The other day I heard shepherds talking
Around the hour of noon.
And Levrins Cope-osiere was saying:
"Gentlemen, yesterday didn't you see
Men on horseback riding by
Or hear talk about houppelande cloaks?
I saw each man wearing one of them,
And the sight brought me such great joy
That, ever since, I've done nothing but wish that I
Could dress in a houppelande."

"A houppelande, dear God, oh my!"
Thus answered Willemes Louviere,
"And what can that be, now tell me that!
I know what a bread sack is, all right,
A tunic and a traveling pouch,
Leggings, a needle holder,
A hare, a collar, a greyhound,
And I know how to guard sheep well,
Care for them and get rid of disease;
But I don't have the slightest idea
What on earth could make you talk about
Dressing in a houppelande."

"Listen, and I will tell you:
It's because it's the latest style,
For the other day I saw someone wearing one,
One sleeve in front, another behind;
I don't know whether such clothes are expensive,
But they certainly are valuable;
They are good both summer and winter,
You can wrap yourself up snugly inside,
You can put whatever you like in there;
You could easily hide a wicker basket—
And that's what makes me think about
Dressing in a houppelande."

"By my faith," said Ansel D'Aubri,
"I am sure that some time ago
Shepherds used to wear cloaks of that kind,
Except theirs were made of light cloth,
For I still have the very first one
That belonged to my grandfather Ogier."
Then Adins, son of Renier, responded:
"Ansel, by the body of Saint Omer,
Please bring it with you tomorrow;
We will use it to cover our food,
For I might also decide that I wish to
Dress in a houppelande."

"Gentlemen," said Aloris d'Oisi,
"By the faith that I owe Saint Peter,
I will go to Douai Saturday,
And buy an entire ell of cloth,
And I will make the most excellent cloak
That anyone has ever seen a shepherd wear.
Will I have enough cloth to have one made
And have a fourth left over?"
—"My, no; to line it you will need
Nine ells of broad Irish cloth."
—"Alas! It would cost me too much to
Dress in a houppelande."

Prince, I saw them thinking it over
And talking among themselves and making plans:
It would be good to require of all shepherds
That every one of them should agree to
Dress in a houppelande.

SOURCE: Jean Froissart, "Pastourelle 1," *The Short Lyric Poems of Jean Froissart: Fixed Forms and the Courtly Ideal* (New York and London: Garland, 1994): 108–111. Translated by Kristen M. Figg.

Countries. The hennin could be as much as a yard tall, and it was worn inclined to the rear. On its peak was attached a thin veil, which might be short, so as to flutter in the wind, or long, reaching all the way to the floor. The Carmelite friar Thomas Conecte (died 1433) singled out hennins in a sermon as among the worst expenditures of women on their fashion. His sermons against gambling and extravagance in clothing were enormously popular in northeast France and what is now Belgium, drawing crowds in the thousands.

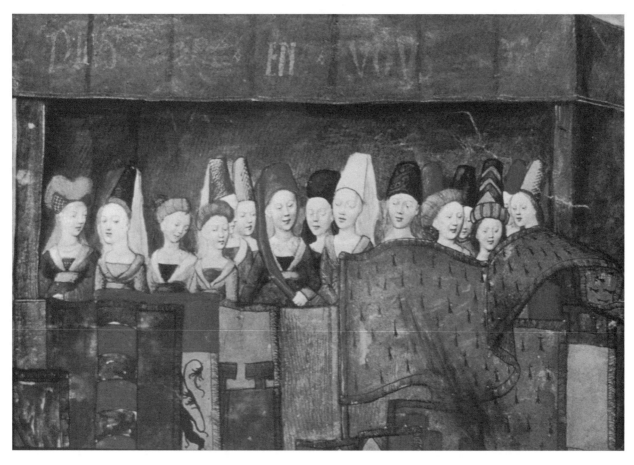

Women with hennins at a tournament, 15th-century manuscript painting. **THE GRANGER COLLECTION, NEW YORK.**

SOURCES

Anonymous Sermon (London: British Library MS Additional 41321 folios 101–102, c. 1380–1440).

Frances Baldwin, *Sumptuary Legislation and Personal Regulation in England* (Baltimore: The Johns Hopkins University Press, 1926).

Jeanne Bayle, *Le costume en Bourgogne de Philippe le Hardi à la mort de Charles le Téméraire (1364–1477)* (Paris: Presses Universitaires de France, 1956).

Friederich W. D. Brie, ed., *The Brut or Chronicles of England*. Early English Text Society OS: 136 (Millwood, N.Y.: Kraus, 1965): 296–297.

Eustache Deschamps, *Oeuvres Complètes de Eustache Deschamps*. Vol. 8. Ed. Gaston Raynaud. Trans. Kristen Figg and John Friedman (London: Johnson Reprint Co., 1966): 169.

James Gairdner, ed., *The Historical Collections of a Citizen of London*. Camden Society, New Series 17 (London: 1876): 238.

Diane Owen Hughes, "Regulating Women's Fashions," in *Silences of the Middle Ages: A History of Women in the West*. Vol. 2. Ed. C. Klapisch-Zuber (Cambridge, Mass. and London: Belknap, 1992): 136–158.

Alan Hunt, *Governance of the Consuming Passions: A History of Sumptuary Law* (New York: St. Martins, 1996).

Catherine Kovesi Killerby, *Sumptuary Law in Italy, 1200–1500* (Oxford: Clarendon Press, 2002).

A. de Montaiglon, ed., *Le Livre du Chevalier de La Tour Landry pour l'Enseignement de ses filles*. Trans. John Block Friedman (Nendeln and Lichtenstein: Kraus, 1972): Ch. 47, 98–99.

Rossell Hope Robbins, ed., *Historical Poems of the XIVth and XVth Centuries* (New York: Columbia University Press, 1959): 138, 139, 149.

Wendy Scase, "'Proud Gallants and Popeholy Priests': The Context and Function of a Fifteenth-Century Satirical Poem," *Medium Aevum* 63.2 (1994): 175–186.

M. Scott, *A Visual History of Costume: The Fourteenth and Fifteenth Centuries* (London: Batsford, 1986).

GUILDS AND CONFRATERNITIES

GROUP IDENTITY AND CONTROLLED COMMERCE.
Guilds and confraternities were an essential phenomenon of life in the early thirteenth and later centuries.

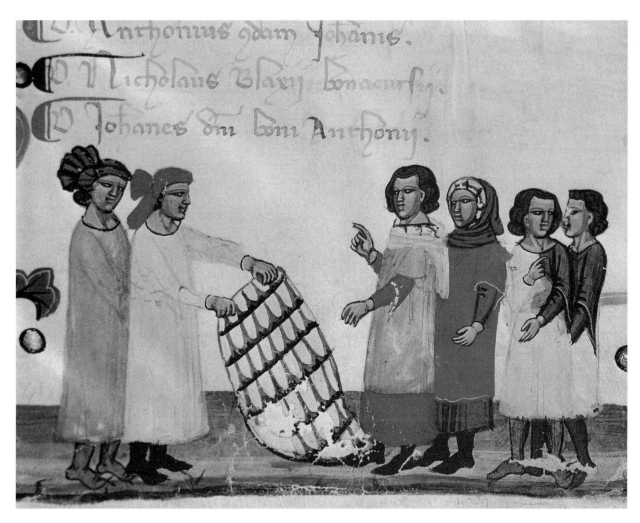

Cloth merchants showing wares. Book of statutes of Siena Drapers Guild, 14th century. THE ART ARCHIVE/MUSEO CIVICO BOLOGNA/ DAGLI ORTI.

They played an important role in the development of the cloth trades and in the consequent rise of fashion in all of its social and aesthetic ramifications. For example, although religious confraternities allied to a particular church or shrine were chiefly organized for the purpose of mutual spiritual and social support, they also played a role in the development of fashion. Their rules and charters designated a particular costume to be worn at meetings to identify members and give a feeling of community. Members prayed together and for each other; they provided mutual financial support and comfort in times of illness and death, and they formed and financially supported groups who went on pilgrimages, often wearing the colors and heraldic insignia of the group. The merchant guild was organized in the smaller cities or towns primarily to enforce a monopoly that ensured its membership—craftsmen, traders, and merchants—the control of commerce within the city or town boundaries. They retained economic control within their geograph-

ical area by imposing fees and rules that non-residents and non-members had to add to their cost of doing business within this town or city. These guilds also provided aid to their members who were sick or needed burial, in addition to meeting regularly for ceremonial and social dinners. They, too, required members to be appropriately dressed in the costume that identified the guild. At least as early as 1216 there were a notable number of these merchant guilds controlling, for example, the transportation trades of carters, watermen, and the like.

STANDARDS OF CRAFTSMANSHIP. In the larger cities such as London and Paris, however, a different kind of guild—that of artisans—sprang up. There, the numbers of craftsmen were great enough that individual crafts might form a guild of their own, and specialization within a craft provided the opportunity for increasing skills, developing talent, and encouraging innovations in style. Such guild members intermarried and tended to live in

A MERCER HAWKS HIS WARES

INTRODUCTION: A French "trade poem" called "Le Dit du Mercier," from a manuscript in Paris, Bibliothèque nationale MS fr. 19152, composed between 1270 and 1340, presents the mercer as a speaker, hawking his merchandise and describing some of his sales practices. The text offered here contains only the portions relating to fashion.

Hello to this very fine company.
I am a mercer, and carry mercery,
which I would sell willingly,
for I am in need of pennies.
Now, if it pleases you to listen,
I can easily describe the goods that I carry,
however heavy the weight of it that I bear—
I have some charming little girdles,
some fine gloves for young girls;
I have gloves in both double and single weight thickness.
I have good belt buckles
and good looking iron chainlets for the belt too—
I have wimples saffron tinted and perfumed;
I have well sharpened needles
and neat little boxes to hide trinkets in—
When you see them you will nearly cry out.
I have leather purses with nice catches,
Indeed, I have too many wares to describe.
I have good otter-skin winter cloaks,
and ermine and silks
and border edging of porpoise.
I have trains of fur
and nicely worked needle cases. ...

I have braies [male underpants] and lovely garter belts
and good saddle bags.
I have sewing thimbles
and various alms purses
of both silk and Spanish leather
which I would love to sell.
And I have some also of plain linen.
I would gladly sell a veil to a Benedictine nun.
I have iron buckles for your shoes. ...

and for ladies horn clips for your hair.
Buckles for your shoes
And even pewter catches for a child's shoe straps.
I have fine laces for felt hats.
I have beautiful silver wimple pins,
as well as some of pot metal too,
that I sell to these fine ladies.
I have some pretty head scarves
and lovely coifs with laces
that I can sell to pretty girls,
and a matching silk
for hats with bordered brims,
and I also have some linen hats for young girls,
embroidered with flowers or birds—
of a smooth and bright warp and woof—
to primp in before their boyfriends,
and for peasants some hats of hemp
and mittens for their hands.
And for monks some purses ...

And knotted laces for surcoats ...

and well-made hose from Bruges ...

the same neighborhoods, which then became identified with those trades. At the same time, the guild developed and maintained standards of craftsmanship and assumed responsibility for punishing any member or apprentice who violated these standards. Like the merchant guilds, artisan guilds also aimed to control commerce, protect it from predatory and innovative non-members or foreigners, and make it work always in their own favor. When towns expanded into cities, these craft guilds supplanted the merchant guilds that had formerly held trade monopolies. Gradually, the number of specialized craft guilds increased. Throughout the Middle Ages, the largest and most powerful of these guilds were those having to do with the cloth trades, but leather crafts were also very important since they supplied shoes, clothes, and belts, as well as other serviceable goods.

COMMERCIAL PRIDE. The flavor of these cloth trade guilds and their enterprise is encapsulated in certain "trade poems" of the thirteenth century. For example, the essence of a medieval tailors' guild is portrayed in the "Song Upon the Tailors," which emphasizes the importance of tailors to society in a time when those who could afford it always ordered their wardrobes from tailors and those who were less affluent had their garments made at home. This poem, written in Latin and dating from about 1260 to 1270, is extremely useful as a glimpse into attitudes towards clothing from relatively early in the Middle Ages. The poem illustrates the thrifty practice of the remaking of old garments into new ones, and, in a subtle play on the religious concept of transubstantiation, the poet elevates the importance of tailors' work by likening it to that of divinities (gods)

and combs for the hair—
I have good Parisian soap
and nice boxes to keep it in.
I have catches of both silvered and
gilded pot metal—and people love those
which are made of pot metal so much
that often we mercers use silver colored pot metal
and call it silver. …

And I have knives both blunt and pointed
to make a knight-to-be look chic …

and ribbons to attach silk-covered gold buttons
and belts red and green, white and black
with iron plates—
that sell very well at fairs. …

I have many fine collars up to the ears, and napkins
that rich women wear on their heads on holy feast days,
and I have much finery for women:
Everything necessary to the toilette:
razors to shave the hairline, tweezers, make-up mirrors
and ear and tooth-picks,
hair preeners and curling irons,
shoehorns, combs, and mirrors,
and rose water with which to cleanse themselves.
I have cotton with which they rouge,
and whitening with which they blanch themselves,
and I have laces for lacing their sleeves …

I have saffron to spice your food
which I sell to ladies to tint their collars,
whole pomegranates (but I think they are expensive).
But nonetheless I know well how to sell them
—and get money or payment in kind—
and very fine belts and deceitful little trumperies. …

I have catches of pot metal and alloy
and girdles and beautiful falls to cover the head
of which I have given three in exchange for one egg!
(But I don't guarantee that they are new!)
I have fine muslin to veil your faces …

and chaplets for the old ones.
I can tell you the world has mercers
so that men and women can buy
all these goods that load me down. …

Come forward ladies, come here.
Come forward, Don't avoid me.
With an egg or a sou or a penny
come lighten my panniers. …

Now there is nowhere a man so rich
who would not better love such a load
Of mercery were he to have it—
and if he knew how to safeguard it well—
But I can get no good from it
nor could I get any profit with it
and from nothing I carried
did I gain enough to eat—
Therefore will I set down my pack
I will not meddle any more with it—
Thus I will go back to the peddlers' tax notice
at the city gates, and pray you God:
shelter me in some castle
and I get some chattel by it.

SOURCE: Philippe Ménard, "Le Dit du mercier," in *Mélanges de langue et de littérature du moyen age offerts à Jean Frappier.* Vol. 2 (Geneva: Droz, 1970): 797–818. Translated from the Old French by John Block Friedman.

active in the lives of humankind. Thus we see commercial hype alive and well in the Middle Ages.

SOURCES

Caroline M. Barron, "The Parish Fraternities in Medieval London," in *The Church in Pre-Reformation Society: Essays in Honour of F. R. H. Du Boulay.* Ed. Caroline M. Barron and Christopher Harper-Bill (Woodbridge, Suffolk, England: Boydell, 1985): 13–37.

Donata Degrassi, *L'economia artigiana nell'Italia medievale* (Rome: La Nuova Italia Scientifica, 1996).

Steven Epstein, *Wage Labor and Guilds in Medieval Europe* (Chapel Hill: University of North Carolina Press, 1991).

Heather Swanson, "The Illusion of Economic Structure: Craft Guilds in Late Medieval English Towns," *Past and Present* 121 (1988): 29–48.

SIGNIFICANT PEOPLE
in Fashion

THOMAS CONECTE

c. 1390–1433

Carmelite friar
Reformer

A CARMELITE PREACHER SATIRIST. Thomas Conecte (or Connect) was born in Rennes, in Brittany in northwestern France in the 1390s. He joined the Carmelite order of friars and by 1428 was a popular preacher in Cambrai, Tournai, and Arras in the area of

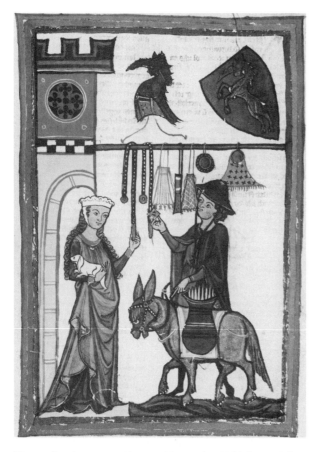

Mercer showing wares, Manesse Manuscript, Heidelberg, Universitätsbibliothek, Cod. Pal. Germ 848, fol. 64. MINNESANGER MS., C. 1300, HEIDELBERG UNIVERSITY (PH. MANSELL).

a PRIMARY SOURCE *document*

SONG UPON THE TAILORS

INTRODUCTION: The poem "Song Upon the Tailors" appears in a manuscript miscellany originally written at Reading Abbey in England, now in the British Library (MS Harley 978, folio 78). The author was a cleric both learned and witty as he plays on both the Christian concept of transubstantiation (the belief that the elements of the Eucharist actually transform into the body and blood of Christ upon consecration) as well as the gods of ancient Greece and Rome to elevate the importance of tailors' activity in reworking older clothes for new owners.

Ye are gods: ...
Gods certainly ye are, who can transform
an old garment into the shape of a new one.
—The cloth, while fresh and new,
is made either a cape or mantle;
but, in order of time, first it is a cape,
after a little space this is transformed into the other:
thus ye "change bodies."
When it becomes old, the collar is cut off;
when deprived of the collar, it is made a mantle:
thus, in the manner of Proteus, are garments
 changed;
nor is the law of metamorphosis a new discovery.
—With their shape they change their sex; ...
—When, at length, winter returns, many
engraft immediately upon the cape a capuce;
then it is squared;
after being squared it is rounded;
and so it becomes an almuce.
—If there remain any morsels of the cloth
or skin which is cut, it does not want a use—:
of these are made gloves; ...
—This is the general manner [in which]
they all make one robe out of another,
English, Germans, French, and Normans,
with scarcely an exception.

SOURCE: *Song Upon the Tailors*, in *Satirical Songs and Poems on Costume: From the 13th to the 19th Century.* Ed. Frederick W. Fairholt (New York: Johnson Reprint Corp, 1965): 29–39. Text modernized by Laura Hodges.

northeastern France bordering on what is now Belgium. Though he denounced gambling, his chief target of criticism was the fashion for very tall and elaborate female headdress. It is said that his sermons—which drew crowds as large as 20,000—were so effective that gamblers destroyed their dice and cards and women their tall headdresses immediately upon hearing his preaching. The famous eighteenth-century English essayist Joseph Addison had heard of, or read of, these sermons and described the women present at them in their tall headdresses "like a forest of cedars with their heads reaching the clouds." Soon caught up in the reform movement among the Carmelites in the fifteenth century, Conecte's denunciations of overly "secular" priests earned him the hostility of the ecclesiastical hierarchy of his diocese; he had to flee France to Italy, where he became involved in the reforms of the Carmelite convents at Florence and later at Mantua. By 1432, he made reforming trips to Venice, and finally to Rome, where he attacked the papal curia and the papacy of Eugenius IV for vices. He was condemned by the Inquisition and publicly burned at the stake as a heretic in 1433.

SOURCES

Joseph Addison, *The Spectator* (Friday, June 22, 1711).

Hervé Martin, *Le Métier du prédicateur* (Paris: Editions du Cerf, 1988).

Henri Peltier, *Histoire du Carme* (Paris: Editions du Seuil, 1958): 60.

Johannes Baptiste Schneyer, ed., *Wegweiser zu lateinischen Predigtreihen des Mittelalters* (Munich: Bayerischen Akademie der Wissenschaften, 1965).

ELEANOR OF AQUITAINE

1122–1204

Queen

SIMPLICITY AND FINE TASTE. Eleanor of Aquitaine, wife of two kings and mother of two more, was born in 1122, the daughter of William X of Aquitaine, a large important duchy in southwestern France. At fifteen Eleanor married a relative soon to be King Louis VII (r. 1137–1180) of France but did not bear him male heirs, and he eventually divorced her in 1152 on the grounds of consanguinity (being too closely related). Eleanor remarried; with her new husband, Henry II of England (r. 1154–1189), count of Anjou and duke of Normandy, she had five sons. She brought to this marriage her lands of Aquitaine. In her roles as queen of France and queen of England, Eleanor was an important arbiter of taste, serving as a patron of the arts, rebuilding deteriorated religious houses, and financing the construction of the first church in the "gothic" style. She also supported manuscript illumination and fine book making and has been associated with the rise of courtly poetry, a literary form that focused attention on the beauty of women and their fashions. Though her son King John (r. 1199–1216) presided over a wealthy court that provided ample opportunities for extravagance of dress, Eleanor encouraged a rather plain style among the women of her court, demonstrating the importance of her influence. She died in 1204.

SOURCES

William Kibler, ed., *Eleanor of Aquitaine: Patron and Politician* (Austin: University of Texas Press, 1976).

Bonnie Wheeler and John Karmi Parsons, eds., *Eleanor of Aquitaine: Lord and Lady* (New York: Palgrave Macmillan, 2003).

FRANCIS OF ASSISI

1181–1226

Founder of the Franciscan Order

THE SIMPLE GARB OF THE FRIAR. Francis of Assisi was born in 1181 and early in life experienced a mystical conversion to a life of poverty, itinerant preaching, and aid to the poor and disenfranchised. Like-minded persons soon gathered to him and by 1209 had formed what was to be the Franciscan Order of Friars or Friars Minor. Authorized by Pope Innocent III as a group of public preachers, they came together for their first general chapter in 1217. A Rule, that is, a guide to the organization and behavior of the order's adherents, was created in 1221 and officially approved for the Order of Friars Minor by Pope Honorius III in 1223. The rule stressed qualities that Francis saw in the apostolic form of Christianity illustrated by the lives and deeds of Jesus and his disciples. One element distinguishing the Friars Minor from the other mendicant or "begging" orders like the Dominicans, Augustinians, and Carmelites was Francis' insistence on absolute personal and corporate poverty. Franciscans were to live by begging or manual labor, reside in simple surroundings, and, most important, own no money or property. This was reemphasized at his death in 1226 in his *Testament*, a last work which again stressed that Franciscan friars were to own nothing, either as individuals or as a group. This issue of extreme apostolic poverty eventually led to divisions within the church, and a bull (the most solemn and weighty form of papal letter) of 1230 by Gregory IX implicitly favored wealth within the church and seemed to allow the order to own some simple property. This position was supported by the faction of "Conventuals" under the leadership of Bonaventure, who, in writing a "life" of Francis, defended the ownership of property such as the highly ornamented priestly garments known as vestments. Against the Conventuals was the Spiritual party, particularly associated with the name of Peter John Olivi (1248–1298) who argued against any type of possession and for an intense apocalyptic spirituality with a focus on the "use" of material goods, such as books, religious ornaments, and clothing, in only the most basic and necessary form. The garb of the Friars Minor, with its simple robe, rope belt, and sandals, was often depicted in medieval art and established a symbolic standard for simplicity of dress.

SOURCES

Richard Howlett, ed., *Monumenta Franciscana* (London: 1882; reprint, Wiesbaden, Germany: Kraus Reprint Co., 1965). Contains a fifteenth-century Middle English translation of the second Rule of St. Francis found in British Library MS Cotton Faustina D. IV, 2:67.

Malcolm D. Lambert, *Franciscan Poverty: The Doctrine of the Absolute Poverty of Christ and the Apostles in the Franciscan Order 1210–1323* (London: Society for the Promotion of Christian Knowledge, 1961).

A. G. Little, *Franciscan History and Legend in Medieval Art* (Manchester, England: Manchester University Press, 1937).

John A. Moorman, *A History of the Franciscan Order from Its Origins to the Year 1517* (Oxford: Clarendon, 1988).

PHILIP THE BOLD

1342–1404

General

Statesman

A MAGNIFICENT DUKE OF BURGUNDY. Philip, known as the Bold, was the son of King Jean II of France and Bonne of Luxembourg. He was born 17 January 1342 at Pointoise. After his capture at the Battle of Poitiers (1356), he was made duke of Burgundy by his father in 1363. He married Marguerite of Flanders, an heiress of great landed wealth, in 1369. Eventually, through his dynastic power, Philip formed a Burgundian state that controlled not only what is now eastern France, but much of the Netherlands and what is now Belgium. In some ways he became the second most important person in France, after the monarch Charles V. His reign of some twenty years was known for its patronage of the arts, and especially for the lavish use of highly ornamented fabrics such as silks, velvets, and cloth with gold and silver wire embroidery. He also favored striking color combinations in the costumes of his courtiers. Because of his influence, the colors blue and black became especially important in late fourteenth-century costume. As interest in clothing grew, extravagant displays of costume became civic ritual, and often the duke and his courtiers changed clothes several times a day. Philip's court left detailed records of purchases of fabric, gifts, descriptions of clothes, and inventories of garments that for the first time created what would later be a virtual library of information for those wishing to study the history of costume. Much of this extravagant fashion was financed from the tax receipts of France. He died in what is now Belgium in 1404.

SOURCES

Michelle Beaulieu and Jeanne Bayle, *Le Costume en Bourgogne de Philippe le Hardi à la mort de Charles le Téméraire (1364–1477)* (Paris: Presses Universitaires de France, 1956).

William Pieter Blockmans, *Promised Lands: The Low Countries under Burgundian Rule, 1369–1530.* Trans. Elizabeth Fackelman. Rev. trans. and ed. Edward Peters (Philadelphia: University of Pennsylvania Press, 1999).

Richard Vaughan, *Philip the Bold: The Foundation of the Burgundian State* (Cambridge, Mass.: Harvard University Press, 1962).

RICHARD II

1367–1399

King

FASHION AND POLITICS. Richard II, king of England, was born not in England, but in Bordeaux, France, on 6 January 1367. He was the son of the legendary knight Edward the Black Prince, who died without ever becoming king. Thus, Richard succeeded his grandfather, Edward III, whose court was already known for its lavish spending on clothes and jewelry. Both Richard's father and his grandfather loved tournaments, and there is evidence from records of the Royal Wardrobe that they always ordered expensive new clothes for these occasions. Indeed, Edward III did not hesitate to spend large amounts of money on gifts and especially on dresses for the queen. In one case it is recorded that he paid more than £200 for jeweled buttons for his wife, an amount that would have equaled a craftsman's salary for more than ten years. It is not surprising, then, that Richard inherited this taste for fine clothing and that he was eager to keep up with the French fashions then emerging in the celebrated courts of England's chief military rival. From fairly early in his reign, however, Richard was criticized for royal extravagance in a way that his predecessors were not, perhaps in part because he had instituted a series of truces with France that cut off the potential for enrichment that had come from earlier wartime victories. Richard was also in nearly constant conflict with his uncle John of Gaunt and with Gaunt's son Henry Bolingbroke, whom Richard sentenced to a ten-year exile for treason in 1397. When Gaunt died in 1399, Richard made Bolingbroke's exile permanent and confiscated the family fortune—an unpopular decision that was associated publicly with his overspending and his taste for what were seen as decadent foreign styles. Opposition to his authority grew among disgruntled lords; finally charges were made against him in Parliament and he was deposed as monarch, with Bolingbroke taking the throne as Henry IV. Imprisoned far from London, in Pontefract, Yorkshire, Richard died, or was murdered, in 1399.

FASHION AS SYMBOL. In many ways, Richard's interest in clothing demonstrates how important fashion had become as a symbol of sophistication. One of his main goals as king was to promote regal ideals and create an image of majesty, a role for which he was well suited physically and intellectually. Handsome and well built, standing six feet in height, he enjoyed such noble pastimes as hunting, observing tournaments, and reading courtly literature. Richard married Anne of Bohemia in 1382, a match that gained him prestige, since she was the daughter of the late emperor Charles IV, but which also contributed to the importation of foreign styles, including the pointed shoes that the French blamed on the Italians and the English blamed on the Flemish. John

Stow's Tudor *Annales* mentions that, since 1382, the points of shoes worn by English courtiers and gallants were of such length that they had to be tied to the knees with silver gilt chains or silk laces. Although Richard was in some ways just continuing a tradition of finery that was already established in the English court, an excess of this kind is a clear example of the sudden acceleration of change that marked the Age of Fashion. Thus, Richard could be said to have done for English costume what his near contemporary, Philip the Bold, Duke of Burgundy (1342–1404), did for fashion in France.

SOURCES

Gervase Matthew, *The Court of Richard II* (London: Murray, 1968).

Nigel Saul, *Richard II* (New Haven, Conn.: Yale University Press, 1997).

V. J. Scattergood and J. W. Sherborne, *English Court Culture in the Later Middle Ages* (London: Duckworth, 1983).

John Stow, *Annales* (London: G. Bishop and T. Adams, 1605).

DOCUMENTARY SOURCES
in Fashion

The Bayeux Tapestry (1080s)—This 231-foot-long embroidery on linen features a continuous pictorial narrative relating the story of the Norman conquest of England in 1066. It is an important source of information on the clothing and arms of the Norman invaders of the eleventh century.

Jean de Brie, *Le Bon Berger* (1379)—This treatise written for King Charles V of France, describing the life and activities of a shepherd, provides detailed information on the costume and appurtenances of shepherds.

"Le Dit du mercier" (thirteenth century)—This thirteenth-century French trade poem found in a manuscript in Paris (Bibliothèque Nationale) presents the mercer—a traveling peddler or salesman who carried his stock with him—as a speaker, hawking his merchandise and describing some of his sales practices. The poem provides information on a variety of inexpensive accessories, such as buckles, combs, hats, and cosmetics that the mercer offers for sale.

Tacuinum sanitatis (1370)—This medieval health handbook exists in a number of manuscripts from about 1370 on, showing a variety of rustic and aristocratic costumes, including the houppelande worn by persons manufacturing pharmaceuticals, or commissioning and selling garments.

Robinet Testard, *Merveilles du monde* or *Les secrets de l'histoire naturelle* (1480–1485)—This manuscript, now in the Bibliothèque nationale in Paris, is a work on geography discussing 56 regions of the world. It shows numerous examples of agricultural, as well as aristocratic, costume.

Très Riches Heures (1390–1416)—Located in Chantilly, France, in the Musée Condé, this luxuriously illuminated manuscript provides detailed illustrations of both peasant and aristocratic life at the end of the fourteenth century.

chapter four

LITERATURE

Lorraine Kochanske Stock

IMPORTANT EVENTS
in Literature

524 Boethius writes the *Consolation of Philosophy*, which will be translated from Latin into every major medieval European language and become highly influential in medieval literature.

800 Charlemagne, who encouraged education and literature, is crowned emperor of the Romans and king of the Franks.

870 Viking settlers found the colony of Iceland, which will become the major source of medieval Scandinavian literature.

c. 895 Anglo-Saxon king Alfred, who encourages learning at his court, translates Boethius's *Consolation of Philosophy* from Latin into Anglo-Saxon.

948 Egil Skallagrímsson, Scandinavian skaldic poet whose life is celebrated in the Icelandic saga, *Egil's Saga* (1230), writes *Head Ransom* while awaiting execution by King Erik Bloodaxe.

c. 970 Anglo-Saxon lyric and narrative poems, including "The Wanderer," "The Seafarer," "The Ruin," and "The Wife's Lament," are copied into a manuscript collection later called *Exeter Book*.

c. 1000 The only surviving manuscript version of the Anglo-Saxon heroic poem *Beowulf* is written down after the poem has circulated through memorization and recitation (known as oral tradition) for several centuries.

1095 Pope Urban II calls for the first Crusade, which many *chansons de geste* (heroic poems) helped to propagandize.

c. 1100 The troubadours in the south of France and the trouvères in the north begin composing lyric poetry in a new style.

The *Song of Roland*, the most famous example of the French *chanson de geste*, appears in manuscript form after several hundred years of circulating orally as a narrative recited along pilgrimage routes to Compostela.

1127 Duke William IX of Aquitaine, first *troubadour* poet and grandfather of Eleanor of Aquitaine, dies.

1137 Geoffrey of Monmouth writes the *History of the Kings of Britain*, which includes the first major literary treatment of legendary King Arthur.

c. 1150 Alan of Lille writes *The Complaint of Nature*, a Latin philosophical dream vision that influences medieval writers such as Jean de Meun and Chaucer.

c. 1150– Hildegard of Bingen, the German abbess
c. 1179 of a convent on the Rhine, writes medical treatises, lapidary books, accounts of her mystical visions, *Scivias*, and lyrical hymns.

c. 1155 The Norman chronicler Wace incorporates inventive embellishments such as King Arthur's "Round Table" and the sword "Excalibur" into his verse narrative, *Le Roman de Brut*.

c. 1160– Marie de France, the earliest known sec-
c. 1180 ular medieval female author, composes her *Lais* (a collection of twelve short story-poems based on traditional Breton tales).

c. 1170– German minnesingers (lyrical poets) such
c. 1190 as Walter von der Vogelweide begin to write lyric love poetry in the manner of the French troubadours.

c. 1170– Chrétien de Troyes, the father of medieval
c. 1185 romance, writes a series of long verse narratives on Arthurian subjects.

c. 1185 Under the patronage of Marie of Champagne, Andreas Capellanus writes the *Art of Courtly Love*, which influenced the depiction of love in romances and lyric poetry.

1200–1235 Robert de Borron and other French writers contribute to the *Vulgate Cycle* of Arthurian romances, incorporating new details about Lancelot and Guinevere and the Grail Quest.

c. 1200 In France, short, clever, and generally bawdy narratives known as *fabliaux* are first composed, preparing for the bourgeois realism of Chaucer in the *Canterbury Tales*.

c. 1201– The Spanish heroic poem *El Cid* is com-
c. 1207 posed in written form from Latin chronicles and the oral songs of *jongleurs* on the pilgrimage route to Santiago de Compostela.

c. 1201 Layamon retranslates Wace's *Roman de Brut* into Middle English alliterative poetry, introducing the motif of Arthur's prophetic dream before Mordred's treachery.

c. 1220– The German writer Wolfram von Eschen-
c. 1230 bach "translates" *Aliscans*, a twelfth-century French *chanson de geste*, into the hybrid heroic romance *Willehalm*.

c. 1230– Guillaume de Lorris writes the first 4,000
c. 1235 lines of the dream vision *Romance of the Rose*.

c. 1275 Jean de Meun adds almost 18,000 lines to Guillaume de Lorris's allegorical *Romance of the Rose*, adopting a more satirical tone and adding philosophical and social commentary.

c. 1280 *Njál's Saga*, the most complex of all the Icelandic family sagas, portrays a violent blood feud and documents the transition of Iceland from pagan Germanic beliefs to Christianity.

c. 1292– Dante Alighieri writes the *Vita Nuova*, a
c. 1295 collection of love lyrics to his muse Beatrice.

c. 1314– Dante Alighieri writes the *Divine Comedy*,
c. 1320 an epic allegory portraying a visionary journey through *Inferno* ("Hell"), *Purgatorio* ("Purgatory"), and *Paradiso* ("Heaven").

c. 1330 The so-called "Harley Lyrics," a collection of Middle English political, devotional, and love poems, are recorded in the Harley manuscript (British Library MS Harley 2253).

c. 1341 Giovanni Boccaccio writes two important texts in Italian about characters from Greek history, *Il Teseide* about Theseus and *Il Filostrato* about the Trojan War, which become the sources for Chaucer's *Knight's Tale* and *Troilus and Criseyde*.

1350 In England, the alliterative Middle English dream visions *Winner and Waster* and the *Parliament of Three Ages* address the pressing post-plague economic issues.

c. 1350 In Spain, Juan Ruiz writes the *Book of Good Love*, a story collection incorporating various genres, loosely connected by the theme of sacred and profane love.

c. 1351 Giovanni Boccaccio's *Decameron* records the ravages of the Black Death, which furnishes him with the premise of his framed story collection.

c. 1360 The anonymous *Alliterative Morte Arthure*, a poem describing King Arthur's death, is composed as part of the Middle English "Alliterative Revival."

c. 1365 William Langland writes the A Text of *Piers Plowman*, focusing on the everyday political and economic life of man in society. It will be revised and expanded into the B Text (1377) and the C Text (1380s), with more emphasis on the quest for spiritual perfection.

c. 1375 An anonymous author composes the Middle English alliterative romance *Sir Gawain and the Green Knight* and the allegorical dream vision *Pearl*.

c. 1380 Geoffrey Chaucer adapts *Troilus and Criseyde* from Boccaccio's *Il Filostrato*, heightening courtly love elements and incorporating Boethian passages about fate and predestination.

c. 1385– Geoffrey Chaucer, the "father" of English
c. 1400 poetry, assembles the *Canterbury Tales*, a

framed story collection illustrating most late medieval literary genres.

c. 1390–
c. 1393
John Gower writes *Confessio Amantis*, a Middle English story collection of biblical, classical, legendary and popular narratives, employing the frame device of a lover confessing to his priest sins committed against love.

c. 1404–
c. 1405
Christine de Pizan, the first professional female writer in Europe, composes *The Book of the City of Ladies*, an allegorical

vision including stories about exemplary women.

c. 1455
Johannes Gutenberg invents the moveable type printing press, essentially replacing hand-copied manuscripts with cheaper and more plentiful books, now available to a broad popular audience.

c. 1469–
c. 1470
Sir Thomas Malory composes a prose version of the corpus of Arthurian legends, which will be edited and published in 1485 by the early printer William Caxton.

OVERVIEW
of Literature

TRIBES INTO NATIONS. Medieval literature must be understood in relation to its Roman heritage. When the Germanic peoples (Goths and Vandals, among others) coming from eastern Europe overthrew the Roman Empire in the fifth century C.E., they also destroyed the idea of political identity, because during the period of the empire all persons had been citizens of Rome. With the breakdown of Roman rule and order came a new system of tribal alliances in which small bands were commanded by warrior leaders. These warrior groups did not imagine themselves as members of a single large geographic entity, and their history was that of a tribe, not a nation. Accordingly, the concept of French or English or Italian states, each with a national literature, does not really appear until about 1100. From the establishment of the Frankish Empire under Charlemagne in the ninth century through the end of the period in the fifteenth century, medieval "Europe" represents less a group of separate national cultures than a single international cultural network within which individual developing nations mutually borrowed, imitated, and reworked their respective literary and artistic forms, which evolved sometimes directly from, and sometimes independent of, their Roman heritage.

THE MONASTIC CONTRIBUTION. With the loss of the Roman social system in the fifth century, culture and the language arts were largely preserved by Christian monasteries from the sixth century onward; culture then was associated with Latin, the language of the Western church. Monasteries copied and preserved manuscripts that they loaned to other monasteries so that classical texts and contemporary religious works, such as lives of the saints and writings of the church fathers, multiplied. Indeed, the Rule of St. Benedict, which gave guidelines for the organization and daily practice of monastic life, specified that monks should engage in the copying of books. The fostering of Latin among both educated secular people and those in religious life meant that ancient writing, such as the poetry of the Roman authors Ovid and Vergil, and the prose of Cicero, was the object of study and im-

itation in whatever new writing was done. Often these new compositions were not attributed to the persons who had actually done them, and many works passed under the names of Ovid and Vergil that were clearly medieval in date. In the cathedral schools established in the ninth century throughout Charlemagne's empire, students learned to read and write Latin by studying Roman authors; thus, the literary forms and language of the Roman world took on great authority. Writings about law, theology, medicine, politics, philosophy, and literature, ranging in date from Boethius' *Consolation of Philosophy* (c. 520) to Alan of Lille's *Complaint of Nature* (c. 1150), were all written in Latin, which became the universal language of the literate minority of the population.

ORIGINS OF VERNACULAR LITERATURE. Around the tenth century, the first vernacular literatures—that is, literatures in developing regional languages like French, English, German, and Italian—began to appear out of an oral rather than a written culture. The two earliest extensive literary works in Old French, *La Chanson de Roland*, and in Old English, *Beowulf*, with surviving manuscripts dating from about the year 1000 (though the events they describe occurred several centuries earlier) evidently were performed for audiences gathered perhaps after dinner to hear of stirring adventures at courts of the nobility. Both of these works are examples of one of the most popular genres or literary types in the earlier Middle Ages: the *chanson de geste* or heroic poem, recounting the military deeds of a national hero like Charlemagne or some of his knights like Roland, or Beowulf's combats with supernatural creatures intent on destroying the tribes in the poem of that name.

ORAL POETRY. These early poems were preserved in the oral tradition through memorization by entertainers, such as the *scop* or minstrel mentioned in *Beowulf*, who recited and perhaps even performed them. Thus, oral forms of composition and performance became part of early medieval popular writing, and "literature" tended to be the province of storytelling entertainers rather than of writers working on their own in private. This communal, oral culture valued collective experience and the description of external events over inward or meditative analysis of personal feelings. Rather, in the early Middle Ages, when people listened to stories—recited from memory or read to them from a prepared text—they liked to hear accounts of the marvelous or the fantastic or exotic on the one hand and the didactic and morally improving on the other. So a poem like the Old English *Beowulf* mixes stories of dragons with speeches about the ethical conduct the ruler owed to his followers, and the Old French *Song of Roland* mixes descriptions of exotic

Moors (strange largely because they are not Christians) with a story of God's raising of the hero Roland to heaven after he has fallen in combat. Even late in the Middle Ages, when reading became more commonplace, ordinary people as well as the nobility often retained "lectors" to read aloud to them, either because they could not or preferred not to read for themselves. Also, since the organization of living space in medieval castles or houses afforded little privacy, there was little private reading.

THE ROLE OF AUTHORITY. The study of ancient authors in schools and religious foundations and the rise of popular oral poetry together had another effect on the development of national literatures in Europe. The authorial originality modern readers have come to take for granted—the experimentation with plots and situations, with the sounds and meanings of words, and the creation of new characters and forms in verse and prose— was very late in occurring. Nothing is known of the "authors" of either the *Song of Roland* or of *Beowulf.* Indeed, even their dates of composition are uncertain. Medieval writers and readers typically favored reworked rather than "original" plots, situations, and genres. Instead of authorial originality, medieval literary culture emphasized the concept of authority—in Latin *auctoritas* (a word expressing "origination," responsibility, support, and power)—of the literary texts and authors who came before them. A common metaphor was that medieval writers thought of themselves as dwarves standing on the shoulders of the Roman "giants" who had preceded them. Thus, for the Italian Dante Alighieri (1265–1321), the greatest author and authority was his Latin predecessor and literary model Vergil, the writer of the classical epic the *Aeneid.* Dante designated Vergil (spelled "Virgilio" in the Italian text and "Virgil" in English translations) as his guide through the circles of Hell in *The Divine Comedy,* a lengthy narrative allegorical poem describing the adventures of a "pilgrim" as he travels through Hell, Purgatory, and Heaven in search of salvation and spiritual understanding. Similarly, for Guillaume de Lorris and Jean de Meun, the authors of the Old French thirteenth-century allegorical poem *The Romance of the Rose,* the great authority was Ovid, especially his *Art of Love.* The English poet Geoffrey Chaucer (1342–1400) took over many plots and stories from earlier Latin and vernacular literature, translated *The Romance of the Rose* into Middle English, and saw several earlier writers—some French like Guillaume de Machaut (1300–1377), some Italian like Dante and Giovanni Boccaccio (1313–1375)—as his masters or "auctours" while writing his *Canterbury Tales,* a collection of stories purportedly told by a group of pilgrims riding together to the shrine of St. Thomas Becket at Canterbury.

THE COMING OF ROMANCE. Two strains of literature develop side by side, then: one in the non-Latin or vernacular languages—those spoken in French, English, Italian, German, Scandinavian, or Spanish regions—and one in Latin. The latter included both the irreverent and comic "Goliardic" poems of learned wandering students and the serious and philosophical poetry of more established clerical authors, often teachers of rhetoric. In time, however, with the rise in literacy and feelings of regional identity among all classes, vernacular literatures came to eclipse those in Latin. Literary types like the short formal lyric, for example, which had earlier been composed in Latin, merged with an oral tradition of popular songs to create vernacular lyrics and even an unusual combination called the macaronic lyric, in which lines alternated among as many as three languages (usually French, Latin, and English). One of the first assaults on the primacy of Latin as a literary language came with the spread of French after the Norman Conquest of 1066. When the Normans—Scandinavian Vikings who had settled in Normandy (now northern France) in 911—conquered England in 1066, their French, called Anglo-Norman, displaced Anglo-Saxon, or Old English, as the language of educated people and the governmental elite. Thus the people of England, as well as those in France, were able to appreciate the extensive body of French literature that was developing, reaching its high point in the courtly romance, a genre that celebrated the values of the more centralized aristocratic system that had replaced earlier tribal social organization. These poems are associated especially with the Continental French writer Chrétien de Troyes (1165–1191), but they spread quickly as a popular form in England where the aristocracy was eager to reinforce its sense of historical legitimacy. Such romances tell stories of chivalry dealing with great heroes of the Crusades, knights of Arthur's Round Table, or such characters from classical antiquity as Alexander the Great. This form was like the modern novel, and it remained perhaps the most widespread literary genre from the late twelfth century through the fifteenth.

ANONYMITY AND FAME. That Chrétien de Troyes' name was connected to his romances is unusual in the history of medieval literature, much of which is anonymous. Indeed, aside from Chrétien, the Anglo-Norman Marie de France (fl. 1160–1210), and some poets writing in Celtic languages, such as the Welsh Rhirid Flaidd (c. 1160), very few names can be attached to works in the early medieval period. There are several causes for this anonymity. One, of course, is the tradition of "authority" that made it desirable to claim to be retelling a story from a reputable source. Another is the fact that texts and

documents were preserved only in laboriously hand-copied manuscripts, carefully written on parchment made of the skins of sheep and goats. In order to be copied, a document had to be considered worthy of this extremely expensive and time-consuming process, which, during the earlier Middle Ages, was almost entirely under the control of the scriptoria in monasteries. Clerical writers would have been discouraged from the vanity of attaching names to their works, and monastic scribes, in general, were not very interested in preserving the identities of secular authors. Somewhat later, when orders for manuscripts came from aristocratic courts, there was often more incentive to preserve the name of the patron who sponsored the work than that of the author who wrote it. It was not until after 1300 that the idea of the "author" as we understand it—particularly in the sense of a self-conscious first-person narrator who seems to have some existence in the real world—became common. When Dante (1265–1321) writes about his love for Beatrice in his collection of lyric poems the *Vita Nuova,* it is clear that these are new poems written from the experience of a particular individual living in Florence and loving a real woman, however idealized she may be in the poems. Likewise, when Boccaccio (1313–1375) joins together one hundred tales supposedly told by a group of young people who have fled the city to avoid the plague, the stories are clearly a fictional work from the hand of a single author, who has planned his manuscript and expects it to enter history in the form in which he conceived it. The French poets Guillaume de Machaut (1300–1377) and Jean Froissart (1337–1404?) are known to have personally planned and supervised the production of manuscripts of their works, and, by the end of the century, Geoffrey Chaucer (1340?–1400) wrote short poems complaining of errors in spelling and meter made by his scribe. Near the end of his life Chaucer even wrote a retraction apologizing for the over-worldly poetry of his youth, taking for granted the fact that he will have a permanent reputation. This public self-consciousness and awareness of oneself as a poet with an audience marks the beginning of the modern era in literature.

TOPICS
in Literature

IDENTITY AND AUTHORITY

FOUNDING HEROES. When the term "Middle Ages" was first used in the eighteenth century, it was in-

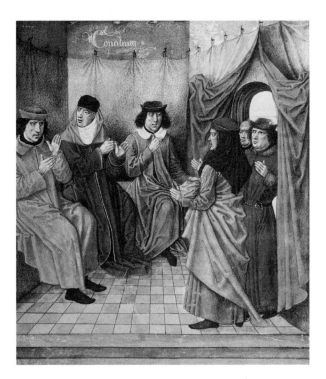

Men in 15th-century dress illustrate a classical text. Le Livre de Valerius Maximus, London, British Library MS, 1479. © THE BRITISH LIBRARY/HIP-TOPHAM/THE IMAGE WORKS.

tended to refer negatively to the long period of European history between the fall of the great civilization of classical (Roman) antiquity in the fifth century and the "rebirth" of cultural greatness in the Italian Renaissance of the early fifteenth century. What this terminology acknowledges is the fact that in the period immediately preceding the Middle Ages, a void had been created by the disintegration of the centralized government of the Romans, leaving most of Europe under the control of tribal peoples with no written literature and no continuity of tradition in a geographically or culturally identifiable location. Thus, the early history of literature in the Middle Ages is in many ways the story of people seeking to define and justify their cultural identity. As the peoples of each region became conscious of themselves as a group distinct from others, they transmitted myths of origin involving a founding hero, passing them on orally within the areas of shared language that would eventually be recognized as countries. In some cases this figure was adapted from classical Greek stories, Homeric and Vergilian accounts of the fall of Troy where the Trojan heroes were dispersed throughout the world; the word "Britain," for example, comes from the name "Brutus" and "France" from "Francus." In other cases, the heroes were homegrown, such as Britain's Arthur and France's Roland. As their stories began to be organized

TECHNICAL
Terms in Medieval Literature

Alliterative Revival: Use of the Anglo-Saxon alliterative poetic line, featuring three to four repetitions of words having the same initial consonant or vowel per line, in fourteenth-century Middle English poems, such as *Sir Gawain and the Green Knight* and *Piers Plowman*.

Comitatus: The early medieval heroic code practiced by male members of a communal group, defined by a reciprocal relationship in which the lord offered material rewards and a social identity in return for his thanes' military and political allegiance.

Contrapasso: The method used by Dante in the *Divine Comedy* to allocate appropriate punishment for sin, where the punishment suits the sin by being its ironic opposite.

Courtly love: The term coined by Gaston Paris in the nineteenth century to describe *fin'amors* (refined love), the extremes of devotion and psychological suffering experienced by male protagonists for their ladies in medieval romances and lyrics, as codified by twelfth-century writer Andreas Capellanus in his *Art of Courtly Love*.

Dolce stil nuovo: The "sweet new style" of Italian love lyrics in the thirteenth century, mirroring the themes of the troubadours of Provence, used by poets such as Dante and Guido Cavalcanti.

Fortune's Wheel: The popular medieval allegorical construct to explain cyclical human misfortune, caused by the turning of a wheel by blindfolded Lady Fortune, on whose "Wheel of Fortune" all men are situated, rising high upon or being cast off of the wheel (regardless of their merits or evil actions) according to their current state of luck.

Four-fold medieval allegory: Four levels of medieval allegorical interpretation: 1) the literal level, 2) the allegorical level, 3) the tropological or "moral" level, 4) the anagogical or eschatological level, about the afterlife.

Kenning: An oral-formulaic phrase used in Anglo-Saxon poetry that employs juxtaposed words as metaphors to imagine familiar objects in a new way, such as "whale-road" (the sea), "earth's candle" (the sun), and "ring-giver" (king).

Laisses similaires ("similar stanzas"): Repeated verse stanzas used to emphasize important and dramatic scenes in French *chansons de geste* and other heroic narratives.

Litotes: The rhetorical device of ironic understatement employed in northern European literature of the Middle Ages, especially in *Beowulf* and other Anglo-Saxon poems and the Icelandic Sagas.

Locus amoenus: Literally the "beautiful place," the locale of most medieval romances, the opening of dream visions, and the troubadours' *chansons d'amour*, featuring soft spring breezes, flowing water, blooming flowers, budding greenery, and the songs of birds.

and then written down in a cultural climate that honored the "authority" of the past (both classical and biblical), they served as the nucleus for thematic clusters known as "matters," the chief examples being the matter of France, the matter of Britain, and the matter of Rome or antiquity.

THE MATTER OF FRANCE. The matter (*matière*) of France provided the plots of many Old French *chansons de geste* (heroic poetry), such as the *Song of Roland*, a poem composed around 1100 which contributed immeasurably to the developing consciousness of what it meant to be French. Based on an historical episode in 778 in which Charlemagne's nephew Roland was killed in an ambush as he was returning home from an unsuccessful campaign against the Saracens (Islamic Moors) in Spain, the poem recounts the heroic defense of a pass in the Pyrenees Mountains by the small French rearguard (with 20,000 men) against the overwhelming Saracen forces (400,000). With its tales of such originary figures as Roland, Charlemagne, and William of Orange, the

matter of France not only created the substance of French literature of the early Middle Ages, but also was imported by other national cultures. For example, by the thirteenth century, many of the tales of Charlemagne and his Twelve Peers (or companions) were translated into prose in the Old Norse *Karlamagnus Saga* (Charlemagne's Saga), while Wolfram von Eschenbach similarly adapted for a German audience the cycle of *chansons de geste* about William of Orange in his *Willehalm*.

STORIES OF KING ARTHUR. The "matter of Britain" made King Arthur first a national hero in England, the equal of Charlemagne in French culture, and later a literary figure of international stature. In his twelfth-century *History of the Kings of Britain*, Geoffrey of Monmouth built upon and embellished earlier fragments of texts documenting a sixth-century Saxon warrior named Arthur, who achieved success in battles against the Romans and other neighboring tribes. Geoffrey created a full biography of the reign of the now familiar King Arthur, complete with some of this matter's

Matter of Britain: Stories about King Arthur and the Knights of the Round Table, which contributed to the development of romance and made Arthur first a national hero in England and later a literary figure of international stature.

Matter of France: Tales of such originary figures in the development of French national culture as Roland, Charlemagne, and William of Orange, contributing especially to the genre of *chanson de geste*.

Matter of Rome the Great and Antiquity: The broad category of plots about classical antiquity in Greece, Troy, Rome, or Northern Africa, retold in medieval vernacular romances such as the French *Roman de Thebes* and Boccaccio's *Teseide*.

Minnesingers (German: *Minnesänger*): Singers about *Minne*, which means "love," such as Walter von der Vogelweide; the German equivalents of the French troubadours and trouvères, who developed the themes of *fin'amors* in German lyrics.

Oral-formulaic tropes: Poetic stock phrases that could be recalled easily or recombined to invent new lines if the *scop* (the Anglo-Saxon minstrel) forgot a line during performance or needed to fill out the meter in a new passage.

***Reverdie*:** A term in Middle English meaning "re-greening," celebrating the reappearance of spring after a long winter, employed to start a lyric poem or song, or to open a love poem or dream vision.

***Sapientia* and *Fortitudo*:** "Wisdom and fortitude," a combination of discretion and cleverness with physi-cal strength and bravery, which contributed to successful lordship or heroism in early medieval literature.

Seven Deadly Sins: The Roman Church's designation of the seven most serious sins—Pride, Wrath, Avarice, Envy, Gluttony, Lust, Sloth—used by medieval writers to organize sections of their literary works.

Story collections: Anthologies of various separate stories that circulated together in a reasonably coherent form, organized around a theme or involving a framing device.

***Translatio studii*:** Reflecting the Latin root of "translate," meaning "to carry across," the transfer of the plot and characters of a tale produced for the audience of one national culture in an earlier period to that of another culture in a later period by medieval writers, involving significant changes in the plot and original roles of the characters as well as the very genre that the model text represented.

Troubadour or Trouvère: Poets, respectively from southern and northern France, attached to particular courts and patrons or wandering from court to court, who composed a new style of lyric love poetry with complex stanzas and rhyme patterns, especially the *chansons de croisade* and the *chansons d'amour* from the twelfth century onwards.

Vernacular: The language of a national culture of medieval Europe—French, English, Spanish, Italian, German, Norse—as distinguished from the language of learning and the medieval Roman Church, Latin.

most memorable characters, including Uther Pendragon, Merlin (the magician and sage counselor of Arthur), and Morgan le Faye (Arthur's antagonistic half sister). Among his accounts of other authentically historical British monarchs, Geoffrey placed the largely fictive story of King Arthur. Already in twelfth-century France, in the earliest examples of the romance genre (a type of long, episodic narrative poem), Chrétien de Troyes created narratives about Arthur and his knights of the Round Table. Indeed, stories of this "matter of Britain" were retold and amplified by romance writers in France, England, Germany, and elsewhere in Europe throughout the Middle Ages, as well as during the Arthurian revival (called "medievalism") of the late eighteenth and nineteenth centuries.

THE MATTER OF ROME THE GREAT. Although in modern times writers are often praised for the originality or the novelty of their plots and characterizations, these qualities were not much valued in the Middle Ages since it was believed that truth lay in stories and situa-tions that had been tested and refined through the passage of time and filtered through tradition. Thus, the "matter of Rome the great" was not exclusively the early history of the region that would eventually become Italy. Rather, this broader category of plot source generally comprised various stories about classical antiquity in Greece, Troy, Rome, or Northern Africa. One of the most popular bodies of material concerned the heroes of the ancient Theban dynasties, whose tragic history was told first in Latin in Statius' *Thebaid* (c. 91 C.E.), then later retold in medieval vernacular (non-Latin) poetry such as the French *Roman de Thebes* (1152) and the Italian poet Giovanni Boccaccio's epic about the war between Athens and Thebes, the *Teseide* (The Tale of Theseus; late 1339–1341), the source story for the English writer Chaucer's *The Knight's Tale* (early 1380s). Another large subject that belonged to the matter of antiquity was the Trojan War and its aftermath, originating in Vergil's *Aeneid*, passed on in Latin versions of Homer, and then portrayed respectively in the French

LITERARY
Genres in the Middle Ages

Allegory: A narrative mode in which abstract ideas are presented either through personifications (that is, characters who embody ideas like Truth or Justice) or through concrete, realistic characters and situations that have an additional layer or layers of symbolic meaning, even though they operate within a literal plot that makes sense in and of itself.

Aubade or Aube or Alba: Literally a "dawn song," a type of troubadour lyric in which lovers lament the coming of the dawn because they must part after a night of clandestine lovemaking.

Breton lay: A short verse narrative, exemplified by the *Lais* of Anglo-Norman poet Marie de France, which were originally performed orally in the Breton language and were transformed into written narratives from the twelfth-century onward, featuring rash promises, erotic entanglements, an ambivalent code of ethics, and a strong supernatural strain.

Chanson d'amour: A troubadour love song in which the vocabulary expressing the roles of the lover and the beloved echoes the terminology of lordship so that the beloved lady plays the role of the haughty "domna" (female "lord") to the poet, her vassal.

Chanson de geste: Literally "song of deeds or exploits," a type of French heroic verse narrative of the eleventh through thirteenth centuries, based on earlier oral accounts, recounting heroic deeds in warfare, often connected with the Crusades.

Dream vision: A medieval poetic genre consisting of a narrator's account of his unusual dream, provoked by his physical surroundings or bedtime reading matter, in which he is often visited by a male or female authority figure who issues guidance or advice. These narratives treated such themes as love, philosophical and spiritual issues, and contemporary mores, often from a satirical perspective.

Eddic Poetry: Heroic and mythological lays composed in medieval Scandinavia in freeform or varying meters, based on Germanic legends and mythology about the pagan northern gods.

Fable (Animal) A story in prose or verse in which animals speak and act as people, with an attached moralization. The fox, called "Reynard," was the most popular medieval fable character.

Fabliau: A brief tale, most often in French, set in the present-day world, populated by stock bourgeois characters, employing clever, complicated plots (often love triangles) about humankind's most basic functions, especially sex.

Goliardic poetry: The irreverent and comic poems of learned wandering students, and the serious and philosophical poetry of more established clerical authors, often teachers of rhetoric.

Icelandic family sagas: Tightly structured, complexly plotted thirteenth-century heroic prose narratives composed from earlier oral accounts, depicting the blood feuds and other events that happened during the settlement of Iceland as a colony of Norway in the tenth and eleventh centuries.

Marian lyrics: Medieval religious lyric poetry written especially in France, Italy, and England devoted to veneration of the Virgin Mary, featuring some of the same tropes used to honor the courtly lady in the *chansons d'amour* of the troubadours and other medieval lyric poets.

Pastourelle: Literally, a "song about a shepherdess," a short, dialogue-filled, narrative account in verse about a courtly knight's attempt to seduce an innocent, but clever shepherdess.

Romance: Episodic narratives composed in verse or prose throughout Europe from the twelfth through fifteenth centuries, whose plots derive from the various "Matters" of France, Britain, Rome, or antiquity and involve a high degree of fantasy and sometimes the attainment of love in a search or quest, as well as the testing of the prowess or morality of their knightly heroes. Romances explored the emotions of their protagonists in a way that heroic narratives avoided.

Saint's life: A medieval narrative about the life of a saint or virtuous person; also known as hagiography.

Skaldic poetry: Verse composed in medieval Scandinavia that employed an erudite, specialized vocabulary in a highly complicated syntax.

Roman d'Eneas (1160), Boccaccio's *Philostrato* (The One Laid Low by Love; late 1330s), and Geoffrey Chaucer's *Troilus and Criseyde* (early 1380s). The matter of antiquity similarly informed the plots and characters of many individual romances about the exploits of Alexander the Great, Queen Dido of Carthage, and other figures or events of Greco-Roman or North African history.

SOURCES

Renate Blumenfeld-Kosinski, "Old French Narrative Genres: Towards a Definition of the Roman Antique," *Romance Philology* 34 (1980): 143–159.

Aymé Petit, *Naissances du roman: Les techniques littéraires dans les romans antiques du XIIe siècle.* 2 vols. (Paris and Geneva: Champion-Slatkine, 1985).

HEROIC NARRATIVE

WAR AND REPUTATION. Throughout the Middle Ages, but especially in the earlier centuries, literary texts composed in poetry and prose and produced in the British Isles, Scandinavia, and throughout Continental Europe reflected both the dominant warrior culture and the emerging ideals of personal reputation and honor. Such literary works typically celebrated the exploits of larger-than-life, hyper-masculine legendary heroes who fought monsters, battled the enemies of Christianity, and often died tragic martyr-like deaths. In heroic tales and in a variation on the genre in French culture, the *chansons de geste* (songs of deeds), the establishment and maintenance of the hero's reputation (the hero's *los* or *pris* in French) was the driving force inspiring the extraordinary feats and physical exploits by which the male protagonists earned their heroic credentials. Such heroes were expected to display a balance of *fortitudo* (physical courage) and *sapientia* (discretion and wisdom). The tragic downfall of the hero often occurred because of an imbalance of these epic virtues, when his discretion waned and he displayed overweening pride in his physical prowess. In the *Song of Roland*, for example, Roland does not heed the cautions of his companion Oliver and delays calling for help until it is too late. Except for emphasis on such single character traits, however, the usually anonymous authors of heroic narratives paid little attention to the psychological motivations of their male protagonists, who demonstrated less emotional interiority and soul-searching than did their later chivalric romance counterparts. Nor were these heroes' exploits literally spurred by an interest in wooing a fair damsel or saving her from distress. Indeed, in these early heroic narratives love and the softening presence of women were almost completely absent. Typically, little to no information was provided about wives, sweethearts, or other emotional entanglements that might distract from the heroic imperative to perform mightily against almost impossibly dangerous foes, often in the interests of preserving physical security or in defense of their Christian faith.

THE HEROIC NARRATIVE IN ENGLAND: BEOWULF. The harsh conditions of early medieval life placed a premium on small tribal units of warriors and an overlord who repelled the raids of neighboring groups and made frequent forays of their own. Early heroic literature celebrated their exploits and memorialized their deeds for later audiences in what has been called "the tale of the tribe." Social conditions, then, led to the rise of a literature peculiarly fitted to immortalizing the heroes of such social units. In English, the first of these heroic narratives was the Anglo-Saxon alliterative poem

Beowulf, which is preserved in only one manuscript (now at the British Library), a miscellany (anthology) of stories of monsters, marvels, exotic locales, and fantastic creatures of huge size. Although it is the earliest major literary text produced in England, this story is actually set in Denmark and other Scandinavian locales. Before it was copied into the manuscript in its present form, the poem now known as *Beowulf* underwent many oral and possibly written revisions during a period from about the seventh to the eleventh century. *Beowulf* celebrates the heroic exploits of its title-hero, who is endowed with youth and superhuman strength, especially a mighty grip. These attributes enable Beowulf to rescue the court of the aged Danish king Hrothgar from the ravages of the semi-human monster Grendel, whose ancestry is traced to the biblical character Cain, Adam's "bad" son. Grendel has terrorized and gruesomely killed Hrothgar's retainers, called *thanes*, who nevertheless remain loyal to their chief despite decades of Grendel's murderous, nightly raids on their residence in Hrothgar's mead hall Heorot. The interior of the hearth-lit Heorot represents a haven of social solidarity, physical safety, and celebratory male bonding that contrasts with the brutally harsh winter landscape outdoors. The thanes' life-risking loyalty was part of the early medieval heroic code practiced by male members of a communal group known as the *comitatus*. In the comitatus the thanes were bound to their overlord in a special reciprocal relationship in which the lord offered material rewards and a social identity in return for his thanes' military and political allegiance.

REPETITIONS AND REINFORCEMENTS. The structure of *Beowulf* reflects not only the simple social life of raiding, distributing booty, and feasting, but also the recurring need for the social values of bravery and measured judgment. The poem has three episodes recounting the hero's contests against three increasingly ferocious monsters. After slaying Grendel, Beowulf and the overconfident Danes are startled out of their victorious complacency by an even more brutal retaliatory attack by Grendel's mother, who kills one of Hrothgar's most valued thanes. Beowulf follows Grendel's mother to an underwater cavern, clearly a monstrous parallel to Hrothgar's Heorot. After defeating this grotesque female in her lair and beheading Grendel, a more difficult struggle than his first monster fight, Beowulf returns a hero to his homeland, the kingdom of the Geats, which is ruled by another king named Hygelac. The hero eventually succeeds Hygelac on the Geatish throne. Following fifty years of successful rule, Beowulf finds himself in a similar position to that of Hrothgar at the poem's beginning when the Geats are attacked by a fire-breathing dragon. Instead of following Hrothgar's example of

THE Tradition of Alliterative Poetry

The literature of the Old English period, lasting roughly until about 1100, had certain distinguishing characteristics, one of the most important of which was the use of alliteration, instead of rhyme, to organize poetic lines. Early medieval verse was presented orally, and sound was as important as sense, so alliteration, the repetition of an initial consonant or vowel in a succession of several words, was an effective technique that was common not only in Old English (a Germanic language that had been brought to Britain by the Angles, Saxons, and other invading tribes beginning in the middle of the fifth century), but also in French and Spanish poetry of this period. *Beowulf* was composed in the Anglo-Saxon alliterative line with three stressed words per line beginning with the same initial sound, and alliteration continued to be used sporadically in English poetry even as the language evolved into Middle English (highly influenced by the French spoken by the ruling class) after the Norman Conquest in 1066. An example from this period is Lawman's thirteenth-century Arthurian poem, *The Brut*. The tradition of alliterative verse became hugely popular again in the second half of the fourteenth century in what some scholars refer to as the "Alliterative Revival" when some of the most beautiful sounding, as well as intellectually challenging, poems in various genres were rendered in alliterative verse. Prominent examples from romance are *The Alliterative Morte Arthur* and *Sir Gawain and the Green Knight*, in which a description of Gawain's travels over cliffs in strange countries, far from his friends, illustrates the power of the alliterative line:

Mony klyf he overclumbe in contrayez straunge,
Fer floten from his frendez fremedly [as a stranger] he
rydez. (713–714)

Dream visions in alliterative verse include *Pearl* and *Piers Plowman*, while allegorical and philosophical poems include *Winner and Waster* and the *Parliament of Three Ages*.

a fiery Viking funeral as Beowulf's now leaderless and vulnerable subjects mourn their king's passing. If Beowulf's attempt to brave the dragon against impossible odds was motivated by pride, his behavior was nevertheless consistent with the heroic ideal. It may, however, be significant that the poem does not eulogize its title hero with the trope "That was a good king!" which had been repeated several times throughout the poem to characterize successful, praiseworthy kings such as the Dane Scyld Scefing. Another ambiguity of the poem's thematic meaning is its use of Old Testament biblical references (for example, the mention of Cain), which are intermingled with pagan values in a way that suggests contact with, but not full conversion to, Christianity.

LITERARY AND HISTORICAL SIGNIFICANCE. Often considered the first great poem in English literature, *Beowulf* is important not only for the story it tells but for its literary qualities as well. Composed and later written down in the language of the Anglo-Saxon tribes who had begun settling in England in the middle of the fifth century, the poem makes skillful use of the distinctive qualities of this Germanic dialect (commonly called Old English), which had a strong stress accent on the first syllable of most words and a tendency to express new ideas through compounding. As the poem was recited, perhaps to the accompaniment of a harp, listeners gathered in a hall would hear the insistent repetition of initial sounds (known as alliteration), which drew attention to key words (usually three to a line). Alliteration also helped the poet to remember the text (3,182 lines in its final form), which was probably passed on, in its early stages, only through memorization. The success of *Beowulf* lies, to a great degree, in its skillful use of oral-formulaic phrases called *kennings* like "whale-road" (the sea) and "ring-giver" (king), which are often concealed metaphors which cast a sharp light on a familiar subject or allow the listener to imagine it in a new way. Thus, the ship travels on the sea just as the whale swims on a "path." Or, when Beowulf speaks, he "unlocks his word-hoard" to give out words just as the lord gives out to his followers rings or other gifts. This diction, then, expresses the values of the society.

SOURCES

Peter S. Baker, *Beowulf: Basic Readings* (New York: Garland, 1995).

R. D. Fulk, ed., *Interpretations of Beowulf: A Critical Anthology* (Bloomington, Ind.: Indiana University Press, 1991).

John D. Niles, *Beowulf: The Poem and Its Tradition* (Cambridge, Mass.: Harvard University Press, 1983).

admitting his limitations, elderly Beowulf insists on fighting the dragon alone when his loyal retainer Wiglaf—a version of himself in his heroic youth—offers to oppose the dragon's venomous flames on his behalf. The old hero succumbs to the monster's venom as young Wiglaf ultimately slays the dragon. The poem ends with

HEROIC LITERATURE IN MEDIEVAL SCANDINAVIA

CULTURAL TRADITIONS OF THE VIKINGS. During the ninth and tenth centuries, migrating northern tribes, now referred to as the Vikings, sailing in lightweight but sturdy and swift longships, invaded almost all regions of Europe, including Russia (named for the rus', the red-haired Scandinavians who settled there), northern France (named Normandy for the "northmen" who settled there), England, Scotland, and Ireland. These Norsemen traded as far east as Byzantium and also forayed westward, to Iceland, Greenland, and as far as North America. The threat of the Vikings unified the formerly disorganized group of competing tribes and small kingdoms of Britain under Alfred the Great (871–899), king of Wessex, who successfully resisted the Viking incursions with military force in 878 and created a fleet of ships, the foundation of the British navy, to defend southern England against the seafaring might of the northern invaders. Eventually, an uneasy peace was reached, with the Norsemen controlling the eastern half of England and Alfred and future Anglo-Saxon kings dominating the rest of the country. The extent of Norse influence on England's literary and linguistic development is measured by the fact that the first major literary work, *Beowulf*, is about Scandinavian tribes, not the original inhabitants of Britain, and there are many Scandinavian loan words in Old English. However, the Vikings did not participate in the mutual imitation of literary forms that took place in other areas of Europe throughout the period. In fact, the literature produced far to the north of central Europe on the remote Scandinavian Peninsula does not parallel whatsoever most of the other medieval genres produced in England and on the Continent. Although some works originated on mainland Scandinavia, the majority of the greatest literary works were produced in Norway's tiny, even more remote, westerly island colony of Iceland, which was settled about 870. By 1000, Iceland had adopted Christianity as its official religion, which had a profound influence on the content of the literary texts produced.

SCANDINAVIAN LYRIC POETRY. Like the very early literary works of many other nations, such as those of ancient Greece, some early Scandinavian lyric poems reflected their culture by incorporating polytheistic theological explanations of the world, involving the exploits of gods who were like men, while others tended to emphasize formal concerns, including the intricacies of language itself. Whereas the rest of Europe developed lyric poetry that celebrated courtly love or devotion to the Virgin Mary, the earliest surviving texts in verse written in the Old Norse language are poems of two distinct types: Eddic and Skaldic poetry. Eddic poems, composed in freeform or varying meters, were heroic and mythological lays (songs) based on Germanic legends and mythology about the pagan northern gods. The Eddic poems incorporating these myths and legends include two major works: *Völuspá* (Sibyl's Prophesy), the history of the world predicted by a sibyl, from creation to Ragnarök, the end of the world when the sun turns black, fire engulfs an earth declining into total darkness, and the gods fall; and *Hávamál* (Words of the High One), a didactic poem wherein Odin instructs mankind about correct social conduct and interaction between the sexes and explains about runes (mystical sayings inscribed using ancient Germanic script) and magic. Composed before the settlement of Iceland, the *Hávamál* as well as these other Eddic poems were handed down orally until they were recorded later in Iceland. This process parallels the development of heroic literature in England and on the Continent where oral versions of the Beowulf story or Roland's tragic stand against the Saracens circulated for sometimes hundreds of years before the texts known to modern readers were established in manuscript form. Unlike the less formal Eddic poetry, Skaldic poetry was much stricter in its poetic technique, employing an erudite, specialized vocabulary in a highly complicated syntax. The most talented skald was Egil Skallagrímsson, whose life was celebrated in *Egil's Saga* (c. 1230), one of the finest Icelandic or family sagas. As recounted in *Egil's Saga*, good poetry could be literally lifesaving. One of this Viking-poet's most successful poems was *Head Ransom*, composed around 948, when Egil was imprisoned awaiting execution by King Erik Bloodaxe, who then ruled in York. The night before the execution, this skald composed a poem honoring Bloodaxe which so pleased his captor that he granted him his head as a reward, hence the poem's title. Although they may have been written on the Scandinavian Peninsula, Eddic and Skaldic poems are nevertheless preserved only in manuscripts found in Iceland.

DEVELOPMENT OF PROSE GENRES IN MEDIEVAL SCANDINAVIA. In addition to poetry, prose genres developed in medieval Scandinavia to a greater degree and earlier than they did on the Continent or in England, apparently out of a desire to record significant historical events, especially accounts of the settlement of Iceland and the reigns of Norwegian kings. For example, the *Landnámabók* (Book of Settlements) details the history of the settlement of Iceland, while *Heimskringla* (Orb of the World), written by Snorri Sturluson (1179–1241), recounts the history of the kings of Norway up to 1184. This writer also composed the *Prose Edda*, a handbook

on the use of literary language, which is an important source of heroic tales of Germanic pagan gods and the human heroes of northern legend. However, the most distinctive literary form that developed in Scandinavia was the saga, a unique kind of prose narrative invented in Iceland (hence they are often referred to as "Icelandic" sagas) during the twelfth through fourteenth centuries. The Old Norse word *saga* literally means "something said," an indication of the ultimate oral origins of most of the narratives that comprise the body of the sagas. As in other national cultures in Europe in the period, accounts of the exploits of noteworthy men or events have always supplied subject matter for orally delivered entertainment or instruction. From such oral narratives, which were amplified, embellished, and transmitted by skilled tale-tellers over the course of several centuries, the written saga evolved.

THE INFLUENCE OF CHRISTIANITY. With the coming of Christian missionaries to Scandinavia, the more advanced Latin culture provided the tools for further development of indigenous literary forms. Although "runic letters" (from a Teutonic alphabet of characters composed of straight lines suitable for inscriptions in stone, metal, or wood) had been employed to convey information in Scandinavia from very early times, runes had not been used to record any lengthy story or even poem since this mode of writing was too cumbersome for communicating anything of considerable length in a manuscript. This situation changed, however, when, after some initial resistance by those favoring the old pagan Germanic faith, Christianity was legally adopted as the state religion of Iceland in 1000, bringing with it the Latin alphabet and manuscript tradition. Following conversion, the clerkly culture, featuring the use of Latin, the language of the medieval Christian church, was introduced into Iceland. Inhabitants of Iceland quickly absorbed the newly adopted ecclesiastical and secular literature. Aided by the far-flung travels of the Vikings, the newly literate Icelandic writers were further exposed to literary genres practiced and themes depicted in other vernacular languages of Europe. The new learning did not eliminate interest in the old largely heroic saga-themes; rather, elements from Continental romance, hagiography (accounts of the lives of the saints), and other forms were grafted onto the traditional saga-lore. Even the pre-Christian mythology, which earlier had been an essential ingredient of the work of Icelandic poets, was not entirely replaced by the imagery of the new religion. Although the Icelandic sagas effectively superimposed Continental Christian influences upon traditional local subject matters, there was always a tension between the pre- and post-Christian materials.

THE ICELANDIC SAGAS. If the sagas, which are the crowning literary achievement of medieval Scandinavia, shared some elements with other medieval heroic texts, their style and content nevertheless stood apart from any other heroic literature produced in medieval Europe. Sagas give the impression of being reliable historical or biographical accounts. However, fact and fiction often are seamlessly blended in these prose narratives, and many sagas resemble modern historical novels more than any expected medieval genre. Moreover, exploiting a variety of influences from abroad, saga style was quite elastic, making possible the development of various sub-genres. Kings' sagas present imaginatively constructed biographies of medieval Norwegian monarchs. "Sagas of Ancient Times," such as the *Saga of the Volsungs*, recreated in prose the kinds of traditional heroic legends from mainland Norway that had been treated by the Eddic poets and the Skalds. Exposure to Continental genres resulted in new hybrids: sagas inspired by characters from the *chansons de geste*, such as *Charlemagne's Saga*; sagas influenced by romances about Arthurian characters like Tristan and Isold, such as *Tristan's Saga*; and Ecclesiastical sagas, inspired by Continental religious writings and hagiography, that deal with the conversion of Iceland to Christianity and the biographies of various Scandinavian bishops.

THE ICELANDIC FAMILY SAGA. The sub-genre for which the sagas are best appreciated and most famed is the "family" saga. These largely thirteenth-century narratives skillfully shaped the traditional oral accounts of the social, legal, and religious practices of Icelandic clans (who had originally settled Iceland in the tenth and eleventh centuries) into tightly structured, complexly orchestrated written texts. In general, saga style is plain and terse. Sentences are short, vocabulary is limited, syntax is simple, the plot moves quickly, and the expected repetitive embellishments of other European medieval heroic narratives are noticeably absent. With little extraneous depiction of places or people, the use of descriptive adjectives is quite sparing. Yet character development is typically vivid, relying on revealing statements made by the individuals themselves in the sagas' extensive use of dialogue, on the actions of the characters, and on brief but pointed summary characterizations made by the usually disinterested narrator. Even these instructive pieces of dialogue, used solely to further the action, are themselves characteristically and disarmingly pithy, exemplifying the literary figure of *litotes* (ironic understatement). A good example of this stylistic feature is the statement made in *Njál's Saga* by Skarp-Hedin when he is about to be burned to death by his enemies and admits casually that his "eyes are smart-

a PRIMARY SOURCE *document*

AN ICELANDIC BLOOD FEUD

INTRODUCTION: This passage reveals the complex chain of violence provoked in Icelandic blood feuds, the wry, ironic understatement [litotes] employed in the discourse of saga heroes like Skarp-Hedin, and the impact of Christianity on both the history of Iceland and the content of the sagas.

[Flosi said], "There are only two courses open to us, neither of them good: we must either abandon the attack, which would cost us our own lives, or we must set fire to the house and burn them to death, which is a grave responsibility before God, since we are Christian men ourselves. But that is what we must do."

Then they kindled a fire and made a great blaze in front of the doors. Skarp-Hedin [Njal's son] said, "So you're making a fire now, lads! Are you thinking of doing some cooking?"— "Yes," said Grani, "and you won't need it any hotter for roasting."— "So this is your way," said Skarp-Hedin, "of repaying me for avenging your father, the only way you know; you value more highly the obligation that has less claim on you."…

[B]efore those inside knew what was happening, the ceiling of the room was ablaze from end to end. Flosi's men also lit huge fires in front of all the doors. At this the womenfolk began to panic.

Njal said to them, "Be of good heart and speak no words of fear, for this is just a passing storm and it will be long before another like it comes. Put your faith in the mercy of God, for he will not let us burn both in this world and in the next." Such were the words of comfort

he brought them, and others more rousing than these. Now the whole house began to blaze. [Njal negotiates for the release of women, children, and servants from the blazing house. He, his wife Bergthora, and their grandchild lie down on their bed beneath an ox hide and are not heard again. Skarp-Hedin climbs along the wall, looking for an escape.]

Gunnar Lambason jumped up on to the wall and saw Skarp-Hedin. "Are you crying now, Skarp-Hedin?" he said. "No," said Skarp-Hedin, "but it is true that my eyes are smarting. Am I right in thinking that you are laughing?" "I certainly am," said Gunnar, "and for the first time since you killed [my uncle] Thrain."— "Then here is something to remind you of it," said Skarp-Hedin. He took from his purse the jaw-tooth he had hacked out of Thrain, and hurled it straight at Gunnar's eye; the eye was gouged from its socket up to the cheek, and Gunnar toppled off the wall…. [T]hen, with a great crash, the whole roof fell in. Skarp-Hedin was pinned between roof and gable, and could not move an inch.

[The next morning, upon learning that one man, Kari Solmundarson, had escaped from the burning building, Flosi, the leader of the burners, speaks:] "What you have told us," said Flosi, "gives us little hope of being left in peace, for the man who escaped is the one who comes nearest to being the equal of Gunnar of Hlidarend in everything. You had better realize, you Sigfussons, and all the rest of our men, that this Burning will have such consequences that many of us will lie lifeless and others will forfeit all their wealth."

SOURCE: "The Fire in which Njal and his Family are Burned to Death," in *Njal's Saga.* Trans. Magnus Magnusson and Hermann Pálsson (Baltimore: Penguin, 1960): 265–270.

ing." In sagas, the mundane details of daily life are never extraneous, but always anticipate some important event or the climax of the plot, which is almost always gruesomely violent. The sagas feature extremes in behavior and emotional range. Plots rarely recount great, history-changing events. Rather, they create moving tragedy out of the petty banalities of everyday life—breaches of loyalty and friendship that result in family feuds and ensuing vengeance, which in turn lead to the tragic destiny of one of the protagonists. Characters either intensely love or hate one another, with little neutral feeling in-between. By showing how ordinary events can unwittingly be pushed to an extreme that provokes significant consequences, sagas express marked sympathy for and understanding of human tragedy.

THE SCANDINAVIAN BLOOD FEUD. What perhaps renders sagas most unique compared to heroic literature in the rest of medieval Europe is that their plots are punctuated by a phenomenon endemic to Scandinavian culture: the blood feud. This social practice requires that a slain character's kin either retaliate against a family member of the offending clan—the new victim must be of equal rank to their lost member—or collect substantial financial remuneration for their loss. The blood feud motivates a degree of physical violence that is extreme even for the medieval romances and *chansons de geste* that were familiar in the rest of Europe, whose audiences were accustomed to exaggerated numbers of anonymous knights being slain on the battlefield. Indeed, sometimes this "eye for an eye" mentality triggers ever-escalating waves

of deadly retaliation. In some sagas, this acceleration of violence culminates in a killing that not only exceeds the legal "rules" of blood feud, but also so shocks the local community by its savagery that it is declared "murder." Technically the worst conceivable violent crime in a close-knit community tightly bound by kinship bonds, murder merits a penalty even worse than death—the social ostracizing of the perpetrator as a declared "outlaw." This plot line characterizes some of the best family sagas, such as *Grettir's Saga*, about the outlaw Grettir the Strong, an analogue of *Beowulf*; *Laxdaela Saga*, a romance-influenced multi-generational tragedy whose female protagonist Gudrun is one of the toughest, most desirable, and most vividly realized women in medieval literature; and *Egil's Saga*, the biography of the cantankerous Viking-skald Egill Skallagrímsson.

NJÁL'S SAGA: A NEW CHRISTIAN SENSIBILITY. Both the traditional influence of the blood feud and the impact of European missionary activity can be seen in the longest Icelandic family saga, *Njál's Saga* (1280), which is now also generally considered the greatest example of the genre. Judging from its survival in 24 manuscripts—the largest number of any of the sagas—this work was also appreciated as a masterpiece in its own age. Its plot revolves around the enduring friendship between two great heroes: Gunnar, a valorous, yet somewhat naive youth, and Njál, a wise older man, highly respected as a community leader, who possesses prophetic gifts. Eventually both of them die heroically. The saga's first third introduces Gunnar of Hlídarend and his courtship and disastrous marriage to the beautiful but proud and fiercely vindictive woman Hallgerd, whose initiation of a series of retaliatory killings between the two friends' households threatens to provoke a breach in the friendship between Gunnar and Njál. However, through their self-restraint and mutual loyalty, the friendship, though extremely strained, never falters. After Gunnar's death, Hallgerd continues to fuel the families' blood feud by provoking her son, son-in-law, and lover to continue to harass and goad Njál's clan. Escalating tensions climax in the intentional burning of Njál's house while he and all his family members, including his wife, adult sons, and little children, are inside it. Since the saga includes an account of Iceland's conversion to Christianity and miracles that occur at the battle waged by the Vikings against the Irish at Clontarf (1029?), the voluntary fiery death of the priest-like Njál suggests the Christian martyrdom characteristic of the medieval saint's life elsewhere in Europe. Indeed, Njál's son, Skarp-hedin—in most respects a Beowulf-like figure—brands crosses into his flesh while he endures the burning, thus introducing Christological motifs into the

saga. Ultimately, the deaths of Njál and his family were probably interpreted by contemporary audiences as either a kind of Christian martyrdom, expiation for sins of violence endemic to the old culture, or as the irrational acts of doomed and perhaps despairing heroes. Among the sagas, *Njál's Saga* is preeminent for its masterly characterization, tight plot structuring, and such memorable scenes as Gunnar's last heroic defense in his house at Hlídarend and the burning of Njál's homestead. These attest to the saga-writer's skill at creating effective fiction. On the other hand, this work can also be appreciated for its presentation of important moments in Icelandic history and its accurate treatment of the development of Icelandic law.

SOURCES

Richard F. Allen, *Fire and Iron; Critical Approaches to Njáls Saga* (Pittsburgh, Pa.: University of Pittsburgh Press, 1971).

Theodore M. Andersson, *The Icelandic Family Saga: An Analytic Reading* (Cambridge, Mass.: Harvard University Press, 1967).

Stefán Einarsson, *A History of Icelandic Literature* (New York: Johns Hopkins Press for the American-Scandinavian Foundation, 1957).

SEE ALSO *Religion: Religion in Scandinavia and Eastern Europe*

THE HEROIC NARRATIVE IN FRANCE

A NEW HISTORICAL CONTEXT. The concern for history illustrated in the Icelandic sagas takes a somewhat different form in France, where a new political and economic system was evolving. Three centuries after the disintegration of the Roman Empire, a system of centralized rule re-emerged in the area of Western Europe now known as France when a dynasty of successful kings, the Carolingians (named after founder Charles Martel, whose Latin name was Carolus), capitalized on remaining links to Roman civilization through alliances with the popes of Rome and churchmen in England and created new political institutions. Culturally, the most important innovation was a system of social, political, and economic relationships of mutual dependency between the kings and their *fideles* ("faithful men") known as *comitatus*. By the tenth century, this system of dependency involved the rulers and their *vassalli* ("vassals") or *homines* ("men"), retainers who exchanged military service for political protection and social benefits conferred by their temporal lords within the complex social-political-economic hierarchy. These *homines* or retainers paid *homage* to their

lords by providing military service in exchange for an estate of land or property, the *feodum* ("fief") from which some historians termed this mutual hierarchical relationship "feudalism." As in Anglo-Saxon literature, where narratives illustrated the virtues of *comitatus*, the emerging literary forms of France demonstrated the values of their social system through the heroic behaviors of characters who participated in this arrangement. The poems often centered on Charles Martel's grandson, the illustrious Charlemagne (768–814) or *Carolus Magnus* (Charles the Great; *le-magne* means "the Great" in Old French).

MODELS OF LEADERSHIP. The key to Charlemagne's "greatness" was his ability to put into practice the heroic formula for successful lordship: *sapientia* and *fortitudo* (wisdom and fortitude). He achieved a reputation for *sapientia* by his encouragement of letters and the arts, an overall program continued by subsequent Carolingian kings (sometimes called the "Carolingian renaissance"). He demonstrated his *fortitudo* by successfully waging warfare for conquest and plunder on many fronts, especially against Saxons in England and the Avars in the southeast. Even if Charlemagne's war against the Spanish Muslims in Andalusia was not a military success, the adventures of his vassals in this campaign provided the raw material for the creation of the quintessential heroic literary form of medieval France, the *chanson de geste* (song of deeds or exploits). Although some of these "songs of deeds" stemmed from oral accounts about major heroic figures like Charlemagne, most were devoted to the exploits of less famous figures like William of Orange, about whom a series of these heroic poems eventually were written (the *William of Orange Cycle*, the most important of which is *Aliscans*). However, the subject of the primary exemplar of the genre was a relatively minor figure, Charlemagne's nephew Roland, who led the rearguard in an otherwise historically insignificant skirmish, the battle of Roncevalles in 778, an event which Einhard, a scholar in residence at Charlemagne's palace school, mentions only briefly in his biography of the emperor.

THE CHANSON DE ROLAND (THE SONG OF ROLAND). The extraordinary appeal of the *chanson de geste* entitled the *Chanson de Roland* probably arose in part from its connections with two major movements of the tenth and eleventh centuries: the Crusades against the Muslim Arabs in the Holy Land and the popularity of pilgrimage to the shrine of St. James of Compostela. The entrapment of Charlemagne's nephew Roland in a mountain pass in the Pyrenees range dividing southern France from Spain was a minor incident within the con-

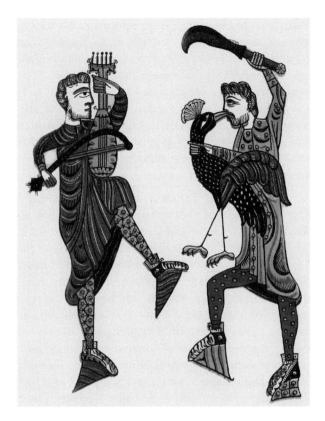

Jongleurs dancing on wooden stilts. London, British Library MS Additional 11695, folio 223, 12th century. © TOPHAM/THE IMAGE WORKS.

text of an ongoing, several-centuries-old animosity between the Christian Franks of France and the "Saracens," North African Muslims who had colonized Spain. In some sense this story reflects microcosmically the cultural and religious clash between European Christians and Muslim Arabs that was to be played out on a large scale in Jerusalem with the calling of the First Crusade in 1095. As it happened, the story underwent two centuries of oral development before this event, in large part because the same mountain pass in which Roland's battle against the Saracen emir Marsile took place was part of the on-land pilgrimage route to the shrine of St. James in Compostela, one of the most popular pilgrimage destinations in medieval Europe. For the entertainment of the steady stream of penitents traveling to Compostela beginning in the tenth century, oral tales concerning Roland's tragically heroic defense in a nearby locale, which was now a part of local folklore, circulated and were performed by *jongleurs* (entertainers) along the pilgrim routes. Thus, by the time the poem was written down around 1100, it was both well known and rhetorically polished, offering a perfect vehicle for Crusading propaganda. Pope Urban II's request in 1095 to European kings for military support for a holy war initiated

a chain of obligation-fulfillment between lords and vassals that soon had many members of the knightly class traveling to Jerusalem to wage war on the Muslim "infidels." With its Christo-centric pronouncement, "The pagans are wrong; the Christians are right," the *Chanson de Roland* supplied in literary form the kind of propaganda that was necessary to help inflame Crusading zeal and to galvanize and popularize the war effort that temporarily united a previously divided Europe against a common enemy.

POLITICS AND TREASON. Even with its political appropriateness and folkloric appeal, the *Chanson de Roland* would not, of course, have been able to fulfill its role of inspiring greatness if it did not illustrate the kinds of troubling situations and complex moral issues that challenged contemporary warriors. In this sense, then, the term "songs of deeds" can be somewhat misleading. To be sure, the *Chanson de Roland* contains numerous "deeds"—the mutual "slashing and bashing" of evenly matched warriors and many almost mindlessly repetitive scenes deployed in *laisses similaires* ("similar stanzas" like those also found in Spain's *El Cid*), that depict Christian Frankish combatants pitted against sometimes outrageously exoticized Saracen warriors, who mutually exchange brutal physical blows. But, more importantly, in the *Chanson de Roland* one also finds interesting scenes that not only reveal the politics of medieval lordship in action, but also depict the homosocial comradeship that bound medieval warriors to one another through their mutual obligations of fealty. This is similar to the *comitatus* ideal described between Beowulf and his retainers or between Beowulf and Hrothgar in the English heroic poem *Beowulf.* The subtleties of medieval politics are exemplified in *Roland* in the complex machinations that occur at the council held by Charlemagne in the poem's opening. Here the Franks argue about continuing their seven-year-long (and thus far unsuccessful) campaign against the Emir Marsile of Saragossa. Roland, one of the youngest at the council, speaks rashly out of turn, urging their continued effort and, after being denied the mission himself (he is deemed too brash for the delicate diplomacy necessary to the negotiation), he nominates his stepfather Ganelon to serve as Charlemagne's envoy to the Saracen camp. Suspecting his nephew's motives, for this has the possibility of being a death mission, Ganelon becomes enraged and vows revenge. Ganelon misrepresents Charlemagne's terms to the Saracen emir, betrays the Franks to Marsile for financial gain, and ensures his nephew's defeat in the narrow pass of Roncevalles by nominating him for rearguard duty in a military trap planned in collusion with the Saracens. This aspect of the story, then, is an *exemplum* of a failure of loyalty, where a retainer allows his personal antipathy to outweigh his duty to his overlord and to a comrade in battle. The scenes of Roland's defeat reinforce the listener's sense of horror at Ganelon's crime, and the ending of the story provides a lesson in justice. After being tried for treason—the worst crime in the fellowship-oriented ethos of the *chanson de geste* genre—Ganelon is hanged, drawn, and quartered.

COMRADESHIP AND LOYALTY. The positive values of comradeship are also present in the poem. The loyalty between men at arms is exemplified in the intense friendship between the hero Roland and his friend, Oliver. This relationship anticipates the chivalric relations between Arthur and his Roundtable knights depicted in the romance genre that was invented in France in the twelfth-century narratives of Chrétien de Troyes. In a dichotomy similar to the simplistic one that distinguished between pagans and Christians, the Roland-poet characterized the two comrades thus: "Roland is brave; Oliver is wise"—a variation on the heroic "sapientia and fortitudo" ideal. Roland may be courageous, but his valor entails a good degree of proud folly when, as it becomes obvious that his army cannot prevail against the Saracen troops, he refuses to heed Oliver's "sage" advice to sound his horn for help from Charlemagne. Later, when his depleted troops number only seventy and Roland rethinks his position about seeking help, Oliver scorns Roland's plan. Distinguishing between "prudent valor" and "recklessness," Oliver claims that if they called for aid now they would lose "los" (renown), the driving force that motivates not only the vassals in the *chansons de geste*, but also the Roundtable knights in the soon-to-be-developed Arthurian romances. Admitting that Oliver is right, in a series of moving *laisses similaires*, Roland nevertheless blows the horn so hard that he bursts the veins of his temples. In the ensuing attack of the Saracens, when Oliver is severely wounded, the blood running into his eyes blinds him and he strikes inadvertently at the weakening Roland. Oliver dies in his comrade Roland's arms and when the French are outnumbered 40,000 to 3, Roland again feebly sounds his horn. After breaking his beloved sword Durendal so that the enemy cannot confiscate it, Roland dies extending his right hand toward Heaven. Angels bear Roland to Paradise, the promised reward for all loyal Crusaders.

PASSION AND THE GRAND GESTURE. As full of "deeds" and broadly drawn differences as their plots are, these heroic poems are also characterized by a depiction of human passions and motives that is intriguing but somewhat baffling, conveying well the inscrutable and perhaps ultimately unknowable causes of their protago-

nists' behavior. What triggered the evident but unexplained animosity between Roland and Ganelon? Why does Ganelon betray kin and country? What personal hubris (pride) prevents Roland from sounding the horn? The poet leaves these motives unexplored and ultimately elusive. This opaque mode of characterization would change with the advent of romance, which intimately explores the inner workings of the knightly protagonists' minds and the sentiments of their hearts. But the *Chanson de Roland* is a poem full of grand and, if not subtle, then unforgettable gestures: Ganelon's flinging of his cloak and backing up against a pine tree; white-haired, silver-bearded, 200-year-old Charlemagne's brooding, almost mythic stroking of his long beard; Roland's pathetically overdue sounding of the horn. It is also marked by touching moments between two male heroes, Roland and Oliver, whose friendship and mutual loyalty ultimately outweigh any differences of opinion they have about military strategy—the same homosocial affinity that saved the strained friendship of Gunnar and Njál in *Njál's Saga*. Although little is made of the relationship in the poem, Ganelon's sister Aude had been betrothed to Roland, and upon hearing of his death, Aude herself dies. One of the greatest changes in the literary treatment of the chivalric knightly ethos that occurs with the rise of the romance genre is the new prominence given to love relations between men and women. Given this same plot, Chrétien de Troyes would have made much more of the Roland-Aude courtship than the Roland-poet could ever care about.

SOURCES

Robert Francis Cook, *The Sense of the Song of Roland* (Ithaca, N.Y.: Cornell University Press, 1987).

Jessie Crosland, *The Old French Epic* (New York: Haskell House Publishers, 1971).

Barton Sholod, *Charlemagne in Spain: The Cultural Legacy of Roncesvalles* (Geneva, Switzerland: Droz, 1966).

François Suard, *La Chanson de geste* (Paris: Presses Universitaires de France, 1993).

Karl D. Uitti, *Story, Myth, and Celebration in Old French Narrative Poetry: 1050–1200* (Princeton, N.J.: Princeton University Press, 1973).

Eugene Vance, *Reading the Song of Roland* (Englewood Cliffs, N.J.: Prentice Hall, 1970).

THE HEROIC NARRATIVE IN SPAIN

THE MULTICULTURAL INFLUENCE IN MEDIEVAL SPAIN. While the emphasis on group deliberation and the successful trial of Ganelon in the *Chanson de Roland* suggests a move towards universal law that supersedes the blood feud of the Scandinavian sagas, the heroic narrative in Spain even more clearly shows an intense interest in the development of a legal system, one of a number of literary themes that arose from the area's unique blend of Eastern and Western cultures. From the mid-eighth century—when a renegade from the Abbāsid dynasty in Persia, Abd al-Rahman I, brought an army to Spain, took possession of Córdoba, and proclaimed himself "emir" (commander) of al-Andalus—Muslim influence became firmly established in the Iberian Peninsula. The Muslim conquest of Spain was accompanied by the transmission to that region of the cultural flowering that had occurred in the eighth through ninth centuries under the Abbasids in Persia, when a widespread effort to translate the great advances in science, medicine, mathematics, astronomy, and philosophy from Greek and Indian sources was undertaken. Great strides were also made in the development of legal treatises and commentaries on laws regarding taxation, religious practices, and rules of warfare. Under the Islamic emirs, medieval Spain was a rich cultural and ethnic mix of Muslims, Christians, and Jews, with over seventy-five percent of the population in al-Andalus (which took in most of the peninsula except for the small Christian kingdoms in the north) being non-Islamic. Resistance to the emirate began with the Christian king Alfonso II of Asturias (791–842), who modeled his reign on that of Charlemagne to the north. Alfonso's descendents, particularly Alfonso VI (1065–1109), moved the capital of his kingdom from Oviedo to León where they erected churches, endowed monasteries, and encouraged literature and the arts to flourish. Moreover, after centuries of isolation from the rest of Europe, starting in the tenth century and continuing throughout the Middle Ages, northern Spain became the destination of pilgrims from all corners of Europe who journeyed there to visit the shrine of St. James at Compostela, contributing further to the rich cultural mix that characterized medieval Spain. Along the pilgrim routes that extended through France over the Pyrenees, the *chansons de geste* were performed orally by French and Spanish jongleurs (entertainers). The reign of Alfonso VI coincided with the period of the First Crusade, when Christian knights were under the obligation as vassals to fight for the pope against Muslim possession of the Holy Land. This constellation of influences—the free intermixing of Christians and Muslims in Spain, the themes of the literary works performed along the pilgrim route, the longtime tradition of caliphate encouragement of interest in laws and legal practices—were uniquely melded into a historical figure who would become the hero of Spain in its national epic.

<hr>

HEROIC
Literature in Ireland and Wales

Just as early medieval literary audiences in England, on the Continent, and on the Scandinavian peninsula (and its colony Iceland) favored long heroic narratives, the same pattern predominated in medieval Ireland and Wales, two remote areas having few direct connections to English and Continental literature. These regions, whose cultural roots lay in the mythology of the Celtic tribes that had colonized these areas centuries earlier, produced works in the heroic mode that later were incorporated into developing Arthurian romances. For example, in Ireland, the great cycle of saga-like stories about such Celtic heroes as the "Hound of Ulster," Cúchulain—involving cattle-raiding, chariot-fighting, and beheading enemies—comprised a collection now generally referred to as the *Táin*. Like its Anglo-Saxon, Continental, and Scandinavian parallels, the *Táin* evolved out of oral celebrations of regional mythology from six centuries earlier and was collected in written form starting in the twelfth century in *The Book of the Dun Cow*. One of the *Táin*'s heroic tales, *Bricriu's Feast*, may have contributed the beheading motif to *Sir Gawain and the Green Knight*. In medieval Wales, the equally ancient Celtic oral tales of the *Four Branches of the Mabinogi*, involving interactions between the human world and that of Celtic faery, began to be written down in the eleventh century in a work that has come to be called the *Mabinogi*. Some parts of this collection were clearly sources for Chrétien de Troyes's romances, *Erec and Enide* and *Yvain*.

THE CAREER OF "EL CID." Rodrigo Díaz de Vivar, whose exploits won him the title *Mio Cid* or "My Lord," was banished twice as an outlaw (from 1081–1087 and from 1089–1092) by Alfonso VI, king of León. In many respects, true to the traditional profile of career outlaws, Rodrigo hired himself out as a mercenary knight for both Christian and Muslim sides in the various wars that occurred during Alfonso's reign. In the first exile, Rodrigo served the Moorish emir Mu'taman of Saragossa in wars against his brother and the count of Barcelona. In the second banishment, Rodrigo captured the count of Barcelona and besieged the Moorish city of Valencia, taking possession of it in 1094 and dying there in 1099. After Rodrigo's widow Jimena Díaz

buried him in the monastery of San Pedro de Cardeña near Burgos, Valencia fell again to the Muslims. Out of these rather mundane threads of an outlaw's life was spun a rich literary tapestry and the greatest heroic narrative of medieval Spain.

THE POEM OF EL CID. Although it is liberally embellished with fictional elements, the oldest nearly complete medieval epic of Spain, *The Poem of El Cid*, like its literary relation the *chanson de geste*, is deeply rooted in historical fact. However, the mode of development of the work, from oral narrative to written epic, resembles the pattern of the *Roland* and the more folkloric, supernatural *Beowulf*. From a few bare facts the poetic treatment of El Cid's career as an outlaw warrior developed in Latin chronicles and songs delivered by *jongleurs* (entertainers) to amuse visitors to Rodrigo's tomb. Sometime between 1201–1207, a century after the events which it portrays, the poem as it is known by modern scholars was most likely composed by a monk at the abbey at Cardeña, who may have been exposed to French heroic poems such as *The Song of Roland* and the William of Orange Cycle, which were performed for entertainment along the enormously popular pilgrimage route to the shrine of Saint James at Compostela. Blurring the historical facts through the lens of fiction, the Spanish poet invents several pivotal characters who enliven his plot either by befriending the hero—his right-hand man Álvar Fáñez—or by providing conflict for the protagonist—two obscure and cowardly Leónese minor nobles, known in the poem simply as the Infantes of Carrión. These villains marry El Cid's daughters and later brutally dishonor them by stripping them of their outer clothes and leaving them in a forest; thus the Infantes provoke the delayed vengeance of their father-in-law, a highlight of the poem.

THE STRUCTURE OF EL CID. From the outset, one of the distinctive cultural features of *El Cid* is its setting in a society with a highly developed "court" system where many people serve as the king's advisors, seeking to be among his favorites and thus receive lands and benefits. The poem's overlapping double plot, structured over three divisions or *cantars* (songs) which may have been orally performed on three separate occasions, concentrates chiefly on El Cid's second term of exile, purportedly instigated by false accusations about him made by jealous courtiers. The first plot depicts the hero's dishonorable exile and his gradual political rehabilitation, achieved by his strategic cunning, his display of physical prowess, and the favor of his Christian God towards him in a series of successful military campaigns against the Moors in the first *cantar*. In an epic exag-

geration the Christian Cid loses only fifteen followers while the enemy Moors suffer thirteen hundred fatalities, yet the defeated Moors respect him so much that they are sorry to see him leave. In the second *cantar*, El Cid vindicates his personal honor, achieving a royal pardon for his triumphant capture of Valencia and, yielding to the king's will, marrying his daughters to the Infantes of Carrión, even though he knows that these alliances will lead to trouble in the future. The importance of the theme of courage as the distinguishing characteristic of the hero is emphasized at the beginning of the third *cantar*, which opens with an invented but powerfully effective episode in which the cowering Infantes physically disgrace themselves at the sudden appearance of an escaped lion. When El Cid so intimidates the lion that he is able single-handedly to recapture and cage the beast, he thus increases his own already considerable fame while disgracing his cowardly sons-in-law. The Infantes subsequently avenge their shame by abducting their wives, stripping them of their outer clothing, beating them brutally, and leaving them for dead in the wild oak forest. El Cid's nephew returns the hero's daughters to their grateful father, who brings a lawsuit against his sons-in-law in the king's court. Here the heritage of the caliphate interest in legal issues reflected in a major section of the plot can be seen. Because the king had arranged the marriage between the Infantes and El Cid's daughters, he shares the dishonor of his vassals. The trial culminates in a judicial combat between three of El Cid's followers, who successfully champion his suit against the Infantes and their family, defeating them in the field. In addition to receiving financial compensation from the Infantes, the hero is further honored at the story's end when the king arranges for El Cid's daughters' marriage to the princes of Navarre and Aragon. The poem's structure well displays in Rodrigo's behavior the hero's possession of *fortitudo* (physical courage) in the conquest of Valencia and the lion episode. El Cid exhibits *sapientia* (wisdom, discretion) in the self-restraint he shows in electing to prosecute rather than physically attack the Infantes, which causes them to lose more honor. The trial, a highlight of the text for the original audience, reflects the cultural inheritance of Muslim learning.

SOURCES

Joseph J. Duggan, *The Cantar de mio Cid: Poetic Creation in Its Economic and Social Contexts* (Cambridge, England: Cambridge University Press, 1989).

Joseph F. O'Callaghan, *A History of Medieval Spain* (Ithaca, N.Y.: Cornell University Press, 1975).

ORIGINS, DEFINITIONS, AND CATEGORIES OF ROMANCE

THE NEW-FOUND POWER OF WOMEN. The invention of the romance genre occurred because of a confluence of historical events, cultural developments, and shifts of literary taste and audience. When Pope Urban II called for the first Crusade in 1095, the lords of hundreds of demesnes (manorial lands) throughout Europe answered the request of their religious lord and marched or sailed to the Middle East to spend years in military combat. These aristocrats and their followers were exposed to Eastern and Arabic cultural and literary influences, as well as opportunities for economic exploitation and importation of the luxury goods, spices, and exquisite fabrics from the region. Literary forms of the first half of the twelfth century, such as the *chanson de geste*, not only reflected the heroic warrior ethic of European Crusaders, but also provided textual vehicles for Crusading propaganda. While these male members of the aristocracy were absent from their courts and manors, life and business went on at home in Europe, chiefly through the management of these estates by their wives and mothers. This trend is reflected in the transitional work, Wolfram von Eschenbach's *Willehalm*, in which the hero Willehalm leaves his citadel in Orange in the capable hands of his wife Gyburc, who not only runs the estate, but also literally defends its ramparts against invading armies of Moors. Two royal women in such circumstances—Eleanor of Aquitaine (1122–1204) and eventually her daughter, Marie—had a particular influence on the development of romance. Duchess of the largest duchy in France, extending from the Poitou to the Pyrenees Mountains near the border of Spain, Eleanor was first married to the king of France, Louis VII, whom she accompanied to the Second Crusade, where according to one chronicler, she paraded herself to the troops dressed as an Amazon queen. When, after fifteen years of marriage, she failed to produce male heirs, Louis divorced her in 1152, and shortly thereafter Eleanor made an even more lucrative marriage to Henry II, Plantagenet king of England.

FEMALE LITERARY INFLUENCE. Eleanor brought to the English court her interests in poetry, music, and the arts, all of which were cultivated at the court of Aquitaine where she was raised by her grandfather William IX of Aquitaine (1071–1127), a Crusader and also the first known troubadour poet. In the vernacular narratives now seen as early "romances" that may have been written for and/or dedicated to Eleanor, an emphasis on the sort of love relationship that is depicted in troubadour poetry, commonly known as "courtly love" (*fin'amors* in

Provençal, the language of troubadour poetry), can be found. In such relationships the female beloved is elevated to have extreme emotional power over her male lover, a supremacy that was probably a literary wish fulfillment fantasy of the female audiences of romances. Marie, Eleanor's daughter by Louis, also made an advantageous marriage by which she became duchess of Champagne, presiding over not only a political court, but also a "court of love," at which troubadour poets and writers of the newly emerging genre of romance, such as Chrétien de Troyes, were supported with her patronage and, at times, that of her mother. Another important writer at Marie's court was Andreas Capellanus, whose *Art of Courtly Love*, a treatise on conducting relationships involving *fin'amors*, reflects the new examination of interior feelings and motives that characterize the heroes and heroines of the emerging romance genre. Thus, the new audience of powerful women who presided over the courts of France, England, and Germany influenced the subject matter of many of the narratives that were written in Europe in the second half of the twelfth century. It is no accident that the earliest romances, which were about the "Matter of Antiquity"—the history of Thebes, the Trojan War, and the settlement of Rome by Aeneas—featured female characters who were militarily powerful, such as Camille in the *Roman d'Eneas*, based on the Amazon warrior queen Camilla in Vergil's *Aeneid*, or the Amazon Penthesileia in the *Roman de Troie*, a romanticized version of the story of the Trojan War.

NEW "MATTER" FOR ROMANCE. Another factor that gave rise to the development of this new genre was the twelfth-century emergence and dissemination of Celtic legends, circulated by traveling *conteurs* (storytellers) and *jongleurs* (court entertainers) from Brittany. These oral tales of Breton folklore contributed such characteristic Celtic themes and motifs as magic, the supernatural, human to animal transformations, and a faery "otherworld" not only generally to the romance genre, but also particularly to its most famous product, Arthurian romance, which got its start in the mid-twelfth century when Geoffrey of Monmouth (1100–55) wrote about a semi-mythical king, Arthur, in his *History of the Kings of Britain*. Geoffrey established Arthur's conception and birth at Tintagel in Cornwall, his marriage to Guinevere, and his reliance on his sorcerer-like advisor Merlin. Geoffrey's chronicling of British royal history, which began with a "Matter of Antiquity," the foundation of Britain by Brutus (great-grandson of Aeneas), soon became disseminated in France when a Norman chronicler named Wace translated these British materials for a French audience in his verse narrative, *Brut* (1155), incorporating his own inventive embellishments to Geoffrey's themes such as the

"Round Table" and the sword "Excalibur." At the end of the twelfth century still another English writer, Layamon (or Lawman), retranslated Wace's French narrative into alliterative poetry in the Middle English *Brut*. This trans-Channel transfer of stories about Arthur rendered him and his Roundtable knights one of the most enduring subjects of medieval romance. When combined with the effects of the first Crusades and the beginnings of troubadour lyric poetry, the dissemination of Celtic and Arthurian motifs resulted in the development of romance, a genre that was to remain popular in nearly all areas of Europe throughout the Middle Ages.

CONVENTIONS OF MEDIEVAL ROMANCE. Medieval romances, which liberally took their plots from the various "matters" of France, Britain, and Rome (or Antiquity), comprised a very elastic form subject to much variation. In certain ways, romances duplicate some of the characteristics of heroic narratives. In fact, both genres are populated by knights who engage in elaborately described martial combat. Nevertheless, certain narrative conventions characteristic of romance help distinguish it from other heroic poetry. A romance is usually a long, loosely organized, episodic narrative, composed in verse or prose, whose plot involves a search or quest and the testing of the prowess or morality of its knightly hero, for whom events are often governed by chance, accident, fate, or supernatural intervention. The romance's handling of narrative time varies: in some cases, plot events are slowly protracted, almost suspended in time; in other cases, there are rapid jumps in narrative time. Observing artificial deadlines is part of the hero's test, as in Chrétien de Troyes's *Yvain*, when the protagonist fails to return to his wife Laudine within a promised year and, to make amends for this betrayal, must spend the second half of the romance in the service of distressed women.

MALE AND FEMALE PROTAGONISTS. The goal of the male protagonist—usually the bravest, most handsome specimen of courtly society—is to achieve self-realization through physical adventures, following a plot pattern of separation from the group (often the other Roundtable knights), disruption, testing, and ultimately a return to harmony, often, but not necessarily, gained through a romantic love interest. The focus of romance is the psychologically flawed and un-self-aware individual hero on a quest or journey away from the known to test his moral strength. It is usually not King Arthur himself, but rather one of his individual Roundtable knights who is the hero of Arthurian romances. The female characters of romance, almost always extraordinarily beautiful, are sometimes peripheral objects of exchange between men, sometimes the goal of the quest, sometimes catalysts to disaster as temptresses, and sometimes the ultimate rewards for the

a PRIMARY SOURCE *document*

A KNIGHT SEARCHES FOR AN ADVENTURE

INTRODUCTION: This passage from Chrétien de Troyes' *Yvain*, in which a knight consults with a churl on the question of where to go to find an opportunity to acquire reputation, illustrates the randomness of the concept of "adventure," the goal of knights on quests to find the self in medieval romance. It is comic that Calogrenant, something of a braggart, must consult with a bull-keeper who fits the medieval description of "ideal ugliness" (as the lady in *Lanval* represents ideal beauty) to fulfill his role as a knight. Calogrenant's assumption that this bull-keeper, probably a rustic who tends cattle for the local lord, is monstrous reveals the contempt the aristocracy had for the lowest class in the social hierarchy, the serfs. The rustic has no time for seeking "adventure," but he does send Calogrenant into a situation that challenges him suitably and disgraces him.

[Calogrenant narrates:] I had not put my lodging-place far behind me when, in a clearing, I came upon some wild, unruly bulls, all fighting together with such a din and displaying such haughty ferocity that, to tell you the truth, I drew back in fear … Sitting on a tree-stump, with a great club in his hand I saw a churl, who looked like a Moor and was immensely huge and hideous: the great ugliness of the creature was quite indescribable. On approaching this fellow, I saw he had a head larger than that of a pack-horse or any other beast. His hair was tufted and his forehead, which was more than two spans wide, was bald. He had great mossy ears like an elephant's, heavy eyebrows and a flat face; with owl's eyes and a nose like a cat's, a mouth split like a wolf's, the sharp yellow teeth of a wild boar; a black beard and tangled moustache, a chin that ran into his chest, and a long spine that was twisted and hunched. He leant on his club wearing a most odd garment containing no linen or wool: instead he had, fastened on his neck,

the recently flayed hides of two bulls or oxen. The instant he saw me approach him, the churl leapt to his feet. Whether he wanted to touch me I don't know, nor what his intention was, but I prepared to defend myself until I saw him standing up quite still and quiet, having climbed onto a tree-trunk. He was a full seventeen feet tall. He looked at me without uttering a word, any more than a beast would have done. Then I assumed he was witless and unable to talk.

At all events, I plucked up my courage to say to him: "Pray tell me if you are a good creature or not!" And he replied: "I'm a man!"—"What sort of a man are you?"—"Such as you see: I'm never any different."—"What are you doing here?"—"I stay here, looking after these animals in this wood."—"Looking after them?…. I don't believe a wild beast can possibly be looked after in any plain or woodland or anywhere else unless it is tethered or penned in."—"I look after these and control them so well that they'll never leave this spot." [The Churl explains how he controls the bulls by brute force.] "That's how I am master of my beasts. Now it's your turn to tell me what kind of a man you are, and what you're looking for."—"I am, as you see, a knight looking for something I'm unable to find: I've sought long and can find nothing."—"And what do you want to find?"—"Some adventure, to put my prowess and courage to the proof. Now I beg and enquire and ask of you to give me advice, regarding some adventure or marvel, if you know of any."—"You'll not get any of that," says he. "I don't know anything about 'adventure' and never heard tell of it." [The Churl then directs Calogrenant to the spring of Broceliande, where he meets the defender of the spring, Sir Esclados, who defeats him and unhorses him.]

SOURCE: Chrétien de Troyes, *Yvain (The Knight With the Lion)*, in *Arthurian Romances*. Ed. and trans. D. D. R. Owen (London: Everyman, 1987): 284–285.

ennobling behavior they elicit from the knightly protagonist. Antagonists are either monsters—giants, mythical beasts, grotesque hybrids like the Green Knight of *Sir Gawain and the Green Knight*—or pathological versions of the self, as in Malory's fratricidal brothers, Balin and Balan. Romances are set in the exotic other world of faery, an "unofficial" or liminal fantasy world that is juxtaposed with the "official" court, from whose safety knights journey through the dark forest of *aventure* (what happens to you) on a quest to discover the self.

CATEGORIES OF MEDIEVAL ROMANCE. Although to modern audiences medieval romances can seem utterly fantastic, completely unconnected to the concerns

of reality, for their original audiences these narratives served not only to entertain but also to instruct. The predicaments in which the heroes of romances found themselves and the manner in which they met these challenges served as models of behavior for aristocratic auditors or readers. For example, in the *roman d'aventure* (romance of adventure) a knight achieves great feats of arms almost solely to enhance his reputation through a series of what appear to be random adventures. The similar "courtly" or "chivalric" romance serves as a vehicle for presenting and examining the chivalric ethic, where each in the progression of adventures demonstrates different things about the hero or represents different stages in his journey towards internal harmony. In the knight's

quest or search, the locales he traverses are meaningfully related to the knight's individual moral progress or expose some aspect of the aristocratic life to critical scrutiny. In this way, courtly romance is educative, proposing for the knight-protagonist (and for the romance's original medieval audience) models of courtly behavior or *courtoisie* (courtesy) in various areas such as combat, social relations, or the service of women and the oppressed. In long romances, the series of adventures becomes something like a fated and graduated test encouraging the knight to strive for personal perfection. Other secular romances follow the general pattern of adventure and quest, but combine these elements with another genre: the allegorical dream vision. For example, the narrator of the *Romance of the Rose*, a work that examines the spectrum of erotic love and satirizes aspects of courtly life, dreams that he undergoes a quest for a special rose (symbolizing the psyche of a young woman), resulting in a poem that, while called "romance," is really more closely related to moral or didactic literature.

RELIGION AND ROMANCE. Medieval romance was not only about the secular subjects of knightly combat, social niceties, and erotic attraction. A large component of many romances reflected the influence of Christianity and its teachings. In "religious romances" the allegorical and symbolic potential of the genre is exploited to direct the action from secular to religious goals. The knight's progress is turned to a narrower examination of the state of his soul; through the process of the quest, the hero arrives at spiritual revelation and, in the end, he rejects the physical world altogether. The romances about Galahad's achievement of the Grail Quest—where Lancelot's son Galahad concludes that he cannot achieve spiritual perfection *and* remain in the earthly world—and Gawain's humble acknowledgment of his flawed troth in *Sir Gawain and the Green Knight* illustrate this romance sub-type. Moreover, in "homiletic" or "didactic romances," the usual elements of romance are superimposed on a story told primarily for its moral significance according to the pattern of a saint's life as established in a narrative genre called "hagiography." In these "hagiographic romances," the central character suffers extreme hardships either as punishment for transgression or as a test of faith in a trial by ordeal rather than by adventure. The romance concludes not with the achievement of self-knowledge, but with the granting of grace or reprieve, as is illustrated by Chaucer's *Clerk's Tale* of Griselda and his *Man of Law's Tale* of Custance, where after seemingly losing children and family, the heroines have their losses restored to them at the end of the tale.

SOURCES

J. F. Benton, "The Court of Champagne as a Literary Center," *Speculum* 36 (1961): 551–591.

John Finlayson, "Definitions of Medieval Romance," *Chaucer Review* 15 (1980): 44–62; 168–181.

June Hall McCash, "Marie de Champagne and Eleanor of Aquitaine: A Relationship Re-Examined," *Speculum* 54 (1979): 698–711.

John Stevens, *Medieval Romance: Themes and Approaches* (New York: Norton, 1973).

COURTLY LOVE.

"COURTLY LOVE" OR FIN'AMORS. One of the most commonly held, and perhaps most misunderstood, modern notions about the Middle Ages is the type of romantic or erotic love believed to have been practiced in the period, popularly referred to as "courtly love." Courtly love is a cluster of related ideas and sensibilities characterizing an extreme expression of romantic passion that was demonstrated frequently by characters in medieval literature, especially in courtly romances and the love lyrics of the French troubadours and the German minnesingers. The term "courtly love" was never used in medieval texts, although medieval authors and poets did use the term *fin'amors* (refined love) to describe the extremes of emotion experienced, often suffered, by male protagonists in romances and by the lover singing love songs to his beloved in the lyric tradition. After observing the phenomenon depicted in various romances, the French literary historian Gaston Paris coined the term "courtly love" at the end of the nineteenth century to describe the devotion of knights for their ladies in medieval romances and love poetry, and the term took on a life of its own. Many general discussions of medieval literature now treat the "courtly love" experienced by various romance heroes—Chrétien's Lancelot, Chaucer's Troilus, or Dante's narrative persona in his ostensibly autobiographical lyric collection *La Vita Nuova*—as if the authors themselves used the term. In fact, although medieval authors never call what they are describing "courtly love," this particular construction of heterosexual love has a long literary history. It is not surprising that the Middle Ages would embrace a variety of love discourse that has such antique, and therefore authoritative, origins.

THE ORIGINS OF COURTLY LOVE. The origins of this form of extreme love can be traced to the Roman poet Ovid, one of the most highly regarded "authorities" in the Middle Ages, whose *Ars Amatoria* (Art of Love; 1 B.C.E.) contributed many of the tropes now fa-

miliar as "courtly love." These include the idea of love as a kind of warfare between the sexes, in which every lover is a soldier in the army of love over which Cupid is the commander-in-chief, and the notion of the absolute power of women over men, who are afflicted by a form of madness because of which they undergo various hardships and physical sufferings and practice absurdly exaggerated behavior. Another likely literary source of more contemporary vintage was *The Dove's Neck Ring*, produced in Muslim Spain (1022) by Ibn Hazm, who was influenced by Platonic ideals about love. Hazm's contributions to the discourse of courtly love include the notion that man reveals and improves his character or good breeding by practicing a chaste (rather than sensual) love. This rarefied love produces an ennobling effect on the male lover, changing a man of humble birth to the equal of the noble lady to whom he aspires. According to Hazm's version of neo-Platonism, true love is a reunion of parts of souls that were separated in the creation.

CHARACTERISTICS OF COURTLY LOVE. But what exactly was the late medieval European phenomenon known popularly as "courtly love"? This medieval pattern of erotic behavior was really a cult of frustrated longing. It involved the male lover's unfulfilled sexual desire for a female love object—an unattainable, extremely beautiful and perfect courtly lady, whose very inaccessibility (because she is married to someone else, often the lover's lord) makes her more attractive to the lover. Thus, for the male lover, the essence of the experience of love is a paradoxical combination of pleasure and pain. He experiences joy at the sight of the beloved whose proximity brings delight; at the same time he endures intense mental and physical suffering— a host of disorders including chills, fevers, aches, insomnia—experienced simultaneously with the pleasure. This paradoxical combination of pleasure and pain is caused illogically by the fact that despite her very nearness, the lover cannot have her. In this topsy-turvy situation, the courtly lady is the "physician" who is both the cause and the potential cure of the courtly lover's painful frustration. Because they often involved marital infidelity on the part of at least one of the pair, courtly love relationships had to be conducted with the utmost secrecy. This necessitated clandestine meetings between the lovers, which ended at dawn, thus giving rise to the lyric genre of the *aubade* or "dawn song." Secrecy and physical separation inspired acute bouts of jealousy in both parties, all part of the phenomenon's allure. Because the attainment and practice of *courtoisie* (courtesy) was limited to the aristocracy, courtly love was only to be practiced by the most elite classes of medieval soci-

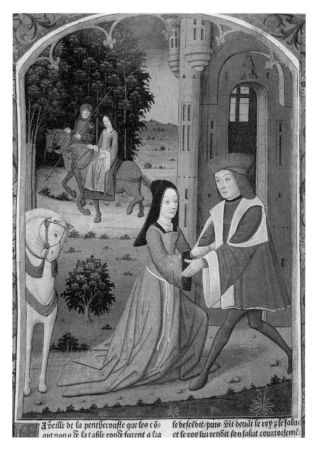

Lancelot embracing Guinevere; Chrétien de Troyes, *Lancelot*, Italy. Turin. Biblioteca nazionale. MS L. I. 3 (1626), 15th century. © ARCHIVO ICONOGRAFICO, S.A./CORBIS. REPRODUCED BY PERMISSION.

ety, the knights and ladies at the aristocratic courts. Indeed, when a knight was attracted to the beauty of a peasant woman, he was instructed simply to take her by force if she did not immediately succumb to his flatteries, a plot situation illustrated in the lyric genre of the *pastourelle*.

REAL AND IMAGINED COURTLY LOVE. Although no concrete evidence exists that the fantastic courtship known as courtly love was actually practiced during the medieval period, this erotic fantasy or game nevertheless had much literary currency from the twelfth century onwards, when the wife of King Louis VII of France, Eleanor of Aquitaine, and their daughter Marie reputedly set up "courts of love" respectively at their estates in Aquitaine and Champagne. Both Eleanor and Marie were literary patronesses of troubadour poets and romance writers, and, through their encouragement, the discourse of courtly love as we know it took shape. At Marie's request, Chrétien de Troyes wrote the unfinished romance, *The Knight of the Cart*, about Lancelot's courtly desire for Guinevere, and at her court another cleric,

a PRIMARY SOURCE *document*

ANDREAS CAPELLANUS'S RULES FOR LOVE

INTRODUCTION: In Book Two of *De arte honeste amandi [The Art of Courtly Love]*, written in France under the patronage of Marie de Champagne in the late twelfth century, Andreas Capellanus (Andrew the Chaplin) enumerates rules for love that mix the cynicism of Ovid's *Art of Love* with the elevated or idealized love of the type called "courtly." This love is manifested by certain conditions such as the married state of the lady, and physical symptoms, such as fainting, palpitations of the heart, or changes of color on the part of the lover. How often these rules were applied in real life is uncertain, but they were highly influential in the development of medieval literature.

Book Two: On the Rules of Love

1. Marriage is no real excuse for not loving.

2. He who is not jealous cannot love.

3. No one can be bound by a double love.

4. It is well known that love is always increasing or decreasing.

5. That which a lover takes against the will of his beloved has no relish.

6. Boys do not love until they arrive at the age of maturity.

7. When one lover dies, a widowhood of two years is required of the survivor.

8. No one should be deprived of love without the very best of reasons.

9. No one can love unless he is impelled by the persuasion of love.

10. Love is always a stranger in the home of avarice.

11. It is not proper to love any woman whom one should be ashamed to seek to marry.

12. A true lover does not desire to embrace in love anyone except his beloved.

13. When made public, love rarely endures.

14. The easy attainment of love makes it of little value; difficulty of attainment makes it prized.

15. Every lover regularly turns pale in the presence of his beloved.

16. When a lover suddenly catches sight of his beloved, his heart palpitates.

17. A new love puts to flight an old one.

18. Good character alone makes any man worthy of love.

19. If love diminishes, it quickly fails and rarely revives.

20. A man in love is always apprehensive.

21. Real jealousy always increases the feeling of love.

22. Jealousy, and therefore love, are increased when one suspects his beloved.

23. He whom the thought of love vexes, eats and sleeps very little.

24. Every act of a lover ends with the thought of his beloved.

25. A true lover considers nothing good except what he thinks will please his beloved.

26. Love can deny nothing to love.

27. A lover can never have enough of the solaces of his beloved.

28. A slight presumption causes a lover to suspect his beloved.

29. A man who is vexed by too much passion usually does not love.

30. A true lover is constantly and without intermission possessed by the thought of his beloved.

31. Nothing forbids one woman being loved by two men or one man by two women.

SOURCE: Andreas Capellanus, *de arte honeste amandi [The Art of Courtly Love]*. Trans. J. J. Parry (New York: Norton, 1969): 184–186.

Andreas Capellanus, wrote his Ovid-influenced treatise *De Amore* (About Love) also titled *De Arte Honeste Amandi* (About the Art of Frank Loving; 1180s), a three-part "guide" to conducting courtly love addressed to a young man named Walter. Andreas's first two books present the rules of the game—what rank the lovers must be and how they must conduct themselves. Ironically, his third book, containing a vehement repudiation of secular love and a misogynistic attack on the vices of women, retracts all the advice offered previously. Placed on the proverbial "pedestal" above the reach of the courtly lover by his frustrated yearning for her, the courtly lady of the first two books enjoyed a position of power that few actual medieval women (except for queens and countesses

like Eleanor and Marie) ever experienced. And even queens, subject to the temporal power of their husbands, could be locked in towers, which happened to Eleanor herself when her second husband, Henry II grew tired of her meddling in his political affairs. Knocked off the "pedestal" of adulation, the courtly lady instead returned to being the object of medieval antifeminism more typical of the period's attitudes toward women.

SOURCES

A. J. Denomy, "Courtly Love and Courtliness," *Speculum* 28 (1953): 44–63.

E. T. Donaldson, "The Myth of Courtly Love," *Ventures* 5 (1965): 16–23.

W. T. H. Jackson, "The *De Amore* of Andreas Capellanus and the Practice of Love at Court," *Romanic Review* 49 (1958): 243–251.

J. J. Parry, trans., *The Art of Courtly Love* (New York: Norton, 1969).

Mary Frances Wack, *Lovesickness in the Middle Ages: The Viaticum and Its Commentaries* (Philadelphia, Pa.: University of Pennsylvania Press, 1990).

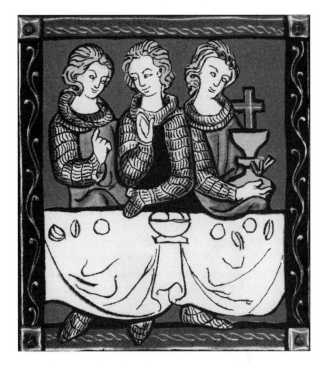

Sir Percival, two knights and Holy Grail. Chrétien de Troyes, *Percival.* Formerly Amsterdam, Holland, Biblioteca Philosophica Hermetica MS 1, ii, folio 140, 1286. © BETTMANN/CORBIS. REPRODUCED BY PERMISSION.

ARTHURIAN ROMANCE

THE HISTORICAL OR PRE-LITERARY ARTHUR.

King Arthur and his knights of the Round Table are to this day the most familiar and beloved medieval literary characters. They continue to fascinate audiences of contemporary novels, scores of cinematic treatments—from the serious John Boorman film *Excalibur* to the parodic farce, *Monty Python and the Holy Grail*—and even print and television advertising employing the Arthurian icons of the sword Excalibur, the ideal of Camelot, and the quest for the Holy Grail. Although the figure of King Arthur known to medieval and modern audiences first took shape in the twelfth century, the product of the accumulation of almost six centuries of legend building, there is some evidence (admittedly slender) for the actual existence of an "historical" Arthur. Contemporary archeological excavation contributes to the still ongoing search for the historical foundations of the King Arthur legend. A leader of the Welsh named "Arthur" who fought against the invading Anglo-Saxons apparently lived in late fifth- to early sixth-century Britain. The historian Gildas first mentioned the battle of Badon (c. 500), which the Welsh poem "Gododdin" (c. 600), in the earliest reference to Arthur's name, later attributed as a triumph to someone named "Arthur." The Welsh historian Nennius, in the *Historia Brittonum* (History of the Britons; c. 800), named this Arthur "Dux Bellorum" (leader of warriors). Two tenth-century Welsh chroni-

cles, the *Spoils of Annwen*, and the *Annales Cambriae* (Annals of the Welsh) added to the growing legend the figure of Mordred, Arthur's illegitimate son, who later kills his father. The tenth- to twelfth-century anthology of Welsh tales titled the *Mabinogion* added other Arthurian characters, including Yvain, whose character was amplified most extensively by Chrétien de Troyes in a romance about his adventures. In 1125, the historian William of Malmesbury wrote his *Gesta Regnum Anglorum* (Deeds of the English Kings), further establishing Arthur's reputation as a British hero.

LITERARY TREATMENTS OF THE ARTHUR LEGEND.

The six centuries of scattered historical fragments giving evidence of the existence of a warrior named Arthur coalesced into a coherent narrative of a heroic life in the mid-twelfth century. The version of King Arthur that has become familiar to post-medieval audiences was first compiled then by Geoffrey of Monmouth (1100–1155), whose Latin text, *Historia Regnum Britanniae* (History of the Kings of Britain; 1137), used the growing legend of Arthur as a unification myth for a Britain divided in civil war between loyalty to King Stephen or to Empress Matilda. Geoffrey introduced many of the features that would become standard Arthur lore—Merlin, the Mont-Saint-Michel giant, the prehistory of Arthur's father Uther Pendragon, and Arthur's

THE
Grail Quest

The "Holy Grail" has by now come to refer to almost anything that is highly desirable, much sought after, and ultimately elusive. This mysterious object is alluded to in modern poetry, most famously in T. S. Eliot's "The Wasteland"; it figures as the goal of the main character in the classic Wagnerian opera, *Parsifal*; it plays a part in contemporary films like *Indiana Jones and the Last Crusade*, *Monty Python and the Holy Grail*, and *The Fisher King*; and it has been the subject of a bestselling novel, Dan Brown's *The Da Vinci Code*. But the mythic resonance of the Holy Grail is rooted in the legends about the Grail that circulated in the Middle Ages and were explored in a series of quest romances composed by medieval authors.

The father of romance, Chrétien de Troyes, in the late twelfth century wrote an unfinished text about the search for the Grail titled *Perceval*, while in Germany Wolfram von Eschenbach translated Chrétien's text into the thirteenth-century Middle High German romance, *Parzival*. In a parallel development, a significant segment of the thirteenth-century French *Vulgate Cycle* was *The Quest of the Holy Grail*, which was translated for a fifteenth-century English audience by Sir Thomas Malory in one of the books of his *Le Morte d'Arthur* devoted to the grail-quest. Indeed, in Malory's estimation, the unsuccessful quest for the Grail signaled the failure of the utopian social experiment that King Arthur's Camelot signified. In Malory's version, out of a large group of Roundtable knights who set out, only a "remnant" return alive from years of questing for the Grail, and such otherwise noble knights as Gawain, Perceval, Bors, and Lancelot fail at the quest because of their sexual impurity and "spotted" Christian virtue. In fact, the only knight who successfully experienced a vision of the Grail was Galahad, Lancelot's illegitimate son by Elaine, who was entitled to this privilege

because of his utter spiritual perfection, a perfection that was so extreme that upon experiencing the Grail, he was no longer capable of living in the compromised (but human) moral climate of Arthur's Camelot. Like Roland in the *Song of Roland*, Galahad was wafted heavenward immediately after his mystical vision.

What was the Grail that medieval knights so avidly sought? Although the Grail is described in different terms in the various romances, it is often an object associated with the last moments of Jesus Christ's life, sometimes a cup or bowl used by Joseph of Arimethea, the man who brought the crucified Christ down from the cross and who may have collected His blood in some vessel, after the Roman soldier Longinus pierced Christ's side with a spear. The objects associated with the Grail are usually a spear or lance and a vessel, either a chalice or a bowl. Sometimes the Grail is associated with the chalice used by Christ at the Last Supper. However, some theorize that the symbols of the Grail, the male lance and the female vessel, originated in pre-Christian fertility myths that became associated with the Grail story through the myth of the "Fisher King," who was wounded in his thigh with a lance and whose infirmity is analogous with the general decline in fertility of his kingdom (hence the "wasteland" motif). The Fisher King is healed through contact with a vessel containing blood, sometimes Christ's blood, at other times the blood of a female virgin, which restores fertility to the land once again. In the Middle Ages, it was believed that at the time of Christ's death, some of the figures associated with this event migrated to Europe: Joseph of Arimethea purportedly came to England and Mary Magdalene reputedly settled in Marseilles, France. Some sites long attached to the legend of King Arthur, like Glastonbury in Somerset, which is reputedly the Isle of Avalon, are also attached to the Grail legend. In fact, in Glastonbury today, one can drink water from the "Chalice Well," a spring under which, local legend claims, Joseph of Arimethea buried the Holy Grail.

final voyage to Avalon. The Anglo-Norman writer, Wace (c. 1100–1175), "translated"—rewrote in Anglo-Norman French with considerable changes to suit his audiences— Geoffrey of Monmouth's chronicle into *Le Roman de Brut* (1155), an originary romance featuring stories about Camelot and the knights of Arthur's court, and inventing the Round Table. In the late twelfth century, Chrétien de Troyes (fl. 1160–1190) appropriated Arthurian knights to produce in Old French a series of long and complex verse romances separately dedicated to the individual stories of several members of Arthur's court: *Yvain: the Knight of the Lion*, *Lancelot: the Knight*

of the Cart, and *Perceval*, who figured prominently in the Quest of the Holy Grail. At about the same time Chrétien was writing his Arthurian romances, Marie de France (1150–1200) also wrote a series of Breton *lais*, two of which feature the Arthurian court—*Lanval*, about an unknown young knight, and *Chevrefoil*, about Tristan and Iseult. Thus by the end of the twelfth century, the constellation of Arthurian characters had become familiar to French and English audiences. Across the English Channel, Lawman (also spelled "Layamon," 1189–1207) translated Wace's *Le Roman de Brut* into alliterative early Middle English in a poem titled *Brut*,

WHAT GAWAIN LEARNED ABOUT HIMSELF

INTRODUCTION: The delightful fourteenth-century Middle English romance, *Sir Gawain and the Green Knight*, illustrates both the secular and the spiritual concerns of romance narratives. In this passage, Gawain returns to Camelot after his adventure with the Green Knight at the Green Chapel, presenting the Green Girdle he accepted from Bertilak's lady and revealing to the court what his adventure, in which he broke his covenant with the Green Knight, taught him about his own moral limitations. The translation attempts to mimic the original alliterative poetic style of the Middle English poem in which the same consonant or vowel begins three words in each line.

"Lo, lord," said Sir Gawain, and lifted the lace,
"This belt caused the blemish I bear on my neck;
This is the damage and loss I have claimed
Through the cowardice and covetousness that I
 acquired there;
This is the token of the untruth I was caught in,
And I must wear it while I still live.
A man may hide his misdeed, but never undo it,
For where once it's attached, it is latched on
 forever."
The king comforts the knight, and all the court also
Laughs loudly about it, and courteously agrees
That the lords and the ladies who belong to the
 Table,
Each guest at the gathering, should have such a belt,
A band of bright green circling slantwise about,
Of the same sort as Sir Gawain's and worn for his
 sake. ...

SOURCE: *Sir Gawain and the Green Knight*, lines 2505–2518. Text modernized by Kristen M. Figg and John B. Friedman.

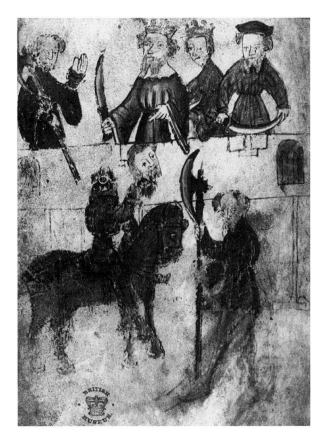

King Arthur and the Green Knight. *Sir Gawain and the Green Knight*, London, British Library MS Cotton Nero A. x, folio 94, 1360.

cle (or *Lancelot-Grail Cycle*) and the later *Post-Vulgate Cycle* of romances, parts of which were translated into German, Dutch, Italian, Spanish, Irish, and Welsh, and were important sources for Sir Thomas Malory's late Middle English *Morte D'Arthur* in the fifteenth century. This vast interrelated but independently authored cycle of romances traced the entire career of the Arthurian cast of characters, including an extensive narrative about the life of Merlin (*The History of Merlin*); the enmity between Morgan le Faye and her half-sibling Arthur; her vengeful desire for Lancelot in order to thwart Guinevere; the knightly adventures of Lancelot as well as the adulterous love between Lancelot and Guinevere (*The Prose Lancelot*); the Grail Quest (*The History of the Holy Grail* and *The Quest for the Holy Grail*); and Arthur's death (*The Death of Arthur*). The *Vulgate Cycle's* authors expanded upon the personal lives of the Arthurian cast more than had ever been done previously and embellished the growing legend with a high degree of magic, mysticism, psychological complexity, and explicit sexuality. This French version of the Arthur story was perhaps the high point in the development of the medieval legend.

which introduced the motif of Arthur's prophetic dream before Mordred's treachery.

LATE MEDIEVAL EXPANSION OF THE ARTHUR STORY IN FRANCE. Although Arthur was the main figure in the "Matter" of Britain, his story was appropriated by all European medieval national literatures, but especially in France. By the thirteenth century, the stories about Arthur and his knights had accumulated to such a degree that between 1215 and 1235 several anonymous French writers contributed to the compilation of what has come to be called collectively the *Vulgate Cy-*

THE
Contours of the Literary Life of King Arthur

The poems and stories about King Arthur that were written over a period of several centuries during the Middle Ages do not all include the same amount of detail of his life. His presence as a figure in British history grew from a mere mention of the name of an actual person in the sixth century to a fairly well-developed legend by the twelfth. By the end of the medieval period, a complete outline had emerged in response to changing concepts of heroism, morality, and statehood.

Arthur began his life as the offspring of an illicit union between Uther Pendragon and Igraine of Cornwall, contrived through the shape-shifting magic of the sage, Merlin, who became Arthur's advisor in his early career. After Merlin took the child away from Uther, Arthur was raised in seclusion until the moment when he pulled the sword from the stone (an incident familiar to modern audiences from its inclusion in most Arthurian films), which established his claim to the throne of Britain. Arthur's lifelong sibling conflict with his half-sister Morgan le Faye ("the fairy") generated many episodes in the Arthurian ro-

mances in which Morgan tried to undermine his power, most notably in the *Vulgate Cycle, Sir Gawain and the Green Knight*, and Malory's *Works*. After marrying Guinevere, daughter of Lodgreaunce, Arthur established a Utopia-like court, Camelot, supported by the fellowship of the Knights of the Round Table. Most romances feature the fatal attraction between Guinevere and Arthur's best knight Sir Lancelot, the revelation of which led to internal strife in the kingdom, civil war between factions of the Roundtable Knights, and eventually the death of Arthur at the hands of his illegitimate son Mordred. The unsuccessful quest for the elusive and highly symbolic Holy Grail by Arthur's knights also contributed to the decline of Arthur's kingdom. Upon his death, Arthur's corpse was transported by the Lady of the Lake, Morgan, and Morgawse, Arthur's other half-sister, to the Isle of Avalon where, according to some versions, he awaits his predicted return as the "Once and Future King." The cycle of stories about the Arthurian characters is vast, and most Arthurian romances feature as protagonist one of Arthur's Roundtable Knights, not Arthur himself. More often, Arthur has little part in the action, except to be present at the beginning and end of the story, as, for example, in Chrétien de Troyes' *Yvain* and in the Middle English *Sir Gawain and the Green Knight*, where the knights in the title are the focus of the adventure.

THE "ENGLISHING" OF ARTHURIAN ROMANCE. Arthur was not neglected by writers in his own Britain, especially in the last two centuries of the medieval era. In the fourteenth century, several important additions to the Arthurian literary corpus were produced in England. The *Alliterative Morte Arthure* (c. 1360), a Middle English poem about Arthur's death which may have been influenced by the *Vulgate Cycle* and later served as an important source for Thomas Malory in his own long collection of Arthurian narratives, is notable for using the Boethian symbol of the "wheel of fortune" (representing the concept of cyclical alternations between worldly prosperity and adversity) in its characterization of Arthur's developing enmity with his illegitimate son Mordred. Written in the last quarter of the fourteenth century, another poem that belongs to the so-called fourteenth-century "Alliterative Revival," *Sir Gawain and the Green Knight*, depicts the challenge brought to Camelot by a monstrous Green Knight, who is elaborately described as a hybrid of courtly elegance and primitive naturalism. With its intricate structure into four parts or "fitts," its employment of extensive number symbolism (the three correlating hunts and seductions at Castle Hautdesert and the highly symbolic pentangle

emblem on the shield carried by Gawain) and color signification (green and gold), and its incorporation of folklore motifs into a courtly romance (the exchange of blows game introduced by the Green Knight and the exchange of winnings game proposed by Bertilak), *Sir Gawain and the Green Knight* is one of the most literarily sophisticated romances in the Arthurian canon. At about the same time, in the *Canterbury Tales*, Geoffrey Chaucer assigned an Arthurian romance to be told by his female pilgrim, the Wife of Bath, in which an unnamed Arthurian knight (analogues suggest the knight was Gawain) rapes a maiden and to avoid execution quests to find out "what women want most."

ROMANCE IN PRINT: MALORY'S ARTHUR. Finally, between 1469 and 1470, Sir Thomas Malory composed a series of tales about Arthur and Camelot in late Middle English prose. Published and edited by the early printer William Caxton, the first printed edition of Malory's Arthurian tales was titled *Le Morte Arthure* by Caxton in 1485. Upon the discovery of the presumably earlier hand-written Winchester Manuscript in 1934, Eugène Vinaver re-edited Malory's romances as Malory's *Works*. Comparison of Malory's texts with earlier versions of the Arthur story reveal that, in addition to the

Alliterative Morte, Malory also drew heavily on the various parts of the French *Vulgate Cycle* for such details as the origins of Arthur, the role of Merlin, the treachery of Morgan le Faye, the affair between Lancelot and Guinevere, the Grail Quest, the extensive story of Tristram and Isolde, and the death of Arthur at the hands of Mordred. While many sections of Malory's version are immediately recognizable as deriving from the *Vulgate* source, Malory is far more reticent than his French authorities were about incorporating elements of magic and details of the sexual passions experienced by these Arthurian characters. Like his model, Geoffrey of Monmouth, whose twelfth-century audience was experiencing civil war between advocates of King Stephen and Empress Matilda, Malory, himself a prisoner when he wrote the book, used the story of Arthur as a unifying myth for a divided Britain. In Malory's hands, Arthur's legend, which culminated in internal strife because of the moral frailties of the inhabitants of Camelot, served as an *exemplum*, a story embodying a moral lesson, for his fifteenth-century English audience, who were now divided, as they had been by the Stephen-Matilda feud in Geoffrey's age, by the War of the Roses.

SOURCES

Elizabeth Archibald and A. S. G. Edwards, eds., *A Companion to Malory* (Cambridge, England: D. S. Brewer, 1996).

Richard Barber, *King Arthur: Hero and Legend* (Woodbridge, Suffolk, England: Boydell, 1986).

Norris J. Lacy, ed., *Lancelot-Grail: The Old French Arthurian Vulgate and Post-Vulgate in Translation*. 5 vols. (New York: Garland, 1993).

Roger Sherman Loomis, *The Development of Arthurian Romance* (New York: Norton, 1963).

Stephen H. A. Shepherd, ed., *Sir Thomas Malory, Le Morte D'Arthur: A Norton Critical Edition* (New York: Norton, 2004).

Judith Weiss and Rosamund Allen, trans., *Wace and Lawman: The Life of King Arthur* (London: Everyman, 1997).

TRANSLATIO STUDII: SOURCES FOR ROMANCE

THE MEDIEVAL DEFINITION OF "TRANSLATION."
Reverence for the past and respect for the "authority" of previous authors and texts determined which plots and characters medieval writers selected to "translate" from a different language, either Latin or another vernacular language, into a new vernacular version for their immediate audience. This process, known as *translatio studii*, was not the equivalent of the modern translator's earnest striving to reproduce with linguistic exactitude the ideas of a foreign language literary text; rather, it reflected the Latin root of "translate," meaning "to carry across." Thus, the medieval translator's goal was to transfer the plot and characters of a tale produced for the audience of one national culture or earlier period to that of another culture in a later period. This process was often accompanied by significant changes in the transfer. Often what got "lost in translation" was not only some of the plot and original roles of the characters, but also the very genre that the model text represented. In France, the twelfth century simultaneously saw a peaking of the popularity and production of *chansons de geste* (heroic poetry), exemplified by the large cycle of William of Orange poems, and the development of a new genre, courtly romance, in the works of Chrétien de Troyes. Given the reluctance of medieval writers to invent new plots, it is not surprising that many older works were "translated" to fulfill the demand for stories that could be reworked into this popular vernacular literary form.

TRANSLATIO STUDII FROM FRENCH TO GERMAN.
In the early thirteenth century, the German writer Wolfram von Eschenbach (d. 1220–1230) "translated" *Aliscans*, a twelfth-century French *chanson de geste* from the William of Orange cycle, for a new German-speaking audience. As a result, the genre of Wolfram's uncompleted *Willehalm* is virtually unclassifiable. This hybrid work exemplifies a significant trend in the development of medieval European literature: the transition in literary taste from the heroic mode to the romance. Wolfram's earlier *Parzival* had already translated Chrétien de Troyes's unfinished *Conte du Graal*, a courtly romance about the "Quest for the Holy Grail," proving him an adept practitioner of the new genre. In *Willehalm*, Wolfram maintains the basic *chanson de geste* plot conflict about the title character, a Frankish warrior, William, who must enlist aid from the reluctant French king Louis to defend the city of Orange against attack by armies of Moors attempting to recapture Willehalm's newly converted Christian bride, Gyburc. However, in importing this plot from the French heroic mode, the German author, a practiced romance writer, adds many romance elements to the received heroic plot. Leading the Moors are the father, former husband, and son of Gyburc, whose family is intent on returning her, dead or alive, to both her original home and her Muslim faith. However, in Wolfram's treatment, Gyburc's conversion results as much from her deep love for the Christian warrior Willehalm as from her altered religious convictions. This change reveals the obvious influence of the development of "Minne," the German concept of courtly love.

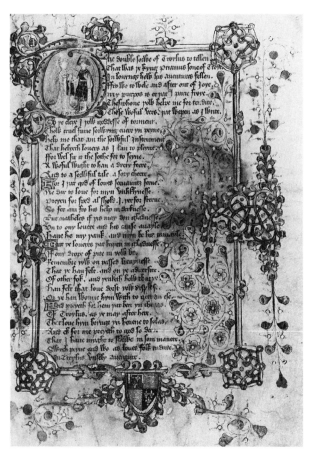

Initial from page of Chaucer's *Troilus and Criseyde*, New York, Pierpont Morgan Library MS M. 817, folio 1, 1400–1410.

THE SHIFT TO ROMANCE. Although the heroic literary tradition exoticized the Moors to the point of their seeming monstrously inhuman and therefore deserving slaughter by the Christian armies, Wolfram also shows a new tolerance for religious difference that replaces the rigid "The Christians are right, the Pagans are wrong" mentality that dominated the earlier heroic mode. He depicts the Moorish leaders as courtly knights who practice the same chivalry as their Christian counterparts. This shift is exemplified in his revised characterization of the giant wild-man-like Moor Rennewart. In the epic exaggeration of the source text, this buffoonish character carries an uprooted tree with which he crushes anyone who causes him trouble. Wolfram's character at first wields a large club, which he later replaces with the more civilized sword. Moreover, his substantial role in the French source is downplayed so as to give Wolfram's hero Willehalm more prominence. On the other hand, Willehalm's doomed nephew Vivianz, whose idealistic heroism reflects Roland's stubborn self-sufficiency and whose saintly death reflects the wafting of Roland heavenward at the end of the *Song of Roland*, seems a throw-

back to the earlier mode. Wolfram's revised treatment of Gyburc, the heroine, also illustrates his bridging of elements of both genres. This engaging and sympathetic female character is shown to be capable both of carrying out the "feminine" duties of the faithful wife and chatelaine of the castle, and of ingeniously defending the citadel of Orange (in Willehalm's absence) against a protracted siege waged by armies of Moors that include her own father, former husband, and son. Whereas typical *chansons de geste* downplayed the role of women in the lives of heroic warriors such as Roland and Oliver, Gyburc is a substantial character in Wolfram's reconceived plot and a major force in the hero's successful defense of home, nation, and religion.

TRANSLATIO STUDII FROM GREEK TO ITALIAN TO MIDDLE ENGLISH. Another case of how *translatio studii* could significantly change the nature of a well-known story involves the transmission of narratives about the ancient Greeks into late medieval literature. Giovanni Boccaccio (1313–1375), an Italian writer more famous for his story collection the *Decameron*, also wrote two important texts about characters from Greek history— *Il Teseide* (The Story of Theseus; c. 1341) and *Il Filostrato* (The One Made Prostrate by Love; c. 1341)— both of which balance heroic and romance style. Geoffrey Chaucer translated these works into Middle English in the late fourteenth century, but significantly altered them, both in content and in genre, while doing so. Both Boccaccio's *Filostrato* and Chaucer's *Troilus and Criseyde* are set during the Trojan War and feature such famous classical characters as Troilus, Priam, Hector, and Cassandra. Although Boccaccio had already somewhat altered the Greek story for his medieval Italian audience in the *Filostrato*, Chaucer added to his own translation (written about forty years later) even more "medievalizing" of the costumes worn, religious faith practiced, and general socio-cultural outlook of the story's characters. For example, Chaucer turned the political tragedy of fallen Troy into a backdrop for complicated interactions between the ill-fated lovers Troilus and Criseyde, their go-between Pandarus (now Criseyde's uncle rather than her cousin as in Boccaccio), and a rival lover Diomede. With its incorporation of courtly love elements such as the enforced secrecy between the lovers and Troilus's protracted languishing in physical afflictions and emotional despair, Chaucer's text more resembles a courtly romance than an epic. In a further example of *translatio studii*, Chaucer also assigned to his character Troilus many speeches about free will versus predestination taken almost verbatim from Boethius's Latin *Consolation of Philosophy*, which Chaucer had himself translated from Latin to Middle English as the *Boece*. At the con-

BOETHIUS and the Consolation of Philosophy

A prominent scholar who translated and harmonized the works of Plato and Aristotle and who wrote treatises on music, arithmetic, logic, and theology, Anicius Manlius Severinus Boethius (480–524) was most famous in the Middle Ages for a work he wrote while awaiting execution in prison, the *Consolation of Philosophy*. This work strongly influenced the visionary literature of the later Middle Ages, whose writers considered Boethius so authoritative that his prison memoir was the most widely copied work of secular literature in Europe. The structure of the Latin *Consolation* alternates between prose and verse sections, a form also used by other writers, such as Martianus Capella in *The Marriage of Mercury and Philology*; Bernard Silvester in *On the Whole World*; and Alain of Lille (Alan of the Island) in *The Complaint of Nature*. Moreover, the *Consolation* was translated into Old English by King Alfred in the ninth century, into Old French by Jean de Meun in the thirteenth century, into Middle English by Geoffrey Chaucer in the fourteenth century, and into Early Modern English by Queen Elizabeth I in the sixteenth century.

The Consolation of Philosophy consists of a dialogue between two characters, the narrative persona called "Boethius," mirroring the author, who laments the series of misfortunes he feels he has undeservedly suffered, and his interlocutor, the majestic allegorical personification Lady Philosophy (Love of Wisdom), who appears to him in his prison to console and enlighten him. Lady Philosophy teaches Boethius to find the insight to distinguish what is truly valuable and "good" from the transitory, valueless, "partial goods" he has been complaining about losing—possessions, honors, titles, even friends and family. Through a series of Socratic questions and answers, Lady Philosophy brings Boethius to recognize that the universe is a rationally ordered whole, a great "chain of love," governed, if not by a benevolent God, at least by a neutral one who can "see" events, even adverse ones, providentially within the grand scheme of time, but whose providential vision of these events does not *cause* the events to happen since man exercises free will. On the other hand, humans only "see" these same events partially and imperfectly—as "fate," not "providence."

To explain how bad things can nevertheless happen to good people, Philosophy introduces the metaphoric construct of cyclical human misfortune, caused by the turning of a Wheel by another allegorical personification, blindfolded Lady Fortune, on whose "Wheel of Fortune" all men are situated, rising high upon or being cast off of the wheel (regardless of their merits or evil actions) according to their current state of luck. Thus Lady Fortune, not God, is responsible for alternations between worldly prosperity and adversity, and good fortune is actually more deceptive than bad, since good fortune deceives through raising false hopes while bad fortune warns man not to seek happiness in the false and temporary goods of fortune. The ultimate lesson Boethius learns from Philosophy is to avoid dependence on any external goods, relying instead on self-sufficiency.

clusion of the *Troilus*, Chaucer's narrator also adopted a medieval Christian perspective that is at odds with his earlier pagan outlook, which had been indicated by invocations to the classical muses and overt references to the Greek pantheon.

BOETHIAN ADDITIONS. In the *Knight's Tale*, the first of *The Canterbury Tales*, Chaucer performs a similar transformation from an epic or heroic mode to romance. He eliminates most of the material in his Italian source *Il Teseide* about Theseus's war against the Amazons and renders Theseus less a tyrant and more a philosopher-king, thus moving the poem towards a consideration of universal order and earthly impermanence. Likewise, by enhancing the courtly love motif in the triangle between the rival lovers Palamoun and Arcite and their love object Emeleye, and eliminating any characteristics that would associate her with the war-like Amazons, he brings the trio into a thoroughly medieval world that includes conventional beauty, love-sickness, jealousy, and the *demande d'amour* (a question of which of the two lovers is worse off, since the one the lady has not chosen can see her from his prison while the other has her love but is exiled). Chaucer also incorporates, as he did in the *Troilus*, significant passages from Boethius's *Consolation* in the discourse between Palamoun and Arcite, whose imprisonment by Theseus in a tower resembles the situation of Boethius. In this way, Chaucer and other medieval authors took material from the past as well as texts of earlier authors and made them relevant to the cultural situation of their immediate audience. In doing so, they created literary works that straddle the genres of epic and romance.

THE BRETON LAY IN FRENCH. Although the transformation from heroic poetry to romance was among the most common kinds of "translation," not all romances were long narratives with grand battles and episodic

AN Example of Translatio Studii: Boccaccio and Chaucer

Although both Giovanni Boccaccio and Geoffrey Chaucer wrote poems about the Trojan warrior Troilus that retold a tale from the matter of antiquity for their medieval audiences, Boccaccio's *Il Filostrato* (1351) is a more epic-like text that does not spend much time on Troilus's response to love. In rewriting Boccaccio's poem for an English audience some thirty years later, Chaucer, in his *Troilus and Criseyde*, adds more romance elements, dwelling on how literally smitten his Trojan hero is by the mere sight of Criseyde. This change reflects the incorporation of the discourse of courtly love into the English author's version of a story that is ultimately about Trojans and Greeks at the time of the Trojan War. Although Boccaccio already has medievalized the story somewhat, Chaucer completely recasts it for a fourteenth-century audience accustomed to the conventions of *fin'amors* in medieval romances. He heightens the Ovidian notion of love piercing the heart through the eye (also employed by Guillaume de Lorris in the Dreamer's being struck by the God of Love in *Romance of the Rose*). Numerous other changes and additions recall the conventions of *fin'amors*: Chaucer softens Troilus's jeering at love to a more light-hearted bemusement; adds Troilus's physical reaction to Criseyde's beauty, as if struck by a blow that stunned him; has Troilus address the God of Love; describes Troilus's lengthened and lingering gaze on the new object of his desire; and has him revert to his former joking demeanor in an attempt at secrecy. All of these features make the poem more like a courtly romance than a heroic narrative.

From Boccaccio's Il Filostrato:

Just then, while Troilus went up and down, jeering now at one and now at another and often looking now on this lady and now on that, it befell by chance that his roving eye pierced through the company to where charming Criseida stood, clad in black and under a white veil, apart from the other ladies at this most solemn festival.

From Chaucer's Troilus and Criseyde:

Inside the temple Troilus went forth,
Making light of every person in the room,
Looking upon this lady, and now on that,
Whether she came from Troy or from out of town;
It happened that through a crowd of people
Troilus's eye pierced, and his stare bore into them so
 deeply,
Until it struck on Criseyde, and there his gaze stopped
 short.

And suddenly he was rendered stunned by the sight,
And he began to observe her more carefully.
"O mercy, God," thought he, "where have you lived,
Who are so beautiful and good to look at?"
Thereupon, his heart began to expand and rise,
And softly he sighed, in case men might hear him,
And he recaptured his original scoffing manner.

SOURCE: Boccaccio, *Il Filostrato*. Trans. R. K Gordon, *The Story of Troilus* (New York: Dutton, 1964): 34. Geoffrey Chaucer, *Troilus and Criseyde*. ll. 267–280. Text modernized by Lorraine K. Stock.

repetitions. Some examples were quite brief. In fact, the structural relationship between what is known as the "Breton lay" and a full-length romance is similar to that between the short story and the novel. During the twelfth century, traveling minstrels and *conteurs* (storytellers) spread a body of tales then originating in Brittany, whose plots reflected and incorporated aspects of Celtic folklore. These tales, originally in the Breton language, were performed orally until eventually a twelfth-century female writer, Marie de France (probably a native of France living in England), transformed her oral sources into formal Anglo-French "lays." Marie's sparely written narratives feature settings in the magical Celtic Other World, rash promises, erotic entanglements between humans and the world of faery, an ambivalent almost amoral code of ethics guiding behavior, and a strong supernatural strain. Marie's *Lanval* exemplifies the genre's main characteristics. This lay depicts the secret erotic relationship between an impoverished Arthurian knight Lanval and a ravishingly beautiful faery mistress, who brings him prosperity and fame in return for his promise not to tell anyone about their relationship. When the jealous Queen Guinevere accuses Lanval of homosexuality, he breaks his promise by praising his absent mistress's beauty, thus revealing her existence to Arthur's court. Although the protagonist is saved by the faery, she whisks him, perhaps ominously, to the Other World of Avalon at the tale's end. In another of the tales, the title-character Bisclavret, although a werewolf, nevertheless is portrayed as being ethically superior to his traitorous human wife, thus exemplifying the moral ambivalence of the genre. Similarly, Marie's *Laüstic*, meaning "Nightingale," tautly narrates the clandestine relationship between an unhappy wife and her lover in a house across the alley from

hers. The adulterous courtly love of these neighbors is symbolized by the title bird, whose evening song is the woman's excuse (to her jealous husband) for standing at the window to communicate with her lover. When the irate husband kills the bird, the lovers enshrine the nightingale—and their love—in a jeweled casket.

THE BRETON LAY IN ENGLISH. Some of the Anglo-Norman *lais* of Marie de France were translated into Middle English. For example, Marie's *Lanval* was rendered by an anonymous author as the fourteenth-century short romance, *Sir Launfel.* Other Middle English romances based on Breton lays include *Sir Orfeo,* retelling the legend of Orpheus and Euridice, *Sir Degaré,* and *Sir Gowther,* the last two of which involve magical transformations and shape-shifting. However, the most famous English example is the typical Breton lay that Geoffrey Chaucer wrote as one of his *Canterbury Tales.* *The Franklin's Tale,* which is set in Brittany, revolves around an intricate exchange of promises made by a husband Arveragus, his wife Dorigen, a neighboring squire Aurelius who is smitten with the wife, and a clerk from Orléans. The tale's crux involves the disappearance, magical or otherwise, of treacherous rocks along the coastline of Brittany, the removal of which Dorigen imposes on the squire as a condition of her love. *The Franklin's Tale* concludes with the ambiguity that is the hallmark of the genre of the Breton lay, an open-ended question asking the audience to choose—from the husband, the squire, or the clerk—whose behavior was the most "free." This key word "free," an adjective that means "generous" and "honest," also refers to the status of a non-noble landowner, the rank of the teller, the *Franklin* ("frank"="free"), who is especially concerned with exhibiting virtues that will associate him with a higher class.

SOURCES

Glyn S. Burgess and Keith Busby, trans., *The Lais of Marie de France* (New York: Penguin, 1986).

Mortimer J. Donovan, *The Breton Lay: A Guide to Varieties* (Notre Dame, Ind.: Notre Dame University Press, 1969).

R. K. Gordon, *The Story of Troilus* (New York: Dutton, 1964).

Ronald G. Koss, *Family, Kinship, and Lineage in the Cycle de Guillaume d'Orange* (Lewiston, N.Y.: Mellen Press, 1990).

Anne Laskaya and Eve Salisbury, eds., *The Middle English Breton Lays* (Kalamazoo, Mich.: Medieval Institute Publications, 1995).

Thomas C. Rumble, *The Breton Lays in Middle English* (Detroit, Mich.: Wayne State University Press, 1965).

SEE ALSO *Philosophy: The Foundations: Augustine and Boethius*

a PRIMARY SOURCE *document*

IDEAL FEMALE BEAUTY

INTRODUCTION: This passage from Marie de France's *Lais,* written in the twelfth century, depicts the idealized beauty of the typical romance heroine, the hero's faery mistress from the lay called *Lanval.* The order of the details—which are entirely conventional—reflects a descriptive method called *ordo effictiones* that was taught in medieval schools, suggesting that Marie had a clerical education of some kind. Often such descriptions worked from the top down, but in this case the author works from the horse up.

There was none more beautiful in the whole world. She was riding a white palfrey which carried her well and gently; its neck and head were well-formed and there was no finer animal on earth. The palfrey was richly equipped, for no count or king on earth could have paid for it save by selling or pledging his lands. The lady was dressed in a white tunic and shift, laced left and right so as to reveal her sides. Her body was comely, her hips low, her neck whiter than snow on a branch; her eyes were bright and her face white, her mouth fair and her nose well-placed; her eyebrows were brown and her brow fair, and her hair curly and rather blond. A golden thread does not shine as brightly as the rays reflected in the light from her hair. Her cloak was of dark silk and she had wrapped its skirts about her. She held a sparrowhawk on her wrist and behind her there followed a dog. There was no one in the town, humble or powerful, old or young, who did not watch her arrival, and no one jested about her beauty. She approached slowly and the judges who saw her thought it was a great wonder. No one who looked at her could have failed to be inspired with real joy.

SOURCE: *The Lais of Marie de France.* Trans. Glyn S. Burgess and Keith Busby (New York: Penguin, 1986): 80.

THE NON-NARRATIVE LYRIC IMPULSE

LYRIC DEVELOPMENT. In addition to long heroic and romance narratives in verse and prose, short "lyric" poems, some intended for singing to musical accompaniment, were composed from the ninth through the fifteenth centuries throughout Europe. Their subject matter varied by region, reflecting local political, religious, and cultural developments. And as these issues changed throughout the European Middle Ages, the trends in what was "sung" or recited in these short poetic works

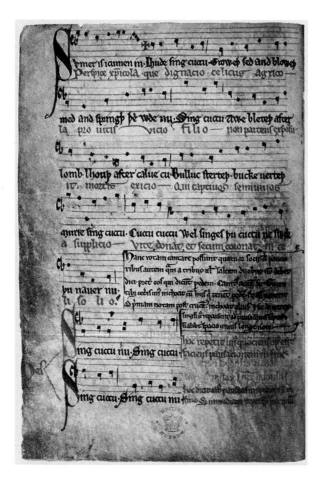

"Sumer is icumen in" round for two or four voices. London, British Library MS Harley 978, folio 11, 1250. THE GRANGER COLLECTION, NEW YORK.

shifted commensurately. Even so, as also occurred with the long heroic narrative and the romance, there was much mutual imitation of short poetic forms among European nations, especially on the Continent.

THE LYRIC IN EARLY MEDIEVAL ENGLAND. In the Anglo-Saxon period in England (ninth through eleventh centuries), lyric poetry had a distinctively nostalgic or elegiac tone. Although the poets could not have known the ancient Greek and Roman elegy lamenting the loss of a person, place, or thing, the brooding or gloomy tone of these poems reflects the harsh conditions of life for isolated tribal peoples who were often separated from their comrades or families by brutal weather, lengthy sea travel, or internecine warfare. Lyric poems produced during this era reflect many of the heroic themes of *Beowulf*, but at the same time sometimes give evidence of a shift in religious sensibility from belief in the old pagan Germanic divinities and myths to the formal adoption of Christianity. More than any poetry of the Continent, these verses resemble the Skaldic and Eddic poems of

early Scandinavian lyricism. These elegiac poems were set against a bleak, wintry seascape, a marked contrast to the spring-like setting of later medieval lyricism on the Continent. For example, the respective narrators of "The Wanderer" and "The Seafarer" are roaming almost aimlessly by ship, traversing the icy winter seas off the coast of England while lamenting the death of an earthly leader, who is sometimes allegorized as the Christian "Lord," indicating the often uneasy transformation of formerly pagan Britain to Christianity. In another elegy, "The Ruin," the narrator recalls with regret a once imposing feasting hall that is now a crumbling pile of stones battered by the elements. As in *Beowulf*, these poems employ the trope of "ubi sunt," a series of unanswered questions ("Where are the brave warriors?"), which underscores the absence either of missing or dead comrades from the *comitatus*, or of buildings demolished by the ravages of time and the harsh northern weather.

A NEW ARAB INFLUENCE. On the Continent, beginning in the eleventh century, a new style of lyric poetry developed, inspired, as in Britain, largely by political, religious, and cultural shifts. Charlemagne's campaigns against the Muslim inhabitants of Spain in the ninth century, illustrated in the *Song of Roland* and other *chansons de geste* (heroic poetry), anticipated the even more extreme anti-Muslim military expeditions to the Middle East called Crusades, which began in 1095. The Crusades changed the cultural life of Europe through the introduction by the returning crusaders of the Arabic music, poetry, and luxury goods to which they had been exposed while in the East. Coming to Europe through southern France, the returning knights brought back a new Arab-inspired approach to lyric poetry, featuring themes of erotic love. A prominent early crusader, William IX of Aquitaine (1071–1127), became one of the first practitioners of this new kind of lyricism. William was the grandfather of Eleanor of Aquitaine, queen of both France and England through her successive marriages to King Louis VII of France and King Henry II of England in the twelfth century. At their respective courts, Eleanor and her daughter by Louis, Marie of Champagne, became patronesses of this new style of French poetry, which reflected the discourse of courtly love described by Andreas Capellanus in his treatise, *De Arte Honeste Amandi*, which may have been commissioned by Eleanor's daughter, Marie of Champagne, at one of her "courts of love."

THE TROUBADOURS IN FRANCE. Paralleling the development of the idea of courtly love in the twelfth century, these Arab-inspired poems, some of which were written about the experience of going on Crusade, called

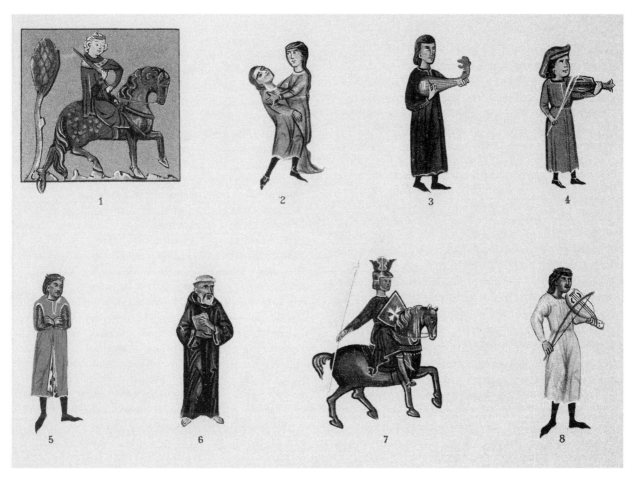

Troubadours, Bernart de Ventadorn, Jaufre Rudel, Perdigon, Marcabru, Monk of Montaudon, Ponds de Chapteuil, Albertet. French manuscript, late 13th century. **THE GRANGER COLLECTION**.

chansons de croisade ("Crusade Songs"), were created first in Provence in southern France by the troubadours and later continued by the trouvères in the north of France. The terms *troubadour* and *trouvère* derived from the verb *trobar*, which meant "to find or make." Although these poets could be attached permanently to a particular court and patron, often they moved about from court to court, seeking more powerful and lucrative patronage. Troubadours in the south include Cercamon (1130–1148), Marcabru (1130–1150), Bernart de Ventadorn (1140–1180), Bertrand de Born (1140–1214), Pierre Vidal (1170–1204), Arnaut Daniel (1170–1210), and even a female poet (female troubadours are known as *trobairitz*) the Countess of Dia (1150–1200). The northern trouvères included Richard the Lion-Hearted (1157–1199), Gace Brulé (1170–1212), the Châtelain de Coucy (d. 1203), and Adam de la Halle (1270–1288). In contrast to the chilly, elegiac mood of Anglo-Saxon lyrics, this Continental poetry, influenced by the Crusaders' experiences in the exotic Middle East, celebrated a new poetic theme: romantic love for a woman—sometimes the lady of the

court to which the poet was attached, who was unattainable because married, and whose every whim controlled the singer of the *chanson d'amour* (love song). The vocabulary expressing the roles of the lover and the beloved of the troubadour songs echoed the terminology of lordship so that the beloved lady played the role of the haughty "domna" (female "lord") to the poet, her vassal. If the poet/lover was successful, these songs were expressed joyously as in the fusion of identities between the human singer and the lark he sings about in Bernart de Ventadorn's "Can Vei la lauzeta" ("When I see the lark"). If the lover was unsuccessful, he might sing mournfully, against the backdrop of a paradise-like setting, the *paradys d'amour* ("paradise of love"), an almost ubiquitous springtime landscape complete with birdsong, gentle breezes, and fragrant flowers that inspire the poet to sing about his love of the lady.

NEW POETIC GENRES. Although these French poets are best known for their crusade songs and songs of love, the poetic repertoire practiced by the troubadours

BIRDS
in Medieval Literature

Birds are among the most commonly encountered creatures in medieval poetry, perhaps because it is so easy to understand the analogy between the poet as *singer* of love "songs" and the bird whose only means of communication is singing. Various types of birds or "fowles" are used to represent many different moods and situations in both English and Continental poetry. The *chanson d'amour*, the lyric poem of love "sung" to the accompaniment of music by the troubadours in France, the *minnesingers* in Germany, and courtly love lyricists in England, nearly always begins with reference to the singing of birds—larks, nightingales, or other woodland birds. In poems such as these, birds evoke the mood of the springtime *reverdie* ("regreening"), and the courtly lover expresses or "sings" his feelings of joy at success or sorrow at disappointment in his love pursuit, as in this example by the troubadour Bernart de Ventadorn, who wrote between 1150 and 1180:

When I see the lark moving
Its wings with joy against the sunlight,
Till he forgets and lets himself fall
For the sweetness that has come into his heart,
Alas! such great envy comes over me
For all those whom I see rejoicing,
I am amazed that my heart—right then—
Does not melt with desire.

So tired! I thought I knew so much
About love, and I really know so little,
For I cannot keep myself from loving
A lady from whom I will get no reward.
She has my whole heart, my whole self,
And herself and the whole world besides;
And when she departed, she left me nothing
But desire and a hungry heart. ...

Dream Visions, such as the *Romance of the Rose* and Chaucer's *Book of the Duchess*, use birds and their song

to awaken the dream-narrator from sleep and to beckon the dreamer into the narrative of his dream. But other literary birds are more verbal in their depiction. Chaucer's *Nun's Priest's Tale* is a delightful beast fable about a rooster, Chauntecleer, and a hen, Pertelote, who are married and who debate over whether or not the rooster's nightmare about being captured by a fox is meaningful. The narrator reminds the audience that although his tale is of a "cock," they must decide what in the tale is "wheat" and what is "chaff," the standard metaphor for the possibilities of simultaneous literal and figurative meanings in allegory. Chaucer's other bird poem, the *Parliament of Fowls*, features a dream in which various species of birds argue with one another about the issue of which aristocratic avian suitor the noble peregrine falcon should choose for her mate. This situation is reminiscent of the many arguments about which rank of suitor is appropriate for which rank of courtly lady in Andreas Capellanus's twelfth-century *Art of Courtly Love*. Chaucer's use of debating birds follows another earlier poem, the thirteenth-century *The Owl and the Nightingale*, in which the two title birds debate such issues as predestination, natural character, and carnal sin. Marie de France's Breton Lay *Nightingale* features a bird whose singing is the occasion for the secret meetings of a married lady and her lover, but which eventually becomes a symbol reminiscent of the nightingale in Ovid's *Metamorphoses*, in which the raped Philomela is transformed into the melodic bird. Chaucer includes this myth of a woman whose tongue is cut out to keep her from telling the story of her attack as one of the tales about tragic females in his *Legend of Good Women*. Although, at first glance, the birds of medieval poetry may appear to be mere background for the immediate plot situation, birds were favored vehicles by which poets expressed ideas about love, the creation of art, and the human voice and its silencing.

SOURCE: Bernart de Ventadorn, "Can vei la lauzeta mover," translated from the Provençal by Kristen M. Figg.

and trouvères included a number of different types reflecting both cultural life and social conditions. Among these were the *jeu parti* (a game-like debate poem reflecting the competition between poets to produce the best lyric poetry); the *chanson d'aventure* (song of adventure) about an unusual encounter experienced by a knight errant; and the *aubade* or *aube*, or *alba* (dawn song), a lyric in which lovers lament the coming of the dawn because they must part after a night of clandestine lovemaking. Troubadours also produced the *planh* (complaint) about unsuccessful love or oppressive political or economic situations; the *pastourelle* (song about shepherdesse), a short, dialogue-filled, narrative account of a courtly knight's attempt to seduce an innocent, but clever shepherdess; the *chanson de toile* (working song), a song voiced by female workers spinning cloth or doing other chores; and the *chanson de mal mariée* (a woman's song about being badly married), a complaint about marital problems often stemming from the practice of arranged marriages. By the fourteenth century, the emphasis shifted from genres based on theme to genres based on form, as French poets like Guillaume de

THE
Cult of the Virgin Mary in Medieval Literature

Modern readers may be surprised by the number of medieval lyric poems that focus on the Virgin Mary not only in her role as intercessor or sorrowing mother of Jesus, but also as a type of idealized woman to be addressed with the language of love. Indeed, Dante's decision to depict the highest reaches of heaven as a celestial rose in which the Virgin Mary is the central petal reflects a medieval devotional practice, the "Cult of Mary," that began in the twelfth century and attracted Christian devotees throughout medieval Europe for centuries to come. This form of intense Marian devotion echoed the language of Courtly Love, with the Virgin metaphorically cast in the role of the chaste and sometimes demanding courtly "domna" (literally the Ma-donna) of a male supplicant. Also about this time, the Cistercian monk Bernard of Clairvaux, who purportedly was permitted to suckle from Mary's breast in an ecstatic vision, promoted special reverence for the Virgin, highlighting Mary's role as Christ's mother, and emphasizing the nutritive function of her breasts in her role as the "nurse" of God. Bernard's *Commentary on The Song of Songs* provided many new poetic images to be applied to the Virgin in lyric poetry. Samples of Mary's milk, brought back from the Holy Land by Crusaders, became highly prized relics to be venerated at various shrines to the Virgin throughout Europe, including the English shrine in Walsingham in East Anglia, which attracted thousands of pilgrims from both England and abroad in the fourteenth and fifteenth centuries.

On the Continent, veneration of the Virgin increased during the fifteenth century through the promotion of the rosary, especially by members of the Dominican Order, as part of the Counter Reformation. The rosary as an aid to Marian devotion consisted of a strand of beads used for counting prayers, called "Aves," as in the prayer "Hail Mary." Increasing numbers of lay confraternities (organizations focused on a religious figure or shrine) devoted to the recitation of the rosary endorsed the rosary's efficacy at attaining from the Virgin both her Son's intercession on behalf of the supplicant, and her defense against physical injury. Mary's protection of supplicants was implied in popular visual images of the monumentally proportioned Virgin who shelters diminutive petitioners, and even whole cities, under her mantle. The belief in her ability to protect her supplicants was so great that, in the fifteenth century, another petition was added to the conclusion of the "Ave," asking Mary in turn to pray for the sinner both immediately and eventually at the hour of death. Also in the fifteenth century, woodcuts or paintings promoting the rosary often represented the "Fifteen Joyful, Sorrowful, and Glorious Mysteries" of Mary and her Son. The Sorrowful Mysteries, which directed the supplicant's attention to Mary's presence at Christ's crucifixion and death, contributed powerful imagery to lyric poems about Christ's Passion, and to Mary's role as "Mater Dolorosa" (sorrowful mother).

Machaut and Jean Froissart perfected "fixed form" lyrics with complicated patterns of rhyme and meter—genres such as the *ballade*, the *rondeau*, and the *virelais*, which at first were matched to complicated new musical forms, but later circulated independently. These challenging genres emphasizing the elevated language that corresponds to refined love were the precursors of the most famous Renaissance lyric form: the sonnet.

THE INFLUENCE OF THE TROUBADOURS IN GERMANY. Eventually, most of these French models were imitated all over the Continent. In Germany, the *minnesingers* (singers about *mine* which means "love"), such as Walter von der Vogelweide (1170–1280), continued to develop the themes of *fin'amors* (refined or distilled love), but the Germans addressed their love poetry to ladies who offered less *daunger* (resistance), and consummation was more realistically attainable in German courtly love poetry than in the French models. On the other hand, the sequences and hymns composed by the polymath Hildegard of Bingen (1098–1179), the abbess of a convent of nuns located on the Rhine and the author of both medical treatises and accounts of her mystical visions, exemplify how secular and religious poetic themes could be fused. Like troubadour lyrics, Hildegard's hymns combine celebrations of the re-greening of nature in springtime with awed praise for God's creations and for the role of the Virgin Mary's paradoxical chaste fertility in the Incarnation. For example, Hildegard's hymn, "O viridissima virga" ("O greenest branch/virgin") develops complex wordplay between conventional springtime tropes about re-greening branches, Mary's role as a metaphoric "branch" on the family tree of Jesse (Christ's genealogical lineage), and her giving birth to Christ, which helped endow the earth's flora and fauna with new life and brought mankind into identification with the human/divine Redeemer, her son.

THE INFLUENCE OF THE TROUBADOURS IN ITALY. In Italy, the poets of the *dolce stil nuovo* ("the sweet new

THE
Spiritual and the Erotic in the Middle English "Foweles in the frith"

Foweles in the frith,
The fisses in the flod,
And I mon waxe wod.
Mulch sorw I walke with
For beste of bon and blod.

A modernization of the Middle English text follows:

Birds in the wood,
The fish in the river,
And I must go mad.
I live in great sorrow
For the best of bone and blood.

"Foweles in the frith" (modernized from Oxford, Bodleian Library MS Douce 139, folio 5, thirteenth century) is one of the simplest and yet one of the most enigmatic of Middle English lyrics. With its terse placement of the birds in the woodlands and fish in the river, it opens with an extremely abbreviated evocation of the landscape of springtime, the traditional opening of many *chansons d'amour*. This traditional start abruptly precedes a statement that the speaker "must" go mad. Is the speaker envious of the birds and fish, who are in their proper element while he "walks" aimlessly in "much sorrow" to the point of madness?

The mysterious source of this extreme feeling of passion is revealed in the next and final two lines: the speaker is sorrowful because he has lost the "best" creature made of bone and blood, that is, the best human ever created. With no other clues as to the meaning of the five lines, one must consider what spring means in the medieval calendar. Spring brings the time of vernal rejuvenation in the natural world, a time when humans feel, like Chaucer's "little birds" in the opening lines of the General Prologue of the *Canterbury Tales*, "pricked by nature" to answer their physical urges. In this sense, the poem seems a spare song of thwarted passion, in which the speaker, wracked by pangs of traditional courtly love, explains how he has become crazed after losing the "best" female made of bone and blood, his lost beloved. In the exaggerated diction of Courtly Love poetry, the male lover's beloved is always the best lady of all women. However, springtime also suggests the season of Lent in the liturgical calendar, a sorrowful time of meditation on the Passion of Christ, leading up to the Resurrection at Easter. In this sense, the poem may also be the lament of a devoted Christian expressed about the loss of the "best of bone and blood," the Godhead in His human incarnation as Christ, who suffered death at the time of year when birds are in the wood and fish are in the river. Whatever the interpretation, this tiny poem packs a great deal of possible meaning in five seemingly simple lines of verse.

Middle English modernized by Lorraine K. Stock.

style") mirrored the themes of the southern French troubadours, many of whom had traveled—wandering from court to court in search of better patronage—from nearby Provence and Aquitaine to Italy. Notably, Dante Alighieri, the author of the *Divine Comedy*, wrote independent love poems and also incorporated songs and sonnets about Beatrice Portinari in his early autobiography *La Vita Nuova* (The New Life). These anticipate his veneration of Beatrice almost as if she were a saint in the *Divine Comedy*, placing her in the highest circles of Heaven with other saints and the Virgin Mary. The troubadour term "ma domna" for the courtly beloved resonated linguistically with *Madonna*, the Italian epithet for the Virgin Mary, encouraging association between the model of divine femininity and the courtly love object. In Italy, late in the medieval period, the humanist scholar and poet Francesco Petrarch (1304–1374) developed the sonnet, a formal fourteen-line poem, in a famous sequence of sonnets, the *canzoniere* (songs) honoring an idealized courtly lady, Laura. This popular lyric form, which had probably been invented by Giacomo da Lentini in the Sicilian court in the mid-thirteenth century, was revived in England in the sixteenth century as the "Petrarchan" or "Italian" sonnet, used to great effect in the hands of Sir Thomas Wyatt, the earl of Surrey, and, of course, Shakespeare.

LYRIC POETRY IN ENGLAND IN THE LATER MIDDLE AGES. After the Norman Conquest (1066) in England, lyric poets also borrowed or absorbed many motifs from the Continental *chansons d'amour*, such as the conventional *natureingang* ("nature-entrance"), also known in Middle English as the *reverdie* ("re-greening"), a song celebrating the reappearance of spring after a long winter. Many *chansons d'amour*, *chansons d'aventure*, and Crusaders' songs begin with an evocative celebration of the glories of the re-greening of nature in April or May, and Hildegard of Bingen had used the idea to great spiritual effect in her hymns. This lyric motif clearly influenced and contributed to the *reverdie*-like openings of dream visions such as the *Romance of the Rose* and the

famous opening sentence of the General Prologue of Chaucer's *Canterbury Tales*, which describes how the sweet showers of April, the tender shoots of plant life, the birds making melody, and the spring breezes inspire sundry folk from all over England to make a pilgrimage to the shrine of Thomas Becket at Canterbury Cathedral. The love professed by the Middle English lyric singer for flesh-and-blood courtly ladies—for example in the Harley Lyrics' "Alysoun"—was less intense and more playful than that of his passionate French counterpart, more like the German minnesingers. As in the case of Hildegard and the Italian practitioners of the *dolce stil nuovo* (sweet new style) of the late thirteenth century, Middle English poets also imaginatively developed the conventional devices and motifs of the Continental courtly love lyric by applying them not to a worldly female love object, but to the Virgin Mary, who became the spiritual "domna" revered by the lyric singer. In fact, Middle English poets wrote various sub-genres of religious lyric poetry devoted to such themes as veneration of the Virgin Mary, *contemptus mundi* (contempt for worldly things), the mutability of earthly life and the permanence of salvation, lamentation for the crucifixion of Christ, and the effect of the Fall of mankind on the human condition. In many Middle English lyrics, genres are combined paradoxically and provocatively, as in the brief lyric "Foweles in the frith," which fuses the spiritual and the erotic in a *reverdie* that can be interpreted as being both about unsuccessful love and about the tragedy of Christ's crucifixion. Perhaps harking back to the earlier dark, brooding Anglo-Saxon elegies at the close of the fourteenth century, Middle English poets like Geoffrey Chaucer also incorporated serious philosophical ideas and political sentiments in lyrics such as "The Former Age," "Truth," and "Gentillesse," which were inspired by passages in Boethius's philosophical treatise *Consolation of Philosophy*. Other Middle English poets used the lyric form to comment on contemporary political acrimony and social dissent that reflected such socioeconomic movements as the "Peasants' Revolt of 1381" in which the lower classes protested against the nobility, the clerical orders, and the legal courts because of heavy taxation and denial of their demands for higher wages and freedom of mobility.

SOURCES

F. P. R. Akehurst, and Judith M. Davis, eds., *A Handbook of the Troubadours* (Berkeley, Calif.: University of California Press, 1995).

Kristen Mossler Figg, *The Short Lyric Poems of Jean Froissart: Fixed Forms and the Expression of the Courtly Ideal.* Garland Studies in Medieval Literature 10 (New York: Garland, 1994).

Frederick Goldin, ed. and trans., *German and Italian Lyrics of the Middle Ages; Original Texts, With Translations and Introductions* (New York: Anchor Books, 1973).

———, *Lyrics of the Troubadours and the Trouvères; Original Texts, with Translations and Introductions* (New York: Anchor Books, 1973).

Douglas Gray, *Themes and Images in the Medieval English Religious Lyric* (London: Routledge and Kegan Paul, 1972).

Laura Kendrick, *The Game of Love; Troubadour Word Play* (Berkeley, Calif.: University of California Press, 1988).

Stephen Manning, *Wisdom and Number: Towards a Critical Appraisal of the Middle English Religious Lyric* (Lincoln, Nebr.: University of Nebraska Press, 1962).

Edmund Reiss, *The Art of the Middle English Lyric; Essays in Criticism* (Athens, Ga.: University of Georgia Press, 1972).

James J. Wilhelm, ed., *Lyrics of the Middle Ages: An Anthology* (New York: Garland, 1990).

SEE ALSO *Music: The Monophonic Secular Tradition*

MEDIEVAL ALLEGORY AND PHILOSOPHICAL TEXTS

RELIGION AND MEDIEVAL ARTISTIC EXPRESSION. The Christian church was the most influential cultural institution in medieval Europe, having far more influence over every facet of life—including response to and production of texts—than any temporal or secular political or economic organizing system. From its earliest inception, the ecclesiastical establishment controlled the dissemination and interpretation of its foundational text, the Bible, accounting for any apparent inconsistencies through an elaborate system of reading that attributed multiple levels of meaning to the Scriptures as well as finding connections between events in the Old Testament and the history of Christ's ministry in the New Testament. This mode of interpretation was invented and disseminated by the early church fathers. Most prominent among these were Augustine of Hippo (354–430), whose autobiography *The Confessions* and treatise *The City of God* exemplify fourfold-interpretation of the Bible, and Pope Gregory the Great (590–604) whose *Moralia in Job* (Moralizing of the Book of Job) took every verse of that Old Testament book and found four different ways of understanding them. These modes of interpreting Scripture not only influenced the expression of spiritual ideas and sentiments in the Middle Ages, but also had significant impact on the visual arts and on literature. When applied to literary texts, this pervasive mode of thinking was known as allegory. In addition to literary

works like *Piers Plowman* or the *Romance of the Rose* which were completely allegorical, many works of medieval literature—even those associated with "realism"—incorporated some limited allegorical aspects in their overall scheme.

MEDIEVAL ALLEGORY DEFINED: THE LETTER AND THE SPIRIT. Allegory, which sometimes employs an extended metaphor, is a narrative mode in which a series of abstract ideas are presented through concrete, realistic characters and situations operating within a literal plot that makes sense in and of itself. Allegorical literature is typically encountered in two distinct forms. In the older type, called personification allegory (the most famous example of which is *The Romance of the Rose*) characters personify abstractions like Jealousy or Friendship, but these characters have no existence in the real world and do not "symbolize" anything more than their name implies. The narrative then dramatizes the encounter between abstractions made visual. In the second type of allegory, called symbol allegory (of which the *Divine Comedy* is the most famous example), the characters are real people who exist, or once existed in the real world, who "stand for" or symbolize something beyond themselves. This literal plot is meant also to convey an extra level or, in the most complicated types of allegory, several levels of moral, religious, political, or philosophical meaning. To medieval readers of allegory, the difference between the literal and the "figural" or allegorical level reflected Saint Paul's pronouncement in 2 Cor. 3:6, that "The letter kills, … but the spirit gives life." The early church father Saint Augustine of Hippo interpreted this to mean that the "letter" or literal level of a text covers and conceals the "spirit" just as the chaff covers the grain, or, in a more familiar comparison, the "nutshell" conceals the "kernel" of the nut.

THE FOUR-FOLD METHOD OF MEDIEVAL ALLEGORIZATION. In interpreting Scripture, the church fathers recognized the potential for up to four levels of allegorical or "exegetical" interpretation:

1. the literal level, the thing as it really stands in the text;

2. the allegorical level, which refers to the Church or something standing for a universal truth;

3. the tropological or "moral" level, which pertains to the spiritual life of individuals, teaching how they should behave; and

4. the anagogical or eschatological level, which stands for something pertaining to the hereafter.

In short, the literal level teaches things; the allegorical level tells what should be believed; the tropological or moral level tells what should be done; and the anagogical level explains where a person goes after death. Although this complex system was seldom used directly in the creation of literature, it was important as a mode of thinking and occasionally appears in some of the more self-consciously religious allegorical texts. In the late fourteenth-century poem that modern editors call *Pearl*, a touching story of a father struggling with the death of his young daughter, the poet meditates on the meaning of the word which has become the poem's title in ways very similar to the "fourfold scheme." The major symbol of the "pearl" is, literally, a lost gem or the dead daughter; allegorically it represents primal innocence before the fall or the state of a baptized infant; tropologically it emphasizes one's duty to regain innocence; and anagogically it points to a beatific vision in the heavenly paradise. Much more common than this complex fourfold allegory was a type of narrative built entirely on personifications, which allowed writers to explore directly the interactions between abstract moral qualities (often characterized as vices and virtues) fighting for control of the human will.

ROMANCE OF THE ROSE. Surviving in over 300 extant manuscripts and translated into nearly every medieval language, the thirteenth-century allegory *Romance of the Rose* was the single most influential secular literary work written in the Middle Ages and a key text in the development of the medieval genres of dream vision, allegory, and romance quest. The text is divided into a pair of opposing but complementary parts, composed by two different thirteenth-century French authors. Guillaume de Lorris wrote the first 4,000 lines of this seminal dream vision in 1230–1235. The dreamer's quest for the rose remained uncompleted until Jean de Meun added almost 18,000 lines, continuing Guillaume's allegorical plot, but adopting a more satirical tone; he completed the work in 1275. This pair of authors exemplifies the medieval reverence for past authorities; both are heavily indebted to Ovid's works in their conception of love. Jean also incorporated the rediscovery of Aristotelian and Platonic texts that had recently become part of the curriculum at the University at Paris.

GUILLAUME DE LORRIS'S ROMANCE OF THE ROSE. Guillaume's section of the poem opens in typical dream vision fashion, set in a May time *locus amoenus* (literally a "beautiful place") in which the narrator, who eventually is identified as *Amant* (lover), dreams that he discovers an enclosed garden. The garden's exterior walls are decorated with images of allegorical figures representing social groups and human types who exemplify the "vices" of

courtly society (such as hatred, felony, covetousness, envy, poverty, hypocrisy) or who are superficially unacceptable for elite membership in the garden of *Deduit* (mirth or diversion). Escorted into the garden by its gatekeeper, Idleness, the dreamer encounters allegorical abstractions representing the qualities of the leisured existence enjoyed by Deduit and the aristocratic inhabitants of his garden, a microcosm of courtly society: Beauty, Wealth, Generosity, Openness, Courtesy, and Youth. Proceeding through the garden, the dreamer encounters the fountain of Narcissus, whose myth literally reflects the self-absorption experienced by lovers. Gazing into the waters of Narcissus's fountain, the dreamer sees a reflected rose and is infatuated by the rosebud's surface beauty. The process of being "smitten" becomes literal and concrete as he is stalked by the God of Love, who shoots into the eyes and heart of the dreamer five allegorical arrows—beauty, simplicity, courtesy, company, and fair seeming—all catalysts to the psychological experience of love.

ALLEGORY IN ROMANCE OF THE ROSE. As personification allegory, Guillaume's Rose represents a courtly lady confronted with the dilemma of erotic desire as it comes into conflict with the need for *mesure* ("restraint," "rational control"), which will protect her reputation. The God of Love instructs the dreamer about how to pursue the goal of a single kiss from his beloved Rose and outlines what he can expect from the experience of love. Guillaume's text here illustrates one especially common aspect of courtly love, whose victims are afflicted with an array of physical discomforts (chills, heat, pangs, sighs, lost appetite and strength, insomnia) and emotional torments (jealousy, despair) that are gladly suffered by the lover for the moral self-improvement conferred by love. Despite her attraction to the nameless young man, called "Amant" or "Lover" in the poem, the Rose is protected from the dreamer's too avid pursuit by a court of attendants (mirroring actual court life), including Shame, Fear, Chastity, and Resistance (depicted as a churlish Wild Man). These abstractions are all allegorized aspects of her own attempt to maintain rational control over her honor. The attributes of the Rose representing her caution are balanced by others indicating her openness to the experience of love—Generosity, Pity, and Fair Welcoming—who encourage Amant to kiss the Rose. As soon as he does so, Jealousy imprisons the Rose and her Fair Welcome in a tower, where *La Vieille* (Old Woman), a cynical bawd experienced in the ways of sex, guards them. The first part of the poem breaks off with the dreamer's pursuit of the Rose at an impasse, when Guillaume de Lorris apparently died before completing his story.

JEAN DE MEUN'S PHILOSOPHICAL CONTINUATION OF ROMANCE OF THE ROSE. In 1275 Jean de Meun more than tripled the length of Guillaume's unfinished text with a continuation of the courtly adventure of Amant's quest to possess the Rose, to which he added new themes and many lengthy digressions from Guillaume's original simple narrative. Jean expands the concept of love from Guillaume's narrow and artificial focus on the emotional satisfaction of love to a more universal concept of fruitful cosmic love presided over by a personification called *Natura.* Whereas Guillaume strove for simplicity and innocence in both content and poetic style, the well-read Jean imbued his section of text not only with the cynical treatments of romantic love and marriage found in popular story collections and misogynistic satires like *The Fifteen Joys of Marriage*, but also the philosophical writings that he had come in contact with at the university. These included Plato and Aristotle, Aristotle's later commentators, and the writings of the Platonists of the twelfth-century School of Chartres such as Bernard Silvestris and Alan of Lille, whose conception of Nature in the *Complaint of Nature* Jean adopted. With lengthy and didactic speeches issuing from their mouths, Jean's allegorical characters resemble masters in medieval universities lecturing their students. Treating the subjects of the purpose of man's existence on earth and his role in the cosmos, these talking abstractions use *exempla* (narrative examples), the "colors" or figures of rhetoric, and classical quotations to illustrate their orations. As Jean continues the plot of the dreamer's erotic quest, Amant is advised by a new set of allegorical characters including Reason, representing the dreamer's own good sense, who "reasons" with him and tries to dissuade him from pursuing love.

JEAN DE MEUN'S SATIRICAL REPUDIATION OF COURTLY LOVE. Abandoned by Reason, Amant seeks the help of Friend, who acts as his go-between to the Rose. *La Vieille* (Old Woman) also lectures the Rose's Fair Welcome about the ways of attracting men through flirtatious behavior, a swaying walk, good table manners, and the employment of eye-catching clothing and cosmetics. By concretizing his abstraction False Seeming as a hypocritical friar, Jean also anticipates the satire of the fourteenth-century clergy created by Chaucer and Langland. Finally, Amant gains entry into the Castle of Jealousy, in which the Rose is imprisoned. With the help of Venus the goddess of love, he wages a "war" against the chastity of the Rose. At this point Jean de Meun interpolates into the love-quest plot several digressive sections borrowed from the Christian-Platonist scholars of Chartres. In a passage heavily indebted to Alan of Lille's *Complaint of Nature*, Nature makes her "confession" to

her priest Genius, representing the generative principle. She complains about how mankind has abused nature by practicing the artifice of courtly love rather than propagating the race. Genius urges the practice of various types of fecundity and recommends taking refuge in a park, which features the Well of Life instead of the Fountain of Narcissus. Jean parallels the major myth that anchors Guillaume's garden, the myth of Narcissus, by using another myth to frame the dreamer's experience—the story of Pygmalion, an artist who fell in love with the sculpture he created to represent his idealized perfect woman.

JEAN DE MEUN'S SATIRE OF MEDIEVAL PILGRIMAGE. As *Romance of the Rose* draws to its climax, the dreamer's identity shifts to a pilgrim figure, allowing Jean de Meun to satirize the widespread medieval experience of pilgrimage. Accessorized with the typical staff and scrip of pilgrim "weeds" or costume, which in Jean's impudent satire represent Amant's genitalia, the dreamer assaults the architectural "aperture" of the Rose/castle into which he is attempting to gain entrance. The castle has now become a hallowed "shrine" to erotic love. Having broken the barricade, the dreamer literally and figuratively deflowers the Rose, following the laws promulgated by Genius and Nature. When Amant impregnates the Rose, the dream suddenly ends. By this time, with the extra layer of pilgrimage added to the many other strata of allegory, Guillaume's original concept of Amant's delicate courtly adulation for a perfect Rose/lady has been satirized to the point of near-blasphemy.

LITERARY INFLUENCE OF THE ROMANCE OF THE ROSE. The *Romance of the Rose* influenced many later medieval writers. Dante adopted this text's highly symbolic rose to other purposes in his *Paradiso*, in which his idealized female figure Beatrice is beatified alongside the Virgin Mary as a petal in the Celestial Rose, a metaphor for the highest reaches of Heaven. Chaucer, who translated Guillaume's text into the Middle English poem known as the *Romaunt of the Rose*, apparently also was familiar with Jean's continuation, for he echoes the arguments of Genius in his own dream vision, *Parliament of Fowls*. In the *Canterbury Tales*, Chaucer modeled the characterization of his pilgrim Pardoner on Jean de Meun's False Seeming, his hypocritical Friar, and *La Vieille* (Old Woman); Chaucer incorporated La Vieille's advice about table manners into the portrait of his pilgrim Prioress Madame Eglantine, whose name means "briar rose." Chaucer also took La Vieille's generally cynical comments about male-female relations and transformed them into the autobiographical discourse of the five-times-married Wife of Bath in her Prologue and her

tale. The *Romance of the Rose* continued to be both influential and controversial throughout the medieval period. In the fifteenth century, Jean Gerson and Christine de Pizan strenuously protested the dubious value of Jean de Meun's text by taking part in a major literary debate with Jean's supporters in the "Quarrel of the Rose." Christine especially took offense at Jean's blatant antifeminism, a far cry from the reverent adulation for the Rose practiced by Guillaume's Amant.

SOURCES

Peter L. Allen, *The Art of Love: Amatory Fiction from Ovid to the Romance of the Rose* (Philadelphia, Pa.: University of Pennsylvania Press, 1992).

Maxwell Luria, *A Reader's Guide to the Roman de la Rose* (Hamden, Conn.: Archon Books, 1982).

J. Stephen Russell, ed., *Allegoresis: The Craft of Allegory in Medieval Literature* (New York: Garland, 1988).

Jon Whitman, *Allegory: The Dynamics of an Ancient and Medieval Technique* (New York: Oxford University Press, 1987).

DANTE ALIGHIERI

POLITICS AND POETRY. While *The Romance of the Rose*, the most influential poem written in French in the thirteenth century, had combined elements of courtly love, allegory, and philosophy, the Italian poet Dante Alighieri chose an even more daring strategy to write, in Italian, the first truly epic poem since Vergil's *Aeneid*. Born in the city-state of Florence in 1265, Dante brought to his poetry the near photographic recall of an intensely political life and the love of his native language, while also having a vision of heaven, earth, and hell that surpassed all previous efforts at encompassing the vast range of human experience. A member of the Guelph party, which supported the power of the papacy against the Ghibbelines, who took the side of the Holy Roman Emperor, Dante attempted a career in politics, which was aborted when his own party split into two groups and the power fell into the hands of the opposing faction, who sentenced him to death. He lived in exile from his beloved Florence for the rest of his life, a circumstance that intensified his sense of the contrast between happiness and deprivation, and allowed him to make literary use of the characters and events of recent history from which he was forcibly distanced. As a man who so intensely defined himself as a Florentine, in an age distinguished by a new sense of civic identity and participation, Dante is significant for employing the vernacular, rather than Latin (the official language of learning), in his most important writings. In fact, he produced a manifesto ad-

vocating the use of vernacular dialects or the "vulgar" tongue to produce serious literature. This treatise, *De Vulgari Eloquentia* (On Eloquence in the Vernacular), is itself expressed in Latin, not Italian. Dante distinguished between natural language, *locutio prima*, that children learn at their mother's breast, and a second artificial language, *locutio grammatica*, that they learn at school. Latin should be used only in technical works, such as the *De Vulgari*, while the first nobler, more natural language should be used to create art.

A POETIC AUTOBIOGRAPHY. Dante was a disciple of the poet Brunetto Latini, and with Latini, Guido Cavalcanti, and other poets early in his career he practiced the *dolce stil nuovo* ("sweet new style"), the expression of courtly love poetry (influenced by the troubadours) in various Italian dialects. Culminating Dante's early attempts to be a lyric poet was his creation of the *Vita Nuova* (New Life; 1292–1295), a 42-chapter collection of these early love poems, which are linked with a prose framework written in Italian, commenting on the poems themselves as well as generally about how to write and interpret poetry. This poetic autobiography, which attests Dante's fidelity to the ideals of the *dolce stil nuovo*, especially to the acceptance of the power of Love as an external force, also chronicles Dante's love for a young Florentine woman, which produced in him a spiritual renewal (hence the title). Although Dante was married to Gemma di Manetto Donati, with whom he had several children, the woman in the poem is Bice di Folco Portinari, whom he refers to in his poetry as Beatrice or *Bea-Trice*, a symbolic name meaning "triple blessed." Beatrice served as an artistic muse and spiritual inspiration to him throughout his writing career. Beginning with Dante's initial encounter with nine-year-old Beatrice and their second encounter nine years later, when she becomes a subject of his love poetry, Dante recounts his prophetic visions about her early death and her ascent to heaven. Upon her actual death in 1290, Dante abandoned writing secular love poetry, for in his perception Beatrice had now gone beyond incarnating earthly love and had become a vehicle of God's larger plan. In *The Divine Comedy*, Beatrice is nearly apotheosized. She not only guides Dante through Paradise towards the Godhead, but also takes her place near the Virgin Mary as a "petal" in the highly allegorical "Celestial Rose," Dante's metaphor for the most sublime reaches of Heaven.

DANTE'S DIVINE NUMBERS. Written over the span of 1314 to 1321, *The Divine Comedy* is a tripartite visionary pilgrimage to hell, purgatory, and heaven, a medieval masterpiece that is considered one of the greatest literary achievements of all time. The poem is a highly structured work revealing Dante's reliance on number symbolism, a favorite device of many medieval authors, including the poet who wrote the romance *Sir Gawain and the Green Knight* and the dream vision *Pearl*, who made repeated use of the numbers three, five, and twelve. The entire *Comedy* is comprised of three major parts: *Inferno* (Hell), *Purgatorio* (Purgatory), and *Paradiso* (Heaven). Each of the three parts, reflecting the sacred number associated with the Christian Trinity, is in turn divided into 33 cantos with one introductory canto in *Inferno* adding up to the sacred and mathematically perfect number of 100 cantos (songs) in all. At the beginning of the poem, after realizing he is lost in a dark allegorical wood of error, Dante envisions (significantly) *three* symbolic beasts—a leopard (lust), a lion (pride), and a she-wolf (greed/avarice)—that paralyze him with fear and prevent him from making further progress toward the hill of salvation, until another figure appears to prod the pilgrim into action. Even the verse form Dante invented for the *Comedy*, *terza rima* ("triple rhyme"), reflects his employment of the Trinitarian pattern to organize and unify the vast literary work in which his muse, triple-blessed Beatrice, leads him to the Beatific Vision at the end of the third part.

THE SPIRITUAL JOURNEY OF THE SELF. Although the *Comedy* is in many ways a very personal poem, its framework ensures that Beatrice and Dante's other guide, whom he calls Virgil (spelled in Italian as "Virgilio" rather than as the Latin "Vergil"), does not lead *only* Dante to his goal. While on one level Dante's mind-boggling experience constitutes his own spiritual autobiography, he is careful to include the reader as a participant on the journey he takes to Hell, Purgatory, and Heaven. In the famous opening lines of the poem, Dante admits, "When I had journeyed half of *our* life's way, I found myself inside a dark wood, for I had lost the path that does not stray." With his significant use of the plural possessive pronoun "our," Dante ensures that his experience will have universal applications. Similar to the trip to the Underworld taken by Vergil's Aeneas or St. Paul's ascent to Heaven in the New Testament (he later compares himself to both figures), Dante's allegorical journey begun in *Inferno*'s first canto builds on a literary tradition of journeys that will later appear in the works of other great poets of the period, including Geoffrey Chaucer and William Langland. Dante's choice of Vergil, author of the *Aeneid*, as his guide in the first part of the poem is hardly random. Significantly, Vergil was the greatest Latin authority for medieval arts and letters, and his epic was also a narrative about the arduous journey of its protagonist Aeneas, the eventual founder of the Roman Empire.

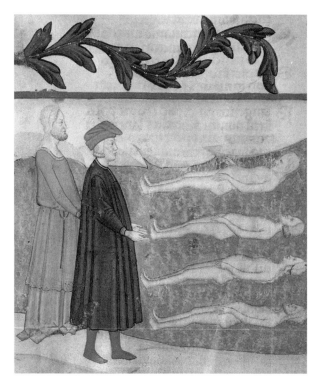

Dante and Virgil with souls in ice. *Inferno*, Biblioteca Nazionale Marciana, Venice, Italy Cod. It. IX, 276 (=6902), 15th century. © ARCHIVO ICONOGRAPHICO, S.A./CORBIS. REPRODUCED BY PERMISSION.

SIN AND RETRIBUTION. The funnel-shaped landscape of Hell through which the character Virgil leads Dante is organized by various sins—not the traditional Seven Deadly Sins, but Dante's own personal ranking of sins that adversely affect mankind not only in the personal sphere of life, but in the public realm of the economic and political operation of the *polis* ("city"). Dante has the various sins and subdivisions of them represented by an assortment of figures that include historical personages, literary characters, mythological figures, and his own local Italian contemporaries, many of whom are now obscure to the modern reader. Dante observes how these sinners are punished for eternity. The principle behind the assignment of the specific punishments is known as *contrapasso* ("opposition"), in which the punishment suits the sin by being its ironic opposite. For example, the gluttons, who ate excessively in life, are punished by being pelted by hurricanes of excrement, the byproduct of their own overeating, raining down upon them for eternity.

THE CIRCLE OF THE LUSTFUL. In each circle Dante observes the sinners from afar, and then, in the most moving encounters, he actually converses with those being punished. For example, in *Inferno*'s Canto 5, devoted to the circle of the lustful, Dante is powerfully affected by the punishment of a pair of near contemporaries, Paolo and Francesca, who, for succumbing to the "storms" of passion that drove them to commit adultery and cuckold her husband (who was also Paolo's brother), are forever within each other's sight, but swept from each other's touch by gale-force winds that fling them airborne. Francesca explains to Dante that what first sexually attracted them, impelling them to commit adultery, was their shared reading of a romance about the adultery of the Arthurian characters Lancelot and Guinevere. The reading led to kissing and beyond, and her husband, catching them, killed both. Dante has a violent reaction to Francesca's characterization of an Arthurian romance as their "go-between" or pimp; he falls into a swoon. Whether Dante's swoon was provoked by his pity for their fate or stemmed from his own stricken culpability as a writer who produced erotic poetry in his earlier career is a matter of interpretation.

TREACHERY, THE BOTTOM OF HELL. Dante and Virgil continue through the circles of Hell, encountering representatives of the sins of gluttony, avarice, wrath, heresy, violence against others (tyrants and murderers), against the self (suicides), and against God (blasphemers, homosexuals, usurers), and fraud in many permutations. The worst sin, and the one punished in the deepest pocket of Hell, is treachery, whose various degrees culminate finally in a monstrous three-headed Lucifer, who betrayed God his creator. Lucifer is seen grinding an anti-Trinity of other traitors in his triple jaws: Judas, Brutus, and Cassius, who respectively betrayed Christ and Julius Caesar, representing Church and Empire. Closing *Inferno* with more "threes," Dante here underscores his significant use of number symbolism in the *Comedy*. Climbing out of Hell, he and Virgil spiral their way up Mount Purgatory, now encountering another varied group of sinners expiating the traditional Seven Deadly Sins (pride, envy, wrath, sloth, avarice, gluttony, lust) with punishments again assigned on the principle of *contrapasso*.

REUNION WITH BEATRICE. Virgil, technically a pagan, is capable only of guiding Dante through the *bolgias* ("pockets") of Hell and up the circular mountain of Purgatory to its pinnacle, the Earthly Paradise. Here he must yield his charge to an even higher authority, Dante's long-lost Beatrice, who leads the pilgrim through the spheres of the planets, to the fixed stars, through the Empyrean to the heights of Paradise, where he has a vision of Beatrice joining the Virgin Mary and other saints in the Celestial Rose, a symbol that had been exploited in a secular way by the authors of the *Romance of the Rose*. In the last moments of *Paradiso*, Dante ex-

periences the light and love of God. In trying to convey his utter incapacity to render his vision into language commensurate with its significance, the great wordsmith compares himself to an infant babbling while suckling at his mother's breast. The poem, which started on a faltering note of moral paralysis, thus ends triumphantly with Dante restored to the primal innocence of a baby. In this way Dante's poem is justifiably called the *Comedy*, a title that, for his medieval audience, indicated its genre. As explained in the *Letter to Can Grande*, duke of Verona, traditionally believed to have been written by Dante himself, a "comedy" is a work with a fortuitous ending and is the opposite of a "tragedy," a story that ends badly for the protagonist. In those terms, Dante's poem is the greatest of all comedies because the plot concludes ultimately with the protagonist experiencing a vision of God in Heaven.

SOURCES

Robert Hollander, *Allegory in Dante's Divine Comedy* (Princeton, N.J.: Princeton University Press, 1969).

Rachel Jacoff, ed., *The Cambridge Companion to Dante* (Cambridge, England: Cambridge University Press, 1993).

Giuseppe Mazzotta, *Dante's Vision and the Circle of Knowledge* (Princeton, N.J.: Princeton University Press, 1993).

Mark Musa, *Advent at the Gates; Dante's Divine Comedy* (Bloomington, Ind.: Indiana University Press, 1974).

Charles S. Singleton, *An Essay on the Vita Nuova* (Baltimore, Md.: The Johns Hopkins University Press, 1977).

THE MEDIEVAL DREAM VISION

AUTHORITIES FOR THE SIGNIFICANCE OF DREAMS. Although many people today associate the study of dreams mainly with Sigmund Freud and Karl Jung and the twentieth-century practice of psychoanalysis, these theorists were anticipated in their investigations by nearly eight centuries, for medieval people were intensely interested in dreams and their meanings. As with other medieval literary forms, the dream vision, a genre unique to the period, was securely founded upon the medieval reverence for classical and ancient authorities. First of all, the use of dreams or visions as a literary device was sanctioned by the highest textual authority, the Scriptures. The Old Testament narrates various dreams, purported visions, or apparitions experienced by Pharaoh, Joseph, Nebuchadnezzar, Ezekiel, and others, while the New Testament features in Corinthians 2:12 St. Paul's vision of being caught up in

Paradise, and in the Book of Revelation, the account of an apocalyptic vision on Patmos. Medieval dream poetry also was preceded and endorsed by classical texts such as Plato's allegory of the cave in *The Republic*, Vergil's account of Aeneas's vision of the underworld in the *Aeneid*, and Macrobius's *Commentary* on Scipio's dream. These early models authorized the creation of a coherent group of texts whose "plot," strictly speaking, consisted of the narrator recounting his or her unusual dream, experienced while literally asleep. Although medieval writers of these narratives never defined their texts by the term "dream vision"—they simply called them "books" or "poems" or "things"—literary historians have attached the term "dream vision" to this recognizable body of medieval texts. This genre, which overlaps with the categories of allegory and philosophical works, was one of the most distinctive and widely practiced literary forms of the Middle Ages.

CHARACTERISTICS OF THE DREAM VISION. Medieval dream visions or dream allegories share certain common features. First, dream poems often employ a prologue consisting of an account of the conditions leading up to the narrator's having the dream, which sometimes is provoked by the dreamer's surroundings in a natural setting such as the *locus amoenus* ("pleasant place") full of spring breezes, birdsong, a flowery grove, and the lulling sound of flowing water. Examples include the May opening of the thirteenth-century *Romance of the Rose* and similar beginnings of later French dream visions by Machaut and Froissart, the Middle English *Piers Plowman*, the Prologue to Chaucer's *Legend of Good Women*, and the fourteenth-century English alliterative poem *Pearl*. At other times the dream is provoked by the content of a book read by the dreamer just before going to sleep, which in turn influences the content of the dream. For example, Chaucer's *Parliament of Fowls* opens with the narrator reading Macrobius's *Commentary on the Dream of Scipio*, which classified and interpreted dreams according to five types. Second, the main "plot" of the poem consists of a dream report or an account of the events occurring in the dream itself. The scope of this "plot" ranges from a limited, self-contained event, such as the dreamer's encounter and dialogue with the pearl maiden in the fourteenth-century alliterative Middle English poem *Pearl*, to a broad, encyclopedic treatment of many political, social, and spiritual issues such as is found in Langland's enormous alliterative dream vision *Piers Plowman*. Third, many dream poems, whether waking or sleeping visions, include the appearance to the narrator of a male or female authority figure who informs the dreamer about some aspect of his life or teaches him

some spiritual or philosophical truth. For example, personified Nature appears to the narrator of Alan of Lille's *Complaint of Nature*, Lady Holychurch appears to Will in *Piers Plowman*, and Reason, Rectitude, and Justice appear to Christine de Pizan in *The Book of the City of Ladies*. Fourth, some dream visions feature a framing epilogue consisting of the dreamer's awakening from the dream and interpretative speculations about its meaning, as occurs in the end of Chaucer's *Book of the Duchess*. Occasionally, the dream simply ends without the closing frame of the dreamer's awakening. Such an absence of closure occurs in Chaucer's *House of Fame*, in which the dream breaks off abruptly with the appearance of an otherwise mysterious "man of great authority," perhaps Chaucer's playful reference to the authority figure convention of dream visions.

CONTINENTAL MEDIEVAL DREAM VISIONS. The dream vision became a favored literary form in the thirteenth century with the appearance of the seminal exemplar of the genre, *Romance of the Rose*, started by Guillaume de Lorris and completed forty years later by another author, Jean de Meun. In Jean's continuation of the work, he demonstrates the potential of the dream vision to break down the rational barriers of waking life and allow for the inclusion of an encyclopedic range of subjects that would seem too random for an account of lived experience. With hundreds of manuscripts of the *Romance of the Rose* in circulation, often elaborately illustrated, by the fourteenth century the taste for dream narratives reached its zenith, with many examples produced by French love poets influenced by the *Rose*. Guillaume de Machaut (1300–1377), well known for his musical compositions and development of the motet, wrote the *Dit dou Vergier* (poem of the garden) in which the lovesick narrator swoons in an April *locus amoenus* and sees a vision of the God of Love, who dispenses advice about how to conduct a courtly love affair, using secrecy and loyalty to the beloved, whereupon the narrator awakens and vows to be true to his lady forever. As one of his earliest works, Jean Froissart (1337–1410) wrote the *Paradys d'Amours* (The Paradise of Love; 1361–1362), in which a lovesick, insomniac narrator prays for relief to the God of Sleep and, in the dream that ensues, gains the God of Love's support in wooing his lady. When, as a more mature poet, Froissart revisits the genre in *Le Joli Buisson de Jonece* (The Fair Bush of Youth; 1373), he demonstrates the dream vision's potential for psychological complexity as the narrator uses his dream of rejection in the garden of love to resolve his mid-life crisis, leading him to abandon love poetry and move on to more responsible authorial pursuits.

CURRENTS IN MEDIEVAL ENGLAND. The earliest dream vision written in England, the anonymous Anglo-Saxon religious lyric "The Dream of the Rood," is not a part of the tradition initiated by the *Romance of the Rose* but rather is a more direct descendant of the apocryphal New Testament stories—very like the canonical Book of Revelation—elaborating events in the life, death, and afterlife of Jesus which are reported by a narrator transported outside himself in a vision. In this remarkable poem, the dreamer-narrator recounts a vision of the crucified Christ on the cross in which the anthropomorphized cross or "Rood" speaks of its anguished feelings when made to serve as the implement of Christ's torture at the Passion. The Rood describes its relation to Christ—who is not the suffering victim depicted in late medieval art, but rather a heroic warrior like Beowulf—as that of a thane to his lord in the *comitatus*. As English society changed with the arrival of the Norman French in 1066, there was no continuity of tradition from this early example. After a hiatus of several centuries, however, dream visions reappeared, in imitation of the French, particularly in the work of Geoffrey Chaucer, who produced several examples: *Book of the Duchess*, which is much indebted to the love poetry of Froissart and Machaut; *House of Fame*, which combines French elements with a motif of ascent reminiscent of Dante's *Divine Comedy*; and *Parliament of Fowls*, which owes its conception of Lady Nature to Alan of Lille's allegorical female authority figure in *Complaint of Nature*. Chaucer and his works had English and Scottish imitators as late as the sixteenth century.

THE ENGLISH PHILOSOPHICAL DREAM VISION. While Chaucer's dream poems dealt with love, personal bereavement, the common profit, and fame, his English contemporaries combined dream vision with allegory to treat more serious, philosophical subjects. During the fourteenth century, the high mortality rate from the Black Death had accelerated economic changes that led to abandonment of the countryside by agricultural workers, periods of famine, sudden growth of urban centers, and the appearance of a new, socially unsettling, mercantile class that blurred old boundaries between noble and commoner. Camouflaging social critique under cover of a narrative that was "only a dream," such works as *Winner and Waster*, the *Parliament of Three Ages*, and *Piers Plowman* responded to the enormous social, religious, and economic changes that occurred in England from about 1350 onwards. The anonymous poet of the unfinished *Winner and Waster* (1350), for example, addressed the pressing economic issues of the proper getting and spending of money, posing the question of how to use national wealth with social responsibility. As the

allegorical armies of Winner and Waster prepare for battle before King Edward III, the king deems that Winner should ally itself with the Church while Waster joins the merchants of London's Cheapside market district. Similar economic concerns dominate the *Parliament [Debate] of Three Ages* (1350), in which the dreamer is visited by three men, representing allegorized Youth, Middle Age, and Old Age. Youth is carefree and thinks little about anything except the immediate moment and his pleasures; Middle Age worries only about keeping what he has earned; Old Age rails against the vices of the previous two ages and reminds Youth and Middle Age about the evanescence of earthly life. Using illustrative *exempla* (parable-like stories of moral instruction), Old Age reminds them that all is vanity and only death is certain. When the dreamer awakens, he is so traumatized by the vision that he remains lodged in a tree house, unable to return to civilized life.

A SPIRITUAL DREAM VISION. One of the most exquisitely constructed poems in Middle English is the late fourteenth-century alliterative dream vision *Pearl*, composed by the same unknown writer who created *Sir Gawain and the Green Knight* and *Patience* (a retelling of the biblical story of Jonah and the whale). As in his Arthurian romance about Sir Gawain, this poet employs striking number and color symbolism in a technically brilliant and emotionally moving poem comprised of 1,212 lines complexly organized into a structure reminiscent of a pearl necklace, with stanzas that are linked by the appearance of a key word in the last line of a stanza and its repetition in the first line of the next. The first stanza group depicts the narrator, a "joyless jeweler," lamenting the loss of some literal object, person, or state of being identified as a "pearl." The poem begins in a garden-like setting that may be the grave of the narrator's deceased young daughter or the literal "spot" where he lost a valuable pearl. After swooning from emotional loss, the narrator has a vision of a landscape suggestive of the terrestrial paradise in which a young woman, the pearl maiden, appears to him as a female authority figure like Boethius's Lady Philosophy. The pearl maiden instructs the literal-minded dreamer how to cope with his loss, using two New Testament parables as *exempla*. When the stubborn dreamer refuses to accept the promotion of such a young girl to one of the "queens" of heaven, she uses the "Parable of the Vineyard," whose moral is that the last shall go first, to explain the democracy of heavenly reward. To console him for his bereavement, she uses another parable from the Gospels, the "Pearl of Great Price," in which a jeweler exchanges a valuable gem for the greater prize of salvation. In an instance of *translatio studii*, John's vision of Revelation

MACROBIUS'S Classification of Dreams

Ambrosius Theodosius Macrobius (399–422 C.E.), a late Roman author, wrote the *Commentary on the Dream of Scipio* (circa 400 C.E.), a long treatise interpreting the *Somnium Scipionis* (Dream of Scipio), the closing section of Marcus Tullius Cicero's *De re publica* (54–51 B.C.E.). Macrobius was an important source for the transmission of Plato's thought for the twelfth century. His *Commentary*, sixteen times longer than Cicero's original text, treats number symbolism, astronomy, cosmography, geography, the classification of the virtues, the division between body and soul, and other subjects, but the section he was best known for was his classification of dreams, which was cited frequently by medieval writers of dream visions, including Guillaume de Lorris, Jean de Meun, and Chaucer. According to Macrobius, there are five types of dreams: 1) the *insomnium* (nightmare), caused by anxiety or physical or mental distress, which had no special meaning and was not considered prophetic; 2) the *visum* (apparition), which occurs in the half sleep state just before one falls in deep sleep, and which also was not considered prophetic; 3) the *oraculum* (oracular dream), in which an authority figure or parent appears in the dream and advises or prophesies to the dreamer; 4) the *visio* (prophetic vision), a prophecy that comes true; 5) the *somnium* (enigmatic dream), whose meaning is veiled and must be interpreted. Macrobius considered only the last three types of dreams significant. Chaucer mentions Macrobius's commentary in his *Book of the Duchess*, the *Parliament of Fowls*, and the *Nun's Priest's Tale*, in which his well-read rooster, Chauntecleer, quotes Macrobius on dreams.

about the procession of the Lamb (representing Christ) into the jeweled city of the New Jerusalem is incorporated almost verbatim into the dream vision. The white-attired maiden, adorned with a huge pearl, joins the procession of 144,000 virgins honoring the Lamb. Against her warnings that it was not his choice to make, the dreamer, who cannot resist trying to cross the river separating him from this scene, is abruptly awakened from his vision. In the final stanza group, he finds himself once again on the mound where he fainted, consoled by a new white, round symbol to replace the lost pearl, the Eucharist. The highly suggestive image of the pearl can be read according to the four levels of allegorical interpretation: literally as a lost gem or the dead daughter;

allegorically as primal innocence before the fall or the state of a baptized infant; tropologically as innocence, with emphasis on one's duty to regain innocence; and anagogically as possession of the beatific vision in the heavenly paradise.

THE IMPORTANCE OF DREAMS TO MEDIEVAL SENSIBILITY. Other medieval literary works that are not, strictly speaking, dream visions also allude to the importance of dreams and attest both their veracity and the possibility of accurately interpreting them. Chaucer's delightful animal fable, the *Nun's Priest's Tale* in the *Canterbury Tales*, features a well-read rooster and hen, Chauntecleer and Pertelote, who argue over the validity and possible significance of the cock's nightmare about capture by a fox, with the cock citing many of the above-mentioned biblical and classical dreams for authority, as well as referring directly to Macrobius. This tale combines dream vision and the animal epic, specifically the story of Reynard the Fox, the most famous example of which is the French *Roman de Renart* cycle, composed between 1174 and 1250 by a number of different authors. By using this important popular genre, where animals take on the roles of people (with the fox representing the voracious, aggressive, and overly clever part of man), Chaucer is able to reinforce a traditional theme about the similarities between animals and humans while at the same time exploring the issue of dreams satirically, drawing on the audience's familiarity with the cock's self-important attitude. Medieval dream visions are often, like this tale, self-referential, with many of them alluding to Macrobius's authoritative typology of dreams, as well as other early dream visions such as Alan of Lille's *Complaint of Nature*, and the *Romance of the Rose*.

SOURCES

Robert J. Blanch and Julian N. Wasserman, *From Pearl to Gawain: Forme to Fynisment* (Gainesville, Fla.: University Press of Florida, 1995).

Derek Brewer and Jonathan Gibson, eds., *A Companion to the Gawain-Poet* (Cambridge, England: D. S. Brewer, 1997).

John Conley, ed., *The Middle English Pearl: Critical Essays* (Notre Dame, Ind.: University of Notre Dame Press, 1970).

Steven Kruger, *Dreaming in the Middle Ages* (Cambridge, England: Cambridge University Press, 1992).

Kathryn L. Lynch, *The High Medieval Dream Vision: Poetry, Philosophy, and Literary Form* (Stanford, Calif.: Stanford University Press, 1988).

J. Stephen Russell, *The English Dream Vision: Anatomy of a Form* (Columbus, Ohio: Ohio State University Press, 1988).

Kenneth Varty, *Reynard the Fox: A Study of the Fox in Medieval English Art* (Leicester, England: Leicester University Press, 1967).

James I. Wimsatt, *Chaucer and the French Love Poets* (Chapel Hill, N.C.: University of North Carolina Press, 1968).

WILLIAM LANGLAND AND PIERS PLOWMAN

WILLIAM LANGLAND AND THE ALLEGORICAL WILL. The long philosophical dream vision—or series of dreams—that editors title *Piers Plowman* is perhaps the finest example of the use of the dream vision for social, political, and spiritual commentary. Composed in alliterative verse in a Northwest Midlands dialect of Middle English, the poem twice was revised and enlarged over the course of the second half of the fourteenth century. Authorship by William Langland is based on internal evidence in some of the more than fifty surviving manuscripts (approaching the number of extant manuscripts of Chaucer's *Canterbury Tales*) whose large number indicates both the high demand for copies of this long and difficult text and, thus, the high regard in which Langland's text was held in the fourteenth and fifteenth centuries. What little concrete evidence about the author's life and background is known comes from inside the text itself. Langland was probably born about 1331 in the region of the Malvern Hills. He was most likely some form of cleric educated at a Benedictine school in that region, judging from his extensive knowledge of, and allusions to, scriptural passages and his use of Latin quotations throughout the poem. Like his narrative persona, Langland seems to have spent much of his life wandering and making a living from offering prayers for the dead for fees. Langland also seems to know a lot about the workings of the royal court and contemporary politics in London, so it is likely that he also lived in London at about the same time that Chaucer was working and writing there, though there is no evidence that they knew one another. The poem's narrator is called "Will"—a pun referring to the author's first name as well as signifying the abstract "human will," rendering Will the Dreamer an Everyman figure. For convenience, modern editors divide the large sprawling allegorical plot into two major parts: the *Visio* and the *Vitae*. Langland subjected his first draft of the poem to two consecutive major re-writings and the three versions have been designated by modern editors the A, B, and C Texts, all of which are divided into chapters or parts called (in both singular and plural) *Passus* (paces or steps). These "steps" on the road to salvation are undertaken by Will through

an allegorical pilgrimage whose goal is attaining a life devoted to "Truth."

LANGLAND'S VISIO. The A Text (1360s), the shortest version, includes only Passus 1–11, the *Visio* (vision) dreamed by Will about the everyday political and economic life of man in society. This section culminates in the appearance of the allegorical character Piers Plowman, an agricultural worker and pilgrim figure who leads Will on the pilgrimage to Truth throughout the remainder of the poem. All three texts begin on a May morning, typical of the dream vision, when the narrator, a wandering cleric named Will, falls asleep in the Malvern Hills and has a vision of a "fair field of folk," a cross-section of the fourteenth-century English population similar to that achieved by Chaucer in the pilgrim portraits of the General Prologue to the *Canterbury Tales*. This initial dream, which merges into a political allegory on the subject of good kingship (presented as an animal fable in which rats and mice—the laboring and middle classes—attempt to bell the cat or king in order to limit his power) becomes highly abstract. Like Boethius and Lady Philosophy or Dante and Beatrice, Will is visited by a female authority figure Lady Holychurch, standing for the institutional Christian Church. To Will's question, "How can I save my soul?" Holychurch replies cryptically, "When all treasure is tried, *truth* is best." She warns him against the temptations of money and worldly goods by showing him a vision of the failed metaphoric wedding of "Conscience" to another female allegorical figure, Lady Meed (fee or payment), who represents all the possible beneficial or corrupting influences of money, whether offered as a just reward or as a bribe. The Lady Meed episode, structured around the metaphor of marriage, illustrates various fourteenth-century crises in language, the economy, politics, and interpersonal relations. Both Langland's allegorical use of marriage metaphors and his designation of "Truth" as the eventual goal of the Visio's pilgrimage can be read in typical patristic fourfold allegorical interpretation as

1. literal marriage between an individual and his spouse;

2. political harmony between an individual subject and his king;

3. social and economic harmony between the individual and the larger community of his fellow men; and

4. spiritual union between the individual's soul and God.

THE ALLEGORY OF THE SEVEN DEADLY SINS. In his dream, Will then witnesses the confession of the Seven Deadly Sins, a parade of allegorical personifications, illustrating various social types from medieval estates satire—also employed by Chaucer in his General Prologue to type his Canterbury pilgrims—that embody in their lifestyles the practice of pride, wrath, avarice, envy, sloth, gluttony, and lechery. This is one of the most allegorical and at the same time most "realistic" sections of Langland's poem. Gluttony's overindulgence and vomiting in the tavern, Pride's preening in her fine apparel, the slothful priest's ignorance of the words to his *Pater Noster* (the Lord's Prayer) when he knows by heart the rhymes of Robin Hood, all give fascinating glimpses into daily life of fourteenth-century London. When the plowing of a half-acre of land is disrupted by the workers' laziness (here Langland is seen incorporating aspects of the new post-Black Death economy), the allegorical figure Piers the Plowman suddenly appears, offering to guide the group on a pilgrimage to "Truth." This multifaceted virtue represents the abstract ideal of what is right, especially through the keeping of promises or contracts. Overall, in its many concrete references to and images of social, political, and economic life, the *Visio* is more "realistic" than the *Vitae*.

THE VITAE OF DO WELL, DO BETTER, DO BEST. The B Text (1370s), three times the length of A, adds to the *Visio* Passus 12–20 comprising the "lives" of the allegorical triad of Do-wel, Do-bet (Do Better), and Do-best (lives of doing well, doing better, and doing best), whose subject is less the reform of general society than an exploration of how the individual Christian (represented by the narrator Will) can strive for spiritual perfection by practicing (with emphasis on *do*-ing) the virtue of Charity. B incorporates many more forms of allegory than A, each of which becomes increasingly more abstract, including the allegorical representation of the frustrating search for spiritual improvement through clerical and academic study, represented in Will's ultimately inconclusive engagement with various personifications of the intellectual faculties such as Wit, Dame Study, Thought, and Scripture. Will's quest to learn how to practice a virtuous life is represented in his attendance at a satirical banquet shared by personifications such as Patience, Conscience, and Haukyn the breadmaker, who represents the Active Life. The *Vitae* speak provocatively about such late medieval social problems as the hypocritical lifestyle of friars, who live luxuriously despite the pervasive poverty in the general populace. Will's dream vision turns nightmarish in the concluding *Passus*, in which the narrator witnesses an attack on the Church's unity by Antichrist, who leads an army of the Seven Deadly Sins. Apprehensive about the imminent collapse of society, the collective Conscience undertakes another

PILGRIMAGE
in Medieval Literature

Making pilgrimages was a popular devotional practice that sometimes became more pastime than penance in the Middle Ages. Christians from all corners of Europe flocked to the major pilgrimage destinations to venerate relics of saints and to undergo spiritual renewal through self-denial. Pilgrims traveled to both nearby shrines and to far-flung destinations such as Compostela in northern Spain, Rome, and Jerusalem. The Wife of Bath in Chaucer's *Canterbury Tales* visited all these pilgrim sites and more. Her real-life counterpart, Margery Kempe, who had visions of a bleeding, crucified Christ while on pilgrimage, wrote *The Book of Margery Kempe*, an account of many of her travels and spiritual experiences.

Although shrines were dedicated to many different international and local saints, medieval devotion to the Virgin Mary was especially widespread. There was special interest in the Virgin in England starting from the Anglo-Saxon period when many cathedrals, monasteries, and convents were rededicated to Mary. The foremost site for veneration of the Virgin in England was a shrine established in 1131 by Richelde de Fervaques, a widow who, after being inspired by a series of visions, ordered the construction of a chapel to Our Lady in Walsingham, a town on the Norfolk coast. Walsingham became a popular local, national, and international pilgrimage destination in the thirteenth and fourteenth centuries, reaching its zenith in the fifteenth through sixteenth centuries, when visitation of Walsingham's shrine surpassed even that of Canterbury.

In the fourteenth century Walsingham became a shrine of national prominence, as indicated by William Langland, who, though he never once mentions Canterbury, describes the Walsingham pilgrimage experience several times in *Piers Plowman*, where Will observes, "A heap of hermits with hooked pilgrim staves/ Went to Walsingham with their wenches following them" and "They were clothed in pilgrim weeds to be distinguished from others" (Prologue: 53-54, 56; modernized by Lorraine K. Stock). Here Langland observes that pilgrims wore a distinctive costume to proclaim their penitent status. These lines also indicate that not all pilgrims practiced sexual abstinence during what was supposed to be a penitential exercise. During the peak of Walsingham's popularity, ordinary travelers as well as royalty stopped at the "Slipper Chapel" at Houghton (circa 1348), less than two miles from their destination, to remove their shoes and walk barefoot the rest of the way to the shrine. This degree of self-denial throws into sharp relief the much more comfortable situation of Chaucer's well-dressed and well-shod pilgrims on horseback to Canterbury. Like the crypt containing the remains of St. Thomas Becket in Canterbury Cathedral, Walsingham also displayed saintly tokens that pilgrims venerated. In addition to a famous statue of the Virgin and a pair of wells noted for their healing waters, the Walsingham shrine displayed a relic of Mary's milk, which was reputed to aid the lactation of mothers. Perhaps because of such superstitions, at the end of the fourteenth century the shrine was a target of the reforming Lollards, led by John Wyclif, who decried Walsingham's Virgin Mary as the "witch of Walsingham."

pilgrimage to find Piers Plowman (who had disappeared from the plot of the dream), thus reprising themes from the *Visio*. Will awakens abruptly in the last lines of the poem to the stricken sound of Conscience's perhaps unanswered cries for grace, leaving the conclusion of the quest for Truth uncertain.

AGRICULTURAL IMAGERY AND PILGRIMAGE. The longest version of *Piers Plowman*, the C Text (written in the late 1380s, about the same time Chaucer wrote the *Canterbury Tales*), is largely the same as B, except for a few details, such as the addition of purportedly autobiographical details about the author and the deletion of certain controversial segments. In both B and C, Langland unifies the disparate themes of his complex philosophical vision through a series of agricultural and organic images and tropes begun in the *Visio* with the "field" of folk, the plowing of the half-acre, and the figure of Piers the Plowman, and continuing in the *Vitae* with the organic

metaphor of the Tree of Charity, the plowing of the four Gospels, and the Universal Church imaged as a Barn called *Unitas* ("unity") at the poem's end. If this set of rural images reflects England's agricultural foundations, then another motif, that of pilgrimage, ties the poem to a more contemporary concern: the popularity of pilgrimages. Langland's selection of an allegorical "pilgrimage" to find Truth as his governing metaphor parallels Chaucer's far more secular employment of the theme of a literal pilgrimage to the shrine of Thomas Becket in Canterbury in the *Canterbury Tales*. Increasingly, as the Middle Ages drew to a close, the undertaking of pilgrimages became a thorny issue as the sometimes less-than-pious motives of pilgrims were questioned by reform movements such as the Wycliffites or Lollards, led by Oxford clergyman John Wyclif. Knowing that the practice was both widespread and controversial, both Langland and Chaucer used the pilgrimage theme to great (if dis-

similar) effect to illustrate some of the most compelling social and spiritual issues of their era.

SOURCES

David Aers, *Chaucer, Langland, and the Creative Imagination* (London: Routledge and Kegan Paul, 1980).

John Alford, ed., *A Companion to Piers Plowman* (Berkeley, Calif.: University of California Press, 1988).

Elizabeth D. Kirk, *The Dream Thought of Piers Plowman* (New Haven, Conn.: Yale University Press, 1972).

THE MEDIEVAL STORY COLLECTION

RESISTANCE TO CATEGORIZATION. A characteristically unique feature of medieval literature is its tendency to mix forms and styles. In the cases of the philosophical dream vision, the romance, and the allegory, individual medieval literary works often combine or incorporate several independently identifiable genres such as prose and verse, or comic and serious elements, within one work. This tendency makes it impossible to classify certain works in a single generic category. For example, the long, highly complex thirteenth-century poem *Romance of the Rose* combines dream vision, courtly romance, adventure quest, allegory, love poem, philosophical treatise, social satire, and more, within a vast plot that was begun by one author, Guillaume de Lorris, and completed a half century later by another writer of a completely different mindset, Jean de Meun. Similarly, *Piers Plowman* combines allegory, dream vision, philosophy, pilgrimage quest, social satire and other forms to such an extent that it is difficult to describe it by a more precise term than "dream vision."

MEDIEVAL MANUSCRIPT MISCELLANIES. One of the more popular ways for medieval readers to obtain copies of literary works was to order manuscripts that collected a variety of kinds of genres and forms within the binding of a single book. Medieval audiences thus might receive a mixture of long romances, mid-length narratives, and short lyrics in manuscripts that were loosely organized "miscellanies" or anthologies containing a sampler of varied genres and modes. Paralleling this manuscript model of the "miscellany," medieval writers themselves were inclined to create what were essentially anthologies of different stories that circulated together in a reasonably coherent form. Sometimes these "story collections" were organized around a theme that provided a reason for a compiler to collect the tales. This variety would include collections of saints' lives like the enormously influential mid-thirteenth-century *Legenda Aurea* (Golden Legend) by Jacob of Voragine; tales of remarkable people and events like the *Gesta Romanorum* (Deeds of the Romans); and the Breton *lais* and animal *fables* of Marie de France. However, the most formal and literarily self-conscious medieval story collections involved a framing device, a larger narrative that linked all the other stories through an author's invented occasion at which stories and exempla were exchanged. In some cases the stories were chosen to illustrate either a moral principle or its violation. Other story-collecting frameworks involve a group of people telling tales to one another as a social exercise, a game, or a way of passing what would otherwise be tedious travel time. Such story-telling "frame" situations were employed to organize several important landmarks of medieval literary culture in Continental Europe and England.

THE LATIN STORY COLLECTION IN ITALY. The Italian writer Giovanni Boccaccio (1313–1375) compiled several story collections, both in Italian and in Latin, although in his own lifetime the Latin works were more popular than the vernacular ones. One Latin collection, *De casibus virorum illustrium* (Concerning the Fates of Illustrious Men; 1355), which was possibly a source for Chaucer's *Monk's Tale*, has no frame, and is almost exclusively didactic. It narrates the rise to fame and fall from fortune of various great men and several women in chronological order, starting with the biblical Adam and going to the middle of the fourteenth century. These tales, which seem overly similar to a modern audience, were enormously popular in Boccaccio's time, and the *De casibus* was the work for which he was then best known, judging from over eighty surviving manuscripts and numerous French translations in luxury illuminated editions. Each narrative offers the same pattern—the turning of Boethius's Wheel of Fortune, the foolishness of pride, and God's humbling of the proud. Boccaccio also wrote a similar Latin collection on women, *De mulieribus claris* (Concerning Famous Women; 1361–1362), which recounts the lives of over 100 mythological and classical women who became famous or infamous for various reasons. This work anticipates Chaucer's *Legend of Good Women*, which has an elaborate frame and prologue, and Christine de Pizan's *Book of the City of Ladies*, a collection structured around the building of an allegorical city comprised of the biographies of illustrious women.

THE DECAMERON. The work for which Boccaccio is now most famous, *The Decameron* (One Hundred Stories), is an Italian anthology organized within

an elaborate fictive structural framework. It starts with a gruesomely graphic description of the physical symptoms of the Black Death, the pandemic outbreak of bubonic plague that swept across Europe in the middle of the fourteenth century, killing off between one-third to one-half of Europe's entire population. If for no other reason than the fact that its opening offers one of the only written eyewitness accounts of the ravages of the Black Death, Boccaccio's *Decameron* would be a landmark of medieval literature. However, additionally, like Chaucer's similarly framed Middle English *Canterbury Tales* and Juan Ruiz's Spanish *Book of Good Love*, this Italian collection of stories serves as a sampler of the variety of types of literary forms available in the late Middle Ages. Like Chaucer's host, who stipulates that the pilgrims' tales must combine "sentence and solas" (moral instruction and enjoyment), Boccaccio's narrator dedicates his collection to the edification and pleasure of "ladies in love" who, confined to their sewing rooms, do not have the freedom of their male counterparts to escape the distress of being in love through outdoor physical activities, hunting, and business affairs.

STORYTELLING IN THE DECAMERON. Boccaccio's fictive frame has ten young Florentines (seven ladies and three men) fleeing from plague-ridden Florence to various estates outside the city to escape infection in the more healthful air of the countryside. They agree to a story-telling game to pass their time pleasantly, with the rule that a queen or king is to be selected daily to determine the theme for that day's ten tales. The assigned themes include positive reversals of fortune; recovery of losses; unhappy love affairs; successful love affairs; clever verbal maneuvers; treachery of wives against their husbands; tricks played by both sexes; the performance of generous deeds; or free topics—in short, the full range of life experiences. After ten days of story telling, the participants return to Florence and go their separate ways. Unlike the other story collections Boccaccio wrote, this group foregoes didacticism for the sheer pleasure of telling and hearing tales. The possibility of complete disorder in so many stories is precluded by the announced themes, which help give the stories coherence. Here, as in Chaucer's *Canterbury Tales*, the sheer abundance and variety of tale-types—ranging from moral tales to romances, to bawdy *fabliaux* (for which Boccaccio is probably most famous)—ensure that all readers will find stories to amuse, provoke, and enlighten them. Moreover, as in Chaucer's *Canterbury* story collection, the delightful interplay between the tellers within the framework of the contest provides additional human interest.

A LITERARY MISCELLANY IN MEDIEVAL SPAIN. One of the landmarks of literary culture in medieval Spain was the 1350 *Book of Good Love* by Juan Ruiz, otherwise identified as the "Archpriest" of Hita, a town north-east of Madrid. Although not a formally framed story collection like Boccaccio's *Decameron* or Chaucer's *Canterbury Tales*, Ruiz's *Book*, a meandering, episodic series of accounts of the Archpriest's fourteen attempted (and sporadically successful) adventures in love, incorporates many literary genres and a wide spectrum of tones, ranging from the academically serious and religiously pious to the satirical and nearly blasphemous. Narrated by a priest who in one episode woos a nun by means of a bawd-like go-between named Convent-hopper, Ruiz offers a scathing treatment of contemporary clergy and religious life. Ruiz parodies the *pastourelle* in the narrator's encounters with the aggressive, ugly Wild Woman-like "mountain girls" who physically overpower the Archpriest, forcing him to have sex in exchange for dinner and a place by the fire. The Archpriest also creates an Ovidian "art of love" similar to Andreas Capellanus's *Art of Courtly Love* in which Sir Love and Lady Venus teach the narrator how to court women. The many allegories include a mock joust between a personified Sir Carnival and the pilgrim-attired Lady Lent (using meat and sardines as cannon balls), an allegory of the seasons and months, an allegory of the arms of a Christian, and an allegory of the seven Vices of Love illustrated by beast fables. Ruiz includes a dream vision in which Sir Love appears to the Archpriest, *exempla*, fables, *fabliaux* exchanged between the nun and the go-between, and other genres.

ALLEGORY AND AMBIGUITY IN RUIZ'S BOOK OF GOOD LOVE. Whereas the intended meanings of other story collections are more obvious, the ultimate signification of Ruiz's complexly woven, tapestry-like collection is equivocal. He repeatedly reminds his audience of the metaphor of the "husk and the kernel," suggesting that the work (or parts of it) may be understood as an allegory meant to convey meaning(s) beyond its sometimes outrageous literal level. Like Boethius in the *Consolation of Philosophy*, the narrator's opening prayer indicates that he is writing from prison. But by "prison," does he mean a literal jail cell, the "prison" of corporeal flesh, or the "prison" of the experience of love? Even the work's title, which initially implies that its subject will be erotic love, proves to be ambivalent, for eventually Ruiz distinguishes between "good love" (defined as love of God and obedience to His Commandments) and "foolish love of *this* world," which many of the Archpriest's adventures illustrate, though it is uncertain whether anything is learned from

DAME SIRITH

INTRODUCTION: *Dame Sirith* [Siriz] (from a manuscript made between 1272 and 1283) is the only known English fabliau besides several of Chaucer's *Canterbury Tales*. Probably Oriental in origin, the story of *Dame Sirith and the Weeping Bitch* offers an attack on bourgeois materialism, hypocrisy, and complacency. At the same time, it satirizes courtly love with masterful irony in a complex stanza form typical of popular romances. The story recounts the passion—complete with the pangs of love sickness—of a young clerk, Willikin (a diminutive of William), for a smug married woman, Margery. All of the protagonists are villagers of the lower middle class, but Willikin's language employs many of the conventions of aristocratic courtly love, which lend an improbable and comic note to the poem. The clerk one day visits the woman when her merchant husband has gone to a fair, revealing that he has loved her for many years and would like her to be his "leuemon" or beloved (a term from courtly love lyrics). But the lady rejects his advances, citing the respectability of her life and the virtues—and wealth—of her husband. Willikin then addresses himself to a go-between, Dame Sirith, a bawd on the order of the woman charmingly called "Convent Hopper" in Juan Ruiz's *Book of Good Love*. Through a clever trick, Dame Sirith convinces Margery to cooperate, and at the end of the tale, she brings Willikin back to Margery with the admonition that he "plow her well and stretch her thighs wide apart," which Willikin, with the now eager Margery, proceeds to do. In the passage modernized here, Dame Sirith prepares for her visit to Margery by feeding her small dog pepper and mustard until it weeps, then goes to see Margery with the weeping dog under her arm. Complaining to Margery of her poverty, she gets her sympathy and attention, as well as food and drink. Margery asks Dame Sirith what has brought her to this miserable condition. The following excerpt is her response.

[Dame Sirith]: "I have a daughter fair and free
No man might find one fairer.
She had a husband great and rich
And generous as well.
My daughter loved him all too much,
Which is why I am so sad.
On a certain day he was out of the house—
Which is why my daughter is ruined.
He had an errand out of town;
A tonsured clerk came by

And offered my daughter his love.
But she would not do as he said—
He might not have his way with her,
No matter how great his desire.
Then the clerk began casting spells
And turned my daughter into this bitch
You see here in my arms.
My heart breaks for her!
See how her eyes run
And how the tears flow down.
Therefore, lady, it's no surprise
That my heart is breaking in two.
And any young housewife cares little for her life
If she refuses a clerk her love,
And doesn't give in to him."—
"Oh my god," said Margery, "what should I do?
The other day a clerk came to me
And bade me love him in just this way,
And I refused him. Now I fear
He will transform me too.
How can I escape?"—
"May God Almighty keep you safe
From becoming a bitch or a puppy!
Dear lady, if any clerk offers his love,
I think you should grant his wish
And become his sweetie straightaway.
And if you don't, a worse fate will befall you."—
"Lord Christ, woe is me
That that clerk went away
Before he had won me.
I wish more than anything
That he had lain with me
And done it right away!
Dame Sirith, evermore I will be in your debt
If you will fetch me Willikin,
That clerk I'm speaking of—
And I will give you gifts
So that you will be better off
Forever, by God's own bell.
Unless you bring me Willikin,
I will never laugh or sing
Or be happy ever again."

SOURCE: *Dame Sirith and the Weeping Bitch*, in *Middle English Humorous Tales in Verse*. Ed. George H. McKnight (Boston and London: D. C. Heath, 1913): 16–18. Text modernized from the Middle English by John Block Friedman and Kristen Figg.

his described experiences. One thing is clear—in a period of extreme antifeminism, the narrator admires and philosophically supports women in all their infinite variety. If the Archpriest's persona remains flat and undeveloped, the characters of several of the eccentric

women he woos (or is wooed by) remain unforgettable: the physically grotesque and sexually voracious "mountain girls," the ever-present and ever-faithful "Conventhopper," and the two women with whom the narrator has most success in love, the widow Lady Sloeberry and

the nun Garoça (with whom he enjoys a platonic relationship).

THE STORY COLLECTION IN ENGLAND: CHAUCER.

In addition to his more famous *Canterbury Tales*—within which is included another incomplete collection, the *Monk's Tale* (consisting of "tragedies" of men's diminished fortunes)—Geoffrey Chaucer also wrote another unfinished collection, *The Legend of Good Women* (1389), his third-longest work, created shortly after *Troilus and Criseyde*. Like Christine de Pizan's French allegory *Book of the City of Ladies* and Boccaccio's Latin collection *Concerning Famous Women*, the Middle English *Legend* provides a story collection about various (sometimes questionably) "saintly" females who were victims of love. Chaucer's female figures were selected from the annals of antiquity and classical myth, including Ariadne, Cleopatra, Medea, Dido, Lucretia, Philomela, and others. The *Legend's* prologue sets the stories within the framework of a dream vision in which the narrator is harassed by Cupid, the God of Love, and his queen, the daisy-like Alceste, for writing literary works that defame women, such as the *Romaunt of the Rose* (Chaucer's translation of the thirteenth-century French dream vision) and *Troilus and Criseyde*, in which Criseyde betrays her lover Troilus. To rectify this literary "sin" against the fair sex, the narrator of *Legend* is issued the "penance" of writing a collection of stories lauding the more than twenty thousand "good women" whose stories he has neglected. However, the legends that follow only tell of ten women. Whether Chaucer tired of this literary exercise and voluntarily abandoned the project or decided to express an ironic view of womanly virtue through the very brevity and inconclusiveness of the collection is impossible to tell.

JOHN GOWER'S STORY COLLECTION, CONFESSIO AMANTIS.

In *Confessio Amantis* (Confession of the Lover; 1390–1393), containing over 30,000 lines of narrative verse, Chaucer's English contemporary John Gower presents a collection of biblical, classical, legendary, and popular narratives, recounted by Genius, priest of Venus, as he hears the confession of *Amans* ("the lover"). The narrative voice represents John Gower, who poses as an elderly lover. The structure of *Confessio* is organized as if *Amans* confesses to his priest the various sins committed against love in seven books of stories organized according to the Seven Deadly Sins—Pride, Avarice, Envy, Wrath, Lechery, Gluttony, and Sloth—with one book assigned to each mortal sin. For Genius and the Lover, Gower obviously is indebted to the same figures in Jean de Meun's continuation of the *Romance of the Rose* as well as Jean's source, Alan of Lille's *Complaint of Nature*. Before the

confessions proper start, there is a Prologue narrated by "John Gower" as well as another book summarizing Aristotelian lore at the lover's request. Even though both Gower and Chaucer sometimes tell analogous stories—for example Gower narrates stories that parallel those of the *Man of Law's Tale* of Constance and the *Wife of Bath's Tale* of a rash promise to a loathly damsel—readers today generally favor the psychological complexity of Chaucer's rendition over Gower's more prosaic version. Gower, however, was a prolific writer, composing thousands of lines of verse in Latin, French, and Middle English, for which he had a large audience in his time.

THE FABLIAU.

This brief type of tale, also known as the short *conte*, was predominantly a French form, the earliest examples dating from 1200. The term is the Old French diminutive for "little fable" and its plural is *fabliaux*; no equivalent name exists in Middle English. Unlike the romance, which often takes place in the far away and long ago Celtic Other World or in some idealized version of Camelot, the *fabliau* is set in the everyday world of the present. Its characters are bourgeois: peasants, clerks, lecherous clergy, oversexed wives, artisans, and cuckolded husbands. Despite its bourgeois or lower-class subject matter, the *fabliau* is not a bourgeois phenomenon, and, indeed, examples of the genre or texts in related forms occur alongside romances and in such important works as Chaucer's *Canterbury Tales,* Boccaccio's *Decameron,* and Juan Ruiz's *Book of Good Love.* The genre may have been an aristocratic form that mocked middle- or lower-class pretensions or the lack thereof. Its clever, complicated plots, often love triangles, are concerned more with cunning and folly than with virtue and evil, and generally concern humankind's most basic functions—mostly sex, sometimes excretion. Little descriptive detail is given and characterization is usually minimal, reducing people to stock character types: the stupid cuckold, the venal woman, and the lecherous clerk. Sometimes, as in an *exemplum* or fable, there is a moral, usually a satirical spoof of the character and his or her "sins." Essentially, however, the whole point of the form is amorality. The *fabliau* expresses the non-official culture of carnal, almost carnival, irreverence, of those feelings suppressed by courtly politeness or religious asceticism.

SOURCES

Larry D. Benson and Theodore M. Andersson, *The Literary Context of Chaucer's Fabliaux: Texts and Translations* (Indianapolis, Ind.: Bobbs-Merrill, 1971).

Robert J. Clements and Joseph Gibaldi, *Anatomy of the Novella: The European Tale Collection from Boccaccio and Chaucer to Cervantes* (New York: New York University Press, 1977).

Thomas D. Cooke and Benjamin L. Honeycutt, eds., *The Humor of the Fabliaux: A Collection of Critical Essays* (Columbia, Mo.: University of Missouri Press, 1974).

Robert S. Dombroski, ed., *Critical Perspectives on the Decameron* (New York: Barnes and Noble Books, 1977).

A. J. Minnis, ed., *Gower's Confessio Amantis: Responses and Reassessments* (Cambridge, England: D. S. Brewer, 1983).

Kurt Olsson, *John Gower and the Structures of Conversion: A Reading of the Confessio Amantis* (Cambridge, England: D. S. Brewer, 1992).

Dayle Seidenspinner-Núñez, *The Allegory of Good Love: Parodic Perspectivism in the Libro de Buen Amor* (Berkeley, Calif.: University of California Press, 1981).

N. S. Thompson, *Chaucer, Boccaccio, and the Debate of Love: A Comparative Study of the Decameron and the Canterbury Tales* (New York: Oxford University Press, 1996).

Anthony N. Zahareas, *The Art of Juan Ruiz, Archpriest of Hita* (Madrid, Spain: Estudios de Literatura Española, 1965).

THE CANTERBURY TALES

A CROSS-SECTION OF FOURTEENTH-CENTURY CHARACTER TYPES. Begun about the late 1380s and still incomplete at Chaucer's death in 1400, the *Canterbury Tales* comprise the most famous story collection in medieval literature. Like the journey to escape the ravages of the plague in Boccaccio's *Decameron*, the frame that holds together this collection of tales is the purportedly random meeting of 29 individuals at the Tabard Inn in Southwark, southeast of the city of London. The common goal of this group of "sundry folk" is to make a pilgrimage to the shrine of St. Thomas Becket in Canterbury. In some ways, this pilgrim group presents a cross-section of late fourteenth-century English people and professions. At the top of the social hierarchy are an aristocratic knight and his entourage (his squire son and their attending yeoman). Also represented are various strata of the clerkly class (an Oxford clerk and a lawyer) and assorted clergy and male and female religious persons (several nuns, a parson, a summoner, a friar, a monk, and a pardoner). Chaucer makes sure to also include representatives of the mercantile class from which he himself originated (a franklin, a merchant, some guildsmen, and a cloth-weaving female entrepreneur from Bath). In a parallel to Langland's agricultural laborers and his title character Piers Plowman, Chaucer went on to include members of the agricultural peasantry (a plowman, a miller, and a reeve), though how they could have afforded the time or the funds to travel on a pilgrimage is left to the reader to wonder about. Chaucer's treatment of the portraits of the pilgrims in the General Prologue to the *Tales* features stock character types from the tradition of medieval estates satire, which assigned recognizably stereotypical traits and appearances to certain professions. To these expected stereotypes, Chaucer added individualizing personal touches, like the hairy wart on the Miller's nose, or the brooch proclaiming "Love conquers all" dangling from the Prioress's rosary, or the gold "love knot" that fastens the Monk's cloak. These details ultimately render the pilgrims vividly realized individuals rather than types.

THE STORYTELLING CONTEST. These pilgrims are gathered together in a common enterprise by the inn's host, Harry Bailly, who proposes a story-telling contest as a pastime to allay the tedium of days of travel on horseback. The promised prize is a free dinner (to be paid for by all the losers) at Harry's inn on the return trip. The winning tale must successfully combine moral instruction and amusement (*sentence* and *solas*). Harry, the self-appointed judge of the contest, rigs the game so that the first contestant, appropriately, is the Knight, the highest-ranking member of the entourage. This aristocrat tells a long, highly philosophical, Boethian-influenced tale about ancient Greek and Theban characters, based on Boccaccio's *Teseide* (Story of Theseus). Although Chaucer did not complete the *Canterbury Tales* (of the contracted two tales per each of the 29 pilgrims going to and returning from Canterbury, Chaucer did not even finish one set of tales apiece), what he did create is a sampler of the various literary genres popular at the time: an Arthurian romance by the Wife of Bath; a Breton lay by the Franklin; *fabliaux* told by the Miller, Reeve, Cook, and Shipman; *exempla* and moral fables offered by the Pardoner and Manciple; hagiographic romances narrated by the Man of Law and the Clerk; an allegory and a metrical romance volunteered by the pilgrim narrator; saints' lives told by the Prioress, Second Nun, and Physician; a beast fable offered by the Nun's Priest; and a treatise on the Seven Deadly Sins and remedial virtues by the Parson, which concludes the journey on the proper penitential note. This catalogue of genres gives little indication of how freely Chaucer intermixed elements of the various literary forms available to him to create new hybrid categories such as: *exempla* with *fabliau* elements by the Summoner and the Friar; a mixed romance-*fabliau* by the Merchant; and a mixed romance-epic by the Knight.

THE PILGRIMS' CONTESTIVE SPIRIT. Beyond the astonishing variety of the tales told by the pilgrims, what sets the *Canterbury Tales* apart from other story collections, such as those by Boccaccio and John Gower, is the dramatic interplay between the tellers, who often

OPENING LINES OF CHAUCER'S GENERAL PROLOGUE TO THE CANTERBURY TALES

INTRODUCTION: The General Prologue to Chaucer's *Canterbury Tales* serves to establish the genre and tone of the collection of stories that follows in much the same way that the opening shot of a movie gives a viewer information about the setting, time period, and mood of a film (comedy? tragedy? historical? modern day?). In this case, however, the message is quite complex, since the "high style" suggests a tone of seriousness, the references to astrological dating give it a sense of a universal or cosmic import, and the descriptions of birds and plants would seem to be leading towards a work focusing on love. At the same time, the passage is configured as one convoluted and extended sentence with a surprising climax about the travel plans of what turn out to be a group of rather ordinary, everyday people who represent almost all of the levels of society in England. This contemporary focus points towards a new kind of literature that addresses social questions and depicts a multitude of occupations—often bourgeois in character—quite out of keeping with the elevated or epic style. All in all, then, these opening lines (modernized from the original Middle English) let the audience know that their expectations are not likely always to be met.

When April with his sweet showers
Has pierced to the root the drought of March,
And bathed every plant's system in such liquor [liquid]
(By which virtue the flower is engendered);
When Zephirus [god of the winds], with his sweet breath,
Has blown life, in every wood and meadow,
Into the tender plant shoots, and the young sun
Has run halfway through his course in the sign of Aries;
And small birds are making melody,
That sleep all night with open eyes
(Nature so excites them in their aroused spirits):
Then people long to go on pilgrimages,
And palmers [pilgrims to Jerusalem] want to seek out
 foreign shores,
And faraway shrines, known in sundry lands;
And especially, from the borders of every area in England,
They go to Canterbury,
To seek the holy blissful martyr [Thomas Becket],
Who had helped to cure them when they were sick.
It befell in that season one particular day,
That in Southwerk, I stayed at the Tabard Inn,
Ready to go on my pilgrimage
To Canterbury with completely devout heart;
That night there came into that hostelry,
A company of twenty-nine people,
Sundry folk, fallen together by chance
In fellowship; and they were all pilgrims
Riding toward Canterbury. ...

SOURCE: Geoffrey Chaucer, "General Prologue," *Canterbury Tales*. Text modernized by Lorraine K. Stock.

seem to be taking the contestive spirit of Harry Bailly's "game" a bit more personally than he had planned. Some pilgrims, like the Miller and Reeve, or the Summoner and Friar, tell thinly disguised tales about their antagonists. Others, like the Clerk, Wife of Bath, Merchant, and Franklin, seem to be playing their stories against the previous one in what amounts to a symposium on power relations between husbands and wives in medieval marriages. Many of the pilgrim narrators are also far more richly characterized than their counterparts in other collections. Most readers easily forget that the Wife of Bath is merely a collection of words on parchment. She seems to burst forth as a three-dimensional figure from off Chaucer's pages, divulging in her Prologue to her tale, which is much longer than the tale itself, many autobiographical details about her married life (since the age of twelve) with five different husbands. In some of her defenses of women, she anticipates Christine de Pizan's championing of womankind and even the arguments of twentieth-century feminists. Thus, the Prologues also often serve as "confessional" literature, revealing the personal and professional secrets of the tellers. The

Pardoner's Prologue reveals the teller's duplicity, hypocrisy, and greed, which ironically, is the very vice that his moral *exemplum* about trying to kill Death condemns.

CHAUCER'S PILGRIM NARRATOR. What also sets this collection apart from others of the period is the complex narrative voice of the pilgrim persona who may or may not be Geoffrey Chaucer. No mere omniscient voice-over, this narrator-character is at times a player in the contest, at other times a disinterested reporter of the appearance and actions of the pilgrims (he claims he is describing the 29 people "as they seemed to me"). However, his seemingly innocent comments, interjected in the otherwise objective reports of the pilgrims' clothing, physiognomy, and behavior, speak volumes about the inner character of his subjects. For example, in describing the Man of Law's busy-ness, the narrator slyly and revealingly interjects, "And yet he *seemed* busier than he was." Like some of Chaucer's earlier narrators in the dream visions or *Troilus and Criseyde*, this narrator is remarkably complex and a character in his own right in the literary work.

THE GENERAL PROLOGUE'S OPENING. This narrator also opens the work with probably some of the most wonderfully poetic and famous lines of verse in the English language. Chaucer's evocation of the re-greening of nature in April—the time of year when the seasonal rains and Zephirus's winds encourage the reseeding and germinating of verdure and flowers, when birds sing love songs "pricked" by nature in their libidos—replicates the "spring opening" tropes of many of the love songs of medieval lyric poetry and the *reverdie* topos. The opening lines comprise one nineteen-line-long compound-complex sentence describing a series of causes and their single effect. Whereas the tradition of love poetry that preceded Chaucer would have prepared his audience—when they heard or read about breezes, April showers, May flowers, and birdsong—to expect that the succeeding text would in some way involve love, Chaucer stuns his audience with an unexpected effect of all these causes: he claims, *then* folk long to go on pilgrimages; especially in England, they long to go on pilgrimage to Canterbury to venerate the holy blissful martyr, Thomas Becket. In addition to being some of the most evocative nature poetry in English, these lines play a joke on the audience, who learn early on that Geoffrey Chaucer is always full of surprises.

SOURCES

Helen Cooper, *The Canterbury Tales* (Oxford: Oxford University Press, 1996).

———, *The Structure of the Canterbury Tales* (Athens, Ga.: University of Georgia Press, 1984).

Laura C. Lambdin and Robert T. Lambdin, eds., *Chaucer's Pilgrims: An Historical Guide to the Pilgrims in The Canterbury Tales* (Westport, Conn.: Greenwood Press, 1996).

Derek Pearsall, *The Canterbury Tales* (London: Allen and Unwin, 1985).

Paul G. Ruggiers, *The Art of the Canterbury Tales* (Madison, Wisc.: University of Wisconsin Press, 1965).

SEE ALSO *Architecture: Pilgrimage Architecture; Fashion: Academic, Clerical, and Religious Dress; Religion: Relics, Pilgrimages, and the Peace of God; Visual Arts: The Cult of Saints and The Rise of Pilgrimage*

CHRISTINE DE PIZAN

MEDIEVAL FEMALE WRITERS. Generally, female children in the Middle Ages were not educated as well as their male brothers were. That is not to say that all women were illiterate, but it was fairly uncommon for women to write literary texts. To be sure, there were prominent exceptions throughout the 600 years of the period, and literary works to which no certain authorship can be ascribed and which seem to voice the female perspective may have been composed by women. In the corpus of Anglo-Saxon lyric poetry is an anonymous first-person narrated poem, "The Wife's Lament," that explores the sadness of a woman who is separated from her husband. It is ultimately impossible to know whether an actual woman wrote it. In twelfth-century France, Marie de France composed her *Fables* and Breton *lais* (lays), apparently enjoying some degree of fame in the English court, though little is known of her actual career. In the same century, a woman named Heloise (1098–1164) had a notorious affair, and later a secret marriage, with Peter Abelard (1079–1142), a prominent and brilliant theologian at the University of Paris. After they parted and she became the abbess of a convent of nuns, Heloise wrote a series of illuminating *Letters* to Abelard, which express her emotional feelings for her former lover as well as detail the running of the convent. But these letters are not what is usually thought of as "literature." The female troubadour poets in the south of France, known as the *trobairitz*, did create lyric poems, but they were amateurs, not professional writers. Also in that century in Germany, Abbess Hildegard of Bingen (1098–1179) wrote prolific letters to various ecclesiasts, as well as treatises on medicine and gemstones, accounts of her visions, the *Scivias* (Ways of Knowing), and many hymns, though these works were intended for the education of other nuns rather than for a larger public. Female visionaries and mystics in late fourteenth- and fifteenth-century England, such as Dame Julian of Norwich and Margery Kempe, left records of their visions, respectively in Julian's *Showings* and Margery's *Book* of memoirs about her marriage, her travels on many pilgrimages, and her visions of a bleeding Christ while on pilgrimage in Jerusalem. However, both these works were dictated to male scribes and we cannot be sure to what extent the resulting text reflects the sensibility of their female "authors." The only female writer to which none of these qualifications applies is a prolific author of the late Middle Ages, Christine de Pizan.

EUROPE'S FIRST PROFESSIONAL FEMALE WRITER. Christine de Pizan (1364–c. 1431) was the first "professional" female writer in Europe. As she admits in her allegorical autobiography *The Book of Fortune's Mutation* (1403), unfortunate circumstances in her life forced her metaphorically to "become a man" in order to achieve such a rare distinction. Christine was widowed young and left with three small children and other family

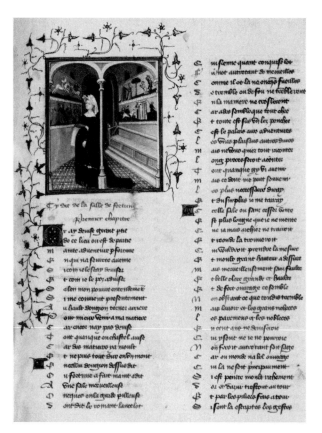

Miniature of Christine de Pizan studying historical wall paintings. Christine de Pizan, *Le Livre de la Cité des Dames* (1405). Munich, Germany, 15th century. BAYERISCHE STAATSBIBIOTHEK, NO. 13963 FROM COD.GALL. 11, FOL. 531. REPRODUCED BY PERMISSION.

members for whom she had to provide. Rather than remarry or enter a convent as most women in her position might do, Christine instead supported herself by writing various popular literary forms such as collections of love lyrics, love debates, devotional texts, female conduct books, and *pastourelles* for aristocratic patrons. Like another unusual female writer three centuries earlier, Abbess Hildegard of Bingen, Christine was both prolific and multifaceted, mastering a dazzling variety of genres in both verse and prose, as well as involving herself not only in the composing, but also in the production and illustration of manuscripts of her works. She began her career at the court of Charles V of France, whose biography, *The Book of the Deeds and Good Conduct of the Wise King Charles V* (1404), she was later commissioned to write. The extraordinary range of her literary output includes examples of genres unexpected from a woman: a military treatise, *The Book of the Deeds of Arms and Chivalry* (1410); a political treatise, *The Book of the Body Politic* (1404–1407), a guide for the behavior of princes, knights, and lesser subjects; and a mythographic work in epistolary form, *The Letter of Othea* (1400), in which the

goddess of wisdom in the title teaches moral lessons to the Trojan prince Hector by using stories from mythology. Just as the twelfth-century female writer Marie de France wrote Ovidian-inspired fables and Breton lays, in *Othea* Christine reveals her knowledge of Ovid's *Metamorphoses*, one of medieval Europe's greatest literary authorities.

CHRISTINE'S ALLEGORICAL WRITINGS. Although she demonstrated skill at nearly all major medieval literary genres, Christine is best known for her allegorical works, which often incorporate autobiographical and political sentiments into the allegory, such as *The Path of Long Study* (1402–1403) and *The Book of Fortune's Mutation* (1403). Of special interest is *The Book of the City of Ladies* (1404–1405), for which she has become noteworthy as an early champion of women. In this allegory, Christine echoes the sentiments of Chaucer's Wife of Bath that female characters have suffered terrible treatment in the writings of male authors, and women would be depicted more positively if female writers had the opportunity to tell their stories. As in Boethius's *Consolation of Philosophy*, or Dante's *Divine Comedy*, Christine is visited in a vision by three allegorical female personifications—Reason, Rectitude, and Justice—who instruct her to create a new literary tradition about women by "constructing" a metaphorical "city" of ladies. In reality, this new tradition is really a story collection in the mode of Boccaccio's *Decameron*, Chaucer's *Canterbury Tales*, or John Gower's *Confessio Amantis*—each building block/story of which narrates the achievements of a praiseworthy, virtuous woman. In creating *City of Ladies*, Christine was responding (as was Chaucer's Wife of Bath) to misogynist collections of tales such as Boccaccio's *Concerning Famous Women*, whose female exemplars were more infamous than famous and more notorious than virtuous. Christine includes in her literary "City" women who excelled in secular fields (painting, poetry, science, farming, military arts) as well as saints. Christine continued to promote the interests of women until her death. The last poem attributed to her was *The Tale of Joan of Arc* (1429), one of the only contemporary literary treatments of the purportedly visionary female warrior who led French troops against the English in the Hundred Years' War. If Christine had lived to revise her text, Joan of Arc surely would have earned a place alongside other Amazon warriors such as Penthesileia in the *City of Ladies*.

CHRISTINE AND THE ROMANCE OF THE ROSE. Christine also demonstrated her advocacy of the female voice by participating in a heated literary debate that took place in 1401–1402. Both as a writer of visions,

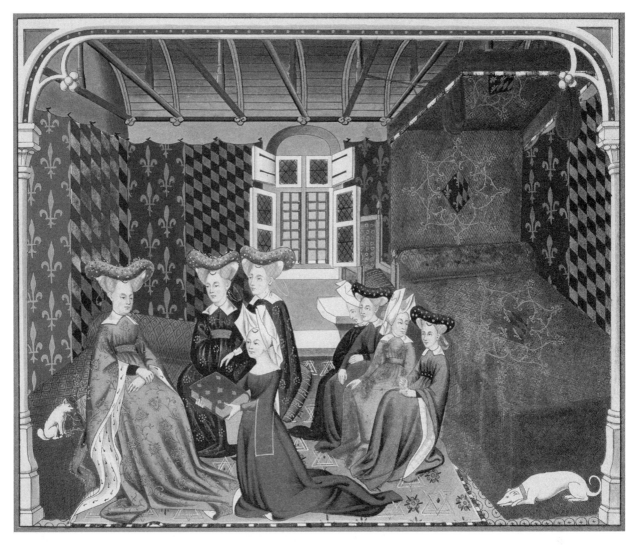

Christine de Pizan presents her book to Queen Isabel of France in a bedroom of the Royal Palace, Paris. London, British Library MS Harley 4431 folio 3, late 15th century. © HISTORICAL PICTURE ARCHIVE/CORBIS. REPRODUCED BY PERMISSION.

such as the autobiographical *Vision of Christine* (1405), and as a literary critic, Christine figured importantly in the development of real-life female characters (not mere personifications) in the dream vision genre. In the "Quarrel over the Rose," Christine sided with the theologian Jean Gerson against other male intellectuals such as Pierre and Gontier Col and Jean de Montreuil over the value of perhaps the most famous and widely read allegorical poem and dream vision of the medieval period, the *Romance of the Rose*. Christine strongly criticized *Rose*, especially the continuation by Jean de Meun, for its antifeminist sentiments. Having collected the letters and arguments of the major antagonists in the quarrel, she presented them to Queen Isabeau, wife of Charles VI. Her very public profile as a professional writer and controversialist prepared the way for literary women who would begin writing in the Renaissance, at the same time that her literary range rivaled that of the great male writers of medieval Europe—Chaucer, Boccaccio, and Dante.

SOURCES

Barbara K. Altmann and Deborah L. McGrady, eds., *Christine de Pizan: A Casebook* (New York: Routledge, 2003).

Joseph L. Baird and John R. Kane, eds., *La Querelle de la Rose: Letters and Documents* (Chapel Hill, N.C.: University of North Carolina Press, 1978).

Renate Blumenfeld-Kosinski and Kevin Brownlee, trans., *The Selected Writings of Christine de Pizan: New Translations, Criticism* (New York: Norton, 1997).

Carol Meale, ed., *Women and Literature in Britain, 1150–1500* (Cambridge, England: Cambridge University Press, 1993).

Charity C. Willard, *Christine de Pizan: Her Life and Works* (New York: Persea, 1984).

SIGNIFICANT PEOPLE
in Literature

GIOVANNI BOCCACCIO

1313–1375

Author

AN EDUCATION IN ARISTOCRATIC VALUES. Giovanni Boccaccio was perhaps the greatest realistic story teller of the later Middle Ages and along with Chaucer did much to develop a vernacular literature of wit, sharp psychological observation, and tolerance for human foibles. He was born the illegitimate child of a merchant of Naples but was later legitimized. His father, a banker, gave him a good education and allowed him to follow a literary career. He claimed that his mother was French, though this, like other supposed "facts" in his biographical comments, may be pure self-construction. Another key element in his life, his love for a certain Fiammetta, may also have been somewhat fictionalized. Boccaccio went to work in Naples in his father's counting house, but he soon left to study canon law at the University of Naples about 1331. All told, he spent some thirteen years in Naples, reading in the Royal Library, learning the life of the court and of the mercantile classes. Thus, books, business, and aristocratic love would all come to be later subjects of his work. It was also in Naples that he started to read Dante.

LIFE IN MERCANTILE FLORENCE. The second phase of Boccaccio's life was in a totally different environment, in the mercantile city-state of Florence, where the nobility were forbidden to hold public office. Here money and political shrewdness were elevated above the virtues he had learned at Naples. In 1340 he became secretary to important Florentines, making a living serving the commune as a roving ambassador or as an emissary to the papal court at Avignon (in 1354 and again in 1365). It was in Florence that he became friendly with the famous poet Francesco Petrarch in about 1350, who helped him with his Latin. He also later learned Greek, though with difficulty. Thus Boccaccio was a man of two worlds: one of the Neapolitan culture of lords and vassals, watching tournaments and pageantry, and reading about aristocratic values and refined love; the other of Florentine mercantilism, in a city dominated by a class struggle for political and social power, where money and opportunism were prized above all things.

WRITING IN THE CLASSICAL STYLE. Boccaccio's early experiences were reflected in poems with mythological titles and classical subjects, like *Diana's Hunt* (1334), the *Filostrato* (about the Troy legend, 1335), and the *Teseida* (c. 1340), about the Theban story of Theseus and the war against the Amazons. In all of these courtly love works, love rules all and knows no law. In his middle period there is evidence of his Florentine learning in works that still use classical materials and feature the power of love, but now more in an allegorical than a narrative mode. By the 1350s, Boccaccio turned from vernacular narrative poetry to Latin learned prose works, such as the *Praise of Famous Women, On the Fall of Famous Men*, and the *Genealogies of the Pagan Gods*, the last reflecting his newly acquired skill in classical Greek.

THE DECAMERON. In 1351, however, Boccaccio turned directly to the contemporary Florentine world with the *Decameron*, a work that has proven to have an enduring influence. In this collection of stories, ten young people—seven women and three men, all rich and cultivated—meet at the Church of Santa Maria Novella in Florence and plan to escape the plague decimating the city by going to a country house, where they will pass time by telling 100 tales—ten from each person. Based on Eastern story collections, classical sources, fabliaux, Florentine gossip, and personal observation, these stories mark a shift from the world of refined erotic fancy illustrated in Boccaccio's earlier writings to the land of things as they are, where calculation displaces illusion. The majority of the characters are middle class, including merchants or wives of merchants, peasants, laborers, and artisans. While Dante believed that only people of prominence could serve a didactic purpose, Boccaccio used people from every walk of life, including a larger proportion of female characters—and of women in important roles—than any other writer of his period. In contrast to earlier works like the *Song of Roland*, the *Decameron* represents a recognition of the triumph of wit over prowess in a world where values were less absolute and increasingly more relativistic.

SOURCES

Vittore Branca, *Boccaccio: The Man and His Works.* Trans. Richard Monges (New York: New York University Press, 1976).

Robert S. Dombroski, ed., *Critical Perspectives on the Decameron* (New York: Barnes and Noble, 1976).

GEOFFREY CHAUCER

c. 1340–1400

Poet
Court administrator

A LIFE AT COURT. Geoffrey Chaucer, arguably the greatest English writer before Shakespeare, was born in London in the early 1340s to a merchant family; the family name suggests the shoe trade, though there is some record of their having been wine merchants. He quickly made his way in the world, apparently acquiring some legal training at the Inns of Court, and by 1357 was in royal service. His wife, Philippa, was an attendant to the queen, and her sister, Katherine Swynford, was the mistress and later wife of John of Gaunt, one of the king's sons. Both through family connections and, most importantly, through his own abilities as an administrator, Chaucer quickly made his way in the royal household and traveled abroad on the king's business several times, holding the posts of controller of the customs and clerk of the king's works. It is chiefly through these positions and various grants and gifts in payment for his services that Chaucer's life is documented; there is no independent record of his activities as a poet. It is clear, however, that during his early years in royal service, Chaucer was reading deeply in French courtly poetry by such poets as Guillaume de Machaut and Jean Froissart (about 1368–1375), on whom he relied heavily in composing his own early works in dream narrative form. He also read Italian literature by Dante, Petrarch, and Boccaccio, the last of whom he resembles in using a framing narrative of tales told by a group of travelers.

THE CANTERBURY TALES. Judging from some of the story lines he sketched out in the 1370s and 1380s, Chaucer was already meditating the *Canterbury Tales*, his best known work, in which a variety of different stories, exemplifying a wide range of literary genres, are told by pilgrim travelers on their way to Canterbury to visit the shrine of Thomas Becket. Each pilgrim—including Chaucer, who pretends to be a pilgrim also—is supposed to tell two tales going to the cathedral and two coming back again, though this plan is interrupted. While Boccaccio had introduced the idea of using non-aristocratic characters in the tales told by his wealthy young Florentines, Chaucer goes a step further by including people from all walks of life among the pilgrim story-tellers themselves, ranging from a knight and his son to a physician, a lawyer, several nuns, a monk, a lower-middle-class widow, a miller, a sailor, and even a plowman. The work as a whole seems to have been put together about 1385 to 1395, but it was never actually finished. The different manuscripts reflect differing arrangements of the parts.

RANGE AND INFLUENCE. Chaucer's other greatest work was *Troilus and Criseyde* (c. 1380), a poem of some 8,000 lines in an elevated style, which relies on Boccaccio's *Filostrato* for its classical plot. Chaucer tells the story of how Criseyde, a widow in the besieged city of Troy, is loved by and then loves Troilus, but then gives him up to try to save herself through another man, Diomede. In a wonderful mix of comic and tragic, aristocratic and bourgeois, this poem, though set in ancient Troy, reflects the changing world of late fourteenth-century England. In addition to other poems of his own, Chaucer did many translations of classic medieval works such as the *Romance of the Rose* and Boethius' *Consolation of Philosophy*, as well as a group of lyric poems. His use of English, rather than French, for courtly poetry is sometimes credited with helping to bring the dialect of London into prominence as the standard for all speakers of English.

SOURCES

Piero Boitani and Jill Mann, eds., *The Cambridge Chaucer Companion* (Cambridge, England: Cambridge University Press, 1986).

Vittore Branca, *Boccaccio: The Man and His Works.* Trans. Richard Monges (New York: New York University Press, 1976).

Jill Mann, *Chaucer and Medieval Estates Satire: The Literature of Social Class and the General Prologue to the Canterbury Tales* (Cambridge, England: Cambridge University Press, 1973).

Charles Muscatine, *Chaucer and the French Tradition: A Study in Style and Meaning* (Berkeley, Calif.: University of California Press, 1957; reprint, 1966).

Derek Pearsall, *The Life of Geoffrey Chaucer* (Oxford: Blackwells, 1992).

Barry A. Windeatt, *Troilus and Criseyde* (Oxford: Clarendon Press, 1992).

CHRÉTIEN DE TROYES

c. 1130–1190

Poet

A WRITER OF ROMANCE. Chrétien de Troyes is the best known of the writers of Arthurian quest romances, especially those telling the love story of Lancelot and Queen Guinevere. He is one of the few early medieval authors whose name has independent corroboration. Nothing is known of his early life and connections, except that he mentions that Marie de Champagne, daughter of Eleanor of Aquitaine, was a patron who provided him with elements of the story of Lancelot and the Cart, and that the count of Flanders, Philippe d'Alsace, provided him with the narrative elements of his Grail story.

Chrétien was a popular author in his own time and after, with anywhere from seven manuscripts of his shorter romances to fifteen of his Grail story surviving, an unusually high number for a secular author.

ARTHURIAN AND ANTIQUE SUBJECTS. Chrétien's works include *Erec et Eneide*; possibly the "antique" *Philomena* from Ovid's *Metamorphoses* and some adaptations of Ovid's two treatises on love; *Cligès*, a romance with an Eastern or Byzantine theme; *Lancelot*, *Yvain* or the *Knight of the Lion*, and *Perceval* or the *Conte de Graal*. A work sometimes attributed to him was a saint's life called *Guillaume d'Angleterre*. As medieval romances go, most of Chrétien's works are relatively short at about 7,000 lines (the *Graal* is about 10,000 lines) and though episodic, have more shape than many examples of the genre. Chrétien's poems were adapted or translated by writers of later romances and serve as the genesis of the Arthurian romance down through its final phase in the work of the Englishman Sir Thomas Malory.

CHIVALRIC VIRTUES. Chrétien is one of the first medieval "self-conscious" authors, writing prologues for his romances in which he comments on his works in the style that is later associated with Dante's *Vita Nuova*. He often enters into the narratives, remarking on characters and actions as well, and even speaks of the structural elements of romance. His poems explore chivalric values, "mésure" (measure or balance in human behavior), and the inevitable conflict between love and the quest for *los* or *pris* (chivalric reputation). This is especially evident in the Arthurian romance *Yvain or the Knight of the Lion*, built on the motif of the "rash vow." Yvain kills Esclados the Red, the husband of Laudine de Landuc, in combat by a mysterious spring in the forest. Falling in love with the new widow, he wins her hand and marries her. But his companion Gawain persuades him to leave his new bride and go in search of adventure at tournaments. He vows to his wife he will return in one year but fails, and she repudiates him. He then goes mad in the forest, where he meets a helpful lion. Eventually, he wins Laudine back, but the poem points up well the difficulties and conflicts between domesticity with a beloved and the attractions of knight errantry.

SOURCES

Jean Frappier, *Chrétien de Troyes, the Man and His Work.* Trans. Raymond Cormier (Athens, Ohio: Ohio University Press, 1982).

Norris J. Lacy, *The Craft of Chrétien de Troyes; An Essay on Narrative Art* (Leiden, Netherlands: Brill, 1980).

Leslie T. Topsfield, *Chrétien de Troyes; A Study of the Arthurian Romances* (Cambridge, England: Cambridge University Press, 1981).

DANTE ALIGHIERI

1265–1321

Poet

EARLY LIFE IN FLORENCE. Dante Alighieri was born in Florence, a great commercial and banking center strategically located on a trade route between the Mediterranean and northern Europe. In Dante's lifetime the city was much involved in the controversy over the relative power of the pope and the Holy Roman Emperors. His father was perhaps a judge and a notary public, a lender of money and speculator in land. At this period the republic of Florence was split into two political factions, the Guelphs (supporters of the papacy) and Ghibbelines (supporters of the emperor), and the Alighieri family, as Guelphs, may have suffered exile at various times when their faction was out of power. Dante married Gemma di Manetto in 1283 and had with her three children, though when he himself was exiled from Florence (in 1301/02), he left without his family. At the age of nine, so the poet says, he had fallen in love with Beatrice Portinari, who served him as a muse. She died in 1290, and he memorialized her in his cycle of poems and prose commentaries *La Vita Nuova*, finished in 1295.

POLITICAL STRIFE. The political life of Florence was dominated by various guilds of artisans and merchants, and only through guild membership could one hold public office; thus, Dante joined the guild of physicians and apothecaries, though it is doubtful that he had any interest in these professions. From about 1295 through 1301 Dante held various public offices and served as an ambassador or emissary, but further political factionalisms were developing between two groups within the Guelph party, the "Whites" and the "Blacks." The latter of these two factions supported Pope Boniface VIII and Charles of Valois, while the whites, the faction Dante was allied with, were much opposed to both of these figures. While Dante was on an embassy to Rome, Pope Boniface VIII and Charles of Valois gained political control of Florence. Charles' forces killed or exiled the Whites, and Dante himself was banished in 1301/1302 for alleged financial misbehavior and for opposition to the political and ecclesiastical power. A second banishment on pain of death was pronounced in 1302. Dante wandered through Italy from 1302 ("eating another man's bread and climbing another man's stair," as he described it) until his death in 1321. Though he broke off his allegiance to the white party and indeed to politics altogether, he never returned to Florence, attaining instead some measure of security and fame in Ravenna.

LEARNED AND LITERARY WORKS. Dante wrote both in Latin and Italian and was the first poet to use the Italian language for a lengthy literary work in the high style, allowing it to compete in prestige with Greek and Latin. His Latin works, which demonstrate the range of his interests and knowledge, included *De Vulgari eloquentia* on the use of Italian as a literary language; *De Monarchia*, on temporal kingship and its relations to papal power; some letters and eclogues; and a scholastic scientific treatise *Questio de aqua et terra* on the levels of land and water on the surface of the earth. He is best known, however, for his Italian works. *La Vita Nuova* is a collection of lyric poems about Beatrice (centering on her death), interspersed with prose commentaries that develop a narrative and explain the poems. He also wrote other lyric poems, called *canzoni*, and a work called *Convivio* or *The Banquet*, a prose commentary on some of his *canzoni*. His three-part masterpiece *The Divine Comedy* appeared in 1314 (for the first part, *Inferno*), 1315 (for the *Purgatorio*), and 1320 (for the last part, the *Paradiso*). This monumental work combines in its three parts a number of important genres: the dream vision allegory of poems like *The Romance of the Rose*; the voyage to the other world, such as *Saint Patrick's Purgatory*; and the medieval encyclopedia, with its attempt to incorporate all human knowledge in a single book. It also made use of Dante's intimate knowledge of the political and social history of Florence, many of whose citizens Dante's narrator encounters on his journey from hell to heaven. A heavy reliance on trinitarian number symbolism, even down to the *terza rima* or three-rime verse structure, is another fascinating feature of the poem. Dante looks to the classical tradition of the *Aeneid* in his use of that work's author, Vergil, as a guide through hell in the first part of his imaginative journey. In the *Inferno* and the *Purgatorio* the poet examines human political and spiritual life, while in the *Paradiso* he considers the mystical union of the soul with the Divine in a beatific vision of God, the saints (including Beatrice), and the heavens.

SOURCES

Erich Auerbach, *Mimesis: The Representation of Reality in Western Literature*. Trans. Willard Trask (Princeton, N.J.: Princeton University Press, 1953).

Robert Hollander, *Allegory in Dante's Divine Comedy* (Princeton, N.J.: Princeton University Press, 1969).

Rachel Jacoff, ed., *The Cambridge Companion to Dante* (Cambridge, England: Cambridge University Press, 1993).

Giuseppe Mazzotta, *Dante's Vision and the Circle of Knowledge* (Princeton, N.J.: Princeton University Press, 1993).

Mark Musa, *Advent at the Gates: Dante's Divine Comedy* (Bloomington, Ind.: Indiana University Press, 1974).

MARIE DE FRANCE
Mid-twelfth century–Early thirteenth century
Poet

AN ANGLO-NORMAN FEMALE POET. The poet known as Marie de France, who apparently wrote between 1160 and 1210, is unusual both for being the earliest known woman writer in French and for the fact that she identifies herself by name. In the epilogue to her *Fables* (a collection of 102 moralized stories about animals in the tradition of Aesop), she states that she is giving her name because she wishes to be remembered, and then she says, "Marie is my name" ("Marie ai num"), adding the final comment "and I am from France" ("si sui de France"). This last phrase has been taken to mean that she had settled in Britain, where the court spoke Anglo-Norman French, since it would be unnecessary for her to indicate that she was from France unless she was living elsewhere. She had perhaps come to England because of marriage or because she wished somehow to further her literary career, and her list of literary patrons and dedications (including one to the "noble king") suggests that she was well connected. Nonetheless, attempts to identify her with any known person have failed. She is believed to have written three surviving works, most likely composed in the following order: the *Lais*, the *Fables*, and the *Espurgatoire saint Patrice* (St. Patrick's Purgatory), a 2,300-line translation of the story of a knight's descent into the Underworld. Of these, her masterpiece is considered to be the *Lais*, a collection of twelve short story-poems based on traditional Breton tales but involving sophisticated crises in love relationships that allow her to explore both contemporary ideas of refined love (so-called "courtly love") and the social complexity of the lives of her often resourceful female characters.

EDUCATION AND BACKGROUND. What is known of Marie's life comes in part from the testimony of Denis Piramus, who, around 1180, mentions her in an Anglo-Norman poem called *The Life of King Edmund*, where he indicates that she is admired in the English court. She was obviously an educated lady of good background who knew Latin well enough to translate the *Purgatory* from Latin to French, perhaps an indication that she had been trained in a convent. References in her texts show that she was also familiar with several of the most popular French and Anglo-Norman works of her day, including Wace's *Brut* (1155) and the *Roman d'Enéas* (1160), but not the romances of Chrétien de Troyes, who wrote between 1165 and 1191.

FABLES AND LAYS. In modern times, until the later eighteenth century, Marie was known only for her fables,

which had been so popular in their day that they can still be found, in whole or in part, in 23 extant manuscripts. In these entertaining moral poems, she reveals a generally aristocratic point of view, with a concern for justice, a sense of outrage against the mistreatment of the poor, and a respect for the social hierarchy, which must be maintained for the sake of harmony. It is to the *Lais*, however, that Denis Piramus was referring when he said that Marie's poetry had garnered great praise and that both lords and ladies loved to have it read out loud again and again. It is important to understand that even though she drew on the "authority" of the Breton source and retained Breton words like "Laüstic" (nightingale) and "Bisclavret" (werewolf), she was not merely writing down a story she had heard, but rather was composing a carefully crafted poem in rhymed octosyllables where the broad outlines of each tale were reshaped to allow her to create individualized heroes and heroines who must deal with the difficulties of enforced separations, love triangles, and even magical transformations. Events in the lays lead to fundamental changes in the lives of the protagonists, in contrast to the slower pattern of development and fulfillment characteristic of romances. Although the *lais* survive in only five manuscripts, their influence established Marie as the initiator of a narrative genre that lasted into the late fourteenth century.

SOURCES

Glyn S. Burgess and Keith Busby, trans., *The Lais of Marie de France* (Harmondsworth, England: Penguin, 1986).

Paula Clifford, *Marie de France: Lais* (London: Grant and Cutler, 1982).

Michael J. Curley, *St. Patrick's Purgatory: A Poem by Marie de France* (Tempe, Ariz.: Medieval and Renaissance Texts & Studies, 1997).

Philippe Ménard, *Les Lais de Marie de France: contes d'amour et d'aventure au moyen âge* (Paris: Presses Universitaires de France, 1979).

Emmanuel J. Mickel, Jr., *Marie de France* (New York: Twayne, 1974).

DOCUMENTARY SOURCES
in Literature

Andreas Capellanus, *Art of Courtly Love* (1185)—Written under the patronage of Marie of Champagne, this treatise on conducting relationships according to the rules of *fin'amors* influenced the depiction of love in medieval romances and lyric poetry.

Beowulf (c. 1000)—The earliest extensive literary work produced in England, this alliterative heroic narrative poem in Old English (Anglo-Saxon) tells the story of a hero with super-human strength who slays the monster Grendel and the monster's vengeful mother, and then, many years later, is killed in a confrontation with a fire-breathing dragon. The poem demonstrates the tribal heroic code of thanes and lords, and illustrates oral-formulaic style.

Giovanni Boccaccio, *Decameron* (c. 1351)—This Italian-language collection of "One Hundred Stories" uses a frame tale about ten young people fleeing the plague in Florence to take refuge in a country house where they tell stories illustrating a wide range of medieval genres and themes.

Chanson de Roland (c. 1101)—The most famous example of the French *chanson de geste*, this heroic poem, based on an historical episode in 778, recounts the defense of a pass in the Pyrenees Mountains by a small French rear-guard against the overwhelming Saracen forces. It portrays the tragic downfall of a hero who fails to maintain a balance between physical courage and good judgment.

Geoffrey Chaucer, *Canterbury Tales* (c. 1380s–1400)—In this most famous story collection in medieval literature, the descriptions and interactions of 29 pilgrim storytellers on their way to Canterbury presents a cross-section of late fourteenth-century English people and professions, while their stories offer a sampling of almost every available prose and verse genre, made new and original by the overall work's complex and often ironic tone.

Chrétien de Troyes, *Yvain* (c. 1170–1185")—This French-language poem by the "father of Arthurian romance" tells the story of a knight who goes off on an adventure with Gawain and suffers severe consequences when he fails to keep his promise (a rash vow) to return to his new wife within one year. This poem is one of several long verse narratives in which Chrétien expands the story of King Arthur and the knights of the Round Table into complex psychological and moral studies.

Christine de Pizan, *City of Ladies* (1404–1405)—In this dream vision, Christine, the first professional woman writer in medieval Europe, is visited in a vision by three allegorical female personifications—Reason, Rectitude, and Justice—who instruct her to create a new literary tradition about women by "constructing" a metaphorical "city" of ladies, a story collection in which each building block/story narrates the achievements of a praiseworthy, virtuous woman.

Dante, *The Divine Comedy* (c. 1314–1321)—This epic allegory in three parts, written in Italian, relates a visionary

pilgrimage to *Inferno* (Hell), *Purgatorio* (Purgatory), and *Paradiso* (Heaven), through which the narrator is guided first by the classical Latin author Vergil and then by his muse Beatrice. Most famous for its portrayal of the punishment of sins in the descending circles of the Inferno, the work combines a realistic treatment of contemporary Florentine politics with a spiritual voyage and the experience of reunion with God.

John Gower, *Confessio Amantis* (Confession of the Lover; 1390–1393)—Containing over 30,000 lines of narrative verse, this collection of biblical, classical, legendary and popular narratives is recounted by Genius, priest of Venus, to whom *Amans*, an elderly lover, confesses the various sins committed against love in seven books of stories organized according to the Seven Deadly Sins, with one book assigned to each mortal sin.

Jean de Meun, *Roman de la Rose* (1275)—This 18,000-line continuation of Guillaume de Lorris's allegorical love poem about a dreamer's quest for a rose adopts a satirical tone and incorporates the rediscovery of Aristotelian and Platonic texts that had occurred in the twelfth century.

Marie de France, *Lais* (c. 1160–1180)—This collection of twelve short verse narratives by medieval Europe's first identifiable female writer (probably a native of France living in England) transforms stories from Celtic oral sources into formal Anglo-French courtly poetry. Marie's sparely written narratives feature settings in the magical Celtic Other World, rash promises, erotic entanglements between humans and fairies, and an ambivalent code of ethics.

Juan Ruiz, *The Book of Good Love* (1350)—This Spanish story collection presents a meandering, episodic series of accounts of the narrator's fourteen attempted (and sporadically successful) adventures in love, incorporating many literary genres and a wide spectrum of tones.

MUSIC

Timothy J. McGee

IMPORTANT EVENTS
in Music

600 St. Gregory the Great, pope from 590 to 604, begins to establish a standardized Christian liturgy, including the plainchant melodies ("Gregorian Chant").

Pope Gregory establishes the papal choir school (Schola Cantorum), which continues to the present day in Rome.

800 Charlemagne, king of the Franks and emperor of the Romans, continues the process, begun by Pope Gregory I, of regularizing the plainchant repertory.

c. 814 Following earlier suggestions by Emperor Charlemagne, the clergy begin to dramatize some of the important stories in church history, an effort that eventually results in the first liturgical dramas that reenact, with sung dialog, the visit of the three Marys to the tomb of Christ.

c. 850 An anonymous author writes *Musica enchiriadis* (Music Handbook), a widely circulated treatise on music theory that is one of the earliest attempts to notate music. It includes the first written attempt at polyphony (music in more than one part).

The earliest manuscripts containing music notation date from this time. The repertory is plainchant, music for the sacred services.

c. 900 The music treatise *De harmonica institutione* (Melodic Instruction) is written by Hucbald, a monk at the Benedictine abbey (or monastery) of St. Amand in Flanders. It describes the modal scale system in detail and discusses the concept of polyphony.

900 Notker Balbulus, a monk at the Abbey of Saint-Gall in Switzerland, writes the *Liber Hymnorum* (Book of Hymns), a book of sequences for the Mass. Notker is the first composer known by name.

c. 1000 Guido, a Benedictine monk in Arezzo, Italy, invents the scale syllables, the staff, and a way of teaching new music by pointing to the knuckles on his hand.

c. 1050 The earliest practical examples of polyphonic music are included in the Winchester Troper, a manuscript from Winchester, England.

1098 Hildegard of Bingen, a Benedictine nun who founded a convent near Bingen, Germany, is born. She is the earliest known female composer.

1100 French and English manuscripts containing the earliest repertory of polyphonic organum begin to appear.

Troubadours, trouvères, and trobairitz (poet-musicians) in France begin the tradition of composing courtly love songs.

c. 1135 Master Leonin, a poet and composer at the Cathedral of Notre-Dame in Paris, is born. He will compose the first comprehensive body of polyphonic music.

c. 1147 Bernart de Ventadorn, one of the most famous troubadours who worked in France and England, is born.

c. 1150 Choir masters centered around the Monastery of Saint-Martial in Limoges (central France) begin extensive experiments with composed polyphony.

c. 1150 Master Perotin, a singer and composer at the Cathedral of Notre-Dame in Paris, is born. Perotin will add to the repertory begun by Leonin.

1170 Walther von der Vogelweide is born. He later becomes the most famous minnesinger (a poet-composer who worked in the courts in Germany and Austria).

c. 1200 A collection of polyphonic sacred music for the important feasts of the liturgical

year, the *Magnus liber organi*, is compiled. Originating in Paris and circulated throughout Europe, it contains the compositions of Leonin and Perotin.

c. 1230 The Fleury Play Book (Orléans, Bibliothèque Municipale, Manuscript 201), the largest collection of extended liturgical dramas, appears.

c. 1250 Motets (polyphonic compositions with different texts for the individual lines) are first created in and around Paris. They become the most important musical form of the late Middle Ages.

The Cantigas de Santa Maria, a collection of more than 400 songs from the court of Alfonso X "el Sabio," king of Castile, appears.

1260 Franco of Cologne writes *Ars cantus mensurabilis* (The Art of Measured Song), a music treatise that assigns specific duration to each of the note shapes, setting the stage for further developments in notation.

c. 1283 Trouvère Adam de la Halle writes *The Play of Robin and Marion,* a *bergerie* (shepherd poem) set to music.

c. 1290 *Carmina Burana* (Songs of Benediktbeuern), a large collection of Latin songs from the south German monastery of Benediktbeuern, includes texts on serious religious subjects, love songs, and drinking songs, some of them in German.

1316 Gervais de Bus and Chaillou de Pesstain write the *Roman de Fauvel,* a long poem that contains numerous musical compositions including several motets that reflect the new French notation developed by Philippe de Vitry.

1318 Music theorist and composer Marchettus of Padua writes *Lucidarium in arte musicae planae* (Explanation of the Art of Unmeasured Music), followed two years later by *Pomerium artis musicae mensuratae* (Orchard-Garden of the Art of Measured Music), two important treatises dealing with Italian notation and harmonic practices.

c. 1320 Three important treatises on music—*Ars Nova* (The New Art) once credited to Philippe de Vitry, *Ars Novae Musicae* (The New Musical Art) by Johannes de Muris, and *Speculum Musicae* (Musical Reflection) by Jacques de Liège—deal with new trends in music composition involving refinements in notation.

1340 Guillaume de Machaut writes *Remede de Fortune,* a lengthy poem that contains a fanciful list of musical instruments at a festivity.

1364 Guillaume de Machaut writes *Messe de Nostre Dame,* one of the first polyphonic settings of six parts of the Mass Ordinary.

1420 The largest collection of late medieval English sacred music is gathered in the Old Hall manuscript.

A large collection of late medieval Italian music is gathered together in a beautifully illustrated manuscript known as The Squarcialupi Codex, which was once owned by the famous Florentine organist, Antonio Squarcialupi.

1436 Guillaume Dufay writes the motet *Nuper rosarum flores* for the dedication of the cathedral in Florence.

c. 1440 *Missa Caput,* the earliest complete set (cycle) of Mass Ordinary movements, is composed in England (composer unknown) using the same phrase of chant for the tenor part in each movement.

1452 Guillaume Dufay composes *Missa Se la face ay pale* for the Savoy court. This is one of the earliest polyphonic mass settings to employ a secular theme as the central point of organization.

OVERVIEW
of Music

THE IMPORTANCE OF MUSIC. Music was a very important part of sacred and secular daily life in the Middle Ages. It was a major component of all religious services in which prayers were chanted, including the Mass services attended each week by all Christians and the canonical office hours observed several times each day by clergy and monks; it also served a less formal religious role in the devotional songs of the laiety. Music for the sacred services, known as plainchant, is by far the largest surviving repertory of music from the period, consisting of thousands and thousands of compositions from all over Europe. The complexity of the music varies from simple settings that resemble heightened speech to extremely elaborate melodies with wide ranges. Some are for soloists, others for choir, and some for an alternation of choir and soloist.

MUSIC FOR EVERYDAY LIFE. Music in the secular (that is, non-religious) world took a number of forms, and included both professional and amateur musicians. Singing and playing instruments was an ever-present part of relaxation for peasants and nobles: music making took place in the village square, the castle and manor house, the local tavern, and the open air. It was part of the foreground and background entertainment on all social levels in a society where everyone sang and danced. Local amateurs provided music for peasant gatherings, while professional minstrels entertained at the banquets of the aristocracy, but on both occasions everyone would be welcome to join in. Although art and literature provide certain kinds of information about the quantity of music in the world of the peasant, nothing survives of their repertory. Much of the music they performed must have been improvised, and the remainder was known only from memory, handed down from generation to generation with no written record. Actual secular music from the late Middle Ages survives only for the upper classes, although from the similarity of the references concerning music at every social level, we can guess that there was a considerable amount of uniformity at least in terms of melodic and rhythmic styles between the music of both classes.

THE MUSIC OF MINSTRELS. The earliest of the professional performers of the period were known as minstrels (*ménestrels* or *jongleurs*), who were actually general entertainers and did not restrict themselves to music; many were also actors, jugglers, animal trainers, and so on. These were the wandering entertainers who moved from place to place in search of a paying audience. The music they performed included not only the usual mixture of love songs and dance songs, but also the *chanson de geste* (song of deeds), a long narrative poem that recounted historic accomplishments, the most famous of which is the French *Song of Roland*. Love songs, drinking songs, and dance music were an essential part of the relaxation of both nobles and peasants; moreover, the songs of minstrels were a major source for the transmission of myths, history, and current news. Musicians performed a variety of repertory in the streets, and groups of trumpets accompanied people of wealth and political power, announcing their daily arrivals and departures.

FROM MONOPHONY TO POLYPHONY. The type of music most frequently heard during the early Middle Ages can be described as monophonic—music with a single melodic line—which included the sacred plainchant heard in church services as well as the secular songs and music played on instruments. This use of a single line is a characteristic that European music has in common with the music of the rest of the world, a repertory that has evolved and grown slowly since antiquity. It was during the period of the late Middle Ages, however, that one of the most striking characteristics of Western music came into existence: the development of music in more than one part, called polyphony. In all cultures there exist performances that are not completely monophonic; the use of drones (continuous accompanying notes, like those produced by a bagpipe), for example, is widespread, as is the practice of parallel performance (singing or playing the same melody on two different pitches simultaneously), or performances that would seem to combine elements of both drone and parallel traditions. All of these embellishments can be considered a part of the tradition of improvisation since they are often produced spontaneously during performance. But although the additions and embellishments to monophonic music in the West undoubtedly began in the same way as in other cultures, the Europeans took it much further, developing a system in which individual parts of a polyphonic composition trace separate melodic and rhythmic profiles. This technique is exclusive to Western culture, and while popular or folk music continued to be mainly

monophonic, polyphony soon became a standard part of all European-based art music.

THE INVENTION OF NOTATION. The technical element that assisted the birth and development of polyphony was the invention of a written musical notation, which happened between the ninth and eleventh centuries. The original reason for the invention of notation was primarily a desire on the part of the Latin Church to standardize the details of the sung parts of the liturgy by exactly transmitting to all parts of Europe the correct notes and rhythms of the vast repertory of plainchant. A secondary motive was to speed the teaching of new repertory, which until then had been taught only by constant repetition and rote memorization, a relatively slow process that was susceptible to frequent error. In the first half of the eleventh century, an Italian monk, Guido of Arezzo, responded to both needs by inventing a notation system that incorporated exact pitch and duration into a code that could be read with ease—a system that became the basis of the notation still in use today. It is no surprise that the first experiments with composed polyphony developed almost immediately after this innovation.

THE SPREAD OF POLYPHONY. The earliest forms of composed polyphony were developed in the twelfth century at the Cathedral of Notre-Dame in Paris when new two-voice sections were composed to replace already existing sections of plainchant. The idea of new polyphonic substitute sections quickly spread to all parts of Europe, where additional local repertory was soon composed. Europeans were attracted to this kind of sound, and the techniques were quickly applied to nearly all forms of music, both sacred and secular. At first polyphony was thought of as little more than an interesting contrast to the most frequently heard type of music, monophony. Its earliest use was for the more lavish church events and celebrations of the wealthiest citizens. Little by little, however, it gained in popularity until by the fifteenth century it was the preferred repertory for the socially conscious art connoisseur. This also led to a class separation in which monophonic music was left to the lower social classes while the educated, aristocratic society adopted the new polyphony, the only exception being plainchant, which remained a major part of all sacred ceremonies. Even in sacred settings, however, polyphony was introduced for the most celebrated occasions, replacing some of the traditional chant.

COMBINING THE SACRED AND SECULAR. Initially the repertories of sacred and secular music were quite separate from one another and consisted of mutually exclusive material. The advent of polyphonic composition and its application to so many areas of sacred and secular repertory helped to break down this distinction as composers began to combine the two. Most of the combinations were more or less innocent, but surprising exceptions can be found as early as the thirteenth century, such as a song based on a chant, with a sacred hymn in one part and a decidedly erotic text in another, all to be sung at the same time. In the early decades of the fifteenth century it became common practice for a composer to adopt secular music, including love songs, as the basic material in the composition of music for the sacred Mass. By the end of the period one of the largest repertories of polyphonic music consisted of settings of five movements for the Mass Ordinary (that is, the parts of the religious ceremony that do not vary throughout the year), all written by a single composer using a sacred or secular melody as a unifying musical theme throughout, and intended to be performed as a celebration of a very special event, such as a coronation, a wedding, or a military victory. The most obvious implication of this practice is that the secular world was increasingly intruding on the sacred. The mixture of secular elements into a sacred repertory that had previously been tightly controlled suggests a slackening of the former rigidity of the Church with regard to its services and ceremonies, as well as a more worldly orientation among those who wrote music for sacred performance. In short, these musical events can be seen as evidence of a general trend in Western history: the weakening of the power and influence of religious authority and the rise of the secular world, a tendency that became the dominant characteristic of the period to follow.

TOPICS
in Music

MUSICAL PERFORMANCE

MUSIC EVERYWHERE. During the Carolingian era —that is, the age of the Frankish emperor Charlemagne and his dynasty (eighth to tenth century)—and continuing through the late Middle Ages, the sound of music was, quite literally, everywhere. Music was so much a basic part of everyday life that it would be difficult to discuss many significant daily events or activities without noting its presence. From the nobles at the highest level of society to the simple peasants who worked the land and the monks who lived in the isolation of monasteries, music, in its various forms, served as one of the

MEDIEVAL Musical Terms

Cyclic: A composition of several movements that are related by the use of some of the same material.

Harmony: The result of two or more notes sounding at the same time.

Isorhythm: A rhythmic pattern that is imposed on a melody and repeated exactly throughout the length of the composition.

Mensural signs: Symbols that indicate tempo and rhythmic subdivisions.

Monophony (mono = one; phony = sound): Music of one part, either a solo song or a single melody performed by more than one person or instrument.

Motet: A polyphonic composition with more than one text.

Motiv: A short passage of music (as short as three notes) that is repeated.

Organum: An early, fairly simple type of polyphony. There are several different types, including one in which the voices sing the same melody at different pitches (known as "parallel organum"). Other varieties include the addition of an upper part over an already-existing melody (that is, a tenor). The upper part usually moves faster than the tenor.

Polyphony (poly = several): Music of more than one part, each musical line having a separate rhythmic and melodic profile.

Substitute clausula: A new section of polyphonic music intended to replace an old one.

Tempo: The speed of the composition.

Tenor: A melody borrowed from another composition and used as a guide for the structure of new polyphonic lines. Sometimes these notes are held as long notes (*tenere* = to hold).

LOST EVIDENCE. What has survived over the centuries is only a pale reflection of the quantity and variety of music that flourished during the early centuries, and, unfortunately, this material represents only certain parts of the repertory—that is, the entire body of works available for performance. Almost completely lost is the music of the lower classes—the songs they sang in the fields, around the hearth, and in the village inns, as well as the dance tunes they sang and played. All of their repertory was learned by ear and passed on in the same manner; nothing was written down. Music of the upper classes—the nobles, and, later, the merchants, teachers, doctors, and lawyers in the developing middle class—fares a bit better since that level of society could read and write and could afford to have written copies made of their favorite repertory, although what remains is rather fragmentary and quite incomplete. Largest by far is the surviving music of the Christian church that comes down to us in thousands of manuscripts that preserve the music that accompanied the weekly Mass in the larger churches and the daily ceremonies in the many monasteries that dotted the landscape all over Europe. The Latin Church was highly organized and had a more or less uniform body of works that was written down and distributed throughout Europe and preserved in church archives through the centuries. For secular society there is a far smaller body of preserved evidence.

THE WRITTEN RECORD. The beginning of the Carolingian Era almost exactly coincides with the earliest written music, and therefore it is possible to obtain an actual sound image of some of the repertory that dates back to the very beginning of the period. But the earliest manuscripts are all from churches and monasteries, meaning that they record only sacred music; manuscripts containing secular music did not appear until the twelfth century. By supplementing the surviving music with information gained from literary accounts, archival documents, personal letters, diaries, and iconography, some of the missing pieces can be filled in, providing a general impression of how music functioned in late medieval society.

A CULTURE OF SINGING. A great variety of musical instruments—plucked, hammered, and blown—populated the medieval world, adding their sounds to most formal and informal occasions. There is little doubt, however, that the vast majority of music heard and performed during this period was vocal. Everyone sang, and most of the occasions for music involved singing, including music for dance. The daily activities of monks in the monasteries revolved around the chanting of prayers every few hours, and for those who lived

stable elements in their lives. It rang in the banquet halls and private chambers of the palaces of the wealthy nobles, resounded through the monastic cloisters and in the churches, and echoed in the streets and taverns of the cities and villages. Music served to mark the presence of nobles in public, it accompanied the tasks of the workers in the field, and it was an inseparable part of the many hours each monk spent daily in the worship of God. And for everyone, the sound of songs and music for dance filled the leisure hours.

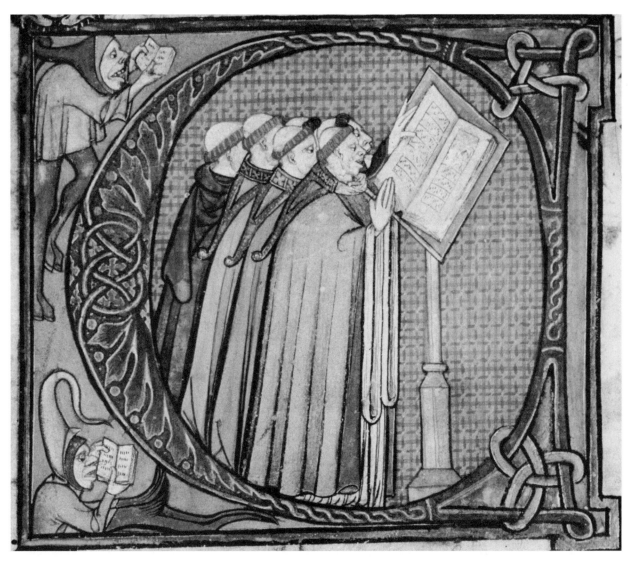

Choir of monks sing from the psalter of Stephen of Derby, Oxford, Bodleian Library MS Rawlinson G. 185, folio 81, 15th century. **THE ART ARCHIVE/BODLEIAN LIBRARY, OXFORD.**

outside of monasteries, singing was the most common form of entertainment and relaxation. The professional musicians also were mainly singers; the minstrels who entertained in the village squares, the inns, and the courts had vast repertories of songs of all types. Even the narrator of heroic poetry, the teller of tales, often performed his verses by improvising a melody while accompanying himself with an instrument. In the later centuries of the Middle Ages the wealthier courts employed resident musicians who sang both the traditional chant and the new polyphonic music in the chapels, as well as entertaining their noble patrons with songs and instrumental music at dinnertime and on all festive occasions.

VOICES AND INSTRUMENTS. In striking contrast to modern practices, the combination of musical instruments with voices was found in only certain circumstances. Solo singers often accompanied themselves, usually with a lute or a harp, and on extremely festive occasions, massed instruments and singers would march in procession through the city streets. Chant, however, was performed only vocally, and the common practice for the performance of polyphonic music—that is, music with multiple parts—was totally by instruments or totally by voices, but rarely a combination of the two. In church an organ would be used to play processions or devotional music, but it performed in alternation with the choir, never at the same time. Further, the choir as a whole usually was restricted to singing monophonic chant. Polyphonic music, no matter what the repertory, sacred or secular, was usually sung by an ensemble of soloists. Choir performance of polyphonic music, meaning several voices

on each musical part, was not part of the performance tradition during this period. A mixture of voices and instruments in a polyphonic performance did not become standard practice until the sixteenth century.

SOURCES

Christopher Page, *Voices and Instruments of the Middle Ages* (London: J. M. Dent, 1987).

MUSIC IN PRIVATE AND PUBLIC

MUSIC FOR THE LOWER CLASSES. Singing and playing musical instruments was one of the main forms of private entertainment, and the usual time for music making was in the evening, following dinner. Everyone sang, and from the literary accounts, it would seem that a large number also played musical instruments. For the lower levels of society—the peasants, small merchants, and artisans—most of this type of entertainment was home grown, meaning that one entertained one another. Professional instrumentalists would be hired only for special occasions such as weddings where, as images from manuscript illuminations and tapestries affirm, they played dance music.

MUSIC IN WEALTHY HOUSEHOLDS. The nobles and wealthier merchants also sang and played instruments, and it is clear that they too often performed for one another in a family setting after dinner. In addition, in contrast to the less affluent people, they often hired professional singers and instrumentalists who would entertain their dinner guests with songs and instrumental music during and after dinner. The distinction as to who performed on any given occasion, however, was not so finely drawn as in the modern world. The troubadour tradition that flourished between the eleventh and thirteenth centuries included noblemen as well as people of lower social levels, meaning that this highly demanding repertory of song was performed by both professionals and amateurs. Many of the wealthier aristocrats had a permanent staff of household musicians, but an evening's entertainment could just as easily include one of the nobles singing his own poetry while accompanying himself on a lute or harp. The duties of the palace and court musicians usually included teaching music to the children and, often, singing for daily Mass in the nobleman's private chapel, in addition to the performances of secular music at dinnertime.

SINGING IN THE CLOISTERS. Music within the monastery consisted of the daily celebration of the Mass and eight services spaced throughout each day known as the Office or the Hours. Most of these included the singing of chant, meaning that on ordinary days all of the monks sang for a total of several hours. On special days—Sundays, or special holy days (e.g. Easter)—the chants were particularly elaborate, and everyone processed through the halls of the monastery while singing. The earliest written music was the sacred plainchant of the church, which is found in a few manuscripts that date from the middle of the ninth century (see Notation, below). This body of works, as well as the bulk of all recorded compositions throughout the entire period, consists of sacred music intended for the various services of the Christian church.

MUSIC IN THE STREETS. Music heard in the city streets took many forms. Songs and chants of the many daily sacred services wafted out of the churches that were located every few blocks. Many of the municipalities employed instrumental ensembles that provided music for the frequent civic ceremonial occasions that happened in public, and for public dancing as well as church celebrations. Wedding receptions included singing and dancing and often took place in a public square; minstrels played and sang in the plazas everywhere; and amateur and itinerant "vagabond" musicians were a common presence—and often a common nuisance—on the streets and in the taverns and barber shops of cities and villages in all regions. Laws imposing a curfew that limited the hours music could be made in public were established in most large communities. The frequency with which these prohibitions were reiterated, as well as the numerous judicial records of people fined for playing instruments such as a bagpipe or singing in the streets after curfew, suggests that the curfews were not always observed.

THE CEREMONIAL TRUMPET. One of the most frequently heard instruments in public places all during the late medieval period was the trumpet. Because of its volume it performed a number of different functions, accompanying ceremonial occasions, celebrations, and military advances in the field. Trumpets, usually in sets of two, were the symbol of power and authority, a tradition inherited from ancient times. In every locale the political leaders and other powerful, wealthy men employed trumpet players as heralds to precede them whenever they went out in public, announcing their presence. These trumpets would often be made of silver with banners suspended from them emblazoned with the coat of arms of the lord or of the community, and the trumpeters wore livery, colorful costumes identifying them as the retainers of civic entities or wealthy lords. Public events, such as jousts, horse races, mock naval battles, and athletic contests, also employed trumpets to heighten the excitement and to signal the beginning and end of various activities. Trumpets were also used by the

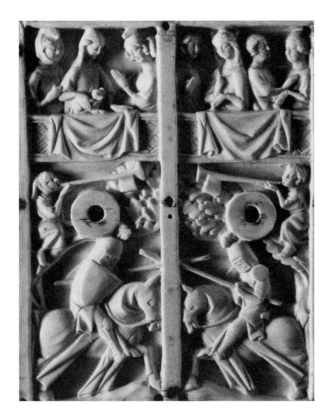

Jousting knights and trumpeters, women watching from above. Ivory casket, 1350. THE ART ARCHIVE/MUSEO DEL BARGELLO, FLO-RENCE/DAGLI ORTI.

a PRIMARY SOURCE document

INSTRUMENTS AT A MINSTREL PERFORMANCE

INTRODUCTION: This fanciful scene from *Remede de Fortune* by Guillaume de Machaut (1340) names a number of instruments, including some that cannot be identified.

But you should have seen after the meal
The minstrels who entered in generous number,
With shining hair and simple dress!
They played many varied harmonies.
For I saw there all in a group
Fiddle, rebec and gittern,
Lutes, morache, micanon,
Citols, and a psalterion,
Harp, tabour, trumpets, nakers,
Organs, more than ten pair of trumpets,
Bagpipes, flutes, chevretes,
Douceinnes, cymbals, clocettes,
Tymbres, flutes from Brittany,
And the large German horn,
Flutes from Scens, panpipes, whistles,
Muse d'Aussay, small trumpets,
Ceremonial trumpets, eles,
and monocords with only a single string,
And muse de blef all together.
And certainly, it seemed to me
That never was such a melody seen nor heard,
For each of them, according to the tone
Of his instrument, without discord
Plays on vielle, gittern, citole
Harp, trumpet, horn, flageolet,
Pipe, bellows, bagpipe, nakers
Or tabor and every sound that one can make
With fingers, quill and bow
I heard and saw in that park.

SOURCE: *Le jugement du roy de Behaigne, and, Remede de fortune/Guillaume de Machaut.* Ed. James I. Wimsatt and William W. Kibler (Athens: University of Georgia Press, 1988): lines 3959–3988. Translation by Robert Taylor.

town criers, who often played from horseback, traveling from one neighborhood to the next where they would sound their trumpets to call the citizens together to hear the latest pronouncements, banishments, or sentences of deaths. In many cities there were watchmen on the towers looking for signs of fire, curfew violations, or an advancing enemy, who signaled their messages with trumpet calls. Both trumpets and drums were a staple of the military where they served to frighten the foe with their loud noise and also to sound attacks and retreats because they could be heard over the din of battle.

SOURCES

Howard Mayer Brown and Stanley Sadie, eds., *Performance Practice; Music before 1600.* The Norton/Grove Handbooks in Music (New York: W. W. Norton, 1989).

Keith Polk, *German Instrumental Music of the Late Middle Ages* (Cambridge, England: Cambridge University Press, 1992).

MUSICAL INSTRUMENTS

LOUD VERSUS SOFT. Musical instruments were divided into two fairly discrete groups—loud and soft—

each group having specific functions and repertories; the two groups were rarely mixed together. The "loud" instruments were trumpets, bagpipes, shawms (double-reed instruments rather like the modern oboe), and drums. These instruments were assigned ceremonial functions, mostly out of doors, and were never found in the company of voices. The remaining "soft" instruments—bowed and plucked strings, woodwinds, and keyboard

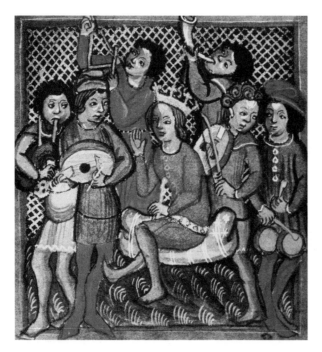

Bagpiper and other instrumentalists with King David, Olomouc Bible, Olomouc University Library, Czech Republic, 1417. THE GRANGER COLLECTION, NEW YORK.

instruments—were played individually or in ensembles; some of them accompanied voices. The instruments that are described in this section are those most often seen in visual art and mentioned in literature.

TRUMPETS. Trumpets came in several sizes, shapes, and materials. Straight trumpets approximately six feet in length and often made of silver were the instruments usually associated with governmental authority. Military trumpets were approximately the same length and made of brass, but beginning in the fourteenth century they were, for practical reasons, folded (similar to a modern bugle). Another popular shape was one resembling an "S," which was used for the smaller trumpets (approximately four feet of pipe) that are often depicted being played at indoor ceremonies such as banquets. All trumpets were without valves or keys, which restricted their notes to those of the natural acoustic overtone series, that is, something similar to the sounds of a modern bugle call. By 1400 a trumpet with a sliding pipe was invented to allow the players to access the complete scale. This was refined by 1480 to a double slide, which improved both speed and accuracy. The new instrument was called *trombone* in Italy, *sackbut* in England, and *saqbutte* in France.

SHAWMS. The shawm, also considered "loud," is a double-reed instrument much like an oboe. It resembles similar instruments popular in the Arab countries and is first depicted in Spanish sources of the late thirteenth century, suggesting that it had been introduced to Europe during the Arab or Moorish occupation of Spain. Since the shawm had a fairly large range and could play many of the chromatic notes, it was capable of performing all of the repertory of the period. By the mid-fourteenth century there were two sizes, the traditional alto range instrument and a newer one that played at a lower pitch (tenor range) called a *bombarde* because of its resemblance to a cannon. Instruments of these two sizes often performed in pairs. By the early fifteenth century an alto and tenor shawm were often depicted with a slide trumpet as a standard dance music ensemble.

BAGPIPE. The bagpipe is found throughout the Middle Ages in most areas of Asia and the Middle East as well as in Europe, with a heritage that goes back to ancient times. There are many different sizes and shapes, but what they all have in common is that the sound is made by squeezing a bag (originally the skin of a goat) and the melody is played on a chanter pipe with finger holes. Instruments could have one, two, or three drone pipes or even none, and there are examples of both one and two chanter pipes. The bagpipe is most often seen playing alone, mostly for dancers, and it is usually associated with rural or pastoral scenes.

PERCUSSION. The percussion instruments make up the final group in the "loud" category. The type most frequently depicted is *nakers*, a pair of small "kettle" drums, usually tied to the performer's waist or over the neck of a horse; tabor, a larger barrel-shaped drum, often called a "side drum," usually associated with the military; and tambourine, a hand-held instrument with jingles, which is usually depicted in conjunction with dancing.

KEYBOARD. The keyboard group, considered "soft" instruments, included organs, harpsichords, and clavichords. Two types of organs were in common use: a portative organ (i.e. small and portable), which was usually held on the lap of the player and played with one hand while the other hand worked the bellows; and a larger positive organ that was not portable and was usually found in church, some of which had multiple keyboards, pedals, and several ranks of pipes. Medieval harpsichords were similar to those in use today. The earliest evidence of their existence comes from the mid-fifteenth century. They had a single keyboard with one wire string for each note, and a sounding device that plucked the strings with a pick called a plectrum, which could be made of leather or quill. The clavichord (also called *exchequer* in England) appears as early as the fourteenth century. It differs from the harpsichord in several ways: it had a very soft volume; it made its sound by striking the strings with a metal

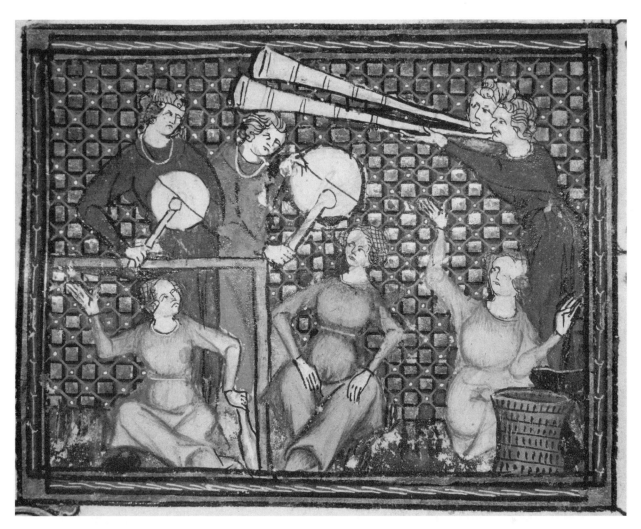

Drummers and trumpeters, Chrétien Legouais, *Ovide Moralisé*, Rouen, Bibliothèque Municipale MS 1044, folio 103, 14th century. **GIRAUDON/ART RESOURCE, NY.**

strip called a tangent; and some of its strings could make more than one pitch according to the amount of force applied to the key—that is, a stronger pressure would result in a higher pitch.

WOODWINDS. The woodwind group was quite small, including only the flute and the recorder. These instruments were similar to those of today, but without keys. Only the higher-pitched (soprano) members of these families existed until late in the fifteenth century. The flute is often depicted with drums in a military setting, while the recorder was used for domestic music making.

BOWED STRINGS. Bowed strings in the Middle Ages ranged from those that are obvious ancestors of modern instruments to some that are much less familiar. One of those that is less well known today was the hurdy-gurdy, which made its sound by the turning of a crank that

caused a wheel to scrape against two or three strings. A set of keys or levers could be pressed against one of the strings to change the pitch, while the other(s) provided a drone. By the late Middle Ages it was played by a single performer, usually in a lower-class setting, but an earlier version, known as an *organistrum* or *symphonia*, requiring two performers, can be found depicted in a sacred setting in the form of stone sculptures on Gothic churches. Other bowed instruments of the period were distinguished mainly by size and pitch. The rebec, a small three-string instrument, played in the soprano range, while the vielle (Italian viola, English fiddle) was a four- or five-string instrument with a range similar to a modern viola. In Italy the *lira da braccio* was used to accompany improvised song. It was a bit larger than a vielle/viola although it was still played while held against the shoulder. It had seven strings, five of which could be "stopped" (i.e. the player could change the pitch with the fingers

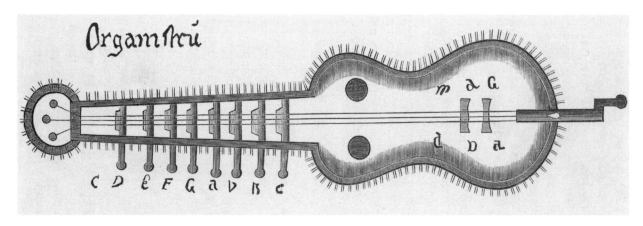

An organistrum, a larger form of hurdy-gurdy. MARY EVANS PICTURE LIBRARY.

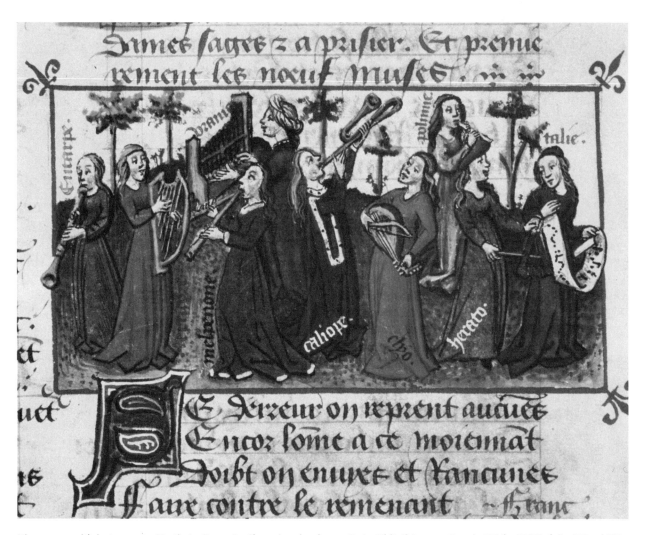

Nine muses with instruments, Martin Le Franc, *Le Champion des dames*, Paris, Bibliothèque nationale MS fr. 12476, folio 109v, 1451. GIRAUDON/ART RESOURCE, NY.

of his left hand, similar to a modern violin), and two more that were plucked by the thumb of the left hand, adding a strummed drone.

PLUCKED STRINGS. Lutes came in several sizes, with frets and four "courses" (paired sets) of strings and a fifth solo string called a *chantarelle*, used for playing melodies.

During this period it was usually plucked with a quill plectrum and played mostly single-line melodies with drones. It is clearly descended from the Arab instrument *oud*. The gittern, in contrast, was smaller and higher-pitched than the lute. It also had frets and was plucked with a plectrum and is depicted with three to five single strings. The final member of the group was the harp. Although harps existed in a variety of sizes and forms, the instrument most often depicted was a small portable harp with 24 or 25 strings.

MUSIC FOR INSTRUMENTS. Although musical instruments were present all through the period and were played at many different kinds of occasions, very little music intended solely for instruments has survived. The repertory of instrumentalists consisted mainly of improvised music and melodies that circulated aurally. The only materials recorded in written form were ornamented versions of some pieces originally written for voice and a small number of dances. It is clear that throughout the period instrumentalists often performed vocal music, but it was not until the period of the Renaissance, beginning at the very end of the fifteenth century, that we begin to find a sizable body of music specifically composed for instrumental performance.

SOURCES

Edmund Bowles, "*Haut* and *bas*: The Grouping of Musical Instruments in the Middle Ages," *Musica Disciplina* 8 (1954): 115–140.

Sibyl Marcuse, *A Survey of Musical Instruments* (London: David and Charles, 1975).

Timothy J. McGee, "Medieval Instrumental Repertoire," in *A Performer's Guide to Medieval Music*. Ed. Ross W. Duffin (Bloomington: Indiana University Press, 2000): 448–453.

Jeremy Montagu, *The World of Medieval and Renaissance Musical Instruments* (London: David and Charles, 1976).

Keith Polk, "Ensemble Performance in Dufay's Time," in *Dufay Quincentenary Conference*. Ed. Allan W. Atlas (Brooklyn: Brooklyn College, 1976): 61–75.

PLAINSONG AND THE MONOPHONIC TRADITION

ORIGINS OF PLAINCHANT. Music can be easily divided into two large categories according to how many parts are performed simultaneously—that is, monophony and polyphony. Monophonic music, which consists of a single line whether performed by a soloist or by many performers in unison, is the oldest tradition of European music and one shared with all other cultures. At the

MUSIC
Sources for Medieval Instrumental Performance

In the medieval music manuscripts that still exist today, there are very few examples of music intended for instrumental performance. The small amount of music written for instruments that has come down to us consists of the following:

The Robertsbridge Codex (English) from c. 1370: a total of six compositions consisting of two-part arrangements of dances, motets, and a hymn, possibly intended for keyboard performance.

The Faenza Codex (Italian) from c. 1430: approximately fifty, mostly two-part arrangements of secular songs, plus a few dances and sacred pieces. It may have been intended for keyboard or lute duets.

The Buxheimer manuscript (German) from c. 1470: over 250 two- and three-part pieces for keyboard, consisting of a few dances, some preludes, and many arrangements of sacred and secular pieces for organ.

A total of 45 pieces, mostly monophonic, known or suspected to be dances, and found in manuscripts from Italian, French, English, and Czech sources, including *estampies*, carols, and *saltarellos*.

beginning of the Carolingian period, the music of the Christian church was a monophonic type called plainchant, a style of music that was originally adopted in the first and second centuries from the traditions of a number of other religious sects—mainly, but not exclusively, Judaism. In the early centuries this repertory was passed on orally, growing and adapting as Christianity and its ceremonies gradually evolved. The name "Gregorian Chant" is often used for this music, based on the erroneous belief that it was composed by Pope Gregory the Great in the seventh century. It is true that some of the chant comes from his era, and Gregory probably had a hand in its organization and promotion. But chants continued to be composed throughout the later centuries of the Middle Ages, and therefore it has recently become the custom to refer to the entire corpus as plainchant (or chant). Chants range from the fairly simple, which involve only a few different pitches and assign a single note to each syllable, to elaborate melodies with large ranges

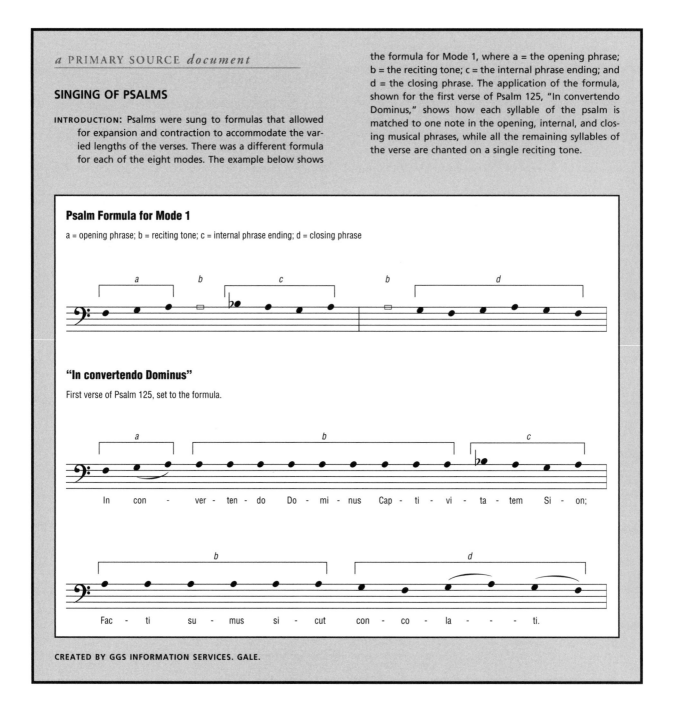

a PRIMARY SOURCE *document*

SINGING OF PSALMS

INTRODUCTION: Psalms were sung to formulas that allowed for expansion and contraction to accommodate the varied lengths of the verses. There was a different formula for each of the eight modes. The example below shows the formula for Mode 1, where a = the opening phrase; b = the reciting tone; c = the internal phrase ending; and d = the closing phrase. The application of the formula, shown for the first verse of Psalm 125, "In convertendo Dominus," shows how each syllable of the psalm is matched to one note in the opening, internal, and closing musical phrases, while all the remaining syllables of the verse are chanted on a single reciting tone.

Psalm Formula for Mode 1

a = opening phrase; b = reciting tone; c = internal phrase ending; d = closing phrase

"In convertendo Dominus"

First verse of Psalm 125, set to the formula.

In - con - ver - ten - do Do - mi - nus Cap - ti - vi - ta - tem Si - on;

Fac - ti su - mus si - cut con - co - la - - ti.

CREATED BY GGS INFORMATION SERVICES. GALE.

of notes and dozens of ornate melodic passages for a single syllable. Some chants are performed by a soloist, some by the entire chant choir (or the entire monastery), and some alternate between soloist and choir. They occur in several principal styles.

PSALMS AND ANTIPHONS. Psalms are sung to relatively elementary music with a single note for each syllable. This music usually involves no more than four or five different pitches, with the majority of each phrase of text chanted on a single note, known as the reciting tone (see Modes). The remainder of the phrase, its beginning and ending words, are sung to simple formulae specified by the mode itself. Since the psalm verses are all in prose lines of different lengths, the reciting tone can easily be adjusted to the length of each verse. When performed during the daily office, the singing of a psalm involved the entire monastic choir divided into two groups, each group alternately singing one of the two balanced phrases that make up the dozens of verses in each psalm. Antiphons, on the other hand, are usually quite melodic, with a somewhat wider range and more

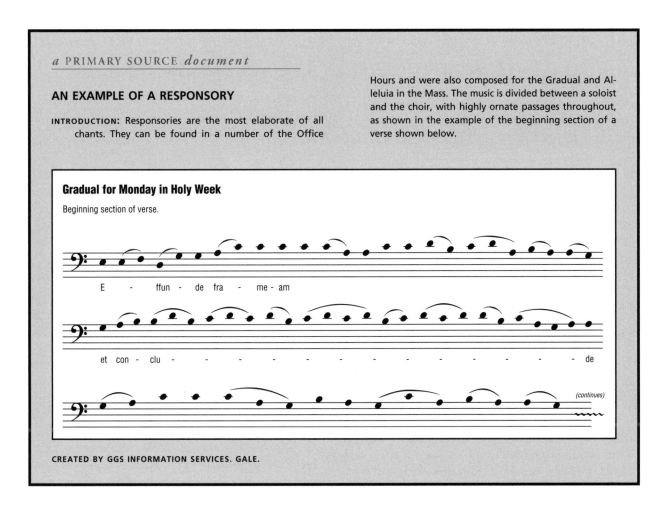

a PRIMARY SOURCE *document*

AN EXAMPLE OF A RESPONSORY

INTRODUCTION: Responsories are the most elaborate of all chants. They can be found in a number of the Office Hours and were also composed for the Gradual and Alleluia in the Mass. The music is divided between a soloist and the choir, with highly ornate passages throughout, as shown in the example of the beginning section of a verse shown below.

Gradual for Monday in Holy Week

Beginning section of verse.

E - ffun - de fra - me- am

et con - clu - - - - - - - - - - - - - de

(continues)

CREATED BY GGS INFORMATION SERVICES. GALE.

frequent variation of pitch, reflecting their performance by the entire choir. They are found in a number of different places in the Mass and office liturgies, often framing (that is, preceding and following) a psalm verse. An introit (entrance song), for example, would repeat a single antiphon in alternation with a succession of psalm verses, resulting in a performance that could be graphed as: Antiphon; Psalm verse 1; Antiphon; Psalm Verse 2; Antiphon; etc.

HYMNS AND RESPONSORIES. Hymns involve poetic texts with regular meter. Their musical construction, therefore, involves matching words to musical phrases, which are composed to fit all of the lines of the first verse of text and intended to be repeated for all successive verses. They are melodic but not overly complex or ornate, and are sung by the entire choir. In contrast, responsories are the most elaborate of all chants, and their music is divided between a soloist and the choir, with highly ornate passages throughout. Responsories are used in a number of the Office Hours, and for the Gradual and Alleluia in the Mass. One responsorial chant, the Mass Alleluia, is a rather special case because it includes a long, rhapsodic melodic section on the final "a" in Alleluia, sung by the choir. The extended melody is called the *jubulus*, and it was originally intended to be an expression of pure, wordless joy. After the ninth century the jubulus was frequently replaced by a new composition with a text, known as a Sequence (see Additions to the Sacred Repertory, below).

MASS. Central to the Christian demonstration of faith is the ceremony of the Mass, which includes the Communion service, a reenactment of the Last Supper. The ceremony itself evolved slowly over the centuries; various prayers and events were added, subtracted, and revised, reaching its present form only in the mid-sixteenth century following the Council of Trent. During the late Middle Ages the Mass included approximately twenty prayers and readings, half of which were spoken and half sung. The texts include some that remain the same throughout the year, known as the Ordinary items, others that change depending on the liturgical season (for example, Christmastime, Easter), and some, known as the Proper, that change each day and are particular to the saint being celebrated on that date (for example,

St. Stephen is celebrated on 26 December, St. John the Apostle on 27 December, and so on). Of the many sung parts of the Mass, it is to five parts of the Ordinary that composers devoted most of their attention during the late Middle Ages. In the order in which they occur in the service the items are:

Kyrie eliesion—"Lord have mercy," a ninefold invocation for mercy;

Gloria—"Glory to God in the Highest," a celebration of the glory of God (omitted during the forty days of mourning preceding Easter);

Credo—"I believe in one God," a declaration of the essential beliefs of the Christian faith;

Sanctus—"Holy, Holy, Holy," the cry of the multitudes when Jesus entered Jerusalem;

Agnus Dei—"Lamb of God," a plea for personal peace.

OFFICE HOURS. In addition to the Mass, the clergy observe eight additional daily prayer rituals at various hours of each day, known as the Office or the Hours, beginning shortly after midnight and lasting until evening. In the monasteries, when it is time for each of the Hours, all of the monks stop whatever they are doing and gather in the Chapel to pray and chant together. Priests not part of a monastic community simply read the prayers to themselves. Most of the Hours have prayers that are sung, including antiphons, psalms, responsories, and hymns. An outline of Matins, the most important of the Hours, will provide an idea of the structure of the service and its contents:

Introduction: *Deus in adiutorium meum intende* (dialogue chant), Psalm 94 with antiphon, hymn

Nocturn I: three psalms with antiphons, three responsories.

Nocturn II: three psalms with antiphons, three responsories

Nocturn III: three psalms with antiphons, three responsories

Conclusion: *Te Deum* (hymn), *Benedicamus Domino* (dismissal)

All five sections in Matins involve the chanting of psalms: an introduction and conclusion, both of which remain the same each day, and three central sections known as Nocturns. The importance of the Psalms to the services is apparent from the fact that the services in monasteries are constructed so that all 150 can be sung each week.

Not all of the eight Offices are as elaborate as Matins, but it can be seen that a very large portion of a medieval monk's day was spent in singing.

SOURCES

Willi Apel, *Gregorian Chant* (Bloomington: Indiana University Press, 1966).

David Hiley, *Western Plainchant: A Handbook* (Oxford: Oxford University Press, 1993).

SEE ALSO *Religion: Medieval Liturgy*

ADDITIONS TO THE SACRED REPERTORY

CONTINUAL CHANGE. It is tempting to view something as old and formal as the sacred liturgy—the Mass and the Hours—as immutable, with a body of works and system of practice that has remained unchanged since it began. Nothing can be further from the truth. The entire liturgy, both its format and repertory, was in a constant state of flux throughout the period. New compositions and ceremonies were added, older items were revised and altered, and regional variants of all types arose and were suppressed all during those centuries. Discussed below are some of the major changes that came about during this period involving music, although there were also numerous changes to the prayers and the format of the ceremonies themselves. The inclusion of musical drama, the addition of new chant items and devotional works, and the application of polyphony to new and old repertory are evidence of a sacred ritual that was constantly under revision.

LITURGICAL DRAMA. During the reign of Charlemagne in the early ninth century, the church authorities at his principal residence in Aachen (northern Germany) decided to dramatize the most important event in the liturgical year, the Resurrection of Christ on Easter morning, by acting out the scene in which the three Marys (Mary the mother of James, Mary Salome, and Mary Jacobi) visit Christ's tomb and find it empty. Three monks were assigned to take the part of the Marys, impersonating women by raising their cowls over their heads, and another monk sang the part of the angel who tells the Marys that Christ has risen. Initially, the entire dialogue consisted of only three lines of text and music, sung during the procession on Easter morning and enframed by a number of processional antiphons. The idea of dramatizing the major celebrations of the Church spread quickly throughout all areas of Europe, where they became immediately popular and

a PRIMARY SOURCE *document*

LINES FROM A SACRED PLAY

INTRODUCTION: The earliest known sacred play with music was the recreation of Christ's Resurrection on Easter morning. There were hundreds of different versions of this play, all of which contain the following basic lines and music.

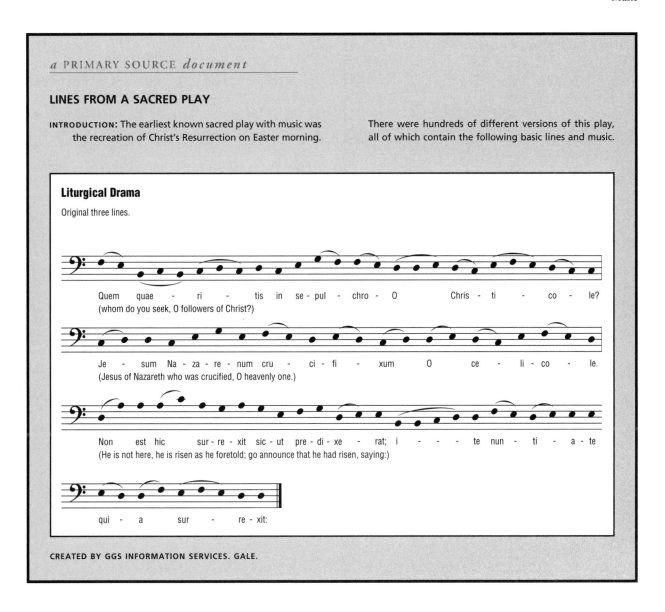

Liturgical Drama

Original three lines.

Quem quae - ri - tis in se - pul - chro - O Chris - ti - co - le?
(whom do you seek, O followers of Christ?)

Je - sum Na - za - re - num cru - ci - fi - xum O ce - li - co - le.
(Jesus of Nazareth who was crucified, O heavenly one.)

Non est hic sur - re - xit sic - ut pre - di - xe - rat; i - - - te nun - ti - a - te
(He is not here, he is risen as he foretold; go announce that he had risen, saying:)

qui - a sur - re - xit:

CREATED BY GGS INFORMATION SERVICES. GALE.

attracted additional creative inspirations. In some places the drama was enlarged by the addition of other scenes from the biblical account of the Easter story: the seller of spices, pilgrims who passed by the grave, apostles who arrived later at the tomb. By the twelfth century the tradition of dramatizing the liturgy had grown in some monasteries to include church celebrations at other times of the year, including biblical events such as the Adoration of the Magi, the Slaughter of the Innocents, and the Raising of Lazarus. In some places the enactments were removed from their original setting within a liturgical ceremony and presented as independent musical plays lasting over an hour. The most elaborate set of plays is found in a manuscript known as the Fleury Play Book (named for the French monastery where it is believed the manuscript originated), written in the early thirteenth century. This source contains a total of eleven grand plays, all set to music, on subjects such as the St. Nicholas legend, the Son of Getron, the Pilgrims, and the Conversion of St. Paul, as well as the original topic of the Resurrection.

TROPES. Tropes were additions of new text phrases and music inserted at the beginning and between the existing text phrases of antiphons for the Mass. The new phrases served as a commentary on the original text. In the example of the *Resurrexi* Antiphon With Trope, the original text is underlined. Just as the new text phrases amplified the original text, the new music was written to match the melodic style of the old. Tropes continued to be added to antiphons to the point that they were even collected in separate manuscripts, called Tropers, which would provide a singer with a choice of a number of different sets of tropes to add to specific antiphons.

AN EASTER INTROIT

INTRODUCTION: The following is an antiphon for Easter Introit with trope lines. The original antiphon, in italics, begins with "I am risen." The trope lines are added before the first line and following each phrase, ending with a final trope line. All of the trope lines and the first phrase of the antiphon are sung by a soloist. The choir sings the rest of the antiphon phrases, alternating with the solo performances of the trope lines. Following this, the soloist sings an antiphon verse, and that is followed by another troped performance of the antiphon.

Today there came forth a strong lion from the
 sepulchre on account of whose victory the heavenly
 ministers shall rejoice in God, and we rejoice singing
I am risen
The prince of hell having been vanquished, all doors
 are open.
And yet I am with you, Alleluia
from whom I never went away while I was lying in
 the flesh, dust
You placed upon me
whom you alone created, O God, before all time
Your hand, Alleluia
By your order death was tasted
A wonderful thing has been done
to one to whom no wisdom in the world can be
 equated
Your knowledge, Alleluia
That wish such a victory you laid low the boastful
 victor, Alleluia.

SEQUENCES. Sequences are additions for the end of the Alleluia, one of the chants for the Mass, as a replacement for the long, extended melodic rhapsody on the final syllable of "Alleluia." The name "sequence" refers to the texts, which are in paired lines all with the same syllable count, although not rhymed. The music is very melodic (as opposed to psalm-tone), but not elaborate in that only one note is assigned to each syllable, much in the style of a hymn. Thousands of sequences were composed beginning in the Carolingian era sometime around 850 and continuing until the twelfth century. One of the earliest sources was the music written by Notker Balbulus (c. 840–912), a monk at the Swiss monastery of Saint-Gall, who gathered his sequences into a book (*Liber Hymnorum*), thus becoming the first known composer. Tropes and sequences continued to be sung until the reforms of the Council of Trent in the sixteenth century, when all tropes were eliminated from the liturgy, as well as all but four sequences.

RHYMED OFFICE. The largest repertory of new sacred material during the late Middle Ages was written for the Office. Over a thousand new saints were added to the liturgical calendar during this period, meaning that new chants had to be written for their services. Although the earliest of the new texts were written in prose, as the older texts had been, by the twelfth century it became the custom to write them as poetry, in strict meter and rhyme. The matching or coupling element of a rhymed text inspired the composers to write music with similarly matching phrases, resulting in new office chants that were quite different from those that preceded them. Since many of the new saints were venerated only in a particular region, this provided the opportunity for new composers in each area to contribute material to their local sacred observances.

SOURCES

Thomas P. Campbell and Clifford Davidson, eds., *The Fleury Playbook; Essays and Studies* (Kalamazoo, Mich.: Medieval Institute Publications, 1985).

Reinhard Strohm and Bonnie J. Blackburn, eds., *Music as Concept and Practice in the Late Middle Ages.* The New Oxford History of Music 3.1 (Oxford: Oxford University Press, 2001).

SEE ALSO *Religion: Medieval Liturgy*

THE MONOPHONIC SECULAR TRADITION

REGIONAL STYLES. At the same time plainchant was being sung in the churches and monasteries, there was a rich body of monophonic music developing for non-religious use. In contrast to the unified nature of chant, which was more or less standard throughout Europe, the music of the laymen varied by region. The entire Western Christian church was controlled centrally by an enormous, stable hierarchy in Rome that extended to all regions, with a single official language—Latin—all of which resulted in a single, uniform practice. The secular world, on the other hand, was divided into autonomous regions that were subject to sudden political change and maintained separate languages and customs. A discussion of secular music, therefore, takes on a geographical/national character, reflecting local cultures and preferences. There are a number of similar basic elements in all areas, but the differences are sufficiently large and striking to warrant a discussion by general regional types.

LOST EVIDENCE. Although we know that there was a thriving tradition of secular music in all areas, not all are well represented by surviving music. Very little secular monophony is preserved from England, for example, in spite of the fact that in the twelfth century Eleanor of Aquitaine was a patron of troubadours and trouvères, and literary sources such as the writings of Geoffrey Chaucer make it clear that there was a great quantity of secular music. The entire English monophonic repertory that has come down to us consists only of three sacred songs attributed to St. Godric, a Saxon hermit who died in 1170, and a handful of love songs. The surviving repertory from Spain is equally slim, although we do have the sacred *cantigas*, discussed below. Given the basic similarities of the social milieu in all parts of Europe, however, we can imagine that repertories and musical practices existed in all of these areas, similar to those that have survived.

TROUBADOURS IN THE COURTS. Although much of the repertory of the minstrels was never recorded, we can catch a glimpse of it through one particular branch of the tradition that flourished in aristocratic circles: the courtly love songs written and performed by troubadours, and *trouvères* (men) and *trobairitz* (women). The name depended on where they lived and performed and the language in which they wrote: the troubadours mostly worked in southern France, northern Spain, and northern Italy, and wrote in the Occitan language (also called *langue d'oc* and Provençal), while the trouvères worked in northern France and wrote in a medieval version of French (Old French, *langue d'oïl*). The names come from the verb *trouver,* meaning "to find," which suggests that they invented ("found") their poetry and music. They were a talented group of professionals and amateurs that included nobles as well as members of the lower classes who lived and performed mostly in the courtly circles of France, England, and northern Italy (where they were known as *trovatori*) during the eleventh through the thirteenth centuries. In contrast to the other minstrels who led a somewhat insecure nomadic existence, these poets/composers were usually attached to a single location for long periods.

COURTLY LOVE SONGS. Much of our impression of courtly life of the period is taken from medieval song texts, although what they describe is often idealized—describing a perfect world—rather than factual. The subject matter of these poems is highly stylized, following a partially imaginary etiquette of courtly love and behavior that is both elaborate and complex. "Lancan vei la folha," by the troubadour Bernart de Ventadorn is a good example of both the musical style of troubadour melodies and the convoluted and decorative language used in a typical love song; the lover expresses his devotion in reverential terms, vowing eternal devotion in spite of the woman being unattainable (often because she is married to someone else). In contrast, Bernart's musical setting is relatively simple: the melody that sets the first four lines of the stanza is repeated for the next four; a new contrasting melody is introduced for lines 9 and 10 (that is, it descends rather than ascends), and then the last half of the earlier melody returns for the final two lines. All of the stanzas are intended to be sung to the same melody, although the singer would be expected to insert different ornaments (embellishing notes, rhythms, or any number of other vocal expressive devices) for each stanza in order to add variety and support the text message.

THE PASTOURELLE. Another of the favorite formats in the troubadour/trouvère tradition was the pastourelle, which had as its theme the romantic pursuit of a shepherdess by a knight. Named after the French word for "shepherdess," these poems usually told the story of a noble visitor to the countryside who catches sight of a pretty rustic girl, approaches her, and offers her gifts in exchange for her acceptance of his advances. Sometimes the nobleman forces his attentions on her, and other times she outwits him. A variant of this form, called the *bergerie*, changes the situation slightly. Now a hidden narrator overhears shepherds, or a shepherd and shepherdess, debating. The 1284 *Jeu de Robin et de Marion* (Play or Game of Robin and Marion), by the trouvère Adam de la Halle, is the most famous of these, and incorporates a number of charming songs for the two principal characters and a narrator who tells the story.

THE CANTIMPANCA AND THE IMPROVISED TRADITION. *Trovatori*, the Italian equivalent of French troubadours, flourished at the northern Italian courts during the twelfth and thirteenth centuries, producing a repertory similar to that of the troubadours. At the same time, outside of the court the centuries-old practice of the village bard survived in the person of the *cantimpanca* (singer on a platform), or *cantastoria* (singer of history), carrying on a tradition that lasted long after the trovatori died out. The cantimpanca was a poet and singer who improvised music while he sang verses about historical subjects, love, and any other topic that interested him. His verses often commented on current political events, and he accompanied himself with a lute or a lira da braccio. Some of these poet/musicians were quite famous and had regular followings; the Florentine cantimpanca Antonio di Guido, who performed on Sundays in the piazza in front of the Florentine Church of San Martino in the late fifteenth century, could count among his fans Lorenzo de' Medici (Lorenzo the Magnificent), the great Florentine statesman and patron of the arts. Pietrobono de

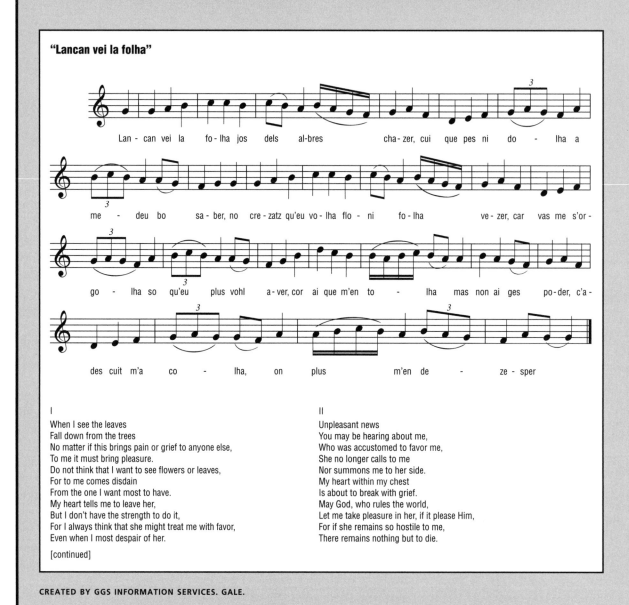

a PRIMARY SOURCE *document*

A TROUBADOUR SONG

INTRODUCTION: "Lancan vei la folha," written by troubadour Bernart de Ventadorn in the twelfth century, is a good example of the musical style of troubadour melodies. All of the stanzas, which illustrate the combination of total loyalty and extreme suffering expected of a lover in the "courtly love" tradition, are intended to be sung to the same melody, although the singer would be expected to insert different ornaments for each stanza in order to add variety and to support the text message.

SOURCE: Bernart de Ventadorn, "Lancan vei la folha" (When I see the leaves). Trans. Robert Taylor. Used by permission.

"Lancan vei la folha"

Lan - can vei la fo - lha jos dels al - bres cha - zer, cui que pes ni do - lha a

me - deu bo sa - ber, no cre - zatz qu'eu vo - lha flo - ni fo - lha ve - zer, car vas me s'or -

go - lha so qu'eu plus vohl a - ver, cor ai que m'en to - lha mas non ai ges po - der, c'a -

des cuit m'a co - lha, on plus m'en de - ze - sper

I

When I see the leaves
Fall down from the trees
No matter if this brings pain or grief to anyone else,
To me it must bring pleasure.
Do not think that I want to see flowers or leaves,
For to me comes disdain
From the one I want most to have.
My heart tells me to leave her,
But I don't have the strength to do it,
For I always think that she might treat me with favor,
Even when I most despair of her.

[continued]

II

Unpleasant news
You may be hearing about me,
Who was accustomed to favor me,
She no longer calls to me
Nor summons me to her side.
My heart within my chest
Is about to break with grief.
May God, who rules the world,
Let me take pleasure in her, if it please Him,
For if she remains so hostile to me,
There remains nothing but to die.

Burzellis, who was located principally in Ferrara, was widely acclaimed both for his virtuosity as a lutenist and for his singing voice, as well as his ability as an improvisor. Although some of the poetry of these popular entertainers still exists, not a note of the music has survived.

MINNESINGERS. The German counterpart to the courtly tradition of the troubadour and trouvère in France was the minnesinger (*Minne* = love), a singer of love songs, popular during the twelfth and thirteenth centuries. Originally the kinds of songs—the subject

"Lancan vei la folha" [CONTINUED]

III

I no longer have faith
In augury or spells,
For straightforward hoping
Has destroyed and finished me,
For the beautiful one whom I love strongly
Casts me so far off,
When I seek her love,
As though I had done her wrong.
I have so much distress from this
That I am deeply afflicted;
But I do not allow it to show
For I go on singing and enjoying myself.

IV

I don't know what else to say,
Except that I am acting very foolishly
In loving and desiring
The most beautiful one in the world.
I really ought to kill
The person who invented the mirror.
When I think carefully about it,
I have no worse adversary than this.
On any day that she looks at her reflection
And thinks about her worth,
I shall surely possess
Neither her nor her love.

V

She does not love me sensually,
For that would not be suitable.
But if it were to please her
To show me any favor at all,
I would swear to her,
In her name and in the name of my faith,
That any favor she might do me
Would not be revealed by me.
Let her will be done,
For I am at her mercy.
Let her kill me if it please her,
For I am not complaining of anything.

VI

I have the right to complain
If I lose through my own pride
The pleasant company
And the pleasure that I used to have.
I gain little profit
From the false bravery that I display,
For the one I most love and desire
Rebuffs me.
Oh Pride! May God crush you,
For now my eyes weep on your account.
It is right that all joy should desert me,
For I myself have driven it from me.

VII

As defence from the suffering
And the pain that I endure,
I have my constant habit
Of thinking always about that place (where she is).
Pride, folly
And villainy will be committed
By anyone who distracts my heart from her
Or makes me think of anything else,
For no better messenger
Can I have in the whole world,
And I send it (my heart) to her as hostage
Until I return from here.

VIII (Envoy)

Lady, I send you my heart,
The best friend that I have,
As hostage,
Until I return from here.

matter and the forms—were similar to those of the troubadours, but in the late thirteenth century many of the minnesingers began to write on more popular themes, including parodies of the idea of courtly love. Many of the songs in this later period are quite humorous and earthy. The tradition lasted into the fifteenth century in Germany, nearly one and a half centuries after it had died out in France. A notable minnesinger of the later period was Tannhäuser, who was involved in the Fifth Crusade (1217–1221), and whose life inspired one of Richard Wagner's operas in the nineteenth century. Tannhäuser's song (*minnelied*) *Est Hiut Ein Wunniclicher Tac* ("Today Is A Wonderful Day"), written in four stanzas around the year 1250, is a song of penitence. Its narrow range and simple rhythms are typical of the genre.

The musical form is known as *Bar*, matching the form of the poetic stanzas. It consists of two unequal sections; the first section is shorter and is repeated immediately (setting the first eight lines of the text, 4+4), the second is longer (setting the last twelve lines) and includes material from the first section plus new melodic phrases. The tradition of the minnesinger gave rise to the highly organized guild of the Meistersingers in the Renaissance, another of Wagner's opera subjects.

CARMINA BURANA. Another repertory of German songs is found in a manuscript known as the *Carmina Burana*, dating from the end of the thirteenth century, which contains over 200 secular poems. The collection is from the Benedictine monastery of Benediktbeuern (south

Walther von der Vogelweide, Manesse manuscript, Heidelberg, Universitätsbibliothek, Cod. Pal. Germ 848, folio 124r., c. 1300. BETTMANN/CORBIS.

of Munich), and consists of a number of poems in Latin as well as some in German. The repertory is quite broad, including drinking songs and parodies of religious songs, as well as some with texts of love, many of which are related to the minnesinger repertory in terms of style and subject matter. In recent times the composer Carl Orff (1895–1982) used the poetry and some of the melodies as an inspiration for his *Carmina Burana*, a substantial work for orchestra, chorus, and soloists.

SOURCES

Elizabeth Aubrey, *The Music of the Troubadours* (Bloomington: Indiana University Press, 1996).

E. J. Dobson and Frank L. Harrison, *Medieval English Songs* (New York: Cambridge University Press, 1979).

Francesco Flamini, *La lirica toscana del Rinascimento anteriore ai tempi del Magnifico* (Pisa: 1891; reprint, Florence, Italy: Olschki, 1977).

William Powell Jones, *The Pastourelle* (Cambridge, Mass.: Harvard University Press, 1931).

William Paden, ed. and trans., *The Medieval Pastourelle.* 2 vols. Garland Library of Medieval Literature 34–35, Series A (New York: Garland, 1987).

Shira I. Schwam-Baird, ed. and trans., and Milton G. Scheuermann, ed., *Le Jeu de Robin et Marion* (New York: Garland, 1994).

John Stevens, *Words and Music* (Cambridge, England: Cambridge University Press, 1986).

Ronald J. Taylor, *The Art of the Minnesinger: Songs of the Thirteenth Century Transcribed and Edited With Textual and Musical Commentaries* (Cardiff: University of Wales Press, 1968).

Michel Zink, *La Pastourelle: Poésies et Folklore au Moyen-Age* (Paris: Bordas, 1972).

SEE ALSO *Literature: Courtly Love; Literature: The Non-Narrative Lyric Impulse*

RELIGIOUS MUSIC OF THE LAYMAN

SONGS OF PERSONAL EXPRESSION. Not all sacred music was for church or monastic services; laymen also participated actively in their faith by singing sacred songs. One of the uses of this repertory was the personal or familial expression of faith done at home, although there was also a widespread tradition of confraternities— societies of laymen who gathered together in a chapel or church to pray and sing devotional songs. These gatherings were not part of a liturgical service, and generally were not presided over by the clergy. The sacred songs of the different regions, sung in the vernacular language, differ from one another in several ways, including subject matter and style of melody.

CANTIGAS DE SANTA MARIA. One of the earliest and most interesting repertories of sacred song has been preserved in three elaborate Spanish manuscripts, dating from the thirteenth century during the time of Alfonso X "el Sabio" (The Wise), king of Castile and León (regions of what is now Spain) from 1252–1284. His reign was one of enormous contrasts. On the one hand, there was political unrest and civil war, but on the other there were great advances in culture, science, and literature. The Cantigas de Santa Maria (Songs of Holy Mary) includes more than 400 songs, all of which are devoted to the Virgin. The subject matter of the texts concerns everyday people in contemporary Iberian life (encompassing Spain and Portugal), all of whom are assisted by miracles performed by Mary. As in the cantiga illustrated here, each song is introduced by a narrative passage that sets the scene. The poems that follow are all in strophes (stanzas or groups of lines in a single metrical form), usually of six to eight lines of verse, with a four-line refrain. The music that sets each of the cantigas is therefore in two parts, reflecting the poetic form and rhyme scheme. The music is fairly simple, having a modest range, simple

A CANTIGA TO THE VIRGIN MARY

INTRODUCTION: "Aquela en que Deus" is one of over 400 songs devoted to the Virgin, known as the Cantigas de Santa Maria (Songs of Holy Mary). They are all preserved in three elaborate Spanish manuscripts, dating from the thirteenth century, during the time of Alfonso X "el Sabio" (The Wise), king of Castile and León. The song in the example below explains how Holy Mary of Ribela does not allow any oil to be burned before her altar except olive oil, which is very clean and pure.

"Aquela en que Deus carne"

CANTIGA DE SANTA MARIA
Text in italics represents the refrain. The music shown here represents the first verse and the refrain.

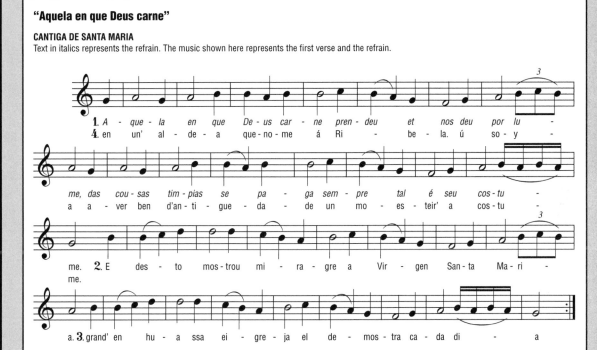

REFRAIN: That One in whom God took flesh and gave to us for light is always pleased by cleanliness, such is Her custom.

VERSE 1: The Holy Virgin Mary performed a great miracle in a church of Hers, as She does every day, in a village called Ribela where long ago there used to be a monastery.

REFRAIN: That One in whom God took flesh and gave to us for light is always pleased by cleanliness, such is Her custom.

VERSE 2: Now only the church remains of the Order of Saint Benedict, which was dedicated to the Virgin (may She be ever blessed), in which there are five altars, and where God sheds wondrous power on the altar consecrated to Her, for no light may burn there.

REFRAIN: [That One …]

VERSE 3: [No light] of any oil except that of olives, very clean and pure. Although linseed oil may burn before the others, it is unthinkable that it should be burned before the Virgin's altar. This is proven many times during the year, and it has become the custom.

REFRAIN: [That One…]

VERSE 4: Knights, farmers, priests, monks, barefoot friars, and preachers often prove this to be true, for although they have tried to light other combustible oils there, they immediately went out and would not burn at all.

REFRAIN: [That One …]

VERSE 5: Therefore, the people of that place do not dare to be so bold as to burn any other oil there, since they fail foolishly each time they try. For this reason they go back to burning olive oil in the lamps, as is the custom.

REFRAIN: [That One …]

CREATED BY GGS INFORMATION SERVICES. GALE.

rhythms, and, for the most part, only one note per syllable of text; all of the settings are monophonic. In "Aquela en que Deus," there are really only two different musical phrases for the entire cantiga. The Cantigas show a number of interesting relationships. The melodies and their form—verse, refrain—are quite similar to the troubadour repertory; they coincide with the end of the era in which troubadours were active on the other side of the Pyrenees Mountains in France, although their subject matter is unique to Iberia. The artistic styles and patterns of the illustrations in the cantiga manuscripts indicate an obvious influence from the Islamic world. The Arabs had been in Spain for several hundred years at that point, and some of the musical instruments in the cantiga manuscript illuminations are clearly modeled on Arab instruments. The rhyme scheme of most of the Cantigas, one that was popular at Alfonso's court, is known as *zajal*, an Arabic form. All of this suggests that while the music seems to be related to the northern repertory, the texts probably were influenced by Arabic literature.

ITALIAN LAUDE. The small body of surviving Italian monophonic songs consists almost entirely of *laude spirituali* (spiritual praises), all of them in the vernacular language and on religious subjects. The laude were the repertory of the numerous religious confraternities (groups united for a common purpose such as the veneration of a saint or other figure) in many North Italian cities during the late Middle Ages. Citizens by the hundreds joined these societies, some joining several, which would meet regularly (sometimes weekly), and sing the laude in procession. Approximately 150 laude exist with music from before the mid-fourteenth century; most are fairly simple in terms of range and rhythms; nearly all of them are in stanza form with a verse and refrain, suggesting soloist-chorus performance.

SOURCES

Higinio Anglès, *La música de las Cantigas de Santa Maria del Rey Alfonso el Sabio.* 3 vols. (Barcelona: Biblioteca Central, 1943–1964).

Fernando Liuzzi, *La lauda e i primordi della melodia italiana.* 2 vols. (Rome: Libreria dello Stato, 1935).

SEE ALSO *Religion: The Laity and Popular Beliefs; Theater: The Development of Liturgical Drama*

THE EARLIEST POLYPHONIC MUSIC

ORIGINS AND DEVELOPMENT. The most far-reaching addition to music during the Middle Ages was the invention of polyphony—music in more than one part—an aspect of Western art that is not duplicated in any other culture. The idea itself undoubtedly originated centuries earlier than the earliest written evidence or even the first mention in theoretical treatises. In its simplest forms polyphony can easily be improvised as, for example, when two or more performers simultaneously sing the same song at different pitches, and it still exists in that form in a number of cultures. But the musicians of Europe took the idea quite a bit further, developing and refining the practice to a level of complexity that could not be extemporized, but required long thought-out and calculated written composition. Monophonic music, both chant and the secular compositions, continued to be performed throughout the Middle Ages and long after, but once invented, polyphony invaded all forms with dramatic consequences. It added an entire new body of works to sacred music, supplementing the chant and even replacing it on special occasions. The effect was somewhat different on secular music, where polyphonic music became the treasured repertory of the upper classes, creating a musical class distinction that had not existed previously.

THE EARLIEST FORMS. Instruction and information about polyphony is found in theoretical treatises from as early as the *De harmonica institutione* (Melodic Instruction), written by the monk Hucbald c. 900, and later expanded and developed in a number of treatises including *Micrologus* (Little Discussion), by Guido of Arezzo. The basis of the technique comes from parallel motion, which is described by Hucbald as the sound that results when a man and a boy sing the same melody simultaneously, each one in his own range. Extensions of this idea include refinements made by one of the voices varying from exact parallel at different times, creating different harmonies, or one voice moving slowly while the other moves quickly, filling in the gap with ornamental passages. All of these techniques are known as "organum," and the earliest written examples of the technique can be found in eleventh- and twelfth-century manuscripts from England and France. By the twelfth century additional experiments revolving around the monastery of Saint-Martial in Limoges (central France) involved composing two lines of music with separate melodic profiles, which resulted in constantly changing harmonies between the two parts. It is at this point that we can mark the true beginning of composed polyphony, the most distinguishing mark of Western art music.

NOTRE DAME ORGANUM AND THE SUBSTITUTE CLAUSULAE. Along with the construction of the Gothic Cathedral of Notre-Dame in Paris in the twelfth century came distinctive and far-reaching experiments in composition of a new polyphonic repertory by two of the

cathedral's choirmasters: Master Leonin and Master Perotin. These compositions, called *organum*, consisted of a new added part above the traditional chant. Leonin (c. 1135–1201) is credited with originating the *Magnus liber organi* (Great Book of Organum), which contains several different kinds of innovative compositions, including organum sections for Graduals, Alleluias, and Responsories for the entire liturgical year. Leonin's organum compositions were intended to be substitutes for those phrases of plainchant usually sung by a soloist. When organum passages are applied to a chant, the result is an interruption of the monophonic performance with a section in which a rapid upper part is sung by a soloist against the long, sustained lower notes of the original chant, followed by a return to the unison chanting of the choir. The new sections are known as *substitute clausulae* because their purpose was to take the place of a phrase (clausula) already present in the chant.

DISCANT. Perotin, who followed Leonin as leader of the Notre-Dame cathedral choir, took the next step and added to the substitute repertory in the form of a new rhythmic organization of the original chant notes with a much lower ratio between the number of notes in the upper and lower parts. Perotin's style of composition, called *discant*, brings a heightened sense of rhythmic flow to the substitute sections. In performance, therefore, an Alleluia in which both organum and discant sections have been substituted would take on a format in which, for example, only three sections of plainchant performed by the whole choir might be alternated with six sections of organum or discant. The change from the original plainchant version of the Alleluia would be that the choir participation has been substantially reduced because both organum and discant sections are performed by two soloists, one of whom sings the original chant while the other adds the newly composed organum or discant melody above it.

SOURCES

Reinhard Strohm and Bonnie J. Blackburn, eds., *Music as Concept and Practice in the Late Middle Ages.* The New Oxford History of Music 3.1 (Oxford: Oxford University Press, 2001).

MOTETS AND CANONS

THE MOTET: A NEW FAVORITE FORM. The motet, which originated in the early thirteenth century, quickly grew to be one of the most important of the new polyphonic inventions. Through the final three centuries of the Middle Ages it became the form of choice for com-

posers who were looking to experiment with techniques, to extend the boundaries of form, harmony, and interrelationship among the parts, and to try new ideas in notation. From its inception it was intended to mark a particular occasion, and this emphasis continued to grow, as did the size of the compositions themselves. The technique of motet writing itself came about as a natural extension of the substitute clausula practice. When composing a new upper part for the chant section, instead of duplicating the text of the lower voice part, the composer would add a new text for the new part. The name *motet* is a Latinized form of the French word "mot," meaning "word," referring to the additional set of words. In the earliest examples, the added text was related to the text of the original part, glossing or amplifying the sentiment. This can be seen as analogous to the trope tradition (see above), except that instead of interrupting the original text with the new commentary, it was sung simultaneously.

MOTET FORMS AND VARIATIONS. The most common format for a motet throughout the thirteenth and fourteenth centuries was three voice parts: two new upper melodies composed above a borrowed (that is, preexisting) melody in the lowest voice. The lowest voice, the one borrowed from a chant (or later, from another composition) was referred to as the *tenor*, from the Latin *tenere* meaning "to hold," referring back to organum in which the chant notes were slowed down—that is, "held out" for a longer duration. The next voice was called alto, meaning "high," and the highest was the soprano, from the Italian *sopra*, meaning "above." Shortly after its invention in the early thirteenth century, composers began to experiment with the motet, and the form quickly took on a number of different genre and variations. From its rather humble and subservient beginning as an addition to a chant section, the motet quickly became a completely independent composition that could be substituted for chants in certain places within the liturgy, for example at the Communion. At first the lowest part, the tenor, was usually chosen from an existing sacred source, and the text of the added part was related to that of the tenor. But many motets were designed for performance outside of the liturgy, some obviously intended for a secular setting. In these, the tenor was not necessarily from a sacred source, nor were the added texts in Latin; the vernacular (that is, the language of the region) could also be used. And the subject matter of the new texts, even for those built on sacred tenors, is sometimes on decidedly earthy topics. This was music for an educated class who reveled in the sophistication of the subtle cross-references among the texts as well as their harmonic, melodic, and rhythmic interplay.

a PRIMARY SOURCE *document*

A MUSICAL PUZZLE

INTRODUCTION: A puzzle canon is an example of the kind of intellectual "games" that were often employed by composers during the late Middle Ages. In the example here, "Agnus dei" from the *Missa L'Homme armé*, the symbol at the extreme left of the staff lines is a clef sign marking F on the middle line, and the vertical grouping of four symbols immediately before the beginning of the music on the top line corresponds to the four parts that will be sung. The musicians would "solve" the puzzle by following the markings at the beginning of the music, which direct them to sing the same melody at four different speeds and pitches, turning it into a four-part composition. The result for the opening section is transcribed on the facing page.

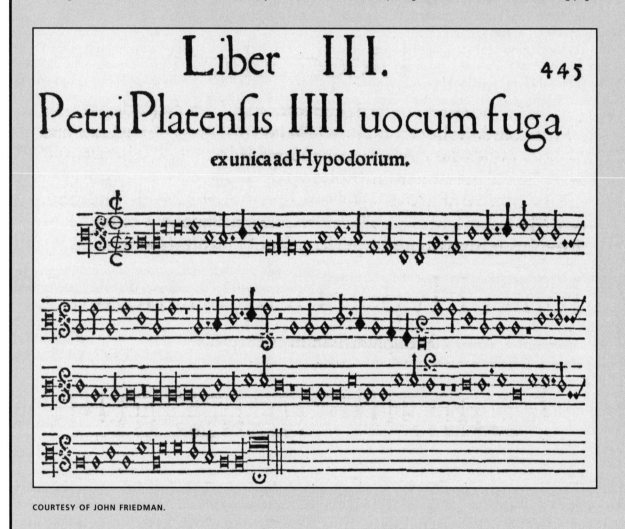

COMPLEXITIES AND PUZZLES. The motet was usually singled out as a format for introducing complexities of melody, rhythm, and tempo into compositional structures. The initial idea of simultaneous sets of words that played on one another suggested to the composers that such intellectual "games" could be extended to the actual construction of the music as well. The most interesting and long lasting of these techniques is known as *isorhythm*, a device in which a particular rhythmic sequence is chosen more or less arbitrarily and the melody is then sung in the chosen rhythmic sequence, repeating the rhythm exactly throughout the composition. Refinements and variations involve whether or not the rhythmic sequence coincides with the length of the melodic phrases, and how many voice parts of any one composition are set in isorhythm. One of the most spectacular displays of the isorhythmic technique can be found in the four-voice motet *Veni sancte Spiritus–Veni Creator Spiritus* by John Dunstaple. The composer writes all four voice parts in different isorhythmic patterns that do not coincide with

A Puzzle Canon: "Agnus Dei"

Transcription of opening section.

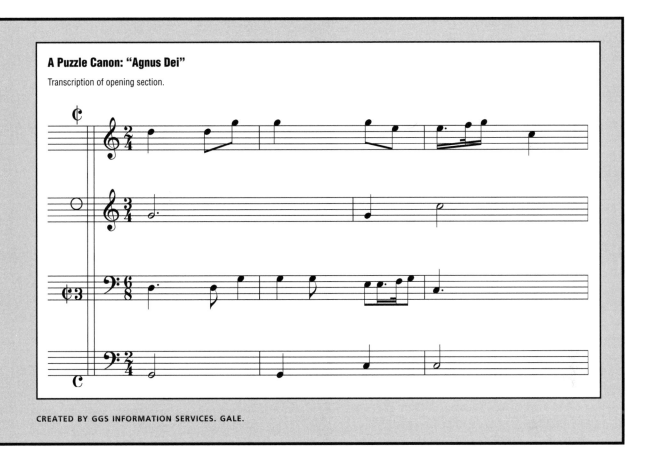

the melodic material, and then further complicates the structure by speeding up the pace of each section of the piece by means of tempo signs based on a mathematical ratio. The imposition of such strict formal devices has the potential of stifling artistic creativity, but in the hands of a skillful composer like Dunstaple, the product is as much a musical triumph as it is a technical *tour-de-force*.

CANON. Another compositional device on the level of an intellectual game, applied to polyphonic music, was *canon* (canon = rule), which required the performers to solve a puzzle presented either in words or in symbols in order to perform the composition, only part of which was actually written down. The written form provided cryptic directions for deriving an added part from what was already on the page. "Cry without ceasing," for example, the only direction given on one such composition, results in the addition of a complete second part if one singer performs only the notes but not the rests, while another singer performs the line exactly as written, including its rests. On a similar level are the compositions written as only a single part with several different symbols indicating tempo (known as mensural signs), which will yield a polyphonic composition when the piece is performed simultaneously at different pitches

and speeds. In the "puzzle canon" illustration, the mensural signs indicate that the melody should be sung in the following manner (the first note is to begin where the sign itself is located).

The uppermost part ¢ begins on high D, and proceeds in duple time.

The next part ○ begins on G, and proceeds in triple time.

The next part ¢3 begins on lower D (the actual notated pitch), and proceeds in a faster triple time.

The bottom part ℭ begins on low G, and proceeds in a slow duple time.

ROUNDS AND CATCHES. Other musical forms also employed the device of canon in performance, although not usually as complicated as those used in the motet. The most obvious of these is the "round" format, in which a single line of music is marked for successive beginnings in the manner of the well-known "Frère Jacques" or "Three Blind Mice." A variation of this is found in the fourteenth-century repertory of both France and Italy, known as *chace* (French), or *caccia* (Italian). The word literally refers to a hunt, but thinly veiled

beneath a superficially naive text, it always has an erotic double meaning. Because the second voice enters later than the first but starts at the beginning, the singers are always at different places in the same text and melody. The composer cleverly constructs the melodic line so that words from one line are interspersed among those of another, producing a completely new meaning, and one that cannot be seen by merely viewing the text itself. These are quite entertaining to hear, many of them containing onomatopoeic sounds such as dogs barking or trumpets sounding. The English "catch" of the seventeenth century is related to this form.

SOURCES

Andrew Hughes, *Style and Symbol: Medieval Music: 800–1453* (Ottawa: Institute of Mediaeval Music, 1989).

Reinhard Strohm and Bonnie J. Blackburn, eds., *Music as Concept and Practice in the Late Middle Ages.* The New Oxford History of Music 3.1 (Oxford: Oxford University Press, 2001).

Jeremy Yudkin, *Music in Medieval Europe* (Englewood Cliffs, N.J.: Prentice Hall, 1989).

POLYPHONIC SECULAR MUSIC AND NATIONAL STYLES

FROM DANCE TO ART MUSIC. Soon after its development, the new polyphonic technique was employed by composers to set non-religious songs, applying it to the different regional types that already existed as monophonic forms. Secular songs stemmed mostly from music intended for dancing, and, in their monophonic format, retained many of the characteristics of dance music, including regular rhythmic patterns and simple melodies with regular phrases. Once polyphony was adopted for this repertory, however, its relationship to dance became increasingly distant. Polyphony, with its potential for complex interrelationships among the parts, tempted the composers to experiment with refinements and sophistications on all levels. The result was a growing body of art music that set traditional poetic text forms, but was technically much more demanding than its monophonic predecessors. By the late fourteenth century the polyphonic secular repertory had replaced much of the monophonic in courtly circles, both in quantity and in prestige.

COURT MUSICIANS. The performance of these pieces required the ability to read music and therefore they were the domain of musically literate performers, both amateur and professional. The resident musicians in the major courts adopted this new collection of compositions in their daily performances; kings, counts, dukes, the pope, and cardinals in all areas prided themselves on the quality of their court musicians, and vied with one another to hire the highest quality performers and composers and to commission manuscripts of the new repertory. Musical establishments such as those at the French court in Paris, the Sforza's in Milan, and the papal court first in Avignon and later in Rome became havens for the finest musicians, but none reached the prestige of that of the duke of Burgundy, whose ensemble of vocal and instrumental musicians set the standards for all of Europe well into the fifteenth century.

BURGUNDIAN DOMINANCE. Initially the styles and techniques of the polyphonic songs were as regional as the monophonic secular repertory, but that soon changed. By the end of the fourteenth century the most influential musical style was that of the area known as Burgundy, including much of what is now northeastern France as well as Belgium and the Netherlands. As the political power of Philip the Bold (duke of Burgundy 1364–1404) grew in the last decades of the fourteenth century, so too did his cultural influence, spreading his musical preferences throughout Europe. Franco-Netherlandish sacred and secular music influenced the writing of composers in all of Europe, especially in Italy where not only the northern repertory was imported, but also the composers and performers themselves. A single example of the influence of the Burgundian musical tastes can be seen in the area of dancing: the fifteenth-century choreographed dances in Italy, Spain, Germany, and England all were modeled on the Burgundian *basse danse*. Not only was the idea of choreographed dancing itself of Burgundian origin, but also the way in which the music was formally composed as only a single line of long notes that was to be expanded in performance into polyphonic form by the musicians themselves. Even the make-up of the usual dance band was copied from the ensemble at the Burgundian court: two shawms and a slide trumpet. There is very little surviving secular polyphony from the other European countries, owing to a combination of factors that include the ravages of time and war, and a preference for the improvisatory style. Whatever the reason, we do not have a significant body of secular polyphony representing England, Germany, or Spain until the very end of the fifteenth century.

FRANCE AND THE CHANSON. The French secular forms of the late Middle Ages were based on earlier dance music, all of which was built on a verse-refrain structure matching the construction of the poetry. The *chanson* (meaning "song") repertory consisted of hundreds of

compositions in the forms well established from the time of the troubadours: *rondeau*, *ballade*, and *virelai*. By the time they became polyphonic, however, around the year 1300, it is doubtful that they still had a practical dance association; their structure and the subtle nature of their rhythmic flow would make them difficult to dance. All of the forms were in two melodic sections, differing from one another only in the way in which the repeat scheme works and whether or not the music for the refrain was also used for part of the verse. The existence of a refrain in each of them suggests a performance in which a soloist sings the verse and everyone else (the chorus) sings the refrain. Undoubtedly this was the performance practice in the earlier Middle Ages, but the later, more complex, polyphonic songs probably were completely sung by soloists. There is a special repertory of chanson from around the year 1400 that is full of notational complexities that make them extremely difficult to read and transcribe into modern notation. They are often referred to as *Ars subtilior* (the subtler art), and when performed have a slightly "jazzy" sound because of their rhythms.

FRENCH FORMS. The rondeau (round dance) is the most complex form because the standard two sections of music are both used as the performer sings first the refrain, then the verse, and then again the refrain. This is further complicated by the insertion of a half refrain in the middle of the verse, as opposed to all other forms, where the refrain is always sung in its entirety, either at the beginning or end of the verse. (For an example of a monophonic rondeau see Dance Chapter, "Vocis Tripudio.") A different complexity occurs in the ballade (which simply means "dance," as in the modern English word *ball*). Although the music of a ballade is again in two sections, the relationship between the verse and refrain is unbalanced because the refrain is usually quite short and therefore occupies only a part of the second section of music. The third type, the virelai (twist) is more similar to the rondeau. In this case, the refrain both begins and ends the musical setting, although it is not inserted in the middle of the verse as is the rondeau refrain.

BIRD-SONG. The texts of all of the chansons were usually the same idealized love topics found in the courtly love poems from the time of the troubadours and trouvères, although by the fourteenth century the language was not quite so stylized. There is one unusual type of text occasionally employed in the virelai, in which birds and their calls are included in the words and the music in order to symbolize particular sentiments. The bird symbolism included the following: the eagle, suggesting power or royalty; the lark, indicating mourn-

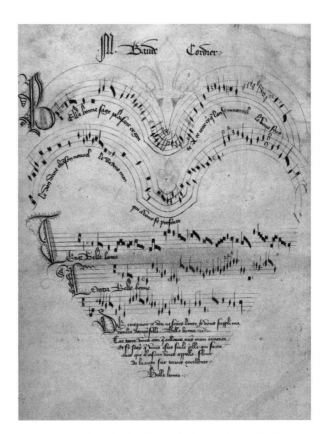

A love song written in the shape of a heart. Baude Cordier, Polyphonic chanson, Chantilly, France, Musée Condé MS 1047, folio 11v., 15th century. GIRAUDON/ART RESOURCE NY.

ing or warning; the crow, a sign of craftiness or mockery; the cuckoo, referring to cuckoldry; the falcon, suggesting power and danger; the peacock, a sign of beauty and vanity; the nightingale, symbolizing night and erotic love; and the turtle dove, indicating fidelity. In some of the polyphonic bird-song virelais, the singer professes one message in words while the bird sounds in the accompanying parts suggest something completely different.

POLYPHONIC MUSIC IN ITALY. There is very little surviving secular polyphonic music from Italy until the mid-fourteenth century, owing to the prominence of improvisation. When we do find some written music, it is quite different from the French style in that the melodies are far more rhapsodic, often organized as elaborations of the notes in the scale in contrast to the French style of short rhythmic-melodic motifs with clear phrase shapes. The early Italian compositions appear to be rather close images of what must have been the free improvisatory style. The largest collection of Italian music from the fourteenth and early fifteenth centuries is contained in a beautifully illuminated manuscript that once belonged to Antonio Squarcialupi (1416–1480),

STRUCTURE
of Medieval Song Forms

Nearly all secular songs in the Middle Ages were composed of two musical sections, but, unlike many modern songs where there is generally one melody for the "verses" (units made of a number of lines, each of which is sung only once) and another for the "refrain" (a line or group of lines that is repeated at regular intervals), the two sections of music in medieval songs were matched in a number of different ways with lines of text. In fact, the main difference between medieval song forms is that they differ in the way in which the lines of the verses and the refrains are distributed between the musical sections.

Modern Song Form

To understand how medieval song form worked, it is useful to look first at a simple modern verse and refrain pattern. In modern songs, including many church hymns and national anthems, verses usually alternate with refrains, either of which may include several musical lines. In some songs the verses may be long and the refrains short, while in others the pattern is reversed. The words of the verses change with each repetition of the verse melody, but the words of the refrain, set to a different melody, remain the same:

Musical Sections	A	B
Text sections	1. verse	2. refrain
	3. verse	2. refrain
	5. verse	2. refrain
	7. verse	2. refrain
	etc.	

Minnesinger Bar Form

In this German form, the singer sings text lines (or groups of lines) one and two to musical phrase A, then sings the third line (or group of lines) to musical phrase B. The first A setting, for example, might contain four lines of text; in this case, then, the second A section would be identical in music and number of text lines, though the words would be different. The B section would introduce another new set of words and music, and might have a different number of lines altogether.

Musical Phrases	A	B
Text lines	1	
	2	
		3

Cantiga Form

In a cantiga, a Spanish song form, the first section of music (A) acts as a setting for the refrain. Then, after two verses that are each sung to a new musical section (B), the first music (A, originally used for the refrain) reappears as a setting for an additional verse. The entire pattern can be repeated, beginning again with the refrain.

Musical Phrases	A	B
Text lines	1 refrain	
		2 verse
		3 verse
	4 verse	

Rondeau Form

In this complex medieval form originating in France, the words of the refrain (which, in this version, is two

Florentine organist, composer, and friend of the powerful Medici family. The Squarcialupi Codex (Florence, Biblioteca Medicea-Laurenziana, MS Palatino 87) contains 354 compositions by twelve of the most important Italian composers of the late Middle Ages, preceding the collection of each composer's works with a portrait. Most compositions are for two or three voices, and all are on secular subjects, written in three of the most important Italian musical/poetic forms: madrigal, ballata, and caccia. Composers represented in the manuscript are known to have worked in important north Italian courts such as Milan, Ferrara, Venice, and Florence.

MADRIGAL. Although the madrigal is one of the dominant musical/poetic forms in late medieval Italy, its origins and even the meaning of the word itself are

unclear. (The medieval madrigal should not be confused with the late Renaissance form.) Several theories have, however, been put forward. Its verse-refrain format suggests a possible relationship with dance forms, although what that might be is not certain. In any case its subject matter is usually a pastoral love theme, although there are some with strong political references. A typical madrigal format is in two musical sections—one for the verse and one for the refrain (ritornello).

BALLATA. The name *ballata*, from *ballare* (to dance), makes the original purpose of this form quite clear. In fact, one of the most striking images of the ballata in fourteenth-century Italian society can be found in Giovanni Boccaccio's *Decameron*, a collection of 100 fictional tales told by ten young people assembled in a

lines in length) and verses (one line each) go back and forth between the two sections of music with three repetitions of the first tune in the middle of the song, so that the order is as follows: Music A (refrain line one), Music B (refrain line two), Music A (first verse), Music A (refrain line one), Music A (second verse), Music B (third verse), Music A (refrain line one), Music B (refrain line two):

Musical Sections	A	B
Poetic lines	1. refrain	2. refrain
	3. verse	
	1. refrain	
	5. verse	6. verse
	1. refrain	2. refrain

Ballade Form

Verses in the French ballade generally ranged from 4 to 6 lines in length; the refrain was shorter, so as to combine with a half-verse on the second singing of musical section B.

Musical Sections	A	B
Poetic lines	1. verse	
	2. verse	
		3. verse
		4. half-verse and refrain

Virelai Form

In the virelai, another French form, the refrain, sung only to melody A, is sung at the beginning of the song and then again following the three verses of each stanza.

The first two verses are sung to the second melody (B), and the third verse uses the melody of the refrain (A).

Musical Sections	A	B
Poetic lines	1. refrain	
		2. verse
		3. verse
	4. verse	
	1. refrain	

Madrigal Form

The format of a madrigal, an Italian form, is fairly simple: the two verses, which are similar in length, are sung to the A melody, and the ritornello, which usually has fewer lines of text, has its own melody (B).

Musical Sections	A	B
Poetic lines	1. verse	
	2. verse	
		3. ritornello

Ballata Form

The Italian ballata form is exactly the same as the French virelai.

Musical Sections	A	B
Poetic lines	1. refrain	
		2. verse
		3. verse
	4. verse	
	5. refrain (same text as 1)	

country home to avoid the plague. In the story, each of the refugees is called upon every evening after dinner to improvise a ballata while the others dance. The ballata is in the verse-refrain form with two musical sections and the subject matter is always love.

CACCIA. The *caccia* (hunt) is usually written as a single melodic line that becomes polyphonic when a second voice enters after the first, singing the same music (see "Complexities" above). A few of these compositions have a textless accompanying part, but the form in all of them is a single verse without a refrain. The texts, although superficially about hunting, fishing, market scenes, and fires, usually carry a double meaning that is revealed only when the words of one phrase are interspersed among those of another during performance.

FRANCESCO LANDINI. Because the Squarcialupi Codex is retrospective, it includes compositions in the older Italian style with long, flowing, elaborate passages, as well as those composed later in the century by Francesco Landini. These are written with shorter, less elaborate phrases, demonstrating the strong influence of the French style. By the mid-fifteenth century, French culture had made such strong inroads into Italy that Italian courts began to import northern composers, performers, and repertory in preference to employing native musicians. Italian performers and composers continued to be hired in Italian courts throughout the fifteenth century, but the most prestigious positions were given to the northerners. It is worth noting that the motets commissioned for some of the most significant people

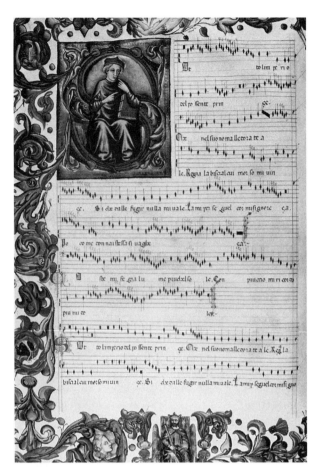

Page from Squarcialupi Codex, 1320. THE GRANGER COLLECTION, NEW YORK.

and events in Italy were written by northerners, as, for example, by Johannes Ciconia for Michele Steno, Doge of Venice, in 1406; by Bertrand Feragut for Francesco Malpiero, Bishop of Vicenza, in 1433; and by Guillaume Dufay for the consecration of the Cathedral of Florence in 1436 (see below).

SOURCES

Viola L. Hagopian, *Italian Ars Nova Music: A Bibliographic Guide to Modern Editions and Related Literature.* 2nd ed. (Berkeley: University of California Press, 1973).

Christopher Page, *The Owl and the Nightingale: Musical Life and Ideas in France 1100–1300* (Berkeley and Los Angeles: University of California Press, 1989).

———, *Voices and Instruments of the Middle Ages* (London: J. M. Dent and Sons, 1987).

Reinhard Strohm, *The Rise of European Music, 1380–1500* (Cambridge, England: Cambridge University Press, 1993).

Kurt von Fischer, *Studien zur italienischen Musik des Trecento und frühen Quattrocento* (Bern, Switzerland: P. Haupt, 1956).

SEE ALSO *Dance: Popular Dances; Dance: Additional Dance Types*

DUFAY AND THE LATE MEDIEVAL CEREMONIAL MOTET

MUSIC FOR SPECIAL OCCASIONS. In addition to its role as the leading format for new and creative experiments, in the fourteenth century the motet expanded its prominence as the composition of choice for the most important occasions. From its origin it was written with a particular function in mind; the form had the flexibility of being appropriate in both sacred and secular settings, and, as the accepted vehicle for the most avant-garde experiments as well as the most sophisticated technical devices, it was suitably elegant to commemorate even the most special affair. From the mid-fourteenth century, a dedicatory or ceremonial motet was the logical form to be adopted by composers who were called upon to set texts celebrating events such as coronations of kings, weddings of nobles, elevation of cardinals, or other such monumental occasions, both sacred and secular.

NUPER ROSARUM FLORES. One such special occasion that called for a ceremonial motet was the dedication of one of the finest cathedrals in Italy. Guillaume Dufay's motet *Nuper rosarum flores* (Recently Roses Blossomed), written for the consecration of Santa Maria del Fiore, the cathedral in Florence, deservedly has become one of the most celebrated compositions of the late Middle Ages. It is a musical masterpiece and exhibits the kinds of sophisticated techniques that were employed by composers to mark such important ceremonies. New construction for the Cathedral of Florence was begun around the year 1300 as an expansion of the older and much smaller Church of Santa Reparata. Construction continued throughout the fourteenth century but could not be completed until the architect Filippo Brunelleschi was able to work out a design for the enormous dome. When this work was finally done, Pope Eugenius IV presided over the consecration of the cathedral on 25 March 1436, with Dufay, Brunelleschi, and numerous other dignitaries in attendance. Dufay's motet to honor the occasion is an excellent example of the kind of sophistication that was built into both the text and music in these symbolic works.

TEXT AND MELODY. The tenor of *Nuper rosarum* is appropriately chosen from the antiphon for the consecration of a church, *Terribilis est locus iste*—"Redoubtable is this place," referring to the unholiness of the edifice prior to its consecration to God. The text of the upper two voice parts is a Latin poem in four stanzas that was

written specifically for the occasion; it refers to the dedication of the cathedral and the city of Florence, mentions Pope Eugenius as the successor of Jesus Christ and Saint Peter, and makes allusions to the Temple of Jerusalem erected by King Solomon. The musical construction is for four voices in four sections that do not coincide with the text stanzas; each section moves at a different pace. The two upper voice parts—the only parts with text—have a continuous flow of melody without repetition. They trace separate rhythmic patterns and do not sing the same words at the same time except for the name of the pope, "Eugenius," which is also set off from the surrounding material by sustained notes. The lower two parts are in strict isorhythm, having a single melody that is repeated for each of the four sections. These two parts—called "tenor I" and "tenor II"—have the same melody, but are performed at different pitches and do not begin or end at the same time. They are written out only once with the four different tempos indicated by mensural signs (see *canons* above).

SYMBOLIC RATIOS. The construction of the motet and its text also incorporates some complex symbolism involving references to the Temple of Solomon that are present in the text and represented in the proportions and ratios of the musical construction; Dufay's tempos for the four sections of the motet are in the ratio 6:4:2:3, which match the dimensions of Solomon's Temple, given in the Bible (I Kings 6:1–20) as 60 x 40 x 20 x 30. *Nuper rosarum flores* is a classic assembly of medieval motet techniques, incorporating the complex musical features as well as the sophisticated textual and symbolic ingredients that mark this form throughout the late Middle Ages.

SOURCES

Julie E. Cumming, *The Motet in the Age of Dufay* (Cambridge, England: Cambridge University Press, 1999).

David Fallows, *Dufay*. Rev. ed. (London: J. M. Dent, 1987).

Reinhard Strohm, *The Rise of European Music, 1380–1500* (Cambridge, England: Cambridge University Press, 1993).

Craig Wright, "Dufay's *Nuper Rosarum Flores*, King Solomon's Temple, and the Veneration of the Virgin," *Journal of the American Musicological Society* 47 (1994): 395–441.

GUILLAUME DE MACHAUT'S MESSE DE NOSTRE DAME

A UNIFIED MASS. Sometime before 1365 the French poet and cleric Guillaume de Machaut composed a new work including the five sections of the Mass Ordinary—

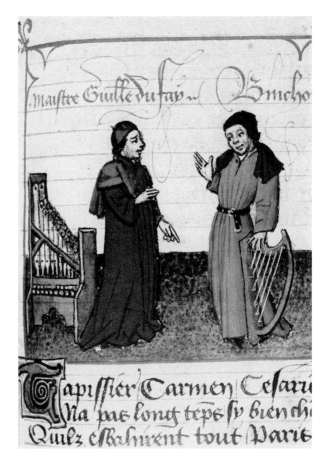

Two composers Guillaume Dufay and Gilles Binchois. Martin Le Franc, *Le Champion des dames*, Paris, Bibliothèque nationale MS fr. 12476, 1451. THE ART ARCHIVE.

Kyrie, Gloria, Credo, Sanctus, Agnus—plus the dismissal, the Ite Missa Est ("Go, the Mass is done"). As a point of unification, the composer selected relevant chants for each section as the borrowed tenor of each movement (that is, a Kyrie chant for his Kyrie, and so on). Each of these came from chants that were assigned for feasts in honor of the Blessed Virgin. In doing this he created the earliest unified set of Mass Ordinary movements. What is unusual about this concept, in addition to the fact that there is no similar model on the level of the chant practices, is that in the celebration of the Mass, with the exception of the Kyrie and Gloria, the items of the Ordinary are separated from one another by a number of different prayers and chants, that is, they are not performed one after the other as in a modern-day concert performance, and therefore to think of these Mass items on the level of an artistic whole is to impose an abstract artistic idea on something that had never been considered from that point of view. The original intention for creating this rather unusual assembly of polyphonic movements was for use at the special mass

in honor of the Virgin Mary (the *Messe de Nostre Dame* or "Mass of Our Lady"), which since 1341 had been celebrated on Saturdays in one of the chapels in Reims Cathedral, where Machaut was a canon (a member of the clergy on the permanent staff). Later, however, in conformity with the wills of both Guillaume and his brother Jean (who also was a canon at the cathedral), the mass was transformed into a memorial service for the two of them following their deaths (Jean in 1372, Guillaume in 1377).

STYLE, FUNCTION, AND FORM. The individual movements of the Mass of Notre Dame employ two distinctly separate structural models and styles, dictated at least in part by the function and form of the movement itself. For the four movements with relatively small amounts of text—Kyrie, Sanctus, Agnus Dei, and Ite Missa Est—Machaut chose the style he used in his elaborate motets: the upper lines proceed with more or less independent rhythmic motion and long rhapsodic (that is, somewhat irregular and richly decorative) melodic sections over a tenor set in isorhythm (see above, "Complexities"). Unlike his motets, however, there is only a single text in each movement, which is sung by all four voices. The texts of both Gloria and Credo are quite lengthy, and therefore Machaut set these movements in a style reminiscent of the earlier discant style (see above, "Notre Dame Organum") having short phrases, similar rhythmic motion in all parts, and a low ratio of notes per syllable of text, both ending with long, rhapsodic sections for the final word, "Amen." An additional feature of the Mass of Notre Dame was that it was for four voices rather than the more common three; Machaut added a voice called *contratenor* (meaning "against the tenor") that moved in the same low range as the tenor part, sometimes replacing it as the lowest voice.

INNOVATION AND INFLUENCE. Machaut's innovations, both the assembling of a complete set of Ordinary movements and the expansion to four-voice texture, became an important influence on sacred musical composition for the next several hundred years. One additional detail also was copied by most composers to follow him; in setting the phrase "Et incarnatus est" ("and He was made flesh") in the Credo, Machaut abruptly stops the motion in all parts so that each syllable is sustained, and then returns to the previous pace, thus drawing attention to a key Christian belief. Although the techniques and styles have changed over the centuries, the concept that originated in the late Middle Ages of a single composer organizing all of the Ordinary movements of a mass into an artistic whole persists to the present day and includes such universally acclaimed contributions as Johann Sebastian Bach's Mass in B Minor.

SOURCES

Gilbert Reaney, *Machaut* (London: Oxford University Press, 1971).

Anne Walters Robertson, *Guillaume de Machaut at Reims: Context and Meaning in his Musical Works* (Cambridge, England: Cambridge University Press, 2002).

THE CYCLIC MASS TRADITION: MISSA CAPUT

SHARED MUSICAL MATERIAL. The term "cyclic mass" refers to a mass in which all five movements have musical material in common. One of the earliest is the *Missa Caput* in which all movements are composed over the same section of chant—a long, rhapsodic passage on the word *caput* (head), the last word in the Holy Thursday chant *Venit ad Petrum*. The anonymous English composer of this work assigns the chant to the tenor part of each of the five movements, and further unifies the movements by beginning each of them with the same small melodic-rhythmic motif.

THE CONTRATENOR BASSUS. The Caput Mass also displays another technique that was more and more becoming the norm in all polyphonic composition: writing the fourth voice part below the tenor rather than above it, creating the *contratenor bassus* ("against the tenor but lower," later known simply as the bass part). The technical implication of this change is substantial, since it is the lowest voice that governs the harmony. When the tenor voice was the lowest, it was the borrowed material that played a substantial role in determining the harmonic content of the composition. By adding a lower, newly composed voice part, the composer had far more control of the harmonic flow of the composition.

ABSTRACT RELATIONSHIPS. The *Missa Caput* probably was written in the 1440s, and it was immediately followed by many more cyclic masses, including two additional masses using the same borrowed tenor. It is interesting to note that while the *Missa Caput* is organized around a tenor melody borrowed from the liturgy, the relationship between the borrowed material and the use to which it is put is far more abstract than when the relationship is direct—that is, when a Kyrie chant is borrowed as the basis for a polyphonic Kyrie, as in the Machaut Mass (see above). The Caput chant, on the other hand, is not from any of the parts of the Ordinary, and therefore it is foreign to each of the sections where it is employed as a controlling and unifying device. Once the model had been set for this kind of abstract relationship, composers felt free to choose their

organizing material from any kind of sacred or even secular source: *Missa Ave maris stella* ("Hail, Star of the Sea"), based on a hymn, took its place next to *Missa L'Homme armé* ("The Armed Man"), on a popular tune, and Guillaume Dufay's *Missa Se la face ay pale* ("If My Face Is Pale"), on a love song also written by Dufay.

SOURCES

Manfred F. Bukofzer, *Studies in Medieval and Renaissance Music* (New York: W. W. Norton, 1950).

Richard Hoppin, *Medieval Music* (New York: W. W. Norton, 1978).

MISSA SE LA FACE AY PALE

SECULAR ELEMENTS IN THE SACRED REPERTORY. In 1434–35, while Guillaume Dufay was first in the service of the duke of Savoy, he wrote a chanson, *Se la face ay pale*, thought to be in honor of Anne de Lusignan, who was the duchess of Savoy (part of the kingdom of Burgundy). Although his whereabouts prior to 1452 are unknown, it is clear that he lived in Savoy between 1452 and 1458, and among the many compositions he wrote for various occasions was a cyclic mass, the *Missa Se la face ay pale*, based on the tenor of the earlier chanson. One can only guess at what might have been the very special significance the earlier chanson had for the Savoy court.

PUNNING RHYMES. The text of the chanson is an unusual ballade because instead of the usual lines of eight or ten syllables, *Se la face ay pale* has only five, in a complicated format known as *équivoquée* (punning rhyme). Unfortunately, the numerous puns (pale/principale, amer/amer/la mer, voir/voir/avoir) in the text do not translate from French to English, but it is possible nonetheless to get an idea of the difficulty of this format from observing the range of meanings that are created from words with almost identical sounds.

Se la face ay pale
La cause est amer. ["amer"=love]
C'est la principale,
Et tant m'est amer ["amer"=bitter]
Amer, qu'en la mer ["amer"=to love, "la mer"=the sea]
Me voudroye voir.["voir"=see]
Or scet bien de voir ["de voir"=truly]
La belle a qui suis
Que nul bien avoir ["avoir"=have]
Sans elle ne puis.

If my face is pale
the reason is love.

That is the main cause,
and love is so bitter
for me that I wish to
drown myself in the sea.
So she can truly know,
the fair one to whom I belong,
that I cannot have any joy
without her. [two more stanzas]

Dufay's musical setting of the chanson text is also unusual in that he wrote a continuous single unit of music with short phrases rather than the usual format with two sections and longer melodic phrases.

FAST AND SLOW. In writing the *Missa Se la face ay pale*, Dufay borrows only the tenor line, which he places in the tenor voice in all five movements. In the shorter movements (Kyrie, Sanctus, and Agnus Dei), the chanson melody closely resembles the tenor part of earlier motets, moving at a much slower pace than the other three voices, thereby calling attention to itself. In both the Gloria and Credo, Dufay extends this idea by employing yet another motet-like technique: he repeats the chanson melody in the tenor at three speeds, beginning it three times slower than the other parts, then twice as slow, and finally at the same speed as the other voices. Borrowing a technique employed in the *Missa Caput*, Dufay further unites the movements of his mass by beginning each of the five movements with the same opening melodic-rhythmic motif.

SOURCES

David Fallows, *Dufay*. Rev. ed. (London: J. M. Dent, 1987).

Reinhard Strohm, *The Rise of European Music, 1380–1500* (Cambridge, England: Cambridge University Press, 1993).

THE MECHANICS OF MUSIC: SCALES AND TREATISES

THE MEDIEVAL SCALES. The medieval musical scales were called modes, which were described by their ranges, the location of the half-steps, the important pitches used at the beginning and end of the composition, and the "reciting tone"—the pitch used for recitation in psalms (see Plainchant, Psalms). During the Middle Ages there were eight modes, grouped into four pairs (this was enlarged to six pairs in the sixteenth century, and reduced to two—the major and minor scales presently in use—in the eighteenth century). Each mode was known by its number and by a Greek name. The names chosen were those of ancient Greek tribes that

a PRIMARY SOURCE document

AN EXAMPLE OF MUSICAL BORROWING

INTRODUCTION: The love song "Se la face ay pale" ("If my face is pale ...") was originally written by Guillaume Dufay for the Savoy court in 1434–1435. Later he used the tenor line of the same song as the basis for an entire mass. The examples below show the opening section of the love song or *chanson*, followed by an excerpt from *Gloria* where the tenor line of the mass (third line down) is borrowed from the tenor line of the chanson (the line on the bottom).

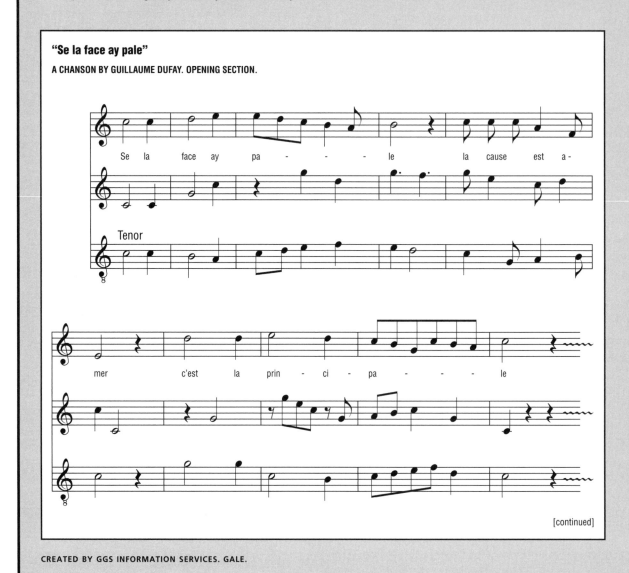

"Se la face ay pale"

A CHANSON BY GUILLAUME DUFAY. OPENING SECTION.

Se la face ay pa - - - le la cause est a-

Tenor

mer c'est la prin - ci - pa - - le

[continued]

CREATED BY GGS INFORMATION SERVICES. GALE.

were believed to have exemplified the emotional character of that mode. Although the system of modes was originally invented to describe and control monophonic music, it was also applied to the polyphonic repertory. In both techniques, modal considerations dictated many decisions concerning choices of notes and harmonies to be put in important structural places in the compositions. The importance of understanding the modes to a medieval composer and performer can be seen in that a detailed discussion of modes constituted a major portion of most theory treatises of the period.

THEORETICAL TREATISES. Much of our understanding of the thinking of medieval musicians, especially composers, comes from the theoretical treatises, books of instruction that provide details about the practice of writing music. The treatises are by and large ret-

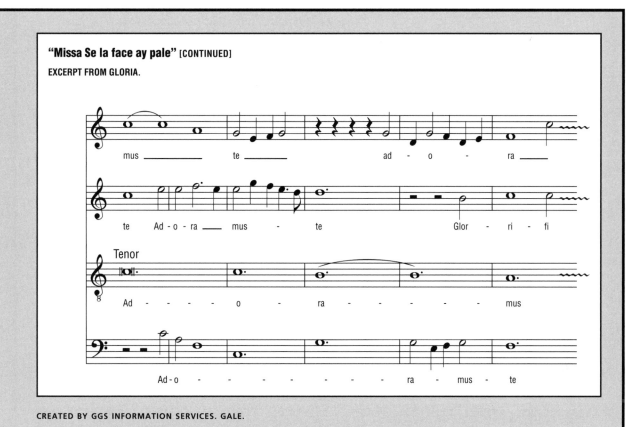

"Missa Se la face ay pale" [CONTINUED]

EXCERPT FROM GLORIA.

CREATED BY GGS INFORMATION SERVICES. GALE.

rospective in that they usually report or explain current practice, rather than propose anything new. The theorists, many of them university professors and/or monks, observed the changes taking place as practices evolved over the centuries and attempted to explain them (or in some cases, condemn the changes). By looking at what issues absorbed their attention, we can follow the revisions in technique that underlay the various compositional practices.

PRACTICAL VERSUS INTELLECTUAL THEORY. When people in the Middle Ages discussed music in learned writings, they made a clear separation between the intellectual consideration of the art and the practical, with the practical (that is, music itself) left mostly to practitioners, and usually thought to be unworthy of intellectual discussion. Throughout the period, music was included as one of the seven liberal arts, placed in the *quadrivium* (four ways) alongside the mathematical arts of arithmetic, geometry, and astronomy, rather than in the *trivium* (three ways) with the verbal arts of grammar, rhetoric, and logic. Its placement indicates the way in which music was addressed: number, ratio, and proportion were actually what was considered under the subject-heading, based on the study of vibrating bodies (for

example, by dividing a vibrating string in the middle, it would vibrate at twice the speed, the ratio of 2:1). Later, these ratios influenced the consideration of perfect and imperfect intervals. Another, more philosophical or theological consideration of music was to divide it into three areas: *musica mundana, musica humana,* and *musica instrumentalis. Musica mundana* (music of the Spheres) referred to the harmony caused by the motion of heavenly bodies. *Musica humana* (music of humans) was the harmony within the human body, having to do with the balance of physical elements. *Musica instrumentalis* (instrumental music) referred to actual sounds, either sung or made by instruments. This division of music was discussed to some extent in most medieval treatises, ending in the late thirteenth century, when *mundana* and *humana* were finally dropped from the discussion following their rejection by Johannes Grocheio in his *De musica* (c. 1300), one of the earliest treatises to concentrate on the practical detail of music and the first to consider secular music, including dance.

HARMONY AND INTERVALS. Practical theorists during the Carolingian era (eighth to tenth centuries) were frequently concerned with the modes (see next page), attempting to regularize the practice and to explain

MEDIEVAL
Modes

The medieval method of describing a melody was to classify it according to the scale used—its distribution of steps and half steps, its final, and its reciting tone. None of the medieval modes corresponds exactly to any of the major and minor scales used today. The sequence of steps and half-steps that differentiate the modes can be most easily described by relating them to the white notes of the piano keyboard.

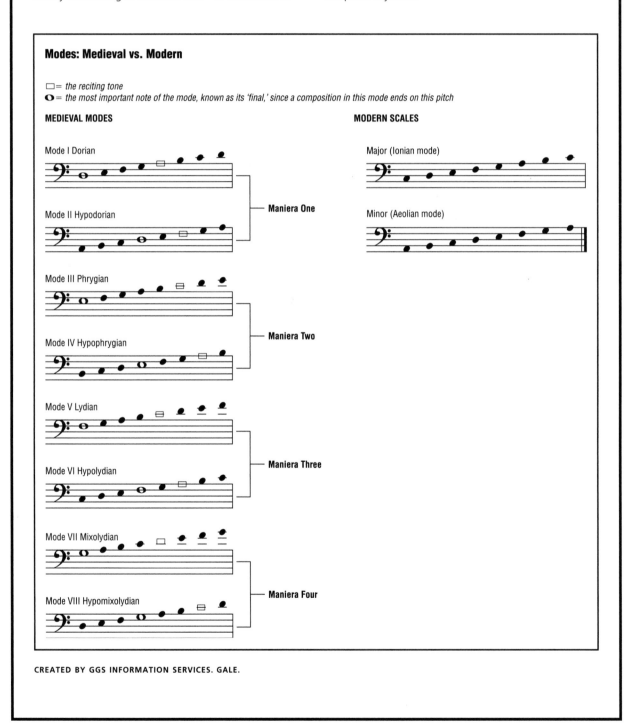

Modes: Medieval vs. Modern

□ = the reciting tone
𝅗𝅥 = the most important note of the mode, known as its 'final,' since a composition in this mode ends on this pitch

MEDIEVAL MODES

Mode I Dorian

Mode II Hypodorian

— **Maniera One**

Mode III Phrygian

Mode IV Hypophrygian

— **Maniera Two**

Mode V Lydian

Mode VI Hypolydian

— **Maniera Three**

Mode VII Mixolydian

Mode VIII Hypomixolydian

— **Maniera Four**

MODERN SCALES

Major (Ionian mode)

Minor (Aeolian mode)

CREATED BY GGS INFORMATION SERVICES. GALE.

certain chants that did not exactly fit the system. By the late ninth century, treatises begin to discuss polyphony—explaining the way in which different notes can be sounded together in harmony, classifying intervals (the distance between the pitch of two notes) as more or less harmonious according to the mathematical ratios of their vibration speeds. Those intervals whose ratios could be expressed in simple numbers were referred to as "perfect" (octave [a distance of eight notes on the diatonic scale, as in C to C], 2:1; fifth [a distance of five notes, as in C to G], 3:2; and fourth [a distance of four notes, as in C to F] 4:3); all other combinations of notes were considered dissonant to varying degrees. The classifications continued to undergo revisions throughout the remainder of the Middle Ages, with the fourth losing its status as a preferred interval, while the imperfect third became more and more accepted. Throughout the period the treatises explored the ways in which harmonies can be used to shape and control compositions.

THEORIES OF NOTATION. Once polyphony was well established in the twelfth century, the next new issue to appear in the treatises was notation, a topic that continues to occupy theorists down to the present day. The earliest notation recognized only three actual values: short, long, and a long that was the value of both the other two notes combined. The system allowed some freedom in the assignment of values to these notes, causing certain situations to be somewhat ambiguous. One of the earliest theorists to tackle the problem of ambiguity was Franco of Cologne, who in 1260 wrote *Ars cantus mensurabilis* ("The Art of Measured Song"), which assigns specific duration to each of the note shapes. The next step along this line was to add new flexibility to the system by subdividing the existing notes, which is the major subject of three different treatises written in Paris at the beginning of the fourteenth century: *Ars nova* ("The New Art") once credited to Philippe de Vitry, *Ars novae musicae* ("The New Musical Art") by Johannes de Muris, and *Speculum musicae* ("Musical Reflection") by Jacques de Liège. The systems they describe are highly sophisticated, allowing accurate notation of minute rhythmic variations and complicated combinations. At the same time as these changes were occurring in French music, Marchettus of Padua was explaining an Italian system that was quite different. In his two treatises from approximately 1320—*Lucidarium in arte musicae planae* ("Explanation of the Art of Unmeasured Music") and *Pomerium artis musicae mensuratae* ("Orchard-Garden of the Art of Measured Music")—Marchettus described a system of notation as well as a group of harmonic practices that set Italian notation and harmonies apart from the French. By the mid-fifteenth century, however, the

Italian composers had abandoned their own notation and adopted that of the French. Treatises from the end of the fifteenth century, such as those by Johannes Tinctoris, demonstrate that a single system of notation and harmonic practices was in use throughout Europe.

SOURCES

Hugo Riemann, *History of Music Theory*. Trans. Raymond Haggh (Lincoln: University of Nebraska Press, 1962).

SYSTEMS OF NOTATION

NEUMES. Before the invention of a system for notating music in the ninth century, music was passed on from one person to the next only by aural transmission—that is, melodies were carried only in the memory, and learned by repeated hearing. A new monk, for example, would spend hours every day for several years learning by rote memory all of the chant melodies for the entire liturgical cycle, taught by the *magister scholarum*—the director of music. The first system of notating music was developed sometime during the Carolingian era after 800 for the purpose of transmitting information about vocal performance, the nuances of a singing style. Although this led eventually to the notation system still in use today, it did not have the same purpose as modern notation, that of presenting the basic information about pitch and duration. The earliest notes, called *neumes*, required the reader to know the melody already—its pitches and its rhythms. The information provided by the neumes indicated performance details such as which sounds to separate and which to join together; when to sing a steady pitch and when to slide the voice. Although its appearance is quite startling to those of us acquainted with modern notes, the notation transmitted its message very clearly by graphically representing what the voice was to do:

a straight line ∕ signified to sing the note with a steady voice.

a curve ‿ indicated which way the voice was to slide.

a jagged line ⌇ directed the singer to move his voice rapidly back and forth from a lower to a higher note.

THE GUIDONIAN HAND. The next step in the development of notation came in answer to a desire on the part of the church leaders to speed up the learning of new material as well as to transmit the melodies more accurately. Over the centuries, the tradition of aural transmission had inevitably resulted in errors and variations in some of the melodies, and church officials wanted to

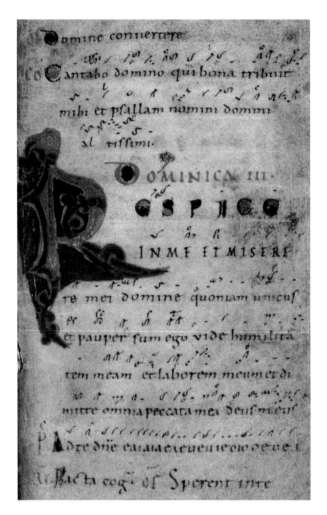

Unheightened Neumes, Music MS page, Einsiedeln. STIFTSBIBL, MS. 121, FOL. 26.

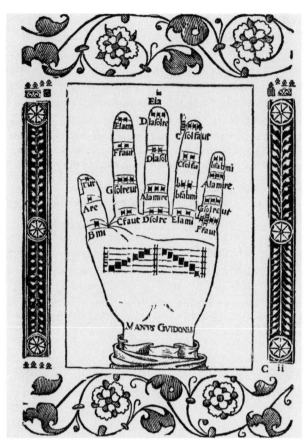

Guidonian Hand. Venice, Italy, 1547. BETTMANN/CORBIS.

standardize the repertory. The result was the placement of the neumes on a graph in which lines and spaces represented the notes of the singing scale. The first such experiment was by a clever monk named Guido, a *magister scholarum* in a Benedictine monastery in Arezzo, a small town in northern Italy. Guido's first invention was to assign the notes of the scale (mode) to the knuckles of his hand, so that by pointing to a particular knuckle he could direct the choir boys to sing a certain pitch. The "Guidonian Hand" caught on very quickly and even after the development of the staff it remained one of the easiest ways to teach chant, staying in use for hundreds of years.

LINES AND SPACES. Guido's next invention was to mark two parallel lines on paper, representing the pitches "c" and "f" which provided two exact places where the singer could orient his voice, with the other notes located either above or below these lines, graphically representing their relationship to the two known pitches. It is this

system that evolved over the next several hundred years to the system of five lines and spaces currently in use. The notation of rhythm followed a somewhat different path. Rhythm in the earliest notation was controlled by the syllables of the text: one syllable was one unit of measure. If there was only a single note for a syllable, it received the entire unit of measure; two or more notes for a syllable all shared the single unit of time. Eventually a system was developed in which the shape of the note indicated its value:

■ was long.

▐ was short.

◆ was shortest.

The basis of measure in this notation was its linkage to the heartbeat that was represented by the long note. The pace of the long note—its tempo—was declared to be the speed of the heartbeat of a healthy man at rest (approximately 60–80 beats per minute in modern terms). Although this system made it very easy to establish a basic tempo, in order to notate music that proceeded either slower or faster than the heartbeat required a complex set of neumes that were modified by stems, flags,

and colors, and a set of other symbols (mensural signs) that could reassign the heartbeat to a subdivision of the long note. This system was somewhat simplified after the fifteenth century, but remnants of it were still in use well into the time of the German composer J. S. Bach. It was eventually replaced by the modern system that developed after the invention of the metronome in the early nineteenth century.

SOURCES

Willi Apel, *The Notation of Polyphonic Music 900–1600.* 5th ed. (Cambridge, Mass.: Medieval Academy of America, 1953).

Timothy J. McGee, *The Sound of Medieval Song* (Oxford: Clarendon Press, 1998).

SIGNIFICANT PEOPLE
in Music

ADAM DE LA HALLE

c. 1240–c. 1285

Performer
Poet
Composer

THE LAST OF THE TROUVÈRES. Adam de la Halle (c. 1240–c. 1285) is considered to be the last of the trouvères, the poet-musicians of northern France who specialized in writing poems and songs of courtly love. He was born in Arras in northern France (Picardy) and later probably studied in Paris. Also known as "Adam le Bossu" (*bossu*= hunchback), he is known for having written one of the earliest recorded secular dramas in French, a 1,099-line satiric play (apparently intended for performance at a local festival) that ridicules character traits of some of the citizens of Arras. Manuscripts of this work include music since songs were a part of the play, which had little plot but was full of proverbs and puns. Sometime after 1276, Adam entered into the service of Robert II, the count of Artois, and accompanied him to Naples where he wrote a poem about Charles d'Anjou, king of Sicily. He was celebrated as a singer as well as a poet-composer, and may have performed at a royal feast in England. His compositions include works both in the traditional monophonic style of the trouvères and also in the newly emerging polyphonic style. He wrote a number of love songs and a 780-line work closely related to the pastourelle, the famous *Jeu de Robin et de Marion* (Play of Robin and of Marion).

SOURCES

The New Grove Dictionary of Music and Musicians. 29 vols. 2nd ed. Eds. Stanley Sadie and John Tyrrell (New York: Grove's Dictionaries, 2001).

BERNART DE VENTADORN

1147–1180 or 1217

Troubadour
Poet
Composer

A TROUBADOUR LOVER. Bernart de Ventadorn (c. 1147–1180 or 1217) is one of the numerous troubadours whose biographies come to us in *vidas*, stories of the poet/composers' lives that were included in the manuscripts along with their compositions. The accounts, which are known to be fanciful and are therefore highly suspect, record that Bernart was the son of servants in the castle of Eble II, viscount of Ventadorn (near Limoges). He fell in love with the lady of the castle about whom he wrote a number of songs, and was therefore banished from the castle. He next went to the Norman court of Eleanor of Aquitaine, again falling in love and composing songs in her honor until she left to become the wife of King Henry II of England. One theory is that at this point he stopped composing and joined a monastery. Another account suggests that he became abbot of the Benedictine monastery of Saint-Martin de Tulle and continued composing. Approximately forty of his poems survive, half of them with music.

SOURCES

Elizabeth Aubrey, *The Music of the Troubadours* (Bloomington: Indiana University Press, 1996).

GUILLAUME DUFAY

1397–1474

Poet
Composer

THE SACRED AND THE SECULAR. Guillaume Dufay (1397–1474) was born near Cambrai in northern France, where he is first recorded as a member of the cathedral choir in 1409. He became a priest and received a degree in canon law from the University of Bologna. Throughout his career he traveled widely, being associated with the court of Burgundy, the Papal Chapel, the duke of Savoy, and the Malatesta family in the Italian towns of Pesaro and Rimini. He was appointed a canon

(a member of clergy on permanent staff) of the Cathedral of Cambrai by Pope Eugenius IV, and he returned there at the end of his life. Dufay's compositions are widely considered to be among the finest creations of his generation. His works include settings of the Ordinary and the Proper of the Mass, Latin motets and hymns, and secular songs in Latin, French, and Italian. His Mass for St. Anthony of Padua may have been written for the dedication of Donatello's great altar in the Church of St. Anthony in Padua in 1450. He was one of the earliest to write cyclic masses based on non-sacred material: his *Missa Se la face ay pale* (1452) is based on a love song he had written earlier. Of the many outstanding compositions by Dufay, two of his motets are especially significant in terms of their commemorations. His *Nuper rosarum flores* was written in 1436 for the consecration of Santa Maria del Fiore, the Florence cathedral, on the completion of the dome by Fillipo Brunelleschi. *Lamentatio Sanctae Matris Ecclesiae* was written in 1454 on the occasion of the Banquet of the Feast of the Pheasant in Lille, in which Philip the Good, duke of Burgundy, pledged to recapture Constantinople and reunite the Holy Roman Empire. The borrowed tenor in this motet is from the Lamentations of Jeremiah in Latin, with a French text in the upper voices that glosses (that is, translates and explains) that of the tenor.

SOURCES

David Fallows, *Dufay*. Rev. ed. (London: J. M. Dent, 1987).

GUIDO OF AREZZO

990–1040

Monk
Music teacher
Music theorist

INVENTING WAYS OF WRITING MUSIC. Guido of Arezzo (c. 990–1040), a Benedictine monk living in a monastery in Arezzo (northeastern Italy), devised novel ways of teaching music. In order to teach young monks new chants much more quickly, Guido first invented a set of syllables for names of the steps of the scale: do, re, mi, etc. (the system, known as *solfège*, is still in use). Then he assigned the scale steps to the knuckles of his hand, so that by pointing from one knuckle to the next the boys would know what note to sing, a teaching device that lasted well into the seventeenth century and is known as The Guidonian Hand. His next invention was to write musical notes (neumes) on a graph consisting of two parallel lines with space between them, which would allow the accurate placement of notes to indicate

exact pitches. This was soon expanded to become the present-day staff of five lines and spaces. These inventions so impressed Pope John XIX that he invited Guido to come to Rome to explain them to him. In addition, his book *Micrologus* (Little Discussion) is considered to contain the final formation of the modal scale system, as well as having one of the earliest detailed discussions of music in more than one part (polyphony).

SOURCES

Warren Babb, *Hucbald, Guido, and John on Music: Three Medieval Treatises.* Ed. Claude Palisca. Music Theory Translation Series, 3 (New Haven, Conn.: Yale University Press, 1978).

HILDEGARD OF BINGEN

1098–1179

Abbess
Author
Composer

THE FIRST FEMALE COMPOSER. Hildegard of Bingen (1098–1179) is the earliest known female composer, and possibly the most famous woman of her time. She was a member of a noble family near Spanheim in the Rhineland (modern Germany), and was educated at the Benedictine cloister of Disiboden. She was elected abbess in 1136, but in 1147 left Disiboden with eighteen other nuns and founded a convent at Rupertsberg in the Rhine valley near the town of Bingen. She was a prolific writer on subjects as diverse as science, medicine, and saints' lives, and during her own time was revered as a prophet and mystic. Her musical compositions include a number of sequences, antiphons, hymns, and other sacred forms for the feasts of women saints and the Blessed Virgin. She also is the author of the *Ordo Virtutum* (Play of Virtues), the earliest surviving morality play with music.

SOURCES

Peter Dronke, *Poetic Individuality in the Middle Ages* (Oxford: Oxford University Press, 1970).

FRANCESCO LANDINI

1325–1397

Organist
Composer

AN EMINENT ORGANIST AND COMPOSER. Francesco Landini (1325–1397) was the most renowned Italian composer of the fourteenth century. His father

was a painter and a member of Giotto's circle of artists in Florence. As the result of smallpox in his youth, Francesco was blind, an affliction that kept him from taking up the profession of his father but did not prevent him from pursuing a distinguished career as an organist, organ builder, singer, poet, and composer. He is described as poet, composer, and performer by Giovanni da Prato in his 1389 *Il Paradiso degli Alberti*: "He plays his love verses so sweetly that no one had ever heard such beautiful harmonies, and their hearts almost burst from their bosoms." Landini was buried in the Florentine Church of San Lorenzo, where his tombstone depicts him holding a portative organ, one of the symbols of a revered musician. He is similarly portrayed in a miniature illumination in the Squarcialupi Codex, one of the most important sources of late medieval Italian music. His compositions were all secular and almost all in a single form, the *ballata*, written for two and three voices. In addition to having written excellent musical compositions, Landini was influential in the adoption of the French compositional style by Italians.

SOURCES

The New Grove Dictionary of Music and Musicians. 29 vols. 2nd ed. Ed. Stanley Sadie and John Tyrrell (New York: Grove's Dictionaries, 2001).

GUILLAUME DE MACHAUT

c. 1300–1377

Cathedral canon
Poet
Composer

COURT AND CHURCH. Guillaume de Machaut (c. 1300–1377) was the most famous and influential French composer and poet of the fourteenth century. As his name indicates, Guillaume was born in Machaut, a small town in northern France. He was educated in Rheims, entered the priesthood, and in 1323 was employed as secretary to King John of Bohemia, traveling with him to many parts of Europe. Following John's death in 1346, Guillaume served at some of the most influential courts in France, including those of Charles, king of Navarre; Jean, duke of Berry; and Charles, duke of Normandy (later King Charles V). He eventually retired to the position of canon (a member of the clergy on permanent staff) at Rheims Cathedral.

MOTETS, DITS, AND POPULAR GENRES. Machaut contributed significant poetry and musical compositions in nearly every genre of the period including the newest, most advanced forms as well as the most traditional. He wrote music in both the monophonic and polyphonic styles, with compositions for sacred occasions as well as motets for secular ceremonies and love songs. Much of the subject matter of his secular work is heavily influenced by the *Roman de la Rose* (Romance of the Rose), the long allegorical poem from the thirteenth century by Guillaume de Lorris and Jean de Meun. His largest secular compositions (known as *dits*) are sets of poems and musical compositions that contain idealized characters, issues, and situations from the courtly love tradition. The longest of these, the *Livre dou voir dit* (True Story), thought to be somewhat autobiographical and written in his later years, concerns a love affair between a young girl, Péronne d'Armentières, and an aging poet. Another dit, the *Remede de Fortune*, includes seven musical compositions, each in a different form, probably intended to provide a model of each of the most popular genres of the period.

AN INNOVATIVE MASS. Machaut's *Messe de Nostre Dame* (Mass of Our Lady) is outstanding and unusual for a number of reasons: it is in four voice-parts throughout (at a time when three-part writing was far more common); the individual movements are much longer than comparable movements of other composers of the time; and it is the first known composition of the movements of the Mass Ordinary by a single composer intended to be performed intact, an idea that would become popular nearly 100 years later. At the end of his life Guillaume assembled all of his compositions into a set of manuscripts, grouping the compositions by formal type.

SOURCES

Gilbert Reaney, *Machaut* (London: Oxford University Press, 1971).

Anne Walters Robertson, *Guillaume de Machaut at Reims: Context and Meaning in his Musical Works* (Cambridge, England: Cambridge University Press, 2002).

NOTKER BALBULUS

840–912

Monk
Historian
Composer

THE FIRST MEDIEVAL COMPOSER. Notker Balbulus (c. 840–912), the earliest known composer, was a monk at the Benedictine Abby of Saint-Gall in Switzerland who wrote history and poetry. Notker (his name Balbulus means "the stutterer") wrote poems and accounts of the lives of a number of saints. His rather idealized history of the life of Charlemagne (*The Deeds of Charles the*

Great) is still consulted as an historical document. His most important contribution to music was the *Liber Hymnorum* (Book of Hymns) which contains a set of 33 sequences that he composed. These were some of the first of what became standard additions to the Alleluia chant in the Mass. According to Notker, his models were from an antiphoner (liturgical book containing antiphons and other items) that was brought to Saint-Gall in 860 by a monk fleeing from the monastery of Jumièges (in northwest France), which had been attacked by the Normans. Notker's sequences were sung throughout Europe until the sixteenth century.

SOURCES

The New Grove Dictionary of Music and Musicians. 29 vols. 2nd ed. Ed. Stanley Sadie and John Tyrrell (New York: Grove's Dictionaries, 2001).

PHILIPPE DE VITRY

1291–1361

Poet
Bishop
Royal advisor

THE NEW ART. Philippe de Vitry (1291–1361) was a poet and composer who taught at the University of Paris, held administrative positions at the French royal court as advisor to kings Charles IV, Philip VI, and John II, and in his later years was Bishop of Meaux. He was once credited with authorship of the treatise *Ars Nova* (New Art), which provided new techniques for writing sophisticated rhythms, paving the way for far more complex musical structures that were soon explored in all of the polyphonic forms, especially in motets. Although Philippe probably did not write the treatise, he was highly influential in the development and teaching of its techniques, and it is likely that he invented the isorhythmic motet and contributed to the dominance of the chanson forms in fourteenth-century French secular music. He was highly regarded as a composer, teacher, and poet during the fourteenth and early fifteenth centuries. Only a few of Philippe's compositions have survived, two of which are musical insertions in the poem *Roman de Fauvel* by Gervais de Bus and Chaillou de Pesstain.

SOURCES

A. Colville, "Philippe de Vitry: Notes Biographiques," *Histoire Littéraire de la France.* Vol. 36 (Paris: Imprimerie Nationale, 1925): 520–547.

Ernest H. Saunders, "Philippe de Vitry," in *The New Grove Dictionary of Music and Musicians.* Vol. 20. 2nd ed. Ed.

Stanley Sadie and John Tyrrell (London and Washington, D.C.: Macmillan, 1980): 22–28.

PIETROBONO DE BURZELLIS

1417–1497

Musician
Poet

THE GREAT IMPROVISOR. Pietrobono de Burzellis (1417–1497) was one of the earliest musicians to be recognized as a performer. His fame rested on his technical virtuosity as a lutenist, his beautiful singing voice, and his skill as an improvisor. He was frequently referred to as Pietrobono del Chitarino, a reference to his improvised singing with the lute (a pear-shaped instrument related to the guitar), which was thought to be a modern version of the classical Greek musical practice of singing to the ancient kithera. He was praised by a number of humanist writers including Aurelio Brandolino Lippi, Battista Guarino, Filippo Beroaldo, Paolo Cortese, and Raffaello Maffei, and his image was immortalized on medals, an honor usually reserved for the nobility. He was a native of Ferrara and served at that court throughout the century, entertaining the most important heads of state. By mid-century his fame brought him numerous invitations to other courts; he is known to have visited the courts of Milan, Naples, and Mantua, and in the 1480s he spent time in the service of Beatrice d'Aragona, the queen of Hungary. In an elaborate tribute written in 1459, the poet, humanist, statesman, and dancing master Antonio Cornazano described his performances by comparing him to Apollo and Orpheus, and claiming that "his music rivals the heavenly harmonies, can revive the dead, turn rivers and stones, and even change people into statues." Because his artistic creations were improvised, nothing is preserved.

SOURCES

Lewis Lockwood, "Pietrobono and the Instrumental Tradition at Ferrara in the Fifteenth Century," *Rivista Italiana di Musicologia* 10 (1975): 115–133.

WALTHER VON DER VOGELWEIDE

c. 1170–c. 1230

Composer
Poet

A FAMOUS MINNESINGER. Walther von der Vogelweide (c. 1170–c. 1230) was one of the most famous of the minnesingers. Most of what is known about him

comes from his own songs where he describes himself as having come from a minor aristocratic family in the area near Vienna. He worked for a number of different dukes, and for three emperors, including Frederick II. Most of his songs are on the usual topics that were popular in all courtly circles—love, politics, and nature—but he also wrote about proper behavior and etiquette. Near the end of his life he composed an elegy in which he looks back over his life, wondering where all the years had vanished and thinking that it was perhaps all a dream. He was immortalized in a manuscript miniature that depicts him as a poet deep in thought.

SOURCES

Ronald J. Taylor, *The Art of the Minnesinger: Songs of the Thirteenth Century Transcribed and Edited with Textual and Musical Commentaries* (Cardiff: University of Wales Press, 1968).

DOCUMENTARY SOURCES
in Music

Ars Nova or *The New Art* (1320)—This treatise, once thought to be written by Philippe de Vitry, is one of three important treatises on music (along with *Ars Novae Musicae* by Johannes de Muris, and *Speculum Musicae* by Jacques de Liège) that dealt with new trends in music composition involving refinements in notation.

The Cantigas de Santa Maria (c. 1250)—This collection contains more than 400 songs from the court of Alfonso X "el Sabio" (the Wise), king of Castile.

Carmina Burana or *Songs of Benediktbeuern* (c. 1290)—This large collection of Latin songs from the south German monastery of Benediktbeuern includes texts on serious religious subjects, love songs, and drinking songs, some of them in German.

Guillaume Dufay, *Nuper rosarum flores* (1436), *Missa Se la face ay pale* (1452)—The works of this composer, which are considered among the finest of his generation, include a motet that was written for the dedication of the cathedral in Florence upon completion of its dome and one of the earliest polyphonic mass settings to employ a secular theme as the central point of organization.

The Fleury Play Book (c. 1230)—Manuscript 201 in the Bibliothèque Municipale of Orléans, France, contains the largest known collection of extended liturgical dramas.

Franco of Cologne, *Ars cantus mensurabilis* or *The Art of Measured Song* (c. 1260)—This music treatise assigns specific duration to each of the note shapes, setting the stage for further developments in notation.

Gervais de Bus and Chaillou de Pesstain, *The Roman de Fauvel* (1316)—This long poem includes numerous musical compositions including several motets that reflect the new French notation.

Hucbald, *De harmonica institutione* or *Melodic Instruction* (900)—This music treatise, written by a monk at the Benedictine Monastery of Saint-Amand in Flanders, describes the modal scale system in detail and discusses the concept of polyphony.

Guillaume de Machaut, *Messe de Nostre Dame* (1364)—This work by the most famous and influential French composer and poet of the fourteenth century is one of the first polyphonic settings of six parts of the Mass Ordinary and the first known composition of the movements of the Mass Ordinary by a single composer intended to be performed intact, an idea that would become popular nearly 100 years later.

Magnus liber organi (c. 1200)—This collection of polyphonic sacred music for the important feasts of the liturgical year, which contains the compositions of Leonin and Perotin, was compiled in Paris and circulated throughout Europe.

Marchettus of Padua, *Lucidarium in arte musicae planae* or the *Explanation of the Art of Unmeasured Music* (1318), *Pomerium artis musicae mensuratae* or *The Orchard-Garden of the Art of Measured Music* (1320)—These two important treatises deal with Italian notation and harmonic practices.

Missa Caput (1440)—This earliest complete set (cycle) of Mass Ordinary movements was composed in England (composer unknown) using the same phrase of chant for the tenor part in each movement.

Musica enchiriadis or *Music Handbook* (c. 850)—This widely circulated treatise on music theory by an anonymous author is one of the earliest attempts to notate music. It includes the first written attempt at polyphony (music in more than one part).

Notker Balbulus, *Liber Hymnorum* or *Book of Hymns* (900)—This book of sequences for the Mass is the first to be written by a composer known by name.

chapter six

PHILOSOPHY

R. James Long

IMPORTANT EVENTS
in Philosophy

354 Augustine of Hippo, who successfully reconciles Neoplatonism and Christianity, is born.

525 Boethius, the "last of the Romans," whose book struggling with the problem of evil fortune will influence generations of medieval thinkers, is executed for treason.

800 Charlemagne, whose establishment of cathedral schools will usher in a reformation of learning, is crowned the first emperor of the Romans.

c. 875 John Scotus Eriugena, author of the first *summa* ("summary treatment") of theology, dies.

950 Alfarabi, a Muslim philosopher who first suggested the distinction between essence (what a thing is) and existence (that by which a thing is), dies in Baghdad.

1033 St. Anselm of Canterbury, who exhibited an "almost unlimited confidence" in the power of reason, is born.

1037 Avicenna, the most influential of Muslim thinkers, dies.

1085 The Christian reconquest of Toledo in Spain gives Western thinkers access to Arabic translations of Greek philosophy and science, including Aristotle, as well as Arab contributions to these disciplines.

1115 John of Salisbury, writer of the *Policraticus*, is born.

c. 1125 Distinctive schools of philosophical thought develop among scholars at Chartres and Paris.

1135 Moses Maimonides, the greatest Jewish thinker of the Middle Ages, is born in Córdoba, Spain.

1141 Peter Abelard's teachings are condemned at the synod of Sens for endangering the faith.

Hugh of St. Victor dies. He developed an elaborate program of the Seven Liberal Arts and their utility for philosophical investigation.

c. 1152 Peter Lombard's *Books of the Sentences* is published.

1153 St. Bernard of Clairvaux dies. Cistercian and preacher of the Crusades, he opposed what he saw as the excessive rationalism of Peter Abelard.

1198 The death of Averroës (Ibn Rushd) brings the Golden Age of Islamic philosophy to a close.

1209 Pope Innocent III approves the first Rule of St. Francis of Assisi; many of his followers (called Franciscans) will make significant contributions to scholastic philosophy and theology.

1210 The first prohibitions of the works of Aristotle are issued in Paris.

1217 The Order of Preachers (Dominicans) establish themselves in Paris, eventually producing such philosophical luminaries as St. Albert the Great and St. Thomas Aquinas.

1231 The papal bull *Parens scientiarum* is issued, which prohibits lectures on the natural philosophy of Aristotle at Paris.

1235 Robert Grosseteste leaves Oxford to become bishop of Lincoln, a diocese which included Oxford.

1255 All known works of Aristotle become required texts in the curricula at the University of Paris and Oxford University.

1267 Roger Bacon sends his *Opus maius* to the pope.

1273 Thomas Aquinas stops writing the *Summa theologiae*, claiming it was like "straw."

1274 Thomas Aquinas and Bonaventure, proponents of opposing views on the value of Aristotle, die.

1277 The Condemnation at Paris by the bishop of 219 mostly philosophical propositions brings to an end the Golden Age of medieval thought.

1280 St. Albert the Great, teacher of Thomas Aquinas, dies.

1284 Siger of Brabant, the Latin Averroist, dies.

1308 John Duns Scotus, the "Subtle Doctor," dies in Cologne.

1328 William of Ockham, the "Venerable Inceptor," whose critical thinking rocked the scholastic synthesis, flees the papal court at Avignon and places himself under the protection of Emperor Ludwig of Bavaria.

1329 Pope John XXII condemns as heretical some of the teachings of Meister Eckhart, who had died two years earlier.

1349–1350 The Black Death ravages Europe, hitting hardest in urban areas and decimating the universities. The plague will contribute to the end of medieval philosophy by claiming the lives of several philosophers.

1464 Cardinal Nicholas of Cusa, widely considered the last medieval philosopher, dies.

OVERVIEW
of Philosophy

DEFINING MEDIEVAL PHILOSOPHY. Philosophy is the discipline that inquires into the first causes and ultimate principles of things; in other words philosophers try to find the answer to the final "why"—why is there being, for example, rather than nothing? Representing the longest period in the long history of philosophy in the Western world, medieval philosophy is distinguished from speculative thought in other periods by more than mere chronology. Philosophers during this period were for the most part theologians who were attempting to integrate what their beliefs told them about God, about themselves, and about the world with what their reason told them.

FAVORABLE CONDITIONS. The story of philosophy in the Middle Ages also reveals two commonplace truths. First, the activity of rational inquiry requires a certain degree of economic and social well-being. Hunger and fear of violence render such an activity unimaginable. Hence, between the fall of the Western Roman Empire, or at least the death of the Roman philosopher Boethius in 524 or 525, and the relative peace and prosperity that resulted from the empire established by Charlemagne in the ninth century, there is virtually no written evidence of philosophical activity. Second, whenever the West came into contact with Greek thought in any of its many guises, philosophical activity flourished. There is an oral tradition in philosophy as in other disciplines, but for the most part the transmission of philosophical thought depends on the written word, and the written legacy left by the ancient world when Rome fell to Germanic tribes from the north was meager indeed: a Latin translation of part of Plato's late and perplexing dialogue, the *Timaeus*, a couple of pieces of Aristotle's *Logic* with commentaries, and some Seneca and Cicero.

PROBLEMS SUGGESTED BY FAITH. By the time philosophy reappeared, the context had changed. During the thousand-year period from approximately 500 to 1500, known by some historians as the Age of Faith, ultimate questions were now being asked by believers, and more specifically, believers in a sacred book, be it the Bible for Christians, the Torah for Jews, or the Koran for Muslims. This new approach entailed first a change in motivation for philosophizing, which was now the understanding of faith; it also entailed new and hitherto unconsidered problems, problems suggested by the text that was regarded by its adherents as the word of God. Can one, for example, demonstrate rationally the existence of the God of religious faith? How does one understand a Being who is regarded as infinite in all respects, or the problems associated with creation, the coming-into-being out of nothing, which seemed to violate an axiom of ancient Greek philosophy: "out of nothing comes nothing"? What is the meaning of human existence, and do the categories of good and evil necessarily entail the power to choose freely? Is there life after death? Many other issues may be cited.

RECONCILING FAITH AND REASON. Though St. Paul was suspicious of, if not hostile towards, pagan philosophy ("Beware the seductions of the philosophers," he tells the Colossians in one of his letters) and though a number of intellectuals in the early Christian Church were likewise opposed to the enterprise of reconciling faith and reason ("What has Athens to do with Jerusalem?" Tertullian asked rhetorically), it was the vision of the Christian philosopher Augustine that prevailed; as he writes in one of his dialogues: "To those who believed, [Jesus] said, 'Seek and you shall find'; for what is believed without being known cannot be said to have been found." With very few exceptions this subordination of reason to faith prevailed throughout the Middle Ages. Philosophy became, in the words of one twelfth-century writer, the *ancilla theologiae* (the serving girl of theology). There remained those who believed that faith alone gave one access to religious truth (known as "fideists" today), and even a few who preferred reason to faith ("rationalists" in modern jargon) and interpreted Scripture figuratively to fit their philosophical conclusions. The paradox, however, is that the best philosophy done during the Middle Ages was done by theologians, within a theological context, and for theological ends.

THE AGE OF SCHOOLMEN. There was another change of context that characterized the later Middle Ages, and that change necessitated a change of methodology. It was the age of the schoolmen—modern-day college professors—and for the first time in the history of philosophy they were producing textbooks as the favored mode of philosophical expression. As with most beginnings, the Age of the Schoolmen began modestly enough: the newly crowned Emperor Charlemagne (or Charles the Great) decreed that there should be a school attached to every cathedral in his realm. Three centuries

later, some of these schools, the one at Paris preeminently, began to evolve into what we know as universities, in large part because new organizational structures were needed to accommodate the thousands of students now flocking to cities like Paris.

THE RECOVERY OF ARISTOTLE. In the thirteenth century conditions conspired to create a Golden Age, one that has been compared with the Athens of Socrates, Plato, and Aristotle in the richness and breadth of its philosophical productivity. Through contacts with the Arabic world, not all of them friendly, Europeans gradually became aware of the wealth of Greek, Arabic, and Jewish philosophy and science of which they had heard only rumors, foremost among which was the complete corpus of Aristotle's writings. Once the translations were underway, the European mind was never to be the same again. It is an exaggeration to claim that the story of philosophy in the thirteenth century is the story of the Christian reaction to the natural philosophy of Aristotle, but it is not much of an exaggeration. The reintroduction of Aristotle to Western thought, moreover, came at precisely the same time that the universities were being shaped. When designing a curriculum, the first thing one has to decide on is a textbook; and in discipline after discipline there was a treatise on the very subject by that universal genius, Aristotle. Thus, just by being a university student in the High Middle Ages, one got a thorough indoctrination in Aristotelian philosophy.

REACTIONS TO ARISTOTLE. There were three distinct reactions to Aristotle's philosophy, which became the litmus test for the three schools that evolved during this period. There were those who learned Aristotle and used his terminology, but consciously opted for the traditional Christian-Neoplatonic synthesis worked out by St. Augustine. Historians refer to this group as "Augustinians." A second group believed that Aristotle was right on every count and that one could not go beyond Aristotle in matters touching on reason. This group was named after the foremost Muslim commentator on the writings of Aristotle, Ibn Rushd, or Averroës (c. 1126–1198), and thus they were referred to as "Latin Averroists." The third group saw in Aristotle a brilliant philosopher whose work provided a better underpinning for Christian theology than Plato's philosophy. These were the "Thomists," followers of St. Thomas Aquinas (c. 1224–1274). The free and untrammeled pursuit of philosophical truth came to an abrupt halt in 1277, when those who saw in Aristotle and his Muslim commentators a threat to Christian truth prevailed. A condemnation of a number of philosophical teachings was issued at Paris and a pared-down version shortly thereafter at Oxford, which changed irrevocably the course of medieval thought. The move thereafter was away from what was regarded as excessive rationalism and toward the absolute power of God: whatever God can do and it is fitting that He do, He does, whether it makes sense to human reason or not.

PHILOSOPHY AND THEOLOGY DIVERGE. The resulting breakdown in the medieval synthesis meant that the disciplines of philosophy and theology began to diverge. The latter, detached from its anchor in reason, moved in the direction of increased fideism, an unquestioning acceptance of the text of Scripture, the logical outcome of which was the Protestant Revolt; figures like Martin Luther railed against what he called punningly "Narristoteles" (fool-istotle). It is no accident that the fourteenth century has been seen as the Golden Age of Mysticism—suggested, for example, in the literary sphere by the mystical journey depicted in Dante Alighieri's *Divine Comedy*. What the mystics were saying, each in his or her unique way, is that God is beyond human understanding, and that the most people can do is empty themselves and wait for God to speak to them individually. Philosophy on the other hand headed off in the direction of increased skepticism and increased triviality, the latter in part because the philosophers were banned institutionally from discussing any doctrine that touched on the faith, such as questions concerning the soul. Skepticism extended to the very questioning of the ability of human reason to know, and the logical conclusion of this direction is Descartes (1596–1650) and his followers, who begin philosophy not with things, but with ideas.

THE END OF MEDIEVAL PHILOSOPHY. History intruded again with the bubonic plague, also known as the Black Death (1349–1350), which killed off about a third of the population of Europe, including many philosophers, among whom was possibly the great champion of nominalism, William of Ockham (c. 1290–1349). Etienne Gilson (1884–1978) once remarked that medieval philosophy did not die for want of issues, but for want of philosophers.

TOPICS
in Philosophy

THE FOUNDATIONS: AUGUSTINE AND BOETHIUS

THE AUGUSTINIAN MODEL. Although Augustine (354–430) lived during the waning decades of the Roman

MEDIEVAL
Philosophical Terms

Augustinianism: The school of philosophy in the thirteenth century that adhered to the teachings of the pre-Aristotelian period, rallying around the name and authority of St. Augustine, and that strongly opposed Aristotelian and Thomistic views.

Cause/Causality: Responsibility of one being for some feature in another (the effect), such as its existence, essence, matter, accidents, or changes.

Contingency: (a) A state of affairs which may and also may not be; (b) a relation between events such that the second would not happen but for the first.

Deism: The view that while God is responsible for the existence of the world, He otherwise has no commerce with it.

Dialectics: (a) The science or art of logic; (b) a method of arguing and defending with probability open questions.

Disputation: A formal and structured dialogue between master and pupil, proposing questions and replies, difficulties to the teacher's reply and solution of these.

Emanation: Flowing forth from a source; the pantheistic view that all things arise necessarily out of the substance of God's being, intellect, etc.

Essence: In the broad sense, what a thing is, all its characteristics, as contrasted with its existence.

Essentialism: The metaphysical view that identifies being with essence or claims that the act of existing is always identified with the actual essence.

Existence: The actuality of an essence; that act by which something is.

Fideism: The thesis that religious belief is based on faith and not on either evidence or reasoning.

Illumination: In the Augustinian sense, the function of the divine light within a human intellect making truths or intellectual knowledge (as opposed to sense knowledge), especially of immaterial things, possible to the rational creature.

Immanence: (a) Presence in and operation within; indwelling: as God is immanent in all things; (b) Pantheistic sense: God's presence in the universe as a real part of it.

Metaphysics: The division of philosophy which studies being as such and the universal truths, laws, or principles of all beings; "the science of being as being" (Aristotle).

Mysticism: The religious theory that conceives of God as absolutely transcendent, beyond reason and all approaches of mind, placing emphasis on the negative way, that is, on what God is not.

Neoplatonism: The philosophical school, founded by Plotinus (205–270), which extended and built the philosophy of Plato into a system, focusing on the emanation of all things from the One (or Good) and their return thereto; a version of this philosophy, made compatible with Christian teachings, was forged by St. Augustine and became the most influential school in the Middle Ages.

Nominalism: The theory that universal terms like *horse* or *equality* are merely names, not real essences.

Pantheism: The doctrine that the world or nature in the widest sense is identical with God.

Principle source: That from which something proceeds.

Quietism: The attitude of passivity and receptivity before God, as opposed to activism (that is, the view that the human agent has some role to play in earning God's favor).

Rationalism: Any one of the views that attribute excessive importance to the human reason: for example, that all authority in matters of truth is subject to the scrutiny and approval of reason, without any duty of obedience or reverence for religious authority.

Realism: (a) The philosophical position that accepts the existence of things prior to and independent of human knowledge; or (b) in relation to the problem of universals, the epistemological view that man's direct universal concepts ordinarily represent natures that are objectively real and in some way fit to be represented as universal by the mind's activity.

Skepticism: The philosophical school that doubts or denies the possibility of any certain human knowledge; the skeptic is therefore enjoined to suspend all judgments in the speculative order.

Transcendence: Existence apart from and superior to the universe: opposed to immanence.

Universal: A term for a typical form that can be affirmed of or is attributed to many in a univocal and distributed sense; one name applied in exactly the same sense to many objects taken singly.

Empire in the West, his influence was crucial in the Middle Ages, for his work as a theologian trying to reconcile belief with reason defined a major problem that would be at the heart of philosophical pursuit for the next thousand years. It was Augustine, the great bishop of Hippo in North Africa, who established the first successful synthesis between a school of Greek philosophy (namely, Neoplatonism) and the Christian religion. A

genius of the first rank, Augustine agonized over the pursuit of truth, falling prey to several positions that he eventually rejected as false, including skepticism. Finally, when in his thirties, he was lent a copy of the treatises of the Greek philosopher and disciple of Plato, Plotinus (205–270). A new world suddenly opened to him, and within the context of the other-worldly philosophy of Plotinus, the teachings of the Christians, previously rejected as primitive and unsophisticated, now made sense. "Far be it from us to suppose that God abhors in us that by which he has made us superior to the other animals [that is, the reason]," he wrote in one of his letters. Faith alone is not sufficient, as it was for Tertullian (c. 160–220), the greatest of the early Latin Christian theologians. Humans are rational creatures and crave to know, and this natural desire for knowledge cannot be quenched. As articulated by Augustine, this stance became the overriding theme of the medieval enterprise: faith in search of understanding. "Unless you believe," wrote the prophet Isaiah, whom Augustine frequently quoted, "you shall not understand." This adage became the motif of the succeeding age, which since the fifteenth century has been labeled the "Middle Ages."

BOETHIUS AS TRANSLATOR. Exactly half a century after the death of Augustine, Anicius Manlius Severinus Boethius, the man sometimes called "The Last of the Romans," was born in privileged circumstances, but privilege that coexisted with a new political reality. The Roman Empire in the West by the late fifth century had ceased to exist, and the Italian peninsula was ruled by the Ostrogoths. Notwithstanding, Boethius received the best philosophical education available. He studied at either Athens in Greece or Alexandria in Egypt, the latter the site of the greatest library of the ancient world, where among other things he mastered the Greek language. Rightly convinced that Greek was becoming a dead language in Western Europe, he undertook what he hoped would be his lifelong project—the translating of Plato's and Aristotle's complete works into Latin—in order to show the ultimate harmony of their thought. Unfortunately for later centuries, Boethius had not made much headway in his project—in fact he had translated only two of Aristotle's six volumes on logic—when he came under suspicion of treason and was cast into prison under sentence of death. Nonetheless, the translations and commentaries he completed formed much of the basis for logical inquiry—what was called the "old logic"—until the recovery of the remaining works of Aristotle, which occurred in the twelfth and thirteenth centuries.

THE CONSOLATION OF PHILOSOPHY. While in prison, awaiting a cruel and, in his view, unjust execu-

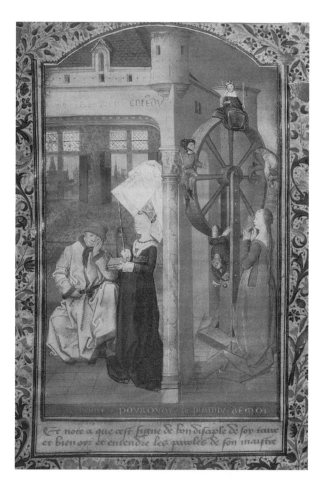

Fortune spins her wheel while Boethius looks on. *Consolation of Philosophy.* PARIS, BIBLIOTHÈQUE NATIONALE MS FR. 809, FOLIO 40, C. 1460.

tion for treason, Boethius wrote his most famous and enduring work, a dialogue entitled *The Consolation of Philosophy.* Destined to become a "best seller" in the Middle Ages (a status determined by the number of Latin manuscript copies and vernacular translations), the work deals with the problem of evil in a very existential setting. Boethius asks why he, a good and virtuous man, lost everything—his power, his wealth, contact with his family, and, not least, his good name. He receives consolation in his troubled state from Lady Philosophy, who is a personification of Boethius's better self. She tells him that happiness does not consist in the goods of fortune (a Stoic message) but rather in the unending possession of the Highest Good, which is God, a goal still within his grasp. The question of whether Boethius was a Christian used to be much debated, since he never made any explicit references to his religion in the *Consolation.* Ever since the discovery and authentication of his tractates on theological topics, however, the question has been laid to rest.

SOURCES

Henry Chadwick, *Boethius: The Consolations of Music, Logic, Theology, and Philosophy* (Oxford: Clarendon Press, 1981).

Alan D. Fitzgerald, ed., *Augustine through the Ages; An Encyclopedia* (Grand Rapids, Mich.: Eerdmans, 1999).

Scott MacDonald, "Augustine," in *A Companion to Philosophy in the Middle Ages*. Eds. Jorge J. E. Gracia and Timothy B. Noone (London: Blackwell, 2003): 154–171.

John Magee, "Boethius," in *A Companion to Philosophy in the Middle Ages*. Eds. Jorge J. E. Gracia and Timothy B. Noone (London: Blackwell, 2003): 217–226.

John Marenbon, *Boethius* (New York: Oxford University Press, 2002).

James O'Donnell, *Augustine* (Boston, Mass.: Twayne, 1985).

Frederick Van Fleteren, "Augustine," in *Dictionary of Literary Biography*. Vol. 115: *Medieval Philosophers*. Ed. Jeremiah Hackett (Detroit, Mich.: Gale Research, Inc., 1992): 53–67.

SEE ALSO *Literature: Translatio studii: Sources for Romance*

RATIONALISM IN THE AGE OF CHARLEMAGNE

THE SCHOOLMASTER ERIUGENA. In the centuries separating Boethius and the Age of Charlemagne (who built the kingdom of the Franks into an empire in the ninth century) there was little philosophical activity. That was, however, soon to change. One of the most fruitful decrees of the newly crowned emperor was to establish a school at every cathedral in his realm, which extended throughout what is now France, Germany, northern Italy, and parts of the Low Countries. Intended for the education of the clergy, the focus in these schools was on basic grammatical and mathematical skills—in other words, the "three R's." The creation of schools, however, meant a need for teachers. It was thus that the Celtic monk from the remote West of Ireland, John Scotus Eriugena, was brought to the court of Charlemagne's grandson, Charles the Bald. Eriugena was destined to become the greatest Irish philosopher of all time, and in a rare tribute his image until recently adorned the five-pound note issued by the Republic of Ireland.

TRANSLATING DIONYSIUS. The Irish monks of this time period, almost alone in the Latin West, had somehow preserved a knowledge of the Greek language. Hence, while serving at the court of Charles the Bald in the middle of the ninth century, Eriugena was asked to translate from Greek the writings of Dionysius, called the pseudo-Areopagite (fl. c. 500). These writings, four in all, constitute the longest-lived forgery in Western history: they were signed "Dionysius, companion of St. Paul" and thus accorded enormous respect, until finally in the Renaissance they were discovered to have been written at least 400 years later than claimed. Working with primitive Greek-Latin glossaries and no knowledge of Greek paleography (unable, for example, to distinguish between "therefore" and "therefore not"), Eriugena produced a translation that was so flawed that the pope's librarian complained that he had buried the meaning of Dionysius in a deep cavern where it must await a new translation. Notwithstanding, Eriugena's translation was the basis for the study of Dionysius for 300 years.

THE CONCEPT OF DIVISION. Stimulated by Dionysius's version of Platonic thought—which was purer than the synthesis achieved by Augustine—Eriugena produced the first *summa* ("summary treatment" of a discipline) in Western philosophy. The work, which he called *Periphyseon* (On the Division of Nature), deals with nature and the ways in which it encompasses the entire universe, both being and non-being. Eriugena divided the summary into four components: that which creates and is not created; that which is created and also creates; that which is created and does not create; and finally that which neither creates nor is created. He treated successively the Creator-God, the primordial causes emanating from Him (Plato's Forms), the material universe, and God-as-End. He looked at creation as a process of division beginning with God, through the primordial causes to a multiplicity of things, and finally returning to God in a cosmic resolution.

RECONCILING PLATONISM AND CHRISTIANITY. Eriugena went further in trusting the powers of his reason than was to be the norm for Christian philosophers, occasionally forcing the biblical text to agree with what his Platonically-schooled reason dictated. One example was the issue of the human body. For Plato, the body was evil. But to a Christian philosopher, the human body was created by God and therefore must be something good. The resolution for Eriugena was that God created humans without bodies, and that the acquisition of bodies as well as sexual differentiation was a result of the Fall. The Genesis text recounting Adam and Eve making loincloths of fig leaves is to be interpreted allegorically, argued Eriugena—that is, that they were making for themselves bodies. Thus, Eriugena remained both a Christian and a Platonist at the same time. In this bold design, Eriugena went further in the direction of Platonism than any other Christian writer, and it is not sur-

prising that long after his death his work was condemned on three counts of heretical teaching early in the thirteenth century.

SOURCES

Deirdre Carabine, *John Scot Eriugena* (Oxford: Oxford University Press, 2000).

Paul Edward Dutton, "John Scotus Eriugena," in *Dictionary of Literary Biography*. Vol. 115: *Medieval Philosophers*. Ed. Jeremiah Hackett (Detroit, Mich.: Gale Research, Inc., 1992): 168–184.

Armand A. Maurer, *Medieval Philosophy*. 2nd ed. (Toronto: Pontifical Institute of Medieval Studies, 1982): 35–46.

Carlos Steel and D. W. Hadley, "John Scotus Eriugena," in *A Companion to Philosophy in the Middle Ages*. Eds. Jorge J. E. Gracia and Timothy B. Noone (London: Blackwell, 2003): 397–406.

ANSELM OF CANTERBURY

THE BEGINNING OF THE MODERN AGE. Whether or not the ending of the first millennium aroused the same apocalyptic fears as the year 2000 witnessed, a growing number of modern historians in fact see the year 1000 as marking the beginning of the modern age. The life of St. Anselm (1033–1109), who is commonly called Anselm of Canterbury, in many ways reflects this new era. Born in the Val d'Aosta area of northern Italy, he left home at an early age to seek an education (and to escape a repressive father). Significantly, he headed not south to Mediterranean countries but north to Normandy in the north of France, attracted to the monastery of Bec because of the reputation of its abbot, the learned Lanfranc. In those dark centuries whatever glimmer of culture and learning still existed was being preserved in these monastic centers. Among other activities at the monasteries that followed the Rule of St. Benedict, monks would copy whatever piece of writing came into their hands, not infrequently without being able to read what they were copying. It was in the quiet and seclusion of Bec that Anselm wrote his best philosophical works. Eventually he succeeded Lanfranc as abbot when the latter was made archbishop of Canterbury, following the Norman Conquest in 1066. Called by historians "the second Augustine," Anselm had an almost unbounded confidence in the power of reason. He even went so far as to seek what he called "necessary reasons" for the Incarnation, the central teaching of Christianity.

PROOF OF GOD'S EXISTENCE. The work of Anselm that is most familiar to contemporary philosophers, however, is a short treatise entitled *Proslogion*, which means an

a PRIMARY SOURCE *document*

ANSELM'S ARGUMENT FOR THE EXISTENCE OF GOD

INTRODUCTION: Anselm's famous argument for the existence of God in the *Proslogion* (or "Allocution"), which was requested by his monks, demonstrates not only that God exists in reality—not simply in the mind—but also that one cannot even think that God does not exist. How then can one explain the atheist, or "the Fool" in the language of the Psalms? In this passage Anselm attempts to explain how the atheist can think the unthinkable.

How indeed has [the Fool, that is, the atheist] "said in his heart" what he could not think; or how could he not think what he "said in his heart," since to "say in one's heart" and to "think" are the same? But if he really (indeed, since he really) both thought because he "said in his heart" and did not "say in his heart" because he could not think, there is not only one sense in which something is "said in one's heart" or thought. For in one sense a thing is thought when the word signifying it is thought; in another sense when the very object which the thing is is understood. In the first sense, then, God can be thought not to exist, but not at all in the second sense. No one, indeed, understanding what God is can think that God does not exist, even though he may say these words in his heart either without any [objective] signification or with some peculiar signification. For God is that-than-which-nothing-greater-can-be-thought. Whoever really understands this understands clearly that this same being so exists that not even in thought can it not exist. Thus whoever understands that God exists in such a way cannot think of Him as not existing.

SOURCE: Anselm of Canterbury, *St. Anselm's Proslogion*. Trans. Maxwell John Charlesworth (Oxford: Clarendon Press, 1965): chapter 4.

address or discourse. It is called this because it is addressed to God, and it asks God's help in proving not only God's existence but also everything else that has been taught about Him. It was a part of Anselm's belief as a Christian that God is something than which a greater cannot be thought. But to be in the mind and in reality is surely greater than to be in the mind alone. Therefore, to deny that God exists, as the atheist does, is to involve oneself in a contradiction: something than which a greater cannot be thought is the same as that than which a greater can be thought.

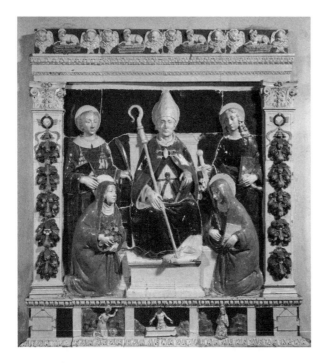

Anselm of Canterbury surrounded by saints, glazed terra cotta relief, school of Lucia della Robbia. Museo della Collegiata di Sant' Andrea, Empoli, Italy, 15th–16th centuries. SCALA/ART RE-SOURCE, NY.

GAUNILON'S RESPONSE. This philosophical argument, which was to receive more attention in future centuries than any other, already proved provocative in Anselm's own day. A monk by the name of Gaunilon, about whom nothing is known except his monastery (Marmoutier in the south of France), wrote a response, which he entitled *On Behalf of the Fool.* "Fool" is Scriptural language for the atheist, and Gaunilon, though a believer, did not think Anselm had proved anything to the man without faith. First, he did not believe this formula for God ("something than which nothing greater can be thought") was meaningful, and therefore it did not exist in the mind in any real way, that is, in any way different from non-real things. And second, even if it did, one could not conclude from this that God existed in reality, just as one could not conclude that the most perfect island that the mind can conjure must really exist; otherwise, any truly existing island, no matter how humble, would be greater.

ANSELM'S REPLY. The long-distance correspondence between Gaunilon and Anselm ended with Anselm's reply to the "fool": of course his way of thinking about God is meaningful to Gaunilon for it is part of his faith as a Christian. But even if his attacker were truly a godless man, Anselm showed how he might construct a meaningful concept of God from his experience

in a contingent world. Everyone has experience of beings that begin and end; is it not clear that beings that begin but never come to an end are greater—even if one has no experience of such beings? And so Anselm concluded that a being that has neither beginning nor end nor duration is greater than any other conceivable being, and therefore close to a being than whom a greater cannot be thought.

THE ADVANTAGES OF DIALOGUE. The "dialogue" between Anselm and Gaunilon shows clearly the great advantages to be gained by such exchanges. As Aristotle had said, philosophical dialogue "polishes" the truth. Though he has been called the "Father of Scholasticism," the fact is that Anselm was a monk, which entailed a retreat from the world to be "alone with the Alone," as Plotinus phrased it; hence the etymology of "monk" from *monos,* meaning "alone." A few decades after Anselm's death, the situation was to change dramatically; institutions were evolving that were to create the proper cultural climate for philosophical activity up to the end of the Middle Ages and beyond.

SOURCES

Jasper Hopkins, "Anselm of Canterbury," in *A Companion to Philosophy in the Middle Ages.* Eds. Jorge J. E. Gracia and Timothy B. Noone (London: Blackwell, 2003): 138–151.

Armand A. Maurer, *Medieval Philosophy.* 2nd ed. (Toronto: Pontifical Institute of Medieval Studies, 1982): 47–58.

Richard Southern, *Saint Anselm: A Portrait in a Landscape* (New York: Cambridge University Press, 1990).

THE PROBLEM OF UNIVERSALS

CONCERNING GENUS AND SPECIES. The question on which Peter Abelard (c. 1079–1142) originally made his name and indeed the question that engaged philosophers at the fledgling school at Paris was the so-called problem of universals (common terms like "animal" or "man"). Sparked by a casual remark by Boethius in one of his commentaries on Aristotle's logic ("concerning genus and species, whether they have real existence or are merely and solely creations of the mind ... on all this I make no pronouncement"), the debate raged for nearly half a century. John of Salisbury (c. 1120–1180), a Paris graduate, visited his *alma mater* twenty years after he had left for England and remarked that the Paris masters in the intervening years had made no progress in resolving the conundrum concerning universals.

REALISM AND NOMINALISM. The debate surrounding universals focused on the problem of whether

universals, essential to speech and communication, had any status outside of the mind. For instance, does "dog-ness" or "horseness" have any reality apart from one's thinking? The question generated two extreme positions: realism—that the universal exists as such outside the mind, like the Forms of Plato—and nominalism—that the universal is only a word, from the Latin *nomen*, meaning "name." According to Roscelin, a member of the latter school, the only reality possessed by the universal was the *flatus vocis*—"the breath made by the voice as it pronounced the word." William of Champeaux (c. 1070–1121), a champion of the former view, believed that there was something that Socrates and Plato, for example, had in common, something by virtue of which each could be called human. When his student Abelard attacked his position, William retreated to a new position: namely, that although Socrates and Plato had nothing in common, each had an element that can be called "indifferently" the same. Abelard again demolished this position as well, and William, thoroughly humiliated, was driven into retirement. Notwithstanding his failure in the battles of academe, William was subsequently consecrated bishop of Châlons-sur-Marne.

ABELARD'S "CONCEPTUALISM." Originally a student of Roscelin's, Abelard himself moved away from his master's position and, partly as a result of his debates with William, adopted a view known as conceptualism, which was close to what Aristotle's would have been had he isolated the problem: that is, that the universal is present within the particular thing, but not as such; it needs to be abstracted by the mind and therefore stands as a mental representation of the nature of the thing, while remaining other than the particular thing itself.

THE TRIUMPH OF NOMINALISM. The harsh reality of a nominalist view is that if universals were only words, then no nature would have any reality. In other words, there would be no such thing as human nature or angelic nature or even divine nature; natural law would be left without a foundation. Only individuals exist; universals are simply a convenience of the human mind. While philosophical interest moved away from the problem by the end of the twelfth century, the nominalists reasserted themselves in the fourteenth century, at which point they triumphed over all other positions, and their victory spelled the effective end of the medieval synthesis. Foremost among the champions of this re-emergent nominalism was the Franciscan William of Ockham (c. 1290–1349), the central theme of whose philosophy was the individual thing. Each individual reality was so self-contained that it shared nothing with anything else. It was a philosophy, in other words, of the singular. For the

THE
Tragic Story of Abelard and Heloise

In the century that saw the introduction of the concept of courtly love into Europe, Abelard was the knight errant of dialectics, vanquishing all in his path. Oral arguments, "disputations" they were called, were more a part of the educational scene in the High Middle Ages than they are today. But students then, as today, love a good show, and Abelard obliged, his skills in logical debate destroying reputations and, in one case, driving his vanquished opponent into the seclusion of a monastery for the rest of his life. That is until he met Heloise. Hired to tutor the precocious teenager by her uncle, a canon of the cathedral, the forty-year-old Abelard was soon smitten, and the ensuing affair produced a son, who was given the name Astrolabe, meaning "fallen from the stars." Though Abelard was canonically free to marry, since he was not at this time a priest, the tradition from Socrates onward was that the philosopher should be celibate, in order to devote himself more completely to his vocation. The ensuing attempt to cover up the disgrace enraged the uncle, who arranged for Abelard's castration. Though today they are buried in the same grave in the Père Lachaise cemetery in Paris, Abelard and Heloise were separated for the rest of their days, each attached to a monastic center.

In the midst of Abelard's misfortunes, recounted in a series of letters between the lovers, a member of a new and strict religious order, the Cistercians, and preacher of Crusades, Bernard of Clairvaux, launched an attack on Abelard's orthodoxy and succeeded at the Council of Sens in having his works condemned. Among other charges, Bernard argued that Abelard was a rationalist, which meant setting the human reason above faith. In a work called *Sic et Non* (*Yes and No*) Abelard had pointed up the number of teachings on which the Fathers of the Church seemed to contradict themselves, but then with an appropriate distinction or bit of linguistic analysis the "contradiction" dissolved. Perhaps Abelard's most important contribution to moral philosophy was his notion that the internal act called consent was what determined an act as good or evil, not the doing or not doing of the deed. For the rest, as with the fate of many a critical thinker before and since, his direct influence on subsequent thinkers was slight.

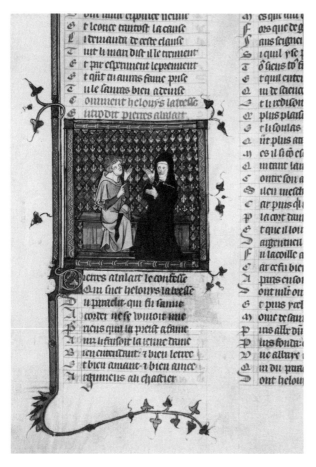

Abelard and Heloise debating. *Romance of the Rose*, Chantilly, France, Musée Condé MS 482/665, folio 60v, 15th century. GIRAUDON/ART RESOURCE, NY.

sake of communication and indeed convenience, words need to be used to represent these singular things, but these are no more than fictions (*ficta*), not reducible to the notion of a thing in the world. The word "man" does not adequately represent Socrates or any part of Socrates, but functions like a mental model. Ultimately, however, this fiction theory fell afoul of his "razor"—the principle of philosophical economy—and Ockham abandoned it in favor of a view that can be more adequately termed "conceptualism": that is, a universal is simply an act of understanding whereby people are aware of things in terms of their more or less generalizable features.

SOURCES

Peter King, "Abelard," in *Dictionary of Literary Biography.* Vol. 115: *Medieval Philosophers.* Ed. Jeremiah Hackett (Detroit, Mich.: Gale Research, Inc., 1992): 3–14.

David Knowles, *The Evolution of Medieval Thought* (London: Longmans, 1962): 107–115.

John Marenbon, "Peter Abelard," in *A Companion to Philosophy in the Middle Ages.* Eds. Jorge J. E. Gracia and

Timothy B. Noone (London: Blackwell, 2003): 485–493.

———, *The Philosophy of Peter Abelard* (Cambridge, England: Cambridge University Press, 1997).

THE SCHOOLS OF THE TWELFTH CENTURY

THE SCHOOL AT CHARTRES. The ascendancy of Paris as the intellectual center not only of France but of all of Europe was by no means inevitable. In the first half of the twelfth century, in fact, Paris's rival was the school at Chartres, some fifty miles to the south. The cathedral school there enjoyed a succession of first-rate masters, whose focus was the seven liberal arts: arithmetic, geometry, astronomy, music, grammar, rhetoric, and dialectics. These subjects of study assumed visible form, carved in stone over the main portal of the cathedral, dialectics being represented by a portrait of Aristotle. Notwithstanding their interest in Aristotle's logic—mediated through the translations and commentaries of Boethius—the masters of Chartres were more at home with the philosophy of Plato. They worked mainly from the *Timaeus,* the only one of Plato's dialogues available to them, and attempted to match up the Platonic myth of cosmogenesis (that is, the generation of the cosmos) with the story of creation in the book of Genesis.

GILBERT OF POITIERS AND ESSENTIALISM. Perhaps the most brilliant and creative of the Chartres masters was Gilbert of Poitiers (1076–1154), who repeated and refined the distinction Boethius made between "that which is" and "that by which a thing is what it is." The individual "Socrates," in short, is distinct from that which makes Socrates what he is—his humanity. These are the foundational principles of a metaphysical view known as essentialism: to be is to be a certain kind. To the extent that a thing changes, to that extent is it not completely what it is. Hence anything that has the ability to change is in flux and has no true identity at any point in time. It is change, finally, that distinguishes the creature from the Creator, who is completely self-identical and therefore completely changeless.

JOHN OF SALISBURY AND THE POLICRATICUS. Also counted by some among the notables of Chartres was the Englishman John of Salisbury (c. 1120–1180). Secretary to Thomas Becket (c. 1118–1170), archbishop of Canterbury, he joined his master in exile following Becket's dispute with King Henry II (1133–1189). After Becket's murder John was appointed bishop of Chartres, where he ended his days. The most influential of John's writ-

ings was the *Policraticus*, whose aim was to demonstrate that secular as well as ecclesiastical courts must be ruled by philosophical wisdom in order to direct that polity to eternal happiness. Though influenced by Plato's political thinking, John expanded Plato's three classes of society into four, adding craftsmen to the ruling, military, and worker classes. The king, representing the King of kings on earth, is responsible for attaining and preserving the common good. The bad king becomes a tyrant, and John invested his subjects with the right, and even the duty, of protecting themselves against such a ruler. Unlike Aristotle's (and later Aquinas's) political philosophy, John's state rested on positive law, not natural law. A law is a law because the king declares it a law and has the power to enforce it. John had his own rather practical solution to the problem of universals: the mind is capable, he says, of contemplating the resemblances between individual things; these things are called by the name of genus or species; they are not, however, realities apart from the things, but merely fuzzy likenesses of them, reflected on the mirror of the mind. Finally, and perhaps most importantly, John's letters as well as his ecclesiastical history provide us with valuable insights into his times. His narrative, for example, of the trial of Gilbert of Poitiers, with whom John had studied and who was tried for heresy in 1148, is the only objective account of that event.

HUGH OF SAINT-VICTOR AND THE VICTORINES. A third school may be mentioned as testimony to the breadth and richness of twelfth-century intellectual currents—namely, the Victorines. Chased out of the schools by the rapier wit of Abelard, William of Champeaux, master of the school of Notre-Dame in Paris and reputed to be the foremost logician of his day, retired to the Augustinian house of canons regular of Saint-Victor on the Left Bank, where he resumed his teaching. There followed a succession of gifted theologians, known collectively as the Victorines, among whom were Hugh of Saint-Victor (1096–1141) and his successor, Richard of Saint-Victor (d. 1173). Dismissed by many historians of philosophy as a mystic, Hugh was, in fact, a rigorous thinker who was nevertheless convinced that the pursuit of truth was inseparable from the pursuit of virtue. "Learn everything you can," he writes, "you will find in time that nothing is wasted." This statement set the tone for Hugh's vision of theology: namely, that the knowledge of all the sciences serves as an introduction to what had been styled the queen of the sciences; philosophy was theology's *ancilla*, its "serving girl." It is this conception that in subsequent generations led to the most intense philosophizing of the Middle Ages—and possibly the most intense philosophizing the world has ever known.

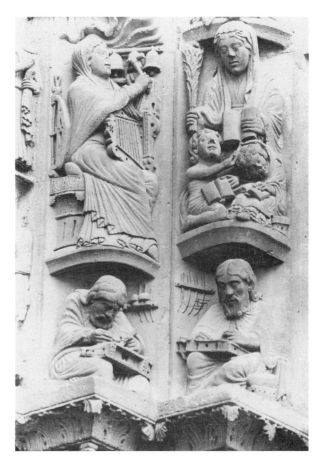

Two of the Seven Liberal Arts, Music and Grammar, with Pythagoras below. Archivolt from right door of Royal Portal, Chartres Cathedral, France, 13th century. **FOTO MARBURG/ART RESOURCE, NY.**

THE VICTORINE PROGRAM OF EDUCATION AND ITS AFTERMATH. Hugh's educational program was laid out in a vast compilation entitled *Didascalicon*, which established in excruciating detail the curriculum to be undertaken by the budding theologian. He divided philosophy into four categories: theoretical, practical, mechanical, and logical. The first, theoretical, was subdivided into theology, physics, and mathematics; practical philosophy was subdivided into solitary, private, and public; mechanical—a Hugonian invention—into clothmaking, armament, trade, agriculture, hunting, medicine, and theater arts; and lastly, logic into grammar and disputation. It was this educational program that linked Hugh to the later Victorines. While it is not clear whether Richard of Saint-Victor was Hugh's personal student or not, he was certainly the latter's doctrinal disciple. Honored by the Italian poet Dante Alighieri (1265–1321) with a place in Paradise in his *Divine Comedy* as one who was "in contemplation more than a man," Richard was a master of spirituality or mysticism.

In his *Benjamin Major* and *Benjamin Minor* Richard stressed love over knowledge, drawing principally from the tradition of Dionysius the pseudo-Areopagite; God is attained only fleetingly and in a "cloud of darkness," a metaphor that was to have great currency in the succeeding centuries. It is a movement known as negative theology—the notion that the truest thing that can be said of God is that no one knows what God is.

PETER LOMBARD AND THE BOOK OF THE SENTENCES. Although there was no actual twelfth-century "school" associated with the teachings of Peter Lombard (c. 1100–1160), bishop of Paris, his contribution to theology in this period was profound: he was the author of what has been referred to as "one of the least read of the world's great books." Called the *Books of the Sentences*, Lombard's great work not only attempts to reconcile seemingly contrary texts in the manner of Abelard's *Sic et Non*, it also arranges the opinions (*sententiae* in Latin) of the church fathers, especially Augustine, into a system with a logical order of development. Canvassing as it does the whole of the discipline, it was an obvious choice for a textbook in theology, and from the end of the twelfth century until the sixteenth every candidate for a terminal degree in the sacred science was required to spend at least two years "commenting" on Lombard's *Sentences*. Literally hundreds of these commentaries survive, most of them still in manuscript form.

SOURCES

Marcia L. Colish, *Medieval Foundations of the Western Intellectual Tradition 400–1400* (New Haven, Conn.: Yale University Press, 1997): 225–233.

Peter Dronke, ed., *A History of Twelfth-Century Western Philosophy* (Cambridge, England: Cambridge University Press, 1988).

David Knowles, *The Evolution of Medieval Thought* (London: Longmans, 1962): 131–149.

Armand Maurer, *Medieval Philosophy*. 2nd ed. (Toronto: Pontifical Institute of Medieval Studies, 1982): 71–81.

Philipp Rosemann, *A Companion to Philosophy in the Middle Ages*. Eds. Jorge J. E. Gracia and Timothy B. Noone (London: Blackwell, 2003): 514–515.

SEE ALSO *Visual Arts: Intellectual Influences on Art in the Later Middle Ages*

PHILOSOPHY AMONG THE MUSLIMS AND THE JEWS

THE INFLUENCE OF ARISTOTLE. While the Latin West was moving toward the triumph of scholasticism, other important developments were occurring in the territories under Islamic rule. Within a century of the appearance of the Prophet Muhammad, his followers had conquered all of the Middle East, North Africa, and the Iberian Peninsula (consisting of modern Spain and Portugal), which they called al-Andalus. Along with other spoils of conquest, the entire corpus of Aristotle's writings, minus the *Politics*, had fallen into their hands. Translated into Arabic with the help of Syrian Christians over a period of a century and a half (c. 750–900), Aristotle, virtually unknown at the time to the Latins, was to become, as it were, the "house philosopher" of the Muslim world. Philosophy for Muslim thinkers primarily consisted of comments on the writings of the pagan Aristotle. Sometimes these commentaries concentrated on explaining phrase by phrase the Aristotelian text. Sometimes the commentaries combined a literal explanation with a more expanded development of Aristotle's teachings. The commentaries could also assume the form of parallel treatments of topics suggested by the Aristotelian text. The prominent Islamic philosopher Averroës, whom Latin-speaking thinkers called simply "Commentator" (The Commentor, as if there were no other) practiced all three kinds.

ALKINDI AND ALFARABI. The first important name in the tradition of commentators on Aristotle's work was Alkindi, who lived most of his years in Persia and in 873 died in Baghdad. In his commentaries on Aristotle's work on the soul, Alkindi elaborated on the philosopher's distinction between the passive and active intellect. According to Alkindi the latter was a single superhuman intelligence active for all mankind; it performed the function of abstracting universals from particulars and depositing them in the particular passive intellects, much like a bee sucks nectar from a flower and deposits it in a hive. An equally original thinker was Alfarabi, who lived his entire adult life in Baghdad, dying there in 950. He was, most notably, the first to distinguish between essence (what a thing is) and existence (that by which a thing is real). With this distinction he was able to account in metaphysical terms for the absolute otherness of the Creator and at the same time for the utter contingency of the creature (creatures may possibly exist, but may possibly not exist; they are, in other words, not necessary). Existence, claimed Alfarabi, was merely an accident of the essence; it did not belong to the nature of anything (except God) to exist rather than not to exist. On the other hand, Alfarabi borrowed from Alkindi (and ultimately from the Neoplatonists) the concept of a single active intellect, which provides for all human minds the intelligibilities of things; ultimately God, and not the senses, is the sole adequate cause of our coming to know the truth about things.

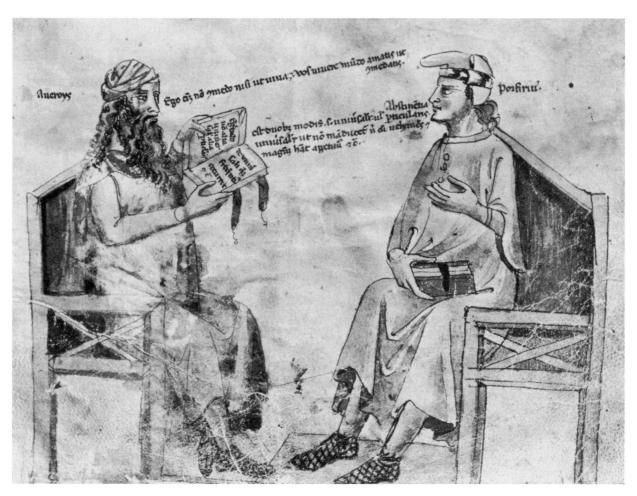

Averroës conversing with the third-century philosopher Porphyry, *De Herbis et Plantis*, Paris, Bibliothèque nationale MS lat. 6823, folio 2v, 14th century. GIRAUDON/BRIDGEMAN ART LIBRARY.

AVICENNA AND THE NECESSARY BEING. A generation later there appeared on the scene the man who would become the most influential of all Muslim thinkers, the Persian Ibn Sina (980–1037) or Avicenna, as the Latins were to call him. He was a person of great learning; his *Canon* (meaning a "rule" or "measure") on the theory and practice of medicine, for example, was the single most authoritative work on the subject between the great physician, Galen (c. 129–c. 200), and the Renaissance. Moreover, his interpretation of Aristotle's thought—more faithful to the text than Alfarabi's—was destined to reverberate in the Christian as well as in the Muslim tradition. Avicenna, for example, was the first to distinguish necessary from contingent or possible being, thus providing St. Thomas Aquinas with one of his arguments for God's existence. The things that are encountered in the world exist, but they need not exist; they do not exist necessarily; there is nothing about their natures that demands that they exist rather than not. But if the universe were composed wholly of such beings, it would have already ceased to exist, given the Aristotelian conviction that the universe has existed eternally. One is therefore compelled to conclude that there is in the universe of beings at least one necessary being, a being which cannot not-exist, a being whom Avicenna called "Allah" or God. Although Avicenna's system had much to recommend it to Christian thinkers of the High Middle Ages, there were nonetheless elements of his teaching that could not be assimilated to medieval Christian theology, such as the eternal existence of the world and the necessary character of God's governance. According to Avicenna, the divinity creates out of necessity and rules the universe through the mediation of a hierarchy of intelligences, which are superior orders of angels, and spheres. God knows the sub-lunar world, the world of humans, only in general terms and does not know particulars. This is, of course, implicitly a denial of divine providence and also of free choice of the will, a doctrine firmly established in the Christian tradition by St. Augustine.

MAIMONIDES' "NEGATIVE THEOLOGY"

INTRODUCTION: Moses Maimonides, in his greatest philosophical work, *The Guide for the Perplexed*, addresses himself to what is now referred to as God-talk, that is, the question of how we talk about God. His conclusion is that we are unable to affirm anything positive of God; we are capable only of negations. Even the metaphors employed by the Bible tell us only something of ourselves. This passage is an argument for what is termed "negative theology."

You must bear in mind, that by affirming anything of God, you are removed from Him in two respects; first, whatever you affirm, is only a perfection in relation to us; secondly, He does not possess anything superadded to this essence; His essence includes all His perfections, as we have shown. Since it is a well-known fact that even that knowledge of God which is accessible to man cannot be attained except by negations, and that negations do not convey a true idea of the being to which they refer, all people, both of past and present generations, declared that God cannot be the object of human comprehension, that none but Himself comprehends what He is, and that our knowledge consists in knowing that we are unable truly to comprehend Him. All philosophers say, "He has overpowered us by His grace, and is invisible to us through the intensity of His light," like the sun which cannot be perceived by eyes which are too weak to bear its rays.

SOURCE: Moses Maimonides, *The Guide for the Perplexed.* Trans. M. Friedländer (New York: Dover, 1956). Reprinted in *Medieval Philosophy*, Vol. II of *Philosophic Classics.* 4th ed. Ed. Forrest E. Baird (Upper Saddle River, N.J.: Prentice Hall, 2003): 271–272.

AVERROËS. The only Muslim philosopher to challenge Avicenna's preeminence was a polymath (one versed in many fields of knowledge) from Córdoba, Spain—then a part of al-Andalus or Western Islam—Ibn Rushd (c. 1126–1198), known to Latin thinkers as Averroës. Trained in medicine and in law, Averroës was not the creative thinker that Avicenna was, but he did have tremendous critical powers and took on the task of commenting on all of Aristotle's works with the purpose of making them more accessible to the Muslims. In this project he was indefatigable, writing over thirty commentaries on the man known simply as the Philosopher,

sometimes as many as three different commentaries on the same work—an epitome or summary, a middle commentary, and a long commentary. Ultimately he fell out of favor with the religious leaders of the country, and by the time of his death in 1198 the Islamic world had begun to de-emphasize the philosophical system-building which had been inspired by Aristotle.

AVERROËS AND THE "THEORY OF DOUBLE TRUTH." Averroës himself can be seen as a rationalist, in much the same vein as Scotus Eriugena. There are three classes of people, he claimed in *The Decisive Treatise*: the simple uneducated workers, the moderately educated people, and, finally, the exclusive coterie of philosophers—a division no doubt reflecting Plato's division of society in the *Republic*. For members of the first class, only authoritative and emotional arguments are effective, and these simple and uneducated people have no choice but to interpret the Koran literally. Members of the second group are capable of probable or rhetorical arguments, and these people are called "theologians." Finally, the rare geniuses, the philosophers, are able to follow—and must follow—demonstrations in the strict sense, even though their conclusions may seem to contradict the teachings of the Koran. In such cases of conflict, says Averroës, they are to read the Koran figuratively, so that they agree finally with the findings of their reason. Here can be found the roots of what will later be dubbed the "theory of double truth."

MOSES MAIMONIDES. The greatest Jewish thinker of the Middle Ages, arguably the greatest Jewish thinker of all time, was also from Córdoba. His given name was Moses ben Maimon, but was known to the Latins as Maimonides or simply Rabbi Moses. Like the great Muslim thinkers, he was a polymath, and for much of his adult life was court physician to Saladin, the Muslim ruler of Egypt. As leader of the local Jewish community, he was also learned in Jewish law or *Torah* and wrote a voluminous legal codification known as the *Mishnah Torah.* The work, however, for which he is most widely known was written in Arabic and addressed to a young protégé named Joseph, *The Guide for the Perplexed.* There can be no conflict between faith and reason, Maimonides writes to Joseph, and any apparent conflict is the result either of misinterpreting the philosophers or misreading the Scriptures. The latter contain manifold metaphors, which are not to be taken literally; these predicates (words that affirm or deny something about the subject), in fact, tell us nothing about God, but only about God's influence on us. For example, to refer to God metaphorically as a mighty fortress, as the Psalmist

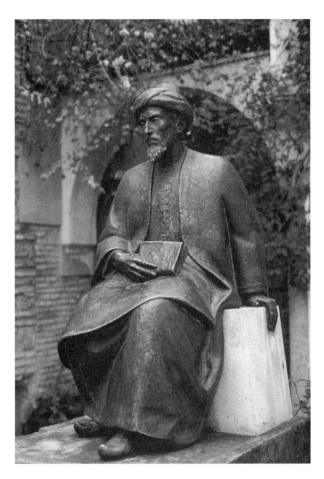

Statue of Moses Maimonides outside synagogue, Córdoba, Spain. 18th–19th century. ©STUART COHEN/THE IMAGE WORKS.

does, is merely to express the comfort and security the believer feels as a result of his faith.

MAIMONIDES AND THE METAPHYSICS OF EXISTENCE. On the thorny question of the eternity of the world, Maimonides reasons both that Aristotle's arguments in favor thereof are not conclusive and that, in any case, his position is not incompatible with God's creation: it is possible, given divine omnipotence, that God created the world eternally. God can create a world of any duration he wishes. It was an argument that was later to be taken up by St. Thomas Aquinas. Three of Maimonides's arguments for God's existence—from change, from efficient causality, and from contingency and necessity—were also to find echoes in Aquinas's *Summa* of theology. But the most profound influence of the Jewish thinker upon the Christian was in the interpretation of the text in Scripture where God names Himself in response to Moses's question. Written in four Hebrew letters and thus called the *Tetragrammaton* (meaning simply "four letters"), the name was never uttered, but Maimonides believed it to mean "existence it-

self." In other words, God's very nature is to exist whereas in all other things—following Avicenna—existence is merely an accident. This insight would later be at the heart of Aquinas's metaphysics of existence.

SOURCES

Marcia L. Colish, *Medieval Foundations of the Western Intellectual Tradition 400–1400* (New Haven, Conn.: Yale University Press, 1997): 129–159.

M. Fakhry, *A History of Islamic Philosophy* (New York: Columbia University Press, 1970).

Armand Maurer, *Medieval Philosophy.* 2nd ed. (Toronto: Pontifical Institute of Medieval Studies, 1982): 93–109.

SEE ALSO *Religion: Medieval Judaism; Religion: The Spread of Islam and Its Relationship to Medieval Europe*

THE UNIVERSITIES, TEXTBOOKS, AND THE FLOWERING OF SCHOLASTICISM

THE GOLDEN AGE OF SCHOLASTICISM. Scholasticism is a term that was borrowed from the Greek word *schole*, which means "leisure," and came to mean the activity of a person of leisure or a *scholastikos*, a scholar. By the twelfth century the term "scholastic" had come to signify the system whereby knowledge was imparted in an organized fashion and with a specific methodology. At first, the term was only applied to those schools which taught a certain curriculum of the seven liberal arts, headed by a *scholasticus*, or master scholar. Yet as more specific forms of study began to appear, there was need to expand the term scholasticism to signify any type of formal learning that occurred between a teacher of great knowledge and a student. Hence, as universities came into existence during the course of the twelfth century, many historians have called the rise in the level of education the "Golden Age of Scholasticism" in reference to the great importance placed on organized knowledge during this period.

THE RISE OF THE UNIVERSITY. The emergence of the university, a medieval invention, is a complex phenomenon, and it happened slightly differently in different parts of Europe during the course of the twelfth century. There is still considerable debate concerning which was first—Paris, Oxford, Salamanca, and Bologna are all in the running—and the resolution hinges on various criteria. What is essential for a school to be a university? If a written charter is key, for example, then the first university was Paris.

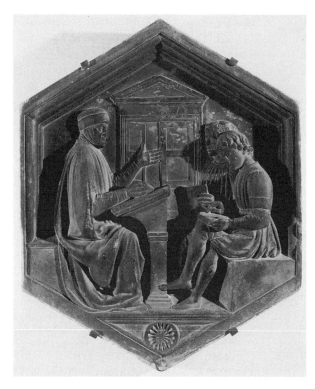

Teacher lecturing to pupils, design by Andrea Pisano for Campanile, Florence, Italy, 1340. THE ART ARCHIVE/DUOMO FLORENCE/DAGLI ORTI.

THE UNIVERSITY OF PARIS. In the case of Paris, what started as a cathedral school on an island in the Seine simply outgrew its locale and its structure, owing to the thousands of students from all over Europe, drawn to Paris by charismatic teachers like Peter Abelard. New organizational structures were needed, and out of this need a new institution began to take shape. Nothing quite like it existed before, and in all of its essentials the medieval university was identical with its modern counterpart. These essentials include a group of learned scholars, in different disciplines, all gathered at one place; a fixed course of study, called a *curriculum*, whose original meaning in the Latin of the day was "a path" or "period of time;" and, at the end of the course of study, a degree, which, proclaimed that its bearer was learned. With this degree in hand (the earliest was descriptively called a *licentia ubique docendi*, "a license to teach everywhere"), the graduate could present himself at universities such as Oxford, Bologna, or Salamanca, and if there was a position available, he got the job.

A LEGAL CORPORATION. This new kind of institution's standing before the law was crucial to its existence: universities were legal corporations, associations of teachers and students with collective legal rights, often guaranteed by charter, originally from a pope, emperor, or king, and later issued by the town or the local prince or the resident prelate. One important aspect of the university's legal standing was its exemption from the civil law. Membership in a university entailed exemption from military service, from taxation, and from trial in a court of civil law. An advantage of the last was that canon law—under whose jurisdiction fell all clerics—dealt out sentences that were more lenient, and never the death penalty. This system of two laws—one for clerics, including university folk, the other for townsfolk—led inevitably to what were called "town-gown" conflicts. Brawling students causing damage to a local tavern, for example, could not be tried by the local civic authorities; resentments were inevitable, as they are to this day.

A STUDENT-CENTERED MODEL. The other model of corporate organization was in force at Bologna in Italy. The university at Bologna was founded for the study of law, itself spurred by the West's recovery in the late eleventh century of the Roman Law issued by Justinian in the sixth century, later called the *Codex Iuris Civilis*. At Bologna the corporation or guild (*universitas*, in medieval Latin) was composed not of faculty, but of students, who ran a tight ship. Faculty members wishing to leave town for any reason were obliged to seek permission of the students; likewise if they wished to marry. Missing classes subjected the truant teacher to a fine. It was also at Bologna that the first women were licensed as teachers, although initially one of them, at least, was obliged to lecture from behind a screen, lest her beauty prove a distraction to her students.

THE FOCUS ON TEXTBOOKS. Courses for either model of university were organized not around a subject, but a text. Since books were expensive and in short supply, masters, scribes, and perhaps even wealthier students rented sections or "pieces" of the books (*peciae*) from "stationers" (so-called from their locations along university streets) to take home and copy, then return to exchange for another. This new book-centered context of learning inevitably left its mark on the way theology and philosophy (and all other disciplines, for that matter) were presented. For the first time in the history of philosophy, philosophers found themselves writing not dialogues or treatises or meditations, but textbooks. A textbook, to be successful, has several requirements: it must be well organized, comprehensive (covering all the essential parts of the discipline), and economically expressed. There was no room or time for fat. The downside was that these works were not especially fun to read.

THE REBIRTH OF ARISTOTLE. In one of those rare coincidences of history, universities were taking shape at the same time that the philosophy of Aristotle was reach-

ing the West. The two occurrences are closely related. At the time when curricula were being established and authorities were looking about for textbooks, a freshly translated treatise from the pen of the pagan Aristotle appeared at hand as if bidden by the fates. Universal genius that he was, Aristotle had written on nearly every discipline known in antiquity. It was no surprise that Aristotle was quickly incorporated into the curriculum, making it impossible for a student at one of these universities, notwithstanding his philosophical prejudices, to ignore Aristotle.

SOURCES

Marcia L. Colish, *Medieval Foundations of the Western Intellectual Tradition 400–1400* (New Haven, Conn.: Yale University Press, 1997): 265–273.

Stephen Ferruolo, *The Origins of the University: The Schools of Paris and Their Critics 1100–1215* (Palo Alto, Calif.: Stanford University Press, 1985).

David Knowles, *The Evolution of Medieval Thought* (London: Longmans, 1962): 153–184.

Timothy B. Noone, "Scholasticism," in *A Companion to Philosophy in the Middle Ages*. Eds. Jorge J. E. Gracia and Timothy B. Noone (London: Blackwell, 2003): 55–64.

Hilde de Ridder-Symoens, ed., *A History of the University in Europe*. Vol. 1: *Universities in the Middle Ages* (Cambridge, England, and New York: Cambridge University Press, 1991).

SEE ALSO *Fashion: Academic, Clerical, and Religious Dress; Religion: Medieval Education and the Role of the Church*

THE REDISCOVERY OF ARISTOTLE

ARISTOTLE IN THE WEST AND THE EAST. Owing to vagaries of history, the complete body of Aristotle's writings was lost to the Latin West. The only bits and pieces available were a couple of treatises on logic, a discipline Aristotle invented, and some commentaries on those works: in particular, the *Categories* and the *On Interpretation* (the texts translated by Boethius, both collectively referred to as the "Old Logic"); the *Topics* of Cicero, and the *Topical Differences* of Boethius, together with the latter's translation of Porphyry's *Isagoge* (Introduction to the *Categories*) as well as his commentaries on the *Isagoge*, *Categories*, and *On Interpretation*. This is all that was known—directly and indirectly—of Aristotle's enormous contribution until the twelfth century. The same was not the case in the Muslim world. As part of the plunder from their conquest of much of the Mediter-

ranean region, the Arabs fell heir to the Aristotelian corpus that had been recorded on scrolls that were in the hands of Nestorian Syrians (a heretical Christian sect). The Muslim conquerors quickly translated these works into Arabic. The pagan Aristotle subsequently became, as it were, the "house philosopher" of Muslim intellectuals, and it is not too much of an exaggeration to say that to philosophize for a Muslim between the ninth and the twelfth centuries was in large measure to comment on the works of the Philosopher (as he was called). The view that was widely held was that one could not go beyond Aristotle in matters of reason.

RECOVERY THROUGH TRANSLATION. The Muslim monopoly on Aristotle's philosophy began to change radically in the twelfth century. Owing to contacts with the Muslim world—some friendly, most hostile—European Christians began the process of recovering the philosophy of Aristotle and translating it into their own language, Latin, sometimes through the intermediary of one of the vernaculars. There were several points of contact: the Middle East, especially the rich capital of Byzantium, Constantinople; Sicily, always a melting pot of cultures; and finally, and most especially, Andalusia (Spain). In the Spanish city of Toledo, for example, re-conquered from the Moors (as Muslims in Spain were called), Christian monks worked with Jewish rabbis to translate the Arabic text first into Spanish, and then into Latin—all without the benefit of dictionaries. Thus it was that many Arabic words entered the West and eventually the English language: words like *alcohol*, *algebra*, *coffee*, *zenith*, plus a word which did not exist in the Roman system of numbering, *zero*, essential for mathematical place-notation and hence for mathematics.

PHILOSOPHICAL DIVISIONS. It is difficult to exaggerate the impact Aristotle's writings had on Western Europe. Here was a new and radically different view of nature, of the cosmos, and of the human person, a view that challenged long-held Christian philosophical understandings adapted from Neoplatonism. The reaction of Christian thinkers to this challenge is essentially the story of philosophy in the thirteenth century. For the first time in Christian history there arose different schools of philosophy, the litmus test being how one reacted to the natural philosophy of Aristotle. Those who thought that Aristotle was right on every count were called "Averroists"—or, better, "Latin Averroists" to distinguish them from their counterparts in the Muslim world. Those who preferred the tried and true synthesis of St. Augustine and rejected the innovations of the pagan Aristotle were known to historians as "Augustinians." A third group that attempted to mediate between

these two radical positions were known as "orthodox Aristotelians" or "Thomists," a name derived from St. Thomas Aquinas, who was responsible for building a masterful synthesis of Christian teachings and Aristotelian philosophy.

ACCESS TO GREEK ORIGINALS. By the middle of the thirteenth century the earliest translations of this Aristotelian material from the Arabic gave way to new translations from the Greek originals, which had been recovered in the meantime. Added to the list was the Greek version of Aristotle's *Politics*, a work that the Arabs never possessed. It was to these new and improved translations that thinkers like Albert the Great and Thomas Aquinas had access, and one would have to have worked with the earlier Arabic-Latin versions to appreciate the improvement.

SOURCES

Bernard G. Dod, "Aristoteles Latinus," in *The Cambridge History of Later Medieval Philosophy from the Rediscovery of Aristotle to the Disintegration of Scholasticism 1100–1600*. Eds. Norman Kretzmann, Anthony Kenny, Jan Pinborg (New York: Cambridge University Press, 1982): 45–79.

David Knowles, *The Evolution of Medieval Thought* (London: Longmans, 1962): 185–192.

Charles H. Lohr, "The Ancient Philosophical Legacy and Its Transmission to the Middle Ages," in *A Companion to Philosophy in the Middle Ages*. Eds. Jorge J. E. Gracia and Timothy B. Noone (London: Blackwell, 2003): 15–22.

Timothy B. Noone, "Scholasticism," in *The Cambridge History of Later Medieval Philosophy from the Rediscovery of Aristotle to the Disintegration of Scholasticism 1100–1600*. Eds. Norman Kretzmann, Anthony Kenny, Jan Pinborg (New York: Cambridge University Press, 1982): 55–64.

SEE ALSO *Visual Arts: Intellectual Influences on Art in the Later Middle Ages*

OXFORD PHILOSOPHY

OXFORD AND THE EMPIRICAL APPROACH. While the University of Paris was earning its reputation as the premier school in the West for the study of theology—the *Parens scientiarum* ("The Mother of all Knowledge") as Pope Gregory IX (c. 1145–1241) put it—the University at Oxford in England was developing its own tradition and making its own unique contribution. Many Englishmen had been active in the translation process in

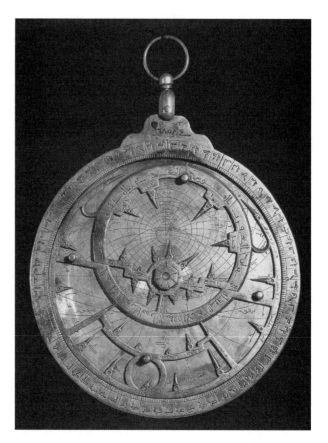

Astrolabe, yellow copper, Islamic, 14th century. **THE ART ARCHIVE/NATIONAL MUSEUM, DAMASCUS, SYRIA/DAGLI ORTI.**

Spain and returned to England with word of new concepts and instruments of which no one in Britain had heard. One example was the astrolabe, used to observe the position of celestial bodies. In response to the interest in these new ideas, the young university at Oxford adopted a decidedly empirical approach to knowledge, even to theological knowledge.

ROBERT GROSSETESTE AND NATURAL PHILOSOPHY. The person most responsible for harnessing and giving direction to these tendencies was the humbly born Robert Grosseteste (c. 1175–1253), "Robert of the large head" in Norman French. A master of arts as early as the last decades of the twelfth century, Grosseteste contributed a number of scientific treatises, displaying wide and original thinking. Perhaps the most important among these was a treatise entitled *De luce* ("On Light"), which was the only treatise on cosmogony (an account of the generation of the universe) between Plato and the Renaissance. In what one modern author has compared to a "big bang" theory, Grosseteste observed that a point of light immediately diffuses itself in all directions, in a spherical shape. Recalling that the Genesis story begins with God's creation of light, Grosseteste found in its

properties a natural explanation for physical reality, which therefore could be explained mathematically.

GROSSETESTE AS THEOLOGIAN AND BISHOP. Well into his fifties, Grosseteste changed careers and became a theologian, accepting a post as the first lecturer to the Franciscans at Oxford, although he never joined the order. As theologian, Grosseteste insisted on the centrality of Scripture as opposed to the more speculative theology practiced by commentators on the *Sentences* at Paris. He also insisted on the importance of mastering the languages of the sacred text and showed the way by learning Greek himself. A third career ensued, that of the powerful bishopric of Lincoln, in whose diocese and jurisdiction lay the university at Oxford. Though Grosseteste took his pastoral duties seriously, he was ever aware of developments at his old university. At one point he wrote a letter to the Oxford masters enjoining them to keep the earliest and preferred lecturing times (the 6 A.M. shift) for Scripture, not the *Sentences*. The master guilty of the contrary practice was a young Dominican by the name of Richard Fishacre, and it took a letter from the pope himself in defense of the practice and of Fishacre's role before Grosseteste would desist.

SCIENCE AS A TOOL FOR UNDERSTANDING. The notion of employing natural philosophy—what moderns would simply call "science"—as a tool for the understanding of the sacred text, however, remained the permanent legacy of the man known as "Lincolniensis" (Grosseteste's sobriquet). A member of his "school," Richard Fishacre, in the prologue to his *Commentary on the Sentences*—the first composed at Oxford—borrows the story of Abraham, Sarah, and Hagar to illustrate the relationship between the disciplines. According to Fishacre's interpretation of the Old Testament story, Abraham's elderly wife Sarah could not become pregnant until Abraham slept with her serving girl, Hagar. Once Abraham had done so, Sarah was able to conceive, and Hagar was banished from the camp. In like manner, before the aspiring theologian can bear fruit, he has to bed down with the sciences, the knowledge of which is a necessary preparation for theology. The aspiring theologian should not, however, linger for too long a time in the bedchamber of the serving girl, but hurry on to the queen of the sciences.

A MODEL FOR ROGER BACON. Grosseteste's approach became the model for the Christian theologian in the eyes of the contentious and outspoken Franciscan friar, Roger Bacon (c. 1214–1292), who praised Grosseteste's knowledge of languages and the experimental sciences. Bacon himself wrote Greek and Hebrew grammars and had some familiarity with Arabic; he also con-

a PRIMARY SOURCE *document*

A METAPHYSICS OF LIGHT

INTRODUCTION: In the first cosmogony (a theoretical account of the origin of the material universe) since Plato's *Timaeus*, the Oxford master and later bishop of Lincoln, Robert Grosseteste, speculates that the property of light is to propagate itself infinitely and instantaneously in all directions to form a sphere. This "metaphysics of light," composed around 1225, is a bold and original attempt to explain how matter was generated from the initial creation of a point of light announced in the Genesis story.

The first corporeal form which some call corporeity is in my opinion light. For light of its very nature diffuses itself in every direction in such a way that a point of light will produce instantaneously a sphere of light of any size whatsoever, unless some opaque object stands in the way. Now the extension of matter in three dimensions is a necessary concomitant of corporeity, and this despite the fact that both corporeity and matter are in themselves simple substances lacking all dimension. But a form that is in itself simple, and without dimension could not introduce dimension in every direction into matter, which is likewise simple and without dimension, except by multiplying itself and diffusing itself instantaneously in every direction and thus extending matter in its own diffusion. For the form cannot desert matter, because it is inseparable from it, and matter itself cannot be deprived of form.

SOURCE: Robert Grosseteste, *On Light (De Luce)*. Trans. Clare C. Riedl (Milwaukee: Marquette University Press, 1978). Reprinted in *Medieval Philosophy*. Vol. II of *Philosophic Classics*. 4th ed. Ed. Forrest E. Baird (Upper Saddle River, N.J.: Prentice Hall, 2003): 292–293.

tributed to the science of optics (according to one legend he was the inventor of eyeglasses) and the rainbow. Never shy about promoting his own projects, Bacon addressed his *Opus maius*, literally the "Greater Work," to Pope Clement IV (d. 1268), who, unfortunately, died before he could give a response.

SOURCES

Jeremiah Hackett, "Roger Bacon," in *A Companion to Philosophy in the Middle Ages*. Eds. Jorge J. E. Gracia and Timothy B. Noone (London: Blackwell, 2003): 616–625.

Neil Lewis, "Robert Grosseteste," in *A Companion to Philosophy in the Middle Ages*. Eds. Jorge J. E. Gracia and

Timothy B. Noone (London: Blackwell, 2003): 597–606.

R. James Long, "Richard Fishacre," in *A Companion to Philosophy in the Middle Ages.* Eds. Jorge J. E. Gracia and Timothy B. Noone (London: Blackwell, 2003): 563–568.

James McEvoy, *Robert Grosseteste* (New York: Oxford University Press, 2000).

R. W. Southern, *Robert Grosseteste; The Growth of an English Mind in Medieval Europe.* 2nd ed. (Oxford: Clarendon Press, 1992).

SEE ALSO *Visual Arts: Intellectual Influences on Art in the Later Middle Ages*

LATIN AVERROISM

ARISTOTLE AND THE UNIVERSITY OF PARIS. While the works of the Muslim commentators on Aristotle were certainly cited by the Oxford masters, it was only at Paris that a distinct school evolved that took its inspiration from one of these commentators. The movement was known as "Latin Averroism," after the Spanish Islamic philosopher Averroës, the principal commentator on Aristotle's work, and originated in the arts faculty in the course of the 1260s. With its concentration on philosophy in its many branches (including disciplines that would today be counted among the sciences, like botany and physics), the bachelor of arts degree was the first earned by a university student in the Middle Ages. The professors in the arts faculty were expected to "reign" for a respectable time and then move on to one of the higher faculties, such as theology, law, or medicine. *Non est senescendum in artibus*—"do not grow old in the arts"— was a well known and widely observed saying.

PHILOSOPHY AS A SEPARATE DISCIPLINE. It was, at any rate, among these philosophy professors that the conviction took hold that Aristotle represented the incarnation of the purest reason and that one could not go beyond the philosopher in matters of the human reason. Not only did they have a model in the great Aristotle, but masters were also gradually becoming more conscious of the value of philosophy as a discipline, a subject of study that could be pursued as an end in itself and not simply as a "handmaid" to theology. In other words, they wished to investigate what the philosophers had to say without concerning themselves about the implications for religious belief. The leaders of the movement, Siger of Brabant (c. 1240–between 1281 and 1284) and Boethius of Dacia (d. before 1277), saw their roles as ascertaining what the philosophers had

held on the subject of the soul, for example, "by seeking the mind of the philosophers rather than the truth, since we are proceeding philosophically." In his earlier writings on the soul (before 1270) Siger maintained that the human intellect was eternally caused by God as Aristotle professed, a view which he regarded as more probable than Augustine's view that God created the soul in time and upon the conception of the body. He later modified this view somewhat, and in a recently discovered treatise he is seen to hold a view that is quite orthodox. Whether orthodox or not, the stratagem adopted by Siger and his associates was that they were presenting views that were not necessarily their own, but rather the views of Aristotle.

THE PROBLEM OF "DOUBLE TRUTH." Siger and Boethius and other Latin Averroists were clerics and hence bound in a kind of institutional way to uphold Christian teachings. So when some of these teachings contradicted positions argued by the pagan Aristotle, as was the case with the mortality of the rational soul and the eternal duration of the world, these philosophers were faced with the difficulty of reconciling their religious beliefs with their philosophical convictions. Although no textual evidence survives to support this, the claim was made by the Averroists' enemies that they held a doctrine of "double truth"—that is, that one could hold one proposition as true according to one's faith and its precise opposite as true according to one's reason. In other words, it was possible for the same intellect to maintain that the soul was immortal (by faith) and yet not immortal (by reason).

LASTING INFLUENCES. This movement came under official condemnation by the bishop of Paris and the archbishop of Canterbury in 1277, but it managed to continue into the Renaissance as a viable school of philosophy. It found a welcome home in northern Italian universities such as Padua, and some say that even Dante, author of the *Divine Comedy*, was influenced by it. Curiously, he places one of its leading lights, Siger of Brabant, in his *Paradiso*, in the company of Aquinas, Bonaventure, Albert the Great, Boethius, Dionysius the pseudo-Areopagite, and a half dozen other saints and doctors.

SOURCES

B. Carlos Bazán, "Siger of Brabant," in *A Companion to Philosophy in the Middle Ages.* Eds. Jorge J. E. Gracia and Timothy B. Noone (London: Blackwell, 2003): 632–640.

David Knowles, *The Evolution of Medieval Thought* (London: Longmans, 1962): 269–277.

Armand Maurer, *Medieval Philosophy.* 2nd ed. (Toronto: Pontifical Institute of Medieval Studies, 1982): 192–204.

John F. Wippel, "The Parisian Condemnations of 1270 and 1277," in *A Companion to Philosophy in the Middle Ages.* Eds. Jorge J. E. Gracia and Timothy B. Noone (London: Blackwell, 2003): 65–73.

THOMISM

CHALLENGING THE AVERROISTS. St. Thomas of Aquino in Italy, more commonly called Thomas Aquinas (1224 or 1225–1274), represents for many the pinnacle and climax of medieval philosophy, and his study has been recommended by popes from Leo XIII to the present occupant of the chair of Peter. A man large in soul as well as in body, Thomas was generally magnanimous in his writings toward his doctrinal enemies: a man must love his enemies, because they help him come closer to the truth. But he reserved his harshest words for the *averroiste*, clerics who upheld the teachings of Aristotle even when they contradicted the Scriptures. Thomas believed that truth is one and cannot contradict itself; therefore the dual truth system of the Latin Averroists was unthinkable. Moreover, he challenged the Averroists to debate him openly and not simply to talk with young boys (a reference to the age of the arts students and the fact that philosophy was taught in the arts faculty) on street corners.

ACKNOWLEDGING THE NATURAL WORLD. Thomas, who as a student at Naples got an early grounding in the New Philosophy, discerned the value in Aristotle's thinking precisely because of its naturalism, the view that there existed a natural explanation for all phenomena. For Aristotle, this world is the real world; reality is not elsewhere in some transcendent realm as in Plato's thought. Christianity, moreover, is in its essence an "incarnational" religion, the foundational doctrine being that God became man. The Christian theologian therefore needs a philosophy that gives an accounting of the natural world, including the autonomy of the human person. A world in which creatures exercise their own proper causality, even while maintaining an existential dependence upon Being itself for their being, renders more glory to God in Thomas's view. This is a radically different view than that taken by the Ash'arites, a group of Muslim theologians, who believed that it is God alone who is acting in all the causes appearing in the world. It is God causing the effect of heat in the presence of the fire or, in a modern rendering, it is God causing letters to appear on the computer screen, not the person entering the data.

a PRIMARY SOURCE *document*

TRANSCENDENCE AND IMMANENCE

INTRODUCTION: Every believing Christian, as well as every believing Jew and Muslim, is obliged to hold that God is both transcendent (that is, totally other than the world) and immanent (that is, somehow present to it). To give a coherent account of this tension, however, requires a sophisticated metaphysics, indeed a metaphysics of existence. St. Thomas Aquinas, here in the eighth question of his masterpiece, the *Summa theologiae*, explains how God is present to the world without being a part of it, thus avoiding the extremes of deism on the one hand and pantheism on the other.

God exists in everything; not indeed as part of their substance or as an accident, but as an agent is present to that in which its action is taking place. For unless it act through intermediaries every agent must be connected with that upon which it acts, and be in causal contact with it: compare Aristotle's proof that for one thing to move another the two must be in contact. Now since it is God's nature to exist, he it must be who properly causes existence in creatures, just as it is fire itself sets other things on fire. And God is causing this effect in things not just when they begin to exist, but all the time they are maintained in existence, just as the sun is lighting up the atmosphere all the time the atmosphere remains lit. During the whole period of a thing's existence, therefore, God must be present to it, and present in a way in keeping with the way in which the thing possesses its existence. Now existence is more intimately and profoundly interior to things than anything else, for everything as we said is potential when compared to existence. So God must exist and exist intimately in everything.

SOURCE: Thomas Aquinas, *Summa theologiae* (Cambridge, England, and New York: Blackfriars, 1964), 1.8.1c. Reprinted in *Medieval Philosophy*, Vol. II of *Philosophic Classics*. 4th ed. Ed. Forrest E. Baird (Upper Saddle River, N.J.: Prentice Hall, 2003): 352.

BEING AS ACT. To claim, therefore, that Thomas worked out a synthesis between Christianity and Aristotelianism is true as far as it goes, but it does not go far enough. It can also be claimed with some justification that Thomas goes beyond Aristotle, not simply because he had the benefit of Divine Revelation, but because he was a better philosopher. His core insight—that being is fundamentally an act, or, in other words,

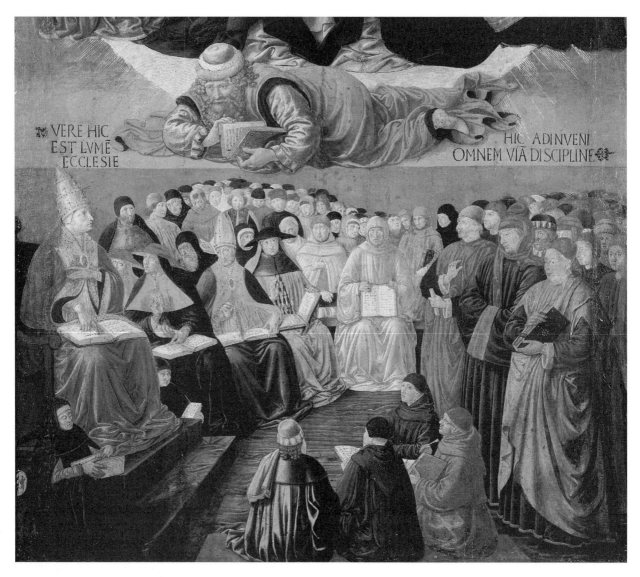

Glorification of St. Thomas Aquinas, Benozzo De Lesse Gozzoli (1421–1497), 15th century. THE ART ARCHIVE/MUSEE DU LOUVRE, PARIS/DAGLI ORTI.

is that which makes any thing real—opens a dimension beyond Aristotle's and, indeed, any predecessor's metaphysics, just as Einstein's fourth dimension goes beyond the speculations of any previous physicist. This being-as-act enabled Thomas to account not only for the absolute transcendence of God—that God is totally other than creation—but also for his immanence—that God is present to creation in some intimate way. Aquinas thus avoids pantheism on the one hand—the view that God is all things or is a part of all things—and deism on the other—the eighteenth-century notion that God is responsible for creating the universe, but that is the end of his involvement, like the clockmaker who winds up the clock and then walks away.

AN AUTHENTIC EXISTENTIALISM. The "concept" of existence is a slippery one—the tendency of the human mind is to think in terms of "things"—and it is little wonder that Thomas's theories were not fully grasped until the twentieth century, spurred by the insights of the school known as Existentialism. Most philosophers in his own time identified Thomas's naturalism with the heterodox Aristotelianism of the Latin Averroists, and when the bishop of Paris drew up his list of condemned teachings three years after Thomas's death in 1274, some two dozen of Thomas's teachings were included. Thus, paradoxically, the thinker who in time became virtually identified with Catholic orthodoxy was shortly after his death under a cloud of suspicion for heresy.

A Rebellious Dominican

Not long after the death of St. Thomas Aquinas, members of his order rallied around his teachings and defended them against attacks from both the seculars and the Franciscans. He was, in short, the official Doctor of the Order of Preachers. There is always someone, however, who refuses to conform, and in this case it was the Dominican friar, Durandus of Saint-Pourçain. He seems to have been a personage of some note, since he was entrusted by Pope John XXII with an important diplomatic mission. For his success he was rewarded with the bishopric of Limoux (1317), a truly singular title since no one before him or after held the title. He soon abandoned that position to become bishop of Le Puy (1318), then of Meaux (1326), a post he held until his death in 1334.

His wrong in the eyes of his fellow Dominicans, however, was that he refused to become a Thomist. He believed that in everything that was not a matter of faith, one should rely upon reason rather than on the authority of any master, no matter how famous or revered. He ended up by writing three commentaries on Peter Lombard's *Sentences*, which is not unlike writing three doctoral dissertations on the same subject. For the first he received a warning from the order, eventually having 91 articles censured by a theological commission. His second version resulted in no fewer than 235 articles being condemned as deviating from St Thomas. His third attempt showed little amendment on his part, but by that time he was bishop (successively of three sees) and seemed no longer to care.

The reaction at his passing gives some sense of how strongly most Dominicans felt about remaining loyal to Thomas and his teachings. The epitaph of the wayward Dominican featured this piece of doggerel, inspired by the fact that the first syllable of Durandus' name is "dur," a Latin root meaning "hard":

Durus Durandus jacet hic sub marmore duro,
An sit salvandus ego nescio, nec quoque curo.
"Here lies the hard Durand beneath the hard
tombstone,
Whether he is saved or not, I don't know, nor do I
care."

SOURCES

Brian Davies, *The Thought of Thomas Aquinas* (New York: Oxford University Press, 1992).

———, "Thomas Aquinas," in *A Companion to Philosophy in the Middle Ages.* Eds. Jorge J. E. Gracia and Timothy B. Noone (London: Blackwell, 2003): 643–659.

Etienne Gilson, *The Christian Philosophy of St. Thomas Aquinas.* Trans. L. K. Shook (New York: Random House, 1956).

SEE ALSO *Visual Arts: Intellectual Influences on Art in the Later Middle Ages*

THE CONSERVATIVE REACTION AND THE CONDEMNATION OF 1277

BONAVENTURE AND THE "AUGUSTINIANS." Even as Aristotle's naturalistic philosophy became foundational to university curricula, there was strong resistance to his ideas. Historians, with their penchant for labeling, have called this group "Augustinians," but in truth the term came to identify a whole complex set of teachings, not all the same. The most articulate of the group was Bonaventure (1217–1274), third successor of St. Francis as Minister General of the Friars Minor or, more popularly, the Franciscans. In the prologue to his major theological work, his *Commentary on the Sentences,* Bonaventure declares that he has no wish to be an innovator, that he wishes only to follow in the footsteps of the great St. Augustine, who not only is a valid guide for the things here below (the extent of Aristotle's competence) but is also master of the things above, sometimes called wisdom. In fact, he claimed that no question had ever been propounded by the masters whose solution may not be found in the works of Augustine. Bonaventure's own work relied heavily on that of Augustine; scholars have identified over three thousand citations of Augustine in the writings of Bonaventure. Like Augustine, moreover, Bonaventure insisted that theology must be rooted in faith; it is, in fact, faith in search of understanding, an idea that echoed St. Anselm's assertion in the eleventh century. He believed that there is an infinite distance between knowing Christ and knowing an axiom of Euclid. Theology cannot be a purely speculative science, but is rather a way of life. It is this emphasis on the affective as opposed to the intellective that distinguished Bonaventure's thought from that of his contemporary and fellow countryman Thomas Aquinas.

THE DOCTRINE OF DIVINE ILLUMINATION. Central to Bonaventure's thought was the Augustinian

doctrine of divine illumination. According to this doctrine, the knowledge received from the senses cannot account for the certitude that man enjoys with respect to truth. The sole sufficient cause of this certitude has to come from within. The problem becomes where this certitude originated. Either man is born knowing these truths (as Plato claimed) or man is dependent upon God's light, which strengthens the mind to know the meanings of things. If the latter is the case—and Christian philosophers (in Bonaventure's view) could not hold the former—then man possesses a simultaneous awareness of the truth of God's existence in every truth that is known, in the same way that man is aware of the presence of light in the perception of color. Bonaventure invented a new word for this concept: *contuitio*, or "contuition"—that is, a "seeing-with" or concomitant realization. It is not that Bonaventure does not have arguments for God's existence; he holds the record—twenty-nine in all, including the shortest ever written: "If God is God, God is." But they are not rigorous and breathe an air of casualness. They are, in short, not demonstrations in the strict Aristotelian sense. Bonaventure himself calls them "exercises for the mind," exercises to make more explicit what one holds already in an implicit way. Bonaventure's certainty of God's existence was such that he claimed to doubt his own existence more easily than that of God. Indeed, he calls the proposition "God exists" a *verum indubitabile*—"a truth which cannot be doubted."

REVELATION AND REASON. Paradoxically, Bonaventure far exceeded Aquinas with respect to the confidence he placed in reason. In his *Quaestiones disputatae de mysterio Trinitatis* (Disputed Questions on the Mystery of the Trinity), Bonaventure maintained that it is possible to make intelligible this most mysterious truth of the Christian religion, namely the Trinity. Given the knowledge of the three Persons in the Godhead from revelation, it is possible for the reason to perceive the doctrine as logically necessary. Like Anselm, Bonaventure looked for "necessary reasons," a notion that Aquinas explicitly denied. Philosophically, Bonaventure's work can be seen as the extension of Augustine's, tempered however by the distinctive spirituality of St. Francis of Assisi. Some scholars, furthermore, have argued for the deep influence of Bonaventure's thought on contemporary philosophy: on hermeneutics, on process philosophy, and on German idealism. Within his own Order, however, he was within a short time supplanted by Scotism, the philosophical system of John Duns Scotus, which then became the quasi-official philosophy of the Franciscans.

THE CONDEMNATION OF 1277. It was the conservatives like Bonaventure who would triumph in the con-

flict with the radical Aristotelians—at least in the short run. The story is easily told, but more difficult to assess. Pope John XXI (c. 1210–1277), who in his earlier life had made a name for himself in logic (in fact, his book, the *Summa logicalis*, was the most widely used logic text in the thirteenth century), had heard rumors of suspicious teachings emanating from the University of Paris, the premier center for theological studies in the West. He ordered Stephen Tempier, the bishop of Paris, to investigate. Taking this papal letter as his warrant, Tempier hastily assembled a panel of theologians and in short order drew up a list of 219 propositions from the teachings of the Parisian masters that he condemned as heretical. Included in the list were approximately two dozen teachings of St. Thomas. The fact that the condemnation was issued three years to the day after Aquinas's death (7 March 1277) led some to suspect a personal insult to Thomas.

THE ANTI-AVERROIST ATTACK. The list itself was a hodgepodge. Condemned as heretical were a book on courtly love, one on geomancy (the art of foretelling the future by studying the patterns formed when earth is randomly thrown on the ground), and one on necromancy (the art of prophesying through communication with the dead). Condemned also were some teachings originally ascribed to Avicenna as well as to St. Thomas Aquinas (as, for example, the teaching that angels are "nowhere," that is, not in a place). But the focus of the document was the teachings of the Latin Averroists: for example, that there is no more excellent state than to study philosophy; that the only wise men in the world are the philosophers; that God does not know things other than himself; that God is eternal in acting and moving, just as he is eternal in existing, otherwise he would be determined by some other thing that would be prior to him, and so forth. In the prologue to this very harsh document the bishop became the first to ascribe to the Averroists (*averroiste*) the teaching by which they came to be known:

> For they [the Latin Averroists] say that these things are true according to philosophy but not according to the Catholic faith, as if there were two contrary truths and as if the truth of Sacred Scripture were contradicted by the truth in the sayings of the accursed pagans …

In other words, they held a theory of double truth.

THE DIVORCE BETWEEN FAITH AND REASON. If the principal aim was to wipe out the Averroist school, the condemnation was a failure. Its unintended effect, however, was wide-ranging: it created a new atmosphere, one in which theologians were more concerned with be-

ing right in the eyes of the Latin Church than they were in pursuing their insights to their logical conclusions. The greatest loss was to speculative theology, namely, a theology grounded in sound reason. In the new mood the trendy phrase became *potentia absoluta* "absolute power": even though it makes no sense to human reason, God can do anything—even make it such that Caesar did not cross the Rubicon (when it is known that he did). It was the divorce between faith and reason and the beginning of the end of the golden age of medieval thought. Philosophy veered off into increased skepticism, doubting the very ability of the mind to know things, the logical conclusion of which was the universal and methodological doubt of Descartes in the seventeenth century, which most recent scholars consider the beginning of modern philosophy. Theology on the other hand headed in the direction of fideism, the view that religious belief is based solely on faith and not on evidence or reasoning, and private religious experience. The outcome of this tendency is to be seen in the flourishing of mysticism in the fourteenth century and ultimately in the Protestant Reformation.

SOURCES

Luca Bianchi, "1277: A Turning Point in Medieval Philosophy?" in *What is Philosophy in the Middle Ages?* Miscellanea Mediaevalia 26. Ed. Jan A. Aertsen (New York: Walter de Gruyter, 1998): 90–110.

Etienne Gilson, *The Christian Philosophy of St. Bonaventure.* Trans. Dom I. Trethowan and F. J. Sheed (Patterson, N.J.: St. Anthony's Press, 1965).

Edward Grant, "The Effect of the Condemnation of 1277," in *The Cambridge History of Later Medieval Philosophy from the Rediscovery of Aristotle to the Disintegration of Scholasticism 1100–1600.* Eds. Norman Kretzmann, Anthony Kenny, and Jan Pinborg (New York: Cambridge University Press, 1982): 537–539.

John E. Murdoch, "1277 and Late Medieval Natural Philosophy," in *What is Philosophy in the Middle Ages?* Miscellanea Mediaevalia 26. Ed. Jan A. Aertsen (New York: Walter de Gruyter, 1998): 11–124.

Anthony Murphy, "Bonaventure," in *Dictionary of Literary Biography.* Vol. 115: *Medieval Philosophers.* Ed. Jeremiah Hackett (Detroit, Mich.: Gale Research, Inc., 1992): 121–129.

Andreas Speer, "Bonaventure," in *A Companion to Philosophy in the Middle Ages.* Eds. Jorge J. E. Gracia and Timothy B. Noone (London: Blackwell, 2003): 233–240.

John F. Wippel, "The Parisian Condemnations of 1270 and 1277," in *A Companion to Philosophy in the Middle Ages.* Eds. Jorge J. E. Gracia and Timothy B. Noone (London: Blackwell, 2003): 65–73.

THE SCOTIST WAY

THE SUBTLE DOCTOR. The most powerful and certainly the most wily thinker of this new era was John Duns Scotus (c. 1266–1308), called the *Doctor Subtilis* or "the subtle doctor." Born in the village of Duns in Scotland, Scotus, declared "Blessed" by the Roman Catholic Church, was educated at Oxford. Following his ordination to the priesthood in 1291 (one of the few solid dates from his life known to scholars), he "reigned" as master of theology at Oxford. He was subsequently sent to Paris, where he wrote a commentary on Peter Lombard's *Sentences.* He occupied one of the chairs assigned to the Franciscans in 1305 and a short time later was sent by his superiors to Cologne, where he taught until his death in 1308. Given the fact that he died at the young age of 42, it is little wonder that much of his promise as a philosopher remained unfulfilled and much of the system he had outlined undeveloped. The fact that some of his works survive only in the form of a *reportatio*—a report taken down by a student—adds to the difficulty in understanding this complex thinker. Reflecting the new spirit of his age, Scotus defended the necessity of divine revelation against those rationalists who advanced the claims of reason alone. The philosophies of Aristotle and his Muslim commentators, by this time so integrated into Christian thinking, were powerless to explain the human condition with its innate sinfulness and need for grace and redemption.

THE CONCEPT OF INFINITE BEING. Unlike St. Thomas, Scotus had a univocal, not an analogous, concept of being; in other words "being" meant the same thing in all of its instances. Scotus' concept of being was everything that is not nothing. Thus emptied of content, being has neither depth nor degrees; nor is there room for the distinction so crucial for Aquinas between essence and being. Thus conceived, being for Scotus eluded comprehension in this life. Given this radically novel metaphysics, Scotus was forced to find a new path to God. All of the beings known to man are finite beings; they therefore demand a cause that is infinite and necessary. If the concept of infinite being is reasonable and not self-contradictory, then it must include the perfection of existence. In other words, if an infinite being is possible, it is necessary.

DIVINE LAW AND DIVINE NATURE. God for Scotus was both completely rational and completely free. Nothing in the immutability of the divine nature demanded one course of action as opposed to another. The moral law was not the result of capriciousness on the part of the divine will, nor was it determined in any

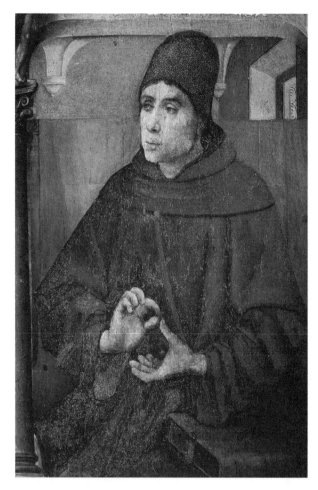

Justus von Ghent, Flemish, panel painting of Duns Scotus, Italy, 1470. THE ART ARCHIVE/PALAZZO DUCALE, URBINO/DAGLI ORTI.

"this-ness." In addition to the formal realities we share in common, such as being embodied, living, sentient, and rational, there is an additional difference that is unique to each of us, and the mind is capable of knowing this uniqueness. The late nineteenth-century English poet Gerard Manley Hopkins, a great admirer of Scotus, called it "the dearest freshness deep down things."

COMPLEXITY AND DISTINCTIONS. Like Augustine—and unlike Aquinas—Scotus gave primacy to the will over the intellect. True, desire is moved only by what is known, but the impetus toward the object comes from the will. The will is thus the higher faculty in that it moves the intellect to know what it knows. The complexity of his thought and the glut of distinctions (of which only a few have been suggested here) led his enemies to dub him the "Duns man," which quickly evolved into the term of denigration that is with us to this day: *dunce*.

SOURCES

Jerome V. Brown, "John Duns Scotus," in *Dictionary of Literary Biography.* Vol. 115: *Medieval Philosophers.* Ed. Jeremiah Hackett (Detroit, Mich.: Gale Research, Inc., 1992): 142–150.

Richard Cross, *Duns Scotus* (New York: Oxford University Press, 1999).

Stephen D. Dumont, "John Duns Scotus," in *A Companion to Philosophy in the Middle Ages.* Eds. Jorge J. E. Gracia and Timothy B. Noone (London: Blackwell, 2003): 353–369.

Armand Maurer, *Medieval Philosophy.* 2nd ed. (Toronto: Pontifical Institute of Medieval Studies, 1982): 220–241.

absolute sense by the divine essence. This meant that the divine law, which is the foundation of the moral law, was the product of the divine will, operating, however, in accord with the non-contradictory character of the divine nature. Thus God can change the rules of morality, according to Scotus, but he cannot contradict his own nature. He cannot, for example, command that he not be loved.

KNOWLEDGE OF UNIQUENESS. Scotus was the first among the Franciscan masters to break with St. Augustine on the question of knowledge; he did not believe that man needed a special divine illumination in order to know truth. On the other hand, he also distanced himself from Aristotle in one important detail. For Aristotle the paradox was that we know individuals but only in a universal way; one knows Callias, said Aristotle, as man (a universal), not as Callias (an individual). Scotus found this explanation wanting and proposed an additional form or entity that makes each individual the individual he or she is; he even invented a word for it: *haecceitas* or

THE MODERN WAY AND THE TRIUMPH OF NOMINALISM

THE WAR OF THE WAYS. The disintegration of the medieval synthesis played itself out in what Germans call *die Wegestreit*, the "war of the ways." The situation was parallel to that which prevailed among Greek philosophers following the death of Aristotle: those with a philosophical bent would join one of the existing schools, learn its teachings, then do battle with the rival schools. The Dominicans had adopted the "Thomist way" after the teachings of Thomas Aquinas; its major challenger, favored by the Franciscans, was the "Scotist way" after the teachings of John Scotus. By mid-fourteenth century these were already seen as the old ways, and many embraced what was called the "modern way" ("modern" being a relative term), that is, the movement begun by William of Ockham (c. 1285–1347) and his followers.

a PRIMARY SOURCE *document*

A PHILOSOPHICAL DEFINITION FROM OCKHAM

INTRODUCTION: This passage from Ockham provides an example of the philosophical definition of a key term ("Universal") in scholastic philosophy. It also demonstrates the use of analogy to clarify discussion.

I maintain that a universal is not something real that exists in a subject [of inherence], either inside or outside the mind, but that it has being only as a thought-object in the mind. It is a kind of mental picture which as a thought-object has a being similar to that which the thing outside the mind has in its real existence. What I mean is this: the intellect, seeing a thing outside the mind, forms in the mind a picture resembling it, in such a way that if the mind had the power to produce as it has the power to picture, it would produce by this act a real outside thing which would be only numerically distinct from the former real thing. The case would be similar, analogously speaking, to the activity of an artist. For just as the artist who sees a house or a building outside the mind first pictures in the mind a similar house and later produces a similar house in reality which is only numerically distinct from the first, so in our case the picture in the mind that we get from seeing something outside would act as a pattern. For just as the imagined house would be a pattern for the architect, if he who imagines it had the power to produce it in reality, so likewise the other picture would be a pattern for him who forms it. And this can be called a universal, because it is a pattern and relates indifferently to all the singular things outside the mind. Because of the similarity between its being as a thought-object and the being of like things outside the mind, it can stand for such things. And in this way a universal is not the result of generation, but of abstraction, which is only a kind of mental picturing.

SOURCE: William of Ockham in *Philosophical Writings: A Selection.* Ed. and Trans. Philotheus Boehner (Indianapolis and N.Y.: Bobbs-Merrill, 1957): 44.

THE
Sword and Pen

Although Ockham finished the requirement for his degree of Master of Theology, he never held the one chair that had been assigned to the Franciscans at Oxford; and because he had "incepted," that is, that he had merely begun his studies, he has been given the sobriquet "Venerable Inceptor." Before his turn came to occupy the chair, he was accused of heresy by John Lutterell, the chancellor of the university and a fanatical Thomist. Subsequently summoned to Avignon, the city to which the papacy had relocated, he waited from 1324 to 1328 at the papal court while a committee examined his writings for suspicious teachings. Before a verdict was rendered, however, he became enmeshed in a controversy over the extreme version of poverty practiced by a wing of the Franciscan Order called the "Spirituals." Convinced that the pope had fallen into heresy, he fled with the deposed General of the Order, Michael of Cessena.

Seeking the protection of the Holy Roman Emperor, Ludwig of Bavaria, whose election the pope had refused to ratify, Ockham and his companions journeyed south to Italy, where the emperor was engaged in a military campaign. One version of what ensued, which is probably apocryphal, is that Friar William knelt before Emperor Ludwig and said: "Protect me with your sword, and I will defend you with my pen." Whatever the accuracy of the incident, Ockham in truth spent his remaining years in Munich under the emperor's protection, where he engaged in political writing, all of it polemical in nature. It is now fairly certain that the sentence of excommunication that was imposed on him was never lifted, and in all probability he died of the plague that swept through Europe in 1348–1350. Today his final resting place is marked by a boss in the pavement at the entrance to an underground parking garage in downtown Munich.

faith, not on evidence. He likewise limited the scope of theology in positing that only those truths that lead to salvation are considered "theological." William's philosophical obsession was the individual, which for him was the sole reality. Scotus's multiplication of formal realities, like his *haecceitas* "this-ness," were pointless distinctions and mere subtleties that needed to be trimmed away. Ockham's relentless wielding of the principle of philosophical economy became known as his "razor."

OCKHAM'S RAZOR. If distrust of the reasoning power is in evidence in the thought of Scotus, a skeptical attitude became a hallmark of the modern way. Whereas St. Thomas opened his *Summa* of theology with a discussion of theology as a science, Ockham refused to grant it such status, asserting that theology is based on

INTUITIVE KNOWLEDGE. This abandonment of realism ("no universal is existent in any way whatsoever outside the mind of the knower," he wrote) also entails for Ockham the abdication of abstractive knowledge. The latter can no more be shown to be real than the universals. According to Ockham, it is only possible to know individual things, and that knowledge is intuitive, not abstractive. For example, if a man has a pet, Buckfield, he attaches that knowledge to a sign, which in his language is "dog"; there is, however, no such thing as canine nature, either in reality or in the mind. Furthermore, what is intuited immediately is not the thing, but the sense image or "phantasm" of the thing. In this atomization of the knowing process, it is generally presumed that the image is caused by the thing, but of this there can be no certainty. The image may be an illusion, a dream, the result of a piece of bad meat; it may for that matter be caused by God, who after all possesses absolute power. For example, a point of light in the night sky is assumed to be a star. Was that image truly caused by the heavenly body so many light-years away? Ockham claimed that there was no way to be certain of this. In modern times, it is known that some of the lights in the night sky are stars that have long ago ceased to exist, but because of the vast distances their light is just now reaching our planet. Ockham would have been fascinated with this notion.

SOURCES

Marilyn McCord Adams, *William Ockham.* 2 vols. (Notre Dame, Ind.: University of Notre Dame Press, 1987).

Armand Maurer, *The Philosophy of William of Ockham in the Light of Its Principles* (Toronto: Pontifical Institute of Medieval Studies, 1999).

Timothy B. Noone, "William of Ockham," in *A Companion to Philosophy in the Middle Ages.* Eds. Jorge J. E. Gracia and Timothy B. Noone (London: Blackwell, 2003): 696–712.

THE RETREAT FROM REASON: MYSTICISM

ESCAPE FROM A HARSH REALITY. The fourteenth century was on many fronts a desperate age, an age of disintegration. The papacy had been weakened morally and militarily by generations of struggle against the powerful rulers of the Holy Roman Empire, a dynasty that traced its legitimacy to the time of Charlemagne in the ninth century and controlled both Germany and northern Italy. As a result of this and other political conflicts, the papacy had become virtually a captive of the French crown at Avignon. Later in the century there were simultaneously three different men claiming to be pope. The magnificent structure of scholastic theology, elaborated as no other system of theology in the history of the world, was crumbling, brought down by the assaults of the Ockhamists. The bubonic plague was ravaging Europe, killing off approximately a third of the population. Especially hard-hit were urban centers, in which the universities were located. We know of at least two philosophers who fell victim to the epidemic. Yet, paradoxically, amid the social and ecclesiastical chaos, the age also witnessed the flowering of mysticism. Perhaps it was in part an escape from realities that had become too harsh, or it represented a retreat from the rational. Whatever the case, it was the age of Dante, exiled from his native city of Florence, who wrote the greatest epic poem in the Italian language, perhaps in any language, detailing his mystic journey through hell, purgatory, and finally paradise.

THE SPIRITUALITY OF MEISTER ECKHART. Especially fertile in spiritual developments was the Rhineland area of Germany and the Low Countries. Of the impressive number of mystics from this area the greatest was the German, John Eckhart, who had earned his degree of Master of Theology at Paris (hence the honorific "Meister"), and who had even served in an important administrative post in the Dominican Order. His academic writings, composed in Latin, were rather traditional and certainly above suspicion. It was in his sermons preached in his native language, however, that Meister Eckhart gave full vent to the exuberance of his spirituality. His following among lay people, especially nuns, soon gained the attention of the archbishop of Cologne, and Eckhart was cited before the Inquisition. Journeying to Avignon to argue his case before the pope, Eckhart intended to defend himself with the claim that heresy was a matter of the will, not the intellect; if he were wrong, he asked for correction, but he did not will to place himself outside of orthodoxy.

TOWARDS DIVINE UNION. Unfortunately, Eckhart died before his hearing. Notwithstanding, two years after his death in 1327, 28 of his teachings were condemned, including the following: "there is in the soul something that is uncreated and uncreatable," "all creatures are a pure nothingness," and "God loves souls, not their external works." Taken out of context, these statements seem to affirm pantheism, deny the reality of creation, and anticipate the German religious reformer Martin Luther's rejection of good works in the early sixteenth century. Such statements were bold and paradoxical to be sure, shocking even, but Eckhart's sermons, when allowances are made for figurative and imaginative language—especially for inspired hyperbole—become expressions of a profound spirituality. It is a spirituality, moreover, that is God-centered,

emphasizing the union of the soul with the divinity without intermediaries, without community, without sacrament. Eckhart urged his congregation to dismiss the agents of the soul—that is, the intellect and the will—and allow God to occupy the core of the soul, the *fünklein*, or "little spark." Eckhart did not believe that man could do anything to merit this divine union, believing that it was all God's doing. Man's efforts count for nothing.

A TRADITION OF PASSIVE RECEPTIVITY. Although they are subject to a Catholic interpretation, these teachings point in the direction of Protestantism, or at least to quietism, a religious attitude of passive receptivity. It was an attitude that drew more from Dionysius and Neoplatonism, and turned away from the relentless rationalism of High Scholasticism. It was an attitude, moreover, that found fertile soil in German-speaking lands, and several disciples followed in Eckhart's footsteps: John Tauler ("the masters of Paris read big books ... but these [the mystics] read the living book wherein everything lives"), Henry Suso, John Ruysbroeck, Gerard Groote, and Thomas à Kempis, the reputed author of *The Imitation of Christ*. The canonization process for Eckhart is currently underway after these many centuries, and it is a certitude that the condemned propositions will be reevaluated.

NICHOLAS OF CUSA AND RHINELAND MYSTICISM. The enterprise of medieval philosophy can with some justification be extended into the fifteenth century and comes to an end with the towering figure of Nicholas of Cusa (1401–1464). Nicholas, or Cusanus, studied with the Brothers of the Common Life, Gerard Groote's foundation, which in turn was inspired by the Rhineland mystics. Cusanus was a prodigious and wealthy scholar; his personal library held over 300 manuscripts, including those authors most influential on his own thinking: Augustine, Proclus, Dionysius, Avicenna, and Eckhart.

THE UNKNOWABILITY OF TRUTH. The title of his major work, *On Learned Ignorance*, summarizes quite accurately his central insight. Reason not only is powerless to reach the infinite, it is likewise incapable of knowing the whole truth about anything. Knowledge is like a polygon inscribed within a circle: sides can be added to the polygon indefinitely, but the polygon will never be identical with the circle. No matter how close the human mind approaches to the truth, it will never completely conform to it. Indeed, as in the Socratic paradox, the more that is known, the more the extent of one's ignorance is recognized. With dazzling originality, Cusanus faulted Aristotle and his logic for the divisions in the Roman Church and in philosophical circles. He instead advocated a logic that was made to unite. He made his own the teaching of the ancient Greek Anaxagoras:

a PRIMARY SOURCE document

MEISTER ECKHART'S SERMON ON THE BIRTH OF CHRIST

INTRODUCTION: Meister Eckhart, a member of the Order of Preachers, preached in both Latin and his native German (when he was addressing laypeople). It was the boldness and exuberance of the latter, however, that got him into trouble with the ecclesiastical authorities. Here, in a sermon on the birth of Christ, is a glimpse of the grounds for two of the charges: pantheism (that the core of the soul is one with God) and quietism (the view that our salvation requires no works on our part).

Let us take first the text: "Out of the silence a secret word was spoken to me." Ah, Sir!—what is this silence and where is that word to be spoken? We shall say, as I have heretofore, [it is spoken] in the purest element of the soul, in the soul's most exalted place, in the core, yes, in the essence of the soul. The central silence is there, where no creature may enter, nor any idea, and there the soul neither thinks nor acts, nor entertains any idea, either of itself or of anything else. ...

In Being there is no action and, therefore, there is none in the soul's essence. The soul's agents, by which it acts, are derived from the core of the soul. In that core is the central silence, the pure peace, and abode of the heavenly birth, the place for this event: this utterance of God's word. By nature the core of the soul is sensitive to nothing but the divine Being, unmediated. Here God enters the soul with all he has and not in part. He enters the soul through its core and nothing may touch that core except God himself.

SOURCE: Raymond Bernard Blakney, trans., *Meister Eckhart: A Modern Translation* (New York: Harper & Row, 1969): Sermon 1.

"everything is in everything." To create all things is for God to be all things. If this sounds dangerously like pantheism, one must remember Cusanus's Neoplatonic roots that recognized that God is above being. Or, conversely, creation is but an explication or unfolding of God; since God is all, the creature is reduced to nothing.

THE FUSION OF PHILOSOPHY AND THEOLOGY. In his treatise *De li non aliud* ("Concerning the Not-other"), Cusanus argued that the absolute cannot stand in a relationship of otherness to any relative being; hence the

"Not-other," or God, is both absolute in its causation and at the same time present to its effect in creation. Here Cusanus, a cardinal of the Catholic Church, proclaimed doctrines very similar to those that had been condemned as heretical a century earlier in Eckhart's sermons. In a new century the assault on the rational structure of theology seems to have been rendered less unacceptable. But what actually happened in the waning of the Middle Ages is that the discipline of philosophy—which was distinct from, but clearly subordinate to, theology for the thinkers of the earlier medieval centuries—had, in the synthesis of Nicholas of Cusa, been assimilated into theology. The two disciplines are fused in Cusanus's mystic vision. This fusion is quite at odds with the estrangement of philosophy and theology which otherwise prevailed in the late medieval period. In some ways Cusanus's thought hearkens back to an earlier golden age.

SOURCES

Jan A. Aertsen, "Meister Eckhart," in *A Companion to Philosophy in the Middle Ages.* Eds. Jorge J. E. Gracia and Timothy B. Noone (London: Blackwell, 2003): 434–442.

Louis Dupré and Nancy Hudson, "Nicholas of Cusa," in *A Companion to Philosophy in the Middle Ages.* Eds. Jorge J. E. Gracia and Timothy B. Noone (London: Blackwell, 2003): 466–474.

Jasper Hopkins, *A Concise Introduction to the Philosophy of Nicholas of Cusa* (Minneapolis, Minn.: University of Minnesota Press, 1978).

Armand Maurer, *Medieval Philosophy.* 2nd ed. (Toronto: Pontifical Institute of Medieval Studies, 1982): 292–324.

Bernard McGinn, *The Man from Whom God Hid Nothing; Meister Eckhart's Mystical Thought* (New York: Crossroad, 2001).

SEE ALSO *Religion: Mysticism and Modern Devotion*

SIGNIFICANT PEOPLE
in Philosophy

AVERROES

1126–1198

Spanish Islamic philosopher

THE LAST OF THE GREAT MUSLIM COMMENTATORS. Ibn Rushd, known as Averroës to Latin-speaking peoples, was the last of the great Muslim commentators on Aristotle. Born in Córdoba in Spain (or al-Andalus, as the Arabs called it) in 1126 to a family of eminent jurists,

Averroës was educated in law, medicine, philosophy, and theology. In addition, he had a deep interest in and knowledge of the literature of the Arabs, a knowledge he exploited in his commentary on Aristotle's *Poetics*.

VALUABLE PATRONAGE. A key moment in Averroës's life was his introduction to the caliph of Marrakech. Although reticent at first, Averroës learned in the course of the conversation that the ruler, Abu Ya'qub Yusuf, was sympathetic to philosophers. Feeling free then to reveal his position on the sensitive topic of the world's eternal duration—a view which Aristotle defended and which the Muslim clerics found sacrilegious—the young scholar revealed his Aristotelian sympathies. As a result of this fateful meeting, Averroës was not only appointed a judge in Seville but also commissioned to write a series of commentaries on the Arabic versions of the writings of Aristotle. With this patronage supporting him, Averroës began the task that was to occupy him for most of his life, writing more than thirty commentaries on Aristotle's treatises. Sometimes, indeed, he wrote as many as three different commentaries on the same work: a long commentary, a "middle" commentary, and an epitome or summary. He did not shy away from controversy, as is evident in his defense of philosophy against the writings of al-Ghazali. A century earlier al-Ghazali had written a work entitled *Tahafut al-Falasifah* (The Incoherence of Philosophy), in which—like David Hume centuries later—he attacked the principle of causality in an attempt to preserve God's infinite power. He argued that human beings do not in fact cause anything, but merely provide the occasion for God to act directly. Al-Ghazali's reasoning thus strips secondary causes of any role in action and in turn renders philosophy a useless pursuit. Averroës answered this attack on philosophy in his work *Tahafut al-Tahafut* (The Incoherence of the Incoherence), pointing out succinctly but effectively the sophistries in al-Ghazali's arguments:

> Denial of cause implies the denial of knowledge, and the denial of knowledge implies that nothing in this world can be really known, and that what is supposed to be known is nothing but opinion, that neither proof nor definition exist, and that the essential attributes which compose definitions are void.

THE SUPERIORITY OF PHILOSOPHY. So unbounded was Averroës' admiration for Aristotle that he penned the most exaggerated praise that one philosopher ever wrote of another.

> I consider that that man [Aristotle] was a rule and exemplar which nature devised to show the final perfection of man … the teaching of Aristotle is the supreme truth, because his mind was the final expression of the human mind. Wherefore it has

been well said that he was created and given to us by divine providence that we might know all there is to be known. Let us praise God …

Averroës was at pains, moreover, to defend the vocation of philosophy, arguing that not only is the pursuit of wisdom not forbidden by the Koran, it is expressly commanded—for those, that is, who have the intellectual acumen. No conflict need arise between the small and exclusive class of philosophers and the common people or even the theologians, if only these classes would confine themselves to the mode of argument of which they are capable. Of the three modes of proof outlined by Aristotle in the *Rhetoric*—exhortations, dialectics, and rational demonstrations—the first was the only appropriate approach to truth for the uneducated masses; the theologians' capacity to understand probable arguments meant that dialectics was most suitable for them; and the philosophers were the only ones able to follow rational demonstrations. They were enjoined, however, not to lord it over the lower classes, but to pursue their studies with the conviction that they enjoyed the most direct road to the truth.

THE END OF THE MUSLIM GOLDEN AGE. Averroës' privileged status came to an abrupt end when his patron died and the patron's son, having decided that the philosophers blaspheme the true religion, sent him into exile. Three years later, in 1198, he was exonerated and allowed to live in Marrakech where he died a short time later at age 72. With the death of Averroës the Golden Age of Philosophy among the Muslims came to an end, a victim of religious fundamentalism. It is ironic that this greatest commentator on Aristotle enjoyed his most avid and attentive readership, not among his own people, but in the Latin West.

SOURCES

Deborah Black, "Averroës," in *Dictionary of Literary Biography*. Vol. 115: *Medieval Philosophers*. Ed. Jeremiah Hackett (Detroit, Mich.: Gale Research, Inc., 1992): 68–79.

F. E. Peters, *Aristotle and the Arabs; The Aristotelian Tradition in Islam* (New York: New York University Press, 1968).

Richard Taylor, "Averroës," in *A Companion to Philosophy in the Middle Ages*. Eds. Jorge J. E. Gracia and Timothy B. Noone (London: Blackwell, 2003): 182–195.

ROGER BACON

c. 1214–1292

Franciscan teacher
Natural philosopher

FROM OXFORD TO PARIS. Notwithstanding his subsequent notoriety, there are very few facts known with certainty about the life of Roger Bacon. Most of the dates listed by scholars are reconstructed from indirect remarks made by Bacon in his *Opus tertium* or "Third Work" (c. 1267). According to one reading of this work, he was born in 1214 of a well-known family of landed gentry, one member of which was the first Dominican master at Oxford and the teacher of Richard Fishacre. He was (according to this same reading) educated at Oxford from 1228 to 1236, then taught as master in the Arts faculty at Paris from 1237 to 1247. There Bacon became one of the earliest Christian thinkers to lecture and to write commentaries on the newly translated natural philosophy of Aristotle. Owing to the discovery in the nineteenth century of a manuscript at Amiens, scholars now have a copy of these commentaries.

PRIVATE RESEARCH. Between the years 1248 and 1256, Bacon, now a Franciscan friar, retreated to what can only be described as private study (possibly at Oxford) and the instruction of others, using his family inheritance to support himself. These studies were to lay the foundation for the positions he passionately held for the rest of his life: the insistence on the practical orientation of theology, the importance of the study of languages (for which he praises the efforts of Robert Grosseteste), the significance of experimental science, and the centrality of the mathematical sciences. He argued for the development of new technologies for the betterment of human life, especially as regards healthcare, military technologies, and warfare.

A FLURRY OF PRODUCTIVITY. Toward the end of this period Bacon was posted by his superiors back to Paris, where he was resident in the Franciscan house of studies from 1256 until 1280. Bacon soon came to regret his "conversion" to the Franciscan Rule, owing to the unwillingness of his superiors to assign him to the classroom. In desperation, he appealed to Cardinal Guy Le Gros Foulques, petitioning him for funds to begin a major research project. As fate would have it, his would-be patron was elected pope in 1265, taking the name Clement IV. In a letter of June 1266, the new pope ordered Bacon to send him a copy of his grand work. Since the book had not yet been written, Bacon set to work feverishly and in three years produced the *Opus maius* ("The Greater Work"), the *Opus minus* ("The Lesser Work"), the *Opus tertium* ("The Third Work"), the *De multiplicatione specierum* ("On the Multiplication of Species"), *De speculis comburentibus* ("On Burning Mirrors"), the *Communia naturalium* ("Common Account of Natural Things"), and the *Secretum secretorum* ("The Secret of Secrets").

BACK TO OXFORD. Tragically, not only did the pope not respond to this deluge of writings (it is unclear

whether he even read them), but now Bacon was in trouble with his superior. Bonaventure, the Minister General of the Franciscans, held strong views on such subjects as astrology and alchemy and regarded Bacon as flirting with dangerous ideas. Furthermore, Bacon seems to have had leanings toward more radical elements in the Franciscan Order, those namely that saw the Order as the fulfillment of the prophecies of the apocalyptic visionary, Joachim of Fiore. As a result he was put under a kind of house arrest. In 1280, Bacon was transferred to Oxford again, where he remained until his death in 1292. His old age did not seem to have mellowed him. He persisted in his outspoken manner to criticize theological education and single out those who were—falsely in his view—reputed as wise. Although he attacked by name Thomas Aquinas and Albert his teacher, noting that he was dubbed "The Great" even during his own lifetime, his primary target was a fellow Franciscan.

> I knew well the worst and most foolish [author] of these errors, who was called Richard of Cornwall, a very famous one among the foolish multitude. But to those who knew, he was insane and [had been] reproved at Paris for the errors which he had invented [and] promulgated when lecturing solemnly on the Sentences there …

Research continues on this figure who was seemingly out of step with his time, but whose attempt to integrate Muslim, Jewish, and Christian wisdom pointed the way to the future.

SOURCES

Stewart Easton, *Roger Bacon and His Search for a Universal Science; A Reconsideration of the Life and Work of Roger Bacon in the Light of His Own Stated Purposes* (New York: Columbia University Press, 1952).

Jeremiah Hackett, "Roger Bacon," in *A Companion to Philosophy in the Middle Ages.* Eds. Jorge J. E. Gracia and Timothy B. Noone (London: Blackwell, 2003): 616–625.

———, "Roger Bacon," in *Dictionary of Literary Biography.* Vol. 115: *Medieval Philosophers.* Ed. Jeremiah Hackett (Detroit, Mich.: Gale Research, Inc., 1992): 90–102.

MOSES MAIMONIDES

1138–1204

Judge
Physician
Commentator

FROM SPAIN TO NORTH AFRICA. Rabbi Moshe ben Maimon, more commonly referred to as Maimonides, was the most eminent Jewish philosopher of the medieval period. He was born in 1138 in Córdoba (the birthplace also of the famous Islamic philosopher Ibn Rushd or Averroës), the court city of the Almoravid caliphate. He came from a long line of Talmudic scholars, including his father, Maimon, who was a rabbinic judge as well as a mathematician and astronomer. It is little wonder then that his earliest education was imparted in the home. Later he was sent to Arab masters for instruction in the natural sciences, medicine, and philosophy. The flourishing Jewish intellectual community into which Maimonides was born and raised, however, came suddenly under threat when the less tolerant Almohads conquered their region. Faced with persecution, the Maimon family fled to North Africa, eventually settling in the city of Fez. It is during this period, according to one account, that the family was offered refuge by Averroës.

EARLY WORKS. In the meantime, the precocious young Maimonides had at age sixteen produced his first philosophical work, a treatise on Arabic logic. Four years later he had also composed a mathematical and astronomical work on the Jewish calendar and commenced a ten-year project: a commentary designed to make the oral law of Judaism more accessible. He came to prominence in the Jewish community at this time, however, for his "Letter on Apostasy," a passionate plea for his coreligionists to emigrate to countries where they would be permitted to practice their faith freely and also to forgive those who had been forced to abandon their observance of the Law.

COMMERCE AND MEDICINE. By 1165 Fez was also to prove inhospitable to the Maimon family. An inquisition was instituted to punish those who had relapsed from Islam (the family had earlier been forced to convert). Once again Maimonides and his family fled, first to Palestine, then to Cairo in Egypt, where he spent the remainder of his years. His livelihood at this time was derived from commerce, but when his beloved brother David died in a shipwreck, Maimonides abandoned the business world and turned to the practice and teaching of medicine. Eventually he became court physician to the great Saladin, Sultan of Egypt and victor over the Crusaders.

FAITH AND PHILOSOPHY. Fluent in both Hebrew and Arabic, Maimonides wrote in the former language when he was addressing the Jewish community, as for example in the *Mishneh Torah* (a clear and systematic exposition of the entire oral law), and in Arabic, the *lingua franca* of most of the Mediterranean world, when he wanted to reach a larger audience. Such was the case with his major philosophical work, the *Dalalat al-Ha'irin,* or

"The Guide of the Perplexed." Addressed to a certain Joseph, a former student and, therefore, one considerably advanced in philosophical knowledge, Maimonides aimed in this lengthy work to clear up his pupil's confusions over the apparent lack of correspondence between his religious faith and his philosophical convictions—to reconcile, in other words, Athens (personifying reason) and Jerusalem (personifying faith).

INFLUENCE ON CHRISTIAN THINKERS. Maimonides was recognized as an authority on the Jewish Law by diaspora communities throughout the Middle East and Mediterranean and his advice was frequently sought. After his death the translation of his *Guide* into Latin extended the influence of his philosophical accomplishments to Christian thinkers of the thirteenth century, where he was cited as an authority ("Rabbi Moyses") by such philosophers as Richard Fishacre, Albert the Great, and Thomas Aquinas.

SOURCES

Idit Dobbs-Weinstein, "Moses Maimonides," in *Dictionary of Literary Biography.* Vol. 115: *Medieval Philosophers.* Ed. Jeremiah Hackett (Detroit, Mich.: Gale Research, Inc., 1992): 263–280.

Alfred L. Ivry, "Moses Maimonides," in *A Companion to Philosophy in the Middle Ages.* Eds. Jorge J. E. Gracia and Timothy B. Noone (London: Blackwell, 2003): 445–457.

Joshua Weinstein, *Maimonides, The Educator* (New York: Pedagogic Library, 1970).

THOMAS AQUINAS

c. 1224–1274

Dominican friar
Philosopher

A LIFE IN THE CHURCH. Thomas Aquinas, called the "Common Doctor" or (some centuries later) the "Angelic Doctor," was born in the family castle of Roccasecca in the county of Aquino (hence his name), which was located in the Kingdom of Naples. The youngest son in a noble family of thirteen children, Thomas was undoubtedly destined by his father for service in the Church. Hence it was that he was packed off at the age of five to the nearby monastery of Monte Cassino as an oblate (a lay member of the religious community), possibly one day to be its abbot, a post befitting his aristocratic status. Thomas's career path took a different turn, however, after his superior transferred him to nearby Naples to continue his studies at the newly founded university, the establishment of the emperor, Frederick II.

There Thomas was exposed, full bore, to the newly translated works of Aristotle. It was also there that he first encountered the religious order of begging preachers, founded by St. Dominic. Attracted to the mendicant way of life, young Thomas took the habit, much to the consternation of his mother. Sending his older brothers, both knights, to seize her youngest son, she had Thomas placed under "house arrest" in the family castle.

A MASTER OF THEOLOGY. A year's captivity was not able to shake his resolve, however, and Thomas was allowed to continue his interrupted journey to Paris, where he came under the tutelage of Albert of Swabia, who was already being called Albertus Magnus, or "Albert the Great." The teacher recognized the genius of his pupil; one time, on overhearing the nickname with which his fellow students had dubbed him, "the dumb ox," he predicted that one day the bellowing of this dumb ox would fill the world. Following a period in Cologne, where he witnessed the laying of the cornerstone of the great cathedral, Thomas was sent back to Paris to study for the terminal degree in theology, the "master of the sacred page" (referring to Scripture). Owing to university politics, however, the degree was withheld, and it took a letter from the pope to the chancellor before Thomas and his fellow student Bonaventure (the future Minister General of the Franciscan Order) were admitted to the "university" of masters.

THE BEGINNINGS OF THE SUMMA. For three years Thomas held the chair assigned to the Dominicans at Paris, then was transferred to his native Italy for the next ten years. While teaching in the house of studies in Rome, Thomas conceived the idea of what was to become his masterpiece, the *Summa theologiae*, the "Summary of Theology," which was written, as he said in the Prologue, for beginners in the discipline. In 1268 Thomas was transferred again to Paris, this time to do battle against the movement that had arisen in his absence, Latin Averroism. One detects in his writings from this period a dramatic change from his usual placid and tranquil demeanor, and Thomas used rather harsh language in challenging the professors who he was convinced were misinterpreting Aristotle and threatening his own project, which was to build a new synthesis of Christian theology on the foundations of Aristotle's natural philosophy.

A REMARKABLE OUTPUT. Thomas left Paris after four years of incredibly intense activity, when in addition to his lectures on Scripture and his continuing work on the *Summa*, he had begun his own commentaries on the works of Aristotle. Although these commentaries were extracurricular for Thomas—that is, they did not

constitute part of his duties as a master of theology—they were written by him precisely to defend his use of Aristotle in theology in the face of the "Augustinians" who had accused him of Averroism. Back in Naples, exhausted by his Herculean efforts (he wrote or dictated fifty works in his forty-nine years), he suddenly stopped writing altogether, leaving the *Summa* incomplete. When questioned by his secretary, Reginald of Piperno, Thomas would only reply that after what had been revealed to him, he realized that he had not come close. The following spring, on his way north to attend the Council of Lyons to which he had been summoned, he fell from his horse and was taken to a nearby monastery, where some days later he died. He was officially recognized as a saint almost fifty years later, after several of his teachings which had been condemned in 1277 were subjected to a re-examination and found to be orthodox.

SOURCES

Albert and Thomas. Selected Writings. Trans. and ed. Simon Tugwell (New York: Paulist Press, 1988).

Jean-Pierre Torrell, *Saint Thomas Aquinas.* Vol. 1. Trans. Robert Royal (Washington D.C.: Catholic University of America Press, 1996).

James A. Weisheipl, *Friar Thomas d'Aquino; His Life, Thought, and Works* (Washington, D.C.: Catholic University of America, 1983).

WILLIAM OF OCKHAM

1285–1347

Franciscan friar
Teacher
Political polemicist

THE VENERABLE INCEPTOR. Few philosophers of the Middle Ages have proved to be as divisive in their own age or since as the Franciscan friar, William of Ockham. Born about 1285 in the town of Ockham in Surrey, a quiet shire south of London, William joined the Order of Friars Minor at the tender age of twelve. Following his novitiate and philosophical studies at the Franciscan convent in London, he began his study of theology at Oxford around 1306. His lectures on Peter Lombard's *Sentences* came in 1317–1319, at which time he was recognized as an "inceptor," or bachelor of theology. With another two years of study he completed the requirements for the degree of Master and had even delivered his inaugural lecture. Owing to a restriction on the number of mendicants allowed to become masters, however, Ockham did not assume the chair in theology at this time, and circumstances later intervened so that he never in fact lectured in theology as a master; his title thus became the Venerable Inceptor.

A FORCIBLE STAY AT AVIGNON. Instead Ockham was posted to the Franciscan house of studies in London where for the next several years he lectured and wrote extensively. It was writings from this period that make up the bulk of Ockham's philosophical output. In 1324, however, the chancellor of Oxford, John Lutterell, charged Ockham with heresy, and he was forced to travel to Avignon in France (where the pope had taken up residence) to defend himself. For four years the investigation into his teachings dragged on, but in the end none of the suspect teachings was formally condemned. Notwithstanding, his academic career was at an end. He would never hold a chair. While Ockham was biding his time in Avignon, however, he encountered his superior, Michael of Cessena, also summoned to Avignon because he had opposed the pope's condemnation of absolute poverty—that is, the surrender of any right to property both on the part of the individual friar and also on the part of the Order. The Minister General had given Ockham the charge of examining three papal documents and rendering a verdict. Ockham's judgment was clearly not tailored to endear him to the pope. The papal assertions were in his words, "heretical, erroneous, foolish, ridiculous, fantastic, senseless, defamatory, and equally contrary and obviously adverse to the orthodox faith, sound morality, natural reason, certain experience, and fraternal charity." Burning their final bridges, Michael and William fled Avignon, taking a boat to Pisa, where they caught up with the Holy Roman Emperor, Ludwig of Bavaria. The story told about the meeting is probably apocryphal, but it is colorful: the friar knelt before the emperor and said, "Defend me with your sword and I will defend you with my pen."

IMPERIAL APOLOGIST. Defend the emperor Ockham did, and for the final seventeen years of his life he abandoned philosophy and theology entirely and wrote polemical works exclusively, analyzing the nature of the Christian Church, the relationship between church and state, and the role of natural law. Death came in 1347, and he was buried in the Franciscan church in Munich. Today the Bavarian National Theater occupies that site. At the bottom of the stairs leading to the parking garage can be found a modest plaque marking the probable burial site of one of the most revolutionary thinkers of the medieval period.

SOURCES

André Goddu, "William of Ockham," in *Dictionary of Literary Biography.* Vol. 115: *Medieval Philosophers.* Ed. Jere-

miah Hackett (Detroit, Mich.: Gale Research, Inc., 1992): 305–315.

Armand Maurer, *The Philosophy of William of Ockham in the Light of Its Principles* (Toronto: Pontifical Institute of Medieval Studies, 1999).

Timothy B. Noone, "William of Ockham," in *A Companion to Philosophy in the Middle Ages*. Eds. Jorge J. E. Gracia and Timothy B. Noone (London: Blackwell, 2003): 696–712.

DOCUMENTARY SOURCES
in Philosophy

Peter Abelard, *Sic et Non* (early 12th century)—Reflecting his age's infatuation with dialectics, Abelard cleverly lines up apparently contradictory teachings on the part of the fathers of the church and shows through logical analysis that the contradictions are only superficial.

Anselm of Canterbury, *Proslogion* (mid 11th century)—Responding to a plea from his monks who wanted one single argument to prove not only God's existence but everything else we believe about God, Anselm creates the most intriguing and most discussed argument of all time, the genius of which is to force the atheist into a contradiction if he continues in his denial of God.

Augustine (Aurelius Augustinus), *On the Free Choice of the Will* (c. 400) and *Confessions* (c. 397–400)—The first work, widely regarded as the best philosophical writing by this early Christian theologian, introduces to Western thought the notion that the human will freely makes choices. The *Confessions*, considered one of the great books of the Western world, is a "letter" to a fellow bishop recounting Augustine's knotted journey to find the Beauty ever ancient and ever new. It is a unique work owing to the fact that we are let in on the workings of the mind of a philosopher.

Anicius Manlius Severinus Boethius, *The Consolation of Philosophy* (523–524)—A "best seller" all through the Middle Ages, the *Consolation* was written by a man facing death and wrestling with the problem of evil and the secret of human happiness.

Bonaventure, *The Mind's Journey into God* (mid-thirteenth century)—Guided by the metaphor of the six-winged seraph that had appeared to St. Francis of Assisi, Bonaventure in this spiritual masterpiece traces the journal of the pious soul from the sensible things of this world, through the soul, into the transcendent God.

Dionysius, the pseudo-Areopagite, *On the Divine Names* (c. 500)—This treatise on divine language—that is, the problem of how to talk about God—had an influence that lasted about a thousand years; the Italian humanist, Lorenzo Valla, finally exposed it as a forgery.

John Scotus Eriugena, *On the Division of Nature* (mid-9th century)—In this first "summa" of the Middle Ages, the Irish monk creatively divides nature into four parts: God as principle of all things, the divine (creative) ideas, creatures, and God as end and goal.

Moses Maimonides, *The Guide for the Perplexed* (late 12th century)—This classic of medieval Jewish thought was written for believers who also knew Greek philosophy and were confused as to how to reconcile faith and reason.

Nicholas of Cusa, *On Learned Ignorance* (mid-fifteenth century)—In a departure from Aristotle's law of non-contradiction, Cusa argues in this most original masterpiece of the medieval period that in all entities, but especially in God, there is a "coincidence of opposites."

John Duns Scotus, *Ordinatio* (1298–1302)—One of two commentaries which Scotus wrote on the *Sentences* of Peter Lombard, this work puts on display the subtle mind of the man awarded the epithet "Subtle Doctor" by his contemporaries.

Thomas Aquinas, *Summa theologiae* (1273)—Though written professedly for beginners in the discipline, this masterpiece of philosophical or speculative theology represents the high point of medieval thought.

chapter seven

RELIGION

Tim J. Davis

IMPORTANT EVENTS
in Religion

800 Charlemagne is crowned emperor of the Romans by Pope Leo III, creating a linkage between spiritual and temporal powers.

813 Charlemagne requires all Christian altars to contain holy relics.

815 Byzantine iconoclastic policies (removal of sacred images from church decoration) are revived by Emperor Leo V.

843 The iconoclastic controversy in Byzantine Christianity comes to an end, and the use of icons is restored.

860 Russian ambassadors to the court of Constantinople embrace Christianity.

909 The founding of the famous Benedictine monastery of Cluny, France, occurs in this year.

945 A Christian church is built in the Russian city of Kiev.

962 The coronation of the German ruler Otto I as emperor of the Romans occurs in this year, reestablishing strong ties between spiritual and temporal powers.

990–1096 Local church councils address Peace of God and Truce of God legislation attempting to lessen medieval violence.

c. 1000–1080 This is the early period of revival for women's monastic life in Europe.

1027 The Danish king Canute makes a famous pilgrimage to Rome.

1054 Rome's excommunication of the patriarch (a bishop in Eastern Orthodox sees) of Constantinople marks a significant early break between Latin and Greek Christian institutions.

1059–1080 The height of papal legislation concerning conflict between secular and religious authority (which historians often label as the "Investiture Controversy") is reached. The contest over various influences and powers in society culminates in a disagreement between churchmen and powerful princes concerning the authority to invest new bishops with their symbols of office.

c. 1075 The military religious order of Hospitallers begins its work in the Holy Land, providing comfort and assistance to pilgrims.

1080 Bruno of Cologne founds the Carthusian Order of hermits, combining the communal (cenobitic) lifestyle with solitary (eremitic) practice.

1095 The First Crusade, a Christian military expedition to free the Holy Land from Muslim domination, is promoted by Pope Urban II.

1098 The formation of the Cistercian Order attempts to reform the abuses of medieval monasticism and return it to a purer interpretation of the Benedictine Rule.

1110–1143 Persecution of the Bogomils, a religious movement holding that the earth was created by Satan, takes place in the Byzantine Empire.

1121 The Premonstratensian Order is founded. The order is unique in that it accepts both men and women and attempts to accommodate them in the same monastery.

1128 The Council of Troyes approves plans for the establishment of the Knights Templar, an order of knights which protected pilgrims and settlers in the Holy Land following the ousting of Muslim forces from the area during the Crusades.

1143 The Cathar movement begins in France. The Cathars desire to purify the church from worldly elements and the corruptions of the flesh.

1145 The Second Crusade, to rescue the city of Edessa in Greece from Muslim control, is preached by St. Bernard of Clairvaux, while simultaneous crusades are planned against European non-Christians (Bohemians, Wends, and Moors).

1170 Archbishop and former English chancellor Thomas Becket is murdered at Canterbury Cathedral following a conflict with the king over the rights and authority of the church.

1184 The papal bull *Ad Abolendam* condemns the teachings of the Waldensians (who preached against clerical corruption), Cathars (who rejected the bodily resurrection of Christ), and certain Humiliati (a lay order).

1189–1192 The Third Crusade is undertaken against the Muslim leader Saladin, and some coastal territory is recovered.

1199–1204 The Fourth Crusade, intended to fight Muslims in Egypt, goes off course and ends with the sacking of Constantinople and establishment of the Latin Empire, which lasts sixty years.

1200 Masters at the University of Paris receive royal charter, which will be approved in Rome in 1231.

1201 The lay spiritual Humiliati movement receives papal recognition.

c. 1205 The lay women's movement of Béguines begins in Germany and the Lowlands.

1209 The Albigensian Crusade is launched against heretical Cathars, and is carried out over the next twenty years with great cruelty.

1210 Pope Innocent III grants Francis of Assisi permission to found an order of mendicants (later called Order of Friars Minor).

1215 The Fourth Lateran Council convenes and implements major reforms for secular clergy.

The Poor Clares, a Franciscan order for women, is formed.

1217 The Dominican Order of Preachers receives papal confirmation.

1232 Pope Gregory IX grants the constitution for the foundation of Dominican nuns.

1249 Oxford University is founded in England. It later becomes one of the institutions where religious orders send their most talented brethren to teach and study.

1250 The Carmelites, who had been hermits in the Holy Land, are approved as an order of friars in European communities.

1265 Thomas Aquinas begins to write the *Summa Theologiae*, which organizes arguments reconciling faith and reason.

1298–1350 This period marks the height of the lay Humiliati movement.

1309 The pope, involved in struggles between religious and secular authority, begins to reside in Avignon, France, where the papacy would remain until 1377 (1408 including anti-popes).

1315–1317 Famine strikes Europe, triggering a heightening of spirituality.

c. 1325 The Cistercian movement peaks in influence, with some 700 male abbeys and 900 women's houses.

1347 The advent of the Black Death (the bubonic plague) reinforces the idea that the world is transitory and only the spiritual life has true value.

1373 The mystical visions of the English anchoress Julian of Norwich begin.

1378 The Great Schism occurs over rival claims to the papacy, dividing Europe's allegiance

between two (and at times even three) different popes.

1382 The teachings of the English reformer John Wyclif, who rejects transubstantiation and supports vernacular Bibles, are condemned.

1416 The Czech reformer Jan Hus, a follower of Wyclif's teachings who preached against clerical corruption, is burned as a heretic.

1417 The Great Schism comes to an end with the Council of Constance.

1453 The fall of Constantinople to the Ottomans diminishes the link between Eastern and Western Christianity.

1455 The Gutenberg Bible is first printed, beginning an era when ordinary people will be able to read and interpret scriptures for themselves.

OVERVIEW
of Religion

A PERVASIVE PRESENCE. The importance of religion in all facets of medieval life can hardly be overestimated. One of the reasons for the pervasive presence of religious ideology was that the dominant or most influential figures (often those in power) in Western European, Byzantine, and Muslim cultures each lived according to a revealed religion that reached deeply into every aspect of daily life. Many historians have attributed the early growth of such influences in northern Europe to the efforts of Christian missionaries, most of whom were members of monastic orders from the remnants of the western Roman Empire. In the Byzantine Empire (the former eastern part of the Roman Empire, centered in what is now Istanbul, Turkey) and areas dominated by Islam, organized religion was connected to the offices of both emperor and caliph (the spiritual and political head of Islam). The shaping of culture was clearly tied to the way each of these religions became a part of people's lives. Substantial support from the monarchies of northern Europe would not become the norm until the ninth century when the scope of secular administrative power became more widespread. Some of the northern European kings were profoundly affected by the Christian message, while others were mainly concerned with making alliances with church leaders who had significant authority, thus assisting the development of the prominent position of religion in the social and ideological landscape.

THE CAROLINGIANS AND THE FRANKISH ROMAN EMPIRE. The great rise of religious influence in northern Europe took hold during the Carolingian period in the late 700s and is often considered to have begun with the reign of the Frankish king Charlemagne (768–814). Charlemagne's successors and the legacy he left behind ensured the ongoing dominance of Christianity by bringing it to both the common people and the nobility. This was done in a variety of ways: through education, personal example of the secular rulers, and church leadership, as well as infusing Christianity into the system of social obligations, particularly those associated with lordship. Fostering the growth of monasteries along with local secular churches ensured a more even distribution of religious program. Strong links to Latin (that is, Roman) Christianity were established by adopting many of the Roman traditions for religious ritual, but a political relationship with the papacy was also forged via the institution that was later called the Holy Roman Empire (a realm centered in the areas that are now France, Germany, Benelux countries, Switzerland, Austria, Bohemia, and northern Italy), whose heads of state, beginning with Charlemagne, were crowned by the pope himself.

MEDIEVAL RELIGION OUTSIDE THE FRANKISH ROMAN EMPIRE. During the tenth century, missionaries continued to facilitate the spread of Christianity outside of the Frankish Roman Empire, particularly in areas to the east of Germany. As bishoprics and their jurisdictions were created, they brought with them certain social structures (such as ecclesiastical courts) and official channels that encouraged the expansion and growth of new Christian states. At the same time, pervasive incursions, attempts at settlement, and large-scale invasions by polytheistic Vikings from Scandinavia and Magyar groups from what is now Hungary proved to be both an interruption to the progress of Christian development and an opportunity for further evangelization. Conversions of Danes, Swedes, Norse, and Magyars, both in their native regions and among those who settled in England, France, and Germany, were attempted with varying degrees of success between the ninth and twelfth centuries. Spain continued to be dominated by Islam at this time, although there were large numbers of Jews and Christians living in the Iberian Peninsula. Jews also had settled early on in the areas that are now Italy, northern France, and Germany, after being displaced from the Holy Land by Muslim invaders, and they remained an important, if marginalized, presence in most areas of Europe throughout the Middle Ages.

BYZANTINE CHRISTIANITY. While the heirs of the ancient Western Christian empire had suffered a period of social and political decline following the final fall of Rome in the fifth century, Eastern Christianity, centered in the capital city of Constantinople, had continued to develop in power, wealth, and influence. The stability of Eastern (Byzantine or Orthodox) Christianity was tested, however, in the ninth century when church authorities revisited the question of whether or not icons—that is, religious images such as wall paintings, panel paintings, and statues—should be allowed in churches. The controversy, essentially a question of what constituted idolatry, caused tension between the crown and the

monasteries, whose members were supporters of the icons. At the same time, theological disagreements between the Eastern (Greek) and Western (Latin) church over the relationship between Trinitarian elements (Father, Son, and Holy Spirit) reappeared and continued to be a source of division throughout the Middle Ages, contributing to the separation between the Roman Catholic and Orthodox Christians that continues today.

EARLY RELIGIOUS AND SECULAR CONFLICTS. Tensions between the Latin Christian religious and temporal authorities increased during the eleventh century, particularly in the growing German Empire and in England. Quite visibly, some of this struggle for control came to a head over the issue of powerful laity—lords and kings—insisting upon having the power to invest new bishops with their symbols of office. This particular conflict (known under the umbrella of "Investiture") culminated in the debate over whether or not church leaders should swear oaths of loyalty to secular leaders. The relationship between temporal and spiritual powers, kings and popes, bishops and nobles, generally was not characterized by smooth cooperation. As both secular leaders and churchmen became more powerful, each attempted to come to terms with the problems and benefits of the system of lordship. In this system, advantages like wealth, power, and influence were tied to the ownership and management of land, particularly as it related to sources of income. But when sons and daughters of nobles became bishops, abbesses, abbots, cardinals, and popes, there was bound to be a complexity of ideological tension. During the tenth, eleventh, and twelfth centuries, the following basic questions would resurface in a variety of ways: Were church leaders superior because of their spiritual connection to God? Should "religious" nobles relinquish or diminish their hereditary stations, step aside, and allow secular leaders to guide and govern? How should church and state cooperate in the promotion of a better Christian society? What was to be done about the problem of violence between various factions of Christians?

MEDIEVAL SPIRITUALITY, LITURGY, AND CHURCH LEADERSHIP. Aspects of spirituality changed gradually during the tenth and eleventh centuries. The Benedictine Order, with its *Rule* for monastic life stressing a corporate existence of prayer, work, humility, and stability under the leadership of an abbot, grew tremendously and became quite popular. As monastic "franchises" such as the houses of Cluny and Gorze began to develop, greater attention was paid to proper practice and the material aspects of worship, including more extensive and elaborate and formulaic prayer, as well as the decoration and enlargement of worship spaces and rubrics for their use. The secular churches underwent their own reforms, which were instituted from the top down (popes to bishops to local priests) to deal with moral and economic abuses. Among the improvements was a new emphasis on education, which was intended to broaden and deepen the clergy's understanding of the sacraments and improve their ability to communicate this knowledge to others. Specialized liturgical books such as the *pontifical* (a comprehensive book of sacraments, ceremonies, and rites performed by bishops) and the *ordo* (a book of directives for the celebration of liturgies) reflected the desire to make Latin Christian worship more uniform throughout all of Europe. As the clergy became more and more elite, however, changes in the liturgy increasingly diminished the role of laity in communal celebration.

MONASTIC REFORMS AND THE RISE OF THE FRIARS. By the twelfth century, there were major attempts on the part of reform orders such as the Cistercians, Carthusians, and Premonstratensians to bring monasticism back to the model of simpler communities or even eremetical (hermit-like) roots. Existing orders, especially the Cluniacs, had grown rich in their control of lands and properties, and seemed to lack the spiritual dimensions intended by the Benedictine Rule. These new orders attracted large numbers of adherents, suggesting some degree of success in dealing with the problems, but by the early thirteenth century, a new major religious movement arose, taking Christian existence out of the formal monastic establishments altogether. Under the leadership of two charismatic preachers, later to be canonized as St. Dominic and St. Francis, these new orders, known as the Dominican and Franciscan friars, emphasized poverty and service to the world. Friars lived on the edges of cities, begged for their sustenance, and spent their time preaching and hearing confessions. While the Dominicans were later associated mainly with education, Franciscans became missionaries, expanding the scope of their activities as far as Mongolia. Among lay Christians, the Béguines sought to de-institutionalize Christian apostolic standards and took on many aspects of Christian discipline without joining formal monastic orders.

RELICS, PILGRIMAGES, AND CRUSADES. During the eleventh through thirteenth centuries, holy relics and the miracles associated with them inspired a great proliferation of pilgrimages within Europe and to the Holy Land. The veneration of the relics in altars contributed to the growing number of private masses in monasteries and churches where there were numerous priests and multiple altars. Popular piety and devotion toward relics

and pilgrimages also helped fuel the crusading movements, which promised to free the Holy Land from Muslim domination and keep it accessible to travelers. The appearance of military orders in the twelfth century primarily arose in response to perceived needs connected to both the Crusades and the Reconquista (Christian Reconquest) in Muslim Spain. Medieval Christianity was not very tolerant of divergent theological opinions. In addition to the struggle for control of the Levant (an area on the eastern shores of the Mediterranean, located between western Greece and western Egypt), Crusades were launched against Christian heretics such as the Cathars and pagan polytheists like the Wends. There were even localized persecutions of Jews, lepers, and homosexuals during this period. While Christians, Muslims, and Jews found it easier to coexist on a daily basis under Muslim rule in Spain, North Africa, and the Middle East, concerted conflict was bound to arise linked to the expansion of political and religious power structures.

CRITICISMS OF CHURCH INSTITUTION AND HIERARCHY. By the thirteenth century, the institutional factors that had contributed to the church's growth, wealth, and influence were being called into question by Christians from all walks of life. The emerging new universities began to pull away from strictly church-centered types of education to accommodate the study of law, rhetoric, medicine, and mathematics required by a more mobile and commercially vibrant Europe. By the thirteenth century theology had begun to emerge as one of the central disciplines within the realm of formal education. Scholastic approaches to philosophy and theology that developed as a result of university influences during the twelfth and thirteenth centuries continue to serve today as a hallmark of medieval intellectual activity. The twelfth and thirteenth centuries also marked a rich period for the development of Gothic architecture, a style in which soaring heights, open space, and increased light created a more inviting and invigorating place for the glorification of God. In addition to church and state struggles, the church in the fourteenth century now faced an ecclesiastical political crisis from within, as disputes over papal elections resulted in a schism or split between several factions who each claimed to have elected legitimate popes. The Avignon Papacy and Great Schism once again raised the issue of secular influences upon church elections, causing Christians to seriously reconsider the nature of papal power and supremacy.

LATE MEDIEVAL RELIGIOUS DEVELOPMENTS. The ravages of famine and plague (the Black Death) during the early and middle fourteenth century gave medieval Christians pause to reexamine the idea of the afterlife, the worth of the human soul, and the fleeting nature of all things temporal. In such times of crisis, people turned to religion once again to provide comfort to the afflicted. In the wake of the plague, the penitent act of flagellation, the desire to seek a personal mystical experience with God, and the organization of groups expressing dissatisfaction with the "human" elements of Christian leadership all influenced the Protestant Reformation that was soon to come. While humanism—a secular cultural and intellectual movement stressing the artistic and philosophical achievements of the Greeks and Romans—flourished in Italy and was beginning to take hold in northern Europe, the papal schism was being healed. But reformers like John Wyclif (in England) and Jan Hus (in Bohemia) were tenacious in protesting the ongoing abuses and corruption of the clergy, and many of Hus's fifteenth-century followers paid with their lives for opposing hierarchical church control. These major movements and events, coupled with an improved economy and the invention of the printing press, eventually set the stage for the great Reformation ideals of sixteenth-century Latin Christendom. The mid-fifteenth century religious climate was imbued with complex and often contradictory attitudes of suspicion, desire to hold on to tradition, optimism, enthusiasm for education, and an impulse towards personal freedom, the combination of which led many to distrust ecclesiastical authority and seek a return to Christianity's earliest roots.

TOPICS
in Religion

EARLY LATIN CHRISTIANITY IN NORTHERN EUROPE

FOUNDATIONS OF CHRISTIANITY. Although medieval Europe is often associated today with the dominance of Christianity, the beginning of the Middle Ages was a period of competing religions when many of the pre-Roman inhabitants and invading tribes who had helped bring about the end of the Roman Empire continued to practice polytheism. Latin Christianity had been established in parts of Western Europe outside of Italy during the time of the Roman occupation (especially from the second through fifth centuries C.E.), and centers of Christianity continued to exist in such cities as Lyon, Arles, Tours, Poitiers, Marseilles, Reims, and Provence (all in modern France); in Silchester, Dorchester, Water Newton, and St. Albans (in Britain); Trier,

Cologne, and Mainz (in modern Germany); and in Toledo, Córdoba, and Elvira (in modern Spain). The increasing presence on the part of bishops, theologians, and monastics fueled growing support for Christian ideas and practices throughout parts of northern Europe. Moreover, during the period of decline and deterioration of the Roman Empire, many members of the invading tribes—including the Visigoths, Ostrogoths, Huns, Franks, and Saxons—accepted Christianity in one form or another. However, the key to Christianizing the north seemed to be the conversion of the tribal leaders, as happened when the Merovingian (Frankish) king Clovis—who ruled over what is now Belgium, northern France, and parts of Germany—and some of his followers were baptized in the mid-490s. A century later, with Rome still serving as the center of Western Christianity, Pope Gregory the Great (590–604) sent monks from the relatively new Benedictine Order to function as missionaries, priests, bishops, and even ambassadors to parts of northern Europe. The influence of the Irish monk St. Columbanus (d. 615) spread more Eastern (Orthodox) traditions of Christian monasticism into centers like Bangor (in Ireland) and Whitby (in Northumberland), as well as Annegray, Fontaine, and Luxeuil (in France). St. Boniface and St. Willibrord had helped spread Christianity in the Germanic regions, while Patrick (d. circa 460), Augustine of Canterbury (d. before 610), Abbess Hilda of Whitby (d. 680) and Columba (d. circa 597) facilitated such growth in the British Isles. By the ninth century, Christianity began to proliferate in parts of France, Britain, Ireland, Germany, and Spain.

MEROVINGIAN AND CAROLINGIAN INFLUENCE. An eighth-century alliance that was formed between the Frankish kings and the bishops of Rome did much to secure the place of Christianity within the circles of the ruling class as they expanded their territory in northern Europe. A forged document known as the *Donation of Constantine*, which asserted that in the fourth century Constantine himself had given the bishop of Rome authority to govern over all territories in the western empire, may have helped legitimize the series of agreements between the Roman pontiffs and the Franks to provide each other with mutual support. In any case, over the last several decades of the eighth century the Carolingian family—rivals of the Merovingians—used their military power to come to the defense of the papal territories in Italy. In return for such protection and support of the papacy, along with support for certain papal claims of jurisdiction, Rome continued to give its blessing to the Carolingians in their usurpation of the Frankish throne from the previous Merovingian line. This alliance (which some have viewed as morally suspect) went on to create

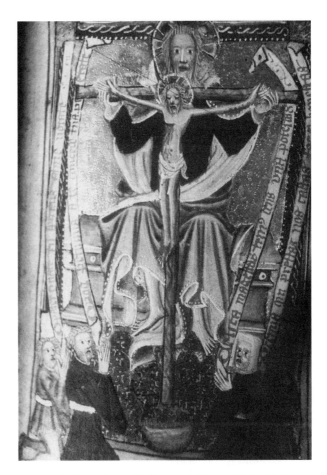

God the father with crucified son and dove as Trinity, Throne of Grace type, The Bolton Hours, York Minster Library MS Additional 2, folio 33, after 1405. BY KIND PERMISSION OF THE DEAN AND THE CHAPTER OF YORK. PHOTO BY JOHN B. FRIEDMAN.

a period of stability that would foster the development of Christian education, ideas, and institutions in the Frankish kingdom. It also set a precedent later on for providing the church with military assistance from Christian kings who were seen as God's representatives, ruling through "divine right." In thanksgiving for the continued support, at a Christmas celebration during the year 800, Charlemagne, the king of the Franks (whose Latin name "Carolus" was the source of the term "Carolingian"), was given the title "Emperor of the Romans" by Pope Leo III. The title linked the Franks to the former Roman Empire in an idealization of the place formerly occupied by Constantine the Great and his important relationship with the Christian church. Within the next century this title would be passed to the German kings (later called "Ottonian") who succeeded the Carolingian line.

CONQUEST AND CONVERSION. The coronation of Charlemagne as emperor of the Romans on Christmas

MEDIEVAL Religion Terms

Ascetic: Devoted to solitude, contemplation, discipline, fasting, denying the body in order to derive spiritual benefits.

Augustinian Rule: A set of guidelines devised by St. Augustine of Hippo in the fourth century for the common life of religious and often used by the canons regular or Austin Friars.

Benedictine Monasticism: Western communal practice begun in the sixth century by Benedict, the abbot of Monte Cassino in Italy. *The Rule of Benedict* stressed a corporate life of prayer, work, humility, and stability under the leadership of an abbot.

Benefice: Certain church offices, such as the rectorship of a parish church, with particular duties for which one would be granted revenues.

Canonical hours: The Divine Offices or daily prayers usually sung or recited by religious (often seven times a day).

Canon Law: The body of church law imposed by the authority of councils and bishops, particularly pertaining to matters of belief, morals, and discipline of the Christian faithful.

Cenobitic: A communal monastic lifestyle.

Chapter: The assembly of a monastic community (often daily) where a chapter of their rule was read, official business was dealt with, and faults of the monks were addressed.

Cloistered: Enclosed in a monastery, literally in the cloister space that forms part of a monastery; not free to leave or have visitors due to one's monastic status.

Crozier: The staff of a bishop, abbot, or abbess, sometimes bearing their insignia, commonly depicted in the form of a shepherd's staff signifying pastoral powers.

Diocese: A geographic division or extent of a bishop's jurisdiction.

Ecumenical: Worldwide, as in a general synod or council called by bishops, church leaders, or a pope.

Episcopal: Having to do with a bishop.

Eremitic: Having to do with the life of a hermit or solitary.

Eucharist: The celebration or reenactment of the Lord's Supper using bread and wine consecrated by a priest.

Excommunication: Church censure imposed by an authority which excludes individuals from communion and deprives them of rights to certain sacraments.

Filiations: Daughter houses, often founded or adopted by the mother monastery. A group of daughter houses dependent upon a main house or linked together in a system.

Filioque: A Latin phrase (literally meaning "and the son") referring to an argument as to whether or not the Holy Spirit proceeded from the Father or emanates from both the Father and the Son. The Latin Church seems to have added the notion that the Holy Spirit can also proceed through Jesus as well as God the Father.

Day of 800 provides a watershed date for the development of a Christianity in northern Europe that had begun to be linked to the monarchy. This Latin Christianity, which was increasingly being embraced by European kings and lords, also began to be urged by the nobility upon the general populace. While Christianity had been firmly in place in northern Europe for several centuries, a majority of people in the areas of the British Isles, France, and Germany had still not embraced the faith. These cultures still retained a mix of polytheistic remnants from the pre-Roman era. Particularly along the border regions of the empire (north of Thuringia and in the east between the Rhine and Elbe Rivers of present-day Germany), groups like the Saxons were forcibly converted to the Christian faith. Saxons could be put to death for following their own traditions and ritualistic religious practices, such as cremation of the dead and human sacrifice, or even for the refusal to observe the Christian Lenten season. Many who were unwilling to submit to Christian baptism or pay tithes (one tenth of their produce or income) to the church were also killed. One of the leading churchmen in Charlemagne's court, Alcuin of York, raised objections to the practice of forced conversion. He wrote:

> Converts must be drawn to the faith and not forced. A person can be compelled to baptism and still not believe. The adult convert should profess a true belief and if he lies, he will not reach salvation.

During the conquest and conversion of the Avars in the southeastern marches of Bavaria and in lands such as Pannonia beyond the Danube River, Alcuin more carefully directed the prelates of the Carolingian realm:

> Be preachers of piety and not exactors of tithes, slowly suckling souls with the sweet milk of apostolic gentleness, lest these new converts to the faith choke upon and vomit the Church's harsher teachings.

Flagellation: Whipping or beating oneself in punishment for sins, or to commiserate with the suffering of Christ.

Host: The consecrated bread at the Mass which medieval Christians believed was changed into the body of Christ in conjunction with the action of the celebrant.

Iconoclast: One who literally would smash religious statues and icons, based on the belief that they were idolatrous.

Indulgence: After the confession of sin, the substitution of penance by another act, such as almsgiving, pilgrimage, crusade, or financial contribution for the construction of a church.

Inquisition: The juridical persecution of heresy by special church courts.

Investiture: The investing or conferring of authority to a church official by a superior in a ceremony involving presentation of the symbols of office, including an exchange of homage before consecration.

Laity: Secular persons, not members of the clergy (monks, priests, canons, bishops, deacons, etc.).

Limbo: An abode of souls for those who, through no fault of their own, are barred from salvation because they were not baptized (as in the case of infants or people who lived before the time of Christ).

Mass: The liturgical rite of Christianity connected to the blessing or consecration of bread and wine along with the conventional prayers, songs and readings which accompany it.

Mendicants: Those religious, specifically friars, who depend upon begging for their support.

Missal: A book containing the complete rite of the Mass, with all prayers, readings, and chants.

Office: From Latin *officium* or duty, the prescribed daily round of prayers, mainly psalms, recited seven times a day in community, called for in the *Benedictine Rule*.

Office of the Dead: Prayers said on behalf of the deceased, often for individuals connected by membership or patronage to the monastery or community offering the prayer.

Papal bull: A written pronouncement or mandate from the pope. In the early days they were sealed with the stamp of the pope's ring (from the Latin *bulla* or seal).

Penance: The sacrament of forgiveness (that is, forgiveness by God through the action of a priest), which in the Middle Ages involved confession of sins followed by an act of restitution.

Psalter: A book of the psalms.

See: Literally, the official seat (from the Latin *sedes*) of a bishop, hence the place where the bishop sits or resides.

Simony: The sale or purchase of a church office.

Stigmata: Bearing the wounds of Christ.

Transubstantiation: Conversion of the substance of the bread and wine into the body and blood of Christ, with appearances of bread and wine remaining.

Votive: A liturgy or offering of prayer that is done with a particular intention in mind.

SCHOOLS AND LAWS. In developing a formal link with the papacy (the bishop of Rome who had authority over Western Christianity) and becoming a defender of the papal holdings of land and interests in northern Italy, Charlemagne and his Carolingian Dynasty, which ruled until the tenth century, united with the legacy of the old Roman Empire as well as the traditions and administration of Western Christianity. Taking this role seriously, Charlemagne sought to establish schools that would be located in the cathedral city centers and at monasteries where boys (mostly from the upper class) could be instructed in mathematics, grammar, and music, as well as in reading from church books such as gospels, psalters, and missals (if such manuscripts were available). Scholars such as Alcuin of York were brought into the kingdom from other lands to serve as teachers in the Frankish schools. Charlemagne also attempted to ensure that Sunday be observed as a holy day and kept free from work. Activities like hunting, farming, construction, gathering for legal procedures, weaving, tailoring, and even doing laundry were discouraged. People throughout the new empire were urged to attend Mass on "the Lord's Day." During the services priests were encouraged by royal directives to teach the notion of the Trinity—made particularly visual in an image from an English book of hours from York—and introduce doctrines associated with judgment, salvation, hell, faith, hope, and charity, as well as the love of God and neighbor. As the influence of Christianity became more pervasive, it appears that a fusion of church traditions and the laws of the Carolingian realm began to intertwine. However, it is not clear as to the extent to which these laws were actually enforced, since a number of forged collections of laws from the period (among them the Pseudo-Isidorian *Decretals*) dominate those that have survived. While some of the false decretals, particularly

THE
Monastic Day

One part of the monastic rule required monks to sing the divine offices at specific times during the day and night. The schedule for this activity (which changed according to the time of year), as well as mealtimes and work periods, is given below with the names of the "canonical hours" of the day. Said privately, the prayers would take up a total of about one and a half hours, but sung in the choir, they would take much longer. "Lauds" are said at first light, "compline" at sunset, with the times for other services determined by dividing the hours of daylight into twelve, so that in summer each daylight hour is longer than each night hour, and vice versa in winter. The version here is based on the Rule of St. Benedict as observed by the Cistercians.

	June	December
Rising	1:45 a.m.	1:20 a.m.
Vigils	2:00–3:00 a.m.	1:30–2:50 a.m.

		[Reading]
Lauds	3:10 a.m.	7:15 a.m.
Prime (first hour)	4:00 a.m.	8:00 a.m.
		[9:20 a.m.–Terce]
Chapter	4:15 a.m.	9:35 a.m.
Manual labor	4:40–7:15 a.m.	9:55 a.m.
Terce (Third hour)	7:45 a.m.	
Sext (Sixth hour)	10:40 a.m.	11:20 a.m.
Dinner	10:50 a.m.	
	[Reading or sleep]	[11:35 –Manual labor]
None (Ninth hour)	2:00 p.m.	1:20 p.m.
		[1:35 p.m.–Dinner]
Manual labor	2:30 p.m.	
Vespers	6:00 p.m.	2:50 p.m.
Supper	6:45 p.m.	
Compline	7:50 p.m.	3:55 p.m.
Sleep	8:00 p.m.	4:05 p.m.

those that favored a strong papacy, were promulgated during this period, there was actually no one official and universally accepted body of canon law until the Decretals of Gregory IX in 1234.

A RULE FOR MONKS. Under the Carolingian kings there was an attempt to create a uniform rule for monks throughout the empire. Charlemagne favored the *Rule of Benedict*, which had been developed in Italy in the sixth century, and encouraged those monastic houses (especially those east of the Rhine River) that were not in compliance to consider seriously adopting this lifestyle of stability and obedience, lived out in a balanced daily spiritual experience of work, study, and prayer. However, it was not until the time of Charlemagne's son Louis the Pious (778–840) that a reformed version of the Rule of Benedict was established. These revisions to the Benedictine lifestyle were introduced by a monk named Benedict of Aniane (750–821) and became universally adopted throughout the Frankish empire. Under these ninth-century monastic reforms additional prayers were included alongside the original sixth-century Benedictine Office. This kept the monks much busier in prayer, often too preoccupied with the Daily Offices to comply fully with the directives for manual labor that were an essential component of the earliest Benedictine Rule. The Frankish crown's endorsement of the Monastic Capitulary of 817, which en-

sured enforcement of Benedict of Aniane's revisions, is most likely responsible for the eventual standardization of the Benedictine Rule throughout Western Europe.

THE MULTIPLICATION OF PRIVATE MASSES. Interestingly, it was also during this time that the number of monks who were also priests (a minority in early monasticism) began steadily to grow. The shift to larger numbers of ordained priests encouraged a more formal liturgical emphasis in the monastic lifestyle, which increasingly attracted members of the nobility. This tendency for some monks to spend most of their time on liturgical duties also left the door open for the appearance of lay brothers (members of a lower class in society whose focus was predominantly on labor), as well as the use of peasants to work on monastic lands and estates. With the increase in monks who were also priests came the development of private masses, where priest-monks would celebrate liturgies ostensibly by themselves, but usually with a lone attendant such as an oblate or lay brother. In cathedrals and larger churches, the presence of multiple altars containing relics of saints requiring veneration on a regular basis also helped create the occasion for private masses. Eventually numerous requests for votive liturgies—those conducted with a particular intention in mind, usually at the behest of wealthy laity—gave rise to the multiplication of private masses

ROLES
and Occupations in the Latin (Western) Christian Church

Acolyte: A person in the beginning stages of the priesthood delegated to assisting priests and deacons in masses of the Latin Church.

Anchoress (f.)/Anchorite (m.): A solitary or hermit who pledges her or his life to prayer and contemplation. Anchoresses often lived in a small room attached or "anchored" to a church or public building. Visitors could come and speak with them and receive spiritual direction.

Archdeacon: The bishop's principal assistant or officer.

Bishop: A senior cleric in charge of the spiritual life and administration of a region known as a diocese.

Canon: A member of the clergy following a rule like those followed by monks but often attached to a cathedral or large urban church; the canon is responsible for the daily running of the church and for educating the children of the nobility (sometimes called "canons regular" because they lived according to a rule and formed groups called "colleges").

Cardinal: A member of the college of Roman princes who are the immediate counselors of the pope and rank second only to the pontiff in the church hierarchy. At various times they meet in conclave to elect new popes. There are also various local and episcopal offices, most in the city of Rome, to which the term "cardinal" is attached: cardinal deacons who took care of the poor in Rome, cardinal priests who were priests of the various Roman churches or parishes, and cardinal bishops (mostly outside of Rome) who were needed for service as the pope's representatives.

Chancellor: A church officer in charge of a university.

Conversi: Lay brothers, or adult converts to religious life, as opposed to those oblates who were raised in the monastery as children.

Deacon: Literally, the servant of the bishop in early Christianity. The status of deacon was one of the early steps on the way to priestly ordination in the medieval period. The deacon could have specific liturgical functions associated with the Eucharist and dismissal at Mass.

Friar: A member of one of several religious orders who served as missionaries, teachers, and confessors; friars (brothers) did not live a cloistered life, but rather lived together in convents on the edges of cities.

Lay brother: A person associated with monastic life, but often of a lower social class than the other monks; lay brothers were commonly less educated or unable to recite in Latin, were not part of the choir, and spent much of their time in manual labor.

Monk: A member of an all-male religious order who follows a Rule requiring withdrawal from society and devotion to prayer, solitude, and contemplation.

Nun: A member of a religious community of women living a cloistered life of religious devotion in a convent or double monastery.

Oblate: A lay person who is part of a religious community. From the Latin word *oblatio*, meaning to offer, this term often refers to children who were "offered" by their families to the service of God in a monastery or convent, to be brought up as a monk or nun.

Pope: The head of the Roman Catholic Church. The pope, or pontiff, was also called the Bishop of Rome since he presided over the entire Latin Church due in part to his authority over the local Roman episcopal see.

Postulant: A person seeking admission to a religious order. Often he or she was allowed to try out monastic life for a brief time.

Secular clergy: Priests living in the world, as opposed to "regular" clergy, living under the rule of a religious order.

Sub-deacon: A minor order of cleric who could not administer sacraments (only sacramentals) and who prepared bread, wine, and vessels at Mass.

in the monasteries. Papal records during the ninth century indicate that certain priests celebrated the liturgy as many as nine times each day.

THE GROWTH OF THE SECULAR CLERGY. Alongside the growing monastic movements, a separate group of secular clergy (those living out in the world rather than in a cloister) ministered to the laity in local parish churches and in large urban cathedrals. The English called these secular churches "proprietary" while the Germans referred to them as *Eigenkirchen* (churches under private control or ownership), since often the local lords helped support them and would commonly appoint the parish priests. The cathedrals—large, important churches, usually in urban areas—often had a number of priests who might reside in the household of the bishop, the senior official in charge of the region or diocese. Eventually the term *canon* was applied to the clerics who lived at the cathedrals because it was said that they were living according to the canons (traditions and laws) of the church. According to the rule developed by Chrodegang

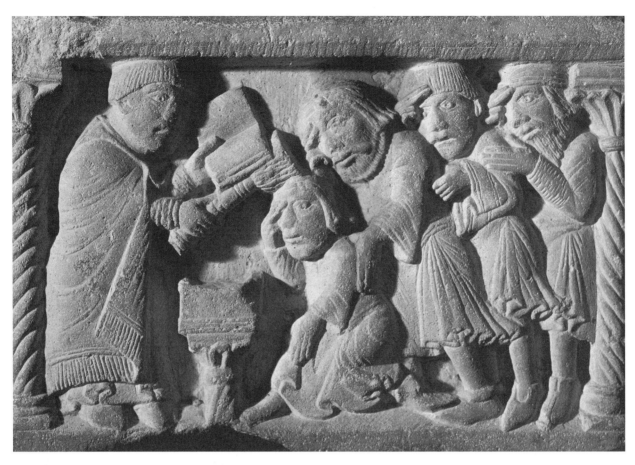

Bishop performing exorcism, bas relief of font, Modena Cathedral, Museo Civico, Modena, Italy, 13th century. THE ART ARCHIVE/MUSEO CIVICO, MODENA/DAGLI ORTI.

of Metz, the canons, unlike monks, could own their own property and were not always required to live under the same roof with their fellow clergy. But like the cloistered monks (those who lived beyond the monastic *cloister*— that is, enclosed space—and took the Benedictine vow of stability), the canons assembled each day to hear a reading of a chapter of sacred scripture and thus were said to belong to a community or *chapter* of canons. Houses for canons began to become more popular by the mid-eleventh century. This communal arrangement worked well for urban dwellers but proved to be difficult for rural clerics. Customs seemed to differ from house to house. They would eventually come to prefer the Rule of Augustine by the twelfth century.

THE DEVELOPMENT OF SACRAMENTARIES. The Carolingian era was an important time for Western liturgical development. Books called *Sacramentaries* which contained prayers and guides for the celebration of Mass and other religious rites began to become common throughout France. However, there seemed to be little uniformity in the way each community used the liturgi-

cal prayer books. Alcuin of York, the primary teacher at Charlemagne's palace school and abbot at several monasteries, began the process of making revisions to the Roman Sacramentary sent to the Franks by Pope Hadrian I (772–795) as usages became refined in the Christian empire over the next two centuries. The Frankish version of the Sacramentary eventually became the standard throughout Europe (preferred even to the Roman text) and continued to be the basis for practice in the Western church right up until the mid-twentieth century.

SOURCES

Peter Brown, *Rise of Western Christendom* (Malden, Mass.: Blackwell, 1997).

Judith Herrin, *The Formation of Christendom* (Princeton, N.J.: Princeton University Press, 1987).

J. N. Hillgarth, *The Conversion of Western Europe: 350–750* (Philadelphia, Pa.: University of Pennsylvania Press, 1986).

Ramsey MacMullen, *Christianizing the Roman Empire: AD 100–400* (New Haven, Conn.: Yale University Press, 1984).

Rosamond McKitterick, *The Frankish Church and the Carolingian Reforms* (London: Royal Historical Society, 1977).

Thomas Noble, *The Republic of St. Peter: Birth of the Papal State* (Philadelphia, Pa.: University of Pennsylvania Press, 1984).

Edward Peters, *Monks, Bishops, and Pagans: Christian Culture in Gaul and Italy, 500–700* (Philadelphia, Pa.: University of Pennsylvania Press, 1975).

J. M. Wallace-Hadrill, *The Frankish Church* (Oxford: Oxford University Press, 1983).

RELIGION IN SCANDINAVIA AND EASTERN EUROPE

EARLY VIKINGS. The term "Viking" has been used to refer to inhabitants of Scandinavia and the northern regions (Denmark, Norway, and Sweden). The native religion of these people was polytheistic (that is, involving worship of more than one deity) and revolved around a pantheon (a system of gods and goddesses) that was anthropomorphic—that is, featuring gods with human characteristics. Viking societies were also reputed to be polygamist, allowing multiple spouses within a family. Some scholars have gone so far as to attribute the invasions to the south and east, which began after 800, to a crisis of overpopulation linked to the polygamist practices of certain Scandinavian groups. Little is known about the actual religious practices of the Vikings before the thirteenth and fourteenth centuries. Most of the information on this era comes from Icelandic sagas that had long been removed from their earlier Scandinavian cultures and were perhaps even further affected by Christian ideas, since they were recorded in Icelandic societies that had long been educated and immersed in Christian tradition. The Saxon chronicler Widukind of Corvey, who wrote in the mid-tenth century, commented that although the Danes converted to Christianity they "continued to venerate idols according to their heathen customs." From this time period in Denmark and Sweden, casting molds were discovered which simultaneously produced crosses for Christians and hammers for devotees of the thunder god Thor.

GODS AND DOMAINS. The Vikings' religious practice helped orient them to the world around them, assisting them in understanding both the present and the past. They perceived the universe to be comprised of a number of worlds (heavens, hells, earth) numbering anywhere from three to nine, depending upon the cultures and particular historical time frame. The gods resided in a variety of these worlds and affected the daily lives of

humans. These divinities had certain domains for which each was responsible. For example, Odin (or Woden) was the god of war, the all-father, a middle-aged kingly figure who in later periods was seen as the god of the sky. He resided in Asgard, the heavenly home of the warrior gods. Odin rode an eight-legged horse named Sleipnir and was accompanied by two ravens (Hugin and Munin) who informed him on a daily basis of the deeds of the other gods, giants, dwarves, and, of course, humans. He was also attended by the Valkyries, female warriors who were said to be responsible for taking those who died bravely in battle to Valhalla, a great palace in the city of heaven close to where Odin resided. In Valhalla the dead war heroes spent eternity fighting by day and feasting at night. Among the more popular Viking gods was Thor. He was said to be tall, strong, determined, and good-hearted, but he was known to have a temper and was lacking in intelligence. The thunder god wielded a throwing hammer forged by dwarves that could, after its release, magically return to his hand at his bidding. Freyr, a nature deity associated with the sun, rain, and agriculture, was also the god of peace and goodness. His twin sister was Freya, the goddess of love and beauty. It was believed that she could turn herself into a bird by donning the skin of a falcon. Some members of the Viking pantheon, of course, reflected the "darker side." Loki was the challenger of order and structure—the god of fire and a sort of "trickster" deity, the one deemed necessary to bring about change. His daughter was Hel, the goddess of death and the afterlife.

RITES AND CEREMONIES. The Vikings believed it was necessary to establish close relationships with the gods as they looked after their families and their honor, as well as their tribes, villages, and kingdom. The gods helped the kings keep peace and looked favorably upon the harvests. The deities were both patrons and companions, to whom the people owed tribute and from whom they received many blessings. Priests functioned as intermediaries and would perform rites to the cults of various gods. However, they were not a professional caste. Chiefs and tribal leaders often functioned as priests, or a father would fulfill that function during family gatherings; however, the priest could often be killed or banished from society for improper or unfavorable mediation. The Scandinavian polytheists most often worshipped in open-air spaces where they could more appropriately connect with nature. There were communal ceremonies in open fields, meadows, and clearings, at gravesites and near massive stones. The dead were often buried with their possessions. At especially solemn feasts there could be blood sacrifice (*blot*). The eleventh-century chronicler Adam of Bremen described

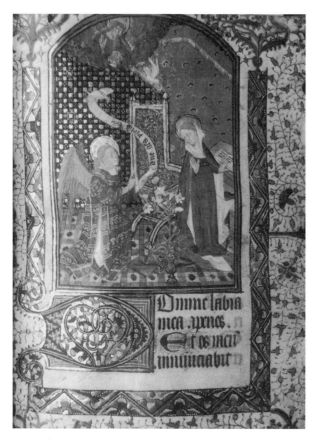

Annunciation to the Virgin with God the Father above, French Book of Hours, York Minster Library MS XV. iv. 9, folio 19, later fourteenth century. BY KIND PERMISSION OF THE DEAN AND THE CHAPTER OF YORK. PHOTO BY JOHN BLOCK FRIEDMAN.

a particular Viking religious ceremony that was supposedly celebrated only every ninth year, explaining that "nine heads were offered from every type of living male creature and the custom was to appease the gods with their blood." Decapitated bodies were hung in a grove, which was considered sacred, as were the trees upon which the victims hung. In fact, the trees were by virtue of their role in the ceremony considered sacred in and of themselves. The details of the event were startling:

> Dogs were hung with horses and men and a Christian told me that he had seen as many as 72 corpses hanging in rows. The blood was collected in a sacred vessel and sprinkled by the priests. The ritual was followed by a feast with offerings to the gods.

THE SPREAD OF CHRISTIANITY. Christian missionaries began to be sent to the Danes and Swedes in the early 800s, though it is unlikely that any of the kings in Scandinavia from that period underwent conversion. What is clear is that Vikings and Christians lived side by side and freely traded goods at stations such as York, Lincoln, Dublin, Fécamp, Rouen, Birka, Kaupang, Nov-

gorod, and Hedeby. Those Vikings who settled in predominantly Christian areas on the European mainland eventually assimilated Christian customs, lifestyle, and faith, and by the mid-1000s Christianity began to become more firmly established in Denmark and Norway, with Sweden following in the middle of the twelfth century. As these conversions took place, some of the pagan sacred sites in Scandinavia were taken over by Christians, and churches were built on or near these places. In Sweden at Gamle Uppsula there are remains of an early Christian church that stands beside a large Viking burial mound. Harold Bluetooth, the king of Denmark from 940 to 986, was quite successful in influencing his people to convert to Christianity. Christian images appear on Danish coinage from his reign and there are records of the establishment of bishoprics in major Danish cities. Christianity became even more pervasive in Denmark once Canute (1018–1035) became ruler of both England and the Danes in 1018. Influenced by the great English bishop Wulfstan of York (d. 1023), Canute became a patron of Christian institutions and a model king, rivaling his royal and noble contemporaries. After Canute's famous pilgrimage to Rome in 1027, other nobles such as Robert of Normandy, Macbeth, Sihtric Silkbeard, Earl Thornfinn, and Earl Tostig all followed his example in undertaking journeys to holy sites. He attached a number of Danish bishops to his court and sent them out to establish churches throughout Scandinavia.

LOOTING OF MONASTERIES. From around the year 800 on, the Vikings engaged in a period of tremendous expansion, using their naval expertise first to engage in raiding and looting along the coastlines of Europe and later to undertake conquest and settlements in England, Ireland, northern France, and Russia, as well as places as far away as Iceland, Greenland, and Finland. During the age of Viking invasions, it was not uncommon for Christian monasteries in coastal regions of England, France, and Germany to endure a certain amount of looting—not, apparently, as a deliberate attempt by the invaders to destroy the system of Christian organization and faith, but for purely material reasons. Not only were the monasteries repositories of church treasure (including gold and silver vessels, jeweled reliquaries, lavishly decorated manuscripts—such as a French book of hours containing an ornate miniature of the Annunciation to the Virgin—and priestly vestments), but some of them acted as banks and safe depositories for the aristocracy. Monasteries located on rivers were also susceptible; for example in Normandy, along the Seine, there are records of displacements at Saint-Audoen and Saint-Filbert at Jumièges. It was also common to find certain breaks in

episcopal succession in areas that were prone to Viking invasion. For example at Avranches in Normandy there was no bishop from 862 to 990. In the British see of Galloway, records of episcopal activity vanish in the ninth century and do not reappear until the office was revived in 1128. Those Christian monasteries and bishoprics that were fairly poor did not seem to be disturbed as much by the Viking invasions.

CONVERSIONS. The period of competing religions in western Europe reached its end by around the beginning of the twelfth century. The story of the conversion of Norse settlers in Iceland, for example, is told in the *Landnamabok* (Book of Settlements). Bishops from the Isle of Iona (off the coast of Scotland), such as Patrick in the late ninth century (not to be confused with St. Patrick of Ireland) and Fothad (c. 960), sent native Scandinavian missionaries that they had trained to Iceland to build Christian churches. Intermarriages between Christian Scottish aristocrats and Scandinavian ruling families were common, and by the mid-1000s many of the Vikings who had settled in the northern British Isles had converted. (Conversions of the native British and Irish were much earlier, mostly during the sixth, seventh, and eighth centuries.) In Ireland more permanent coastal commercial centers of Viking traders were established during the ninth century, and certainly by the tenth and eleventh centuries there are records of conversions of leaders such as King Olaf Cuaran of Dublin and his son Sihtric, who made a pilgrimage to Rome in 1028, issued coins with Christian symbols, and founded Christ Church Cathedral in Dublin. Likewise, the conversion of tribes of the Rus' in eastern Europe (the area near modern Kiev, Russia) was a lengthy process. In the 860s Rus' ambassadors to the court at Constantinople had embraced Christian monotheism, and in the 870s a bishop was sent to live among them, but it is more likely the primary concern was ministry to those Christian merchants who routinely made journeys into the Russian territories, not ministry to the Rus' themselves. Indeed, in the early 900s the Muslim traveler Ibn Fadlan still relates tales of offerings made by the polytheistic Rus' to their gods for success in commercial endeavors. The Byzantine emperor Constantine Porphyrogenitus (913–959) wrote in his diplomatic manuals about the practice of sacrificial offerings made by Rus' merchants for safely navigating the rapids of the Dnieper river during their trade with the west. By 945 there was a Christian church in the city of Kiev, and Olga, the wife of Prince Igor, was baptized in 957 while on a visit to the city of Constantinople. Upon her return she built a church in Kiev dedicated to the *Hagia Sophia* (holy wisdom) in commemoration of her admiration for the fa-

mous cathedral of the same name in Constantinople. Olga's grandson Vladimir was baptized at Kiev in 988 and was married to Anna, the sister of the Byzantine emperor Basil II. Shortly after this, there were mass baptisms in Russia, followed by the establishment of more churches, bishoprics at Belgorod and Novgorod, and a school to educate clergy. In the eleventh century native Rus' such as Luke of Novgorod were elevated to episcopacies, the monasteries of St. George and St. Irene were built in Kiev, and Jaroslav the Wise (d. 1045) rebuilt Kiev's Hagia Sophia on an extraordinary scale. Additional monastic establishments followed.

SOURCES

Adam of Breman, *The History of the Archbishops of Hamburg-Bremen.* Trans. Francis J. Tschan (New York: Columbia University Press, 1959).

Thomas Dubois, *Nordic Religions in the Viking Age* (Philadelphia, Pa.: University of Pennsylvania Press, 1999).

Richard Fletcher, *The Barbarian Conversion* (Berkeley, Calif.: University of California Press, 1999).

Simon Franklin and Jonathan Shepherd, *The Emergence of Rus, 750–1200* (New York: Longman, 1996).

F. Donald Logan, *Vikings in History* (London: Routledge, 1991).

SEE ALSO *Literature: Heroic Literature in Medieval Scandinavia*

THE SPREAD OF ISLAM AND ITS RELATIONSHIP TO MEDIEVAL EUROPE

GROWTH OF ISLAM. When Islam first emerged in Arabia during the mid-seventh century, there was little indication that within 150 years the movement would come to dominate the entire Middle East, as well as northern Africa and Spain. The early spread of Islam was directly linked to the revelations and work of the Prophet Muhammad who preached religious and moral reform throughout Arabia between 610 and 632 C.E. However, the origins of the movement were fraught with struggle. Acceptance of the faith in the polytheistic city of Mecca along with much of the rest of Arabia was gradually accomplished after a series of military campaigns, treaties, and non-violent pilgrimages undertaken by the newly formed Ummah (the gathered community of believers). The earliest Muslims were scorned in the major trade center of Mecca and began assembling their community under the leadership of Muhammad at the more northerly city of Yathrib in the Arabian peninsula.

Several generations of the Prophet's successors (known as caliphs) during the eighth century spread the faith through both religious and political programs into North Africa, the Middle East, and even as far as Spain. Still, despite its widespread geographic success, until about the year 1000 Islam was more of an administrative presence than an ideology that had won over the majority of the populace. In many areas, the growth of converts was gradual, perhaps because (at least until the twelfth century) the Muslim conquerors seemed quite tolerant of other faiths. It has also been suggested that political, economic, and military control of strategic geographic locations was more important than converting entire populations. Forced conversion to Islam was not practiced in many non-pagan areas, especially where Jews and Christians were living in newly occupied Muslim territories. In fact, they were often referred to as the "People of the Book," since all three traditions shared common elements in their sacred scriptures and traced their heritage back to the figure of Abraham. While members of other faiths were often tolerated, they usually were not allowed to participate in government and had to pay special but not exorbitant taxes. The cultures and faiths affected by the early growth of Islam were quite diverse: not only the formerly polytheistic people of Arabia, but the Coptic Christians in North Africa, Eastern Orthodox in Palestine and Asia Minor, Roman Christians in Spain, Nestorian and Arian Christians in the Holy Land, polytheistic Berber tribes in North Africa, and Jews of various kinds throughout the Mediterranean and Middle East all became subjects of Muslim caliphates. By the year 1000 it is believed that nearly eighty percent of the population in the Dar-al-Islam (Islamic territory) had converted to faith in Allah as it had been revealed to the Prophet Muhammad in the seventh century and handed down through succeeding generations by way of the holy Koran (Qur'an).

ELEMENTS OF ISLAMIC BELIEF. Requirements for participation in the religion of Islam were not extreme compared to some Jewish and Christian practices. The Muslim theological notion that people tended to be "forgetful" of Allah (God) seemed to be reinforced by directives for prayer five times a day (*salat*) and a month-long season of fasting (*sawm*) during the season of Ramadan. However, the most important religious act was that of simple belief, reciting the creed or confession of faith (*shahadah*), that "there is no God but Allah, and Muhammad is His prophet." Almsgiving (*zakat*) was also expected of Muslims, charity both to the poor and in support of religious institutions. Although these were not practices all people readily desired to embrace, the potential for reward seemed not to be fraught with

as many of the complex and confusing doctrines or laws as existed in Christianity and Judaism. Those who followed without question the teaching of the Prophet and the will of Allah were assured eternal paradise. As time passed, the Islamic holy book, the Koran, began to be seen as an infallible scripture, the mother of all books, the literal word of Allah, sealed as the final revelation that humans will ever need. Islamic law (or *shari'a*) seems not to have been divided between separate religious and civil realms. By the ninth century, law began to be viewed as descending not only from the authority of God's scripture but also from the practices and sayings of the Prophet (*sunna*), which were handed down orally and eventually written into the *Hadith*. Added to this law was the *ijma* or traditions of historic Islamic communities. Later works like the ninth-century *Tasfsir* became important commentaries on the Koran and formed the basis for Islamic theology.

DYNASTIES AND RELIGIOUS DIVISIONS. Islamic presence in Spain appeared at a very early juncture during the evolution of the major Muslim dynasties. The presence of the Umayyad Dynasty, which began in Damascus in the middle eighth century and continued in Spain until the eleventh century, put Muslim Spain (known as al-Andalus or Andalusia) into commercial contact with the North African coast, Palestine, and Syria. This led to the development of flourishing trade centers and a period of artistic and intellectual growth. Under the Umayyads, Jewish merchants enjoyed more tolerance than in Christian states, although persecution increased with the arrival of the Almoravids in the eleventh century and the Almohads in the twelfth, each of whom brought their own cultures and customs to the interpretation of Islam. There were also major religious divisions within Islam that began to emerge after 1000. The *Sunni* and *Shi'ite* positions, which go back to seventh-century disputes over the requirements for who might succeed the prophet Muhammad as caliph and still divide Islam today, became strongly linked to ideological and political separations dictating the way Islam would be practiced and perceived. The Sunni, who were in the majority, most often preferred to be directed by teachers, scholars, preachers, and government officials. They subscribed to interpretations of an eternal and uncreated Koran, the word of Allah, which was to be obeyed without question, but expressed concepts of an Allah that could not be completely known to humankind. The Shi'ites, making up roughly a fifth of medieval Muslims, had migrated toward stricter and even more literal interpretations of Islamic law and ideology, as well as relying upon religious leadership that was more charismatic. The mystical branch of Islam called *Sufism*, which be-

gan as more of a monastic movement in the eighth and ninth centuries, became popular among individuals who rejected the formalized trappings of Islamic religious life and were looking for more inward and personal expressions concerning their relationship with Allah.

LAW AND PHILOSOPHY. There were no priests with sacramental powers in Islam, as individuals were considered accountable directly to Allah and needed no spiritual intermediaries. Any devout Muslim could lead prayer, so that all were regarded as equal in the eyes of Allah. However, certain dynasties subscribed to the notion of a *mahdi* (that is, a divinely guided savior or messiah) who might bring justice and righteousness to the earth, restoring the true and proper message of Allah, if one would only follow his lead. The observance of religious law became most important, particularly as a variety of dynasties began to compete with each other for political control of Arabia, Persia, North Africa, Spain, and Asia Minor. As early as the eighth century, Muslim schools sprang up which were devoted to examining the roots of Muslim law. This process was called *ijtihad*, meaning a strenuous examination. Sunni schools of religious law called *madhhabs* began to emerge which would establish norms for Muslim practice. Four distinct schools came into being at the major centers of Damascus, Medina, Baghdad, and al-Andalus. The growth of learning centers and formalized education as well as interest in mathematics, astronomy, and philosophy began to create divisions in Islam and give rise to a host of theological debates. Unlike the Christian scholars, the organization of knowledge for medieval Muslims took in separate religious and non-religious categories. However, like Christian scholastics, there were prominent Muslim philosophers, such as Al-Ghazali (b. 1058) in Baghdad, Averroës (1126–1198) in Spain, and Avicenna (980–1037) in Persia, who struggled to reconcile the notions of faith and human reason. The numerous advances of Muslim thinkers had important influence on philosophers in the Christian West. Based upon the works of the Greek philosopher Aristotle, Islamic examination of natural and metaphysical truths attempted to link everything in the universe to Allah.

CONFLICTS WITH CHRISTIANITY. During the first several centuries of Muslim control over the Holy Land, Christian pilgrims were able to visit the sacred sites with relative freedom. Their overland route usually took them across southeastern Europe, through Hungarian territory, Greece, Anatolia (Turkey), and Syria. Those who traveled by sea landed in Egypt or directly in Palestine. The growing threat of the Muslim presence on the border of the Byzantine (Eastern Christian) Empire and the loss of Byzantine control over the Holy Land served as a pretext for the Christians initiating the Crusades, which were in part due to religious ideological differences (Pope Urban II characterized the First Crusade as the will of God), but not completely driven by a desire to eradicate Islam. The factor most likely responsible for the early successes of the Christian invasions of the Holy Land was the internal disorder among the various Muslim dynasties, several of which were on the brink of controlling the area. Since the concept of the "Crusades" is something that developed from a European mindset, Muslims did not write their history about the wars for the Holy Land in the same way as Christians. These conflicts are more or less seen as any other wars with an invading enemy (most particularly in this case the French or "Franks"). The idea of *jihad*, struggling or fighting to maintain excellence (or striving for an ideal society in which Islam might flourish), is present almost from the beginning of Muslim thought, but not in terms of physical battle as much as a spiritual and a collective duty expected of all Muslims. Emphasis was upon the "greater jihad," that is the struggle within oneself. The "lesser jihad" was connected to the idea of the physical struggles on the path to God. Endeavors connected to the "lesser jihad," such as mission effort, good works, building mosques, even ideas such as physically overcoming the enemies of the faith, would not become significant to Muslim theology and ideology until the twelfth century. Those who lived in the part of the Islamic world that was spreading the faith were, for example, linked to the ongoing missionary activity in the *Dar al-harb* (the abode of conquest or expansion). Throughout its early history, Islam did carry out large-scale military conquest, but the term *jihad* as specifically connected to holy war only began to appear much later, at the time of the Second Crusade (1146–1148), in response to the Christian military threats.

SOURCES

Carole Hillenbrand, *The Crusades: Islamic Perspectives* (New York: Routledge, 2000).

Marshall Hodgson, *The Venture of Islam* (Chicago: University of Chicago Press, 1974).

P. M. Holt, Ann K. Lambdon, and Bernard Lewis, eds., *The Cambridge History of Islam* (Cambridge, England: Cambridge University Press, 1977).

The Koran Interpreted. Trans. A. J. Arberry (New York: Simon and Schuster, 1996).

J. J. Saunders, *A History of Medieval Islam* (London: Routledge, 1978).

SEE ALSO *Philosophy: Philosophy among the Muslims and the Jews; Visual Arts: Spanish Culture and the Muslims*

MEDIEVAL JUDAISM

DIASPORA AND REESTABLISHMENT. Judaism came to Europe as a result of a process known as *diaspora* (from the Greek "scattering"), which can refer to any number of migrations of Jewish communities when they were forced to leave their homes and live among Gentiles outside the Holy Land. Major diaspora occurred after the Babylonian exile in the sixth century B.C.E., after the destruction of the Second Temple in Jerusalem in the first century C.E., in the early medieval period following Muslim conquest of the Holy Land, and in the late medieval period linked to Christian inquisitions and persecutions. Medieval Jewish religious communities were quite diverse as the various diaspora movements resulted in pockets of settlement all over the Middle Eastern, Mediterranean, and European world. Those settling in Spain, known as the Sephardim, created a golden age of Jewish culture in Muslim Andalusia. Those who settled in Germany and eastern Europe following the diaspora of late antiquity and the early medieval period were known as Ashkenazim (from a word meaning "Germany"). These two groups came to be distinctive in their liturgy, religious customs, and pronunciation of Hebrew, but both revered the Torah, the scriptures which constitute the Jewish "Law," identified by Christians as the first five books of the Old Testament: Genesis, Exodus, Leviticus, Numbers, and Deuteronomy. Both were also guided by rabbis, the teachers of classical Jewish tradition who, after the second diaspora in the first century C.E., came to serve as legal and spiritual leaders for the Jewish communities.

TORAH AND TALMUD. Among the various groups of Jews who settled in Europe, some chose to hold on to the traditions of the Talmud (from the Hebrew word for "study"), a collection of commentaries on the Hebrew scriptures that had begun as an "oral Torah" in the first century B.C.E. and was eventually codified by rabbis. Those inclined toward liberal education embraced more philosophical understandings of their traditions, while others adopted more decidedly mystical approaches to God. Centers of higher learning known as the yeshivah (*yeshivot*) began to arise in cities with significant Jewish populations. Among the more famous were Córdoba in Spain, al-Qayrawan in Tunisia, and Mainz in Germany. These schools began to produce scholars, rabbis, and poets who made rich contributions to medieval Jewish tradition. As early as the ninth century, a Jewish movement developed that saw the Talmud as a departure from the divinely revealed truth of the Torah, which was the supreme authority in matters of faith. This group, which drew ideological inspiration

from the eighth-century scholar Anan ben David of Baghdad, soon became known as the "Children of the Text" or the *Karaites* (*Qaraites*, literally, "readers"). The Karaites abstained from eating meat, seeking treatment from physicians, and using lights on the Sabbath. They practiced personal interpretation of the scriptures and challenged Orthodox Judaism's juristic interpretations of God's Law. In the midst of this awakening, a Babylonian scholar, Saadiah ben Joseph (882–942), rejected the more radical Karaite notion of completely eliminating Talmudic interpretation, but he did endorse the return to the Hebrew Scriptures themselves. In order to provide a fuller appreciation for the language and voice of the scriptures, he had the Hebrew texts translated into Arabic for Jews in Muslim-controlled areas. He also introduced the idea that the Creator may have had some purpose for giving humans a rational side, one that might lead them to a greater understanding of God's purposes. Reflecting the Aristotelian naturalism and logic that were beginning to be introduced into Jewish thought through intellectual interaction with the Arabic culture, Saadiah's most famous work, *The Book of Beliefs and Opinions* (*Sefer Emunot ve-De'ot*), carved the way for the tradition of rationalism in the rabbinic authority of Judaism. After this period, rabbis moved in two directions, either embracing or rejecting the role of philosophical reason in Jewish theology and practice, a pattern that would be repeated among Christian philosophers and theologians several centuries later when these same Aristotelian ideas began to form part of the European university curricula.

THE JEWISH INTELLECTUAL MOVEMENT IN MUSLIM SPAIN. As Arabic translations of the Greek philosophers were introduced to Jewish schools, reason and revelation began to be seen as working hand in hand to bring about a more balanced and enlightened system of Jewish thought. Many of the Babylonian scholars (in modern-day Iraq) who held such notions migrated to the Muslim-controlled portion of Spain (al-Andalus), where they founded universities such as the tenth-century Jewish Academy at Córdoba and encouraged new interpretations of Jewish tradition infused with the light of philosophical reason. One such scholar, Judah Halevi (1075–1141), argued that while philosophy might be compatible with the Torah's depiction of the Almighty, the revelations in the Torah gave a much more complete rendering of the human relationship with God. Halevi's view warned against too rigorous an incorporation of philosophy and supported the interpretive role of the rabbi in Jewish religious life. Other eleventh- and twelfth-century Spanish scholars, rabbis, and poets, such as Solomon ibn Gabirol, Bahya ben Joseph ibn Pakuda, and Abraham ben David Halevi ibn Daud, were quite

supportive of Neo-Platonic and Aristotelian philosophies. Out of this growing and diverse intellectual Jewish environment came Moses Maimonides (1135–1204), the most famous and influential Hebrew scholar and philosopher of the medieval period. When Maimonides and his family had to flee Córdoba and relocate in North Africa to escape Muslim persecution, Moses continued his education within a liberal Jewish philosophical and theological environment. His writings—based upon the scriptural traditions, the Mishnah (the authoritative legal tradition), Aristotelian principles, and some ideas of his own—emphasized a practical, ethical, rational, and balanced Jewish life. His greatest work, the *Guide for the Perplexed* (*Moreh Nevuchim*), sought to articulate Jewish belief in light of Torah revelation, faith, reason, science, and philosophy. Maimonides felt that faith must supplement human reason, which can only go so far. He also taught that miracles might be explained rationally, and scriptural accounts that defy reason might better be interpreted in a more allegorical fashion. Some of his realizations concerning God, the soul, and the place of humanity were written into the Thirteen Articles of Jewish Faith, which formed a creed that was used in later medieval Jewish worship.

CHRISTIAN OPPOSITION. As the general knowledge of the Hebrew language declined in northern Europe, European Jews began increasingly to rely upon interpretations of their tradition in the form of the Talmudic texts instead of a direct reading on their own of the collected Hebrew scriptures. Although medieval Christians accepted the entirety of the Hebrew canon as what they called the "Old Testament," they harbored much suspicion concerning the Talmudic traditions. Certain writers such as Peter the Venerable (1092–1156), the abbot of Cluny, went so far as to suggest that these texts contained material that was blasphemous to Christian belief. (Scholars are not in complete agreement as to whether or not Peter actually read the Talmud.) In 1240 at the request of Pope Gregory IX, Jewish books were seized from synagogues throughout England, France, and Spain, and a trial at the city of Paris was conducted accusing Jews of being discontent with the "Old Law" of Moses and affirming another law, the Talmud. In France, rabbis were imprisoned and forced to defend their position in disputations with Christian scholars. In May of 1248 the Talmud was condemned at Paris by the Christian commission. Cartloads of the document had been burned, and the practice continued throughout Europe over the next few decades. However, Innocent IV had made certain provisions for some tolerance of the Talmudic traditions inasmuch as they were not harmful to Christian teaching and assisted Jews in com-

ing to the light of conversion, against their old ways. In the early fifteenth century, repeated condemnations of the Talmud under (the extremely anti-Jewish) Pope Benedict XIII continued, but many of these statutes were reversed by Pope Martin V in 1419 at the behest of a Jewish delegation to Rome.

MYSTICISM IN THE KABBALAH AND ZOHAR. The Jewish word *qabbalah* (tradition) is often equated with a movement toward medieval Jewish mysticism which has its roots in scriptural accounts of visions, such as the "visions of the chariot" in the text of the prophet Ezekiel or apocalyptic notions from the book of Daniel. Works of the philosopher Philo, ideas from the Talmud, and lost books like the *Sefer Adam* (Book of Adam) also contributed to these mystical ideas. The major texts of the Kabbalah (or Qabbalah) were composed or edited sometime in the late twelfth century, likely in Provence or Spain. Many scholars suggest that the development of the Kabbalah came as a reaction against the Jewish philosophical schools in Spain that emphasized a more rational approach to one's faith. The Kabbalah was written in various chapters over many decades and is comprised of several strands of mystical thought from gnostic ("secret knowledge") to theosophical (concerning intuition and perception of the spiritual or divine) and visionary. At the heart of the work was the notion of uncovering hidden symbolic meanings and secret wisdom by interpreting the arrangement of words and numbers in the Hebrew scriptures. The interplay of letters, numbers, and their ciphering was believed to yield speculative insights into the nature of Godhead, on the principal that one who searches to find God in the "beyond" comes to discover that what one is seeking actually lies within. The Kabbalah addresses such issues as how a perfect God might create an imperfect world. Did God compromise Himself by bringing forth the finite from His infinite splendor? Interpreters went so far as to think they might be able to use Kabbalic ciphering to predict or identify the Messiah. Certain movements connected to Kabbalic spirituality would go on to produce a series of false messiahs in central Europe, which proved to be of tremendous disappointment to the medieval adherents of this mystical path. The Zohar, a part of the body of the Kabbalic literature touted to be the mystical work of an earlier Talmudic sage but later discovered to have been composed in the late thirteenth century by Moses de Leone, attacks those who would neglect the commandments or seek solace in the rationality of things philosophical, and seeks a deeper penetration into the mysteries of the Torah. The human body is seen as a composite soul, as a perfect balance of male-female, reflecting spiritual elements, those "holy forms" of God

that can be unified in humanity with the supernatural soul of God.

THE MEDIEVAL HASIDIC MOVEMENT. Ashkenazi Jews in Germany developed a form of *hasidic* (pious) practice between the twelfth and fourteenth centuries. Their focus seems to have been on the love of God, not the more prevalent legalistic notions of fear or punishment. They were strict and demanding of themselves, feeling they should provide an example to the world, but lenient toward those outside their immediate communities. The Hasidei Ashkenazim were concerned with educating people toward an ethical life. Their *Sefer Hasidim* provided a guide toward a moral conversion of the heart. It was their fear that the world of humanity was besieged by demons and spirits of evil. Some became attentive to the power contained in the names of God and were attracted to the Kabbalist literature. Others were interested in living lives of a more ascetic nature. These German Ashkenaz communities were often caught up in sporadic persecutions by Christians. It was said that the greatest expression of one's love for God could be shown by enduring a martyr's death. Stories of pious Ashkenazim, exhibiting acts of charity, love, and moral rectitude, continued to provide inspiration for European Jews for centuries beyond the Middle Ages. The medieval movement is distinct, however, from the Hasidic movement of the eighteenth and subsequent centuries, whose members, distinguished by conservative clothing and hairstyles, can still be found today in communities in Israel, Canada, New York City, and elsewhere.

THE DEVELOPING SPIRITUAL AND LEGAL ROLES OF RABBIS. In the period before there was widespread Jewish migration to Europe, the title *rav* (*rabbi*) had been given to one who had received a type of ordination based upon his ability to teach and judge the law or his mastery of the Talmud. It was not quite like sacramental Christian clerical ordination, but it was conferred by the Sanhedrin or leading teachers of the community. During the diaspora in the centuries following the destruction of the Second Temple, the title "rabbi" became one of respect but most generally was applied specifically to those who were experts regarding Jewish law, particularly those formally trained by other Talmudic scholars. By the Middle Ages, then, rabbis were scholars, teachers, judges (particularly in Muslim Spain), and preachers, but not necessarily clergymen. Among their responsibilities, medieval rabbis were charged with composing commentaries on the scriptures, Talmud, and Halakah (legal texts), as well as works on ethics. One of the most famous contributors to this body of commentary known as the Midrash was Solomon ben Isaac (Rashi) who emphasized the notion of uncovering the "plain meaning" of texts, both scriptural and Talmudic. Also produced by the rabbis were the *responsa*, which were legal opinions, arguments, or precedents, some of which even became codified into medieval Jewish law. Examples of the responsa might include a discussion of the ethical questions faced by Jewish tailors employed to sew crosses on the clothing of crusaders, the issue of allowing candles to burn on the eve of the Sabbath in a Jewish home, or whether it was permissible for the windows on one's house to be constructed so that one could look out into the house of a neighbor. Medieval ethical treaties were composed by rabbis such as the Spaniard Jonah Gerundi and the German Judah Samuel, responsible for *Sefer Hasiydiyum*. Because of the variety of roles they performed, rabbis sometimes faced ethical problems themselves, since they were not, at least in theory, to receive payment or salaries for their rabbinical functions, even though many, for example, were expected to serve as judges for their people. Thought and practice regarding compensation of rabbis began to change during the fourteenth century, and, similar to the medieval Christian controversy over lay investiture, the issue of governmental interference in rabbinical appointment became a problem. Some Spanish rabbis were even required to pay the royal treasury certain fees for their appointment.

THE SYNAGOGUE. While it seems logical that synagogues might be the natural and most essential center of medieval Jewish religious life, this was not necessarily the case. Sites for other activities, such as the *miqveh* (a ritual bath for women) and schools for both younger and older children, far outweighed the importance of a formal house of prayer and worship. In medieval Judaism, individuals could pray wherever they liked, as long as the area was clean, and there was no obligation to attend services regularly at the synagogue. However, group prayer, by a *minyan* of ten or more adults, was encouraged under Jewish law and required for certain prayers or for the reading of the Torah. Because of this practice, and also because Jewish worship was so often officially proscribed in the medieval era, private homes were often used for these gatherings. In fact, in many Muslim cities, construction of a large synagogue was prohibited. In European Christian cities, according to canon law, Jewish congregations could maintain small synagogues, but new and enlarged buildings were not allowed. Although very few synagogues from the medieval period have survived (those that have were often converted into churches), descriptions have been pieced together from limited archaeological evidence and extant historical accounts. At the center of the worship space was usually located a large table on which the Torah

THE
Midrash

The Midrash was a body of folkloric commentary gathered by rabbis from the third through the twelfth centuries to explain difficult passages of the Hebrew Old Testament. Tracing its origins to Moses, who was believed to have received teachings directly from God and then begun a chain of oral transmission through subsequent generations (the "Oral Torah"), the Midrash was especially known for its clarifications of elements of the book of Genesis and the story of the Creation and Fall of man. Many of these midrashic explanations were of striking charm and originality, and they were often incorporated by Christians into their own retellings of Bible stories, probably first transmitted when social relationships developed between some medieval rabbis (or "Hebraei" as Christians called them) and Christian commentators interested in the original Hebrew text of scripture. They were also known through the *Historia Scholastica*, a glossed Bible abridgment by Peter Comestor, dean of the Cathedral at Troyes, France, written about 1170. This work served as the basis of popular Bibles as it was widely translated into vernacular languages, and its Latin text formed part of university study. Peter Comestor seems to have acquired a considerable amount of Hebrew learning through direct or indirect contacts with rabbis, most particularly the work of Rashi (1040–1105) in the Jewish community of Troyes.

The Midrash is especially important to the study of medieval art and literature because, in various forms, rabbinic explanations of scripture were used in Byzantine and Catalan painting. Particular representations of Moses in art, for example, are based on midrashic additions or glosses to the story of Moses in the Book of Numbers, and images of a tall, upright serpent who has not yet lost his legs appear in representations of the Garden of Eden before the Fall. An example of one of these midrashic glosses—apparently known to the author of the Middle English poem *Patience*—attempts to solve a problem in the Old Testament book of Jonah. The difficulty, which is glossed in the work of Rashi, is the puzzling fact that, in the Hebrew text, the gender of the whale who swallows the reluctant prophet Jonah changes from masculine to feminine from one verse to the next. Actually, Rashi said, there were two whales, a male and a female. Jonah was first swallowed by a male whale, and finding his quarters pleasant, he was not penitent. Then God commanded him to be spat up and swallowed by a pregnant female whale. Jonah now found himself so crowded and squeezed on every side by baby whales that he called out to the Lord for mercy.

Such midrashic glosses so captured popular attention that church authorities were concerned lest they form a sort of parallel Bible, and, as a result, there was something of a campaign to discredit them. For example, a Dominican friar, Raymond Martini, who died in 1285, quotes in Hebrew from midrashic glosses and follows them up with Latin translations in his *Pugio fidei*, a controversial work directed against the Jews. Even more significant was the *Extractiones de Talmud*, which consists of charges made during the Dominican "trial" in 1240 of the Talmud for advancing positions contrary to Christian doctrine. The *Extractiones* mainly single out Rashi from among the French Jewish rabbinic commentators for condemnation, and a great deal of his writing is quoted very exactly by the compiler, Thibaut de Sezanne, who is thought perhaps to have been a Jewish convert to Christianity since he obviously was working directly from Hebrew manuscripts.

scrolls could be rolled out and read. In Spain the scrolls remained upright in containers from which the scripture text was then moved to the proper place and recited. To store the Torah scrolls, many worship spaces had arks, which ranged from chests large enough to hold several scrolls to decorative niches constructed in the walls. The more elaborately decorated synagogues had desks or stands where prayer leaders could be located and even elevated pulpits (*minbar*) for preaching. In some worship spaces there were seats, but in many medieval synagogues, as in most medieval churches, the congregations would stand. Participants would often face the minbar or ark, which was oriented in the direction of Jerusalem. One of the oldest surviving synagogues from the medieval period is at Worms in Germany, dating to the late twelfth century. Its floor plan may have been borrowed from monastic chapter houses with two large intersecting halls. Wings of the structure possibly served as galleries for women who remained separate from men in some synagogues. The Worms synagogue had two exterior arched entrances with adjacent arched windows, and a ceiling that was vaulted in the style of Christian churches and supported by columns with decorative floral patterns. Building styles of this type endured and became a common architectural plan for synagogues throughout eastern and central Europe.

SOURCES

H. H. Ben-Sasson, *A History of the Jewish People* (Cambridge, Mass.: Harvard University Press, 1994).

Robert Chazan, ed., *Church, State, and the Jew in the Middle Ages* (New York: Behrman House, 1980).

Louis Ginzberg, *The Legends of the Jews.* Trans. Henrietta Szold (Philadelphia, Pa.: Jewish Publication Society of America, 1909).

Norman Roth, ed., *Medieval Jewish Civilization: An Encyclopedia* (New York: Routledge, 2003).

Gershom Scholem, *Origins of the Kabbalah* (Philadelphia, Pa.: Jewish Publication Society of America, 1987).

Colette Sirat, *A History of Jewish Philosophy in the Middle Ages* (Cambridge, England: Cambridge University Press, 1990).

SEE ALSO *Philosophy: Philosophy among the Muslims and the Jews*

EARLY MEDIEVAL CHRISTIANITY IN THE EAST

THE PROBLEM OF ICONOCLASM. Although Rome had remained the center of Western Christianity after the disintegration of the empire in the fifth century, the center of Eastern Christianity—that is, Christianity as it was practiced in Asia Minor, the Balkan peninsula, Greece, and certain other Mediterranean regions—was in Constantinople, the city that Constantine the Great had chosen in 330 to serve as the capital of the Roman Empire of the East. Known as Byzantium, this area maintained a high level of social organization at a time when conditions in Western Europe had seriously deteriorated, and thus the Byzantine church was highly influential in the development of not only Western (or Latin) Christianity, but Western art and architecture as well. One of the more pressing issues facing the early ninth-century medieval Eastern Christian church was the revival of iconoclastic practices—that is, the smashing of statues and icons—under the emperor Leo V (813–820). A number of opponents of the use of statues and images in the churches had returned to old eighth-century prohibitions against idol worship, which, at that time, had culminated in the practice of Christian icons being defaced and destroyed. It had been perceived by some—particularly those tied to the imperial court—that the extensive use of icons in Eastern Christian churches was one of the major obstacles to the conversion of Muslims and Jews throughout the Byzantine Empire. In 815, a council at Constantinople reiterated that the practice of venerating religious images was idolatrous. Probably the hardest hit by the iconoclastic movements were the monasteries where, in the previous centuries, Byzantine monks had ardently opposed the iconoclastic movement.

Many monasteries had become great repositories of religious artwork. Images in countless Eastern Christian monasteries and churches were once again destroyed by the iconoclasts.

POWER STRUGGLES. Because they were such strong supporters of the use of religious images and were not under the direct control of the bishops, monks became caught up in the emperor's struggle to become the highest authority in the Byzantine church. Byzantine emperors began to see the independence of the monasteries as a threat to their control over the church. What began as an eighth-century theological controversy developed into a power struggle between church leaders, who felt best equipped to direct religious practice, and a secular power that wished to exert control over the church through imperial policy. During the late eighth century, Theodore the Abbot of Studius at Constantinople led a resurgence of Greek monastic life. He was also on hand at Constantinople in 815 to protest the iconoclastic revival. Soon after, Theodore was sent into exile. Emperors Michael II and Theophilus continued to support the iconoclastic position. It would not be until the regency of the Empress Theodora (wife of Theophilus) in 843 and the elevation of Methodius as patriarch (a bishop in Eastern Orthodox sees) of Constantinople that icons would once again be allowed in the worship life of Byzantine Christians, a change that is celebrated in an excerpt from a homily at Hagia Sophia given by the patriarch of Constantinople two decades after the restoration of the icons. After 843, the monks were again viewed with greater respect as they regained their former influence. Some monks were even allowed to go on to serve the church as bishops. In 862 the emperor Michael sent Bishop Methodius and his brother Cyril to Moravia where they taught Christianity in the vernacular language. Cyril is credited with assembling a Slavic alphabet and producing a Slavonic translation of the scriptures. Missionary work continued on the eastern borders of the Byzantine Empire. Cyril and Methodius also went to Bulgaria where they converted and baptized the khan (ruler), Boris, in 865. As the Latin church also began to send missionaries to Bulgaria, the eastern borderlands became contested territories of potential conversion between East and West.

THE PHOTIAN SCHISM. The Moravian and Bulgarian churches continued to grow throughout the late ninth century but became the focus of a controversy when the lay bishop Photius of Constantinople attempted to exert his authority over these sees. The Latin church had protested the legitimacy of his election as patriarch of Constantinople, which allowed him to claim

a PRIMARY SOURCE *document*

A HOMILY AT HAGIA SOPHIA

INTRODUCTION: This homily was delivered by Photius, the Byzantine Patriarch, on Holy Saturday, March 29, 867, at the great basilica Hagia Sophia in Constantinople. It celebrates the gradual return of icons to the Byzantine churches and public spaces following the Iconoclastic Contest. Present at this service were the Emperors Michael III (of the Amorian Dynasty) and Basil I (of the Macedonian Dynasty).

But the cause of the celebration, whereby today's feast is conspicuously adorned, is, as we have already said, the following: splendid piety erecting trophies against belief hostile to Christ; impiety lying low, stripped of her very last hopes; and the ungodly ideas of those half-barbarous and bastard clans which had crept into the Roman government (who were an insult and a disgrace to the emperors) being exposed to everyone as an object of hatred and aversion. Yea, and as for us, beloved pair of pious Emperors, shining forth from the purple, connected with the dearest names of father and son, and not allowing the name to belie the relationship, but striving to set in all other aspects also an example of superhuman love, whose preoccupation is Orthodoxy rather than pride in the imperial diadem—it is in these things that the deed which is before our eyes instigates us to take pride. With such a welcome does the representation of the Virgin's form cheer us, inviting us to draw not from a bowl of wine, but from a fair spectacle, by which the rational part of our soul, being watered through our bodily eyes, and given eyesight in its growth towards the divine love of Orthodoxy, puts forth in the way of fruit the most exact vision of truth. Thus, even in her images does the Virgin's grace delight, comfort and strengthen us! A virgin mother carrying in her pure arms, for the common salvation of our kind, the common Creator reclining as an infant—that great and ineffable mystery of Dispensation! A virgin mother, with a virgin's and a mother's gaze, diving in indivisible form her temperament between both capacities, yet belittling neither by its incompleteness. With such exactitude has the art of painting, which is a reflection of inspiration from above, set up a lifelike imitation. For, as it were, she fondly turns her eyes on her begotten Child in the affection of her heart, yet assumes the expression of a detached and imperturbable mood at the passionless and wondrous nature of her offspring, and composes her gaze accordingly. You might think her not incapable of speaking, even if one were to ask her, "How didst thou give birth and remainest a virgin?" To such an extent have the lips been made flesh by the colours, that they appear merely to be pressed together and stilled as in the mysteries, yet their silence is not at all inert, neither is the fairness of her form derivatory, but rather is it the real archetype.

SOURCE: Photius, "Homily xvii," in *The Homilies of Photius Patriarch of Constantinople.* Trans. Cyril Mango (Cambridge, Mass.: Harvard University Press, 1958); reprinted in *The Early Middle Ages 500–1000.* Ed. Robert Brentano (New York: Free Press of Glencoe, 1964): 281–282.

jurisdiction over the eastern border areas. Photius, an extremely learned scholar and theologian (but not a priest), was elected by the imperial administration to replace the rather conservative Bishop Ignatius in 858. Pope Nicholas I attempted to have Photius deposed in a bid to exert primacy—the idea that the bishop of Rome had a primary place over all other bishops—over Constantinople and Eastern Christianity. In 863 Photius was excommunicated by Rome. In a similar move, Photius attempted to excommunicate Nicholas for supporting what he believed was a heretical position on the doctrine of *filioque*, an argument as to whether or not the Holy Spirit proceeds from the Father or emanates from both the Father and the Son, which had been previously debated at the Council of Nicea (325). This medieval disagreement, sometimes called the Photian Schism, would signal continuing unrest between Eastern and Western Christianity over issues of doctrine and the primacy of bishops—controversies that have separated the churches up to the present day. As a compromise, Photius, for a time, was forced by the new Byzantine emperor to relinquish his see at Constantinople, thus creating easier relations with the Latin church. The Photian Schism was finally healed by certain changes in imperial and papal administration and compromises at the Council of Constantinople in 870. Photius returned to power from 877 to 895. His *Treatise on the Holy Ghost,* which outlines the major Eastern objections to Latin *filioque* theology, remained an important work used by theologians throughout the Middle Ages to support the Eastern viewpoint on the relationship between the Holy Spirit and God the Father.

EXTENSIONS OF EASTERN INFLUENCE. Byzantine missionary efforts continued in the East as Bulgarian, Serbian, and Russian converts to Christianity continued to follow Greek practice. In 927 the Bulgarian church was even given its own patriarch. Vladimir, the prince of Russia, converted to Christianity in 998 when he married the princess of Byzantium, and bishops were sent to

ROMAN Catholic and Eastern Orthodox: Some Modern Differences

The disputes between the Eastern (Byzantine) and Western (Roman) branches of Christianity in the Middle Ages, including the Photian Schism of the ninth century and later tensions over the Latin Church's assertion of primacy, have kept the two churches under separate leadership for over a thousand years, allowing each to become distinctive in a number of different ways. Presented below is an overview of the modern remnants of the medieval East-West division in Christianity.

Latin Catholic Christianity

Theology is more scholastic, philosophical, doctrinal

Emphasis is more juridical (influenced by medieval canon law)

Leadership is more monarchial (authoritative pope assisted by teaching tradition of church, cardinals, and bishops)

Clergy are celibate (influenced by medieval directives toward universal practice); more pronounced distinction between lay and clergy

Religious orders include many distinct orders of religious (Benedictine, Franciscan, Cistercian, etc.)

Seven distinct sacraments

Baptism by sprinkling/pouring

Still supports doctrine of purgatory

Fasting is much less significant (especially after Vatican II)

Divorce discouraged (no sacramental re-marriage without annulment)

Domed, cruciform, and contemporary worship spaces all in use

Rood screen removed after Middle Ages; communion rails removed after Vatican II

Statues, paintings, crucifixes (no restrictions)

Vernacular used in Mass (not Latin, as it was until the 1960s)

Less elaborate Mass since Vatican II (elaborate liturgy reserved for special occasions)

Daily Mass

Greek Orthodox Christianity

Theology is more liturgized, spiritualized, monastic, and patristic (directed by the church fathers)

Emphasis is more mystical (influenced by monastic and Hesychastic traditions)

Leadership more conciliar and episcopal (relies on authority of councils and bishops)

Clergy are married (except bishops and monks)

No defined religious orders

No First Communion or Confirmation (communion and confirmation at Baptism)

Baptism by immersion

No purgatory

Rigorous fasting by both clergy and laity

Divorce allowed (up to three times)

Most churches (even the newer ones) follow traditional dome-shaped design

Iconostasis (icon screen) still persists, separating the sanctuary from the laity

Icons (mosaics and paintings) but no statues; religious art is two-dimensional

Greek, plus vernacular, used in liturgy

Longer, more dramatic Mass: many songs, much incense, use of bells

Daily Mass only in monasteries

Eucharist not consecrated every day

Russia from Constantinople to guide the development of Christianity in the region. By the eleventh century, Mount Athos in the northern part of Greece was becoming a major center of monastic spirituality. Orthodox Christians from the Greek mainland, Serbia, Bulgaria, Russia, and Georgia established communities in this secluded area, located on a peninsula that juts into the Aegean Sea and ends on an imposing mountain. Access to the mountain was quite limited—indeed, visitors were raised up in baskets attached to a rope and windlass, and women were never allowed entry at all. Thus, the solitude of the monastic groups was ensured

in a system somewhat different from the Benedictine way of life as it developed in the West. Many Western monastic houses, although controlled by vows of stability and the rule of enclosure, began to develop limited ties with various secular entities that surrounded their communities, and so had connections to outside society that were more integral to their existence than those in the East.

CONTINUING TENSIONS. In 1053 a dispute between the patriarch of Constantinople, Michael Cerularius, and Pope Leo IX of Rome caused a schism which resulted in the East and West once again attempting to excommunicate one another. Cerularius wanted Constantinople to have equal status with Rome and to be able to operate independently in the Eastern sphere. To show his opposition to Rome's position, Michael closed all of the Latin rite churches in Constantinople. He also solicited other bishops to write letters in support of the traditional theological objections that had long divided the two rites. This time one of the major objections was the use of unleavened bread by the Armenian and Latin church. Churches in Russia, Serbia, and Bulgaria, and even the Melkites in Egypt, sided with the Greek church and initiated a break with Rome. Tensions were further exacerbated during the Crusades as Latin armies en route to the Holy Land pillaged the countryside in order to feed the troops. In 1204 Western crusaders even succeeded in taking military control of the city of Constantinople, which was followed by three days of looting. An attempt at reconciliation and reunification between the Greek and Latin churches was made at the Second Council of Lyon in 1274 by Pope Gregory X (1272–1276) and efforts continued throughout the following centuries. A rather unexpected concord came at an ecumenical council in 1439, with Greek acceptance of the Roman pontiff's primal place as successor to the apostle Peter as head of the Roman church. The most significant outcome of this agreement was the notion of the unity of faith and diversity of rite (ritualistic practice), a principle that is still respected between Eastern and Western Christians today.

SOURCES

Francis Dvornik, *The Photian Schism* (Cambridge, England: Cambridge University Press, 1970).

Joan Hussey, ed., *The Orthodox Church in the Byzantine Empire* (Oxford, England: Clarendon Press, 1986).

John Meyendorff, *The Orthodox Church: Its Past and Its Role in the World Today* (Crestwood, N.Y.: St. Vladimir's Seminary Press, 1981).

George Ostrogorsky, *History of the Byzantine State* (Rutgers, N.J.: Rutgers University Press, 1986).

Steven Runciman, *The Eastern Schism* (Oxford: Oxford University Press, 1955).

MEDIEVAL LITURGY

BLENDED FORMS. The development of the Christian liturgy in Europe—that is, the forms and arrangements of public worship—reflects shifts in political and cultural dominance throughout the medieval period. Roman liturgy (that form of Christian worship practiced in the city of Rome) began to find its way into northern Europe during the eighth century with encouragement from Charlemagne's father, Pepin the Short. As its use became more widespread, the Roman liturgy also assimilated many older uses that were native to Frankish Gaul. In circulation at this time were two major sacramentaries (books of prayers for sacramental services): the Gregorian (dating from the late sixth and early seventh centuries at Rome) and the Frankish-Gelasian (which had Gallic and Benedictine influences, parts of which dated from the early seventh through mid-eighth centuries). The earliest surviving medieval liturgical manuscripts, in fact, blend these Gallic and Roman types. During the reign of Charlemagne, the Hadrianum, a sacramentary sent by Pope Hadrian, further assisted in the promotion of Roman elements in the Frankish liturgy. This hybrid or "mixed" liturgy spread into Germany with renewed support from Rome during the tenth century. The Gallo-Roman liturgy actually found its way back to Rome during the tenth century and further added to the rich blend of medieval liturgical practices.

MISSALS AND ORDINES. Since the old-style sacramentary did not include all the information necessary for conducting a service, it eventually gave way to the missal (*Missalis Plenarius*), a type of book that included not only the aspects of former sacramentaries, but also epistles (letters of St. Paul in the New Testament), antiphons (chants used during the canonical hours), and directives for preaching. This change did not happen all at once, but the missal virtually replaced the sacramentary by the eleventh century. Not only did celebrants find it easier to use because all the components of the liturgical prayers, songs, and readings were in one volume, but the missal also included more specialized liturgical formulas for use in commemorative services like the private mass. To understand exactly what went on during the medieval liturgies, however, one must look not only at prayers, readings, and songs in the missals, sacramentaries, lectionaries, and antiphonaries, but more importantly to a book called the *ordo*, which gave directives for liturgical action or served as a guide for liturgical procedure. One problem, however, is that these books (called *ordines* in the plural) were constantly changing, and there did not seem to be much of a need to save those that had become outdated. Some of the directives

existed as individual manuscripts and actually had to be gathered in collections. Like the sacramentaries, antiphonaries, and lectionaries, the disparate directives of the ordo were eventually replaced by a more comprehensive single-volume work which later became known as the *pontifical.* Again, it took some time for the full transition of such usages to occur, depending upon local customs, between the tenth and twelfth centuries.

THE SETTING OF THE EARLY MEDIEVAL MASS. By looking at some of the early medieval ordines, scholars have been able to reconstruct aspects of the medieval mass. Particularly in the urban areas and especially in the cathedrals, there seems to have been a great deal of pomp and ceremony connected to these services. Indeed, medieval masses were quite extravagant affairs. The papal and episcopal liturgical directives from the eighth century still followed old Roman and Byzantine courtly rituals for the robing of participants in the sacristy (a room for keeping vessels, candles, and other ceremonial objects, near the front of the basilica). The vestments worn were very similar to those used today by Roman Catholic, Anglican, and Lutheran clergy. Deacons, sub-deacons, and acolytes acted as ministers for the celebrant. In the cathedrals and at papal services, the bishops and presbyters (priests) sat near a throne in the apse (an addition at the eastern end of the church, usually near or connected to the altar area) awaiting the arrival of the main celebrant and his attendants. Lesser clergy and those in training sat in the choir near the front altar. Lay men and women of the congregation were seated in separated rows throughout the nave of the church, with members of the aristocracy always seated in the front.

THE PROCESSION, PRAYERS, AND READINGS. The service proceeded with Gospels being carried in by an acolyte, then placed reverently upon the altar by the sub-deacon, a minor order of cleric. Candles were lit (there were often seven candle bearers), incense was employed, and an Introit (opening) antiphon was begun as the celebrant and his entourage processed to the altar of the church. Bread that had been consecrated (blessed) at the most recent mass was handed to the celebrant by the deacons. Once members of the procession reached the altar, they would bow, then make the sign of the cross, as the celebrant proceeded to give the attendants a kiss of peace. This was followed by the prayers *Gloria Patri* ("Glory to God the Father"), the kissing of the Gospels by the celebrant, and then his return to the throne. While facing east, the choir sang the litany *Kyrie Eleison* ("Lord Have Mercy"). This was followed by the hymn *Gloria in Excelsis Deo* ("Glory to God in the Highest") sung by the congregation. Afterward, the celebrant turned and

greeted the people with *pax vobiscum* (peace be with you) and began to pray the *Collect.* The celebrant then sat back on the throne, the congregation sat, and the sub-deacon proceeded to a raised platform (the *ambo*) to read scriptures from the lectionary. A response to the readings (*gradual*) was sung by a cantor, and then the deacon who was appointed to read the Gospel proceeded to the throne to receive a blessing from the celebrant. If the pope was present, the reader was to first kiss his feet, a practice from an old Byzantine court ritual. The deacon then removed the Gospel book from the altar, first kissing it, then processed with two sub-deacons carrying candles and incense to the ambo to read the Gospel. After the reading, the book was carried by the sub-deacons to the places in the sanctuary where clergy were seated so that all might venerate the book of Gospels by kissing it. The book was then returned in its cover or *capsa* (which was usually decorated with ornate precious stones) to the main altar. During the eleventh century the creed or *Credo* (literally "I believe") was added after the reading of the scriptures.

PREPARATION FOR THE EUCHARIST. Following the service of the Word of God, there was an offertory procession, during which those lay participants at the liturgy would present the gifts that they had brought by coming forth toward the altar. The bishops and priests would receive the gifts, including the offerings of bread and wine for the eucharist (commemoration of the Last Supper of Christ). In large congregations this was quite a time-consuming process. The flasks of wine were poured into a large vessel (the *scyphus*) and the loaves of bread were placed in linens (called *sindones*). The celebrants and attendants would then wash their hands. Additional wine, brought by the celebrants, was then poured into the large common chalice (sometimes so big it had to have handles), and the celebrant also poured in a bit of water. While all of this was going on, the various hymns, antiphons, and psalms prescribed for the day would be sung. The next action involved the clergy taking positions around the altar in the sanctuary. They would be arranged according to rank, with priests and deacons closest to the altar, and sub-deacons and acolytes closer to the nave. The celebrant would then sing a prayer of thanksgiving (later called the Preface) followed by the *Tersanctus* sung by the sub-deacons. The lay community did not always take part in the singing.

THE EUCHARIST. Once all the elements were in place, the celebrant recited the Eucharistic prayers while those in the sanctuary bowed their heads. The chalice was lifted by one of the bishops or assistant celebrants for all to see, while the celebrant held the offering of bread on the edge of the chalice. Following this action, the celebrant recited or sang the Lord's Prayer ("Our Father"),

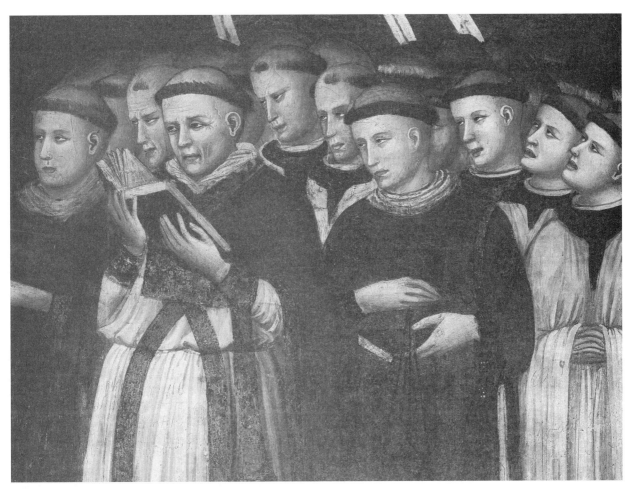

Monks sing in choir. Life of St. Nicholas, fresco, Pietro da Rimini, San Nicola basilica, Tolentino, Italy, 14th century. THE ART ARCHIVE/SAN NICOLA BASILICA, TOLENTINO/DAGLI ORTI.

deposited particles of consecrated bread both from that celebration and the previous day, and then returned to his throne to sit. The consecrated loaves of bread were next broken for distribution while the *Agnus Dei* (Lamb of God) was sung. The celebrant then broke his own bread and dropped a piece into his chalice of wine, to symbolize that both elements of bread and wine represented one true Lord. Bread and wine were then consumed by the celebrant. Once the bread was consecrated, fragments were carried by sub-deacons to local parish churches in order to connect them to the episcopal or papal service. Consecrated wine from the celebrant's chalice was poured into the larger common cup, and the clergy then received bread from the hands of the seated celebrant. Clergy went to the altar to drink wine from the smaller cups. The celebrant with bishops, priests, and deacons then brought the consecrated bread to the laity (which they handed to them) and filled smaller cups from the large scyphus, which were also presented to the congregation for consumption. It is likely that the bread and wine were brought whenever pos-

sible directly to the people instead of there being a procession to the altar area by the laity who elected to receive communion. It is quite clear that by the medieval period the sanctuary was off limits to the laity. By the eleventh century, a screen (made of wood or metal, sometimes called the rood screen) was erected in certain churches to separate the clergy and altar from the laity. These became more common in the abbey churches and larger cathedrals. During the reception of the bread and wine by the laity, songs and antiphons were sung, often by a choir. After the communion, the celebrant returned to the altar, faced east (toward the altar itself), and said a post-communion prayer; then the congregation was dismissed by the deacon. In the closing activity, the celebrant processed out of the church toward the sacristy with the acolytes, sub-deacons, and other attendants, blessing the congregation along the way.

A DECLINE IN LAY PARTICIPATION. While simpler liturgical forms likely took place in the smaller and rural

churches, the directives of the ordines clearly stated that celebrants were to try to stay as close to the urban and Roman rituals as possible. Some of the Frankish changes to the old Roman rite found their way back to Rome as early as the eleventh century. But the old Roman liturgy imported to France by Charlemagne underwent only minor changes in northern Europe during the following three centuries. One important trend that increasingly became more evident during the late eleventh century was that the members of the laity were losing their participatory voice in medieval liturgy. Prayers of the celebrant, once said aloud so that all in the congregation could hear, began to be whispered. The prayers of the laity began to be limited to short acclamations and then to fall into total disuse. Burchard of Worms (d. 1025) in his list of penitentials wrote that the growing failure of people to respond in church constituted "unbecoming" behavior. However, it might be said that the environment for participation was not especially inviting, since in most parts of medieval Europe the laity usually stood for the entire mass. There were no seats or pews, though there were stalls for the monks or canons of the choir. By the thirteenth century, the laity began to be instructed to kneel during the consecration. It was not until the fifteenth century in Germany that preachers began to direct the laity to sit for their sermons. Thus, the strong ties that once existed in early Christianity between the celebrant and people were being gradually loosened throughout the medieval period.

SOURCES

Bernard Cooke, *Ministry to Word and Sacraments* (Philadelphia, Pa.: Fortress Press, 1976).

Joseph Jungman, *The Mass of the Roman Rite* (Westminster, Md.: Christian Classics, 1986).

Theodor Klauser, *A Short History of the Western Liturgy* (Oxford: Oxford University Press, 1979).

Cyrille Vogel, *Medieval Liturgy* (Washington, D.C.: Pastoral Press, 1981).

SEE ALSO *Music: Plainsong and the Monophonic Tradition; Music: Additions to the Sacred Repertory; Theater: The Development of Liturgical Drama*

CLUNY AND THE MONASTIC REFORMS OF THE TENTH AND ELEVENTH CENTURIES

THE FLOWERING OF CLUNY. As the pervasive presence and influence of Benedictine monasticism emerged from Carolingian reforms of the ninth century, a par-

ticularly powerful house at Cluny (in the Burgundy region of eastern France) became the embodiment of church leadership, independence, and success in Western Christianity. Through cooperation with its benefactor, Duke William the Pious of Aquitaine, the monastery (founded in 909) adopted an original charter that allowed the monks to choose their own succession of abbots without interference or intervention from outside secular or church authorities. The abbot and community were also to have complete control over all of the monastery's properties, being answerable only to the Apostolic See in Rome. A string of influential and creative abbots—Odo (926–944), Mayeul (965–994), Odilo (994–1048), and Hugh (1049–1109)—caused the house to become a major center of spirituality that quickly spread its influence over much of Europe. The notion that the present evil age was signaling the end of the world and that monastic life was the most perfect embodiment of the Christian vocation became cornerstones of Cluniac spirituality. The monks believed that if they renounced the world and undertook a life of silence and interior transformation they would experience God in the unceasing prayer of their community and the paradise of the cloister. Due to their high standards of observance, European houses as far away as Italy and Spain asked the Cluniacs for assistance with their own reforms. Although the community was poor at first, it did not take long for admirers of their lifestyle to become supporters and benefactors, creating a wealth of endowments. Secular estates and even entire monasteries were given over for Cluny to manage.

ARCHITECTURAL AND POLITICAL EXPANSIONS. During the abbacy of Odilo, further exemptions from outside secular or episcopal influences were obtained, placing Cluny and all its daughter houses and dependencies under direct control of the pope. This was highly unusual for the time since local bishops and lords commonly exercised certain jurisdictions and rights of taxation over the monasteries. As the number of filiations grew, however, their care and management continued to be shouldered by the abbot of Cluny, the spiritual father of all Cluniacs throughout Europe and the one to whom postulants, novices, and newly professed monks from all the dependent houses took their vows. Portions of the incomes from these dependent houses also flowed into Cluny itself, financing a period of architectural expansion replete with elements of religious grandeur. Under Abbot Hugh, a 530-foot basilica with four transepts, fifteen towers, and five radiating chapels was constructed. After subsequent additions, Cluny boasted the largest Christian church that had ever been built in Europe up to this time. By the early twelfth century, Cluny had be-

come one of the wealthiest and most influential establishments in all of Christendom. Within the next fifty years, Cluniac dependencies numbered over one thousand. Many leaders of the Cluny organization were from the most significant noble families of Europe. Not only was there a close relationship between Cluny and Rome, but the abbey also forged strong links with the Holy Roman emperors. Abbot Hugh was the godfather of Emperor Henry IV, and he arranged for a marriage between his niece and King Alphonso VI of León and Castile. Pope Urban II was a former grand prior of Cluny, and a long list of monks to follow (from both Cluny and its filiations) went on to serve in the episcopal ranks.

LITURGY AND LAY CONNECTIONS. The liturgical practices at Cluny were rooted in the notion that the monastic life was the only sure way to salvation, and this idea applied not only to the monks themselves, but to members of the surrounding lay communities as well. The monks believed that the monastery should be a place where continuous prayer was lifted up to God. According to the order's *customals* (books containing instructions for monastic daily life), the monks extended the time for prayer well beyond the earlier Benedictine directives to the point where as many as eight hours of their day were dedicated to activity in the *choir*, the special seating area near the altar. In addition to the extra offices, two daily community masses were often celebrated. Extra psalms recited for benefactors, longer night offices on saints' days, and the chanting of the entire books of Genesis and Exodus prior to the Lenten season also served to lengthen the time of prayer. During Lent so many prayers were added that the offices became almost continuous. Those laity who could not make such an extreme commitment to the monastic lifestyle might share in the merits of the monks' work by associating themselves with the monasteries. This could be accomplished through donations, sending family members (sometimes child *oblates*) to the monasteries, being buried on the monastic property, or requesting the prayers of the monks during their various offices. One could even apply for confraternity, an arrangement by which the community chapter would vote to accept a person as an associate member of the house, sharing in the same spiritual benefits as the monks and even being remembered in the Office for the Dead like a regular member of the community. Lay members' names could also be written in the *Liber Vitae* (Book of Life), which occupied a place on the high altar during Mass. Much of the theology behind lay association with the monasteries was linked to the belief in petitionary prayer, which allowed individuals to direct specific requests to God.

GERMAN REFORM MOVEMENTS. Cluny was not the only major reform group from the tenth and eleventh centuries, nor did it offer the only new model for monastic organization and liturgy. In 933 the Abbey of Gorze (near Metz, Germany) began a revival of the community once formed by Chrodegang in the eighth century. During the ninth century it had been run by a series of lay abbots. With the help of German nobility and bishops, the new Gorze reform extended to Trier, Verdun, and Lorraine (now in France), as well as Hesse, Swabia, and Bavaria. The customal of Gorze soon began to be used by over fifty monasteries. Houses of women also took up the customs in Bavaria during the 900s. While Gorze followed the Benedictine traditions as introduced during the Carolingian era by Benedict of Aniane, there were a number of differences from the Cluniac foundations. Some of the early reform abbots (Arnold, John, and Immo) had placed themselves in positions of obligation to lay patrons, nobles, and bishops who had invited the Gorze reformers into their territories. Control of the Gorzer monasteries resided with the bishops. Also those German abbeys and daughter houses that embraced the Gorze reform were not dependent upon the motherhouse but operated in an autonomous fashion. There were a number of core monasteries connected to the reform that became the nucleus of a group of confraternal houses. The Gorze lectionary and liturgical ceremonies were also different from Cluny's. What turned out to be most significant were the liturgical enactments and performances that were linked to the seasonal celebrations such as Easter. These are said to have been the origins of the mystery plays that evolved into medieval drama.

ENGLISH REFORM. The English monasteries of the tenth and eleventh centuries were affected in various ways by both Gorzer and Cluniac reforms. As was the case at Cluny, carrying out the liturgy of the daily offices became the primary focus of the monastic life. However, more in keeping with the Gorzer model, connections between English monasteries and English monarchs were quite strong. In 970 abbots and abbesses from all over the realm attended a royal assembly at Winchester where an agreement of customs known as the *Regularis Concordia* was drawn up. The result of this convention was that the king became the overseer of a uniform set of monastic observances. Prayers for the king and queen were included in most of the daily offices. Monasteries were even given by the crown certain jurisdictions over secular matters, such as land management and the courts. Thus, a unique type of unity developed between the monasteries and the monarchy, one that was also linked with the English people themselves.

SOURCES

H. E. J. Cowdrey, *The Cluniacs and the Gregorian Reform* (Oxford, England: Clarendon Press, 1970).

Noreen Hunt, *Cluny under Saint Hugh 1049–1109* (Notre Dame, Ind.: Notre Dame University Press, 1968).

C. H. Lawrence, *Medieval Monasticism* (New York: Longman, 1984).

Barbara Rosenwein, *Rhinoceros Bound* (Philadelphia, Pa.: University of Pennsylvania Press, 1982).

SEE ALSO *Architecture: Monastic Architecture*

RELICS, PILGRIMAGES, AND THE PEACE OF GOD

INTEREST IN RELICS. Much of the activity related to pilgrimages and holy sites in the Middle Ages can be connected to a renewed interest in relics that began in the ninth century in northern European Christendom. Any physical objects tied to famous saints or holy personages, such as body parts, bones, hair, fingernails, or even clothing worn during their lifetime, qualified as relics. In 801 and again in 813 the emperor Charlemagne revived a statute from the Council of Carthage (401) that required all altars to contain relics. The Carolingians went so far as to import relics from Italy and Spain. Pilgrimages to the tombs of saints were also encouraged. Charlemagne even suggested that important oaths were to be sworn upon relics. Not all relics were kept in churches, however. Charlemagne himself kept relics in his throne room for the occasion of oaths. There were even special decorative containers called *reliquaries* where these holy objects were kept for veneration on ceremonial occasions. In the tenth and eleventh centuries, nobles would swear peacekeeping oaths upon relics. Cults to the physical remains of saints did not take long to develop, an attraction that may have gone back to the practice of pre-Christian hero cults in Europe, and pictures of them were common in churches and religious manuscripts of all sorts, as illustrated in an English book of hours now in Oxford. For many ordinary Christians, sacred objects connected to the saints and particularly their remains were often thought to be conduits to the holy. Churches and monasteries that had such important relics in their possession would be considered prestigious. Places such as Dijon, Fulda, Vézelay, Verdun, Cologne, Bruges, Verona, Milan, Loreto, Trier, Conques, and Compostela attracted visitors due in part to their famous relics. This did much for the income and morale of congregations and communities. In theory, the objects were not to be worshipped in and of themselves.

Theologically it was argued that the relic allowed humans to come close to the spirit of the prescribed saint who then became an intercessor for humanity assisting in the transmission of God's grace. The relics would, of course, have only as much significance as a group of worshipers gave them. But they did provide a point of contact between their perception of the divine and their everyday mortal lives.

PILGRIMAGES. The Christian practice of making pilgrimages to holy sites dates back to the fourth century. The theology behind this was the notion of establishing a connection to places significant to the incarnate Christ. As early as the seventh century, Christians in northern Europe were making pilgrimages to Rome, where they wished to visit the supposed tombs of saints Peter and Paul, and by the eighth century such visitors could follow a written guide with an established itinerary. Around this time, the notion of remitting the public penance (assigned by a priest in confession) for one's sins through some sort of pilgrimage had become common. Thus, pilgrimages often became associated with the notion of penitence. By the tenth century pilgrimages began to be organized on a grander scale. Noblewomen, dukes, bishops, abbots, and even those from lesser walks of life, from as far away as England, Normandy, Bavaria, and Swabia, sought to visit the Holy Land. With the conversion of the Hungarians in the late 900s, overland routes to the Levant (the area comprising modern-day Lebanon, Israel, and parts of Syria and Turkey) began to be developed through southeastern Europe. The monks of Cluny also assisted with the organization of the pilgrimages, particularly from France. Even when sites of Christian shrines were located in Muslim-controlled areas such as the Holy Land and Spain, Christians were traditionally allowed access since a deep respect for the notion of pilgrimage was a vital part of the Islamic faith. However, when these holy places became inaccessible, Christians believed that they were justified in attempts to secure these areas by force.

POPULAR JOURNEYS. Depending upon the balance of power in the Levant and the route of travel one chose, journeys to the Holy Land could be quite dangerous. Pilgrimages to sites in western Christendom such as Conques (southeastern France), Rome, and Santiago de Compostela (northwestern Spain), which were more associated with the relics of saints, could be much safer. By the twelfth century, sites such as the shrine of St. James at Compostela became tourist attractions and local economies flourished along their travel routes. Sites like Canterbury commemorated both relics and events, such as the twelfth-century murder of Thomas Becket

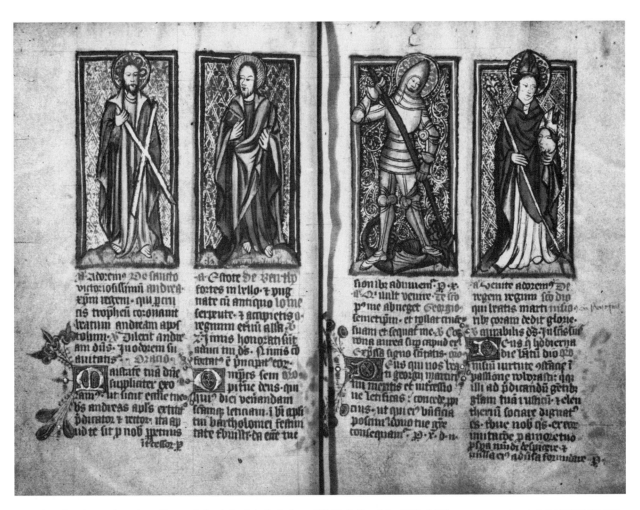

Portraits of various saints. Lacy Hours, Oxford, St. John's College MS 94, folios 4-4v, 1430–1434. BY PERMISSION OF THE PRESIDENT AND SCHOLARS OF SAINT JOHN BAPTIST COLLEGE IN THE UNIVERSITY OF OXFORD.

(chancellor of England and archbishop of Canterbury). Becket's grave as well as the spot upon which he was murdered in Canterbury Cathedral became a popular destination for both the pious and the curious. Miracles were recorded at Becket's tomb, and eventually his remains were moved to the choir of Trinity Chapel in 1220 where they stayed until the shrine was destroyed by Henry VIII in 1538. In effect, Becket became one of the first saints elevated by popular acclaim and enthusiastic devotion in medieval European tradition. Geoffrey Chaucer's *Canterbury Tales* (1390s) remind us of the Becket tradition and testify to the fact that these pilgrimages were not always somber affairs. Certainly, such expeditions contained elements of adventure and entertainment as well as spiritual satisfaction.

TRUCE OF GOD AND PEACE OF GOD. The experience of pilgrimage was made possible, in part, by attention to the issue of safety both for travelers and for the broader European society. Effective peacekeeping in

the early part of the Middle Ages was a major problem not only for secular rulers, but also for the church, as uncontrolled violence posed threats to both church property and those in religious life. Also caught up in these dangers were innocent lay people who would often find themselves at the mercy of armed local warriors. Without physically fighting back, the church found it necessary to create ways to disarm a society where violence seemed to have become an all too commonplace occurrence. Legislation at tenth- and eleventh-century assemblies known as *synods* began to reflect principles such as the Peace of God (*Pax Ecclesiae*) and the Truce of God (*Treuga Dei*). Between 990 and 1096 at least thirty church councils addressed the problem of unchecked martial activity in European society. At these synods the church promoted the cessation of unnecessary violence through the Truce of God and imposed penalties, under threat of excommunication, for carrying on warfare during certain holy seasons, on Sundays, and in certain

holy places. In an attempt to save the weak and innocent from the horrors of unjust physical abuse, the knightly order was obliged through the ideals of the Peace of God to protect unarmed poor, children, women, clerics, merchants, and pilgrims. This also extended to their property, merchandise, and even farm products, animals, and equipment.

THE CONCEPT OF JUST WAR. The idea of war which could be justified in the service of the church—a principal that was applied to the Crusades both in connection with protecting pilgrims and with maintaining access to holy places—may have been indirectly tied to notions of curbing the outright martial character of medieval society as a whole, although it certainly was rooted in the drive for the church to gain more control over secular affairs. During the eleventh century, the notion of "Christian" knighthood had begun to moralize the activities of a knight, turning him from full-time warrior to part peacekeeper, as would be encouraged by the Peace of God and Truce of God movements. Bishops even went so far as to impose spiritual sanctions on offenders who refused to put down their weapons. Soldiers fighting for the church on the advice of their bishops or in a war against heretics, on the other hand, could be forgiven without penance for their violent acts. In 1085 Anselm of Lucca published the *Collectio Canonum*, which assembled just war texts from St. Augustine to Gregory I (fifth through seventh centuries). This literature supported the ecclesiastical right actively to direct the *ius gladii* (literally: by right of the sword) in the service of the church. Actions like blessing the weapons of a knight for the service of justice and God came from a century earlier. The idea of the *militia Christi* (army of Christ) certainly precedes the Crusades, but it had been used more in a metaphorical sense by the Gregorian reform movement (beginning in 1059) to address the spiritual battles fought by the monks. As it began to be applied to the military during the time of the Crusades, it probably reflected the growing need of the church to justify protecting itself from secular powers or taking up a noble cause.

SOURCES

Tim Davis, *Saint Bernard of Clairvaux: A Monastic View of Medieval Violence* (New York: McGraw-Hill, 1998).

Patrick Geary, *Furta Sacra* (Princeton, N.J.: Princeton University Press, 1991).

Thomas Head and Richard Landes, eds., *The Peace of God: Social Violence and Religious Response in France Around the Year 1000* (Ithaca, N.Y.: Cornell University Press, 1992).

G. J. C. Snoek, *Medieval Piety from Relics to Eucharist* (New York: Brill, 1995).

Jonathan Sumption, *The Age of the Pilgrimage* (Manwah, N.J.: Hidden Springs, 2003).

Diana Webb, *Medieval European Pilgrimage 700–1500* (New York: Palgrave Publishing, 2002).

SEE ALSO *Architecture: Pilgrimage Architecture; Fashion: Academic, Clerical, and Religious Dress; Literature: The Canterbury Tales; Visual Arts: The Cult of Saints and the Rise of Pilgrimage*

GROWING CHURCH POWER AND SECULAR TENSIONS

A PERIOD OF PAPAL WEAKNESS. In the tenth century, as the Carolingian Empire started to break apart and the Germanic Empire rise, increasing tension developed between bishops, the pope, and secular rulers. Strong local nobility had begun to emerge during the age of the Viking invasions in Italy, France, Germany, and England, while the Roman bishops themselves were hardly in a position to wield significant political power at all. The last of the noteworthy early medieval popes was Nicholas I (858–867), after whom there would not be meaningful individual ecclesiastical authority directed from Rome until the eleventh century. In fact, the majority of the popes in the early Middle Ages functioned primarily as liturgical leaders and guardians of tradition (not political figures). While holy and accomplished Roman bishops such as Hadrian I, Nicholas I and John VIII did much to direct the positive course of early medieval Christianity, near the early part of the tenth century, a series of degenerate popes (John VIII, Formosus, Lambert, Stephen VI, Leo V, Christopher, and Sergius II) succeeded one another by each deposing his predecessor. These changes in leadership included a chain of nine successive pontiffs within the span of an eight-year period. Probably the most bizarre story connected to this era was that of Formosus (891–896), whose dead body was exhumed and put on trial by his rivals for a variety of offenses that he had committed while in office. After being found guilty, his corpse was defrocked of its vestments and his consecrated fingers (those used in blessing and holding the host, or consecrated bread, during Mass) were severed from his body. There was even a teenage pope (John XII) elevated in 955 whose father was the half-brother of a former pope (John XI). While abstinence from sexual activity among Western Christian clerics had begun to be legislated in the late 300s and several edicts in the 400s had imposed oaths of celibacy upon the clergy, there were still many who refused to comply. By the sixth century, only a small percentage of priests and bishops openly continued to have

a PRIMARY SOURCE *document*

PAPAL POWER: THE DICTATUS PAPAE (MARCH 1075)

INTRODUCTION: This statement of papal authority was crafted during the first two years of Gregory VII's pontificate (1073–1085). It systematically sets forth the claim (likely for the first time) that the pope had the power to depose an emperor.

1. That the Roman Church was founded by God alone.

2. That the Roman Pontiff alone is rightly to be called universal.

3. That he alone can depose or reinstate bishops.

4. That his legate, even if of lower grade, takes precedence, in a council, of all bishops and may render a sentence of deposition against them.

5. That the Pope may depose the absent.

6. That, among other things, we also ought not to stay in the same house with those excommunicated by him.

7. That for him alone it is lawful to enact new laws according to the needs of the time, to assemble together new congregations, to make an abbey of a canonry; and, on the other hand, to divide a rich bishopric and unite the poor ones.

8. That he alone may use imperial insignia.

9. That the Pope is the only one whose feet are to be kissed by all princes.

10. That he alone is to be recited in churches.

11. That his title is unique in the world.

12. That he may depose Emperors.

13. That he may transfer bishops, if necessary, from one See to another.

14. That he has power to ordain a cleric of any church he may wish.

15. That he who has been ordained by him may rule over another church, but not be under the command of others; and that such a one may not receive a higher grade from any bishop.

16. That no synod may be called a general one without his order.

17. That no chapter or book may be regarded as canonical without his authority.

18. That no sentence of his may be retracted by any one; and that he, alone of all, can retract it.

19. That he himself may be judged by no one.

20. That no one shall dare to condemn a person who appeals to the Apostolic See.

21. That to this See the more important cases of every church should be submitted.

22. That the Roman Church has never erred, nor ever, by the witness of Scripture, shall err to all eternity.

23. That the Roman Pontiff, if canonically ordained, is undoubtedly sanctified by the merits of St. Peter; of this St. Ennodius, Bishop of Pavia, is witness, many Holy Fathers are agreeable and it is contained in the decrees of Pope Symmachus the Saint.

24. That, by his order and with his permission, subordinate persons may bring accusations.

25. That without convening a synod he can depose and reinstate bishops.

26. That he should not be considered as Catholic who is not in conformity with the Roman Church.

27. That the Pope may absolve subjects of unjust men from their fealty.

SOURCE: *Dictatus Papae* (March 1075), in *Church and State Through the Centuries.* Trans. S. Z. Ehler and J. B. Morrall (London: 1954): 43–44. Reprinted in Brian Tierney, *The Crisis of Church and State 1050–1300* (Toronto: University of Toronto Press, 1988): 49–50.

wives, but much larger numbers had *focariae* or mistresses. Violations of clerical celibacy defiantly continued through the eleventh century, particularly in the more rural areas. Pope John XII was himself openly sexually active (he is accused of turning the papal residence into a brothel) and was said to have died of a stroke while in bed with a married woman. However, historians remember John XII for breathing new life into the power of the western Christian Roman Empire. His coronation of the German emperor, Otto I, on Candlemas Day in 962 saw (through military means) the return of former Italian papal territories to the church. This also rekindled the strong ecclesiastical and secular relationship that had once existed between the Roman bishops and the powerful institutional western European kingdoms.

THE INVESTITURE CONTROVERSY. The Latin Church's dependence upon lay powers for support (both

economic and military) had allowed for the development of a practice during the ninth and tenth centuries where kings and princes reserved for themselves the power of investiture over bishops and abbots. That is, these secular powers, operating according to the patterns established in the broader society, literally would invest high-ranking clergy with the symbols of their office. In the case of bishops and abbots, this was the presentation of the ring and staff (*crozier*) that served as visible signs of ecclesiastical authority. In return, the bishop or abbot would pay homage to the king and swear an oath of *fealty* or loyalty, just as a vassal or land-tenant might. The kings and nobility who owned much land might grant *benefices* or tenure on the land for a particular number of years. Powerful secular leaders granted such lands to local churches or even would give over church-owned lands to laity as they saw fit. By the mid-eleventh century, church leaders began to condemn the practice, which resulted in a contest between church and state. The Investiture Controversy was sparked by church legislation initiated in 1059, 1075, 1076, 1078, and 1080 under Popes Nicholas II and Gregory VII. Humbert of Silva Candida published a work entitled *Three Books Against the Simoniacs* which not only was a polemic against simony (the sale or purchase of a church office), but supported the notions of clerical celibacy and papal primacy. Humbert's treatise was also an attack upon lay authority as it related to the power of the priesthood. According to Humbert, church authority came from God and was to be carried out through the electoral will of his people and priests, not the kings and nobility, whose power extended only to secular matters. These reforms attempted to purify the ordination process from selfish secular interests, first by placing the election of the pope in the hands of the cardinals, and later by ruling against lay influence in ecclesiastical elections and, eventually, lay investiture of any kind under any circumstance.

AN AUTHORITY STRUGGLE. Royal and noble compliance with these church directives was difficult to obtain, however. The distinctions between the spiritual office of the bishop and the material possessions or physical powers linked to the post were not clearly defined during the early years of the investiture contest. The issue came to a head with the authority struggle between Pope Gregory VII (1073–1085) and the German emperor Henry IV. Gregory was credited with issuing the famous decree *Dictatus Papae* which stated that the pope, not the emperor, was to be seen as the vicar of Christ. (It was the pope who was the successor of Constantine.) The pontiff alone could both depose and install princes, emperors, and bishops. The pope could be judged by no mortal man. He might also absolve individuals of their fealty to evil persons of power. While the struggles between the bishop of Rome and the German emperor were real, scholars now suggest that *Dictatus Papae* was later submitted into the register of documents for 1075 in order to bolster claims for papal power. It is likely that the term "paptus" was not even used until decades later, around the beginning of the twelfth century. In any case, Henry IV refused to recognize Gregory's authority, and the bitter struggle continued for some ten years. The crown attempted to depose the pope in 1076 and shortly thereafter the papacy declared the emperor excommunicated. Bishops and princes from all parts of Christendom intervened and took sides. The northern Italian and German bishops even went so far as to side with Henry and ratify the emperor's decision to depose the pontiff. Lay nobility who were plotting Henry's demise forced the emperor into reconciliation, and there appeared to be some change in the balance of power during the early part of 1077 when the penitent Henry appeared before Pope Gregory barefoot in the middle of winter at Canossa begging forgiveness for his immortal soul.

THE REASSERTION OF THE CHRISTIAN ROMAN EMPIRE. Henry's apparent sincerity demonstrated in the Canossa incident was short-lived. In fact, some historians have suggested that this entire act of penitence may have been a ploy on the part of Henry to buy the cooperation of German nobles. Several years after he had been forgiven, in 1080, the emperor managed to invade Italy and forcibly have Pope Gregory exiled and deposed. Henry elevated a new pope, Clement III, who officially restored Henry IV's place as emperor of the Romans. Henry IV renewed his quarrel with the papacy after the elevation of Urban II (1088–1099), whose organization of the First Crusade helped solidify the public view of the papacy as the visible head of the Roman Church in administrative, judicial, and military capacities. Urban eventually succeeded in rallying the bishops of Germany against lay investiture, but after Urban's death Henry IV again came into conflict with Pope Paschal, and the emperor was again excommunicated by Rome in 1102. The controversy between the German emperors and popes continued for another generation as each side gained and lost ground. Some of the difficulties between spiritual and temporal powers during these decades may have been tied up in disagreements over valid canonical election. Between 1059 and 1179 a series of some fourteen anti-popes served sporadically alongside or in conflict with the pontiffs now recognized by historians. With

a PRIMARY SOURCE *document*

A RECONCILIATION AT CANOSSA

INTRODUCTION: During the period of the Investiture Controversy, when lay rulers struggled with the papacy over the right to ordain or depose princes and bishops, one of the most dramatic confrontations was a ten-year struggle between Pope Gregory VII and Emperor Henry IV, who refused to follow church directives and even attempted to depose the pope. Finally, after the pope declared the emperor to be excommunicated and other princes began plotting against him, Henry was forced to attempt reconciliation, which he did by appearing barefoot outside the pope's residence at Canossa in the middle of winter. The following account (dated the end of January 1077), which relates the Canossa event, appears in a letter to the German princes written by Gregory:

Whereas for love of justice you have made common cause with us and taken the same risks in the warfare of Christian service, we have taken special care to send you this accurate account of the king's penitential humiliation, his absolution and the course of the whole affair from his entrance into Italy to the present time. According to the arrangements made with the legates sent to us by you we came to Lombardy about 20 days before the date at which some of your leaders were to meet us ... [and] we received certain information that the king was on his way to us. Before he entered Italy he sent us word that he would make satisfaction to God and St. Peter and offer to amend his way of life and to continue obedient to us, provided only that he should obtain from us absolution and the apostolic blessing. For a long time we delayed our reply and held long consultations, reproaching him bitterly through messengers back and forth for his outrageous conduct, until finally, of his own accord and without any show of hostility or defiance, he came with a few followers to the fortress of Canossa where we were staying. There, on three successive days, standing before the castle gate, laying aside all royal insignia, barefoot and in coarse attire, he ceased not with many tears to beseech the apostolic help and comfort until all who were present or who had heard the story were so moved by pity and compassion that they pleaded his cause with prayers and tears ... At last overcome by his persistent show of penitence and the urgency of all present, we released him from the bonds of anathema and received him into the grace of Holy Mother Church, accepting from him the guarantees described ...

SOURCE: Pope Gregory VII, Letter to the German Princes, in *The Correspondence of Pope Gregory VII.*, Book IV, 6, Columbia University Records of Civilization. Trans. by Ephraim Emerton (New York: W. W. Norton, 1960): 109–110.

rival claimants to support, emperors, princes, and kings were not always in agreement over who represented the church's position and which religious leader the secular powers should choose to recognize. A compromise between German kings and bishops of Rome finally came at the Concordat of Worms in 1122 with an agreement executed by Pope Calixtus II and Henry V of Germany. A similar compromise had been struck in England during the early 1100s between Anselm, the archbishop of Canterbury, and King Henry I, who had agreed that secular leaders would still invest bishops but with the understanding that they were only granting the bishop earthly temporal authority. The church would also have its representative (usually a higher ranking bishop, pope, or cardinal) invest the bishop with symbols of priestly authority, namely the ring and staff. In some areas the king conferred power through the touch of his scepter. While the presence of the king or secular noble leaders was permitted at a bishop's elevation, it was by the authority of the leading local bishops that a candidate was placed in office. However, it is more likely that leaders in significant church positions (such as bishops, abbots, and even popes) had the blessing of both clergy and secular leaders.

SOURCES

A. L. Barstow, *Married Priests and the Reforming Papacy* (Lewiston, New York: Mellen Press, 1982).

Eamon Duffy, *Saints and Sinners: A History of the Popes* (New Haven, Conn.: Yale University Press, 2002).

Gerd Tellenbach, *The Church in Western Europe from the Tenth to the Early Twelfth Century.* Trans. Timothy Reuter (Cambridge, England: Cambridge University Press, 1993).

———, *Church, State, and Christian Society at the Time of the Investiture Controversy* (Oxford: Basil Blackwell, 1959).

THE CRUSADES

MOTIVATIONS. The Crusades were a series of military campaigns waged by Christian armies against Muslim-controlled areas in the Holy Land beginning in 1095 and continuing on an intermittent basis even as late as the sixteenth century. While the Crusading momentum seems to have begun with the justification of rescuing holy places from Muslim control, it is likely that the motivation for the First Crusade was a complex

mixture of religious emotion, individual ambition, and political programs. Pope Urban II's call to crusade was in response to the March 1095 request from the court of Byzantine emperor Alexius for military assistance against the Turks threatening to take control of much of Asia Minor. It is clear that Urban was concerned about the pressure Islam was exerting on the eastern frontiers of Christendom. He was also anxious to improve relations between the Greek and Latin Churches. At the Council of Clermont in November of 1095, Urban's call for pilgrims to respond to a war (that was God's will) to liberate the land of Jesus's birth from the Infidel (one who is "unfaithful to the true teaching," a terminology used by both Christians and Muslims to refer to each another) had decidedly religious overtones. It is no surprise that the first group to whom he presented this idea were predominantly clergy. Many of these clerics were sons of knights, hardly any were pacifists, and it appears there were few objections to this justification for war. Clearly, at the heart of his agenda was the desire to free the Greeks from Muslim oppression. However, the idea of the liberation of Jerusalem and its pilgrim routes seemed to be what was most ideologically appealing to Western Christians. The response to Urban's 1095 tour of preaching, beginning at Clermont, moving through various parts of France (Limoges, Toulouse, Angers, Le Mans, Nîmes, Tours) and ending in Italy, was impressive. The fact that the pope had made a personal and individual appeal to local people may have had a tremendous impact. An army of 70,000 to possibly 130,000 Christians (many of them French, probably fewer than ten percent from the nobility) followed bishops like Adhémar of Le Puy, preachers such as Peter the Hermit and Walter Sans-Avoir, and veteran knights like Raymond of Toulouse and Godfrey of Bouillon through strange territories they had never before seen, under the religious pretext of rescuing the Holy Places. Not all departed together or took the same routes. Many of them never reached the Holy Land and, clearly, fewer than a third returned. The successful response to the First Crusade may have been due to several factors: it was completely voluntary, it was proposed as an act of devotion, and it carried with it a means to ensure remission of sin. Indeed, while the initial indulgence proposed by Urban granted a remission from temporal penance, during later Crusades it would be modified to include punishments both in this life and the next.

RELATED PERSECUTIONS. Several of the armies from Germany began their crusade against infidels by unleashing violence upon Jews living in Europe. In 1096 at Worms, Mainz, Ratisbon, Neuss, Wevelinghofen, Xanten, and Prague, Jewish residents were massacred in the name of the Christian holy war, partially justified by the popular notion that it was the Jews who had killed Jesus. Such persecutions of non-Christians outside the Holy Land would not be limited to the First Crusade, but were tied to subsequent holy wars as well. They included not only Jews, but other ethnic and religious groups living throughout Europe. Muslims in Spain, Wends (Slavic people) on the German borderlands, multiple pagan groups in the Baltic, and the Cathars (a heretical Christian sect who believed that Satan ruled the earth) in France also suffered during the various Crusades.

OUTCOMES OF THE FIRST CRUSADE. The First Crusade was relatively successful despite the loss of large numbers of troops along the way, as well as some questionable pillaging by Latin crusaders in Hungarian and Byzantine cities. While only one-third of the initial contingent reached Jerusalem, they were able not only to free major Byzantine centers such as Nicea from Muslim control, but also to secure Christian settlements along the way, particularly on the western coast of the Mediterranean in the future Latin kingdoms of Edessa, Antioch, and Jerusalem. At the outset, a Latin principality at Edessa was established under Baldwin, the brother of Duke Godfrey of Bouillon, in 1198. This was followed by the siege of Antioch, which took over a year but resulted in Latin control of that fortress as well as the surrounding area. In the summer of 1099 Jerusalem was finally toppled. However, with the death of Bishop Adhémar of Le Puy at Antioch, there was no strong, rational voice of the church to stop the bloodbath in the city of Jerusalem following the siege. Soldiers, women, children, Muslims, Jews—indeed, most of the inhabitants of the city—were slaughtered by the crusading army. Shortly thereafter, the remnants of the army returned to Europe in triumph.

THE CRUSADING KINGDOMS. Subsequent establishment of the Latin Crusading Kingdoms would take place within the next few decades under a second generation of French campaigners, all with papal support. The Knights Templar set up headquarters in Jerusalem under Hugh de Payens to ensure that the Holy Places and Christian pilgrims remained protected. A continued military presence was required for the western Christians to maintain control of the region. An additional kingdom was established at Tripoli between Jerusalem and Antioch. Each Latin kingdom had its own rulers or princes, most of which were drawn from the French nobility who decided to settle and manage the area. Vassal

a PRIMARY SOURCE *document*

SPIRITUAL PRIVILEGES GRANTED TO CRUSADERS

INTRODUCTION: This is likely the first of two crusade encyclicals issued by Pope Eugenius III (one in December of 1145 and the other in March of 1146). *Quantum Praedecessores* was directed at the French nobility and it is likely that Eugenius would not have attempted to call for such an action if he did not have the support of the French king Louis VII. The bull emphasized the religious nature of the crusade and outlined spiritual privileges for participants.

Moreover, by the authority vested by God in us, we who with paternal care provide for your safety and the needs of the church, have promised and granted to those who from a spirit of devotion have decided to enter upon and accomplish such a holy and necessary undertaking and task, that remission of sins which our predecessor Pope Urban instituted. We have also commanded that their wives and children, their property and possessions, shall be under the protection of the holy church, of ourselves, of the archbishops, bishops and other prelates of the church of God. Moreover, we ordain by our apostolic authority that until their return or death is fully proven, no lawsuit shall be instituted hereafter in regard to any property of which they were in peaceful possession when they took the cross.

Those who with pure hearts enter upon such a sacred journey and who are in debt shall pay no interest. And if they or others for them are bound by oath or promise to pay interest, we free them by our apostolic authority. And after they have sought aid of their relatives or lords of whom they hold their fiefs, and the latter are unable or unwilling to advance them money, we allow them freely to mortgage their lands and other possessions to churches, ecclesiastics or other Christians, and their lords shall have no redress.

Following the institution of our predecessor, and through the authority of omnipotent God and of St. Peter, prince of the Apostles—which is vested in us by God—we grant absolution and remission of sins, so that those who devoutly undertake and accomplish such a holy journey, or who die by the way, shall obtain absolution for all their sins which they confess with humble and contrite heart, and shall receive from the Remunerator of all the reward of eternal life.

Granted at Vetralle on the Kalends of December.

SOURCE: Pope Eugenius III, *Quantum Praedecessores Nostri*, 1145, in *The First Crusade, The Chronicles of Fulcher of Chartres and Other Source Materials*. Ed. Edward Peters (Philadelphia: University of Pennsylvania Press, 1971): 239.

territories and Latin castles were established throughout the Levant. A small number of Westerners (possibly 2,000) acted as administrators and lords over numerous Muslim and Jewish subjects. Part of the task of the settlers, especially in Jerusalem, was to rebuild the shrines associated with the holy sites. During the twelfth century, once the territory was secure, large numbers of European pilgrims came to visit and venerate the sacred places. Schools, hostels, monasteries, and churches began to proliferate throughout Jerusalem. One of the great accomplishments of the early crusader period was the rebuilding of the Holy Sepulchre (the supposed location of the tomb of Christ) into one of the greatest Romanesque churches in Christendom. What the First Crusade actually accomplished was to establish Latin dominance in the Holy Land, creating wealth for many French noble families, and to set into motion the religious and political mechanisms for future defense and campaigns.

THE FAILURE OF THE SECOND CRUSADE. After the successes of the First Crusade, the concept of Holy War and the religious obligation of Christians to control the

Holy Land and purge society of non-believers was firmly entrenched. The Second Crusade was spurred by the fall of Edessa (then part of Syria, now Urfa in Turkey) on Christmas of 1144 to the Muslim leader Zengi. At stake for Western Christians was the impending threat to Jerusalem itself. There seemed to have been somewhat less enthusiasm for this second campaign, but Pope Eugenius III's papal bull *Quantum Praedecessores* spelled out for the first time specific spiritual privileges available to participating crusaders. The crusade proclamation was delivered by Eugenius at Vetralle and later recorded in Bishop Otto of Freising's *Gesta*. Assisted by the charismatic preaching of St. Bernard of Clairvaux and other Cistercians, the Second Crusade organization gained some momentum. Secular bishops like Henry of Olmütz were directed to preach the Bohemian Crusade, while there were simultaneous crusades launched against the Wends in northern Europe and the Moors in Spain. When the effort to recapture Edessa ultimately proved unsuccessful, the crusaders decided instead to journey on to Jerusalem (which was still secure) to do homage to the holy sites. At that point, the crusaders attempted a joint attack upon the city of Damascus. This military

a PRIMARY SOURCE document

A CRITICAL LOOK AT THE CRUSADES

INTRODUCTION: At the beginning, the Crusades were a popular movement, both because they reopened the Holy Land to pilgrimage travel and because they provided an opportunity for Christian service and reward. But eventually the Crusades began to draw increasing criticism. A number of church councils (beginning in 1149) were called to debate the merits of crusading or to discuss whether or not failed crusades should be revived. The following excerpt comes from a report by Humbert of Romans, fifth Master General of the Dominican Order, delivered at the Second Council of Lyon in 1274.

There are some of these critics who say that it is not in accordance with the Christian religion to shed blood in this way, even that of wicked infidels. For Christ did not act thus ...

There are others who say that although one ought not to spare Saracen blood one must, however, be sparing to Christian blood and deaths ... Is it wisdom to put at risk in this way so many and such great men of ours? ...

There are others who say that when our men go overseas to fight the Saracens the conditions of war are much worse for our side, for we are very few in comparison to their great numbers. We are, moreover, on alien territory ... And so it looks as though we are putting God to the test ...

There are others who say that, although we have a duty to defend ourselves against the Saracens when they attack us, it does not seem that we ought to attack their lands or their persons when they leave us in peace ...

There are others who say that, if we ought to rid the world of Saracens, why do we not do the same to the Jews? ...

Other people are asking, what is the point of this attack on the Saracens? For they are not roused to conversion by it but rather are stirred up against the Christian faith ...

Others say that it does not appear to be God's will that Christians should proceed against the Saracens in this way, because of the misfortunes which God has allowed and is still allowing to happen to the Christians engaged in this business.

How could the Lord have allowed Saladin to retake the land won with so much Christian blood, the emperor Frederick to perish in shallow water and King Louis to be captured in Egypt ... if this kind of proceeding had been pleasing to him?

SOURCE: Humbert of Romans, "Humbert of Romans to the Second Council of Lyon, 1274," in *The Atlas of the Crusades*. Ed. Jonathan Riley-Smith (New York: Facts on File, 1991): 80.

effort proved to be a disaster, and the crusaders returned home shortly after. The failure of the Second Crusade was attributed to the sinfulness, pride, and bickering of the contestants who traveled to the Holy Land under the pretense of being pilgrims. Instead, they insulted God with their unworthiness. According to St. Bernard, it was God who allowed the bungled Christian attempt to fail, not merely due to the sins of the crusaders themselves, but the collective sinfulness of all of Christianity.

SUCCESSES AND DISASTERS. It took some time after the failure of the Second Crusade for Christians to be able to legitimize another campaign. Christian presence in the Holy Land did not altogether disappear as Templar and Hospitaller strongholds dotted the landscape along the Mediterranean, where Latin Christians maintained control of the kingdoms at Antioch, Tripoli, and Jerusalem, sustaining a presence in an area some 100 miles long and 30 miles wide. However, the southern part of that territory around the city of Jerusalem was conquered in 1187 by the Muslim leader Saladin, resulting in a massive response of combined European forces descending upon the port city of Acre over the next four years. By 1192 the Third Crusade succeeded in recovering some of the coastal territory along the Mediterranean, particularly around the cities of Tripoli, Antioch, and Jerusalem. The following Crusade, however, went seriously off course. While originally intended to fight Muslims in Egypt, the Fourth Crusade instead engaged itself with interventionary efforts in Christian cities. Departing from Venice in Italy during 1202, the crusaders first rescued the Croatian city of Zara, which had previously been lost to the Hungarians in 1186. Behind schedule and short on cash, they were convinced—by arguments ranging from Christian charity and a promise of permanent papal jurisdiction to a substantial monetary reward—to go to Constantinople in 1204 to assist in resolving a dispute between rival Byzantine factions. Having little to show for their previous efforts, the crusaders ended up engaging in a three-day sacking of the city that left all of the Byzantine Christian holy places, including Hagia Sophia, defiled and stripped of everything of value. While most crusaders simply went

home with their loot, some stayed to support the new Latin Kingdom that would last for fifty years.

CONTINUING CAMPAIGNS. Perhaps because the Crusades blended religious motivation with opportunities for political domination and enrichment, new campaigns continued throughout the Middle Ages. The Fifth Crusade of the early thirteenth century was intent upon rescuing Jerusalem, which was still under Muslim dominion. But it also targeted the power base of the Ayyubid dynasty in Egypt in an effort to stabilize Christian control of the Holy Land. After four years of effort, the Fifth Crusade inevitably failed. Crusades against the heretical Cathars and pagans in the Baltic during the early thirteenth century, as well as crusades to restore papal power in the late thirteenth century, were more successful. They were all attempted under the guise of similar crusade ideals—ridding the Western Christian world of threats to the orthodoxy of its belief system. The Crusades of St. Louis in the thirteenth century and the Popular Crusades (Children's in 1212, Shepherds' in 1251 and 1320, as well as the People's in 1309), all of noble intent, were highly influenced by the crusading propaganda of the time. Crusaders were convinced that righteous participants were the key to success in defeating the Infidel. St. Louis's initial crusade effort in 1248 is sometimes known as the Sixth Crusade, but, after this, historians seem to stop counting. There were a variety of smaller crusades that continued through the next several centuries linked to both religious and political agendas. At this point, all sorts of arguments were presented concerning the pros and cons of crusading, as illustrated in a report given to the Second Council of Lyon during 1274 by Humbert of Romans. Despite objections and the fall of Acre to the Islamic Mamluk dynasty in 1291, the idea of the crusade remained alive in Latin Christendom through the sixteenth century.

SOURCES

Hans Eberhard Mayer, *The Crusades* (Oxford: Oxford University Press, 1996).

The Oxford Illustrated History of the Crusades (Oxford: Oxford University Press, 1995).

J. M. Powell, *The Anatomy of a Crusade 1213–1221* (Philadelphia, Pa.: University of Pennsylvania Press, 1986).

D. E. Queller, *The Fourth Crusade* (Leicester, England: Leicester University Press, 1978).

Jonathan Riley-Smith, *The Crusades; A Short History* (New Haven, Conn.: Yale University Press, 1987).

Christopher Tyerman, *The Invention of the Crusades* (Toronto: University of Toronto Press, 1998).

SEE ALSO *Visual Arts: Spanish Culture and the Muslims*

THE MILITARY ORDERS

RELIGIOUS CONGREGATIONS OF KNIGHTS. One of the most distinctive developments of the period following the First Crusade (begun in 1095) was the creation of "military orders," religious congregations of knights whose initial purpose was to protect pilgrims and maintain control of the "Crusader Kingdoms" established by the French in the Holy Land. Clearly the military religious orders began with the justification of Christian warfare during the First Crusade. The act of killing the enemies of Christ was not seen as a sin but rather as necessary and meritorious. Thus, if a Christian soldier died in such a war, it brought him the status of martyrdom. Also, the Crusades themselves had taken on the character of a special pilgrimage, and, like pilgrims, a participant in a Crusade could be granted an indulgence, or remission from temporal penances associated with his sins. As the size of pilgrim groups to the Holy Land increased, the church felt somewhat obliged to provide for their protection. While the First Crusade had temporarily eliminated the threat of Muslim control of the Holy Land, the area itself remained relatively unprotected since most knights returned home once the military campaigns ended. The population of Christian settlers in the Crusader Kingdoms around the city of Jerusalem and along the Palestinian coast of the Mediterranean was rather small and unable to provide pilgrims with adequate protection. A group of knights led by Hugh de Payens decided to make a vocation out of protecting pilgrims who were on their way to visit the holy places. They formed a religious group that resided in the city of Jerusalem and became known as the "Templars."

SOLDIER-MONKS. Hugh envisioned the Templars as an army of soldier-monks whose martial duties contained a decidedly spiritual element. In a sense, they embodied the highest ideals of Christian knighthood. These Templars took vows of obedience and chastity, and they followed the spiritual lives of the canons that resided at the church of the Holy Sepulchre. They were called "Templars" or "Knights of the Temple" because they lived in an area of Jerusalem believed to be near the old Temple of Solomon. Their movement seems to have evolved out of the spirituality connected to Crusade ideology. The journey of a crusader to Jerusalem was justified as a penitential process, an ascetical exercise of self-denial, prayer, mortification, and fasting. All of these idealized crusader elements were incorporated into the Templar spirituality. When the plan for the group was first approved in 1128, they were not considered monks but fell into the category of "lay religious." For a time this seems to have appeased critics who were in staunch

support of church directives against monks bearing arms. Templars wore their hair short, donned white robes, and avoided women. Sometime after 1132, the Cistercian abbot Bernard of Clairvaux was asked to write a treatise supporting the Templars. It may not have been so much a direct approval of their movement as an exposition on monastic life as the highest form of knighthood, or possibly an attempt to help reform the knighthood of Bernard's time. He wrote:

> Thus in a wondrous and unique manner they appear gentler than lambs, yet fiercer than lions. I do not know if it would be more appropriate to refer to them as monks or as soldiers, unless it would perhaps be better to recognize them as being both. … What can we say of this except that this had been done by the Lord, and it is marvelous in our eyes. These are the picked troops of God, whom he has recruited from all ends of the earth …

THE TEMPLAR RULE. A rule was eventually composed for the Templar lifestyle which contained elements of the Benedictine Rule along with particular aspects of Cistercian spirituality and practice. The rule and the order were approved in 1139 by Pope Innocent II in his bull *Omne Datum Optimum*. The Templars were not under the control of local bishops but answered directly to the pope. About the time of the Second Crusade (1146), the Templars came to be seen as religious knights whose commitment to protecting the holy places was permanent. There were several levels to the order, which consisted of knights of noble birth, sergeants who were not nobles, chaplains who were clerics and not allowed to take up arms, and, in addition to all these, their servants. Only the knights took permanent vows. They continued to operate in the Holy Land until the fall of Acre (the main port of entry to Palestine) in 1291, but were eventually suppressed by Pope Clement V in 1312. The Templars also participated in campaigns in Spain and the Baltic area of Europe. While they became famous for their almsgiving, along the way the knights began to lose sight of some of their founding principles. After a century in the Holy Land, they had succeeded in amassing great wealth and had significant involvement with banking. Their massive fortifications functioned as depositories as they transported wealth to and from the East and brokered loans. Indeed, their wealth may have been their undoing. Despite the Templars' attempt to merge with the Hospitallers after the end of the Crusades, their assets were seized by the French king Philip the Fair and their leaders executed as heretics.

THE HOSPITALLERS. The Hospitallers (also known as the Knights of St. John) originated as a brotherhood that served poor or sick pilgrims in the city of Jerusalem.

About 25 years before the First Crusade, they began their work in a Benedictine monastery, St. Mary of the Latins, near the Holy Sepulchre. The hospice was staffed both by the Hospitaller brothers and by monks. All those who worked there followed the Benedictine lifestyle. Following the First Crusade, the Hospitallers were given additional lands in the Levant (an area on the eastern shores of the Mediterranean, located between western Greece and western Egypt) along the pilgrim routes on which to establish daughter houses. They also had establishments in the port cities of Italy and southern France, from which pilgrims would normally depart. In 1113 the Hospitallers were given a charter from Pope Paschal II establishing them as a unique order to be supervised by their own master and (like the Templars) answerable only to the pope. Initially they were a charitable order, not a military group, dedicated to the care of pilgrims and almsgiving, but in 1123 they added a military element due to the shortage of Christian knights in the Holy Land. They continued to protect and serve pilgrims as well as to provide military assistance to the local nobility against the Muslims. By the 1130s they had begun to construct and defend fortified castles throughout the Holy Land. Soon their order began to resemble the Templars with divisions of service for clerics, knights, sergeants, and laborers in the houses. And like the Templars they were considered lay religious and took vows of chastity, obedience, and poverty following whenever possible the daily monastic routine. The order also admitted women, who had separate accommodations. In 1141 they moved their headquarters to a castle called Krak des Chevaliers, situated on a high plateau in what is now Syria, and after 1187 they were forced to withdraw from Jerusalem. With the fall of Acre and the final destruction of the Latin Kingdoms in the Holy Land, they established themselves on Cyprus, and in 1309, after taking Rhodes from the Greeks, made a new headquarters there. The order still functions today as a charitable organization.

OTHER CHIVALRIC ORDERS. By the middle of the twelfth century other chivalric orders had begun to appear in Spain with the intention of assisting with the *Reconquista*, the reconquest of the Iberian peninsula from the Moors. Orders like Calatrava and Alcantara took their lead from the Templars. The Calatrava group began in 1158 when local monks allied themselves with knights to fight the Almohads, a Muslim dynasty that replaced the short-lived Almoravids. Eventually the knights of Calatrava went on to form their own order, but in 1164 they were attached to the Cistercians (a reform monastic movement that had begun in 1098) by Pope Alexander III. By the fourteenth century the order

was responsible for protecting some 350 towns in the area of Castile. Following the reconquest, the order became more of a political entity. Alcantara began functioning in 1156 to defend the towns of León. They received papal approval in 1177 and began to follow the Rule of Benedict. Eventually they became allied with the Calatrava knights in driving out the Muslims. The Knights of the Teutonic Order and the Order of Santiago functioned more on military and hospitality levels, although they strove to maintain the highest standards of Christian knighthood. Their groups were also composed of warriors, clerics, and brothers. The Teutonic Knights began in 1198 during the time of the Third Crusade and eventually returned to Germany in the thirteenth century to function in the campaigns against the pagans on the borderlands of Prussia, while the Order of Santiago was formed in the late twelfth century to protect pilgrims traveling to the shrine of St. James at Compostela. The Santiago knights ruled almost as lords protecting territories throughout reconquered parts of Spain. The order survived through the end of the *Reconquista*.

SOURCES

Malcolm Barber, *The New Knighthood* (Cambridge, England: Cambridge University Press, 1994).

Bernard of Clairvaux, "In Praise of the New Knighthood," in *The Works of Bernard of Clairvaux.* Cistercian Fathers Series, 19, IV, 8. Trans. Conrad Greenia (Kalamazoo, Mich.: Cistercian Publications, 1977): 140–141.

Alan Forey, *Military Orders and the Crusades* (Brookfield, Vt.: Variorum, 1994).

Jonathan Riley-Smith, *The Knights of St. John in Jerusalem and Cyprus* (London, England: Macmillan, 1967).

Desmond Seward, *The Monks of War: The Military Religious Orders* (Hamden, Conn.: Archon Books, 1972).

SEE ALSO *Fashion: Armor and Heraldry*

TWELFTH- AND THIRTEENTH-CENTURY MONASTIC MOVEMENTS

ANCHORITES AND HERMITS. From the end of the eleventh and throughout the twelfth centuries, groups of religious began to react against the extravagant growth and development of monastic orders like that at Cluny. The desire for a return to primitive Christian experience was now reflected in monastic practices. New religious orders seeking quiet, solitude, poverty and simplicity began to appear, likely in reaction against the highly liturgized and richly endowed Benedictine monasteries. While some twelfth-century secular communities supported the hermit-like activity of anchorites who chose to live a spiritual existence in a cell that was often located outside the village or even attached to the structure of a church, some individual monks began leaving their communities to take up the solitary lives of hermits completely removed from the rest of society. In northern Italy during the early eleventh century, eremitic (solitary) monks like the Greek-speaking St. Nilus chose their own paths. St. Romuland organized huts for hermits in the hills of Camaldoli that attracted only the most serious monks, the contemplative elite. At Vallombrosa, John Gaulberto also founded a cenobitic (communal) group who chose to persevere in the strictest observance of the Benedictine Rule. They lived in complete isolation, buffered from the world by professed lay brothers who were administrators of the monastery's secular affairs. The lay brothers were dedicated to keeping outsiders away.

THE TEACHINGS OF PETER DAMIAN. One of the most influential monastic figures of this period was Peter Damian (1007–1072), who received an education in the city schools of Italy. He abandoned formal learning for a time and joined a group of ascetics at Fonte Avellana in the Apennine hills. Peter denounced the pleasures of the flesh, producing marvelously mystical poetry. He also wrote a treatise for hermits entitled *Institutes for the Order of Hermits*. In this work he spelled out guidelines for brothers who wished to live under the strictest regimen. The monks were to occupy cells in pairs, living in a perpetual state of fasting, remaining barefoot in both summer and winter. While most of the Italian men who were attracted to these severely contemplative groups were drawn from among the wealthiest of the nobility, Peter was himself of humble origin. Peter Damian was particularly drawn to the practice of the mortification of his flesh through flagellation, that is, the practice of whipping oneself as punishment for sins or in commiseration with the suffering of Christ. When a community member died, the entire group would undergo a seven-day period of fasting, recite the entire psalter thirty times over on behalf of the deceased, and experience the whip seven times. Peter was also active in a campaign against simony (the buying and selling of clerical offices) and clerical marriage. In 1051 he wrote the *Book of Gomorrah* (*Liber Gratissimus*), which was a polemic against sexual activity among the Italian clergy, including prohibitions against masturbation and homosexual conduct.

CARTHUSIANS. In 1080 Bruno of Cologne, a former master and chancellor of the cathedral school at

Side wound of Jesus with wounded heart within. BODLEIAN LI-BRARY, UNIVERSITY OF OXFORD. MS LATIN LITURGIES F.2, FOLIO 4V, 1405–1413.

monks. The conversi were usually illiterate. They had their own dormitory, which was slightly removed from the community, and would sit silently while their procurator chanted the daily offices for them in an oratory quite separate from the hermits. Growth within the Carthusian Order was rather slow, but the establishments were deliberately small. Gradually, between 1178 and 1400 they added some nine houses in England. As Bruno of Cologne once wrote, "The sons of contemplation are slower than the sons of action."

THE FOUNDING OF THE CISTERCIANS. One of the most explosive movements of the twelfth century was the Cistercian Order. It had been founded in 1098 by a group of former French Benedictines from Molesme who were dissatisfied with their observances. The Molesme community had originally lived as hermits in the forests of Burgundy. Eventually they came back to following the Benedictine Rule. The abbot, Robert of Molesme, set out one day in 1098 with 21 of his monks for a more remote site at Cîteaux (the Latin word for Cîteaux is *Cistercium*, meaning "a marshy place"). The Cistercian movement that began from the vision of Robert blossomed into one of the largest and fastest growing religious movements of the Middle Ages. The Cistercian Order was directed toward a reform of the perceived growing laxities within the French Benedictine system, especially among the Cluniacs. In the mode of the other reform orders, they were focused upon moving away from the "worldliness" that had crept into medieval monasticism. Like the hermits, they attempted to separate from secular society in a quest for solitude, a simpler life, and a renewed focus on connecting the scriptures to one's spiritual and human nature. This reform community wished to continue the cenobitic existence in fidelity to the Rule of Benedict, along with greater independence from secular entanglements and obligations of vassalage, and a vision of poverty and self-sufficiency. The monastery began as a series of wooden huts that were built by the monks themselves. Their first decade at Cîteaux saw little growth, but in 1112 the charismatic St. Bernard of Clairvaux appeared at the gate of the monastery with thirty companions. From that point on, the order began to flourish. Cîteaux started sending out small groups to found daughter houses throughout France and eventually all of Europe. Bernard was made abbot of Clairvaux in 1115, and within the next twenty years engendered some twenty daughter houses of his own. During the order's first fifty years, 339 houses were established, and by the middle of the thirteenth century the number had grown to 640. At its height in the fifteenth century, the order boasted close to 700 abbeys of men and 900 houses of women. The

Reims, left teaching to become a hermit in the forest of Colan. He was credited with founding the Carthusians, an order that mixed both eremitical and cenobitic elements. The monks lived in a group hermitage where each member spent most of his time in the solitude of a private cell, except for communal prayer twice a day. Mass and chapter were held once a week. Monks took most of their meals alone and had a private garden, toilet, and area for study. At first they lived lives centered around deliberate simplicity. Their churches were unadorned, their clothing and bedding of the coarsest materials. The original Carthusian settlements were comprised of a series of huts, but by the twelfth century more elaborate stone structures took their place. Because of their strict rules, the Carthusians needed *conversi* (lay monks) to deal with the outside world, tend to the labor of the monastery, and function as go-betweens for the hermit

development of the order was strongly influenced by charismatic leaders and spiritual writers, including William of St. Thierry (1085–1148) and Aelred of Rievaulx (1109–1167) among the men, and Mechtild of Hackenborn (1241–1299) and Gertrude of Hackenborn (1251–1292) among the women. Mechtild's allegory of how Anima or the Soul comes to the side wound of Christ and sees it as a cavern of burning flames and vapor is one of the great pieces of mystical writing of the period. The side wound with wounded heart within is vividly seen in a miniature from a devotional manuscript in Oxford. Often, such miniatures give evidence of being kissed and stroked by pious owners of the books over a long period of time.

THE CISTERCIAN CONCEPT OF REFORM. The original charter for the Cistercian Order was presented to Pope Calixtus II for approval in 1119. These documents provided for nurturing filial relationships (that is, relationships to daughter houses), annual chapters (assemblies) for all the order's abbots, uniformity in practice among the houses, fair treatment of the monks, elections of the abbots by their peers, checks on corruption in leadership, fair but limited dealings with outside secular interests, and, most importantly, the ability to change its own constitution. What is essential to an understanding of the Cistercian tradition is the concept of "reform." The reform that seems to be constantly ongoing within the Cistercian and other Benedictine-related traditions might be more simply understood as a "re-reading" of the Benedictine Rule. This re-reading is what happens each time a new generation picks up the Rule and begins to read it in light of their own time, in a way which seems to allow the greatest progress toward spiritual transformation and a vision of communal charity. The twelfth-century charter documents most clearly reflect the way the early Cistercians had devised a plan in which their vision of the Rule could be continually re-examined. The yearly meetings of the General Chapter of all Cistercian abbots allowed for an ongoing interpretation of the monastic tradition. These traditions were passed down to the monks on a daily basis through their reading, activities, and communal prayer, as well as through the abbot's chapter sessions. The Cistercians in general never really made much effort to focus upon the intellectual and philosophical dimensions of the faith, a fact that eventually made them less attractive to the nobility in the thirteenth and fourteenth centuries, when scholasticism and the work of the friars (who served as missionaries and teachers) began to take hold. Instead, they were known for their great spiritual reforms and return to the ideals of the early Benedictine experience. The simplicity

of their cloistered monastic life is what the Cistercians believed best led them to God.

CISTERCIANS AND MEDIEVAL INDUSTRY. The proliferation of Cistercian houses led to a great increase in their holdings of land. Granges (monastic farms) and large farm estates began to be managed or rented, and significant incomes began flowing into the Cistercian enterprises. Many houses even owned or controlled property in other countries. Unlike the Cluniacs, the Cistercians allowed each house and daughter to control its own finances directly. The drive toward self-sufficiency led the Cistercians to create independent industries at each monastery. Many chose sites near running water. They actually became known for their use of hydraulics. As a result there were numerous mills and waterwheels employed by the Cistercians. They sold items produced at the mills, and often would rent their grain mills to neighboring laity in order to facilitate the production of local food stuffs. As industrious as they were, and as prosperous as many of their houses became, one thing that can be said of the Cistercians is that they were adamant about charging fair prices for their products.

CISTERCIANS AND THE LITURGY. Cîteaux's second abbot, Alberic (1099–1108), sought to introduce a profound simplicity into the Cistercian liturgy. Benedictine choral chants of the daily offices were deemed too melodic. The second abbot, Stephen Harding (1108–1134), reformed the hymnal and antiphonaries by going back to the basics of the old Ambrosian hymns (of the fourth century) because they had been recommended by St. Benedict in the Rule. St. Bernard, abbot of Clairvaux from 1115 to 1153, sought to simplify melodies and eliminate repetitions in the chants, though some new texts and melodies were added to express devotion to the Blessed Virgin. The Cistercians chanted the entirety of their office (with the exception of the scriptural readings) in low, unembellished plainchant. Their offices contained only the very few psalms prescribed by the Rule of Benedict, so they spent much less time in the choir than many of their medieval counterparts. A twelfth-century Benedictine monk writing to Cistercians on behalf of Cluny once remarked that their prime alone (the office celebrating sunrise) was lengthier than the entire set of daily offices of the Cistercians. Fewer feast days were celebrated, and reception of communion by the monks was limited. Processions of any kind were prohibited. Cistercian liturgical directives of the General Chapter from the early twelfth to the thirteenth centuries echoed the sentiments of their foundational documents. The altar was to be completely unadorned, relics were not permitted in altars until 1185, and the use of

candles was extremely limited. The celebrant's vestments were not to be made of silk (except the stole and maniple) and all liturgical ornaments and vessels were to be made without silver, gold, or precious stones, except for the chalices for the wine and the fistula (a straw used to sip the wine), which could be gold or silver plated. There were no pictures or sculptures in the early worship spaces with the exception of painted wooden crosses. Window glass was to be plain, not stained or decorated. Genuflections (bending down on one knee) were discouraged and monks could not lie prostrate in prayer. In 1261 communion under both species (bread and wine) was suppressed for members of the community.

SOURCES

Constance Berman, *Cistercian Evolution* (Philadelphia, Pa.: University of Pennsylvania Press, 2000).

Bruno of Cologne, *Patrologia Latina*: 152, 421.

Giles Constable, *The Reformation of the Twelfth Century* (New York: Cambridge University Press, 1998).

Mary Jerome Finnegan, *The Women of Helfta, Scholars and Mystics* (Athens, Ga.: University of Georgia Press, 1999).

Jeffrey Hamburger, "The Visual and the Visionary: The Image in Late Medieval Monastic Devotions," *Viator* 20 (1989): 161–182.

Louis Lekai, *The Cistercians* (Kent, Ohio: Kent State University Press, 1977).

SEE ALSO *Architecture: Monastic Architecture*

WOMEN RELIGIOUS

MONASTIC WOMEN IN THE EARLY MIDDLE AGES.
It is interesting to note that a substantial amount of information from the early Middle Ages about women's religious houses was written by male clerics from the period. Throughout much of the Middle Ages many of the women dwelling in monastic communities lived lives not that much different from individuals in the male houses. In fact, there is not even a specific medieval Latin term for a female monastic house. The term "nunnery" only comes into use in the late medieval period and the term "convent" (*conventus*) could actually have applied to houses for both men and women. As early as the sixth and seventh centuries, a large number of noble female saints emerged from monastic houses in Merovingian territories, such as Gandersheim and Quedlinburg. They espoused a form of spirituality that put less emphasis on virginity and asceticism than on compassionate leadership, performance of miracles, and service (both charity and peacemaking) to the surrounding community. From the ninth through tenth centuries it appears there were very few women's monastic houses (likely fewer than forty in all of Europe) compared to the much larger numbers two centuries earlier. This is due in part to their destruction during the age of invasions and the reluctance to rebuild amid the insecurities of civil governments. Some of the early medieval convents and double houses (for both males and females) served as viable opportunities for women to devote themselves to spirituality during this period. Mixed houses in Germany, northern parts of Gaul, and Anglo-Saxon England were even run by abbesses instead of abbots.

RETREATS AND RENEWED OPPORTUNITIES.
During the tenth through mid-eleventh centuries, women in Europe lost some of their independence as the male-dominated church, which was putting more emphasis on celibacy, began to stress the moral and intellectual weakness of women. At this time, some of the nunneries began to function more or less as secure places for the retirement of widows and daughters of the nobility, who often had little vocation for the spiritual lifestyle. Such houses tended to be well endowed and frequently rather exclusive. The Canonesses at Farmontiers (France) and Essen (Germany) provided such comfortable living for eleventh-century women. While the number of nunneries declined throughout the tenth and early eleventh centuries, there were a few significant communities operating in Germany such as Herford, Gandersheim, and Quedlinburg. All of these houses received patronage from Matilda, the mother of Emperor Otto I. Women's houses in France and England began to rebound after 1000 with new or transplanted communities being established in Picardy, Arles, Nîmes, and Marseille. Between 1000 and 1080 some 36 convents were founded or restored in France and England. They were present in the French cities of Beauvais, Angers, Evreux, Angoulême, Rennes, LeMans, Rouen, Tours, and Verdun, as well as English centers such as Canterbury, Chatteris, Elstow or those attached to men's houses at Bury St. Edmunds, Ely, St. Albans, and Evesham. When double monasteries began to reappear in the eleventh-century reform movements, it was rather uncommon for abbesses to have any control over the male elements of the community. The female houses associated with the Cluny movement, while they did have claustral prioresses, were answerable to the priors of affiliated males houses who were under the authority of the abbot of Cluny. But, by the end of the eleventh century, there appears to have been a rapid proliferation of women's houses.

FEMALE ACHIEVEMENT. Early medieval Germanic communities often allowed females to occupy a higher position than their counterparts in other cultures or countries, which may be the reason why there were more independent houses for women in the Anglo-Saxon territories. That the middle twelfth century offered good examples of the heights to which women's religious life extended can be seen in the case of Hildegarde, the leader of the women's community at Bingen, just northwest of Mainz (1098–1179). Not only was she thought to be the spiritual equal to men of her day, but she left behind an immensely vivid body of literature that recounts the lives and thought of women within the cloister, along with their spiritual activities and the labors of their hands. Some of the twelfth-century mendicant orders of hermits had mixed houses associated with movements from places like Fontevrault (founded in 1101) and Prémontré (1115) in France. They attracted large numbers of women, and the fifteen Fontevrault communities all seemed to be female-centered, although they were clearly mixed houses; both the great patroness of courtly literature, Eleanor of Aquitaine, and her daughter, who ended her days as a nun, are buried there. At Prémontré the women occupied a less prominent place in the community, remaining strictly cloistered and tending to do much of the manual labor of the community. Double monasteries were also common in the Low Countries. Some of these double houses that felt it necessary to practice strict segregation gave way to allowing the nuns to run their own affairs and resulted in the eventual separation of these double communities when the women took up their own residences.

THE BÉGUINES. The appearance of the Béguines in the early 1200s had much to do with the growing sense of lay piety that had developed throughout the preceding century. In the beginning the movement was not very organized, but it seems that groups of urban lay women began to assemble together in parts of Germany and the Lowlands to attempt to live holy lives in a similar fashion. Many were inspired by the story of Marie d'Oignies, a Flemish noble and mystic who renounced her family's wealth and gained stature as a spiritual healer. Eventually some of these women sought to live together in community. The Béguines came from all walks of life and all social classes although the wealthier members tended to congregate together. Attitudes toward poverty varied. While many members rejected the wealth of their families and chose to live in deliberate austerity, the decision to embrace radical poverty or to retain possessions was individual. A few groups even formed their own little villages in areas that were near

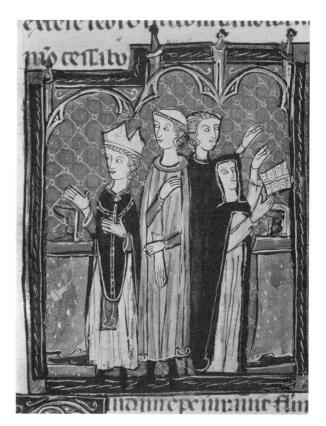

Nun saying vows, Decretals of Gratian, Laon, Bibliothèque Municipale MS 372 folio 59v, 13th century. THE ART ARCHIVE/ BIBLIOTHÈQUE MUNICIPALE, LAON/DAGLI ORTI.

large cities. They supported themselves with the labor of their own hands: many undertook weaving, sewing, and embroidery, although some groups resorted to begging. The Béguines took no formal vows but were committed to living in chastity. Some eventually left the communities and went on to marry, and many of the non-communal members continued their connection with the order though married. Their male counterparts were the Beghards, who commonly worked as weavers, fullers, or dyers. The Beghards did not own property and spent much of their time engaged in charity work or spiritual contemplation.

PATRONAGE AND PERSECUTION. The Beghards' and Béguines' lifestyles were ascetical, but they rejected the formalism of some of the other orders of their time. The Béguines often attended Mass and the daily offices at their local churches. Gradually these movements gained widespread acceptance from both church and secular authorities. Hundreds of houses sprang up throughout northern European towns. By the end of the thirteenth century, there were 54 houses in the city of Cologne alone. While noble families' or members' fortunes tended to support these groups, chapels like those

of la Vigne were given over to Béguine communities for their use. Eventually church legislation of the thirteenth century forced the Béguines to confine themselves strictly to communal activities similar to those being practiced by contemporary convents. This did not stop outspoken Béguines like Marguerite Porete, who reproached the weakness of a male-dominated church and its outward signs, which served as a crutch to aid religion. Her book *The Mirror of Simple Souls* received much criticism, but remained immensely popular, even without the attribution of her authorship. She was eventually accused of heresy and burned at the stake in 1310. As hostility towards the Béguines grew in the church hierarchy, the movement suffered persecution in Germany, but it fared better in France, where it had the protection of powerful patrons.

CISTERCIANS, FRANCISCANS, AND DOMINICANS. In the years that followed the ground-swell of lay initiatives, there are numerous accounts of women connected to the Cistercian, Franciscan, and Dominican movements, thus contributing significantly to the European monastic presence. Although the male Dominican movement that arose after 1217 was defined as an order of preachers (called friars), St. Dominic's first religious house, founded in 1207 at Prouille, was a convent established for former Cathar women (members of a heretical sect chiefly in southern France). Likewise, although St. Francis of Assisi's male order, based on the ideal of complete poverty, sent friars on preaching missions throughout the world, his conversion of a wealthy young woman named Clare led to the founding of a female order (later known as the Poor Clares) that required a strictly enclosed life of asceticism, fasting, and perpetual silence. By 1223 there was already significant opposition throughout the Dominican Order in regard to the admission of more nuns. Maintaining convents would require ordained resident Dominican men who would say Mass and serve as confessors. Some felt such duties compromised the early mission and ideal of the friar ministry. The Dominican General Chapter of 1228 discouraged the admission of additional convents. The Cistercians also came to a similar conclusion at their General Chapter the very same year. But after 1245, papal legislation allowed for the multiplication of Dominican convents, particularly in Germany. The Dominican nuns, quite unlike the friars, could not leave their convents to beg or minister. Instead, they remained strictly cloistered, encouraged to develop interior lives of humility, poverty, and simple spirituality. Male Dominicans had no idea how popular this movement would become for medieval women, as some 150 Dominican convents were organized by 1300. The Cistercians experienced much greater growth with some 900 houses claiming to be Cistercian or Cistercian affiliates founded by 1325. Within less than a hundred years, however, the number of registered Cistercian convents dropped to somewhere around 211.

SOURCES

Caroline Walker Bynum, *Jesus as Mother: Studies in the Spirituality of the High Middle Ages* (Berkeley: University of California Press, 1982).

Peter Dronke, *Women Writers of the Middle Ages* (Cambridge, England: Cambridge University Press, 1984).

Jeffrey Hamburger, "The Use of Images in the Pastoral Care of Nuns: The Case of Heinrich Suso and the Dominicans," *Art Bulletin* 71 (1989): 20–46.

Margaret Wade Labarge, *A Small Sound of the Trumpet* (Boston, Mass.: Beacon Press, 1986).

J. A. Nichols and L. T. Shand, eds., *Distant Echoes; Medieval Religious Women.* Vol. I (Kalamazoo, Mich.: Medieval Institute, 1984).

Walter Simons, *Cities of Ladies: Béguine Communities in the Medieval Low Countries* (Philadelphia, Pa.: University of Pennsylvania Press, 2001).

Bruce Venarde, *Women's Monasticism and Medieval Society* (Ithaca, N.Y.: Cornell University Press, 1997).

Ulrike Wiethaus, "Religious Experience of Women," in *Medieval France: An Encylopedia.* Ed. William W. Kibler and Grover A. Zinn (New York: Garland, 1995).

MEDIEVAL EDUCATION AND THE ROLE OF THE CHURCH

THE RISE OF EDUCATION. During the twelfth and thirteenth centuries, the many social and economic changes which came about in European society helped create an increased interest in education. Burgeoning bureaucratization within both civil and church administration created the need for educated men with abilities in the area of law (both canon and civil). The universities also began to teach medicine. In cities like Bologna, the study of rhetoric and Roman law was useful for both canonists and those who drafted legal documents in secular society. Such a school or *studium* during the twelfth century drew such people as the great medieval canon lawyer Gratian, Thomas Becket, and Pope Innocent III. It was at this time, also, that the universities slowly began to separate themselves from the firm control of the church. However, as late as 1200, the majority of students were still ecclesiastics. For example, at Bologna, no one could be made a medical doctor without permission of the archdeacon.

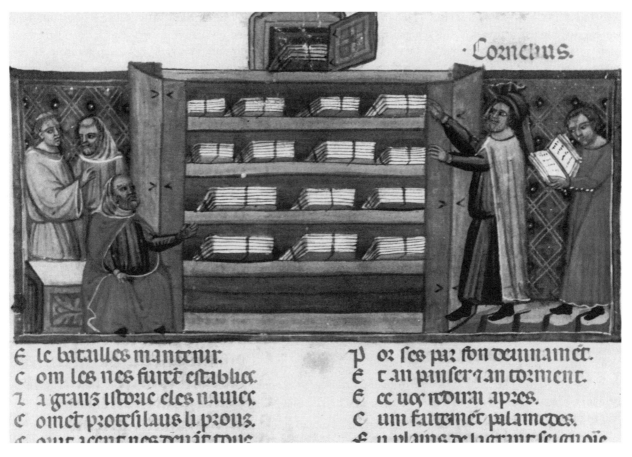

· Corncbus ·

E le batailles manttenir.
C om les nes furet establics.
Z a grans istoric eles nauces.
C omet protesilaus li proux.

P oz ses par son deminameet.
E t an pinser an torment.
E ce nos reduran apres.
C um fautonet palameoes.

Monks using a monastic library from a 14th-century French MS. THE GRANGER COLLECTION.

Monastic and Cathedral Schools. Prior to the age of the studium or of university scholars (through the mid-eleventh century), monastic schools had been the most stable force in education. Although the boys who were sent there were children of the nobility who may or may not have had an interest in clerical life, much of the schools' curriculum focused on teaching them to read and write Latin, and preparing them to join the ranks of the church. Monastic lives of prayer, silence, labor, and meditation were not, of course, always conducive to the free exchange of thought. However, these monasteries did become great repositories of knowledge, in that many of the books of the day (particularly religious texts) were copied by hand in monastic *scriptoria* and stored in their libraries, as shown in an illustration of monks using a monastic library from a French manuscript of the fourteenth century. On the secular side, some women, as well as young men of privilege, were instructed at court, learning to read and write Latin; but their education was rarely broad or extensive. Between 1050 and 1200 the cathedral schools (or bishop's schools) assumed the leading role in education. Bishops had traditionally been entrusted with providing for the education of the secular clergy. Cathedral schools were often staffed by clerics who lived as canons, residing on the grounds of the bishop's estate or in the town nearby. These schools were rather flexible in their structure and invited learned men or "masters" to come and lecture to their students. The effectiveness of the system, however, was somewhat variable since the school's reputation depended on a single master and often, when he was gone, did not survive him. Thus, both masters and students traveled from cathedral town to cathedral town looking for the best environments in which to teach and learn. Eventually the cathedral schools insisted that the masters possess formal licenses to teach, which were issued by the chancellors (*licentia docendi*). These are actually the pre-cursors of modern academic degrees. Anyone attending a cathedral school at this time took minor church orders and held status as a cleric. This status gave them immunity from civil courts—that is, they were under the jurisdiction of canon (church) law and ecclesiastical courts, which usually gave milder sentences for serious crimes. This distinction in legal status applied also to the new universities and was at times a source of conflict between "town and gown."

THE BIRTH OF UNIVERSITIES. As the number of traveling students increased, some schools tried a new plan of keeping students in one place by engaging multiple masters, who then separated from the cathedral schools and took up residence in other parts of major cities. These new teachers were paid directly by the students, so, in effect, the least popular instructors often found themselves out of work. This competitive climate of intellectual revival brought about the appearance of the great universities in the 1200s and 1300s. To protect their interests, the students and scholars began to form guilds, from which the university structure eventually grew (*universitas* was a Latin word for corporation). The universities literally became independent legal entities. Masters in Paris received a royal charter around 1200 for their university. Some of the finest churchmen and independent clerical scholars came to Paris to teach. Originally they rented out halls for their classes on the left bank of the Seine River, which soon became known as the Latin Quarter because Latin was the language of learning. The guild received approval from Rome in 1231 and soon became a model for other European universities, although some cities, such as Oxford and Cambridge in England as well as Salerno and Reggio in Italy, had begun university-style systems of education even earlier, during the twelfth century. While these universities were growing in secular influence, they also became the place where religious orders like the friars sent their most talented brethren to teach and study. The curriculum was comprised of the *Trivium* (grammar, rhetoric, logic) and *Quadrivium* (arithmetic, astronomy, geometry, and music). There was master's level work offered at these universities in law, medicine, and theology, which took five to seven years to complete. Theology students had to be thirty years of age before they could undertake the degree. However, education which was once geared exclusively toward the clergy (although this is not completely true of the Italian schools) had now become much more liberal and was certainly not just for clerics. Most students were from the upper and lower nobility, some sons of knights, although offspring of the merchant class soon began to break into their ranks. The founding of hundreds of European universities continued through the thirteenth, fourteenth, and early fifteenth centuries. Over time, fewer than half of the students in these institutions were seeking education related to the service of the church. The advent of humanism saw a greater variety of other disciplines added to the curriculum.

SCHOLASTIC INQUIRY IN THE MEDIEVAL UNIVERSITY. While, strictly speaking, scholasticism was the intellectual tradition of logical inquiry practiced in medieval schools, it has come to be understood as the attempt to use techniques of Aristotelian logical inquiry to link Christian revelation, church doctrine, and the mysteries of the natural universe in a deeper and more reasonable understanding of the Christian life. While the theoretical basis for scholasticism was introduced in the late Roman period by early philosopher-theologians like St. Augustine and Boethius, in the medieval period it appears in the ninth century in the work of John Scotus Eriugena who made the important distinction between reason and the revelation of sacred scripture. The scholastics drew upon the logical analysis of the Greek philosopher Aristotle, establishing a common method of inquiry by posing a question, following lines of thought presented by earlier authoritative scholars, and attempting to reason their way to a logical conclusion. Early scholastic problems dealt with attempts to explain the notion of Christ's presence in the Eucharist. A debate between the theologian Berengar of Tours (998–1088) and the Benedictine Lanfranc of Bec (1010–1089) during the mid-eleventh century resulted in the development of the doctrine of transubstantiation (conversion of the substance of the bread and wine into the body and blood of Christ, with appearances of bread and wine remaining). Anselm of Canterbury (1033–1109), a pupil of Lanfranc, employed a dialectical method (a form of debate marked by the dynamic of inner tension, conflict, and interconnectedness), and began to examine necessary truths of the Divine mysteries, attempting to postulate them in a logical argument. Anselm's famous proofs for the existence of God, while subsequently refuted, formed the departure point for problems of scholastic theological inquiry that preoccupied scholars for the rest of the Middle Ages.

THE HEIGHT OF SCHOLASTICISM. Around the middle of the thirteenth century, the scholastic tradition reached its peak with the work of Albertus Magnus (1200–1280), St. Thomas Aquinas (1225–1274), and St. Bonaventure (1215–1274). The establishment of the universities with their faculties of theology contributed greatly to the development of this scholarship, as did the promulgation of Aristotle's concept that all human thought originates with the senses. Western interest in Aristotle and other classical texts was revived in part due to contact with Eastern Christian and Muslim ideas during the time of the Crusades. European scholars eagerly began to translate Greek and Arabic works into Latin. Patristics (works of the early church fathers), classical philosophy (some of which included commentary by Muslim philosophers such as Avicenna and Averroës), and Jewish thought (such as that represented by Moses Maimonides) became sources of new learning in Western Europe. Most scholastic argumentation was driven

by the Aristotelian questions (sometimes described as the Four Causes) regarding the nature of things in the universe: What are these things made of? What shape do they take? How do they come to be? What were their purposes? The use of categories and the notion of causality led to attempts to place the existence of God and the mysteries of creation philosophically within the limits of human understanding.

SOURCES

A. B. Cobban, *Medieval Universities* (London: Methuen, 1975).

Hilde de Ridder-Symoens, ed., *A History of the University in Europe*. Vol. I (Cambridge, England: Cambridge University Press, 1992).

Armand Maurer, *Medieval Philosophy* (Toronto: Pontifical Institute of Medieval Studies, 1982).

R. W. Southern, *Scholastic Humanism and the Unification of Europe* (Oxford: Blackwell, 1995).

SEE ALSO *Philosophy: The Universities, Textbooks, and the Flowering of Scholasticism*

SECULAR CLERGY: REFORM AND REACTION

SIMPLICITY AND CELIBACY. The eleventh-century clerical reforms directed by the papacy called for a new discipline among secular priests. Proponents of reform stressed simplicity of lifestyle and singular dedication (including celibacy), as well as the need to break ties with secular interests and worldliness. The two most troublesome issues involving corruptions of the priesthood at this time were those related to simony (the buying or selling of church office) and clerical marriage. The momentum of reform also ushered in a rise in the number of individuals seeking the monastic life at places like Cluny. The character of priesthood was also an issue, but more importantly the social distinctions between the powers of the church and the laity were being clarified during this time. Pope Nicholas II's legislation of 1059 reflects Rome's awareness of the acute need for clerical reform at the most basic level. It is also a reminder of the growing power of organized religion and its competition with the laity for control of society.

EDUCATION AND RESTRAINTS ON PERSONAL BEHAVIOR. The need for more systematic clerical reform was the agenda of twelfth-century bishops. They were charged with personally controlling the quality of candidates for the priesthood as well as their instruction. Education of the clergy was a major issue since many

clerics in the more rural areas often had not received a thorough theological or scriptural orientation. The Third Lateran Council of 1179 decreed that each cathedral should have a master for the instruction of grammar and each major city a master of theology. They assisted the priests in their understanding of the scriptures and the nature of the sacraments. These teachers also ensured that the clergy not only had training in the implementation of ritual, but also knew something about the proper care of souls. An educated clergy also needed to combat the erroneous teachings of self-styled wandering preachers and zealots, who themselves quite often lacked formal religious education. At this time, control over localized preaching was a problem not only for local priests but bishops as well. Parochial jurisdictions seemed to be an important but often criticized aspect of clerical life. With the advent of the Crusades, the issue of whether or not clerics could bear arms or participate in an excursion of holy war came to public attention as well. Other behavioral issues, including excessive immoral public displays, such as drinking or concubinage, were also addressed by the councils. The more extreme monastic reform movements like Cistercians and Carthusians served as a gentle reminder that the secular clergy were certainly not living the most ideal or perfect Christian lives.

AWARENESS OF INSTITUTIONAL PROBLEMS. The thirteenth-century reforms of the secular clergy were spurred by the realization that the church in its domination of European culture had become more institutional than spiritual. The 1215 *Magna Carta*, an English document laying out the rights of free men, even included provisions for relief of the institutional church by the crown. Despite the power amassed by the church, however, it was the increasingly frequent development of lay spiritual movements and the establishment of four new mendicant orders that finally delivered the wake-up call to the hierarchy, who were inundated with requests for confirmation of new religious lifestyles. Canon 16, decreed by the Fourth Lateran Council, sheds some light on the problems of the day:

> Clerics shall not hold secular office nor indulge in commerce, especially unseemly commerce. They shall not attend performances of mimes, jesters or plays and shall avoid taverns except only out of necessity while traveling. Nor shall they play with dice; they should not even be present at such games. They should wear the clerical tonsure and be zealous in the performance of their divine offices and in other responsibilities. Moreover, they shall wear their garments clasped and neither too short nor too long. And they shall eschew bright colors such

a PRIMARY SOURCE *document*

CLERICAL REFORM: THE LEGISLATION OF 1059

INTRODUCTION: Pope Nicholas II (1058–1061) was a leading figure in the eleventh-century drive toward clerical reform. He was significantly influenced by fellow reformers such as Humbert of Silva Candida, Peter Damian, and Hildebrand (later to become Gregory VII). At this time the church was rife with corruption. Particular concerns surrounded the inappropriate elevation of the hierarchy and the practice of simony as many unqualified candidates found their way into ecclesiastical office.

Since we must be diligently solicitous for all men with the vigilance that pertains to our universal rule, taking heed for your salvation, we are carefully sending to you the decrees that were canonically enacted in a synod recently held at Rome in the presence of one hundred and thirteen bishops and, despite our unworthiness, under our presidency; for we desire that you give effect to them for your salvation, and by apostolic authority we command this.

1. Firstly it was enacted in the sight of God that the election of the Roman pontiff should be in the power of the cardinal bishops, so that anyone who is enthroned without their previous agreement and canonical election and without the subsequent consent of the other orders of clergy and of the people shall not be held for a pope and an apostle, but rather for an apostate.

2. That when the bishop of Rome or of any city dies no one shall dare to plunder their possessions, but these shall be preserved intact for their successors.

3. That no one shall hear the mass of a priest who, he knows for certain, keeps a concubine or has a woman living with him. ...

4. And we firmly decree that those of the above-mentioned orders who, in obedience to our predecessors, have remained chaste, shall sleep and eat together near the church to which they have been ordained as is fitting for pious clergy and that they shall hold in common whatever revenues come to them from the church, and we urge them especially that they strive to attain the apostolic way of life, which is a life in common.

5. Further, that tenths and first fruits and gifts of living or dead persons be faithfully handed over to the church by lay folk and that they be at the disposal of the bishop. Any who keep them back are cut off from the communion of holy church.

6. That no cleric or priest shall receive a church from laymen in any fashion, whether freely or at a price.

7. That no one shall receive the habit of a monk in the hope or with the promise of becoming an abbot.

8. Nor shall any priest hold two churches at the same time.

9. That no one shall be ordained or promoted to any ecclesiastical office by simoniacal heresy. ...

SOURCE: Pope Nicholas II, "The Legislation of 1059," in *The Crisis of Church and State 1050–1300*. Ed. and Trans. Brian Tierney (Toronto: University of Toronto Press, 1988): 43–44.

as red and green as well as ornamentation on their gloves and shoes. [Canon 16]

Another passage (Canon 17) suggests that even within the cloister, behavior was often inappropriate:

We regret that not only some clerics in minor orders but also some of the prelates of churches spend half of the night eating and talking, not to mention other things that they are doing, and get to sleep so late that they are scarcely wakened by the birds singing and they mumble their way hurriedly through morning prayers. There are some clerics who celebrate Mass only four times a year, what is worse, they disdain even attending Mass. And, if they happen to be present at Mass, they flee the silence of the choir to go outside to talk with laymen, preferring things frivolous to things divine. These and similar practices we totally forbid under penalty of suspension.

After the Fourth Lateran Council, the clergy were prohibited from having anything to do with the spilling of blood, including service as a soldier or a physician. Priests were not allowed to hunt or participate in fowling. The giving of a benefice (an ecclesiastical office to which an endowment is attached) to any unworthy cleric was also deemed an offense. In the late thirteenth century, the English bishop Robert Grosseteste wrote the *Templum Dei* (the Temple of God), a simple and clear guide for the performance of clerical duties including the distinctions among particular vices and virtues. Around the same time in France, Bishop William Durandus put together a work outlining priestly functions and the teaching mission of clergy.

UNCLOISTERED RELIGIOUS LIFE. An important outgrowth of the lay religious movements of the twelfth century was the notion of living an apostolic life outside

THE
Battle over Magna Carta

The significance of the thirteenth-century English document called *Magna Carta* (the Great Charter) is often thought of not in relation to religion, but in terms of its influence upon the evolving notion of constitutional liberties. King John of England (1199–1216) was forced to admit that, even as king and lord, he had certain contractual obligations to individuals at many levels of society. On 15 June 1215 at Runnymede, under mounting pressure from the barons of England (led by Stephen Langton, the archbishop of Canterbury), King John set his seal to the document, consenting to certain rights and freedoms for the church, as well as his barons, and granting relief from unjust legal, financial and tax-based statutes for subjects of the crown. Magna Carta's provisions for trials by jury, consent to taxation by common council, fishing and hunting rights, the imposition of an aristocratic king's council, and adjustments to standard legal procedures created precedent for a more participatory government and set the stage for the necessary developments of a representative parliamentary process. Over the centuries, the precedent and spirit resulting from these events would continually remind the English people that even the king, like those over whom he ruled, should be subject to the law. Rather than being just a single document, Magna Carta actually went through several drafts and a period of negotiation, and its implementation led to further developments of parliamentary and constitutional governance in England. These events then influenced other European constitutional monarchies, but most significantly fostered the representative, constitutional, and republican ideals that gave birth to the government of the United States.

What is most interesting is the role played by the Roman Church in the whole chain of events. Some of this had to do with the tenuous nature of John's power in England. A rift between King John and Pope Innocent III (1198–1216) went back to the disputed election of the archbishop of Canterbury in 1205. Despite English clerical opposition, John had favored his secretary, the bishop of Norwich, for elevation to the vacant post and forced the clergy to elect his candidate. Innocent, however, invalidated the election and persuaded the Canterbury clerics to support Stephen Langton, an English scholar who was teaching university students at the time in Paris. (Tradition has suggested that Innocent and Stephen were friends while studying together at the University of Paris.) Despite the pope's consecration of Stephen as Canterbury's archbishop, King John would not allow Stephen to occupy that important ecclesiastical office. Langton remained in France for some six years until the pope forced John's hand in 1208 by excommunicating him and placing the entire English kingdom under interdict. John's response was an abusive taxation of church property, to which Innocent responded by authorizing the French king, Phillip Augustus, to depose John by force and take over England. John was eventually compelled to submit to the papacy and Stephen was placed in power. In addition, the kingdoms of England and Ireland were made subject to the papacy, and King John was only allowed to rule them as a vassal of Rome. This formal relationship of vassalage between England and the papacy continued for the next hundred years. (Events such as this leave little doubt as to why animosity persisted between the English monarchs and the papacy.)

Once at Canterbury, Langton quickly took the side of the barons in attempting to lessen the king's domination of the English people. It is quite clear that Stephen Langton, as archbishop, assisted the nobles in the drafting of Magna Carta, which included provisions to guard against excessive taxation of the church, even though this issue had been resolved long before the drafting of the document. In spite of this, Pope Innocent III, now symbolically entrusted with the care of England, was not in favor of many of the elements in the great charter. He particularly did not agree with the provisions in the document concerning the liberties of the barons. Powerful dukes and princes in Italy had caused much trouble for the church. In August of 1215, Innocent annulled Magna Carta. Some scholars have argued that the pope found the document too politically liberal. Others suggest that Innocent felt he needed John on his side in the implementation of the directives from the Fourth Lateran Council. Innocent called the king's "forced" concessions to the nobles which were set forth in the charter unjust, degrading, shameful and illegal. In fact, Langton was soon removed from his episcopal office by the pontiff. What is interesting to note is that this was a case in which the pope felt he not only had the authority to manipulate the running of a kingdom, but also the power to invalidate a secular legal document. After both Innocent and John died in 1216, Magna Carta was reissued, and Stephen Langton was eventually re-appointed as archbishop of Canterbury.

the cloister. The practices of preaching, teaching, ministry, and living in simplicity or poverty, as well as performing charitable work, became focal points for some of the more socially oriented religious movements of the 1100s. One of the reasons behind such reform was the feeling that these were the very apostolic activities that

were somehow being neglected by the secular clergy. However, some of the lay spiritual movements that developed over the next several centuries, such as the Waldensians, Humiliati, Béguines, and Beghards, came under criticism from Rome or were even accused of heresy. Regardless, the laity throughout medieval Europe began to listen to these reforming voices for inspiration in their own spiritual lives. It was believed by many members of the church establishment that such loosely organized movements lacked the order, direction, and type of training or education necessary to carry out the orthodox mission of the church in a responsible way.

THE ORIGINS OF THE FRIARS. As interest in religious reform increased, the growing urban cultures were giving rise to greater commerce, more mobile populations, an increase in education, and a broader distribution of wealth. With this rising prosperity came sophistication, greed, skepticism, and a growing distrust of wealthy and powerful religious institutions. An outgrowth of this skepticism was the development within the church itself of a new form of religious life emphasizing a combination of poverty and preaching. The friars, as they came to be known, proved to be an answer to some of the tensions being experienced both within institutional Christianity and outside it. On the one hand, the friars belonged to organized and papally sanctioned orders, yet on the other, they were not obligated to the Benedictine vow of cloistered stability. The two major movements of friars, the Dominicans and the Franciscans, were substantially different, both in their origin and character. The Dominicans evolved from canons regular (clergymen belonging to a cathedral or collegiate church) while the Franciscans were more akin to the simple lay spiritual movements. Once established and accepted by Rome, these friars were free to minister to the poor as well as preach, teach, and counter the spread of heretical ideas, all within the authority of the institutional church. With the benefit of theological education, the sanctioned orthodox preaching of the Dominicans was quite befitting of their name, Order of Preachers (O.P.).

SERMONS. The friars targeted urban areas in their ministry, supporting themselves by begging in communities along the major European trade routes. In these cities, where medieval commerce was thriving, there were large numbers of people with a certain amount of disposable income. Members of this rising merchant class needed direct and practical spiritual guidance, and they were open to hearing the messages of educated preachers. The preaching of homilies by secular clergy at Mass in both local churches and cathedrals had all but disap-

peared by this time. Among the Dominicans and Franciscans, however, the sermon became an art form. Manuals for preaching such as *The Instruction of Preachers* by the Dominican Humbert of Romans or *The Art of Preaching* by Thomas Waleys became important tools for evangelization. *Exempla* (moralizing anecdotes drawn from the lives of saints, animal fables, or wise sayings about everyday life) were used as effective aids in the delivery of clever sermons, while biblical concordances (books where all the key words in the Bible are arranged so that they might be referenced or cross-referenced) helped bolster the preacher's arsenal of effective speech. The message the friars brought to the laity incorporated a theology that was reasonable, optimistic, human, accommodating, and directed toward living a fruitful life in this world. These qualities made the laity more willing to confess their sins to the friars. In fact, Dominican convents gave their brothers regular instruction in the theology of penance.

SOURCES

Leonard Boyle, *Pastoral Care, Clerical Education and Canon Law 1200–1400* (London: Variorum Reprints, 1981).

J. H. Burns, ed., *Cambridge History of Medieval Political Thought* (Cambridge, England: Cambridge University Press, 1991).

Gerhardt Ladner, *The Idea of Reform* (Cambridge, Mass.: Harvard University Press, 1959).

F. Donald Logan, *A History of the Church in the Middle Ages* (New York: Routledge, 2002): 196.

Kenneth Pennington, *Popes and Bishops: The Papal Monarchy in the Twelfth and Thirteenth Centuries* (Philadelphia, Pa.: University of Pennsylvania Press, 1984).

Norman Tanner, ed., *Decrees of the Ecumenical Councils* (Washington D.C.: Georgetown University Press, 1990).

Brian Tierney, *The Crisis of Church and State* (Toronto: University of Toronto Press, 1988).

MEDIEVAL HERESY

DEFINING LIMITS. While the twelfth century was a great period of religious reform and revitalization, there were also harsh caveats that came from Rome regarding unworthy priests, schismatic groups, and, in their opinion, wrong-thinking leaders of movements. The same climate that fostered reform was also a breeding ground for ideas not in keeping with the basic doctrines of Christianity. It was actually Rome who decided which groups had gone too far. But they almost always allowed opportunities of forgiveness for the wayward to come back

to the fold. This made the heresies more a matter of disobedience, failure to accept correction, and open rejection of the church's official position than the adherence to a belief which brought with it permanent condemnation. The early heretics in Western Europe were not always theologians; rather, they were sometimes merely simple people who condemned worldliness and hierarchical church institutions in favor of evangelical simplicity. Rejection of institutional marriage, emphasis on chastity, disputing the authority of the Old Testament, questioning some of the sacraments, and, above all, denial of the Trinity were elements of the twelfth-century movements that were soon branded heretical in the West. Preachers like Tanchelm in the Low Countries, Henry of Lausanne in the south of France, Peter of Bruys in the Rhône Valley, Eudo in Brittany, and Arnold of Brescia in Rome were all accused of initiating popular heretical movements.

BOGOMILS. While the most actively persecuted group in the Western Christendom was the Cathars, a number of historians have attempted to trace their roots to a much earlier medieval heresy practiced by the Bogomils in the east. Bogomil was a tenth-century preacher in Macedonia who taught a life of prayer, penitence, wandering, and simplicity of worship. He rejected sacraments, church feasts, icons, liturgy, vestments, and veneration of the cross. His basic message was quasi-dualist in nature: he claimed the world was evil because it had been created by the Devil, the eldest son of God. Christ was seen as the youngest son of God who came to earth to redeem, but never fully became human. Bogomil and his followers saw the Devil as inferior to God (which actually makes for a sort of "uneven" dualism). The Bogomils espoused complete renunciation of the world. Consumption of meat and wine was forbidden, marriage was discouraged, and obedience to church hierarchy was seen as having no validity. Their scriptural focus was on the New Testament. For a time the group seemed to gain favor at the court of Constantinople. In this cosmopolitan Byzantine environment, Bogomilism was transformed into a more philosophical movement, even an academic religion. It appealed to the upper classes in the Byzantine Empire, and evolved from its former roots as a religion of the peasantry, deeply connected to New Testament ethics. After Bulgaria's conquest of parts of the Byzantine Empire in 1018, the Bogomils retreated into a more monastic existence, while persecutions in 1110 and 1143 at Constantinople forced them to move to Dalmatia and Bosnia. In later years, their worship became more ritualized. They baptized by laying hands on converts and holding the Gospel of John over their heads. In Bosnia and the Bulgarian Empire, Bogomilism became the state religion after 1218. The Bogomils sent missionaries to Western Europe, and it is likely that by the middle of the twelfth century they were active in Germany and the Rhineland. Such dualist ideas—that is, beliefs emphasizing opposing elements, such as good and evil—were also carried by merchants and pilgrims who had come into contact with the Bogomils and other forms of dualism in the east.

CATHARS. It was out of the religious fervor of the mid-twelfth century that the Cathar movement came to light. It was reported to be present at Cologne as early as 1143 when Everwin of Steinfeld wrote to Bernard of Clairvaux about the practice. Soon after, it had quickly spread into Flanders. Cathar disdain for the corruption of the medieval clergy bred in them a desire to purify the church (thus the term *katharos*, meaning "pure"). They believed that the material world was impure and that the soul must strive to free itself from the evils of this existence. The Cathars were vegetarians; they fasted regularly, avoided sexual activity, and rejected material possessions. Like the Bogomils, they regarded Jesus not as God, but as more of a super-angelic being who came to lead people on the right path. They rejected the notion of the bodily resurrection of Jesus and suggested that true redemption comes from the teaching of Christ, not his redemptive act. Affirming a philosophy similar to that of the Docetists in early Christianity, Cathars questioned the actual physical sufferings of Christ, seeing them as apparent rather than real. The more serious adherents and leaders of the movement were known as *Perfects*. Their lives were basically ascetical in nature. In 1167, during a Cathar council at St. Felix de Caraman, a missionary named Nicetas pushed for a more absolute dualist position concerning the nature of the world. Most dualists in the Languedoc (southern) region of France began to follow his directive. Similar to the Bogomils, they believed that the earth was created and controlled by Satan. Human spirits, which are heavenly and connected to God, have been trapped in bodies created by Satan. The greatest of sins, the original sin, was that of procreation, which Adam and Eve began and which has generationally continued to entrap the good spirits that have fallen from heaven. Salvation can only come from *consolamentum*, which is the path of moral standards that all Perfects have begun, creating a dialogue of forgiveness from sin and restoration to relationship with God the Father. Baptism seems to have been a major step on one's way to perfection. It was at baptism that the Cathari entered into the state of consolamentum. Like the Bogomils, they employed the Gospel of John and laying on of hands in the ceremony. This was a baptism of Spirit, not of water. As such, John the Baptist was not seen as a saint.

CATHAR BELIEFS AND INFLUENCE. Both men and women were equally able to embrace the level of Perfect and thus engage in communal leadership. This notion seems to have been particularly appealing to many spiritually inclined women from the noble families of Languedoc, though they were not allowed to become bishops. The Cathars had a significant following of *credentes* (or believers) who supported the work of the Perfects and hoped that they too might be committed enough to accept baptism. The credentes were allowed to remain married, own property, eat meat, and even participate in the Roman church in the hopes that their conversion might someday be full. Cathars believed that the souls of those who died in an unconsoled state would be reincarnated and allowed to make further progress along the road to freedom from their sinful flesh. Someday, once purified, they could finally return to the heaven from which they had originally come. Cathars made their way into northern Italy between 1150 and 1160 as their numbers grew rapidly. They were given many names in Europe. One such group was called the Albigenses after the town of Albi in the southern part of France where the first Cathar bishopric was established. Often welcomed into the courts of the nobility, Cathar preachers on the streets attracted listeners and even had public debates with Catholic bishops as well as with the Waldensians. They organized their own church with its own clergy, liturgy, and doctrine. By 1190 Italian Cathars had split into six churches. In Languedoc some of the nobility embraced the Cathar heresy in order to overthrow powerful local Catholic bishops. At its height there were eleven Cathar bishoprics, six of which were in France, with the remainder in Italy. All of the bishops were seen as equals.

WALDENSIANS. Another popular movement of the time were the Waldensians or Poor of Lyon. They insisted upon living lives of poverty, reading the Gospels in the vernacular (language of the people), and encouraging lay people to preach. The group was founded in 1170 by Peter Waldo, a wealthy merchant who, after a powerful conversion experience, began giving away his possessions to the poor. Interest in the movement was fueled by a famine that struck the city of Lyon in 1176, creating a tremendous inequity in the distribution of resources. After expending a good deal of his personal assets on good works during the famine, Waldo adopted a mendicant lifestyle and went about the countryside preaching. The Waldensians had little tolerance for the kind of clerical corruption Waldo had witnessed at the church of Lyon, which was very powerful and strongly tied to the aristocracy. Waldo had reluctantly been granted approval from Pope Alexander III to form a

community based upon a lifestyle of poverty, but he was not given permission to preach. This may have had something to do with the fact that Waldo was not formally educated and had learned the Bible by committing parts of it to memory as it was translated to him in the vernacular. In 1184 the teachings of Peter and the Waldensians were condemned as heresy, and members were forced to stop preaching and leave the city of Lyon. Many of the group's members chose to capitulate. After a series of condemnations and reprimands, Waldo and his followers moved into Italy and the southern part of France. There they began attracting attention by preaching anti-clericalism, stirring up reaction against secular authority, and performing the sacraments without authorization. The movement later split between French and Italian groups, perhaps because they did not have a clearly defined theology. The Italian movement went so far as to condemn the sacraments that were dispensed by unworthy priests. Subgroups of the Waldensian movement, such as the Poor Lombards, eventually merged with the late twelfth-century Humiliati. A number of thirteenth-century Waldensians, including leaders like Durand of Huesca and Bernard Prim, were brought back into the church. Underground contingents continued to survive through the seventeenth century, when they eventually joined groups of Protestant reformers.

POLITICS AND INQUISITION. In 1184 Pope Lucius III issued the bull *Ad Abolendam* which prescribed penalties for heretical activity and condemned such groups as the Cathars, Patarines, Humiliati, Poor of Lyon, Arnoldents, and Josepheni. A system of inquisition led by the bishops was soon developed. In order to combat the spread of Cathar teaching, a number of religious orders were employed. At first, in the early part of the thirteenth century, the Cistercians attempted to convince the Cathars of their error. The Dominicans (Order of Preachers) were in part born out of a second wave of the missionary work to the Cathars. In 1209 the Albigensian Crusade, which lasted for some twenty years, began to be carried out with tremendous cruelty. It may have been spurred by the murder of a papal legate, Peter of Castelnau, in 1208. As a result, the papacy increasingly pressured the counts of southern France to help put an end to local heresies. Uncooperative nobles (such as Raymond, the count of Toulouse) found themselves at odds with Rome. Caught up in the military campaigns to root out the Cathars during this period was Peter, the king of Aragon. Not a Cathar himself, he chose to fight against the Albigensian crusade forces and to use the conflict in southern France to gain greater control of the region. Peter was soundly defeated and killed at the battle of Muret in 1213 by outnumbered crusader forces under Captain

Simon de Montfort. The crusade continued for a couple of decades as military force seemed more effective than counter-preaching at keeping the movement from growing. In 1233 Gregory IX launched an inquisition that was responsible for torturing, imprisoning, and burning at the stake thousands of unrepentant Cathars. The extermination of the Cathars came to an end after 1243 with the capture of the fortress at Montsegur.

SOURCES

Malcolm D. Lambert, *Medieval Heresy: Popular Movements from the Gregorian Reform to the Reformation* (Oxford and Malden, Mass.: Blackwell, 2002).

Lester K. Little, *Religious Poverty and the Profit Economy in Medieval Europe* (Ithaca, N.Y.: Cornell University Press, 1983).

R. I. Moore, *Origins of European Dissent* (New York: Basil Blackwell, 1985).

FRIARS

PREACHING AMONG HERETICS. The Dominican Order of Friars was founded by an Augustinian canon named Domingo (Dominic) de Guzman from the cathedral at Osma in Spain. Dominic left his duties at the cathedral when he developed an interest in doing missionary preaching among the heretical Cathars in Languedoc. During 1203, while traveling through Toulouse in the southeastern part of France with his companion Diego Acevedo, the bishop of Osma, Dominic first encountered the Cathars. Upon their return, the two clerics petitioned Rome for a commission to preach. It was Diego's idea that conversion might be accomplished by competing with the Cathar Perfects, living an austere apostolic life of self-denial with no concern for material goods. Depending upon others for their daily bread, they were able to move about the countryside freely, preaching and interacting with the Cathars. This plan met with some success. In 1207, Dominic and Diego established a nunnery for converted Cathar women at Prouille. During that year, Diego died and it was left up to Dominic to carry on the mission. With the help of Peter Seila, a wealthy benefactor from Toulouse, houses were donated for the work, and Dominic was given charge of a group of diocesan preachers to address the Cathar heresy. Dominic and his ministers went on foot to preach the word of God in evangelical poverty, living according to the Augustinian Rule and the usages of Prémontré. The preachers recited divine offices, had a daily chapter of faults (a community meeting to confess their failings or have their im-

perfections pointed out), and followed the penitential directives of the Premonstratensians. In 1217 Pope Honorius gave official confirmation to the Order of Friars Preachers (*fratres praedicatores*), a name suggested by Honorius himself, but around the time of Dominic's death, the order began to be referred to more affectionately as the Dominicans. Later that year, preaching associates were sent to Paris, Bologna, Rome, and Madrid to study, preach, and found houses. They adopted a mendicant lifestyle (that is, they lived by begging) and did not own material possessions; they began to work among the urban poor. General Chapters (an assembly of all the heads of houses) were called during 1220 and 1221 in order to give some direction to the new movement. A Master General of the order was chosen for life to oversee the geographic provinces, which were each supervised by a provincial prior; individual houses also had their own local priors. Since Dominic had hoped that new recruits would receive solid theological education, headquarters were established in the great university towns of Bologna and Paris. When Dominic died in 1221, his successor Jordan of Saxony, began to target these university areas, seeking young educated recruits. By 1230 there were over fifty Dominican houses and twelve provinces, some as far away as Poland, Denmark, England, Hungary, and the Holy Land.

DOMINICAN EXPANSION AND NEW DIRECTIONS. After this, the order began to expand exponentially. In 1256 there were estimated to be some 13,000 Dominican friars, many located near university towns such as Paris, Bologna, Valencia, Cologne, and Montpellier. By the early 1300s, there were over 600 Dominican houses; about 150 of them were for women. While preaching remained the Dominican focus, teaching, writing, and combating heresy became their strengths. No friar was allowed to preach without at least three years of study with a trained theologian. The thirteenth century produced such great Dominican philosopher/theologians as Albertus Magnus and Thomas Aquinas. The fourteenth century was famous for the Dominican mystics Meister Eckhart and Johannes Tauler; the latter devoted himself completely to the spiritual care of the sick during the Black Death. Dominican struggle against heresy waned somewhat after the demise of the Cathars, but it did not completely end. The order continued to be involved in aspects of inquisition (juridical persecution of heresy by special church courts) during the fourteenth century. Figures like Bernard Gui made sure orthodox practice and teaching were preserved throughout institutional Christendom. Participation in rooting out heresy more vehemently resurfaced at the time of the Spanish Inquisition when Jewish and Muslim converts

to Christianity were suspected of having relapsed and were either directed back to the faith or to their death by infamous fifteenth-century Dominicans such as Tomas de Torquemada.

THE EARLY CAREER OF ST. FRANCIS. St. Francis of Assisi (1181–1226) was clearly the most important figure in the early development of the friars. A special place has been given to him in church tradition, some going so far as to call him the quintessential medieval model of Jesus, an example of love and humility to which all Christians should aspire. He was born Giovanni Bernardone in 1181, the son of a merchant family living in Assisi, above Italy's Spoleto Valley. His French-speaking father gave him the nickname Francesco, reminiscent of their heritage. Francis was probably not very well educated as a child. He lived the type of comfortable, carefree, enjoyable existence that his father's success as a cloth merchant afforded him. While he was drawn to luxury, he was also known to be extremely generous. Francis joined a military campaign in his early twenties, fighting a war in Perugia in Italy and spending almost a year in a military prison. Upon his return to Assisi he lived an unsettled existence. While on a pilgrimage to Rome, it is said he encountered two beggars. Francis exchanged clothes with one of them and went about experiencing what it was to live in poverty. In 1205 he again joined a military expedition to fight against the enemies of the pope. At that point, a dream influenced him to abandon his secular life, and he retreated to a hermitage. For the next several years he lived in relative seclusion, befriending lepers and the unfortunate, living in the ruins of the abandoned church of San Damiano outside of Assisi. When he attempted to use some of his father's wealth to rebuild an old church and assist the poor, his father had him dragged before the local magistrate. Shortly after this he completely renounced his heritage, removed his clothing and shoes, and took up living in a coarse garment with a rope for a belt, traveling about the countryside in absolute poverty, begging for his necessities, attempting to live an apostolic life.

THE FOUNDING OF THE FRANCISCANS. Soon other sons of the merchant class joined him, selling all they owned, becoming mendicants and preachers. In 1210 it is said that Francis walked barefoot to Rome to meet with the pope and petition for official approval of a group, though Pope Innocent III had reservations about such notions of radical poverty and itinerancy. Medieval monasticism had long been troubled by *gyrovagi*, wandering monks who moved from monastery to monastery in search of the best possible circumstances. Itinerant

preachers like Peter Waldo and members of the late twelfth-century lay spiritual movement called the Humiliati had been condemned less than thirty years earlier. Nonetheless, the group was given limited papal approval, and Francis returned to Assisi to begin his ministry. Their lives were extremely simple, not attached to property of any kind, and their daily routines were largely unregulated, save for a few offices they could pray when appropriate or convenient in the midst of ministry. Later popes (Honorius III and Gregory IX) gave formal approval to Franciscan rules, which became more detailed over time. The group called themselves *fratres minores* (brothers minor). They were given an old Benedictine church, the Portiuncula, outside of Assisi, which they restored and around which they began to build huts. In 1212, this growing brotherhood of mendicants grew to include sisters. The Poor Clares (or second order), who based their community at the restored church of San Damiano, were not allowed to beg or preach, but they did live out the ideal of poverty within their community. Soon Francis and his followers began to travel about southern France and Spain. By 1217 they had organized into provinces with superiors appointed over each area, and in 1221 Francis founded the Tertiaries (or third order), a lay movement that adapted Franciscan ideals to daily life. Francis' order of friars grew so rapidly that they were able to extend their ministry into Eastern Europe and North Africa, though their preaching in Muslim areas did not meet with great success. Francis himself accompanied the Fifth Crusade and even attempted to convert the Sultan al-Kamil. Of great benefit to the order was Francis's friendship with Cardinal Ugolino, who later became Pope Gregory IX. It is said that in 1224 Francis received the *stigmata* (gift of the wounds of Christ). He died two years later and was canonized (declared a saint) by Pope Gregory in 1228. Legends of Francis' life abound and have been used by Franciscans, as well as Christians in general, as a source of inspiration for their lives.

THE PROBLEMS OF PROPERTY AND EDUCATION. After Francis' death, the order was forced to deal with two growing problems: how to educate the brothers and whether or not the Franciscans would own their own houses, books, and trappings. The earliest Franciscans had gotten around the issue of ownership by entrusting all their possessions to Rome. While there were some friars who wished to share in the more radical vision of Francis, living in caves or huts and shunning formalized university education, many of the recruits to the Franciscan Order were from the literate and elite classes of society. This tension continued to be present in the order for the next several centuries. By the 1230s the uni-

THREE
Stories of St. Francis

One of the most fascinating legacies of St. Francis of Assisi (1181–1226) is the wealth of biographical information, anecdotes, stories, and legends connected to his life. Many of these stories were compiled in the thirteenth century during the decades following Francis' death by biographers such as Thomas of Celano. These accounts were written mainly by individuals who had contact with the saint during his life. Later thirteenth-century compilations, such as the work of St. Bonaventure (a second generation Franciscan and Minister General of the Order), reflected the earliest Francis traditions but were also linked to elements of the growing ideological debate over apostolic poverty. Numerous fourteenth-century documents and elaborations trace their roots to writings and oral traditions of Francis' disciples, such as those of Brother Leo who was the famous traveling companion of the saint. The *Little Flowers*, *Considerations on the Holy Stigmata* and the *Actus Beati Francisci* were fourteenth-century creations based upon a variety of earlier accounts.

Among the hundreds of tales he relates, Bonaventure (a spiritualist) was particularly fond of recounting stories he had gathered from individuals who had witnessed Francis' stigmata. In one of his sermons Bonaventure makes a point about the authority of those who had seen the wounds, comparing the many lay witnesses and more than a hundred clergymen who vouched for Francis to the "two or three" who were considered sufficient by Jesus to establish veracity (Matt. 18:16). The fact that the key witnesses were virtuous and holy men who swore under oath is provided as further evidence of the truth of Francis' holy status. Most notable in his account, however, is the description of the marks themselves, which he says are "contrary to the laws of nature"—first because he never wore a bandage, in spite of the fact that the wound in his side was continuously bleeding as he went about his work, and second because the wounds in his hands were not merely piercings that could easily have been counterfeited, since the nails "actually grew out of his flesh, with the head on one side and the point bent back on the other." Bonaventure concluded that such an "extraordinary" sight would convince any Christian that the stigmata were miraculous.

Tensions between the radically active, less austere, and spiritual elements of the fourteenth-century Franciscans are manifest in a particularly moving story from the *Little Flowers* which demonstrates both Francis' humility and sanctity. It was written by a friar of the Marches around 1330. In it he describes how Francis was praying and weeping aloud through the night until he was so exhausted that he could not walk the next day. His companions went to a local peasant to find a donkey for Francis, and, upon hearing that the animal was for this man who had a reputation for doing so much good, the peasant approached him with advice:

> "Well then," said the peasant, "try to be as good as everyone thinks you are, because many people have great faith in you. So I urge you: never let there be anything in you different from what people expect of you." When Francis heard these words, he did not mind being admonished by a peasant, and he did not say to himself, as many proud fellows who wear cowls nowadays would say, "Who is this brute who admonishes me?" But he immediately got off the donkey and threw himself on his knees before the farmer and humbly kissed his feet, thanking him for having deigned to admonish him so charitably.

It may be safe to say that throughout the medieval period, there were few individuals whose legends attesting to their character had such an encompassing effect upon the spirit and development of Christianity. In yet another story, Francis is approached by a friar novice who has obtained his own copy of a book of Psalms, against the usual Franciscan policy of not owning personal possessions such as books. Concerned about this breach of conduct, he approaches Francis, who says to him:

> "Once you have a psalter, you will want a breviary. And when you have a breviary, you will sit in a high chair like a great prelate and say to your brother, 'Bring me my breviary.'" As he spoke, blessed Francis in a great fervor of spirit took up a handful of ashes and placed them on his head, and rubbing his hand around his head as though he was washing it, he exclaimed, "I, a breviary, I, a breviary!" And he repeated this many times, passing his hand over his head. And the friar was amazed and ashamed.

versities of Paris, Padua, Bologna, and Oxford had become a breeding ground for Franciscan ideas. Franciscan scholars like Alexander of Hales, Robert Grosseteste, and Anthony of Padua were among the leading theologians of the day. After 1239, it was decided that all the leaders within the order needed to be priests. When the great theologian and philosopher St. Bonaventure became minister general of the order (1257–1274), admission was limited to clerics who were educated or to lay persons of distinction (something of a contradiction,

since Francis himself had taken only the order of a deacon and had at best a working knowledge of Latin). During this period the order began to grow tremendously. While in 1250 there were fifty Franciscan houses in England and some several hundred in Italy, by the early fourteenth century the order had grown to 1,400 houses. With this growth, debates over the issue of radical poverty and the order's ownership of property intensified. Notions of a new age of religious orders who would come to reshape the world and usher in the final phase of a spiritual church had been predicted by the mystic Joachim of Fiore (1132–1202) in his apocalyptic writings. Members of the Spiritual Franciscans led by Gerard of Borgo San Donnino and various other Fraticelli (general and fringe mendicant groups) took these ideas to heart in the mid-thirteenth and early fourteenth centuries, attempting to bring Joachim's prophecies to fulfillment. Following the Black Death and a dwindling of numbers in the order, however, there was an increased laxity of practice and tolerance for material possessions. The issue of property and observance continued to agitate the Franciscan Order, and finally in 1415 and again in 1443 the Conventual (the more lax) and Observant (the more traditional) branches were granted separate provinces and eventually their own Vicar Generals. Not until 1517 would there be a formal division between the Conventualists (who felt that they were the real order) and the Observants.

CARMELITE FRIARS. Both the Carmelite and Augustinian (Austin) friars began as hermits who gradually adopted the practices of the mendicants. The real strength of these movements is that they were able to blend the ministerial ideals of the life of the apostles with the contemplative calling of the earliest Christian desert fathers. The Order of Our Lady of Mount Carmel originated in mid-twelfth century Palestine where hermits gathered in a community under a common rule at Mount Carmel near Haifa. The group had been founded by a pious crusader named Berthold of Cambria. Tracing their origins to the biblical Elijah, by the early 1200s they undertook a strict rule of asceticism, which was condoned by the Latin patriarch (bishop) of Jerusalem. The Carmelite hermits fasted regularly, avoided meat, and observed lengthy periods of quiet. With the fall of the Holy Land and the demise of the Latin Christian Kingdoms in the early part of the thirteenth century, the Mount Carmel community slowly began to break up into several groups that moved into Italy, Spain, Cyprus, Sicily, southern France, and England. Some Carmelites were said to have come back with troops returning from the Third and Fourth Crusades. At first the European Carmelites continued to live a cloistered existence, but soon they became engaged in a more active life of preaching, poverty, and active study in the world, modeling their new way of life on the Dominicans. Corporate poverty, teaching, preaching, and mendicancy were the cornerstones of their movement. By 1300 there were at least a thousand Carmelites in England alone.

AUSTIN FRIARS. The origin of the Austin friars is much more documented than that of the Carmelites. They began with a group of hermits that were spread throughout Italy, particularly in the regions of Tuscany and Lombardy. St. John Buoni of Mantua had begun to organize the group in the mid-thirteenth century. In 1243 Pope Innocent IV prescribed the Rule of St. Augustine for these hermits and in 1255, under Pope Alexander, all hermits living in Italy were brought into one group called the Order of Hermits of St. Augustine. The following year they adopted a constitution similar to that of the Dominicans. Their lifestyle became more mendicant in nature, and they were given exemptions from the control of local bishops. Based upon the influences of the other friar orders, the Austins moved from their hermitages and took up residence in the cities where they began to minister and preach. They also became interested in university education, taking up the formalized study of theology, the scriptures, and the philosophy of St. Augustine. Toward the end of the thirteenth century, they began founding priories throughout Italy, Spain, France, Germany, and England. Gregory of Rimini, who taught at the University of Paris, was possibly their finest scholar. He later became general of the Austin Order in 1357. The most famous of the Augustinians is the sixteenth-century reformer Martin Luther, who first entered as a hermit in 1505.

THE SECULAR-MENDICANT CONTROVERSY. Conflicts between secular clergy and the new mendicant orders began to occur once the friars (who were not under permanent obligation to local bishops) came to urban areas to preach and hear confessions. As the friars moved in, they began to establish schools and build churches. Members of the laity were attracted to these educated friars who were living in poverty, and local secular clerics noticed that the flow of offerings and bequests to their churches was dwindling. The resources of lay nobility that once had gone to the benefices and holdings of the secular clergy were being diverted to build and decorate such magnificent centers of the preachers as Santa Croce in Florence. Around 1250, the Burgundian schoolmaster William of Saint-Amour, who taught in Paris, began to crusade against the rights of the friars to compete with secular clergy for pastoral ministry and even their right to monopolize the chairs at prestigious

a PRIMARY SOURCE *document*

A LATE MEDIEVAL SATIRE ON FRIARS

INTRODUCTION: Chaucer's *Summoner's Tale*, one of the stories in the *Canterbury Tales* from about 1390, indicates the poet's general distaste for friars and brings together many of the conventional charges against them. The Summoner, who was like a bailiff "summoning" or calling offenders to the Bishop's court, was the friar's natural professional enemy, since friars often tried to evade the bishop's control over his diocese when they came to a community to preach, hear confessions, and collect charitable donations, often leaving with monies which the parish priest felt were properly due him. In this excerpt from the Prologue to the Tale, the use of references to excrement and defecation in the treatment of the friar, while coarse, was not at all uncommon in late medieval religious controversy; indeed, many of the attacks over a hundred years later during the Reformation—both by the Lutherans and by those writing against them—employed scatological imagery of a very similar type.

This friar boasts that he knows all about hell—
And God knows, that can hardly to be wondered at
Since between friars and fiends there is little difference.
You have often heard tell

How a friar was carried off to hell
In the spirit in a vision,
And as he was led up and down there
By an angel, to show him the various torments,
In the entire place he saw not one friar,
Though he saw plenty of other people in misery and woe.
Then the friar asked the angel,
"Now sir, have friars such grace from God
That not one of them comes to hell?"
"Yes indeed," said the angel, "many millions do,"
And he led him further down to where Satan dwelt
Who had a tail broader than the sail on a barge.
"Lift up your tail, Satan," the angel commanded.
"Show your arse-hole and let this friar see
Where the nest of all his fellow friars is found"—
And before five minutes had passed,
Just as bees swarm from the hive when troubled,
So out of the devil's arse poured forth
Some twenty thousand friars in a pack
And swarmed all about hell,
And then just as rapidly as they came out,
Each crept back into Satan's arse.
Satan then dropped his tail and lay still.

SOURCE: Geoffrey Chaucer *Summoner's Prologue*, in *Canterbury Tales* (c. 1390). Text modernized by John Block Friedman.

universities. These arguments spun into an ideological battle over *ecclesiology*, that is, whether secular priests or religious should hold authority over the teaching and preaching of the church. The friars were seen by some as extensions of lay orders—mendicant, and thus not completely devoted to either institution or rule. Notions of hierarchy, diocesan boundaries, and the rights of local churches were defended by the secularists. Friars such as St. Bonaventure wrote *apologia* for their orders, defending themselves by appeals to their papal commissions and authentic apostolic lifestyles. The old medieval power of clerics in isolated communities was giving way and being challenged by a European society that was open to mobility, education, competition, and diversity of opinions, all of which the friars brought to the church by way of emerging societal changes and conventions. The erosion of secular church authority continued when the Franciscan pope Martin IV (1281–1285) issued his *Ad Fructus Uberes* which allowed the friars to perform any pastoral duties they deemed necessary in any diocese where they were present without first seeking a license from the local bishop. A compromise was later struck by Boniface VIII in 1300 which limited the jurisdictions of the friars and returned to the bishops certain controls over them in their diocese. However, remnants of this dispute lingered on to the 1400s. Examples of this are the manuals of instruction for parish priests in England, which questioned whether or not absolution of a penitent by a friar was sufficient or whether it might be helpful and even necessary for the parish priest to re-hear the confession of their parishioner. Another good example is seen in the negative image of the friar described by the character of the Summoner in *The Canterbury Tales*, a description that illustrates Chaucer's dislike of the friars and support of the secular party in this ongoing conflict.

SOURCES

Decima L. Douie, *The Conflict Between the Seculars and the Mendicants at the University of Paris in the Thirteenth Century* (London: Blackfriars, 1954).

William Hinnebusch, *The History of the Dominican Order: Origin and Growth to 1500* (Staten Island, N.Y.: Alba House, 1973).

C. H. Lawrence, *The Friars* (New York: Longman, 1994).

John R. H. Moorman, *A History of the Franciscan Order: From Its Origins to the Year 1517* (Chicago: Franciscan Herald Press, 1988).

Francis X. Roth, *The English Austin Friars 1249–1638.* 2 vols. (New York: Augustinian Historical Institute, 1961–1966).

Joachim Smet, *The Carmelites: A History of the Brothers of Our Lady of Mount Carmel, ca. 1200 A.D. until the Council of Trent.* Rev. ed. 5 vols. (Darien, Ill.: Carmelite Spiritual Center, 1988).

Penn R. Szittya, *The Anti-Fraternal Tradition in Medieval Literature* (Princeton, N.J.: Princeton University Press, 1986).

SEE ALSO *Fashion: Academic, Clerical, and Religious Dress*

THE LAITY AND POPULAR BELIEFS

SEPARATIONS BETWEEN CLERICS AND LAITY. Even though people today view the Middle Ages as a time of great religious faith, it is clear that the role of the laity within official medieval Christianity was relatively limited. By the thirteenth century, the majority of people who lived in Western Europe were nominally Christian. Most had received Christian baptism and professed to practice the faith, the exceptions being the minority of Jewish people scattered throughout various European cities and the Muslims who were still living in Spain. For those who were not part of the clerical world, however, it seems there was not much access to the richness of the Christian tradition. Nobles and royalty who had clerics living among them at court clearly had the advantage of daily contact. But since many others did not know how to read, and understood Latin (the language of most prayers) in only a limited way, contact for the laboring and commercial classes did not extend much beyond attending worship and interacting with local clergy. Lay experience of the holy was mostly visual and auditory, including encounters with religious art and the stories portrayed in these artworks, as well as the homilies of their priests (during the time periods that medieval liturgies incorporated preaching). Such religious art often showed biblical typology or foreshadowing of New Testament events in Old Testament stories; for example, David struggling with a bear foreshadows Christ's conquering of Satan in a miniature from the Winchester Bible of 1160–1175. During Christian feast days, they may have heard or seen enacted stories connected to the saints and the important events from the life of Christ. Members of the laity were not, however, encouraged to receive communion during the earlier medieval centuries. In fact, it was not until the Fourth Lateran Council in 1215 that they were required to go to confession and receive the eucharist at least once a year.

LAY OBSERVANCE AT MASS. In the absence of receiving communion, the only contact with the sacrament was visual, when the priest elevated the host and chalice. However, in churches with rood screens (wooden or metal par-view gates separating the altar area from the rest of the church), visual contact was often impaired. Mothers did teach their children statements of faith and prayers, particularly the *Credo, Pater Noster,* and *Ave Maria.* In urban areas where there were schools, clerics taught children to read Latin from the Bible or a psalter (a book containing the psalms). These city-dwellers received formal religious education from the clerics who taught them, and, in imitation of their teachers, might set aside certain times of the day to pray. If they were literate and wealthy enough to own psalters, they might recite the written prayers. Daily attendance at Mass for the laity was limited to those who had both the piety and leisure to comply. In most cases, these masses were held in small chapels and provided opportunity for greater contact with the clergy, although the priest's back was turned to the congregants for most of the liturgy. Again, it was not until the thirteenth-century Lateran Council that serious directives were issued in regard to weekly attendance at Mass. Some evidence of contemporary expectations for participation is offered by a twelfth-century book of instructions and devotion for laity called the *Lay Folk's Mass Book,* written by an archdeacon of York named Jeremiah. The instructions were originally written in French for Norman aristocrats, but only the late thirteenth-century English translation survives. A collection of directives that indicate the role of the worshipers and how they should be positioned, such as kneeling at the elevation of the consecrated elements, are contained in the work.

THE SACRAMENT OF MARRIAGE. The notion of marriage as a sacrament began to be connected in the Middle Ages to certain rituals and exchanges of consent that took place at the front door or on the porch of churches. Marriage did not become an official sacrament of the church until the Fourth Lateran Council (1215). Emphasis on assent and mutual giving, including consent of both partners along with the physical act of consummation, mark the canonical parameters of the essence of the union. While local customs and laws varied widely throughout Europe, the role of the church in witnessing and binding the union seems to have only been prevalent from the twelfth century onward. However, once it became a sacrament, the church also played an important role in the dissolution or annulment of marriage and the integrity of family life. All marriages from the early thirteenth century on were to be public. *Banns* (formal public announcements) were to be published, and pri-

vate or clandestine unions were forbidden (although, if secretly performed, these marriages were not invalid). Marriage of blood relatives (consanguinity) within the fourth degree of relationship and marriage within a spouse's family (affinity) within the third degree was forbidden. Later, the statute concerning affinity was revised to forbid only the first degree (marrying a dead spouse's parent or sibling). In many cases, marriage was certainly not even seen as an idealized or spiritualized form of love, but a contractual arrangement. The attitude towards marriage and love held by most celibate theologians was far removed from the ideal of courtly love espoused by Eleanor of Aquitaine, Christine de Pizan, Chrétien de Troyes, Gottfried von Strassburg, and Dante Alighieri in the literature that developed during this period.

THE AFTERLIFE. In medieval Christianity everyone believed in an afterlife where the good were rewarded and the evil were punished. But the idea of going directly to heaven or hell upon one's death was not firmly entrenched in the popular lay mentality. Sometimes souls were visualized being raised to God in a napkin as in a miniature from a book of hours from York, England. It was believed that souls lingered among the living (almost as ghosts), possibly to keep promises, solicit prayers, or even settle old accounts. Dances for the dead in cemeteries, some attempting to drive the deceased back to the spirit world, were banned by synods in the twelfth century. It was necessary for the church to affirm the doctrine of purgatory, a place where the distressed souls would be allowed to linger. It was not that people during this era had a greater fear of death than in other historical periods, but they did fear dying in a state of sin, without the comfort of the sacraments or forgiveness. People began leaving property to the church or to the poor so that their souls would be prayed for after their death. Even the most corrupt of princes and knights on their deathbeds sought to make reparations for their evil deeds. This may be the reason why many people in the final years of their lives would retire to monasteries and convents to be connected to God and the prayers of a community in death and be remembered in the community's masses for the deceased.

MIRACLES. The laity also believed in miracles and divine interventions, with saints often playing a major role. Indeed, at times it seems people were more interested in miracles and relics than in the accumulation of countless good deeds that might earn them a way into heaven. Pious lay persons could distinguish themselves through generosity, hospitality, and almsgiving. However, taken more seriously was the idea of penitence and making reparations for one's sins, even after absolution

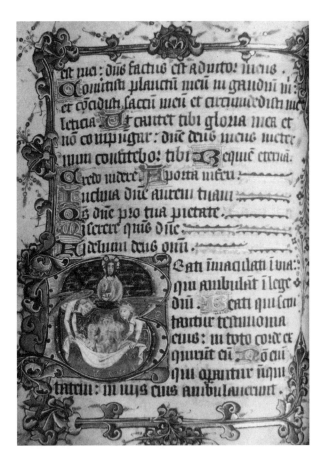

Souls raised to God in a napkin, Book of Hours, York, York Minster Library MS XVI.K.6, folio 67v, 1405–1413. BY KIND PERMISSION OF THE DEAN AND THE CHAPTER OF YORK. PHOTO BY JOHN BLOCK FRIEDMAN.

through a priest was given in confession. Piety found its expression most clearly in outward signs and rituals. *Sacramentals* (such as blessings, benedictions, exorcisms, stations of the cross, dubbing of a knight, coronations, ceremonies, receiving palms and ashes, and litanies) were often as important to the medieval laity as the *Sacraments* (Baptism, Eucharist, Confession, Confirmation, Marriage, Holy Orders, Anointing of the Sick). The church of the thirteenth century did a number of things to eliminate the power of popular piety by creating more rigid standards for the canonization of saints, rather than allowing the cults of these figures to develop from popular acclaim. The condemnation of practices such as trial by combat (in which the accused and the accuser of a crime engaged in physical combat with the belief that right would triumph over wrong) or trials by fire and water (in which a guilty person thrown into a body of water would float and one whose hand was burned would become infected) were included in the Fourth Lateran Council in order to allow church courts rather than miraculous intervention to rule the day. Priests were

forbidden to be present at the ordeals, thus discouraging the notion that these affairs might be orthodoxy.

LAY SPIRITUAL MOVEMENTS. Since the laity were in many ways excluded from active participation in the official life of the church, it is not surprising that lay spiritual movements began to flourish. One late twelfth-century movement developed into a group called the Humiliati, which actually evolved into an officially sanctioned lay order during the early thirteenth century. The Humiliati began in Lombardy and Milan around the time of the Waldensian controversy, which arose in the late 1170s when a rich merchant named Peter Waldo in Lyon, France, underwent a religious conversion and started a lay spiritual movement—unsanctioned by the church hierarchy—based on voluntary poverty, vernacular translation of the Scriptures, and public preaching. Some Humiliati were married and lived with their families. Others lived in community, almost like a religious order. They held meetings in common houses owned by the local groups. Most Humiliati were nobility or, at the least, educated people of some means. Their first obligation was to embrace apostolic simplicity. They wore simple clothing, lived simple lives and sought to stand at odds with enemies of the true Christian faith. Unlike the Waldensians, they found it distasteful to preach in public. Each group had a minister or lay leader but in general they did not abide by a rule.

THE LIFE OF THE HUMILIATI. While several popes like Lucuis III and Alexander III tried to legislate against the Humiliati, other pontiffs wrote them letters calling on them to live lives of penitence, to be peaceful and forgiving, to act against usury (charging interest for loans), to keep their married state if already wed, and to prepare to enter the narrow gate of heaven. Some members recited the seven canonical hours, others fasted twice a week. They gave charity to all those in need and showed special concern for lepers. One of the things the group became famous for was the making of cotton cloth and inexpensive wools. During this period, producers of fine cloth often belonged to guilds that controlled prices, so there was a great need, especially among the lower classes, for inexpensive cloth. In a sense, the production of such cloth became part of their "ministry," to the point where it even began to be asked for by the trademark of Humiliati. The lamb of God became their symbol. By 1216 there were 150 communities of Humiliati in the Diocese of Milan alone. In 1201 Pope Innocent III gave permission for the Humiliati to continue their work under two conditions: that they not own land that they themselves did not work with their own hands, and that their preaching be limited to the sharing of faith and exhort-

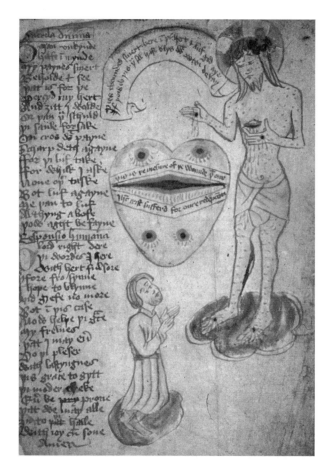

Christ with side wound and bleeding heart revered, *Desert of Religion*, London, The British Library MS Stowe 39, folio 20, c. 1420. © THE BRITISH LIBRARY.

ing of one another. Eventually the Humiliati fell into three orders: canons and canonesses, monks, and lay people. Like other European religious, Humiliati monks followed the Rule of Benedict, and their canons followed the Augustinian Rule. In 1246 they had grown large enough that Pope Innocent IV decreed that all the Humiliati orders take direction from one Master General for their group. By 1298 there were 389 houses of Humiliati of the second order in Italy. The third order of laity was, of course, immense and beyond calculation. The group began to decline in number after the fourteenth century but continued through the 1500s.

DEVOTIONAL IMAGES. Another effect of the increasing lay desire for direct participation in spiritual experience was the development, in the fourteenth and fifteenth centuries, of devotional art, with a distinctive emphasis on images of the Passion of Christ. While earlier lay Christians, particularly women in the upper class, had relied on beautifully illustrated texts called Books of Hours to guide and inspire their devotions, later worshippers focused specifically on the pictures themselves as

they appeared in wall paintings, stained glass, and scrolls, as well as amulets, charms, and individual parchment or paper broadsheets that could be owned even by people of modest means. Among the most popular images were the Holy Face—an image of Christ's countenance supposedly imprinted on a cloth (*sudarium*) held by Saint Veronica when Christ used it to wipe his face—and the Sacred Heart bearing the evidence of the side wound Christ suffered at the crucifixion and showed to Doubting Thomas (John 20:27). Various meditational techniques were employed to make the Passion vivid, among which was a strong interest in the damage wrought to Christ's body both before and after his crucifixion and the physiological changes it underwent on the cross. For example, Christ's torment was often expressed in metaphors comparing the body to a book, or a scroll, or even a shield bearing a coat of arms whose "armorial bearings" were made of the tools and weapons—called the *arma Christi*—used in his torment. Thus, the words of Christ's "book" are his deeds, suffering, and passion, and the letters are the five wounds of his hands, feet, and body. Often all of the wounds can be placed on a heart-shaped shield such as the one revered in a late medieval English devotional work called *The Desert of Religion*.

SOURCES

Francis Andrews, *The Early Humiliati* (Cambridge, England: Cambridge University Press, 1999).

Brenda Bolton, "Innocent III and the Humiliati," in *Innocent III: Vicar of Christ or Lord of the World?* Ed. James M. Powell (Washington, D.C.: Catholic University of America Press, 1994): 114–121.

Rosalind Brooke and Christopher Brooke, *Popular Religion in the Middle Ages* (London: Thames and Hudson, 1984).

John B. Friedman, "Images of Popular Piety in the North," in *Northern English Books, Owners, and Makers in the Late Middle Ages* (Syracuse, N.Y.: Syracuse University Press, 1995): 148–202.

André Vauchez, *The Laity in the Middle Ages* (Notre Dame, Ind.: University of Notre Dame Press, 1993).

SEE ALSO *Music: Religious Music of the Layman; Visual Arts: Spiritual Life and Devotion*

CHILDREN AND MEDIEVAL CHRISTIANITY

THE INNOCENCE OF CHILDREN. The notion of the innocence and purity of children was a concept which became connected to a host of medieval religious images. Beginning in the ninth century, children were depicted nude in art to signify their purity. They were often depicted as cherub-like or cupid-like angelic figures. Quite commonly, children were also connected to the notion of the infant Son of God. Many medieval monks claimed to have seen an infant in the consecrated bread during the liturgy at the moment of its ritual elevation by the priest. Familiar scripture quotations that supported the sacred role of children are still often cited: from Psalms 8:2–3 and Matthew 21:16, "out of the mouths of babes;" Psalms 85:12, "truth will spring from the ground;" and Mark 10:15 and Luke 18:17, "whoever does not receive the Kingdom of God as a little child." These scriptural ideas supported the special place children occupied in the medieval religious consciousness. Very young children were often asked to open the Bible at any spot they would choose, and adults would interpret the verse that appeared as some sort of prophecy in a divinatory process called the *sortes biblicae*.

INFANT BAPTISM. In spite of the apparent purity of intention and deed in small children, the medieval church held that they were inherently tainted by the doctrine of Original Sin, a state of separation from God that all people were born into as a result of the disobedience of Adam and Eve. By the early Middle Ages, infant baptism was standard practice. In fact, during that period it was generally believed that children who died unbaptized went to hell. In 830 Jonas of Orléans wrote, regarding the children of Christian parents, that it was "necessary that they be presented without delay to receive the gift of baptism, even if they do not yet speak. We are right to do this as children are guilty of the sins of others (original sin)." Failure to baptize a child was a serious matter. Most unbaptized children were not even allowed Christian burials in the early medieval period. Parents who neglected to have infant children baptized before death could be required to do penance up to seven years. Cemetery records throughout France after the Carolingian baptismal legislation was enacted strongly support claims of adherence to the practice of early baptism. Hincmar of Reims expressed similar sentiments around 850 in a letter to Loup de Ferrières: "If they die after having receiving the gift of baptism, they are saved by the will of God; on the other hand, deprived by God's judgment of this very gift of baptism, they are damned by the fault of hereditary sin."

CHANGING REGULATIONS. Rules regarding baptism and confirmation of children changed gradually throughout the Middle Ages. The liturgist Amalarius of Metz commented in the ninth century that baptism should take place at the ninth hour of a child's life, as it was during the ninth hour that Christ breathed his last on the cross. During the ninth century in England, both civil and religious regulations required baptism for Christian infants

before they reached one month of age. Following such guidelines would, however, be almost impossible in France after the ninth century, since most baptisms there were performed only at Easter and Pentecost. In the High Middle Ages (after 1200) there were more widespread canons that required children to be baptized before the age of three. Formal creedal confessions more appropriate to adult initiates gave way to rites of exorcism, signing of the cross, and prayers for the infant, to be followed by confirmation of the child's baptism (which consisted of the laying on of hands and the bishop's anointing of the child using blessed oils) once the child reached the age of reason (normally seven or older). This practice became more common between the tenth century and the twelfth, when the doctrine of *limbo puerorum* was promulgated, stating that children who died unbaptized went to a state in the afterlife that was slightly removed from the sight of God, but where they were outside the torments of hell. Thomas Aquinas in the thirteenth century went so far as to suggest that those in limbo actually enjoyed a type of natural happiness. The notion of limbo remained a matter of evolving theological opinion throughout much of the medieval period. In contrast to the debate over baptism, however, many medieval Christians were not particularly concerned with the sacrament of confirmation. In the early Middle Ages, the reception of communion and penance usually did not occur until adulthood or adolescence, and, in fact, the Council of Tours in 813 had discouraged communion for children unless there were special circumstances warranting it. It was not until the thirteenth century that the Fourth Lateran Council decreed that all children past the age of seven should confess their sins and receive communion at least once a year.

SOURCES

Danièle Alexandre-Bidon, et al., *Children in the Middle Ages* (Notre Dame, Ind.: University of Notre Dame Press, 2000).

Loup de Ferrières, *Correspondences.* Trans. L. Levillain. Vol. II (Paris: Les Belles Lettres, 1964): 42–43.

Jonas d'Orléans, "De Institutione Laicali," in *Patrologia Latina,* as quoted in Daniele Alexandre-Bidon and Didier Lett, *Children in the Middle Ages.* Trans. Jody Gladding (Notre Dame, Ind.: University of Notre Dame Press, 2000): 27.

PAPACY AND POLITICS IN THE LATE THIRTEENTH AND EARLY FOURTEENTH CENTURIES

A PIOUS MONARCH. Many of the developments within Christianity during the late thirteenth and early fourteenth centuries were tied to the might of monarchies and the shifting of papal powers. When the goals of monarchs were consistent with the ideals of a Christian life, both ecclesiastical and political functions ran smoothly. In France, King Louis IX (1214–1270), for example, did much to advance the ideals of piety and the prominent place of the church within the European consciousness. He was noted for personal religious devotion, prayer, liturgical attendance, and even wearing the humble attire of Franciscan friars. Some 27 years after his death, he was canonized as Saint Louis. Not only did he personally lead two crusade campaigns (on one of which he was taken prisoner, and on the other of which he died of illness), but Louis was responsible for bringing peace among contentious nobles in Flanders, Aragon, and England. He endowed many religious foundations throughout his reign and supported the initiation of the Sorbonne theological college in 1257. His devotion extended to the building of Sainte-Chapelle in Paris (between 1245 and 1248) where he placed relics from what he believed to be the crown of thorns worn by Jesus (obtained from Baldwin II, the Latin emperor at Constantinople) and a piece of the true cross on which Christ was crucified. His biographer Jean de Joinville told stories of him washing the feet of the poor and going to the countryside in the summer to talk with the more lowly subjects of his kingdom.

POLITICAL DOMINATION. Many of the rulers and members of the religious hierarchy of the period did not, however, follow Louis' example. In the southern part of Italy and in Sicily, there was continual conflict between powerful noble families and the church. Charles of Anjou (the brother of Saint Louis) had been placed in control of the region by the church, after authority was wrested from the German Hohenstauffen monarchs. Charles' role became self-serving, however. He began allying himself with Italian political elements (powerful nobles and clergy) and even gained control of a number of cardinals—councilors to the pope who ranked second in power only to the pontiff himself. The result was years of political wrangling, stalled papal elections, and vacancies in the office of bishop of Rome. Indeed, as a result of the political conflicts in this region, there were nine popes from 1276 to 1295, with a total of 42 months in which there was no pope at all. A brief period of sanity came with Pope Boniface VIII (r. 1294–1303), who proclaimed 1300 a "jubilee year" and also promulgated a very responsible body of canon law (*Liber Sextus*) in 1298, which supplemented previous codes, particularly those of Gregory IX. Nonetheless, Boniface's tenure was tarnished by acrimonious disputes with the French king Philip the Fair (1268–1314), who was taxing church

properties to finance a war against England. The result of this was the papal bull of 1296, *Clericis Laicos,* condemning the unnamed laity (the kings of England and France) for unjust taxation supporting a war between Christians (prohibited without papal consent). It took several months and much political maneuvering before the taxations ceased. Boniface continued to have difficulties with Italian cardinals and nobles who allied themselves with Philip until, finally, the French plotted to have the pope's elevation nullified. In 1302, Boniface issued his famous *Unam Sanctam,* calling for the unity of the church under one pope, whose authority extended to the secular subjects because his spiritual power took precedence over secular powers. The bull sparked flaming invectives from both sides, including physical attacks upon the pope by agents of the French king. With Boniface's death in 1303, the vestiges of medieval papal power began to slip away. Philip soon succeeded in expelling most of the merchant Jews from the growing French realm and divesting the Knights Templar of their wealth and resources.

THE AVIGNON PAPACY (1309–1377). After the death of Pope Boniface VIII, Philip the Fair continued attempting to weaken the church in order to further his political aims. Popes Benedict XI (r. 1303–1304) and Clement V (r. 1305–1314), a Frenchman, proved ineffective at limiting royal authority. Following the deaths of Boniface and Benedict, bitter factions formed in Rome over the direction the papacy would take. Clement, who had been crowned in Lyon, was unable to occupy the papal residence in the city of Rome due to a variety of political complications. In 1309, during a prolonged illness, he finally decided to remain at Avignon, which was located in what is now southern France on the lower Rhône River. The location had for some time been under papal control connected to its vassals, the Angevin kings of Naples. Since Avignon bordered France, Philip the Fair was quite pleased to have the French pope much closer at hand. It was not unprecedented for a pope to reside outside Rome or spend extended periods of time outside the city, but in this case his decision had dire consequences.

THE GROWTH OF SECULAR POWER. Under Pope Clement, and Pope John XXII who followed him, the papacy was characterized by a mixture of valuable reforms and increasing assertions of secular power. Clement appointed nine French cardinals, four of whom were his nephews, and he was forced by the French king into some serious compromises of papal integrity. Some of his reforms proved productive, however. At the suggestion of the Catalan theologian and missionary Ray-

mond Lull, Clement began to encourage the development of chairs at the various leading universities (Bologna, Oxford, Paris, and Salamanca) for the study of Arabic, Hebrew, and Chaldaic, believing that knowledge of both scriptural and local languages would lead to success in the conversion of Muslims and Jews. Likewise, his successor, John XXII, might be admired for his personal simplicity, as well as a program of almsgiving (distribution of food, clothing, and medication to the poor). However, as the papacy continued to reside in Avignon, the desire for power and opulence became ever more apparent. The city of Avignon was virtually a military fortress with some three miles of walls surrounding the papal palace. Pope John XXII allowed for the securing of additional resources to decorate the palace and brought artists, artisans, and scholars to the city. During a dispute over control of the Holy Roman Empire (1316–1326), Pope John refused to recognize all three claimants to the position of emperor and asserted his right to administer the empire himself during the void in leadership, a move that elicited protest in many parts of European society. Treatises by writers like John of Paris, Marsilius of Padua (*Defensor Pacis,* 1324) and Dante Alighieri (*De Monarchia,* c. 1310) stressed the parallel and autonomous natures of papal and imperial powers. While such power came from God, one authority did not have the right to interfere in the other's domain. Marsilius, a philosopher and canonist, went so far as to suggest that it was the people who held the basis of power. He felt that all clergy were equal in status and that no human had the right to define Christian truth, or dispense interdicts and excommunications that would be deemed universal. Infallibility, according to Marsilius, could only come from the consensus of the faithful. The Italian poet Petrarch, in his *Book Without A Name,* railed against the abuses and scandal at Avignon, calling it a medieval Babylon.

THE GREAT SCHISM. The abuses of the Avignon papacy were so great that they eventually led the church to split into two, and even three, separate entities. One of the most abusive aspects of the Avignon regime was its policy of taxation. Due to the loss of revenues from the papal states, additional revenues had to be extracted. Church benefices began to be bought, sold, and traded, and such sales were supplemented by the *annates,* a tax amounting to approximately one year's income on all new appointments. Out of the seven Avignon popes, six were French. All continued to function as the bishop of Rome, although residing outside the city. (A vicar was appointed to attend to the necessary ministry there.) Many of the cardinals that had been appointed were

a PRIMARY SOURCE *document*

UNAM SANCTAM: A PAPAL BULL

INTRODUCTION: Following a series of bitter disputes with the French king Philip the Fair (1268–1314), who was taxing church properties to finance a war against England, Pope Boniface VIII went on to address the issue of the church's authority in the 1245 bull *Unam Sanctam*. King Philip IV of France, in reaction to the earlier *Clericis Laicos*, had prohibited the transfer of money outside of his realm and, as a result, had quite effectively reduced French support to Rome. Many of the French bishops had given in to pressures from the king and became less than supportive of the pontiff. The bull *Unam Sanctam* once again outlined papal claims of authority over God's people, with its spiritual exigencies exceeding those of the temporal judgments of the crown. Philip's outrage at the bull resulted in the ransacking of the papal palace and the brief imprisonment of Boniface.

That there is one holy, Catholic and apostolic church we are bound to believe and to hold, our faith urging us, and this we do firmly believe and simply confess; and that outside this church there is no salvation or remission of sins, as her spouse proclaims in the Canticles, "One is my dove, my perfect one. She is the only one of her mother, the chosen of her that bore her" (Canticles 6:8); which represents one mystical body whose head is Christ, while the head of Christ is God. In this church there is one Lord, one faith, one baptism. At the time of the Flood there was one ark, symbolizing the one church. It was finished in one cubit and had one helmsman and captain, namely Noah, and we read that all things on earth outside of it were destroyed. This church we venerate and this alone, the Lord saying through his prophet, "Deliver, O God, my soul from the sword, my only one from the power of the dog" (Psalm 21:21). He prayed for the soul, that is himself, the head, and at the same time for the body, which he called the one church on account of the promised unity of faith, sacraments and charity of the church. This is that seamless garment of the Lord which was not cut but fell by lot. Therefore there is one body and one head of this one and only church, not two heads as though it were a monster, namely Christ and Christ's vicar, Peter and Peter's successor, for the Lord said to this Peter, "Feed my sheep" (John 21:17). He said "My sheep" in general, not these or those, whence he is understood to have committed them all to Peter. Hence, if the Greeks or any others say that they were not committed to Peter and his successors, they necessarily admit that they are not of Christ's flock, for the Lord says in John that there is one sheepfold and one shepherd.

We are taught by the words of the Gospel that in this church and in her power there are two swords, a spiritual one and a temporal one. For when the apostles said "Here are two swords" (Luke 22:38), meaning in the church since it was the apostles who spoke, the Lord did not reply that it was too many but enough. Certainly anyone who denies that the temporal sword is in the power

French, and internal secular political strife that had besieged Italy continued. There was a brief return to Rome between 1367 and 1370 under Pope Urban V, but he reconvened his court at Avignon the following year. A general plea for returning the papacy to Rome came from many parts of Europe. Following the pontificate of Gregory XI in 1378, an Italian, Urban VI, was named pope, quite possibly under the pressure of demands from the Roman people. In less than a year, however, the curia was dissatisfied with Urban's leadership and asked the pope to step down. When Urban refused, Clement VII, a cardinal from Geneva who was a cousin of the French king, was elected to replace him. Clement was forced to withdraw from Rome and move the papal court back to Avignon. There were now two popes. This is the event that likely started the Great Schism (1378–1417). While it was certainly not historically unusual for there to be two rival claimants to the papacy (pope and anti-pope), this Rome-Avignon split caused a rift that lasted some forty years. The two courts existed side by side, with the Avignon popes being recognized in France, Spain, Scotland, Naples, Sicily, and parts of Germany while the Roman popes were acknowledged throughout northern and central Italy, much of Germany, Bohemia, England, Poland, Hungary, and Scandinavia. Abuses of power continued and church-related taxation became overwhelming. There were now two sets of cardinals, each connected to a pope.

SOURCES

C. M. Baron and C. Harper-Bill, eds., *The Church in Pre-Reformation Society* (Dover, N.H.: Boydell Press, 1985).

H. L. Kessler and J. Zacharias, *Rome 1300: On the Path of the Pilgrims* (New Haven, Conn.: Yale University Press, 2000).

G. Mollat, *The Popes at Avignon* (New York: Harper and Row, 1965).

Yves Renouard, *The Avignon Papacy* (New York: Barnes and Noble, 1994).

John Holland Smith, *The Great Schism 1378* (London: Hamilton, 1970).

a PRIMARY SOURCE *document*

of Peter has not paid heed to the words of the Lord when he said, "Put up thy sword into its sheath" (Matthew 26:52). Both then are in the power of the church, the material sword and the spiritual. But the one is exercised for the church, the other by the church, the one by the hand of the priest, the other by the hand of kings and soldiers, though at the will and suffrance of the priest. One sword ought to be under the other and the temporal authority subject to the spiritual power. For, while the apostle says, "There is no power but from God and those that are ordained of God" (Romans 13:1), they would not be ordained unless one sword was under the other and, being inferior, was led by the other to the highest things. For, according to the blessed Dionysius, it is the law of divinity for the lowest to be led to the highest through intermediaries. In the order of the universe all things are not kept in order in the same fashion and immediately but the lowest are ordered by the intermediate and inferiors by superiors. But that the spiritual power excels any earthly one in dignity and nobility we ought the more openly to confess in proportion as spiritual things excel temporal ones. Moreover we clearly perceive this from the giving of tithes, from benediction and sanctification, from the acceptance of this power and from the very government of things. For, the truth bearing witness, the spiritual power has to institute the earthly power and to judge it if it has not been good. So is verified the

prophecy of Jeremias [1.10] concerning the church and the power of the church, "Lo, I have set thee this day over the nations and over kingdoms" etc.

Therefore, if the earthly power errs, it shall be judged by the spiritual power, if a lesser spiritual power errs it shall be judged by its superior, but if the supreme spiritual power errs it can be judged only by God not by man, as the apostle witnesses, "The spiritual man judgeth all things and he himself is judged of no man" (1 Corinthians 2:15). Although this authority was given to a man and is exercised by a man it is not human but rather divine, being given to Peter at God's mouth, and confirmed to him and to his successors in him, the rock whom the Lord acknowledged when he said to Peter himself "Whatsoever thou shalt bind" etc. (Matthew 16:19). Whoever therefore resists this power so ordained by God resists the ordinance of God unless, like the Manicheans, he imagines that there are two beginnings, which we judge to be false and heretical, as Moses witnesses, for not "in the beginnings" but "in the beginning" God created heaven and earth (Genesis 1:1). Therefore we declare, state, define and pronounce that it is altogether necessary to salvation for every human creature to be subject to the Roman Pontiff.

SOURCE: Pope Boniface VIII, *Unam Sanctam*, Papal Bull, November 1302, in *The Crisis of Church and State 1050–1300*. Trans. Brian Tierney (Toronto: University of Toronto Press, 1988): 188–189.

Robert N. Swanson, *Universities, Academies, and the Great Schism* (Cambridge, England: Cambridge University Press, 1979).

FROM SCHISM TO REFORM

REFORMING COUNCILS. The need to resolve the Schism brought about new kinds of efforts to unify and reform the church. Dietrich von Neiheim, a bishop from Verden in Germany, who had spent much of his life in the service of the papacy, proposed a reforming union that might be brought forth by an authoritative council superseding the voice of the popes, with the power to determine the general direction the church should take. In 1409, the first council, the Council of Pisa, met and began a series of general reforms. The council tried to deal with the problem of the schism by deposing the two rival popes and electing a new one, hoping this action would cause a merger of the two Cardinal Colleges. Unfortunately, the plan did not work, and now all three

continued in power. A second council was then called at Constance in the southern part of Germany in 1414 by the Holy Roman Emperor Sigismund to continue the reforms started at the Council of Pisa. Of the three schismatic popes, John the XXIII (supported by the Pisan group) presided as the dominant papal figure. The council took three and a half years to finish its work, holding some 45 sessions. Representatives from all of Christendom were present: bishops, university representatives, leaders of religious communities, and secular rulers (observers even came from the Eastern churches). Among the matters addressed were the ideas of reform through regularly scheduled councils, the superiority of a council over the pope, and certain heresies that were gaining ground among the common people.

THE END OF THE SCHISM. The theologian Pierre d'Ailly played a significant role in the direction of the council. He suggested that in addition to completing the reforming work of Pisa, they might attempt again to heal the schism. He asked John XXIII, by far the strongest

a PRIMARY SOURCE *document*

THE CALL FOR A GENERAL COUNCIL

INTRODUCTION: At the time of the Great Schism, when rival popes held power in Avignon and Rome, Dietrich von Nieheim, the bishop of Verden in northern Germany, strongly advocated the convocation of a council to heal the disorder within the Western Christian Church. He suggested that the council should be called by the collective authority of churchmen representing the interests of Christendom. But he also suggested that an emperor, in time of need, had the authority to convene a general council.

Now take the pope. He is a man of the earth, clay of clay, a sinner liable to sin, a mere two days ago the son of a poor peasant. Then he is raised to the papacy. Does such a man, without any repentance of sin, without confession, without inner contrition, become a pure angel, become a saint? Who has made him a saint? Not the Holy Spirit, because it is not as a rule the office which confers the Holy Spirit but only the grace and love of God; nor his place of authority which may come to both the good and the wicked. Therefore, since the pope can be no angel, the pope as a pope is a man, and being a man he thus is pope: and as pope, and as a man, he can err. For a good many of them, as you may read in the chronicles, were not very spiritual. ... It is absurd to say that one mortal man should claim the power to bind and to loose from sin in heaven and earth, even though he may be a son of perdition, a simoniac, miser, liar, oppressor, fornicator, a proud man and arrogant, one worse than the devil. Therefore human judgment neither can nor ought to assume one to be a saint who in that Seat, by his evil deeds, proclaims the contrary. ...

These various members [of the Church], however, stand diversely—higher and lower—in its mystical body. They must all be brought back to the unity of the Church in a double manner: by obedience as well as by withdrawal. That is to say, they must obey the one universal and undoubted vicar of Christ, and they must by common consent and with a single will withdraw their obedience from these two or three contenders for the papacy who are a scandal to the whole Church. This withdrawal, as I have said, is binding uniformly on all Christians under the pain of mortal sin. For supposing the Universal Church, whose head is Christ, have no pope, the faithful dying in charity shall yet be saved. For when two or more compete for the papacy and when the truth of the matter is not known to the Universal Church, it is neither an article of faith, nor a deduction from one, that this man or that must be accepted as pope, nor can any faithful Christian be obliged to believe so. ...

Now, since the General Council represents the Universal Church, I shall speak my mind about the assembling of this Council. I have said elsewhere that when the issue is the reconstruction of the Church and the matter of the pope—whether to get him to resign, or whether he should be deposed for his evil living and the scandal in the Church—it by no means belongs to the pope, however sole, universal and undoubted he be, to call a General Council. Nor is it his place to preside as a judge, or to lay down anything concerning the state of the Church; but the duty belongs in the first place to the bishops, cardinals, patriarchs, secular princes, communities and the rest of the faithful. In equity no man of ill-fame can or may be a judge, particularly in his own cause. ... I tell you, the prelates and princes of the world must, under pain of mortal sin, call and summon [a Council] as quickly as they can; they must cite to it this pope and those who strive with him for the papacy, and, if they will not obey, must depose and deprive them. ... But is then such a Council, in which the pope does not preside, above the pope? Indeed it is: superior in authority, superior in dignity, superior in competence. For even the pope must obey such a Council in all things. Such a Council can limit the pope's power because to it, representing the Universal Church, are granted the keys to bind and to loose. Such a Council can abrogate the papal decrees. From such a Council there is no appeal. Such a Council can elect, deprive and depose the pope. Such a Council can make new laws and repeal old and existing ones. The constitutions, statutes and regulations of such a Council are immutable and cannot be dispensed from by anyone inferior to the Council. The pope cannot, nor ever could, issue dispensations contrary to canons made in General Councils, unless the Council, for good reason, specifically empowered him to do so. Nor can the pope alter the decisions of the Council, or even interpret them or dispense from them, for they are like Christ's gospels from which there is no dispensing and over which the pope has no jurisdiction. Thus there will come to the members the unity of the Spirit in the bonds of peace; thus we shall live in the Spirit and shall walk in the Spirit. ...

Therefore, if a General Council, representing the Universal Church, is anxious to see an entire union and to repress schism, and if it wants to put an end to schism and exalt the Church, it must before all else, following the example of the holy fathers our predecessors, limit and terminate the coercive and usurped power of the pope.

SOURCE: Dietrich von Nieheim, *The Union and Reform of the Church by a General Council*, 1410, in *Renaissance and Reformation 1300–1648*. 3rd ed. Ed. G. R. Elton (New York: The Macmillan Company, 1976): 16–18.

of the three schismatic popes, to step down and allow for the election of one pope. The voting blocks were divided into regions since it was feared that the Italian cardinals and bishops would easily dominate the election. John stepped down after considerable posturing on the part of his opponents and proponents. John's absence gave the council the opportunity to broach the issue of *conciliarism*, a supreme church authority which rested with the general council, not the pope. The decree *Haec Sancta* supported the authority of the council and all future general councils, demanding that all Christians (even the pope) adhere to its decisions. The council, in the name of the church, representing the interests of the church, would draw its authority from Christ. The council went on to depose the other two papal claimants, Gregory XII (almost ninety, who resigned) and Benedict XIII (who refused and died in exile). In November of 1417 the electorate, represented by 23 cardinals and delegates from the European nations, elected Martin V, to whom all would claim obedience. He presided over the remaining concordats and reform. Significant among the actions of the Council of Constance were the reforms on papal taxation, the ability as a body to call future councils with their own authority, and the resolution of the issue of transfer of bishops by Rome. There was also a condemnation of the heresies that had been propagated by the Englishman John Wyclif (who had died in 1384) and the Czech reformer Jan Hus.

JOHN WYCLIF. Although the Council of Constance resolved issues having to do with political power and the papacy, the concern over the preaching of John Wyclif was an indication that the public perception of church corruption ran much deeper. Wyclif had been a teacher at Oxford whose controversial theological views were condemned by the Blackfriars Council of 1382. Despite the fact that he himself held several absentee benefices (positions from which he received income by delegating the work to a curate), he had railed vehemently against clerical abuse. He felt that unrighteous church leaders had no religious authority whatsoever. In his work *On the Truth of the Holy Scriptures*, he wrote that scripture was the church's highest and truest authority. Wyclif had rejected the church's teaching on transubstantiation, calling it unscriptural, illogical, and unfaithful to the teaching of the early church. In 1380 he wrote his treatise *On the Eucharist*, which advanced a literal interpretation of the substances of bread and wine after consecration. He intimated that Christ was not corporeally present after the blessing, that the bread and wine remained physically unchanged. Wyclif also insisted that preaching was more important than the encounter of the sacraments. *On the Power of the Pope* claimed that the office of the papacy was completely of human origin. Wyclif also did not believe in the existence of purgatory. Toward the end of his life he began producing a vernacular translation of the Bible so that individuals who did not have an opportunity to learn Latin could read the Bible in English, without the need for a clerical intermediary.

LOLLARDRY. After Wyclif's death in 1384, his followers, often called the Lollards (literally the mumblers), continued his attempts to reform the church. Most of the early Lollards were Wyclif's students from Oxford, but soon the movement began attracting individuals from the lower and middle classes. The term Lollard also was applied to the Béguines and Beghards in the Netherlands. In England, Lollard preachers, based upon their reading of the Bible, went about the countryside protesting the corruption, abuse, and excesses of the clergy. During the reign of Richard II (1377–1399) a number of Lollard preachers were imprisoned, but the movement continued to grow. Not only did they have disdain for clerical wealth and power, but their indictments extended to members of the lay nobility as well. They also opposed clerical celibacy and use of the Latin Bible, and some even espoused free love and pacifism. In 1401, under Henry IV, a statute was passed making heresy a crime punishable by death. Lollards were quickly branded as heretical and many were executed, some being burned at the stake. While the movement was eventually driven underground, it took root in northern England, where it was embraced in certain circles through the sixteenth century. Wyclif's ideas proved to provide a fertile base for the eventual success of Protestant reformers. So powerful was the fear of Wyclif's reforms that in 1428 the bishop of Lincoln had his body exhumed and burned, and his ashes thrown into the river.

JAN HUS. In 1382 Wyclif's teachings had found their way from England to Bohemia by way of a member of the household of the English queen Anne, who was the sister of the Bohemian king Wenceslas IV. It was at the University of Prague that Wyclif's ideas gained popularity among Czechs, and it was there that Jan Hus came under its influence. In 1407, some 23 years after Wyclif's death, his theology was being discussed at Prague's university. Soon after, the teaching was condemned by the archbishop of that city. Hus, who was rector of the University of Prague, embraced many of Wyclif's ideas, however. He especially appreciated Wyclif's arguments concerning church authority and the fact that it should be limited only to those who were righteous enough to treat it responsibly. Hus began to preach aggressively against simony (the buying and selling of clerical offices) and the greed of the clergy. He

also openly criticized the sale of indulgences and believed that the church should always accommodate itself to be at the disposal of the faithful. In 1410, while the works of Wyclif were being burned, Hus's theological viewpoints were being scrutinized by the church. Although attempts were made to silence him, Hus continued to preach and even succeeded in rousing an angry mob to storm the archbishop's residence, which led to the burning of Hus's theological writings and his eventual excommunication in 1411. Throughout the next year, Hus continued to stir up revolt and was forced to leave Prague. Further condemnation of Wyclif's teachings was launched by the Council of Pisa in 1413; but this did not stop Hus, who all along wished for a reform of the church, never a break with it. To make his point, he even appeared at the Council of Constance in 1414, arguing that the church was founded on Christ and that the church hierarchy was a creation of mankind. While the conciliarists were in agreement with some of Hus's ideas, they found the majority of his teachings far too radical. Some thirty errors were pointed out in Hus's *De Ecclesia* ("Concerning the Church"). Hus denied teaching these heretical ideas but never formally denounced them. He was condemned and burned by a group of secular officials. It was said that a paper hat with the word "heretic" was placed upon his head during the fiery execution.

THE HUSSITE WARS. Upon news of Hus's death, riots broke out in Prague, and his followers, who became known as the Hussites, continued to preach throughout Germany and the Czech territories with both a religious agenda and one that supported Czech nationalism. A persecution of the Hussites, sometimes referred to as the Hussite Wars, took place between 1419 and 1436. According to the provisions created at the Council of Constance, Pope Martin was obliged to call subsequent councils to steer the direction of the late medieval church, and at the one in Basel, in 1433, a group of 300 Hussites came to debate the issue of the church's condemnation of their beliefs. The council at Basel turned into more of an academic debate, but like the previous council at Siena, suffered poor attendance. It was not until 1437 that a compromise was reached which brought an end to the religious revolts in the Czech region.

SOURCES

Margaret Aston, *Faith and Fire: Popular and Unpopular Religion, 1350–1600* (Rio Grande, Ohio: Hambledon Press, 1993).

Anthony Black, *Council and Commune* (London: Burns and Oates, 1979).

Eamon Duffy, *The Stripping of the Altars* (New Haven, Conn.: Yale University Press, 1992).

Anne Hudson and Peter Biller, eds., *Heresy and Literacy, 1000–1530* (Cambridge, England, and New York: Cambridge University Press, 1994).

Howard Kaminsky, *A History of the Hussite Revolution* (Berkeley, Calif.: University of California Press, 1967).

Anthony Kenny, *Wyclif* (Oxford: Oxford University Press, 1985).

FAMINE, THE BLACK DEATH, AND THE AFTERLIFE

FAMINE. Despite the divisive fourteenth-century power struggles that shook the papacy and church hierarchy, there were other events which even more gravely affected the religious outlook of all Christians. A devastating famine that ravaged Europe between 1315 and 1317 delivered its most violent shocks throughout much of northern Europe. Weather patterns during those years that produced extremely cold winters and rainy summers resulted in crop failures that left many urban dwellers without food. Significant failure of wheat crops in France caused prices to double. In England it was much worse, and livestock were forced to go with little food. Fish and meat became scarce, as the fishing industry in Holland was affected by the imbalance of trade, and diseases began to kill the cattle in England that had survived the famine. Germany may have fared the worst. The toll on human lives may have reached twenty percent of the northern European population, affecting the wealthy as well as the poor. The monasteries and convents were particularly devastated. In addition to large numbers of religious succumbing to starvation and related disease, properties had to be sold off at greatly reduced rates. There are harrowing stories of religious going without food in order to save the lives of their tenant farmers and families. Such devastation was thought, in part, to be linked to God's wrath upon sinful humanity. Thus, both in popular consciousness and in church doctrine, notions relating to death, heaven, hell, and purgatory became the subject of speculation. The famine, as such, never became a subject of religious and popular literature, but it created conditions of psychic unease that planted the seeds for the proliferation of literature concerning sin, human destruction, and death that would burst on to the scene during the period of the bubonic plague (1347–1350).

THE BLACK DEATH. As northern Europe barely began to recover from the famine, the bubonic plague known as the "Black Death" plunged much of Europe

into a state of widespread contagion. Some estimate that as many as one-half of Europe's population perished (possibly thirty million lives). As with the famine, no social class, station, faith, or age group escaped the ravages, save those in a few isolated cities who had the luck or foresight to quarantine themselves (a practice invented in Venice around 1360). The clergy were particularly concerned with ministering to the dying and, of course, burial. Sacramental anointing of the dying, extreme unction, had been reduced in the thirteenth century to a much simpler formula of forgiveness that could be administered by one priest, usually at the time near death. Given the necessity of such contact with the infected, it is surprising that any priests survived. Due to the resulting shortage of priests in England, the bishop of Bath gave permission to the people to confess their sins to laity, men or women, if no priest was available. Canons were appointed to the parishes of dead secular priests. There are also French accounts of cowardly parish priests fleeing their stations, leaving members of the religious orders with the task of ministering to the dying. It has been suggested that the friars were the division of religious with the largest number of afflicted. The cloistered groups were particularly susceptible to the plague once it entered their community. Hundreds of monasteries and convents were completely wiped out.

PERSECUTIONS. In the midst of this devastation, attempts were made to determine its causes. Aside from the scientific theories of physicians, irrational blame began to be directed toward certain social groups: Muslims in Spain, strangers in small villages, pilgrims, ethnic minorities, those who spoke foreign languages, lepers, and, most virulently, Jews. Sporadic and spontaneous attacks upon Jewish people were common throughout the time of the plague. They were most often accused of poisoning the wells and drinking water of Christians. Punishments ranged from imprisonment to burning. Accounts of mass incineration are documented in the German cities of Worms, Dresden, Stuttgart, Erfurt, Memmingen, Freiburg, and Lindau. Other murders took place in Speyer, Cologne, and Mainz. Clement VI called for the excommunication of Christians who persisted in persecuting the Jews. Pedro IV of Aragon attempted to give protection to the Jews of his kingdom and prosecuted Christian assailants. Efforts at stemming the violence were also made at Cologne and in Austria. Despite such attempts, the attacks upon European Jews did not substantially subside until after the plague ended.

THE FLAGELLANT MOVEMENT. The religious fervor accompanying the Black Death could be seen in a most extreme form in the practice of flagellation, self-administered whippings that were intended to punish the body as penance, both for personal sins and for the sins of mankind which were thought to have caused the plague. The flagellant movement had been going on for some time in the Middle Ages (dating to the twelfth century), when individuals punished their sinful flesh or brought it under control through the sting of the beatings. These inflictions were often done in public by groups connected to the movement, accompanied by procession and the singing of psalms. The earlier practices were condemned by church authorities, but during the bubonic plague they seem to have made a strong reappearance. Some believed the plague was signaling the end of the world, and groups of flagellants began to organize and march about Europe calling for general repentance. Processions of hundreds of flagellants are recorded, marching in twos, with crosses and purple banners (purple was seen as the color of penitence). The groups would often move into village squares, or to local churches, announced by the ringing of bells, strip off their outer hooded garments, lie upon the ground with outstretched arms (cruciform) and begin to take turns scourging one another, chanting as they proceeded. Their whips were made of leather thongs, and many brandished instruments with barbed metal tips. Spectators frequently were so moved by the emotional and disturbing scene that they themselves joined in the penance.

THE CULT OF THE AFTERLIFE. One outcome of the plague for most Europeans was a preoccupation with the afterlife. It was not an issue of whether or not there was an afterlife, since the need for hope amid daily experiences of loss assured the continuation of that expectation. But there were a number of different approaches to the question of how to maintain a spirit of hope and how to avoid dying without proper preparation of the soul. One development that occurred was the rise of treatises called *Ars moriendi* (literally "art of dying"), intended to prepare Christians for the act of death. These treatises taught *contemptus mundi*, the hatred of the goods of the world and an awareness of the transience of the flesh, illustrated in a form of popular poetry that asked the question *ubi sunt* ("Where are they?") of long lists of kings, queens, beautiful women, and heroes who are, inevitably, dead. Doctrines and popular notions of the world beyond included the notion of purgatory. Even in earliest medieval Christianity, prayers were regularly said on behalf of those who had died but whose souls were still awaiting eternal reward. Only a few heretical theologies dismissed the notion of purgatory: the Waldensian, the Cathar, and the Wycliffite. With so many people involved in some form of religious life, it was easy to see by contrast that spiritual perfection,

which must be the key to heaven, was not easy to attain. Hell was for the worst of sinners; purgatory was for the rest. The period of one's stay in purgatory depended upon the number of unrepentant venial sins that a person died with. If so many would be in the state of purgation from life's sins before entering heaven, there was need for prayers, devotions, and even strategies for making the stay less punishing. The theologian Peter Lombard in the twelfth century had addressed many of these issues, which were further considered by thirteenth-century philosophers and theologians such as William of Auvergne, Alexander of Hales, Bonaventure, Albertus Magnus, and Thomas Aquinas. A culminating statement came from the Council of Lyon in 1274, the year of Aquinas' death, and by the early fourteenth century, the beliefs were so widespread that they served as the basis for Dante Alighieri's *Divine Comedy* of heaven, hell, and purgatory. Thus, in the wake of the plague, prayers were said, masses were offered, and indulgences were earned or purchased to assist both self and loved ones with the arduous task of navigating the afterlife. Fraternal and guild organizations starting in the thirteenth century compiled lists of members needing prayer. Thousands of these confraternities existed throughout the thirteenth, fourteenth, and fifteenth centuries all over Europe. Protestant theologians during the sixteenth century would reject these beliefs.

SOURCES

Marcia Colish, "The Development of Lombardian Theology," in *Centres of Learning*. Ed. J. W. Drijvers and A. McDonald (Leiden, Netherlands: E. J. Brill, 2001).

David Herlihy, *The Black Death and the Transformation of the West*. Ed. Sam K. Cohn, Jr. (Cambridge, Mass.: Harvard University Press, 1997).

Rosemary Horrox, *The Black Death* (Manchester, England: Manchester University Press, 1994).

William Chester Jordan, *The Great Famine: Northern Europe in the Early Fourteenth Century* (Princeton, N.J.: Princeton University Press, 1996).

Jacques Le Goff, *The Birth of Purgatory* (Chicago: University of Chicago Press, 1986).

Philip Zeigler, *The Black Death* (London: Penguin, 1969).

MYSTICISM AND MODERN DEVOTION

AN AGE OF PERSONAL PIETY. The late Middle Ages witnessed a period of popular piety and mysticism that is quite unparalleled in Christian history. Ideas of service to others in the world combined with spirituality, which came on the heels of twelfth- and thirteenth-

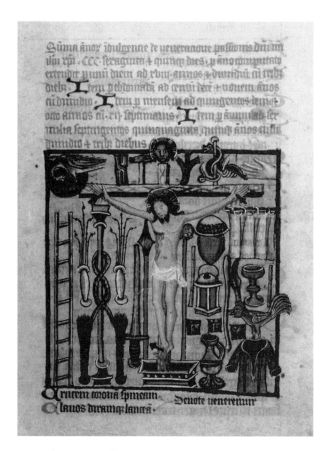

Arma Christi, book of hours, Oxford, Bodleian Library MS Rawlinson 553, 3r. **MASTER AND FELLOWS OF TRINITY COLLEGE, CAMBRIDGE.**

century monastic and religious reforms and found itself deeply imbedded in the fourteenth- and early fifteenth-century religious mindset. The search for a direct and personal communication with God, whether it was through mystical experience or a life of quiet inner contemplation of images (such as the *arma Christi* or the implements used to torment Christ, as in a miniature from a book of hours now in Oxford, England), seemed to replace the notion of conformity to institutional rituals. Like the religious reformers in the centuries before them, however, the proponents of this new kind of spirituality were often seen as bordering on the edge of heterodoxy—holding opinions at variance with established belief. Their desire for personal religious experience also prepared the way for the pre-reformation idea that the mediation of priests and sacraments was not the only way, and maybe not even the best way, for people to live meaningful Christian lives centered on a quest for spiritual perfection. Exactly what the mystics experienced is hard to grasp objectively. Their own writings report their personal ecstatic experiences which, whether real, imagined, or induced, have helped shape a broad tradition of spiritual understanding in the Latin Christian tradition.

MEISTER ECKHART. Germany seems to have been a center for mystical and spiritual activity in the late thirteenth and fourteenth centuries. Among those mystics whose ideas proved influential was Johannes "Meister" Eckhart (1260–1327). Eckhart was a leader in the Dominican Order whose studies of Thomas Aquinas and Albertus Magnus led him to reflect upon some of the more Neoplatonic elements of theology (relating back to the Greek philosopher Plato and his theories of the soul). Eckhart, during his later career, became absorbed in the notion of the soul's relationship to God. This led him to adopt ideas of the indwelling "spark" or spirit of God that not only allowed people a glimpse of the divine but was what truly made them "one" with the divine. He felt the soul could literally experience the Word of God dwelling within, and become that Word, just as Jesus became the Incarnate Word. This transformational mystical experience, quite unlike what the great twelfth-century mystics like Bernard of Clairvaux wrote about, appeared to eliminate the distance between God and people. Bernard's "affective" mysticism (focused on emotions rather than intellect) was grounded in humility and love, which is seen as the experience of God, since God is love itself. Bernard had believed that one came to know and love the self for the sake of God. But in Bernard's opinion, the self did not become a realization of the divine, as Eckhart seems to imply. This is what brought Eckhart into conflict with church doctrine, resulting in the condemnation of some 28 of his propositions by Pope John XXII in 1329.

MYSTICS IN GERMANY. One of Eckhart's disciples, another Dominican named Johannes Tauler (1300–1361), studied with Eckhart at Cologne and later became a preacher and spiritual advisor at Strasbourg and Basel. Like Eckhart, Tauler was also convinced that a "grounding" of God's image existed in the soul, but he felt that it was something that came from God and was not intrinsic to humans. He believed the return of the soul to its source in God was an operation of grace where Christians absorb something of God into themselves. Another of the great German Dominican mystics was Henry Suso (1295–1366). Henry was also part of the Cologne school and defended Eckhart during his condemnation. Suso lived as an ascetic and later launched his career in preaching and ministry. His approach to the mystical experience was expressed in the idea of the uncreated and created wills of God and humans. He wrote treatises called the *Little Book of Truth* and the *Little Book of Eternal Wisdom*, meditations on Christ's passion and guides to mystical questions which gained wide popularity. Some of his treatises were translated into other languages and were beautifully illustrated. All three of the preced-

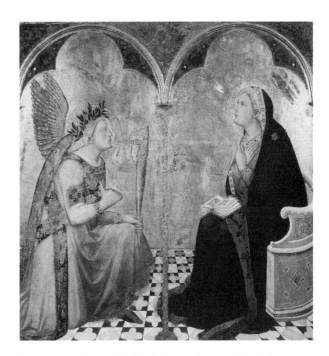

Annunciation to the Virgin, Ambrogio Lorenzetti, Pinoteca Nazionale di Siena, Italy, 1340. THE ART ARCHIVE/PINACOTECA NAZIONALE DI SIENA/DAGLI ORTI.

ing German Dominican mystics were spiritual advisors to groups of Dominican nuns and Béguines. The particular brand of German mysticism that emerged from these groups was grounded in personal piety, vernacular preaching, and the care of souls. Eckhart and his disciples also wielded much influence over the religious and lay mystics of the Rhineland who called themselves "The Friends of God." This group produced the late fourteenth-century work *Theologica Deuch* which had profound effects upon sixteenth-century reformers like Martin Luther, the Anabaptists, and the Spiritualists, including Caspar Schwenkfeld and, much later, the Quakers, who espoused a mystical form of Christianity which emphasized "following an inner light."

ENGLISH CONTEMPLATIVE MYSTICS. England also produced its own brand of fourteenth-century mystics who were more inclined to the eremitical and contemplative lives, unconnected to religious orders, away from the world (quite different than the German Dominicans). Richard Rolle (1300–1349) became a hermit at the age of eighteen and began to write about his mystical experiences. His most distinctive writings, in a work called *Incendium amoris* (The Fire of Love), concern his physical sensations of spiritual union with God, what he refers to as heat (actual warmth in his body), sweetness, and song. He also wrote *De amore dei contra amatores mundi*, which compares the love of God with the transient pleasures of this world. One of Rolle's followers,

Walter Hilton, who died in 1396, wrote *The Scale of Perfection*, which was not published until 1494. Hilton's work describes the restoration of the defaced image of God on our souls through faith and feelings, hindered by a mystical darkness and attachment to earthly things, aided by the spirit. Both Rolle and Hilton worked with religious communities at the very end of their lives—Rolle directing Cistercian nuns at Hampole, and Hilton living with Augustinian canons. Most likely one of the greatest women mystics of the Middle Ages, Julian of Norwich (1342–1416), also lived in England during this period. She took up the life of an anchoress outside the walls of St. Julian's Church in Norwich. On 8 May 1373, after taking ill and being near death, she reported receiving a series of fifteen revelations lasting almost five hours. Many of these were visions of the crucified Christ. She made a complete recovery in a little over a week. It was not until some twenty years later, reflecting upon these experiences, that she completed *Revelations of Divine Love*, also called *The Showings*. Much of her spirituality is intertwined with her visions of Christ's Passion and the Trinity. In God's love lay the answers to all of the world's difficulties, including the solution to the problem of evil. She felt that evil was linked to the human will and was the clear absence of the divine reality. Human ability to desire to glimpse the divine love was an indication of God's true mercy.

AN ITALIAN MYSTIC. St. Catherine of Siena (1347–1380), a Dominican tertiary, lived a different type of spiritual and mystical life. At an early age it is reported that she began mortifying her flesh, and at sixteen she entered a Third Order group of Dominicans. She spent most of her time in secluded contemplation at her family's home. A vision persuaded her to begin doing apostolic work in the world. Catherine assembled about her a devoted group of religious and began employing her gifts of infused prayer (emotional prayer over an extended period) to bring about a devotion to the Precious Blood and a greater understanding of the reconciliation of sinners. Her reputation as a mystic grew to the point that she was forced to defend her activities in front of a Dominican General Chapter in 1374, at which time she was cleared of suspicion of heresy. In 1376 Catherine made a journey to Avignon to plead for a return of the papacy to Rome. She is most famous for her series of letters and spiritual instructions, which were dictated to her scribes.

DEVOTIO MODERNA. One of the most expansive ideological developments in late medieval spirituality was initiated in the Netherlands by Gerard Groote (1340–1384) and one of his followers, Florentius Radewijns (1350–1400). This movement, later known as the *Devotio Moderna* (modern devotion), was based upon the philosophy of Groote, a university master, who renounced his wealth, which had been derived from church benefices, to become a religious reformer living a life of piety and simplicity. Radewijns' and Groote's work strongly influenced three early reform communities: the Deventer groups of both Sisters and Brothers of the Common Life, and the community of Augustinian canons at Windesheim. The idea was for groups of Christians to live in common, not separating themselves from the secular world, carrying on shared religious observances, with no vows, hopefully preventing them from falling into the institutional traps that had snared the monastic reform movements. Many laypersons were attracted to this lifestyle, and branch communities began to spring up throughout western Germany. Some who desired an existence with more structure and monastic influences, yet grounded in Groote's philosophy, joined a tertiary Franciscan group that had formed a chapter at Utrecht. After Groote's death the groups were recognized by Pope Gregory XI and continued to spread their ideology throughout Germany and the Low Countries. Radewijns' Brothers of the Common Life were organized in his vicarage in Deventer where he was a parish priest. They spent time copying books, distributing pamphlets, and founding schools throughout the Netherlands, providing individuals with a general education that was free and of surprisingly good quality. Thomas à Kempis, Pope Hadrian VI, Erasmus, and Nicholas of Cusa were all famous products of this educational system. In 1387 a congregation adhering to the lifestyle of Augustinian canons was founded at Windesheim. Their constitution was approved by Pope Boniface IX in 1395, and three other Dutch monasteries soon joined them. The Windesheim canons soon became a full monastic order and developed into the most ardent proponents of the Devotio Moderna. They encouraged the laity toward frequent reception of the Eucharist as well as the devotion and veneration of the Blessed Sacrament. Thomas à Kempis, a member of one of the Windesheim daughter houses at Agnietenberg, is credited with writing the great spiritual work *Imitation of Christ*. In this work he suggests that all Christians are pilgrims in this life and are but on a journey to the next. *Imitation of Christ* appealed to people living simple lives in the world. It was soon translated into the vernacular (Dutch in 1420 and German in 1434). There were few other books from the fifteenth century that had such an impact upon lay spirituality.

SOURCES

Harvey Egan, *Christian Mysticism* (Collegeville, Minn.: Liturgical Press, 1992).

Jeffrey Hamburger, "The Use of Images in the Pastoral Care of Nuns: The Case of Heinrich Suso and the Dominicans," *Art Bulletin* 71 (1989): 20–46.

————, "The Visual and the Visionary: The Image in Late Medieval Monastic Devotions," *Viator* 20 (1989): 161–182.

John Van Engen, *Devotio Moderna* (New York: Paulist Press, 1988).

Henk van Os, *The Art of Devotion in the Late Middle Ages in Europe*. Trans. Michael Hoyle (Princeton, N.J.: Princeton University Press, 1994).

C. Trinkaus and H. Oberman, *The Pursuit of Holiness in Late Medieval and Early Renaissance Religion* (Leiden, Netherlands: Brill, 1974).

Barbara Tuchman, *A Distant Mirror: The Calamitous Fourteenth Century* (New York: Ballantine, 1978).

SEE ALSO *Philosophy: The Retreat from Reason: Mysticism*

SIGNIFICANT PEOPLE
in Religion

THOMAS BECKET

1120–1170

Archbishop of Canterbury
Diplomat
Martyr

COMPANION TO THE KING. Thomas Becket was the son of Norman settlers who lived in the city of London. His father was a merchant who traveled among the circles of French-speaking Norman immigrants. The name "Becket" is likely a nickname, possibly meaning beak or nose, which was given to his father. As a boy, Thomas studied with the Augustinian canons at Merton Priory and later at the cathedral school of St. Paul. Some suggest that as a young man Becket studied in Paris under Thomas Melun. Around 1141 he came into the service of Theobald, the archbishop of Canterbury, whose household companions included several future bishops. Thomas was later sent to study law at Bologna and Auxerre, likely entering into minor clerical orders along the way, and eventually becoming a subdeacon. Theobald consecrated Thomas as an archdeacon at Canterbury in 1154, and he continued in the service of the bishop's household where he had been for nearly ten years prior. Soon after, the young king Henry II's backers chose Thomas for the position of chancellor of the realm, which was essentially a secular position as royal counselor. While working in the English court, Becket developed an extremely close friendship with the king, accompanying him on hunting expeditions and even a successful military campaign in Aquitaine, where Thomas commanded an army of hundreds of knights and thousands of mercenary soldiers. Upon the death of Archbishop Theobald in 1162, Henry asked Thomas to take the position of archbishop of Canterbury. It may have been Henry's wish that his close friend hold both positions of chancellor and archbishop since the king then would be able to exert significant influence over the English church.

A SURPRISING CONVERSION. To Henry's surprise, upon his friend's ordination to the priesthood in June of 1161, and his elevation to the archbishopric one day later, Thomas resigned his post as chancellor. He quickly began to take his new office very seriously. It is said that he lived an almost ascetic lifestyle, rising early to pray, enduring humilities like washing the feet of the poor, wearing a purposely uncomfortable hair shirt, scourging himself out of indifference to his flesh, studying the scriptures, and surrounding himself with learned churchmen. It was not long before he came into conflict with the king over the rights and authority of the church, as well as the notion of church taxation. One particularly distasteful battle took place over a document known as the Constitutions of Clarendon. Issued by Henry II near Salisbury in 1164, it reasserted the church-state customs and relationship conducted during the time of Henry's grandfather, Henry I (r. 1100–1135). Issues concerning the judgment and punishment of clerics by secular powers, freedom of the bishops to travel outside the realm without royal consent, the requirement that the church obtain the king's permission before excommunicating his tenants, and the crown's entitlement to income from vacated church lands were among the more vexing statutes. In essence, these propositions gave the king specific and, as Thomas saw it, excessive legal authority over the church. Henry demanded that the bishops swear oaths to the effect that they would uphold the Clarendon conditions. Thomas reluctantly did so, along with other bishops present. However, Thomas later regretted the decision when Pope Alexander III openly denounced the Constitutions of Clarendon. Thomas felt obliged to uphold the opinion of Rome and, after being found guilty at a public trial, escaped England and fled to France where he lived in exile for six years. His years living as a penitent monk in Cistercian and Benedictine houses were not comfortable, especially since he had little support from his fellow bishops or even from Pope Alexander,

who was distracted by the claims of an anti-pope. After several attempts at reconciliation and the threat of interdict issued by Alexander III, Thomas and Henry agreed to a "rhetorical" compromise, which in no way actually modified either man's position. Becket returned to England in 1170 and resumed his role as archbishop of Canterbury. But less than a month after his arrival, disgruntled elements in the royal circle inflated issues related to Thomas's excommunication of several bishops who had acted in defiance of Rome, on the king's behalf, and were being punished by Thomas. Hearing Henry II's displeasure over another confrontation with Thomas, four of the king's knights took the initiative to rid the realm of the troublesome cleric for good. After an argumentative exchange in Thomas's chambers, the knights followed the archbishop into Canterbury Cathedral, where they attacked and killed him.

SAINTHOOD AND KINGLY PENANCE. Upon news of Thomas Becket's murder, Pope Alexander III went into mourning, then placed an interdict (exclusion from sacraments) upon King Henry II. At Sens, the French archbishop imposed interdict over the inhabitants of all the king's lands on the European continent. Henry was eager to make peace with the church, and at Avranches in 1172 conceded to give in to the notion of appeals to Rome in all cases of church disputes. He also restored all property to the archbishopric of Canterbury and made a vow to go on a crusade to the Holy Land. Henry even agreed to the exemption of clerics from the jurisdiction of secular courts. In 1173, just two years after his death, Thomas was canonized as a saint of the church. The cathedral at Canterbury where he was murdered became a famous pilgrim site, one even visited by the penitent Henry II himself in July of 1174. It is said that he walked barefoot from the city gates to the tomb of his former friend, admitted his guilt in the archbishop's death, and submitted himself to some 240 lashes administered by the monks from Canterbury Cathedral. As in the case of Henry IV of Germany during the investiture crisis (some 100 years earlier), a monarch's act of penitence and humility, whether calculated or not, demonstrated the power of devotion that was held by Christians in Europe, even in the face of dominant secular authority.

SOURCES

Frank Barlow, *Thomas Becket* (Berkeley, Calif.: University of California Press, 1986).

Anne Duggan, *The Correspondence of Thomas Becket* (Oxford, England: Clarendon Press, 2000).

David Knowles, *Thomas Becket* (London: A. and C. Black, 1971).

GREGORY VII
1021–1085
Pope

A SKILLED ADMINISTRATOR. Gregory VII served the church in Rome for many long and distinguished years before becoming pope in 1073. Consequently, he is more often than other popes referred to by his given name, which was Hildebrand. He was born to a poor family in Tuscany and came to Rome as a boy to be educated at the monastery of St. Mary on the Aventine Hill. Although it has been suggested that he spent his early days as a monk, scholars now think that unlikely. Hildebrand served under seven different popes before his own elevation. He was the chaplain of Pope Gregory VI and even accompanied him in exile to Germany during 1046 and 1047. Upon Gregory VI's death, Hildebrand remained in Germany and worked with reform groups to create a more serious, committed, and spiritual outlook among European clergy. He returned to Rome in 1049 to work under Leo IX as an administrator of papal estates and properties (called the Patrimony of St. Peter). Hildebrand guided other papal successors through their pontificates (such as Nicholas II and Alexander II) and may even have been responsible for helping them get elected. There is little doubt Hildebrand came to influence a crafting of the legislation for the process by which cardinals eventually came to vote on papal successors. In 1059 he was given the title Archdeacon of the Roman church and also held the title of Chancellor of the Apostolic See. His election as pope in 1073 came as no surprise since he had held major administrative posts in Rome for some thirty years prior.

A MAJOR REFORMER. Upon his elevation to the Roman bishopric, Hildebrand began to work more aggressively to reform the morality of the church and clergy by issuing decrees against simony (the buying and selling of clerical offices), clerical participation in sexual activity, and lay investiture (conferring of authority to a church official by a secular prince or landowner). *Dictatus Papae*, which has been attributed to Gregory, declared Rome's supreme authority in all religious matters. Monarchs reacted to these changing ideas of church authority in varying ways. In England, William the Conqueror saw to it that all of the Gregorian reforms, with the exception of rules against investiture, were rigorously carried out. In France, despite King Phillip I's opposition, the bishops complied. Henry IV of Germany, however, posed a major stumbling block for Gregory's vision, the most important results of which were to raise the

moral awareness of the clergy, create a more unified and powerful church governance, and establish an organized administrative system of papal legates. These changes set in place the ideology for the new reforming monastic movements beginning in the late eleventh century, the rebirth of Roman legalism linked to canon law, the condemnation of growing materialism in European society, and even the new theological and scholastic attitudes of the time. Moreover, he created an atmosphere of dialogue that eventually led to some measure of agreement on the vexed question of the existence of the "real presence" in the Eucharist (Christ's actual presence in the elements of bread and wine). It was from the seeds of that resolution that the twelfth-century doctrinal view of transubstantiation would emerge. Although his effort to unite Eastern and Western Christianity were unsuccessful, only two other bishops of Rome, Gregory I (r. 590–604) and Innocent III (r. 1198–1216), could be said to have had as great an impact on the future of medieval Western Christianity.

SOURCES

H. E. J. Cowdrey, *Gregory VII* (Oxford, England: Clarendon Press, 1998).

I. S. Robinson, *Henry IV of Germany* (Cambridge, England: Cambridge University Press, 1999).

———, *The Papacy 1073–1198* (Cambridge, England: Cambridge University Press, 1993).

Brian Tierney, *Gregory VII: Church Reformer or World Monarch?* (New York: Random House, 1967).

INNOCENT III

1160–1216

Pope

SECULAR INTERVENTIONS. Innocent III was born Lotario de Segni to a noble family and was educated at Paris and Bologna. As a young cleric, he rose through the ranks of the papal service, becoming a cardinal in 1190 and being elevated to the papacy in 1198 upon the death of Celestine III. It is interesting to note that Innocent was not yet ordained a priest at the time of his election. His strength lay in his ability to intervene effectively in secular affairs, and it has been suggested that no pope in the entire medieval era had a greater impact on the period in which he lived. Innocent reduced the size of the papal curia (the court or administrative body), wresting it from the grasp of Italian secular politics. He also was able to restore papal territories that had been lost over time to the Holy Roman Empire. Interventions in several conflicts over disputed succession to the Ger-

man throne were also among the accomplishments of Innocent. Examples of involvement in major European church and state politics include his interaction with the emerging kingdoms on the Iberian Peninsula, the struggle for the conversion of eastern Europe to Christianity, and settlement of political disputes involving Bosnia, Bulgaria, and Hungary. Above all, he sought to extend the powers of the bishop of Rome. Innocent was the first pope to employ the title "Vicar of Christ," which implies the ability to act as Christ's representative on earth. This is certainly a testament to the broad extent of his ecclesiastical jurisdiction.

MAJOR ACHIEVEMENTS. Another matter concerning spiritual and temporal powers which drew considerable attention during his reign was Innocent's intervention in the issue of the succession of the archbishop of Canterbury in England. After declaring the election of 1205 invalid, Innocent placed his own candidate, Stephen Langton, in office after overriding separate decisions about candidacies by both the local bishops and King John. John's failure to cooperate in the matter resulted in the entire kingdom of England being placed under an interdict which limited reception of the sacraments by all of the English people. Irreconcilable positions between crown and church resulted in the king's excommunication (just prior to his capitulation in 1211). After a series of political twists involving Innocent's revocation of Magna Carta, John finally took the position of accepting the pope as his overlord. Possibly the crowning achievement of Innocent's pontificate was the fact that he presided over the Lateran Council of 1215. This massive gathering of clergy made major reforms to the medieval church, possibly marking it as the most important council of the entire Middle Ages. Nearly every bishop from the Catholic territories, some 25 churchmen from the Latin East (including Maronite bishops), representatives of canons from every cathedral chapter, the heads of the major religious orders, as well as secular representatives of the major kingdoms attended. Literally thousands of participants were summoned to the council. Most of the seventy or so decrees that were drafted by Innocent and his curia were not debated, but presented to the church. The majority of these decrees (or canons) involved pastoral care and the reform of the clergy, including their careful education by the bishops. There were also several crusades during his tenure, including the failed Third Crusade and the successful campaign against the Albigensian (Cathar) heretics. Innocent's approval of the Franciscan and Dominican orders of friars proved to be of major significance to the growth of ministry and education for the church in the centuries to follow.

SOURCES

Brenda Bolton, *Innocent III: Studies on Papal Authority and Pastoral Care* (Brookfield, Vt.: Variorum, 1995).

John C. Moore, *Pope Innocent III (1160/61–1216): To Root Up and to Plant* (Leiden, Netherlands; Boston: Brill, 2003).

———, ed., *Pope Innocent III and His World* (Brookfield, Vt.: Ashgate, 1999).

James Powell, ed., *Innocent III: Vicar of Christ or Lord of the World?* (Washington, D.C.: Catholic University of America Press, 1994).

Jane Sayers, *Innocent III: Leader of Europe 1198–1216* (New York: Longman, 1994).

MECHTHILD OF MAGDEBURG

1212–1281

Mystic
Spiritual writer

A VISIONARY BÉGUINE. Mechthild of Magdeburg was a German spiritual writer as well as a great mystic of the thirteenth century. She came from a noble Saxon family but rejected her heritage for an existence of simplicity and prayer. Mechthild joined a Béguine community at Magdeburg, devoting herself to a life filled with penance and humility. Like another of the great Béguine mystics, Hadewijch of Antwerp, she saw herself as a vessel of divine inspiration. Mechthild believed she had received the ability to speak, as inspired by God, directly from her visions of ecstasy, led by a charismatic spirit. One of her common themes was the notion that from weakness comes strength. Like other Béguines, she saw that a life lived in imitation of Christ was something open to all Christians, not just clerics and individuals in orders. Her prophetic calling was viewed as a transcendent communion with the love of God.

A THREAT TO CHURCH AUTHORITY. Like the Cistercian abbot Bernard of Clairvaux, Mechthild employed the image of bride and bridegroom from the Old Testament Song of Songs to convey her spiritual union. Because of her association with the secular world, it was also permissible for her to use the language of courtly love in her writings. Between 1250 and 1269 she produced a book about her visions entitled *Das Fliessende Licht der Gottheit* (Outflowing Light of the Godhead). The work was written in bold poetic style and became quite influential on subsequent German medieval mystics. Mechthild, like Marie d'Oignies, was not afraid to point out the prevalent immoral activity of the clerics that she saw around her. She drew great criticism from the male-dominated church, both for her freedom of expression and for her claims to receive direct divine communication. The period in which the Béguines operated was clearly a time when clerics were threatened by the profound piety of holy secular women, particularly when they admitted to having mystical experiences or direct illuminations. Not only did they undermine the authority of the hierarchy, but also it was felt that their lack of formal theological training might lead them into some type of heresy. The anti-mendicant Parisian master William of Saint-Amour once wrote that the laity stood in constant need of perfection through the ministry of the clergy. Since the Béguines were not under the authority of a religious order or secular clerics, the direction of their spiritual leadership and influence was seen as unregulated, uninformed, and unprofessional. Eventually, as with many other outspoken Béguines of the thirteenth and fourteenth centuries, Mechthild was pressured into retreating to a convent. At the age of 62, she entered the Cistercian house at Helfta, where she continued writing and added one more volume to her work.

SOURCES

Marie Conn, *Noble Daughters* (Westport, Conn.: Greenwood Press, 2000).

Bernard McGinn, ed., *Meister Eckhart and the Béguine Mystics: Hadewijch of Brabant, Mechtild of Magdeburg, Marguerite Porete* (New York: Continuum, 1994).

Saskia Murk-Jansen, *Brides in the Desert: Spirituality of the Béguines* (Maryknoll, N.Y.: Orbis Books, 1998).

MARIE D'OIGNIES

1177–1213

Mystic
Founding mother

A SPIRITUAL HEALER. Marie was born into a noble Flemish family near Liège in the Low Countries and was one of the first women to be recognized as a Béguine. Although she was married at fourteen, she and her husband did not consummate their marriage, but rather worked together in the care of the sick. At thirty, she renounced her wealth and retired to a cell at an Augustinian monastery, devoting herself to an ascetic, Christ-centered life in which she experienced ecstasies and visions, even to the point of accomplishing a miraculous three-day feat of incessant chanting and scriptural exegesis (critical interpretation). She was particularly well known as a spiritual healer, and her reputation inspired the growing groups of urban laywomen who were beginning to assemble together in parts of Germany and

the Lowlands to attempt to live holy lives in austere communities, but without taking formal vows as required within the official structure of recognized convents and monasteries. She is thus recognized as a founding mother of the movement of spiritual women know as the Béguines.

AN EXAMPLE OF A VIRTUOUS LIFE. The story of the life of Marie d'Oignies was written by Jacques de Vitry, who had relayed stories of virtuous Béguines to the papal curia. Jacques de Vitry had begun his career as an Augustinian canon and for one year was a neighbor and confessor to Marie, along with being a disciple of her spirituality. His biography of Marie d'Oignies was written to show the heretics of Languedoc an example of what a truly holy woman's life should be. Jacques wrote of Marie's extreme piety, her disdain for her fleshly self, and the inspiration that he drew from her criticisms of his own life of spiritual inadequacy. When Jacques became bishop, he used his stories to help the Béguines gain from Rome some type of temporary recognition, although he could not get them formally approved as an order. Gregory IX's bull *Gloriam Virginalem* did later recognize these chaste virgin women of Germany and afford them papal protection.

SOURCES

Marie Conn, *Noble Daughters* (Westport, Conn.: Greenwood Press, 2000).

Thomas de Cantimpré, *Supplement to the Life of Marie d'Oignies.* Trans. Hugh Feiss (Saskatoon, Canada: Peregrina, 1987).

Jacques de Vitry, *The Life of Marie D'Oignies.* Trans. Margot H. King (Saskatoon, Canada: Peregrina, 1986).

Saskia Murk-Jansen, *Brides in the Desert: Spirituality of the Béguines* (Maryknoll, N.Y.: Orbis Books, 1998).

DOCUMENTARY SOURCES
in Religion

Benedict of Nursia, *The Rule of St. Benedict* (early 6th century)—This set of guidelines for monastic living, written by the abbot of Monte Casino for his own monastery and possibly some neighboring houses, focuses on humility and obedience. Promoting stability and stressing the need to give up all personal property, it offers practical and moderate advice for a community of monks designed to function almost as a family under a fatherly abbot. This rule was the most widely adopted by monasteries throughout medieval Europe from the ninth century onward.

St. Bernard of Clairvaux, *Sermons on the Song of Songs* (c. 1153)—This unfinished work by the first leader of the Cistercian Order follows the medieval exegetical scheme of fourfold meaning of Scripture: literal, allegorical, moral, and mystical. Themes range from behavior of monks to the mystical union between the Bridegroom (Christ) and the Bride (the Church).

St. Bonaventure, *Itinerarium Mentis in Deum* (The Journey of the Mind into God, 1259)—This Franciscan theologian, philosopher, and leader of his order (born John of Fidanza, c. 1217–1274) took a more traditional view than Thomas Aquinas of the relationship between human reason and the mysteries of God. In this work he puts forth the notion that human wisdom meant nothing or was a waste of time when compared to the profound mystical understanding that could be imparted by God to those of His faithful who were receptive to such enlightenment.

Boniface VIII, *Unam Sanctam* (1302)—This papal bull, named after its opening statement, claimed that there was "One Holy, Catholic and Apostolic Church" outside of which eternal salvation did not exist. The pope was seen as supreme head of the church, and to reject his authority was to sever ties with the institution to which God had granted spiritual authority. In short, obedience to the pope was necessary to salvation. While this statement was not universally accepted by all Christians and it really was not a new dictum, it did represent a summation concerning the church's vision of papal authority.

St. Francis of Assisi, *Canticle of the Sun* (1225)—This work is a hymn of praise to God's creation and the revelations of the divine that are found in nature. Traditionally thought to have been composed at the Garden of the Poor Clares at San Damiano, the poem was not written in Latin but in the Umbrian dialect of the Italian people. Francis encouraged his friars to recite or sing it while they were out preaching, and it is often mentioned in medieval writings concerning Franciscan spirituality. Many scholars now think that the second part of the hymn, dealing with the notions of peace, pardon, and death, was composed during a later period, possibly before the death of Francis.

Gratian, *Decretum* or *Concord of Discordant Canons* (early twelfth century)—The man called "the father of the science of canon law" (now believed to be two separate people) wrote this work, which had as its purpose the reconciliation of diverse and often contradictory thought on church law through the application of dialectic. It is divided into a treatise on law, a series of hypothetical cases, a tract on penance, and a sacramental tract.

Gregory of Palamas, *Heihasmos* or *Triads in Defense of the Holy Hesychast* (c. 1338)—This theologian and monk of Mount Athos became immersed in the Hesychast tradition of mystical prayer. He wrote this famous treatise against Barlaam, a Greek Calabrian monk who supported the notion that God was unknowable. Gregory contended that it was possible for humans to experience the Divine Light. While he believed that God's essence might be unknowable, his energies—that is, the reality of God himself—are in all things and can be experienced and visualized by people in a direct sense through the workings of God's grace.

Hildegard of Bingen, *Scivias* (c. 1151)—One of the first medieval women to write about theology and Christian spirituality, Hildegard (1098–1179) became widely known during her own lifetime. Her prophecies and visions were written down in a three-volume Latin work, the *Scivias*, often translated as "Know the Ways." The work includes some 26 visions, a number of which were composed in poetry or later set to music. Hildegard used images to express spiritual concepts and discussed a range of topics from the Fall of Humanity to depictions of the institutional church, as well as renderings of the end of the world.

Julian of Norwich, *The Showings* (c. 1373–1393)—This work consists of the recounting and interpretation of a series of ecstatic revelations of the Passion of Christ and the Holy Trinity received in 1373 by Julian, an anchoress of Norwich. She completed the work some twenty years after the revelations took place, recounting her lifelong meditation upon the experience. Julian's writing on the mystery of faith and the life of prayer became a classic, reprinted in numerous fifteenth-century devotional works, where it served to emphasize the central place of God's love as the root of spiritual growth, determination, and perseverance.

Peter Lombard, *Four Books of the Sentences* or *Quattuor libri sententiarum* (1155–1157)—This comprehensive work arranges the opinions (*sententiae* in Latin) of the church fathers, especially Augustine, into a system with a logical order of development. It was legislated into the curriculum of all theology students at the University of Paris in 1215 and remained there until the sixteenth century.

Summa Cartae Caritas or *The Charter of Love* (twelfth century)—This important charter laid out the constitution of the Cistercian Order and expressed a departure from the relationship between houses in the Benedictine Order, particularly as practiced in the tradition of Cluny. The document was said to have first been presented to Pope Callixtus II in 1119, outlining the autonomy of Cistercian houses, their system of visitations by abbots of their motherhouses, and the call for yearly meetings or General Chapters, where monks would meet to decide collectively upon their order's legislation and governance. The document was subsequently revised during the early Cistercian period and may have reached a final form around the middle of the twelfth century.

Thomas Aquinas, *Summa Theologiae* (before 1273)—This massive statement of the whole of Christian theology is divided into three parts treating God, God's relations with humanity and humanity's relations with God, and Christ and the Sacraments. This work became the basis of medieval clerical education and is still recognized today for its system and clarity.

Thomas à Kempis, *Imitation of Christ* (c. 1418)—This manual of spiritual devotion was written by an ascetical monk from the reform house of Zwolle, a daughter house of Windesheim. Thomas was influenced by the tradition of the Brethren of the Common Life and directed this work toward achievement of a life of spiritual perfection based upon the Christ as its model.

Urban II, *Clermont Sermon* (27 November 1095)—This is the speech that Pope Urban gave in support of the First Crusade at the Council of Clermont. There are actually five surviving versions of the speech, all of which put forth the principles and justification for crusading that would set the theological tone relied upon by churchmen in their promotion of subsequent campaigns.

THEATER

Carol Symes

IMPORTANT EVENTS
in Theater

814 Emperor Charlemagne dies. Under his auspices, numerous innovative programs are undertaken that contribute, directly and indirectly, to the development of medieval theater and the preservation of ancient Roman plays.

c. 825 Amalarius, bishop of Metz (778–850), expresses concern over the overtly dramatic nature of the Mass, indicating that he views the devotional practices of the medieval Christian Church as inherently theatrical.

c. 850 Heroic poems in many European languages have already been written and performed, notably the Anglo-Saxon *Beowulf* and the Germanic poems that will later contribute to the *Nibelungenlied*.

c. 900 Evidence shows that many European monasteries, like that of Saint-Gall in Switzerland, are developing new and dramatic approaches to worship.

c. 950 Revivals and imitations of ancient Roman comedy are being performed.

c. 960 King Edgar of England complains that the monasteries of his realm are so decadent they are being publicly mocked by professional actors.

c. 975 Ethelwold, bishop of Winchester, promulgates the *Regularis Concordia* (A Harmony of the Rules) for use in the Benedictine monasteries of England, including instructions for the performance of liturgical drama.

The Easter sequence built around the question *Quem queritis in sepulcro?* ("Whom do you seek in the sepulchre?") is already central to the liturgical re-enactment of Christ's Resurrection.

c. 1002 Hrotsvit, a nun in the imperial abbey of Gandersheim (Germany), dies. Her Christian Latin comedies borrow the techniques of the Roman playwright Terence.

1066 Portions of the Old French heroic poem *The Song of Roland* are performed by a minstrel prior to the victory of William the Conqueror at the Battle of Hastings in England.

c. 1080 William IX, duke of Aquitaine and one of the first troubadours, dies. His songs are composed in his native Occitan (southern French) dialect.

c. 1090 The earliest liturgical drama to make use of the vernacular, a play called *Sponsus* (The Bridegroom), is recorded at the abbey of Saint-Martial at Limoges (France).

c. 1100 *The Song of Roland* is written down for the first time.

c. 1110 A French schoolmaster named Geoffrey de Gorran produces a play about the martyrdom of St. Catherine of Alexandria with the help of his students and some borrowed vestments from St. Albans Abbey in England.

c. 1140 Numerous Latin comedies, among them *Pamphilus* and *Babio*, are being composed and performed in monasteries, cathedral schools, and princely courts.

c. 1150 The liturgical plays that make up the manuscript known as the *Fleury Playbook* are put together at about this time; they are usually associated with the abbey of Saint-Benoît-sur-Loire in France.

c. 1155 Hildegard of Bingen composes the *Ordo virtutum* (Service of the Virtues) for the nuns of her convent at Rupertsberg, one of many dramas mingling song, dance, and elaborate costumes to create special effects.

1160 The monks of Tegernsee Abbey compose and perform the *Play of Antichrist* in honor of Frederick Barbarossa, the Holy Roman Emperor.

c. 1180 Two early vernacular plays based on the Bible, the *Service for Representing Adam* and the *Play of the Magi Kings*, are composed at about this time in Anglo-Norman French and Castilian Spanish.

c. 1191 Following the conquest of Arras by King Philip II Augustus of France, Jehan Bodel composes the *Play of St. Nicholas*, the first non-biblical play written entirely in a vernacular language (Picard French).

c. 1200 The monks of the Bavarian abbey of Benediktbeuern compose the songs and plays that will be collected as the *Carmina Burana*. Their Easter play makes use of the local German dialect.

1205 Henry of Livonia, a missionary to the people of Riga (in what is now Latvia), describes an unsuccessful production of an *ordo prophetarum* or "Play of the Prophets."

c. 1210 The young men and boys of the cathedral school at Beauvais, in northern France, preserve the script for their musical, *The Play of Daniel*.

1215 The Fourth Lateran Council calls for the recruitment of effective and charismatic preachers to minister to the newly urbanized population of Europe; they will have to compete with professional entertainers for the attention of the people.

c. 1230 Bawdy verse tales known as *fabliaux* are being widely circulated; many were probably dramatized as plays, among them *Courtois of Arras*.

c. 1250 Two manuscripts of a second play in Anglo-Norman French, *The Holy Resurrection*, are copied at about this time.

c. 1267 The script for a comic French dialogue called *The Boy and the Blind Man* is written down.

c. 1270 By this date, the aristocracy of Europe enjoys participating in elaborately staged tournaments, many of which involve dramatic recreations of popular Arthurian romances.

c. 1276 Adam de la Halle, French playwright and poet, composes a second play set in contemporary Arras, the *Jeu de la feuillée* (The Play of the Bower); it may have been modeled on the earlier *Play of St. Nicholas* by Jehan Bodel of Arras.

c. 1283 While in the service of Robert II, count of Artois, Adam de la Halle composes a musical comedy called *The Play of Robin and of Marion*.

c. 1311 The Feast of Corpus Christi, originally established in 1264, is officially promulgated at the Council of Vienne. It will become the major occasion for community theatricals, most notably in England.

1339 In this year, the Parisian guild of goldsmiths and its religious confraternity begin sponsoring the annual performance of plays devoted to the miracles of the Blessed Virgin; forty of these survive in a single, deluxe manuscript.

1376 This year marks the first documented mention of the York Corpus Christi cycle.

1378 A play about the Crusades is performed at a banquet in Paris hosted by King Charles V of France, according to an illuminated manuscript.

1381 The English Peasants' Revolt takes place on and around the Feast of Corpus Christi, replacing theatrical violence and public displays of civic harmony with real violence and civil unrest.

c. 1400 By this date many major European cities are performing annual Passion plays or staging other types of civic spectacles on a grand scale.

1415 The *ordo paginarum* ("order of the pageants") for the performance of the York cycle is written down at this time.

The manuscript of the oldest Middle English play, *The Castle of Perseverance*, is copied around this date.

c. 1450 A play celebrating the Assumption of the Blessed Virgin is being performed annually on August 15 in the Basque town of Elche by this date; its performance will continue into modern times.

1452 The invention of the printing press spurs the widespread dissemination of play scripts throughout Europe, especially the texts of morality plays and farces.

c. 1465 The play *Mankind* is scripted for a troupe of traveling professional actors.

1468 The 43 plays that make up the *N-Town Cycle* (sometimes known as the *Ludus Coventriæ*) are written down after this date.

1477 The 48 pageants of the York Cycle are committed to parchment around this time.

c. 1480 Two ambitious English plays, one devoted to the life and deeds of Mary Magdalene and the other to the conversion of Saint Paul, are written down after this date.

c. 1495 A Dutch morality play called *Elkerlyke* (Everysoul) is in print; it is eventually translated into English as *Everyman* and made available in several editions.

c. 1500 The so-called Towneley (or Wakefield) cycle of 32 English plays is copied into a manuscript at about this time.

1567 Matthew Hutton, the dean of York Minster cathedral, advises the mayor and council of York not to perform the *Creed Play* of the Corpus Christi cycle, on the grounds that it would be considered heretical by the Protestant authorities and Queen Elizabeth I.

1576 The Theater, the first modern purpose-built venue for the performance of plays, is constructed in London.

1579 The final performance of the Corpus Christi play of Coventry takes place in this year. The young William Shakespeare would have been able to see this and many other examples of medieval drama.

1634 The people of the village of Oberammergau (Germany) begin to perform their *Passion Play*; it becomes an ongoing devotional ritual and is still performed in modern times, at ten-year intervals.

OVERVIEW
of Theater

THE ROLE OF MEDIEVAL THEATER. During the Middle Ages, theater was both a part of daily life and a way of celebrating special occasions. It was not limited to scheduled presentations of formally composed and fully scripted plays, and performances were not confined to particular buildings, dependent on a caste of professional actors or a paying clientele. Rather, medieval theater was a means of communication within and between communities, from monasteries to parish churches to princely courts to urban marketplaces. There was a wide array of theatrical styles and genres: musical dramas performed as part of the liturgy of worship; bawdy Latin comedies written for the amusement of students and clerics; biblical dramas that translated sacred stories into familiar languages and scenarios; ballads and tales of heroic deeds chanted and dramatized by professional entertainers; obscene jokes and sketches for late-night entertainment after feasts; royal entries and pageants that made a dramatic spectacle of power; morality plays; farces; and civic rituals on a grand scale. Medieval theaters were not built, but rather made use of pre-existing locations such as the town square, the street, the inn yard, the lord's hall, and the church. Plays of a kind more familiar to modern readers thus shared the same spaces. They also shared the same audiences as other civic activities such as the preaching of sermons, the news of town criers, royal proclamations, public executions, and religious processions. Theater was woven into the very fabric of medieval life and was the most effective medium for entertainment, religious instruction, and political propaganda.

SOURCES OF INFORMATION. Evidence for the workings of theater within medieval culture must be traced through that dense fabric, like gold threads in a richly colored tapestry. The study of theater in the Middle Ages is not so much the study of individual plays and particular dramatic productions as the study of myriad interactions between performers, audiences, and the larger social context in which performers and audiences participated. These interactions were only loosely scripted, if they were written down at all. As a result, the sources scholars would normally rely on for the history of theater—a group of documents identifiable as plays, whose circumstances of performance can also be documented—rarely exist for the Middle Ages. Either such information was not written down, or (if it was) these written records have disappeared. By contrast, the wealth of material that survives from the early-modern period (after 1500), and which makes the study of Renaissance drama so appealing, is partly owing to the development of an important new technology: the printing press. The people of the Middle Ages, like those of the ancient world, produced only handwritten records known as manuscripts (from the Latin *manuscripta*, "things written by hand"). In consequence, most of the texts that survive from these early eras, theatrical or otherwise, were not available in multiple copies and did not circulate widely. Many ancient and medieval sources have not survived at all. To take but the most famous example, the great library of Alexandria, founded by Ptolemy II (309–246 B.C.E.) to house the books of antiquity, was destroyed by fire sometime in the first century B.C.E.—and with it, most of the body of Greek drama. The few classical plays that are still read today—for example, the tragedies of Aeschylus, Sophocles, and Euripides, or the comedies of Aristophanes—have survived only because copies were made and kept in other places than the library at Alexandria. Hundreds more plays, by these and other Greek and Roman authors, have vanished. During the Middle Ages, and up to the present day, natural disasters, warfare, theft, arson, and ordinary wear and tear continue to diminish the number of theatrical artifacts available from this era. Fortunately, quite a few significant plays do survive, and what they communicate about this period can be supplemented by information gleaned from an array of other materials, including scholarly treatises, legal documents, church records, letters, and chronicles.

THE CREATIVE PROCESS. A medieval play generally came into being as the end result of a process quite the reverse of what modern readers would expect. In the twenty-first century, a play begins with the playwright, and the playwright's idea is then expressed in written form, in a script, which is then marketed to a theatrical producer, who then hires a director, finds a theater, casts the actors, and finally tries to capture the attention of an audience, who will in turn pay to see a certain performance in the theater at a fixed time. Throughout the Middle Ages, a play began with the community. Liturgical dramas embellished the rituals of the church, and used actors drawn from the monastery or cathedral churches—monks and nuns, students, and clerics. Plays performed in towns promoted the harmony of the community or celebrated their histories. Many were acted by members

of the newly emerging trade guilds, and became a source of solidarity and pride. The various entertainments of the princely court involved the aristocracy in performance, side by side with professional actors and minstrels. Rural communities all over Europe had their own local performance traditions for celebrating special feasts and important events like weddings and funerals. In all of these cases, it was the community's need—its ideas or message or conflict—that would shape the story that was eventually dramatized by actors engaged by, or chosen from among, the members of that community. The resulting play would then be performed in some space deemed appropriate to the material, at a time of the year and of the day that was also considered appropriate. Only at the very end of this process might someone decide that the play should be written down and saved for posterity; more often, the theatrical moment would pass unrecorded, or be revived from memory at another time, or freely adapted for another occasion or audience.

THE VARIETY OF MEDIEVAL THEATER. Medieval theater developed through a number of stages. In the earliest period, the theatrical legacy of ancient Rome was passed down and revived in the newly Christian world of early medieval Europe. Some classical plays continued to be copied and performed by educated men and women with a knowledge of Latin, while the timeless craft of professional entertainers found new audiences, occasions, and places for its expression. Alongside these established forms, a new and unique type of Christian theater emerged in church liturgy, which created numerous opportunities for the dramatization of significant events in the life and ministry of Jesus, and in the history of human salvation. By the twelfth and thirteenth centuries, significant surviving texts show that the drama of the medieval Christian Church was becoming a powerful theatrical genre in its own right, blending the Latin language of worship with the vernacular languages of daily life in order to communicate more directly with the growing populations of prosperous towns. Bible stories were updated in order to convey messages of contemporary importance, and plays also became a vehicle for serious social or political commentary. At the same time, plays independent of the liturgy addressed an ever wider array of topics and problems, and experimented with new performance venues and new types of engagement between actors and audiences.

NEW OPPORTUNITIES. The largest number of surviving plays, however, are those composed and performed during the fourteenth and fifteenth centuries. By this time nearly every sizable community in Europe developed and fostered a local theatrical tradition that promoted the growth of urban and regional identities, and

traveling troupes of professional actors were taking advantage of the new commercial opportunities afforded by the cultivated audiences of cosmopolitan centers and the sophisticated courts of the aristocracy. By the sixteenth century, the cultural heritage of the Middle Ages would prove indispensable to the playwrights and performers of the Renaissance, whose fascination with classical drama was grafted onto that tradition, producing a modern mixture of the ancient and the medieval.

ORAL TRANSMISSION AND PATTERNS OF PRESERVATION. Since performance traditions were usually passed down by word of mouth, only a tiny percentage of the entire theatrical legacy of the Middle Ages was preserved in writing; and even these scripts are often incomplete because they would have been accompanied by further oral instructions and improvisations. It is arguable, in fact, that the survival of a text is an indicator that the play recorded there was thought to be in danger of extinction, or even that it was marginal, about to be relegated to obscurity. Ironically then, the most popular performance pieces may never have been written down, for the very reason that everybody knew them so well and thought that they would never be forgotten. This is particularly true for the early medieval period, until about 1100. Thereafter, writing became more widespread, and more widely trusted, so that by 1300 the number of available plays is relatively large. Histories of medieval theater thus focus more attention on these later centuries, because more documents were produced—not because it was only at this late date that people began to participate broadly in theatrical activities. Furthermore, the predominance of religious drama among the surviving plays does not necessarily mean that the theater of the Middle Ages was always, or even primarily, dominated by religion. Prior to 1300, written records were mainly produced by men and women connected with the church, so, of course, most surviving early plays are in Latin, the language of learning and ritual, and were generally connected to major religious holidays and performed as part of the liturgy. These few scripted plays, however, represent only a tip of the iceberg.

THE EMERGENCE OF NEW DRAMATIC FORMS. The answer to the question "What is medieval theater?" depends on how one decides to read the historical record. Does the available evidence indicate that there was very little theatrical activity in Europe for over a thousand years? Some scholars have argued that this is so, and that the history of theater in the Middle Ages is tantamount to the history of the destruction of ancient dramatic traditions, which were replaced by a purely Christian series of "static" or boring ceremonies. In this formulation, drama must first "break free" from the "oppressive" rit-

uals of medieval religion before it can enter the modern age, ushered in by the Renaissance. Very recently, however, this argument has been challenged: it is now being shown that medieval people made use of classical models while at the same time developing their own unique theatrical practices, which eventually contributed to the emergence of the new dramatic forms associated with the Renaissance. In other words, modern scholars can interpret the evidence to mean that the theater of the Middle Ages was diverse and vibrant, that it had the immediacy and impact associated today with modern sketch comedy, street theater, or live television—as well as (depending on the occasion) the pageantry characteristic of grand opera, the beauty of a carefully choreographed dance, the solemnity of a state funeral, the festivity of a carnival, or the violence and eroticism of action films.

TOPICS
in Theater

THE LEGACY OF ROME

THEATER OR LITURGY? The theater of ancient Rome was both challenged and enriched by the demands of the Christian religion, which rose to prominence during the early decades of the fourth century. On the eve of an important battle in the year 312, a Roman general called Constantine (c. 274–337) prayed to the Christian god to assist him in defeating his enemies, rival claimants to the leadership of the Roman Empire. According to his biographer, Eusebius of Cæsarea (c. 260–340), Constantine had a vision in which he saw the image of the cross, and was told that "under this sign" (*in hoc signum*, abbreviated IHS) he would be victorious. Painting crosses on his banners and the shields of his legions, he marched into battle. When he won, his loyalty to Christianity was assured, and the traditional monogram IHS that had stood for the Greek name of Jesus was now reinterpreted by historians of the church to refer to this event. A year later, Emperor Constantine issued the Edict of Milan, making Christianity a legal religion in the Roman Empire, and just over a decade later, in 325, Constantine would spur the rapid growth of Christianity as an institutional religion by convening the Council of Nicea (an ecumenical or official church gathering) in Asia Minor. Here, for the first time in the history of the young church, bishops and teachers from all over the Roman world could meet and compare their views on how that church should be organized, and what its official teachings should be. Once an official doctrine was in place, there arose other

pressing topics of debate for succeeding generations of Christians, one of which was the relationship between the theatrical spectacles of pagan Rome—many of which had a strong religious component—and the new Christian theater of worship: the liturgy. The prayers, chants, hymns, and ceremonies that made up the liturgy emphasized Christianity's debt to the stories of the Old Testament and its commitment to the teachings of the New Testament. The liturgy also dramatized the life and ministry of Jesus through a series of powerful rituals. The most fundamental of these was the daily ritual of the Mass, a re-enactment of the Last Supper when Jesus had performed the highly-charged act of breaking bread and inviting his disciples to eat this potent symbol of his own flesh, at the same time bidding them to drink the wine representing the blood he would shed for them the following day, Good Friday. But the very theatricality of the Mass engendered controversy, and it continues to do so in modern times. Some scholars argue that the Mass, as well as the many festive rituals of the church calendar, should be considered an integral part of medieval theater history. Others insist that the liturgy should not be classified as a type of theater, and make careful distinctions between a religious service (Latin: *ordo*) that merely performs a set of symbolic actions, and a play (*ludus*) that attempts to represent events through the impersonation of the characters involved.

THE THEATER OF WORSHIP. This modern distinction between dramatic ceremony and "real" drama is not one that medieval audiences appear to have made. In fact, a contemporary (medieval) definition of theater offered by the respected teacher and biblical scholar Hugh of Saint-Victor (1096–1141) includes divine worship in an extensive catalogue of entertainments and leisure activities, listing it alongside plays, sporting competitions, gambling, puppet shows, public reading, dancing, instrumental music, singing, and other pastimes. Writing at about the same time, an influential theologian called Honorius of Regensburg (fl. 1106–1135) explicitly compared the celebration of the Mass to the performance of a classical tragedy.

> It is known that those who used to recite tragedies in the theaters would perform, through their actions, a display of their struggles. In just this way does our own tragedian, Christ, perform his actions before the Christian people in the theater of the church, and impresses on them the victory of redemption.

A century later, a Latin sermon would echo these sentiments when preachers began to complain that the emotive power of the Mass needed to be emphasized even more convincingly, so that it could compete effectively with other types of entertainment—in this case, attractive

MEDIEVAL
Theater Terms

Antiphon: A style of liturgical chant in which the chanted verses constitute a conversation between two choirs, with solo interventions by a cantor.

Apocrypha: The non-canonical books of the Old and New Testaments. For theater the most important of these is the Acts of Pilate, more commonly called the Gospel of Nicodemus in the New Testament apocrypha, believed genuine in the Middle Ages. It details how Christ descends to the underworld after his death, struggles with Satan in Hell, binds him in chains, and leads the Patriarchs, like Adam and Eve, out of Hell up to heaven again.

Corpus Christi: Festival dedicated to the "body of Christ." Instituted in 1311 by Pope Clement V, it became the occasion around which many of the mystery cycles and Passion plays of Europe were performed.

Eucharist: The consecration and communion of bread and wine which memorialize Christ's death and resurrection in the liturgy of the Roman Catholic Church. A "miracle" play was performed in England by the bakers' guild, whose bread became the body of Christ during their re-enactment of the first Eucharist.

Feast: A certain day in the liturgical calendar of the Roman Catholic Church devoted to the birthday or martyrdom of a particular saint or event of significance in the Christian year.

Jongleur: An Old French word associated with modern English "juggler," used as a catch-all term to identify a person with the array of talents shared by the professional performers of the Middle Ages.

Liturgy: In the Roman Catholic Church, the forms of prayers, acts, and ceremonies used in public and official worship. The main parts of the liturgy are the offering of the Eucharistic sacrifice called the Mass, the singing of the divine office, and the administration of the sacraments. It was from elements of the Mass that the earliest medieval drama is thought to have developed.

Ludus: From the Latin word for a game, it later came to mean "play." Thus the name *Ludus Coventriae* refers to the cycle of Coventry plays.

Mass: The official name of the Eucharistic sacrifice and associated ceremonies and rituals. The word seems to have come from the words of dismissal that end the Mass—*ite missa est*— meaning "go, the mass is done." It is a re-enactment of the Last Supper when Jesus had broken bread, asked his disciples to eat this symbol of his own flesh, and bid them to drink wine representing the blood he would shed for them the following day, Good Friday. Some scholars argue that the Mass, and the many festive rituals of the Latin Church, should be considered the source of medieval theater.

Monasticism: The way of life typical of monks or nuns who dwell together for life, living austerely and sharing in common according to a rule; their lives are devoted to the service of God.

Mystery: The term has two meanings in medieval drama. First it means one of the "mysteries" of Christianity, a miraculous event which must be accepted on faith such as the idea of the Virgin birth of Jesus. Second, it means a play put on by a craft guild, a group who have trade secrets or mysteries.

Office: The prayers and ceremonies in the Roman Catholic Church for some particular purpose such as the Office for the Dead, or the church's services in general, such as the Divine Office.

Ordo: The service for representing some aspect of the liturgy or of dramatic events.

Pageant: A separate event in a pageant cycle or large group of plays on Old and New Testament themes, such as a pageant of Christ's nativity.

Passion: The events of Christ's last hours, his torments, suffering, and crucifixion. The term also refers to Passion Sunday or the fifth Sunday in Lent as these are dramatized in Passion plays of the late Middle Ages.

Rubric: From the Latin word for red (*rubeo*), the larger script indicating a chapter heading or division in a manuscript and particularly the directions (often printed in red in missals and breviaries) for the conduct of church services and the carrying out of liturgical rites.

Sequence: A type of hymn, but not in a regular meter, said or sung between the gradual and the Gospel of certain masses.

Trope: An antiphon or verse interpolated into a liturgical text.

Vernacular: The popular or non-Latin language of a country, such as French or English.

street-corner performances of the Old French heroic poem *The Song of Roland.*

When in the voice of the jongleur, sitting in the public square, it is recited how those errant knights of old, Roland and Olivier and the rest, were killed in war, the crowd standing around is moved to pity, and oftentimes to tears. But when in the voice of the Church the glorious wars of Christ are daily commemorated in sacrifice—that is to say, how He

THE Festive Year

The liturgical calendar of the medieval Latin Church begins at Advent, four Sundays before Christmas (25 December). It consists of fixed feasts, whose dates (like that of Christmas) never change, and moveable feasts, whose dates depend on the dating of Easter, which in turn is dependent on the Paschal Moon, the first full moon of the Vernal Equinox (March 21). The following is a list of the principal feasts, many of which provided the occasion for the performance of plays and related festivities. Also included are some non-religious celebrations based on the change of seasons.

Event	Date(s)
Advent	Season begins four Sundays before Christmas
St. Nicholas	6 December
Conception of the Blessed Virgin	8 December
Nativity or Christmas	25 December
Holy Innocents or "Feast of Fools"	28 December
Presentation of Jesus or Circumcision	1 January
Epiphany ("Twelfth Day of Christmas")	6 January
Purification of the Virgin or Candlemas	2 February
Lent, beginning Ash Wednesday	Season begins six weeks and four days before Easter
Maundy (Holy) Thursday	The Thursday before Easter
Good Friday	The Friday before Easter
Holy Saturday	The Saturday before Easter
Easter	Falls between 21 March and 25 April
Annunciation of the Blessed Virgin	25 March
First day of the medieval summer	1 May
Ascension Day	Fortieth day after Easter (a Thursday)
Pentecost Sunday or Whitsunday	Fiftieth day after Easter, 14 May–14 June
Holy Trinity	Sunday after Pentecost, 21 May–21 June
Corpus Christi	Thursday after Trinity Sunday, 25 May–25 June
"Midsummer night"	23 June (vigil of the feast of St. John the Baptist)
Nativity of St. John the Baptist	24 June
Visitation of Our Lady	2 July
Assumption of the Blessed Virgin	15 August
Nativity of the Blessed Virgin	8 September
All Hallows' Eve	31 October (vigil of the feast of All Saints)
All Saints Day	1 November
All Souls Day	2 November

defeated death by dying, and triumphed over the vainglory of the enemy—where are those who are moved to pity?

However, the theatricality of the Mass was not an issue for the people of the Middle Ages. Put more strongly, the Mass was fundamental to the culture of medieval Christianity because it was "good theater." The priest, standing at the altar of the church, spoke the very same words that Jesus had spoken to his disciples on the night of his betrayal and arrest, and performed the same actions. He enacted the role of Christ and, when he did so, the bread he blessed and broke became the body of Christ. In short, this miraculous occurrence, crucial to the Christian faith, was achieved through dramatization

of the event. The many feasts that made up the liturgical calendar of the church's ritual year, which began at Advent and climaxed at Easter, were likewise valuable because they provided further opportunities for festive drama. (The word "festive" derives from the Latin for "feast," *festum*.) Those who performed these rites and those who participated in them understood that these rites were supposed to enlighten, inspire, even entertain. They were theatrical.

PAGANS AND CHRISTIANS. The testimonies of later medieval theologians represent the perspectives of medieval people who were far removed from Christianity's pagan past and, at the safe distance of several centuries, appear to have felt comfortable in making comparisons

a PRIMARY SOURCE document

A MEDIEVAL DEFINITION OF THEATER

INTRODUCTION: Hugh of Saint-Victor, an influential teacher and scholar of the Bible at the monastery of Saint-Victor, outside Paris, included the science of "theatrics" (*theatrica*) as one of the seven "Mechanical Arts" in Book Two of his encyclopedia, the *Didascalicon* (circa 1125). In this passage Hugh exhibits a familiarity with Roman spectacle.

The science of playing is called theatrics from the theatre, the place where people used to gather for entertainment—not because a theatre was the only place in which entertainment could be had, but because it was more well-known than the rest. Some types of play were indeed done in theatres, some in the entrances of buildings, some in gymnasia, some in circuses, some in arenas, some at feasts, some at shrines. In the theatre, deeds were related either in verse, or by characters, or by means of masked figures or puppets. In entrance halls, they held dances or processions; in gymnasia they wrestled; in the circuses they ran races on foot or on horseback or in chariots; in the arenas, boxers exercised their skill. At banquets, they made music with harmonious and rhythmic instruments, recited stories, and played at dice. And in the temples at solemn festivals they sang the praises of the gods. ... For since it is necessary for people to get together in some place for amusement, they decided that certain spaces for entertainment should be defined, rather than that there should be many different meeting-places where they could perform shameful acts and misdeeds.

SOURCE: Hugh of Saint-Victor, *Didascalicon* (circa 1125). Translation by Carol Symes.

between the tragedies of Greece and Rome and the Christian tragedy of the daily Mass. But in Constantine's day, as in modern times, there was controversy over the overt theatricality of Christian worship. In the fourth and fifth centuries, Christianity was still a minority religion, newly legal and as yet unformed. The theologians who came of age in those heady days were among the first generation of Christians who were able to discuss the tenets of their faith openly, and many were eager to distinguish it from the other sects with which it competed for attention in the crowded religious marketplace of late antiquity. They were also eager to show that Christianity offered the conscientious citizen of the Roman Empire an opportunity to rise above the distractions and

vices of that empire. Even in the days before Constantine's conversion, when Christians were still—literally—fighting for survival, some prominent Christians had been outspoken in their denunciations of Roman decadence, especially the decadence of its theater. The writings of the Christian apologist Tertullian (c. 155–c. 221) offer extended, biting critiques of Roman beliefs and morals, and explicitly contrast the bloodless symbolism of Christian worship with the bloody sacrifices of pagan religions and the blood sports of the amphitheater and the coliseum. Yet Tertullian's views on theater were, in their day, a reactionary, minority opinion. They could not hope to prevail against the overwhelming power of the empire, or its attractive program of public entertainments.

THE INGREDIENTS OF MEDIEVAL THEATER. The opinions of St. Augustine (354–430), who ended his life as the bishop of Hippo Regis in the Roman province of North Africa, carried much more weight. A late convert to Christianity, Augustine was the chief doctrinal architect of the fledgling Roman Church, one of the devout men who came of age in the decades after Constantine's establishment of Christianity as a viable state religion. It is through him that we can best trace the strand of anxiety that led to some of the most stringent denunciations of the corrupting dangers of Roman theater, and its potential influence on Christian worship. In many of his writings, notably his autobiographical *Confessions* and his Christian revision of history, *The City of God*, Augustine described the dangerous seductions of theater in all its forms. But these descriptions readily betray the source of his anxiety: his own youthful, dramatic passions, and his mature conviction that the devout Christian must turn his back on the worldly pleasures of Rome, the city of man, in order to attain salvation in the celestial City of God. It would therefore be a mistake to assume that Augustine's Christian contemporaries shared a negative view of theater, or that—even if they did—such a view would lessen the attraction of traditional entertainments, or diminish the importance of pre-Christian Roman culture. They also had little negative effect on the way that a new Christian theatricality grew and flourished. It is actually rather ironic that Augustine's own intellectual sparring-partner, St. Jerome (c. 340–420), would at the very same time be laboring to produce the greatest theatrical script of the Middle Ages. For it was Jerome's Latin translation of the Hebrew and Greek scriptures that would form the Old and New Testaments of "the people's Bible" (*Biblia vulgata*), which provided the raw material for the vast majority of medieval plays. At the same time, the order of service of the Mass and the fes-

tive calendar of the church began to take on their familiar forms, while the legacy of Roman theater continued to be passed down by professional entertainers and lovers of classical literature, both pagans and Christians. All of these elements would be woven together in the rich theatrical tapestry of medieval Europe.

SOURCES

T. P. Dolan, "The Mass as Performance Text," in *From Page to Performance: Essays on Early English Drama.* Ed. John A. Alford (East Lansing, Mich.: Michigan State University Press, 1995): 13–24.

Eckehard Simon, ed., *The Theater of Medieval Europe: New Research in Early Drama* (Cambridge, England: Cambridge University Press, 1991).

William Tydeman, ed., *The Medieval European Stage* (Cambridge, England, and New York: Cambridge University Press, 2001).

Glynne Wickham, *The Medieval Theater.* 3rd ed. (Cambridge, England: Cambridge University Press, 1987).

THE RENAISSANCE OF CHARLEMAGNE

A NEW ROMAN EMPIRE. Charles the Great, king of the Franks and emperor of the Romans (742–814), presided over a cultural revolution known as the Carolingian Renaissance. ("Carolingian" is the adjective derived from the Latin form of Charles, *Carolus.*) He would do more for the preservation of Roman plays and the promotion of medieval theater than any other person, before or since. Ruler of a territory that included much of present-day France, Belgium, Holland, Germany, Austria, and Italy, Charlemagne (as the French would call him) knew that governing his vast empire would be easier if the many different people who inhabited these lands had a common culture. In addition, therefore, to promoting peace within the empire's borders, he promulgated new laws and codified old ones, established procedures for the administration of justice, and encouraged the conversion of the many pagan tribes in his domain to Christianity. To aid in this task, he also embarked on a series of church reforms. The papacy of his time was weak, and it was Charlemagne's political and military power that provided the channels through which the doctrines and ideals of Christianity could be disseminated. This was the beginning of the politico-religious entity that would later be known as the Holy Roman Empire. And more than law or justice, more than the development of bureaucratic institutions, it was liturgy—the theater of worship—that would help to bring the disparate peoples of Europe together to form an entity known as Christendom.

a PRIMARY SOURCE *document*

ST. AUGUSTINE CONFESSES HIS LOVE OF THEATER

INTRODUCTION: St. Augustine, bishop of Hippo (354–430), was the most important theologian of the early Christian Church. Born in the Roman colony of North Africa, in the small town of Thagaste, he was educated in Carthage and Rome, where he became a successful teacher of rhetoric. During a stay in Milan, he encountered its bishop, St. Ambrose (c. 339–397), under whose guidance he first began to investigate the claims of Christianity. He eventually converted, but not before living a full and varied life, described in his *Confessions.*

The spectacles of the theatre ravished me, for they were filled with representations of my own miseries and were the kindling that ignited my fires. Why is it that a person should want to suffer pain in such places, by watching sorrowful and tragic things—things which he himself would never wish to suffer? And yet he wants to suffer from them, to feel sorrow as a spectator, and let sorrow itself become his pleasure. What is this, but a strange madness? For the more anyone is excited by such things, the less capable he is of governing his emotions. For when he himself suffers it is misery, and when he is compassionate for others it should be called mercy; but what kind of mercy should there be for made-up characters and scenarios? The person in the audience is not called upon to relieve, but invited only to grieve; the more he sorrows, the more he approves the performance of the actors in these scenes. And if the misfortunes of these people, whether they are long dead or purely fictitious, happen to be acted in such a way that the spectator is not saddened by them, he walks out, disgusted and critical. But if he is forced to be sad, he stays attentive and weeps, rejoicing.

SOURCE: St. Augustine, *Confessions*, c. 390. Translation by Carol Symes.

THE UNIFYING FORCE OF RELIGION. Christendom was a spiritual empire whose borders coincided, roughly, with the secular empire of Rome, and whose unifying power is expressed in the name of the Roman Catholic Church, the "universal" church (from the Greek adjective *katholicos*) established in Rome. It was under Charlemagne's patronage that the many disparate rituals, prayers, ceremonies, and music developed by individual Christian communities throughout the Roman Empire

were eventually brought together to form a cohesive liturgy. Some of these rituals, like the solemn performance of the daily Mass, were almost as old as Christianity itself. Others, like the annual feasts commemorating significant episodes in the life of Christ (his Nativity at Christmas, his resurrection at Easter) or honoring the deeds of the saints, were later additions, often in response to the needs of recent converts. The observance of Christmas on 25 December, for example, was tied to that date in order to coincide with the winter solstice and the celebration of Yule, which was sacred among the pagan peoples of northern Europe because it marked the darkest day of the year and the subsequent return toward light; thus, the symbolism of Jesus' birth and the rebirth of the sun reinforced one another. By contrast, Easter continued to be a "moveable feast," whose date was not constant from year to year, but was instead tied to the dating of Passover, which was calculated according to the lunar calendar in use by the Jews, rather than the solar calendar that had governed the reckoning of time in the territories of the Roman Empire. Nevertheless, the English name of the most important feast in the Christian calendar, Easter, has nothing to do with Christ, but is the name of the Saxon fertility goddess, *Eastra*.

THE CONTRIBUTIONS OF MONASTICISM. In the sixth century, Pope Gregory the Great (540–604) had begun laying the groundwork for Charlemagne's later program of liturgical reforms. Under his direction, the musical sequences that accompanied the recitation of the Psalms and other biblical verses were brought together into a corpus of melodic material that is commonly called Gregorian chant. Like the Mass, many of these chants were very old. Others had been composed to support the expanded services of the newly legalized church in the fourth and fifth centuries, notably under Ambrose, bishop of Milan (c. 339–397), the mentor of St. Augustine. Still others were the artistic product of the monasteries that were being founded throughout Europe, and which would be the recipients of Charlemagne's generosity. The Rule of St. Benedict of Nursia (c. 480–543), which provided the basic guidelines for monastic life in much of Europe—and which is still in use in modern Benedictine monastic houses all over the world—had instituted an elaborate schedule of daily worship called the *opus Dei*, "the work of God." The phrase indicated that it was the special job of monks and nuns to pray continually for the welfare of Christendom. At seven intervals throughout the day, and once in the middle of the night, the monastic choir would perform the office (from the Latin word for "duty," *officium*), each segment of which involved the chanting of the Psalms, singing of hymns, recitation of prayers, and reading of Scripture.

This program of prayer was, in many respects, inherently dramatic; the selection of Bible passages, the choice of the music, the display of certain ornaments and colors, and the wearing of special vestments (ceremonial costumes) all contributed to the theatrical expression of devotion to God. The very calendar of the church was theatrical, turning the cycle of the seasons into a year-long drama which re-enacted the stages of Christ's mission on earth and showed the continual workings of God in the world by commemorating the deeds of holy men and women.

CHARLEMAGNE'S ACHIEVEMENT. Charlemagne's contribution to the theatrical innovations of the early Middle Ages was material, in several senses. By financing churches and monasteries throughout his domain, he helped to enrich the celebration of the liturgy and to make Christian worship an increasingly attractive interplay of music, light, color, and ceremony. But even more importantly, he ensured that the rituals and chants of the early church would not be forgotten, collecting the scattered manuscripts and oral traditions by which they had been conveyed and having them copied and disseminated throughout his realm. These new manuscripts, many of them beautifully decorated with colored inks and gold leaf (the brightness of their pages gives the impression that they are "illuminated") were written in a script that was also new. Called "Carolingian minuscule," it abandoned the laborious square capital letters that had been in use since antiquity in favor of a rounded hand that was easier to write and to read, the ancestor of modern typefaces like those in printed books. Finally, the scribes of Charlemagne's court developed a system of musical notation, which operated like a recording device, enabling the transmission of music through writing (rather than by word—or song—of mouth). In addition to preserving and augmenting the unique heritage of early medieval Christianity, the artists and intellectuals of Charlemagne's court devoted themselves to preserving and honoring the classical age, especially the legacy of Rome. The universal language of Western Europe was still Latin, the language of the Romans, but that language was rapidly becoming specialized, a language of scholarship and worship. It was no longer the language of conversation, prayer, or writing. It was only one of many European languages, some derived directly from Latin (the "romance" or Roman languages of French, Italian, Spanish, Catalan, Romanian, Portuguese, Occitan), others rooted in Germanic or Celtic dialects (Anglo-Saxon or Old English, Gaelic, Breton). These vernacular or "native" languages were much more widely spoken than Latin, and in the centuries after the death of Charle-

magne they would become literary languages in their own right.

PRESERVING THE PAST FOR THE FUTURE. The Carolingian Renaissance is so called, then, because it suggests a "rebirth" of interest in the past, and a desire to emulate the literary and artistic forms of that past. Not surprisingly, one of the most compelling aspects of the Roman past was its theater. In *scriptoria* ("workshops for writing") throughout Charlemagne's realm, scribes and illuminators turned out hundreds of lavishly illustrated manuscripts of Roman plays, especially the comedies of Terence (Publius Terentius Afer, c. 190–158 B.C.E.), which were among the entertainments that had made so indelible an impression on St. Augustine. Of course, Carolingian scribes also preserved other classical texts, not just plays: the poetry of Vergil, Catullus, Horace, and Ovid; the speeches and letters of Cicero; and the histories of Livy, Sallust, and Tacitus. Hence, most of what is known about Rome is known because of the work of the copyists who saved the endangered texts of antiquity from oblivion. The surviving knowledge of Greek drama, on the other hand, is attributed to the Greek-speaking heir of the Roman Empire, Byzantium, where Constantine had founded his new capital of Constantinople in 325. The knowledge of Greek was unavailable to the people of medieval Western Europe. Thus, it was not until Constantinople was captured by the Ottoman Turks in 1453 that the tragedies and comedies of the Greek dramatists became accessible to the West, helping to fuel the artistic endeavors of another Renaissance.

SOURCES

Andrew Hughes, "Charlemagne's Chant or the Great Vocal Shift," *Speculum* 77 (2002): 1069–1106.

Rosamond McKitterick, *The Carolingians and the Written Word* (Cambridge, England, and New York: Cambridge University Press, 1989).

Leo Treitler, "Reading and Singing: On the Genesis of Occidental Music-Writing," *Early Music History* 4 (1984): 135–208.

SEE ALSO *Religion: Early Latin Christianity in Northern Europe; Visual Arts: The Carolingian Restoration of Roman Culture*

THE DEVELOPMENT OF LITURGICAL DRAMA

THE TRADITION OF THEATRICALITY. The liturgy of the medieval church was essentially theatrical, as was the festive cycle of the Christian year. But at certain times

during that year, this theatricality took on a special character. At Easter, and on the days leading up to its celebration of Christ's Passion ("suffering") and Resurrection, and again at the Christmas season, churches throughout Europe provided the settings for musical dramatizations of scenes from the gospels. It is hard to know when these liturgical plays were first performed, because the oldest manuscripts that record them were copied after the Carolingian Renaissance had made the preservation of texts a high priority. Often, the late dates of manuscripts have been taken to indicate that medieval drama itself was a late invention—that in order for there to be a play, there must be a script. But this is obviously not the case: all that a play requires is a story, some performers, and an audience. And medieval people had a wealth of stories at their disposal, thanks to St. Jerome's translation of the Bible, which was supplemented by a series of popular tales from the Apocrypha or "hidden" books of Hebrew scripture, among them the stories of Judith, Susannah, and Daniel. Surviving manuscripts, therefore, allow scholars to view only the skeletal remains of liturgical drama, giving some indication of how these stories were performed. Most of these plays are undetailed and would have existed long before the time of Charlemagne. For example, it is evident that elaborate processions commemorating the entry of Jesus into Jerusalem on Palm Sunday had been staged in that holy city for years, but the earliest record of them comes from the *Itinerarium* or travel journal of Egeria, a high-born lady or perhaps a nun from the Roman province of Galicia (Spain), written about 384. By the same token, the ceremony for the consecration of churches is surely older than its first ninth-century manuscripts, which show that it was loosely based on the story of the Harrowing of Hell presented in the apocryphal Gospel of Nicodemus, when Jesus, on the Saturday between the Crucifixion and the Resurrection, descended to the underworld and led out from it the souls of Adam and Eve and other Old Testament heroes and prophets, taking them with him to glory.

BASIC COMPONENTS. The many manuscripts which provide us with different versions of important Christmas and Easter plays are all of more recent date than the dramatic traditions to which they refer. These plays demonstrate that there were many ways to perform the story of Christ's Birth and Resurrection, some highly creative. But all shared certain essential components. At Easter, the most important component was a vital question: *Quem quæritis?* ("Whom do you seek?"). The question is that of the angel guarding the empty tomb on Easter Sunday morning, when the Three Marys (Mary, the mother of Jesus; Mary Magdalene; and the Mary

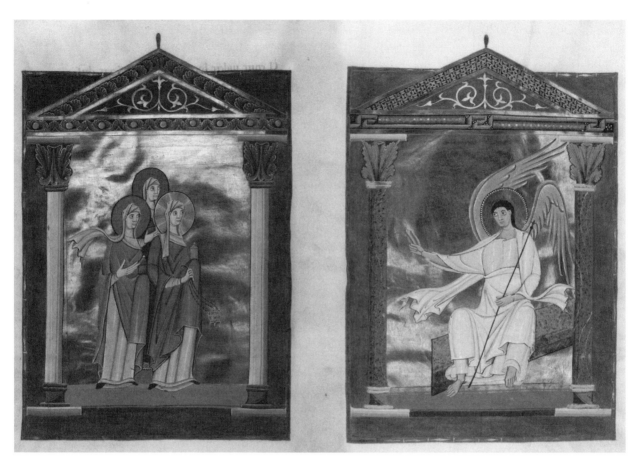

Three Marys visiting Christ's sepulchre, Pericopes of the Emperor Henry II, MS CLM 4452, folio 117v, 1010. MUNICH, BAYERISCHE STAATSBIBLIOTEK.

described in the gospel of Mark as "the mother of James and Salome") approach with oils and incense to anoint the body of Jesus. But Jesus, unbeknownst to them, has risen from the dead, so the women are surprised to see the angel, and to be asked "Whom do you seek in the sepulchre, O followers of Christ?". These fateful words, sung in Latin, have been used to describe the entire dramatic genre of Easter liturgies: they are often called *Quem quæritis?* or *Visitatio sepulchri* tropes (traditional phrases inserted into the Mass) since they all make use of the same symbolic elements to dramatize "The Visit to the Sepulchre." Their essential melodic dialogue consisted of an imaginative pastiche of words and phrases from the gospel accounts of the Resurrection, sung in the antiphonal or "call-and-response" style that was a feature of the monastic office, in which the chanted verses constitute a conversation between two choirs, with solo interventions by a cantor.

THE INTEGRATION OF DRAMA AND WORSHIP. It is worth noting that what made these musical dramatizations effective was not their separation from the theater of

worship, but their participation in it. One of the earliest manuscripts of the Easter play, the *Visitatio sepulchri* from Winchester in England, demonstrates this beautifully. Four members of the religious community are instructed to disguise themselves by dressing up in costumes taken from the monastery's storehouse of liturgical vestments: an alb (white robe) for the angel, and copes (long hooded capes) for the three women—all of whom would be portrayed by men when this play was produced in a male monastic house. The props they carry are also items in use for daily worship: thuribles (censers, containers for holding aromatic spices and incense) representing the vessels of oil and myrrh carried by the Marys. The location of the tomb is not specified in the script, but here again the church space and its furnishings would be put to use. Perhaps the tomb was represented by the altar, or perhaps it was a real tomb in one of the church's side chapels, or a "prop," a special tomb erected expressly for the performance of this play. In any case, the symbolic significance of staging this sacred story using actors, props, and sets provided entirely by the resources of the community underscores the intimacy and immediacy of

a PRIMARY SOURCE *document*

THE VISIT TO THE SEPULCHRE

INTRODUCTION: Between the years 965 and 975, Bishop Ethelwold of Winchester promulgated a series of liturgical reforms which were crystallized in a collection called the *Regularis Concordia*, a "Concordance of the Rules" for worship and religious life among the monastic communities of England during the reign of King Edgar (959–975). These guidelines, similar in many respects to those circulated by Charlemagne nearly two centuries earlier, were one long-term result of an ambitious program of civil engineering and religious instruction introduced by King Alfred the Great (r. 871–900), whose leadership had united warring English tribes during the Viking invasions of the ninth century and who had strengthened that new political unity by promoting an idea of a shared Anglo-Saxon heritage. The guidelines quoted here contain numerous quotations from *The Visit to the Sepulchre*. When reading the texts of liturgical plays, it is important to bear in mind that all of the dialogue was sung, and would have been much more effective in performance than it appears.

While the third lesson is being read aloud, four of the brothers should dress themselves. One of them, wearing an alb, should come in as though intent on other business and go stealthily to the place of the sepulchre, and there he should sit quietly, holding a palm in his hand. Then, while the third response is being sung, the three remaining brothers, all of them wearing copes and carrying thuribles with incense in their hands, should walk slowly and haltingly, making their way to the place of the sepulchre as if they are seeking something. For these things are done in imitation of the angel seated on the tomb and of the women coming with perfumes to anoint the body of Jesus. When, therefore, the one sitting there sees the three drawing near, who are still wandering about as though seeking something, he should begin to sing sweetly in a moderate voice: "Whom do you seek [in the sepulchre, O followers of Christ]?" When this has been sung through to the end, the three should answer together in one voice: "Jesus of Nazareth [who was crucified, O heavenly one]." He to them: "He is not here. He has risen as he predicted. Go, tell the news that he has risen from the dead." Heeding the call of this command, the three should turn toward the choir saying: "Alleluia. The Lord has risen, [today the mighty lion has risen, Christ the Son of God]." When this has been said, the seated one again should say the antiphon, as if calling them back: "Come and see the place [where the Lord was laid. Alleluia]." And then, having said these things, he should stand up and raise the veil, showing them the empty place where the Cross had been laid [i.e., during the liturgy of Good Friday], where there should be nothing but the linen bands in which the Cross had been wrapped. Seeing this, they should put down the thuribles which they have carried into the sepulchre, and taking up the linen cloths they should hold them out toward the assembled clergy, as though showing them that the Lord has risen and is now no longer wrapped in them; and they should sing this antiphon: "The Lord has risen from the tomb, [He who was hung upon the Cross. Alleluia]." And they should lay the linen cloths upon the altar. When the antiphon has ended, the prior should begin the hymn *Te Deum laudamus* ("We praise you, O God"), rejoicing at the triumph of our King, who was delivered from the conquest of death. When the hymn has begun, let all the bells peal in unison.

SOURCE: Bishop Ethelwold of Winchester, *Regularis Concordia*, ca. 975. Translation by Carol Symes.

the play's message: it is as if Jesus has been resurrected in their own church, as if members of the monastic community are themselves going mournfully to anoint his body, only to be greeted by the angel's question, "Whom do you seek in the sepulchre?" and the joyful news of Christ's Resurrection. Whereas people today imagine the events of the Bible as taking place in the distant past, medieval people reminded themselves constantly of their proximity to those events. Their theater underscored the messages implicit in this proximity, year after year.

THE EXPANSION OF CHRISTMAS THEATRICALS. Some of the same dramatic techniques featured so prominently in the Easter liturgies were also put to use in the performance of plays at Christmastime. Even the important question *Quem quæritis?* could be asked again, this time of the shepherds who come to Bethlehem, seeking the birthplace of the child Jesus: "Whom do you seek in the manger, shepherds? Tell us!" But because Christmas was a less solemn feast than Easter, greater liberties were taken with the biblical text. In some places, by the eleventh century at the latest, Christmas theatricals had expanded to include not only the story of Jesus' birth, but of the angels' address to the shepherds, the journey of the Magi, their interview with Herod, Herod's violent response to their news, and the flight of the Holy Family into Egypt. Numerous extra characters were added: Mary has midwives to help her in the birthing of Jesus; Herod, as befits a great king, has men-at-arms, attendants, courtiers, ambassadors, diplomats, and ineffectual bureaucrats surrounding him; the Old Testament matriarch, Rachel, is brought on to witness Herod's massacre of the

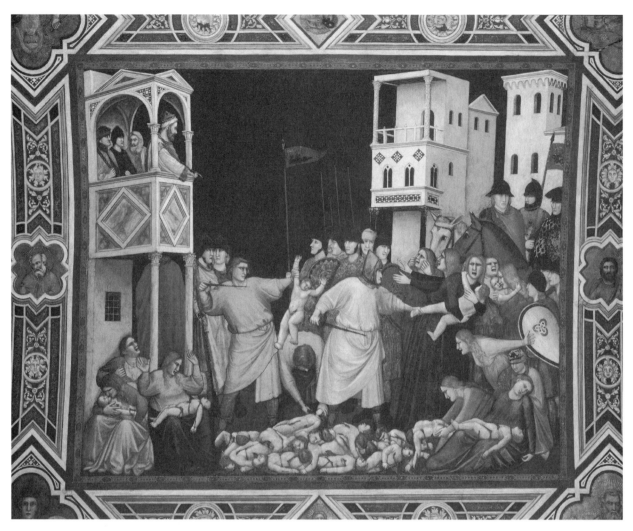

Herod and the Innocents, Fresco, School of Giotto, Church of San Francesco, Assisi, Italy, 14th century. THE ART ARCHIVE/SAN FRANCESCO, ASSISI/DAGLI ORTI.

innocents, and mourns for the lost children of Israel. All of these people and events could scarcely be encompassed within a single morning's liturgy, and it became traditional to celebrate Christmas over a twelve-day period, beginning on 25 December and ending on the Feast of the Epiphany (from the Greek word for "manifestation") on 6 January, the holiday celebrating the arrival of the Magi in Bethlehem. The play commemorating Herod's Slaughter of the Innocents was usually performed on 28 December, which became the Feast of the Holy Innocents. Like the tragic episode that it commemorated, it occurred a few days after the Nativity. In many monasteries and cathedral schools throughout Europe, this feast was also called "the Feast of Fools," since the boys of these communities were allowed special privileges on that day, their festive misbehavior sanctioned in compensation for the cruel deaths meted out to the children of Judea. This was a time of carnival, one of several occa-

sions in the year when the "world turned upside down" and hierarchies of power, social status, and gender roles were reversed.

THE LONG REIGN OF KING HEROD. Not surprisingly, the Magi and King Herod were the stars of many Christmas plays, since these characters have always held a special fascination for audiences. During the Middle Ages, the Magi were intriguing because they were exotic, mysterious men from the fabled Orient, astronomers and astrologers who could read the stars and look into the future. Herod was fascinating because of his blustering, ranting manner and excessive cruelty, and it is for this reason that the part has been a perennial favorite among actors who like to play the villain. When Shakespeare's Hamlet complains that over-acting "out-Herods Herod," he is referring to an ongoing tradition that dates back to medieval liturgical drama, and which inspired

Shakespeare's own characterizations of Richard III and Iago. But Herod, because he was a king, also stood in for the ultimate tyrant, and in an age when monarchy was becoming a powerful political institution, the representation of bad lordship as exemplified in Herod could serve as a warning to real lords. So there was a political dimension to liturgical drama, as well as a religious one. In the two twelfth-century Christmas plays associated with the monastery of Saint-Benoît-sur-Loire, in France, Herod's central place in the Christmas story is evident from the title of the drama, which is called *The Service for Representing Herod.* Throughout the play, Herod's violent behavior, and that of his murderous soldiers, must have seemed to the audience to resemble that of real rulers and their henchmen. But there were elements of comedy as well. When the Magi tell Herod about the miraculous star they have seen, Herod sends for his own experts, to see whether they can corroborate the story. The monks playing the scribes are described in the rubrics (stage directions written in red ink) as bumbling idiots, carrying stacks of moldy books and wearing false beards; they have to "turn over the leaves of the books for a long time" before they finally find the correct prophecy.

THE CHURCH AS PERFORMANCE SPACE. The geography of the medieval church was vitally important to the staging of Christmas drama. At Easter, the sole stage setting could be "the place of the sepulchre," which was usually located at or near the altar. At Christmastime, the entire church became a theater, if only because so much of the action of these plays involved traveling: Mary and Joseph journey to Bethlehem, the Magi come "from the East" to Herod's court and from there to Bethlehem, Mary and Joseph flee to Egypt, the Magi return to their homes. Each of these trips provided an opportunity for the actors to process around the church and through the audience, who would be standing in the nave (the central hall). Since all medieval churches were oriented on an East-West axis, with the altar in the apse at the eastern end, it would be from this part of the church that the Magi would "come together, each one from his own corner as though from his own region," according to the rubrics of the play from Saint-Benoît. The star that guides them rises from behind the altar, also in the east, and then leads their procession around the church. The citizens of Jerusalem are the members of the choir, while the members of the congregation are the people of Bethlehem. When the shepherds find the baby Jesus in the manger, they worship him and then "they invite the people standing all around to worship the child." Through such simple, effective techniques, the staging of liturgical drama allowed the events of the

Bible to be mapped onto the church space, collapsing the distance between actors and audience, the past and the present, the local and the universal.

SOURCES

William T. Flynn, "Medieval Music as Medieval Exegesis," in *Studies in Liturgical Musicology 8* (Lanham, Md. and London: Scarecrow Press, 1999).

Thomas J. Heffernan and E. Ann Matter, eds., *The Liturgy of the Medieval Church* (Kalamazoo, Mich.: Medieval Institute Publications, 2001).

Andrew Hughes, *Medieval Manuscripts for Mass and Office: A Guide to Their Organization and Terminology* (Toronto: Pontifical Institute, 1982).

SEE ALSO *Music: Additions to the Sacred Repertory; Religion: Medieval Liturgy*

SERIOUS COMEDY

ROMAN THEATER IN THE MIDDLE AGES. The initiative of the artists and intellectuals who contributed to the Carolingian Renaissance provided the tools that would make the transmission of liturgical drama possible, but it also ensured the preservation of older theatrical traditions. Hundreds of manuscripts containing the Latin comedies of the popular Roman playwright Terence were made in the centuries between 800 and 1200. Many were lavishly illustrated and suggest that some medieval people knew a great deal about Roman comedy. These illustrations show lively, two-dimensional stagings of key scenes, in which actors are depicted wearing the masks and costumes typical of Roman performances. Their very gestures are meticulously rendered, contributing to the illusion that the viewer is looking at "snapshots" of Terence's comedies as they would have been presented around the time of Constantine or St. Augustine, in the fourth century C.E. It would have been easy for the medieval readers of these plays to reconstruct some of the circumstances of their performance, as they looked at the pictures and read aloud the various parts. However, the careful authenticity of the manuscripts' representations of ancient comedy also suggests that the copyists were striving to preserve information about an archaic art form: medieval audiences were not used to seeing masked actors, nor did they frequent the same types of theaters as the people of ancient Rome. When Hugh of Saint-Victor offered his definition of the "theatrical arts" in the early twelfth century, he was trying to capture the timeless diversity of human amusements and leisure activities; yet he was also aware that times had changed, that the theater "was the place people used

Masks from Terence, *Andria*, line drawing from an edition of Terence, 1736. BETTMANN/CORBIS.

to gather for entertainment"—employing the past tense, to emphasize that the pagan theater of ancient Rome was not the same as the theater of medieval Christendom. Hugh himself would have seen the remains of Roman theaters and other buildings (baths, temples, an amphitheater) on the Left Bank of the River Seine, nestled in the hills where the new University of Paris would be founded during the course of the twelfth century. And he knew that it had been a long time since those structures had been used for the purposes for which they were originally designed. But this did not stop other medieval writers from making constant—and knowing—references to Roman theater and its many attractions.

COMIC REVIVALS. If knowledge of Roman theater, the scripts of Roman plays, and even Roman theater buildings survived into the Middle Ages, why was medieval theater not more like the theater of that distant past? One reason is that the church had made an effort to promulgate a special type of Christian theater, the liturgy, and had also worked hard to modify the pagan festivals that had provided many of the occasions for the

performance of Roman plays. More to the point, though, is the fact that the Latin language of these plays was no longer a language readily understood by most people in Europe, so their popular appeal was largely lost. Still, there is plenty of evidence that new forms of medieval comedy continued to draw heavily on ancient traditions and techniques, retaining some of the same plots, gags, and characters regardless of the language in which the lines were spoken. Moreover, the plays of Terence were constantly revived and performed in venues where the love of Latin was continuously cultivated: in monasteries and cathedral schools, universities, royal courts, and any place where the performers could speak the language of Vergil, Cicero, and Ovid. In fact, Latin comedies would have been performed by many of the same amateur actors who also appeared in the Latin liturgical dramas. And because these plays made the learning of Latin fun, they were often used as teaching tools in medieval classrooms. They were also widely emulated by a new generation of playwrights; at the same time that the manuscripts of Roman plays were being copied, and the Easter and Christmas liturgies written down, there were men and women composing their own comedies in Latin, some with contemporary—even Christian—themes. The simultaneity of these different dramatic traditions and genres is one of the most intriguing aspects of medieval theater.

THE PLAYS OF HROTSVIT. One of the most famous playwrights of the Middle Ages embodies what might be considered some of the paradoxes of medieval drama. Her name was Hrotsvit (or Hroswitha), and she was a canoness (a member of a religious order) vowed to the religious life at the abbey of Gandersheim in Germany. But she was probably brought up and educated at the imperial court of Otto I (912–973) who ruled a large portion of Charlemagne's former empire after 951. Moreover, Hrotsvit (c. 935–1002) is remembered today not only for her dramatic works, but for her skills as a mathematician and theologian. Together with her childhood friend Gerberga, who was the emperor's niece and the future abbess of Gandersheim, Hrotsvit probably entered the convent when she was in her late teens or early twenties, and it is reasonable to speculate that she intended her seven comedies to be performed by her sister nuns, whose knowledge of Latin and of the Christian faith would have been strengthened at the same time, in a highly amusing manner. Among Hrotsvit's achievements, therefore, is the invention of a distinctly Christian form of comedy, in which many comic devices as old as the comedies of Aristophanes (448–385 B.C.E.)— trickery, role-playing, delusion, love-sickness, youthful rebellion, pompous old age—are blended with the divine "comedy" of the ultimate sacrifice: death for one's

Early medieval conception of a Roman theater performance. Rhabanus Maurus, *De universo*, Abbey of Montecassino MS 132, folio 489, Montecassino, Italy, tenth century. **A. M. ROSATI/ART RESOURCE, NY.**

faith, a death that cannot be viewed as tragic, since it earns the martyr the bliss of eternal life.

TWO CHRISTIAN COMEDIES. Hrotsvit's *Gallicanus* tells the story of the Roman general Gallicanus, a ruthless pagan whose command over the legions of the Emperor Constantine gives him great power. In the play, Gallicanus uses his clout to secure the hand of Constantine's daughter Constance, despite the fact that both father and daughter oppose the match because of their intense devotion to Christianity. But Constance advises her father to trick Gallicanus into thinking that she will marry him after he has successfully completed his military campaigns, cunningly sending two of her Christian advisors to help convert him to Christianity, while inviting Gallicanus' young daughters into her house, where they are quickly persuaded to join Constance in vows of virginity. Meanwhile, in the heat of a losing battle, Gallicanus (like the historical Constantine before him) prays to the Christian God for assistance and sees a vision of Christ himself marching into battle, carrying the cross. He is immediately converted and, taking vows of celibacy, becomes a hermit. Years later, he suffers martyrdom under the pagan emperor Julian the Apostate, but when Julian's son is possessed by the devil as a punishment for his father's crimes, both father and son agree to be baptized. In another comedy, *Dulcitius*, Hrotsvit embroiders some of the same themes through a spicier plot set during the time of Great Persecution of the Roman emperor Diocletian (284–305). A lascivious Roman official, Dulcitius, schemes to deflower three beautiful Christian maidens who have been arrested for their faith, but their virginity is protected when Dulcitius falls victim to a delusion in which he believes the dirty pots and pans in

the girls' kitchen to be the bodies of his intended victims. He embraces them passionately and covers them with kisses, blackening himself with soot in the process and becoming a laughing-stock among his fellow pagans. Later on, when the evil executioner Sisinnius attempts to send one of the defiant virgins to a brothel, she is miraculously rescued from this fate, although she (like her two sisters) is eventually—but triumphantly—martyred.

THE PERFORMANCE OF LATIN PLAYS. Hrotsvit's plays are particularly sophisticated examples of what could be achieved through the creative blending of classical and medieval ideas of comedy, but they are not the only examples. A later group of about two dozen Latin comedies, composed by a variety of authors over the course of the late eleventh through early thirteenth centuries, take a more conventional approach to updating classical genres. Most are much shorter than Hrotsvit's, and many are anonymous, but like hers they are written in Latin verse and would have been performed by and for well-educated men and women in the service of the church or of the great secular rulers of Europe. Walter Map, a member of the entourage of King Henry II of England (r. 1154–1189), related that his clerks would often spend the evenings play-acting or making "jokes to take the weight off their minds." But so, it seems, did many other people, including monks, nuns, priests, schoolmasters, and their pupils. Froumund of Tegernsee (d. 1008), a prolific poet and dedicated teacher at the important Bavarian abbey of Tegernsee (a place well-known for its later contributions to medieval drama), complained good-naturedly that it was hard to engage his students' attention unless he indulged them with comic displays and other antics, anything "ridiculous, that cracks up all the boys." Geoffrey de Gorron (d. 1146), the abbot of St. Albans in England, began life as a schoolmaster whose enthusiasm for theatrical display led him to borrow valuable vestments from the monastery to use as costumes in a play about St. Catherine of Alexandria; when they were accidentally destroyed by fire, he himself became a monk to compensate for the loss. Writing at the end of the twelfth century, Reinerus of Liège revealed that classroom performance of Terence's comedies was a favorite exercise at his own monastery of Saint-Laurent, so much so that one over-zealous teacher was visited in a dream by the abbey's patron saint, who chastised him for behaving too much like a comedian.

A LATIN SITUATION COMEDY. Given that the plots of most medieval Latin comedies revolve around sex, it is easy to see why they might have been controversial when produced in an ecclesiastical setting. The play *Babio*, probably written in England during the mid-twelfth

century, was therefore heavily edited when it was adapted for performance by the choirboys at Lincoln Cathedral, to judge by the state of one surviving manuscript. A glance at the plot-summary added to another manuscript copy offers an explanation for this censorship:

> Babio was a priest, Petula his wife, Fodius the household servant of Babio and Petula. Viola was the daughter of the latter, the daughter of the wife and not the daughter of Babio, but his step-daughter as it were, whom both Babio and Fodius love, unknown to one another. Croceus was a certain knight, lord of the town where the girl was, and he was the lord of Babio the priest. This Croceus loved the girl Viola and wished to have her, and the priest was upset about that. Fodius had an affair with the wife of the priest, that is with Petula, and his master, in other words Babio, didn't know it, even though he had his suspicions.

Add to this situation the humor of Babio's relationship with his dog (who makes a brief appearance early in the play), and it is easy to see why Latin comedies continued to be written and performed throughout the Middle Ages, even though they may have raised a few eyebrows. One of the most popular, the play known as *Pamphilus*, survives in so many manuscripts that it gave its name to the term *pamphlet*. Along with a number of other medieval Latin comedies—such as the *Geta* of Vitalis of Blois written in the twelfth century—it endured the test of time, appearing among the earliest printed books of the late fifteenth century and thereby influencing the work of countless Renaissance dramatists.

SOURCES

Keith Bate, "Twelfth-Century Latin Comedies and the Theater," in *Papers of the Liverpool Latin Seminar, 1979*. ARCA Classical and Medieval Texts, Papers, and Monographs, no. 3. Ed. Francis Cairns (Liverpool, England: Francis Cairns, 1979): 249–262.

Anne Lyon Haight, ed., *Hroswitha of Gandersheim: Her Life, Times, and Works, and a Comprehensive Bibliography* (New York: privately printed, 1965).

Michael Lapidge, trans., "Pamphilus," in *Medieval Comic Tales*. Eds. Peter Rickard et al. (Totowa, N.J.: Rowman and Littlefield, 1973): 114–127.

Paul Ruggiers, ed., *Versions of Medieval Comedy* (Norman: University of Oklahoma Press, 1977).

THE POPULAR BIBLE

MEDIEVAL MASS MEDIA. The Latin Bible in use throughout the Middle Ages had been translated from Greek and Hebrew by St. Jerome around the turn of the

fifth century, when Latin was still the mother tongue of the Roman Empire. This Bible was therefore called the "popular Bible" (*Biblia vulgata*) because it could be understood by those who could not read Hebrew or Greek. By the time of Charlemagne, however, Latin had ceased to be a language for everyday use, while the need to educate people about the Bible, and to instruct them in the tenets of the Christian faith, was greater than ever. The world was changing rapidly. By the end of the eleventh century, Western Europe was more culturally diverse and more densely populated than it had been since the power of the Roman Empire was at its height, nearly a thousand years before. Improvements in agricultural technology, the development of long-distance trading networks both by water and by land, and the flourishing of local economies during the twelfth century meant that people enjoyed greater freedom of mobility, both geographical and social. The availability of cathedral schools in major cities and the founding of the new universities in Paris, Bologna, Oxford, and Cambridge made it easier for young men from humble families to acquire an education, and thereby to fit themselves for careers in the church or in the increasingly powerful courts of secular rulers. Some of these men—those who preferred a more free-wheeling lifestyle—took what they had learned and applied it to the performing arts and to communication in the emerging vernacular literatures, which more and more people were able to read. Moreover, the fact that the population of Europe was increasingly concentrated in cities meant that it was possible to reach and to influence larger numbers of people at a time. This new urban audience was the focus of a renewed effort on the part of the church to make religious instruction available to all and, where possible, in the vernacular. Theater provided the perfect mass medium for conveying the message.

THE COMING OF "THE BRIDEGROOM." This is not to suggest that only secular urban audiences were more comfortable with their own vernaculars than with Latin. In fact, the first surviving medieval play with a significant vernacular component comes not from a prosperous town but from a powerful monastery, the abbey of Saint-Martial in Limoges, France. The monks of Limoges would have learned Latin from an early age, and most probably spoke, wrote, and even thought in Latin during daily worship, study, and conversation. But no man or woman in Europe, no matter how well educated or intellectually inclined, would have learned Latin in the cradle; the language that would always be the most comforting, the most familiar, was the language of childhood. In Limoges, that language was known as Occitan, and indeed the whole southern and southwestern portion of

what constitutes modern-day France (from Provence to the Pyrenees) was really Occitania, a politically and culturally distinctive region where the people spoke Provençal or what was often called the *langue d'oc*, the language in which the word for "yes" is *oc* (as opposed to the language of northern France, the *langue d'oïl*, in which the word for "yes" is *oui*). One of the plays that used the vernacular Occitan, which was copied into a manuscript toward the end of the eleventh century, is about the *Sponsus*, or "the Bridegroom." It is a musical dramatization of the Parable of the Wise and Foolish Virgins (Matthew 25:1–13), in which ten bridesmaids take lighted lamps and go out to wait for the arrival of the Bridegroom (in allegorical terms, they are Christian souls waiting for the Second Coming of Jesus Christ). When the Bridegroom's coming is delayed, all of them fall asleep. But five of the maidens are wise and bring extra oil for their lamps; the other five are foolish and let their lamps go out. (Again, in allegorical terms, some souls remain vigilant and virtuous, while others become complacent and slack.) At midnight, when the Bridegroom finally arrives, the foolish maidens are left out of the triumphal procession because they cannot help to light him on his way. Running home, they try to buy more oil from merchants in the town, but this means that they are late to the wedding banquet, and are not admitted. The use of the vernacular in the *Sponsus* underscores the drama inherent in this story of human frailty and salvation. While most of the dialogue is sung in Latin, there is a plaintive refrain in Occitan after each exchange: "Sorrowing, sinners, alas we have slept too long!" Furthermore, the exchange between the foolish maidens and the oil merchants takes place entirely in the vernacular, emphasizing the worldliness and futility of their failed business transaction.

THE CHRISTIAN MESSAGE IN TRANSLATION. Although very few plays survive from the twelfth and thirteenth centuries, it is clear that the use of the vernacular to heighten the effects of liturgical drama was becoming widespread. In the important episcopal city of Toledo in Spain, the *Auto de los reyes magos* (an Epiphany play about the Three Magi) was composed in the Castilian Spanish of that region at about the same time that the great heroic poem the *Poema del Cid* was written down. Because Toledo was close to the border separating the Muslim territories of Spain from those held by Christians, it is possible that the play—about pagan kings doing homage to the Christ Child—also carried a strong political message. Far to the northeast, in the influential Bavarian abbey of Benediktbeuern, the Easter drama of Christ's suffering and death—the events collectively known as the Passion—came to include a number of

significant vernacular elements. The characters most sympathetic to the German-speaking spectators of the play often talk directly to them in their own language. Mary Magdalene flirts with the young men in the audience in German, and also sings in German when she buys cosmetics from a merchant—foreshadowing the moment when she will buy ointments to anoint the dead body of Jesus in the sepulchre. The Virgin Mary, the mother of Jesus, wins special sympathy by expressing her sorrows in German. Longinus, the blind soldier who stabs the crucified Jesus with his lance, speaks German to reveal that the blood flowing from Christ's wounded side has restored his sight. Finally, Joseph of Arimathea and Pontius Pilate close the play with a dialogue conducted entirely in German. Similar popularizing techniques are used in a "Visit to the Sepulchre" liturgy from the convent of Origny-Sainte-Benoîte in northeastern France, which was sung almost entirely in French, and in a play called *Suscitio Lazari* (The Raising of Lazarus) written in the Anglo-Norman French dialect spoken in northern France (Normandy) as well as in England after the Norman Conquest of 1066.

THE CELEBRATION OF YOUTH.

Perhaps the most famous musical drama of the Middle Ages, *Danielis ludus* (The Play of Daniel), is another play that intermingles Latin and the vernacular in effective ways. Based on stories about the youthful prophet Daniel (stories that form part of the non-canonical Apocrypha, or "hidden writings" of the Bible), it was written by and for the youths of Beauvais cathedral in France—for the young men and boys who sang in the cathedral choir and attended the choir's school. Copied into a deluxe manuscript around the year 1230, it proudly proclaims the authorship and provenance of the play in the opening song:

The play of Daniel we record:
it was created in Beauvais
the work of youth, in every way.

Daniel was a particularly attractive hero for these young performers, since his boyish curiosity, compassion, and wit were the qualities that allowed him to solve riddles, investigate puzzling crimes, and foil the evil designs of his elders. In the version of his story dramatized at Beauvais, the precocious sage is able to decipher the mysterious handwriting that appears on a palace wall of the pagan king Belshazzar. Later, when he is wrongfully imprisoned by Belshazzar's successor, Darius, he will make a miraculous escape from the lions' den. Finally, he astonishes everyone with his perspicacity, by prophesying the future birth of the Savior, Jesus. The use of French in the lyrics of this musical is not extensive, but it does add an especially festive element to a play already rich in pageantry, humor, intrigue, and suspense. Performed annually on 1 January, *The Play of Daniel* was an integral part of the liturgy for the Feast of the Circumcision (also known as the Feast of the Presentation), one of several feasts that punctuated the Twelve Days of Christmas, from 25 December to the Feast of the Epiphany on 6 January (the first day of January was not celebrated as New Year's Day in northern France at this time). And, like the Feast of the Holy Innocents on 28 December, it compensates for the pain inflicted on the children of the gospel narrative (Herod's slaughtered innocents, or the circumcised baby Jesus) by allowing contemporary children a special license for revelry and misbehavior. Depending on the locale, any of these feasts could become a "Feast of Fools," when the traditional rituals of the church, including the Mass, were parodied and lampooned in ways that modern-day theologians might find shocking but which were widely accepted and greatly enjoyed during the Middle Ages.

TELLING IT STRAIGHT.

Many of the religious-themed plays make use of the vernacular in conjunction with Latin in a form sometimes called "macaronic," and these would have been chanted and sung as part of the dramatic liturgies that highlighted the importance of certain feasts. But there is no reason to believe that these same stories were not also told in plain language, unadorned by music and unaccompanied by Latin. Surviving sources often mention the performance of biblical plays, or plays about the lives of saints, without specifying which language they used—Abbot Geoffrey's play about St. Catherine is one. Some may have been spoken entirely in the vernacular, but perhaps it scarcely mattered. After all, every man, woman, and child in Europe would have been intimately familiar with these stories; like the audiences of Greek tragedies, they knew what would happen before the play even began. They may not have needed to understand every word in order to participate in a satisfying theatrical experience. And many of these plays may never have been scripted to begin with; it would have been very easy for the performers to ad-lib their roles. However, we do have part of the written texts for two early biblical plays that were performed almost entirely in rhyming French couplets: *Ordo representacionis Ade* (The Service for Representing Adam), sometimes called *Jeu d'Adam* (The Play of Adam), and *La seinte resureccion* (The Holy Resurrection). Both may have been composed during the latter half of the twelfth century, and were probably originally intended for audiences in southeastern England and Normandy, since their dialect is the Anglo-Norman French of those regions. Both are incomplete, but appear to have been ambitious in scope. *The Play of Adam* is particularly well known,

and it is possible that it was designed to tell the entire story of human salvation, from the Fall of Man in Eden to the Last Judgment. But the sole surviving manuscript ends abruptly, with the Old Testament prophets foretelling the birth of Jesus (in a *processio prophetarum* or "procession of prophets," similar in some respects to that which was probably performed at Riga, now the capital of modern Latvia). This play is also noteworthy for its careful instructions to the actors (written in Latin, to better distinguish them from the vernacular dialogue) with regard to costuming, set design, and the proper speaking of the verse. Most remarkable of all is the way that old stories are transformed when performed in modern dress—literally and figuratively. Here, Adam and Eve are a young, upwardly mobile couple; he's hard-working and away from home a lot, while she's ambitious but has too much time on her hands. They are perfect prey for a con-man like Satan. Later on, Cain and Abel's quarrel over the offering of sacrifices becomes a controversy about the payment of church tithes, taxes levied on parishioners for the support of priests; Abel is resigned and pious, Cain is angry and frustrated that the fruits of his hard labor should go into someone else's belly. This is serious social commentary, as well as sound religious doctrine.

SOURCES

Richard Emmerson, "Divine Judgment and Local Ideology in the Beauvais *Ludus Danielis*," in *The Play of Daniel: Critical Essays*. Early Drama, Art, and Music Monograph Series, no. 24. Ed. Dunbar H. Ogden (Kalamazoo, Mich.: Western Michigan University, 1996): 33–61.

Margot Fassler, "The Feast of Fools and *Danielis ludus*: Popular Tradition in a Medieval Cathedral Play," in *Plainsong in the Age of Polyphony*. Cambridge Studies in Performance Practice, no. 2. Ed. Thomas Forrest Kelly (Cambridge, England: Cambridge University Press, 1992): 65–99.

Carol Symes, "The Appearance of Early Vernacular Plays: Forms, Functions, and Future of Medieval Theater," *Speculum* 77 (2002): 778–831.

PLAYS ON THE CUTTING EDGE

AIRING DIFFICULT ISSUES. Medieval theater could simultaneously instruct and challenge its audiences. It would be a mistake to assume that just because a play contained an important religious message, and may in fact have been performed as part of the liturgy, that it could not also be funny or "edgy." Even liturgical dramas could be controversial, depending on how they chose to

a PRIMARY SOURCE *document*

THE INCIDENT AT RIGA

INTRODUCTION: In his chronicle history of the Baltic region, completed around the year 1225, a priest called Henry of Livonia described what happened when a play was performed for an audience that had no prior acquaintance with the conventions of medieval European theatre. In the excerpt below, Henry describes an incident that took place at Riga, on the coast of the Baltic Sea in what is now Latvia. He and his fellow German-speaking missionaries had been sent to convert the native peoples to Christianity, and they decided that putting on a play was the most effective way of doing this. However, the assembled audience did not understand that the violence in the play was not directed toward them; perhaps they were far too well acquainted with real violence to be able to grasp the meaning of theatrical violence.

Concerning the big play put on in Riga

That same winter [of 1205], an extremely well-produced play of the prophets was put on in the middle of Riga, in order that the folk might be taught the rudiments of the Christian faith as though through eye witness. The subject-matter of this play was most carefully explained to new converts, as well as to the pagans who came to see it, through an interpreter. However, at the place where Gideon's soldiers were fighting with the Philistines, the pagans began to run away, fearing that they would be killed—and could only be coaxed back with some care. But finally, after a while, the congregation grew calm and quieted down. Indeed, this very play was like a prelude or foreshadowing of the future, for in the play there were wars, such as those of David, Gideon, Herod; and there was the teaching of the Old and New Testaments. And in fact, through the many wars that followed the folk were going to be converted, and through the teaching of the Old and New Testaments they were to be instructed in such a way so as to arrive at true peace-making and eternal life.

SOURCE: *The Chronicle of Henry of Livonia*, 1225. Translation by Carol Symes.

represent the power of kings, how much they emphasized the importance of the vernacular, or how they depicted the relationships between men and women, lords and servants, sinners and saints. King Herod's tyrannical behavior is held up as a warning to contemporary rulers. The pagan wisdom of the Magi, which includes

a PRIMARY SOURCE *document*

THE SERVICE FOR REPRESENTING ADAM

INTRODUCTION: *The Service for Representing Adam* (1180), also known as *The Play of Adam,* is one of the earliest surviving dramas to have been written in a vernacular language—in this case, the French dialect known as "Anglo-Norman," because it was spoken in Normandy (northern France) and in England after the Norman Conquest of 1066. Like other biblical plays in the vernacular, it was designed to "update" the stories of the Old and New Testaments, making them accessible and relevant to a contemporary audience using vivid, colloquial language and familiar situations. In this scene, the Devil has just failed to tempt Adam into eating the forbidden fruit of Paradise (a scene that is not in the original story, as told in Genesis 3), so he turns his attention to Eve. Note that while the play is in rhyming octosyllabic verse couplets (reproduced in this translation), the rapid-fire exchange of dialogue between the characters creates a very naturalistic effect.

Devil: Look, Eve, I'm here to talk with you.
Eve: Tell me, Satan, what you're up to.
Devil: To do you good, that's why I'm here
Eve: God grant it, then.
 Devil: Oh, have no fear.
For many years, I've kept my eyes
On what goes on in Paradise.
Do you like secrets? Should I tell?

Eve: Yes, go ahead: I'll listen well.
Devil: You hear me?
 Eve: Yes, I said I do.
I'll trust that what you say is true.
Devil: Then you'll believe me?
 Eve: By my faith!
Devil: And you'll not tell?
 Eve: The secret's safe.
Devil: You've given me your guarantee;
That's fine, that's good enough for me.
Eve: Oh, you can trust me, as a rule.
Devil: You've clearly been to a good school!
But Adam, now: he's pretty thick!
Eve: He's a bit slow …
 Devil: You'll make him quick.
Now, iron's not as hard, or rock—
Eve: He's noble.
 Devil: He's a laughing-stock!
That's why he can't take care of you.
He should do as you want him to.
You are so dainty (may I say?)
More lovely than a rose in May
As white as crystal, or as snow
That falls on icy streams below.
That was a bad day's work for God
When he matched you with that big clod.
You're soft, he's hard; he's dumb, you're smart—
You have great courage in your heart.

detailed knowledge of mathematics and astronomy, is depicted as both glamorous and dangerous. Satan's temptation of Eve, in *The Service for Representing Adam,* suggests that women can easily succumb to flattery and ambition, but it also acknowledges their intelligence and their influence over men. One of the liturgical dramas associated with the monastery of Saint-Benoît-sur-Loire in France, *The Service for Representing How St. Nicholas Freed the Son of Getron,* describes the capture of a beautiful Christian boy by the pagan king Marmorinus, who takes the boy into his household and treats him with great tenderness. When the child is miraculously restored to the care of his grieving parents, the play does not go on to show the punishment of the king, but instead leaves the viewer with a sense of his probable grief over the loss of his treasured companion (his last words to the boy are: "No one can take you away from me, so long as I do not wish to lose you"). A respected modern scholar of medieval theater has suggested that this play confronts the problem of homosexual desire within the closed community of the monastery.

FAITH VERSUS REASON AT BENEDIKTBEUERN. It is arguable that the Latin dramas developed and performed by monastic communities could be more explicit in their treatment of controversial issues precisely because these were close-knit communities. Theater provided an outlet for the discussion of disturbing ideas. At the monastery of Benediktbeuern, where the Passion play's surprisingly extensive use of the vernacular suggests that it was geared toward the entertainment and edification of the local German-speaking population, the Christmas play is striking for a very different reason. It makes no use of the vernacular, and does not appear to have been designed primarily as a vehicle for popular piety. Rather, it addresses—at some length—the sophisticated intellectual concerns of well-educated churchmen who, by the end of the twelfth century, were trying to come to terms with Aristotelian philosophy, which had recently been re-introduced into the medieval West via increased contact with Jewish and Muslim scholars. In this context, the celebration of the event of Jesus' birth is subordinated to the problem of believing in the Virgin Birth,

I knew we'd get along, we two.
So now let's talk.

 Eve: I'll listen well.

Devil: You'll tell no one?

 Eve: Who would I tell?

Devil: Not even Adam?

 Eve: Very well.

Devil: All right. Let me just take a glance
To see that no one's come by chance—
Save Adam, who's just over there.

Eve: Speak up, he'll never overhear.

Devil: There is a great conspiracy
Against you in this garden, Eve.
The fruit that God gives you for food
Is not enough to do you good;
But that on the forbidden tree
Has powerful efficacy.
If you eat that, you'll never die
You'll have God's power, majesty,
Know good and ill—eternally.

Eve: How does it taste?

 Devil: Oh, heavenly!
And with your body, and your face,
You should be ruler of this place—
Of all the world you'd be the queen,
Surveying what no man has seen.
You'd know what all the future brings,
You'd be the master of all things.

Eve: Is that the fruit?

 Devil: Yes. Go and see.

Then Eve should very carefully consider the forbidden fruit and, after having admired it for a long time, say:

Eve: Just looking at it pleases me.

Devil: And if you eat, what happens then?

Eve: How can I know?

 Devil: Don't you listen?
You take it first, and then Adam:
That done, you'll wear the crown of heaven.
You'll then be your Creator's peer,
He'll have to share his powers here.
The instant that you taste the fruit
You'll be transformed; he'll follow suit.
You will be gods in your own right,
With equal graces, equal might.
Come, taste the fruit.

 Eve: I think I may—

Devil: Don't trust Adam—

 Eve: —but not today.

Devil: When?

 Eve: Let me be.
When Adam is asleep, maybe.

Devil: Eat it right now! Are you afraid?
You'll lose this, if it's long delayed.

SOURCE: *Jeu d'Adam* (c. 1200). Translation by Carol Symes.

a phenomenon that can only be accepted through arguments based on faith, rather than by rational proof. The spokesman for these new, disturbing arguments in the Christmas play from Benediktbeuern is a character called Archisynagogus, "the leader of the synagogue" or "the head Jew." While Archisynagogus is described in some of the stage directions as a comic character, behaving in ways that a medieval Christian audience might have considered stereotypically "Jewish," he is also the character who represents scientific truth and intellectual rigor—qualities very attractive to the community's scholars. Initiating a debate over the Old Testament prophecies of the Virgin's miraculous conception, Archisynagogus defeats all of his opponents single-handedly, confidently refuting the pious arguments of the prophets, the Boy Bishop (a choirboy appointed to preside over the Christmas festivities), and even St. Augustine. In the end, faith does triumph over reason—but only by virtue of superior numbers and the "proof" offered by the gospel story. Moreover, Archisynagogus is not vilified for his "great arrogance" but is brought back on stage toward the end

of the play to advise Herod in his dealing with the three Magi, speaking "with great wisdom and eloquence." Even the shepherds in this play fall prey to doubts, and are nearly convinced by the devil that the angels' glorious proclamation must be a lie. This is no simplistic re-enactment of the Christmas story, but a serious attempt to come to terms with the central problem of religious belief. The Middle English *Second Shepherds' Play* provides another example of the degree to which medieval plays allowed audiences to express their doubts, and challenged them to think about their faith in new ways.

THE JOURNEY OF A SOUL AT GANDERSHEIM. A very different type of challenge is offered by another play from a German monastic community, composed and performed around the middle of the twelfth century. This is the *Ordo virtutum* (The Service of the Virtues) by Hildegard of Bingen (1098–1179), abbess of a convent that she herself founded at Rupertsberg on the Rhine river. Hildegard was famous in her own day for her scientific and medical knowledge, her preaching, her

A SHEEP IN THE MANGER: THE SECOND SHEPHERDS' PAGEANT

INTRODUCTION: *The Second Shepherds' Pageant* forms part of the Corpus Christi play known as the *Wakefield* cycle (from the Yorkshire village mentioned in the play) or as the *Towneley* cycle (the name of the family in whose private library the manuscript was preserved). It is literally the second of two pageants devoted to the Christmas story—or, more specifically, to the role of the shepherds in that story. The biblical shepherds were popular characters in northern England during the Middle Ages. Many of the local people would have made their living in similar ways, and would have identified with the shepherds' plight: their poverty and loneliness, the terrible wintry weather they endured, their fear and surprise on hearing the angels' greeting, their joy at the Christ Child's birth. They would also have enjoyed the shepherds' irreverent attitude toward authority in this pageant, which goes so far as to poke fun at the doctrine of the Virgin Birth by introducing a plot which parallels that of Jesus' Nativity. A pair of unsavory characters, Mak and his wife Gill (Jill), steal one of the shepherds' precious sheep and hide it in a cradle, pretending that Gill has just miraculously given birth. When the shepherds come to look for their lost property, they are fooled into thinking that the creature in the manger is really a baby—until one of them is overcome with sentimental feelings and returns, intending to give the child a gift. The sheep is discovered, and so is Mak and Gill's deception. This is the scene excerpted below. The language of this play is the Middle English of the North—the language of the poet Geoffrey Chaucer (c. 1343–1400), but with a strong Yorkshire accent. The verse is the work of an anonymous poet known as the "The Wakefield Master," who favored a distinctive nine-line stanza and complex rhyme scheme. Some words have been modernized, but for the most part the text is as it appears in the play's fifteenth-century manuscript.

Shepherd 2: Mak, friends will we be, for we all are one.
Mak: We? Now I hold for me—[*Aside*] For amends get
 I none.
 Farewell all three!—[*Aside*] All glad were ye gone.
Shepherd 3: Fair words may there be, but love is there
 none
 This year. [*The shepherds depart.*]
Shepherd 1: Gave ye the child anything?
Shepherd 2: I trow, not one farthing.
Shepherd 3: Fast again will I fling—
 Abide me ye here. [*He goes back in.*]

 Mak, take it no grief if I come to thy bairn.
Mak: Nay, thou does me great reproof, and foul has
 thou fared.
Shepherd 3: The child it will not grieve, that little
 day-star.
 Mak, with your leave, let me give your
 bairn
 But six pence.
Mak: No, do way! He sleeps.
Shepherd 3: Methinks he peeps.
Mak: When he wakens, he weeps.
 I pray you, go hence! [*The other shepherds enter.*]

Shepherd 3: Give me leave him to kiss, and lift up the
 clout. [*He lifts the cloth covering the
 sheep.*]
 What the devil is this? He has a long snout!
Shepherd 1: He is markèd amiss. We wait ill about.
Shepherd 2: Ill-spun weft, I wis, aye comes foul out.
 Aye, so! [*Suddenly, realization dawns.*]
 He is like to our sheep!
Shepherd 3: How, Gib, may I peep?
Shepherd 1: I trow kin will creep
 Where it may not go.

Shepherd 2: This was a quaint gaud and a far cast:
 It was a high fraud!
Shepherd 3: Yea, sirs, it was.
 Let's burn this bawd and bind her fast.
 [*Pointing to Gill.*]
 A false scold hangs at the last.
 So shall thou.
 Will ye see how they swaddled
 His four feet in the middle?
 Saw I never in a cradle
 A horned lad ere now.

Mak: Peace, bid I. What, let you be far!
 I am he that him got, and yon woman him bore.
Shepherd 1: What devil [name] shall he have, Mak?
 Lo, God, Mak's heir!
Shepherd 2: Let be all that. Now, God give him care,
 I saw—
Wife: A pretty child is he
 As ere sat on a woman's knee
 A dillydown, perdy,
 To make a man laugh.

SOURCE: *The Second Shepherds' Pageant*, in *Medieval Drama*. Ed. David Bevington (Boston: Houghton Mifflin, 1975): 402–405.

tremendous literary and artistic productivity, her mystical visions, and her highly unconventional approach to worship. Visitors to the convent reported that her nuns often wore elaborate costumes on special occasions and were encouraged to find new and creative outlets for the worship of God, celebrating the feasts of the church with

unusual songs and liturgies composed by Hildegard herself. *The Service of the Virtues* may have been intended to celebrate the dedication of the convent around 1151; it could also have been performed more frequently, to honor the monastic profession of a new postulant, or simply to commemorate the challenges and rewards of the monastic life as it was experienced by women. Anticipating the morality plays of the later Middle Ages, it tells the story of a single (female) soul, Anima, and her journey through life, beginning with her embodiment in the "beautiful garments" of the flesh and the happy innocence of her childhood. Early on, Anima is introduced to the (female) Virtues and, through them, is made aware of life's temptations and difficulties. But living in God's created world is delightful to her, and Anima unabashedly revels in the delights of her body—until her encounters with the Devil leave her bruised and terrified. Calling on the Virtues to rescue her, Anima flees from the evil influence of her sins and eventually succeeds in escaping from the embrace of the Devil, yet not before she is reminded of how difficult her chosen path will be and how many earthly joys she is missing, including the pleasures of sexual intercourse and the joys of motherhood. Although there are few stage directions, the language of Hildegard's play is full of action verbs, sensuality, and violence. The virility and power of the Devil is underscored not only by the masculinity of the actor portraying him (the role was probably assigned to the convent's chaplain or to Hildegard's male secretary) but also by the fact that he is the only character who either cannot or does not sing. Instead of communicating through melody, like the female characters played by the nuns, he speaks or shouts his lines, by turns insinuating and threatening. It would be anachronistic to call this a "feminist" play, but it is certainly a play that does not shy away from dealing with the special concerns of women vowed to lives of celibacy, poverty, and domination by men.

APOCALYPSE PLAYS. Yet another Latin play created by a monastic community in twelfth-century Germany reveals that withdrawal from the temptations of the world did not necessarily imply a retreat from interest in worldly affairs. *The Play of Antichrist* from the imperial abbey of Tegernsee probably dates from the years around 1160, which marked important developments in the political career of Frederick II "Barbarossa" (c. 1123–1190), who had been elected emperor of the Romans in 1152. Nicknamed "red beard," and as hottempered as he was redheaded, Frederick was extremely ambitious, and spent his long reign attempting to exercise control over a vast and diverse region, which included the principalities of Germany, the city-states of

northern Italy, and parts of Eastern Europe. Constantly in conflict with the pope, and jealous of the success of his contemporary, Henry II of England, Frederick saw himself as the rightful successor of Constantine and Charlemagne—and seemingly believed that he was also destined to unify Europe; in fact, it was Frederick who coined the term "Holy Roman Empire" to describe the loose configuration of territories that made up his domain. *The Play of Antichrist* dramatizes Frederick's political pretensions, and may have been performed in his presence at Tegernsee. It draws upon Christian teachings about the Apocalypse—the second coming of Christ— suggesting that Frederick might well have seen himself in the role of the triumphant world leader whose restoration of Roman power would eventually bring about the coming of the Antichrist, thereby ushering in an era of fear, hypocrisy, and false miracles. But this time of uncertainty is a necessary precursor to the salvation of the human race, since the duplicity of the Antichrist is destined to be revealed by the prophets Enoch and Elijah, who will also succeed in bringing about the conversion of the Jews to Christianity, which is necessary to pave the way for the Second Coming of Christ, the Last Judgment, and the End of Days. This is hardly a comfortable subject for a play, and it is difficult for a modern reader to understand the messages that may have been conveyed in its performance. But the staging must have been a revelation in itself. Like the liturgical dramas devised for Christmas and Easter, *The Play of Antichrist* was designed for performance at various stations or sites, with some of the action taking place in several locations simultaneously. In this case, however, the relatively simple requirements of *The Visit to the Sepulchre*, or even the plays of Herod and the Magi, are replaced by the full-scale deployment of armies, the negotiations of ambassadors, and the ceremonious subjugation of kings; the stage directions in the manuscript reveal that *The Play of Antichrist* required seven "thrones" or scaffolds representing the major powers of the known world, each of which is vanquished by the emperor of the Romans and then reconquered by the Antichrist and his minions. The trickery of the Antichrist also calls for special effects of a more subtle kind, since it must be made evident to the audience that he is not the real Christ, and that his promises are lies. Accordingly, the actor performing this role is directed to wear armor that is only partly concealed by his outer garments, while the performer playing the part of a man whom Antichrist will pretend to raise from the dead is carefully instructed to make it clear that he is only "faking death." But the very theatricality of the Antichrist's "miracles" is itself disturbing and potentially subversive, since it brings to mind the overt theatricality

of the church's own performance of sacramental miracles, notably in the daily celebration of the Mass.

ACTING LOCALLY IN ARRAS. The surviving plays dating from the years prior to 1300 suggest that the theater of the Middle Ages was well equipped to address timely issues through the retelling of timeless stories. Even when performed in Latin, and as part of the liturgy, plays could contribute to ongoing debates within a community, or provide incisive commentary on the world outside. When performed in the vernacular, such plays worked even more powerfully, and could reach a wide audience. The thriving mercantile center of Arras in northeastern France provides scholars with the first vernacular plays written specifically for an urban population and developing plots that owe little to biblical models. The *Jeu de saint Nicolas* (The Play of St. Nicholas), composed after 1191 by Jehan Bodel (a professional entertainer and town clerk whose written works contributed new vocabulary to the language now called Old French), is based in part on stories of the saint's many miracles, but its real purpose is to describe a set of recent and momentous occurrences in the life of the town. In 1191, Arras became part of the expanding kingdom of Philip II "Augustus" (r. 1180–1223), the medieval architect of the modern French state; prior to that date, it had formed part of the independent county of Flanders. Jehan chose to tell the story of his town's changing political, cultural, and economic climate through the lens of saintly legend. In the play, a greedy pagan king wages war against a wealthy town, easily identifiable as Arras, and takes one of its official representatives captive. He also captures an icon of St. Nicholas, which the man from Arras tells him is capable not only of safeguarding treasure, but increasing it. Intrigued, the king places the icon in his treasury and advertises the fact that the money could easily be stolen. But when three thieves from a tavern in the marketplace of Arras try to make off with it, they are confronted by the angry St. Nicholas himself, who forces them to return the gold. When the king counts his money, he finds that there is more of it than ever before, so he converts to Christianity. Medieval Arras was renowned for its strong currency and its banking industry; Philip Augustus was famous for taking advantage of every opportunity that came his way, using the raw ingredients available to him, and Jehan created his own allegorical reading of the situation. About 75 years later, another famous son of Arras, the composer and poet Adam de la Halle, would imitate the artistry of Jehan Bodel in *Jeu de la feuillée* (The Play of the Bower), which would make even greater use of local settings, characters, and controversies. In fact, the humor of this later play is so specific to Arras around 1276 that it is very difficult for modern readers to understand what it is really about, let alone to laugh at its jokes.

SOURCES

Charles Burnett and Peter Dronke, eds., *Hildegard of Bingen: The Context of Her Thought and Art.* Warburg Institute Colloquia, no. 4 (London: Warburg Institute, 1998).

V. A. Kolve, "Ganymede *Son of Getron:* Medieval Monasticism and the Drama of Same-Sex Desire," *Speculum* 73 (1998): 1014–1067.

Barbara Newman, ed., *Voice of the Living Light: Hildegard of Bingen and Her World* (Berkeley and Los Angeles: University of California Press, 1998).

PROFESSIONAL PERFORMERS

THE MARK OF THE PROFESSIONAL. Most often, the plot of a medieval play addressed the specific concerns of the community for which it was performed, while the actors performing the play represented the community at large. By the same token, the resources for a play's production were furnished by the community; audiences did not pay for the privilege of attending, nor were actors paid to perform. This begs the question of the existence of professional entertainers in the Middle Ages and their role in the development of medieval theater. It is a difficult question to answer, largely because the material that these professionals developed and performed was almost entirely improvised, or at least unscripted. The men and women who made a living through performance had to be ready to practice their crafts anywhere, at any time, for any audience. They prepared routines and gags, sketches and bits, tricks and acts; they did not, for the most part, memorize texts or preserve what they performed in writing. This occurred for many reasons. A professional performer's livelihood could be dependent on the originality of his or her approach to the material; publishing trade secrets would diminish their value. Also, most actors, singers, musicians, dancers, acrobats, and clowns learned their skills by watching and listening to one another; as they traveled and worked, on their own or in groups, they were constantly developing, devising, copying, changing, adapting, and inventing. Certainly, some could and did read; some could also write, a skill that (unlike reading) was rare in the Middle Ages. Thus only a very few would produce scripts or songs; Jehan Bodel and Adam de la Halle of Arras are unusual exceptions to the rule. In general, it was not until the late sixteenth century that performers came to depend on written scripts for their craft. Throughout the Middle

Ages, the mark of the true professional was the ability to work independently, relying on memory and skill.

THE ROLE OF THE JONGLEUR. Edmond Faral, one of the only scholars to attempt a systematic study of medieval entertainers, used the Old French word *jongleur* or "juggler" as a catch-all term to describe the array of talents and practices shared by the professional performers of the Middle Ages. His attempt to answer the question "What is a jongleur?" forms the opening paragraph of the book he first published in 1910:

> A jongleur is a being of multiple personalities: a musician, poet, actor, mountebank; a sort of steward for the pleasures associated with the courts of kings and princes; a vagabond who wanders the roads and puts up shows in the villages; a hurdy-gurdy man who, at a resting-place, sings of glorious deeds for the pilgrims; a charlatan who amuses the crowd at the crossroads; an author and actor of plays played on feast-days outside the church; a lord of the dance who makes the young people caper and skip; a taborer, a blower of trumpet and horn who keeps time in processions; a teller of tales, a bard who enlivens the feast, the wedding, the watches of the night; a circus-rider who vaults onto the backs of horses; an acrobat who dances on his hands, who juggles with knives, who jumps through hoops, who eats fire, who bends himself back in two; a buffoon who struts and mimics; a clown who plays the fool and speaks blarney; a jongleur is all that, and more besides.

However, no single performer could be master of so many skills, or practice them all at once. Faral's essential point is that the medieval entertainer was a jack-of-all-trades, since his livelihood depended on his willingness to be all things to all people, to turn his hand to anything. In fact, like most professional entertainers in modern times, the medieval jongleur also held a variety of "day jobs." A jongleur often worked as a servant in the houses of the wealthy when he was not entertaining there, or acting as a herald, messenger, or secretary. He also worked for the town where he performed on street corners or in the market square, as a crier, clerk, schoolmaster, or craftsman. Many jongleurs, however, were vagrants, traveling from place to place, begging for food or doing odd jobs when they could not earn enough money passing the hat during performances. It was a hard life, and it often earned the performer a bad reputation. Medieval people respected stability and feared the unfamiliar. Men and women who were constantly on the move, constantly changing jobs, and perpetually versatile could be objects of mistrust as well as sources of delight. This is why so much of the anecdotal evidence relating to the status of performers in the Middle Ages is negative.

ENTERTAINMENT AT COURT. Most professional entertainers were wanderers, but a privileged few were able to find steady employment in the entourages of the rich and powerful. They provided their masters with theater on demand, and with the prestige derived from patronage of the arts; in return, they received food and shelter, clothing and occasional gifts, and sometimes a steady wage. Depending on their individual talents, these men and women would have been called by a variety of names. The term *jongleur* was sometimes used generically, but it usually applied more specifically to clowns or jesters, many of whom also called themselves "fools." The (unnamed) Fool in *King Lear*, Feste the jester in *Twelfth Night*, and Touchstone the clown in *As You Like It* are a few of their Shakespearean offspring. Entertainers who specialized in music, vocal or instrumental, were often called minstrels, but this does not mean that they devoted themselves exclusively to music. Some were also capable of reciting tales of heroic deeds, like those described in the heroic poem *Song of Roland*; in Scandinavia, they helped to develop the intricate adventure narratives that would later come together to form the great Norse sagas; in Ireland, bards sang the exploits of the giant Cuchulain, and the cycle of stories that now make up the *Táin*; in England before the Conquest performers boasted of Beowulf, and other heroes of the Anglo-Saxon past. By the thirteenth century, all over Europe, the deeds of King Arthur and his knights eclipsed all of these, and were especially popular in courtly circles, where tournaments were often designed to resemble those described in story and song.

THE POET-MUSICIANS. There was also the special class of poet-musicians who composed and sang their own lyrics of love and longing in the new vernacular languages of Europe, and who were known as troubadours, trouvères, or minnesingers, depending on whether they were from northern or southern France, or Germany. They were the entertainment elite. In fact, some were not professional entertainers at all, but clerics or noblemen "moonlighting" as performers. Adam de la Halle of Arras, the author of *The Play of the Bower*, exemplifies the traits of this group. Well-educated, with perhaps some training at the university in Paris, he was active in the multifarious theatrical activities of his hometown but also appears to have been attached to the court of Count Robert II of Artois (1250–1302), for whom he may have written *The Play of Robin and of Marion*, a musical comedy with a romantic—and spicy—pastoral plot (one focusing on shepherds and shepherdesses). While it was almost certainly intended for performance at court, with a cast consisting of Robert's household entertainers, its manuscript indicates that it was later revived for

Castle of Perseverance, Drawing of staging, Macro Manuscript, 15th–16th century. BY PERMISSION OF THE FOLGER SHAKESPEARE LIBRARY. V.A. 354, F. 191 VERSO.

performance in the very different urban milieu of Arras, another indication of medieval theater's versatility.

FABLES AND FARCES. While it has often been assumed that certain plays, jokes, or songs would have been more appropriate to a courtly setting than to an urban one, there is plenty of evidence to suggest that medieval performers and their audiences enjoyed a wide variety of entertainments, regardless of social class. Urban audiences wept when they heard the tale of noble Roland's death, and so did the knights who strove to emulate him. Rustic audiences laughed at the antics of clowns and the scatological humor of the short, salacious stories known as fabliaux, as did kings. The manuscript books that preserve the raw materials of the performers' repertoire as it had evolved by the thirteenth, fourteenth, and fifteenth centuries were obviously made for aristocratic or well-to-do collectors, but the materials themselves could have been adapted for performance in taverns or halls or market-squares, on streets or at fairs, after feasts or before campfires. The plays that survive from this era were not only adaptable to occasion and circumstance, but

also to the number of available performers. Two of the earliest examples come from the region around Arras: a dialogue called *The Boy and the Blind Man* and a retelling of the Parable of the Prodigal Son (Luke 15:11–32) called *The Courtly Lad of Arras*. The extant manuscripts of these two short pieces indicate that both were performed many times over a period of several centuries, and they make use of some of the same plot-lines and devices that would later be recycled in the comic interludes or farces that were literally sandwiched in between longer or more serious plays in the fifteenth and sixteenth centuries (the French word *farce* means "stuffing," while the Latin *interludium* means "a play between the plays or games"). Both consist of rhymed couplets (easily memorized) and both could have been performed in under an hour, perfect for any occasion. *The Boy and the Blind Man* uses the tried-and-true formula of the comic duo, one the mastermind (the Boy), the other the straight man and butt of the jokes (the Blind Man). The aim of the characters is the same as that of the performers—to entertain a crowd of people and con them out of as much money as possible. While it calls for two actors, it could probably be performed by a single jongleur with the help of his fool's "bauble," the jester's puppet-on-a-stick. *The Courtly Lad* could have been recited by a single performer as well, but it could also have been divided into parts. Its re-working of the biblical story provides a new parable for the fast-moving world of late medieval Europe, when hapless young men from the countryside were easily attracted to the pleasures of town life and often lost their money to gamblers and prostitutes. The fact that it could easily have been performed in a tavern is a constant reminder of the interaction between theater and public life in the Middle Ages.

MIRACLES AND MORALITIES. The plays performed by professional actors had to be as adaptable as the performers themselves, shrinking or expanding to fill any space, or to accommodate any cast. Because there were no permanent acting companies in Europe until the late sixteenth century, no troupe of actors could be sure that it would have unlimited resources, human or material, when it was time to perform. There were exceptions, of course. Occasionally, wealthy individuals and corporations hired professional actors to perform plays on festive occasions, or to supplement the talents of amateur actors. For example, a remarkable group of forty plays from Paris, each devoted to a miracle attributed to the intercession of the Blessed Virgin, survives in a deluxe manuscript copied in the last decades of the fourteenth century. These *Miracles de Nostre Dame* were performed between 1339 and 1382 at the annual feasts of the Paris guild of goldsmiths (an association of craftsmen who

a PRIMARY SOURCE *document*

STAGING THE CASTLE OF PERSEVERANCE

The Castle of Perseverance may be the oldest play text in Middle English, dating from the first quarter of the fifteenth century (c. 1405–1425). It is certainly one of the most unusual. For one thing, it survives in a remarkable manuscript (now at the Folger Shakespeare Library in Washington, D.C.)—remarkable not only because of its length, but because it provides detailed instructions and a schematic plan to facilitate the staging of the play. Designed to be presented in the round, *The Castle of Perseverance* has thirty-five speaking parts and would have taken several hours to perform. It is often classified as a morality play, but unlike most morality plays it was probably not intended for production by a troupe of traveling players; instead, it may have been written for a cast that included professional and amateur actors. But like *Everyman* and *Mankind*, it tells the allegorical story of one human being's journey through life, from birth to death.

As the manuscript's stage plan indicates, *Humanum genus* or "Mankind" makes his entrance on the stage of the round world as a naked infant, "born" in a bed sheltered by the Castle of Perseverance. He is accompanied throughout the play by two Angels, one Good and one Bad, who offer constant advice and are always at odds with one another. As he grows to adulthood, Mankind is attracted to the empty promises of the World, the Flesh, and the Devil, each of which occupies a scaffold beyond the moat that encircles the Castle, to the west, south, and north. Goaded by Backbiter, the World's minion, Mankind is tempted by the vices of youth: Lust and Folly; Covetousness (Greed), Pride, Wrath, and Envy; Gluttony, Lechery, and Sloth. As he grows older, however, Mankind begins to repent with the help of Shrift (Confession) and Penance,

and is brought to the Castle of Perseverance, to be sheltered by the Virtues: Charity, Abstinence, Chastity, Industry, Generosity, and Humility. No sooner is he safely inside its stronghold, but the Castle is besieged by the Vices, who attempt to "rescue" Mankind with the help of his Bad Angel, and the combined forces of the World, the Flesh, and the Devil. But because Mankind is older and wiser, his Good Angel and the Virtues remain strong, and are able to vanquish the Vices—all but one, the special Vice of old age: Covetousness (Greed). Lured out of the Castle by Covetousness, leaving his Virtues behind, the unprotected Mankind quickly succumbs to Death. But as he dies, he cries for mercy, and this cry will be what saves the Soul that now issues from his body. For just as the Bad Angel is triumphantly leading the damned Soul to the Devil, the four daughters of God appear: Mercy, Righteousness (Justice), Truth, and Peace. Accompanied by the Good Angel, they lead the Soul to the throne of God in the east. There, the daughters of God sit in judgment on the past sins of Mankind, and in the end Mercy triumphs, pleading successfully for his Soul's salvation. So God pardons the Soul, and then speaks the closing lines of the play:

And they that well do in this world, here wealth shall
 awake:
In heaven they shall heightened be, in bounty and in bliss.
And they that evil do, they shall to hell-lake
In bitter bails to be burnt: my judgment it is.
My virtues in heaven then shall they quake;
There is no one in the world that may escape this.
All men example here then may take,
To maintain the good and mend what is amiss.
 Thus endeth our games!
 To save you from sinning,
 Ever, at the beginning,
 Think on your last ending!
 Te Deum laudamus.

banded together to protect and regulate their trade), and they often call explicitly for the talents of professional musicians and possibly of dancers; since a new play appears to have been staged every year, it is not unlikely that professional actors were also called in. But usually when actors banded together to perform plays, they developed a limited repertoire and took the show on the road, moving from place to place and performing in taverns, inn yards, and private houses. One of the earliest scripts for a portable play of this kind is *Mankind*, a Middle English "morality play" written down between 1465 and 1470. Morality plays addressed the problems and temptations faced by ordinary people by following a representative human being through daily life. Because

they aimed to be accessible to everyone, they generalized common experiences through the use of allegory, a technique which relied on personifications of abstract qualities in characters with names like "Good Works" and "New Guise" (Trendy Fashion); and although the central message was religious, the dramatization of the allures of vice and the struggle for virtue was intended to be highly entertaining. The actors would go hungry if their play was boring, since the most common way of collecting money was to ask for donations during or after the performance. An interval for the collection of cash is actually written into *Mankind*, which is designed for performance by a cast of six actors, one playing the title character, four playing the pranksters who plague him—

aptly named Mischief, New-Guise, Nowadays, and Nought—and the sixth doubling the key roles of Mercy and Titivillus, the "All-Vile" chief devil. The pairing of these two very different roles is itself suggestive of the lead actor's virtuosity, as well as of the playful quality of even the most moral of medieval morality plays. It was for precisely this reason that contemporary critics condemned their performance, no matter how religious the theme. *The Tretise of Miraclis Pleying*, written in England probably by a proponent of Lollardry (a pre-Protestant group hostile to the hierarchical nature of the Roman Church) several decades before *Mankind*, argues that the "playing" or performance of miracles and moralities "taketh away the dread of God." But when plays and their performers are controversial, it is a good sign that both are doing their job.

SOURCES

Timothy J. McGee, *Improvisation in the Arts of the Middle Ages and Renaissance*. Medieval Institute Publications: Early Drama, Art, and Music Monograph Series, no. 30 (Kalamazoo, Mich.: Western Michigan University, 2003).

Domenico Pietropaolo, ed., *The Science of Buffoonery: Theory and History of the Commedia dell'Arte*. University of Toronto Italian Studies, no. 3 (Ottawa: Dovehouse Editions, 1989).

William Willeford, *The Fool and His Sceptre: A Study in Clowns and Jesters and Their Audience* (Evanston, Ill.: Northwestern University Press, 1969).

COMMUNITY THEATERS

URBAN CENTERS. Toward the end of the twelfth century, a cleric called William FitzStephen included a lengthy description of the city of London in his biography of St. Thomas Becket (1118–1170), written to attract visitors to the new martyr's shrine at Canterbury and to his birthplace nearby. Among the city's attractions, William emphasized its opportunities for entertainment, listing an array of pleasurable pastimes that resembles the catalogue of theatrical activities outlined by Hugh of Saint-Victor.

> I do not think that there is any city deserving greater approval for its customs, with regard to church-going, ho\noring divine ceremonies, the keeping of feast-days, the giving of alms, reception of strangers, confirmation of betrothals, making of marriages, celebration of weddings, preparation of banquets, welcoming of guests, and also in the observance of funeral rites and the burying of the dead.

He goes on to paint a tantalizing picture of "the sports of the city, since it is appropriate that a city be not only useful and important, but also a source of mirth and diversion." Acknowledging that London, unlike ancient Rome, has no theater buildings in which plays can be seen, he assures his audience that it "has dramatic performances of a holier kind, plays wherein are shown either the miracles wrought by holy confessors or the sufferings which glorified the faith of the martyrs." Moreover, he says, London has Carnival plays and games, tournaments and processions, mock naval battles, hunting and hawking, summer games showcasing feats of athletic skill, and winter sports like bear-baiting and ice-skating. In many ways, urban communities such as London showcased the quintessential community of medieval theater—which used the resources of the community to which it performed in order to deliver its message—more fully even than the closed community of the monastery. The city could be the theater when it provided the stage for theatrical activities mounted at different times and seasons of the year; or it could be an actor in great pageants of national significance when it arrayed itself in finery and put on parades and plays to welcome visiting kings and dignitaries. And sometimes it could represent the whole world, and the whole history of human salvation, when it staged the great cycle plays of the later Middle Ages.

CHRISTMASTIDE AND CARNIVAL. Like the drama of the church, the drama of the medieval town was governed by the liturgical calendar and the seasons of the year. Certain seasons were especially conducive to theatricality, either because they were times of comparative leisure and plenty, when the rhythms of sowing and harvest had slowed, or because they were times when people were drawn together by sociable impulses as old as humanity, as at the dark time of the winter solstice. While spring and summer offered numerous opportunities for the games, dances, and diversions described by William FitzStephen—played out in towns and villages all over Europe—Christmastide and Carnival were the major occasions for festive theater in most communities. The week after Christmas was a busy time in churches, and it is important to remember that the liturgical plays celebrating Jesus' birth and the events leading up to the Epiphany of the Magi were in performance throughout the Middle Ages, and would have been extremely familiar to everyone. Supplementing these formal dramas were the revels associated with Christmas, which included a variety of small-scale dramatic productions often called "mumming plays." These drew upon the same ancient inclinations that had prompted the church to attach the celebration of Christmas to the winter solstice in the first

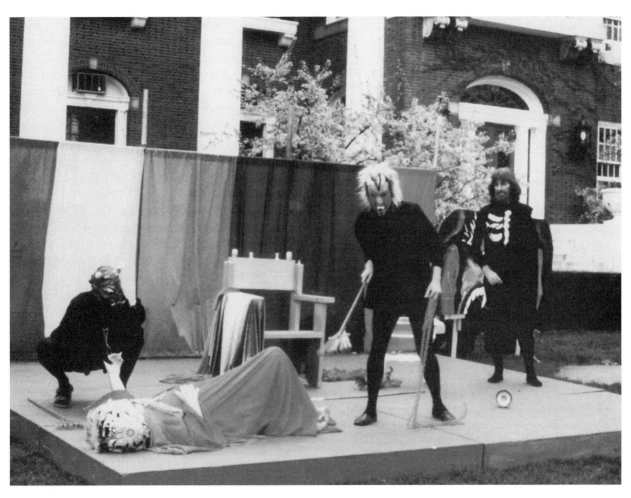

Death of Herod, Performance of *Massacre of the Innocents*, University of Illinois, Urbana, Illinois, Spring 1983, produced by John Block Friedman. **COURTESY OF JOHN BLOCK FRIEDMAN.**

place. The birth of a marvelous child, the rekindling of light in a dark place, the miraculous recycling of the new year—the simple plays that dramatized these things reached deep into the primal mythology in which medieval Christianity was already firmly rooted. So did the revelry of Carnival, the season of license and conspicuous consumption that followed Epiphany and ended on "Fat Tuesday" (Mardi Gras), when Ash Wednesday ushered in the six weeks of fasting and penance that preceded Easter. Carnival, Lent, and Easter were also products of the natural cycle, since the meat from animals slaughtered in late autumn would not last through the winter and had to be eaten, thus providing for the feasting of Carnival; Lent, by contrast, institutionalized the basic necessity of rationing the remaining store of grains and legumes that had been put up at the autumn harvest and had to last until spring, when earth's fertility would be renewed, just as Christ's body was resurrected from the tomb. The theater of Carnival resembled the foods of Carnival: excessive, rich, and unlike the normal fare of everyday life. Carnival plays, like the *Fastnachtspiele* of Germany, accordingly reveled in cross-dressing, the reversal of hierarchies, and the flouting of acceptable conventions. As at the Feasts of Fools during Christmastime, the world was turned upside down. The celebration of subversive behavior may seem strange to us, but in many ways it was the glue that held these communities together. Carnival allowed the people of Europe to use up excess energy, as well as excess food—both being commodities which, if stored too long and allowed to go bad, would be far more dangerous than a period of organized dissipation.

PASSION AND MYSTERY. The further development of towns in the later Middle Ages led to the growth of new identities within these communities, as well as to a growing sense of shared identity—local, regional, and even national. Theater became a medium for expressing these identities. In Italy, where towns had long been the fundamental units of political as well as economic organization, lay confraternities often took the lead in

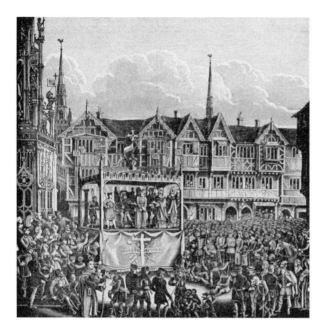

An imagined performance of a fifteenth-century mystery play, engraving in a study by Thomas Sharp, early nineteenth century. THE GRANGER COLLECTION, NEW YORK.

displays of public religious fervor, competing with one another in the performance of *laudes*—songs and ritual processions staged in honor of the Blessed Virgin or the saints—which by the fifteenth century were accompanied by *sacra rappresentazioni*—theatrical presentations of events from sacred history performed on major feasts. In Spain and Catalonia, the Feast of the Assumption of the Virgin, celebrated on the 15th of August, became an especially important occasion for dramatic demonstrations of collective piety, and plays glorifying the life and miracles of the Virgin were performed annually; the *Misteri d'Elx* is still performed every year in the Basque town of Elche, the oldest European play in continuous production. Elsewhere on the Continent, community theater received its fullest expression in plays devoted to the life, ministry, death, and resurrection of Jesus. In some places—notably in the major cities of the Low Countries, Switzerland, France, and Germany—these Passion plays (plays dramatizing the suffering of Christ) came to be called "mystery" plays, not only because they delved into the mysteries of faith, but because they were produced by representatives of the various trade guilds, associations of craftsmen who banded together to protect and regulate the secrets or "mystery" of their trades. Depending on the size of the city, the number of its guilds, and the generosity of their budgets, these plays could be more or less elaborate. In some places, episodic plays chronicling the entire history of human salvation were performed on successive days in a cycle that could last nearly a month. The geography of the town would often dictate where and how such plays were performed, whether in the round, using several scaffolds or platforms, or in procession at various stations throughout the city. Continental towns in northern Europe tended to have larger market squares that could accommodate large-scale spectacles and their audiences; in England and in Spain, by contrast, more constricted spaces favored the use of pageant wagons that were drawn through the narrow streets, stopping at certain pre-arranged sites for the performance of individual plays.

A NEW OCCASION FOR THEATER. It is clear that members of medieval communities eagerly sought opportunities to take part in dramatic productions. In *The Miller's Tale*, one of the stories in *The Canterbury Tales* by Geoffrey Chaucer (c. 1342–1400), a parish clerk called Absolon falls in love with Alison, the pretty young wife of a wealthy carpenter; but she is already infatuated with Nicholas, a student who lodges in her husband's house. Desperate to win her for himself, Absolon woos Alison with gifts and sweets, tender ballads, and proofs of his prowess. These include demonstrations of dramatic skill, when "to show his lightness and his mastery, / He playeth Herod upon a scaffold high." Given the ubiquity of community-sponsored theater in late medieval Europe, young men with a penchant for acting had many opportunities to showcase their talents—especially in England, where the celebration of the Feast of Corpus Christi provided the opportunity for towns and guilds to advertise themselves and their piety, as well as to satisfy the histrionic ambitions of their members. This new feast, dedicated to the "Body of Christ," was formally instituted in 1311 by Pope Clement V and became the occasion around which many of the mystery cycles and Passion plays of Europe were performed. This new focus on Christ's corporeality, his mystical body as well as his physical humanity, and on the manifestation of his miracles in the world, tied in beautifully with the conventions of medieval theater.

THE CORPUS CHRISTI PLAY. From the liturgical dramas of the early church to the moralities of the later Middle Ages, medieval performers and audiences had developed a shared vocabulary that used symbols, spatial orientation, and sophisticated storytelling techniques to convey meaning in direct, immediate, even visceral ways. Biblical events were not treated as part of the past, but as aspects of a continuous present that affected the actions of men and women in the here-and-now. The fact that an episodic staging of the gospel narrative might require dozens of actors playing the role of Christ is already a profound theological statement in the making (as Jesus himself had taught, all men and women should

a PRIMARY SOURCE *document*

LIST OF PROPS, SETS, AND COSTUMES FOR THE LAST JUDGMENT AT YORK

INTRODUCTION: One of the most elaborate pageants in the York Corpus Christi cycle was *The Last Judgment*, performed annually by the Guild of Mercers (cloth merchants). This was the finale of the day-long theatrical event, and was therefore expected to be particularly impressive—and to require significant expenditure on the part of the guild's members. The mercers therefore accumulated an impressive array of costumes, props, and set-pieces, which they inventoried in 1433. The list (given below) suggests that the pageant wagon represented the Earth, on which Christ and his apostles were enthroned as judges. It may also have featured trap doors for the graves out of which the righteous and the damned souls could have risen to receive their sentences. Heaven would have been situated on a higher scaffolding rigged out with moving mechanical angels, and the mouth of Hell on the street itself, in front of the wagon.

First a Pageant [wagon] with 4 wheels, Hell Mouth, 3 garments for 3 devils, 6 devils' faces in 3 Visors [i.e., masks], Array [i.e., costumes] for 2 evil souls, that is to say: 2 Shirts, 2 pairs of hose, 2 visors & 2 wigs, Array for 2 good souls, that is to say: 2 Shirts, 2 pairs of hose, 2 visors & 2 wigs, 2 pair of Angels' wings with iron in the ends, 2 trumpets of White plate, & 2 reeds, 4 Albs for 4

Apostles, 3 diadems with 3 visors for 3 Apostles, 4 diadems with 4 Wigs of yellow for 4 Apostles, A cloude and 2 pieces of rainbow [made] of timber, Array for God [i.e., Christ], that is to say: a Shirt wounded, a diadem, With a visor gilded, A great coster [i.e., hanging] of red damask painted for the back side of the Pageant, 2 other lesser costers for the 2 sides of the Pageant, 3 other costers of linen broadcloth for the sides of the Pageant. A little coster 4-squared to hang at the back of God. 4 Irons to bear up Heaven, 4 small cotter-pins & an Iron pin, a grate of Iron that God shall sit upon when he shall rise up to Heaven, With 4 ropes at 4 corners. A Heaven of Iron, with a hub of wood, 2 pieces of red clouds and stars of gold belonging to Heaven, 2 pieces of blue clouds painted on both sides, 3 pieces of red clouds, with sun beams of gold & stars for the highest of Heaven, with a long small border of the same Work. 7 great Angels holding the Passion of God [i.e., the symbols of Christ's Passion: crucifix, nails, crown of thorns, and so on], One of them has a vane of copper & a cross of Iron in his head, gilded. 4 smaller Angels, gilded, holding the Passion. 9 smaller Angels painted red to run about in the Heaven. A long small cord to make the Angels run about, 2 short rollers of wood to put forth the pageant.

SOURCE: "The Mercers' Indenture of 1433," in *Medieval Drama: An Anthology.* Ed. Greg Walker (Oxford: Basil Blackwell, 2000): 159. Text modernized by Carol Symes.

be treated as though they were Christ). These civic exhibitions of piety often began with the Creation and ended with the Last Judgment, and were produced over several days. In England, some communities attempted to perform this feat in a single day, beginning at dawn with the prehistory of mankind as described in Genesis, and ending late into the midsummer night with the bodily resurrection of the dead, the eternal damnation of sinners, and the salvation of the righteous. This was the case in the ancient city of York, where the pageant wagons carrying the actors and the scenery for individual plays followed a route that can be traced even today; each play would be performed several times at certain key locations. The props, costumes, and special effects were the jealously guarded property of the guilds that performed the plays, and particular roles may have been passed on from father to son over several generations. Moreover, the subject matter of a given play often said something about the guild, or its craft. At York, "The Last Supper" was performed by the bakers, whose bread became the body of Christ during their re-enactment of the first Eucharist; "The Crucifixion" was performed by

the pinners or nail-makers, samples of whose wares were on prominent display when Jesus was nailed to the cross.

SOURCES

Clifford Davidson, ed., *Material Culture and Medieval Drama.* Medieval Institute Publications: Early Drama, Art, and Music Monograph Series, no. 25 (Kalamazoo, Mich.: Western Michigan University, 1999).

Hans-Jürgen Diller, *The Middle English Mystery Play: A Study in Dramatic Speech and Form.* Trans. Frances Wessels (Cambridge, England: Cambridge University Press, 1992).

Alan Hindley, ed., *Drama and Community: People and Plays in Medieval Europe.* Medieval Texts and Cultures of Northern Europe, no. 1 (Turnhout, Belgium: Brepols, 1999).

Gordon Kipling, *Enter the King: Theater, Liturgy, and Ritual in the Medieval Civic Triumph* (Oxford: Clarendon Press, 1998).

Martin Stevens, "From *Mappa Mundi* to *Theatrum Mundi:* The World as Stage in Early English Drama," in *From Page to Performance: Essays on Early English Drama.* Ed. John A. Alford (East Lansing, Mich.: Michigan State University Press, 1995): 25–49.

THE AFTERLIFE OF MEDIEVAL THEATER

CIRCUMSCRIBING THE THEATER: ENCLOSURE, REGULATION, AND CENSORSHIP. In 1598, John Stowe (1525–1605) published his *Survey of London,* a record of the city's rich history, changing geography, and rapidly disappearing theatrical traditions. Among other things, he noted with regret the loss of traditional recreations, "which open pastimes in my youth, being now suppressed, worser practices within doors are to be feared." Citing William FitzStephen's description of London, written four centuries earlier, Stowe devoted page after page to a description of the Christmas revels, Carnival celebrations, city festivals, athletic contests, religious processions, and plays which had been the focus of community life in the days before the Reformation. In one section in particular, he focuses on May games, describing first the pleasures of the "sweet meadows and green woods" and other pleasures of the season, and then providing detail about the nature of the celebrations themselves:

> I find also, that in the month of May, the citizens of London of all estates, lightly in every parish, or sometimes two or three parishes joining together, had their several mayings, and did fetch in Maypoles, with divers warlike shows, with good archers, morris dancers, and other devices, for pastime all day long; and toward the evening they had stage plays, and bonfires in the streets.

Some of those plays featured the exploits of Robin Hood and his men, who would entertain the company with "other pageants and pastimes." These, despite the potential they afforded for stringent social commentary, continued to be popular in England. But other types of entertainment, particularly those plays associated with religious holidays like Corpus Christi, would be increasingly suppressed during the Reformation, when the Roman Catholic Church, with its emphasis on feast days, was being displaced by the new Church of England. By the end of the sixteenth century, the rulers of most Protestant countries were actively engaged in rooting out and destroying the theatrical traditions of the Middle Ages, which had become associated with "popish idolatry" and superstition. In Catholic countries, the Counter Reformation, a movement to suppress Protestant ideas, produced ironically similar results, as religious and secular authorities attempted to control and regulate plays that might potentially preach unsound doctrine or carry unsavory political messages. The advent of the printing press after 1450 also made it easier to control the reproduction and dissemination of texts; for although print made more and more plays available to a wider public,

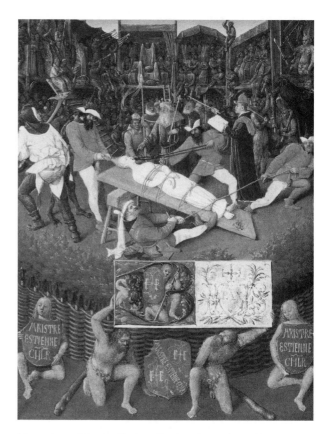

Martyrdom of St. Apollonia reflecting dramatic staging. Jean Fouquet, Hours of Etienne Chevalier, Chantilly, Musée Condé MS 71 folio 39, 1445. GIRAUDON/ART RESOURCES.

this new technology also made effective censorship of these plays more efficient and more complete. These circumscriptions of medieval drama were matched by another new trend: the enclosure of theater itself, as plays were now confined to purpose-built structures that required the payment of admission. Not only was access to theater now limited to those who could pay, and performance of plays increasingly the province of a specialized acting profession, but the plays themselves had to be vetted and licensed by the authorities. Finally, the teachings of Renaissance humanism advocated a return to classical dramatic forms and the Aristotelian conventions of comedy and tragedy, which were now considered superior to the dramatic genres invented during the Middle Ages. Together, these modern innovations posed a threat to the continued survival of medieval theater.

RECEPTION AND REVIVAL. Yet varieties of medieval theater persisted, despite these strictures. Renaissance dramatists continued to use themes, characters, and devices borrowed from the plays they had grown up watching. William Shakespeare could well have witnessed the performance of a Corpus Christi cycle, possibly at Coventry, and would certainly have seen miracle and morality

a PRIMARY SOURCE document

THE CENSORSHIP OF A MEDIEVAL PLAY

INTRODUCTION: In 1567, the mayor and Council of York decided to seek expert advice. With the accession of Queen Elizabeth I in 1558, and the re-establishment of the Protestant faith in England, it was becoming increasingly dangerous to perform plays that might be construed as sympathetic to the Catholic Church. The most controversial of the Corpus Christi pageants was the "Creed Play," and it was this pageant, in particular, that caused the men of York a great deal of anxiety. Therefore, they approached the dean of York Minster (cathedral), Matthew Hutton, and asked for his opinion as a theologian. He responded to them in a letter, excerpted below. Perhaps the best proof that the "Creed Play" was ultimately deemed too dangerous for public performance is the fact that it no longer survives: it appears that all extant copies were destroyed sometime after the receipt of this letter.

To the right honourable my Lord Mayor of York, and the Right worshipful his Brethren.

I have perused the books that your Lordship with your Brethren sent me, and as I find many things that I much like because of their antiquity, so see I many things that I can not allow, because they are Disagreeing from the sincerity of the Gospel, the which things, if they should be altogether cancelled or altered into other matter, the whole drift of the play should be altered, and therefore I dare not put my pen to it, because I want both skill and leisure to amend it, though in goodwill I assure you, if I were worthy to give your Lordship and your Right worshipful Brethren council, surely my advice should be that it should not be played. For though it was plausible forty years ago, and would now also of the ignorant sort be well liked, yet now in this happy time of the Gospel I know the learned will dislike it, and how the State will bear with it, I know not.

SOURCE: Matthew Hutton, Letter to the Mayor and Council of York, 1567, in *Medieval Drama: An Anthology.* Ed. Greg Walker (Oxford: Basil Blackwell, 2000): 206. Text adapted from Early Modern English by Carol Symes.

a PRIMARY SOURCE document

MEDIEVAL THEATER IN THE NEW WORLD

INTRODUCTION: After the Incident at Riga, it will come as no surprise that medieval drama was also used as a conversion tool to help complete the Spanish conquest of Mexico in the sixteenth century. Toward the end of that century, a native Aztec poet translated a Spanish sacred drama called *The Beacon of Our Salvation* into the indigenous Nahuatl language of his people, so that it could be performed by and for the new Mexican converts to Christianity. The Holy Week play is not only one of the oldest documents written in Nahuatl, it is the oldest surviving play in any Native American language. Like all translations, the resulting rendition demonstrates that it is not only words that must be translated, but entire concepts. In the excerpt below, Jesus says farewell to his mother, the Blessed Virgin Mary, explaining to her—and to the audience—why he must suffer crucifixion for the sins of mankind.

May you know,
oh noblewoman, oh my mother,
that God, the divinity, the sovereign, who lives
 forever,
he is a divinity of utterly surpassing goodness.
And he made Adam and Eve, and he placed them
there in terrestrial paradise.
He gave them orders
so that they would stay there,
in the very good place, in the very fine place.
And he gave them orders
so that they would not approach, they would not eat
the fruit of the tree of life.
But later on, the Devil, the demon deceived them,
so that they stretched out their hands to it, they ate it,
the fruit, the produce, of the tree of life,
which he had prohibited to them.
Thus they fell into the anger of God.
Thus here in the place of weeping, hither he exiled
 them.
He placed eternal death upon them
But my precious father, God, has decided
that I will rescue them.
For this reason I will die.

SOURCE: Louise M. Burkhart, *Holy Wednesday: A Nahua Drama from Early Mexico* (Philadelphia: University of Pennsylvania Press, 1996): 125.

plays performed by troupes of traveling players. One such professional troupe performs "The Mousetrap" or play-within-the-play devised by Hamlet; a very different group of amateur performers stages "The most lamentable comedy and most cruel death of Pyramus and Thisbe" after Bottom the weaver recovers his senses (and loses his ass's head) in *A Midsummer Night's Dream*.

The comedies of Molière, which still form the cornerstone of the repertoire of the Comédie Française, are essentially reworkings of medieval French farces. In Spain,

the Assumption play of Elche continues to be performed every year on 15 August. In the German village of Oberammergau, the entire population is required to perform the Passion Play staged every ten years since 1634. At York and Chester in England, and at Toronto in Canada, groups of performers drawn from local community theaters and universities regularly organize Corpus Christi pageants; in London, the National Theater of Great Britain has twice produced *The Mysteries*, a cycle of plays presented over the course of an entire day. Early music ensembles, beginning in 1958 with a landmark production of *The Play of Daniel* by New York Pro Musica, have found audiences increasingly receptive to medieval liturgical dramas; the works of Hildegard of Bingen have become perennial favorites, and her *Ordo virtutum* has been staged at the Cathedral of Notre-Dame in Paris and at the National Cathedral in Washington, D.C., among other venues. But medieval dramatic forms also influence modern theatrical genres, indirectly and directly. Mel Gibson's 2004 film *The Passion of the Christ* is one of the most obvious modern-day examples, but the "rock opera" *Jesus Christ, Superstar* by Andrew Lloyd Webber and Tim Rice is more closely based on medieval models. This is to say nothing of the ways that the humor, pageantry, cruelty, and humanity of medieval drama have contributed to the development of everything from television sit-coms to grand opera. In the end, medieval theater proved too elusive, too multi-dimensional, and too powerful to be eradicated by the more limited theatricality of the modern world.

SOURCES

John Block Friedman, "The Performance of Some Wakefield Plays on the University of Illinois Campus," in *From Page to Performance: Essays on Early English Drama*. Ed. by John A. Alford (East Lansing. Mich.: Michigan State University Press, 1995): 99–108.

SIGNIFICANT PEOPLE
in Theater

GEOFFREY DE GORRON

c. 1080(?)–1146

Schoolmaster
Abbot

FROM ACTOR TO ABBOT. Geoffrey de Gorron (d. 1146), who in 1119 became abbot of one of the most powerful monasteries in England, came to his religious career by a surprising turn of events. Born into an aristocratic family in Normandy (now part of northern France), Geoffrey appears to have been good-natured, somewhat accident-prone, and not especially ambitious. After working as a clerk and schoolmaster at the cathedral of Le Mans, he was eventually offered a job teaching in the new school founded by the abbey of St. Albans, across the channel in England. But he took his time getting there, and when he finally arrived at the monastery, he found that the job had been given to someone else. Undaunted, and probably too poor to afford the passage home to Normandy, Geoffrey opened his own school in the nearby village of Dunstable, and proceeded to indulge his real passion: theater. The chronicle history kept at St. Albans vividly describes what happened next.

> While he was there, he put on a certain play about St. Catherine, the sort of play that we commonly call a "miracle play." And in order to enhance the production, he begged the sacristan of St. Albans to loan him some of the copes used by the abbey's choir, which he was allowed to borrow. And so he performed the play about St. Catherine. But it so happened that, the following night, the house of Master Geoffrey caught fire and was burned, and so were all his books, as well as the vestments he had borrowed. Not knowing how else to make amends for damage done to God's property, and that of St. Alban, he offered himself as a sacrifice to God, and assumed the habit of a monk at the monastery of St. Albans. And this is the reason why he always took so much care to compensate for the loss of the choir's copes, by making rich gifts to adorn the abbey in later years.

The chronicle goes on to say that, when Geoffrey was elected abbot some years later, he commemorated the events that had led him to the monastery by celebrating the anniversary of his ordination on the feast of St. Catherine, at which time he would treat the monks to a display of the new vestments he had commissioned for the abbey over the previous year.

INSTRUCTIONAL THEATER. Geoffrey's interest in theater and its instructional uses did not end when he was elected abbot. It was almost certainly Geoffrey who commissioned and designed the famous St. Albans Psalter, which contains, among other fascinating elements, the oldest copy of the dramatic Old French poem known as "The Song of St. Alexis" and the oldest script for a liturgical play performed, in many different versions, all over Europe. This is the *Peregrinus* play (The Play of the Pilgrim), based on the gospel story of two disciples' meeting with the resurrected Jesus on the road to Emmaus (Luke 24:13–29). The manuscript image

depicts the initial meeting of Luke and Cleophas with an unknown Pilgrim (they do not recognize Jesus) and uses some of the same stylized techniques as the manuscripts of Terence's comedies; however, the dialogue spoken among the characters seems to have been added as an afterthought, in alternating lines of red, blue, and green ink in the upper left-hand corner of the page. The following two pages in the Psalter complete the story in pictures, showing Jesus the Pilgrim sitting down to supper with the disciples and then his mysterious disappearance. No dialogue accompanies these images, since all of the important action takes place in silence.

SOURCES

David Knowles, et al., *The Heads of Religious Houses England and Wales*. Vol. 1: *940–1216*. 2nd ed. (Cambridge, England: Cambridge University Press, 2001).

ARNOUL GRÉBAN

1420–1471

Playwright
Musician

A MYSTICAL DRAMATIST. Arnoul Gréban, with his brother Simon, is one of the very few named authors of a medieval play of any sort and the first named author of a passion play. He wrote a *Mystère de la Passion* or *Mystery of the Passion of Christ*, a strongly visual, lyrical, and carefully structured work of some 35,000 lines containing music and involving a variety of literary styles such as the sermon form, the debate, and the lamentation; the play moves from comic to tragic in tone and back again. Passion plays of this kind were quite popular in France from the late thirteenth century (with the *Passion of Paulinus*) and were performed as late as 1549. More than 100 performances are recorded at French cities like Arras, Valenciennes, Angers, and Clermont-Ferrand in the Auvergne.

A PLAYWRIGHT AND TEACHER. Gréban was born in Le Mans in France, and seems to have been in religious orders, as he was a student of theology in the early 1450s at the University of Paris and a singer and a performer on the great organ of the Cathedral of Notre Dame at Paris. It was during this time as a teacher that he is believed to have composed the *Mystère de la Passion* in about 1451. Against a cosmic backdrop of a sort of Manichaean struggle—that is, a war between the principles of good and evil—he set the passion of Jesus. The play is of great scope and takes in both Old and New Testament time, beginning with a Prologue describing the Creation and Lucifer's or Satan's rebellion against

God and his temptation of Adam and Eve through the serpent. The Trial in Heaven occupies Day 1 with sections on the Annunciation to the Virgin, the Nativity of Jesus, and his *enfance* or miracles of childhood (a very popular extra-biblical subject). Day 2 of the play concerns the preaching of John the Baptist, Jesus' public activities and ministry, his entry into Jerusalem on a donkey, and then his arrest by the Roman authorities. Day 3 is devoted to the earlier phases of the Crucifixion to the moment when guards are placed at the tomb. Day 4 is entirely occupied with the Resurrection and Christ's ascension to the heavens. Though the exact conditions of these performances are not known, there were at least three performances of Gréban's Passion before 1473 in Paris; it was adapted by a later French dramatist, Jean Michel, and was also performed in the 1490s in the city of Troyes. A lesser known play by Gréban concerns only the Nativity of Jesus, and with his brother Simon he seems to have written a *Mystère des Actes des Apôtres* in 62,000 lines treating the dispersion of the Apostles through many countries and with highly dramatic episodes of shipwrecks and martyrdoms. This last play was performed at Bourges and at Paris between 1536 and 1541.

THE PASSION PLAY GENRE. In addition to the stories of Jesus' passion recounted in the Gospels, passion plays were also based on a variety of extra-biblical materials such as the apocryphal Gospel of Nicodemus, the *Golden Legend* of Jacob of Voragine, and the *Meditations on the Blessed Mary*, as well as a popular French narrative poem of the late twelfth century called the *Passion des Jongleurs*. The early Passion plays, like the *Passion of Paulinus*, dramatize only the events of Holy Week, commencing the action with Jesus's entry into Jerusalem and concluding it with his resurrection and appearances to his followers, but later ones, such as Gréban's, could be much longer and more complex, forming part of what was called the Trial of Heaven, a sort of court proceeding in which God listens to testimony from personifications called Justice and Mercy about the deceptions of Satan on earth and finally agrees to send his son—through the incarnated Jesus—to ransom or redeem mankind. This Trial idea was codified and developed by the Passion dramatist Eustache Marcadé (d. 1440). The later Passion plays were very long, often requiring many days to perform, and Gréban's appears to have taken four days to complete. In smaller towns, the expanded forms of these plays in performance may have occupied the attentions of nearly all the adults of the community. As is true of medieval drama elsewhere, very few scripts contemporary with the Passion plays survive, as it appears they were memorized and only later written down. But

Gréban's *Mystère* exists in three complete manuscripts and several fragmentary texts.

SOURCES

Maurice Accarie, *Le Théâtre sacré de la fin du moyen âge* (Geneva: Droz, 1979).

Micheline de Combarieu du Graes and Jean Subrenat, modernizers, *Le Mystère de la Passion de notre sauveur Jesus-Christ/Arnoul Gréban traduction et présentation* (Paris: Gallimard, 1987).

Grace Frank, *Medieval French Drama* (Oxford: Clarendon Press, 1960).

Paula Giuliano, trans., *The Mystery of the Passion. Day Three* (Binghamton, N.Y.: Medieval and Renaissance Texts and Studies, 1996). [A portion of Gréban's vast Passion play.]

Omer Jodogne, ed., *Le Mystère de la Passion.* 2 vols. (Brussels: Académie royale de Belgique, 1965–1983).

Anne Amari Perry, ed., *La Passion des Jongleurs* (Paris: Beauchesne, 1981).

Sewall Shelley, trans., *Mistere de la nativité de Nostre Saulveur Jhesu Crist/The Nativity/by Arnoul Gréban* (Carbondale, Ill.: Southern Illinois University Press, 1991).

Eckehard Simon, ed., *The Theater of Medieval Europe* (Cambridge, England: Cambridge University Press, 1991).

HILDEGARD OF BINGEN

1098–1179

Abbess
Composer
Playwright

A MYSTICAL DRAMATIST. Hildegard of Bingen (c. 1098–1179) is one of only a few of the men and women known by name who authored plays in the Middle Ages, and the only one about whom modern scholars have a substantial amount of information. Abbess Hildegard of Bingen, polymath and mystic, was the composer of the *Ordo virtutum* or "Service of the Virtues," among many other works. Hildegard's extraordinary life and achievements have attracted the attention of an extremely wide and varied audience—including medievalists, feminist critics, New Age spiritualists, historians of science, and fans of medieval music.

AN ECLECTIC EDUCATION. Hildegard was the tenth child born into an aristocratic family. She suffered from ill health throughout her life, and by the time she was eight years old her parents apparently decided that she should be dedicated to religion. She was entrusted to the care of a young anchoress called Jutta, who lived in seclusion in a cell attached to the Benedictine

monastery at Disibodenberg, near the German city of Speyer. There, Hildegard learned some Latin and also apparently received informal instruction in a wide and eclectic array of subjects, including medicine and the natural sciences. Above all, she learned the elements of musical composition, which she would later employ in her drama. At the same time, Hildegard began to experience the visions for which she would later become renowned. By the time Jutta died in 1136, Hildegard had acquired a secretary, the monk Volmar, to whom she dictated and described the visual and aural messages that came to her from God. In the ensuing decade, Hildegard attracted many young women to the tiny convent that had grown up around her, and by 1147 was actively in search of a new home for her burgeoning community.

DRAMA IN THE CONVENT. In the meantime, the fame of her visions and holiness had spread, and Hildegard began to preach in public, as well as to circulate her writings. These controversial activities brought her to the attention of the bishop of Mainz and also to that of Pope Eugenius III (r. 1145–1153), both of whom eventually declared her teachings to be divinely inspired and encouraged her to complete work on what is now recognized as one of the great mystical books of the Middle Ages, the *Liber Scivias*, roughly translated as "The Book on Knowing the Ways." By 1150, Hildegard and her followers were established in a new and larger convent at Rupertsberg on the banks of the Rhine, near Bingen. It was here that Hildegard composed the *Ordo virtutum*, a drama about a female soul appropriately called "Anima" and her journey through life. This work is only one of many innovative liturgies, hymn sequences, and song-cycles intended for performance by her nuns. She also oversaw the copying of the books containing her writings and personally directed the production of the many manuscript images designed to illustrate these books and to capture the extraordinary visual qualities of her mystical communications with God. The color, vibrancy, and sensuality of these illuminations provide some indication of the qualities that must also have enriched the spectacle of performance in the convent.

AN UNORTHODOX CAREER. Hildegard died in 1179, and it was widely believed that she would be canonized as a saint. An official biography was produced, and a number of miracles were attributed to her. However, the late twelfth century was a time when the process of canonization was becoming highly politicized, and when control over this procedure had shifted from local authorities to the papal court. Official enquiries were conducted four times over the course of the next two

centuries but, on each of these occasions, objections to the orthodoxy of Hildegard's life and works were raised by various factions within the church. To this day, only a few religious communities acknowledge her sanctity and celebrate her feast on 18 September.

SOURCES

Charles Burnett and Peter Dronke, eds., *Hildegard of Bingen: The Context of Her Thought and Art.* Warburg Institute Colloquia no. 4 (London: Warburg Institute, 1998).

Barbara Newman, ed., *Voice of the Living Light: Hildegard of Bingen and Her World* (Berkeley and Los Angeles: University of California Press, 1998).

DOCUMENTARY SOURCES
in Theater

Adam de la Halle, *Jeu de la feuillée* or *The Play of the Bower* (c. 1276) and *The Play of Robin and of Marion* (1283)—The works of this dramatist and poet include a satiric drama set in contemporary Arras, naming and assigning recognizable traits to 49 citizens, and a musical comedy where spoken dialogue alternates with singing.

Jehan Bodel, *Play of St. Nicholas* (c. 1191)—This trouvère and minstrel composed the first non-biblical play written entirely in a vernacular language, Picard French. It is a dramatized miracle play celebrating the heroic victory of Christian forces over Moslems, called Saracens.

The Castle of Perseverance (1415)—This morality play, the oldest play text in Middle English, had 35 speaking parts and was designed to be performed in the round.

Hildegard of Bingen, *Ordo virtutum* or *Service of the Virtues* (1155)—The Abbess Hildegard composed this work for the nuns of her convent at Rupertsberg; it is one of many dramas she wrote mingling song, dance, and elaborate costumes to create special effects.

Mankind (1465)—One of the earliest scripts for a troupe of traveling professional actors, this morality play follows a representative human being through the problems and challenges of everyday life.

N-Town Cycle or *Ludus Coventriæ* (1468)—This collection of 43 plays from the West Midlands region of England actually has no connection with the town of Coventry, after which the cycle was once named. Performed as early as the 1370s for the feast of Corpus Christi, sixty days after Easter, the plays portray the scope of Christian history from the fall of Lucifer to the Last Judgment.

Pamphilus (1140)—One of the most popular of the Latin comedies composed and performed in the monasteries, cathedral schools, and princely courts, this dramatic poem was copied so often that it gave its name to the word "pamphlet."

Play of Antichrist (1160)—Composed and performed by the monks of Tegernsee Abbey, this play draws on the Christian teachings of the Apocalypse to dramatize the political career of Frederick Barbarossa, the Holy Roman Emperor.

Sponsus or *The Bridegroom* (1090)—This musical dramatization of the Parable of the Wise and Foolish Virgins (Matthew 25: 1–13), recorded at the abbey of Saint-Martial at Limoges (France), is the earliest liturgical drama in a vernacular language.

The Towneley Cycle (1500)—This collection of 32 English plays, which includes the excellent work of the so-called "Wakefield Master," was copied into manuscript after 1500. These plays are considered among the most performable and "modern" in sensibility of all the English Cycle plays.

The York Cycle (1477)—Performed as early as 1376, the 48 pageants or separate episodes of this cycle were produced cooperatively between the City of York and its craft guilds. Since the city had no open spaces, the plays were performed as a procession of wagons stopped at designated stations.

chapter nine

VISUAL ARTS

Véronique P. Day and Michael A. Batterman

IMPORTANT EVENTS
in Visual Arts

768 Charlemagne becomes king of the Franks, and the Carolingian era begins; cultural policy encourages opulent artistic production.

c. 776 Abbot Beatus of Liébana in Spain begins writing an extended commentary to the biblical book of Revelations, which either in its original or in early copies incorporated a program of illustrations that was quickly reproduced.

c. 780 Charlemagne's first book-painting workshop begins to produce illuminated manuscripts.

c. 800 Vikings begin to invade England, Ireland, and the Continent. Their technically accomplished decorative metalwork will have an important impact on the visual arts.

c. 870 The Lindau Gospels, with front cover of hammered gold, gems, and pearls, are created for Charles the Bald, whose death in 877 marked the end of the Carolingian era.

900 The Alfred Jewel, made of gold and enamel, is created for King Alfred of England.

908 The Victory Cross of Oviedo is presented to Oviedo Cathedral by King Alfonso III of León.

962 The German Imperial Crown is made for Otto I, who is crowned emperor by Pope John XII in Rome.

966 The New Minster Charter, the first illuminated manuscript of the Winchester school in England, is commissioned by Bishop Aethelwold.

c. 985 A golden reliquary statue of St. Foy is newly decorated in south-central France.

c. 998 A Gospel Book and the Lothair Cross are created for Emperor Otto III.

1016 The first Normans arrive in southern Italy, initiating a period of cross-cultural interaction in the visual arts.

1063 The Romanesque-style reliquary shrine of San Isidoro is installed to house relics newly transferred from Seville to León in Spain.

c. 1080 The Bayeux Tapestry, commemorating and justifying the Norman invasion of England, is created.

c. 1100 A marble relief of Abbot Durandus is installed in the cloister of the Cluniac abbey of Moissac, in Languedoc, France.

1111 Illuminated manuscripts of Gregory the Great's *Moralia in Job* are completed in three volumes for the Abbey of Cîteaux in France.

c. 1133 An embroidered coronation mantle is created for the Norman king Roger II, crowned king of Sicily in 1130.

c. 1135 A deluxe psalter (a collection of psalms) is illustrated for Queen Melisende of the Latin Kingdom of Jerusalem.

c. 1140 Early Gothic style begins under patronage of Abbot Suger at Saint-Denis near Paris.

c. 1156 The Stavelot Triptych is commissioned by Wibald, the Benedictine abbot of Stavelot (in modern-day Belgium).

1170 Abbess Herrad of Landsberg creates the *Garden of Delights* (*Hortus Deliciarum*), an encyclopedic work that includes some 636 illustrations.

1181 Nicholas of Verdun creates the Klosterneuberg altarpiece.

1210 The English natural scientist Roger Bacon, who will influence art through his interest in optics, is born.

c. 1230 A *Bible moralisée*, an ambitious and lavishly decorated new kind of picture Bible, is made for Blanche of Castile and her son Louis IX of France.

Villard de Honnecourt produces a sketchbook showing the influence of Aristotle and Aquinas in its use of basic geometry.

1252 The minting of the florin in Florence, Italy, introduces the first gold coinage of purely Western conception to Europe.

1260 Meister Eckhart, a German Dominican whose emphasis on Christ's suffering will influence devotional art, is born.

1280 The *Cantigas de Santa Maria* written for King Alfonso the Wise in Spain is a collection of some hundred songs in praise of the Virgin Mary, with narrative illustrations describing many of her miracles.

c. 1295 Marco Polo returns to Italy from China and writes an account that is accompanied by images encouraging empirical knowledge of the world.

1307 Work begins on the tomb (Gloucester Cathedral) of Edward II of England.

1308 The Duccio Maiestà altarpiece in Siena, Italy, is commissioned.

1325–1328 Famous painter Jean Pucelle illuminates manuscript for Jeanne d'Evreux in France, introducing *grisaille* technique.

1330 The Röttgen Pietà, an example of the *vesperbilden* genre, is created in the Rhineland region of Germany.

1338 Ambrogio Lorenzetti begins painting a fresco, "The Effects [Allegory] of Good Government in the City and Country," for the Siena town hall.

1340 Altarpiece painting of St. Thomas Aquinas, an Italian Dominican theologian, is begun by artists in the circle of Simone Martini.

1349 Jean le Noir paints "The Three Living and the Three Dead" in the Psalter of Bonne of Luxembourg, France.

1356 The second decorative campaign of the papal palace begins at Avignon, France.

1364 Christine de Pizan, author and counselor to King Charles V of France, is born. Scenes from her books were important subjects for tapestry, manuscript illumination, and wall painting.

André Beauneveu begins carving recumbent tomb figure of King Charles V of France.

1374 Geert Groote, a Flemish mystic, is converted. He will found the Brethren of the Common Life and promote the ideals of *Devotio Moderna*, which encourages meditation on the Passion of Christ and has a profound influence on devotional art.

1413 The Limbourg brothers begin painting the *Très Riches Heures* for Duke Jean de Berry of France.

1420 The illustrated *Book of Wonders* containing the travel accounts of John Mandeville and Marco Polo is created.

The Master of Rohan paints the *Grandes Heures of Rohan* in France.

1423 An anonymous woodblock print of St. Christopher is produced in Germany.

OVERVIEW
of Visual Arts

AN ERA OF RECONSTRUCTION. The Roman Empire, which at its height encompassed most of Europe, disintegrated during the fourth and fifth centuries, and the culture of classical antiquity disintegrated along with it. The next thousand years, a period known as the Middle Ages, was an era of gradual reconstruction and original invention. During this time ambitious rulers consolidated former Roman and non-Roman territories into the various European states. Social and economic expansion accompanied this political process, and by the latter part of the Middle Ages, European civilization had reached a new height of cultural achievement, although in terms that were very different from those of ancient Rome. The visual art of this period is therefore, at its most fundamental, the art of a civilization rebuilding itself and redefining its social and political institutions. As the medieval economy expanded and developed, creating greater financial surpluses and more readily available resources, art became more abundant, more ambitious, and more technically refined.

THE INFLUENCE OF CHRISTIANITY. Also fundamental to medieval art is its predominantly Christian character. The Latin (western) and Greek (eastern) Christian churches emerged from their origins in the late Roman period to become the dominant religious and social institutions of medieval Europe. The word "Europe" was thought of in the Middle Ages not simply as an expanse of territory or a collection of kingdoms or states, but as Christendom, the realm of the Christian church. The visual arts, whether functioning in the service of the church or not, participated in a lively Christian culture and, more often than not, were formulated in expressly Christian terms.

THE DEBATE OVER VISUAL IMAGES. Church authorities continually sought to define the role of the visual arts in the Christian experience. In the early medieval period (850–1150) especially, heated debates over the proper use and significance of images were a testament to churchmen's efforts to come to terms with a form of

visual expression that predated Christianity. Noting the pagan origins of the visual arts, some Fathers and Doctors of the church, like Tertullian (c. 160–225) and Augustine (354–430), condemned the use of visual imagery within the church as inappropriate and idolatrous. The most radical among them followed a policy of iconoclasm, the actual destruction of images. Others, such as Pope Gregory I (or "Gregory the Great," c. 540–604) defended the value and significance of images and art objects within a Christian context, citing biblical precedents such as Solomon's Temple, with its sumptuous and divinely sanctioned decoration. Variations on these two basic positions (for and against visual images) appeared in the writings of church leaders and reformers throughout the early Middle Ages, and such discussions provide important insight into medieval understandings of the visual arts. But regardless of the often theoretical debates of churchmen, the arts flourished, providing a visually stunning record of cultural achievement.

POLITICS AND PATRONAGE. During the early part of the Middle Ages, one of the most distinctive cultural phenomena was the influence of powerful rulers who acted as patrons seeking to express their ambitions and political ideals in visual terms. Unlike the works of later periods that were often created by artists who then hoped to sell them on the open market, early medieval art objects owe their existence to the beneficence of individuals who generally had something to gain by their patronage of the arts. The art itself, produced typically in royal or monastic workshops, stands as a record of the political agendas and cultural policies of those individuals.

CULTURAL SYNTHESIS. Early medieval art can also be viewed as a synthesis of the different cultural traditions that found expression in the visual arts and elsewhere. The Romans passed on to the early Middle Ages the remnants of a highly developed visual tradition which, together with the visual heritage of the various Germanic and Eastern peoples who settled in Europe, was transformed into something essentially new. But during these early centuries the art also retained more or less visible traces of the different visual traditions to which it was indebted. Only later, from about 1200 onward, did there emerge a European visual art that fully transcended its origins as a mixture of separate artistic legacies.

THE BEGINNINGS OF THE "MODERN." By the end of the twelfth century, the rebuilding and reorganization of social and political institutions since the collapse of the Roman Empire was largely accomplished. The visual arts of this period demonstrate a new level of aesthetic confidence and technical mastery. They also manifest a transformation undergone in order to adapt to changing

conceptions of the state, of society, of God, of the physical world, and of the relationship of the individual to each of these. Many of the developments that we tend to think of as characterizing the Renaissance in European art and culture—the renewed interest in classical antiquity, the more scientific observation of nature, the pursuit of more naturalistic ways of depicting the world—in fact have their origins in the later Middle Ages. It would not be an overstatement to say that during the period from about 1050 to 1400, many "modern" institutions came into existence. The modern nation-state has its origins in the royal states consolidated under monarchs like King Philip Augustus of France (r. 1180–1223) and King John of England (r. 1199–1216). Representative government, international commerce and finance, university learning, vernacular literatures (that is, those in the newly developing non-Latin languages), exploration and colonization of distant lands, and many other practices and institutions familiar in the modern age can be traced to this dynamic period in the history of Europe.

NEW SOCIAL AND INTELLECTUAL INFLUENCES. In the visual arts, the later Middle Ages witnessed a significant "modernization" as well. Beginning in the thirteenth century, visual art could sometimes express a "national identity"—for example, writers of this period became conscious of "national" art, and the terms *opus francigenum* (French work) and *opus anglicanum* (English work) can be found in written sources from the period. The arts also reflect, in their attention to details of nature, the new Aristotelian learning of the twelfth and thirteenth centuries, and iconographic programs are often more complex and comprehensive. Philosophers like Thomas Aquinas and Albert the Great applied the rules of logic and rational analysis to the interpretation of Scripture and the natural world, and their methodology broke large categories of experience into many smaller ones. This approach allowed abstract subjects like theology to be subdivided into concrete elements that provided a virtual handbook of figures and ideas that artists could express in paint, glass, stone, wood, and other media. Art production itself, while still located in courtly workshops as it was during the early Middle Ages, increasingly leaves the monastic setting for the new, professional lay (non-religious) workshops located in towns and cities, often in particular areas of a city which became devoted to that craft through intermarriage among members of artisan families. There was a much more socially diverse audience for art than was the case in the early Middle Ages, and patrons of art also come from different segments of society: royal, aristocratic and middle class, lay and religious, urban and rural manorial, male and female.

THE GOTHIC STYLE. Although artistic styles varied greatly over time and from place to place, the term "Gothic" has been used for some 500 years in reference to the arts (and to the architecture as well) produced during the later Middle Ages and until the onset of the Renaissance. In fact, "Gothic" was an adjective first used by Renaissance humanists as a pejorative term for the late medieval style that was thought of as "monkish"—inferior and barbaric next to the new Renaissance classicism, essentially a revival of Greek and Roman rules of simplicity and clarity. (The Goths, as one of the migratory Teutonic tribes that settled in western Europe in the early medieval period, were blamed for the downfall of classical civilization, but they actually had nothing to do with the style that later took their name.) One of the principal characteristics of Gothic art, when compared to visual art of the earlier Middle Ages, is its greater and more consistent reliance upon nature as inspiration and model. This "naturalism" or "realism" has a connection to the rediscovery of ancient Greek philosophical texts treating the physical world, preserved over the centuries by Muslim scholars and newly translated from Arabic into Latin in the later twelfth century. The philosophical, logical, and scientific writings of Aristotle, in particular, spurred medieval scholars to examine the natural world more closely, and the arts expressed this newfound interest. Artists increasingly sought to visualize the world and human experience during the later Middle Ages, and there was less discussion—even among churchmen—about the legitimacy or appropriateness of visual images than was the case in earlier centuries. One could increasingly take for granted that the visual arts now had their place. Of course, to the medieval mind, which understood nature as God's creation (and art as human invention), "naturalism" in art was always tempered with the authority of inherited artistic practices (a conservatism that helped ensure some measure of continuity over time) and the inevitability of ornament.

A THEMATIC VIEW. Because the explosion of art production in many centers, media, and social contexts makes a strictly chronological and geographical account of later medieval art impractical, it is perhaps most productive to discuss the art of the mid-twelfth through the mid-fifteenth centuries according to certain thematic categories having to do with the political, intellectual, social, and spiritual realms of human experience. Within each of these categories it is possible to consider a range of examples from the visual arts, and, indeed, most works can be discussed in terms of two, three, or even all four of these categories of experience, which suggest not only the many motivating circumstances that contribute to the production of art, but also its potential audiences and

MEDIEVAL Art Terms

Altarpiece: A devotional, religious work (painting or sculpture) placed usually on or above a church altar (where the Mass is celebrated). It can depict one or several different scenes, the imagery usually referring to the doctrine of the Mass or to the saint to whom the church or chapel is dedicated. It can include one or multiple panels (can be a *diptych* with two panels; a *triptych* with three; or a *polyptych* with more).

Arch: An architectural formation that spans an opening in such a manner that the weight of the material is converted into outward thrusts, carried to the sides and then down along flanking columns, piers, or buttresses. The *rounded* arch was common in ancient Rome and in Romanesque Europe and is made from wedge-shaped blocks. The *Gothic* or *pointed* arch forms a central point above. The *Ogival* (or *Ogee*) arch is formed by double curved lines (like two S-curves mirroring each other) that meet at a point.

Benedictine monastery: Monastic house or community of monks adhering to the Rule of St. Benedict.

Christendom: The extent of Christianity on earth, often configured in the Middle Ages as a series of Christian states.

Enamelwork: The artistic use of enamel, a substance formed from colored glass particles that are melted and fused, usually to a metal surface. *Champlevé* enamel is a process whereby the substance is poured into grooves that are previously engraved into the metal surface, so that the hardened enamel is flush with the surface of the metal. In *cloisonné* enamel, the substance is poured into compartments formed by a network of metal bands such that the exposed tops of the bands serve to divide the areas of colored enamel.

Filigree work: Fine metalwork created using tiny beads or very fine threads of metal to create the effect of delicate, lacelike, openwork ornament.

Grisaille: Monochrome painting, usually in tones of gray, found especially in stained glass and painted altarpieces (and sometimes illuminated manuscripts, textiles, etc.) from the later Middle Ages.

Iconic: The quality of a visual image or object that is generally static, frontal, and non-narrative.

Iconography: The pictorial representation of a subject, especially when comparing the particular character of a represented subject to the complete visual record of that subject throughout the history of art; also the study of the meaning of the subject matter of visual images.

Illuminated manuscript: A manuscript (that is, handwritten book) with hand-painted decoration or illustrations, usually employing silver, gold, and different colored pigments.

Lancet window: A tall, narrow window usually ending in a sharply-pointed arch and found mainly in Gothic architecture.

Niello: A metalwork process whereby a design is engraved in a metal surface and then filled with a black alloy of sulfur with gold, silver, copper, or lead and then fused with heat.

Pilgrimage: A journey made usually for spiritual reasons, to reach a particular shrine or sacred place; a pilgrim is one who makes such a journey.

Pinnacle: A small, decorative turret or end of a spire, buttress, or other such architectural element, generally pointed, conical, or pyramidal in shape.

Repoussé: Relief (that is, raised) decoration on a metal surface produced by hammering from the underside.

Rose Window: A large, circular stained-glass window placed centrally above the portal(s) on the façade of a Gothic church.

Scriptorium: The workshop found especially in abbeys and monasteries where manuscripts are copied and decorated.

Tracery: Ornamental, openwork sculptural decoration, in wood or stone, found especially above Gothic windows and on screens or panels.

effects. Thus, while these themes do not refer to separate categories of works as they were understood by medieval people, collectively, the examples chosen will encompass the range of places (England, France, Spain, Flanders, Germany, and Italy), social contexts (royal, aristocratic, middle class, secular, religious, urban, manorial, male, female), and artistic media (wood, stone, ivory, metalwork, enamelwork, illuminated manuscripts, prints, tapestry, fresco, and panel painting) that together describe the world of the visual arts in the later Middle Ages.

TOPICS
in Visual Arts

THE CAROLINGIAN RESTORATION OF ROMAN CULTURE

CHARLEMAGNE AND THE RESTORATION OF EMPIRE. The first enduring attempt at a restoration of

Roman culture since the fall of Rome was accomplished under the rule of Charles the Great (768–814), king of the Franks, known to history as Charlemagne (Carolus Magnus, in Latin; the "Carolingian" dynasty was named for Charlemagne and his grandfather, Charles Martel or Carolus Martellus). One of the many migrant Germanic tribes that came from the east to settle in early medieval Europe, the Franks were able to consolidate their power into a kingdom (more or less corresponding to present-day France, Germany, and the Benelux countries [or Belgium, the Netherlands, and Luxembourg]) of formidable size and strength. Charlemagne's ambition was stated on his royal seal—*renovatio Romani imperii* (restoration of the Roman Empire)—and in the realm of politics as well as culture and the arts, he expressed the spirit of a classical revival, a trend that would continue into the following centuries with art objects such as the processional Lothair Cross (c. 1000, today in the Schatzkammer of the Aachen Dom), which features a cameo with a portrait bust of the emperor Augustus in the center of the cross's triumphal side. Politically, Charlemagne sought to make his rule a continuation of the western empire of Rome and a counterpart to the great Byzantine Empire of Constantinople, the eastern part of the late Roman Empire and center for Greek Orthodox Christianity. He took a major step toward this goal when, on Christmas Day in the year 800, he had himself crowned emperor in Rome by Pope Leo III.

DECORATED BOOKS. Charlemagne and his successors, from their capitals in Aachen (in present-day Germany) and elsewhere, developed a cultural policy that depended upon the opulent and aristocratic artistic heritage of the Roman and Byzantine imperial courts. Books were an important part of the literary, intellectual, and religious culture of the Carolingians, and manuscripts that were beautifully illuminated (illustrated with colored and gilded pictures) and adorned (provided with richly decorated covers) represent the peak of achievement in the visual arts during this time. In Latin manuscripts—copied in a stately round, wide, and highly legible script called Carolingian minuscule and decorated in royal and monastic workshops—Carolingian notions of sacred kingship and courtly refinement were strongly expressed. Some of the most extravagant of these books—usually copies of the Gospels according to Matthew, Mark, Luke, and John, intended for use by the emperor—had covers made of gilt silver and precious stones or of ivory panels carved in relief in the Byzantine manner.

THE LORSCH GOSPELS. An excellent example of such a work of decorative art is the preserved back cover of the Lorsch Gospels, produced in about 810. It is composed of five ivory panels carved in relief and arranged

THE
Making of an Illuminated Manuscript

In the Middle Ages, each book, or *codex*, was made by hand through the collaboration of several skilled craftsmen under the direction of a designer who oversaw the whole work. The creation of an illuminated manuscript was time-consuming and expensive, and took place within a monastic *scriptorium* or a royal workshop in the earlier Middle Ages, or else a professional, lay workshop in a later medieval town. First, in the earlier period before paper was introduced (around 1350), the scribe must choose parchment or vellum made from animal skin (calf, goat, sheep) that has been prepared by cleaning, scraping and dipping in lime, then drying and stretching. The object was to create a smooth surface, free of blemish. The next step was cutting the parchment into double leaves (*folios*) of appropriate size and assembling the double leaves into *quires* or gatherings of a fixed number of pages that could be distributed to different artisans for the next stage of work. Next, a layout person would rule the pages and create spaces for pictures in which the designer would add brief notes to guide the scribe(s) and illuminator(s). At this point the scribe begins the copying of the text, usually working from a written exemplar, and he or another scribe, called a *rubricator* (from the Latin *rubeo*, meaning "red") puts in the large red or blue letters that indicate divisions of the text. The decoration is carried out by one or more illuminators, who follow the designer's explicit instructions as to subject matter of illustrations, type, and extent of decoration in initial letters, borders, margins, full-page illumination, etc. Different skilled artisans carry out different parts of the decoration, from the under-drawing to the illumination of figures and scenes, to the foliate (ivy or acanthus leaf) decoration, to the application and burnishing of gold foil. Sometimes a *colophon* is included at or near the end, with the completion date and the name of the scribe (and sometimes the names of the illuminators). Then the various gatherings are sewn together in the proper order and the manuscript is bound in thin boards with vellum or leather covering.

so that the Virgin and Child appear in the center flanked by the figures of Zacharias and John the Baptist, with a scene of the Nativity below and two angels supporting an image of Christ in Majesty above. The iconography

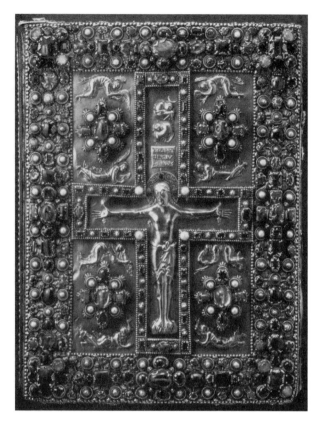

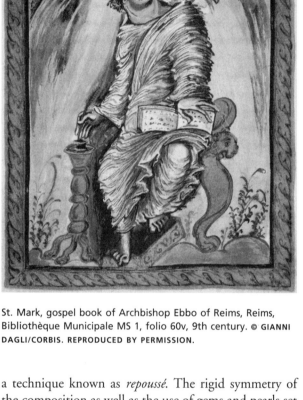

Crucifixion scene, embossed and jeweled front cover of Lindau Gospels, New York, The Pierpont Morgan Library MS M. 1, 875. **THE GRANGER COLLECTION.**

St. Mark, gospel book of Archbishop Ebbo of Reims, Reims, Bibliothèque Municipale MS 1, folio 60v, 9th century. © **GIANNI DAGLI/CORBIS. REPRODUCED BY PERMISSION.**

or image-types depicted, as well as the style of carving and the use of the luxury material ivory all suggest an interest in emulating the sumptuous art of the Byzantine imperial court. A full-page illumination depicting the evangelist John contained within a gospel book executed for Charlemagne around 800 demonstrates how the royal painting workshops very often depended upon classical Roman models. Not only does this image hark back to antiquity in its naturalistic treatment of the human figure, but it also adopts the antique motif of the author portrait in its representation of John as author of his gospel. Such artistic masterworks as these ivory panels and this manuscript painting showcase the abilities of Carolingian craftsmen and express a clear cultural policy of classical revival and courtly opulence.

THE LINDAU GOSPELS. Luxury book covers, executed in metal and precious stones, conveyed a similar sense of courtly magnificence and sacred kingship. The front cover of the Lindau Gospels is a prime example of such work. Both the central figure of the crucified Christ (the prototype of the "sacred king") and the angels and mourners hovering above and below the arms of the cross were created by hammering designs into sheets of gold,

a technique known as *repoussé.* The rigid symmetry of the composition as well as the use of gems and pearls set within the gold cover are a fine example of how the sacred, royal art of the early Middle Ages was meant to communicate a particular idea in powerful and unambiguous terms. It was also meant to flatter the royal patron (in this case the Emperor Charles the Bald) and impress the members of his court, since it clearly encouraged imperial pretensions and implied that the ruler was worthy of such a magnificent object.

THE MONASTIC INFLUENCE. Benedictine monasteries had a particularly important role to play in the elaboration of the visual arts of the period, in no small part because of the royal support of Benedictine monastic houses within the Carolingian Empire and emphasis on the Rule of St. Benedict in preference to other monastic rules. This was true especially under the rule of the Carolingian king Louis the Pious (814–840), who endowed major monastic foundations at Reims, Metz, and Tours (all in present-day France), each of which produced some of the most important decorated manuscripts that have survived. The portrait of the evangelist St. Mark in the gospel book of Archbishop Ebbo of

MONASTICISM and the Production of Medieval Art

Christian monasticism began with the hermit monks, individuals who left society behind to lead ascetic lives—that is, lives of self-denial—in the wilderness, devoted to prayer. Most influential were the Egyptian desert fathers of the late third and early fourth centuries, such as St. Anthony of Egypt and St. Paul the Hermit. Loose communities began to form around some of these figures, and established communities of monks were commonplace in the West by the fifth century. The monastic rule written by St. Benedict of Nursia in the sixth century for his monastery in Monte Cassino, Italy, became standard throughout the West. This Rule sought to regulate all aspects of monastic life and assigned to each monk his place, from the abbot on down to the novice. The production of visual art, especially in the form of manuscript illumination and metalwork, was among the types of manual labor practiced by the monks. In part because of the great success of Benedictine monasticism—especially after its institutionalization under Carolingian rule—many different religious figures began to take issue with the growing wealth and worldliness of the Benedictines, leading to various efforts at monastic reform.

The most important early reformed community was that of Cluny, founded in Burgundy in 910, although the great wealth and power amassed by the Cluniacs during the eleventh century precipitated another wave of reforms, including that of the Carthusians, established in Cologne in 1084, and the Cistercians, founded in Burgundy around 1100. To a greater or lesser degree, such movements sought a more ascetic existence that was closer to the model of the early hermit monks. Debates over appropriate forms of Christian monasticism often focused on the "problem" of the sumptuous and highly refined art produced by some communities, which, it was argued, distracted the faithful and represented a misuse of needed funds. The major reform movement of the later Middle Ages was the creation of the mendicant orders, initially the Franciscans (1210) and Dominicans (1216). These friars and preachers renounced all worldly goods and dedicated themselves to serving society at large. Thus, they were not bound to particular monastic houses but circulated more freely and became integrated into society at all levels. Dominicans, for example, often served as royal confessors and took an active role in the struggles against heresy, and mendicants played an important role in the life of medieval universities and in the study of medieval theology, philosophy, and mysticism. Despite their vow of poverty and their commitment to live lives more in accordance with Christ's own example, the mendicants were in fact not monks and the period of their rise in influence (and that of other non-monastic religious orders) coincided with the decline of more traditional monasticism in the medieval period.

Reims (816–835) shares with the portrait of St. John—from one of Charlemagne's personal copies of the gospels—a dependence upon a classical formula, but the more dynamic and expressive style hints at the creative vigor of monastic artists of the period, especially in the strong lines of the garment folds. A similar linear dynamism and pictorial inventiveness can be seen in the illustrations to the famous Utrecht Psalter (a book of psalms used during the Liturgy of the Hours), also from the Reims school of manuscript decoration. Once again, the style of the drawings (like the minuscule script modeled on what the scribe imagined was "Roman" writing) are unmistakably classical in inspiration, though the images, which provide literal illustrations to the text of the psalms, are without precedent in late Roman wall and book painting. In a detail from Psalm 11, the figure of Christ literally rises up and steps out from the confines of his divine aureole (a circle of light around the head or body of a divine being) in illustration of the text: "For the oppression of the poor, for the sighing of the needy, now will I rise, said the Lord." Below that, the wicked actually "walk round about," again in a playful and literal response to the text. These few examples from the visual art of the Carolingian period give a sense of the ingenuity of Carolingian artists; they point to the centrality of luxury books within the religious, intellectual, and political culture; and they represent the early medieval adaptation of artistic techniques (in metalwork, ivory carving, and manuscript painting) inherited from classical antiquity.

SOURCES

Roger Hinks, *Carolingian Art: A Study of Early Medieval Painting and Sculpture in Western Europe* (Ann Arbor: University of Michigan Press, 1962).

Jean Hubert, et al., *The Carolingian Renaissance (Arts of Mankind)* (New York: Braziller, 1970).

Florentine Mütherich and Joachim E. Gaehde, *Carolingian Painting* (New York: Braziller, 1976).

SEE ALSO *Architecture: The Influence of the Carolingians; Theater: The Renaissance of Charlemagne*

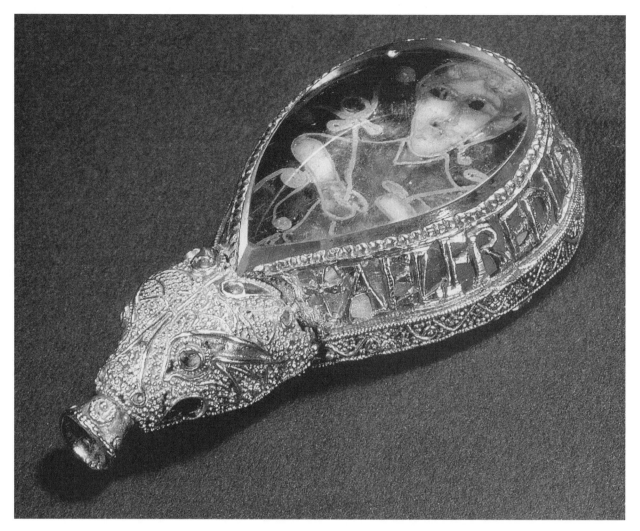

Portrait of King Alfred, The Alfred Jewel, probably intended to be the top of a royal scepter. England, 900. THE ART ARCHIVE/ASH-MOLEAN MUSEUM, OXFORD/EILEEN TWEEDY.

ENGLAND AND THE VIKINGS

THE RISE OF ENGLISH UNITY. The empire of the Carolingians began to decline after the monarchy of Louis the Pious (814–840), but its artistic influence was felt for centuries to come, often far outside its borders. England, settled by the Germanic tribes known as Angles and Saxons, developed a political model of sacred kingship that was based on Old Testament precedents and that was dependent upon the official sanction of Christian churchmen, just as Carolingian kingship had been. This early medieval notion of sacred kingship implied that the authority of the church was exercised through the person of the king or emperor, whose claim to both political and religious authority was based on the precedent of the Old Testament kings and, more recently, the Frankish (or Carolingian) emperors of Rome. It was an accommo-

dation between spiritual and temporal authority that served the interests of both, as each sought to gain legitimacy and power by association with the other. The "golden age" in early medieval English culture is usually associated with the reign of King Alfred the Great (871–899) of the royal house of Wessex, the unifier of the various Anglo-Saxon kingdoms in their defense against the invasions of the Vikings. A Scandinavian people not yet converted to Christianity, the Vikings raided and looted all over western Europe in the ninth century, destroying many wealthy monastic houses but invigorating interregional trade in early medieval Europe through their establishment of routes along which their precious booty (slaves as well as gold and silver) was exchanged for goods from the East. The Vikings, and in particular their technically accomplished and decorative metalwork, had an important impact upon the visual arts in Western Europe.

THE ALFRED JEWEL. The Alfred Jewel, made from gold and enamel and probably intended to be the top of a royal scepter, reveals quite a bit about the state of the visual arts in England around 900. First, there is the connection of this object to a king. The arts would not have flourished as they did in the early Middle Ages were it not for the sponsorship of rulers, who saw the propaganda value of art and often lavished great resources upon the royal and monastic workshops that produced all sorts of luxury objects. Second, an inscription around the edge of the Alfred Jewel reads "Alfred ordered me to be made," an attribution that demonstrates the general anonymity of the early medieval artist in contrast to the all-importance of the (royal) patron. Additionally, the style and craftsmanship of the jewel shows the way that different cultural traditions were often combined in the creation of works of art: the goldwork resembles that of the Vikings, who specialized in small-scale portable objects in metal, stone, and wood and were especially known for detailed and decorative metalwork, while the half-length enameled figure of the ruler is based on earlier English indigenous traditions of semi-abstract figure drawing. The Carolingian (and more Roman) impact on the visual arts in England is not yet evident in the Alfred Jewel, but would appear soon in the illuminated manuscripts of the tenth century.

MONASTIC CENTERS OF ILLUMINATION. King Alfred presided over a flourishing and vibrant court culture, and in the manner of Charlemagne he invited scholars from all over the continent to come to his court and work under his patronage. Because monasteries were the preservers of the intellectual heritage and many of these had recently been destroyed or looted by the Vikings in the ninth century, Alfred and some of his successors helped to rebuild monastic libraries in England in the tenth and eleventh centuries. Illuminated manuscripts, therefore, constitute an important part of the artistic legacy from England in the early Middle Ages. Important schools of manuscript illumination sprang up in cathedral centers like those of Canterbury and Winchester, thanks to the efforts and patronage of church leaders like St. Dunstan (d. 988), the abbot of Glastonbury and later the archbishop of Canterbury, and St. Aethelwold (d. 984), a monk at Glastonbury who was made bishop of Winchester.

THE NEW MINSTER CHARTER AND BENEDICTIONAL OF AETHELWOLD. The first known work of the new Winchester school of manuscript decoration shows the close relationship between pictorial imagery and accompanying text. The book called today the New Minster Charter was commissioned by Bishop Aethelwold in 966 to commemorate the introduction of Carolingian-style

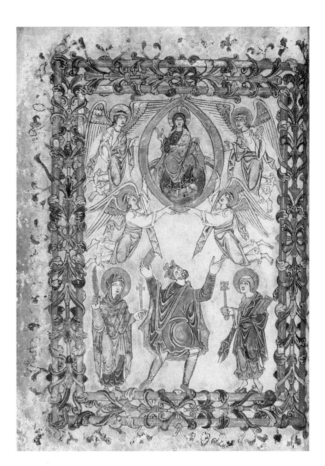

King Edgar between the Virgin and St. Peter offering the Charter to Christ. Frontispiece, New Minster Charter, London, British Library MS Cotton Vespasian A. viii, fol. 2v, c. 966. BRIDGEMAN ART LIBRARY.

monastic reform (focused on eliminating "worldly" behavior) into a Winchester monastery. The frontispiece of the charter depicts King Edgar between the Virgin Mary and the Apostle Peter, the two patron saints of the abbey. Edgar is shown extending the charter—a document outlining and confirming the royally granted holdings and privileges of a monastery—up to the enthroned Christ, visualizing the royal donations made to the abbey by the king on this occasion. The accompanying text says, "Thus resides on his heavenly throne he who created the stars. The devout King Edgar humbly adores him. King Edgar issued this privilege to the new monastery and, with praise, granted gifts to the almighty Lord and his mother Mary." Just as monastic reform was introduced to England from France, so too were later Carolingian traditions in manuscript illustration brought to England and adapted to local tastes, as shown by this image. In the 970s Aethelwold ordered a lavishly decorated benedictional (a book containing blessings spoken by the bishop during the Mass) in which each major feast is accompanied by a pair of full-page illustrations. The illustration

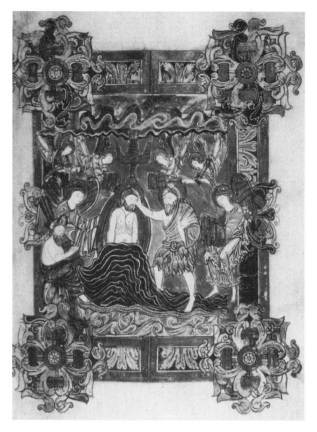

Baptism of Christ, Benedictional of St. Aethelwold, London, British Library MS Add. 49598, fol. 25, c. 980. © THE BRITISH MUSEUM.

of the Baptism of Christ demonstrates further how Carolingian traditions in manuscript illumination found new life in the vibrant monastic houses of Anglo-Saxon England. The figures of Christ, John, and the angels, as well as some of the narrative details (like the water), are rendered in a linear style reminiscent of the French "Reims Cathedral" school, but the complex color scheme and the profusion of leafy ornament that literally bursts out of the frame indicate a rising interest in decorative embellishment and a new artistic complexity.

SOURCES

Janet Backhouse, et al., *The Golden Age of Anglo-Saxon Art, 966–1066* (Bloomington: Indiana University Press, 1984).

David Wilson, *Anglo-Saxon Art: From the Seventh Century to the Norman Conquest* (Woodstock, N.Y.: Overlook Press, 1984).

SPANISH CULTURE AND THE MUSLIMS

PROMOTING THE RECONQUISTA. Like their counterparts in England, the tenth-century rulers of the Christian kingdoms of Spain were consolidating power in the face of enemy resistance and developing a visual culture of ornament and symbols to express their political aspirations. Muslim forces had crossed from northern Africa into Spain in the year 711 and proceeded to defeat the Visigoths, a Germanic people converted to Christianity who had ruled Spain until that time. After the Muslim conquest of most of Spain, the Christian territories occupied only the northernmost and northeastern parts of the Iberian Peninsula. Here, Christian rulers held their ground against Muslim incursions and gradually expanded the area of their control. Clinging to the hope that all of Spain would one day be united under Christian rule, as it was before the Muslim conquest, Christian rulers in Spain developed the notion of the Christian Reconquest of Spain (*Reconquista*), and they sponsored a program of visual arts to advance this notion. From liturgical objects (objects used in church services) created out of precious materials to illuminated manuscripts of Bibles and other religious texts, the arts of early medieval Christian Spain proclaimed Christian victory to be inevitable. In the Christian kingdoms of Asturias, León, Castile, and Navarre, these luxury arts combined established Visigothic visual traditions with Carolingian influences, as well as artistic motifs and styles derived from the neighboring Islamic culture.

THE VICTORY CROSS OF OVIEDO. The royal ideology of Christian Reconquest is clearly evident in the spectacular Victory Cross of Oviedo, donated in 908 by King Alfonso III of Asturias to the cathedral of Oviedo, and probably made a few years earlier. This fine object draws upon the tradition of the cross as an image of Christian victory, which originated in the fourth century with the Roman Emperor Constantine (who was told in a dream that he would defeat his enemies "under this sign"). As an object of richness and beauty, it perfectly showcases the artistic splendor and magnificence that in the early Middle Ages was the aesthetic counterpart to the Christian idea of worldly triumph in its figural embodiment. The iconography of this cross displays no humility or poverty, virtues often associated with Christianity in other contexts.

APOCALYPTIC IMAGERY. Monastic communities in Christian Spain, just as in Carolingian France and Germany, and Anglo-Saxon England, played a major role in the elaboration of the visual arts. As scribes and illuminators of decorated and illustrated manuscripts, Spanish monks developed a recognizable visual language that was the unique expression of their culture. An illustration from a manuscript produced around 950 is a fine example. The work is an illustrated commentary on the Book of Revelation, also known as the Apocalypse of St.

John in the modern New Testament. The text of this commentary was compiled before 800 by a Spanish monk known as Beatus of Liébana, and, as the idea of Christian Reconquest picked up momentum in the tenth century, it was expressed anew in the monastic houses of the Christian north through extensive programs of illustration. The apocalyptic theme of these books may have appealed to monks of the time, who imagined the Christian Reconquest of Spain as an apocalyptic battle between good and evil. An illustration from one manuscript of the Beatus Commentary, perhaps produced for the monastery of San Miguel de Escalada in the kingdom of León, shows the Heavenly Jerusalem, a mystical vision presented in highly schematized (rather abstract and diagrammatic) form. The visual language of intense color and ornamental flatness—for the image lacks any suggestion of naturalistic or three-dimensional space—hearkens back to some Visigothic precedents but may also be understood in relation to the very impressive and influential art of Islamic Spain. Islamic art is noted for its geometric patterns, its profusion of ornament, its rich colors, and its general avoidance of figuration because the Koran forbade the reproduction of human and animal forms in art as idolatrous. Of course, in such Beatus illustrations, the inclusion of human (and divine) figures indicates a specifically Christian point of view. The decorative and somewhat formulaic presentation provides an effective way to express in pictorial form a text that is full of mystical imagery.

MOZARABIC INFLUENCE. Also typically Spanish in such illustrations of the Heavenly Jerusalem is the "horseshoe" arch that often frames the figures arranged around the central square or circle. This is an architectural form common in Islamic Spain and certainly familiar to those Christians, known as "Mozarabs," who had lived under Islamic rule before coming north to the Christian kingdoms in the tenth century. The Mozarabs brought their knowledge of Islamic culture and artistic traditions along with them, and the image of the Heavenly Jerusalem is an example of how those traditions were incorporated into the visual art of Christian monasteries in tenth-century Spain. Another example of Mozarabic influence can be found in a Beatus manuscript from about 970, made for the monastery of San Salvador at Tábara in the kingdom of León. The image on the colophon page (at the end of the manuscript where the scribe provides identifying information about his involvement in the production) shows the same architectural feature—the horseshoe arch—in the representation of the tower and scriptorium of the monastery. In this earliest surviving image of a medieval scriptorium (where manuscripts were copied by hand and sometimes deco-

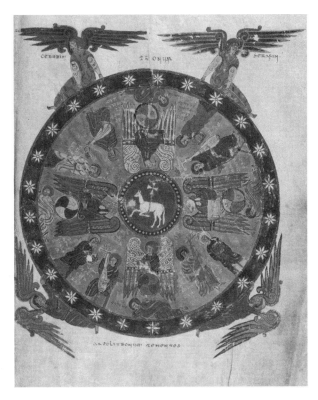

Vision of the Lamb surrounded by 4 Evangelists and 12 Elders. Commentary on the Apocalypse of Beatus of Liébana, Pierpont Morgan Library MS M 644, folio 87, 950. THE PIERPOINT MORGAN LIBRARY/ART RESOURCE, NY.

rated), the scribes named "Emeterius" and "Senior" are hard at work. It is a testament to the cultural importance of monasteries such as this one that the likely creators of this illuminated manuscript are known to us by name.

COMMON ELEMENTS. The ongoing struggle between Christianity and Islam in medieval Spain clearly was (and continued to be) a significant factor in the development of unique and often hybrid artistic forms. Yet the visual art of early medieval Spain shares many commonalties with other artwork being produced outside of Spain during the same period: its undeniably Christian character; its royal and/or monastic context of production; its relationship to earlier and contemporary artistic traditions; and its ambitions, which at this early stage in the history of medieval Europe sometimes exceeded the level of technical ability or the availability of wealth and resources.

SOURCES

The Art of Medieval Spain, A.D. 500–1200—Exhibition Catalogue (New York: Metropolitan Museum of Art, 1993).

John Williams, *Early Spanish Manuscript Illumination* (New York: Braziller, 1977).

SEE ALSO *Religion: The Spread of Islam; Religion: The Crusades*

REVIVAL OF EMPIRE IN GERMANY

THE OTTONIANS. Although the Carolingian Empire lasted hardly a hundred years, the mantle of empire was passed in the tenth century to a dynasty of rulers from Saxony, in Germany, known as the Ottonians (after "Otto," the name used by three of them). These rulers styled themselves "Roman Emperors" and very self-consciously attempted to recapture the power and prestige of Rome and Constantinople for their reigns, just as Charlemagne had done. In the sumptuous production of the cathedral and monastic workshops (which were supported by imperial donations), precious metalwork objects, carved ivory panels, and deluxe manuscripts speak of the Ottonian reign as decreed by God, and, in particular, they show a strong debt to Byzantine artistic practices. Like Charlemagne, the Ottonian rulers were formally recognized by the Byzantine emperors and the two realms were soon connected by marriage ties. Byzantine visual arts and fashions of all kinds were imitated by Ottonian artists and court officials. This imperial art in the center of Europe, with its impressive synthesis of Carolingian, Byzantine, and other, especially Roman, traditions, would play a major role in the elaboration of the early Romanesque style by the mid-eleventh century.

THE IMPERIAL CROWN. In its material and symbolic richness, the German Imperial Crown fashioned for the coronation of Otto I as emperor in 962 (and used as well by subsequent German emperors) is a wonderful example of German imperial art of the early Middle Ages. Its eight arched golden plates form an octagon, in deliberate reference to the architecture of Charlemagne's palace chapel in Aachen. The many gemstones and pearls arranged on the eight plates make explicit reference to the number and distribution of pearls and gems on the walls of the Heavenly Jerusalem as described in the biblical Book of Revelation. The symbolic schema applied to the construction of this crown therefore serves both to associate Otto's rule with that of his famous Carolingian predecessor and also to lend biblical authority to that rule. The crown's structure and arrangement of parts clearly demonstrate that monastic artists of the time could combine their masterful craftsmanship with their scriptural and theological knowledge. In this way a work of medieval art also becomes a document of medieval learning and culture in a broader sense.

THE LOTHAIR CROSS. The Lothair Cross, a work created around the year 1000 for processional use or for

BYZANTINE Visual Arts

In the year 330 the Roman emperor Constantine founded a new capital at an ancient site in Asia Minor (modern-day Turkey) known as Byzantium. Here at this strategic location on the eastern frontier of the empire he set out to reconstitute the city of Rome, thus establishing a tradition of magnificence for his new capital, renamed after himself, "Constantinople" (modern Istanbul). When the Roman Empire split in 395 into a western half and an eastern half, Constantinople became the capital of the latter, a vast empire with borders that, by the sixth century, extended as far as North Africa and Italy in the west and the Caucasus and northern Mesopotamia (modern Syria and Iraq) in the east. After the fall of the Western Roman Empire in the late fifth century, it was the Eastern Roman Empire, known today as the Byzantine Empire, that would carry forward into the Middle Ages the memory and the traditions (especially legal and administrative) of Roman antiquity.

Byzantine civilization, however, was distinct from that of ancient Rome. Its language was not Latin, but Greek, and its unique form of government, elaborate court ceremonial, famous material refinement, and distinctive national church (Greek Orthodox, not Roman Catholic) all helped to keep the Byzantine Empire separate from, and alien to, the culture of Latin Christendom in Western Europe. The Byzantine visual arts—painted icons, silks, mosaics, enamels, and illuminated manuscripts—were celebrated in the medieval West for their beauty, richness, and high degree of technical development. The commercial supremacy of Byzantium insured that its luxury goods (especially silks, spices, and jewelry) would be known all over the world. For the less highly developed civilization of western Christendom, Byzantium was the standard of courtly sophistication and cultural achievement (as were the Islamic court cultures centered in Córdoba and Baghdad from the eighth century onward). The visual arts of Byzantium were therefore admired and emulated at various times throughout the western Middle Ages, and it was in particular the Byzantine emphasis on the human figure in art that made that civilization such an important link between the arts of classical antiquity and those of the Renaissance. When the empire finally fell to the Ottoman Turks in 1453 (over eleven hundred years after it was first established), it was the end of what had been the longest-lived state in medieval Europe.

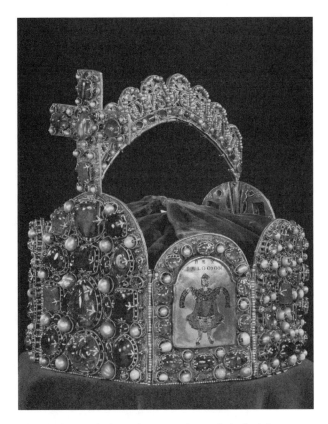

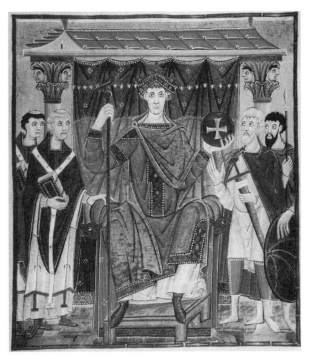

Emperor Otto III enthroned and flanked by ecclesiastical and civil dignitaries. Dedication miniature, Gospel Book of Otto III. Munich, Bayerische Staatsbibliothek MS CLM 4453, folio 1, 997–1000. THE GRANGER COLLECTION.

Enamel plaque of King Solomon as the symbol of wisdom. Crown made for coronation of Otto I, the "Great," Vienna, Austria, Kunsthistorisches Museum, 962. BRIDGEMAN ART LIBRARY.

display on the church altar during a mass before an imperial audience bears a clear relationship to earlier examples such as the Spanish Victory Cross of Oviedo. With its very different front and back configurations, however, the Lothair Cross expresses the dual, antithetical character of medieval Christianity. On the one side, a simple linear engraving of the dead Christ on a silver ground embodies the notion of the cross as an instrument of suffering and death. On the other side, an array of jewels upon a golden ground proclaims Christ's victory over death and recalls the magnificent, visionary images of the cross as an apocalyptic sign of Christian triumph. Early medieval art objects and images were very often designed in this way so as to negotiate between such antithetical concepts as luxury and austerity; biblical past and apocalyptic future; time-bound narrative and eternal symbol. The Roman cameo with its portrait bust of the emperor Augustus, set in the center of the cross's triumphal side, provided a worthy model for the imperial rule of the reigning emperor, Otto III (983–1002). It also illustrates the interrelationship between religion and politics that was crucial in the configuration of so much early medieval art.

THE GOSPEL BOOK OF OTTO III. Ottonian artists were equally accomplished in the field of manuscript illumination, and this pictorial medium was just as important as metalwork objects in expressing the ideals of the Ottonian emperors and bishops who commissioned particular manuscripts. The deluxe Gospel Book of Otto III is a case in point. Upon opening the jewel-encrusted golden cover, with its inset carved ivory panel, one finds a painted ceremonial portrait of the emperor and members of his court spread across two full pages. The very formal, frontal depiction of the larger-than-life emperor hearkens back to late Roman and early Christian ruler portraits. His large scale and central placement with respect to his attendants (bishops on his right, secular lords on his left) indicates his place at the top of the hierarchy and his sovereignty over both church and state. The four female figures that approach in homage on the facing page are personifications of the four provinces of the empire bearing tribute for the emperor. In early medieval painting as in metalwork or sculpture, any attempt at naturalism is generally subordinated to the symbolic or hieratic (traditional) expression of key ideas in unambiguous terms. Naturalism did exist in early medieval art, but not in any absolute sense, and always in tension with non-naturalistic modes of representation.

SOURCES

William Diebold, *Word and Image: An Introduction to Early Medieval Art* (Boulder, Colo.: Westview Press, 2000).

Henry Mayr-Harting, *Ottonian Book Illumination: An Historical Study.* 2 vols. 2nd rev. ed. (London: Harvey Miller, 1999).

Marilyn Stokstad, *Medieval Art.* 2nd ed. (Boulder, Colo.: Westview Press, 2004).

THE CULT OF SAINTS AND THE RISE OF PILGRIMAGE

AN INVESTMENT IN PILGRIMAGE ART. Although the concept of Christian pilgrimage to a sacred site was almost as old as Christianity itself, pilgrimage as a social phenomenon in medieval Europe increased dramatically during the tenth and eleventh centuries as more people visited traditional shrines where saints' relics had long been venerated. A relic is what's left of a saint, either a part of the body (a tooth, an arm, a skull, some blood, etc.) or an article of clothing or other accessory (ranging from Christ's own Crown of Thorns to a shoe or garment belonging to the most minor of saints). Such holy objects, increasingly in the possession of churches, cathedrals, and abbeys all over Europe, were venerated by members of all social classes who attributed to them a divine power. Their custodians preserved and honored these relics by creating beautiful containers, known as reliquaries, to house them.

THE IMPACT OF PILGRIMAGE. The impact on European culture and visual art of this new flourishing of the cult of saints is difficult to overestimate. Whether pilgrims traveled to fulfill an oath, to seek a cure for an illness, to gain the favor of a particular saint, or as an act of penance, they spent money along their journeys and gave donations at local shrines. Recognizable by their large brimmed hats, walking sticks, and food bags called scrips, pilgrims collected small tokens or badges at shrines along the way, which they could bring home as souvenirs of their journey. Fundamentally a spiritual endeavor, pilgrimage also became a big business in the eleventh century, stimulating the economy and motivating secular rulers and monastic communities to invest heavily in the visual arts associated with the cult of saints. Thus, in addition to new and larger churches along the major pilgrimage routes designed to accommodate greater numbers of pilgrims, this period witnessed an explosion of metalwork and enamelwork reliquary containers for saints' relics; illustrated books narrating the lives and miracles of saints; other decorated religious books such as Bibles and psalters; and liturgi-

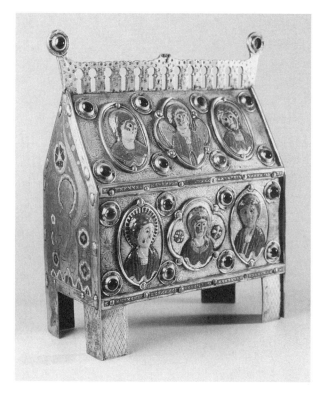

Christ, the Virgin, angels and saints. Reliquary casket, champlevé enamel on gilt copper, Limoges, France, Bargello Museum, Florence, Italy, 13th century. **THE ART ARCHIVE/BARGELLO MUSEUM, FLORENCE/DAGLI ORTI.**

cal vestments and vessels used for the performance of the Mass before ever-larger crowds of Christian pilgrims. The powerful abbey of Cluny in Burgundy, France, promoted the growth of pilgrimage across Europe and profited immensely, while kings and bishops found political as well as economic advantage in supporting and endowing popular shrines with costly art objects.

RELIQUARY SHRINE OF ST. FOY. A wonderful example in many ways is the golden reliquary statue of St. Foy (or Foi), currently in the Cathedral Treasury of Conques, in south-central France. Foy was a martyr saint, a young girl executed by the Romans for her Christian beliefs. Her relics were brought to the abbey of Conques in the later ninth century. During the expansion of pilgrimage to Conques in the tenth century, the monks there actively promoted the cult of this saint and over time built for her relics a magnificent statue-like container (which was embellished further in the centuries afterward). Gold sheeting was laid over a wooden core, and a metal crown and throne were added along with the jewels, antique cameos, and gold filigree work that adorn the garment. The head is actually a late-Roman parade helmet, readapted for this new purpose. The resulting representation of the saint is a powerful object of

PILGRIMAGE
to Santiago de Compostela

Pilgrimages in the Middle Ages were such an important part of the general culture that they were represented in a wide range of art forms, including sculpture, jewelry, and manuscript illumination. One of the most famous pilgrimage sites in Europe was the shrine of St. James of Compostela in the mountains of what is now northwestern Spain. According to Christian legend, the apostle James the Greater evangelized Spain before his martyrdom in Asia Minor and his body was subsequently returned to Spain for burial. In the early ninth century, the hidden or forgotten grave was discovered at a site known as Compostela, and King Alfonso II of Asturias ordered the construction of a church at the site, designating it a cathedral. Almost immediately, pilgrims from other regions journeyed to the shrine, such was the importance of the cult of St. James, or Santiago. Within Spain, St. James came to stand for the ideal of a Spain made fully Christian again (since the Muslim conquest of most of the peninsula in 711). He became the patron saint of the Christian "Reconquest" of Spain. The traffic of pilgrims from all over Europe to the shrine of Santiago de Compostela increased dramatically over the next two centuries (in line with the general increase of pilgrimage activity in Europe) until by about 1100 the cathedral of Santiago was one of the three most important pilgrimage centers in Latin Christendom, along with St. Peter's in Rome (where the relics of St. Peter were preserved) and the Church of the Holy Sepulchre in Jerusalem (site of Christ's own—empty—tomb). The volume of pilgrims necessitated a bigger church, and a new Romanesque cathedral was erected over the early medieval church. A description of the new structure can be found in the *Pilgrim's Guide to Santiago*, written before the middle of the twelfth century.

As was the case with pilgrimage routes elsewhere, commerce prospered with the increasing flow of pilgrims. Economic expansion due to pilgrimage brought about the growth of towns along the route and encouraged rulers and wealthy landowners along the way to capitalize on the traffic by promoting the cults of local saints and patronizing the arts associated with pilgrimage. Thus, the major routes through France and Spain to Santiago can be traced today from one pilgrimage church to another, through once-thriving town centers and along major monastic foundations. In the visual art of the Middle Ages, pilgrims can be recognized by the walking staffs and scrips or food sacks that they carry with them. Pilgrims to Santiago also wear the signature scallop shell of St. James on their cloaks, hats, and bags. One of the most interesting phenomena associated with the shrine was the invention of the pilgrim souvenir, in the form of a pewter badge that pilgrims could take away with them as evidence that they had completed their pilgrimage. Decorated with the motif of the scallop shell, such badges were mass-produced in an effort to keep pilgrims from dismantling the shrines themselves, but they also served the purpose of identifying pilgrims who could then receive both safe passage through dangerous territories and the charity that aided their travel. The badges also became an important source of income for the shrine, and many people believed they had healing powers, especially when they were made of fine metals and embellished with gems. So familiar were these souvenirs that images of the badges were often painted in a highly realistic *trompe l'oeil* manner in the margins of Books of Hours to look as if the actual objects were attached to the page.

devotion, and as an image of sacred authority (following the ancient Roman visual tradition of seated authority figures), it was an effective visual aid in the abbey's campaign to solicit donations in gold from the surrounding region. Some of the donations were used in the creation of this exquisite reliquary, but most of the abbey's income from this campaign was used for trade and other projects. The St. Foy statue thus represents and visualizes the very straightforward economic power of the reinvigorated cult of saints, just as it suggests how the devotional power of a relic could be enhanced by the creation of a work of visual beauty to contain it.

ENAMELWORK RELIQUARIES. Less magnificent and imposing but still very fine and much more abundant were the box- and casket-reliquaries composed of metal plates (sometimes over a wooden core) decorated with enamel panels, such as a twelfth-century container for a fragment of the True Cross (the cross upon which Christ was crucified) that seems to have been made specifically for the church of Saint-Sernin in Toulouse, France. The figures decorating the box are labeled by name and tell the story of the relic's journey from the East to Saint-Sernin. On the lid is an image of Christ in glory. The beauty of the container with its fine craftsmanship and colorful surface suggests the importance and value of the relic within. The two main centers for the production of such small, portable enamelwork objects beginning in the twelfth century were Limoges, in central France (where the Saint-Sernin reliquary was produced), and the Mosan region in the Rhine and Meuse River valleys. The type of enamelwork seen in the Saint-Sernin reliquary is known as

a PRIMARY SOURCE *document*

A RELIQUARY AND A CHALICE AT ST. ALBAN'S

INTRODUCTION: Although there are not many written descriptions of art works during the Middle Ages, there were numerous records of the building of churches and cathedrals, some of which also included mention of the treasure of the church. The following passage from the chronicle of the abbey of St. Alban's in Hertfordshire, England, describes the origins, crafting, and purposes of a reliquary and a chalice, with some appreciation of how the shape and ornamentation were conceptualized, as well as a show of contemporary pride in their possession and display.

Abbot Simon [1167–1183] of pious memory started to collect from that time, zealously and with foresight and wisdom, a considerable treasure of gold and silver and precious stones, and to fashion the outside of the repository which we call a reliquary or *feretrum* (than which we have seen none finer at this time), undertaken by the hand of Master John, goldsmith and most excellent craftsman. He completed this most painstaking, costly, and artistic work most successfully within a few years. He placed it in a prominent position, namely above the main altar, facing the celebrant, so that anyone celebrating Mass at this altar would have before his eyes and in his heart the memory of the Martyr [Saint Alban]; thus facing the celebrant was portrayed the martyrdom, that is, the beheading. Moreover, around the reliquary, namely on the two sides, he had clearly depicted a series from the life of the Blessed Martyr, which consisted of his passion and the preparation for his passion, with raised figures of gold and silver, which is embossed work (commonly called relief). On the main side, which faced east, he reverently placed the image of the Crucified with the figures of Mary and John in a most

fitting arrangement of divers jewels. On the side facing west he portrayed the Blessed Virgin enthroned and holding her child on her lap, an outstanding work surrounded by gems and precious jewels. And thus, with a row of martyrs arranged on both sides of the lid, the reliquary rises to an elaborate and artistic crest; at the four corners it is beautifully and harmoniously shaped with windowed turrets covered by crystals. In this [reliquary] then, which is of extraordinary size, is appropriately enclosed the reliquary of the Martyr himself (being, as it were, his own chamber in which his severed bones are known to be contained), a fitting repository first commissioned by Abbot Geoffrey. ...

The same Abbot Simon also had made and bestowed to his everlasting renown, and to the glory of God and the church of the Blessed Martyr Saint Alban, a great golden chalice than which we have seen no finer in the kingdom of England. It is of the best and purest gold, encircled by precious stones appropriate to the material in such a work, made most subtle with a delicate and fine composition of interwoven flowers. This chalice was made by Master Baldwin, a preeminent goldsmith. He also had made by the hand of the same Baldwin a small vessel, worthy of special admiration, of standard yellow gold, with jewels of divers priceless kinds fitted and properly placed on it, in which "the artistry surpassed the material;" this work was to hold the Eucharist, to be hung over the main altar of the Martyr. When this became known to King Henry II, he sent with joy and devotion to the church of Saint Alban's a most splendid and precious cup in which was placed the repository immediately holding the body of Christ. ...

SOURCE: William Durandus, *The Symbolism of Churches and Church Ornaments: A Translation of the First Book of the Rationale Divinorum Officiorum.* Trans. and Eds. John Mason Neale and Benjamin Webb (Leeds, England: T. W. Green, 1843): 17–30.

champlevé, created by a process in which the desired forms and lines are engraved into the metal surface and filled with colored glass powder, which is then heated until it fuses, producing a glass-like surface. Such works were exported all over Europe, helping to promote the veneration of relics while contributing to a greater uniformity of style and iconography in the visual arts of the period.

THE THRONE OF WISDOM. Another important benchmark in the rise of European devotional culture is the increasing presence of sculpted representations of the Virgin Mary (or the Virgin and Child), usually on church altars. One striking twelfth-century example carved in wood illustrates a specialty of the Auvergne region in central France. With its rigid frontality and rather abstract ren-

dering of drapery and other details, this statue and others of its kind were meant to project an iconic presence and to convey a theological notion of the Virgin as "Throne of Wisdom" (*sedes sapientiae* in Latin). Such objects often doubled as reliquary containers, and they flourished in churches along the pilgrimage roads. The expression of stern authority and devotional intensity of this Virgin and Child is clearly related to that of the St. Foy statue. It is this period, in fact, that witnesses the return of monumental figurative sculpture which had been generally absent in European art since the fall of the Roman Empire.

SOURCES

Peter Brown, *The Cult of Saints: Its Rise and Function in Latin Christianity* (Chicago: University of Chicago Press, 1981).

Gesta 1 (1997). [This entire issue is devoted to body parts and body-part reliquaries.]

SEE ALSO *Architecture: Pilgrimage Architecture; Literature: The Canterbury Tales; Religion: Relics, Pilgrimages, and the Peace of God*

ROMANESQUE ART: AN INTERNATIONAL PHENOMENON

AN AGE OF SURPLUS. Until the eleventh century (and so, throughout the early medieval period), the visual arts in western Europe were an index of a young civilization's efforts to recapture a former grandeur and to express the ideals of the developing culture of Latin Christendom. Beginning around the end of the first Christian millennium (and certainly by the mid-eleventh century), European culture and the visual arts reached a new plateau and entered into a wonderfully rich and fertile period that we have come to call "Romanesque." The historical factors underlying this cultural development are well known. Improved agricultural technology helped to bring about an historic expansion of the European economy and society in the eleventh century. Old centers of production were revitalized, interregional trade increased (as did the use and circulation of gold and silver coinage), and populations grew. Unprecedented surpluses, controlled by the landed aristocracy, made possible the burst of building activity and art production that is associated with the Romanesque period, the beginning of what might be called the "High Middle Ages."

THE ROMANESQUE STYLE. The art-historical designation "Romanesque" was first used in the nineteenth century to describe the architecture of eleventh- and twelfth-century Europe, which, with its rounded arches, barrel vaults, and columns with decorative capitals, seemed derivative of ancient Roman architectural forms. Today the term Romanesque is used to describe the general style of the visual arts from the period. For the first time since ancient Rome, a genuinely international movement in the visual arts is apparent, united by common forms, subjects, and styles and stretching across the regions that now comprise England, France, Spain, Germany, and Italy. The arts reached a new level of coherence in the integration of Roman, Byzantine, Carolingian, Ottonian, and Islamic traditions. The imperial art of Germany was an especially important influence with its Byzantine connections and its powerful visual language, while the explosion of pilgrimage activity helped to establish pathways throughout Europe over which artistic styles and techniques could be spread.

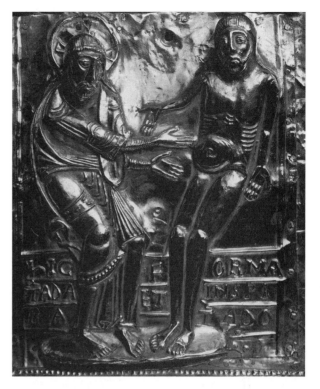

God creating Adam detail from silver gilt relief reliquary shrine of San Isidoro, Spain, 1063. THE ART ARCHIVE/REAL COLLEGIATA SAN ISIDORO, LEÓN/DAGLI ORTI.

While the renaissance of Charlemagne in the Frankish Empire around 800, or of King Alfred the Great in England around 900, represented the ambition of a ruler to project a higher level of civilization, the Romanesque era was more than a projection; European civilization legitimately began to rival both Byzantium and Islam in terms of cultural development and sophistication. The visual arts—sculpture in stone and wood, metalwork, textiles, manuscript illumination, and mural painting—bear witness to this remarkable achievement.

THE RELIQUARY SHRINE OF SAN ISIDORO. The Reliquary Shrine of San Isidoro in León is a good example of how royal sponsorship helped to bring about the production of what may be considered the earliest known Romanesque reliquary shrine. In its monumentality of conception and execution, it anticipates works of the following century. The occasion for the creation of this shrine was the defeat of the Muslim forces at Seville and the capture of that city by King Fernando I of León in 1063 (a major advance in the Christian Reconquest of Spain). The prized relics of San Isidoro (who was something of a Spanish national saint) were transferred at this time from Seville in the south to León in the north and deposited in a church that was rededicated to the saint. The ideological importance of the relics

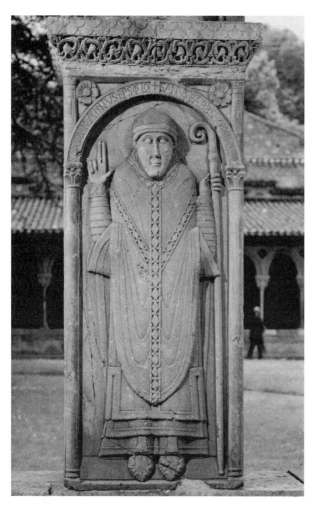

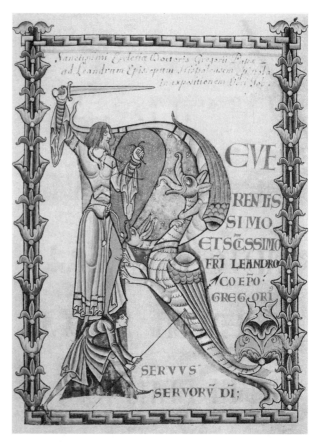

St. George and the dragon initial, Gregory the Great, *Moralia in Job*. Dijon, France, Bibliothèque Municipale MS 168, folio 4v, 1111. THE ART ARCHIVE/BIBLIOTHÈQUE MUNICIPALE, DIJON/DAGLI ORTI.

Marble cloister pier relief of Abbot Durandus of Brédon, bishop of Toulouse. Church of Saint-Pierre, Moissac, France, 1100. PETER WILLIAMS/BRIDGEMAN ART LIBRARY.

within the kingdom of León and the political importance of the occasion warranted the creation of the gilt silver container. The five scenes from the biblical book of Genesis (two additional scenes have been lost) as well as the figure of Fernando I appear on plaques that adorn the shrine. The choice of scenes and particular compositions recall both Carolingian Bible illustration from the Tours school and figurative bronze work from the Ottonian era (specifically a set of bronze-relief doors from Hildesheim in Saxony). The decorative silks lining the casket are of Islamic origin, their re-use a customary practice for Christian reliquary containers in Spain.

ABBOT DURANDUS AT MOISSAC. The effectiveness of so much Romanesque art in conveying a sense of political authority by drawing upon powerful, iconic modes of representation is well illustrated by an image of Abbot Durandus from about 1100, carved in low relief on the central marble pier in the cloister of the abbey church of Saint-Pierre, in Moissac (southwest France). This church, an important stop on one of the major pilgrimage roads, was a key outpost of the powerful monastic order of Cluny. It was reformed according to the Cluniac Order by Durandus, who ruled the religious community there as abbot from 1047 to 1072. This marble slab, erected later in his memory, commemorates the period of his rule and serves as a visualization of the authority that was so important within a monastery. This sense is conveyed by the rigid symmetry and frontality of the figure and by the ceremonial vestments and gesture. In its position facing the room where the monks regularly held meetings, this image functioned very well as a reminder of the abbot's supremacy. Romanesque art does not always display such rigidly abstract qualities; in fact the period after 1100 saw the spread of a more dynamic expressiveness in many works of visual art. But the close physical connection between the figure of Durandus and the architectural frame enclosing him (and also the structural support upon which he appears) is very characteristic of the Romanesque aesthetic.

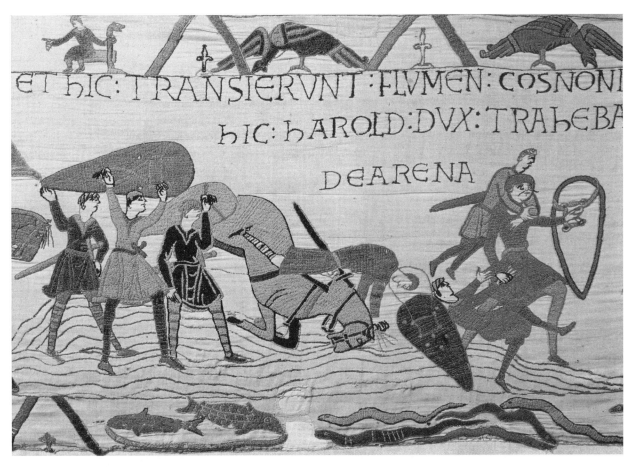

ET HIC : TRANSIERVNT : FLVMEN : COSNONI
HIC : HAROLD : DVX : TRAHEBA
DEARENA

Harold II King of England assisting Duke William, later William I the Conqueror, to escape from quicksand near Mont Saint-Michel, France, Bayeux Tapestry, France, 1080. **THE ART ARCHIVE/MUSÉE DE LA TAPISSERIE, BAYEUX/DAGLI ORTI.**

THE CISTERCIAN MORALIA IN JOB. The close relationship between figure and support was even more creatively explored in the realm of manuscript illumination, a much more fluid medium. Text and image were often conflated in "historiated" or "inhabited" initials, in which the form of a letter provides space and structure for one or more figures to appear and to act out scenes related to the text. An example is the initial "R" from the title page of an early twelfth-century manuscript of the *Moralia in Job*, a well-known commentary on the Old Testament Book of Job composed centuries earlier by Pope Gregory the Great. The title *Moralia* indicates the "moralities" or allegories of New Testament events Gregory found contained in the story of Job. Literally occupying the space within the letter is a dragon confronted by a sword-wielding knight who stands upon the back of a lance-wielding soldier or servant. The monastic community responsible for the production of this manuscript and its decorations is that of the new Cistercian Order, founded in 1098 in Cîteaux (in Burgundy, France) by Benedictine monks who op-

posed what they saw as the worldly excesses of the Cluniac Order (the leading order of Benedictine monasticism). They wished to live a more austere life closer to the model of the early Christian hermit monks, and their outlook eventually carried over into the visual art (and architecture) that they produced. By the time this manuscript was completed in 1111, the Cistercians' most rigorous strictures regarding the artistic embellishment of books and other objects had not yet been enforced (although there is a conspicuous absence of gold leaf, and there are no full-page illustrations within). Decorated initials such as this one were seen by the monastic audience in terms of spiritual meanings; in this case the fight between dragon and knight represented the spiritual struggle of the monks over evil impulses. Although involved in a scene of strenuous action that might seem to call for a realistic style, the figures are depicted with fantastically proportioned bodies and decorative, stylized clothing characteristic of the Romanesque. Naturalism here is clearly subordinated to a scheme that is decorative and made to literally "fit" the text it embellishes.

a PRIMARY SOURCE *document*

BERNARD OF CLAIRVAUX ON THE VANITY OF SACRED ART

INTRODUCTION: The following is an extract from a letter written in 1125 by St. Bernard (Bernard of Clairvaux, 1091–1153) to the monk William of Thierry, in which he builds upon the early Christian critiques of sacred art production in offering an elaborate complaint against what he argues are the excesses and the inappropriateness of art in a monastic context. Bernard was a leader of the new Cistercian Order of monks, a group that formed in reaction to the more permissive and worldly Benedictine orders, which were associated with the sponsorship of artistic works and monuments. This critique of the Benedictine (especially Cluniac) approach to the visual arts in a sacred context was written in 1125.

Their eyes are feasted with relics cased in gold, and their purse-strings are loosed. They are shown a most comely image of some saint, whom they think all the more saintly that he is the more gaudily painted. Men run to kiss him, and are invited to give; there is more admiration for his comeliness than veneration for his sanctity. Hence the church is adorned with gemmed crowns of light—nay, with lustres like cartwheels, girt all round with lamps, but no less brilliant with the precious stones that stud them. Moreover we see candelabra standing like trees of massive bronze, fashioned with marvellous subtlety of art, and glistening no less brightly with gems than with the lights they carry. What, think you, is the purpose of all this? The compunction of penitents, or the admiration of beholders? O vanity of vanities, yet no more vain than insane! The church is resplendent in her walls, beggarly in her poor; she clothes her stones in gold, and leaves her sons naked; the rich man's eye is fed at the expense of the indigent. The curious find their delight here, yet the needy find no relief. In short, so many and so marvellous are the varieties of divers shapes on every hand, that we are more tempted to read in the marble than in our books, and to spend the whole day in wondering at these things rather than in meditating on the law of God. For God's sake, if men are not ashamed of these follies, why at least do they not shrink from the expense?

SOURCE: Bernard of Clairvaux, "Letter to William of St. Thierry," in *A Mediaeval Garner*. Trans. G. G. Coulton (London: Constable and Co., 1910): 70–72.

a PRIMARY SOURCE *document*

ARTISTIC TECHNIQUES FROM DIFFERENT LANDS

INTRODUCTION: This extract is from *De diversis artibus* (On Divers Arts), considered the foremost medieval treatise on the arts of painting, stained glass, and metalwork techniques. It was written around 1125 in western Germany by a certain Theophilus, who is tentatively identified with the goldsmith Roger of Helmarshausen from Lower Saxony. As a defense of the liturgical and decorative arts, the treatise offers a response to St. Bernard's critique of sacred art. It argues that art for liturgical purposes follows God's own specifications, and that the work of artists aware of this religious significance is an inspired spiritual activity that imbues the whole process of making and using liturgical art with a dignity transcending decorative concerns. The passage excerpted here from the introduction presents the author's claim to include descriptions of artistic techniques from all over the known world.

Wherefore, gentle son … covet with greedy looks the "Book on Various Arts," read it through with a tenacious memory, embrace it with an ardent love.

If you scrutinize this book most diligently, you will find the mixtures and kinds of various colors which they use in Greece; whatever Russia knows about the crafts of enamels and niello; how Arabia is distinguished by skill in repoussé or casting or openwork; how Italy decorates vessels with gems and gold and excels in carving of ivory; how France delights in the precious tracery of windows; and whatever subtle Germany appreciates in the fine working of gold, silver, copper, and iron, and in wood and precious stones.

SOURCE: Theophilus, *De diversis artibus*, in Robert Hendrie, *An Essay Upon Various Arts, in Three Books by Theophilus, called also Rugerus, Priest and Monk* (London: John Murray, 1847): 1. Translated by John Block Friedman.

THE BAYEUX TAPESTRY. The relationship between text and image is just as important in the 231-foot-long "Bayeux Tapestry," which is technically not really a tapestry at all but an embroidery on linen. Commissioned in the 1080s, it features a continuous pictorial narrative relating the story of the Norman conquest of England in 1066. This secular work, apparently unique, follows very closely the written narrative account of the conquest by William of Poitiers, the chaplain of the victorious Duke

William of Normandy. Captions throughout identify figures and scenes. In one section, for example, the Earl Harold of England can be seen accompanying Duke William of Normandy on his military campaign in Brittany; another section shows the Battle of Hastings, where William's forces defeated Harold and paved the way for William's ascent to the English throne. Meant largely as a justification for the Norman Conquest and subsequent rule over the English, this monumental work draws inspiration from the ancient Roman tradition of the continuous picture roll, which similarly served a political function. The combination of forms, colors, composition, and iconography marks this work as distinctly Romanesque. It is also worth noting that the Bayeux Tapestry shares with other Romanesque works a certain focus on the contest for power and authority (whether secular or religious). Interestingly, its theme and its lively narrative have appealed to more modern military leaders and would-be conquerors (such as Napoleon and Hitler, who sought to study this work), just as its abundant imagery continues to inspire new art-historical scholarship.

SOURCES

Shirley Ann Brown, *The Bayeux Tapestry: History and Bibliography* (Woodbridge, Suffolk: Boydell, 1988).

Walter Cahn, *Masterpieces: Chapters on the History of an Idea* (Princeton, N.J.: Princeton University Press, 1979).

C. M. Kauffmann, *Romanesque Manuscripts, 1066–1190* (Oxford, England: Oxford University Press, 1985).

Andreas Petzold, *Romanesque Art* (New York: Prentice Hall Press, 1995).

George Zarnecki, *Romanesque Art* (New York: Universe Books, 1982).

ART AT THE CULTURAL FRONTIER IN THE TWELFTH CENTURY

A MULTICULTURAL ART. Interregional trade in luxury and art objects helped make it possible for Romanesque art to synthesize many different visual languages. But there were also particular regions where Latin Christians from Europe coexisted or came into frequent contact with members of other cultures, and these points of contact were important in giving Romanesque art its international character. Spain continued to be a frontier region where Christians and Muslims intermingled, sometimes sharing in a common artistic culture. In southern Italy and Sicily, a dynasty of Norman rulers presided over "a kingdom of the Two Sicilies" in which Latin, Greek (Byzantine), and Islamic traditions all had a share in defining the local culture. The eastern Mediter-

WEAVING and Embroidery

Because they were so often damaged or destroyed through use, exposure, or some other calamity, medieval textiles have not survived in numbers indicative of their actual importance for medieval culture. Decorative woven and embroidered textiles were used most often in the creation of ceremonial vestments (for bishops or secular rulers) or for large wall-hangings and floor-coverings.

Weaving is a process used in the production of carpets, tapestries, and other textiles, and is carried out on a loom. The structure of vertical threads is known as the warp; the weft refers to the horizontal threads woven across to form the pattern or decoration. Different artisans were involved in the design and execution of a piece of artistic weaving. A famous example is the series of tapestries illustrating the Apocalypse commissioned in 1376 by Louis of Anjou for the decoration of his castle. A master weaver named Nicholas Bataille was commissioned to do the work, but he in turn ordered designs to be drawn up by the king's painter, Jean Bandol of Bruges.

Embroidery is a needlework technique in which designs are sewn in a fine material (like silk) onto a support made of another material, such as wool, cotton, or linen. The most famous example of a medieval embroidery is the improperly named "Bayeux Tapestry." It is a 70-meter long strip of linen embroidered in dyed wool with narrative scenes relating the story of the Norman conquest of England in 1066 in great detail—over 50 scenes with more than 600 human figures. This example is unique; more common were the many decorative textiles used for liturgical purposes by priests and bishops. English embroidery became well known throughout later medieval Europe as *opus Anglicanum*. An example is the Chichester-Constable Chasuble, a velvet vestment worn during performance of the Mass and probably made for Edward III (r. 1327–1377), whose family emblem appears in the top portion of the decoration. Embroidery on the back of the vestment, done in gold, silver, and silk threads adorned with seed pearls, depicts scenes from the Life of the Virgin.

ranean—the Holy Land—was another crucible of cross-cultural interaction where Latin Christian crusaders, Byzantine Christians, and Muslims fought each other and yet gained knowledge of each other's traditions in the visual arts. Sometimes, art objects produced by one

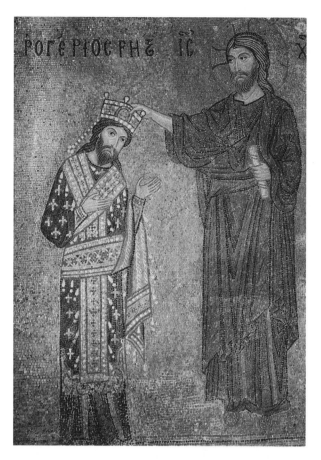

Christ crowning King Roger II of Sicily, Mosaic, St. Mary's of the Admiral (Martorana) church, Palermo, Sicily, Italy, 1151. © ARCHIVO ICONOGRAFICO, S.A./CORBIS.

Cast bronze Griffin, Museo delle Opera del Duomo, Pisa, probably Fatimid Egypt, 11th–12th centuries. SCALA/ART RESOURCE, NY.

culture were taken and reused in a new context by another culture. Some hybrid art forms (Christian or Islamic? Latin or Greek?) carried across Europe through trade, war, or diplomacy were expressive of this medieval multiculturalism. With such a rich and cosmopolitan art scene in twelfth-century Europe, the stage was set for the advent of the more complex, intellectually sophisticated, and naturalistic visual art of the later Middle Ages.

NORMAN SICILY. The Normans, who had recently invaded and conquered England, established dominion over Sicily in the early twelfth century and founded a state which became a major power in the Mediterranean basin. The mantle for the coronation of the Christian king Roger II, created between 1133 and 1134, is a work of Islamic art made by Muslims in the royal workshop in Palermo (as its Arabic inscription states). It features a central Tree of Life flanked by lions attacking camels, a common hunting motif that signified royal power and dominion. What is meant by the commissioning and ceremonial employment of Islamic art by a Christian king? A comparison with the Spanish situation is in-

structive. Christian kings of Spain brought back Islamic textiles or carved ivory caskets (often produced at the caliph's court in Córdoba) as spoils of war and then often incorporated them into Christian shrines (as in the Reliquary Shrine of San Isidoro). This sort of hybridization in the arts, however, must be seen in the light of the ongoing military struggle between the two communities and the practice of despoiling one's enemy and then neutralizing enemy symbols by re-contextualizing them. In Norman Sicily, Muslims were recognized subjects and even members of the royal administration; they were not the enemy. The coronation mantle, when worn by the king, visualized his claim to be ruler over a diverse ethnic constituency. His appeal to the visual tradition of his Muslim subjects demonstrates that rulers during this period could no longer assert their authority in the early medieval terms of absolute power. In multicultural contexts, they increasingly relied on a visual language of inclusiveness.

THE PISA GRIFFIN. Sometimes works of art from this period are not so easy to identify with one specific cultural group or another. This may be because of the fact that they were moved from region to region, or perhaps because many of the same techniques and visual

Beatus Vir initial, Psalter of Queen Melisende, MS Egerton 1139, folio 23v, c. 1135. © THE BRITISH LIBRARY.

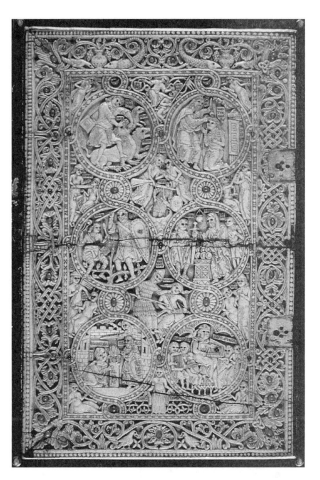

Scenes from life of King David, ivory cover from the Psalter of Queen Melisande, MS Egerton 1139. © THE BRITISH LIBRARY.

motifs were often employed in different places. A long-celebrated enigma of Islamic craftsmanship in bronze, the so-called "Pisa Griffin" has been alternatively assigned to Ummayad Spain, Fatimid Egypt (the first two named for the dynasties of their Muslim rulers), Sicily, Italy, or Iran. Each of these places had bronze-working traditions as well as flourishing court cultures that produced luxury objects and engaged in trans-regional trade. For some 700 years the Griffin stood proudly atop Pisa Cathedral in Pisa, Italy; how it got there is something of a mystery. It is thought to have been made in the late eleventh or early twelfth century, but was it given as a gift, exchanged through channels of trade, or taken as booty during a military campaign? Standing just over three and a half feet tall, this majestic creature would have been understood by any number of Mediterranean communities as a symbol of power and victory (hence its placement as a trophy atop the cathedral). It is the circulation of such works from place to place that gives evidence for cross-cultural relations during the period.

But surely these works also played a role in establishing pan-cultural identities and fostering knowledge of neighboring and distant peoples. In an era long before "globalization," individual works of art very often did the work of establishing connections between places or attesting to the existence of those connections.

QUEEN MELISENDE'S PSALTER. One outpost of Latin Christendom that served as a crucible of cross-cultural exchange in the visual arts was the Holy Land during the period of the Crusades (from about 1100 to almost 1300). During this time, knights and adventurers from all over Western Europe established states along the coast of the eastern Mediterranean, the most important of which was the Latin Kingdom of Jerusalem. Here, rulers of Latin or sometimes mixed Latin-Byzantine ancestry asserted their sovereignty over a mixture of peoples, not unlike the rulers of Norman Sicily. One such ruler was Queen Melisende, who ruled alongside her husband Fulk until his death in 1143, after which she enjoyed exclusive sovereignty over the kingdom until 1152. One of the greatest monuments of visual art from the

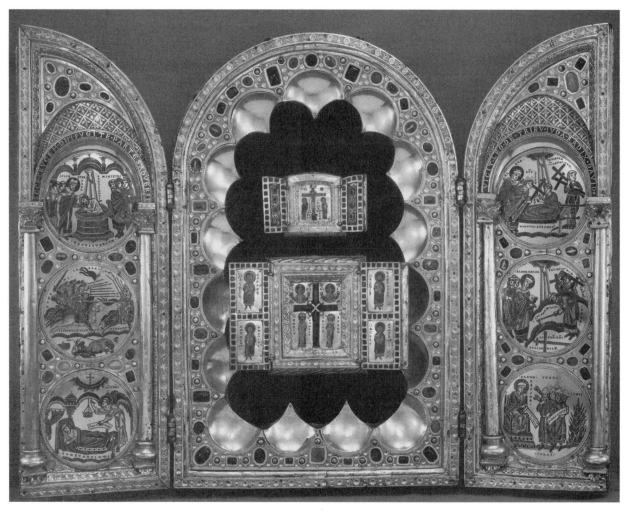

Biblical scenes from Stavelot Triptych, Mosan enamel and metal work. New York, Pierpont Morgan Library, 1156–1158. THE PIERPOINT MORGAN LIBRARY/ART RESOURCE, NY.

period of her reign is a deluxe psalter, or book of Psalms, currently preserved in the British Library. The psalter text itself, the first page (and the first letter, an historiated letter "B" for "Beatus vir," the first words of one of the Psalms), begins after a cycle of full-page New Testament illustrations and a calendar of the feasts of the saints. The golden script used throughout, as well as the overall sumptuousness of the book, indicates royal patronage and imitates the manner of imperial manuscripts from the Byzantine court in Constantinople. The text was copied by a scribe in a northern French style, and the figural work within the initial letter "B" imitates an English style. This mixture of influences can be found throughout the manuscript; the illustrations are largely Byzantine with some western touches, and the carved ivory covers recall textile motifs from the Near East. A work that truly synthesizes various cultural influences, the psalter expresses the queen's desire to establish royal

authority over a mixture of peoples by accommodating their various traditions within the new visual culture of the royal court. Other strategies are employed as well, such as the propagandistic scenes of King David on the front ivory cover which suggest a biblical prototype for the crusader rulers of Jerusalem.

THE STAVELOT TRIPTYCH. That a single work of art may express inter-regional connections by the literal incorporation of other works within it is clear from the example of the Stavelot Triptych, thought to have been commissioned by Wibald, the Benedictine abbot of Stavelot (in modern-day Belgium) sometime after 1155. It is a portable gilt copper altarpiece whose doors open to reveal scenes from the life of the Roman emperor Constantine in circular enamel panels, an assortment of gems and pearls, and two smaller triptychs in the central section. Wibald had just returned from a trip to Constantinople, and this altarpiece, executed by master

metalsmiths in the Mosan region, emphasizes the abbot's regard for Byzantine traditions in the visual arts. The two small triptychs in the center are actually reliquary containers from Constantinople, given as gifts by the Emperor Manuel I. The fragment of the True Cross that each contains as well as the particular type of enamelwork used to decorate the small reliquaries are both decidedly Byzantine intrusions into a work from Western Europe. The pride of place they are given within the overall work suggests that Byzantine sacred objects were held in especially high regard in the West. Perhaps the patron is also making a statement about the interconnectedness of different Christian traditions or about his own enlightened cosmopolitanism. Regardless of the specific meaning, it is works such as this that tell us that twelfth-century Europeans were finding many ways to assimilate influences from neighboring and distant cultures in the forging of new works of visual art. It is this openness to the larger world, as much as any internal developments, that helped pave the way toward the magnificent visual arts of the later Middle Ages.

SOURCES

Jaroslav Folda, *The Art of the Crusaders in the Holy Land, 1098–1187* (Cambridge, England: Cambridge University Press, 1995).

Eva R. Hoffman, "Pathways of Portability: Islamic and Christian Interchange from the Tenth to the Twelfth Century," *Art History* 24:1 (Feb. 2001): 17–50.

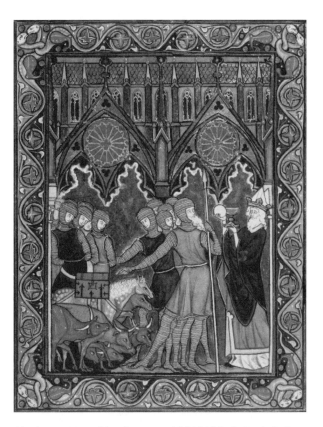

Abraham presents his prisoners to Melchisidek, St. Louis Psalter, Paris, Bibliothèque nationale MS lat. 10525, folio 6, 1250. **GIRAUDON/ART RESOURCE, NY.**

POLITICAL LIFE AND THE NEW STATE

ACHIEVEMENT OF THE ROYAL STATE. By the later Middle Ages the various European states reached a crucial stage in their political development. England, France, and the Spanish kingdoms were each able to consolidate power and territory, asserting royal prerogatives and centralizing the administration of the realm. In France of the Capetian and Valois dynasties (987–1498) and in England of the Plantagenet dynasty (1154–1399), particularly, this resulted in the achievement of the royal state—the predecessor of the modern nation-state. The case of France is especially important because it is there that centralized political authority coincided with the development of the Gothic style—the prevailing style of European art in the later Middle Ages. Generally associated with the patronage of Abbot Suger of Saint-Denis in the 1140s, outside of Paris, and emerging first in architecture, the new style very quickly came to be thought of as both "modern" and native to France. Leaving behind all notions of aesthetic and spiritual austerity, Gothic art fully embraced visual splendor for the greater glory of God, not to mention the glory of the monarchs, bishops, and noble individuals that promoted it. It was elegant and awe-inspiring, human-centered and otherworldly. The Gothic spread rapidly throughout the Ile-de-France (Paris and the surrounding region) and then on to England and elsewhere. It is found first in architecture but soon became predominant in all the visual arts, in fashion, and even in the design of mundane and everyday objects.

THE GOTHIC AS A FRENCH STYLE. If the maturity of the Gothic style in France and its dissemination throughout Europe can be associated with the reign of a single monarch, then that ruler is King Louis IX (r. 1226–1270). This "most Christian king" (Louis was made a saint 27 years after his death) patronized the arts in grand fashion as part of his effort to glorify Paris as the "new Jerusalem" and exalt the French nation as the "true Israel." Convinced he was favored by God and destined for greatness, Louis spared no expense in pursuing his ambitious plans, both at home in Paris and on Crusade in the Holy Land. Because Paris became such an important and influential center during Louis' 44-year reign, the mature Gothic style found its way from there to all corners of Europe. As a strong monarch and a

a PRIMARY SOURCE document

ABBOT SUGER ON ALTAR DECORATION

INTRODUCTION: Suger (1081–1151), abbot of Saint-Denis out-side of Paris from 1122 onward, is one of the most fa-mous and best-documented medieval patrons of the arts. The text below comes from Book XXXIII of *De Adminis-tratione* (1144–1149), Suger's treatise detailing the change in his abbey's economic fortunes and the remodeling and artistic embellishment of the church's interior. It is one of three treatises he wrote concerning the rebuilding and redecorating campaign that he led. In it, we see Suger's effort to glorify as well as describe; he was well aware of the artistic importance of his patronage. The latter part of the excerpted passage describes the "anagogical" power attributed to religious art by Suger: this is the abil-ity of art and material beauty to help transport the hu-man spirit into closer proximity to the Divine.

We hastened to adorn the Main Altar of the blessed Denis where there was only one beautiful and precious frontal panel from Charles the Bald, the third [Carolingian] Emperor; for at this [altar] we had been offered to the monastic life. We had it all encased, putting up golden panels on either side and adding a fourth, even more pre-cious one; so that the whole altar would appear golden all the way round. On either side, we installed there the two candlesticks of King Louis, son of Philip, of twenty marks of gold, lest they might be stolen on some occa-sion; we added hyacinths, emeralds, and sundry precious gems; and we gave orders carefully to look out for others to be added further …

But the rear panel, of marvelous workmanship and lavish sumptuousness (for the barbarian artists were even more lavish than ours), we ennobled with chased relief work equally admirable for its form as for its material, so that certain people might be able to say: "The workman-ship surpassed the material. …"

Often we contemplate, out of sheer affection for the church our mother, these different ornaments both new and old…Thus, when—out of my delight in the beauty of the house of God—the loveliness of the many-colored gems has called me away from external cares, and worthy meditation has induced me to reflect, transferring that which is material to that which is immaterial, on the diver-sity of the sacred virtues: then it seems to me that I see myself dwelling, as it were, in some strange region of the universe which neither exists entirely in the slime of the earth nor entirely in the purity of Heaven; and that, by the grace of God, I can be transported from this inferior to that higher world in an anagogical manner.

SOURCE: *Abbot Suger On the Abbey Church of St.-Denis and its Art Treasures.* 2nd ed. Eds. and trans. Erwin Panofsky and Gerda Panofsky-Soergel (Princeton, N.J.: Princeton University Press, 1979): Book XXXIII, 64–65.

patron of the arts, Louis came to be a model for other late medieval kings, most notably his contemporaries kings Henry III of England (r. 1216–1272) and Alfonso X of León-Castile (r. 1252–1284), as well as later rulers like King Charles V of France (r. 1364–1380) and King Edward III of England (r. 1327–1377).

THE PSALTER OF SAINT LOUIS. Created between 1253 and 1270 for the private devotion of the French king, the Psalter of Saint Louis defines the Gothic as a courtly French art. This exquisite small-format manu-script (5 cm x 3.5 cm), along with the many other high-quality illuminated manuscripts produced for the royal court of France during this time, earned for France its reputation as a center of Gothic art and culture. As a bibliophile whose library was famous throughout the royal courts of Europe, King Louis commissioned the psalter to be decorated with more than 78 full-page il-lustrations of Old Testament scenes. Each scene is set in an architectural frame adorned with lancets, pinnacles, tracery, and rose windows that seem to echo in minia-ture the architectural elements of Louis's newly built Sainte-Chapelle (1243–1248). Along the borders run scrolls with an ivy leaf motif and fantastic animals in the corners. The program of illustrations lacks a clearly-defined relationship with the psalter text, and the choice of scenes—many of which concentrate on biblical he-roes, such as Abraham and David—suggests that Louis probably intended there to be an association between himself and the biblical figures who were seen as his pro-totypes. In one example two episodes from a biblical story are depicted, conveniently separated by an oak tree. On the left, three strangers appear before the bearded and kneeling Abraham; on the right, the men have been invited in to break bread with their host, who has just learned that Sarah—who peeks through the open cur-tain in the back—will bear a child. Such a story would have been understood in thirteenth-century Christian Europe as a prefiguration of the Annunciation to the Virgin, a pattern of symbolism in which the Old Testa-ment episode was intended to foreshadow a New Tes-tament event, thus showing that the New Testament stories fulfilled prophecies in the Old. For Louis, pro-grammatic and jewel-like works of art like this psalter were part of a coordinated cultural policy that exalted

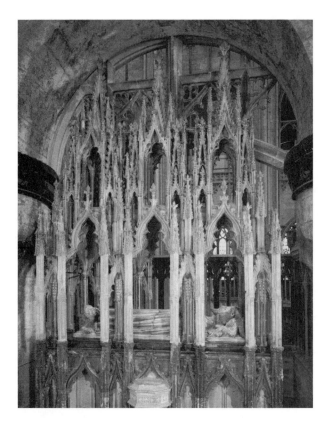

Canopied marble tomb of King Edward II. Gloucester Cathedral, England, 1330. ANGELO HORNAK/CORBIS.

the ruler as saintly and his kingdom as a latter-day Israel, chosen by God and destined for greatness.

THE SPREAD OF THE GOTHIC STYLE. Within the culture of the aristocratic and royal courts, the arts continued to flourish, sponsored by men and women who shared a common culture and held fast to the noble virtues of rank, wealth, and vestiges of chivalry. These individuals decorated castles, erected public monuments, and sought to commemorate their own deeds and those of their ancestors. They also turned to the visual arts to celebrate the more mundane pleasures and activities of courtly life, such as hunting, jousting, and literary invention. The taste and high standards of the nobility—visualized in illuminated manuscripts, goldsmith work, tapestries, and sculpture—translated into an aesthetic of opulence, elegance, and technical complexity that created a fashion across Europe. Drawing their inspiration from the new Gothic style in architecture, both visual artists and sculptors endowed their works with a decorative style of intricate lacy designs, sinuous curves, and a taste for architectural motifs such as high, pointed arches and pinnacles. Stone- and wood-carvers tended to favor patterns inspired by nature, such as vine and ivy foliage and acanthus flowers. The tomb of King Edward

BOOK of Hours

One of the most popular types of privately owned books in the later Middle Ages was the illuminated Book of Hours (called *horae* in the Latin plural). A devotional book, almost always illuminated, it was intended for laypeople so that they could imitate the devotions of the monastic hours followed by monks and nuns. They did, in fact, contain liturgical texts borrowed from the Breviary, the book used by monks that contained the complete service for the Divine Office (the daily cycle of prayers for the eight canonical hours). At the heart of the Book of Hours was the Little Office of the Blessed Virgin (or Hours of the Virgin), a series of prayers to be recited at seven different times during the day: *matins* and *lauds* at daybreak, *prime* at 6 a.m., *terce* at 9 a.m., *sext* at noon, *nones* at 3 p.m., *vespers* at sunset, and *compline* in the evening. This was supplemented by many other elements, such as a calendar, a litany of saints, the Office of the Dead, the Penitential Psalms, other offices (of the Trinity, of the Passion, etc.), and other prayers and suffrages (which typically contained a picture and a prayer to a specific saint).

Texts varied quite a bit depending upon the needs and preferences of each owner; for example, books of hours owned by women often had prayers for St. Apollonia, connected with childbirth, and St. Anne, who taught Mary to read. Likewise books often provide clues to their region of origin. The calendar of a Book of Hours intended for someone living in Paris, for example, would contain the festival days for certain saints such as Dionysius (St. Denis) who was especially venerated in central France, while a Book of Hours for Oxford (called "Oxford use") would include the city's patron saint, Frideswide. Even the date of the book can sometimes be determined by its content, since suffrages for St. Sebastian and St. Roche, associated with protection from plague, would have begun to appear only after 1349. The book of hours assumed its standard form in the thirteenth century and continued to be produced in large numbers, especially in northern Europe, until the sixteenth century, when print versions with hand-colored woodcuts replaced painted decoration. Its popularity was an expression of the growing piety of laypeople in the later Middle Ages, though books of hours also showcased the wealth and taste of patrons. Typically, major divisions would feature an illustration or a cycle of illustrations, and decoration throughout the book could be quite extensive.

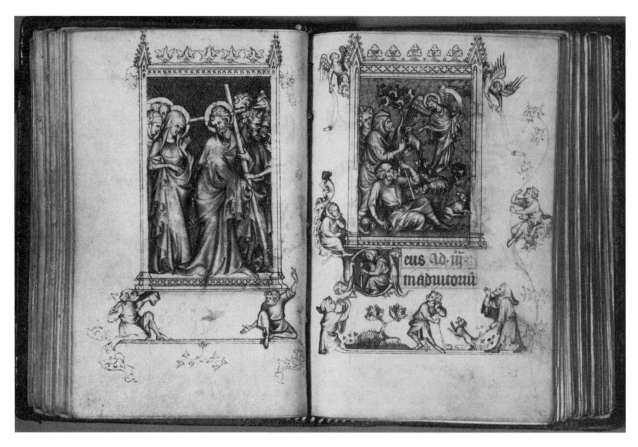

Christ carrying the cross and Annunciation to the Shepherds, double page. Hours of Jeanne d'Evreux, New York, The Cloisters, Metropolitan Museum of Art, MS 54.1.2 folios 61–62, 13th century. **FRANCIS G. MAYER/CORBIS.**

II of England (Gloucester Cathedral, 1307–1327) illustrates all these characteristics and shows how thoroughly this style of French origin was now implanted in England. It features an effigy of the deposed monarch reclining beneath a canopy of marble adorned with high pinnacles and ogival (curved and pointed) arches. With its complex architectural structure, its profuse ornament and overwhelming size, the marble canopy sets the deceased king apart from the viewer as it elevates him to an unattainable heavenly resting-place. Enshrined in this highly decorative structure, the idealized alabaster portrait of the king, contrasting in size and sobriety with the canopy, rests undisturbed in a majestic dignity. Here we see the Gothic in the service of the later medieval royal state, expressing the power and importance of the royal office while commenting upon the greatness of the honored individual.

THE HOURS OF JEANNE D'EVREUX. Charles IV of France was another of the monarchs whose patronage expressed the elegant and aristocratic quality of the Gothic style. His wedding present to his wife, Jeanne d'Evreux, was a precious Book of Hours executed between 1325 and 1328. The small size of this manuscript (8.2 cm x 5.6 cm)

made it a perfect present for the queen. Like many other ladies of the court, she most certainly treasured compact and portable manuscripts that could easily be carried in a pouch on the belt and read at intervals throughout the day. Books of Hours were very often personalized with portraits of the owner (Jeanne appears kneeling in an initial D below an image of the Annunciation) and with coat of arms when appropriate, and their pages were also used to press flowers or to hold images of favorite saints on tabs of parchment attached to the margins.

ICONOGRAPHY AND DECORATION. Both the iconographic program of the Hours of Jeanne d'Evreux and its decoration point to its essentially aristocratic nature. The book includes a special cycle of devotions to Saint Louis (King Louis IX of France), newly canonized and favored at the French court. In the borders and the lower margins, small human figures and animal or hybrid grotesques are performing courtly games and secular activities such as jousting, hunting, and musical performance, so as to amuse the reader. The famous Parisian illuminator Jean Pucelle was responsible for the majority of the decoration, most notably the innovative technique of grisaille painting in manuscripts. Grisaille

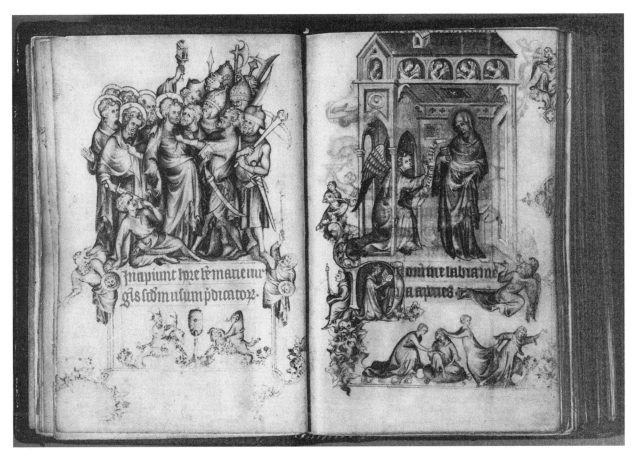

Arrest of Christ, Annunciation to the Virgin. Double page, Hours of Jeanne d'Evreux, New York, The Cloisters, Metropolitan Museum of Art, MS 54.1.2 folios 15–16. 13th century. FRANCIS G. MAYER/CORBIS.

or monochrome painting (in shades of gray) was better known as a stained-glass technique and was also used in fresco painting when artists wished to emulate the volumetric quality of sculpture. During his travels in Italy, Pucelle may have been inspired by the works of Italian painters from whom he borrowed technical as well as compositional features. Besides the grisaille technique, he employed the device of the apparently three-dimensional volume of space containing each scene, the mannered drapery of the figures, and their swaying posture. The double page showing the Annunciation and the Betrayal of Christ illustrates some of these characteristics: the architectural device that encloses the Virgin and the archangel Gabriel resembles an Italian loggia, with decorative niches housing cherubs watching the scene. Mary's mannered position and elegant drapery fit the delicate attitude of the court ladies of France, but Pucelle could also have seen examples of this style in Italy. Below, young girls and boys play a game of "froggy in the middle," mocking one of the children, perhaps a deliberate reference to the mocking of Christ. On the facing page, below the Betrayal of Christ, two knights

mounted on goats attack a barrel, possibly an allusion to military training.

THE INTERNATIONAL STYLE. The Hours of Jeanne d'Evreux expresses a courtly aesthetic that was increasingly international and that would before long give rise to the well-known and aptly-named "International Style" of aristocratic art by the end of the fourteenth century. Following the blood lines and the marriage ties that linked aristocratic courts, the International Gothic style could be found by the later fourteenth century in France, Italy, England, Germany, Bohemia (the western part of the modern Czech Republic), and Aragon. Instrumental in the establishment of interregional connections were the artistic commissions of the papal court in its new surroundings in southern France. By the early fourteenth century, political intrigue had combined with a weakened papacy in bringing about the pope's exile from Rome to Avignon in 1305. This exile lasted for much of the fourteenth century, only to be followed by the Great Schism (beginning 1379), in which two and, at one point, even three rival popes each claimed absolute spiritual authority over Christendom. Pope Clement VI

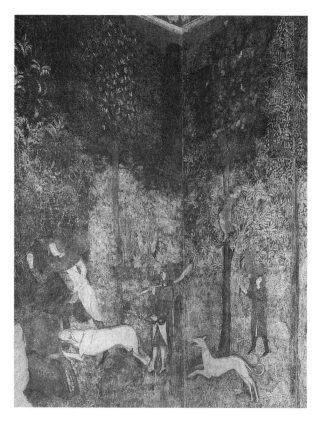

Hunting scene fresco in the Stag Room, by Matteo Giovanetti (1322–1368). Papal Palace, Avignon, France, 1356–1364. THE ART ARCHIVE/ PAPAL PALACE, AVIGNON/DAGLI ORTI.

(r. 1342–1352) saw himself as a worldly sovereign and member of the aristocratic elite, and his grandiose palace in Avignon was meant to express this status. He employed both French and Italian artists under the supervision of the Italian master Matteo Giovanetti to decorate his private apartment with scenes that convey all the pleasures of courtly life. The Stag room (or *camera cervus*), the antechamber leading to the pope's private bedroom, gets its name from one of the scenes that decorate the walls. Each of the four walls presents a large fresco depicting several scenes of fishing, stag hunting, falconry, fruit gathering, and bathing. Only the two windows of the south wall interrupt the scenes, which are set upon a continuous landscape background (complete with animals, men, and all sorts of naturalistic detail), itself presented upon a lavish red ground. In terms of style, the frescoes combine the elegance of Parisian court painting, the realism of Flemish painting, and the Italian fresco technique in a truly international style.

SOURCES

François Avril, *Manuscript Painting at the Court of France: The Fourteenth Century (1310–1380)* (New York: Braziller, 1976).

Florens Deuchler and Konrad Hoffmann, *The Year 1200.* 2 vols. (New York: Metropolitan Museum of Art, 1970).

Alain Erlande-Brandenburg, *Gothic Art* (New York: Abrams, 1989).

Philippe Verdier, et al., *Art and the Courts: France and England from 1259 to 1328* (Ottawa: National Gallery of Canada, 1972).

SEE ALSO *Architecture: Immediate Impact: Notre-Dame and Chartres; Architecture: The Gothic in England*

INTELLECTUAL INFLUENCES ON ART IN THE LATER MIDDLE AGES

ACADEMIC INFLUENCES ON NATURALISM. Already in the twelfth century, formal education had moved from monastic houses to urban cathedral schools, and by the turn of the thirteenth century, the latter had given rise to the first universities, which quickly became the center of later medieval intellectual life throughout Europe. Although the traditional seven "liberal arts" (grammar, rhetoric, logic, geometry, arithmetic, astronomy, and music) remained part of the curriculum, it was the newly translated writings of Aristotle that were most highly valued. Because of the perceived heretical ideas in the more naturalistic of his works, university scholars often dedicated themselves to the integration of this classical inheritance with Christian theology. Thomas Aquinas and Albertus Magnus were two of the most important masters in the project of integrating faith and reason. More important for the visual arts, however, were the teachings of Robert Grosseteste (who wrote a treatise on light) and his admirer, Roger Bacon, who argued for greater attention to what can be seen with the human eye and more intellectual emphasis on empiricism and experimentation. Aristotle had placed the sense of sight at the top of the hierarchy of human senses, but these medieval thinkers formulated new ideas that harmonized with, perhaps justified, and possibly even helped to bring about the greater naturalism of later Gothic art. Artists always reserved a place for copying designs from model-books, but as the Middle Ages progressed, more artistic attention was also devoted to the observable world as inspiration.

A VISUAL STATEMENT ON LEARNING. The "Allegory of Learning," an illustration from an early thirteenth-century encyclopedic work known as the *Garden of Delights* (*Hortus Deliciarum*), provides a clear visual statement of the interrelationship of faith and reason (and the curricular dominance of theology and philosophy) in the Gothic era. The original manuscript of the *Gar-*

den of Delight, preserved in Strasbourg until it was destroyed by fire during the bombardment of the city in 1870 (and after which reproductions of some illustrations were made based on nineteenth-century drawings from the originals), was the ambitious product of Herrad von Landsberg, abbess of the convent of St. Odile in Hohenbourg (near Strasbourg) from 1167 to 1195. The new genre of the Christian encyclopedia or compendium of knowledge was a product of the twelfth century that sought to accommodate biblical, moral, and theological material. The *Garden of Delights* included nearly 1,200 texts by various authors, as well as some 636 illustrations that were so closely tied to their texts it is thought that Herrad must have supervised their planning, if not their execution (the manuscript illumination was most likely completed after her death). Although she undertook this massive project in "praise of Christ and the Church," Herrad's privileging of intellectual pursuits is obvious. "The Allegory of Learning" illustration in the text represents the seven liberal arrayed in niches around the central personification of Philosophy, who is enthroned and holding a scroll that reads, "All knowledge comes from God." Socrates and Plato sit at her feet, emphasizing further the prominence of the Greek intellectual heritage within the now-Christian world of later medieval Europe. That such an undisguised tribute to pagan learning was possible at the time is a testament to the efforts of theologians and scholars who made this material "safe" by enveloping it within a thoroughly Christian worldview. It is notable in the history of medieval visual arts that such innovative compendia as the *Garden of Delights* relied so heavily upon their visual component. Certainly the compelling visual images helped to define the new construct according to which reason and revelation would continue to be reconciled.

ATTENTION TO HUMAN PHILOSOPHY. Two fourteenth-century paintings from Italy demonstrate a similar concern for the intellectual preoccupations of medieval scholastic philosophers, and they present them in a format that offered much greater public access than Herrad's manuscript, which was produced solely for the nuns in her convent. The first, an altarpiece from Santa Caterina in Pisa, created by artists working in the circle of Simone Martini and Lippo Memmi (c. 1340–1345), depicts the glorification of St. Thomas Aquinas (See Philosophy, Challenging the Averroists, for a portrait of this type.) Aquinas had recently been canonized, and such images were meant in part to combat the spread of heretical ideas by reminding Christians that this saint's approach to synthesizing philosophy and theology had become part of church doctrine. Accordingly, the painting shows the saint receiving his inspiration directly from

God as he reads from the books presented to him by none other than Aristotle and Plato. This knowledge is transmitted to lay and religious figures alike in the form of golden rays, a motif traditionally used to depict the transmission of divine revelation. The figures of the evangelists above, accompanied by Paul and Moses, represent the enduring authority of God's revelation, newly accommodated (but not subordinated) to the wisdom of human philosophy. At the bottom, the Muslim philosopher Averroës (1126–1198) reclines half-asleep. Another work that visualizes this theme for a Christian public is the fresco painting of the Apotheosis of St. Thomas Aquinas, made by Andrea da Firenze in the vault of a chapel in Santa Maria Novella in Florence (c. 1360–68). Clearly, the church wished for the saint to be viewed as the model of Christian wisdom, for here he is enthroned with the representation of the seven liberal arts as well as leading figures from the various sacred and secular realms of knowledge. Such attention to human philosophy, here and elsewhere, did not pose a threat to the church's authority because according to Aquinas, the physical world (as described by the philosophers) is a metaphor for the divine cosmos. Likewise, the work of art was to be seen as only a mirror image of the physical world. By cultivating the virtues of order, clarity, and harmony in their work, artists approach the ideal of beauty that for Aquinas refers ultimately to the perfection of the divine. Hence there was not only a justification for visual representation, but also an argument for greater realism in art, greater fidelity to the physical world.

ART FROM SKETCHBOOKS. Direct evidence for such an approach to art-making is available in the preserved notebooks of an architect from early thirteenth-century France named Villard de Honnecourt. His ink sketches on parchment, dating from the 1220s or 1230s, illustrate Aquinas' Aristotelian belief that "all causes in nature can be given in terms of lines, angles, and figures." Since basic geometry (one of the liberal arts) was thought to assist artists and practitioners of all kinds in the creation of ideal structures in any medium, it was the essential tool in reconciling the observable physical world with the perfect and transcendent divine cosmos. Honnecourt's notebook, used as a teaching manual, shows how such lofty ideas, conceived by great thinkers like Aquinas, translated into the relatively mundane and humble practice of art and architecture during the later Middle Ages.

ART FOR MORAL INSTRUCTION. In addition to the famous naturalism of Gothic art, university teaching also gave rise to new kinds of texts with commentaries used

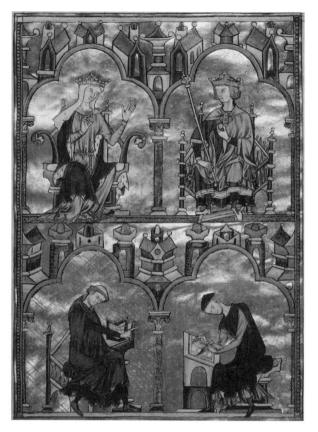

Blanche of Castile, King Louis IX, author dictating to scribe. *Bible Moralisé*, MS M 240, fol. 8r., 1226–1234. THE PIERPOINT MORGAN LIBRARY, NEW YORK.

posed medallions. The first of each vertical pair illustrates a scriptural verse, which is duly transcribed in a separate column just to the left of the medallion. The second of each pair illustrates the commentary text, also located on the left, which was intended to elucidate the contemporary meaning of the scriptural passage. The illustrations were generally configured according to a system of biblical typology: the first medallion of each pair illustrates an Old Testament scene while the second illustrates a New Testament scene. The former was understood to be a "type" (i.e., prototype) for the latter, the relationship between them helping to describe how the truth of the New Testament was "disguised" in the verses of the Old Testament, which has been superseded but which, through typological connections, continues to bear witness to Christian truth. Sometimes a medallion depicted a biblical scene while its companion illustrated a scene from contemporary life in order to show how real-life events unfold according to scriptural truth. In contrast to this innovative arrangement, the frontispiece of the book shows a conventional set of portraits, including Blanche of Castile, King Louis IX, the author, and a scribe.

ILLUSTRATIONS FOR DIDACTIC TEXTS. Another, more secular kind of morally didactic art appears in a work by Christine de Pizan, a prolific author who supported herself with her writing after the death of her husband, Estienne Castel, in 1389. Because they were responsible for the rearing of children, medieval women were often recognized as ambassadors of lay education, and it was not all that uncommon for women to be tutors or advisors in the employ of kings and queens, as Christine de Pizan was at the courts of Charles V (r. 1364–1380) and Charles VI (r. 1380–1422) of France. Born in Venice, she embraced French aristocratic culture at the court of Charles V where her father was appointed as court doctor and astrologer. She became an important figure at court, advising and tutoring the princes through her didactic texts, which were often preserved in manuscripts with illustrations and lavish decoration meant to amuse the reader and to augment the text. Sometime after 1405 all of her existing works were collected in one manuscript now in Paris. Often her works focused on moral precepts as do two illustrations from *Epître d'Othéa* (Letter from Othéa), a work that takes the form of a letter to the warrior Hector from the goddess Othéa (See illustration in Literature, Europe's First Professional Female Writer). One illustration depicts the "Wheel of Fortune," a device that demonstrates the ephemeral nature of fame and fortune by sending each figure in turn from the top of the wheel down to the bottom (and then back again). Related in its con-

at court for the instruction of princes. From the viewpoint of the visual arts, an especially notable group of such texts are the ones developed in Paris and known as "moralized Bibles" (*Bibles moralisées*). A sophisticated program of illustrations was developed for this book; copies of this work were among the most ambitious and beautifully decorated illuminated manuscripts of the thirteenth century. The creation of the illustrations, as well as the writing of the commentary texts, was overseen by clerics and theologians associated with the university in Paris. They were concerned with maintaining influence at court despite the increasing independence of the state from the church. In addition to advising lay rulers on how best to govern, they also wished to combat any heretical ideas associated with pagan learning or with Jewish traditions. One surviving example of a moralized bible was produced in Paris around 1230 under the patronage of Blanche of Castile and her son, the young king Louis IX. Preserved today as a fragment (of what was originally a three-volume work with over 5,000 illustrations) in the Pierpont Morgan Library in New York, this volume follows the typical format for arranging the illustrations in two columns of four superim-

cern for the vanity of worldly happiness, the second illustration depicts two lovers who are criticized for confusing the happiness of their carnal embrace with a more meaningful and transcendent happiness.

SOURCES

Gérard Cames, *Allégories et symbols dans l'hortus deliciarum* (Leiden, Netherlands: Brill, 1971).

Gerald B. Guest, *Bible Moralisée: Codex Vindobonensis 2554. Vienna, Osterreichische Nationalbibliothek* (London: Harvey Miller, 1995).

SEE ALSO *Philosophy: The Schools of the Twelfth Century; Philosophy: The Rediscovery Of Aristotle; Philosophy: Oxford Philosophy; Philosophy: Thomism*

ART AND THE KNOWLEDGE OF DISTANT LANDS

SATISFYING THE THIRST FOR KNOWLEDGE. The Crusades to the Holy Land during the twelfth and thirteenth centuries had whetted the European appetite for contact with foreign and distant lands and knowledge of strange peoples and customs. Despite the risks of travel, individuals set out on long-distance journeys and brought back tales that circulated throughout Europe and inspired the late medieval imagination. The travels of the young Venetian Marco Polo to the Mongol court of Khublai Khan and of the Englishman John Mandeville to both familiar and exotic regions became known through written accounts as well as through the programs of illustration developed to accompany these texts. During this period there also developed a new genre of world map, offering large circular depictions of the earth that included not only place names and topographical features, but images of unusual peoples and mythical animals believed to live in remote parts of the world. The largest example (destroyed in an air raid on Hanover, Germany, during World War II) was the Ebstorf Map (c. 1239), which was twelve feet in diameter and painted on thirty goatskins. In a typical symbolic representation of cosmology, the world is depicted as a disc in the hand of Christ, with his head at the top and feet below. Still to be seen today is the Hereford Map in Hereford Cathedral in England (65 by 53 inches, dated 1290), which shows an image of the crucifixion in Jerusalem, as well as a griffin fighting with men over emeralds, and numerous other exotic animals such as parrots, crocodiles, and camels. Visual images therefore assisted the growing late medieval thirst for empirical knowledge of the world.

THE BOOK OF WONDERS. "Empirical knowledge" is a relative term when applied to the Middle Ages. Most of the works of travel literature and accounts of journeys relied at least in part upon standard formulas, previous works, or even ancient accounts of the "monstrous races" of the earth. A good example is a manuscript of the *Book of Wonders*, produced in early fifteenth-century France. This work included the travel accounts of both Marco Polo and Sir John Mandeville. Marco Polo (c. 1254–1324) was a Venetian who set out for China in 1271 with his father and uncle, both merchants. At that time China was ruled as one of four Mongol khanates under Khublai Khan, and the Polo family bore letters for the Mongol leader from Pope Gregory X. The journey took four years and was followed by a seventeen-year sojourn in the service of the great Khan, during which Marco traveled extensively throughout China. He returned to Italy in 1295 and dictated his book, *A Description of the World*, while a prisoner during the war between the rival city-states of Venice and Genoa. *The Travels of John Mandeville* was in fact a compilation of geographical texts from diverse sources (including medieval encyclopedic works), and, although attributed to an Englishman, was probably first written in mid-fourteenth century Flanders. It was divided into two parts: a sort of pilgrim's guide to the Holy Land and a description of travels in the Far East. Like Marco Polo's text, it circulated widely in the late Middle Ages and helped spur a popular fascination with outlying territories and exotic peoples (the circulation of such works would only increase with the invention of printing and the voyage of Columbus to the New World).

ILLUSTRATING THE MONSTROUS RACES. One famous image from the *Book of Wonders* depicts three inhabitants of "Syberia," who were described by Marco Polo as "wildmen" and who were illustrated as representative of the marvelous races of the East. In fact, these figures—one a *blemmyae* with his head on his chest; the second a *sciopode* or shadow foot with only one leg ending in a huge foot that provided shade from the sun; and the third a naked wildman with club and shield—refer back to the descriptions of the monstrous races from antiquity (such as those encountered by Alexander the Great) that were compiled in the early Middle Ages by Isidore of Seville and passed along into later medieval compendia. Extreme climates were often thought to account for the deformities of these grotesque figures. Although opportunities for travel were increasing and readers were eager for factual information, the images in these books tended to reproduce mythical and imaginary legends, so that, ironically, real travelers, even as late as

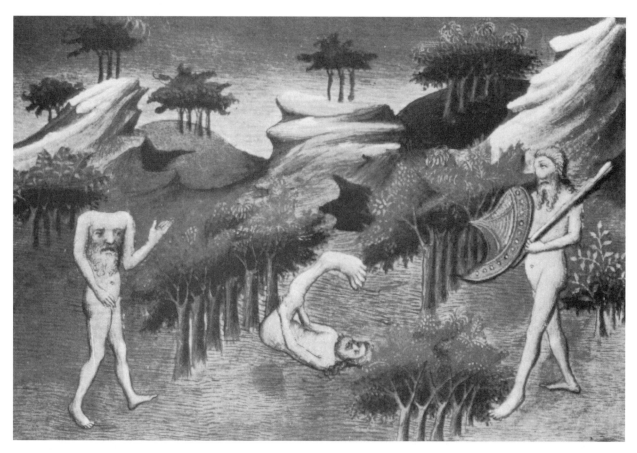

Three monstrous inhabitants of Syberia, Marco Polo, *Divisement du Monde*, French, Paris, Bibliothèque Nationale MS fr 2810, folio 29v, 1415. THE GRANGER COLLECTION.

Christopher Columbus, continued to expect to find such peoples.

TOPOGRAPHICAL MAPS. Another perspective on the world, with attendant visual imagery, was provided by late medieval cartographers. Knowledge of classical cartography combined with newer and more accurate technology enabled the creation of topographical maps that bore little resemblance to the earlier maps that typically placed Jerusalem at the center of the world and imagined the earth as the very body of Christ, whose head, hands, and feet could often be seen projecting from the top, bottom, and sides. A splendid example of the newer variety is the famous "Catalan Atlas" of 1375, commissioned by King Pedro IV of Aragon and executed by a Jewish cartographer from Palma de Mallorca named Abraham Cresques (1325–1387). The completed Atlas was given as a gift to King Charles V of France, and was intended to assist in the navigation of the seas. Several different cosmographical, astronomical, and astrological texts were copied onto the parchment in order to provide practical information on how to gauge tides and reckon time at night. Other illustrations, calendars, and charts document the state of contemporary knowledge on the planets and constellations, the tides, and so on. The actual map itself shows an indebtedness to the literary traditions of Marco Polo, Mandeville, and their precursors. There are also many biblical and mythological references, such as Moses' crossing of the Red Sea with the Israelites, the Tower of Babel, the magi following the star, Alexander the Great, pygmies battling cranes, etc. Overall, this unique artifact provides a very compelling demonstration of the accumulated learning of the Middle Ages and the effectiveness of visual traditions when deployed for such a purpose. Of course, it also points toward the historic sea voyages of over a century later and their discoveries that would forever alter the European outlook on the world and that belong more properly to the period of the Renaissance.

SOURCES

John Block Friedman, *The Monstrous Races in Medieval Art and Thought* (Cambridge, Mass., 1981; rpt. Syracuse, N.Y.: Syracuse University Press, 2000).

G. Grosjean, ed., *Der Katalanische Weltatlas* (Dietikon-Zurich, Switzerland: Graff, 1977).

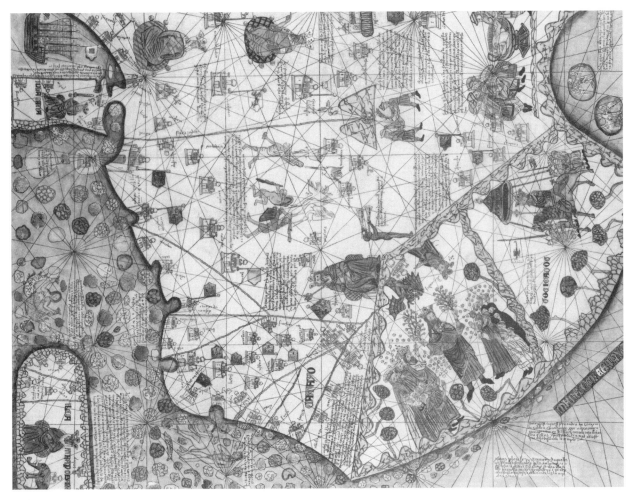

Asia with king from the Catalan Atlas by Abraham Cresques, Maritime Museum, Barcelona, Spain, 1375. COURTESY MUSEO MARITIMO (BARCELONA); RAMON MANENT/CORBIS.

Iain Higgins, *Writing East: The 'Travels' of Sir John Mandeville* (Philadelphia, Pa.: University of Pennsylvania Press, 1997).

John Larner, *Marco Polo and the Discovery of the World* (New Haven, Conn.: Yale University Press, 1999).

J. R. S. Phillips, *The Medieval Expansion of Europe* (Oxford, England: Oxford University Press, 1988).

SOCIAL LIFE AND THE INDIVIDUAL

THE RISE OF URBAN CENTERS. With the continued growth of the mercantile economy throughout Europe, towns and cities flourished and became the vital centers of late medieval culture and art production. At the forefront of this new urban culture was the middle class, a social group that increasingly came to be associated with the patronage base for much art of the period. They were merchants and financiers, manufacturers and craftsmen, and they could afford to acquire works of art

that accorded with their tastes and growing sense of their social status. With the rise of a professional class of artists organized by trade or specialty into guilds, cities such as Paris, London, Barcelona, Siena, Cologne, and Brussels became booming marketplaces for the production and sale of art. Art from such a context was very often secular in nature and in its new subjects and themes it tended to express the materialism and social experience of the middle class.

DAILY LIFE IN ART. These new clients for art encouraged artists to explore new themes in their work. Painters, in particular, increasingly turned to the objects of everyday life, which when rendered in a naturalistic style expressed the taste of their middle-class patrons. Subjects such as landscapes, cityscapes, still lives, and portraits became more and more prominent in art, whether the work was to have a religious or a purely secular function. In works of a religious nature, complex theological ideas were made more accessible to a middle-class viewer

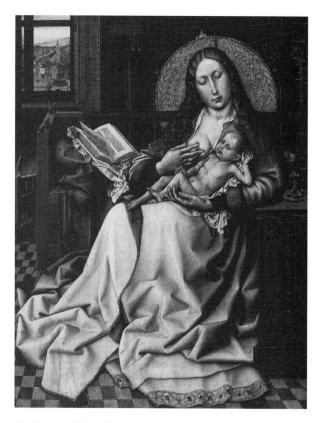

Virgin and Child before a Firescreen (sometimes called the Salting Madonna), oil on oak panel by Robert Campin (Master of Flémalle), National Gallery, London, England, 1425–1430. THE GRANGER COLLECTION.

was part of the new urban social fabric and thus he well understood the milieu of his patrons.

CIVIC IDENTITY. Town life also bred a sense of civic identity, and as urban populations assumed more control over society and politics, the arts provided a visual expression of this new sense of civic pride and power. This is especially evident in the case of the rival city-states in Italy like Florence, Siena, Pisa, and Venice, which commissioned major civic monuments throughout the later Middle Ages. Increasingly specialized and organized into guilds, artists participated in a professional culture that was more highly regulated and standardized than ever before. Regulations stipulating the civic responsibilities of artists were laid out in compilations such as the *Livre des Métiers* (Book of the Trades) written in Paris in 1268.

COMPETITION FOR ART. In thriving European cities, cathedral and town hall often competed with one another in luring the best artists and commissioning works that combined in equal parts civic pride and Christian piety. The case of fourteenth-century Siena is exemplary in this regard. The acclaimed painter Duccio di Buoninsegna (active 1278–1318/19) was commissioned in 1308 to create a large altarpiece for the cathedral's main altar. It was to depict the Virgin Mary in glory according to an established format and type known as Maestà. Duccio's completion of the project in 1311 occasioned citywide festivities. The huge altarpiece, made up of a large central panel and 26 smaller side panels, was carried in procession from Duccio's workshop to the cathedral accompanied by the music of tambourines, trumpets, and castanets. In acknowledgment of Duccio's great renown and his importance to the city, his signature was prominently displayed on the face of the altarpiece. In this case the artist and the work of art are both emblems of civic pride and identity. But this status was not conferred only upon one artist or one work: six years later the acclaimed painter Simone Martini was commissioned to paint the same subject for Siena's city hall.

A FRESCO OF GOOD GOVERNMENT. In 1338, the elected city council of Siena (the nine good and lawful merchants of the city, known simply as The Nine) requested the services of Ambrogio Lorenzetti to create an elaborate program of frescoes to decorate their meeting chamber (the Sala della Pace) in the Palazzo Pubblico or town hall. A Siena native, Ambrogio (with his brother Pietro) was perhaps the chief rival to the great Simone Martini. The commission was granted in the hope that the work—in its quality as well as its subject—would reflect well upon the governing administration. The subject consisted of three scenes depicting the effects of good

when expressed in a visual language of everyday naturalism. In the oil painting known as the Salting Madonna, Robert Campin, an artist from the city of Tournai in Flanders, placed the Virgin Mary within a contemporary domestic setting, complete with fireplace, a bench with comfortable pillows (upon which lies an open Book of Hours), and a window with an open shutter allowing a view of the town outside. An attentive mother dressed in contemporary bourgeois clothing, Mary holds her baby gently and prepares to nurse. Except for the occasional visual clue that a contemporary viewer would recognize in this or similar paintings—the fire screen that frames Mary's head like a halo, in this case (the chalice is part of a modern restoration)—little about such paintings suggests a divine, otherworldly subject. In fact, bourgeois viewers would have easily identified with the familiar scene and its homey details. The modest size of this work and others like it stood in contrast to the more lavish and grandiose productions destined for the church or the aristocracy and suited the taste and the needs of a middle-class urban clientele. As head of the Tournai painters' guild (as well as holder of several other prominent positions in the city), Campin

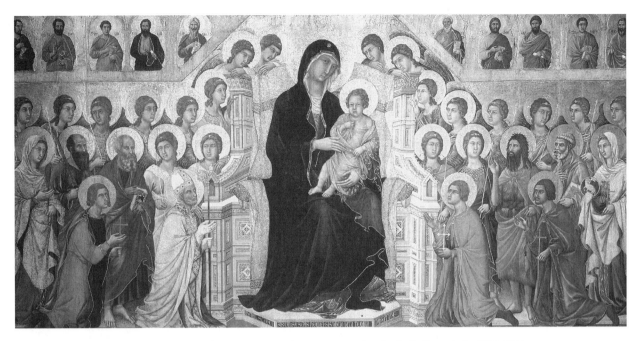

La Maestà or Virgin and Child in Majesty, fresco by Duccio di Buoninsegna (1278–1318), Siena, Italy, 1308–1311. THE ART ARCHIVE/ MUSEO DELL'OPERA DEL DUOMO, SIENA/DAGLI ORTI.

and bad government and an allegory of good government. Ambrogio chose the wall receiving the most light (East) to paint the Effects of Good Government, while leaving the Effects of Bad Government on the darker side. (For Ambrogio's Effects of Good Government, see the paragraph "Round Dance" in the Dance chapter.) In the former, Ambrogio depicted the interrelated urban and rural economies by means of realistic topographical representations of a town and its surrounding countryside, with all the details of an organized landscape and the industrious work of its inhabitants. The view of the town offers a panorama of late medieval occupations that included, among others, carpenters, shopkeepers, shoemakers, and shepherds. A school recalls the importance of education for good government, and the tavern perhaps alludes to the necessity of some leisure in a balanced society. To complete this image of harmony, a group of elegant ladies are dancing and playing tambourines in the foreground. Painted with utmost realism, this picture of civic life in Siena impressed upon any visitors to the Palazzo Pubblico the soundness of the local government and the pride of the citizens.

INDIVIDUALISM AMONG ARTISTS AND PATRONS. Both patrons and artists came to imprint their own personal identities on works of art. Although patrons now included members of the rising civic elite, they shared with the most exalted rulers a desire to express their pretensions and their ideology in commissioned works. Artists, encouraged by demanding clients to achieve ever-

greater levels of technical mastery, developed innovative approaches and personal styles that increased their status and their appeal among patrons. Aristocratic patrons especially sought out some of the most well-known and accomplished painters, illuminators, sculptors, and goldsmiths of their day, from the late twelfth-century's Nicholas of Verdun to later masters such as William de Brailes, Jean Pucelle, Jean de Liège, Simone Martini, Ferrer Bassa, the Limbourg brothers, and Giovanni Pisano. Because society recognized the importance of the arts for the promotion of particular values, the status and role of the artist in society advanced from that of a simple artisan to the more distinguished rank of ambassador or city councilor. With this upwardly mobile status came the prospect of steady commissions as well as special tax exemptions and other advantages. Many of the best artists were drawn to important urban centers for these reasons, while the competition among artists encouraged innovation and technical virtuosity.

COMMISSIONS IN GOLD AND ENAMEL. Perhaps the practice of the goldsmith best represents the patrons' demands for singularity and perfection in their commissioned works. Religious commissions in gold and silver were intended to express the brilliance of the celestial city and they often occupied a proud spot within their respective church treasuries. The durability of the material was seen as fitting for a representation of an eternal concept, and the economic and symbolic value of the precious metals meant that such commissions were

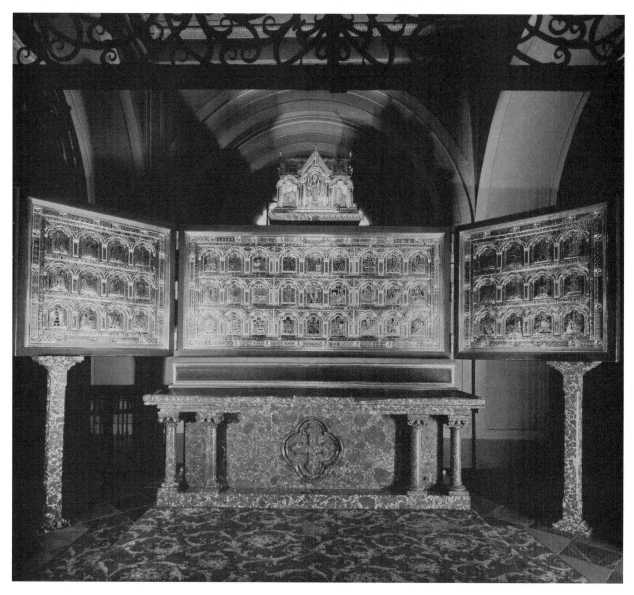

Panels depicting biblical scenes. Altarpiece, Mosan, champlevé enamel, niello, and gold by Nicholas of Verdun. Stiftsmuseum, Abbey of Klosterneuberg near Vienna, Austria, 1181. **ALI MEYER/BRIDGEMAN ART LIBRARY.**

generally entrusted to the expert hands of the most talented craftsmen. An important center for this kind of work was the Meuse Valley, in northwest Germany. The goldsmiths, aware of their own status and importance, typically signed their work, and some even included a self-portrait within a completed art object. Nicholas of Verdun's Klosterneuburg altarpiece, executed around 1181, is a good example. The work was originally conceived as a pulpit for the abbey of Klosterneuburg near Vienna, Austria, and it was later reconstructed as an altarpiece after it was damaged in a fire in 1330. In this most excellent example of the goldsmith's craft, Nicholas employed both the *niello* and *champlevé* enamel techniques on bronze-gilt panels. The translucent blue

enamel technique vividly contrasts with the gilt-bronze, and the virtuoso chiseling of the metal creates a fine design delineating sinuous figures and details of drapery folds, hair, beards, and muscle definition. A certain Provost Wernher, whose name is recorded with that of the artist, was presumably responsible for orchestrating the iconographic program that contains typological comparisons between the Life of Christ and the Old Testament scenes. These scenes, reconstructed into three horizontal rows are organized into the following categories: *ante legem* (before the Law of Moses: scenes from Genesis and Exodus), *sub lege* (under the Law of Moses: scenes from subsequent sections of the Old Testament), and *sub gracia* (under Grace: the new dispensa-

METALWORK
and Enamel

Always important in medieval Europe (especially as part of the luxury trade), the so-called decorative arts of metalwork and enamel reached a new peak of technical accomplishment and popularity during the Romanesque and Gothic periods. Metal smiths applied their skill to the creation and embellishment of liturgical (church) objects, secular objects such as vessels for use at royal and noble courts, and decorative covers for deluxe illuminated manuscripts. They used both precious and non-precious (base) metals, and often ornamented their objects with gems (precious and semi-precious stones) and enamels. Vessels, candlestick holders, and other objects used for church services were cast in bronze, brass, or copper, and their production seems to have increased beginning in the twelfth century. The surfaces of these cast objects were often tooled for decorative effect, gilded, or enameled. Sometimes they were ornamented using *niello*, a metalwork process (from the Italian *niellare*, meaning to fill in) whereby a design was engraved in the metal surface and then filled with a black substance made from sulfur combined into an alloy with gold, silver, copper, or lead, and then fused with heat so that the image is in contrast to the background.

Gold and silver were more highly valued metals. They were considered precious because of their sheer material splendor and their rarity, but also because of their malleability. Most often these metals were not cast but were made into reliefs using a process known as embossing or *repoussé* (literally "pushed away") in which the sheet is hammered from behind to create a raised design. Further texture and detail is created by *chasing*, or indenting the surface with a blunt instrument. Reliquary containers were often made using these techniques.

Enamel is a substance formed from colored glass powder that is melted and fused, usually to a metal surface. It was developed into a major art form in medieval Europe and was used principally for liturgical objects, such as reliquary containers, altarpieces, crowns, chalices and other vessels, and altar crosses. The enamel itself is not expensive, though the objects adorned with this colorful, durable, jewel-like medium were highly valued. In *cloisonné* enamel, a technique more associated with the Byzantine Empire where it was likely invented (and known in the West thanks to the trade in luxury goods), a network of metal bands or strips of gold (*cloison* in French means "partition") is soldered together on a thin, usually gold surface to form the structure of the design. The enamel is then set within these compartments, which are visually separated by the exposed top edge of the dividing bands. The very delicate effect suited the Byzantine aesthetic. *Champlevé* enamel was practiced long before it was reinvigorated in twelfth-century Western Europe. It is a process whereby the substance is poured into grooves that are previously engraved into the metal surface, so that the hardened enamel is flush with the surface of the metal (*champlevé* is French for "raised field"). Production was concentrated in two main areas: the Mosan region in the Meuse River Valley, today's Belgium, and the southwest of France (most notably in the city of Limoges).

tion of Christ, with scenes from the Annunciation to the Pentecost).

PROFESSIONAL ARTISTS IN THE COURT. As artists' sense of self-worth and social importance increased, patrons and artists developed new kinds of relationships. Artists working in the service of kings and dukes were often recognized with courtly titles, such as Valet de Chambre, which guaranteed them lifelong security. A well-known example is that of the brothers Limbourg and the duke of Berry. The story of Pol, Herman, and Jean Limbourg, manuscript illuminators, begins in Nijmegen in the northern Netherlands where they were born to a family of artisans. While traveling to Brussels where they planned to join their uncle the painter Jean Malouel, who worked for the Duke Philip the Bold of Burgundy, they fell victim to the conflict between the regions of Brabant and Guelders, and were imprisoned. Thanks to the intervention of their uncle, the generos-

ity of the duke of Burgundy (who paid their ransom), and the duke's family ties to Jean, duke of Berry, the three brothers ended their journey at the court of Jean, duke of Berry, in Poitiers (south-central France). There, they entered into a privileged relationship with the duke that ended only with his death in 1416. An exceptional art amateur, a great collector of gems and precious objects, and a renowned bibliophile, Jean, duke of Berry, became for the three brothers an ideal patron and benefactor. Expert in the art of illuminations, the Limbourg brothers offered to the duke, in exchange for his protection and support, some of the most excellent manuscript decorations of the late fourteenth and early fifteenth centuries. Their best-known production is the very famous *Très Riches Heures* (Very Rich Hours) executed between 1390 and 1416.

THE TRÈS RICHES HEURES. The decorated book of hours was a quintessentially late medieval product

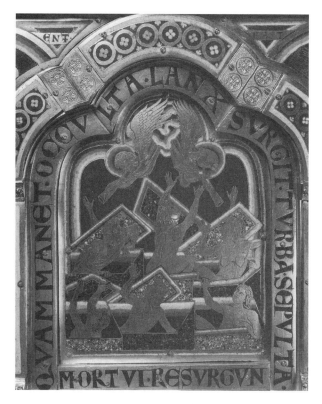

Resurrection of the Dead, Altarpiece, Mosan, champlevé enamel, niello, and gold by Nicholas of Verdun. Stiftsmuseum, Abbey of Klosterneuberg near Vienna, Austria, 1181. THE ART ARCHIVE/KLOSTERNEUBURG MONASTERY, AUSTRIA/DAGLI ORTI.

with which some of the most familiar artistic personalities and the most pretentious and demanding patrons found common cause. A compendium of devotional texts that developed from the psalter and the monastic breviary but that was intended for private use among the laity, the book of hours became a showcase for both illuminators and patrons to express their identities and to champion the individualism and the artistry of the late Middle Ages. In the *Très Riches Heures*, the Limbourgs present a wonderfully detailed panorama of the duke's properties and of courtly life in later medieval France. In the calendar pages, scenes depicting the "labors of the months" feature aristocrat pleasures or peasant activities set against the background of the duke's castles. In the January page, for instance, the duke receives his guests at a lavish banquet. Jean can be identified sitting at the center of the group with a "halo" that is in fact a fire screen. The master of the ceremony welcomes his guests ("approche, approche") who warm their hands near the fire, and servants bring more food and wine to the table. The detailed depiction of the trappings of courtly life helps to showcase the wealth and extravagance of the duke: for example, the bells hanging from the lavish costumes of the courtiers, gold thread embroideries, the

a PRIMARY SOURCE *document*

TWO DECORATED BIBLES

INTRODUCTION: Decorated books were among the treasured works of art that often were passed down from one generation to another and thus appear in wills and inventories. The first of the two illuminated Bibles described below originally belonged to the French king Charles V, was inherited by Charles VI, and then was loaned to his uncle, Jean, duke of Berry, one of the great collectors of the Middle Ages (he had, for example, 1,500 hunting dogs). Jean never returned the book to its owner, and, judging from the mention of the swan—one of Jean's personal insignia—on the metalwork of the cover, perhaps had it rebound to his own taste. Jean's interest in clothing and fashion is reflected in the mention of the three different kinds of fabric used to make the covers of the second Bible. The importance of the decoration on these two books is illustrated by the fact that the secretary entering the items into an inventory of Jean's possessions in 1413 says almost nothing about the contents of the books, but offers careful descriptions of the bejeweled covers.

Item, a very beautiful Bible in French, written in Gothic book script, richly illuminated at the beginning, decorated with four gold clasps, two with two light-colored rubies and the other two with sapphires, each with two pearls, enameled with the arms [of the king] of France; the bars on the other side each having a pearl at the ends and on top tiny gold fleurs-de-lys nailed to them, the edge being rimmed with two heads of serpents adorned with small swans.

Also another Bible in two small volumes, written in French in Gothic book script, well illuminated with narrative and decorative designs; at the beginning of the second leaf of the first volume it contains the sermon and on the second leaf of the second volume the inscription: "Whatever is born (*nais*) will be destroyed." Each volume is covered with a flowered silk cloth having four gold clasps, each enameled with the royal arms and with a portrait. There is also a gold border enameled with said arms. The whole is covered with a jacket of purple damask, lined with black *tiercelin* [a textile woven of three kinds of thread]. The Bible was given to my lord in August 1407 by the now deceased commander (Vidame) of the province of Laon, who used to be great master of the palace of the king. My lord had the jacket made.

SOURCE: Jean, Duke of Berry, *Inventaires de Jean Duc de Berry (1401–1416).* Ed. Jules M. J. Guiffrey (Paris: E. Leroux, 1894–1896). Translation by John Block Friedman.

ducal coats of arms and emblems woven into the tapestries that hang on the walls, the golden vessels, and the generous display of food upon the table. The Limbourgs' knowledge of the duke's collection is demonstrated by their faithful rendering of particular objects, such as the golden vessel in the shape of a boat or the tapestries with battle scenes. Their views of several of the duke's castles suggest that they at times accompanied their patron on his journeys to these residences.

SOURCES

Dirk de Vos, *The Flemish Primitives; The Masterpieces: Robert Campin, Jan van Eyck, Rogier van der Weyden, Petrus Christus, Dieric Bouts, Hugo van der Goes, Hans Memling, Gerard David* (Princeton, N.J.: Princeton University Press; Amsterdam: Amsterdam University Press, 2002).

Arnold Hauser, *The Social History of Art.* Vol. I. Trans. Stanley Godman (New York: Vintage Books, 1985).

Felix Thürlemann, *Robert Campin: A Monographic Study with Critical Catalogue* (Munich, Germany; New York: Prestel, 2002).

SPIRITUAL LIFE AND DEVOTION

THE CHURCH IN CRISIS AND THE RISE OF DEVOTIONAL ART. Throughout the medieval period, the church continued to be a powerful force in the dissemination of the aristocratic tastes and styles of the Gothic movement. At the same time, however, the later medieval papacy experienced a number of crises that served to diminish both its political authority and its spiritual credibility among the faithful. German emperors such as Frederick II (1212–1250) enjoyed an expanded sphere of influence and challenged the authority of the popes, and widespread perceptions of corruption in the church—particularly on such issues as the sale of indulgences, which promised sinners a reduced period of time in purgatory—caused ordinary people to turn away from the authority of hierarchical religion. While a good deal of art continued to celebrate the "Church Triumphant" during the Gothic era, a new artistic trend based on the imagery associated with private devotional practices resulted from the spiritual needs of individual Christians. Moreover, the interest in this devotional imagery in later medieval Europe was reinforced by a growing middle-class demand for privately owned images of all kinds. At the center of this world was the *Devotio Moderna*, an approach to personal devotion that was newly formulated by the Flemish Dominican mystic Geert Groote (1340–1384) and was soon widespread (especially in northern Europe). In appealing to popu-

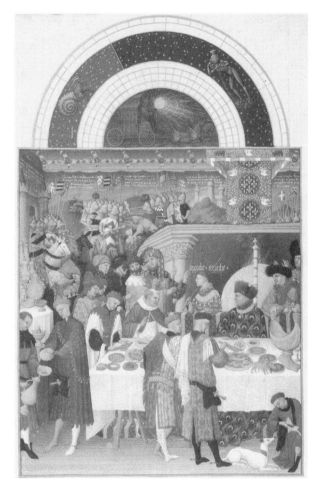

Nobles feasting. Calendar page for the month of January.
CHANTILLY, MUSÉE CONDÉ MS 65, FOL. 2R IN JEAN LONGNON AND RAYMOND CAZELLES EDS. *THE TRÈS RICHES HEURES OF JEAN, DUKE OF BERRY* (NY: BRAZILLER, 1969): PL. 2. REPRODUCED BY PERMISSION.

lar belief and practice, the *Devotio Moderna* relied a great deal upon the cult of saints and especially of the Virgin Mary, a practice that was centuries old, but now more popular than ever. Marian devotion prompted Christians to visit shrines of "Our Lady" all over Europe, and the many images of Mary created during this time expressed the popularity of the accessible and ever-compassionate Virgin.

PRINTED IMAGES OF SAINTS. The various saints were popular as subjects in later medieval art because as role models, personal protectors, and intercessors they were so well-positioned to attend to the needs of individual believers. Cities and guilds all had their own patron saints, and routine events and solemn occasions both required special devotion. Individuals also turned to particular saints at specific times and for specific reasons: St. Margaret watched over pregnancy, St. Apollonia could be helpful in soothing a toothache, and St.

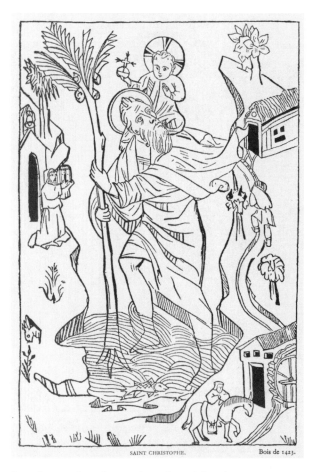

SAINT CHRISTOPHE. Bois de 1423.

A modern tracing of a woodcut of St. Christopher carrying Jesus across the river. **MARY EVANS PICTURE LIBRARY.**

Sebastian received particular devotion during outbreaks of plague. A woodblock print image of St. Christopher carrying Jesus across the river, produced in Germany anonymously in 1423 illustrates the contemporary piety for individual saints and the new medium of woodblock printing, through which their images were so easily disseminated. A necessary companion to the medieval traveler, St. Christopher's image facilitated devotion to the saint who provided protection on the difficult and often unsafe journeys of tradesmen, artisans, noblemen, clerics, students, soldiers, and pilgrims. Easily reproduced by mechanical means (though colored by hand) and reasonably priced, prints were an ideal form of portable devotional image that gained tremendous popularity in the later Middle Ages. Prints were pasted in books, jewel boxes, and on walls. They were kissed and handled, prayed to, and wept upon. Such popular devotional practices have been learned from written sources, but the images themselves, with the material evidence of their use, are silent witnesses to a vibrant and flourishing visual tradition.

THE CANTIGAS OF SANTA MARIA. The art of devotion also made an impact in more elite contexts. Created for Alphonso X (the Wise), king of Castile, around 1280 by an anonymous court illuminator, the *Cantigas de Santa Maria* demonstrates both the importance of Marian devotion in later medieval culture and the obsession with tangible signs of divine intervention in everyday life. The royal manuscript is a collection of some hundred songs in praise of the Virgin Mary, with narrative illustrations describing many of her miracles. In one illustration that tells the story of how the Virgin miraculously saved a man from falling, the page is split up into six different scenes. A line of text below each scene provides the reader with an abbreviated version of the story. The first scene shows an artist perched on scaffolding beneath the vaults of a church interior as he paints images of both the Virgin and the Devil. The Devil, apparently not flattered by his portrait, confronts the painter and causes the scaffolding to fall in the next scene. Thanks to the intervention of the Virgin, the man remains suspended in mid-air in the following scenes so that he can finish his work, which is subsequently admired by the community in the final scene. The moral here, as in each Cantiga, is that the sincerity of one's devotion to the Virgin will protect him or her from harm.

THE HUMANITY OF CHRIST AND THE DIPTYCH. Another important facet of late medieval devotional culture was the focus on the humanity (as opposed to the divinity) of Christ. Mystic writers of the fourteenth century, such as the German Meister Eckhart (a Dominican) and his disciple Henry Suso, focused their attention on Christ's suffering, spurring the production of new visual images, such as the Pietà (Mary cradling the limp, dead Christ) and the Man of Sorrows (the dead Christ displaying his bloody wounds to the viewer). These images were meant to convey the grief and pathos that would prompt a viewer's empathy, and were thus aids to devotion. One painted diptych (a pair of paintings on two hinged panels) produced around 1350 depicts Christ as Man of Sorrows on one side and the Madonna and Child on the other. Viewers are meant to be struck by the contrasting (though interrelated) images of maternal compassion and pitiful suffering. The figures are depicted on a gold-tooled ground that recalls the aesthetic of Byzantine icon painting. The tilt of the Virgin's face, saddened with the foreknowledge of her son's sacrifice, echoes that of Christ, and her pensive gaze foretells her future grief. Meanwhile the infant seems to provide reassurance to his mother with a gentle caress on her cheek. Such painted images were often produced in small format and used as private devotional altarpieces. Opened up at times of prayers and for special celebrations, dip-

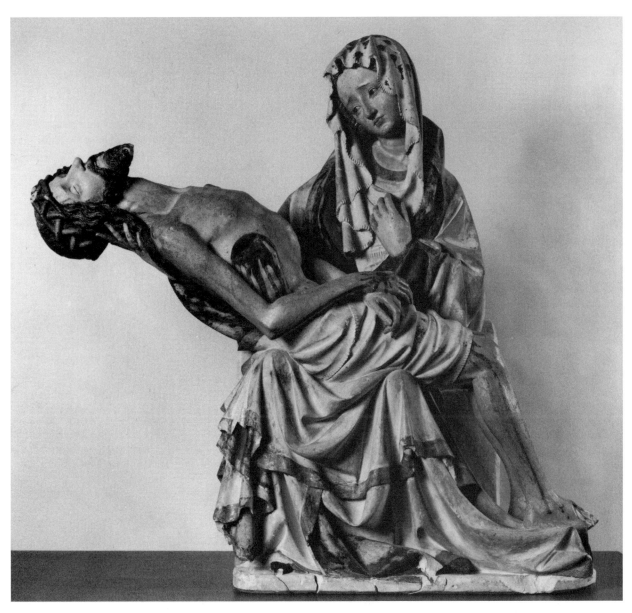

Pietà, painted limestone, Stiftsmuseum, Seeon Monastery, Seeon-Seebruck, upper Bavaria, Germany, 1400. BAYERISCHES NATIONAL MUSEUM, MUNCHEN. REPRODUCED BY PERMISSION.

tychs could easily be personalized with their owners' mottos, monograms, or coats of arms, usually on the back of the panels.

THE INFLUENCE OF THE MENDICANT ORDERS. Individual piety and affective devotional practices were advanced early on by the friars of the new mendicant orders, the Franciscans (founded 1210) and Dominicans (founded 1216). Poverty, asceticism, and preaching were the ideals from the Gospels that the mendicants espoused, providing all Christians access to personal and profound spiritual experience. Instead of the almighty and powerful judge familiar from the early Middle Ages,

God was increasingly imagined in human terms as the suffering and merciful Christ. In the visual arts Christ was more consistently presented in these terms, his humanity and earthly life eclipsing images of apocalyptic Majesty or stern judgment. During times of plague or pestilence mendicant preachers reassured the populace with verbal imagery that was closely connected to the visual imagery of devotion. Conversely, new visual images drew upon the preaching of the mendicants. Works of visual art from the Rhineland, intended to trigger a viewer's empathy for the suffering Christ, show a particularly striking connection to the sentiments often conveyed orally by preachers. Known by the term *Vesperbilden*,

such images and objects aroused a sense of grief comparable to that experienced by the Virgin (and commemorated during the Vespers celebration on Good Friday). The Seeon Pietà, sculpted around 1400, effectively conveys a sense of emotional distress through the representation of suffering. The grief-stricken Virgin holds the oversized body of her dead son on her lap. The contorted body of Christ prominently displays bleeding wounds. Similarly moving is the Pestkreuz Crucifix (plague crucifix) of around 1304 that displays an emaciated Christ on the cross. By visualizing Christ's suffocation, dehydration, and dislocation, the work encourages viewers to contemplate and meditate upon this ultimate sacrifice, endured for the sake of their own salvation.

SOURCES

Jean Vincent Bainvel, *Devotion to the Sacred Heart: The Doctrine and Its History* (London: Burns and Oates, 1924).

Christopher Brooke, "Reflections on Late Medieval Cults and Devotions," in *Essays in Honor of Edward B. King.* Ed. Robert G. Benson and Eric W. Naylor (Sewanee, Tenn.: University of the South Press, 1991): 33–45.

Rosalind Brooke and Christopher Brooke, *Popular Religion in the Middle Ages: Western Europe 1000–1300* (London: Thames and Hudson, 1984).

Susan Dackerman, *Painted Prints: The Revelation of Color in Northern Renaissance and Baroque Engravings, Etchings and Woodcuts* (University Park, Pa.: Pennsylvania State University Press, 2002).

Richard Kieckhefer, "Major Currents in Late Medieval Devotion," in *Christian Spirituality: The High Middle Ages and Reformation.* Ed. Jill Raitt et al. (New York: Crossroads, 1987): 75–108.

Henk van Os, *The Art of Devotion in the Late Middle Ages in Europe, 1300–1500* (Princeton, N.J.: Princeton University Press, 1995).

André Vauchez, *The Laiety in the Middle Ages: Religious Beliefs and Devotional Practices.* Ed. Daniel Bornstein. Trans. Margery G. Schneider (Notre Dame, Ind.: Notre Dame University Press, 1993).

Roger S. Wieck, *Time Sanctified: The Book of Hours in Medieval Art and Life* (New York: Braziller, 2001): 124–148.

SEE ALSO *Religion: The Laity and Popular Beliefs*

IMAGES OF DEATH

CONSCIOUSNESS OF MORTALITY. Whether or not one's pious devotions assured him or her of salvation, the specter of death continued to provoke anxiety among

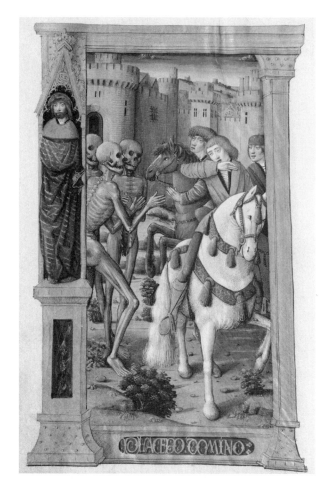

Three Living and Three Dead. Office for the Dead, Book of Hours, Musée Condé, Chantilly, France MS 72, folio 50v, 1530. **RÉUNION DES MUSÉES NATIONAUX/ART RESOURCE, NY.**

even the most faithful. In the later Middle Ages, the visual arts record this anxiety with a particular vividness. Climaxing around the time that the worst epidemic of the bubonic plague (referred to as the Black Death) wiped out a third of the European population (1347–1350), visual images of death and mortal decay appear throughout Europe. Scenes of the Dance of Death, the Three Living and Three Dead, the Apocalypse, and the Last Judgment reminded viewers of their inexorable fate. Hoping to guarantee salvation or lessen their time in purgatory, the poor often undertook arduous pilgrimages to shrines of their favorite saints, while the rich commissioned lavish tombs, public monuments, and private works of art to express their piety and devotion.

THE OFFICE OF THE DEAD. Such apprehension about death is illustrated in the scene of the Last Judgment from the Office of the Dead in the Grandes Heures de Rohan. The manuscript, named after its last owner, was probably commissioned by Yolande of Aragon (widow

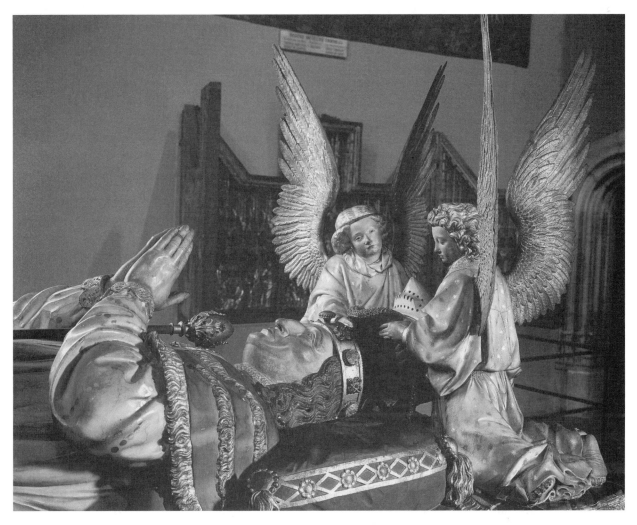

Effigy of Duke Philip the Bold with angels. Tomb begun in 1386 by Jean de Marville, continued by Claus Sluter, and finished in 1411 by Claus de Werve. Charterhouse of Champmol, France. THE ART ARCHIVE/MUSÉE DES BEAUX ARTS, DIJON/DAGLI ORTI.

of Louis II, duke of Anjou) and executed by an anonymous French master illuminator between 1420 and 1427. In books of hours the office of the dead (a series of prayers) functioned as a sort of gateway into paradise for those who read it regularly. Since all believing Christians were concerned with the fate of their souls after death and wished desperately to find salvation, with little or no time spent in purgatory (in Catholic thinking, the place where souls expiate their sins before going to heaven), the prayers read as part of the office of the dead were a special focus of attention. Another illustration from the Grandes Heures de Rohan depicts the ultimate combat between the archangel Michael and the devil for the soul of a deceased man, whose naked body reclines on a burial ground scattered with bones and skulls. He engages a conversation in Latin with the almighty God above: "Into thy hand I commit my spirit, thou hast redeemed me, O Lord of Truth" (Psalm 31:5). God's

response in French comes as a modified version of his response to the repentant thief who died with Jesus at the Crucifixion (Luke 23:41–43): "For your sins you shall do penance. On Judgment Day you shall be with me." The grayish body of the man features realistic details such as stiff limbs, crooked feet, and a limp neck that all imply the artist's direct observation of death or dying. The aristocratic beholder of this image took the opportunity to meditate upon her own mortality and to consider the likelihood of salvation.

THE THREE LIVING AND THE THREE DEAD. Humor—usually mixed with a dose of moralizing—focused on human vanity and foolishness and helped the medieval Christian community to deal with the certainty of death. A popular visual "lesson" was the theme of the "Three Living and the Three Dead." Based on a subject from thirteenth-century troubadour poetry, the image

flourished in several different versions in later medieval Europe and was reproduced in various media, including manuscript paintings, fresco painting, and sculpture in stone, in addition to printed images. The image normally depicts three noblemen, often hunting on horseback, who suddenly come across three dead men near a cemetery. The three grotesque specters of death harangue them with testimonies of their own past deeds, as a warning to the noblemen about the folly of pride and the inevitability of death. The lesson warns the three noblemen as well as the beholder of the image that "what you are now we once were, and what we are you will become." This is an admonition to abandon fleeting worldly pleasures for eternal life in the love of God.

FUNERARY ART. In the funerary art of later medieval Europe, the obsession with confronting death and publicly visualizing one's piety and hope for salvation took many forms. Many great cycles of frescoes and sculptures were commissioned to express devotion to saints and to proclaim the virtue of the deceased. Tombs themselves were often framed by elaborately carved niches in the walls of a chapel or by ornately embellished canopies (as was the case with the tomb of King Edward II of England). Very often tombs containing the mortal remains were topped with carved representations of the deceased in idealized, peaceful repose. The most elaborate of these tomb chests had multiple levels—called *transi tombs*—with portrait effigies accompanied by solemn funeral processions and grieving figures. Sometimes sculpted effigies took the form of decaying corpses in order to emphasize the divergent paths of the soul and the body after death. A notable example is the tomb of the Burgundian duke Philip the Bold, originally situated in the Chartreuse (or monastic charterhouse) of Champmol. Executed by the renowned artist Claus Sluter and two other sculptors, the tomb (finished by 1414, ten years after the death of the duke) features a portrait effigy reclining above the sarcophagus with some forty mourning Carthusian monks within a curtain of niches below, in a carved evocation of the actual procession that took place between Brussels, near the duke's place of death, and Dijon, where he was laid to rest. This six-week procession over more than 250 arduous miles was undertaken on foot, though the carved representation expresses more playfulness than exhaustion. Each monk, draped in a heavy woolen garment, expresses a unique attitude: one is absent minded, another is bored, one is pinching his nose in mock disgust, and yet another grieves in silence. The striking naturalism with which Sluter is associated (and that was such a hallmark of the later Middle Ages) is employed here both to capture a real-life event and to guarantee the eternal rest of one mortal soul.

SOURCES

Philippe Ariès, *The Hour of Our Death*. Trans. Helen Weaver (New York: Random House, 1981).

Michael Camille, *Master of Death: The Lifeless Art of Pierre Remiet, Illuminator* (New Haven, Conn.: Yale University Press, 1996).

James M. Clark, *The Dance of Death in the Middle Ages and the Renaissance* (Glasgow: Jackson, 1950).

Kathleen Cohen, *Metamorphosis of a Death Symbol: The Transi Tomb in the Late Middle Ages and the Renaissance* (Berkeley, University of California Press, 1973).

Henriette Eugenie s'Jacob, *Idealism and Realism: A Study of Sepulchral Symbolism* (Leiden, Netherlands: Brill, 1954).

Millard Meiss and Marcel Thomas, *The Rohan Master: A Book of Hours*. Bibliothèque Nationale, Paris (MS Latin 9471) (New York: Braziller, 1973).

Ethel C. Williams, "The Dance of Death in Painting and Sculpture in the Middle Ages," *Journal of the British Archaeological Association* 3rd ser. 1 (1937): 229–257.

———, "Mural Paintings of the Three Living and the Three Dead in England," *Journal of the British Archaeological Association* 3rd ser. 7 (1942): 31–40.

SIGNIFICANT PEOPLE
in Visual Arts

ROBERT CAMPIN

c. 1376–1444

Painter

AN URBAN PAINTER. Robert Campin (d. 1444) exemplifies the late medieval urban artist, with his middle-class connections and civic activism. A highly respected resident of Tournai, in Flanders, Campin held the positions of dean of the Guild of St. Luke (the guild of painters), member of the *stewards* (a committee entrusted with the accounts and finances of the city), warden of his parish, bursar of his church, and captain of the city militia. He was probably already a recognized painter in 1406 when his name first appears in the city archives. He received commissions from the local bourgeoisie, city officials, and clergy members, and he also lent his talent to the city by creating banners, coats of arms, and costumes for civic events. Formerly referred to by modern scholars as the Master of Flémalle (from a set of paintings wrongly ascribed to the Abbey of Flémalle on the Lower Rhine), Campin is well known for the realism of his work and especially for his inclusion of domestic details, such as

those in his *Salting Madonna* of about 1430. His best known work, a triptych (three-panelled altarpiece) called the *Merode Altarpiece* (dated about 1425, now in the Cloisters Museum in New York), presents significant aspects of Flemish art. Filled with religious symbolism, this work comprises a wealth of domestic details painstakingly depicted with special care for realistic textures, surfaces, and portraits, generous draperies, and an intuitive use of perspective. In placing his religious subjects in domestic interiors, Campin brought a sense of actuality and reality to the divine that spoke more directly to his lay audience. This innovative way of treating religious scenes also echoes the contemporary piety that required a more "down to earth" and tangible experience of the divine. Campin collaborated with other important artists such as Jacques Daret and Rogier van der Weyden, whose careers flourished respectively in France and Flanders during the fifteenth century. His work remained influential well into the sixteenth century when a number of his compositions were still being copied or imitated.

SOURCES

Dirk de Vos, *The Flemish Primitives; The Masterpieces: Robert Campin, Jan van Eyck, Rogier van der Weyden, Petrus Christus, Dieric Bouts, Hugo van der Goes, Hans Memling, Gerard David* (Princeton, N.J.: Princeton University Press; Amsterdam: Amsterdam University Press, 2002).

Felix Thürlemann, *Robert Campin: A Monographic Study with Critical Catalogue* (Munich, Germany; New York: Prestel, 2002).

JEAN, DUKE OF BERRY

1340–1416

Duke
Patron of the arts

AN ARISTOCRATIC PATRON OF THE ARTS. Jean, duke of Berry, was a Capetian prince and brother to the French king Charles V, Duke Philip the Bold of Burgundy, and Duke Louis I of Anjou. He was born in 1340 in Vincennes and died in Paris in 1416 during a plague epidemic. Probably one the greatest art patrons of his time, Jean had an eclectic taste and collected a variety of artifacts of immeasurable value, both ancient and modern, including antique coins and cameos, jewels, gold and silver vessels, tapestries, 1,500 dogs, and even ostriches and camels. Most noteworthy, however, was his collection of illuminated manuscripts. Three extant inventories provide a glimpse of the range and scope of his library of 300 books, of which only about 100 have survived, scattered today among various libraries through-

out the world. His outstanding collection of books, which he tended to maintain at his castle at Mehun, comprised many kinds of texts, such as Trojan histories, chronicles, astronomical treatises, *mappaemundi* (representational maps), and religious books. He attracted artists of renown to his court, and his enlightened patronage encouraged their creativity and originality, as well as the mixing of stylistic influences from France, Flanders, and Italy. Jacquemart de Hesdin, Jean Le Noir, André Beauneveu, and the Limbourg brothers were just a few of the most famous artists who produced works for the duke's collection and for his many castles (seventeen in all) at Poitiers, Dourdan, Mehun, Lusignan, Bicêtre (Paris), and other places. In some of his books can be found the duke's coat of arms, emblem, and the motto "The time will come." His portrait appears in several manuscripts: in a wishful entry into heaven in the *Grandes Heures* (Great Hours); introduced to the Virgin by his patron saints Andrew and John the Baptist in the *Belles Heures* (Beautiful Hours); or welcoming his guests at his first-of-the-year banquet in the *Très Riches Heures* (Very Lavish Hours). In his *Grandes Heures*, a bear and a swan occupy the margins of a page that features the arms of France. This is a play on the words *ours* (bear) and *cygne* (swan) that together stand for *Oursine*, the name of a mysterious woman the duke once loved. Records show that Jean, duke of Berry, was a generous patron with his artists, bestowing upon them many gifts (such as coins, rings, and diamonds, on special occasions) in addition to substantial financial compensation, which was often sufficient to enable the purchase of a house. Artists traveled with the duke from one to the other of his many residences. All in all, the duke stands as an example of the type of enlightened collector and patron of the arts who helped bring about the creation of many great works in a period generally known for its artistic excellence.

SOURCES

Françoise Lehoux, *Jean de France, duc de Berri: sa vie, son action politique*. 4 vols. (Paris: Picard, 1966–1968).

Millard Meiss, *French Painting in the Time of Jean de Berry: The Late Fourteenth Century and the Patronage of the Duke* (London: Phaidon, 1969).

THE LIMBOURG BROTHERS

1380s–1416

Manuscript illuminators

ILLUMINATORS AT THE DUKE'S COURT. The Limbourg Brothers (Pol, Herman, and Jean) were born into

a family of artisans in Nijmegen, in the northern Netherlands, and their names were mentioned as apprentices in the goldsmith shop of Alebret de Bolure in Paris as early as 1399. Caught between the rival regions of Brabant and Guelders, they were imprisoned and held for ransom while on their journey home from Paris. Only after the intervention of their uncle, Jean Malouel, a highly regarded painter at the court of Duke Philip the Bold of Burgundy, and a generous ransom payment from the duke himself, were they finally freed. Afterwards, they resided at the court of Burgundy long enough to produce an illuminated manuscript for the duke (a *Bible Moralisée*, or moralized bible), and then they entered into the service of the Philip's brother, Jean, the duke of Berry, in 1404. Their art flourished under the patronage of Jean, whose collections of rare objects, antique coins, precious stones, and jewelry provided primary source materials for the artists' study. Their brief training as goldsmiths probably enabled them to render the minute details of jewelry and other objects found in their paintings. The duke held his artists in very high esteem, granting Pol one of the largest houses in the city of Bourges. As an example of the affection and good humor that characterized their relationship with their patron, the Limbourg brothers presented the duke with an unusual New Year's gift. They created a "fake" manuscript from a piece of wood that they painted with a *trompe-l'oeil* design (illusionistic, means "trick of the eye") simulating a vellum cover with gilt silver clasps featuring the arms of the duke. Their most famous work is the *Très Riches Heures* (or Very Lavish Hours), an ornate book of hours made for the duke. Mixing the spheres of religious devotion and secular life, the miniatures offer a vision of the duke's world—his chateaux, tapestries, coins, and other belongings—in alternating scenes of aristocratic pleasure and peasant toil on the duke's lands. Although they demonstrated their knowledge of Italian paintings in some of their compositions, they remained true northerners in their depiction of realistic details and life-like textures. In terms of their elegant representations of aristocratic figures, they were working in true Parisian fashion. All three brothers and their patron died in the same year (1416), probably from an outbreak of plague, leaving the Most Lavish Hours to be completed (in 1485) by another famous painter, Jean Colombe.

SOURCES

Jean Longnon and Raymond Cazelles, *The Très Riches Heures of Jean, Duke of Berry* (New York: Braziller, 1989).

Millard Meiss, *French Painting in the Time of Jean de Berry; The Limbourgs and Their Contemporaries* (New York: Braziller, 1974).

LOUIS IX

1214–1270

King of France
Patron of the arts

PATRON OF THE GOTHIC STYLE. Born in 1214, Louis IX was king of France from 1226 until his death in 1270. During his minority he ruled under the regency of his mother Blanche of Castile (1226–1242) who even afterwards remained an influential counselor to the king in matters of politics, culture, and religion. Guided as a young man by his mother's interest in education, he later confirmed the foundation of the University of Paris (the Sorbonne, 1257), where significant theologians and intellectuals such as Thomas Aquinas, Bonaventure, and Roger Bacon came to teach and contribute to Paris's fertile intellectual climate. Louis also followed his mother in becoming a famous bibliophile, commissioning numerous illuminated manuscripts and thereby contributing to the development of a Parisian court style in painting. Among the many such works of which Louis oversaw the production and likely also the iconographic programs are a well-known psalter and a *Bible Moralisée*. Works such as these and the many architectural projects undertaken under Louis' patronage brought about a consolidation of the Gothic style. A devout Christian, Louis understood his royal mission to include evangelizing, the giving of charity, and the administration of justice, and he strove to make France a model Christian state. He participated in the seventh and eighth Crusades (during the second of which he contracted the plague), founded public hospitals, and presided over a court of justice, which later evolved into the Paris Parliement. Hence, during his reign, considered the Golden Age of French monarchy, Paris became a flourishing intellectual, administrative, and artistic capital, full of Gothic masterworks such as the flamboyant Sainte-Chapelle, built in the 1240s to house the relics of the Passion that Louis acquired from the East. His wisdom, magnanimity, and mediating prowess were recognized throughout Europe, and he was often solicited to intervene in conflicts outside of France. He was canonized by Pope Boniface VII in 1297, and his cult was especially honored thereafter at the court of France (the Office of St. Louis appears in some notable illuminated books of hours created for members of the royal court). Louis was a patron of the arts *par excellence*, and subsequent rulers sought to emulate him in this regard.

SOURCES

William Chester Jordan, *Louis IX and the Challenge of the Crusade: A Study in Rulership* (Princeton, N.J.: Princeton University Press, 1979).

Jean Richard, *Saint Louis: Crusader King of France*. Trans. Jean Birrell (Cambridge, England: Cambridge University Press, 1992).

SIMONE MARTINI

1283–1344

Painter

AN ITALIAN MASTER. A close imitator and perhaps even a pupil of the famous painter Duccio in Siena, Italy, Simone Martini (active 1315–1344) might have worked on some of his master's later commissions and perhaps even on the famous *Maestà* (an altarpiece featuring the Virgin enthroned). He was himself commissioned to paint a *Maestà* in 1315 for the council chamber in the Palazzo Pubblico (town hall) in Siena. Invited to Naples by Robert of Anjou, king of Naples, he painted a portrait of the king receiving his crown from the hands of his brother St. Louis of Toulouse. His most notable works, however, remained in Siena. For the city council there he created an equestrian portrait of Guidoriccio da Fogliano (to celebrate the Sienese victory of Montemassi in 1328), and for the Cathedral he painted an impressive *Annunciation* set in a French gothic flamboyant frame with twisted colonnades. He spent the last six years of his life in the service of the pope in Avignon, decorating the papal palace and probably instructing French artists on the Italian art of fresco painting. His works continued the tradition of Duccio, with their Italo-Byzantine aesthetic and abundant ornamentation. With his elegant figures draped with weightless fabrics silhouetted against decorative, flat grounds, his work exemplifies the Italian court style, which contributed to the formation of the International Gothic Style at the turn of the fifteenth century.

SOURCES

Alessandro Bagnoli, *La Maestà di Simone Martini* (Cinesello Balsamo, Milano: Silvana, 1999).

Cecilia Jannella, *Simone Martini* (Florence, Italy: Scala; New York: Riverside, 1989).

DOCUMENTARY SOURCES
in Visual Arts

Aelred of Rievaulx, *De institutione inclusarum* or *On the Institution of the Recluse* (1109/10–1167)—Written by an English monk, this work contains a description of the devotional practices of the recluse who concentrates on images of the life and death of Christ in order to identify mystically with the event. It illuminates the practices of individuals like Christina of Markyate who turned to illustrated psalters for their devotions in the twelfth century.

Bernard of Clairvaux, *Letter to William of St. Thierry* (1125)—Written by the Cistercian founder of the monastery of Clairvaux who would later be canonized as St. Bernard (1091–1153), this critique of the Benedictine (especially Cluniac) approach to the visual arts in a sacred context is part of the twelfth-century debate over the appropriateness of sacred art.

Etienne Boileau, *Le Livre des métiers* (1268)—Written in Paris, this work discusses the city regulations of the artistic trades in the thirteenth century.

The Pilgrim's Guide to Santiago de Compostela—Written in France in the twelfth century, this guide for pilgrims includes excerpts about shrines and relics to visit along the way, and the many perils of the journey.

Theodulf, Bishop of Orléans, *Opus Caroli regis contra synodum* or *Libri Carolini* (c. 791)—Probably authored by Theodulf, bishop of Orléans (c. 760–821), a member of Charlemagne's court chapel, this theological treatise on the religious significance of visual imagery was ordered by Charlemagne as a direct response to the Byzantine Council of Nicaea of 787, which restored the cult of images for the Greek church. Denying that human-made images are intrinsically sacred, the *Libri Carolini* concluded that images should be neither worshipped nor condemned, and that as a human art, painting could legitimately be used in the service of the church or for secular purposes.

Theophilus, Presbyter, *On Divers Arts* (c. 1125)—Written in western Germany, offering a response to St. Bernard's critique of sacred art, this treatise on painting, glasswork, and metalwork argues that art for liturgical purposes follows God's own command and specifications, and that the work of artists aware of this religious significance is an inspired spiritual activity which imbues the whole process of making and using liturgical art with a dignity transcending decorative concerns. Theophilus is tentatively identified with goldsmith Roger of Helmarshausen from Lower Saxony.

Villard de Honnecourt, *Sketchbook* (c. 1230)—This book of 33 leaves (from probably what were originally around fifty) was created by an artist from Picardy in northern France, who traveled widely and drew animals, cathedrals, abbeys, carpentry, church furnishings, geometrical figures, people, masonry, mechanical devices, and surveying implements and techniques, as well as recipes and formulas. Addressed to an unspecified audience, the book gives advice on the professional practice of the arts in the thirteenth century.

GLOSSARY

Abbey: A monastery under the supervision of an abbot or a convent of nuns under the supervision of an abbess.

Acolyte: A person in the beginning stages of the priesthood delegated to assisting priests and deacons in the service of the Latin Church.

Affective mysticism: Religious spirituality taking place in the emotions as opposed to the intellect, to the extent that a spirituality of the heart becomes the center of one's piety.

Aisle: A long, open, narrow area at the sides of a church used to walk through the structure.

Al-Andalus: The Muslim-controlled portion of Spain from 711 to 1492.

Albigensian Crusade: A series of military campaigns, beginning in 1209, intended to put an end to Cathar heresy in southern France.

Allegory: A narrative mode in which abstract ideas are presented either through personifications (that is, characters who embody ideas like truth or justice) or through concrete, realistic characters and situations that have an additional layer or layers of symbolic meaning, even though they operate within a literal plot that makes sense in and of itself.

Alliterative revival: Use of the Anglo-Saxon alliterative poetic line (featuring three to four repetitions of words having the same initial consonant or vowel per line) in fourteenth-century Middle English poems, such as *Sir Gawain and the Green Knight* and *The Alliterative Morte D'Arthure*.

Almuce: An elongated, fur-lined hood initially worn by the general population but later becoming the headdress worn by clerics, especially canons.

Altar: The elevated place in a church where rites are performed.

Altarpiece: A devotional, religious work (painting or sculpture) placed usually on or above a church altar (where the Mass is celebrated). It can depict one or several different scenes, the imagery usually referring to the doctrine of the Mass or to the saint to whom the church or chapel is dedicated. It can include one or multiple panels (*diptych* with two panels; a *triptych* with three; or a *polyptych* with more).

Ambulatory: The passageway around the end of the choir.

Anchoress (f.)/Anchorite (m.): A solitary or hermit who pledges her or his life to prayer and contemplation. Anchoresses often lived in a small room attached or "anchored" to a church or public building. Visitors could come and speak with them and receive spiritual direction.

Antiphon: A style of liturgical chant in which the chanted verses constitute a conversation between two choirs, with solo interventions by a cantor.

Antiphonary: A choir book containing chants used during the canonical hours in a monastery.

Antipope: Someone who claims or is declared to be pope, even though a pope recognized by the orthodox canonical system already holds office.

Apocrypha: The non-canonical books of the Old and New Testaments, many of which were believed genuine in the Middle Ages.

Apologia: Something written in defense or justification of a position.

Apostolic: Relating to the pope, or connected with the Apostles (one of the twelve followers of Jesus chosen by him to preach Christianity) and their teachings.

Apse: A vaulted semicircular or polygonal recess in the church at the end of the choir.

Arcade: A series of arches supported by piers or columns.

Arch: An architectural formation that spans an opening in such a manner that the weight of the material is converted into outward thrusts, carried to the sides and then down along flanking columns, piers, or buttresses. The rounded arch was common in ancient Rome and in Romanesque Europe and is made from wedge-shaped blocks. The Gothic or pointed arch forms a central point above. The ogival (or ogee) arch is formed by double curved lines (like two S-curves mirroring each other) that meet at a point.

Archdeacon: The bishop's principal assistant or officer.

Arian Christianity: A sect founded upon the ideas of an Alexandrian priest, Arius, who came into conflict with mainstream Christianity at the Council of Nicea in 325. Arians believed that Jesus and the Father were not one in the same being, that is, as God's son Jesus possessed a certain creaturehood. The doctrine became popular for a brief period in the East at the imperial court and was adopted by Western Goths and Vandals.

Ascetic: Devoted to solitude, contemplation, discipline, and fasting; denying the body in order to derive spiritual benefits.

Ashlar: Stone that is faced and squared, often with a chipped or irregular surface.

Atrium: A front court, sometimes covered, sometimes containing a fountain, before the entry to the church proper.

Aubade, or Aube, or Alba: Literally a "dawn song," a type of troubadour lyric in which lovers lament the coming of the dawn because they must part after a night of clandestine lovemaking.

Augustinianism: The school of philosophy in the thirteenth century that adhered to the teachings of the pre-Aristotelian period, rallying around the name and authority of St Augustine, and strongly opposing Aristotelian and Thomistic views.

Augustinian Rule: A set of guidelines devised by St. Augustine of Hippo in the fourth century for the common life of the religious and often used by the canons regular or Austin Friars, but rarely before the eleventh century.

Austin Friars: An order of friars that began as hermits in Italy in the mid-thirteenth century. Brought together into one group called the Order of Hermits of St. Augustine, they eventually began ministering and preaching in urban areas and became interested in the formalized study of theology, the scriptures, and the philosophy of St. Augustine.

Avignon Papacy: A period from 1309 to 1377 when the leadership of the Latin Christian Church was located in Avignon (now southern France) rather than in Rome.

Bagpipe: An instrument found throughout the Middle Ages in most areas of Asia and the Middle East as well as in Europe, in many different sizes and shapes. The sound is made by squeezing a bag (originally the skin of a goat), and the melody is played on a chanter pipe with finger holes, accompanied by a sustained tone created by one or more drone pipes. The bagpipe is most often seen playing alone, frequently for dancers, and it is usually associated with rural or pastoral settings.

Bailey: The open courtyard in a castle between the outer ring of fortified walls and the keep.

Ballo: A late medieval form of dance that is the precursor of ballet. Unlike the earlier bassadanza, which is danced at a single steady tempo and measure, the ballo is made up of an irregular series of up to four different tempos (called *misura*), each having a different kind of rhythmic organization and speed.

Banns: A formal public announcement of weddings, required in Christian Europe after the early thirteenth century.

Basilica: An early Christian church which borrows elements from Roman public buildings called basilicas (often oblong or rectangular in shape) used for law courts, tribunals, and meetings. Some Roman basilicas were given to the Christians to use as churches. The title of basilica was also given by Rome to denote certain privileged churches.

Bassadanza: An Italian dance similar to the Burgundian basse danse in that it was a processional dance, moving at a single steady tempo, and organized around a number of relatively simple basic steps. The bassadanza, however, had nine basic steps and allowed the choreographers and dancers more freedom, as, for example, in the addition of "ornamental" steps.

Basse danse: An elegant choreographed processional dance originating in Burgundy by the early fourteenth century

and consisting of five basic steps that are arranged in a unique sequence for each composition. The steps themselves are not complicated, and all require that the feet stay close to the floor.

Battlement: The low parapet at the top of a fortified wall composed of solid shields of masonry, called merlons, alternating with openings, called crenels.

Bay: In architecture, any of a number of similar spaces or compartments between the vertical dividing structures of a large interior.

Béguine: A member of a lay movement based on piety that began in the early 1200s when groups of urban lay-women in Germany and the Low Countries came to-gether to live celibately in communities, supporting themselves with the labor of their own hands. The movement suffered persecution in Germany but had the protection of powerful patrons in France.

Benedictine monastery: Monastic house or community of monks adhering to the Rule of St. Benedict.

Benedictine monasticism: Western communal practice begun in the sixth century by Benedict, the abbot of Monte Cassino in Italy. *The Rule of Benedict*, one of the first of its kind for western monks, stressed a corpo-rate life of prayer, work, humility, and stability under the leadership of an abbot. By the eighth century, the Benedictine lifestyle had become an important blue-print for the development of western monasticism.

Benefice: Originally a manor, estate, or land that one held (often for life) at the pleasure of the donor. In later periods, the term under canon law came to refer to certain church offices, such as the rectorship of a parish church, with particular duties for which one would be granted revenues.

Berbers: A people living in northern Africa, especially in the area that is now Algeria and Morocco.

Bishop: A senior cleric in charge of the spiritual life and ad-ministration of a geographical region known as a diocese.

Bishop of Rome: A title used by the pope since his author-ity over the entire Latin Church was due, in part, to his control over the local Roman Episcopal See. The symbol of Rome as the center of the empire gradually gave way to the place of Rome as the center of Christendom.

Black Death: An epidemic of bubonic plague that killed over 50 million people in Asia and Europe in the four-teenth century.

Blessed Sacrament: The sacrament of the Eucharist or Lord's Supper, often referring to the consecrated ele-ments of wine and wafer themselves.

Bliaut: Either a costly fabric, a knight's court tunic, or a lady's court dress. When this term refers to the lady's garment, it signifies a gown of the richest fabrics, banded at neck and wrist edges with strips of embroidery, fur-lined, having a tightly-laced (at the sides) elongated bodice, a full, long skirt, and sleeves of various styles. As a fabric, bliaut meant silk, satin, or velvet imported from the Orient, frequently woven with gold thread and embroidered with gems.

Bogomils: Followers of Bogomil, a tenth-century preacher in Macedonia who taught a life of prayer, penitence, wandering, and simplicity of worship, and subscribed to a quasi-dualist view that the world was evil because it had been created by the devil, the eldest son of God.

Bonnet (English "cap"): A general French term, used from the Middle Ages onward to denote a small head-covering.

Breton Lays: Short verse narratives, exemplified by the *Lais* of the Anglo-Norman poet Marie de France, which were originally performed orally in the Breton language and were transformed into written narratives from the twelfth-century onward, featuring rash promises, erotic entanglements, an ambivalent code of ethics, and a strong supernatural strain.

Bubonic plague: *See* Black Death.

Bull: *See* Papal bull.

Burgundian: Relating to the area and court of Burgundy (now part of France), an independent duchy beginning in the eleventh century lying halfway between Paris and the Mediterranean. In the late fourteenth and fifteenth centuries, Burgundy became the capital of a powerful principality that included not only northeastern France but much of Lorraine, Luxembourg, Hainaut, Brabant, and Flanders (present-day Belgium and the Netherlands).

Byzantine: Relating to the eastern part of the late Roman Empire or to the Orthodox Christian Church and its traditions.

Caliphs: Literally, successors to the Prophet Muhammad who are temporal and spiritual heads of the religious community in the Muslim world.

Canon: A member of the clergy following a rule like those followed by monks but often attached to a cathedral or large urban church; the canon is responsible for the daily running of the church and for educating the children of the nobility (sometimes called "canons regular" because they lived according to a rule and formed groups called "colleges.")

Canon law: The body of Latin Church law imposed by the authority of councils and bishops, particularly pertaining

to matters of belief, morals, and discipline of the Christian faithful. One schooled in canon law is a canonist.

Canonical: Belonging to a set of religious writings regarded as authentic and definitive, and forming a religion's body of scripture.

Canonical hours: The Divine Office or daily prayers usually sung or recited (often 7 times a day) by members of religious orders as part of their required normal routine.

Canonize: In western Christianity, to declare an exceptionally holy person who is deceased to be a saint.

Capital: The uppermost portion of a column or pillar, often carved with relief sculpture on several faces.

Cardinal: A member of the college of Roman princes who are the immediate counselors of the pope and rank second only to the pontiff in the church hierarchy. At various times they meet in conclave to elect new popes.

Carmelite Friars: Members of the order of Our Lady of Mount Carmel, which originated in mid-twelfth-century Palestine as a group of hermits following a strict rule of asceticism. With the fall of the Holy Land and the demise of the Latin Christian kingdoms in the early part of the thirteenth century, the community broke up into several groups that moved into Italy, Spain, Cyprus, Sicily, southern France, and England, where they soon became engaged in a more active life of preaching and study in the world.

Carol: The most popular dance of the medieval period, a type of line dance in which the principle arrangement calls for dancers to join in a line holding hands, fingers, or a scarf, while they move along, often through the streets, following the leader.

Carolingian: Relating to the dynasty of Frankish kings, descended from Emperor Charlemagne, that ruled an area corresponding to modern France and Germany (expanding into northern Italy and as far east as Austria) in the eighth to tenth centuries.

Carthusians: Members of an order of monks, founded in 1080 by Bruno of Cologne, that mixed both eremitical (hermitic) and cenobitic (communal) elements. The monks lived in a group hermitage where each member spent most of his time in the solitude of a private cell, except for communal prayer twice a day.

Cathars: A mid-twelfth-century movement that taught that the material world was impure and that the soul must strive to free itself from the evils of this existence. Like the Bogomils, they regarded Jesus not as God, but as more of a super-angelic being who came to earth to lead people on the right path.

Cathedral: The church which forms the seat or throne of a bishop and is the main church in a diocese or large administrative division of the church in a region.

Catholic: A term meaning "all inclusive" that was used to refer to the Roman Christian church from the fourteenth century onward and became official with the Council of Trent in the sixteenth century.

Cause/Causality: In philosophy, responsibility of one being for some feature in another (the effect), such as its existence, essence, matter, accidents, or changes.

Cellar: Space used for storage and located on the ground level of the west range of a monastery.

Cenobitic: Having to do with the communal aspect of monasticism; monks or nuns living a communal lifestyle.

Champlevé: A form of enamel work in which the melted glass is poured into grooves that are previously engraved into the metal surface, so that the hardened enamel is flush with the surface of the metal.

Chancellor: A church officer in charge of a university.

Chanson de geste: Literally "songs of deeds or exploits," a type of French heroic verse narrative of the eleventh through thirteenth centuries, based on earlier oral accounts recounting heroic deeds in warfare, often connected with the Crusades.

Chapel: A small space for private worship, located off the aisle of a church.

Chaperone: A hood with a lower edge long enough to cover the nape of the neck and upper shoulders, having a circular opening for the face and often a long point, sometimes with a tail or tippet added. In the fifteenth century, the chaperone was often worn in an elaborate curved turban-like arrangement on top of the head, with the tippet wrapped to retain the desired shape.

Chapter: The assembly of a monastic community (often daily) where a chapter of their rule was read, official business was dealt with, and faults of the monks were addressed. This term can also refer to a group of clergy (often canons) serving a cathedral.

Chapter of faults: A community meeting where religious individuals can make confessions of their failings or imperfections to leaders, or the failings of individuals may be pointed out by leaders and other community members.

Chapter room: A room usually located along the east range of the cloister used by the monastic community for daily meetings.

Charismatic: Christian groups or forms of worship characterized by a quest for spontaneous and ecstatic experiences, such as healing, prophecy, and speaking in tongues.

Chastity: The practice of abstaining from sex on moral grounds; one of the basic vows of monastic life.

Chevron: A pattern of angled stripes.

Choir (or quire): The part of the church to the east of the transept containing seats for the monks, canons, or clergy, often near the altar; the place where monks and canons would sing the daily offices.

Choreographed dance: A dance having a unique sequence of steps (in contrast to conventional dance).

Christendom: The extent of Christianity on earth, often configured in the Middle Ages as a series of Christian states.

Cistercian Order: A reform monastic movement that began in 1098 and became one of the largest and fastest growing religious movements of the Middle Ages. The Cistercian Order was directed toward reform of the perceived growing laxities within the French Benedictine system, especially among the Cluniacs, and focused on moving away from the "worldliness" that had crept into medieval monasticism.

Clerestory: A portion of the interior of a church rising above adjacent rooftops and having windows to admit light.

Cloisonné: A kind of enamel work in which the melted glass is poured into compartments formed by a network of metal bands such that the exposed tops of the bands serve to divide the areas of colored enamel.

Cloister: An enclosed space (often in the form of a roofed walkway with arches and columns) that forms part of a monastery.

Cloistered: Enclosed in a monastery, literally in the cloister space that forms part of a monastery; not free to leave or have visitors due to one's monastic status.

Cluniacs: Members of a reform Benedictine monastic movement (founded at Cluny, Burgundy, in 909) whose members sought to experience God in the unceasing prayer of their community and the paradise of the cloister. The order is known for its large abbey church and its elaborate liturgy based on the idea of continuous prayer. By the mid-twelfth century, Cluny had expanded to over 1,000 dependencies and had become one of the wealthiest and most influential establishments in all of Christendom.

Coif: A small covering for the head, usually of linen, that tied under the chin, resembling a present-day baby bonnet.

It was worn beneath other types of headdresses. Dating from the early thirteenth century, it disappeared from men's fashionable dress by the middle of the fourteenth century, except that it continued to be worn by Sergeants at Law in England even after they became judges.

Collect: A short form of prayer or petition in the Mass, originally used to denote the collecting of petitions.

College of canons: A group of religious leaders charged with the administration of a cathedral and living together in a group (college).

Column: A large post-like support holding up an arch or other architectural feature. The tops of columns were often decorated with sculpture.

Comitatus: The early medieval heroic code practiced by male members of a communal group in a special reciprocal relationship in which the lord offered material rewards and a social identity in return for military and political allegiance.

Conciliarism: The notion that an assembly of Christian bishops who are gathered in the name of the church have the right to make binding decisions for the church in the absence of the pope, especially during a time of crisis. This idea was advanced by bishops during the Great Schism.

Confraternity: Association with a monastic community granted to a layperson, conferred by prayers, including the sharing in the spiritual privileges of the monastery.

Consecration: The action of blessing by a priest or bishop and made holy by the power of God. Bread and wine are consecrated in the Eucharistic action.

Consummation: The act of making a marriage legally complete and fully valid through physical sexual union.

Contemptus mundi: Literally "scorn of worldly things," especially wealth, beauty, social status, and political power. This attitude of rejecting earthly life in favor of hope of the world to come was particularly pervasive in medieval Europe during the fourteenth-century famine and plague, and is reflected in literature and art.

Contingency: (a) In philosophy, a state of affairs which may and also may not be; (b) a relation between events such that the second would not happen but for the first.

Contrapasso: The method used by Dante in the *Divine Comedy* to allocate appropriate punishment for sin, where the punishment suits the sin by being its ironic opposite; for example, the gluttons, who ate excessively in life, are punished by being pelted by hurricanes of excrement, the byproduct of their own overeating.

Convent: Living quarters of nuns or a community of friars.

Conventional dance: A dance consisting of the continuous repetition of a single pattern of steps.

Conversi: Lay brothers, or adult converts, to religious life, as opposed to those oblates who were raised in the monastery as children.

Corbel: A short horizontal bracket of stone or timber projecting from a wall and supporting an architectural element.

Corpus Christi: Festival dedicated to the "body of Christ" instituted in 1311 by Pope Clement V; it became the occasion around which many of the mystery cycles and Passion plays of Europe were performed.

Corse: The bodice of a bliaut, or a stiffened garment worn underneath a bodice made of lighter-weight fabric. It could be laced tightly to shape the waist and torso.

Cotehardie: A short, tightly-fitting jacket-like garment for men popular from around 1333 through the mid-fifteenth century. In its earliest form, it was a low-necked garment reaching only to the knee, worn over a shirt, distinguished by a row of buttons that ran from the neckline to the low waistline.

Courtepie: A short version of the houppelande for men, worn over other garments in the fourteenth and fifteenth centuries.

Courtly Love: The term coined by the nineteenth-century French scholar and critic Gaston Paris to describe *fin'amors* (refined love), the extremes of devotion and psychological suffering experienced by male protagonists for their ladies in medieval romances and lyrics. This medieval amatory experience was codified by twelfth-century writer Andreas Capellanus in his *Art of Courtly Love.*

Crenellation: A battlement (protective wall) with tapered embrasures or squared openings.

Crosier: The staff of a bishop, abbot, or abbess, sometimes bearing his or her insignia, commonly depicted in the form of a shepherd's staff signifying pastoral powers.

Cruciform: In the shape of a cross.

Crusade: One of a series of military campaigns, first promoted in 1095, in which European Christians attempted to retake the Holy Land from Muslim domination. The term was also applied to campaigns against heretics inside Christendom, as well as campaigns against pagans on the boundaries of Europe.

Crypt: A chamber or vault below the main floor of a church, often used as a burial spot.

Cubit: A measurement of ancient origins corresponding to the length of the forearm (about 17–21 inches), sometimes used in medieval architecture.

Customals: Books containing the instructions for practice and celebration of the divine office and other activities of monastic daily life. The customals also spelled out rubrics or instructions for processions, and the use of candles, incense, crosses, and reliquaries in liturgical and devotional celebrations or commemorations. In addition, they might contain customs concerning the manors and estates controlled by a monastery along with information concerning rents and obligations.

Cyclic: A musical composition of several movements that are related by the use of some of the same material.

Dagging: Fancy cut-work decorating the edges of sleeves and hems in medieval clothing.

Dance of Death (Danse macabre): In late medieval literature, sermons, and iconography, a dance involving humans and skeletons, intended as a reminder of mortality.

Dar-al-Islam: The abode of Islam or the Islamic territory.

Day room: A room in which monks pursued manual labor within the cloister, sometimes a scriptorium. The day room was often located next to the chapter room along the east range and below the dormitory.

Deacon: Literally, the servant of the bishop in early Christianity. The status of deacon was one of the early steps on the way to priestly ordination in the medieval period. The deacon could have specific liturgical functions associated with the Eucharist and dismissal at mass.

Deism: The view that while God is responsible for the existence of the world, He otherwise has no commerce with it.

Dialectics: (a) The science or art of logic; (b) a method of arguing and defending with probability open questions.

Diocese: A geographic division or extent of a bishop's jurisdiction.

Diptych: A pair of painting or carvings on two panels, usually hinged together.

Disputation: A formal and structured dialogue between master and pupil, proposing questions and replies, difficulties to the teacher's reply, and solution of these.

Docetism: From the Greek "I seem," a belief popular among early Christian gnostic groups (sects claiming superior knowledge of spiritual things) that the human-

ity and suffering of the earthly Christ were apparent, but not real.

Dolce stil nuovo: In Italy, the "sweet new style" of poetry practiced by such poets as Dante and Guido Cavalcanti, who mirrored the themes of the southern French troubadours in Italian love lyrics of the thirteenth century.

Dominican friars: Members of the Order of Preachers, which originated when an Augustinian canon (Dominic de Guzman) from Spain began preaching against the heretical Cathars in southern France in 1203. Given official confirmation in 1217, the order frequently located near university towns and maintained a focus on preaching, teaching, writing, and combating heresy.

Donjon: The great tower or keep of a castle, sometimes thought to be the residence of the lord of the castle.

Dormitory: The common sleeping room of the monks. The dormitory was customarily attached directly to the south arm of the church and was located above the chapter room on the east side of the cloister.

Double monastery: The buildings used by a group of cloistered religious individuals that includes both monks and nuns.

Doublet (pourpoint, gambeson): A short garment for men with a tight waist and a thickness of padding through the chest; also a garment worn by knights both as an outer garment (coupled with hose) and as padding under armor.

Dream vision: A medieval poetic genre consisting of a narrator's account of his unusual dream, provoked by his physical surroundings or bedtime reading matter, in which he is often visited by a male or female authority figure who issues guidance or advice. These narratives treated such themes as love, philosophical and spiritual issues, and contemporary mores, often from a satirical perspective.

Dualism: Belief consisting of, or focusing upon, two elements, often the spiritual and the corporeal, or forces of good and evil.

Ecclesiology: The study of the church, or theories concerning the organizational and spiritual body of believers.

Ecumenical: Worldwide, as in a general synod or council called by bishops, church leaders, or a pope. Ecumenical councils were often called to resolve issues that affected the entirety of Christendom.

Eddic poetry: Heroic and mythological lays composed in medieval Scandinavia in free form or varying meters, based on Germanic legends and mythology about the pagan northern gods.

Effigy: The likeness of a person, sculpted in wood, plaster, stone, or bronze, and placed on top of the person's tomb; effigies often adorned the aisles of medieval churches.

Eigenkirchen: A church under private control or ownership. Many rural churches in the early Middle Ages were of this kind.

Emanation: Flowing forth from a source; the pantheistic view that all things arise necessarily out of the substance of God's being, intellect, etc.

Enamelwork: The artistic use of enamel, a substance formed from colored glass particles that are melted and fused, usually to a metal surface.

Episcopal: Having to do with a bishop.

Eremitic: Having to do with the life of a hermit or solitary.

Essence: In the broad sense, what a thing is, all its characteristics, as contrasted with its existence.

Essentialism: The metaphysical view that identifies being with essence or that holds that the act of existing is always identified with the actual essence.

Estampie: Mentioned in literature from France and Italy, a dance or musical form whose name derives from the Latin *stante pedes* (stationary feet), referring to the fact that the dance steps remain close to the ground, in contrast to those dances that employ jumps or kicks.

Eucharist: In Christianity, the celebration or reenactment of the Lord's Supper using bread and wine consecrated by a priest in order to memorialize Christ's death and resurrection.

Excommunication: Church censure imposed by an authority which excludes individuals from communion with the faithful and deprives them of rights to certain sacraments.

Exemplum (pl. exempla): Moralizing anecdotes drawn from the lives of saints, animal fables, or wise sayings about everyday life, assembled to help a preacher make a powerful connection with his audience.

Existence: In philosophy, the actuality of an essence; that act by which something is.

Extreme unction: The sacrament of the sick and dying, usually accompanied by prayers and an anointing, given as a last grace and opportunity of forgiveness.

Fabliau: A brief tale, most often in French, set in the present-day world, populated by stock bourgeois characters, employing clever, complicated plots (often love triangles) about humankind's most basic functions, especially sex.

Façade: The front of a church, usually imposing and decorated.

Fasting: Abstinence from food as a religious observance.

Feast: A certain day in the liturgical calendar of the Catholic Church devoted to the birthday or martyrdom of a particular saint, or event of significance in the Christian year.

Feudalism: *See* **Lordship.**

Fideism: The thesis that religious belief is based on faith and not on either evidence or reasoning.

Filiations: Daughter houses, often founded or adopted by the mother monastery. A group of daughter houses dependent upon a main house or linked together in a system.

Filigree work: Fine metalwork created using tiny beads or very fine threads of metal to create the effect of delicate, lacelike, openwork ornament.

Filioque: A Latin phrase (literally meaning "and the son") referring to an argument as to whether or not the Holy Spirit proceeded from the Father or emanates from both the Father and the Son. The Latin Church seems to have added the notion that the Holy Spirit can also proceed through Jesus as well as God the Father.

Flagellation: Whipping or beating oneself in punishment for sins or to commiserate with the suffering of Christ.

Flying buttress: A segmental arch transmitting outward and downward thrust to a solid buttress or square column which transforms the force into a vertical one.

Fortune's wheel: The popular medieval metaphoric construct to explain cyclical human misfortune, caused by the turning of a Wheel by an allegorical personification, blindfolded Lady Fortune, on whose "wheel of fortune" all men are situated, rising high upon or being cast off of the wheel (regardless of their merits or evil actions) according to their current state of luck.

Four-fold medieval allegory: Four levels of medieval allegorical interpretation: 1) the literal level; 2) the allegorical level; 3) the tropological or "moral" level; and 4) the anagogical or eschatological level, about the afterlife.

Franciscan friars: The Brothers Minor, an order based on the principles of extreme poverty and itinerancy, first proposed by Francis of Assisi in 1210. In the early fifteenth century, the order split into the conventual (the more lax) and observant (the more traditional) branches in a disagreement over the issue of property and observance.

Fresco: A technique of painting on a moist lime plaster surface with colors ground in water or a limewater mixture.

Friar: A member of one of several religious orders who served as missionaries, teachers, and confessors; in contrast to monks, friars (brothers) did not live a cloistered life, but rather lived together in convents on the edges of cities.

Gallery: A long, narrow area in a church, open at each end or at sides and sometimes elevated.

Gambeson: *See* **Doublet.**

General Chapter: An assembly bringing together all the abbots, abbesses, heads, or representatives of the houses of a monastic order for a general meeting.

Genuflection: A Christian practice of bending down on one knee, as it touches the ground in veneration.

Girdle: A kind of belt introduced into female costumes in the eleventh century to give the female figure a more distinctive outline, but later worn by both men and women. Girdles were usually constructed as twisted cords, sometimes knotted, made from gold or silver wire and dyed wool or silks, and bound with ornamental fasteners or finished off with tassels. Simpler girdles were also constructed from a length of fabric that was decorated with stitching of a contrasting color.

Gittern: A plucked string instrument that was smaller and higher-pitched than the lute, depicted with three to five single strings.

Gothic: A term originating in the Renaissance to refer to the architectural style that dominated the western half of Europe from the twelfth through the mid-sixteenth centuries, distinguished by the use of pointed arches, ribbed vaults, flying buttresses, and stained glass windows.

Gown: One of several garments worn by both men (over an under-tunic) and women (over a chemise), distinguished, according to a principle of layering, as an under-gown or over-gown.

Grace: The theological notion of the free gift of love and unmerited assistance that God gives individuals so that they bridge the gap between humanity and divinity, attain salvation, and participate in the life of God.

Grail: An object, apparently originating in medieval literature, associated with the last moments of Jesus Christ's life, sometimes identified as the chalice or bowl used by Joseph of Arimethea to collect Christ's blood after the Roman soldier Longinus pierced His side with a spear.

Grange: A monastic farm settlement at a distance from the monastery that was part of an abbey's estates, usually

supervised by a monk and worked by the lay brothers, but sometimes contracted out to others.

Great Schism: The period from 1378 to 1417 during which there were two, and sometimes three, claimants to the papal office.

Grisaille: Monochrome painting, usually in tones of gray, found especially in stained glass and painted altarpieces (and sometimes illuminated manuscripts, textiles, etc.) from the later Middle Ages.

Groin vault: In architecture, the curved line or edge formed by the intersection of two vaults.

Guild: An association of persons belonging to the same class or job, often connected with a particular profession, joined together for the betterment or promotion of their situation.

Gyrovagi: Monks or clergy who wandered from institution to institution, a practice frowned upon by the Church; these unsettled religious and clerics were sometimes referred to as "professional guests."

Hagia Sophia: A famous sixth-century church in Constantinople, Byzantium, now Istanbul in modern Turkey.

Hagiography: Medieval narratives about the lives of saints or virtuous people.

Haincelin: A short version of the houppelande, sometimes said to have been named for the jester Haincelin Coq in the court of Charles VI of France, who may—as was the case with many jesters—have been a dwarf.

Hammerbeam: One of a pair of short cantilevered timbers supporting a ceiling arch.

Harmony: The result of two or more notes sounding at the same time.

Harp: A common medieval musical instrument that existed in a variety of sizes and forms. The type most often depicted in art was a small portable harp with 24 or 25 strings.

Hennin: A French headdress of the second half of the fifteenth century that had a cone-shaped construction with soft veiling attached at the peak that hung behind it in varying lengths, sometimes reaching to the floor.

Heresy: Opinion or doctrine at variance with the orthodox or accepted doctrine of a church or religious system.

Hierarchy: A chain of office, consisting of a body of officials organized by rank.

Holy Roman Empire: The term used from the twelfth century onward for a Germanic empire (originating with the coronation of Otto I of Germany in 962) that was viewed theoretically as the continuation of the Western Roman Empire and as the temporal form of a universal dominion whose head was the pope.

Homage: The formal public acknowledgment by which a knight or tenant declared himself a vassal of his lord, owing him fealty and service. See also *Lordship*.

Host: The consecrated bread at the Mass which medieval Christians believed was changed into the body of Christ in conjunction with the action of the celebrant.

Houppelande: A fourteenth-century garment of variable length that was worn over the doublet and hose. The longest version of this garment was worn for formal occasions and was ground-length or somewhat longer. A short version reached halfway between ankle and knee, and one of an even shorter length hit some inches above the knee. Initial forms of the houppelande had high collars that fanned out, but later collar styles differed. Sleeves were funnel shaped, increasingly wide at their ends, and often edged with fancy cut-work (dagging) and slashed to show fur linings of complementary colors. After 1450, the more usual term for this garment was "gown."

Humiliati: A lay spiritual movement, eventually given papal approval, that developed in the late twelfth century and emphasized voluntary poverty and vernacular translation of the scriptures. The Humiliati became known for the production of inexpensive cloth for the poor.

Hurdy-gurdy: A musical instrument that made its sound by turning a crank that caused a wheel to scrape against two or three strings. A set of keys or levers could be pressed against one of the strings to change the pitch, while the other(s) provided a drone.

Hussite Wars: A persecution of the followers of Jan Hus that took place between 1419 and 1436 when they continued to preach throughout Germany and Czech territories after Hus was burned for heresy.

Icelandic family sagas: Tightly structured, complexly plotted thirteenth-century heroic prose narratives composed from earlier oral accounts, depicting the blood feuds and other events that happened during the settlement of Iceland as a colony of Norway in the tenth and eleventh centuries.

Iconic: The quality of a visual image or object that is generally static, frontal, and non-narrative.

Iconoclast: One who literally would smash religious statues and icons, based on the belief that they were idolatrous.

Iconography: The pictorial representation of a subject, especially when comparing the particular character of a

represented subject to the complete visual record of that subject throughout the history of art; also the study of the meaning of the subject matter of visual images.

Illuminated manuscript: A manuscript (handwritten book) with hand-painted decoration or illustrations, usually employing silver, gold, and different colored pigments.

Illumination: In the Augustinian sense, the function of the divine light within a human intellect that makes truths or intellectual knowledge (as opposed to sense knowledge), especially of immaterial things, possible to the rational creature. Also, the gilded hand-painted decoration or illustrations in an illuminated manuscript.

Immanence: (a) Presence in and operation within; indwelling: as "God is immanent in all things"; (b) Pantheistic sense: God's presence in the universe as a real part of it.

Indulgence: After the confession of sin, the substitution of penance by another act, such as almsgiving, pilgrimage, crusade, or financial contribution for the construction of a church.

Infirmary: The building devoted to the care of sick and infirm monks. Often situated outside the cloister precinct to the east with its own cloister and chapel, it formed a monastery in miniature.

Inquisition: The juridical persecution of heresy by special church courts.

Interdict: A ban imposed by a pope, church council, or bishop that excludes a person, group or country from the sacraments.

Investiture: The investing or conferring of authority to a church official by a superior in a ceremony involving presentation of the symbols of office, including an exchange of homage before consecration.

Isorhythm: A rhythmic pattern that is imposed on a melody and repeated exactly throughout the length of the composition.

Jihad: The Muslim duty of struggling or fighting to maintain excellence or striving for an ideal society in which Islam might flourish. Early interpretations emphasized the "greater jihad," that is the struggle within oneself, while the "lesser jihad," connected to the idea of the physical struggles, such as mission effort, good works, building mosques, and overcoming the enemies of the faith, would not become significant to Muslim theology and ideology until the twelfth century.

Jongleur: An Old French word associated with modern English "juggler," used as a catch-all term to identify a person with the array of talents shared by professional performers of the Middle Ages.

Jubilee year: A holy year in which special blessing and indulgences remitting time spent in purgatory are granted to Christians who visit Rome and fulfill certain spiritual requirements. Jubilees come every fifty years.

Kabbalah: Meaning "tradition," a medieval Jewish mystical movement which has its roots in scriptural accounts of visions.

Karaites: Meaning "readers," a ninth-century Jewish movement (also known as "Children of the Text") that saw the Talmud as a departure from the divinely revealed truth of the Torah, which was the supreme authority in matters of faith.

Keep: The multi-storied tower that combined living quarters and defensive features in a medieval castle.

Kenning: In Anglo-Saxon poetry, an oral-formulaic phrase that employs juxtaposed words as metaphors to imagine familiar objects in a new way, such as "whale-road" (the sea), "earth's candle" (the sun), and "ring-giver" (king).

Keystone: A wedge-shaped stone at the summit of an arch serving to lock the other stones in place and create structural strength.

Kirtle: Originally a short linen undergarment, later an overgown, and still later, analogous to the French *cote*, the outer garment also known as robe or surcote.

Knight: A member of the warrior sector of medieval European culture, who owed homage as a vassal to a duke or baron (his temporal lord), usually in the form of military service. See also *Lordship*.

Koran (Qur'an): The sacred text of Islam, believed to have been dictated to Muhammad by the angel Gabriel.

Laisses similaires: Literally "similar stanzas," repeated verse stanzas used to emphasize important and dramatic scenes in French *chansons de geste* and other heroic narratives.

Laity: Secular persons, not members of the clergy (monks, priests, canons, bishops, deacons, etc.)

Lancet window: A tall, narrow window usually ending in a sharply pointed arch and found mainly in Gothic architecture.

Lay brother: A person associated with monastic life, but often of a lower social class than the other monks; lay brothers were commonly less educated or unable to recite in Latin, were not part of the choir, and spent much of their time in manual labor.

Lectionary: A book containing readings (usually of sacred scriptures) for use at Mass in a church or during the offices of monks and nuns.

Lent: A forty-day period of penance, fasting, and reflection leading up to the commemoration of the death and resurrection of Christ.

Limbo: An abode of souls for those who, through no fault of their own, are barred from salvation because they were not baptized (as in the case of infants or people who lived before the time of Christ).

Litotes: The rhetorical device of ironic understatement employed in northern European literature of the Middle Ages, especially in *Beowulf* and other Anglo-Saxon poems and the Icelandic sagas.

Liturgy: In the Latin Christian church, the forms of prayers, acts, and ceremonies used in public and official worship. The main parts of the liturgy are the offering of the Eucharistic sacrifice called the Mass, the singing of the divine office, and the administration of the sacraments. It was from elements of the Mass that the earliest medieval drama is thought to have developed.

Locus Amoenus: Literally the "beautiful place," the locale of most medieval romances, the opening of dream visions, and the troubadours' *chansons d'amour*, featuring soft spring breezes, flowing water, blooming flowers, budding greenery, and the songs of birds.

Lollards: Literally the "mumblers," followers of John Wyclif after his death in 1384. Lollards (or Wycliffites) subscribed to John Wyclif's belief in the importance of preaching and vernacular Bibles, and rejected beliefs in transubstantiation, purgatory, and clerical celibacy.

Lordship: A complex network of interlinked political, economic, and social obligations (formerly called "feudalism") that extended to and involved almost all sectors of the socioeconomic hierarchy in the Middle Ages.

Low Countries: The lowland regions near the North Sea, divided in the Middle Ages into numerous small states (Brabant, Flanders, Hainaut, Holland, etc.) and corresponding today to Belgium, the Netherlands, and Luxembourg (sometimes called, as a group, "Benelux").

Ludus: From the Latin word for "game," it later came to mean "play." Thus the name *Ludus Coventriae* refers to the cycle of Coventry plays.

Lute: A plucked musical instrument that came in several sizes, with frets and four "courses" (paired sets) of strings and a fifth solo string called a *chantarelle*, used for playing melodies. During the medieval period it was usually plucked with a quill plectrum and played mostly single-line melodies with drones.

Machicolations: A projecting gallery at the top of a fortified wall with floor openings through which heavy objects or boiling liquids could be dropped on attackers.

Magyars: An ethnic group that makes up the predominant element of the population of Hungary.

Maniple: A church vestment consisting of a narrow strip of cloth usually worn over the arm in the service of the Eucharist.

Mantle: An outer garment, usually bordered with embroidery or gold and silver threads, worn to protect its wearer from bad weather while serving also to designate high social status and power. In the period from 1066 to 1154, two shapes of mantles had long been in use—the semicircular and the rectangular. A mantle was often received from an overlord as a valuable gift, then bequeathed from generation to generation.

Manuscript: A hand-written or hand-copied book or document, which may, if created for a wealthy patron, be decorated with elaborate painted illustrations and a highly ornate cover. Before the fourteenth century, the pages of manuscripts were generally made of vellum (parchment) prepared from the skin of a lamb or goat.

Marian lyrics: Medieval religious lyric poetry, especially in France, Italy, and England, devoted to veneration of the Virgin Mary but featuring some of the same tropes used to honor the courtly lady in the *chansons d'amour* of the troubadours and other medieval lyric poets.

Mass: The official name of the liturgical rite of Christianity commemorating the Eucharistic sacrifice, involving the consecration of bread and wine, along with the conventional prayers, songs, and readings that accompany it. It is a reenactment of the Last Supper when Jesus broke bread, asked his disciples to eat this symbol of his own flesh, and then bade them drink wine representing the blood he would shed for them the following day, Good Friday.

Matter of Britain: Stories about King Arthur and the Knights of the Round Table, which contributed to the development of romance and made Arthur first a national hero in England and later a literary figure of international stature.

Matter of France: Tales of figures in the development of French national culture such as Roland, Charlemagne, and William of Orange, contributing especially to the genre of *chanson de geste*.

Matter of Rome the Great and Antiquity: The broad category of plots about classical antiquity in Greece, Troy, Rome, or Northern Africa, retold in medieval vernacular romances such as the French *Roman de Thebes* and Boccaccio's *Teseide*.

Mendicants: Those religious peoples, specifically friars, who depend upon begging for their support.

Mensural signs: In music, symbols that indicate tempo and rhythmic subdivisions.

Merovingian: Pertaining to the Frankish dynasty established by Clovis I, which reigned in Gaul and Germany from about 500 to 751. The dynasty was named after the semi-legendary Merovech, Clovis' grandfather.

Metaphysics: The division of philosophy which studies being as such and the universal truths, laws, or principles of all beings; "the science of being as being" (Aristotle).

Midrash: In Judaism, a body of oral commentary on the scriptures, Talmud, and Halakah (legal texts), collected and expanded by rabbis beginning about the ninth century.

Military orders: Religious congregations of knights whose initial purpose was to protect pilgrims and maintain control of the Crusader Kingdoms in the Holy Land, but who, in different orders, engaged in various activities, including protecting holy places, campaigning against pagans, staffing hospices, and providing hospitality to travelers.

Minnesingers (German Minnesänger): Singers about *minne*, which means "love," such as Walter von der Vogelweide; the German equivalents of the French troubadours and trouvères, who developed the themes of *fin'amors* in German lyrics.

Miracle: An extraordinary event that surpasses what is known of natural laws and is considered a work of God.

Missal: A book containing the complete rite of the Mass, with all prayers, readings, and chants.

Moat: A ditch of some width and depth around a fortified area like a castle serving to repel intruders.

Monasticism: The way of life typical of monks or nuns who dwell together for life, living austerely and sharing in common according to a rule; their lives are devoted to the service of God.

Monk: A member of an all-male religious order who follows a rule requiring withdrawal from society and devotion to prayer, solitude, and contemplation.

Monophony: Music of one part, either a solo song or a single melody performed by more than one person or instrument.

Monotheism: The doctrine or belief that there is only one God.

Moresca: A special dance in which the dancers all blackened their faces in imitation of Moors (people of northern Africa), and dressed in what were thought to be "Moorish" costumes with bells attached to their legs. The dance sometimes depicts a fight between Moors and Christians, a reference to Spanish history, and sometimes includes a fool as part of the cast of characters.

Motet: A polyphonic composition with more than one text, first created in or near Paris around 1250.

Motiv: A short passage of music (as short as three notes) that is repeated.

Motte: A fortification consisting of a timber tower set atop a conical earth mound. The motte often was surrounded by a ditch and wooden palisade.

Mystery: a) A term referring to one of the "mysteries" of Christianity, a miraculous event which must be accepted on faith, such as the idea of the Virgin birth of Jesus; or b) A play put on by a craft guild, a group who have trade secrets or mysteries.

Mysticism: The religious theory that conceives of God as absolutely transcendent, beyond reason and all approaches of mind, placing emphasis on the negative way, that is, on what God is not.

Nakers: A pair of small "kettle" drums, usually tied to the performer's waist or over the neck of a horse.

Narthex: An enclosed passage between the main entrance and the nave of a church.

Nave: The main longitudinal area of a church.

Neoplatonism: The philosophical school, founded by Plotinus (205–270), which extended the philosophy of Plato and built it into a system, focusing on the emanation of all things from the One and their return thereto. A version of this philosophy, made compatible with Christian teachings, was forged by St Augustine and became a very influential school in the Middle Ages.

Niello: A metalwork process whereby a design is engraved in a metal surface and then filled with a black alloy of sulfur with gold, silver, copper, or lead and then fused with heat.

Nominalism: The theory that universal terms like *horse* or *equality* are merely names, not real essences.

Nun: A member of a religious community of women living a cloistered life of religious devotion in a convent or double monastery.

Obedience: An oath taken to a superior (often religious) to abide by that person's judgment and jurisdiction.

Oblate: A lay person who is part of a religious community. From the Latin word *oblatio*, meaning to offer, this

term often refers to children who were "offered" by their families to the service of God in a monastery or convent, to be brought up as a monk or nun.

Office: From Latin *officium*, or duty, the prescribed daily round of prayers, mainly psalms, recited seven times a day in community, called for in the *Benedictine Rule*. Also, the prayers and ceremonies in the Latin Christian church for some particular purpose, such as the Office for the Dead, or the church's services in general, such as the Divine Office.

Office of the Dead: Prayers said on behalf of the deceased, often for individuals connected, by membership or patronage, to the monastery or community offering the prayer.

Oral-formulaic tropes: Poetic stock phrases that could be recalled easily or recombined to invent new lines if the scop (the Anglo-Saxon minstrel) forgot a line during performance or needed to fill out the meter in a new passage. Examples from *Beowulf* include the exclamation "That was a good King!"; the formula for introducing a new speaker, "Beowulf unlocked his word-hoard"; and the term for the temporal lord in the *comitatus*, "ring giver."

Ordo (pl. Ordines): A book of directives for the celebration of liturgies, including Mass, the order of the Divine Office, and other religious rituals.

Organum: An early, fairly simple type of polyphony. There are several different varieties, including one in which the voices sing the same melody at different pitches (known as "parallel organum"). Other varieties include the addition of an upper part over an already-existing melody (that is, a tenor). The upper part usually moves faster than the tenor.

Orthodox: A sound or correct theological or religious doctrine.

Orthodox Church: The Christian church of those countries formerly comprising the Eastern Roman Empire and of those countries evangelized by it; the Byzantine Church.

Ottonian: Pertaining to the German dynasty that ruled from 962 to 1002 as the emperors of the Romans (later the Holy Roman Empire).

Pageant: A separate event in a pageant cycle or large group of plays on Old and New Testament themes, such as a pageant of Christ's nativity.

Paletot: A short-sleeved short and loose gown for men, sometimes worn as an over-garment with the doublet.

Pantheism: The doctrine that the world or nature in the widest sense is identical with God.

Pantheon: In polytheism, the system of all the gods and goddesses.

Papal: Having to do with the bishop of Rome and his authority as pope over Western Christendom.

Papal bull: A written pronouncement or mandate from the pope. In the early days, these pronouncements were sealed with a large circular wax disk containing an impression of the pope's ring (from the Latin *bulla*, or seal).

Parapet: A battlement wall protecting the wall-walk and roof.

Parish church: The local church attended by the people of a parish and ministered to by a rector or sometimes a curate whose living comes from rent provided from the lands of that community.

Passion: The events of Christ's last hours, his torments, suffering, and crucifixion. The term also refers to Passion Sunday or the fifth Sunday in Lent as these are dramatized in Passion plays of the late Middle Ages.

Pastourelle: Literally, a "song about a shepherdess," a short, dialogue-filled, narrative account in verse about a courtly knight's attempt to seduce an innocent but clever shepherdess.

Peace of God: An ideal articulated by numerous church councils between 990 and 1096 obliging the knightly order to protect unarmed poor, children, women, clerics, merchants, and pilgrims.

Penance: The sacrament of forgiveness (that is, forgiveness by God through the action of a priest), which in the Middle Ages involved confession of sins followed by an act of restitution.

Penitential: A book setting out recommended penances or satisfactions associated with particular sins.

People of the Book: A category of people in Islam that consisted of monotheists with written scriptures, including most types of Christians and Jews. Because of the common heritage of faith that they shared, Muslims often extended to them the status of *dhimmi*, or protected people.

Perfects: Leaders of the Cathars who had developed a high level of spiritual attainment.

Pier: In architecture, a support for the ends of adjacent spans of arches.

Pilgrimage: A journey made usually for spiritual reasons, to reach a particular shrine or sacred place; a pilgrim is one who makes such a journey. The Haj was the Arabic term for the pilgrimage required of all adult Muslims.

Pilgrimage church: A large church on one of the major pilgrimage routes (for example, the shrine of St. James at Compostela) that often offered shelter and provided maps and information about the route.

Pinnacle: A small, decorative turret or end of a spire, buttress, or other such architectural element, generally pointed, conical, or pyramidal in shape.

Plainchant: Music for the sacred services, the largest surviving repertory of the medieval period.

Plate: A horizontal timber laid flat atop a pier or wall used to attach the ends of rafters.

Polyphony: Music of more than one part, each musical line having a separate rhythmic and melodic profile.

Polytheism: The belief that there are many gods within the religious system.

Pope: The head of what is now called the Roman Catholic Church. The pope, or pontiff, was also called the Bishop of Rome since he presided over the entire Latin Church due, in part, to his authority over the local Roman Episcopal See.

Portcullis: A heavy iron or wooden grill, set in vertical grooves, that can be raised or lowered by chains to protect the entrance to a castle.

Postulant: A person seeking admission to a religious order. Often he or she was allowed to try out monastic life for a brief time.

Pourpoint: *See* Doublet.

Premonstratensians: An order founded in 1121 that was unique in its policy of accepting both men and women and attempting to accommodate them in the same monastery.

Primacy: The idea that the Bishop of Rome had a primary place over all other bishops by virtue of the tradition of St. Peter being at Rome and the idea that Rome was the center of the old Roman Empire.

Prime: The liturgical office celebrated at sunrise (or the first hour of the day).

Principle source: In philosophy, that from which something proceeds.

Procession: A type of stately dance in which couples move forward side by side, often holding hands.

Psalter: A book containing the Psalms for liturgical or devotional use.

Purgatory: According to medieval Christian doctrine, a place where the souls of those who die penitent remain to be purified from sins before they go to heaven.

Purlin: A longitudinal member in a roof frame usually for supporting common rafters between the plate and the ridge.

Qabbalah: *See* Kabbalah.

Qaraites: *See* Karaites.

Quietism: The attitude of passivity and receptivity before God, as opposed to activism (that is, the view that the human agent has some role to play in earning God's favor).

Quire: *See* Choir.

Qur'an: *See* Koran.

Rabbi: A title used in early Judaism to identify one who had received a type of ordination based upon his ability to teach and judge the law or his mastery of the Talmud, and applied specifically to those who were experts regarding Jewish law. By the Middle Ages, rabbis were scholars, teachers, judges (particularly in Muslim Spain), and preachers.

Rafter: The beam, usually angled and joined at the top to a similar beam in the form of an inverted V, which is used to support a roof.

Rationalism: Any one of the views that attribute primary importance to the human reason: for example, that all authority in matters of truth is subject to the scrutiny and approval of reason, without any duty of obedience or reverence for religious authority.

Realism: (a) The philosophical position that accepts the existence of things prior to and independent of human knowledge; or (b) in relation to the problem of universals, the epistemological view that man's direct universal concepts ordinarily represent natures that are objectively real and in some way fit to be represented as universal by the mind's activity.

Rebec: A small three-string musical instrument, played in the soprano range.

Reconquista: The process of recovering Christian lands from the Moors who had control of Spain or various parts of the Iberian Peninsula during the Muslim occupation from 718 to 1492.

Refectory: The dining hall of a monastery, usually located on the south walk of the cloister.

Relic: Something that is kept and venerated because it once belonged to a saint, martyr, or holy person, especially a part of his or her body.

Reliquary: A box, container, or shrine in which relics are kept for veneration, often highly decorated and made of precious materials.

Repoussé: Relief (that is, raised) decoration on a metal surface produced by hammering from the underside.

Reticulated headdress: A style in the fourteenth and fifteenth centuries characterized by the enclosure of hair arrangements in a net-like receptacle. The forerunner of this headdress was the *caul* or *crispinette*. Reticulated headdresses were made of gold, silver, or silk nets, sometimes set with jewels at intersections, and fashioned into bags to hold the hair in place.

Revelation: The word of God as it is manifest through the sacred scriptures and the church tradition.

Reverdie: A term in Middle English meaning "re-greening," celebrating the reappearance of spring after a long winter, employed to start a lyric poem or song, or to open a love poem or dream vision.

Rigoletto: A dance that includes forward and backward jumps and some type of "waving" motion.

Robe: A name applied to many different garments during the Middle Ages, ranging from the long tunic in England (late eleventh century) to a complete outfit of a varying number of layers intended to be worn together, some of them made of silk, some furred (fourteenth century).

Romances: Episodic narratives composed in verse or prose throughout Europe from the twelfth through fifteenth centuries, whose plots derive from the various "Matters" of France, Britain, Rome, or Antiquity and involve a high degree of fantasy and sometimes the attainment of love in a search or quest, as well as the testing of the prowess or morality of their knightly heroes.

Rose window: A large, circular stained-glass window placed centrally above the portal(s) on the façade of a Gothic church.

Round dance: One of the most popular forms of medieval dance, a dance in which a group of people hold hands in the form of a circle, usually with a leader in the center. The dance steps require the circle to move first in one direction and then the other, reversing its direction at the beginning of each new verse. The leader sings the verses and the entire group joins in the chorus.

Rotunda: A circular high space in a church surmounted by a dome.

Rubble: A wall made of different sizes and types of uncut stone.

Rubric: From the Latin word for red (*rubeo*), the larger script indicating a chapter heading or division in a manuscript and particularly the directions (often printed in red in missals and breviaries) for the conduct of church services and the carrying out of liturgical rites.

Rus': Tribal people, perhaps originally Scandinavian Vikings who, by the ninth century, had settled in what is now the area around Kiev, Russia.

Sacrament: A visible sign instituted by Jesus Christ to symbolize or confer grace. Those accepted in medieval Christianity were baptism, confirmation, the Eucharist, matrimony, penance, holy orders, and extreme unction.

Sacramentals: Actions or ceremonies resembling sacraments but regarded as originating with the church rather than with Jesus Christ himself.

Sacramentary: A book used in the celebration of the Mass and for other liturgical rites.

Saga: A unique kind of prose narrative invented in Iceland during the twelfth through fourteenth centuries. The Old Norse word *saga*, literally "something said," indicates the oral origins of most of these accounts of the exploits of noteworthy men or events that were later amplified, embellished, and transmitted by skilled taletellers over the course of several centuries.

Saint: In Christianity, a person who led a holy life on earth and has been declared to have a privileged place in heaven and be worthy of veneration.

Sanctuary: The part of the church containing the altar.

Sapientia and Fortitudo: Wisdom and fortitude, a combination of discretion and cleverness with physical strength and bravery, which contributed to successful lordship or heroism in early medieval literature.

Schism: The division of a group into mutually antagonistic factions, as, in the Middle Ages, the Photian Schism (ninth century), between Eastern and Western Christianity; the ongoing schism between the Greek and Latin churches that began in 1053; and the Great Schism within Western Christianity (1378–1417) when there were two, or even three, popes.

Scop: An Anglo-Saxon minstrel who recited poems, perhaps to a harp accompaniment.

Screen: A wooden or iron structure separating the nave from the choir of a church, sometimes called "rood screen" if it had a large crucifix ornamenting its top.

Scriptorium: The workshop or area found especially in abbeys and monasteries where manuscripts are copied and decorated.

Secular clergy: Priests living in the world (as, for example, parish priests serving local churches), as opposed to regular clergy living under the rule of a religious order.

See: Literally, the official seat (from the Latin *sedes*) of a bishop, hence the place where the bishop sits or resides.

Sequence: A type of hymn, but not in a regular meter, said or sung between the gradual and the gospel of certain masses.

Serf: A member of the agricultural workforce that tilled the land of the medieval estates and manors owned by temporal lords such as dukes and barons, and was bought and sold with the land.

Seven Deadly Sins: The Roman Church's designation of the seven most serious sins—pride, wrath, avarice, envy, gluttony, lust, and sloth.

Shawm: A double-reed instrument much like an oboe first depicted in Spanish sources of the late thirteenth century, suggesting that it had been introduced to Europe during the Arab or Moorish occupation of Spain.

Shi'ite: The more conservative branch of Islam that accepts only the direct descendants of the Prophet as legitimate successors, beginning with Ali Talib, the fourth caliph who was the cousin and son-in-law of Muhammad.

Simony: The sale or purchase of a church office or possession.

Skaldic Poetry: Verse composed in medieval Scandinavia that employed an erudite, specialized vocabulary in a highly complicated syntax.

Skepticism: The philosophical school that doubts or denies the possibility of any certain human knowledge; the skeptic is therefore enjoined to suspend all judgments in the speculative order.

Spiritual authority: The power exerted by the institutional church, its leaders, and other religious entities, as opposed to the "temporal power" wielded by political institutions or individuals such as kings and lords. Spiritual power included the authority to excommunicate and to place a temporal leader's subjects under interdict.

Stability: The vow taken, often by monks, to remain stable in one place as part of their profession, until death.

Stadia: Ancient units of measurement of about 607 feet, used in medieval architecture to liken church buildings to biblical descriptions of the celestial Jerusalem.

Stigmata Marks on the hands and feet resembling the wounds from Jesus Christ's crucifixion, thought to be supernaturally impressed on the person as a sign of spiritual similarity to the Christ.

Stole: A long narrow cloth worn around the neck by priests and bishops as part of their vestment.

Story collections: Anthologies of various separate stories that circulated together in a reasonably coherent form, organized around a theme or involving a framing device, a larger narrative that linked all the stories through an author's invented occasion at which tales were exchanged, as in Boccaccio's *Decameron* or Chaucer's *Canterbury Tales.*

Studium: An institution of higher education, not just for clerics, which taught law, medicine, and rhetoric, as well as theology.

Sub-deacon: A minor order of cleric who could not administer sacraments (only sacramentals) and who prepared bread, wine, and vessels at Mass.

Substitute clausula: A new section of polyphonic music intended to replace an old one.

Sufism: A mystical branch of Islam, which began as a monastic movement in the eighth and ninth centuries and became popular among individuals who rejected the formalized trappings of Islamic religious life and were looking for more inward and personal expressions of their relationship with Allah.

Sunni: The branch of Islam that believes anyone from the Qurayish clan or tribe of Muhammad can succeed him as caliph. Sunnis recognize the first four caliphs and their traditions as the rightful succession.

Synagogue: A building used by a Jewish community as a formal house of prayer and worship, but also as a gathering place for other communal activities.

Tabor: A large barrel-shaped drum, often called a "side drum," usually associated with the military.

Talmud: From the Hebrew word for "study," a collection of commentaries on the Hebrew scriptures that was begun in the first century B.C.E. and was eventually codified by rabbis.

Tambourine: A hand-held percussion instrument with jingles, usually depicted in conjunction with dancing.

Tempo: The speed of a musical composition.

Temporal authority: The power exerted by political institutions or individuals such as kings and lords, as opposed to the spiritual authority of religious institutions. The word "temporal" refers to the limitation of time associated with earthly life, in contrast to the timelessness of eternity.

Tenor: A melody borrowed from another composition and used as a guide for the structure of a new polyphonic composition. The notes are held as long notes. Music for dance sometimes was written only as a tenor line, requiring the musicians to improvise the accompanying lines.

Tertiary: "Third Order," or lay groups that came into existence in the thirteenth century to give the laity living in the world opportunities to live lives of religious dedication. Many of the Third Orders are linked to the mendicant movements.

Tithes: Payment of a portion (customarily one-tenth) of one's produce or income to the church, clergy, or the clergy person's office.

Torah: The scriptures that constitute the Jewish law, identified by Christians as the first five books of the Old Testament: Genesis, Exodus, Leviticus, Numbers, and Deuteronomy.

Tracery: Ornamental, openwork, sculptural decoration, in wood or stone, found especially above Gothic windows and on screens or panels.

Transcendence: Existence apart from and superior to the universe; opposed to immanence.

Transept: The transverse part of the rectangular body of the church, usually crossing the nave.

Translatio studii: Reflecting the Latin root of "translate," meaning "to carry across," the transfer of the plot and characters of a tale produced for the audience of one national culture or earlier period to that of another culture in a later period by medieval writers, involving significant changes in the plot and original roles of the characters as well as the very genre that the model text represented.

Transubstantiation: In the sacrament of the Eucharist, the conversion of the substance of the bread and wine into the body and blood of Christ, with appearances of bread and wine remaining.

Trial by combat: Rooted in the medieval notion that God punished evil and preserved good, a judicial process in which the accused and the accuser of a crime (or a contracted "champion") would engage in physical combat in the expectation that right would triumph over wrong.

This judicial remedy was never officially approved by the church and was eventually outlawed.

Trial by fire: A means of allowing divine intervention in the case of a dispute, often involved the burning of the accused's hand. The wound was bandaged for three days and then examined. If the area had become infected, the person was seen as guilty.

Trial by water: A means of allowing divine intervention in the case of a dispute, in which the accused were tied up and thrown into a body of water. If they floated, they were deemed guilty (the common belief being that water as a pure element would reject the sinner). Jews were exempt from the ninth century onward since it was believed that their rejection of Christ caused disfavor in the eyes of God.

Triforium: The wall at the side of the nave, choir, or transept of a church corresponding to the space between the vaulting or ceiling and the roof of an aisle.

Trinitarian: Subscribing to the doctrine of the Trinity, the union of three persons (Father, Son, and Holy Sprit) in one Godhead.

Triptych: A group of paintings or carvings on three panels, usually hinged together.

Trope: An antiphon or verse interpolated into a liturgical text.

Troubadour: Poets, such as Bernart de Ventadorn and Adam de la Halle, respectively from southern and northern France, attached to particular courts and patrons or wandering from court to court, who composed a new style of lyric love poetry with complex stanzas and rhyme patterns, especially the *chansons de croisade* and the *chansons d'amour* from the twelfth century onwards.

Trouvère: *See* **Troubadour.**

Truce of God: A policy developed at a series of church councils between 990 and 1096 to promote the cessation of unnecessary violence in Western Europe by imposing penalties for carrying on warfare during certain holy seasons, on Sundays, and in certain holy places.

Truss: A triangle of timbers used to support compression, used in the construction of a roof.

Tunic: A loose wide-necked garment, usually extending to the hip or knee and gathered with a belt at the waist.

Ulama: A class of learned Islamic scholars, particularly those who have special knowledge or expertise in theology and Muslim law.

Ummah: The collective community of Islam.

Universal: In philosophy, a term for a typical form that can be affirmed of or is attributed to many in a univocal and distributed sense; one name applied in exactly the same sense to many objects taken singly.

Unleavened bread: Bread that is flat, containing no yeast or leavening agent to make the dough rise, used in many Christian eucharistic services in imitation of the unleavened bread from the Jewish Passover service, in recognition of the fact that three of the four New Testament Gospel writers describe the Last Supper as taking place during the week of the Jewish Passover.

Usury: The charging of interest (or excessive interest) for a loan.

Vassal: A person granted the use of land, in return for which he rendered homage, fealty, and usually military service to his lord or other superior. See *Lordship*.

Vernacular: The language of a national culture of medieval Europe—French, English, Spanish, Italian, German, Norse—as distinguished from the language of learning and the medieval church, Latin.

Vielle: A four- or five-string medieval musical instrument with a range similar to a modern viola.

Vikings: Migrating northern tribal people from Scandinavia who traveled along coastlines in swift longships and invaded almost all regions of Europe during the period between the eighth and the mid-eleventh centuries.

Vocal dance: A dance song—that is, one with words to be sung, as differentiated from an instrumental dance.

Votive: A liturgy or offering of prayer that is done with a particular intention in mind.

Voussoir: A wedge-shaped brick or stone used to form the curved part of an arch or vault.

Waldensians: A popular movement of the late twelfth century (also called the Poor of Lyon) whose members (followers of Peter Waldo) led lives of poverty, read the Gospels in the vernacular, and encouraged lay people to preach. Interest in the movement was fueled by a famine that struck the city of Lyon in 1176, creating inequity in the distribution of resources, as well as by evidence of clerical corruption in the church of Lyon.

Warming room: A space, often adjacent to the refectory on the south side of a monastery (under the dormitory in the Saint-Gall plan), where a fire was kept burning during the winter months.

Wattle and daub: A building material consisting of wattle, a light mesh of laths or interwoven twigs, covered with mud, stucco, or brick.

Westwork: The monumental western front to a church involving a tower or group of towers and containing an entrance and vestibule below and a chapel above.

Wimple: A small veil or shawl-like garment worn over the neck and upper chest, usually draped, pleated, or tucked. Attached at the sides of the head either by ties or pins, they were worn sometimes as loose coverings and at other times fitted so as to adhere closely to the neck. Wimples were stylish in the late thirteenth and early fourteenth centuries, but by the second half of the fourteenth century, they were primarily conservative garments worn only by nuns, ladies in mourning, and elderly women.

Wycliffites: Followers of the reform movement originated by the Oxford clergyman John Wyclif. See *Lollards*.

FURTHER REFERENCES

GENERAL

O. Benedictow, *The Black Death 1346–1353: The Complete History* (Woodbridge, Suffolk, England: Boydell and Brewer, 2004).

M. de Jong and F. Theuws, eds., *Topographies of Power in the Early Middle Ages* (Leiden, Netherlands: Brill, 2001).

J. Dunbabin, *France in the Making 843–1180* (Oxford: Oxford University Press, 2000).

C. Dyer, *Making a Living in the Middle Ages* (New Haven, Conn.: Yale University Press, 2001).

Encyclopedia of Islam [Electronic resource]. Vols. 1–11 (Leiden, Netherlands: Brill, 2003).

C. Harper-Bill and E. Van Houts, eds., *A Companion to the Anglo-Norman World* (Woodbridge, Suffolk, England: Boydell, 2003).

J. Haywood, ed., *Encyclopedia of the Viking Age* (London: Thames and Hudson, 2000).

K. Helle, ed., *The Cambridge History of Scandinavia.* Vol. I: *Prehistory to 1520* (Cambridge: Cambridge University Press, 2003).

J. Herrin, *The Formation of Christendom* (Princeton, N.J.: Princeton University Press, 1987).

J. Hilgarth, *The Conversion of Western Europe: 350–750* (Philadelphia, Pa.: University of Pennsylvania Press, 1969).

C. Hillenbrand, *The Crusades: Islamic Perspectives* (New York: Routledge, 2000).

M. Hodgson, *The Venture of Islam* (Chicago, Ill.: University of Chicago Press, 1974).

G. Holmes, *The Oxford Illustrated History of Medieval Europe* (Oxford: Oxford University Press, 2001).

R. Horrox, *The Black Death* (Manchester, England: Manchester University Press, 1994).

C. S. Jaeger, *The Envy of Angels: Cathedral Schools and Social Ideals in Medieval Europe, 950–1200* (Philadelphia: University of Pennsylvania Press, 1994).

W. Jordan, *The Great Famine: Northern Europe in the Early Fourteenth Century* (Princeton, N.J.: Princeton University Press, 1998).

C. Kleinhenz, ed., *Medieval Italy: An Encyclopedia* (New York: Routledge, 2004).

F. D. Logan, *Vikings in History* (London: Routledge, 1992).

J. Longnon and R. Cazelles, *The Très Riches Heures of Jean, Duke of Berry: Musée Condé, Chantilly* (New York: Braziller, 1969).

R. MacMullen, *Christianizing the Roman Empire: AD 100–400* (New Haven, Conn.: Yale University Press, 1984).

C. Mango, *The Oxford History of Byzantium* (Oxford: Oxford University Press, 2002).

R. McKitterick, *The Carolingians and the Written Word* (Cambridge and New York: Cambridge University Press, 1989).

———, *The Frankish Church and the Carolingian Reforms* (London: Royal Historical Society, 1977).

W. Naphy and A. Spicer, *The Black Death: A History of Plagues 1348–1730* (Charleston, S.C.: Tempus, 2001).

A. Neuman, *The Jews in Spain: Their Social, Political and Cultural Life During the Middle Ages.* 2 vols. (New York: Octagon, 1969).

T. Noble, *The Republic of St. Peter: Birth of the Papal State* (Philadelphia, Pa.: University of Pennsylvania Press, 1984).

E. Peters, *Monks, Bishops and Pagans: Christian Culture in Gaul and Italy, 500–700* (Philadelphia, Pa.: University of Pennsylvania Press, 1975).

B. Rosenwein, *A Short History of the Middle Ages* (Peterborough, Ontario; Orchard Park, N.Y.: Broadview Press, 2002).

N. Saul, ed., *The Oxford Illustrated History of Medieval England* (Oxford: Oxford University Press, 2000).

J. Saunders, *A History of Medieval Islam* (London: Routledge, 1978).

P. Sawyer, ed., *The Oxford Illustrated History of the Vikings* (Oxford: Oxford University Press, 1997).

J. Strayer, ed., *Dictionary of the Middle Ages* (New York: Scribner's, 1984).

B. Tierney, *The Crisis of Church and State* (Toronto: University of Toronto Press, 1988).

B. Tuchman, *A Distant Mirror: The Calamitous Fourteenth Century* (New York: Ballantine, 1978).

David Wagner, ed., *The Seven Liberal Arts in the Middle Ages* (Bloomington, Ind.: Indiana University Press, 1983).

J. Wallace-Hadrill, *The Frankish Church* (Oxford: Oxford University Press, 1983).

D. Webb, *Medieval European Pilgrimage, c. 700–c. 1500* (New York: Palgrave, 2002).

ARCHITECTURE

E. Armi, *Design and Construction of Romanesque Architecture* (Cambridge: Cambridge University Press, 2004).

J. Bony, *The English Decorated Style: Gothic Architecture Transformed* (Ithaca, N.Y.: Cornell University Press, 1979).

———, *French Gothic Architecture of the 12th and 13th Centuries* (Berkeley, Calif.: University of California Press, 1983).

K. Conant, *Carolingian and Romanesque Architecture, 800–1200* (New Haven, Conn.: Yale University Press, 1993).

C. Coulson, *Castles in Medieval Society: Fortresses in England, France, and Ireland in the Central Middle Ages* (Oxford: Oxford University Press, 2003).

P. Cowen, *Rose Windows* (New York: Thames and Hudson, 1990).

J. Crook, *The Architectural Setting of the Cult of Saints in the Early Christian West c. 300–c. 1200* (Oxford: Oxford University Press, 2000).

A. Erlande-Brandenburg, *Cathedral and Castles: Building in the Middle Ages* (New York: Abrams, 1995).

E. Fernie, *The Architecture of Norman England* (Oxford: Oxford University Press, 2002).

J. Fitchen, *The Construction of Gothic Cathedrals* (Oxford: Clarendon, 1961).

J. Fleming, *Gille of Limerick (c. 1070–1145): Architect of a Medieval Church* (Dublin: Four Courts Press, 2001).

P. Frankl, *Gothic Architecture* (Baltimore, Md.: Penguin, 1962).

J. Gimpel, *The Cathedral Builders.* Trans. Teresa Waugh (New York: Harper Collins, 1983).

L. Grodecki and C. Brisac, *Gothic Stained Glass 1200–1300.* Trans. B. Drake-Boehm (Ithaca, N.Y.: Cornell University Press, 1985).

J. Harvey, *The Medieval Architects* (New York: St. Martin's, 1972).

D. Heald and T. Kinder, *Architecture of Silence: Cistercian Abbeys of France* (New York: Abrams, 2000).

L. Hervé, *Architecture of Truth: The Cistercian Abbey of Le Thoronet* (London and New York: Phaidon, 2001).

N. Hiscock, *The Wise Master Builder: Platonic Geometry in Plans of Medieval Abbeys and Cathedrals* (Aldershot, England; Brookfield, Vt.: Ashgate, 2000).

M. Hislop, *Medieval Masons* (Princes Risborough, England: Shire, 2000).

H. Kennedy, *Crusader Castles* (Cambridge: Cambridge University Press, 2001).

J-D. Lepage, *Castles and Fortified Cities of Medieval Europe: An Illustrated History* (Jefferson, N.C.: McFarland, 2002).

V. Mouilleron-Rouchon, *Vézelay: The Great Romanesque Church* (New York: Abrams, 1999).

S. Murray, *Building Troyes Cathedral* (Bloomington, Ind.: Indiana University Press, 1987).

E. Norman, *The House of God: Church Architecture, Style, and History* (New York: Thames and Hudson, 1990).

N. Nussbaum, *German Gothic Architecture* (New Haven, Conn.: Yale University Press, 2000).

A. Prache, *The Cathedrals of Europe* (Ithaca, N.Y.: Cornell University Press, 2000).

A. Quiney, *Town Houses of Medieval Britain* (New Haven, Conn.: Yale University Press, 2003).

J. Schofield, *Medieval London Houses* (New Haven, Conn.: Yale University Press, 1995).

R. Stalley, *Early Medieval Architecture* (Oxford: Oxford University Press, 1999).

O. von Simpson, *The Gothic Cathedral* (Princeton, N.J.: Princeton University Press, 1988).

J. White, *Art and Architecture in Italy 1250–1400* (Harmondsworth, England: Penguin, 1987).

N. Wu, ed., *Ad Quadratum: The Practical Application of Geometry to Medieval Architecture* (Aldershot, England: Ashgate, 2002).

DANCE

I. Brainard, *The Art of Courtly Dancing in the Early Renaissance* (West Newton, Mass.: Brainard, 1981).

S. Cohen, ed., *The International Encyclopedia of Dance*. 6 vols. (New York: Oxford University Press, 1998).

T. McGee, *Medieval Instrumental Dances* (Bloomington, Ind.: University of Indiana Press, 1989).

W. Prevenier and W. Blockmans, *The Burgundian Netherlands* (Cambridge: Cambridge University Press, 1986).

C. Sachs, *World History of the Dance* (New York: W. W. Norton, 1963).

S. Sadie and J. Tyrell, eds., *The New Grove Dictionary of Music and Musicians*. 2nd ed. 29 vols. (New York: Grove's Dictionaries, 2001).

FASHION

F. Baldwin, *Sumptuary Legislation and Personal Regulation in England* (Baltimore: Johns Hopkins University Press, 1926).

M. Barber, *The New Knighthood* (Cambridge: Cambridge University Press, 1994).

W. Bonds, "Genoese Noblewomen and Gold Thread Manufacturing," *Mediaevalia et Humanistica* 17 (1966): 79–81.

F. Boucher, *20,000 Years of Fashion: The History of Costume and Personal Adornment* (New York: Abrams, 1987).

J. Bradbury, *The Routledge Companion to Medieval Warfare* (New York: Routledge, 2004).

G. Brault, *Early Blazon: Heraldic Terminology in the Twelfth and Thirteenth Centuries with Special Reference to Arthurian Literature* (Oxford: Clarendon Press, 1972).

E. J. Burns, *Courtly Love Undressed: Reading Through Clothes in Medieval Culture* (Philadelphia: University of Pennsylvania Press, 2002).

K. Clark, *The Nude: A Study in Ideal Form* (New York: Doubleday, 1956).

C. Cunnington and C. Beard, *A Dictionary of English Costume* (London: Adam and Charles Black, 1960).

C. Cunnington and P. Cunnington, *The History of Underclothes* (London: Michael Joseph, 1951).

G. Egan and F. Pritchard, *Dress Accessories 1150–1450* (Woodbridge, Suffolk, England: Boydell, 2002).

A. Hunt, *Governance of the Consuming Passions: A History of Sumptuary Law* (New York: St. Martins, 1996).

D. Jacoby, "Silk in Italy," in *Medieval Italy: An Encyclopedia*. Ed. C. Kleinhenz (New York: Routledge, 2004): 1046–1048.

D. Jenkins, ed., *The Cambridge History of Western Textiles* (Cambridge: Cambridge University Press, 2003).

M. Jones, *The Secret Middle Ages* (Thrupp, Stroud, Gloucestershire: Sutton, 2002).

C. Killerby, *Sumptuary Law in Italy, 1200–1500* (Oxford: Clarendon Press, 2002).

D. Koslin and J. Snyder, eds., *Encountering Medieval Textiles and Dress* (New York: Palgrave, 2002).

G. Lipovetsky, *The Empire of Fashion: Dressing Modern Democracy.* Trans. Catherine Porter (Princeton, N.J.: Princeton University Press, 1994).

P. Martin, *Arms and Armor from the 8th to the 17th Century* (Rutland, Vt.: Tuttle, 1968).

J. Mayo, *A History of Ecclesiastical Dress* (London: Batsford, 1984).

D. Nicolle, *Arms and Armor of the Crusading Era, 1050–1350.* 2 vols. (White Plains, N.Y.: Kraus, 1988).

————, *Companion to Medieval Arms and Armour* (Woodbridge, Suffolk, England: Boydell, 2002).

A. Oakes and M. Hill, *Rural Costume; Its Origins and Development in Western Europe and the British Isles* (London: Batsford, 1970).

G. Owen-Crocker, *Dress in Anglo-Saxon England* (Woodbridge, Suffolk, England: Boydell and Brewer, 2004).

F. Piponnier and P. Mane, *Dress in the Middle Ages* (New Haven, Conn.: London: Yale University Press, 1997).

A. Racinet, *Illustrated History of European Costume.* Ed. and trans. P. Vance (London: Collins & Brown, 2000).

M. Scott, *A Visual History of Costume: The Fourteenth and Fifteenth Centuries* (London: Batsford, 1986).

S. Slater, *Complete Book of Heraldry* (New York: Hermes House, 2003).

M. Warner, *Joan of Arc: The Image of Female Heroism* (Berkeley, Calif.: University of California Press, 1981).

LITERATURE

P. Acker and C. Larrington, eds., *The Poetic Edda; Essays on Norse Mythology* (New York: Routledge, 2002).

P. Baker, ed., *The Beowulf Reader* (New York: Garland, 2001).

R. Barber, *Legends of Arthur* (Woodbridge, Suffolk, England: Brewer, 2003).

M. Bowden, *A Reader's Guide to Geoffrey Chaucer* (Syracuse, N.Y.: Syracuse University Press, 2001).

D. Brewer, *The World of Chaucer* (Woodbridge, Suffolk, England: Brewer, 2000).

P. Brown, ed., *A Companion to Chaucer* (Oxford: Blackwells, 2002).

J. Carney, *Studies in Irish Literature and History* (Dublin: Dublin Institute for Advanced Studies, 1979).

C. Chism, *Alliterative Revivals* (Philadelphia, Pa.: Pennsylvania University Press, 2002).

R. Correale, ed., *Sources and Analogues of the Canterbury Tales* (Woodbridge, Suffolk, England: Brewer, 2003).

J. Crosland, *The Old French Epic* (New York: Haskell House, 1971).

M. Lida de Malkiel, *Two Spanish Masterpieces: The Book of Good Love and the Celestina* (Urbana, Ill.: University of Illinois Press, 1961).

P. Dronke, *Women Writers of the Middle Ages* (Cambridge: Cambridge University Press, 1984).

J. Duggan, *The Romances of Chrétien de Troyes* (New Haven, Conn.: Yale University Press, 2001).

K. Figg, ed., *Jean Froissart: An Anthology of Narrative and Lyric Poetry* (New York and London: Routledge, 2001).

R. Flower, *The Irish Tradition* (Oxford: Clarendon Press, 1978).

B. Fowler, ed., *Medieval Irish Lyrics* (Notre Dame, Ind.: University of Notre Dame Press, 2000).

W. Gerritsen and A. Van Melle, *A Dictionary of Medieval Heroes* (Woodbridge, Suffolk, England: Boydell, 2000).

M. Gibbs and S. Johnson, *Medieval German Literature: A Companion* (New York: Garland, 1997).

D. Green, *The Beginnings of Medieval Romance* (Cambridge: Cambridge University Press, 2002).

J. Grimbert, ed., *Tristan and Isolde: A Casebook* (New York: Routledge, 2002).

A. Gunn, *The Mirror of Love: A Reinterpretation of the "Romance of the Rose"* (Lubbock, Tex.: Texas Tech Press, 1952).

P. Hardman, ed., *The Matter of Identity in Medieval Romance* (Woodbridge, Suffolk, England: Brewer, 2002).

L. Hawood and L. Vasvari, eds., *A Companion to the "Libro de Buon amor"* (London: Tamesis, 2004).

U. Holmes, *A History of Old French Literature from the Origins to 1300* (New York: Russell and Russell, 1962).

K. Jackson, *Studies in Early Celtic Nature Poetry* (Felinfach, Ireland: Llanerch, 1995).

E. Kennedy, ed., *King Arthur: A Casebook* (New York: Routledge, 2002).

E. Knott and G. Murphy, *Early Irish Literature* (New York: Barnes & Noble, 1966).

R. Krueger, *The Cambridge Companion to Medieval Romance* (Cambridge: Cambridge University Press, 2000).

C. S. Lewis, *The Allegory of Love: A Study of Medieval Tradition* (London: Oxford University Press, 1973).

E. Macdonald, *Juan Ruiz; The Book of Good Love* (London; Rutland, Vt.: Dent and Tuttle, 1999).

C. Marshall, *William Langland: Piers Plowman* (Tavistock, Devon: Northcote, 2001).

B. Murdoch, ed., *German Literature of the Early Middle Ages* (Woodbridge, Suffolk, England: Boydell and Brewer, 2004).

R. O'Connor, *Icelandic Histories and Romances* (London: Tempus, 2002).

A. Orchard, *A Critical Companion to Beowulf* (Woodbridge, Suffolk, England: Boydell and Brewer, 2004).

P. Pulsiano and E. Treharne, eds., *A Companion to Anglo-Saxon Literature* (Oxford: Blackwells, 2001).

P. Rickard, *Britain in Medieval French Literature 1100–1500* (New York: Kraus, 1968).

E. Simon, *Neidhart von Reuental* (Boston: Twayne, 1975).

C. Snyder, *Exploring the World of King Arthur* (London: Thames and Hudson, 2000).

D. Wallace, ed., *The Cambridge History of Medieval English Literature* (Cambridge: Cambridge University Press, 2002).

MUSIC

E. Aubrey, *The Music of the Troubadours* (Bloomington, Ind.: Indiana University Press, 1996).

N. Bell, *Music in Medieval Manuscripts* (London: British Library, 2001).

A. Butterfield, *Poetry and Music in Medieval France* (Cambridge: Cambridge University Press, 2003).

E. Dillon, *Medieval Music Making and the "Roman de Fauvel"* (Cambridge: Cambridge University Press, 2002).

R. Duffin, ed., *A Performer's Guide to Medieval Music* (Bloomington, Ind.: Indiana University Press, 2000).

W. Flynn, "Medieval Music as Medieval Exegesis," *Studies in Liturgical Musicology.* No. 8 (Lanham, Md.; London: Scarecrow Press, 1999).

D. Hiley, *Western Plainchant* (Oxford: Clarendon Press, 1993).

R. Hoppin, *Medieval Music* (New York: W. W. Norton, 1978).

A. Hughes, "Charlemagne's Chant or the Great Vocal Shift," *Speculum* 77 (2002): 1069–1106.

———, *Medieval Manuscripts for Mass and Office: A Guide to Their Organization and Terminology* (Toronto and London: University of Toronto Press, 1982).

———, *Style and Symbol: Medieval Music: 800–1453* (Ottawa: Institute of Mediaeval Music, 1989).

E. Leach, ed., *Machaut's Music: New Interpretations* (Woodbridge, Suffolk, England: Boydell and Brewer, 2004).

T. McGee, *Medieval and Renaissance Music: A Performer's Guide* (Toronto: University of Toronto Press, 1985).

———, *The Sound of Medieval Song* (Oxford: Clarendon Press, 1998).

D. Munrow, *Instruments of the Middle Ages and Renaissance* (Oxford: Oxford University Press, 1976).

C. Page, *Voices and Instruments of the Middle Ages: Instrumental Practice and Songs in France 1100–1300* (London: J. M. Dent & Sons, 1987).

K. Polk, *German Instrumental Music of the Late Middle Ages* (Cambridge: Cambridge University Press, 1992).

S. Sadie and J. Tyrrell, eds., *The New Grove Dictionary of Music and Musicians.* 2nd ed. 29 vols. (New York: Grove's Dictionaries, 2001).

J. Stevens, *Words and Music.* Chapter 5 (Cambridge: Cambridge University Press, 1986).

R. Strohm, *Music in Late Medieval Bruges* (Oxford: Clarendon, 1965).

———, *The Rise of European Music, 1380–1500* (Cambridge: Cambridge University Press, 1993).

R. Strohm and B. Blackburn, eds., *Music as Concept and Practice in the Late Middle Ages.* The New Oxford History of Music 3.1 (Oxford: Oxford University Press, 2001).

L. Treitler, "Reading and Singing: On the Genesis of Occidental Music-Writing," *Early Music History* 4 (1984): 135–208.

N. van Deusen, ed., *The Cultural Milieu of the Troubadours and Trouvères* (Ottawa, Canada: Institute of Mediaeval Music, 1994).

——, *The Harp and the Soul: Essays in Medieval Music* (Lewiston, New York: Mellen, 1989).

D. Wilson, *Music of the Middle Ages* (New York: Schirmer Books, 1990).

J. Yudkin, *Music in Medieval Europe* (Englewood Cliffs, N.J.: Prentice Hall, 1989).

PHILOSOPHY

R. Arnaldez, *Averroës: A Rationalist in Islam* (Notre Dame, Ind.: Notre Dame University Press, 2000).

J. Brower and K. Guilfoy, èds., *The Cambridge Companion to Abelard* (Cambridge: Cambridge University Press, 2004).

M. Clanchy, *Abelard: A Medieval Life* (Oxford: Blackwell, 1997).

A. Cobban, *Medieval Universities* (London: Methuen, 1975).

M. Colish, *Medieval Foundations of the Western Intellectual Tradition 400–1400* (New Haven, Conn.: Yale University Press, 1997).

F. Copleston, *A History of Medieval Philosophy* (London: Methuen & Co., 1972).

E. Gilson, *History of Christian Philosophy in the Middle Ages* (New York: Random House, 1955).

J. Gracia and T. Noone, eds., *A Companion to Philosophy in the Middle Ages* (London: Blackwell, 2003).

E. Grant, *God and Reason in the Middle Ages* (Cambridge: Cambridge University Press, 2001).

A. Hyman and J. Walsh, eds., *Philosophy in the Middle Ages; The Christian, Islamic, and Jewish Traditions* (Indianapolis, Ind.: Hackett Publishing Co., 1987).

D. Knowles, *The Evolution of Medieval Thought* (Toronto: Longmans, Green and Co., 1962).

N. Kretzmann, et al., eds., *The Cambridge History of Later Medieval Philosophy from the Rediscovery of Aristotle to the Disintegration of Scholasticism 1100–1600* (New York: Cambridge University Press, 1982).

G. Leff, *Medieval Thought; St. Augustine to Ockham* (Baltimore, Md.: Penguin, 1958).

J. Marenbon, *Aristotelian Logic, Platonism and the Context of Early Medieval Philosophy in the West* (Aldershot: Ashgate/Variorum, 2000).

——, *The Philosophy of Peter Abelard* (Cambridge: Cambridge University Press, 1997).

A. Maurer, *Medieval Philosophy* (Toronto: Pontifical Institute of Mediaeval Studies, 1982).

A. McGrade, ed., *The Cambridge Companion to Medieval Philosophy* (Cambridge: Cambridge University Press, 2003).

R. Pasnau, ed., *The Cambridge Translations of Medieval Philosophical Texts.* Vol. 3, *Mind and Knowledge* (Cambridge: Cambridge University Press, 2002).

B. Radice, ed., *The Letters of Abelard and Heloise* (Harmondsworth, Middlesex, England: Penguin, 1974).

A. Schroedinger, ed., *Readings in Medieval Philosophy* (Oxford: Oxford University Press, 1996).

H. Shapiro, ed., *Medieval Philosophy; Selected Readings from Augustine to Buridan* (New York: Random House, 1964).

C. Sirat, *A History of Jewish Philosophy in the Middle Ages* (Cambridge: Cambridge University Press, 1990).

R. Southern, *Robert Grosseteste; The Growth of an English Mind in Medieval Europe* (Oxford and New York: Clarendon Press, 1992).

——, *Scholastic Humanism and the Unification of Europe* (Oxford: Blackwell, 1995).

E. Stump and N. Kretzmann, eds., *The Cambridge Companion to Augustine* (Cambridge: Cambridge University Press, 2001).

P. Vignaux, *Philosophy in the Middle Ages; An Introduction.* Trans. E. Hall (New York: World Publishing Company, 1959).

RELIGION

C. Berman, *Cistercian Evolution* (Philadelphia, Pa.: University of Pennsylvania Press, 2000).

R. Brooke and C. Brooke, *Popular Religion in the Middle Ages* (London: Thames and Hudson, 1984).

M. Bull, et al., eds., *The Experience of Crusading.* (Cambridge: Cambridge University Press, 2003).

A. Burl, *God's Heretics: The Albigensian Crusade* (Thrupp, Stroud, Gloucestershire: Sutton, 2002).

P. Brown, *The Rise of Western Christendom: Triumph and Diversity, A.D. 200–1000* (Oxford: Blackwell, 2003).

M. Carver, ed., *The Cross Goes North: Processes of Conversion in Northern Europe, AD 300–1300* (York, England: York Medieval Press, 2003).

R. Chazan, ed., *Church, State and Jew in the Middle Ages* (New York: Behrman House, 1980).

T. Davis, *Saint Bernard of Clairvaux: A Monastic View of Medieval Violence* (New York: McGraw-Hill, 1998).

G. Dickson, *Religious Enthusiasm in the Medieval West* (Aldershot, England: Ashgate, 2000).

M. Dunn and L. Davidson, eds., *The Pilgrimage to Compostela in the Middle Ages* (New York: Routledge, 2000).

F. Dvornik, *Byzantium and the Roman Primacy* (New York: Fordham University Press, 1979).

L. Fine, ed., *Judaism in Practice from the Middle Ages through the Early Modern Period* (Princeton, N.J.: Princeton University Press, 2001).

S. Flanagan, *Hildegarde of Bingen* (New York: Routledge, 1998).

T. Heffernan and E. A. Matter, eds., *The Liturgy of the Medieval Church* (Kalamazoo, Mich.: Medieval Institute Publications, 2001).

W. Hinnebusch, *The History of the Dominican Order: Origin and Growth to 1500* (Staten Island, N.Y.: Alba House, 1973).

J. Hussey, *The Orthodox Church in the Byzantine Empire* (Oxford: Oxford University Press, 1986).

H. Kessler and J. Zacharias, *Rome 1300: On the Path of the Pilgrims* (New Haven, Conn.: Yale University Press, 2000).

M. Lambert, *Medieval Heresy* (Oxford: Basil Blackwell, 2002).

C. Lawrence, *Medieval Monasticism: Forms of Religious Life in Western Europe in the Middle Ages* (Harlow, England; New York: Longman, 2001).

F. D. Logan, *A History of the Church in the Middle Ages* (New York: Routledge, 2002).

C. Mango, ed., *Oxford History of Byzantium* (Oxford: Oxford University Press, 2002).

J. Moorman, *A History of the Franciscan Order: From Its Origins to the Year 1517* (Chicago, Ill.: Franciscan Herald Press, 1988).

S. Murk-Jansen, *Brides in the Desert: Spirituality of the Beguines* (Maryknoll, N.Y.: Orbis Books, 1998).

B. Newman, *Voice of the Living Light: Hildegarde of Bingen and Her World* (Berkeley, Calif.: University of California Press, 1998).

H. Nicholson, *The Knights Hospitaller* (Woodbridge, Suffolk, England: Boydell and Brewer, 2004).

———, *The Knights Templar* (Thrupp, Stroud, Gloucestershire: Sutton, 2002).

Y. Renouard, *The Avignon Papacy: Popes in Exile 1305–1403* (New York: Barnes and Noble, 1994).

J. Richard, *Louis IX; Crusader King of France.* Trans. Jean Birrell (Cambridge: Cambridge University Press, 1992).

S. Ridyard, ed., *The Medieval Crusade* (Woodbridge, Suffolk, England: Boydell and Brewer, 2004).

J. Riley-Smith, *The Oxford Illustrated History of the Crusades* (Oxford: Oxford University Press, 2001).

Norman Roth, ed., *Medieval Jewish Civilization: An Encyclopedia* (New York: Routledge, 2003).

W. Scheepsma, *Medieval Religious Women in the Low Countries: The "Modern Devotion": The Canonesses of Windesheim and Their Writings* (Woodbridge, Suffolk, England: Boydell and Brewer, 2004).

W. Simons, *Cities of Ladies: Beguine Communities in the Medieval Low Countries, 1200–1565* (Philadelphia, Pa.: University of Pennsylvania Press, 2001).

R. Swanson, *Universities, Academics and the Great Schism* (Cambridge: Cambridge University Press, 1979).

C. Trinkaus and H. Oberman, *The Pursuit of Holiness in Late Medieval and Early Renaissance Religion* (Leiden, Netherlands: Brill, 1974).

C. Tyerman, *The Invention of the Crusades* (Toronto: University of Toronto Press, 1998).

J. Van Engen, *Devotio Moderna* (New York: Paulist Press, 1988).

A. Vauchez, *The Laity in the Middle Ages* (Notre Dame, Ind.: University of Notre Dame Press, 1993).

B. Venarde, *Women's Monasticism and Medieval Society* (Ithaca, N.Y.: Cornell University Press, 1997).

D. Webb, *Medieval European Pilgrimage 700–1500* (New York: Palgrave Publishing, 2002).

THEATER

K. Bate, "Twelfth-Century Latin Comedies and the Theatre," *Papers of the Liverpool Latin Seminar*. Ed. F. Cairns. Vol. 2, ARCA Classical and Medieval Texts, Papers, and Monographs 3 (1979): 249–262.

C. Burnett and P. Dronke, eds., *Hildegard of Bingen: The Context of Her Thought and Art*. Warburg Institute Colloquia 4 (London: Warburg Institute, 1998).

J. Cox, *The Devil and the Sacred in English Drama, 1350–1642* (Cambridge: Cambridge University Press, 2000).

C. Davidson, ed., *Material Culture and Medieval Drama*. Medieval Institute Publications: Early Drama, Art, and Music Monograph Series 25 (Kalamazoo, Mich.: Western Michigan University, 1999).

R. Emmerson, "Divine Judgment and Local Ideology in the Beauvais *Ludus Danielis*," in *The Play of Daniel: Critical Essays*. Ed. D. Ogden. Early Drama, Art, and Music Monograph Series, no. 24 (Kalamazoo, Mich.: Western Michigan University, 1996): 33–61.

J. Enders, *Rhetoric and the Origins of Medieval Drama* (Ithaca, N.Y.: Cornell University Press, 1992).

M. Fassler, "The Feast of Fools and *Danielis ludus*: Popular Tradition in a Medieval Cathedral Play," in *Plainsong in the Age of Polyphony*. Ed. T. Kelly. Cambridge Studies in Performance Practice no. 2 (Cambridge: Cambridge University Press, 1992): 65–99.

A. Haight, ed., *Hroswitha of Gandersheim: Her Life, Times, and Works, and a Comprehensive Bibliography* (New York: privately printed, 1965).

A. Hindley, ed., *Drama and Community: People and Plays in Medieval Europe*. Medieval Texts and Cultures of Northern Europe 1 (Turnhout, Belgium: Brepols, 1999).

G. Kipling, *Enter the King: Theatre, Liturgy, and Ritual in the Medieval Civic Triumph* (Oxford: Clarendon Press, 1998).

T. McGee, ed., *Improvisation in the Arts of the Middle Ages and Renaissance*. Medieval Institute Publications: Early Drama, Art, and Music Monograph Series no. 30 (Kalamazoo, Mich.: Western Michigan University, 2003).

B. Newman, ed., *Voice of the Living Light: Hildegard of Bingen and Her World* (Berkeley and Los Angeles: University of California Press, 1998).

D. Ogden, *The Staging of Drama in the Medieval Church* (Newark, Del.: University of Delaware Press, 2003).

D. Pietropaolo, *The Science of Buffoonery: Theory and History of the Commedia dell'Arte*. University of Toronto Italian Studies no. 3 (Ottawa: Dovehouse Editions, 1989).

P. Ruggiers, ed., *Versions of Medieval Comedy* (Norman, Okla.: University of Oklahoma Press, 1977).

E. Simon, ed., *The Theatre of Medieval Europe: New Research in Early Drama* (Cambridge: Cambridge University Press, 1991).

C. Symes, "The Appearance of Early Vernacular Plays: Forms, Functions, and Future of Medieval Theatre," *Speculum* 77 (2002): 778–831.

W. Tydemann, ed., *The Medieval European Stage, 500–1550* (Cambridge: Cambridge University Press, 2001).

G. Wickham, *The Medieval Theatre* (Cambridge: Cambridge University Press, 1987).

W. Willeford, *The Fool and His Sceptre: A Study in Clowns and Jesters and Their Audience* (Evanston, Ill.: Northwestern University Press, 1969).

VISUAL ARTS

J. Backhouse, *The Illuminated Page* (Toronto: University of Toronto Press, 1997).

C. Barber, *Figure and Likeness: On the Limits of Representation in Byzantine Iconoclasm* (Princeton, N.J.: Princeton University Press, 2002).

L. Bourdue, *The Franciscans and Art Patronage in Late Medieval Italy* (Cambridge: Cambridge University Press, 2004).

B. Cardon, et al., eds., *Medieval Mastery; Book Illumination from Charlemagne to Charles the Bold 800–1475* (Turnhout, Belgium: Brepols, 2002).

J. Friedman, *The Monstrous Races in Medieval Art and Thought* (1981; rpt. Syracuse, N.Y.: Syracuse University Press, 2000).

N. Kline, *Maps of Medieval Thought* (Woodbridge, Suffolk: Boydell, 2001).

M. Lillich, *The Armor of Light: Stained Glass in Western France* (Berkeley, Calif.: University of California Press, 1994).

A. Martindale, *Gothic Art from the Twelfth to the Fifteenth Centuries* (New York: Praeger, 1967).

D. Pearsall, *Gothic Europe 1200–1450* (Harlow, England; New York: Longman, 2001).

V. Sekules, *Medieval Art* (Oxford: Oxford University Press, 2001).

V. Sève-Minne and H. Kergail, *Romanesque and Gothic France: Art and Architecture* (New York: Abrams, 2000).

MEDIA AND ONLINE SOURCES

GENERAL

The Labyrinth: Resources for Medieval Studies (http://labyrinth.Georgetown.edu)—Produced by Georgetown University, this is one of the best resources, growing all the time, for materials about texts and culture in all languages of Medieval Europe. It contains a multitude of links to other sites about various medieval authors, online texts and translations of medieval literary works, related visual images, and other materials that bring the Middle Ages to life for students, whether beginners or advanced.

The ORB: On-Line Reference Book for Medieval Studies (http://the-orb.net)—This comprehensive site features a general compendium of resources, textual and otherwise, for the study of the Middle Ages, including electronic texts and translations, an encyclopedia of terms, and links to other important sites about medieval European culture.

ARCHITECTURE

Amiens Cathedral: An Animated Glossary (http://www.learn .columbia.edu/amiens_flash/)—Produced by the Media Center for Art History, Archæology & Historic Preservation at Columbia University in New York City, this useful beginners-level site matches the cathedral's ground plan and elevation to key terms in architecture. Clicking on a term causes the appropriate area on the diagram to be highlighted, and vice versa.

Cathedrals: Notre Dame to the National Cathedral, A&E, 50 minutes, 1995. VHS Media for the Arts #AAE95010—

This video explores the engineering feats (some of which have not changed in 900 years) involved in creating Gothic cathedrals.

A Digital Archive of Architecture (http://www.bc.edu/bc_ org/avp/cas/fnart/arch/contents_europe.html)—This site was created by Professor Jeffery Howe at Boston College. Images include Romanesque cathedrals, Gothic cathedrals, medieval fortifications, rural architecture, and half-timbered houses, with special attention to Belgian architecture, including Bruges.

The Great Cathedral at Amiens, VHS or DVD. Films for the Humanities & Sciences, 29 minutes color, #JEY11430— Looking at both the history and the engineering of one of the monumental achievements of the High Gothic period, this film examines a thirteenth-century cathedral that stands 140 feet high, is virtually all windows, and could accommodate 10,000 people.

The Jeweled City: The Cathedral of Chartres, BBC. Text written and narrated by Professor Christopher Frayling. 50 minutes color, 1995. Films for the Humanities & Sciences #JEY7624—This documentary is a narrated tour of the cathedral, a masterpiece of Gothic architecture built between 1150 and 1220, with commentary on the religious and political sentiments of the time. It is one of five films in a series now entitled *The Medieval Mind* but originally called *Strange Landscape: The Illumination of the Middle Ages.*

The Lost Medieval Village (http://loki.stockton.edu/~ken/ wharram/wharram.htm)—This site about the lost village of Wharram Percy contains descriptions and artist's renderings of both peasant houses and manor houses

from a long-deserted village in northern England as it was in the thirteenth century.

Notre Dame: Cathedral of Amiens, Media Center for History, Columbia University, 2 vol., 1997. VHS Media for the Arts Series #CP6152—This two-part high-tech architectural video describes the thirteenth-century construction of Amiens Cathedral.

Walls Of Light: The History of Stained Glass, VHS, 85 minutes, 1997. Media for the Arts #CP6153—This is a documentary on the history of stained and leaded glass from its beginnings in the Middle East 5,000 years ago up to the exciting works of today's artists. Rare pieces are included from locations in five continents.

DANCE

A L'Estampida: Medieval Dance Music. Dufay Collective. Audio CD Avie #AV0015. ASIN: B00008LJGB—This CD recording, released in August 2003, offers examples of several estampies and saltarellos, including the Robertsbridge Codex estampie and "La Rotta."

Chevrefoil, Istanpitta Medieval Music Ensemble. Audio CD. Avatar Music.—Besides including the complete text of *Chevrefoil* by the Anglo-French twelfth-century poet Marie de France, this CD made by a Texas-based early music group includes examples of an estampie, a salterello, and the ballo "Petit Vriens," performed on oud, saz, medieval bagpipes, recorder, vielle, Gothic harp, and long tabors.

The Library of Congress page on Burgundian Dance in the Late Middle Ages (http://lcweb2.loc.gov/ammem/dihtml/diessay1.html)—This site discusses the history of western social dance.

Medieval Dance Picture Collection (http://www.uni-mainz .de/~khoppe/sammlung/)—This repository includes images of medieval dance, including manuscripts, wall-paintings, sculpture, and photos of modern performances.

Music of the Troubadours, Ensemble Unicorn and Ensemble Oni Wytars. Dir. Michael Posch and Marco Ambrosini. Naxos 8554257—Songs in French and Provençal are sung by a female voice with instrumental accompaniment.

FASHION

Circa: 1265, Male Clothing and Armor (http://www.bumply .com/Medieval/Kit/kit.htm)—This site, designed to give information for historical re-enactors, provides

detailed descriptions and drawings of each piece of medieval male clothing, along with photographs of modern reproductions and links to thirteenth-century source images.

Extant Clothing of the Middle Ages (http://www.virtue.to/ articles/extant.html)—This site, assembled by Cynthia du Pré Argent, contains photographs and descriptions of complete garments, generally earlier than 1500, which are preserved in museums. It includes men's and women's clothing, jewelry, and shoes.

Footwear of the Middle Ages (http://www.personal.utulsa.edu/ ~marc-carlson/shoe/SHOEHOME.HTM)—This site examines the history and development of footwear and shoemaking techniques up to the end of the sixteenth century. Includes discussion and illustrations of particular shoe types, such as turned shoes, pattens, clogs, and long-toed shoes, as well as details about shoe decorations, tools and techniques, and methods of construction. It provides detailed instructions and patterns for making shoes, as well as a bibliography of research about them.

Historical Clothing from Archaeological Finds (http://www .personal.utulsa.edu/~marc-carlson/cloth/bockhome .html)—This document is intended to be a cursory examination, for people interested in historical recreation and replication, of the extant archaeological and museum materials relating to clothing in the Middle Ages, with images redrawn by the author. It covers all the basic garments—kirtles, cotes, tunics, gowns, chemises, smocks, etc.—as well as hoods, hats, hose, shoes, and weaving and spinning.

Index of Resources: Skin Out (http://www.maisonstclaire .org/resources/skin_out/)—This index of costume resources, prepared for re-enactors, provides access to an excellent collection of actual manuscript miniatures illustrating all aspects of male and female costume. Most useful are the links called "Menswear," "Womenswear," "Skin Out," and "Bare Necessities," which illustrate each type of garment one by one.

LITERATURE

The Camelot Project at the University of Rochester (http://www .lin.Rochester.edu/Camelot/cphome.stm?CFID=890430 &CFTOKEN=5688408)—This compendium of resources having to do with the world of King Arthur, medieval Arthurian romance, and Arthurian medievalism includes links to electronic texts, visual images, and related websites. The Main Menu lists Arthurian characters, symbols, and sites; sub-menus direct visitors to basic information, texts, images, and a bibliography about that subject.

The Decameron. Dir. Pier Paolo Pasolini, Italian, subtitled, 1971, Water Bearer Films, 116 min., VHS and DVD.—An adaptation of eight stories of the hundred in Boccaccio's *Decameron*, this is part of the director's medieval trilogy, which included films of the *Arabian Nights* and Chaucer's *Canterbury Tales.* This film captures the earthy spirit of the Italian author's realism. Rated R.

The Decameron Web (http://www.brown.edu/Departments/Italian_Studies/dweb/dweb.shtml)—Sponsored by the Italian Department at Brown University, this site is an interlinked resource containing the text of Boccaccio's *Decameron* as well as many links to information about cultural contexts of Boccaccio's Italy and medieval Europe.

Gawain and the Green Knight. Dir. John Phillips, Thames Productions, 90 minutes, VHS and DVD, 1991. Films for the Humanities & Sciences FFH 3084.—This feature film is an extraordinarily faithful cinematic rendering of the Middle English romance *Sir Gawain and the Green Knight.* Phillips succeeds in getting settings, costumes, the material culture of the feast and hunt scenes accurate for the period, and the depiction of the human-monstrous Green Knight surpasses other earlier film versions such as Stephen Weks's *Sword of the Valiant.*

Excalibur. Dir. John Boorman, Orion, 141 minutes, VHS and DVD, 1981.—This feature film, though it claims to be based on Malory's *Morte D'Arthur*, actually better reflects the vast thirteenth-century *Vulgate Cycle* of Arthurian romances, including major treatments of not only all aspects of Arthur's life, but also Perceval's Grail Quest and the activities of such important Arthurian characters as Merlin, Morgan le Faye, Guinevere, Lancelot, and Mordred. Boorman's film is noted for its epic sweep and its employment of a mythic perspective to the legend. Rated R.

The Harvard Chaucer Page (http://www.courses.fas.Harvard.edu/~chaucer)—Sponsored by Harvard University, this site offers a multitude of materials to enhance the study of Chaucer's texts and his cultural milieu both in England and on the Continent.

Lancelot of the Lake. Dir. Robert Bresson, French, subtitled, 1974, New Yorker Video, VHS and DVD—A dark, de-romanticized cinematic version of the Arthurian legend, particularly the Grail Quest and the romance between Guinevere and Lancelot, very different from Boorman's grand epic treatment or Bresson's simplicity and stylization. Rated PG.

The Middle English Collection at the Electronic Text Center, University of Virginia (http://etext.lib.Virginia.edu/mideng.browse.html)—This site features electronic texts of most major works of Middle English Literature, including those by Geoffrey Chaucer, John Gower, the Gawain-poet, and William Langland.

Perceval (also titled *Perceval le Gallois*). Dir. Eric Rohmer, Fox Lorber, 141 minutes, French with English subtitles, VHS and DVD, 1979—This feature film is an extraordinarily faithful cinematic rendering of Chrétien de Troyes's romance about the Grail Quest, *Perceval.* Rohmer's visual direction is very stylized, achieving an effect of having twelfth-century manuscript illuminations come to life.

MUSIC

The Age of Cathedrals: Music from the Magnus Liber Organi. Theatre of Voices. Dir. Paul Hillier. Harmonia Mundi France 907157—This 1996 CD includes anonymous works, as well as works by such composers as Leonin and Perotin, documenting the emergence of polyphony. The disc comes with a deluxe set of notes, including texts, translations, and color photographs of the manuscript basis of the music.

Ancient Voices: Vox sacra. Anonymous 4, Ensemble Organum, Marcel Pérès, Soeur Marie Keyrouz. Harmonia mundi HMX 290 608—This collection presents a selection of masses, lyrics, sequences, antiphons, hymns, motets, and offices, as well as Byzantine, Maronite, and Melchite chant.

Chant: The Benedictine Monks of Santo Domingo de Silos. Dir. Ismael Fernandez de la Cuesta and Francisco Lara. EMI Angel 55138—In this 1994 recording, a twenty-man choir sings in the Solesmes style.

Early Music FAQ (http://www.medieval.org/emfaq/)—This website provides lists of recordings, biographies, discographies, and helpful short articles on such technical topics as "Pythagorean Tuning and Medieval Polyphony" and "Chord Structure in Medieval Music."

A Feather on the Breath of God: Sequences and Hymns by Abbess Hildegard of Bingen. Gothic Voices. Dir. Christopher Page. Hyperion 66039—This 1981 recording began the popularization of Hildegard's music, with performances alternating soloists and unison choir over a drone (bagpipes) or using a single unaccompanied voice. It is Hyperion's best-selling title.

The Gregorian Chant Home Page (http://www.music.princeton.edu/chant_html/)—Chant Research Sites listed include Medieval Music Theory Sites, Resources for Chant Performance, Other Chant Web Sites, and Web Sites Helpful for Chant Researchers.

A Guide to Medieval and Renaissance Instruments (http://www.s-hamilton.k12.ia.us/antiqua/instrumt.html)—

This website provides illustrations and short sound recordings to demonstrate 32 medieval instruments.

Malaspina Great Books (http://www.malaspina.com/site/ results_c5_p7_page1.htm)—This site offers biographies, bibliographies, and links on ten medieval composers.

Music of the Troubadours. Ensemble Unicorn and Ensemble Oni Wytars. Dir. Michael Posch and Marco Ambrosini. Naxos 8554257—Songs in French and Provençal are sung by a female voice with instrumental accompaniment.

Musica humana. Anonymous 4, Ruth Cunningham, and Marsha Genenski, et al. Dir. Brigitte Lesne and Marcel Pérès. Empreinte digitale (L') ED 13 047—This wide-ranging 1996 CD includes selections from Machaut and Ockeghem, as well as a variety of music from the Byzantine world and the Middle East.

My Fayre Ladye: Tudor Songs and Chant. Lionheart. Nimbus 5512—This 1997 CD performed by a male ensemble includes a number of types of late medieval English music, some based on the Eton choirbook. Texts and modern English translations are given.

Paschale Mysterium: Gregorian Chant for Easter. Aurora Surgit. Dir. Alessio Randon and Alberto Turco. Naxos 553697—This CD featuring a female vocal ensemble and solos by Alessio Randon takes chant from various eras to create a program for the Catholic Easter vigil.

The Recorder in Literature and Art (http://members.iinet .net.au/~nickl/fortune.html)—In a site entitled "A Pipe For Fortune's Finger: The Recorder in Literature and Art," Nicholas S. Lander presents a thorough history of the recorder from medieval to modern times, with a wealth of illustrations from medieval art, numerous literary references, and a list of bibliographical sources.

El Sabio: Songs for King Alfonso X of Castile and Leon (1221–1284). Sequentia. Deutsche Harmonia Mundi 77234—This 1991 CD includes songs mostly from the collection of over 400 *Cantigas de Santa Maria*, made for Alfonso X "The Wise."

Sumer is Icumen in: Medieval English Songs. Hilliard Ensemble. Dir. Paul Hillier. Harmonia Mundi 1951154—Songs are performed in Middle English, Middle French, and Latin, including secular and many religious lyrics.

PHILOSOPHY

EpistemeLinks.com (http://www.epistemelinks.com/Main/ Topics.aspx?TopiCode=Medi)—This site provides a collection of links to resources in medieval philosophy—a good source for information about philosophers from all periods, portraits, chat about matters of current philosophical interest, and hot buttons to other sites that provide lists of reference materials, books, academic departments, and special features, such as famous quotations.

Medieval Philosophy Texts Online (http://www.fred.net/ tzaka/medvtxt.html)—An excellent source of various full and excerpted texts from the time period, this site also provides links to other websites on the medieval period.

Society for Medieval and Renaissance Philosophy (http:// www.lmu.edu/smrp/)—This site provides updated bibliographies (twice yearly) and other information of interest to historians of medieval philosophy.

Society for Medieval Logic and Metaphysics (http://www .fordham.edu/gsas/phil/klima/SMLM/index.htm)—This site provides links to professional societies and recent publications.

RELIGION

Becket. Dir. Peter Glenville, with Richard Burton and Peter O'Toole (1964)—This film depicts the relationship between the English king Henry II and his friend Thomas Becket. A serious conflict occurs when Becket, who is Henry's chancellor, accepts an appointment as the archbishop of Canterbury. Traditional elements of the medieval church-state rivalries are portrayed. Rated R.

Charlemagne and the Holy Roman Empire. Europe in the Middle Ages Series (1989), dist. Films for the Humanities & Sciences—This 31-minute color documentary depicts life at court as well as the Battle of Roncevaux; it ends with the critical church-state confrontation between Henry IV and Gregory VII.

Franciscan Authors, 13th–18th Century: A Catalogue in Progress (http://users.bart.nl/%7eroestb/franciscan/ index.htm)—This alphabetical list of Franciscan authors from the thirteenth century onwards includes biographies and information on miracles, manuscripts, editions, and studies.

Internet Medieval Sourcebook (www.fordham.edu/halsall/ sbook.html)—This general website on the Middle Ages includes countless links to topics concerning religion.

The Passion of Joan of Arc. Dir. Carl Theodor Dreyer, with Maria Falconetti and Eugene Silvain (1928)—A new boxed DVD collection includes this classic silent film, which has been digitally restored and enhanced by original orchestral work from Richard Einchorn's *Voices of*

Light. The music is performed with lines from actual texts of medieval women mystics by Anonymous 4 and soloist Susan Narucki. There are also interactive essays on the production of the film, a libretto booklet from Einchorn, and historical information on Joan's life. Much of the film was inspired by the transcripts of the trials of Joan, an early fifteenth-century teenage peasant girl who is called by heavenly voices to lead the French army against the English, subsequently captured by the Burgundians, and tried in a church court for heresy and witchcraft.

THEATER

European Medieval Drama in Translation (Steve Wright, Catholic University of America) (http://arts-sciences.cua.edu/engl/faculty/drama/index.cfm)—This site provides an online bibliography of published English translations of early European drama, including Latin, French, German, Italian, Dutch, Spanish, Cornish, Welsh, and Croatian.

Hildegard of Bingen, *Ordo virtutum.* Performed by Sequentia. Dir. Barbara Thornton and Benjamin Bagby. Deutsche Harmonia Mundi. 05472-77394-2—Recorded in the Basilica of Knechsteden, Germany, in June 1998, this two-CD set offers a full performance of the innovative twelfth-century musical drama *The Service of the Virtues.* Music ranges from the Soul's weary lament as she returns from her sojourn with the devil to the grunts and shouts of the devil himself, who cannot sing because music is heavenly.

Lo Gai Saber: Troubadours and Jongleurs, 1100–1300. Performed by Camerata Mediterranea. Dir. Joel Cohen. Erato 2292-45647-2—Among its 21 performances, this 1992 CD includes *Le jeu de Robin et de Marion* (The Play of Robin and Marion) by Adam de la Halle, as well as songs by famous troubadours, such as "Lancan vei la folha" by Bernart de Ventadorn and "Dirai vos senes duptansa" by Marcabru.

Ludus Danielis. Performed by the Harp Consort. Deutsche Harmonia Mundi. 05472-77395-2—Recorded in April 1997 at St. Bartholomew's Church, Oxford, this CD captures a live performance of a medieval "opera" (The Play of Daniel) from the 13th-century cathedral in Beauvais. Musical instruments include the vielle, the shawm, the gittern, the psaltery, and the medieval harp, lute, and drone organ.

The Medieval and Renaissance Drama Society (http://www.byu.edu/~hurlbut/mrds/mrds.html)—The site for this academic organization offers twice yearly news-letters and information about research opportunities.

Medieval Drama Links (University of Leeds) (http://collectorspost.com/Catalogue/medramalinks.htm)—This set of about 200 links, collected personally by Sydney Higgins, is most useful for its access to information on sets, props, and make-up, and to images of manuscripts (such as the *Jeu de Robin et de Marion*).

The Mysteries. Produced by the Royal National Theater of Great Britain. Heritage Theater Video Production/BBC. VHS 3904013—This work is a complete performance of a medieval play, recorded in September 2002.

The St. Albans Psalter (http://www.abdn.ac.uk/stalbanspsalter/)—This website includes an introduction to the story of the Psalter, as well as page-by-page photographs of this beautiful multi-colored document, with English transcription of the text printed alongside.

The Oberammergau Passion Play (http://www.passionsspiele2000.de/passnet/english/index_e.html)—This is the official site, including tourist information, for the German town where performances of their local medieval passion play have taken take place every ten years since 1634, with the next performance scheduled for 2010.

The Play of Daniel and *The Play of Herod.* Performed by New York Pro Musica. Dir. Noah Greenberg. MCA Classics. MCAD2-10102—This two-CD set offers a compilation of earlier recordings of the Play of Daniel at The Cloisters in New York City, January 1958 (40 minutes), and The Play of Herod from January 1964 (75 minutes). Both feature vocal and period musical performances, including the boy choristers of the Church of the Transfiguration, New York.

Poculi Ludique Societas—Medieval and Renaissance Players of Toronto (http://www.chass.utoronto.ca/~plspls/)—This site offers information on past, present, and future productions, with extensive archives of photos.

The York Cycle in York, England (http://www.yorkearlymusic.org/mysteryplays/index1.htm)—This official site for the York Early Music Foundation includes a history of the York Corpus Christi plays and video clips from the 1998 production.

The York Cycle in Toronto, Canada (1998) (http://arts-sciences.cua.edu/engl/toronto/york98.htm)—This record of the performance of the entire York cycle in Toronto in 1998 includes discussions of history, staging, and sources, as well as pictures from all 47 plays.

VISUAL ARTS

The Aberdeen Bestiary (http://www.clues.abdn.ac.uk:8080/bestiary_old/firstpag.html)—Sponsored by the University

of Aberdeen Library and Department of History of Art, this website offers a full set of digitized images from a medieval bestiary, a type of book that probably originated in Greece and that began to be produced in Britain by the twelfth century. The manuscript is organized as a collection of short descriptions of all sorts of animals, real and imaginary, birds and even rocks, accompanied by a moralizing explanation.

Corpus of Romanesque Sculpture in Britain and Ireland (http://www.crsbi.ac.uk/)—The first searchable digital archive of Romanesque British and Irish stone sculpture, this site is adding new data county by county to provide images and detailed descriptions from all locations representing the Romanesque period.

A Hypertext Book of Hours (http://members.tripod.com/~gunhouse/hourstxt/hrstoc.htm)—This site offers side-by-side Latin and English texts illustrating the structure and contents of a Book of Hours. It can be downloaded as a zip file and used off-line. The site also offers numerous links to sites with illuminated images from Books of Hours.

Medieval Illuminated Manuscripts (http://www.kb.nl/kb/manuscripts/)—Hosted by the National Library of the Netherlands, this site allows visitors to browse through the library's manuscripts, as well as to search by subject or by more specialized categories, such as scribe, miniaturist, language, and place of origin. Text is available in English, German, and French.

Timeline of Art History (http://www.metmuseum.org/toah/splash.htm)—Hosted by the New York Metropolitan Museum of Art, this site allows visitors to choose a spot on a timeline and a location on a world map to see images of individual works of art owned by the museum that represent the indicated time and place. Each work is carefully labeled and shown in the context of other objects from the same region and period.

Web Gallery of Art (http://gallery.euroweb.hu/welcome.html)—This website "contains over 11,600 digital reproductions of European paintings and sculptures created between the years 1150 and 1800" supplemented with commentary on their technique and history. The site has been online since 1996.

ACKNOWLEDGMENTS

The editors wish to thank the copyright holders of the excerpted material included in this volume and the permissions managers of many book and magazine publishing companies for assisting us in securing reproduction rights. Following is a list of the copyright holders who have granted us permission to reproduce material in this publication. Every effort has been made to trace copyrights, but if omissions have been made, please let us know.

COPYRIGHTED EXCERPTS IN ARTS AND HUMANITIES THROUGH THE ERAS: MEDIEVAL EUROPE WERE REPRODUCED FROM THE FOLLOWING BOOKS:

Anonymous. From "Dictatus Papae," in *The Crisis of Church of State 1050–1300.* Edited by Brian Tierney. Prentice-Hall, Inc., 1964. Copyright © 1964 by Prentice-Hall, Inc. Copyright renewed © 1992 by Brian Tierney. All rights reserved. Reproduced by permission of Simon & Schuster Adult Publishing Group.—Boniface VIII, Pope. From "Unam Sanctum, Papal Bull, November 1302," in *The Crisis of Church & State 1050–1300.* Edited by Brian Tierney. Prentice-Hall, Inc., 1964. Copyright © 1964 by Prentice-Hall, Inc. Copyright renewed © 1992 by Brian Tierney. Reproduced by permission of Simon & Schuster Adult Publishing Group.—Burkhart, Louise M. From *Holy Wednesday: A Nahua Drama from Early Colonial Mexico.* University of Pennsylvania Press, 1996. Copyright © 1996 by the University of Pennsylvania Press. All rights reserved. Reproduced by permission.—de Lorris, Guillaume and Jean de Meun. From "An Introduction" in *The Romance of the Rose.* E. P. Dutton & Co., Inc. 1962. Edited by Charles W. Dunn. Translated by Harry W. Robbins. Copyright © 1962 by Florence L. Robbins. Renewed 1990 by Penguin Books USA, Inc. Reproduced by permission of Dutton, a division of Penguin Group (USA) Inc.—Ebreo, Guglielmo. From "Rules for Women," in *De Pratica Seu Arte Tripudii: On the Practice or Art of Dancing.* Edited and translated by Barbara Sparti. Clarendon Press, 1993. Copyright © Barbara Sparti 1993. Reproduced by permission of Oxford University Press.—Elton, G. R. From "Dietrich von Nieheim (c. 1340–1418): The Union and Reform of the Church by a General Council (1410)," in *Renaissance and Reformation 1300–1648.* Edited by G. R. Elton. The Macmillan Company, 1963. Copyright © 1963 by The Macmillan Company. Copyright renewed © 1991 by G. R. Elton. Reproduced by permission of the Gale Group.—Grosseteste, Robert. From *On Light or The Beginning of Forms.* Translated by Clare C. Riedl. Milwaukee, WI: Marquette University Press, 1942, 1978. Reproduced by permission of Marquette University Press.—Nicholas II, Pope. From "The Legislation of 1059," in *The Crisis of Church and State 1050–1300.* Edited by Brian Tierney. Copyright © 1964 by Prentice-Hall, Inc. Copyright renewed © 1992 by Brian Tierney. All rights reserved. Reproduced by permission of Simon & Schuster Adult Publishing Group.—Peters, Edward. From "Quantum Praedecessores Nostri, 1146," in *The First Crusade, The Chronicles of Fulcher of Chartres and Other Source Materials.* Edited by Edward Peters. University of Pennsylvania Press, 1971. Reproduced by permission.—Photius. From "Homily XVII," in *The Early Middle Ages 500–1000.* Edited by Robert Brentano. Free Press of Glencoe, 1964. Reproduced by permission of The Gale Group.

INDEX